Media Literacy

PETER LANG
New York • Washington, D.C./Baltimore • Bern
Frankfurt am Main • Berlin • Brussels • Vienna • Oxford

Media Literacy

A Reader

Edited by
Donaldo Macedo & Shirley R. Steinberg

PETER LANG
New York • Washington, D.C./Baltimore • Bern
Frankfurt am Main • Berlin • Brussels • Vienna • Oxford

Library of Congress Cataloging-in-Publication Data

Media literacy: a reader / edited by Donaldo Macedo, Shirley R. Steinberg.
p. cm.
Includes bibliographical references.
1. Media literacy. I. Macedo, Donaldo P. (Donaldo Pereira).
P96.M4M45 302.23—dc22 2006101077
ISBN: 978-0-8204-9726-6 (hardcover)
ISBN: 978-0-8204-8668-0 (paperback)

Bibliographic information published by **Die Deutsche Bibliothek**.
Die Deutsche Bibliothek lists this publication in the "Deutsche
Nationalbibliografie"; detailed bibliographic data is available
on the Internet at http://dnb.ddb.de/.

Cover art by Giuliana Cucinelli
Cover design by Lisa Barfield

The paper in this book meets the guidelines for permanence and durability
of the Committee on Production Guidelines for Book Longevity
of the Council of Library Resources.

In Memory

of

Jésus Gómez, affectionately known as Pato
—a special friend, an exquisite human being—
whose untimely death leaves a marked emptiness
in our hearts. At the same time, his passion and
compassion will always guide and re-energize our
collective struggle to eradicate hatred as we
embrace what he always and generously shared
with us: Love

En Memoria

de

Jesús Gómez, cariñosamente conocido como Pato
—un amigo especial, un ser humano único—
cuya prematura muerte nos deja un profundo vacío
en nuestros corazones. Al mismo tiempo, su pasión
y compasión siempre guiará y volverá a dar energía
a nuestra lucha colectiva por erradicar el odio mientras
acojamos lo que él siempre y generosamente
compartió con nosotros: AMOR

Table of Contents

Part Two: Doing Media Literacy

Part Three: Media Literacy and Pedagogy

Reading Media Critically

Shirley R. Steinberg

It actually took us quite a while to decide upon the appropriate title for this reader. Should we use literacy, should we use reading? Should we include the descriptor, *critical*, was anything in the book *not* critical? As simple as our title appears, it did take some effort in making the decision. Reading media is never easy. It is precisely the nature of media to often appear innocent, benign, yet to be incredibly complex and often insidious….At any rate, we decided to make the text a reader, a collection of essays that had contributed or would contribute to the field of media literacy. Choosing between the notions of a reader and a handbook, we found that there had not been a large collection of works that could take a student through an initiation to media literacy, to the theoretical, the ideological, the practical, and the pedagogical constructs of reading media critically. We included works that had been previously published, works by voices in the field that needed to be reiterated in this reader, and the work of those newly known to the field of media literacy.

I playfully see media through the eyes of different *camps* of consumers:

- those who take it for what it is—who do not see anything more or less than that which is placed before them…sort of existential media consumers;
- those who devour it, believe it, and live it…the media sponges;

- those who deny its existence, demand censorship, and claim it has no effect on their lives; and,
- those who are suspicious of media and who critique it

Not attempting to essentialize media readers/consumers, I merely enjoy viewing the viewers, reading the readers, and observing the myriad of cognitive, physical, and political activities which come from the act of reading media. Media have become the oxygen of our existence, that which once was seen as a medium for the educated, the privileged, the initiated, has become the essence upon which surrounds our daily existence…for good, for bad, or for the ugly, media affect us all. It becomes our responsibility, then, as educators, to prepare our student/citizens, to learn how to use it, consume it, and to have personal power over it. Empowerment comes when we are able to read media and make informed decisions about what we have read. Media have been and can continue to become the ultimate hegemonic WMD to a complacent or ignorant audience. As you will read in many of these essays, the power of media is anything but innocent. Through television, film, advertisements, print, and the Internet, political and ideological monologues feed our heads. Most media do not engage in dialogue, merely a larger-than-life Huxleyian plasma screen that captures our attention, desire, and consent.

The authors of the essays in this volume are critically aware of the blatant and insidious uses and effects of the media. Few states or provinces have any educational requirements with their curriculum guides for the teaching of media literacy, whether critical or not critical. We have organized this book to lead the reader through theories of media literacy, to the actual practice of doing media literacy, and finally, the teaching of media literacy. Each author has contributed their unique expertise and original work in creating this reader. Part One: *Reading Media Critically* situates media literacy as a political economic critique which we can use to comprehend our surroundings. The twenty chapters in this section are written by some of the finest media and political theorists of our time. We have included seminal pieces from scholars like Noam Chomsky, Ed Herman, Howard Zinn, and the late George Gerbner, pieces that need to be re-circulated and reconsidered in light of times that have ushered in new media. Joined by these giants, scholars from critical pedagogy, cultural studies, and communications theory complete the section.

Part Two: *Doing Media Literacy* begins with pieces by scholars who combine their theory with the practice of reading media. This section begin with five pieces devoted to the reading of the political within the current media. Beginning with Henry Giroux's compelling essay on the submersion of democracy through the media's coverage of Hurricane Katrina, the authors all reveal terrifying scenarios of media manipulation, political interference, and the possible death of democracy. Chapters twenty-six through thirty-eight address film and television culture and specific readings of different genres within cinematic and small screen production. We follow with three pieces specifically examining media through the lenses of queer theory. Finally, the last five chapters discuss various new medias, and consequently, new literacies.

Part Three: *Media Literacy and Pedagogy* gives a specific acknowledgment to those who teach media, or teach the reading of media, it also encourages all educators to incorporate

media literacy into their curricula. This section includes media industry authors as well as classroom teachers and will inform and strongly encourages all teachers to become both critical teachers and critical readers of media.

Both Donaldo and I are eternally grateful to those friends and colleagues who have spent so much of their time and scholarship in making this reader a reality. We especially would like to thank our partners, Lilia Bartolomé and Joe Kincheloe for their insight, intellect, and their own critical readings which inform our own work. Special thanks also to John Pascarella and Frances Helyar and their long-suffering work in assembling the volume. By reading this book, we hope you are engaged in what we believe is the goal of media: to entertain and to inform.

Deconstructing the Corporate Media/Government Nexus

Donaldo Macedo

During a 1998 visit to Guinea-Bissau in West Africa, that country's former Minister of Finance, Manecas Santos, shared with a group of colleagues his insight that one cannot conceive of democracy unless the media are totally free and independent. A few days after his remark, the enormously fragile democracy of Guinea-Bissau came to an abrupt end via the usual *coup d'état* that plagues the democratic aspirations of all those African nations that want to emerge from the yoke of neocolonialism and totalitarianism.

The rebel group that successfully put an end to all democratic hopes in Guinea-Bissau understood too well that their success rested not only on the supremacy of its military prowess but also on the manipulation of the masses' collective imagination as a means to control the "bewildered herd" and subjugate it, once again, to their proper role—a role that, according to Walter Lippmann, should be as "'spectators' and not participants in actions."[1] It is for this reason that the rebel forces immediately seized control of an important radio station, and, in a short few days, they secured the support of "the bewildered herd." This sudden shift of mass support from one form of government to another reflects the inherent disarticulation between those in control of power and the masses maintained through a propaganda apparatus designed with the sole purpose of "manufacturing consent" to the

extent that, "'the common interests elude public opinion entirely' and can only be under-stood and managed by a 'specialized class' of 'responsible men' who are smart enough to fig-ure things out."[2]

Within this model, which depends heavily on safeguarding power control in the hands of a few while relying on the propaganda apparatus to impose obedience on the masses, there is, according to Noam Chomsky, little difference between "[t]he liberal democratic theory and Marxism-Leninism [because they] are very close in their common ideological assump-tions. I think that this similarity in ideological assumption is one reason why people have found it so easy to drift from one position to another without any particular sense of change."[3] In other words, in the case of Guinea-Bissau, both the deposed leaders of its frag-ile democracy and the victorious rebel leaders coincided in their views regarding the elite control over the masses. The difference between developing countries like Guinea-Bissau and highly developed nations like the United States is that in the developing nations the "bewildered herd" more fully understands its impotence in affecting the power structure, whereas in the United States, the propaganda apparatus makes the "bewildered herd" believe that they are active participants in the democratic process and not merely "spec-tators" in the theater of voting cycles. That is, the voting theatrics affirms the "[media]-induced illusion"[4] of democracy. However, elite policy makers "make sure they remain at most spectators of action, occasionally lending their weight to one or another of the real leaders, who they may select among."[5] The propaganda apparatus succeeds to the degree that people willingly engage in the construction of "not seeing" by ignoring the already highly feeble democratic institutions and the unjust, asymmetrical power relations that char-acterize the hypocritical nature of contemporary democracies. The inherent hypocrisy in the actual use of the term "democracy" is insightfully captured by Noam Chomsky in his analysis of the United States. Chomsky wrote:

> "Democracy" in the United States rhetoric refers to a system of governance in which elite elements based in the business community control the state by virtue of their dominance of the private soci-ety, while the population observes quietly. So understood, democracy is a system of elite decision and public ratification, as in the United States itself. Correspondingly, popular involvement in the formation of public policy is considered a serious threat. It is not a step towards democracy; rather, it constitutes a "crisis of democracy" that must be overcome.[6]

Although Noam Chomsky's alert to the "crisis of democracy" took place in 1987, the crisis has been exacerbated exponentially by the current Bush administration's refusal of any form of accountability, including the disregard toward the Congress of the United States. For example, the energy policy was written by businessmen in the energy industry, and Vice-President Dick Cheney has remained steadfast in his refusal to reveal the identity of the members of the committee who wrote the energy bill, snubbing both Congress and the pub-lic. The Enron and Jack Abramoff of scandals have, in a macabre manner, not only exposed the corrupted coziness between lobbyists and legislators, but they have also denuded "the dominance of the private society" over the general public interest with impunity and arrogance. For example, the bill for a fifth round of tax cuts, in the amount of $137 billion, was signed by President Bush, but its details and results were hardly covered by the com-

pliant media, and the general public was kept in the dark regarding "one of the largest industry giveaways in two decades."[7] President Bush "told a roaring audience at a hockey arena in Wilkes-Barre, Pennsylvania . . . [that] '[t]he rich hire lawyers and accountants for a reason when it comes to taxes. . . . That's to slip the bill, and stick you with it.'"[8] Although President Bush's objective was to manipulate the audience to support his tax cut for the rich, in an ironic way, he could not have been more accurate: "As a percentage of the gross domestic product, corporate taxes are now at the lowest level since the Great Depression. . . . Nearly 95 percent of corporations pay less than 5 percent of their income in taxes. This despite a tax rate that officially stands at 35 percent." For instance, "Bush's tax cuts assured that General Motors received tax benefits worth more than $1 billion over the next decade."[9] Not only did President Bush engage in the most obscene transfer of wealth from the working and middle classes to the ruling elites, but he also hid the dire consequences for the working stiffs who will have to pay for this Robin Hood in reverse: draconian cuts in education, leaving millions of children behind; food-stamp cuts, exacerbating and extending hunger to over 12 million who go to bed hungry every night provoking the government to cover up this scandalous misery by proposing to exchange the term "hungry" with the euphemism "food challenged." That is, the documented 12 million children who experience hunger every day in the United States are no longer hungry. According to the government, they are merely "food challenged."

Against this Orwellian distortion of reality by a supposedly democratic nation—a distortion which, in turn, is fed uncritically to the public by the compliant corporate media, our edited text, *Media Literacy: A Reader,* could not have been timelier. It is designed to challenge educators who falsely believe that education is neutral and is limited to the confines of the classroom. The disarticulation between what goes on in the classroom and the socio-cultural, economic, and political realities that shape, guide, and determine the educational enterprise have led to a de facto construction of not seeing, proving once again the old proverb, "The eyes do not see; they only record while the mind sees." To the extent that the mind can be ideologically controlled, it filters in order to transform what the eyes record, as in the transformation of the civil war in Iraq into sectarian insurgency. Because the media represent a mechanism for ideological control, educators need to understand that the popular press and mass media educate more people about issues related to our society and the world than all other sources of education. By shunning the mass media, educators are missing the obvious: More public education is carried out by the media than by teachers, professors, or anyone else, particularly in the rapidly changing technological world.

Media Literacy: A Reader brings together the research, insights, and ideas by scholars whose major goal it is to expose the nexus between government, corporations, educational institutions, and the media in the production of the "manufacture of consent" through ideological manipulation—a process that Edward Bernays called the "engineering of consent," which he described as "the essence of democracy."[10] The "essence of democracy" comprises the success of the ideological manipulation, which depends on to what degree one invests in the doctrinal system and expects to be rewarded by it. This dynamic obviously includes the members of the media whose seemingly objective posture to protect our democracy col-

lapses under the weight of its own ideology. Ideological obedience was clearly demonstrated when CBS News anchor Dan Rather relinquished all pretenses of journalistic objectivity and declared himself ready in September 2001 "to line up" for President Bush's war on terror, stating that "George Bush is the President, he makes the decisions, and . . . as just one American, he wants me to line up? Just tell me where."[11] Dan Rather was setting the tone for the subsequent sad chapter of the U.S. media's capitulation to Washington's raw power and its continued complicity with the manufacture of the Bush administration's mass deception.

Given the overwhelming evidence of the Bush administration's *mass deception*, the media are belatedly attempting to rescue their image of objectivity as evidenced by the *The Nation* editorial that stated "there was never any evidence of a link between Iraq and Al-Qaeda, between Saddam Hussein and Sept. 11,"[12] "and demanded an 'apology' to the American people from President Bush."[13] The *New York Times* should also have demanded that Congress apologize to the American people because it became a rubber stamp that ratified all of the policies of the conservative agenda, in which the ideological distinctions between Republicans and Democrats have simply collapsed. In reality, the Democratic Party, in its role as the opposition party, became a lapdog for an otherwise belligerent, reactionary, and unprincipled Republican Party. More importantly, the *New York Times* should have demanded that both Congress and President Bush apologize to and make financial reparations to the relatives of the 60,000 innocent Iraqis (mostly civilians killed, which represents a very low estimate) by our illegal war. In addition, it should also demand that financial reparations be made to the families of over 3,000 American soldiers who needlessly were killed in Iraq. Financial reparation should also be made to the thousands of injured American soldiers who often return to the United States with few job prospects and little support from the government. Moreover, the *New York Times* should also remind the U.S. administration that the rules of law should be applied universally and not unilaterally only to Saddam Hussein (while he was still alive), Osama bin Laden, and those the administration characterizes as "enemy combatants." This assessment means that the International Criminal Court in The Hague should be given jurisdiction to indict President Bush and his commissars for their violation of international laws by waging an illegal war on Iraq, by violating the Geneva Convention, as exemplified in the Abu Ghraib torture of Iraqi prisoners, and by the amply documented human rights violations committed by the U.S. military in both Iraq and Afghanistan. It is no wonder that the United States would vehemently oppose the existence of the International Criminal Court and has launched an aggressive "diplomatic campaign to compel other countries to sign bilateral agreements exempting U.S. citizens, whether military or civilian, from potential jurisdiction of the new International Criminal Court in The Hague."[14]

Against a backdrop where "it's the defeated who are tried and not the victors,"[15] it is unlikely that President Bush and his commissars will ever face justice in court, and in order to assure the victorious Americans a sense of rectitude and moral high ground, it becomes imperative that history be written from the victors' perspective. This approach requires that the media become complicit with the dominant posture that demands that the "enemy's"

story is never told. More specifically, the teaching of history must also be manipulated and distorted through a type of educational training that makes it possible for us to rally behind our political leaders wrapped in the American flag, who ritualistically call for the protection of human rights all over the world, without our recognizing that these same leaders are complicit in the denial of rights of the human beings who live under the cruel dictatorships that we either overtly or covertly support.

The teaching of history from the victors' point of view invariably imposes historical blinders so as to keep the citizenry docile, domesticated, and historically ignorant, even though this ignorance is never innocent. More precisely, those who are either willingly or unwillingly historically ignorant are still actors of history and, as a result, are ultimately implicated in the making of history. The victors' teaching of history must inevitably rely on a pedagogy of big lies that gives rise to historical amnesia—a form of anesthetization of consciousness administered by the complicit and compliant media. The anesthetization of consciousness is reinforced by a process that blocks any and all historical analyses where the root cause of a historical event is never allowed to be referenced as Edward Herman so clearly points out in chapter 7 of this volume:

> Usually, root causes are not on the Western agenda, and when it is suggested that they may be relevant in developing a rational response, as in the case of street crime, or the reasons for the 9/11 attack, officials and establishment pundits have regularly declared that this is intolerable—reference to root causes is a form of apologetics for actions that must be condemned in and of themselves without "excuses." But in the Lebanon case, where the large-scale violence comes from the United States and its client, an axis that for weeks resisted international calls for a cease fire, the need to address root causes is not apologetics, it is merely an explanation of why extreme violence is needed in this particular case (and of course in Iraq as well, and maybe Iran next).
>
> [. . .] This line of thought on root causes violates the rules mentioned above: only the other side terrorizes, and we must carefully stop the tracing of cause and effect at the point where our side must retaliate to their "terrorism." The state terrorism of the IDF, killing a thousand civilians and putting to flight a million civilians does not make Israel a terrorist state, by rule of proper language usage.

If it were not for historical amnesia, how could one accept Bush's propositions that "states that harbor terrorists are as guilty as the terrorists themselves"[16] and, as a consequence, that the United States has the right to wage war against such states as we did aggressively in Afghanistan? Noam Chomsky correctly argues that if we apply this doctrine universally and not unilaterally (meaning that the doctrine does not apply to the United States), Washington would have to bomb itself, because the harboring and/or training of terrorists on U.S. soil is an integral part of our history. Let's not forget that the United States was a main supporter of terrorist militias in Afghanistan, including militants like Osama bin Laden, who waged war against the Soviet occupation of that country. If it were not for historical amnesia, we would remember the material and intelligence support that the United States provided Saddam Hussein when he invaded Iran, a war that caused more than one million deaths. When Saddam Hussein was our friend, we showed no displeasure in his use of chemical weapons against Iranians. In fact, the propaganda apparatus was working overtime to

keep us from learning about our complicity in the atrocities and carnage of the war between Iraq and Iran. A simple test unveils our double standard concerning the U.S. posture regarding cruel dictators like Saddam Hussein. For the sake of argument, let's say that during the standoff between President Bush and Saddam Hussein, as Americans were being drummed up for war by the media, an Iraqi warplane had fired a missile at an American frigate, igniting a "huge fire that damaged the frigate heavily"[17] and killing a number of sailors. How would the United States respond to such an unprovoked attack? At the very least, it would have spared President Bush the need to fabricate lies providing a rationale to attack Iraq—lies that included stories of weapons of mass destruction and the categorical belief that Iraq could use these weapons within forty-five minutes, creating an urgency to launch a preemptive attack. The United States would have milked the United Nations, even though this international organization is despised by the Bush administration, for all the necessary diplomatic public relations, ensuring world support to counteract Iraq's aggression. The attack would have been brutal and decisive, and there would have been no limit to the power used to destroy a tentacle of the "axis of evil." This unchecked power to wage preemptive war would have also included the use of small nuclear bombs, as was widely discussed by Bush policy makers. Most Americans would have more or less agreed with this response and, certainly, would also have supported what would be viewed as a provoked war.

The attack on the American frigate by an Iraqi fighting air force jet I just described did not happen in 2003, but it did take place during the war between Iran and Iraq when Iraq was considered an ally of the United States, even though it was ruled by the same cruel and despotic dictator, Saddam Hussein, we attacked in March 2003. In 1987, an Iraqi warplane attacked a U.S. frigate in the Persian Gulf, causing serious casualties. However, the U.S. response was diametrically opposed to what would be expected in 2003. In fact, in 1987, the U.S. media went out on a limb to soften the news. According to the *Boston Globe* report "A US guided-missile frigate patrolling in the Persian Gulf was attacked by Iraqi aircraft yesterday in what appears to be an error, the Pentagon said."[18] True to their servitude to the power structure, the media often take their cues from the administration and report accordingly. In this case, the Pentagon saw [it] fit to protect Saddam Hussein, leading Robert Sims, the Pentagon's chief spokesman, to state: "We believe this was a mistaken attack. . . . There is no indication of any deliberate, hostile intent"[19]—an apologist posture reproduced uncritically by the media designed to keep the "bewildered herd" in perpetual obedience.

The question that needs to be raised is why there was no outcry and flag-waving against Iraq then for this unprovoked attack while there was an avalanche of support to attack Iraq in 2003, when there was no evidence that it had acted aggressively against the United States. The answer to this simple question would unveil the lies that usually inform our foreign policies, and the present antiterrorist doctrine of the Bush administration is no exception. According to Chomsky,[20] a very short list of examples would suffice to unmask U.S. complicity with the harboring and training of terrorists:

1 The United States launched a terrorist war against Cuba in 1959. It picked up rapidly under President Kennedy with Operation Mongoose—a major escalation that

actually came close to leading to nuclear war. And all through the 1970s, terrorist actions against Cuba were being carried out from U.S. territory, in violation of U.S. law and, of course, international law.

2 The FBI accuses Orlando Bosch of thirty serious terrorist acts, including participation in the destruction of the Cubana airliner in which seventy-three people were killed back in 1976. The Justice Department wanted him deported. It said he's a threat to the security of the United States. George H. W. Bush, at the request of his son Jeb, gave Bosch a presidential pardon. Bosch is now sitting happily in Miami, and we are harboring a person whom the Justice Department regards as a dangerous terrorist, a threat to the security of the U.S.

3 The Venezuelan government is now asking for extradition of two military officers who were accused of participation in bombing attacks in Caracas before fleeing the country. These military officers participated in a coup that overthrew the government for a couple of days. The United States openly supported the coup and, according to British journalists, was involved in instigating it. The officers are now pleading for political asylum in the United States.

4 Emanuel Constant's death squad killed about four thousand to five thousand Haitians [during the early 1990s while he was on the payroll of the CIA]. Today, he is living happily in Queens because the United States refused to even respond to requests from Aristide for extradition.

The unveiling of the U.S. complicity with the harboring and training of terrorists as factually provided by Noam Chomsky and others leads to a series of other questions regarding our seemingly free press. Why is it that these historical facts are not widely covered by the major media outlets in the United States? Why is it that U.S. journalists and reporters are so eager to investigate and report acts of terrorism carried out by others and refrain from exposing the U.S. involvement in terrorism as a vehicle for a regime change in Latin America and other parts of the world. According to Noam Chomsky, "the most major international terrorism organized yet has been the Kennedy administration's Operation Mongoose, then the things that followed along, against Cuba."[21] However, the American public is led to believe in its manifest destiny to crush anti-democratic monsters—sometimes "chimerical monsters"—created by the media in order to justify militaristic adventures that support the interests of the ruling elites and the business class. The creation of "chimerical monsters" is "necessary, as the *Washington Post* put it rather proudly during the Gulf War hysteria, to instill in people respect for 'martial values.'"[22]

The answer to these questions rests, partially, with the new concept of embedded journalists (read in bed with the administration) whose role it is "to instill in people respect for 'martial value,'" even if it means the blind acceptance of lies as we witnessed with the manufacture of mass deception in preparation for the illegal and immoral attack on Iraq with the tragic consequence of over 60,000 mostly civilian deaths.

Even within the embedded context, the U.S. administration was seriously concerned with the probable reporting of what the administration considered wrong news (i.e., the

wanton killing of Iraqi civilians, including women, the elderly, and children) as Ari Fleischer, "the White House press secretary, warned Americans that they should 'watch what they say' about U.S. military, intelligence, and police operations. He warned all five major American television networks, as well as the wire services, not to carry any advance information about Bush and Cheney's schedule, nor use the names of military personnel engaged in combat."[23] Not only did the "network chiefs all acquiesce with the Pentagon's demands,"[24] but they also deferred to Fleischer's concern about the types of questions that were being raised by journalists and reporters. That is, according to Fleischer, "It's not what the government officials are saying that's the issue. . . . It's the type of questions that reporters are asking that's the issue."[25]

According to Hugh Miles in his book, *Al-Jazeera*, "the Pentagon had done an impressive job of taming the American media . . . [to the extent that] . . . a senior executive at CNN sent a follow-up email suggesting some sample reports: 'We must keep in mind, after seeing reports like this from Taliban-controlled areas, these U.S. military actions are in response to a terrorist attack that killed close to 5,000 people in the U.S.' or, 'The Pentagon has repeatedly stressed that it is trying to minimize civilian casualties in Afghanistan, even as the Taliban regime harbors terrorists who are connected to the September 11 attacks that claimed thousands of innocent lives in the U.S.'"[26]

The tragic killing of thousands of American civilians in the World Trade Center attack became a cover and a justification for the wanton killing of over 60,000 mostly innocent civilians in Iraq and Afghanistan. It is immaterial that the killing of these civilians had nothing to do with the World Trade Center attack, counting that the intellectual class and the mass media would fall into line and to censor the graphic display of the carnage that resulted from the thousands and thousands of U.S. smart bombs dropped on the civilian population in Iraq and Afghanistan, where in "July 2002 an American B52 heavy bomber dropped a two-thousand-pound laser-guided bomb on an Afghan wedding ceremony. The bomb, which was primed to detonate after landing, for maximum effect, was uranium-based. Besides killing scores at the time, people who visited the site suffered nosebleeds, radiation sickness and burns months later."[27]

The U.S. tamed media not only would not show the graphic carnage by the uncontained bombing of the civilian population, but they aggressively engaged in the demonization of Al-Jazeera for its uncensored footages of similar carnages of civilians that resulted from the U.S. bombs. According to Hugh Miles,

> In the press [Al-Jazeera] was compared to the former organ of Soviet propaganda, Pravda, and Nazi propaganda newspapers. Its immediate closure or destruction was advocated as a top national priority. The New York Times decreed that Al-Jazeera "slants its news with vicious anti-Israel and anti-American bias." Its "deeply irresponsible reporting reinforces the region's anti-American views." National Public Radio warned listeners that Al-Jazeera's coverage should "come with a health warning." CBS celebrity news anchor Dan Rather wondered whether perhaps bin Laden might be behind Al-Jazeera. Was there "any indication that Osama bin Laden has helped finance this operation?" he mused. The New York Daily News summed up concerns about Al-Jazeera and offered a violent final solution. . . ."Dealing with Al-Jazeera is a job for the military. Shutting it down should be immediate priority because, left alone, it has the power to poison the air more efficiently and lethally than anthrax ever could."[28]

The Pentagon must have paid a lot of attention to the *New York Daily News'* proposed violent solution by bombing Al-Jazeera's offices on several occasions in both Afghanistan and Iraq, where a "U.S. A10 'tank killer' aircraft unexpectedly fired two missiles in their direction. These struck the pavement in front of the office and generator nearby, blasting windows and doors into the street. An Al-Jazeera correspondent and producer, Tareq Ayyoub, was seriously injured by shrapnel from the blast . . . he was rushed to the hospital, but his wounds proved too severe and he died a short time later."[29] It is again immaterial that the United States illegally attacks Iraq with the pretext of spreading democracy in the Middle East, even if it means imposing democracy undemocratically through violent means or that the supposed freedom given to Iraqis meant bombing the office of news outlets and killing journalists that ask the wrong questions and report the vivid images of the carnage of civilians being killed by the U.S. smart-uranium filled bombs. The tamed U.S. media and the domesticated intellectual class could be counted on to provide the necessary spin and rewrite history in a way that not only feeds into the American sense of righteousness but also as a means to "instill in people respect for 'martial values.'" In essence, the U.S. corporate media have not only become domesticated, but they also have unabashedly become tools to reproduce the White House's and the Pentagon's directives. For instance, the *New York Times* withheld information about the illegal surveillance of U.S. citizens for over a year so as to comply with the White House's request. The decision not to publish this blatant violation of U.S. laws during the presidential campaign probably secured President Bush's re-election.

In the name of "security," most Americans have willingly accepted President Bush's directive for neighbors to spy on neighbors, for citizens to lose protection from racial and ethnic profiling, and for citizens and non-citizens alike to be jailed indefinitely without being charged with a crime and without the right to legal counsel—characteristics that are reminiscent of totalitarian states that we have no difficulty recognizing and are eager to denounce whenever and wherever they occur, provided these totalitarian measures are practiced by official enemy states. For instance, the U.S. media had a field day covering and denouncing through editorials Fidel Castro's cracking down on dissent a few years ago. The crackdown led to long-term jail sentences of several dozen people under the pretext that they were organizing to undermine the government and that they had also received U.S. aid to maximize their goals. Castro's regime at least understood that a trial would be necessary to the degree that it would provide the dissenters with the appearance of legal venues to defend themselves in the court of law. In truth, this legal window dressing could have been nothing more than to ameliorate Cuba's undemocratic image abroad and at home. This is a pretense that the Bush administration finds unnecessary, given the effectiveness of its propaganda apparatus to control the "bewildered herd," meaning the U.S. citizenry, in a state of quasi-perpetual stupidification: "From a propaganda point of view, the most powerful state in history needs no justification or serious arguments for its actions: declaration of noble intent should suffice,"[30] such as ridding the world of weapons of mass destruction. When the WMD rationale collapsed under the weight of its falsehoods proven even by official documents, all the propaganda apparatus had to do was just announce another noble intent—that of bringing democracy to Iraq. It is immaterial that democracy is

imposed undemocratically through violent means or that the supposed freedom given to Iraq has meant curtailing freedom at home, counting on the fact that the vast majority of the intellectual class and the mass media would fall into line. According to the journalist, editor, and former assistant secretary of state in the Carter administration, Holding Carter, "it's a 'lead-pipe cinch,' . . . the mass media in America have an overwhelming tendency to jump up and down and bark in concert whenever the White House—any White House—snaps its fingers."[31]

The draconian measures legalized under the Patriotic Act and supported by both Republicans and Democrats smack of totalitarianism, which is summarily denounced by the American administration and the public when they are practiced by countries that are considered "rogue states." When totalitarianism is practiced by friendly countries such as Chile under Pinochet, Nicaragua under Samoza, the Philippines under Marcos, and Cuba under Batista, the U.S. government and the compliant corporate media usually engage in a social construction of not seeing the state terrorism these dictators practice against their own people often with the support of the United States. The shrinking of civic rights through the Patriot Act has aroused little dissent from most intellectuals, and the media have very much toed the administration's line as exemplified by a piece published in the *Washington Post* that cites "FBI and Justice Department investigators as saying that 'traditional civil liberties may have to be cast aside if they are to extract information about Sept. 11 attacks and terrorist plans.'"[32] Most Americans may rationalize that given the aftermath of September 11, 2001, these undemocratic measures are necessary to protect Americans and their hard earned freedom, which, they blindly believe, is unparalleled in the world. However, they fail to understand that, according to policy makers and the ruling intellectuals that advise them, freedom can be freely enjoyed so long as self-censorship guarantees that the policy makers continue, as Walter Lippmann has stated "to live free of the trampling and the roar of a bewildered herd . . . ignorant and meddlesome outsiders [whose role in a democracy should be that of] spectators not participants [in the democratic process]."[33]

Hence, the current curtailment of democratic rights through imposed censorship and denial of civic rights is not a temporary aberration that will eventually correct itself and prove that the democratic system works after all and that it is part and parcel of the very design of American democracy. For example, James Madison, one of the founding fathers, opined that "power must be delegated to the 'wealth of the nation,' 'the more capable of men,' who understand that the role of the government is 'to protect the minority of the opulent against the majority.'"[34] What appears to be an occasional aberration in an otherwise functional democracy is, in reality, the fulfillment of the need for corrective measures to ensure the continuation of undemocratic principles that shaped and continue to reshape the appearance of democracy. The periodic democratic corrective measures that abound in the history of the United States range from the "civilizing" crusade that imposed a quasi-genocide on American Indians in order to save them from their savageness, to the enslavement of African Americans, to the denial of rights to women, to preventive wars (both overt and covert) against countries that flirted with nationalistic fervor (Guatemala,

Cuba, Chile, Vietnam, Nicaragua, among others) that could affect U.S. national interests (meaning the interests of the business class), to McCarthyism, and to the Patriot Act, and the now perpetual war on terror.

If it had not been for the historical amnesia partially imposed by the selective teaching of history written always from the victors' point of view and aided by the compliant media, one could easily make the linkage between historical events in order to gain a more comprehensive understanding of reality. The ability to make the necessary linkages would also help to unveil the reasons why lies and contradictions are more readily embraced by the educated class to the degree that the more educated and specialized individuals become within a domesticating model of education, the more interest they have invested in the dominant system that provides them with special privileges and rewards. For this reason, we often encounter people whose consciousness has not been totally atrophied, yet who fail, sometimes willfully, to see the obvious contradiction that a nine-year-old boy named Alejandro readily discerned in Bush's hypocritical justification to launch an illegal war against Iraq. He astutely asked, "Why is President Bush going to war to bring freedom to Iraq and he is passing laws to take away freedom at home?" In most cases, these individuals begin to believe the lies, and in their roles as functionaries of the state, they propagate these same lies. That is why over 60 percent of college students supported the war against Iraq and believed the administration's contention of a linkage between Iraq and Al-Qaeda. According to Howard Zinn, these college students "didn't get anything in their education that would prepare them to look critically at what the government says, so they listen to the government say again and again that something is true or hint and suggest and make connections, and then when the president denies it in one statement, it's not enough to penetrate what has already become a mountain of lies."[35] However, pointing out these blatant contradictions would invite a barrage of assault from policy makers and the mass media. James Rubin, a former State Department spokesman, has advocated in this context that we "need to spotlight the 'excuse makers.'"[36] Because it is a "lead-pipe cinch" for "the mass media in America" . . . "to jump up and down and bark in concert whenever the White House" . . ."snaps its fingers," it should be unsurprising that Thomas L. Friedman of the *New York Times* would take a cue from James Rubin and castigate those he calls apologists and who "[a]fter every major terrorist incident, the excuse makers come out to tell us why imperialism, Zionism, colonialism or Iraq explains why the terrorists acted. These excuse makers are just one notch less despicable than the terrorists and also deserve to be exposed."[37] Thus, for Thomas L. Friedman, historical analysis is confused with justification as he preaches the virtues of open societies without acknowledging that his own framework of freedom of speech in an open society is undermined by his aggressive exclusion of historical analysis that could illuminate the root cause of terrorism. According to Friedman, "[w]hen you live in an open society like London, where anyone with grievance can publish an article, run for office or start a political movement, the notion of blowing up a busload of innocent civilians in response to Iraq is somehow 'understandable' is outrageous."[38] Just as outrageous is the current suppression in the *New York Times* of historical facts that point to U.S. support of Saddam Hussein's regime of terror (mostly against his own people):

The warmth of the relations [between Saddam Hussein and the Reagan/Bush administration] was indicated when a delegation of senators, led by majority leader and future Republican presidential candidate Bob Dole, visited Saddam in April 1990. They conveyed President Bush's greetings and *assured Saddam that his problems did not lie with the US government* [emphasis added] but with "the haughty and pampered press." Senator Alan Simpson advised Saddam "to invite them to come here and see for themselves" to overcome their misconceptions. Dole *assured Saddam that a commentator on Voice of America who had been critical of him had been removed."* (emphasis added)[39]

Just as outrageous is the removal of the Voice of America commentator because, according to Bob Dole, he "had been critical" of Saddam Hussein when he was considered a valuable friend of the Bush I administration—a friendship that lasted "long after Saddam's gassing of the Kurds" and translated into the issuance of "a national security directive declaring that 'normal relations between the United States and Iraq would serve our long-term interests and promote stability in both the Gulf and Middle East.' [Former President Bush] took the occasion of the invasion of Panama shortly after to lift a ban on loans to Iraq."[40] If President Bush were to apply his current laws governing, supporting, and abetting terrorist organizations universally and not selectively, he would be forced to arrest his father, former President Bush, given the considerable aid his administration provided Saddam Hussein who oversaw despicable state terrorism that ranged from the gassing of the Kurds to the use of chemical weapons against Iran as the U.S. military supplied significant intelligence aid during the Iran/Iraq war. Instead of being rewarded for their complicity with state terrorism and crimes against humanity, many officials of the Reagan/Bush administration would have to be tried and convicted in a court of law given the current promulgation of the anti-terror legislations and the Patriot Act.

The Bush administration's lies reached phantasmagorical proportions, yet there was little urgency on the part of policy makers to even mask them. This lack of urgency not only undermines our already fragile democracy, but it also confirms the comment from the former Finance Minister from Guinea-Bissau that one cannot conceive of democracy without totally free and independent media. At least the citizens of Guinea-Bissau are under no illusion that they live in a democracy. They know that their government would summarily weed out or, at least, neutralize all those who question the system. In open "democratic" societies such as the United States, the obedience is imposed via the sophistication of a propaganda apparatus that relies religiously on the media and educational institutions to reproduce signs and slogans to allow their citizens to conceal from themselves "the low foundations of [their] obedience, at the same time concealing the low foundations of power. It hides them behind a façade of something high. And that something is ideology."[41] Thus, any attempt to live "in truth" represents a real threat to the dominant doctrinal system and must be cast out. Let's take Senator John Kerry's pronouncement at a rally in California "You know, education, if you make the most of it, you study hard, you do your homework, and you make an effort to be smart, you can do well. If you don't, you get stuck in Iraq."[42] The political class and the media had a field day castigating him, demanding an apology because, according to them, he has devalued and belittled our troops who are making the ultimate sacrifice to protect our "freedom" and to bring "democracy" to Iraq. The truth of the matter is that Senator Kerry was correct in his pronouncement to the degree

that the vast majority of volunteers into the armed forces are not your college graduates but individuals whose career options are immensely restricted by their lower class status, their race, and their ethnicity. Even though empirical evidence would support Senator Kerry's position that "if you don't [get an education], you get stuck in Iraq," being correct is considered immaterial while the lie "support our troops" is propagated by the media and the educated class so that the "bewildered herd" would not lose face. This is no different from what happens in totalitarian states where, according to Vaclav Havel, lies have the same ideological function as is illustrated by the example of the greengrocer who displays "among the onions and the carrots, the slogan: 'Workers of the world unite.'"[43] Havel points out that the greengrocer puts slogans on the window of his shop "simply because it has been done that way for years, because everyone does it, and because that is the way it has to be. If he were to refuse, there could be trouble."[44] He argued that if the greengrocer were forced to display the slogan " 'I am afraid and unquestionably obedient,' he would not be nearly as indifferent to its semantics, even though the statement would reflect the truth. The greengrocer would be embarrassed and ashamed to put such an unequivocal statement of his own degradation in the shop window, and quite naturally so, for he is a human being and thus has a sense of his own dignity."[45]

Similarly, the greengrocer in the United States would display yellow ribbons "among the onions and carrots" and affix magnetic ribbons that say "Support our Troops," and his refusal to do so would immediately imply a lack of patriotism and anti-Americanism. The yellow ribbon and "Support our Troops" slogans function to cage the American minds by making them sufficiently complacent so that they can be more easily complicit with the "manufacture of consent" for a fabricated war. The end result is little different from the slogan "Workers of the World, unite" that served to anesthetize the minds of citizens in totalitarian communist regimes. The high-level domestication of American minds is evidenced in the almost total lack of courage by the media, the intellectual class, and a very large segment of the population toward the falsehoods that informed and shaped the rationale for the war against Iraq, which ranged from falsification of documents used by former Secretary of State Colin Powell in his justification for the war before the United Nations Security Council to President Bush's false claims in his State of the Union Address, where he contended that Iraq possessed "30,000 warheads, 500 tons of chemical weapons, 25,000 liters of anthrax, 38,000 liters of botulinum toxin."[46] It does not matter that no weapons of mass destruction were ever found because when the lies cease to provide the necessary rationale, the doctrinal system can always pull another noble cause out of the hat: "Support our Troops." Any attempt to deconstruct the lies that undergirded the rationale to invade Iraq was viewed as not supporting our troops. It is for this reason that the dominant doctrinal system could not tolerate Senator Kerry's ever too late critique of the war in Iraq, and it astutely boxes his critique within the slogan "Support our Troops"—a mechanism that brooks no interrogation or dissent.

Given the sophistication of the propaganda apparatus in the wholesale domestication of American minds, it is most imperative that educators embrace forms of literacy that encourage critical thinking and the ability to make linkages among historical events as a

process to read reality more comprehensively and critically—forms of literacy that provide the necessary critical tools to unmask the human catastrophe unleashed by our imperialistic adventurism characterized by carnage and wanton killing of innocent victims, including women, children, and the elderly—bombardments that are cynically labeled "Pacification Operation" as in Vietnam and "Operation Just Cause" as in Panama. Educators need to courageously reject forms of literacy based on a web of lies so as to provide individuals with "the repository of something 'supra-personal' an objective [that] enables people to deceive their conscience and conceal their true position and their inglorious modus vivendi, both from the world and from themselves."[47] Educators need to forcefully expose forms of literacy designed to infuse people with permanent fear under the cover of security and with the goal of keeping them "quiet and instill . . . [them] with the beliefs and doctrines that will serve the interest of those in power."[48] Educators not only need to understand the government-media-education nexus in the "manufacture of consent," but they must also create pedagogical structures that produce individuals with conviction, ethical posture, courage to speak to power, and willingness to change—all of which cannot be "disconnected from ethical principles . . . [and] require that the possibility or the right to change be not simply rhetorical. In other words, to claim the right to change requires a coherence that makes a difference. There is no point in making such a claim and continuing as if nothing had changed."[49]

NOTES

1 Noam Chomsky, "Media Control: The Spectacular Achievements of Propaganda" (Westfield, New Jersey: Open Magazine, 1991), p. 3.

2 Ibid.

3 Ibid.

4 Elaine Woo, "George Trow, Social Critic, Writer for the *New Yorker*," *The Boston Globe*, December 18, 2006, p. B8.

5 Chomsky, "Media Control," 1991, p. 4.

6 Noam Chomsky, *On Power and Ideology* (Boston: South End Press, 1987), p. 6.

7 Cited in Donaldo Macedo, *Literacies of Power: What Americans Are Not Allowed to Know* (Boulder, Co.: Westview Press, 2006).

8 Cited in Donaldo Macedo and Paulo Freire, *Ideology Matters* (Boulder, Co.: Westview Press, forthcoming).

9 Ibid.

10 Chomsky, "Media Control," 1991, p. 8.

11 Donaldo Macedo, *Literacies of Power: What Americans Are Not Allowed to Know* (Boulder, Co.: Westview Press, 2006), p. 185.

12 Jonathan Schell, "The Lexicographers," *The Nation*, July 12, 2004, p. 10.

13 Ibid., p. 10.

14 Alexander Cockburn, "Green Lights for Torture," *The Nation*, May 31, 2004, p. 9.

15 David Barsamian, "The Progressive Interview," *The Progressive*, May 2004, p. 37.

16 Ibid., p. 20.

17 "Pentagon: US Frigate Attacked by Iraq in Gulf Possible Error Cited," *The Boston Globe*, May 18, 1987, p. 1.

18 Ibid., p. 1.

19 Ibid., p.1.

20 Barsamian, "The Progressive Interview," p. 36.

21 Chomsky, "Media Control," 1991, p. 13.

21 Ibid., p. 9.

22 Hugh Miles, *Al-Jazeera: The Inside Story of the Arab News Channel That Is Challenging the* West (New York: Grove Press, 2005), pp. 139–140.

23 Ibid., p. 140.

24 Ibid., p. 140.

25 Ibid., pp. 140–141.

26 Ibid., pp. 168–169.

27 Ibid., pp. 149–150.

28 Ibid., p. 265.

29 Noam Chomsky, *Hegemony or Survival: America's Quest for Global Dominance* (New York: Henry Holt and Company, 2004), p. 124.

30 Ibid., p. 117.

31 Alexander Cockburn, "Green Lights for Torture," *The Nation*, May 31, 2004, p. 9.

32 Noam Chomsky, *Hegemony or Survival*, p. 6.

33 Ibid., p. 7.

34 Howard Zinn with Donaldo Macedo, *Howard Zinn on Democratic Education* (Boulder, Co.: Paradigm, 2005), p. 54.

35 Thomas L. Friedman, "Expose the Haters," *International Herald Tribune*, July 23–24, 2005, p. 5.

36 Ibid.

37 Ibid.

38 Noam Chomsky, *Hegemony or Survival*, p. 112.

39 Ibid., pp. 111–112.

40 Vaclav Havel, *Living in Truth* (London: Faber and Faber, 1989), p. 42.

41 Quoted in *The Patriot Ledger*, November 1, 2006, p. 3.

42 Ibid..

43 Ibid.

44 Ibid., p. 42.

45 Joan Vennochi, *The Boston Globe*, June 17, 2003, p. A17.

46 Vaclav Havel, *Living in Truth,* p. 42.

47 Noam Chomsky, *Chomsky on Miseducation* (Boulder, Co.: Rowman & Littlefield, 2000), p. 24.

48 Paulo Freire, *Pedagogy of Freedom* (Boulder, Co.: Rowman & Littlefield, 1998), p. 39.

Part One

Reading
Media
Critically

Chapter 1

Critical Media Literacy, Democracy, and the Reconstruction of Education

Douglas Kellner and Jeff Share

Introduction

The world we live in today is very different than the world that most of us remember from our childhood. The twenty-first century is a media saturated, technologically dependent, and globally connected world. However, most education in the United States has not kept up with advances in technology or educational research. In our global information society, it is insufficient to teach students to read and write only with letters and numbers. We live in a multimedia age where the majority of information people receive comes less often from print sources and more typically from highly constructed visual images, complex sound arrangements, and multiple media formats. The influential role that broadcasting and emergent information and computer media play in organizing, shaping, and disseminating information, ideas, and values is creating a powerful *public pedagogy* (Giroux, 1999; Luke, 1997). These changes in technology, media, and society require the development of critical media literacy to empower students and citizens to adequately read media messages and produce media themselves in order to be active participants in a democratic society (Kellner, 1995; Kellner & Share, 2005).

Even so, despite the ubiquity of media culture in contemporary society and everyday life, and despite criticism of the distorted values, ideals, and representations of the world in popular culture, media education in K-12 schooling in the United States has never really been established and developed. The current technological revolution, however, brings to the fore, more than ever, the role of media like television, popular music, film, and advertising, as the Internet rapidly absorbs these cultural forms and creates ever-evolving cyber-spaces and emergent forms of culture and pedagogy.

It is highly irresponsible in the face of saturation by the Internet and media culture to ignore these forms of socialization and education. Consequently, a critical reconstruction of education should produce pedagogies that provide media literacy and enable students, teachers, and citizens to discern the nature and effects of media culture. From this perspective, media culture is a form of pedagogy that teaches proper and improper behavior, gender roles, values, and knowledge of the world. Individuals are often not aware that they are being educated and positioned by media culture, as its pedagogy is frequently invisible and is absorbed unconsciously. This situation calls for critical approaches that make us aware of how media construct meanings, influence and educate audiences, and impose their messages and values.

Critical media literacy expands the notion of literacy to include different forms of mass communication and popular culture as well as deepens the potential of education to critically analyze relationships between media and audiences, information and power. It involves cultivating skills in analyzing media codes and conventions, abilities to criticize stereotypes, dominant values, and ideologies, and competencies to interpret the multiple meanings and messages generated by media texts. Media literacy helps people to discriminate and evaluate media content, to critically dissect media forms, to investigate media effects and uses, to use media intelligently, and to construct alternative media.

In this chapter, we explore different approaches commonly used for teaching media education and propose a conception of critical media literacy that moves media education into the sphere of twenty-first-century transformative pedagogy. We present competing approaches to media education and, building on these conceptions, develop a critical media literacy addressing issues of gender, race, class, sexuality, and power to explore the interconnections of media, cultural studies, and critical pedagogy. We argue that alternative media production can help engage students to challenge media texts and narratives that appear natural and transparent. In the contemporary era of standardized high stakes testing and corporate structuring of public education, radical democracy depends on a Deweyan reconceptualization of literacy and the role of education in society. We argue that critical media literacy must expand our understanding of literacy so that these ideas become integrated across the curriculum at all levels from pre-school to university, leading to a reconstruction and democratization of education and society.

Literacies

Literacy involves gaining the skills and knowledge to read, interpret, produce texts and arti-

facts, and to gain the intellectual tools and capacities to fully participate in one's culture and society. Both traditionalists and reformists would probably agree that education and literacy are intimately connected. "Literacy," in our conception, comprises gaining competencies involved in effectively learning and using socially constructed forms of communication and representation. Because literacies are socially constructed in various institutional discourses and practices within educational and cultural sites, cultivating literacies involves attaining competencies in practices in contexts that are governed by rules and conventions. Literacies evolve and shift in response to social and cultural change and the interests of elites who control hegemonic institutions, as well as to the emergence of new technologies.

To the domains of reading, writing, and traditional print literacies, one could argue that in an era of technological revolution educators must develop robust forms of media literacy, computer literacy, and multimedia literacies, thus cultivating "multiple literacies" in the restructuring of education.[1] Computer and multimedia technologies demand novel skills and competencies, and if education is to be relevant to the problems and challenges of contemporary life, engaged teachers must expand the concept of literacy and develop new curricula and pedagogies.

We would resist, however, extreme claims that the era of the book and print literacy are over. Although there are new media and literacies in the current constellation, books, reading, and print literacy continue to be of utmost significance. Indeed, in the current information-communication technology environment, traditional print literacy takes on increasing importance in the computer-mediated cyberworld as people need to critically scrutinize and scroll tremendous amounts of information, putting new emphasis on developing reading and writing abilities. For instance, Internet discussion groups, chat rooms, e-mail, text-messaging, blogs, wikis, and various Internet forums require writing skills in which a new emphasis on the importance of clarity and precision is emerging.[2] In this context of information saturation, it becomes an ethical imperative not to contribute to cultural and information overload and to concisely communicate thoughts and feelings.

The traditional ideas of literacy that focus on a standard national language and phonetic decoding are no longer sufficient in an age of proliferating communication systems and increasing linguistic and cultural diversity (The New London Group, 1996). The psychological model of reading and writing as individual cognitive skills needs to advance to a deeper understanding of literacy as a social practice "tied up in the politics and power relations of everyday life in literate cultures" (Luke & Freebody, 1997, p. 185).

Today, novel forms of media and technoculture are proliferating and evolving as technology develops and spreads. These changes in technology and society have led to a call for a broader approach to literacy by many, including The New London Group (1996) whose members propose a pedagogy of "multiliteracies" to address multiple cultural and linguistic differences, as well as the multitude of communication media; advocates of "silicon literacies" to engage new computers, information, communication, and entertainment technologies (see, for example, Snyder, 2002); or advocacy of "multiple literacies" to take account of the full range of proliferating and emergent technologies (Kellner, 1998, 2004).

These scholars suggest that media literacy is one of the many literacies that students need in the twenty-first century to participate more effectively in the democratic process. We agree with these perspectives and in the following analysis suggest how critical media literacy can reconstruct education for the contemporary era, expand the concept of literacy, and contribute to the radical democratization of education and society.

Approaches to Media Education

While there is growing interest in the need for media literacy, there is also much debate about *why* and *how* to teach it (Hobbs, 1998). Four major approaches to media education have appeared, which we will discuss, and then sketch out our own conception of critical media literacy. Just as we suggest that new literacies studies should build on and not leave behind traditional print media, so too do we argue that development of new multiple literacies should build upon and not abandon contributions within the field of media education that have emerged to counter the growing impact of broadcasting media.

Protectionist Approach

One approach to media education emerges from fear of media and aims to protect or inoculate people against the dangers of media manipulation and addiction. This *protectionist approach* posits media audiences as passive victims and values traditional print culture over media culture as exemplified by Neil Postman (1985) in *Amusing Ourselves to Death*. Postman warns that TV has become a powerful force of pedagogy that dominates the attention, time, and cognitive habits of young people. Many activists on both sides of the political spectrum come to media education as a way to push their agenda through blaming the media. Some conservatives blame the media for causing teen pregnancies and the destruction of family values while some on the left criticize the media for rampant consumerism and making children materialistic. Critics of this anti-media approach suggest that it will cause students to either regurgitate "politically correct" responses to media critiques or reject the ideas of media literacy altogether (Buckingham, 1994).

While we are not claiming that media do not contribute to and at times cause many social problems, we take issue with this approach because of its decontextualization and anti-media bias which over-simplifies the complexity of our relationship with media and takes away the potential for empowerment that critical pedagogy and alternative media production offer. When the understanding of media effects is contextualized within its social and historical dynamics, then issues of representation and ideology are extremely useful to media education to explore the interconnections between media and society, information and power (Ferguson, 1998, 2004). This approach is important when it addresses the naturalizing processes of ideology and the interrelationships with social injustice, but it is deeply flawed when it does so through dogmatic orthodoxy and undemocratic pedagogy where teachers merely denounce the media and students are encouraged or coerced to follow this anti-media line.

Media Arts Education

A second approach to teaching about media is present in media arts education, where students are taught to value the aesthetic qualities of media and the arts while using their creativity for self-expression through creating art and media. These programs can be found most often inside schools as stand-alone classes or outside of the classroom in community-based or after-school programs. While many of these programs are excellent examples of critical media literacy, we have concerns with the media arts approach that favors individualistic self-expression over socially conscious analysis and alternative media production. Education loses its transformative potential when programs unproblematically teach students the technical skills to merely reproduce hegemonic representations or express their voice without the awareness of ideological implications or any type of social critique.

Feminist standpoint theorists explain that coming to voice is important for people who have seldom been allowed to speak for themselves, but without critical analysis it is not enough (Collins, 2004; Harding, 2004; Hartsock, 1997). Critical analysis that explores and exposes the structures of oppression is essential because merely coming to voice is something any racist or sexist group of people can also claim. Spaces must be opened up and opportunities created so that people in marginalized positions have the opportunity to collectively struggle against oppression, to voice their concerns, and create their own representations.

Incorporating the arts and media production into public school education holds important political benefits for making learning more experiential, hands-on, creative, expressive, and fun. Media arts education can bring pleasure and popular culture into mainstream education, thereby making school more motivating and relevant to students. When this approach moves beyond technical production skills or relativist art appreciation and is steeped in cultural studies that address issues of gender, race, class, and power, it holds dramatic potential for transformative critical media literacy.

Media Literacy Movement

A third approach to media education can be found in the *media literacy movement* in the United States. While the movement is relatively small,[3] it has made some inroads into mainstream educational institutions and established two national membership organizations in the United States (Kellner & Share, 2005). According to the definition of media literacy provided by one of these organizations, "media literacy is seen to consist of a series of communication competencies, including the ability to ACCESS, ANALYZE, EVALUATE and COMMUNICATE."[4] This approach attempts to expand the notion of literacy to include multiple forms of media (music, film, video, Internet, and so on) while still working within a print literacy tradition.

While we agree with the need to begin with these ideas of expanding our understanding of how we communicate with more than just printed words, this is not enough to bring about a democratic reconstruction of education and society. Robert Ferguson (1998) uses

the metaphor of an iceberg to explain the need for critical media analysis. Many educators working under an apolitical media literacy framework guide their students to only analyze the obvious and overt tip of the iceberg they see sticking out of the water. Ferguson asserts that this is a problem because "The vast bulk which is not immediately visible is the intellectual, historical and analytical base without which media analysis runs the risk of becoming superficial, mechanical or glib" (p. 2). The critical component of media literacy must transform literacy education into an exploration of the role of language and communication media in order to define relationships of power and domination because below the surface of that iceberg lie deeply embedded ideological notions of white supremacy, capitalist patriarchy, classism, homophobia, and other oppressive forces.

Many media educators working from a conventional media literacy approach openly express the myth that education can and should be politically neutral, and that their job is to objectively expose students to media content without questioning ideology and issues of power. Giroux writes, "The notion that theory, facts, and inquiry can be objectively determined and used falls prey to a set of values that are both conservative and mystifying in their political orientation" (1997, p. 11).

The mainstream appeal of the U.S. media literacy movement, something that it is only just starting to develop, can probably be linked to its conservative base that does not engage the political dimensions of education and especially literacy. While this ambiguous nonpartisan stance helps the dissemination of media education, thereby making some of the ideas and tools available to more students, it also waters down the transformative potential for media education to become a powerful instrument to challenge oppression and strengthen democracy. The media literacy movement has done excellent work in promoting important concepts of semiotics and intertextuality, as well as bringing media culture into public education. However, without cultural studies, transformative pedagogy, and a project of radical democracy, media literacy risks becoming another cookbook of conventional ideas that only improve the social reproductive function of education.

Critical Media Literacy

The type of critical media literacy that we propose includes aspects of the three previous models, but focuses on ideology critique and analyzing the politics of representation of crucial dimensions of gender, race, class, and sexuality; incorporating alternative media production; and expanding textual analysis to include issues of social context, control, and pleasure. A critical media literacy brings an understanding of ideology, power, and domination that challenges relativist and apolitical notions of much media education in order to guide teachers and students in their explorations of how power, media, and information are linked. This approach embraces the notion of the audience as active in the process of making meaning, as a cultural struggle between dominant readings, oppositional readings, or negotiated readings (Hall, 1980; Ang, 2002).

Critical media literacy thus constitutes a critique of mainstream approaches to literacy and a political project for democratic social change. This involves a multiperspectival crit-

ical inquiry of media culture and the cultural industries that address issues of class, race, gender, sexuality, and power and also promotes the production of alternative counter-hegemonic media. Media and information communication technology can be tools for empowerment when people who are most often marginalized or misrepresented in the main-stream media receive the opportunity to use these tools to tell their stories and express their concerns. For members of the dominant group, critical media literacy offers an opportu-nity to engage with the social realities that the majority of the world are experiencing. The new technologies of communication are powerful tools that can liberate or dominate, manip-ulate or enlighten, and it is imperative that educators teach their students how to critically analyze and use these media (Kellner, 2004a).

These different approaches to media education are not rigid pedagogical models, but they are rather interpretive reference points from which educators can frame their concerns and strategies. Calling for critical media literacy is important to identify the elements and objectives necessary for good media pedagogy, understanding that principles and pro-grams may be different in varying contexts.

Alan Luke and Peter Freebody (1997) have been developing a dynamic understand-ing of literacy as a social practice where critical competence is one of the necessary com-ponents. This sociological framing of literacy as a *family of practices*, in which multiple practices are crucial and none alone is enough, fits well into our multiperspectival approach to critical media literacy. Luke and Freebody (1999) write that effective literacy requires four basic roles (not necessarily sequential or hierarchical) that allow learners to: "break the code," "participate in understanding and composing," "use texts functionally," and "crit-ically analyze and transform texts by acting on knowledge that texts are not ideologically natural or neutral." This normative approach offers the flexibility for literacy education to explore and critically engage students with the pedagogy that will work best for individ-ual teachers in their own unique situation with the different social and cultural needs and interests of their students and local community.

When educators teach students critical media literacy, they often begin with media arts activities or simple decoding of media texts in the mode of the established media literacy movement, perhaps adding discussion of how audiences receive media messages. However, critical media literacy also engages students in exploring the depths of the iceberg with crit-ical questions to challenge "commonsense" assumptions concerning the meaning of texts with negotiated and oppositional interpretations, as well as seeking alternative media with oppositional and counterhegemonic representations and messages, and, where feasi-ble, teaching critical media literacy through production. While not everyone has the tools to create sophisticated media productions, we strongly recommend a pedagogy of teach-ing critical media literacy through project-based media production (even if it is as simple as rewriting a text or drawing pictures) for making analyses more meaningful and empow-ering as students gain tools for responding and taking action on the social conditions and texts they are critiquing. The goal should be to move toward critical media literacy with the understanding of literacy as a social process that involves multiple dimensions and inter-actions with multiple technologies and that is connected with the transformation of edu-cation and democratization of society.

For example, in her course on critical media literacy at UCLA, Rhonda Hammer has her students work in teams to create their own counterhegemonic movies and Web sites that explore issues they feel are underrepresented or misrepresented in the mainstream media (see Hammer, 2006).[5] During the ten-week quarter, her students produce movies and Web sites that challenge the "commonsense" assumptions about a wide assortment of issues dealing with gender, ethnicity, sexuality, politics, power, and pleasure. Through the dialectic of theory and practice, her students create critical alternative media while engaging the core concepts of critical media literacy as they apply to audience, text, and context.

Along with the media production, students are also required to do particular readings from the course reader, as well as produce a short analytical final paper in which they discuss their group project within the context of critical media literacy. They are asked to incorporate course readings, guest lectures, and films presented in the class. Notions of ideology and hegemony as well as the "politics of representation" in media (which includes dimensions of sexism, racism, classism, and homophobia, to name a few) are central concerns. Also, the ideas and realities of resistance, social and political change, and agency are emphasized.

Feminism and Critical Media Literacy

Feminist theory and standpoint epistemologies provide major contributions to the field of critical media literacy. Carmen Luke (1994) combines cultural and feminist studies to allow for an "epistemological standpoint which acknowledges difference(s) of identity, the cultural constructedness of 'Theory,' 'History,' and 'Truth,' and the cultural dynamics of our own labor as academic researchers and teachers" (p. 33). She links a feminist political commitment to transformation with recognition of media misrepresentation and stereotyping. This approach requires unveiling the political and social construction of knowledge, as well as addressing principles of equity and social justice related to representation. Through the inclusion of some groups and exclusion of others, representations benefit dominant and positively represented groups and disadvantage marginalized and subordinate ones.

These biases become especially pernicious when two factors exist:

- limited and dominant groups do the majority of the representing, as in the case of the multinational corporate mass media;
- when the messages are naturalized, people seldom question the transparent social construction of the representations.

Luke argues that it is the teacher's responsibility within the classroom to make visible the power structure of knowledge and how it benefits some more than others. She insists "that a commitment to social justice and equity principles should guide the media educator's work in enabling students to come to their own realizations that, say, homophobic, racist or sexist texts or readings, quite simply, oppress and subordinate others" (p. 44).

Further, a student-centered, bottom-up approach is necessary for a standpoint analysis to come from each student's own culture, knowledge, and experiences. Luke suggests that

collaborative inquiry and media production can be ways for students to voice their discoveries. Poststructuralist, feminist, and critical pedagogies all stress the importance of valuing students' voices for deconstructing media as well as creating their own. While these practical suggestions are congruent with much current advice on media literacy education, Luke asserts the need to take media education beyond just analyzing the production of meaning. She writes that critical media studies must "extend to explorations of how individual and corporate sense-making tie in with larger socio-political issues of culture, gender, class, political economy, nation, and power" (Luke, 1994, p. 31).

Feminist standpoint epistemologies offer a methodology to study up from subordinate positions to reveal structures of oppression, the functioning of hegemony and alternative epistemologies. Uma Narayan states, "[I]t is *easier* and *more likely* for the oppressed to have critical insights into the conditions of their own oppression than it is for those who live outside these structures. Those who actually *live* the oppressions of class, race, or gender have faced the issues that such oppressions generate in a variety of different situations. The insights and emotional responses engendered by these situations are a legacy with which they confront any new issue or situation" (2004, p. 220). Standpoint theories thus offer important concepts for seeing through the naturalization of the dominant perspective. Sandra Harding (2004) suggests we begin our attempt to perceive and understand phenomena from the standpoint of marginalized groups in order to gain multiple perspectives on issues and phenomena that appear as common sense.

Cultural and Media Studies

While media education has evolved from many disciplines, an important arena of theoretical work for critical media literacy comes from the multidisciplinary field of cultural studies. This is a field of critical inquiry that began decades ago in Europe and continues to grow with new critiques of media and society. From the 1930s through the 1960s, researchers at the Frankfurt Institute for Social Research used critical social theory to analyze how media culture and the new tools of communication technology induce ideology and social control. In the 1960s, researchers at the Centre for Contemporary Cultural Studies at the University of Birmingham added to the earlier concerns of ideology with a more sophisticated understanding of the audience as active constructors of reality, not simply mirrors of an external reality. Applying concepts of semiotics, feminism, multiculturalism, and postmodernism, a dialectical understanding of political economy, textual analysis, and audience theory has evolved in which media culture can be analyzed as dynamic discourses that reproduce dominant ideologies as well as entertain, educate, and offer the possibilities for counterhegemonic alternatives (see Kellner, 1995).

In the 1980s, media studies research began to enter the educational arena. With the publication of Len Masterman's *Teaching the Media* (1985), many educators around the world embraced media education less as a specific body of knowledge or set of skills, and more as a framework of *conceptual understandings* (Buckingham, 2003). Different people and organ-

izations across the globe have generated and continue to create different lists of media literacy concepts[6] that vary in number and wording but, for the most part, tend to coincide with a handful of basic principles:

1 recognition of the construction of media and communication as a social process as opposed to accepting texts as isolated neutral or transparent conveyors of information;

2 some type of semiotic textual analysis that explores the languages, genres, codes, and conventions of the text;

3 an exploration of the role audiences play in actively negotiating meanings;

4 problematizing the process of representation to uncover and engage issues of ideology, power, and pleasure;

5 examination of the production and institutions that motivate and structure the media industries as corporate profit seeking businesses.

Critical media literacy challenges the power of the media to present messages as non-problematic and transparent. Because messages are created by people who make decisions about what to communicate and how to communicate, all messages are influenced by the subjectivity and biases of those creating the message as well as the social contexts within which the process occurs. Along with this encoding subjectivity come the multiple readings of the text as it is decoded by different audiences in different contexts. Media are thus not neutral disseminators of information because the nature of the construction and interpretation processes entails bias and social influence.

Semiotics, the science of signs and how meanings are socially produced from the structural relations in sign systems, has contributed greatly to media literacy. Roland Barthes (1998) explains that semiotics aims to challenge the naturalness of a message, the "what-goes-with-out-saying" (p. 11). Masterman (1994) asserts that the foundation of media education is the principle of non-transparency. Media do not present reality like transparent windows or simple reflections of the world because media messages are created, shaped, and positioned through a construction process. This construction involves many decisions about what to include or exclude and how to represent reality. Exposing the choices involved in the construction process is an important starting point for critical inquiry because it disrupts the myth that media can be neutral conveyors of information.

From the study of semiotics, media literacy practitioners analyze the existence of dual meanings of signs: denotation and signifier (the more literal reference to content) and connotation and signified (the more associative, subjective significations of a message based on ideological and cultural codes) (Hall, 1980). When connotation and denotation become one and the same, representation appears natural, making the historical and social construction invisible. Therefore, a goal of cultivating media literacy is to help students distinguish between connotation and denotation and signifier and signified (Fiske, 1990). With younger students the terms are simplified into separating what they see or hear from what they think or feel. Creating media can be a powerful vehicle for guiding students to explore these ideas and learn how different codes and conventions function. For example, discus-

sion of the representation of class, gender, and race in media such as television or film requires analysis of the codes and stereotypes through which subordinate groups like workers, women, and people of color are represented, in contrast to representations of bosses and the rich, men, and white people. The analysis of different models of representation of women or people of color makes clear the constructedness of gender and race representations and that dominant negative representations further subordination and make it look natural. Thus, while signifiers that represent male characters like Arnold Schwarzenegger seem to just present a male actor, they construct connotative meanings and signify certain traits such as patriarchal power, violent masculinity, and male dominance. Media texts are thus highly coded constructions with specific rules and practices.

One of the most important components of critical media literacy evolves from work at the Birmingham Centre for Contemporary Cultural Studies in the UK and involves the notion of an active audience, challenging previous theories that viewed receivers of media as passive recipients and often victims. Building on semiotic conceptions developed by Roland Barthes and Umberto Eco, Stuart Hall (1980) argues, in a study of "Encoding/Decoding," that a distinction must be made between the encoding of media texts by producers and the decoding by consumers. This distinction highlights the ability of audiences to produce their own readings and meanings, to decode texts in aberrant or oppositional ways, as well as the "preferred" ways in tune with the dominant ideology.

The cultural studies approach provides a major advance for understanding literacy as Ien Ang (2002, p. 180) explains: "Textual meanings do not reside in the texts themselves: a certain text can come to mean different things depending on the interdiscursive context in which viewers interpret it." The notion that audiences are neither powerless nor omnipotent when it comes to reading media contributes greatly to the potential for media literacy to empower audiences in the process of negotiating meanings. As bell hooks (1996, p. 3) puts it: "While audiences are clearly not passive and are able to pick and choose, it is simultaneously true that there are certain 'received' messages that are rarely mediated by the will of the audience." Empowering the audience through critical thinking inquiry is essential for students to challenge the power of media to create preferred readings. Audience theory views the moment of reception as a contested terrain of cultural struggle where critical thinking skills offer potential for the audience to negotiate different readings and openly struggle with dominant discourses.

The ability for students to see how diverse people can interpret the same message differently is important for multicultural education because understanding differences means more than merely tolerating one another. Research, for example, has shown that the U.S. television series *Dallas* (Katzman et al., & Preece et al., 1978–1991) has very different cultural meanings for people in various countries. Dutch and Israeli audiences, for instance, decode it very differently from American audiences (Ang, 2002). Likewise, different subject positions like gender, race, class, or sexuality will also produce different readings and one's grasp of a media text is enriched by interpreting from the standpoint of different audience perspectives.

This process of grasping different audience readings and interpretations enhances

democracy as multicultural education for a pluralistic democracy depends on a citizenry that embraces multiple perspectives as a natural consequence of varying experiences, histories, and cultures constructed within structures of dominance and subordination. Feminist Standpoint Epistemologies offer a starting point for this type of inquiry by beginning all analyses from a subordinate position whereby the preferred hegemonic readings are denaturalized and exposed as merely one of many ways to understand the message. Understanding dissimilar ways of seeing is essential to understanding the politics of representation.

Critical media literacy involves the politics of representation in which the form and content of media messages are interrogated in order to question ideology, bias, and the connotations explicit and implicit in the representation. Cultural Studies, Feminist Theory, and Critical Pedagogy offer arsenals of research for this line of inquiry to question media representations of race, class, gender, and so on. Beyond simply locating the bias in media, this concept helps students recognize the ideological and constructed nature of all communication.

For example, reading the content of a TV series like *Buffy, the Vampire Slayer* (Berman et al., & Whedon et al., 1997–2003) discerns more positive representations of young women than are typical in mainstream media artifacts and sends out messages of teen female empowerment (Kellner, 2004b). The positive representations of gays and lesbians on the show also transmit messages that suggest more multiple and pluralistic representations of sexuality than is usual in U.S. network TV programs (although representations of sexuality have greatly expanded over the past decade). The monsters on *Buffy* can be read as signifying dangers of drugs, rampant sexuality, or gangs producing destructive violence.

Content is often highly symbolic and thus requires a wide range of theoretical approaches to grasp the multidimensional social, political, moral, and sometimes philosophical meanings of a cultural text. Analyzing content also requires questioning the omissions in media representations. Working with students as young as preschool age, Vivian Vasquez (2003) encourages them to ask the following questions: "Whose voice is heard? Who is silenced? Whose reality is presented? Whose reality is ignored? Who is advantaged? Who is disadvantaged?" (p. 15).

In terms of critically engaging the forms of media culture, semiotic analyses can be connected with genre criticism (the study of conventions governing established types of cultural forms, such as soap operas) to reveal how the codes and forms of particular genres follow certain meanings. Situation comedies, for instance, classically follow a conflict/resolution model that demonstrates how to solve certain social problems by correct actions and values, and thus provide morality tales of proper and improper behavior. Soap operas, by contrast, proliferate problems and provide messages concerning the endurance and suffering needed to get through life's endless miseries, while generating positive and negative models of social behavior. Advertising in turn shows how commodity solutions solve problems of popularity, acceptance, success, and the like. In a high school media literacy class, students retold the same story in different media genres as a method of exposing how different genres position audiences for different readings (Hobbs, 2007).

Other formal techniques also contribute to the construction of meaning such as analy-

sis of narrative, editing, the assemblage of scenes and images, and how the technical features of specific media like film contribute to the construction of meaning. A semiotic and genre analysis of the film *Rambo* (Kassar, Vajna, & Kotcheff, 1982) for instance, would show how it follows the conventions of the Hollywood genre of the war film that dramatizes conflicts between the United States and its "enemies" (see Kellner, 1995). A semiotic analysis would describe how the images of the villains are constructed according to the codes of World War II movies and how the resolution of the conflict and happy ending follows the traditional Hollywood classical cinema, which portrays the victory of good over evil. A semiotic analysis would also include the study of the strictly cinematic and formal elements of a film like *Rambo*, dissecting the ways that camera angles present Rambo as a god, or slow-motion images of him gliding through the jungle code him as a force of nature, or images of him on a Russian torture-wrack with a halo of light illuminating his head construct him as Christ on a cross.

Critical media literacy also encourages students to consider the question of *why* the message was sent and *where* it came from. Too often students believe the role of media is simply to entertain or inform, with little knowledge of the economic structure that supports it. Where once there were many media outlets in every city competing for viewers and readers, a few years ago, there were less than ten transnational corporations dominating the global media market. In the most recent revised edition of Ben Bagdikian's *The New Media Monopoly* (2004), Bagdikian states that there are now just five corporations that dominate the U.S. media market. He writes:

> Five global-dimension firms, operating with many of the characteristics of a cartel, own most of the newspapers, magazines, book publishers, motion picture studios, and radio and television stations in the United States . . . These five conglomerates are Time Warner, by 2003 the largest media firm in the world; The Walt Disney Company; Murdoch's News Corporation, based in Australia; Viacom; and Bertelsmann, based in Germany. (p. 3)

The consolidation of ownership of the mass media has given control of the public airwaves to a few multinational oligopolies to determine who and what is represented and how. This concentration of ownership threatens the independence and diversity of information and creates the possibility for the global colonization of culture and knowledge (McChesney, 1999a, 2004). Robert McChesney (1999b) insists that the consolidated ownership of the media giants is highly undemocratic, fundamentally noncompetitive, and "more closely resembles a cartel than it does the competitive marketplace found in economics textbooks" (p. 13).

For example, mainstream media in the United States tended to present Republican candidates and presidents like Ronald Reagan and George W. Bush favorably because, in part, the conservative Republican agenda was in line with the corporate interests of media companies that favored deregulation, absence of impediments to corporate mergers, and tax breaks for their wealthy employees and advertisers (Kellner, 1990 and 2001). Certain media corporations, like Rupert Murdoch's News Corporation and Fox television network, pursue aggressively right-wing agendas in line with the corporate interests of its owner, board of directors, and top executives who closely follow Murdoch's conservative line. Thus, know-

ing what sort of corporation produces a media artifact, or what sort of system of production dominates given media, will help to critically interpret biases and distortions in media texts.

Transformative Pedagogy and Multiculturalism

Our multiperspectival approach to critical media literacy is most relevant to progressive and transformative education when taught through a democratic approach with critical pedagogy that follows the ideas of progressive educators like John Dewey and Paulo Freire. Dewey championed education for democracy and placed emphasis on active learning, experimentation, and problem solving. Dewey's pragmatic approach connects theory with practice and requires students to similarly connect reflection with action (1916/1997). Using a problem-posing pedagogy, Freire (1970) calls for critical consciousness that involves perception of concrete situations and problems, as well as action against oppression. The problem-posing alternative that Freire exercises requires dialogical communication between students and teachers where both are learning and teaching each other. This method necessitates praxis, critical reflection, together with action to transform society. For this reason, media education should ideally involve both critical analysis and alternative student media production.

Developing critical media literacy involves perceiving how media like film or video can be used positively as well to teach a wide range of topics, like multicultural understanding and education. If, for example, multicultural education is to champion genuine diversity and expand the curriculum, it is important both for groups marginalized from mainstream education to learn about their own heritage and for dominant groups to explore the experiences and voices of minority and oppressed people. When groups often underrepresented or misrepresented in the media become investigators of their representations and creators of their own meanings, the learning process becomes an empowering expression of voice and democratic transformation.

Thus, critical media literacy can promote multicultural literacy, conceived as understanding and engaging the heterogeneity of cultures and subcultures that constitute an increasingly global and multicultural world (Cortés, 2000; Courts, 1998; Weil, 1998). Critical media literacy not only teaches students to learn from media, to resist media manipulation, and to use media materials in constructive ways, but it is also concerned with developing skills that will help create good citizens and that will make individuals more motivated and competent participants in social life.

In the evolving multimedia environment, media literacy is arguably more important than ever. Cultural and media studies have begun to teach us to recognize the ubiquity of media culture in contemporary society, the growing trends toward multicultural education, and the need for media literacy that addresses the issue of multicultural and social difference.[7] There is expanding recognition that media representations help construct our images and understanding of the world and that education must meet the dual challenges of teaching media literacy in a multicultural society and sensitizing students and the pub-

lic at large to the inequities and injustices of a society based on gender, race, and class inequalities and discrimination. Recent critical studies see the role of mainstream media in exacerbating or diminishing these inequalities and how media education and the production of alternative media can help create a healthy multiculturalism of diversity and a more robust democracy. They confront some of the most serious difficulties and problems that currently face us as educators and citizens.

Radical Democracy

Critical media literacy in our conception is tied to the project of radical democracy and concerned to develop skills that will enhance democratization and civic participation. It takes a comprehensive approach that teaches critical skills and how to use media as instruments of social communication and change. The technologies of communication are becoming more and more accessible to young people and ordinary citizens and can be used to promote education, democratic self-expression, and social progress. Technologies that could help produce the end of participatory democracy, by transforming politics into media spectacles and the battle of images, and by turning spectators into passive consumers, could also be used to help invigorate democratic debate and participation.

Indeed, teaching critical media literacy should be a participatory, collaborative project. Watching television shows or films together could promote productive discussions between teachers and students (or parents and children), with an emphasis on eliciting student views, producing a variety of interpretations of media texts, and teaching basic principles of hermeneutics and criticism. Students and youths are often more media savvy, knowledgeable, and immersed in media culture than their teachers, and can contribute to the educational process through sharing their ideas, perceptions, and insights. Along with critical discussion, debate, and analysis, teachers ought to be guiding students in an inquiry process that deepens their critical exploration of issues that affect them and society. Because media culture is often part and parcel of students' identity and a most powerful cultural experience, teachers must be sensitive in criticizing artifacts and perceptions that students hold dear, yet an atmosphere of critical respect for difference and inquiry into the nature and effects of media culture should be promoted (Luke, 1997).

> A major challenge in developing critical media literacy, however, results from the fact that it is not a pedagogy in the traditional sense with firmly established principles, a canon of texts, and tried-and-true teaching procedures. It requires a democratic pedagogy that involves teachers sharing power with students as they join together in the process of unveiling myths and challenging hegemony. Moreover, the material of media culture is so polymorphous, multivalent, and polysemic, that it necessitates sensitivity to different readings, interpretations, perceptions of the complex images, scenes, narratives, meanings, and messages of media culture, which in its own ways is as complex and challenging to critically decipher as book culture.

Teaching critical media literacy involves occupation of a site above the dichotomy of fandom and censor. One can teach how media culture provides significant statements or insights about the social world, empowering visions of gender, race, and class, or complex

aesthetic structures and practices, thereby putting a positive spin on how it can provide significant contributions to education. Nevertheless, we ought to indicate also how media culture can advance sexism, racism, ethnocentrism, homophobia, and other forms of prejudice, as well as misinformation, problematic ideologies, and questionable values, accordingly promoting a dialectical approach to the media.

Conclusion

Critical media literacy gives individuals power over their culture and thus enables people to create their own meanings and identities to shape and transform the material and social conditions of their culture and society. Many critical educators have been promoting these goals, including Masterman (1994) who proposes that media education aim for critical autonomy, empowering students to be independently critical. Robert Ferguson (2001) suggests that our relationships with media are not autonomous; rather, they depend on taking positions related to social contexts. Because we are always taking sides, Ferguson calls for critical solidarity, which he describes as "a means by which we acknowledge the social dimensions of our thinking and analysis. It is also a means through which we may develop our skills of analysis and relative autonomy" (p. 42). Critical solidarity means teaching students to interpret information and communication within humanistic, social, historical, political, and economic contexts for them to understand the interrelationships and consequences of their actions and lifestyles. If we combine critical autonomy with critical solidarity, we can teach students to be independent and interdependent critical thinkers, who will be less dependent on media framing and representations. Critical media literacy offers an excellent framework to teach critical solidarity and the skills that can challenge the social construction of information and communication, from hypertext to video games.

The absence of critical analysis and production in most schools, along with the last decades of unprecedented technological innovations and globalization, make critical media literacy so vital and timely. The current fascination with technology and interest in computer literacy has been receiving significant public support yet lacks a critical-analytical framework to analyze these new tools. The focus on acquiring technological skills, as if technology were neutral, has left a major pedagogical void that presents an excellent opportunity for critical media literacy. Carmen Luke (2004) suggests that if media literacy can be brought into schools through "the 'backdoor' into computer literacy education," then it may have a better chance of being accepted and greatly improving computer education. We agree with this position and would propose that critical media literacy be applied to new information and computer technologies, as well as more (now) traditional broadcast media.

We believe twenty-first century schools must change the way they teach by empowering students to analyze and use media and technology to express their views and visions in critical solidarity with the world around them. Literacy instruction needs to change, and this movement must come from both the top down and the bottom up. This is a big project and to be successful, it requires that teachers, administrators, and policy makers work

together. Literacy must be reframed to expand the definition of a text to include new modes of communication and to enhance our critical analytical processes to explore audience reception, ideology, social justice, and oppression, as well as the political, economic, historical, and social contexts within which all messages are written and read.

Cultural studies and a radically democratic transformative pedagogy offer the theoretical and pedagogical background to inform practice that can democratically reconstruct education and society. To move forward with critical media literacy we need to lobby for better funding for education, especially where it is needed most—in the inner cities and other oppressed areas. We need to challenge the false wisdom of high stakes testing and deficit thinking, as well as to train teachers in critical pedagogy and empower them to use their creativity more than scripted curricula. In addition, we need conferences, teacher education, and continuing professional development that teach cultural studies, critical pedagogy, and practical applications for how to engage students in the classroom with critical media literacy concepts.

We recommend that media education programs be instituted throughout K-12 and that linking media literacy with production become a regular practice. Standards for media literacy programs should include criticizing how media reproduce racism, sexism, homophobia, and other prejudices and encouraging students to find their own voices in criticizing media culture and producing alternative media. Media education should be linked with education for democracy, where students are encouraged to become informed and media literate participants in their societies. Critical media literacy should thus be linked with information literacy, technological literacy, the arts, and the social sciences, and the democratic reconstruction of education. Critical media literacy should be a common thread that runs through all curricular areas because it deals with communication and society.

The basis of media literacy is that all messages are constructed, and when education begins with this understanding of the social construction of knowledge, the literacy process can expand critical inquiry into multiple forms of information and communication, including television and other modes of media culture, the Internet, advertising, artificial intelligence, biotechnology, and, of course, books. Literacy is thus a necessary condition to equip people to participate in the local, national, and global economy, culture, and polity. As Dewey (1916/1997) argued, education is necessary to enable people to participate in democracy, for without an educated, informed, and literate citizenry, strong democracy is impossible. Moreover, there are crucial links between literacy, democracy, empowerment, and social participation in politics and everyday life. Hence, without developing adequate literacies, differences between "haves" and "have nots" cannot be overcome, and individuals and groups will be left out of the emerging global economy, networked society, and culture.

Living in what Marshall McLuhan (1964/1997) coined the global village, it is not enough to merely understand media, students need to be empowered to critically negotiate meanings, engage with the problems of misrepresentations and underrepresentations, and produce their own alternative media. Addressing issues of inequality and injustice in media representations can be a powerful starting place for problem-posing transformative

education. Critical media literacy offers the tools and framework to help students become subjects in the process of deconstructing injustices, expressing their own voices, and struggling to create a better society.

NOTES

1 On multiple literacies, see Kellner (1998, 2004).

2 On the new forms of Internet culture and online communities,see Kahn & Kellner (2003 and 2005).

3 See Kellner & Share, 2005. In 2006, the two national US media literacy organizations boasted memberships of about 500 people each.

4 This is part of The Alliance for a Media Literate America definition available online at: http://www.amlainfo.org/medialit/index.php

5 Hammer's course website can be viewed at: http://www.sscnet.ucla.edu/05F/womencm178-1/

6 Canada's Ontario Ministry of Education's Eight Key Concepts, British Film Institute's Signpost Questions, The Center for Media Literacy's Five Core Concepts, and so on. See the latter's website at: http://www.medialit.org/bp_mlk.html

7 For examples of analyses of media literacy and pedagogy, see Cortés (2000), Fleming (1993), Giroux (1992, 1993, 1994, 1996), Giroux and McLaren (1994), Giroux & Shannon (1997), Goodman (2003), Kellner (1995a, 1995b), Kellner & Ryan (1988), Luke (1994, 1997), Masterman (1985/2001), McLaren, Hammer, Sholle, and Reilly (1995), Potter (2001), Semali and Watts Pailliotet (1999), Schwoch, White & Reilly (1992), Sholle and Densky (1994). See also the work of Barry Duncan and the Canadian Association for Media Literacy (website: http://www.nald.ca/province/que/litcent/media.htm) and the Los Angeles based Center for Media Literacy (www.medialit.org). It is a scandal that there are not more efforts to promote media literacy throughout the school system from K-12 and into the university. Perhaps the ubiquity of computer and multimedia culture will awaken educators and citizens to the importance of developing media literacy to create individuals empowered to intelligently access, read, interpret, and criticize contemporary media and cyberculture.

REFERENCES

Ang, I. (2002). On the politics of empirical audience research. In M.G. Durham & D. M. Kellner (Eds.), *Media and cultural studies: key works* (pp. 177–197). Malden, MA: Blackwell.

Bagdikian, B. H. (2004). *The new media monopoly*. Boston: Beacon Press.

Barthes, R. (1998). *Mythologies*. New York: Hill and Wang.

Berman, G., et al. (Producers), & Whedon, J., et al. (Directors). (1997–2003). *Buffy the vampire slayer* [Television series]. USA: WBTN and UPN.

Buckingham, D. (1994). *Children talking television: The making of television literacy*. London: Falmer.

Buckingham, D. (2003). *Media education: Literacy, learning and contemporary culture*. Cambridge: Polity Press.

Collins, P. H. (2004). Learning from the outsider with: The sociological significance of black feminist thought. In S. Harding (Ed.), *Feminist standpoint theory reader: Intellectual and political controversies* (pp. 103–126). New York: Routledge.

Cortés, C. (2000). *The children are watching: How the media teach about diversity*. New York: Teachers College Press.

Courts, P. L. (1998). *Multicultural literacies: Dialect, discourses, and diversity*. New York: Peter Lang.

Dewey, J. (1916/1997). *Democracy and education*. New York: The Free Press.

Ferguson, R. (1998). *Representing 'race': Ideology, identity and the media*. New York: Oxford University Press.

Ferguson, R. (2001). Media education and the development of critical solidarity. *Media Education Journal, 30*, 37–43.

Ferguson, R. (2004). *The media in question*. London: Arnold.

Fiske, J. (1990). *Introduction to communication studies* (2nd ed.). London: Routledge.

Fleming, D. (1993). *Media teaching*. Oxford: Basil Blackwell.

Freire, P. (1970). *Pedagogy of the oppressed*. New York: Seabury Press.

Giroux, H. (1997). *Pedagogy of the politics of hope: Theory, culture, and schooling*. Boulder, CO: Westview Press.

Giroux, H. (1999). *The mouse that roared: Disney and the end of innocence*. Boulder, CO: Rowman & Littlefield.

Giroux, H., & McLaren, P. (Eds.). (1994). *Between borders: Pedagogy and the politics of cultural studies*. New York: Routledge.

Goodman, S. (2003). *Teaching youth media: A critical guide to literacy, video production, and social change*. New York: Teachers College Press.

Hall, S. (1980). Encoding/Decoding. In S. Hall, D. Hobson, A. Lowe, & P. Willis (Eds.), *Culture, media, language* (pp. 128–138). London: Hutchinson.

Hammer, R. (2006). Teaching critical media literacies: Theory, praxis and empowerment. *InterActions: UCLA Journal of Education and Information Studies, 2*(1). Retrieved February 17, 2006, from http://repositories.cdlib.org/gseis/interactions/v012/iss1/art7/

Harding, S. (Ed.). (2004). *Feminist standpoint theory reader: Intellectual and political controversies*. New York: Routledge.

Hartsock, N. (1997). The feminist standpoint: Developing the ground for a specifically feminist historical materialism. In S. Kemp & J. Squires (Eds.), *Feminisms* (pp. 152–160). New York: Oxford University Press.

Hobbs, R. (1998). The seven great debates in the media literacy movement. *Journal of Communication, 48*(1), 16–32.

Hobbs, R. (2007). *Reading the media: Media literacy in high school English*. New York: Teachers College.

hooks, b. (1996). *Reel to real: Race, sex, and class at the movies*. New York: Routledge.

Kahn, R., & Kellner, D. (2003). Internet subcultures and oppositional politics. In D. Muggleton (Ed.), *The post-subcultures reader* (pp. 299–314). London: Berg.

Kahn, R., & Kellner, D. (2005). Oppositional politics and the Internet: A critical/reconstructive approach. *Cultural Politics, 1*(1), 75–100.

Kassar, M., & Vajna, A. G. (Executive Producers), & Kotcheff (Director). (1982). *Rambo: First blood* [Motion picture]. United States: Orion.

Katzman, L., et al. (Producers), & Preece, M., et al. (Directors). (1978–1991). *Dallas* [Television series]. New York: CBS.

Kellner, D. (1990). *Television and the crisis of democracy*. Boulder, CO.: Westview Press.

Kellner, D. (1995). *Media culture: Cultural studies, identity and politics between the modern and the postmodern*. London and New York: Routledge.

Kellner, D. (1998). Multiple literacies and critical pedagogy in a multicultural society, *Educational Theory*, 48(1), 103–122.

Kellner, D. (2001). *Grand theft 2000: Media spectacle and a stolen election*. Lanham, MD: Rowman and Littlefield.

Kellner, D. (2003). *Media spectacle*. London and New York: Routledge.

Kellner, D. (2004a). Technological transformation, multiple literacies, and the re-visioning of education, *E-Learning, 1*(1), 9-37.

Kellner, D. (2004b). *Buffy the vampire slayer* as spectacular allegory. In S. Steinberg & J. Kincheloe (Eds.), *Kinderculture: The corporate construction of childhood* (2nd ed.) (pp. 49–71). Boulder, CO: Westview.

Kellner, D., & Share, J. (2005). Toward critical media literacy: Core concepts, debates, organizations and policy. *Discourse: Studies in the Cultural Politics of Education, 26* (3), 369–386.

Kellner, D., with R. Kahn). (2003). Internet subcultures and oppositional politics. In D. Muggleton (Ed.), *The post-subcultures reader* (pp. 299–314). London: Berg.

Kellner, D., & Ryan, M. (1988). *Camera politica: The politics and ideology of contemporary Hollywood film*. Bloomington: Indiana University Press.

Luke, A., & Freebody, P. (1997). Shaping the social practices of reading. In S. Muspratt, A. Luke, & P. Freebody (Eds.), *Constructing critical literacies: Teaching & learning textual practice*. Sydney: Allen & Unwin; and Cresskill, NJ: Hampton Press.

Luke, A., & Freebody, P. (1999). Further notes on the four resources model. *Reading Online*. Retrieved February 12, 2006, from http://www.readingonline.org/research/lukefreebody.html

Luke, C. (1994). Feminist pedagogy and critical media literacy. *Journal of Communication Inquiry, 18*(2), 30–47.

Luke, C. (1997). Media literacy and cultural studies. In S. Muspratt, A. Luke, & P. Freebody (Eds.), *Constructing critical literacies: Teaching & learning textual practice* (pp. 19–49). Cresskill, NJ: Hampton Press, Inc.

Luke, C. (2004). Re-crafting media and ICT literacies. In D. E. Alvermann (Ed.),. *Adolescents and literacies in a digital world*. (pp. 132–146). New York: Peter Lang.

Masterman, L. (1985/2001). *Teaching the media*. New York: Routledge.

Masterman, L. (1994). A rationale for media education:First part. In L. Masterman & F. Mariet, *Media education in 1990s' Europe* (pp. 5–87). Strasbourg: Council of Europe.

McChesney, R. (1999a). *Rich media, poor democracy: Communication politics in dubious times*. Urbana: University of Illinois Press.

McChesney, R. (1999b, November 29). The new global media: It's a small world of big conglomerates [Special issue]. *The Nation, 269*(18), 11–15.

McChesney, R. (2004). *The problem of the media: U.S. communication politics in the 21st century*. New York: Monthly Review Press.

McLaren, P., Hammer, R., Sholle, D., & Reilly, S. (1995). *Rethinking media literacy: A critical pedagogy of representation*. New York: Peter Lang.

McLuhan, M. (1964/1997). *Understanding media: The extensions of man*. Cambridge, MA: MIT Press.

Narayan, U. (2004). The project of feminist epistemology: Perspectives from a nonwestern feminist. In S. Harding (Ed.), *Feminist standpoint theory reader: Intellectual and political controversies* (pp. 213–224). New York: Routledge.

The New London Group. (1996). A pedagogy of multiliteracies: Designing social futures. *Harvard Educational Review, 66*(1), 60–92.

Postman, N. (1985). *Amusing ourselves to death: Public discourse in the age of show business*. New York: Penguin Books.

Potter, J. (2001). *Media literacy*. Thousand Oaks, CA: Sage.

Schwoch, J., White, M., & Reilly, S. (1992). *Media knowledge*. Albany: State University of New York Press.

Semali, L., & Watts Pailliotet, A. (1999). *Intermediality: The teacher's handbook of critical media literacy*. Boulder, CO: Westview Press.

Sholle, D., & Denski, S. (1994). *Media education and the (re)production of culture*. Westport, CT.: Bergin & Garvey.

Snyder, I. (Ed.). (2002) *Silicon literacies*. London and New York: Routledge.

Vasquez, V. (2003) *Getting beyond "I like the book": Creating space for critical literacy in k-6 classrooms*. Newark, NJ: International Reading Association.

Weil, D. K. (1998). *Toward a critical multicultural literacy*. New York: Peter Lang.

Preface to *The Myth of the Liberal Media: An Edward Herman Reader*

Noam Chomsky

Edward Herman's invaluable studies of the media in market-oriented democracies find their natural place in the broader sweep of contemporary history.

From the earliest modern democratic revolutions of seventeenth-century England, one leading theme has been the concerted effort of dominant economic and political elites to keep privilege and power from the "rascal multitude" that sought to enter the public arena, and sometimes succeeded. "The men of best quality," as they called themselves, expressed their willingness to grant the people rights, but only within limits, and on the principle that by "the people" they did not mean the confused and ignorant rabble. The founding fathers of American democracy faced similar problems and discussed them in almost the same words. As one put it, "when I mention the public, I mean to include only the rational part of it. The ignorant vulgar are as unfit to judge of the modes [of government], as they are unable to manage [its] reins." The people are a "great beast" that must be tamed, Alexander Hamilton exclaimed. In more nuanced tones, the leading framer of the constitutional order, James Madison, lucidly elaborated the reasons why that order must be designed to ensure that authentic power remained in the hands of "the wealth of the nation," "the more capable set of men," who could be "expected to sympathize sufficiently

with [the] rights [of property]"—meaning the right to property, which the founding fathers needed to privilege above all other rights.

The concerns of the "responsible men" only heightened as popular struggle extended the opportunities for meaningful public participation in policy making. Early in this century, corporate leaders recognized that "the public mind" was "the only serious danger" that confronted their domination of the social order. By the roaring twenties, business leaders confidently assumed that labor had been tamed for good. But order had been restored in "a most undemocratic America" that was "created over its workers' protests," as Yale University labor historian David Montgomery describes the process. A few years later, the great beast once again escaped its cage. Popular mobilization and struggle at last brought the U.S. closer to the mainstream of industrial society with regard to the rights of poor and working people.

The "more capable set of men" reacted in the standard way, and warned of the "hazard facing industrialists in the newly realized political power of the masses," which had to be beaten back. Corporate propaganda offensives in the postwar era reached an extraordinary scale, targeting captive audiences in factories, schools, churches, and even sports leagues. And of course these efforts used corporate media as a major instrument of their campaign to wage and win "the everlasting battle for the minds of men" and to "indoctrinate citizens with the capitalist story" until they "[were] able to play back the story with remarkable fidelity." That "story" also includes what leaders in the corporate-state nexus required to ensure passive obedience to, if not active participation in, the domestic and international programs they designed.

The "bewildered herd," as Walter Lippmann described the great beast in his influential essays on democratic theory, are to be "spectators" but not "participants" in the political system. Their role is limited to periodic choice among selected members of the "specialized class" of "responsible men," who, it is unnecessary to observe, typically serve the interests of "the wealth of the nation" if they are to retain their status. They intend that the herd perceive few real options in life beyond their "function" as atomized consumers who are granted "consumer choice" but not "consumer sovereignty," as Herman explains.

In the United States, the power of the state to coerce is limited by comparative standards, at least for those with some share in privilege—which is a large part of the population in a very rich society. Not surprisingly, control of opinion and attitudes has been honed to a high art, particularly because civil and political rights were won in this country—not granted. The interplay between freedom and thought control is clearly understood by the "experts in manipulation," to borrow Gramsci's phrase. One of the founders and leading figures of the huge public relations industry, Edward Bernays, reminded his colleagues that with "universal suffrage and universal schooling . . . even the bourgeoisie stood in fear of the common people. For the masses promised to become king." That unfortunate tendency could be contained and reversed, he urged, by new methods of "propaganda" that could be used by "intelligent minorities" to "[regiment] the public mind every bit as much as an army regiments the bodies of its soldiers." Bernays had in mind the dramatic successes of Anglo-American propaganda, which enabled the Wilson administration to whip up jin-

goist war hysteria among a generally pacifist population. As a member of Wilson's state prop-
aganda agency, Bernays was well-placed to observe the operation and draw lessons from it.
So was Walter Lippmann, another participant, who perceived a "revolution" in 'the prac-
tice of democracy' as the manufacture of consent" became "a self-conscious art and a reg-
ular organ of popular government."

Reasoning along similar lines in the second leading Western democracy, the chair of
the British Conservative Party, who recognized the threat that the extension of the fran-
chise posed to party dominance, advised his associates of the need to "apply the lessons"
of wartime propaganda "to the organization of political warfare." So the party did with much
success, drawing on the ample resources provided by the business world. The founders of
modern political science were also impressed by these successes, as were others, among them
Adolf Hitler, who determined that next time Germany would forge its own propaganda tools
to combat those of the Western democracies.

It would be close to a miracle if the practices of corporate and state media shapers were
not influenced significantly by their institutional structure and position within power sys-
tems. The critical question is to discover how these institutional factors operate in the con-
text of many other tendencies and influences, some convergent and others discordant.
Herman's incisive case studies have lent powerful empirical support to his theses about mar-
ket control of media, the triumph and consolidation of market failure that for systemic rea-
sons is rooted in prevailing institutional structures and power relations, and the ways the
media shape the picture of the world that reaches the general public—the audiences who
are, in effect, the "product" that is sold by the owners and managers to their market (other
businesses, advertisers), all of which are closely linked to state power. Herman's essays pro-
ceed beyond analysis to constructive proposals to democratize the media, in both the short
and the longer term, with a realistic and instructive review of prospects and opportunities.

Herman quotes James Madison's observation in later life that "a popular government
without popular information, or the means of acquiring it, is but a prologue to a farce or
tragedy, or perhaps both." The observation is apt; formal guarantees of personal freedom
do not suffice to prevent the farce or the tragedy, even if the guarantees are observed. These
issues should be at the center of the concerns of those who seek to create a society that is
more free and more just.

This preface was previously published in Herman, E. (1999). *The Myth of the Liberal Media: An Edward Herman
Reader*. New York: Peter Lang.

Chapter 3

Word Tricks and Propaganda

Edward S. Herman

The mainstream media carry out their propaganda service on behalf of the corporate and political establishment in many ways: by choice of topics addressed (government rather than corporate abuses, welfare rather than Pentagon waste, Khadaffi rather than Guatemalan state terrorism), by their framing of issues (GDP growth rather than distribution, Federal Reserve policy effects on inflation and security prices rather than on unemployment), by their choice of sources of information (heavily depending on officials and think tank flacks), and by their use of language, among other practices.

I want to focus here on the tricks of language that serve propaganda ends, although it should be recognized that biased word usage is closely tied to the other modes of bias. Heavy reliance on officials allows the officials to frame the issues and to use words in ways that serve their agenda. The word "terrorist" is applied to the target enemy (Iran), or the enemy of our friend (Hamas, the PLO, the Kurdish PKK), not the "constructively engaged" governments of Colombia, Israel, Turkey, or, back in the 1980s, Savimbi and the apartheid government of South Africa. The examples below will show how story framing and word usage are essentially two aspects of a single process.

The Struggle over Words

The integration of word usage, framing, and source selection points up the fact that language is an arena of conflict and struggle. Word meanings, connotations, and applications are fluid and change in the course of struggle. For example, labor has long fought to have the word "strike" mean a legitimate labor tactic and part of the institution of collective bargaining, whereas management has always tried to get the word to symbolize labor violence, inconvenience to the community, and damage to the GDP and balance of payments. Management has been pretty successful in getting the word interpreted with negative connotations. Similarly, "welfare" has taken on negative connotations as part of the 25-year-long corporate and right-wing attack on the welfare state. This same campaign has seen the word "government" become a word of derogation. Politicians run against "Washington" and "government." At the same time, interestingly, as the right wingers are fond of the military establishment, they have succeeded in making the word government applicable only to the government in its civil functions; in denouncing the "government," they do not denounce the Pentagon.

Words are regularly transformed in the service of the powerful. "Terrorism," originally used to describe state violence, as in the French Revolution era's "reign of terror," has evolved in modern times to focus mainly on anti-government, anti-establishment forms of political violence. "Political correctness," originally an ironical left term for the standards of comrades prone to sectarianism, was seized by establishment spokespersons for a broad-brush castigation of the academic left. "Freedom" has been subtly transformed in the New World Order from political to economic liberty (including liberty for GE, GM, Exxon, and Royal Dutch Shell), just as "democracy" has lost its substantive qualities in favor of adherence to electoral forms. "Entitlement" has taken on negative connotations because the dominant class has succeeded in identifying it with claims of the weak, as in "Social Security entitlements" (there are no military-industrial complex "entitlements," only "procurement," service contracts, and occasionally acknowledged "subsidies").

"Reform" is the classic of word revisionism in the service of those in power, transformed from meaning institutional and policy changes helpful to the afflicted and weak to move away from the welfare state and toward free markets, thus helping the the afflictors and strong. In an Orwellian twist, "reform" that frees the poor and weak of their "entitlements"—pushing them into a labor market kept loose by Alan Greenspan—is referred to as "empowerment."

Dossier of Word Tricks

Let us review some of the common word tricks of the servants of power in the media and think tank-academic community, taking examples from recent press usage.

PURRING. Purr words are those with positive and warming overtones that create an aura of decency and virtue. Reform, responsible, accountability, choice, jobs, growth, modern-

ization, flexibility, cost-benefit analysis, national security, stability, and efficiency are all prime purr words. The "reformers" are always having their "patience tested," while never testing the patience of others.[1] And reformers are invariably moderate, centrist, courageous, daring, and proud. *The New York Times'* *(NYT)* Leslie Gelb spoke of Les Aspin, Stephen Solarz, and Al Gore as "courageous" for having broken ranks and supported George Bush's decision to bomb Iraq rather than pursue any less violent course of action.[2] A *NYT* headline of April 11, 1997, reads "Proud but Cornered, Mobutu Can Only Hope." Mobutu was one of the great thieves and scoundrels of modern times, but because he was installed by the CIA and protected by the West until 1997, even now he is accorded the purr word "proud," which the paper would never apply to Kim Il Sung or Saddam Hussein.

We can make a long list of purr words from names of congressional bills, always designed to express positive values, even if in substance they threaten enormous pain: New Jersey's "Family Development Initiative Act" (stripping benefits from the poor); the "National Security Revitalization Act" (more boondoggle money); the August 1996 "Personal Responsibility and Work Opportunity Reconciliation Act" (which includes five purr words in a single Orwellian classic of doublespeak for a law that ended the federal commitment to help poor people). Republican pollster and deception manager Frank Luntz carefully tested the "resonance" of words in advising Gingrich and company on the language to be used in the Contract with America. He quite openly sought and used purr words that misrepresented intent, yielding the deception masterpiece "Job Creation and Wage Enhancement Act," for a proposal whose core content was sizable cuts in capital gains taxes.

The use of "flexibility" in "Democrats Show Flexibility on Capital Gains Tax Cut"[3] illustrates how word usage and framing are integrated—"flexibility" gives a positive resonance and tacit approval within a frame stressing political compromise. The paper could have used words like "cave in" or "weakening" and framed the issue as one of Democratic acceptance of a further regression in the tax structure.

For the *New York Times*, spokespersons for the military-industrial complex like Sam Nunn (Georgia, Lockheed), the late Henry Jackson (Washington, Boeing), and the recently retired Republican Senator Alan Simpson are "moderates" and automatically get words expressing approval—an article by Claudia Dreifus on Simpson is titled "Exit Reasonable Right," and in an interview she allows Simpson uncontested justifications for his "rough" usage of Anita Hill and assailing Peter Arnett's Gulf War reporting as traitorous.[4] A column on Jeane Kirkpatrick, by Barbara Crossette was titled "A Warrior, a Mother, a Scholar, a Mystery."[5] Kirkpatrick was most memorable as a "scholar" for her view that "totalitarian" regimes like those in the Soviet bloc can never open up; and as a humanist she was perhaps best known for alleging that the four American nuns raped and murdered in El Salvador in 1980 had asked for it.

For the *Times*, the Arab world is "split into a clearly moderate, pro-Western camp led by Egypt . . . and a fiercely nationalistic anti-Western coalition gathered around Iran."[6] Moderate and pro-Western are synonymous and sources of "stability," as in "In Uneasy Time, Saudi Prince Provides a Hope of Stability."[7] Pro-western moderates like Saudi princes, or

Suharto, are never "tyrants" like Fidel Castro, and if they are not explicitly tagged moderates, approval is expressed by references to their economic accomplishments in "growth"—as regards Suharto, for example, "even his critics [unnamed] acknowledge that he has brought growth and prosperity to this country of 190 million people."[8]

A moderate program is one approved by the Western establishment, whatever its impact on the underlying population, as in "Jose Maria Aznar was appointed prime minister [of Spain] on a moderate platform, promising strict austerity to put the economic house in order." [9] As noted earlier, those implementing approved programs are accorded other purr words—they are bold, courageous, slay ogres, and they do things "quietly," never noisily and recklessly.[10] These purr words often not only express approval but mislead as to substance. Thus, James Sterngold says that "NAFTA is all about corporate efficiency,"[11] which is false—it is about corporate bargaining power, corporate rights to invest abroad, etc. If "moderates" carrying out neoliberal programs do so in violation of election promises, this is seen as courageous and meritorious to the dominant western media. Politicians must "not flinch," "stay the course" and avoid "pandering to fears" (i.e., do what the electorate wants),[12] which displays the triumph of media class bias over the nominal commitment to democratic processes.

SNARLING. Snarl words are those that induce negative reactions and feelings of anger and rejection, like extremist, terrorist, dictator, dependency, welfare, reckless, outlaw, and "snarling" itself. Moderates never snarl, nor can they be outlaws, terrorists, dictators or reckless. Established institutions like the Pentagon and large corporations don't suffer from "dependency" or receive "welfare payments." There is "waste" in social budgets, so assassins of the welfare state pretend that that is what they seek to contain in budget cuts (along with "dependency" and immorality). They can count on the mainstream media not to make comparisons of waste in social and military budgets.

Fidel Castro runs an "outdated police state."[13] Leslie Gelb speaks of the "vicious dictator" of North Korea in an article entitled "The Next Renegade State."[14] To the mainstream media, there is no "outdated police state" or "vicious dictator," let alone renegade, among the "commercially engaged" countries of the world. The *NYT* has never used "vicious dictator" to describe the leader of Saudi Arabia, Pinochet, or the Argentinian generals of 1976–83 who, in the words of an Argentinian truth commission, brought to Argentina a terrorism "infinitely worse" than what they were allegedly combatting.

Environmental "extremists" using "junk science" are now frequently encountered in the mainstream media, especially with the numerous industry mouthpieces like ABC reporter John Stossel, Gina Kolata of the *New York Times*, and the editors of the *Wall Street Journal*. This reflects the intensified corporate assault on environmental regulation, which feeds into the media through corporate public relations and corporate-funded think tanks.[15] The industry-think-tank-media use words like extremism and junk science to characterize oppositional positions and data. There is a struggle over who perpetrates junk science, but the monied interests have a strong edge in defining the terms of the debate and word usage in the mainstream media.

PUTDOWNS. These are less aggressive words of denigration that chide rather than snarl. Leftists are "noisy,"[16] whereas those pursuing neoliberal ends like Mexico's Zedillo, as noted, are "quiet." Leftists are victims of dogmas,[17] whereas those pursuing neoliberalism are showing courage and realism in advancing what by implication are true principles. And when leftists are not noisy but recognize their setbacks and need to adapt, they are "chastened."[18] That they may be chastened by systematic state terror that decimates their ranks need not be mentioned.

PLAYING DOWN VIOLENCE. Economic "reforms" are "tough" and toughening; Latins are "Toughened by experience."[19] Our own managers of terror abroad are "tough,"[20] and our client state leaders who kill and torture are not ruthless killers and torturers but "tough" or merely "forceful" in their pursuit of security.[21] Their massacres are muted into the use of "disproportionate" force or "repressive tactics" ("Mr. Clinton made the requisite complaints about Indonesia's repressive tactics in East Timor")[22]; their torture is "physical force" or "harsh interrogation."[23] After each Israeli invasion of Lebanon—referred to as an "incursion"—the *NYT* refocuses attention away from the killed, wounded, and dispossessed victims to the "new opportunities" for diplomacy.[24]

Back in 1982, U.S. officials brought to the United States a Nicaraguan officer allegedly captured in El Salvador who "confessed" that Nicaragua and Cuba were aiding the Salvadoran rebels. In a press conference in Washington, he declared that his confession had been extracted under torture. The *New York Times* article describing this was entitled "Recanter's Tale: Lesson in Humility for the U.S." (April 2, 1982). The use of "humility" allowed the story to be framed around U.S. official embarrassment at the failure to properly assess the Nicaraguan's shrewdness and ability to "hoodwink" us, and away from the fact that our clients torture. This kind of trick helps explain why torture was so readily institutionalized in the U.S. provinces under U.S. training. We should be "humble" in expecting torture payoffs.

OBSCURING APPEASEMENT OF CLIENT STATE TERROR. Key phrases serving this function include "quiet diplomacy," "commercial diplomacy," and "constructive engagement," which are intended to suggest that the appeasing administration is really bargaining hard for human rights rather than putting a public relations face on its appeasement. We also "de-link" commerce and human rights, which implies that we merely separate the two rather than that we attend to the former and ignore the latter. With commercially important client states, it is notable how often relations are "complex" and negotiations with them "delicate" ("The American relationship with Saudi Arabia is complex and delicate . . . ," *NYT*, ed., Jan. 29, 1997), in contrast with our dealings with, say, Cuba where words and action can be "rough." This language covers over the fact that material interest causes us to appease and even aggressively protect regimes that grossly exploit and deny basic rights to their populations.

FACILITATING INNUENDO. Words and phrases like "linked" and "it is reported" and "officials claim" permit connections and actions to be presented without verifiable evidence. The headline "Link to Iran Suspected in Saudi Blast" (*Philadelphia Inquirer*, Aug. 3, 1996) illustrates an important mode of disseminating propaganda; and the more the allegation fits existing biases, the easier it is to pass it along without supporting evidence. Only the powerful can play this game on a regular basis.

The way this system manifests bias can be seen by comparing Eric Schmitt's "Few Links in Church Fires, Panel Is Told: Official Sees Racism but No Sign of Conspiracy in Firebombings" (*NYT*, May 22, 1996), and William Broad's "Unabomb Case Is Linked to Antiwar Tumult on U.S. Campuses in 1960s" (*NYT*, June 1, 1996). The *Times* has always treated the 1960s resistance with hostility, so here Broad "links" the accused Unabomber Theodore Kaczyinski to the antiwar movement simply because some of his teachers and fellow students opposed the Vietnam War and urged peaceful resistance, even though Broad admits that "by all accounts he was cool to the antiwar unrest." Broad could have "linked" Kaczynski's alleged violent acts to the actual violence of the war itself, which was the source of the peaceful protests that he "links" to Kaczynski. Broad also could have said there is no evidence tying Kaczynski to any groups advocating violence, but that would have precluded making use of the thin and even ludicrous link that allows trashing the 1960s antiwar movement once again.

In the case of the church bombings, the *Times* chose to play down the linking possibilities. It is evident from the subhead given above that the paper could have "linked" the church bombings to racism, but instead it chose to deny a link to a "conspiracy." This makes the bombings sound less ominous and pernicious than if they were "linked" to something. The bombings of the black churches didn't offer the paper any links they were eager to make, as in the case of the Unabomber.

PERSONIFICATION AND USE OF COLLECTIVE WORDS. Personification of groups and nations and the use of collective words are other devices commonly employed to get across preferred positions not supported by evidence. The use of "Brazil" in "Faith in Reform Buoys Brazil" (*FT*, Feb. 24, 1997) is based entirely on attitudes expressed by Brazilian bankers and securities market professionals, who constitute less than a quarter of 1 percent of the Brazilian people.

A classic of this genre was David Sanger's "Jittery Asia Has Visions of a Nuclear North Korea" (*NYT*, April 7, 1991); the generalization to Asia was apparently based on statements of three individuals, two of them officials, one Japanese, the other South Korean. David Rosenbaum's "The Tax Break America Couldn't Give Up" (*NYT*, Oct. 8, 1989), illustrates the use of a collective term to confuse an issue. He claims a generalized feeling among Americans of being overtaxed, but this overlooks class differences in attitude toward specific taxes. It is possible that ordinary Americans feel overtaxed but would be pleased to see higher taxes on the affluent and corporations. "America" could not give up these tax breaks because ordinary citizens have little weight in national policy making. Rosenbaum effectively obscures such consideration by his use of "Americans."

FALSELY IMPUTING BENEVOLENT MOTIVES. My current favorites are "risk" and "gamble," as these are now being applied to the savage welfare "reform" bill of August 1996. The *Philadelphia Inquirer* asserts that "Congress and Clinton are gambling that many poor Americans won't need a safety net to land on their feet" (Aug. 4, 1996). The *New York Times* editorialized on the "gamble," and their house economist, Peter Passell, quoted a think-tank analyst that the bill was taking a "risk" that the people thrown off welfare might not find jobs (Aug. 8, 1996). The use of these words implies that Clay Shaw, Newt Gingrich, David McIntosh, and Bill Clinton are really concerned about those poor folks being pushed out on the streets and no doubt weighed the costs and benefits in some kind of humanistic calculus. This is apologetic nonsense. These politicians weren't taking any risks or gambles; they were serving their own political ends and/or completely unconcerned, if not actually pleased, about any pain the victims would suffer.

It is of course absolutely standard media practice to assume that their own country has good intentions as it ravages in its backyard or other parts of the world (e.g., in the Persian Gulf or Indochina). We always strive for "democracy" and resist somebody else's aggression, but never commit aggression ourselves. Even when we have destroyed a democracy, as in Guatemala in 1954, the U.S. mainstream media uniformly found this justifiable in view of "the threat of communism," which was entirely concocted (although conveniently internalized) and a cover for the pursuit of the interest of United Fruit and a determination to get rid of a seriously reformist leadership that wouldn't take orders. The power of media rationalization of U.S. aggression reached its limit in the Vietnam War where, despite the U.S.'s exclusive reliance on force, and official recognition that our agents could not compete with the "enemy" politically, in James Reston's classic of apologetics, we were in Vietnam to establish the principle "that no state shall use military force or the threat of military force to achieve its objectives." With a "liberal media" that can serve state policy so egregiously, there has not been much in the way of constraint on external aggression that comes from the media itself.

REMOVING AGENCY. Where we or our allies have done terrible things, watch for the resort to the passive voice and other modes of removing agency. Thus the *New York Times* subhead for the article on the ending of the Guatemalan civil war (Dec. 30, 1996) is "After 100,000 dead, the peace ceremony is more solemn than celebratory." Actually, the numbers are well above 100,000 dead, but note the failure to say who did virtually all the killing or what government in 1954 displaced a non-killing elected regime with the regime of terror whose violence is supposedly now ending? In its Indonesia reporting, also, the *Times* has trouble identifying an agent: "More than 500,000 Indonesians are estimated to have died in a purge of leftists in 1965, the year Mr. Suharto came to power" (April 8, 1997). Actually, the "purge" went well beyond "leftists," including several hundred thousand peasant farmers, and there is no doubt who did the purging and what great power supporting the purge viewed it as a "gleam of light in Asia."[26]

Concluding Note

These are just some of the modes by which words are manipulated to serve bias and propaganda. In many cases the process entails passing along the word usage and frame of the originating source. But the media claim to be seeking truth and serving the public (not corporate and elite) interest. That should be the standard by which we evaluate and criticize them as we seek to shrink the immense gap between their own proclaimed ideal and actual performance.

This chapter originally appeared in E. Herman (1999). *The Myth of the Liberal Media: An Edward Herman Reader*. New York: Peter Lang.

NOTES

1 "Labour Costs Test Patience at US Airways," *Financial Times*, 14 April 1997.

2 Leslie Gelb, "Party Derided," *New York Times*, 10 March 1991.

3 Richard Stevenson, "Democrats Show Some Flexibility on Capital Gains," *New York Times*, 1 June 1996.

4 Claudia Dreifus, "Exit Reasonable Right," *New York Times*, 1 June 1996.

5 Barbara Crossette, "A Warrior, a Mother, a Scholar, a Mystery," *New York Times*, 17 August 1994.

6 Youssef Ibrahim, "The Split Among Arabs Unleashes a People's Anger," *New York Times*, 12 August 1990.

7 Douglas Jehl, "In Uneasy Time, Saudi Prince Provides a Hope of Stability," *New York Times*, 19 January 1996.

8 Seth Mydans, "Protesters Angered by Raid Battle Police in Indonesia," *New York Times*, 19 January 1996.

9 Andres Wolberg-Stok, "Conservative Prime Minister Brings Spain's Socialist Era to a Close," *Philadelphia Inquirer*, 5 April 1996.

10 David Pilling, "Argentina Slays ogre of inflation," *Financial Times*, 16 December 1996; Thomas Friedman, "Mexico's Quiet Revolution," *New York Times*, 17 December 1995.

11 James Sterngold, "NAFTA Trade-Off: Some Jobs Lost, Others Gained," *New York Times*, 9 October 1995.

12 Editorial, "Why Poland Can't Flinch," *New York Times*, 17 October, 1991.

13 Bill Keller, "Soviet Press Snaps Back at Castro, Painting an Outdated Police State," *New York Times*, 8 March 1990.

14 Leslie Gelb, "The Next Renegade State," *New York Times*, 10 April 1991.

15 See Sheldon Rampton and John Stauber, *Toxic Sludge Is Good for You* (Monroe, ME: Common Courage Press, 1996.); Dan Fagin and Marianne Lavelle, *Toxic Deception* (Secaucus, NJ: Birch Lane Press, 1996); "A Million for Your Thoughts: The Industry-funded Campaign Against the FDA by Conservative Think Tanks," Public Citizen (1996).

16 Thomas Vogel and Matt Moffett, "Latin Leftists Make a Noisy Comeback," *Wall Street Journal*, 2 January 1997.

17 Wolfgang Munchau, "German Unions Dump Left-wing Dogmas, *Financial Times*, 16–17 November 1996.

18 Larry Rohter, "A Chastened Latin Left Puts Its Hope in Ballots," *New York Times*, 29 July 1996.

19 Virginia March and Kevin Done, "Tough Reforms Bring Rewards," *Financial Times*, 16 December 1996; Stephen Fidler, "Toughened by Experience," *Financial Times*, 10 February 1997.

20 Phillip Shenon, " 'Tough' Guy for Latin Job: (Elliot Abrams), *New York Times*, 1 May 1985.

21 Argentinian General Robert Viola was described as "tough," though a "populist Figure," by Edward Schumacher in the *New York Times*, 6 October 1980; see Also, "Sharon, the Forceful General Intent on Security for Israel," *New York Times*, 11 February 1983 (no byline).

22 Lionel Barber, "EU Criticizes Israel's Use of Disproportionate Force," *Financial Times*, 2 October 1996; the Clinton quote is from David Sanger, "Real Politics: Why Suharto is In and Castro Is Out," *New York Times*, 31 October 1995.

23 Serge Schmemann, "Israel Allows Use of Physical Force in Arab's Interrogation," *New York Times*, 16 November 1996; Joel Greenberg, "Israel Is Permitting Harsher Interrogation of Muslim Militants," *New York Times*, 17 November 1994.

24 Bernard Gwertzman, "Shock of War Could Improve Opportunities for Diplomacy, *New York Times*, 11 July 1982: Leslie Gelb, "U.S. Sees Opportunities and Risks in Mideast After War in Lebanon," *New York Times*, 31 October 1982.

25 James Reston, "The Guiding Principle in Vietnam," *New York Times*, 26 February 1965.

26 James Reston, "Washington: A Gleam of Light," *New York Times*, 19 June 1996. Many more illustrations of the *Times's* playing down of the Indonesian killings are given in chapter 16 of Herman, E. *The Myth of the Liberal Media: An Edward Herman Reader*. New York: Peter Lang Publishing, 1999.

Toward a Democratic Media

Edward S. Herman

Democratic media are a primary condition of popular rule, hence of a genuine political democracy. Where the media are controlled by a powerful and privileged elite, whether it be by government leaders and bureaucrats or those from the private sector, democratic political forms and some kind of limited political democracy may exist, but not genuine democracy. The public will not be participants in the media; instead, they will be consumers of facts and opinions distributed to them from above. The media will, of structural necessity, select news and organize debate supportive of agendas and programs of the privileged. They will not provide the unbiased information and opinion that would permit the public to make choices in accord with its own best interests. Their job will be to show that what is good for the elites is good for everybody, and that other options are either bad or do not exist.

Media Sovereignty and Freedom of Choice

Economists have long distinguished between "consumer sovereignty" and "freedom of consumer choice." The former requires that consumers participate in deciding what is to

be offered in the first place: the latter requires only that consumers be free to select among the options chosen for them by producers. Freedom of choice is better than no freedom of choice, and the market may provide a substantial array of options. But it may not. Before the foreign car invasion in the 1960s, U.S. car manufacturers chose not to offer small cars because the profit margin on small cars is small. It was better to have choices among four or five manufacturers than only one, but the options were constrained by producer interest. Only the entry of foreign competition made small cars available to U.S. buyers. Freedom of choice prevailed in both cases, but consumer sovereignty did not. The cost of *producer* sovereignty was also manifest in the policy of General Motors Corporation, in cahoots with rubber and oil interests, of buying up public transit lines and converting them to GM buses or liquidating them.[1] The consumers of transportation services, if fully informed, might well have chosen to preserve and subsidize the electric transit option, but this sovereign decision was not open to them.

This distinction between sovereignty and free choice has important applications to both national politics and the mass media. In each case, the general population has some kind of free choice, but lacks sovereignty. The public—actually, a shrinking fraction of the public—goes to the polls every few years to pull a lever for slates of candidates chosen for them by political parties that are heavily dependent on funding by powerful elite interests. The public has "freedom of choice" only among a very restricted set of what we might call "effective" candidates, effectiveness being defined by the ability of candidates to attract the funding necessary to make a credible showing.

At the level of mass communication as well, the dominant media with large audiences are owned by an overlapping set of powerful elite interests. There are fringe media with very limited outreach that might support "ineffective" candidates, but because of their marginal status they and the candidates they support can be easily ignored. As with the candidates, the populace has "freedom of choice" among the dominant set of mainstream media, but it lacks sovereignty except in a legalistic and formal sense (we are each legally free to start our own newspaper or buy our own paper or TV network).[2] The elite-dominated mass media, not surprisingly, find the political system admirable, and while they sometimes express regret at the quality of candidates, they never seriously question the absence of citizen sovereignty in decisions about the effective options.

Naturally, also, the mass media hardly mention the undemocratic underpinning of the political process in the media themselves. In fact, one of the most disquieting features of propaganda systems of the constrained democracies of advanced capitalism is that the consolidation of mass media power has closed down discussion of the need for radical restructuring of the media. It has also pushed such changes off the political agenda. As the "gatekeepers," the mass media have been in the enviable position of being able to protect themselves from debate or political acts that threaten their interests, which illustrates the deeply undemocratic character of *their* role.

The last great fight over structural change in the mass media was in 1934, when the FCC was created and broadcasting policy was fixed. At that time, an important lobbying effort pressed for the reservation of 25 percent of air channels for nonprofit operations. This

was defeated by the power of the commercial lobby and by their assurance that they would service public interest needs.[3] As advertising grew, however, and entertainment and "non-controversial" programming proved more profitable than public affairs and educational children's programming, the latter were gradually abandoned—but all on the quiet, as the gatekeepers determined, without any public debate or public decision.

Occasionally, issues like TV violence have aroused public opinion and caused the Congress to hold hearings and assail the TV networks, but the whole business has always been settled by appeals to corporate responsibility and self-regulation, and the media barons' assurance of their deepest concern and commitment to rectifying the situation. In 1977, however, an unusually aggressive and naive congressional subcommittee actually drafted a report that called for investigation of the structure of the TV industry, as a necessary step toward attacking the violence problem at its source. As George Gerbner described the sequel;

> When the draft mentioning industry structure was leaked to the networks, all hell broke loose. Members of the subcommittee told me that they had never before been subject to such relentless lobbying and pressure. Campaign contributors were contacted. The report was delayed for months. The subcommittee staffer who wrote the draft was summarily fired. The day before the final vote was to be taken, a new version drafted by a broadcast lobbyist was substituted. It ignored the evidence of the hearings and gutted the report, shifting the source of the problem from network structure to the parents of America. When the network-dictated draft came to a vote, members of the full committee (including those who had never attended hearings) were mobilized, and the watered down version won by one vote.[4]

In short, the power of the highly undemocratic mass media is enormous.

What Would Democratic Media Look Like?

Democratic media can be identified by their structure and functions. In terms of structure, they would be organized and controlled by ordinary citizens or their grassroots organizations. This could involve individuals or bodies that serve local or larger political, minority, or other groups in the social and political arena. Media fitting these structural conditions would be bound to articulate demands of the general population because they are either part of it or instruments created to serve its needs.

In the mainstream system, the mass media are large organizations owned by other large organizations or shareholders and controlled by *members* of a privileged business elite. The ownership structure puts them at a distance from ordinary people. They are funded by advertising, and advertisers have to be convinced that the programs meet their needs. Thus in terms of fundamental structure, the mainstream media are not agents serving the general public: The first responsibility of their managers by law is to stockholders seeking profits; and as advertisers are the principal source of revenue, their needs come second. There is no legal responsibility to audiences at all; consumers must be persuaded to watch or buy, by any means the gatekeeper chooses, within the limits of law and conventional standards of morality.

As regards function, democratic media will aim first and foremost to serve the informational, cultural, and other communications needs of the members of the public that the media institutions comprise or represent. The users would determine their own needs and fix the menu of choices either directly or through their closely controlled agents, and debate would not be limited to selected voices chosen by corporate or governmental gatekeepers. The sovereign listeners would not only participate in choosing programs and issues to be addressed, they would be the voices heard, and they would be involved in continuous interchanges with other listeners. There would be a horizontal flow of communication, in both directions, instead of a vertical flow from officials and experts to the passive population of consumers.

At the same time, democratic media would recognize and encourage diversity. They would allow and encourage minorities to express their views and build their own respective community's solidarity within the larger community. This would follow from the democratic idea of recognizing and encouraging individual differences and letting all such flowers bloom irrespective of financial capability and institutional power. This idea is also consistent with the ideal of pluralism, which is part of mainstream orthodox doctrine but is poorly realized in mainstream practice. The commercial media serve minority constituencies badly; they tend to repeat homogenizing mainstream cultural and market themes and ignore groups entirely when they are really *poor*. In Hungary, for example, the new commercial media have a radio program for tourists from German-speaking countries, but none for hundreds of thousands of gypsies living in Hungary (7 percent of the population).[5] The same criticism often applies to state controlled media.[6] Democratic media would encourage people to know and understand their neighbors and to participate in social and political life. This is likely to occur where media structures are democratic, as such media will be open to neighbors who want to communicate views on problems and their possible communal resolution. Commercial media aim to entertain and divert, and tied in as they are to the dominant institutions, they serve the dominant elites and the status quo, and avoid controversial messages by people who want to initiate change. The commercial and state media treat the citizenry as passive recipients of entertainment and information that are offered from above. The media are not agents of a democratic citizenry, but of a business and the state elite.

Talk Shows: Phony Populism, Phony Democracy

The talk show radio and TV "revolution" in the United States offers the facade of something democratic, but not much of the substance. The interaction of talk show hosts with the public is carefully controlled by screening out undesired questions, and there is very limited exchange between hosts and a "statistically insignificant" proportion of the listening audience.[7] Rush Limbaugh, for example, has a sizable audience of proud self-styled "ditto heads," but they are entertained in pseudo-postmodern monologues with a minimum of genuine interaction. There is a kind of quasi-community built among the followers, who lis-

ten, meet together, buy, and discuss the master's (and other recommended) books, but if community has a cultish quality, and the master's discourse is no more democratic than was Father Charles Coughlin's radio talk show back in the 1930s. The community is led by a leader who possesses, and guides the followers to, the truth.

As is well known, many of the talk show hosts are right-wing populists who claim concern over the distress of ordinary citizens but never succeed in finding the sources of that distress in the workings of corporate capital and its impact on politics, unemployment, wage levels, and economic insecurity. They focus on symptoms and scapegoats, like crime, black welfare mothers, environmental extremists, and "family values" issues. Their service is comparable to that of the Nazi movement during the Weimar Republic years in Germany in the 1920s in that they divert attention from real causes of distress, and by obfuscating issues and stirring up forces of irrationality, they serve to weaken any threat of meaningful organization and protest from below.

Routes to Democratizing the Media

There are two main routes to democratizing the media. One route is to try to influence the mainstream media to give more room to now-excluded ideas and groups. This could be done by persuasion, pressure, or by legislation compelling greater access. The second route is to create and support an alternative structure of media closer to ordinary people and grassroots organizations that would replace, or at least offer an important alternative to, the mainstream media. This could be done, in principle, by private and popular initiative, by legislative action, or by a combination of the two.

The first route is of limited value as a long-run solution to the problem precisely because it fails to attack the structural roots of the media's lack of democracy. If function follows from structure, then the gains from pursuit of the first route are likely to be modest and transitory. These small gains may also lead both activists and ordinary citizens to conclude that the mainstream media are really open to dissent, when in fact dissent is securely kept in a non-threatening position. And, it may divert energy from the task of building alternative media. On the other hand, the limited access obtained by pursuit of the first route may have disproportionate and catalyzing effects on elite opinion. This route may also be the only one that appeals to many media activists, and there is no assurance that the long run strategy of pursuing structural change will work.

The second route to democratization of the media is the only one that can yield truly democratic media, and it is this route that I will discuss in greater detail. Without a democratic structure, the media will serve a democratic function inadequately at best, and very possibly even perversely, by working as agents of the real (dominant corporate) "special interests" to confuse and divert the public. The struggle for a democratic media structure is also of increasing urgency because the media have become less democratic in recent decades with the decline in relative importance of the public and nonprofit broadcasting spheres, increased commercialization, and integration of the mass media into the market, conglom-

eration, and internationalization. In important respects the main ongoing struggle has been to prevent further attrition of democratic elements in the media.

This has been very evident in Western Europe, where powerful systems of public broadcasting as well as non-profit local radio stations have been under relentless attack by commercial and *conservative* political interests that have become increasingly influential in state policy. These changes have threatened diversity, quality, and relatively democratic organizational arrangements. In the former Soviet bloc, where state controlled media institutions are being rapidly dismantled, there is a dire threat that an undemocratic system of government control will be replaced by an equally undemocratic system of commercial domination. The same is true of Third World nations, which, while presenting a mixed picture of a government sector, private/commercial sector, and a sometimes important civic sector, have increasingly been brought within the orbit of the globalizing commercial media.

It is obvious that a thorough democratization of the media can only occur in connection with a drastic alteration in the structure of power and political revolution. Democratizing the national media would be very difficult in a large and complex society like the United States even with unlimited structural options, just as organizing a democratic polity here would be a bit more tricky than in a tiny Greek city-state or an autonomous New England town. An important step toward democratic media would be a move back to the Articles of Confederation and beyond—to really small units within which people can interact on a personal level. For larger political units personal interaction is more difficult; efficiency and market considerations make for a centralization of national and international news gathering, processing, and distribution, and of cultural and entertainment productions as well. Funding would have to be insulated from business and government, but it could not be completely insulated from democratic decision-making processes. Maintaining involvement and control by ordinary citizens, while allowing a necessary degree of specialization and centralization, and permitting artistic autonomy as well, would present a serious challenge to democratic organization. As this is not on the immediate agenda, however, I will not try to spell out here the machinery and arrangements whereby these conflicting ends can be accomplished.

Some partial guidelines for the pursuit of democratic structural change in the media here can be derived from the current debates and struggles in Europe, where the democratic forces are trying to hold the line (in Western Europe) and prevent wholesale commercialization (in the East). The democrats have stressed the deadly effects of privatization and commercialization on a democratic polity and culture and have urged the importance of preserving and enlarging the public and civic sectors of the media. The public sector is the government-sponsored sector, which is far more important in Western Europe than it is in this country. It is funded by direct governmental grants, license fees, and to an increasing but controlled extent, advertising. This sector is designed to be and is responsible for serving the public interest in news, public affairs, educational, children's, and other cultural programming. It is assumed in Europe that the commercial sector will pursue large audiences with entertainment (movies, sitcoms, cowboy and crime stories) and that its long-term trend toward abandonment of non-entertainment values will continue.[8]

The civic sector comprises the media that are noncommercial but also not government sponsored, and that arise by individual or grassroots initiatives. This segment includes some mainly local newspapers and journals, independent movie and TV producers, and radio broadcasters. The civic sector has virtually no TV presence in Europe, but radio broadcasting by nonprofit organizations is still fairly important, sufficiently so to have produced a European Federation of Community Radios (FERL) to exchange ideas and coordinate educational and lobbying efforts to advance their ideals and protect their interests.

FERL has been lobbying throughout Europe for explicit recognition of the important role of the noncommercial, and especially the civic sector in governmental and intergovernmental policy-making. It has urged the preservation and enlargement of this sector by policy choice. In France, the civic sector actually gets some funding from the state through a tax on commercial advertising revenues. This is a model that could be emulated elsewhere. It should be noted, however, that in the conservative political environment of the past decade, the policies of the French regulatory authority, the Higher Broadcasting Council, have reduced the number of nonprofit radio stations from 1,000 to under 300, and have also discriminated heavily in favor of religious and right-wing broadcasters.

Democratizing the U.S. Media

Democratizing the U.S. media is an even more formidable task than that faced by Europeans. In Western Europe, public broadcasting is important, even if it is under siege, and community radio is a more important force there than it is in the United States. In Eastern Europe the old government-dominated systems are crumbling, so that there are options and an ongoing struggle for control. In the United States, commercial systems are more powerfully entrenched; the public sector is weak and has been subject to steady right-wing attack for years; and the civic sector, although it is alive and bustling, is small, mainly local, and undernourished. The question is, what is to be done?

Funding

An extremely important problem for those who want to democratize the media is that the commercial sector *is* self-funding, with large resources obtained from advertising, whereas the public and civic sectors are chronically starved. This gives the commercial media an overwhelming advantage in technical quality, polish, price, publicity, and distribution. An important part of a democratic media strategy must consist of figuring out how to obtain sizable and more stable resources for the public and civic sectors. The two promising sources are taxes on commercial media revenues and direct government grants. Commercial radio and TV are getting the free use of the spectrum and satellite paths, which are a public resource, to turn a private profit, and there is an important record of commitments to public service made by commercial broadcasters and the FCC in 1934 and 1946 that have been quietly sloughed off. These considerations make a franchise or spectrum use tax, with

the revenues turned over to the public and civic sectors that have taken on those abandoned responsibilities, completely justifiable. We could also properly extend a tax on spectrum use to cellular and other telephone transmission, which also use public airwaves, possibly placing the tax revenue into a fund to help extend telephone service as well as other communications infrastructure to Third World areas at home and abroad.

The funding of the public and civic sectors from general tax revenues and/or license fees on receiving sets is also easily defended, given the great importance of these sectors in educational, children's, minority group, and public affairs programming. These services are important to the cultivation of a democratic citizenry, among other aims.

In sum, local, regional, and national groups that are interested in democratizing the media should give high priority to organization, education, and lobbying designed to sharply increase and stabilize the funding of the financially strapped public and civic sectors. Success in these endeavors will depend in large measure on the general political climate.[9]

The Commercial Sector

The commercial sector of the media does provide some small degree of diversity, insofar as individual proprietors may allow it and advertisers can be mobilized in niche markets of liberal and progressive bent (such as *The New Yorker*, the *Village Voice*, and the urban alternative press). But this diversity is within narrow bounds, and rarely if ever extends to support for policies that involve fundamental change. Furthermore, the main drift of commercial markets is absolutely antithetic to democratic media service, and although we may welcome offbeat and progressive commercial media institutions, we should recognize the inherent tendencies of commercial media. [10]

It will still be desirable to oppose further consolidation, conglomeration, cross-ownership of the mainstream media, and discriminatory exclusions of outsiders, not only because they make the media less democratic, but also because they help further centralize power and make progressive change in the media and elsewhere more difficult.[11] I also favor "fairness doctrine" and quantitative requirements for local, public affairs, and children's programs for commercial radio and TV broadcasters. Part of the reason for this is straightforward: it is an outrage that they have abandoned public service in their quest for profit. A more devious reason is this: pressing the commercial broadcasters, and describing in detail how they have abandoned children and public service for "light fare," will strengthen the case for taxing them and funding the public and civic sectors.

In Europe, commercial broadcasters are sometimes obligated by law or by contract arrangements that were made when spectrum rights were given, to provide a certain amount of time to quality children's programs at prime time, or to give blocks of broadcasting time to various groups such as labor organizations, church groups, and political parties in proportion to their membership size (not their money). In Europe and elsewhere, also, broadcasters are obligated to give significant blocks of free time to political parties and can-

didates in election periods. These are all desirable and should be on the agenda here in the United States. They are not being considered because the media would suffer economic costs, so that the public is not even allowed to know about and debate these options.[12]

Various groups have been formed in this country to lobby and threaten the media, the most important and effective of which are those on the right. Notable among those that represent a broader public interest was Action for Children's Television (ACT), which was organized in 1968 to fight the commercial media's degradation of children's programming.[13] Also worthy of special mention is Fairness and Accuracy in Reporting (FAIR), a media monitoring group that has published numerous special studies of media bias as well as an ongoing monitoring review, *EXTRA!* FAIR also produces a weekly half-hour radio program, "Counterspin," heard on over 115 (mostly public, community, and college) stations, that provides media criticism and alternative news analysis.

The Public Sector

The Corporation for Public Broadcasting was brought into existence in 1967, with the acquiescence of the commercial broadcasters, who were pleased to transfer public interest responsibilities elsewhere as long as they were funded by taxpayers. Over the years, public radio and public TV have been more open to dissent and minority voices than the commercial broadcasting media, partly a result of original design, but also because, despite their ties to government, they have proven to be somewhat more independent of government and tolerant of the controversial than the commercial broadcasters.[14]

The independence and quality of the public sector depend heavily on the political environment. As long as it is kept on a short financial leash, underfunded, and worried mainly about attacks from the right, it will feature a William Buckley and John McLaughlin, with Mark Shields on the "the left," and offer mainly bland and cautious news and commentary along with noncontroversial nature programs and news on cultural events.[15] Not surprisingly, public broadcasting went into serious decline in the Reagan-Bush years. It needs a lot more money, longer funding periods, more autonomy, and less continuous threatening pressure from the right wing to perform well. There is an important role for the public sector in a system of democratic media, and its rehabilitation should definitely be on the democratic media agenda.

The Civic Sector

For real progress in democratizing the media, a much larger place must be carved out for the civic sector. This is the nonprofit sector organized by individuals or grassroots organizations to serve the communications interests and needs of the general population—as opposed to the corporate community-building and the democratic process itself. Democratic media analysts stress that the public must participate in the media, and in the public sphere in which public opinion is formed, if they are to participate in public life.[16]

Alternative Press

There is an alternative local press in many cities in the United States, usually distributed without charge and funded by advertising that provides a small but shrinking opening for dissent and debate. This alternative press has a national Association of Alternative News Weeklies with 113 members and a readership of over six million, but there may be as many more nonmember alternative papers. Most of its members came into existence in the 1970s and 1980s as businesses, targeting young, affluent audiences, and advertisers of fashion, food, movies, and popular music. As David Armstrong points out, this press was a "depoliticized successor" to the highly committed underground press of the 1960s, and it "is looking less 'alternative' all the time, becoming in subtle degrees safer and softer, emphasizing more entertainment coverage and lifestyle journalism."[17] It has been integrated even more closely into the market system through a merger movement that has absorbed a quarter or more of the alternative papers into chains, with New Times and Stem Publishing in the vanguard.[18] This has further weakened the alternative press as a force for dissent and diversity.

Although it is possible to depend on advertising and still maintain press substance, the costs of serious dissent may be heavy and the sorry evolution of the alternative news weeklies is not encouraging. Nevertheless, the *Village Voice* has provided a small quantum of dissent in the huge market of New York City. Even more interesting is the *Anderson Valley Advertiser (AVA)* of Boonville, California, a local paper that has survived in a small town despite the radical perspectives of its editor. It has been subjected to advertising boycotts and is avoided regularly by some advertisers on political grounds, but its advertising penalties are partially offset by the wider readership generated by its exciting quality and vigor. *AVA* is a model of democratic newspaper work in its good local news coverage, its exceptional openness to letters and petitions, and the continuous and sometimes furious debates among readers and between readers and editors that constitute a kind of town meeting on paper. A host of local issues are addressed, and national and global issues are debated in columns and letters, although no attempt is made to provide national and international news coverage. A thousand papers like *AVA* would make this a much more democratic country.

With the demise of the *New York Guardian* in 1992, the only national alternative newspaper is the biweekly *In These Times*, with a circulation of only 15,000, despite its high quality and avoidance of the doctrinaire. Even this one publication struggles each year for reader and other subventions to keep afloat. It deserves support, and its continued existence and growth, and the addition of other alternative national papers, is important in a democratic media project.

Alternative Journals

There are a fair number of liberal and left alternative journals in the United States, including *The Nation, Z Magazine, The Progressive, Mother Jones, Dollars and Sense, Monthly*

Review, *MS Magazine*, *The Texas Observer*, *Covert Action Quarterly*, *EXTRA!* and others. Apart from *Mother Jones*, which has sometimes crossed the quarter million mark in circulation, based on large promotional campaigns, *The Nation* has the largest readership, with about 100,000. Most of the alternative journals have circulations between 2,000 and 30,000 and have chronic financial problems. By contrast, *Time* has a circulation of some four million, and *Reader's Digest* 15 million in North America alone (both have large sales overseas as well). Some of the alternative journals could expand circulation with aggressive and large-scale publicity and higher quality copy, but this would cost a lot of money. Not many of the 189 U.S. billionaires are inclined to set up trust funds to help enlarge the circulation of alternative journals.[19] Advertisers are also not bending over backwards to throw business their way.

Alternative Radio

Radio may be a more promising avenue for growth and greater outreach of alternative media than the print media. More people are prone to listen to radio and watch TV than read journals, or even newspapers, which are harder to get into the hands of audiences. Radio broadcasting facilities are not expensive. Community radio grew rapidly in the early 1970s, but its growth then tapered off, in part a result of the shortage of additional frequencies in the larger markets. Of the roughly 1,500 noncommercial radio licenses outstanding, half are allocated to religious broadcasters. Many of the remaining 750 are college and university linked, and Larry Soley estimates that fewer than 150 licenses are held by community organizations.[20]

Many of the community stations have languished for want of continuity of programming and spotty quality. Discrete and sporadic programs do not command large audiences; building substantial audiences requires that many people know that particular types of programs are going to be there, day after day, at a certain time period. (This is why stations become "all news," or have talk shows all morning and rock music all afternoon.) There are also the usual problems of funding and threats to licenses by more powerful commercial interests seeking to enlarge their domains. Nonetheless, these stations are precious in their pluralism in programming and diversity among staff and volunteers, and they meet the democratic standard of community involvement and serious public debate. Noam Chomsky "has observed that when he speaks in a town or city that has an alternative radio station, people tend to be more informed and aware of what is going on."[21]

Pacifica's five-station network and News Service have done yeoman work in providing alternative and high-quality radio programming and in developing a sizable and loyal listenership. Under constant right-wing attack and threat, and suffering even more from a centralization and abuse of top management power in the late 1990s, it is in constant turmoil and its important dissident role has been put in jeopardy. Radio Zinzine in Forcalquier, a small town of Upper Provence in France, provides an important model of constructive use of radio. Organized by the members of the progressive cooperative Longo Mai, Radio Zinzine has given the local farmers and townspeople a more vigorous and action-oriented

form of local news (as well as broader news coverage and entertainment), but also an avenue for communication among formerly isolated and consequently somewhat apathetic people. It has energized the local population, encouraged its participation, and made it more of a genuine community.

In a dramatic example of how democratic media come into existence out of the needs of ordinary people who want to speak and encourage others to communicate, M'Banna Kantako, a 31-year-old black, blind unemployed public housing resident in Springfield, Illinois, organized Black Liberation Radio in 1986, out of frustration with the failure of the major media to provide news and entertainment of interest to the black community. Kantako was ignored by the FCC and dominant media till he broadcast a series of interviews with blacks who had been brutalized by the local police. Soon thereafter the FCC tried to get him off the air and a court order was issued to close him down, but it remains unenforced. Undefended by the local media, Kantako has gotten considerable national publicity and support. Grassroots organizers and student groups from practically every state and a number of foreign countries have contacted him, and numerous other similar "micro-radio" stations have gone on the air.[22] As Soley says, "free radio broadcasting has emerged as a major tool for circumventing government restrictions on free expression,"[23] and it is a genuinely democratic medium. But it remains under steady FCC attack and threat, even as the FCC approves gigantic media mergers that increase concentration and weaken the public sphere.[24]

Another important model is David Barsamian's Alternative Radio, which has produced and distributed a weekly one-hour public affairs program since 1986, using rented space on a satellite channel to provide solid alternative programming to U.S. stations interconnected with the satellite. Alternative Radio uses a one-on-one interview format, and has focused on the media, U.S. foreign policy, racism, the environment, NAFTA/GATT and economic issues, and other topics, with guests like Elaine Bernard (Canadian labor activist, speaking on Creating a New Party), Juliet Schor (author of *The Overworked American*), Charles Kernaghan (speaking on the Global Factory, Kathie Lee, The Gap and Disney), John Stauber (on Lies, Damn Lies and Public Relations), and Vandana Shiva (on Biopiracy: The Plunder of Nature and Knowledge).[25] These are quality offerings of unusual depth and commentators of high merit rarely encountered in the mainstream media. Some 400 stations have a capacity to receive Alternative Radio's offerings; foreign stations in Canada, Australia, and elsewhere have to be reached by tapes that are mailed.

Alternative TV

The mainstreaming and commercialization of public TV led to the entry of several new public TV stations in the 1980s that were designed to service the public interest function abandoned by the dominant PBS stations. In an embarrassing episode for PBS, an internal PBS research study found that the new applicants and entrants would not be competing much with the older stations, as the older ones had moved to serve an upscale audience.[26] Meanwhile, the older stations have lobbied aggressively to prevent the new ones

from sharing in government funding slotted for public TV stations. It goes without saying that the new stations deserve support as a democratizing force, although the older ones should not be written off—rather, they need reorganization and regeneration to allow them to throw off the Reagan-Bush era incubus and better serve a public function. This renewal has not taken place in the Clinton era, during which time the line has barely been held against further erosion.

The growth of cable opened up democratic options, partly in the greater numbers of channels and potentially enlarged diversity of commercial cable, but more importantly in the frequent obligation of cable systems to provide public access channels and facilities. First imposed as a requirement by the FCC in 1972, partly as an impediment to cable growth by an FCC that was still serving the commercial broadcasters' interests, the public access movement was eventually institutionalized as part of negotiated agreements between cable companies seeking franchises and community negotiators. In many cases the contracts called for cable companies to provide facilities and training to public access users, and in some instances a percentage of cable revenues (1 to 5 percent) was contracted to be set aside to fund the access operations. [27]

This important development offers a resource and opportunity that demands far more attention from media activists than it has gotten. Spokespersons for the public access movement call attention to the fact that there are over 1,200 public, educational, and governmental access organizations and local origination services where TV production takes place for access on cable, and that more than 20,000 hours of original material is transmitted over public access channels per week to an unknown but probably fairly sizable audience. The problems here, as with community radio, lie in the spotty quality of original programming, the frequent absence of the continuity that makes for regular watching, and the lack of promotional resources. The existing levels of participation are valuable, but public access remains marginal and has been under increasing attack from cable owners who no longer need public access supporters as allies and have been trying hard to throw off any public access responsibilities. Although important for democratic media—along with community radio, this is democratic media-public access under threat; the relevant cable contracts are up for renewal over the next few years and cable access needs to be used, enlarged, and protected from attrition.

A strenuous effort has been made by some media democrats to fill the programming gap with centrally assembled or produced materials that are made available through network pools of videotapes and by transmission of fresh materials through satellites. Paper Tiger TV has been providing weekly programs on Manhattan Cable for years and has been making these programs available to public access stations and movement groups who want to use them in meetings. [28] An affiliated organization, Deep Dish Network, has tried to provide something like a mainstream network equivalent for public access stations, assembling and producing quality programs that are publicized in advance and transmitted via satellite to alerted individual dish owners, groups, and university and public access stations able to downlink the programs. There are some 3 million home satellite dish owners in North America

who can receive Deep Dish offerings, and it is programmed on more than 300 cable systems and by many individual TV stations.

In addition to its notable ten-part Gulf Project series, which provided an alternative to mainstream TV's promotional coverage of the Persian Gulf War, Deep Dish has had a six-part program on Latino issues (immigration, work exploitation and struggles, history, etc.), and during 1992, counter-celebratory programs on Columbus's conquest of the New World. On December 1, 1991, it transmitted an hour-long live program by Kitchen Center professional artists in conjunction with Visual AIDS, entitled *Day Without Art,* as part of a day of action and mourning in response to the AIDS crisis. Although the program was performed in New York City, live audiences received the program in eight cities, and a much wider audience call-in operation was organized as part of the program. Group viewings and cable showings were encouraged in advance. Deep Dish has also broadcast a series on *Beyond Censorship: The Assault on Civil Liberties,* a program on *Staking a Claim in Cyberspace,* a twelve-part series on the U.S. healthcare system entitled *Sick and Tired of Being Sick and Tired* and most recently, two series on the U.S. prison system and the prison-industrial complex (*Bars and Stripes* and *Lockdown USA*).

Deep Dish has tried to use its productions as an organizing tool and has worked with community groups to help them tell their stories and to get them to mobilize their constituencies to become aware of access and other media issues. This is extremely valuable, but Deep Dish suffers from the sporadic nature of its offerings, which harks back to the basic problem of funding. An excellent case can be made for funding Deep Dish and similar services to the civic sector out of franchise taxes on the commercial stations or from general tax revenues.

Internet

The Internet affords a new mode of communication that opens some possibilities for democratizing communications. It allows very rapid communication locally, nationally, and beyond national borders; it is relatively cheap to send messages to a potentially wide audience; and up to this point it is not completely dominated by advertisers, governments, or any other establishment institutions. This and related forms of relatively uncontrollable communication were important in bringing about the collapse of the Soviet Union; the Internet allowed dissident forces to maintain close contact and helped keep foreign allies abreast of events. It has also been important in the Chiapas revolt in Mexico and its aftermath; it enabled the Zapatista rebels to get out their messages at home and abroad quickly, and interfered with government attempts to crush the rebellion quietly, in the traditional manner.[29] This caused Rand Corporation analyst David Ronfeldt to speak of "netwar" and a prospective problem of "ungovernability" in Mexico that followed in part from this uncontrollable media.[30] This recalls Samuel Huntington's and the Trilateral Commission's fears of ungovernability in the United States and other Western countries based on the loss of apathy of the unimportant people in the 1960s. In short, the new media-based "threat"

of ungovernability is establishment code language for an inability of government to manipulate and repress at will, or an increase in democracy.

However, it is important to recognize the limitations of the Internet as a form of democratic media, both currently and in the more uncertain future. Access to the Internet is not free; it requires a powerful computer, programs, the price of access, and some moderate degree of technical know-how. Business interests are making very rapid advances into the Internet, so that problems of more difficult and expensive access and domination and saturation by an advertising-linked system is a real possibility. Furthermore, the Internet is an individualized system, with connections between individuals that require prior knowledge of common interests, direct and indirect routes to interchanges and shared information, and the build-up of information pools. It is well geared toward efficient communication among knowledgeable and sophisticated elites and elite groups, but its potential for reaching mass audiences seems unpromising. This is extremely important, as constructive change is not likely to come about unless supported by a mass movement, built on a rational understanding of social forces, and with a coherent vision of an alternative set of institutions and policies. Otherwise, those in command of access to mass audiences (and military forces) will eventually restore "law and order" in a more repressive environment, with business institutions and priorities intact.

Technological Change

More generally, the sharp reductions in price and increased availability of VCRs, camcorders, FAX machines, computers, modems, e-mail, the Internet, and desktop publishing have made possible easier communication among individuals, the low cost production of journals and books, and new possibilities for TV production and programming. Of course, the telephone, mimeograph, offset printing, and photocopying machines had the same potential earlier and were put to good use, but they never put the establishment up against the wall. When significant technological changes occur, those with money and power tend to guide innovation and use the new technologies first, and frequently have moved on to something better by the time these innovations reach ordinary citizens. Camcorders do not solve the problem of producing really attractive TV programs, let alone getting them shown and widely distributed. Although books may be produced more cheaply with new desktop facilities, changes in commercial distribution-blockbusters, saturation advertising, deals with the increasingly concentrated distribution networks may easily keep dissident books as marginalized as ever. It remains to be seen whether the Internet produces an exception to this tradition of commercial domination.

In perhaps the most dramatic illustration of the problem of catch-up, the new communications technologies in the possession of the Pentagon and mainstream media during the Persian Gulf War—video, satellite, and computer—conferred a new and enormous power to mold images, block out history and context, and make instant history. John M. Phelan summarized his analysis of the new, centrally controlled communications technology with the title "Image Industry Erodes Political Space."[31] And George Gerbner pointed out that

"past, present and future can now be packaged, witnessed, and frozen into memorable moving imagery of instant history-scripted, directed, and produced by the winners."[32]

The point is it is important for democratic media advance that democratic participants be alert to and take advantage of every technological innovation. The growth of common dissident carriers like EcoNet, LBBS, and PeaceNet has been an important source of tools for education, research, and a means of alerting and communicating among activists.[33] But the challenge of reaching large audiences, as compared to the relative ease with which democratic activists can communicate within and between small groups, remains severe.

Concluding Note

The trend of media evolution is paradoxical: On the one hand, there is an ongoing trend in the West toward increasing media centralization and commercialization and a corresponding weakening of the public sector. On the other hand, the civic sphere of nongovernmental and noncommercial media and computer networks linked to grassroots organizations and minority groups has displayed considerable vitality; and even though it has been pressed to defend its relative position overall, it has a greater potential than ever for coordinating actions and keeping activists at home and abroad informed.

It has been argued in this chapter that the civic sector is the locus of the truly democratic media and that genuine democratization in Western societies will be contingent on its great enlargement. Those actively seeking the democratization of the media should seek first to enlarge the civic sphere by every possible avenue, to strengthen the public sector by increasing its autonomy and funding, and lastly to contain or shrink the commercial sector and work to tap its revenue for the civic sector. Funding this sector properly will require government subvention. Media democrats should be preparing the moral and political environment for such financial support as they do their utmost to advance the cause of existing democratic media.

This piece originally appeared in E. Herman, *The Myth of the Liberal Media: An Edward Herman Reader*. New York: Peter Lang, 1999.

NOTES

1 R. B. Du Boff, *Accumulation and Power* (Armonk, NY: M. E. Sharpe, 1989), 103.

2 There is a wider array of choices on the fringe, but a large fraction of the population doesn't even know these fringe publications exist.

3 See Robert McChesney, "The Battle for the U.S. Airwaves, 1928–1935." *Journal of Communication* (Autumn 1990), 29–57.

4 George Gerbner, "Science or Ritual Dance? A Revisionist View of Television Effects Research," *Journal of Communication* (Spring 1984), 170.

5 European Federation of Community Radios, Final Report, 1st Congress (May 16–20, 1991), 5.

6 The state-owned radio station RAI does not provide programming in Friulian, a language spoken by two-thirds of the population of the northern Italian province of Friuli. A community radio station, Radio Onde Furlane, now serves this 5 million person audience. See previous note.

7 "Factor in the prevalence of repeat callers, and it's clear that the caller pool on radio talk shows [represents] a statistically insignificant slice of the electorate," Jon Keller, "'Hi, I'm Bill, a first-time caller,'" *Boston Globe,* 30 April 1995.

8 A major spokesperson for this form of critique and analysis has been Karol Jakubowicz, an official in the General Secretariat of Polish Radio and Television. See his background paper, "Post-Communist Central and Eastern Europe: Promoting the Emergence of Open and Plural Media Systems," 3rd European Ministerial Conference on Mass Media Policy, Cyprus, Oct. 9–10, 1991. Similar views are common among members of European Federation of Community Radios. See text below and document cited in note 5 above.

9 The victory of Gingrich and company in the national elections of 1994 was a setback for democratic broadcasting, among many other matters; Gingrich immediately began a campaign to defund PBS entirely. This has been a longtime aim of Reed Irvine of Accuracy in Media and the extreme right in general, who are opposed to any independent broadcasting and prefer the air waves to be under the protective control of commercial interests. President Clinton and the dominant Democrats have helped PBS survive, but they have not done more than that.

10 See Edward F. Herman and Robert McChesney, *The Global Media* (London: Cassell, 1997), chaps. 5 and 6.

11 For example, John Malone's and Tele-Communications Inc.'s destructive treatment of the only full-time liberal TV network, The 90s Channel, in 1995.

12 A variant of the European system of allocation of time to citizens groups was proposed by Ralph Nader in espousing an "audience network." This would be a national membership institution of viewers and listeners that would he granted a congressional charter as a nonprofit corporation and would also be given 60 minutes of prime radio and TV time each day to air programs of its choice. Audience member contributions would be the prime source of funding; members would vote for a governing board, which would decide on programs. Apart from its extreme political unrealism, both at the level of legislative possibilities and the potential of democratic organization and participation involving something as amorphous as an "audience," the proposal would not change the structure of the media; it would only insert an hour of noncommercial time in the midst of 23 hours of commercial programming. The proposal has never gotten off the ground. See Ralph Nader, "The Audience Network: Time for the People" (undated, provided by the Nader-related Audience Network Coalition); also, Ralph Nader and Claire Riley, "Oh Say Can You See: A Broadcast Network for the Audience," *Virginia Law Review* (Fall 1988).

13 See Herman and Chomsky, *Manufacturing Consent*, 26–28. [provide pub. data]

14 Many illustrations are provided in Erik Barnouw, *The Sponsor* (New York: Oxford University Press, 1978).

15 For history and analysis, see Ralph Engelman, *Public Radio and Television in America: A Political History* (Thousand Oaks, CA: Sage, 1996); William Hoynes, *Public Television for Sale* (Boulder: Westview, 1994); "The Broken Promise of Public Television," *EXTRA!* (September/October 1993); "Tilting Right," *EXTRA!* (April/May 1993).

16 Robert H. Devine, "The Future of a Public," *Community Television* Review (April 1992), 8–9.

17 David Armstrong, "Alternative, Inc.," *These Times,* August 21, 1995.

18 Eric Fredericksen, "Merger Madness in Newsweekly Biz," *These Times,* June 16, 1997.

19 They are, of course, lavish in funding right-wing journals and TV programs that propound market-friendly

messages. See John Saloma III, *Ominous Politics: The New Conservative Labyrinth* (New York: Farrar, Straus and Giroux, 1984). In 1995 billionaire Rupert Murdoch committed $3 million to help fund *The Standard*, to fill a perceived niche in the lineup of right-wing journals.

20 Larry Soley, *Free Radio: Electronic Civil Disobedience* (Boulder, CO: Westview Press, 1999), 34.

21 David Barsamian, "Audio Combat," *Z Papers* (October/December 1993), 12.

22 Micropower station Free Radio Berkeley, which has so far fended off attempts by the FCC to shut it down, claims that micropower stations are now able to broadcast to 60 countries via a shortwave radio station in Costa Rica. It reports that excerpts from broadcasts of microwave stations Anarchy Radio, Radio Free Detroit, San Francisco Liberation Radio, and its own station have been relayed through Costa Rica. Free Radio Berkeley and the Free Communications Coalition puts out a newsletter, "Reclaiming the Airwaves," available from Free Radio Berkeley, 1442 A Walnut Street #406, Berkeley CA 94709 (510) 464–3041.

23 Soley, *Free Radio*, 4.

24 For an account of the FCC's attack on micro-radio, ibid., chaps. 7–9.

25 See Barsamian, "Audio Combat," 11.

26 John Fuller and Sue Bomzer, "Friendly (and Not So Friendly) Competition in the PTV Overlapped Markets," PBS Meeting Presentation, PBS Research Department (June 19, 1990).

27 For details on this process, see Diana Agosta, et al., *The Participate Report: A Case Study of Public Access Cable Television in New York State* (New York: Participate/AMIC, 1990).

28 *Roar: The Paper Tiger Television Guide to Media Activism*, published in 1991 by Paper Tiger and the Wexner Center for Arts of Ohio State University, provides a short history of Paper Tiger plus other materials, including an excellent bibliography on the media and media activism.

29 See DeeDee Halleck, "Zapatistas On-Line," NACLA Report on the Americas (September/October 1994), 30–32.

30 Ronfeldt's views are summarized in "Netwar Could Make Mexico Ungovernable," a Pacific News Service report dated March 20, 1995.

31 *Media Development* (Fall 1991), 6–8.

32 "Persian Gulf War: The Movie," in Hamid Mowlana et al., eds., *Triumph of the Image*. (Boulder: Westview, 1992), chap. 20.

33 BBS, a community bulletin board system initiated by *Z Magazine* began offering a "Left on Line School" in January 1995, with courses given by Barbara Ehrenreich, Holly Sklar, Noam Chomsky, and others.

Chapter 5

Critical Media Literacy for the Twenty-First Century

Taking Our Entertainment Seriously

Pepi Leistyna and Loretta Alper

While capitalism consists of a structural reality built on political and economic processes, institutions, and relationships, its proponents also rely on the formative power of culture to shape the kinds of meaning, desire, subjectivity, and thus identity that can work to ensure the maintenance of its logic and practice. Corporate bodies take very seriously the fact that culture shapes our sense of political agency and mediates the relations between everyday struggles and structures of power.[1] In fact, in this age of postmodern technologies that can saturate society with media messages, elite private interests have worked diligently to monopolize the means of production and distribution of information and ideas so as to be able to more effectively circulate, legitimate, and reproduce a vision of the world that suits their needs; a world where profit trumps people at every turn.

While there is a plethora of ways in which agencies of knowledge production like schools, houses of faith, and the media are strategically used to engineer history and shape public consciousness, one of the pedagogical forces that needs to be watched more closely is entertainment television. Though media executives and producers insist that television is meant to entertain and not to educate, TV shows have undeniably played a pivotal role in shaping our perceptions of the world (Allen & Hill, 2004; Bourdieu, 1996; Carey,

1995; Durham & Kellner, 2001; Hall, 1997; Parenti, 1992). However, because we generally see television as just entertainment, we readily disregard its impact on our thinking. It is precisely because we believe television is merely entertainment, that we need to take its power and influence seriously.[2]

Television in the United States is largely controlled by five massive transnational corporations: Time Warner (which among its many assets, owns and operates CNN, Turner Classic Movies, HBO, Court TV, TNT, TBS, and the Cartoon Network), Disney (owns ABC, ESPN, the Disney Channel, the History Channel, A&E, Biography, Military History, Lifetime, E, the Style Network, and Soapnet), News Corporation (owns Fox, National Geographic Channel, Direct TV, FX, and STAR), General Electric (owns NBC, Telemundo, Bravo, MSNBC, CNBC, Sci Fi, Paxon, the USA Network, and Sundance—which is a joint venture with CBS), and Viacom (owns CBS, MTV, Showtime, Comedy Central, BET, TV Land, VH1, CMT, Nick at Nite, Spike TV, and Nickelodeon). As the Federal Communications Commission continues to pass legislation that allows these conglomerates to further monopolize the use of public airwaves (McChesney, 2004)—while it buries research that clearly shows how such forces are breaking the law by neglecting to serve the needs of the general populace—such private interests have been effective in using this medium to disseminate messages that serve their ideological and economic imperatives. This chapter provides an example of this common practice as it examines how the working class in the United States has been framed by corporate media in ways that reinforce classist, racist, and sexist stereotypes that serve to justify the inequities inherent in capitalism's class structure.[3]

Class Matters

Because the subject of class is so taboo in the United States, we lack a conceptual framework for understanding television's portrayal of the working class. Having a basic definition of class will not only give us insight into why people occupy their class positions, it will also enable us to make sense of TV's representations and their broader social implications.

Social class—an essential component of capitalist social relations, is experienced in three separate but interconnected ways. Economic class pertains to one's income and how much wealth/or capital a person has accumulated. Political class is the amount of power that a person has to influence the workplace and the larger social order; this includes social capital—those interpersonal connections that make it easier to effect change. Cultural class has more to do with taste, education, and lifestyle, or what is also referred to as cultural capital. While the economic, political, and cultural are always in flux, so is the definition of class.

Since the early colonial years, the United States has largely been built on the interests of the elite business classes, which, needless to say, have benefited greatly from a long-standing denial of the structural realities of a class system. Intended to perpetuate faith in

the "American dream"—which ironically implies a class hierarchy as it romanticizes move-
ment from the bottom to the top of the economic ladder—this disavowal is buttressed by
an ideology that reinforces the myth of meritocracy where hard work and persistence are
perceived as the essential ingredients for success; with no mention of any of the critical fac-
tors that inhibit upward mobility such as labor, wage, and tax laws that favor the wealthy,
a public school system that is largely funded through property taxes, or gender discrimina-
tion and racism—just to name a few. Far beyond the limits of individual virtue, class divi-
sions and conflicts in the United States are inherent to an economic system that not only
unjustly discriminates against different groups of people, but also subdivides power along
the lines of owners and professional, managerial, and working classes.

In what is now a post-industrial society in the United States—one that relies on serv-
ice industries, knowledge production, and information technologies rather than industrial
manufacturing to generate capital—the average wage is 29% less than it was during the days
of industry. Class mobility in this country is more restricted than ever before, unless of course
the direction is downward. Within these economic shifts, the middle class is imploding into
the working class, which in turn is imploding into the working poor who are literally rel-
egated to life on the streets.[4]

Census data show that the gap between the rich and the poor in this country is the widest
it has been since the government started collecting information in 1947. In fact, with the
exception of Russia and Mexico, the United States has the most unequal distribution of
wealth and income in the industrialized world. Nevertheless, in this post-Katrina economic
climate—where federal malfeasance unwittingly exposed the raw poverty that exists in this
country, the current administration and both republican-run houses, just before Christmas,
pushed through $50 billion in spending cuts to such social programs as food stamps and
Medicaid.[5]

Since 2000, unemployment in the United States has hovered between 5% and 6%, and
millions of jobs have been lost during this period.[6] These job losses are neither merely lay-
offs caused by hard economic times nor are they a direct result of 9/11 as conservatives would
have us believe. With capital flight and global out-sourcing, both blue-collar and white-
collar jobs have been and continue to be exported by U.S. corporations to nations that pay
below a living wage and that ensure that workers have no protection under labor unions
and laws that regulate corporate interests and power. By cheap labor, we are often talking
between 13.5 and 36 cents an hour; we're also talking about a total disregard for child-labor
laws and environmental protections (National Labor Committee for Worker and Human
Rights, 2003). Moreover, as the Federal Reserve has noted, these jobs will not be return-
ing, even if there is a major upswing in the U.S. economy.

The current administration has bragged about creating new jobs for Americans, but it
fails to inform the public that these are overwhelmingly part-time, adjunct, minimum-wage
positions that provide no pension, union protection, or healthcare benefits. Part-time, temp,
or subcontracted jobs currently make up 30% of the workforce, and this number is rapidly
increasing.

As the federal minimum wage is currently $5.15 an hour—a wage that is sustained by powerful corporate lobbyists, full-time workers in the United States make about $10,712 a year. Keep in mind that the federal poverty level for an individual is $9,214. This makes it impossible to afford adequate housing throughout the country. "In fact, in the median state a minimum-wage worker would have to work 87 hours each week to afford a two-bedroom apartment at 30% of his or her income, which is the federal definition of affordable housing" (National Coalition for the Homeless, 1999, p. 3). It is no wonder that one out of every five homeless people is employed. It is important to note that contrary to popular myth, the majority of minimum-wage workers are not teenagers: 71.4% are over the age of 20. Nonetheless, in March 2005, the Republican majority-Senate voted once again against an increase in the minimum wage.

The average income in the United States is shrinking and workers are earning less, adjusting for inflation, than they did a quarter century ago. Real wages are falling at their fastest rate in 14 years. Meanwhile, median CEO pay at the 100 largest companies in Fortune's survey rose 14 percent last year to $13.2 million. Still, average CEO pay in *Business Week's* survey was $7.4 million. It would take 241 years for an average worker paid $30,722 to make that amount. (Sklar, 2003, p. 4)

The ratio of average CEO pay in the United States to the average blue-collar pay in the same corporation is 470 to 1.

As far as political influence is concerned, in the United States "some 80% of all political contributions now come from less than 1% of the population" (Collins, Hartman, & Sklar, 1999, p. 5). It should thus come as no surprise that most of the public policy debate in this country remains in the confines of the Wall Street and Fortune 500 agenda. The richest 1% of Americans control about 40% of the nation's wealth; the top 5% have more than 60%. While the nation's median household income is $44,389—down 3.8% from 1999, the average income for the top 0.1% of the population is $3 million.

According to *Forbes Magazine* (2006), for the fourth consecutive year, the rich got richer: The collective net worth of the nation's wealthiest has climbed to $1.25 trillion. For the first time, everyone on the list is a billionaire.

Even the current tax system in this country is structured to perpetuate the class hierarchy. "People making $60,000 paid a larger share of their 2001 income in federal income, Social Security and Medicare taxes than a family making $25 million, the latest Internal Revenue Service data show" (Ivins, 2005, p. 1).

The nation's wealthiest 10% own almost 90% of all stocks and mutual funds (Dollars & Sense & United for a Fair Economy, 2004). While one in two Americans does not own stocks, the ubiquitous numbers from Wall Street imply that the market will help those in need and the country as a whole.[7] Meanwhile, the poor and the rich are depicted as living on the polar edges of society's economic spectrum, which is predominantly occupied by a grand middle class—a romanticized category that works to obfuscate the realities of class conflict.[8] According to the mythology, the rich, the poor, and the working and middle classes are not dialectically intertwined given that one's class position is a product of individual efforts rather than structural forces.[9]

The working class is in fact the majority of the population in this country. As Michael Zweig notes:

> It turns out that in the United States about 62% of the labor force are working-class people. That is, people who go to work, they do their jobs, they go home, they go to another job, but they don't have a lot of control or authority over their work. These are people who are blue collar, white collar, and pink collar. That's the working-class majority. Those are most people in this country. (interview in *Class Dismissed: How TV Frames* the Working Class, 2005)

However, regardless of the aforementioned conditions that the working-class majority endures on a regular basis, corporate-managed media have constructed their own tales about the lives of everyday people. It is very important to look at the stories they tell and to ask the critical question: Whose interests are served by such representations?

Class Identity in the Age of Television

While the working class is largely missing from the public discourse, it has always had a place in the world of entertainment television. In fact in the early days, working-class and immigrant families were a regular part of the TV repertoire on shows like *I Remember Mama* (1949–1957), *The Goldbergs* (1949–1955), and *Life with Luigi* (1952–1953), which featured Norwegian, Jewish, and Italian families.[10]

As TV evolved as a commercially sponsored medium, advertisers began to play an increasingly important role in creating programs. Their impact went far beyond on-screen sponsorship to having a hand in the actual production, including scriptwriting and hiring of talent (Barnouw, 1978). Due to their power and influence, advertisers were able to redefine the meaning of the American Dream, from the search for a better life to the pursuit of a consumer lifestyle.

Different from radio, where many of the earlier shows got their start, on television one can really see what the assimilation process is supposed to look like according to the advertising-driven media. It is the acquisition of consumer goods, becoming less ethnic, and looking more like aspirational middle-class American families (Lipsitz, 2002). As Bambi Haggins points out:

> In the late 40s and the early 1950s there is a very specific instruction on consumerism that takes place within narratives . . . that if we have these products then we can move into this different place on this socio-economic hierarchy. *The Goldbergs* is an excellent example of the ethnicom that starts out in urban America then moves to the suburbs. And in that movement you get a very specific idea of the things you need to have in order to gain access to the suburban American dream. Even in a show like *Amos and Andy* [1950–1953], which is problematic for a lot of reasons, you have Sapphire wanting to buy a new dining room table because that table is going to afford her access to a higher social and intellectual strata. (interview in *Class Dismissed*, 2005)

Working together, producers and advertisers understood that associating products with middle- and upper-class lifestyles would increase both ratings and sales. The stark contrast between the gritty image of working-class life and the shiny sanitized world of consumer advertising proved to be irreconcilable (Barnouw, 1978). As television became more con-

solidated in the late 1950s and the early 1960s, working-class and immigrant families would gradually disappear. On the contrary, programs that could provide a pristine setting for product placement and articulate the needs of a healthy, successful middle-class family living the American dream would take center stage—shows such as: *I Married Joan* (1952–1955), *The Adventures of Ozzy and Harriet* (1952–1966), *Make Room for Daddy* (1953–1965), *Father Knows Best* (1954–1960), *Leave it to Beaver* (1957–1963), *Dennis the Menace* (1959–1963), and *The Dick Van Dyke Show* (1961–1969).

In part, the reason that the working class seems to disappear from public discourse and from the world of entertainment television is because there was a real economic boom going on at the time. Within this post-WW II economic climate, many workers, especially white workers, did achieve a better standard of living. This was due to organizing and collective bargaining, as well as to government programs that provided a real safety net. However, there is also an ideological reason for the disappearance of class from the public eye. The country was moving into the cold war—the McCarthy era, and it is ironic that unions, the very organizations that enabled workers to achieve a better standard of living, are seen as a real threat now. Any effort to further democratize industry, technology, and economic and social relations gets branded as communist and has to be crushed. As Zweig explains:

> So what we had was this presentation of living standards as the measure of class because the old notion of class as power was being wiped out, was being crushed. That was the left . . ."Oh you're a communist. Let's not talk about class that way. What we really want to talk about is that you're doing better than you ever have before. Workers in this country are all middle class now . . ." And even union leaders talk about how they made their members middle class. Well they didn't make their members middle class. They made their working-class members have a better standard of living. That's a very different thing. (interview in *Class Dismissed*, 2005)

Television would continue to play a central role in touting the great openness and comforts of the middle class.

From the Margins to the Middle

In the 1950s as the white working class was disappearing into the classless middle, African Americans and other racially subordinated groups continued to endure the horrors of white supremacy coupled with the exploitative logic of capital.[11] Disregarding these harsh realities, TV's fantasy land only allowed people of color to be visible as happy servants or entertainers on programs like *Beulah* (1950–1953) and *The Nat "King" Cole Show* (1956–1957) (Riggs, 1991; Gray, 1995).[12]

In order to gain broader access to television, blacks and other marginalized groups would have to learn to play by TV's rules—namely to have faith in the American Dream.[13] While this logic has served television's commercial imperatives, it has also reduced struggles for economic justice and social equality to a simple matter of inclusion.

In the post-civil rights era, the arrival of African Americans onto primetime television with shows like *Sanford and Son* (1972–1977), *Fat Albert and the Cosby Kids*

(1972–1980), *Good Times* (1974–1979), *Grady* (1975–1976), *What's Happening?* (1976–1979), and *That's My Momma* (1974–1975), suggests that there is no need for the redistribution of wealth and power because on TV there is plenty of room for everyone. As Marlin Riggs (1991) notes in his documentary film *Color Adjustment*, in large part these sitcoms cast ghetto life in a happy light where opportunity was simply a question of initiative. He also reveals how *Good Times* showed real potential to take on some of the harsh realities of class exploitation and racism—potential that was quickly extinguished because of the transparent political content of some of the earlier episodes. Furthermore, in the spirit of the American Dream and meritocracy, by the last episode—as with so many of these programs,[14] the family escapes the ghetto and moves into the middle class.

The other storyline running through black sitcoms during this period dealt with this idea of "moving on up." However, these shows did not address economic hardship at all. The best known example is *The Jeffersons* (1975–1985) with the self-made man, George Jefferson. George's hard work and entrepreneurial spirit ensure the success of his dry cleaning business and consequently allow his family to "move on up" to the East Side. As Robin Kelly argues:

> He proves that black people are successful, so therefore the Civil Rights Movement is over. He proves that there is no need for affirmative action because he is a self-made man. He proves that there is no need for welfare because these people can make it on their own. (interview in *Class Dismissed*, 2005)

This message is clear in the following scene with the Jeffersons' neighbors:

> *Mrs. Willis:* Your family started at zero and look at what you've got now: a son going to college, a lovely wife, a successful business, and a beautiful apartment.

> *Louise (George's wife):* And you did it all by yourself.

> When Mr. Willis (Tom, the white husband) tries to shake George's hand in acknowledgment and celebration of his success, George pushes it away as if to say I do not need your help, or anybody else's for that matter.[15]

The Cosby Show (1984–1992) was also controversial in this respect. While the sitcom provided an important non-stereotypical image of a black family that countered the overwhelmingly pejorative representations that preceded it, the show nonetheless disregarded the harsh realities faced by poor and working-class people of color (Dyson, 1993; Jhally & Lewis, 1992; Riggs, 1991). As Herman Gray argues: "It [*The Cosby Show*] continues to do the general work of affirming the openness of a kind of middle-class society and an arrival of racial difference into that . . ." (interview in *Class Dismissed*, 2005). It is important to note that, while still very popular, the show went off the air the same year as the L.A. uprisings.

This same ideology of openness and arrival is embedded in more recent shows that feature African Americans such as *Martin* (1992–1997), *The Hughleys* (1998–2002),[16] *The Bernie Mac Show* (2001–present), *My Wife and Kids* (2001–2005), *All of Us* (2003–present), and *That's So Raven* (2003–present). While these shows depict the everyday lives of people, they are scripted outside of the reality that 30.4% of black workers and 39.8% of Latino/a

workers earn low wages (Economic Policy Institute, 2004/2005). The median income of racially subordinated families is $25,700, as compared with white families—$45,200 (Dollars & Sense & United for a Fair Economy, 2004). The unemployment rate for African Americans and Latino/as over the years has remained more than double that of whites. While about 10% of white children live in poverty in the United States, over 30% of African American and Latino/a kids experience economic hardship. Representations that capture these realities are at best few and far between.

There have been some black working-class characters on situation comedies; for example, the *Fresh Prince of Bel Air* (1990–1996). This character played by actor Will Smith is having some trouble in the ghetto and so he is shipped off to live with his rich relatives in Bel Air—leaving his single mom behind in the hood. In this post-Cosby world, there is no need for government programs to provide social services and economic support because there are wealthy black families that can rescue troubled youths and offer them all of the necessities for social advancement.[17]

There are other shows like *Eastside Westside* (1963), *Frank's Place* (1987–1988), and *Roc* (1991–1994) that have taken up some of the complexities of race and class politics. However, either because of the controversial nature of the material or the fact that networks have done such a poor job of promoting these shows and building audiences for them, they do not last long.

With the exception of a few prominent roles (featuring middle- and upper-middle-class characters) on shows like *ER* (1994–present), *Law & Order: Special Victims Unit* (1999–present), and *Grey's Anatomy* (2005–present), Asian Americans are still largely excluded from prime time or relegated to bit parts (Hamamoto, 1994). In addition, while the growing importance of the Latino demographic has resulted in a small increase in representations, e.g., *The Brothers Garcia* (2000–2004), *Resurrection Blvd.* (2000–2002), and *American Family* (2002–2004), most Latinos are still confined to cable and Spanish-language networks and are overwhelmingly middle class (Davila, 2001; Negrón-Muntaner, 2004; Rodriguez, 1997).[18] The only show to feature a working-class Latino character since *Chico and the Man* (1974–1978) is *The George Lopez Show* (2002–present).[19] However, different from the characters of the ghetto sitcom era who are trying to move out of the working class, George Lopez has already left it behind and moved up to the comfortable familiarity of the middle-class family sitcom.

The George Lopez Show is a perfect example of how the American dream is supposed to work. A former assembly line worker, George is promoted to manager of the factory. Suddenly he has no problems. He lives in a beautiful space. His family has no problems other than what typical American middle-class families supposedly go through. In fact, the only thing that marks him as working class is his mom and his buddies back at the factory who refer to him as "Mr. Clipboard."[20] It is pretty comical that the producers chose to use *Low Rider* as the theme song for the show. While this is a song about urban Latino culture, there is a total disconnect between the song and who this middle-class character is—there is nothing low rider about George Lopez. In fact, if anything, the show eclipses the reality that the overwhelming majority of Latino/as in the United States suffer the abuses of immigration discrimination, labor exploitation, unemployment, and racism.[21]

Women Have Class

While they have never been excluded like other underrepresented groups, television largely ignores the economic realities faced by many women in this country (Bettie, 2003; Douglas, 1995; Press, 1991). Across the board, women earn less than men regardless of education, and they often work a double shift as part of the paid labor force and as unpaid caretakers of the home and family. On average, women make 77 cents to a man's dollar. The median income for men in the United States is $40,800; for women, it is $31,200. The leading occupations for women are all lower-middle and working-class jobs. In addition, the majority of jobs at the bottom of the economic scale are held by women, especially women of color. In 2003, "33.9% of Black women and 45.8% of Latinas earned low wages" (Economic Policy Institute, 2004/2005, p. 130). Not only does television disregard these realities, it rarely even depicts work as an economic necessity. This is evident in older shows that feature female characters such as *Bewitched* (1964–1972) and *The Brady Bunch* (1969–1974) (where even Alice, the family maid, is happy and carefree),[22] and in more recent programs like *Friends* (1994–2004) and *Sex & the City* (1998–2004).

In the last three decades, the number of households headed by single moms has remained fairly constant, at around 80%. With an average income of only $24,000, single moms experience poverty at a rate that is substantially higher (28%) than the national average (13%) (U.S. Census Bureau, 2003). Single moms, in shows like *Julia* (1968–1971), *The Partridge Family* (1970–1974), *One Day at a Time* (1975–1984), *Murphy Brown* (1988–1998), *Ally McBeal* (1997–2002), *Judging Amy* (1999–2005), *The Parkers* (1999–2004), *The Gilmore Girls* (2000–present), and *Reba* (2001–present) do not reflect the reality of single mothers' lives.[23]

We have only seen a handful of working-class female characters on entertainment television. Most women, even single moms, have been middle-class characters in career jobs where money is not paramount. The few shows that have portrayed women struggling economically don't deal directly with class issues.[24] These are women who are simply down on their luck (e.g., *Alice* (1976–1985) either because they have lost their husbands or they have made a really bad choice for a husband. A perfect example of this is *Grace under Fire* (1993–1998). She is divorced with two kids. She is a recovering alcoholic. Her ex-husband Jimmy, also an alcoholic, offers the family very little support. While she deals with serious issues, what this show is really about is one woman's determination to not make the same mistakes that she has made in the past. In other words, her obstacles are self-imposed and so it is her responsibility to transcend them. As she tells her children in one episode:

> I really want you to get a fair shake out of life and that's not gonna happen if you take the easy way out. It's a bad habit to get into, because then you will get into some relationship that you don't want, or some job, and the next thing you know you'll be doing the hootchie-coo on top of a Formica table wearin' a bunch of blue eye shadow in front of a bunch of tractor salesmen that don't even tip real good . . .

Really the only show to put gender and class together is *Roseanne* (1988–1997).[25] It aired in the late 1980s at a time when network ratings were down, and ABC was willing to take

a chance on it. It is important to note that the decision to air the show was not made in order to democratize the air waves by finally including the realities and struggles of a working-class family. With ratings down, the corporate media were simply desperate for new and attractive ideas. In addition, as Rhoda Zuk (1998) reveals, the production company responsible for putting the program together was able to hire non-union workers for all aspects of the show:

> Such activity gives the lie to an apparently well-meaning production designed to communicate the affective life of a large group materially disadvantaged by the overriding of workers' organization. (p. 3)

Roseanne also appears in the midst of a feminist backlash where the ideology is essentially that women have won equal rights, they have arrived, and they do not need feminism anymore. However, what was really going on at the time was an attack against all working women, who were being blamed for the disruption in the family for going to work.

Regardless of the pressures to tone down the program and her public political persona, Roseanne insisted that her sitcom be a feminist show about a working-class family. As Andrea Press notes:

> *Roseanne* is a show that addresses issues that are basic to feminism: the division of labor in the family, the need for good childcare for women who work, the need for working-class women to work . . . on *Roseanne* you saw an image of a working-class woman who felt she was a great mother. She worked around some of the challenges she faced not having a lot of extra money, not having a lot of extra time, and not really being able to purchase a lot of advantages for her children. (interview in *Class Dismissed*, 2005)

Barbara Ehrenreich adds: "Now and then it would actually follow Roseanne into her workplace, her confrontations with her bosses; that is a rare event on TV—might give people ideas I guess so they do not show it too often" (interview in *Class Dismissed*, 2005).

Roseanne was also revolutionary in that it did not use the father figure to reinforce the stereotype that working-class men are all a bunch of buffoons (Freed, 2002).[26]

Class Clowns

In order to reinforce its middle-class ideology, television must account for the members of the working class who have not made it. TV reproduces the deeply ingrained belief that workers' inadequacies are to blame for their lack of advancement. In reality, most Americans do not change their class position, and the boundaries of social class are now more restrictive than ever. As Stanley Aronowitz argues:

> For a very long time, I believe ending in the early 1980's or the late 1970's, it was possible for a quarter of the working class to move beyond its class origins to professional and managerial categories. And that developed into both mythology as well as an ideology. The mythology was that everybody in America can gain social mobility. The ideology was that it's a personal question. (interview in *Class Dismissed*, 2005)

Television representations either perpetuate the idea that the cream always rises to the top, or they reinforce stereotypes about workers' failure to succeed due to their inferior qualities such as bad taste, lack of intelligence, reactionary politics, poor work ethic, and dysfunctional family values (Aronowitz, 1992; Butsch, 2002).[27]

One of the flaws that is supposedly characteristic of the working class that is widely circulated in popular culture, and TV plays an important role in that circulation, pertains to taste, lifestyle, and leisure. A stereotypical image that we get is a bunch of slobs sitting around on some cheesy couch drinking beer, preferably brown bottle or can beer, and staring endlessly at the tube. Given their love of junk culture, we do not get the sense that they are deserving of the finer things in life—they would not appreciate them anyway. This stereotype is exemplified in an episode of *Yes Dear* (2000–present):

> *Wife:* I'm just trying to give your family a little culture [they don't like her gazpacho soup]. Bet if I shoved it in a Hot Pocket and smothered it in Velveeta the four of you would be out back wrestlin' over it.

On entertainment television, we do not get the idea that working-class characters are economically deprived; rather, their low tolerance and limited access to the "virtues of high culture" are attributed to personal taste and choice.

When working-class characters do try to move out of this space and hob-knob with the middle and upper classes, it is made really laughable because they are so awkward in this new environment—they do not have the cultural capital to navigate it. TV plays off of this, in particular sitcoms (e.g., older shows like *Laverne & Shirley* (1976–1983) and more recent programs such as *The Nanny* (1993–1999)). This ridicule is evident in the following scene in *The King of Queens* (1998–present):

> *Well-to-do neighbor:* It's really nice of you to have us over. *Neighbor's husband:* Yeah thanks, this is for you. Scotch, hope you like it. *Doug's wife:* Like it? He loves it! Big scotch guy right here. *Doug: (a delivery service driver):* Scotch is great. Love the drink. Love the tape.[28]

One way for the working class to fit into this upper-class world is to get a personal make over. There are a slew of reality shows that are dedicated to this process.[29] In the opening credits of *I Want to Be a Hilton* (2005), a "poorly dressed" young woman is standing in front of her trailer-like home and says into the camera, "I want to trade in my blue-collar life." This statement is followed by all the contestants on the show proclaiming, "I want to be a Hilton," that is, a member of the wealthy hotel family, as they prepare themselves for the etiquette classes and challenges that the multi-millionaire matriarch will put them through in order to win this status.

Joe Millionaire (2003–2004) is another prime example of this make-over process where members of the working class are equipped with the necessary social skills and etiquette to pass as money.

There are a number of other shows that are about physical transformation and class advancement. The idea that bodily perfection leads to upward mobility is reinforced on shows like *The Swan* (2004) and *Extreme Makeover* (2003–2005), where people even go under the knife in order to change the way they look. This myth is also perpetuated by the slew of

talk shows like *Oprah* (1986–present) that dedicate enormous amounts of airtime transforming guests with the help of hair, make-up, and style experts. And not only that, now you can makeover your house on shows like *Trading Spaces* (2000–present) and *Design on a Dime* (2003–2006), as well as your junk box car—on *Pimp My Ride* (2004–present). Then there's *Queer Eye for the Straight Guy* (2003–present) that goes for the whole package—the body and the house.[30]

This ideological thread has been woven into Web TV as well. The new program, *Brawny Academy.com* (2006) is an attempt to clean up sloppy men.[31]

None of these things actually changes a person's class position or the economic conditions that have created their situation in the first place. If you want a real class makeover, you are going to have to radically change the economic system. Now that would make for a really interesting reality show![32]

Another debilitating characteristic of this group of people according to the stereotype is that working-class men lack intelligence. It is obvious they were not good students. They often fumble the language and a lot of basic stuff just goes right over their heads. The classic character of the lovable but laughable buffoon that is still very much with us today is played by Jackie Gleason in *The Honeymooners* (1955–1956) in the character of Ralph Cramden (Aronowitz, 1992; Butsch, 2002). This show was preceded by *Life of Riley* (1945–1950) where Gleason played the bumbling father.[33]

In *The Honeymooners*, Gleason is a city bus driver who hates his job. He is loud and blustery and always coming up with ridiculous money-making schemes; and the real joke is that we know that he is not that smart. He has this sidekick, Ed Norton, who is this dimwitted, but lovable, happy-go-lucky sewer worker. While eating, Ed tells Ralph, "Man: I'm telling you if pizzas were manhole covers, the sewer would be a paradise!"

These class clowns get reproduced in the 1960s with *The Flintstones* (1960–1966). Even though it is set back in the Stone Age, Fred is the direct descendant of Ralph Cramden, and Barney is definitely the son of Ed Norton. And what follows is a whole parade of dumb working-class guys whose stupidity is the brunt of the joke (e.g., *Gilligan's Island* (1964–1967), *Welcome Back Kotter* (1975–1979), *Taxi* (1978–1983), *Working Stiffs* (1979), *Cheers* (1982–1993), *Momma's Family* (1983–1990—which was taken from a skit on *The Carol Burnett Show* (1967–1978)), *Married with Children* (1987–1997), *The Simpsons* (1989–present), *Dinosaurs* (1991–1994), *The Drew Carey Show* (1995–2004), *King of the Hill* (1997–present), *The King of Queens* (1998–present), *My Name Is Earl* (2005–present), and *Lucky Louie* (2006–present).[34]

The Honeymooners is also an important prototype for a particular gender dynamic. Because these husbands are so lacking in common sense, and the wives are obviously smarter, it is the women who end up ruling the roost (Butsch, 2002; Riggs, 1991). As Ralph's wife Alice demands:

Now you listen to me Ralph. You are not going bowling!

Ralph: I gotta go Alice, I promised the guys!
Alice: The guys? What about me Ralph? What about your job? What about our future?

What we end up with is a reversal of traditional gender roles where these caricatures of men are essentially incapable of taking their place at the head of the household. Take, for example, this scene in the more recent show *Rodney* (2004–present):

> *Rodney:* I just gambled away my paycheck, that's all.
> *Rodney's wife Trina:* You lost that too? Rodney, we don't have money to gamble!
> *Rodney:* I know, that's why I was trying to get it back.
> *Trina:* Rodney, we agreed that you were going to use that paycheck to pay off our property taxes.
> *Rodney:* Trina, I have a problem.
> *Trina:* You don't have a problem! I do, I'm married to an idiot!

It is not just the wives. In a typical working-class household, even the kids are smarter than the dad. This is really evident in shows like *The Simpsons* (1989–present), in the father son relationship in *Married with Children* (1987–1997), and in *Still Standing* (2002–present)

The working class is being blamed for not being educated enough to compete in a global economy, and yet we have one of the most educated workforces in the world regardless of the fact that our public education system is highly class based. It is also ironic that given this claim of lack of education, corporations are moving to "Third-World" countries, where there is enormous illiteracy in order to find "cheap" labor.

On corporate-run TV, there is a recurring representation that the working class has no interest in education as they wallow in anti-intellectualism. They have no interest in reading, unless it is the sports page, the comics, or a tabloid of some sort. Aronowitz asks:

> Why do we get this image of the anti-intellectual and the stupid worker even though workers historically were the reasons we have public education because their organizations among others were people who fought for the public education system . . . and that working-class kids now go to community colleges and four-year colleges in record numbers. . . (interview in *Class Dismissed*, 2005)

There is a reason for these stereotypes: They distract us from the structural realities, especially the unequal distribution of resources in public education, that inhibit people's lives. However, what is worse is they disregard the fact that the overwhelming majority of working-class parents really do care about their kids' education.

The working class is also represented as being disinterested in politics, which is ridiculous if you think about working-class history and the struggle for basic rights and a living wage. This supposed apathy is embodied in a classic scene on *Cheers* (1982–1993) where Norm and Cliff bump into Senator John Kerry in front of the bar. Kerry is talking to a gentleman in a trench coat. The man (a typical character that one would find in the wealthy Back Bay area of Boston) walks off after Kerry gives him the thumbs up as a sign that the two men had understood and agreed with one another:

> *Norm* (excited): Oooh, Oooh, look at that. Look what we got here.
> *Cliff:* What?
> *Norm:* Look!
> *Cliff:* Oooh, it's the film critic . . . channel 11.
> *Norm:* It's the anchorman . . . Channel 8. (Both are excited.)
> *Norm:* You wanna get an autograph?
> *Cliff:* Yeah, yeah!

Norm (to Kerry): Excuse me . . .

Kerry: Hi Guys, how ya doing, how are you?

Cliff (nervous): We're really big fans of yours (he fumbles the language a bit), can we have . . . can we get your autograph?

Kerry: Yeah, sure . . . Ah, here, let me get something to write on. (Cliff and Norm both search for a pen in their pockets—of course only as a gesture as they both know that they don't have a writing utensil on them; a sign of their lack of professionalism.)

Cliff: You know, I love that . . . that report you did on that train wreck. Ya know, they oughta get you at *60 minutes* as an anchor.

Norm: Pulitzer Prize.

Kerry: No, I'm John Kerry, Senator Kerry from Massachusetts.

Norm: Oh, our senator. I'm sorry man, so sorry.

Both: Sorry to bother you pal (they both walk away and head down the bar entrance stairs; Kerry puts his hands in the air as if to say, what was that all about).

Cliff (on the way down the stairs): Hey wait, hold on. Maybe he knows Senator Gopher from *The Love Boat.*

Norm (both men running back up the stairs to catch up with Kerry): Hey, yo!

When we do get characters that are interested in politics, they are almost always staunch conservatives, bigots, and closed-minded. The archetypal figure here is Archie Bunker from *All in the Family* (1971–1979). As Ehrenreich states:

> So, while we laughed, it also made me very uncomfortable because Archie Bunker was a stand in for so many blue-collar guys. But the upper-middle class and the upper classes have always liked to believe they are the enlightened ones and it's the working class that is full of these bozos. (interview in *Class Dismissed*, 2005)

Perhaps the most blatant representational crime against the working class by the corporate media is this image of this lazy incompetent worker who is complacent and not interested in improving his or her lot in life. In *Still Standing* (2002–present), Bill, a toilet salesman, is talking with his wife's sister's date:

> *Date:* Actually, I'm a psychologist. If I wanted to be a psychiatrist, I'd have to go through medical school and residency and all that.
>
> *Bill:* Yeah, I know how you feel, buddy. I was going to take the management course at work, but it was like three Saturdays.

These characters have no leadership skills, and they are in constant need of supervision. As we see on *King of the Hill* (1997–present), when Hank is showing a wealthy investor around town and the two come across a construction site where the workers are on break:

> *Potential customer:* Something's wrong.
>
> *Hank:* Yeah it's the darn unions. Come on boys, finish up them Little Debbies and get back to work!

In this era of globalization with enormous job loss, outsourcing and off-shoring, corporations need a scapegoat for their avarice activity and the scapegoat is the working class whose members are not working hard enough, and yet, since 1975, productivity is way up (163%). Furthermore, they are supposedly asking for too much money, and yet wages are stagnant (115%), and profits are through the roof (758%).

When it comes to family values, in the late 1980s and early 1990s there is a dramatic shift away from the omnipresent image of the happy homogenous nuclear family. This era that is often referred to as "Loser TV" gave birth to shows like *Married with Children*, *The Simpsons*, *Jerry Springer* (1991–present), and *Beavis and Butthead* (1993–1997). These shows appear at the tail end of eight years of Ronald Reagan, when the country was going through some serious economic turmoil. However, instead of looking at downsizing, lay-offs, unemployment, and corporate greed, these working-class couples are seen as the poster child of bad parenting, and hence the source of all of society's ills. They certainly lack the wisdom, discipline, and morality of the middle-class parents of other shows.[35]

These families give rise to a couple of different kinds of children; either they are smart and talented, which reinforces the myth of meritocracy—these kids are going to make it out regardless of the circumstances; or they are deviant in a number of ways—the Bart Simpson type.[36]

The two biggest troublemakers are definitely Beavis and Butthead. These guys celebrate stupidity, and they live for sex and violence. The show plays on a generation of youths raised on a media saturated society of junk culture, commodity, and alienation where the parents are driven out of the home and into the labor force and where the TV becomes the babysitter and the role model (Kellner, 1997). As Doug Kellner notes, there surely is an element of working-class revenge for these two guys who come from broken homes in a disintegrating community where school and work in the fast-food industry are meaningless, and where they are downwardly mobile with a bleak future, if any. Shows like *The Simpsons* and *Beavis and Butthead* do offer a critique of our corporate-driven society. These characters know that something is wrong. However, the problem is that their actions are just individualized acts of rebellion—their response is to trash stuff. As a consequence, such behavior ends up being self-destructive rather than transformative.

No Class

Outside of the comic frame, there is a different and more threatening image of the working class on crime shows. Because this genre does not use class as a lens to view criminal behavior, deviance is most often framed in racial or cultural terms. As Kelly notes:

> Something happens in the 70s and 80s where all these cop shows really put a lot of emphasis on working in ghetto communities. They are the most dangerous places to work. And it coincides again, with this image that the black poor, or black criminal behavior, is a result of a lack of guidance, the lack of strong father figures, a matriarchy that explains criminal violence because these mothers are not able to control their youth.; and in a criminal culture. It also reinforces, I think, white, and black fears in some ways, that youth, particularly young males in inner-city communities, are dangerous. They are all suspect. They deserve to go to jail. (interview in *Class Dismissed*, 2005)[37]

The more recent incarnation of such shows, e.g., *Cops* (1989–present), *Homicide: Life on the Street* (1993–1999), *NYPD Blue* (1993–2005), *Oz* (1997–2003), *The Shield* (2002–present), and *Dog the Bounty Hunter* (2004–present) continue to do important ideological work. They justify the growing prison population with a record 2.1 million people behind bars—

over 70% of whom are non-white. African American males make up the largest number of those entering prisons each year in the United States. Racially subordinated women are also being incarcerated in epidemic proportions. As Loic Wacquant (2002) states, "The astounding upsurge in Black incarceration in the past three decades results from the obsolescence of the ghetto as a device for caste control and the correlative need for a substitute apparatus for keeping (unskilled) African Americans in a subordinate and confined position—physically, socially, and symbolically" (p. 23).

Addressing the links between the racialization and criminalization of people and television's role in this pedagogical process, Herman Gray notes:

> Even the attempts to mediate it by having black authority figures like black lieutenants and black judges [on TV shows] doesn't necessarily change the logic by which these two forms of meaning come together that is to say, blackness and criminality. (interview in *Class Dismissed*, 2005)[38]

Of course, these images are scripted outside of any analysis of racism and the poverty caused by capitalism.

Thirty-seven million people in this country live in poverty, a number that is up 1.1 million from 2003. According to the U.S. Department of Agriculture, there are 25.5 million people who rely on food stamps to avoid hunger—a number that is up 2 million from 2004. In other words, 6.8 million families live in poverty, and 17% of the nation's children, or about 12 million kids, are compelled to endure inhumane economic conditions. An Urban Institute study has revealed that about 3.5 million people are homeless in the U.S. [a number projected to increase 5% each year], and 1.3 million (or 39%) of them are children (National Coalition for the Homeless, 2002).

The largest group of poor people in the United States is white. However, we have a very limited understanding of who they are because their images historically have been so few and far between. Because whiteness is associated with a dominant culture, poor and working-class whites are usually portrayed as cultural outcasts or a subculture. While TV mocks their condition, it gladly uses their image to entertain us.

The rural working class is nearly invisible in mainstream culture. What we find on television are these twisted comedic images, which, like the ghetto sitcoms, really pastoralize poverty. The earlier images were of hillbilly characters popularized on shows like *Ma & Pa Kettle* (1954) and *The Real McCoys* (1951–1963). These are followed by the "idiot sitcom era," with country bumpkin shows like *The Beverly Hillbillies* (1962–1971), *Andy Griffith* (1961–1968), *Gomer Pyle* (1964–1970), *Green Acres* (1965–1971), and *Petticoat Junction* (1963–1970), which featured characters who were simple-minded, non-threatening, and really easy to laugh at. These shows would be followed by *Hee-Haw* (1969–1993), *The Dukes of Hazard* (1979–1985), *Newhart* (1982–1990), *Enos* (1980–1981), and *The Dukes* (1983–1984).[39]

The person who has resurrected the hillbilly and given it new life as "redneck pride" is Jeff Foxworthy. From comedy tours to films to a cable show, *Blue Collar TV* (2004–present), being a redneck seems like a lifestyle which includes NASCAR and country music. More specifically, Foxworthy has taken what in reality is an economic position and made it look like a lifestyle choice.

Foxworthy on comedy tour: Sophisticated people invest their money in stock portfolios. Rednecks invest our money in commemorative plates. Yeah, that's the legends of NASCAR series right there . . .

Co-opting redneck pride is also a way that the Republican party has tried to brand itself as a friend of working people and to develop its political clout in the so-called red states.

George W. Bush (describing NASCAR while at the race): This is more than an event, it's a way of life for a lot of people.
Female organizer for the Republican party at NASCAR: This is the first time that we have done this. We recognize that this is a happy hunting ground for new Republican voters.

The hypocrisy and deceit here are difficult to swallow—not that the democrats have done much for the working class lately, but the Republican agenda has always been a war against the working class, working poor, and unemployed.

As the effects of the economic downturn become more visible, so is this more threatening image of the white poor who are being popularized as white trash. All these types, the hillbilly, the redneck, and white trash are racially coded terms to describe a genetic subset of white people—lowlifes. So Jerry Springer, who introduces his show with a television in the trashcan, is where all the qualities associated with white trash are on display: a lack of desire to work, sexual perversion, incest, and so on. In a similar spirit, *Geraldo* (1987–1998—hosted by Geraldo Rivera), created a perverse spectacle that was described by *Newsweek* as "trash TV." It is interesting because this is a multiracial world—it is a sort of equal opportunity spectacle. The common link that brings them all together is social class. As Lisa Henderson argues:

I think that it's important to recognize that all those so-called practices, airing dirty laundry, fighting, cheating, are things that middle-class people do too, but when they do them, they are screwed up; when working-class people do them, especially on television, well, that's just the way they are, they're trash. (interview in *Class Dismissed*, 2005)

While presented with a touch of seriousness and professionalism, there is a similar entertainment strategy used on talk shows such as *Sally Jesse Raphael* (1985–2002), *Montel Williams* (1991–present), *Jenny Jones* (1991–2003), *Ricki Lake* (1993–2004), and *The Maury Povich Show* (1998–present). They often have programs about working-class children who are out of control. A popular response is to send these deviant youths to military boot camp or prison and televise the spectacle.

Courtroom series also play a role in reproducing the image of working-class cheats and buffoons, e.g., *Judge Judy* (1996–present) and *Judge Joe Brown* (1998–present).

Class Action: Media Literacy for the Twenty-First Century

While television has long used the image of the working class to entertain us, current labor conditions are no laughing matter. Today's workers face a declining standard of living and

the loss of job security. They also risk falling victim to corporate greed and malfeasance such as the recent atrocities of Enron, Tyco, Wal-Mart, Worldcom, or any of the other over 20,000 acts of corporate lawbreaking that are documented annually. The working class is also experiencing a concerted effort to dismantle the democratizing force of organized labor. While workers in unions earn 30% more than non-union people doing the same job and get far more guaranteed benefits such as a pension and healthcare, the Republican assault on organized labor has been devastating. By 2002, only 13.2% of wage and salary workers were union members—a number that is getting smaller every year (Bureau of Labor Statistics, 2003). Regardless of the federal law (Section 7 of the National Labor Relations Act) that states that

> Employees shall have the right to self organization, to form, join or assist labor organizations, to bargain collectively through representatives of their own choosing and to engage in other concerted activities for the purpose of collective bargaining or other mutual aid or protection . . .

the harsh reality is that those who try to organize often face serious repercussions. Human Rights Watch has recorded that ten to twenty thousand people a year are fired or punished for trying to unionize. Low-wage earners in particular face an atmosphere of intimidation and as a result many, desperate for work, steer clear of union activity.

Regardless of the neoliberal promise of prosperity for all, it is more than obvious that the structural dimensions of social class within this economic logic remain profoundly in place. In fact, economic conditions for millions of people in the United States and for billions of people worldwide are worsening as a direct result of privatization, deregulation, and restructuring; as well as by the ways in which elite private powers have been successful in using the State to protect corporate interests and dismantle many of the rights and protections achieved locally and internationally by grassroots activists, organized labor, and social democracies.

Corporate media's narrow, unrealistic images conceal the extent of this assault on America's workforce, so we can no longer afford to ignore TV's framing of the working class or see it as just entertainment.[40]

The media reform movement has already begun to educate the general population about the political economy of the mass media—that is, ownership and regulation of this industry—and challenge the FCC and Congress to democratize the airwaves and new technologies and to diversify representations that reflect both the new realities of work and the changing face of the working class in the United States.

A key component of any activist effort should be to encourage the widespread development of critical media literacy, that is, the ability to read the values and beliefs embedded in the knowledge that is circulated throughout society so as to be able to defend ourselves from propaganda and participate in its eradication.

A critical model of media literacy is primarily concerned with the kinds of theories and practices that encourage people to develop an understanding of the interconnecting relationships among ideology, power, meaning, and identity that constitute *culture*. Literacy of this sort entails understanding culture as a pedagogical force in which the multiplicity of

aural and visual signifying systems that people are inundated with every day, through language, TV, advertising, radio, print journalism, music, film, and so on, are ideological and formative, rather than merely vehicles for expression or reflections of reality. They are the conduits through which values and beliefs that work to shape how people see, interpret, and act as socialized and political beings are promoted.

Critical media literacy encourages us to not only think about culture politically, but also to think about politics culturally. Political consciousness and action do not take place in a vacuum. As argued in the introduction of this chapter, oppression not only consists of a structural reality built on political and economic processes and relationships, it also relies on symbolic systems to shape the kinds of meaning, identity, desire, and subjectivity that can work to ensure the maintenance of what Antonio Gramsci referred to throughout his work as the hegemony of "common sense."

The ability to demystify social reality requires both theory and action. *Theory* in this sense is how people interpret, critique, and draw generalizations about *why* the social world spins the economic, cultural, political, and institutional webs that it does. From this working definition, theory is the ability to make sense of all levels of the everyday—that is, the *why* and *how* of what has been happening in people's lives, and not simply a focus on *what* is occurring and how to effectively respond. As an integral part of any political project, theorizing also presents a constant challenge to imagine and materialize alternative political spaces and identities and more just and equitable economic, social, and cultural relations. It makes possible consciousness raising, coalition building, resistance, activism, and structural change.

In such undemocratic times, it is not surprising that critical media literacy is often discouraged. As people, especially students, are distracted or lured away from critically reading historical and existing social formations, in particular those that maintain abuses of power, they often become the newest wave of exploited labor power and reproducers, whether they are conscious of it or not, of oppressive social practices.

On the contrary, critical media literacy is rooted in a democratic project that emphasizes new theories and languages of critique, resistance, and possibility capable of engaging the oppressive social practices that maintain the de facto social code in the United States. These new theories and languages provide the necessary analytic stepping stones for realizing a truly democratic process through which we can better identify the sociopolitical realities that shape our lives and where necessary, transform our practices.

As argued throughout this chapter, any such movement to raise consciousness and democratize economic, social, and technological relations has to reflect the diverse interests and experiences of the working class. In this battle for economic justice and racial and social equality, TV, regardless of its sordid past, can play an important role.

NOTES

1 Anti-colonial activists have long recognized how material conditions, politics, and culture are interlaced and how subordination, resistance, and opposition take place in both the physical and symbolic realm.

2 It is also important to look at how the news media and Hollywood frame the working class. For information about how labor is depicted in the news media, see Puette, William (1992). *Through Jaundiced Eyes: How the Media View Organized Labor.* Ithaca, NY: Cornell University Press; Buckingham, David (2000). *The Making of Citizens: Young People, News and Politics.* New York: Routledge; and Martin, Christopher (2004). *Framed: Labor and the Corporate Media.* Ithaca, NY: Cornell University Press. For an analysis of Hollywood films and their depiction of the working class, see Booker, Keith (1999). *Film and the American Left: A Research Guide.* Westport, CT: Greenwood Press; Buhle, Paul & Wagner, Dave (2002). *Radical Hollywood.* New York: The New Press; Ross, Steven (1998). *Working-Class Hollywood.* Princeton, NJ: Princeton University Press, and Horne, Gerald (2001). *Class Struggles in Hollywood: 1930–1950.* Austin: University of Texas Press.

3 This process is far more complicated than simply a bunch of media moguls and corporate heads sitting around making these decisions together—which needless to say, does happen. Someone like Rupert Murdoch is very clear about his political agenda, and that agenda is evident in the representations circulated by FOX. The same goes for the rest of the so-called liberal media, which in reality are also in favor of monopolizing the airwaves and circulating corporate logic (Herman & Chomsky, 2002). This is no conspiracy. These people are simply protecting their own best interests. At the same time, while major decisions are made by bigger power brokers, writers and producers do not really need big brother around to monitor their work. In most cases, they have been properly educated so as to know what is appropriate and what is not. At the same time, writers and producers may not be conscious of the fact that they are reproducing oppressive ideologies. They too are the product of representation, and their sense of humor, for example, is constructed within accepted discourses and circulated through society's institutions—they have already been called into that ideological space and thus know what will make people laugh or cry. In the end, whether they are conscious of it or not, they play a central role in reproducing discriminatory images and social practices.

4 It is important to note that the use of class stratification here is referring to standard of living and not to class as a category of power.

5 45.8 million Americans lack health insurance, which includes 9.2 million kids. "Overall, nearly 1 in 5 full-time workers today goes without health insurance; among part-time workers, it is 4 to 1" (Krim & Witte, 2004, p. A01). As compared with 2001, there were 5 million fewer jobs providing health insurance in 2004. These statistics are particularly interesting given that "the average compensation for the top health care executives at the top 10 managed healthcare companies, not including unexercised stock options, is $11.7 million per year" (Jackson, 2001, p. 3).

6 It is important to note that the Census also bypasses the long-term unemployed and the homeless.

7 Of course Republicans are working to do away with the capital gains tax so as to reap the full benefits of their stock portfolios and other investments.

8 The super rich are made virtually invisible—other than showing off their lavish lifestyles on entertainment television or their wealth and power in the Forbes report. As Michael Parenti (2000) points out, 1% of the population goes undocumented in income distribution reports because U.S. Census Bureau surveys are not distributed to the wealthiest of Americans such as Bill Gates who is worth $53 billion, or Warren Buffett who has accumulated a cool $46 billion.

9 The best way to attain upward mobility is the old fashioned way—to inherit it. Republicans are working diligently to do away with inheritance taxes, or what they strategically refer to as "death taxes." Countering this strategic use of language, many people trying to keep the laws in place refer to this tax as the "Paris Hilton tax."

10 While it wasn't a regularly scheduled program, *Marty* (1953), the story of the everyday life of a butcher living in an urban environment provided an interesting image of the working class.

11 While racism can't simply be conflated with the economic base of capitalism, we certainly need to look
 at the ways in which it is used to exploit diverse groups within capitalist social relations. It is also cru-
 cial to look at the ways in which historically racism, and sexism for that matter, has served an impor-
 tant role in keeping at bay working-class unity and maintaining a system of labor exploitation.

12 A classic example of this is the character "Rochester" on *The Jack Benny Program* (1951–1965). It is
 important to note that *The Nat "King" Cole Show* ran up against racist sponsors, which ultimately led
 to its premature death.

13 This can be seen in shows like *Julia* (1968–1971) and *I Spy* (1965–1968) which featured a young Bill
 Cosby.

14 Fred and Lionel get out of the ghetto and move to Arizona, and in 1977 a spin off of *Sanford and Son*
 is released—*The Sanford Arms*. The storyline is about turning the old rooming house into a successful
 hotel. Archie Bunker also makes it out of his working-class neighborhood and opens a bar. The fea-
 tured characters on *What's Happening* either escape the ghetto or enter the middle-class therein.

15 Kelly adds: "Another example of 'moving on up' suggests that what black youths need are white peo-
 ple to come in and step in with superior parenting skills and resources to basically bring them out of
 the ghetto. *Diff'rent Strokes* [1976–1986] is a classic example." He also uses the show *The White Shadow*
 (1978–1981) to illustrate this point.

16 As in the typical format, the family moves from the inner city to the suburbs.

17 *704 Hauser Street* (1994) is a show with African American, working-class characters. They live in Archie
 Bunker's old house in Queens, NY. While the two parents are portrayed as "typical working-class, blue
 collar liberals," their son is very conservative and fancies a Jewish girl from the neighborhood. While
 this may be Norman Lear's attempt to make up for pigeon-holing the working class through the ear-
 lier depiction of Archie Bunker as a working-class yahoo, the show only lasted for six episodes. In 1996,
 Bill Cosby initiated and co-produced the show *Cosby*. The short-lived sitcom was based on a retired
 old man who loses his job and searches for another. Most of the episodes are preoccupied with this char-
 acter driving his wife crazy. What is interesting is that the show was based on the English program *One
 Foot in the Grave* (1990–2001), which entertained some serious political criticism. On the contrary, Cosby
 lightened the humor and thus the content of his version. *The PJs* (1999–2001), an animated show cre-
 ated by actor Eddie Murphy, offered insight into life in a housing project and the chief superintendent,
 but it was more about comical adventures than any explicit critique of the formation of such projects.
 The Tracy Morgan Show (2003) is built around the life of an African American family in a tiny
 Brooklyn apartment, and while Tracy struggles working as an auto mechanic, the show, in its short life,
 was preoccupied with trying to fulfill his dream of expanding his business. *Everybody Hates Chris*
 (2005–present) is set in Brooklyn, New York during the early 1980s. Chris is sent to a primarily white
 middle school, and so while it has the potential to reveal some of the realities of that world, it is more
 about coming of age.

18 Latino/a characters have appeared on shows like *Norm* (1999–2001), *Walker, Texas Ranger* (1993–2001),
 (1999–2001), *Gideon's Crossing* (2000–2001), *Third Watch* 1999–2005), *Nash Bridges* (1996–2001), *That
 70s Show* (1998–2006); and Latino/a characters have appeared in secondary roles on such shows as *ER*
 (1994–present), *Jag* (1995–2001), *Felicity* (1998–2002), and *Family Law* (1999–2002).

19 The show *CHIPS* (1977–1983) did feature Erik Estrada as officer Frank "Ponch" Poncherello.

20 In this racialized space, his father is missing and is assumed to have abandoned the family.

21 There are no programs that take up the conditions of persons with disabilities. Disability is also a class
 issue in that two-thirds of people with disabilities are unemployed. The material conditions of the eld-
 erly are also neglected by the corporate media. When they are included it is in drug commercials, retire-
 ment success stories on advertisements, or on shows where money is not an issue, such as *The Golden
 Girls* (1985–1992).

22 All of the maids/housekeepers/butlers/servants on TV are depicted as complacent, without serious worries, and often empowered to question the boss; e.g., *Beulah*, *Hazel* (1961–1966), Mr. French on *A Family Affair* (1966–1971), Florence on the *The Jeffersons*, Bentley, Florida on *Maude*, Geoffrey on *The Fresh Prince of Bel Air*, Paul Hogan on *Joe Millionaire*. There are no scenes of them scrubbing toilets and taking abuse.

23 While beyond the scope of this chapter, it is important to take up the stereotype of working-class women as trashy and slutty, especially "fake blonds." It would then be interesting to analyze *The Anna Nicole Smith Show* (2002–2003), as we have the movement of a woman from Texas, where she was abandoned by her father and raised by her mother and aunt, to exotic dancer, to billionaire, to see what she brings to that new class status. The opposite is also true in that *The Simple Life* (2002–2003) with Paris Hilton, which mocks everyone.

24 The cartoon *As Told by Ginger* (2000–2004) offered an interesting perspective of a working-class girl living with her single mom. Ginger's mom is a nurse who is on strike and works for her own cleaning business. While the show is by no means radical, it does move a bit beyond the typical TV content.

25 The show *Maude* (1972–1978) did provide a good deal of feminist critique, but it was coming from an upper-middle-class white woman, who had a housekeeper.

26 While *Roseanne* was a breath of fresh air, the show was more about working-class moms getting the recognition that they deserve than what would need to change in order to democratize wealth and power in this country. When I asked Ehrenreich about this critique of the show, she responded with a giggle, "These are capitalist media, they're supported by sponsors . . . You're gonna have to make those shows if that's what you want."

27 Advertising also relies on these stereotypes. The strategy is to use humor to create fear by showing the audience what they should avoid.

28 It is interesting how these shows often assume class integration in neighborhoods', and unlike the rather bleak household settings depicted in some of the earlier shows, today's working-class families usually live in very comfortable homes that are equipped with all the modern amenities associated with the good life.

29 The reality show *Survivor* (2000-present) drew a great deal of attention because of Susan Hawk, a Midwestern truck driver whose accent and etiquette epitomized the stereotype of the tacky abrasive working-class character.

30 Since the early 1990s, television has cautiously opened the door to a few gay and lesbian characters, e.g., *The Real World* (1992–present), *Ellen* (1994–1998), and her newest talk show (2003), *ER* (1994–present), *Spin City* (1996–2002), *The View* (1997–present), *Will & Grace* (1998–2006), *Queer as Folk* (2000–2005), *Survivor* (2000–present), *Six Feet Under* (2001–2005), *The Amazing Race* (2001–present), *The L-Word* (2004–present), and in many soap operas. Queer visibility on prime time as with other marginalized groups is due in part to changing social conditions and also with the networks' need to spice up existing repertoires with small variations, but at the exclusion of working-class, gender variant, and other non-conforming individuals.

31 Reality shows like *Wife Swap* (2004–present) also play this role.

32 While reality shows such as *American Chopper* (2003–present), *Dirty Jobs* (2003–present), *Deadliest Catch* (2005–present), and *Miami Ink* (2005–present) don't provide any substantive critique of society, they do offer an interesting view into the lives of a diversity of working-class people.

33 An interesting show that needs further attention when it comes to these representations is *The Three Stooges* (1930–2006).

34 Comedy shows like *Saturday Night Live* (1975-present), *In Living Color* (1990–1994), and *Mad TV* (1995) all have characters and skits that mock the working class. While they also poke fun at the rich, the impact is surely not the same.

35 One of the most fascinating examples of shows that romanticize the virtues of family even in the worst of conditions is *The Waltons* (1972–1981). Taking place during the Depression, the family survives the hard times because of the caring and dedication of the entire family. In the mythology, this is what pulled the country out of trouble, not F.D.R.'s socialist response in the form of the New Deal, or the economic revitalization caused by the war.

36 While the shows *Nanny 911* (2004–present) and *The Super Nanny* (2005–present) help fix families from most diverse backgrounds, the majority of the troubled families screaming for help are working class.

37 The crime shows of the 1970s and 1980s include: *Streets of San Francisco* (1972–1977), *The Rookies* (1972–1976), *Kojak* (1973–1978), *Police Woman* (1974–1978), *Starsky & Hutch* (1975–1979), *Baretta* (1975–1978), *S.W.A.T.* (1975–1976), *Hunter* (1984–1991), *Hill Street Blues* (1981–1987), *Miami Vice* (1984–1991), and *21 Jump Street* (1987–1991).

38 *Law and Order* (1990–present) occasionally provides some interesting political commentary about race, class, and gender discrimination, as do the shows *Cold Case* (2003–present) and *CSI* (2000–present, *CSI Miami*, 2002–present).

39 For a long time now, cartoons such as *Deputy Dog* (1959–1972) have often played off of this country-bumpkin stereotype.

40 While this chapter and research are not about audience reception, that is, how people interpret these messages, we would argue that workers themselves often internalize this stigma. They may see themselves as working men and women, working families, but they reject the label working class. As a result they do not have a sense of class solidarity or class-consciousness.

REFERENCES

Allan, Robert & Hill, Annette (Eds.) (2004). *The Television Studies Reader*. New York: Routledge.

Aronowitz, Stanley (1992). "Working-Class Culture in the Electronic Age." In: *The Politics of Identity: Class, Culture, Social Movements*. New York: Routledge.

Barnouw, Erik (1978). *The Sponsor: Notes on a Modern Potentate*. New York: Oxford University Press.

Bettie, Julie (2003). *Women without Class: Girls, Race, and Identity*. Berkeley: University of California Press.

Bourdieu, Pierre (1996). *On Television*. New York: The New Press.

Butsch, Richard (2002). "Ralph, Fred, Archie and Homer: Why Television Keeps Recreating the White Male Working-Class Buffoon." In *Gender, Race and Class in Media*. (Eds.) Gail Dines and Jean Humez. Thousand Oaks, CA: Sage.

Carey, Alex (1995). *Taking the Risk out of Democracy: Corporate Propaganda Versus Freedom and Liberty*. Chicago: University of Illinois Press.

Class Dismissed: How TV Frames the Working Class (2005). A project by Pepi Leistyna, narrated by Ed Asner, co-written and produced with Loretta Alper, executive producer Sut Jhally, directed by Loretta Alper. Northampton, MA: Media Education Foundation. (All of the interview references are from this source.)

Collins, Chuck, Hartman, Chris & Sklar, Holly (1999). "Divided Decade: Economic Disparity at the Century's Turn." United for a Fair Economy. Available at: www.ufenet.org/press/archive/1999/Divided_Decade/divided_decade.html

Davila, Arlene (2001). *Latinos Inc.: The Marketing and Making of a People*. Berkeley, CA: University of California Press.

Dollars & Sense and United for a Fair Economy (Eds.) (2004). *The Wealth Inequality Reader.* Cambridge, MA: Economic Affairs Bureau.

Douglas, Susan (1995).*Where the Girls Are: Growing Up Female with the Mass Media.* New York: Three Rivers Press.

Durham, Meenakshi Gigi & Kellner, Douglas (2001). *Media and Cultural Studies: Key Works.* Malden, MA: Blackwell.

Dyson, Michael Eric (1993). *Reflecting Black: African-American Cultural Criticism.* Minneapolis: University of Minnesota Press.

Economic Policy Institute (2004/2005). *The State of Working America.* Ithaca, NY: ILR Press.

Forbes (2006). "The 400 Richest Americans." Available at: http://www.forbes.com/lists/

Freed, Rosanna (2002). "The Gripes of Wrath: Roseanne's Bitter Comedy of Class." *Television Quarterly.* Available at: www.emmyonline.org/tvq/articles/30–2-15.asp

Gray, Herman (1995). *Watching Race: Television and the Struggle for "Blackness."* Minneapolis: University of Minnesota Press.

Hall, Stuart (Ed.) (1997). *Representation: Cultural Representations and Signifying Practices.* London: Sage.

Hamamoto, Darrell (1994). *Monitored Peril: Asian Americans and the Politics of TV Representation.* Minneapolis: University of Minnesota Press.

Herman, Edward & Chomsky, Noam (2002). *Manufacturing Consent: The Political Economy of the Mass Media.* New York: Pantheon.

Ivins, Molly (2005). "April 15th: You're Getting Screwed." AlterNet. Available at: http://www.alternet.org/story/21760

Jackson, Derrick (2001). "Who's Better Off This Labor Day? Numbers Tell." Available at: www.raisethefloor.org/press_bostonglobe.html.

Jhally, Sut & Lewis, Justin (1992). *Enlightened Racism: The Cosby Show, Audiences, and the Myth of the American Dream.* Boulder, CO: Westview.

Kellner, Douglas (1997). "Beavis and Butt-Head: No Future for Postmodern Youth." In: *Kinder-Culture: The Corporate Construction of Childhood.* (Eds.) Steinberg, Shirley & Joe Kincheloe. Boulder, CO: Westview.

Krim, J. & Witte, G. (2004, December 31). "Average Wage Earners Fall Behind: New Job Market Makes More Demands but Fewer Promises." *Washington Post*, p. A01.

Lipsitz, George (2002). "The Meaning of Memory: Family, Class and Ethnicity in Early Network Television." In: *Gender, Race and Class in Media* (Eds.) Gail Dines & Jean Humez. Thousand Oaks, CA: Sage.

McChesney, Robert (2004). *The Problem of the Media: U. S. Communication Politics in the Twenty-First Century.* New York: Monthly Review Press.

Meiksins Wood, Ellen (1995) *Democracy against Capitalism: Renewing Historical Materialism.* Cambridge: Cambridge University Press.

National Coalition for the Homeless (1999). Available at: www.nationalhomeless.org/jobs.html

National Coalition for the Homeless (2002). Available at: www.nationalhomeless.org/who.html

National Labor Committee for Worker and Human Rights (2003). Available at: www.nlcnet.org

Negrón-Muntaner, Frances (2004). *Boricua Pop: Puerto Ricans and the Latinization of American Culture.* New York: New York University Press.

Parenti, Michael (1992). *Make-Believe Media: The Politics of Entertainment.* Belmont, CA: Wadsworth.

Parenti, Michael (2000). "The Super Rich Are out of Sight." Available at: www.michaelparenti.org/ Superrich.html

Press, Andrea (1991). *Women Watching Television: Gender, Class, and Generation in the American Television Experience*. Philadelphia: University of Pennsylvania Press.

Riggs, Marlon (1991). *Color Adjustment*. San Francisco: California Newsreel.

Rodriguez, Carla (Ed.) (1997). *Latin Looks: Images of Latinas and Latinos in the U.S. Media*. Boulder, CO: Westview.

Sklar, Holly (2003). "CEO Pay Still Outrageous." Available at: www.raisethefloor.org/press_ceo_oped.html

U.S. Census Bureau (2003, September 15). "Poverty in the United States: 2003." Report.

Wacquant, Loic (2002). "Deadly Symbiosis: Rethinking Race and Imprisonment in Twenty-First-Century America." *Boston Review: A Political and Literary Forum*. 27(2) (April/May): 23–31.

Zuk, Rhoda (1998). "Entertaining Feminism: *Roseanne* and Roseanne Arnold." *Studies in Popular Culture*. Available at: http://pcasacas.org/SPC/spcissues/21.1/kuk.htm

Chomsky, the Empire, and Media Literacy

Contextualizing Chomsky's "New World Order"

Joe L. Kincheloe

There is no doubt that Noam Chomsky is one of the most important intellectuals of the last one hundred years. In addition to his work in linguistics, philosophy, and cognitive studies, Chomsky has become one of the most important political critics of U.S. foreign policy of the last several decades. Always abhorring the "cult of personality," Chomsky embodies the humble critical intellectual who understands the debt he owes to the countless nameless people around the world whose critical activism in the face of death and torture prepared a place for him to operate.

No compendium of work in media literacy would be complete without a contribution from and understanding of the importance of Noam Chomsky in this domain. The quality, indeed, the intellectual rigor of his work, is an inspiration to many of us involved in critical media literacy, the quest for global justice, and the effort to produce a more complex yet useful mode of scholarship in both educational institutions and the pedagogical sphere broadly defined. Chapter 7, "The New World Order," provides us a sense of Chomsky's prescience and insight into the emergence of the new U.S. empire and the media sphere that supports it. What follows is a set of brief comments that help contextualize Chomsky's insights as written in 1991.

Writing about President George H. W. Bush's call for a "new world order" at the time of the First Gulf War, Chomsky documents what Aaron Gresson (2004) and I (Kincheloe & Steinberg, 2004) have called the recovery movement. In this recovery context dominant power blocs formed around the axes of race, class, gender, sexuality, etc. sought to reestablish their dominance around what they perceived to have lost during the Civil Rights Movement, anti-corporate activism, anti-imperialist activity, the women's movement, and the gay rights movement. In particular Chomsky is documenting the effort of the elder President Bush to overcome what had come to be known as the "Vietnam Syndrome."

Because of the U.S. loss in Vietnam and the passion of the anti-war movement within and outside the United States, many Americans had become wary of fighting foreign wars to gain political, economic, and geopolitical advantages. George H. W. Bush and his advisors viewed their attack on Saddam Hussein's Iraqi occupation of Kuwait as a golden opportunity to subvert this Vietnam Syndrome and the anti-imperialist activism that accompanied it and "recover" America's dominant role in the world. We can understand Chomsky's prescience, as the success the United States enjoyed in the First Gulf War helped create an ideological climate that would tolerate the neo-conservative effort in the George W. Bush Administration to bolster the American empire with its post 9/11 War on Terror and, in particular, its misguided invasion of Iraq in 2003.

With the military, political economic, and sociocultural empire firmly in place, the United States and many of its English-speaking and European allies could pursue their free market globalization agenda unimpeded, bolstered by the threat of violent coercion if "renegade" countries failed to cooperate with the U.S.-controlled World Bank, World Trade Organization (WTO), and the International Monetary Fund (IMF). As Chomsky and many others have argued (see, for example, Chomsky & Herman's *The Manufacturing of Consent*), the U.S. empire has worked carefully to use various media forms to create an ideological climate both domestically and abroad that supports the efforts of a "benevolent" America to establish new forms of military, political, and economic dominance. Such power has worked to transfer billions of dollars from the poorest countries in the world to the wealthiest corporate tycoons of the richest countries on the planet. Such actions have impoverished hundreds of millions of people.

Even in an era when millions of Americans oppose the war in Iraq, many fail to understand the ideological, hegemonic, economic and geopolitical dynamics involved in the twenty-first century phase of the new world order. In the same way that Americans from all ideological backgrounds turned against the Vietnam War, most Americans of the last half of the first decade of the twenty-first century oppose the Iraqi War because it has become a quagmire. Many in the U.S. media turned on George W. Bush for his failure to win the war in Iraq, not for the arrogant, duplicitous, unilateral policy of world domination that grounded the "pre-emptive" assault on Iraq. As Chomsky argued in an interview in August of 2006, the fact that we killed and are killing huge numbers of people in Vietnam and Iraq for economic and geopolitical gain is not the issue in the public conversation in the United States. The fact that we did not/are not winning the war is the matter that concerns the media and most Americans (Aksan & Bailes, 2006).

The George W. Bush administration and their fellow proponents of empire fear the ene-

mies of globalization and the political insights they attempt to bring to the public conversation. In what Chomsky defined in Chapter 7 as the new world order, many observers maintain that an important strategic dynamic has involved and continues to involve the corporate-owned media that suppress the voices of such opponents of empire. As in the Patriot Act in the U.S. and other anti-terrorist legislation in other countries, both government and dominant media do little to distinguish between terrorists and those like Chomsky, Donaldo Macedo, Shirley Steinberg, and myself, who question the foundations of American foreign policy and the ideological role that many movies and television and radio news and other entertainment programming play in promoting public acceptance of imperial strategies.

From New World Order to Twenty-First Century Empire

As Chomsky writes in Chapter 7: "[T]he Third World will be controlled by economic pressures if possible, by force if necessary." Understanding the mechanisms of imperial control, Chomsky foresaw the coming of the neo-conservative empire builders of the George W. Bush administration. Of course, these empire builders were not creating something new but were resurrecting or recovering something they believed had been allowed to atrophy in the post-Vietnam era. Indeed, right-wing intellectuals gaining access to corporate media made the argument that colonialism was not all bad and that it was the righteous obligation of western powers to revive reasonable modes of colonial rule of developing countries. Dinesh D'Souza (2002) writing an invited piece for the *Chronicle of Higher Education*, entitled "Two Cheers for Colonialism," promoted this line of thinking. Colonialism was good for developing countries, D'Souza proclaimed, and many of the critiques of its unfairness were misguided. Those who oppose colonialism

> relieve the third world of blame for its wretchedness. Moreover, they imply politically egalitarian policy solutions: The West is in possession of the "stolen goods" of other cultures, and it has a moral and legal obligation to make some form of repayment. I was raised to believe in such things, and among most third-world intellectuals they are articles of faith. The only problem is that they are not true. (D'Souza, 2002)

Thus, "our" colonialism is benign and in everyone's best interest D'Souza argues. Chomsky replies to such imperial arrogance:

> What evidence is there that [the U.S. empire] is going to be an empire for good, anymore than in the past? That aside, what right do we have to decide what should happen to other people? Is it because we're so magnificent? Did we have some God given right to determine the fate of the world? (quoted in Aksan & Bailes, 2006)

In building the imperial new world order, Bush the elder may have undermined the Vietnam Syndrome only for Bush the younger to have created in the catastrophic war to topple Saddam Hussein an "Iraqi Syndrome." Indeed, the American and British public will be less disposed in the future to watch their young people die in wars of empire. This is an amazing turn of events in light of the George W. Bush Administration's prevarications about the reasons for going to war in the post-9/11 era and the fawning media that transformed

a comically uninformed and inept president into the most powerful and popular leader of modern times in the months following the attacks on the World Trade Center and the Pentagon.

The lack of public debate about the pre-emptive strike on Iraq in 2003 was in part the responsibility of the news media in that they failed to investigate the bogus claims made about Iraq's connection to al-Qaida and its threat to the United States. Indeed, before the fires of the World Trade Center and the Pentagon were extinguished, empire builders, both military and corporate, were making use of the attacks to regain momentum for the globalization process stung by the protests at the Seattle meeting of the WTO in 1999. The television news media represented the war in Afghanistan and then Iraq as an Arnold Schwarzenegger action film. In the hands of CNN, FOX, MSNBC, NBC, CBS, and ABC producers, the Afghan and Iraqi Wars in their early phases became battles between a kind and generous U.S. army and a group of primitive and insane Muslims bent on destroying all that was good in the world.

In such media representations, the Schwarzeneggers and Rambos of the U.S. military used their technological superiority—a supremacy that signified in the spirit of Calvinism a moral superiority—to righteously kill the psychopaths of the moment (wild Indians, Jap kamikaze, and communists of all stripes had preceded them in the litany of crazed enemies). In such mediated imagery the larger ideological issues behind the war, the historical context in which it emerged, the forces that shaped the perspectives of the "enemy," and its death and human costs were conveniently brushed aside. One can easily understand that such representations helped shape the consciousness of viewers (Kincheloe & Steinberg, 2004; Aksan & Bailes, 2006).

There are many other ways to read such representations and many modes of consciousness that develop in opposition to dominant forms of colonizing power. Indeed, the empire always constructs modes of resistance to its military, political, economic, semiotic, sociocultural, and pedagogical pursuits. Of course, in the case of the military dimension of the twenty-first century American empire, the more the U.S. media displayed the superiority of the U.S. military forces, the more resistance it evoked around the world. Not only did the Muslim world from North Africa to Indonesia react negatively to the pre-emptive American wars, but also the world in general discerned little benevolence in U.S. military action in Afghanistan and Iraq. As the resistance to the U.S. military action coalesced and expanded in both countries and the American death toll began to rise, even the U.S. media backed away from its glorification of smart bombs and exalted political leaders. Slowly but steadily the imagery of a military quagmire began to filter into U.S. media representations. The notion of a high tech/low casualty military empire directed by the neo-conservatives died on the streets of Fallujah. The situation demanded new imperial strategies.

The Motive: The Spoils of Empire

The two-tiered society that presently exists in the United States has been expanded via imperial policies to the world. The developed North composed of Europe and North America

has worked to devise new and better ways to exploit the people and the natural resources of the "developing" South composed of South Asia, Africa, and Latin America. Using the logic of unfettered, free-market economics, the Northern colonial powers via their puppet institutions, the previously referenced World Bank, IMF, and WTO, demanded that the poor countries of the South dismantle social services and other public services that worked to help their poorest citizens. In the spirit of Ronald Reagan, Margaret Thatcher, and George W. Bush, such social services were deemed to be the greatest impediment to economic growth. Thus, the last couple of decades have witnessed laissez-faire economics deployed on a global scale.

These market-driven "structural adjustment policies" foisted upon the Southern nations with threats and warnings of exclusion from the world economic community if they didn't comply have been miserable failures. As Northern economies boomed, the fiscal state of the Southern nations fell into a financial black hole. More concerned with losing credibility than with the human suffering caused by its policies, the World Bank engaged in a variety of public relations campaigns designed to show that it was responding to the declining health of Southern economies. Such strategies have failed to convince the peoples of Africa, Latin America, and South Asia that their economies are improving. Listening only to operatives in the U.S. Treasury Department and their counterparts in a few other western nations, the World Bank, WTO, and the IMF continue to manifest a northern elitism that refuses to learn from the insights and experiences of individuals from the poor countries (Bello, 1999, 2001, 2006).

As Chomsky has understood for decades, the objective of these so-called economic reforms promoted by the Northern nations and their international financial institutions was little more than an ideologically justified mode of economic exploitation. Free-market economic policies in this context provided the United States and its Northern allies greater access to the developing countries' natural and human resources while cultivating new markets for Northern products. The media in the Northern countries played along, portraying the entire ideological house of cards as a form of benevolence, an effort of the developed world to bring its undeveloped brothers and sisters along with it on the road to progress and prosperity.

In every domain—agriculture, industrial production, privatization of social services, medicine, debt repayment, natural resources, labor policy, tariffs, and so on—the house of cards has been stacked for the benefit of the wealthiest operators. The more image-conscious leaders of the international financial institutions talk about "ending poverty" in the developing nations, the poorer the people living in such nations get. Every institution in the affluent countries has done its part in creating and justifying such an inequitable and disastrous system. Economists and political scientists have created what Michel Foucault called epistemes or "regimes of truth" where market-driven international development policies came to be seen as the only viable options for constructing a world political economic system (Kincheloe, 1999). The American empire in this episteme is essential—indeed, it will save the world.

The imperial way is the only way, even though it creates conditions where billions and

billions of dollars are transferred from the world's poorest nations to the corporate coffers of the world's richest nations. As Chomsky has recently maintained, the media representations of this unholy process are just part of a larger "imperial mentality" (cited in Aksan & Bailes, 2006) that thinks only in terms of what is in the immediate "best interests" of the most powerful elements in American society. Indeed, the news media have Walter Benjamin's "angel of history" locked up in a spider hole. The corporate media's erasure and creation of historical memory (see my chapter on the media and U.S. foreign policy in Iran in Kincheloe, 2004) is a central component of the needs of the twenty-first-century empire.

In this context, it is easy to see how the American pre-emptive strike on Iraq fits into the imperial puzzle. The neo-conservative plan was to run the world's economy via the international agencies that in actuality were arms of the U.S. Treasury Department. In those regions of the world that failed to submit to this grand market-driven scheme, a high-tech, low-risk military would use its overwhelming air power to bomb uncooperative countries into submission—a process thought by its devisors to be successful in the early months of the Afghanistan and Iraq wars.

Planning to build permanent military bases in Iraq for geopolitical advantage and corporate riches, the Bush Administration and its neoconservative operatives were giddy with anticipation after the Taliban government in Afghanistan fell and Hussein's Bathists were toppled in Iraq. The world in the late spring of 2003 was theirs. By 2007, though, after four years of insurrection and over 3,000 dead American troops, their plans were in shambles. The empire builders would have to reassess. The architects of the new world order would have to change their strategies and regain the support of the American people. Chomsky's valuable work continues to keep us informed of the status of this ongoing imperial process.

REFERENCES

Aksan, C., & Bailes, (2006). On media: An interview with Noam Chomsky. Retrieved from http://www.stateofnature.org/noamchomsky.html.

Bello, W. (1999). *Jurassic fund: Should developing countries push to decommission the IMF?* Retrieved from HYPERLINK http://ww.ifg.org/analysis/imf/waldenimf.htm http://ww.ifg.org/analysis/imf/waldenimf.htm.

Bello, W. (2001). *The American way of war.* Retrieved from HYPERLINK http://www.zmag.org/bellowarway.htm.

Bello, W. (2006). *Why today's collapse of the Doha round negotiations is the best outcome for developing countries.* Retrieved from HYPERLINK http://www.tni.org/archives/bello/dohacollapse.htm.

D'Souza, D. (2002). Two cheers for colonialism. *The Chronicle of Higher Education.* Retrieved from HYPERLINK http://chronicle.com/free/v48/i35/35b00701.htm.

Gresson, Aaron (2004). America's Atonement: Raocial pain, recovery rhetoric, and the Pedagogy of Healing. New York: Peter Lang.

Kincheloe, J. (1999). *How do we tell the workers? The socio-economic foundations of work and vocational education.* Boulder, CO: Westview.

Kincheloe, J. (2004). Iran and American miseducation: Cover-ups, distortions, and omissions. In J. Kincheloe & S. Steinberg (Eds.), *The miseducation of the West: How schools and the media distort our under-*

standing of the Islamic World. Westport, CT: Praeger.

Kincheloe, J., & Steinberg, S. (2004). *The miseducation of the West: How schools and the media distort our understanding of the Islamic World*. Westport, CT: Praeger.

Chapter 7

The New World Order

Noam Chomsky

A truism about the New World Order is that it is economically tripolar and militarily unipolar. Recent events help one to understand the interplay of these factors. As the glorious "turkey shoot" began in the desert, the *New York Times* published a fragment of a national security review from the early days of the Bush Administration, dealing with "Third World threats." It reads: "In cases where the US confronts much weaker enemies, our challenge will be not simply to defeat them, but to defeat them decisively and rapidly." Any other outcome would be "embarrassing" and might "undercut political support."

"Much weaker enemies" pose only one threat to the US: the threat of independence, always intolerable. The US will support the most murderous tyrant as long as he plays along, and will labor to overthrow Third World democrats if they depart from their service function. The documentary and historical records are clear on this score.

The leaked fragment makes no reference to peaceful means. As understood on all sides, in its confrontations with Third World threats the US is "politically weak"; its demands are not likely to gain public support, so diplomacy is a dangerous exercise. And a "much weaker" opponent must not merely be defeated but pulverized if the central lesson of the world order is to be learned: We are the masters, and you shine our shoes.

There are other useful lessons. The domestic population must appreciate "the stark and vivid definition of principle . . . baked into [George Bush] during his years at Andover and Yale, that honor and duty compels you to punch the bully in the face." These are the admiring words of the reporter who released the policy review, then quoting the hero himself: "By God, we've kicked the Vietnam syndrome once and for all." No longer, the President exults, will we be troubled by "the sickly inhibitions against the use of military force," to borrow the terms of Reaganite intellectual Norman Podhoretz.

The ground had been well prepared for overcoming this grave malady, including dedicated efforts to ensure that the Vietnam war is properly understood as a "noble cause," not a violent assault against South Vietnam, then all of Indochina. Americans generally estimate Vietnamese deaths at about 100,000, a recent academic study reveals. Its authors ask what conclusions we would draw if the German public estimated Holocaust deaths at 300,000, while declaring their righteousness. A question we might ponder.

The principle that you punch the bully in the face when you are sure that he is securely bound and beaten to a pulp is a natural one for advocates of the rule of force. Cheap victories may also mobilize a frightened domestic population, and may deflect attention from the domestic disasters of the Reagan-Bush years, no small matter as the US continues its march towards a two-tiered society with striking Third World features.

George Bush's career as a "public servant" also has its lessons concerning the New World Order. He is the one head of state who stands condemned by the World Court for "the unlawful use of force." He dismisses with contempt the Court's call for reparations for these particular crimes (others are far beyond reach), while he and his sycophants solemnly demand reparations from Iraq.

Bush opened the post-Cold War era with the murderous invasion of Panama, imposing the rule of the 10 percent White minority and guaranteeing US control over the canal and the bases that have been used to train the gangsters who terrorize Latin America. Since he became UN Ambassador in 1971, the US is far in the lead in vetoing Security Council resolutions and blocking the UN peace-keeping function, followed by Britain. Bush was called to head the CIA in 1975, just in time to support near-genocide in East Timor. He then lent his talents to the war against the Church and other deviants committed to "the preferential option for the poor" in Central America, now littered with tortured and mutilated bodies, perhaps devastated beyond recovery.

In the Middle East, Bush supported Israel's harsh occupations, its savage invasion of Lebanon, and its refusal to honor Security Council Resolution 425 calling for its immediate withdrawal from Lebanon (March 1978, one of several). The plea was renewed by the government of Lebanon in February, ignored as usual while the US client terrorizes the occupied region and bombs at will, and the rest of Lebanon is taken over by Bush's new friend, Hafez al-Assad, a clone of Saddam Hussein. The Turkish "peacemakers" were also authorized to intensify their repression of Kurds, in partial payment for their services.

Plainly, we have here a man who should be lauded for rare principle as he leads us to a New World Order.

The principles of the policy review were followed throughout the Gulf crisis. In July, Bush indicated that he had no objections to Iraq's rectifying its border disputes with Kuwait by force, or intimidating its neighbors to raise the price of oil. Misreading the signals, Saddam took all of Kuwait, thus demonstrating that he was not only a murderous gangster, which is fine by US-UK standards, but an independent nationalist, which is quite improper. Standard policies were then invoked.

The US and UK moved at once to undermine sanctions and diplomacy, which had unusually high prospects of success. From late August, Iraqi settlement offers were released that State Department officials regarded as "serious" and "negotiable," including complete withdrawal from Kuwait on terms that would have been pursued by anyone interested in peace. Efforts to avoid the ground war with full Iraqi withdrawal, saving tens of thousands of lives, were contemptuously brushed aside. Diplomacy is ruled out, and since this Third World country, with its peasant army, is plainly a "much weaker enemy" it has to be crushed, so that the right lessons are taught.

The intellectual community swung into action, portraying Saddam as a new Hitler poised to take over the world. When Bush announced that there would be no negotiations, a hundred editorials lauded him for his extraordinary efforts at diplomacy. When he proclaimed that "aggressors cannot be rewarded," instead of collapsing in ridicule responsible commentators stood in awe of his high principles.

Some agreed that the US and Britain had been "inconsistent" in the past (in fact, they had consistently pursued their own interests). But now, we were assured, all had changed; they had learned that the right way to respond to aggression is by the quick resort to violence. We can therefore expect that the RAF will be sent to bomb Damascus, Tel Aviv, Jakarta (after British Aerospace stops arming the killers), Washington, and a host of others.

Oddly, these new insights were not accompanied by praise for Saddam for attacking Israel, though his sordid arguments compare well enough with those of his fellow-criminal and long-time friend in Washington.

In such ways, the ground was prepared for the merciless slaughter that a leading Third World journal describes as "the most cowardly war ever fought on this planet." The corpses have quickly disappeared from view, joining mounds of others that do not disturb the tranquility of the civilized.

There also seems to be no concern over the glaringly obvious fact that no official reason was ever offered for going to war—no reason, that is, that could not be instantly refuted by a literate teenager. Again, this is the hallmark of a totalitarian culture, and a signpost to the New World Order.

No less revealing are the few extra-official efforts to justify the rejection of peaceful means. Thus, we read that this case was different, because of the annexation; the US reaction was under way before the annexation, and continued unchanged after Iraqi proposals that would have reversed it, not to speak of the US-UK response to other cases of annexation, no less horrifying. Other arguments are equally weighty.

In one of the rare efforts to face the crucial question, Timothy Garton Ash explains in the *New York Review of Books* that, while sanctions were possible in dealing with South Africa

or communist Eastern Europe, Saddam Hussein is different. That concludes the argument. We now understand why it was proper to pursue "quiet diplomacy" while our South African friends caused more than $60 billion in damage and 1.5 million deaths from 1980 to 1988 in the neighboring states putting aside South Africa and Namibia and the preceding decade. They are basically decent folk, like us and the communist tyrants. Why? One answer is suggested by Nelson Mandela, who condemns the hypocrisy and prejudice of the highly selective response to the crimes of the "brown skinned" Iraqis. The same is true when the *New York Times* assures us that "the world" is united against Saddam Hussein, the most hated man in "the world" . . . the world, that is, minus its darker faces.

It is understandable that Western racism should surface with such stunning clarity after the Cold War. For 70 years it has been possible to disguise traditional practices behind the veil of defense against the Soviets, generally a sham, now lost as a pretext. We return, then, to the days when the New York press explained that "we must go on slaughtering the natives in English fashion, and taking what muddy glory lies in the wholesale killing till they have learned to respect our arms. The more difficult task of getting them to respect our intentions will follow." In fact, they understand our intentions well enough.

For the people of the Middle East, the New World Order looks grim. The victor is the violent state that has long rejected any serious diplomatic approach to regional disarmament and security problems, often virtually alone. The US's strategic conception has been that the local managers of Gulf oil riches should be protected by regional enforcers, preferably non-Arab, though bloody tyrants of the Hafez al-Assad variety may be allowed to join the club, possibly even Egypt if it can be purchased. The US will seek some agreement among these clients and might finally even consider an international conference, if it can be properly managed. As Kissinger insisted, Europe and Japan must be kept out of the diplomacy, but the USSR might now be tolerated on the assumption that it will be obedient in its current straits, possibly Britain as well.

As for the Palestinians, the US can now move towards the solution outlined by James Baker well before the Gulf crisis: Jordan is the Palestinian state; the occupied territories are to be ruled in accordance with the basic guidelines of the Israeli government, with Palestinians permitted to collect taxes in Nablus; their political representatives will be chosen for them, with the PLO excluded; and "free elections" will be held under Israeli military control with the Palestinian leadership in prison camps. New excuses will be devised for the old policies, which will be hailed as generous and forthcoming.

Economic development for the Palestinians had always been barred, while their land and water were taken. They had been permitted to serve the Israeli economy as virtual slave labor, but this interlude is passing. The recent curfew administered a further blow to the Palestinian economy. The victors can now proceed with the policy articulated in February 1989 by Yitzhak Rabin of the Labour Party, then Defence Secretary, when he informed Peace Now leaders of his satisfaction with the US-PLO dialogues, which are nothing but meaningless discussions to divert attention while Israel suppresses the intifada by force.

The Palestinians "will be broken," Rabin promised, reiterating the prediction of Israeli Arabists 40 years earlier: The Palestinians will "be crushed," will die or "turn into human

dust and the waste of society, and join the most impoverished classes in the Arab countries."
Or they will leave, while Russian Jews, now barred from the US by policies designed to deny
them a free choice, flock to an expanded Israel, leaving the diplomatic issues moot, as the
Baker-Shamir-Peres plan envisaged.

The political leadership in Washington and London has created economic and social
catastrophes at home and has no idea how to deal with them, except to exploit their mil-
itary power. Following the advice of the business press, they may try to turn their countries
into mercenary states, serving as the global Mafia, selling "protection" to the rich, defend-
ing them against "Third World threats" and demanding proper payment for the service.
Riches funnelled from the Gulf oil producers are to prop up the two failing economies.
German-led Europe, later Japan, will carry out the task of "Latin Americanizing" most of
the domains of the collapsing Soviet tyranny, with the former communist bureaucracy prob-
ably running the branch offices of foreign corporations. The rest of the Third World will
be controlled by economic pressures if possible, by force if necessary.

These are some of the contours of the planned New World Order that come into view
as the beguiling rhetoric is lifted away.

This chapter originally appeared in *Journal for Urban and Cultural Studies*, Vol. 2, Number 1, 1991. Copyright:
Noam Chomsky 1991.

Their Atrocities—and Ours

(NATO Bombs Killing Innocent People)

Howard Zinn

There was a headline recently in my hometown newspaper, *The Boston Globe*:

PENTAGON DEFENDS AIRSTRIKE ON VILLAGE.
U.S. SAYS KOSOVARS WERE "HUMAN SHIELDS."

That brought back the ugliest of memories. It recalled My Lai and other Vietnam massacres, justified by such comments as "the Vietnamese babies are concealing hand grenades."

Here's the logic: Milosevic has committed atrocities; therefore, it is OK for us to commit atrocities. He is terrorizing the Albanians in Kosovo; therefore, we can terrorize the Serbs in Yugoslavia.

I get e-mail messages from Yugoslav opponents of Milosevic, who demonstrated against him in the streets of Belgrade before the air strikes began. They now tell me their children cannot sleep at night, terrified by the incessant bombing. They tell of the loss of light, of water, of the destruction of the basic sources of life for ordinary people.

To Thomas Friedman, columnist for *The New York Times*, all Serbs must be punished, without mercy, because they have "tacitly sanctioned" the deeds of their leaders. That is a novel definition of war guilt. Can we now expect an Iraqi journalist to call for bombs placed

in every American supermarket on the grounds that all of us have "tacitly sanctioned" the hundreds of thousands of deaths in Iraq caused by our eight-year embargo?

Official terrorism, whether used abroad or at home, by jet bombers or by the police, always receives an opportunity to explain itself in the press, as ordinary terrorism does not: For example, there are the thirty-one prisoners and nine guards massacred on orders of New York Governor Nelson Rockefeller in the Attica uprising; the eleven MOVE members, five of whom were children, killed in a fire after their homes were bombed by Philadelphia police; the eighty-six Branch Davidians, including twenty-four children, who died at the Waco compound in an attack ordered by the Clinton Administration; the African immigrant murdered by a gang of policemen in New York. All of these events had explanations that, however absurd, are dutifully given time and space in the media.

One of these explanations seeks comfort in relative numbers. We have heard NATO spokesperson Jamie Shea, as well as Clinton, pass off the bombing of Yugoslav civilians by telling us the Serb forces have killed more Albanians than we have killed Serbs—although as the air strikes multiply, the numbers are getting closer. No matter: This math work justifies NATO's killing not just Serbs but Albanian refugees, not just adults but children.

There were those who defended the 1945 firestorm bombing of Dresden (100,000 dead?—we can't be sure) by pointing to the Holocaust. As if one atrocity deserves another! I have heard the deaths of more than 150,000 Japanese citizens in the atomic strikes on Hiroshima and Nagasaki justified by the terrible acts of the Japanese military in that war.

I suppose if we consider the millions of casualties of all the wars started by national leaders these past sixty years as "tacitly supported" by their populations, some righteous God who made the mistake of reading Thomas Friedman might well annihilate the human race.

The television networks, filling our screens with heartrending photos of the Albanian refugees—and those stories must not be ignored—have not given us a full picture of the human suffering in Yugoslavia. An e-mail came to me, a message from Djordje Vidanovic, a professor of linguistics and semantics at the University of Nis: "The little town of Aleksinac, twenty miles away from my hometown, was hit last night with full force. The local hospital was hit, and a whole street was simply wiped off. What I know for certain is six dead civilians and more than fifty badly hurt. There was no military target around whatsoever."

That was an "accident." As was the bombing of the Chinese Embassy. As was the bombing of a civilian train on a bridge over the Juzna Morava River. As was the bombing of Albanian refugees on a road in southern Kosovo. As was the destruction of a civilian bus with twenty-four dead, including four children. Some stories come through despite the inordinate attention to NATO propaganda, omnipresent on CNN and other networks (and the shameless Shea announced we bombed a television station in Belgrade because it gives out propaganda).

There was a rare description of the gruesome scene at the bus bombing by Paul Watson of *The Los Angeles Times*.

The New York Times reported the demolition of four houses in the town of Merdare by anti-personnel bombs, "killing five people, including Bozina Tosovic, thirty, and his eleven-month-old daughter, Bojana. His wife, six months pregnant, is in the hospital."

Steven Erlanger reported, also in *The New York Times*, that NATO missiles killed at least eleven people in a residential area of Surdulica, a town in southern Serbia. He described "the mounded rubble across narrow Zmaj Jovina Street, where Aleksandar Milic, thirty-seven, died on Tuesday. Mr. Milic's wife, Vesna, thirty-five, also died. So did his mother and his two children, Miljana, fifteen, and Vladimir, eleven—all of them killed about noon when an errant NATO bomb obliterated their new house and the cellar in which they were sheltering."

Are these "accidents," as NATO and U.S. officials solemnly assure us? One day in 1945 I dropped canisters of napalm on a village in France. I have no idea how many villagers died, but I did not mean to kill them. Can I absolve what I did by calling it "an accident"?

Aerial bombings have as inevitable consequences the killing of civilians, and this is foreseeable, even if the details about who will be the victims cannot be predicted.

The deaths and mutilations caused by the bombing campaign in Yugoslavia are not accidents but the inevitable result of a deliberate and cruel campaign against the people of that country.

There was an extraordinary report by Tim Weiner in *The New York Times* contrasting the scene in Belgrade with that in Washington where the NATO summit was taking place. "In Belgrade . . . Gordana Ristic, thirty-three, was preparing to spend another night in the basement-cum-bombshelter of her apartment building. 'It was a really horrible night last night. There were explosions every few minutes after 2 A.M. . . . I'm sorry that your leaders are not willing to read history.'"

"A reporter read to her from Clinton's speeches at the summit meeting. She sounded torn between anger and tears. 'This is the bottom to which civilization, in which I believed, has gone. Clinton is playing a role, singing a song in an opera. It kills me.' As she slept, NATO's leaders dined on soft-shell crabs and spring lamb in the East Room of the White House. Dessert was a little chocolate globe. Jessye Norman sang arias. And as the last limousine left, near midnight, Saturday morning's all-clear sounded in Belgrade."

When I read a few weeks ago that cluster bombs are being used against Yugoslavia and have caused unprecedented amputations in Kosovo hospitals, I felt a special horror. These bombs have hundreds of shrapnel-like metal fragments that enter the body and cannot easily be removed, causing unbearable pain. Serb children have picked up unexploded bombs and have been mutilated. I remember being in Hanoi in 1968 and visiting hospitals where children lay in agony, victims of a similar weapon—their bodies full of tiny pellets.

Two sets of atrocities, two campaigns of terrorism—ours and theirs. Both must be condemned. But for that, both must be acknowledged, and if one is given enormous attention, and the other is passed over with official, respectful explanations, it becomes impossible to make a balanced moral judgment. Yes, Milosevic should stand in the dock to answer for war crimes. Clinton, Albright, Cohen, and Clark should stand with him.

There is another factor that we as Americans must consider when we confront the atrocities on both sides. We bear a moral responsibility in any situation to the extent that we have the capacity to affect that situation. In the case of the Milosevic cruelties against the Kosovars, our capacity to intervene—which may have been greater before we rushed to

bomb—is very limited, unless we go into a full-scale ground war. If that happens, the result-ing tragedy will far exceed the one that has already taken place. But we have a direct respon-sibility for the cruelties our government inflicts by bombing innocent people in Yugoslavia.

We are seeing liberals and even some radicals, forgetting their own harsh criticism of the controlled press, succumb to the barrage of information about the horrors inflicted on the people of Kosovo. That information is isolated from its context—the human conse-quences of our bombing campaign, the record of the United States government in ignor-ing or abetting "ethnic cleansing" in various parts of the world, the refusal of the U.S. and NATO to respond to reasonable and negotiable proposals from the other side. And so those who should know better are led to support violent solutions.

George Seldes, that fierce exposer of the press, and Upton Sinclair, who wrote of the prostitution of the newspapers in *The Brass Check,* both lost their sense of proportion as they were inundated with Allied propaganda in World War I and found themselves supporting a military debacle that ended with ten million dead. Seldes later wrote: "Of the first war years, I will say just this: I made a total fool of myself when I accepted as true the news reports from New York and Europe, which by their volume and repetition overwhelmed what lit-tle objective intelligence I had. . . ."

If the Serbian military are killing and expelling the Albanians in Kosovo, it is a rea-sonable reaction to say: "We must do something." But if that is the only information we are getting, it is a quick and reckless jump to: "We must bomb," or "We must invade." If we don't want to perpetuate the violence on both sides, we will have to demand of our lead-ers that they discard their macho arrogance ("We will win!" "Milosevic will lose!" "We are the superpower! "Our credibility is at stake!"). We must demand that they stop bombing and start talking.

There will, at some point, be a negotiated end to the violence in Yugoslavia. But how many people on both sides will have died needlessly and horribly in the interim? That depends on how quickly the American people can raise a powerful cry of protest against the actions of our government.

This chapter originally appeared in *The Progressive* 63.7 (July 1999): 20. Published here with permission of
The Progressive.

Chapter 9

Language and Institutional Perversions in a Time of Painful Birth Pangs

Edward S. Herman

It is the powerful who control language as well as policy and its institutional apparatus. The two are of course closely interrelated. If the powerful can successfully label their targets "terrorists," it is easier to put in place policies to slaughter them. With a sufficiently compliant media system, you can make yourself into a victim engaging in "self-defense," even as you attack a virtually disarmed country across the ocean by "shock and awe" tactics openly designed to terrorize the target population into submission. Killing and terrorizing via helicopters, gunships, and assorted bombs from the air, and search and destroy operations and invasions and terrorization of households are not terrorism. By the internalized rule of the compliant media, according to which invidious language applies only to others, this clear terrorization does not make you a terrorist. On the other hand, the resistance is quickly found to be terroristic by its use of IEDs, suicide bombers, and other weapons of the weak.

This internalized double standard also applies to word usage in reporting on the Israeli, Palestinian, and Hizbollah conflict. Israel may openly acknowledge an effort to frighten and intimidate Gaza residents by violent attacks and threats of attacks, even including deliberate noise creation by jets producing terrifying sonic booms through the night ("I want nobody to sleep at night in Gaza," Ehud Olmert)—and a planned increase in Palestinian

hunger ("The idea is to put the Palestinians on a diet, but not to make them die of hunger," Dov Weinglass).[1]

Israel's systematic bombing of civilian sites in Lebanon has even been explained in part as an effort to cause the victim civilians to rise up against Hizbollah—a standard Israeli practice going back at least 25 years, when former Israeli Foreign Minister Abba Eban admitted to having bombed civilians in the hope that the "afflicted populations would exert pressure for the cessation of hostilities." But even though this fits Benjamin Netanyahu's own definition of terrorism—"the deliberate and systematic murder, maiming, and menacing of the innocent to inspire fear for political ends"—the Israelis are not terrorists, they are fighting terror, by their own preferred usage and the double-standard rule, which applies to U.S. clients as well as the United States itself.

It is possible to get around this seeming disconnect between the definition of terrorism and exemption of our side from designation as terrorist by claiming that those civilians our side attacks are not "innocent." This is based on the facts that large numbers of civilians frequently support the resistance, are the "sea" in which the terrorist "fish" swim, or they are "willing executioners" supporting a government that we have declared evil and made into a target. In these cases the drying out of the "sea" or killing of the willing executioners can be made to seem reasonable, or at least acceptable—these civilians are "unworthy victims," so that treating them ruthlessly is nothing to get upset about.

In fact, a good propaganda system will keep these victims largely out of sight and not display the indignation the media reserve for the victims of target states and "terrorists." This was true in the Vietnam War, where several million civilians were killed and seriously injured; and in Serbia, Afghanistan, Iraq, and now Lebanon (where the Israelis have sometimes "warned" civilians of imminent bombing, but sometimes bombed them in flight, or blocked their exit routes, and have made it clear that the civilians in South Lebanon are an intolerable "sea" helping the Hizbollah "fish" or are themselves all terrorists. "All those now in South Lebanon are terrorists who are related in some way to Hizbollah," Israeli Justice Minister Haim Ramon, July 27, 2006).

On the other hand, U.S. and Israeli civilians are always innocent and never willing executioners. Their governments may kill and terrorize vast numbers, and, having nominally democratic governments, these citizens could be said to have given their approval to the killing and terrorization (in contrast to civilians in say Afghanistan, who were living under a dictatorship). But in the propaganda system, U.S. and Israeli citizens are still innocent because their governments only kill for good reason, in "self-defense" against terrorists or to prevent people like Saddam Hussein from using his weapons of mass destruction or giving them to terrorists.

It is also always a part of the word usage and framing process that the "terrorists started it," by their past terrorist actions and more recently by "provocations."[2] The United States and its allies and clients never engage in "provocations," by media rule, but also because anything our side might have done which might be a provocation if done by the enemy is normalized. This is partly because being good and always in the right by patriotic assump-

tion, it is acceptable that we or our clients do things that the bad guys shouldn't do because they are bad.

The perfect illustration can be found in the events leading to the reinvasion and further devastation of Gaza by Israel from June 26, 2006. The excuse for the reinvasion was the Palestinian capture of an Israeli soldier, Corporal Gilad Shalit, on June 25th. This led to an outcry and outrage by Israel at this clear provocation, and the U.S. mainstream media featured this seizure and created the impression that it was a serious provocation indeed. They even followed Israeli usage in calling this a "kidnapping," although the victim was a uniformed soldier and member of an armed force that regularly attacks the Gaza population. Furthermore, on the previous day (June 24th), the Israelis had crossed into Gaza and seized two Palestinian civilians whom they declared to be members of Hamas. Now arguably this was a genuine "kidnapping," and also a clear "provocation" that on provocation logic would justify the Palestinian capture (or responsive "kidnapping") of Shalit. But the media played this strictly according to the applicable double-standard rules:

1 they mainly didn't even mention the Israeli action, leaving the seizure of Shalit as the only relevant fact;
2 they allowed Shalit to have been "kidnapped" rather than taken prisoner in a military conflict;
3 when, on the rare occasion, they mentioned the Israeli action of the previous day, they failed to elevate it to "provocation" and even rationalized it as a legitimate "arrest" (*Washington Post*); the Israelis, engaged in an illegal occupation, violating scores of UN rulings and the Fourth Geneva Convention and committing war crimes on a daily basis,[3] have a right to "arrest" any Palestinian, but Palestinians have no right to reply in kind.

The main trick here is to cut off "provocations" just at the point that justifies the actions of "our" side. If there is a steady flow of attacks and counterattacks, stop just at the helpful point. This process underlies the development of the convenient distinction between terrorism and "retaliation." The propaganda system rule is to stop at the violent action of the bad guys, make the responsive violence by our side "retaliation," and ignore any evidence that the bad guys were "retaliating" for something our side had done. There are thousands of illustrations of this cut-off process in serving to make the proper villains terrorists, of which the Shalit case just discussed is merely the latest example. One of my favorite illustrations is Paul Berman's analysis in *Terror and Liberalism* where he has everything starting with suicide bombing in Israel—"Our current predicament was brought upon us by acts of suicide terrorism"—leading to Israeli retaliation. The Israeli Elik Elhanan, formerly in the Israeli Special Forces, and whose sister died in a suicide bombing attack in 1997, says "She died because there is an occupation." For Berman, in contrast, the occupation, the prior several decades long racism, large-scale ethnic cleansing, a ratio of Palestinian to Israeli deaths of 20 to 1 or higher in the years before the suicide bombings, and the thousand Palestinian deaths in the first intifada during which there were no suicide bombings, all disappear as

he makes the cutoff necessary to protect Israeli terrorism.

It was something of a surprise to see Condoleezza Rice and other U.S. and Israeli officials and experts speak of the need to get at "root causes" in the Middle East. This was in support of Israel's right to continue devastating Lebanon in a civilian-oriented attack and to create a million refugees: these were merely "birth pangs" for a new order that the United States and Israel were establishing in the Middle East. Usually, root causes are not on the Western agenda, and when it is suggested that they may be relevant in developing a rational response, as in the case of street crime, or the reasons for the 9/11 attack, officials and establishment pundits have regularly declared that this is intolerable—reference to root causes is a form of apologetics for actions that must be condemned in and of themselves without "excuses." But in the Lebanon case, where the large-scale violence comes from the United States and its client, an axis that for weeks resisted international calls for a ceasefire, the need to address root causes is not apologetics, it is merely an explanation of why extreme violence is needed in this particular case (and of course in Iraq as well, and maybe Iran next).

And of course the "root causes" in Lebanon turn out to be Hizbollah and its strong position in southern Lebanon. By rule of affiliation Hizbollah is a "terrorist" organization that threatens Israel,[4] although it is in no way capable of invading or devastating Israel as Israel has done to Lebanon. But it can resist Israel, and in the case of a possible further U.S.Israeli aggression—against Iran—a Hizbollah capability of inflicting damage on Israel might put a crimp in that further "birth pang" to bring the new order to the Middle East. It should be noted, though, that Hizbollah only came into existence in the wake of Israel's 1982 invasion and occupation of Lebanon, as a means of defense against Israeli brutality. This means that the "root cause" of the Hizbollah threat lies in Israeli policy. This line of thought on root causes violates the rules mentioned above: only the other side terrorizes, and we must carefully stop the tracing of cause and effect at the point where our side must retaliate their "terrorism." The state terrorism of the IDF, killing a thousand civilians and putting to flight a million civilians, does not make Israel a terrorist state, by rule of proper language usage.

As noted earlier, it is also part of the language of power that the United States was engaging in "self-defense" in attacking Afghanistan and Iraq, and that Israel is also just defending itself in its attacks on Gaza and Lebanon. However, in neither the Afghan nor Iraq case was the United States meeting the standards for an appropriate self-defense response laid out in the UN Charter. Therefore, in both cases it was a legal case of aggression in violation of the Charter. It didn't meet any substantive case either, as neither country had attacked the United States or threatened to do so, and the basis for the attack on Afghanistan was the claim that bin Laden and Al Qaeda had attacked this country from a base in Afghanistan. No proof was offered to the Afghan government that this was so, and apparently none was available at the time of the attack. In any case, "self-defense" was in no sense the basis for these attacks, but that didn't prevent their support at home or eventual acceptance by the leaders of most states and the UN.

In accord with the power-language rules those attacked by the United States and

Israel don't have any right of self-defense; they are terrorists or pose an intolerable threat to the superpower and its regional client, so that what might appear to be their attempts to defend themselves are ominous, threaten U.S. and Israeli self-defense, and are unjustified. These power-language rules are now being played out in the case of Iran, threatened with a regime change by the United States and an attack by Israel, both nuclear powers, but where it is absolutely out of the question for the "international community" to even suggest that, given these threats, the U.S. refusal to give Iran any security guarantees or to carry out its promises under the Nuclear Proliferation Treaty, and the ongoing aggressions in the region by both the United States and Israel, Iran has an urgent need for nuclear weapons as a means of *real* self-defense.

The Institutional Counterpart of the Control of Language by the Powerful

Those in power control many levels of institutions (corporate, mass media, government, international). This position of control is the source of their power and domination. I want to focus here, briefly, on their domination of UN responses to violence. When Saddam Hussein invaded Kuwait in 1990, the UN's response was aggressive, and armed force was soon employed to oust him, after which Iraq was subjected to deadly sanctions and forced to pay reparations. Yugoslavia was also subjected to sanctions and then a bombing war, and its leaders were brought to trial in a specially organized tribunal to deal with their alleged war crimes.[5] In these cases the United States and its allies opposed the parties subjected to these aggressive UN responses and supported harsh action.

On the other hand, when the United States invaded Vietnam and attacked Cambodia and Laos, killing millions and ravaging the entire Indochinese peninsula, the UN didn't lift a finger. The U.S. mass media never once referred to the U.S. attack on Indochina as "aggression"; it was a struggle to protect "South Vietnam"—a U.S. creation in which the indigenous population had to be crushed into submission to a U.S.-imposed "leader"— against an alleged North Vietnamese, or Chinese, or Soviet, or generalized "communist" aggression. The UN and "international community" never contested this Orwellian word usage nor did anything to contain the aggressor or protect his millions of victims.

In short, the de facto double standard antedates the collapse of the Soviet Union and the emergence of a superpower-dominated world. But now, without even the containing effects of a relatively weak and cautious rival, the superpower has been able to run wild: ignoring the UN Charter with serial aggressions, whip-sawing and making a laughing stock of the UN, but getting it to ratify its invasion-occupation of Iraq (Security Council Resolution 1511 of October 16, 2003), and while improving its own nuclear arsenal and threatening to attack Iran, getting the UN to issue deadlines to the threatened country that are similar to those given Iraq, which set the stage for that earlier aggression. Its preeminent client, Israel, has also been freer to ethnically cleanse in its occupied territories, enlarge and consolidate its illegal settlements on the West Bank, and take over Jerusalem, and ter-

rorize and impoverish its Palestinian victims.

Focusing here on the Lebanon invasion and UN response, we may note that Israel was violating the UN Charter in attacking Lebanon, was openly attacking its civilian population and infrastructure, and was using cluster bombs in violation of international law—UN official Jan Egeland was especially outraged that it used them heavily in the 72 hours before the cease-fire; Human Rights Watch found the density of cluster bombs in southern Lebanon the greatest it had ever seen; and the head of an IDF rocket unit in Lebanon stated in regard to the use of cluster bombs and phosphorous shells during the war that "What we did was insane and monstrous, we covered entire towns in cluster bombs."[6] But at no point has it been suggested that Israel be threatened under Section VII of the UN Charter for these gross law violations. Section VII, which allows the use of force to end threats to international peace and security, is what the United States regularly strives to bring into play for its targets like Iraq, Yugoslavia, Iran, or Hizbollah, but as regards Israel the matter isn't even up for debate given the double standard rules. Nor could a cease-fire even be insisted on, despite the open attacks on civilians and deliberate creation of a huge refugee exodus (such as provoked hysterical outcries and calls for a more aggressive response by the media, NATO officials, and UN representatives during the 78-day bombing war against Yugoslavia in 1999). The cease-fire was stalled because the United States and Israel wanted Israel to be able to achieve its military and political objectives in its aggression, which required a sizable quota of civilian killings and massive destruction.

The cease-fire finally negotiated represented an almost complete accommodation to the interests of the aggressor and its partner, and tried to accomplish by the negotiated settlement what Israel failed to achieve by force of arms. UN Security Council Resolution 1701 does not condemn Israel for its major UN charter violation and assorted crimes, and does not suggest that Israel should pay reparations for its immense destruction, as Iraq was made to pay for its attack on Kuwait—1701 calls on the "international community" to help the stricken Lebanon! It doesn't even insist that Israel immediately stop all action and get out of the invaded and severely damaged country—it must merely cease its "offensive" actions, which will allow continued Israeli offensive actions as Israel can always claim its operations to be defensive and based on "provocations." In fact, one month after the signing of the truce, "according to Alexander Ivanko, spokesman for the UN interim force in Lebanon (Unifil), there have been more than 100 recorded cease-fire violations by Israeli forces in the last month. These have been mostly over-flights and incursions by tanks, troops, and bulldozers. Mr. Ivanko said that 24 Lebanese civilians—including four men from Aita al-Shaab—had been detained at gunpoint by Israeli troops. All were later released."[7] If Hizbollah someday reacts vigorously, as they surely will, and Israel wants to reinvade, they will once again have the needed "provocation," based on the language and cutoff rules.

Under 1701 only Hizbollah is required to terminate all military actions entirely: it is implicitly the aggressor (1701 says that the violence has escalated "since Hizbollah's attack on Israel on 12 July, 2006"); no differentiation is made in the scale of violence (which "has already caused hundreds of deaths and injuries on both sides"), and no party is named responsible for "extensive damage to civilian infrastructure and hundreds of thousands of inter-

nally displaced persons." These evasions help the authors of 1701 make Israel the victim requiring protection.

The UN Resolution calls for the "unconditional release of the abducted Israeli soldiers," but it is only "*encouraging* the efforts aimed at urgently settling the issue of the Lebanese prisoners detained in Israel," in accord with the power rules on provocations and the locus of root causes.

Only Hizbollah, an "armed group," is required to disarm under 1701, and the United Nations Interim Force in Lebanon (UNIFIL) is only authorized to take "all necessary action" to ensure that the areas under its mandate are not the source of "hostile activities." Israel is not an area within its mandate. There will be no international forces placed in Israel to assure that no "hostile activities" are begun there, and the aggressor that has invaded Lebanon on a regular basis since 1978 does not have to disarm. The Resolution calls for an international arms embargo, but only for supply to "armed groups" in Lebanon, and UNIFIL is to help enforce that arms embargo. Kofi Annan has already visited Syria to try to persuade that country's leaders to terminate any supplies sent to Hizbollah, but there is no hint anywhere that he or anybody else is concerned with the U.S. resupply of Israel's cluster bombs and other weapons that it might use in a further attack on Lebanon.

In short, the parallel between the effect of power on the perversion of language and institutional behavior is very close. For the powerful, in this case Israel and its sponsor, aggression entails no penalty, in accord with the power-language rule that their attacks are only "self-defense," nor do Israel's massive war crimes elicit any action—only plaintive cries of the victims and some human rights organizations, whose cries do not translate into meaningful action. As regards the resistance, however, as "terrorists" and by power-language rule provokers of the violence, they are the "root cause," and 1701 is designed to provide the basis for disarming them and protecting Israel from their violence. As 1701 is vague, if its implementation does not result in the actual disarming of Hizbollah, this will justify the aggressor country's renewed attack on Lebanon.

So the UN and "international community" are doing their Kafka-era work once again, failing to contain or punish blatant aggression when this is done by the powerful, as it so frequently is in the new world order, and even allowing these perpetrators of violence to shape the international response. That response is zero penalties for major crimes and a mobilization of the UN and international community to facilitate further violence by the criminals.

NOTES

1 When Weinglass told this joke to a group of officials assigned the duty of responding to the Hamas victory, and who all agreed that it called for an economic siege of the Palestinians, "the participants reportedly rolled with laughter." Gideon Levy, "A Chilling Heartlessness by Israel's Hamas Team," *Counterpunch*, Feb. 20, 2006.

2 For a satirical analysis of the Israeli misuse of "who started it" and "provocations," such as you will never see in the *New York Times*, see Gideon Levy, "Who started?" *Ha'aretz*, July 10, 2006.

3 In an Oral Statement of March 2002 dealing with the "Question of the violation of human rights in

the occupied Arab territories, including Palestine," Amnesty International stated that "they can never justify the human rights violations and grave breaches of the Geneva Conventions which, over the past 18 months, have been committed daily, hourly, even every minute, by the Israeli authorities against Palestinians. Israeli forces have consistently carried out killings when no lives were in danger." http://web.amnesty.org/library/index/ENGMDE150272002 .

4 Because the Nicaraguan Contras were organized by the United States to attack Nicaragua, they were officially designated "freedom fighters," and the mainstream media did not treat them as they treat Hizbollah. The same is true of Jonas Savimbi's UNITA in Angola, a truly terrorizing organization, but supported by apartheid South Africa and its U.S. ally, hence "freedom fighters" rather than terrorists, by rule of affiliation.

5 Other leaders in Yugoslavia whose armies and paramilitaries killed large numbers of civilians in ethnic cleansing operations, such as Izetbegovic and Tudjman, were never indicted or brought to trial, nor were Clinton and Blair, whose armed forces killed many hundreds of innocent civilians. Elsewhere also, major killers such as Indonesia's Suharto or Haiti's Constant or Chile's Pinochet have not been subject to extradition and prosecution because they were on the right side and were thus official freedom fighters by rule of affiliation. For a compelling analysis of this process, see Michael Mandel, *How America Gets Away with Murder* (London: Pluto, 2004).

6 Meron Rappaport, "IDF Commander: We fired more than a million cluster bombs in Lebanon," *Ha'aretz*, September 12, 2006.

7 Clancy Chassay (in Aita al-Shaab), "One month on, uneasy truce holds in battle-scarred border villages; Hizbullah fighters patrol hills while Israeli forces commit daily violations," *Guardian*, September 14, 2006.

Published with permission: [*Z Magazine*, October 2006] Language and Institutional Perversions in a Time of Painful Birth Pangs (Kafka Era Studies, No. 2)

Chapter 10

Television Violence at a Time of Turmoil and Terror

George Gerbner

Humankind may have had more bloodthirsty eras but none as filled with images of violence as the present. Even in ordinary times, TV's stress on crime and violence skews news priorities. Since September 11, 2001, however, the monopoly media have been carrying virtually no other major news.

Shocking and tragic as the attacks were on the World Trade Center and the Pentagon, they should not have come as a surprise. America bears some culpability for the conditions that provoked the murderous attacks. Rich countries should act to ease the global economic inequalities that provide a breeding ground for terrorism. French Prime Minister Lionel Jospin and German Chancellor Gerhard Schroeder said to a Franco-German discussion forum in Paris that more initiatives like the 1999 agreement on debt relief for poor nations were needed as well as a greater commitment to solving existing conflicts. Schroeder noted that "You have a situation which is favorable to terrorism if you do not deal with these problems. . . . Terror does not have poverty as its root cause, but the idea of sustainability has got to include the people of the Third World, otherwise these people become radicalized." As they do, the vicious cycle of fear, insecurity, prejudice, and hatred against people of color thrives in the white communities and helps drive crime reporting and its racist fallout.

Even before the recent escalation of violent rhetoric and imagery the *Des Moines Register* found that of the six top news events on Des Moines evening newscasts during February 1994, 118 stories dealt with crime and violence, 27 featured business, 17 dealt with government, 15 reported on racial relations, and two discussed schools. A recent study of local news by the University of Miami found that time devoted to crime ranged from 23 to 50 percent (averaging 32 percent) while violent crime in the city remained constant, involving less than one-tenth of 1 percent of the population.

Community leaders have often said that blacks, Hispanics, and now people of Middle Eastern appearance or Muslim religion are demonized by the choice of faces shown in crime stories. Evidence supports that charge. For example, a study for the Chicago Council on Urban Affairs found that "a high percentage of African-Americans and Latinos are shown as victimizers of society, and few as social helpers." This distorted portrayal, the council said, contributes to the notion that "the inner city is dominated by dangerous and irresponsible minorities." Similarly, the *Journalism Quarterly* reported that Chicago newspapers carried stories on only one of every three homicides in the city and that the slayings most likely to be selected were those in which the victims were white, contrary to actual crime statistics.

We have been studying local news on Philadelphia television stations since 1967 as part of the Cultural Indicators monitoring project.[1] We found that crime and/or violence items usually lead newscasts and preempted balanced coverage of the city. Furthermore, only 20 percent of crime and violence on local news was local to the city, only 40 percent was local to the region, and since September 11, 2001, that proportion has shrunk even further. As also found in other studies, whites are more likely to be reported as victims and people of color as the perpetrators.

Crime and violence also play a prominent and pervasive role in TV entertainment. Scenes of violence occur an average three to five times per hour in prime-time dramatic fiction, and between twenty and twenty-five times per hour in cartoons. We are awash in a tide of violent representations such as the world has never seen. Images of expertly choreographed brutality at home and half a world away drench our homes. There is no escape from the mass-produced mayhem pervading the life space of ever larger areas of the world.

The television overkill has clearly drifted out of democratic reach. Children all over the world are born into homes dominated by television's global monopoly of turmoil and terror. They are fully integrated into television's mean and violent world. The United States dominates that world, throwing its military weight around from Panama to Afghanistan. As Sam Smith, editor of the online *Undernews*, wrote: "Our leaders have failed us by creating a world so filled with hatred for our land."

TV's investment in mayhem was first reported by the National Association of Educational Broadcasters in 1951. The first congressional hearings were held by Senator Estes Kefauver's Subcommittee on Juvenile Delinquency in 1954. Through virtually all medical, law enforcement, parents,' educational and other organizations, and in the face of international embarrassment, violence still saturates the airways (Gerbner et al., 1993).

Broadcasters are licensed to serve "the public interest, convenience, and necessity." But they are paid to deliver a receptive audience to their business sponsors. Few industries are

as public relations conscious as television. What compels them to endure public humiliation, risk the threat of repressive legislation, and invite charges of visions that violence undermines health, security, and the social order? The answer is *not* popularity.

The usual rationalization that television violence "gives the audience what it wants" is disingenuous. As the trade knows well, violence is not highly rated. But there is no free market or box office for television programs through which audiences could express their wants.

Unlike other media use, TV viewing is a ritual; people watch by the clock and not by the program. Ratings are determined more by the time of the program, the lead-in (previous program), and what else is competing for viewers at the same time than by program quality or other attractions. Ratings are important only because they set the price the advertiser pays for "buying" viewers available to the set at a certain time, but they have limited use as indicators of popularity.

Therefore, it is clear that something is wrong with the way the problem has been posed and addressed. Either the damage is not what it is commonly assumed to be, or television violence and global mayhem must have some driving force and utility other than popularity, or both. Indeed, it is both, and more.

The usual question—"Does television violence incite real-life violence?"—is itself a symptom of the problem. It obscures and, despite its alarming implications and intent, trivializes the issues involved.

Television violence must be understood as a complex scenario and an indicator of social relationships. It has utility and consequences other than those usually considered in media and public discussion. And it is driven by forces other than free expression and audience demand.

Whatever else it does, violence in drama and news demonstrates power. It portrays victims as well as victimizers. It intimidates more than it incites. It paralyzes more than triggers action. It defines majority might and minority risk. It shows one person's, country's, race's, or ethnic group's place in the "pecking order" that runs the world.

Violence and now war, no matter how distant, is but the tip of the iceberg of a massive underlying connection of television's role as universal storyteller and an industry dependent on global markets. These relationships have not yet been recognized and integrated into any theory or regulatory practice. Television has been seen as one medium among many rather than as the mainstream of the cultural environment in which most children grow up and learn. Traditional regulatory and public interest conceptions are based on the obsolete assumption that the number of media outlets determines freedom and diversity of content. Today, however, a handful of global conglomerates can own many outlets in all media, deny entry to new and alternative perspectives, and homogenize content. The common-carrier concept of access and protection applicable to a public utility like the phone company also falls short when the issue is not so much the number of channels and individual access to them but the centralized mass production of the content of all the stories.

Let us, then preview the task of broadening a discourse that has gone on too long in a narrow and shallow groove. Violence on television is an integral part of a system of global

marketing. It dominates an increasing share of the world's screens despite its relative lack of popularity in any country. Its consequences go far beyond inciting aggression. The system inhibits the portrayal of diverse dramatic approaches to conflict. It depresses independent television production and thereby diversity of choice, views, perspectives, and, not incidentally, political parties. No other country that calls itself democratic has such a monopoly on political expression and organization, while lacking socialist, communist, religious, and regional parties, and therefore, alternative views on how society might be organized.

Television's socio-political-cultural monopoly deprives viewers of more popular choices, victimizes some, and emboldens others, heightens general intimidation, and invites repressive measures that exploit the widespread insecurities it generates.

The First Amendment to the U.S. Constitution forbade the only censors its authors knew—government—from interfering with the freedom of the press. Since then, large conglomerates, virtual private governments, have imposed their formula of overkill on media they own. Therefore, raising the issue of overkill directs attention to the controls that, in fact, abridge creative freedom, dominate markets, and constrain democratic cultural policy.

Behind the problem of television violence is the critical issue of who makes cultural policy on whose behalf in the electronic age. The debate about the current tidal wave of mayhem creates an opportunity to move the larger cultural policy issue to center stage, where it has been in other democracies for some time.

The convergence of communication technologies concentrates control over the most widely shared messages and images. Despite all the technocratic fantasies about hundreds of channels, it is rare to encounter discussion of the basic issue of who makes cultural policy. In the absence of such discussion, cultural policy is made on private and limited grounds by an invisible corporate directorate whose members are unknown, unelected, and unaccountable to the public.

We need to ask the kinds of questions that can place the discussion of television violence as a cultural policy issue in a useful perspective. What creative sources and resources will provide what mix of content moving on the "electronic superhighway" into every home? Who will tell the stories and for what underlying purpose? How can we assure survival of alternative perspectives, regardless of profitability and selling power?

There are no clear answers to these questions because, for one thing, they have not yet been placed on the agenda of public discourse. It will take organization, deliberation, and exploration to develop an approach to answering them. What follows, then, is an attempt to draw from our research answers to some questions that can help develop such an approach. We will be asking: What is unique about television and about violence on television? What systems of "casting" and "fate" dominate its representations of life? What conceptions of reality do these systems cultivate? Why does violence play such a prominent, pervasive, and persistent role in them? And, finally, how can we as a society deal with the overkill while, at the same time, enhancing rather than further curtailing cultural freedom and diversity?

The New Cultural Environment

Nielson figures show that an American child today is born into a home in which television is on an average of over seven hours a day. For the first time in human history, most of the stories about people, life, and values are told not by parents, schools, churches, or others in the community, who have something to tell, but by a group of distant conglomerates that have something to sell.

Television, the mainstream of the new cultural environment, has brought about a radical change in the way children grow up, learn, and live in our society. Television is a relatively non-selectively used ritual; children are its captive audience. Most people watch by the clock and not by the program. The television audience depends on the time of the day and the day of the week more than on the program. Other media require literacy, growing up, going out, selection based on some previously acquired tastes, values, and predispositions. Traditional media research assumed such selectivity. But there are no "previously acquired tastes, values, and predispositions" with television. Viewing starts in infancy and continues throughout life.

Television helps to shape from the outset the predispositions and selections that govern the use of other media. Unlike other media, television requires little or no attention; its repetitive patterns are absorbed in the course of living. They become part and parcel of the family's style of life, but they neither stem from nor respond to its particular and selective needs and wants. It is television itself that cultivates the tastes, values, and predispositions that guide future selection of other media. That is why television has a major impact on what movies, magazines, newspapers, and books can be sold best in the new cultural environment.

The roles children grow into are no longer homemade, handcrafted, community inspired. They are products of a complex, integrated, and globalized manufacturing and marketing system. Television violence, defined as overt physical action that hurts or kills (or threatens to do so), is an integral part of that system. A study of the "Limits of Selective Viewing" (Sun, 1989) found that, on the whole, prime-time television presents a relatively small set of common themes, and violence pervades most of them.

Of course, representations of violence are not necessarily undesirable. There is blood in fairy tales, gore in mythology, murder in Shakespeare. Not all violence is alike. In some contexts, violence can be a legitimate and even necessary cultural expression. Individually crafted, historically inspired, sparingly and selectively used expressions of symbolic violence can indicate the tragic costs of deadly compulsions. However, such a tragic sense of violence has been swamped by "happy violence" produced on the dramatic assembly line. This "happy violence" is cool, swift, painless, and often spectacular, even thrilling, but usually sanitized. It always leads to a happy ending. After all, it is designed to entertain and not to upset; it must deliver the audience to the next commercial in a receptive mood.

The majority of network viewers have little choice of thematic context or character types, and virtually no chance of avoiding violence. Nor has the proliferation of channels led to greater diversity of actual viewing. (See, e.g., Morgan & Shanahan, 1991, Gerbner,

1993b, Gerbner et al., 1993) If anything, the dominant dramatic patterns penetrate more deeply into viewer choices through more outlets managed by fewer owners airing programs produced by fewer creative sources.

Television Violence: Message System Analysis

Cultural Indicators is a three-pronged research effort. "Message System Analysis" is the annual monitoring of television program content; "Institutional Policy Analysis" looks at the economic and political bases of media decision-making; "Cultivation Analysis" is an assessment of the long-range consequences of exposure to television's system of messages.

Message system analysis includes every dramatic (fictional) program in each annual sample. It provides an unusual view of familiar territory. It is not a view of individual programs but an aggregate picture of the world of television, a bird's eye view of what large communities of viewers absorb over long periods of time.

The role of violence in that world can be seen in our analysis of prime time network programs and characters. "Casting" and "fate," the demography of that world, are the important building blocks of the storytelling process. They have presented a stable pattern over the almost thirty years of monitoring network television drama and coding every speaking character in each year's sample. Middle-class white male characters dominate in numbers and power. Women play one out of three characters. Young people comprise one-third and old people one-fifth of their actual proportions of the population. Most other minorities are even more underrepresented. That cast sets the stage for stories of conflict, violence, and the projection of white male prime-of-life power. Most of those who are underrepresented are also those who, when portrayed, suffer the worst fate.

The average viewer of prime time television drama (serious as well as comedic) sees in a typical week an average of 21 criminals arrayed against an army of 41 public and private law enforcers. There are 14 doctors, 6 nurses, 6 lawyers, and 2 judges to handle them. An average of 150 acts of violence and about 15 murders entertain viewers and their children every week, and that does not count cartoons and the news. Those who watch over three hours a day (more than half of all viewers) absorb much more.

About one out of three (31%) of all characters and more than half (52%) of major characters are involved in violence either as victims or as victimizers (or both) in any given week. The ratio of violence to victimization defines the price to be paid for committing violence. When one group can commit violence with relative impunity, the price it pays for violence is relatively low. When another group suffers more violence than it commits, the price is high.

In the total cast of prime time characters, defined as all speaking parts regardless of the importance of role, the average "risk ratio" (number of victims per 10 violent acts) is 12. Violence is an effective victimizer—and characterizer. Its distribution is not random; the calculus of risk is not evenly distributed. Women, children, poorer and older people, and some minorities pay a higher price for violence than do males in the prime of life. The price paid in victims for every 10 violent acts is 15 for boys, 16 for girls, 17 for young women,

18.5 for lower-class characters, and over 20 for elderly characters.

Violence takes on an even more defining role for major characters. It involves more than half of all major characters (58% of men and 41% of women). Most likely to be involved either as perpetrators or victims, or both, are characters portrayed as mentally ill (84%), characters with mental or other disability (70%), young adult males (69%), and Latino/Hispanic Americans (64%). Children, lower class, and mentally ill or otherwise disabled characters pay the highest price—13 to 16 victims for every 10 perpetrators.

Lethal victimization further extends the pattern. About 5 percent of all characters and 10 percent of major characters are involved in killing (kill or get killed, or both). Being Latino/Hispanic, or lower class means bad trouble: these characters are the most likely to kill and be killed. Being poor, old, Hispanic, or a woman of color means double trouble, a disproportionate chance of being killed; they pay the highest relative price for taking another's life.

Among major characters, for every 10 "good" (positively valued) men who kill, about 4 are killed. But for every 10 "good" women who kill, 6 women are killed, and for every 10 women of color who kill, 7 women are killed. Older women characters get involved in violence *only* to be killed.

We calculated a violence "pecking order" by ranking the risk ratios of the different groups. Women, children, young people, lower class, disabled, and Asian American characters also pay a higher than average price. In other words, hurting and killing by most majority groups extracts a tooth for a tooth. But minority groups tend to pay a higher price for their show of force. That imbalance of power is, in fact, what makes them minorities even when, as women, they are a numerical majority.

Cultivation Analysis: The "Lessons" of Television

What are the consequences? These representations are not the sole or necessarily even the main determinants of what people think or do. But they are cultural contributions to what large communities absorb over long periods of time. We distinguish the long-term cultivation of assumptions about life and values from short-term "effects" that are usually assessed by measuring change as a consequence of exposure to certain messages. Television tends to cultivate and confirm stable conceptions about life.

Cultivation analysis measures these "lessons" as it explores whether those who spend more time with television are more likely than comparable groups of less frequent viewers to perceive the real world in ways that reflect the most common and repetitive features of the television world. (See Morgan & Signorielli, 1990, for a detailed discussion of the theoretical assumptions and methodological procedures of cultivation analysis.)

The systemic patterns in television content that we observe through message system analysis provide the basis for formulating survey questions about people's conceptions of social reality. These questions form the basis of surveys administered to large and representative national samples of respondents. The surveys include questions about fear of crime, trusting other people, walking at night in one's own neighborhood, chances of victimiza-

tion, inclination to aggression, etc. Respondents in each sample are divided into those who watch the most television, those who watch a moderate amount, and those who watch the least. Cultivation is assessed by comparing patterns of responses in the three viewing groups (light, medium, and heavy) while controlling for important demographic and other characteristics such as education, age, income, gender, newspaper reading, neighborhood, etc.

These surveys indicate that long-term regular exposure to violence-laden television tends to make an independent contribution (i.e., in addition to all other factors) to the feeling of living in a mean and gloomy world. The "lessons" range from aggression to desensitization and to a sense of vulnerability and dependence.

The symbolic overkill takes its toll on all viewers. However, heavier viewers in every subgroup express a greater sense of apprehension than do light viewers in the same groups. They are more likely than comparable groups of light viewers to overestimate their chances of involvement in violence, to believe that their neighborhoods are unsafe, to state that fear of crime is a very serious personal problem, and to assume that crime is rising regardless of facts. Heavy viewers are also more likely to buy new locks, watchdogs, and guns "for protection." It makes no difference what they watch because only light viewers watch more selectively; heavy viewers watch more of everything that is on the air. Our studies show that they cannot escape watching violence. (See Gerbner, Morgan, Gross, & Signorielli, 1984; Sun, 1989.)

Moreover, viewers who see members of their own group underrepresented but overvictimized seem to develop a greater sense of apprehension, mistrust, and alienation, what we call the "mean world syndrome." Insecure, angry people may be prone to violence but are even more likely to be dependent on authority and susceptible to deceptively simple, strong hard-line postures. They may accept and even welcome repressive measures such as more jails, capital punishment, harsher sentences—measures that have never reduced crime but never fail to get votes—if that promises to relieve their anxieties. That is the deeper dilemma of violence-laden television.

The Structural Basis of Television Violence

Formula-driven violence in entertainment and news is not an expression of freedom, viewer preference, or even crime statistics. The frequency of violence in the media seldom, if ever, reflects the actual manufacturing and marketing machine.

Mergers, consolidation, conglomeration, and globalization speed the machine. "Studios are clipping productions and consolidating operations, closing off gateways for newcomers," notes the trade paper *Variety* on the front page of its August 2, 1993, issue. The number of major studios declines while their share of domestic and global market rises. Channels proliferate while investment in new talent drops, gateways close, and creative sources shrink.

Concentration brings denial of access to new entries and alternative perspectives. It places greater emphasis on dramatic ingredients most suitable for aggressive international promotion. Having fewer buyers for their products forces program producers into deficit

financing. That means that most producers cannot break even on the license fees they receive for domestic airings. They are forced into syndication and foreign sales to make a profit. They need dramatic ingredients that require no translation, "speak action" in any language and fit any culture. That ingredient is violence and mayhem. September 11, 2001, was a striking example. (Sex is second but, ironically, it runs with more inhibitions and restrictions.)

Syndicators demand "action" (the code word for violence) because it "travels well around the world," said the producer of *Die Hard 2* (which killed 264 compared to 18 in *Die Hard I*). "Everyone understands an action movie. If I tell a joke, you may not get it, but if a bullet goes through the window, we all know how to hit the floor, no matter the language" (cited by Ken Auletta in "What Won't They Do?" *The New Yorker*, May 17, 1993, pp. 45–46).

Our analysis shows that violence dominates U.S. exports. We compared 250 U.S. programs exported to 10 countries with 111 programs shown in the United States during the same year. Violence was the main theme of 40 percent of home-shown and 49 percent of exported programs. Crime/action series comprised 17 percent of home-shown and 46 percent of exported programs.

The rationalization is that violence "sells." But what does it sell to whom and at what price? There is no evidence that, other factors being equal, violence per se is giving most viewers, countries, and citizens "what they want." The most highly rated programs are usually not violent. The trade paper *Broadcasting Cable* editorialized (Sept. 20, 1993, p. 66) that "the most popular programming is hardly violent as anyone with a passing knowledge of Nielsen ratings will tell you." The editorial added that "Action hours and movies have been the most popular exports for years," i.e., with the exporters, not the audiences. In other words, violence may help sell programs cheaply to broadcasters in many countries even if audiences dislike such programs. But television audiences do not buy programs, and advertisers, who do, pay for reaching the available audience at the least cost.

We compared data from over 100 violent and the same number of nonviolent prime time programs stored in the Cultural Indicators database. The average Nielsen rating of the violent sample was 11.1; that of the nonviolent sample was 13.8. The share of viewing households in the violent and nonviolent samples was 18.9 and 22.5, respectively. The amount and consistency of violence in a series further increased the gap. Furthermore, the nonviolent sample was more highly rated than the violent sample for each of the five seasons studied.

However, despite their low average popularity, what violent programs lose on general domestic audiences, they more than make up by grabbing younger viewers the advertisers want to reach and by extending their reach to the global market hungry for a cheap product. Even though these imports are typically also less popular abroad than quality shows produced at home, their extremely low cost, compared with local production, makes them attractive to the broadcasters who buy them. Of course, some violent movies, videos, video games, and other spectacles do attract sizeable audiences. But those audiences are small compared to the home audience for television—they are the selective retail buyers of what tel-

evision dispenses wholesale. If only a small proportion of television viewers growing up with the violent overkill become addicted to it, many movies and games will be spectacularly successful.

Public Response and Action

Most television viewers suffer the violence daily inflicted on them with diminishing tolerance. Organizations of creative workers in media, health professionals, law enforcement agencies, and virtually all other media-oriented professional and citizen groups have come out against "gratuitous" television violence. A March 1985 Harris survey showed that 78 percent disapprove of violence they see on television. A Gallup poll of October 1990 found 79 percent in favor of "regulating" objectionable content in television. A *Times-Mirror* national poll in 1993 showed that Americans who said they were "personally bothered" by violence in entertainment shows jumped to 59 percent from 44 percent in 1983. Furthermore, 50 percent in 1993 said entertainment violence was "harmful" to society, compared with 64 percent in 1983.

Local broadcasters, legally responsible for what goes on the air, also oppose the overkill and complain about loss of control. *Electronic Media* reported on August 2, 1993, the results of its own survey of 100 general managers across all regions and in all market sites. Three out of four said there is too much needless violence on television; 57 percent would like to have "more input on program content decisions."

The Hollywood Caucus of Producers, Writers, and Directors, speaking for the creative community, said in a statement issued in August 1993: "We stand today at a point in time when the country's dissatisfaction with the quality of television is at an all-time high, while our own feelings of helplessness and lack of power, in not only choosing material that seeks to enrich, but also in our ability to execute to the best of our ability, is at an all-time low."

Far from reflecting creative freedom, the marketing of formula violence restricts freedom and chills originality. The violence formula is, in fact, a de facto censorship extending the dynamics of domination, intimidation, and repression domestically and globally. Much of the typical political and legislative response exploits the anxieties. Violence itself generates and offers remedies ranging from labeling and advisories to even unsure censorship.

There is a liberating alternative. It exists in various forms in most other democratic countries. It is public participation in decisions about cultural investment and cultural policy. Independent grassroots citizens organization and action can provide the broad support needed for loosening the global marketing noose around the necks of producers, writers, directors, actors, and journalists.[2] More freedom from violent and other inequitable and intimidating formulas, not more censorship, is the effective and acceptable way to increase diversity, reduce the dependence of program producers on the violence formula, and reduce television violence to its legitimate role and proportion. The role of Congress, if any, is to run its anti-trust and civil rights oversight on the centralized and globalized industrial structures and marketing strategies that impose violence on creative people and foist it on the children and adults of the world. It is high time to develop a vision of the *rights* of children

to be born into a reasonable free, fair, diverse, and non-threatening cultural environment. It is time for citizen involvement in cultural decisions that shape our lives and the lives of our children.

This chapter is a revised and updated version of an article that originally appeared in G. Dines & J. M. Humez (Eds.) (1995). *Gender, race, and class in media. A text reader.* Newbury Park, CA: Sage.

The chapter was republished in M. Morgan (2002). *Against the mainstream: The selected works of George Gerbner.* New York: Peter Lang.

NOTES

1 Cultural Indicators is a database and research project that relates recurrent features of the world of television to viewer conceptions of reality. Its cumulative computer archive contains observations on over 3,000 programs and 35,000 characters coded according to many thematic, demographic, and action categories. These form the basis for the content analyses cited in the references. The study is conducted at the University of Pennsylvania's Annenberg School for Communication in collaboration with Michael Morgan at the University of Massachusetts at Amherst and Nancy Signorielli at the University of Delaware. Thanks for research assistance are due to Mariaelena Rartesaghi, Cynthia Kandra, Robin Kim, Brian Linson, Amy Nyman, and Nejat Ozycgin.

2 One such alternative is the Cultural Environment Movement. CEM is a non-profit educational corporation, an umbrella coalition of independent media, professional, labor, religious, health-related, women's, and minority groups opposed to private corporate as well as government censorship. CEM is working for freedom from stereotyped formulas and for investing in a freer and more diverse cultural environment. It can be reached by writing to Cultural Environment Movement, P.O. Box 31847, Philadelphia, PA 19104.

REFERENCES

Bandura, A., Ross, D., & Ross, D. (1967). Transmission of aggression through imitation of aggressive models. *Journal of Abnormal and Social Psychology, 63*, 575–582.

Bryant, J., Carveth, R. A., & Brown, D. (1981). Television viewing and anxiety: An experimental examination. *Journal of Communication, 31*(1), 106–119.

Eleev, M. (1969). *Variations in generalizability resulting from sampling characteristics of content data: A case study.* Unpublished master's thesis, The Annenberg School of Communications, University of Pennsylvania, Philadelphia.

Ellis, G. T., & Sekyura, F., III. (1972). The effect of aggressive cartoons on the behavior of first grade children. *Journal of Psychology, 81*, 7–13.

Gerbner, G. (1969). Dimensions of violence in television drama. In R. K. Baker & S. J. Ball (Eds.), *Violence in the Media* (pp. 311–340). Staff Report to the National Commission on the Causes and Prevention of Violence. Washington, DC: Government Printing Office.

Gerbner, G. (1972). Violence and television drama: Trends and symbolic functions. In G. A. Comstock & E. Rubinstein (Eds.), *Television and social behavior, Vol. I, Content and Control* (pp. 28–187). Washington, DC: U.S. Government Printing Office.

Gerbner, G. (1988a). Violence and terror in the mass media. *Reports and Papers in Mass Communication, No.* 102. Paris: UNESCO.

Gerbner, G. (1988b). Television's cultural mainstream: Which way does it run? *Directions in Psychiatry, 8(9)*.

Gerbner, G. (1993a). *Violence in cable originated television programs*. A Report to the National Cable Television Association.

Gerbner, G. (1993b). Miracles of communication technology: Powerful audiences, diverse choices and other fairy tales. In J. Wasko, V. Mosco, & P. Manjunath, (Eds.), *Illuminating the blind spots: Essays honoring Dallas W. Smythe*. New York: Ablex.

Gerbner, G. (1993c). Women and minorities on television: A study in casting and fate. A report to the Screen Actors Guild and the American Federation of Television and Radio Artists.

Gerbner, G., Gross, I., Morgan, M., & Signorielli, N. (1980). Aging with television: Images on television and conceptions of social reality. *Journal of Communication, 31(1)*, 37–17.

Gerbner, G., Gross, L., Morgan, M., & Signorielli, N. (1982). Charting the mainstream: Television's contributions to political orientations. *Journal of Communication, 32(2)*, 100–127.

Gerbner, G., Gross, L., Morgan, M., & Signorielli, N. (1984). Political correlates of television viewing. *Public Opinion Quarterly, 48(1)*, 283–300.

Gerbner, G., Gross, L., Morgan, M., & Signorielli, N. (1993). Growing up with television: The cultivation perspective. In J. Bryant & D. Zillmann (Eds.), *Media effects: Advances in theory and research*. Hillsdale, NJ: Lawrence Erlbaum.

Gerbner, G., & Signorielli, N. (1990). Violence profile 1967 through 1988–89: Enduring patterns. The Annenberg School for Communication, University of Pennsylvania.

Gross, L. (1984). The cultivation of intolerance: Television, blacks, and gays. In G. Melischek, C. E. Rosengren, & J. Stappers (Eds.), *Cultural indicators: An international symposium*. Vienna: Austrian Academy of Sciences.

Hawkins, R., & Pingree, S. (1982). Television's influence on social reality. In D. Pearl, L. Bouthilet, & J. Lazar (Eds.), *Television and behavior: Ten years of scientific progress and implications for the 80's, Vol. II, Technical Reviews*. Washington, DC: Government Printing Office.

Lovaas, O. (1961). Effects of exposure to symbolic aggression on aggressive behavior. *Child Development, 32*, 37–44.

Morgan, M. (1983). Symbolic victimization and real-world fear. *Human Communication Research, 9(2)*, 146–157.

Morgan, M. (1984). "Heavy television viewing and perceived quality of life." *Journalism Quarterly, 61 (3)*, 499–504.

Morgan, M. & Shanahan, J. (1991). "Do VCRs change the TV picture?: VCRs And the cultivation process." *American Behavioral Scientist, 35(2)*, 122–135.

Morgan, M., Shanahan, J., & Harris, C. (1990). "VCRs and the effects of television: New diversity or more of the same?" In J. Dobrow (ed.), *Social and Cultural Aspects of VCR Use* (pp. 107–123). Hillsdale, NJ: Erlbaum.

Morgan, M. & Signorielli, N. (1990). "Cultivation analysis: Conceptualization and methodology." In N. Signorielli & M. Morgan (eds.), *Cultivation Analysis: New Directions in Media Effects Research* (pp. 13–33). Newbury Park, CA: Sage Publications.

Pingree, S. & Hawkins, R.P. (1980). "U.S. programs on Australian television: The cultivation effect." *Journal of Communication, 31 (1)*, 97–105.

Signorielli, N. (1990). "Television's mean and dangerous world: A continuation of The cultural indicators perspective." In N. Signorielli & M. Morgan (eds.), *Cultivation Analysis: New Directions in Media*

Effects Research (pp. 85–105). Newbury Park, CA: Sage Publications.

Signorielli, N., Gross, L., & Morgan, M. (1982). "Violence in television programs: Ten years later." In D. Pearl, L. Bouthilet, & J. Lazar (eds.), *Television and Behavior: Ten Years of Scientific Progress and Implications for the 80's, Vol. 2, Technical Reports* (pp. 154–174). Washington, DC: Government Printing Office.

Srole, L. (1956). "Social integration and certain corollaries: An exploratory study." *American Sociological Review*, 21, 709–712.

Sun, L. (1989). "Limits of selective viewing: An analysis of 'diversity' in dramatic programming." Unpublished Master's Thesis, The Annenberg School for Communication, University of Pennsylvania, Philadelphia.

Chapter 11

Media Knowledges, Warrior Citizenry, and Postmodern Literacies

Peter McLaren and Rhonda Hammer

The actants, those structures of narrative action, had to sustain the drama of masculine words and deeds for the most ethereal and most lusted-after of goals— to be seen by all not to have backed down, to have drawn the line in the sand and made the inscription matter. The sands turn to concrete when the manly write in them. These are old, indeed old-fashioned, tendentious, unscrupulously generalizing feminist remarks. They need to be made again, as long as *virtu*, the quality of manliness, means the readiness to kill, that is, to be a replicant, of whatever biological or technological description, in the reproductive dramas of the Father, who forever structures the action in order to produce, again and again, the sacred image of the same. *In saecula saeculorum*. And, ageless, Bush and Saddam Hussein, those two secular figureheads of secular states, each declaring holy war, figured in blinding mirror image as autocrat and democrat, are surely knowingly enmeshed in the brotherly salvation histories that have driven their two Peoples of the Book for centuries.

—Donna Haraway, 1991, pp. 42–43

The subject is constructed through acts of differentiation that distinguish the subject from its constitutive outside, a domain of abjected alterity conveniently associated with the feminine, but clearly and not exclusively so. Precisely in this recent war we see the Arab as figured as the abjected Other, a site of homophobic fantasy well made clear in the abundance of bad jokes grounded in the linguistic sliding from Saddam to Sodom.

—Judith Butler, 1991, p. 76

Postmodern wars are not fought for clearly defined goals. Combatants may well invoke pretexts, but these pretexts are subject to change. As goals change, these wars come to assume an anarchic aspect. Postmodern wars ha~~ multiple discursive spaces in which individuals can find a~~ always been part of war can find in postmodern war a sp~~ ticipation. This articulation threatens to undermine the Ho~~ itself always threatened by the entrenchedness of that~~ franchised who before submitted to the distortions of domin~~ ing their voices heard and their faces seen and thus exposir~~ power consolidation.

—Miriar~~

Media Knowledges: A Bricolage

We have for some time been chilled by the recognition that we are living in an age gone mad. Such madness is of an escalating variety, not unlike that characterized by Lewis Carroll's "Mad Tea Party" where Alice's recognition of the privileging discourses of Wonderland— as pathological—was essential for her survival and ultimate escape.

News events of recent years have greatly confirmed our suspicion that the madness surrounding us functions within wider discursive practices. We have referred to the outcome of such practices as "media knowledges." As we followed the media coverage related to the Iran/Contra hearings, the expulsion of the televangelist Jim Bakker, and the ignominious fall from political grace of the Democratic Party's "great white hope," Gary Hart (coverage that was referred to as the three "gates"—specifically "Contra," "Holy," and "Forni"— that followed in the wake of Watergate), Bill Clinton and his famed cigar, a vial of white powder demanding that the United Nations confirm the attack of Iraq, the "swift-boating" of presidential candidate John Kerry, and we became convinced that our liberation from Wonderland (were it at all possible) would in no way be comparable to the conditions surrounding Alice's escape. For unlike Alice, who never doubted the lunacy of Wonderland, most North Americans give some semblance of credibility to the mythical landscape of representations and literacies constructed by contemporary media.

We are interested in providing conditions for educators to approach the issue of literacy critically, by recognizing that we live in a world of multiple literacies—you could call them "postmodern literacies"—in which knowledge can be understood as a form of meaning-making. Such knowledge production consists of both our cognitive engagement with and affective investment in various cultural forms (print, film television, and radio). In this chapter, we want to draw on Walter Benjamin's figure of the flaneur to discuss the role of media commentators as popular intellectuals. More specifically, we want to draw attention to the way media knowledges constitute possibilities for human agency as well as textual restraints placed on teachers as cultural workers—as workers who deal in codes, social texts, and the semiotic circuitry of classrooms and everyday life, and who act as cultural cartographers, mapping cultural life in terms of understanding whose stories are visible and whose stories lie buried in the established archives of history.

The News Reporter as Postmodern Flaneur

When Walter Benjamin wrote about the nineteenth-century figure of the flaneur or "street reader," the bohemian prototype of the modern intellectual whose method of literary production consisted in strolling the city streets and reflecting upon the everyday production of cultural life, he was essentially describing a particular generation of cultural workers whose "object of inquiry was modernity itself" (Buck-Morss, 1989, p. 304). For Benjamin, the poet Baudelaire best embodied the figure of the intellectual flaneur as teacher—a socially rebellious cultural worker who was sympathetic to the needs of the proletariat and was able to teach Benjamin's generation of intellectual producers about the social, culture, and economic conditions that informed their lived experience.

The status of the flaneur was always precarious: "Unlike the academic who reflects in his room, he walks the street and 'studies' the crowd. At the same time, his economic base shifts drastically, no longer protected by the academic's mandarin status" (p. 304). As capitalism expanded into hitherto uncommodified social and cultural realms, and further implicated itself in the signifying practices of mass communications media, fascism became its after-image, and Benjamin began to notice that the modern role of the flaneur was changing to its peril. As cultural producer, the flaneur increasingly came under the spell of the dreaming collective created by consumer capitalism" (p. 312), which removed him more and more from the historical conditions that produced his own social universe.

The transformation that the flaneur gradually underwent could be seen in the degraded incarnation of the sandwichman. As the structured unconscious of the collective (*Kollektiv*) or the masses (*die Massen*) became porous receptacles for the political phantasmagoria and staged extravaganzas of mass spectacles of Germany in the 1930s and 1940s, the most degraded caricature of the flaneur was eventually to appear in the streets of Munich in the form of Jews marching through the city bearing placards—barbaric self-advertisements the Nazis forced upon the Jews as emblems of their ethnic disgrace (p. 312), which have become social hieroglyphs of the most profound evil of the twentieth century.

The Flaneur in Postmodern Culture

We'd like to use our analysis of the media production of the war against Iraq (the first war) by CNN and its valorization of the viewer as "phallomilitary warrior-citizen" (Cooke, 1991; Butler, 1991) which follows the observation by Susan Buck-Morss (1989) that the role of the news reporter as "flaneur-become detective [who] covers the beat" or "photo-journalist [who] hangs about like a hunter ready to shoot" has changed as capitalism has expanded into hitherto uncommodified social and cultural realms and has further implicated itself in the signifying practices of mass communication media. We have followed Buck-Morss in tracing the views of Walter Benjamin toward his figure of the flaneur, the "street reader" who strolls ambiguously and ambivalently through the city streets, projecting as Terry Eagleton describes: a "distaste for the industrial labour through which he glides" and abandoning himself to the crowd like a commodity.

According to Buck-Morss, Benjamin saw the flaneur in shifting roles, from a "person of leisure *(Musse)*" to someone engaged in "loitering *(Müssiggang)*" to the "prototype of the new form of salaried employee who produces news/literature/advertisements for the purpose of information/entertainment/persuasion" (p. 306). Buck-Morss paints a final portrait of the flaneur as someone who, Benjamin felt, advertised not simply commodities but ideological propaganda. Like a "sandwichman" who is "paid to advertise the attractions of mass culture" (pp. 306–307), the flaneur as "journalist-in-uniform" advertises the state and "profits by peddling the ideological fashion" (p. 307).

Benjamin's early depiction of the flaneur, who "moves majestically against that historical grain that would decompose his body into an alien meaning, reduce his numinous presence to an allegory of loss," (Eagleton, 1981, p. 154), was that of a socially rebellious cultural worker, the bohemian prototype—or "Urform"—of the modern intellectual (Buck-Morss, 1989, p. 304). His method of literary production rejected the mandarin status of the metropolitan intellectual and consisted of strolling the city streets and reflecting on the everyday production of cultural life.

Our understanding of contemporary forms of electronically produced media knowledges has been informed by what we perceive as the changing role of the flaneur in the age of late capitalism, one that is as ominous and drastic as the changes that Benjamin perceived. We suggest that the flaneur no longer provides the service of teaching his or her generation about "their own objective circumstances"; rather, we suggest that the flaneur, as global newscaster, has transmogrified into the after-image of fascism.

Today, we are living in a precarious historical moment in which the flaneur—as signifying agent—is undergoing even further metamorphosis. The postmodern flaneurs of today are corporate individuals cunningly managing and shaping the world of mass-produced images, superannuated servants of the state whose forms of knowledge production are mediated by and fastened securely to the logic of consumption. They still stroll the city streets, as they did in Benjamin's era, but this time they are accompanied by a video production crew and, in times of war, a military censor. Often salaried employees of transnational corporations and other standard bearers of imperialism, the insights served up by the global,

postmodern flaneur (to audiences exceeding millions at one viewing) more often than not serve to mystify and further camouflage race, class, and gender antagonisms, and thereby hinder rather than help viewers understand the conditions of everyday existence.

As reality increasingly becomes confused with the image, and the mediascape becomes the driving force of our time, the image of the postmodern flaneur becomes embodied not in human presence but in human immanence transmuted through an electronic signal, a satellite beam roaming the earth in search of new spectacles through which to present and contain reality. We are entering an age of painful loss of everyday history and shared popular memory that has followed the development of media technology since the beginning of the century (Schwoch, White, & Reilly, 1992).

Media knowledges produced by the postmodern flaneur serve as a discourse about action that teleologically fulfills itself in the sense that it recounts an event, that is, in the sense that it *emplots* an event. Yet, paradoxically, it is an emplotment of a history, an event that is manufactured not simply as narrative but also as mood, as a "structure of feeling." Often it has no real beginning (*arche*) or end (*telos*) other than the illusion created by the context of its production. The Gordian knot of history is cleaved as history is declared dead in the frozen moment of the image. For instance, the bloody aftermath of the war with Iraq continues today, although the media have officially declared the war to be over.

Media knowledges offered up by the postmodern flaneur—what we refer to as "perpetual pedagogy"—constitute a moving, circulating sign work that possesses a valorizing and legitimating function in the way that it marks off the territory of the real. In the case of the First Gulf War, it was able to situate the mobile self of postmodernity in a synecdochical relation to a hyper-real, apocalyptic event, one that came ideologically unannounced yet was able to "cue" both our sign membership and our "affective investment" (Grossberg, 1988) into the political economy of patriotism and global citizenry.

Colonization of the Interior

Today's cultural and historical events bombard our sensibilities with such exponential speed and frequency, and through such a variety of media forms, that our critical comprehension skills have fallen into rapid deterioration. This collective loss of reasoning, and of history, appears to be reaching epidemic proportions, with little hope of abatement. The etiology of this "plague," many scholars argue, stems from the expanding sophistication and complexity of networks of social relations that we call "television" (Gitlin, 1986).

It is indeed a paradox that a piece of videotape has no visible image inscribed upon it because, like audiotape, it holds nothing but electrical impulses. Television works by electronic scanning in which tiny dots of light on the screen are lit up, one at a time, by the firing of cathode ray guns across alternate lines on the front of the picture tube (Nelson, 1987, p. 71). Joyce Nelson describes the process as follows:

> The succession of glowing dots moves rapidly across and down, along alternate lines, in a sweep that lights up the first series of phosphors. In all there are 525 such lines of miniscule dots on North

American TV sets. During each one-thirtieth of a second, the scanning process completes two full sweeps of the screen, one on each alternative set of lines, to create, by electrical impulse, the whole mosaic of an instant's image. In terms of micro-seconds, however, there is actually never more than a single dot of light glowing on the screen. Our eyes receive each dot of light, sending its impulse to the brain. The brain records this bit of information, recalls previous impulses, and expects future ones. We "see" an entire image because the brain fills in or complete 99.999 percent of the scanned pattern each fraction of a second, below our conscious awareness. The only picture that ever exists is the one we complete in our brain. (1991, p. 71)

Whereas in film viewing, the viewer fills in the motion between the frames, which change twenty-four times a second, in the case of watching television, the viewer fills in the motion *and* the picture (pp. 71–72). Researchers such as Krugman (cited in Nelson, p. 71) have reported that watching television shuts down the left hemisphere of the neocortex of the brain (that deals with part-by-part analytical thinking and logical analysis) and disengages information processing. This occurs either because of habituation to the scanning dot or "overloading" during the scanning process. Whatever the case may be, direct access to the right hemisphere is unquestionably enabled (because it goes into an alpha rhythm state), and this promotes "evoked-recall" rather than "learned recall" as well as free associations and unconscious connections.

In effect, this process opens up the private space of the individual viewer to feelings and associations that are ripe for colonization by the advertising industry. Messages are designed by advertisers that seek to match the coded expectations of viewers through the use of associative memory response, free association, rhythm, melody, rhyme, harmony, pictorial triggers, and so on (p. 77). This provides optimal conditions for advertisers to label our feelings for us: With the help of advertisements and their products, we can purchase "feeling 7-UP" and "Oh what a feeling—Toyota" or Bell Telephone's "long distance feeling" (p. 78).

As a form of knowing, of what we refer to as "perpetual pedagogy," mainstream television programming is decidedly anti-dialogical and rarely evokes acts of political refusal. Unreflective television viewing has a homogenizing, unifying force by unfixing the space of cultural enunciation through the right hemisphere and simultaneously recolonizing it through the left hemisphere. This process resembles a form of double-encoding that rehistoricizes and translates heterogeneity and the instability of deep memories and associations into a mimetic correspondence with the real-like Coke, it becomes "the real thing." In effect, the television viewer becomes constructed within the pulsations of electronically mediated desire. Read against this televisually constructed and radically decentered subjectivity, we are able to conceive of the Kantian and Cartesian tradition of viewing the self as rational, unified, and autonomous as little more than a monstrosity. Within the dominant logocentric tradition, viewers are taught to mis-recognize in the private space of their phantom self the deep memories and associations that are evoked below the threshold of conscious awareness as self-conscious, autonomous, and willed desire, that is, from the perspective of the rational subject as a detached, disembodied, and sovereign (patriarchal) observer of a transparent reality. Furthermore, the illusion that televisual desire can be controlled by an autonomous, self-effulgent ego occludes from viewers the way television works as a corpo-

rate mobilization of desire for objects that are constantly misrecognized as real in that liminal space between consciousness and repression.

In fact, the television images that we see are never really there. They exist as furtive shadows that we capture as viewers through forms of televisual address that are variously shaped by our "viewing formations," that is, through our deep cultural memories, our fears, our repressions, and our anxieties. Watching television is not so much to have the self decentered or turned nomad against a totalizing regime of logocentric representation: rather it is to have one's sense of self-contained identity desituated and deformed into concatenated levels of desire. We are not so much dealing here with regimes of signification as we are with what Larry Grossberg (1988) calls "mattering maps"—with investments of desire and pleasure.

Television viewing is like watching the world not through the rose-colored glasses of naive hope but through a glass coffin inside memory's prison house. It offers us a new means of constituting subjectivity, a new "assemblage" formed within capitalism that "reterritorializes" the relation of human and the machine (Poster, 1991, p. 136). As Deleuze and Guattari put it:

> with automation comes . . . a new kind of enslavement . . . one is enslaved by TV as a human machine insofar as the television viewers are no longer consumers or users, nor even subjects who supposedly "make" it, but intrinsic component pieces, "input" and "output" feed-back or recurrences that are no longer connected to the machine in such a way as to produce or use it. In machine enslavement, there is nothing but transformations and exchanges of information. (cited in Poster, 1991, p.136)

However, the subjectivity constructed through machine enslavement is more than the subject's positioning within the circuit of information flows or the "schizoid pulsations of the unconscious." According to Poster, there occurs a radicalization of anti-logocentric bearings of the self brought on by electronically mediated communication, and the undermining of the space/time coordinates that hold together the Cartesian view of the subject as autonomous and rational. In Poster's view, this "reterritorialization" of subjectivity offers the possibility for radically new and potentially emancipatory forms of community." Because, for Poster, electronically mediated communication both supplements and substitutes for existing forms of sociability (Poster, 1991, p. 154), there always exists a space for the construction of "new and unrecognizable modes of community." Even so, as we shall argue in the final section, whether or not these new modes of sociality and community will be emancipatory will depend to a large extent on what types of media literacy are permitted.

George Gerbner (1989/90) has made a good case for the development of critical media literacy. His research has revealed that U.S. television viewers accept a distorted picture of the real world "more readily than reality itself." According to Gerbner, television reality is one in which men outnumber women three to one, where women are usually portrayed as either mothers or lovers, rarely work outside the home, and are natural victims of violence. It is a reality in which less than ten percent of the population hold blue-collar jobs, where few elderly people exist, where black youths learn to accept their minority status as inevitable and are trained to anticipate their own victimization (they are usually cast as the

white hero's comic sidekick or else as drug addicts, gang members, or killers). It is a world in which 18 acts of violence an hour occur in children's prime time programs. Violence on television, Gerbner insists, demonstrates the social power of adult white males who are most likely to get involved with violence but most likely to get away with it. It also serves as a mass spectacle reflecting and legitimating the allocative power of the state. That such an unreality could be rendered natural and commonsensical in a country that in 1990 reported the largest number of rapes against women in its history and a prison incarceration rate of blacks that exceeds that of South Africa, where rich Angelenos are hiring private police, where wealthy neighborhoods display signs warning "Armed Response!" and where security systems and the militarization of urban life are refiguring social space along the lines of the postmodern film *Blade Runner,* is symptomatic of a moral and epistemological crisis of astonishing proportions.

Death as Entertainment: For Patriots Only

A highly precipitous occasion for our reflection on these themes has been the coverage of three seemingly unrelated historical events known as the "gates." What struck us as most disconcerting was the conflation of these diverse and unrelated newsworthy events into a single representative category of public consumption, namely entertainment, and thus, of being (at least in the public eye) of equal import. To reduce the complex interactions of these events to the noun "gates" transforms these events into soap opera spectacles of individual transgression while ignoring their national, cultural, and geopolitical situatedness as social practices occurring in specific contexts at particular historical moments. What reduces these events to the same level of importance is their entertainment value: the sexual and political intrigue, the attempted cover-ups, the image value elicited by the personalities of the offenders, and so on. This type of reductionism is what Wilden (1987) refers to as "symmetrization." Symmetrization involves the ideological and epistemological process of making hierarchically distinct levels of a relationship appear to be "equal" or on the same level when in reality one class of relationship is a different logical type than another. Indeed, the pathology of symmetrized and inverted levels has evolved into a multidimensional profitable industry. The O. J. Simpson saga was further testimony to the escalating phenomenon.

In *Amusing Ourselves to Death,* Neil Postman assured us that what we have been describing is neither hallucination nor historical accident. The culprit, as Postman saw it, is the complex multi-level system of communication known as the television industry:

> Our politics, religion, news, athletics, education, and commerce have been transformed into congenial adjuncts of show business, largely without protest or even much popular notice. The result is that we are people on the verge of *amusing ourselves to death.* (1985, pp. 3–4; emphasis ours)

Within this context, we view these three news events as a representative metaphor for the state of news reporting in the age of the "postmodern flaneur" and an apt indicator of

the shape of things to come in the state of 1990s broadcast news. Regardless of the relationships that both constrain and enable the construction of content, television's politics of representation and mode of information reduce everything from commercials to comedy, to local, national, or international events to the same meta-form: entertainment.

Profane Illumination: Entertainment as the Structuring of Colonialist Modes of Subjectivity

America: heroic, phallic America is dead. Great God America proclaimed itself the paramount power, the vital cultural center, and all the other gods died laughing.
—*McKenzie Wark, 1991, p. 48*

Our previous investigations of the media did little to prepare us for the violent semiotics of the media spectacle surrounding the coverage of the First Gulf War, especially the way it was able to meld the apocalyptic genre of catastrophe with the nonsense genre of carnival. More specifically, we were struck by the ability of the media to transform the military campaigns in Kuwait and Iraq into a 24-hour advertising spectacle in which the newscaster as postmodern flaneur was (with the few notable exceptions of reporters who chose not to cooperate with military censors) reduced to a carnival huckster for patriotic zeal and a salesperson for machineries of destruction and death.

The propagandistic construction of the Gulf War is an extreme example of how the media serve up death for surplus consumption in a politics that centers primarily on the lifestyle industry and what Stuart Ewen (1988, p. 264) has termed "info-tainment." As Ewen (p. 265) notes, "in the ratings game, the news—out of economic necessity—must be transformed into a drama, a thriller, entertainment. Within such a context, the *truth is* defined as *that which sells*" (original emphasis). Especially with reference to the CNN coverage of the war, a kindred range of films and videos dealing with war at a distance (*Top Gun, Iron Eagle*, etc.) tacitly coordinated the reception of many viewers to the aerial shots of "precision" hits through a super-imposition of images and forms of emplotment—memories from postmodern war's electronic and celluloid Hollywood archive—transforming the war coverage into a type of palimpsest blending the discontinuity of war with the continuity of western narratives about it. Mark Poster (1991, p. 221) remarks that there existed a "déjà vu" effect with aerial shots that provoked memories of computer games of flight simulations— "Just when you are taken to the place of impact, the intensifying rhetoric of realism implodes into the hyperrealism of computer games."

The mass production of patriotic sentiment and the mobilization of consent that allowed such a disproportionate and excessive use of force to literally disintegrate hundreds of thousands of Iraqi soldiers fleeing north out of Kuwait (described as "one of the most terrible harassments of a retreating army in the history of warfare"; Ellis, Saeeda, & Plott, 1991) was, in our minds, unquestionably designed as a *mass advertisement*; the hidden payoff was

not the construction of a more critically informed public, but rather an electronic display for showcasing weapons of mass destruction in a way that benefited the arms dealers, the war industry, and a phallic warfare state deploying identities politically and strategically by preparing its citizenry to assume a leadership role in a "new world order."

Can we tell the difference between actual and simulated war? It is difficult when the investigative gaze of the viewer is replaced by a giddy acquiescence to the accredited expertise of visiting military experts and politicians. This is not to suggest that there exist no readings among viewers that aggravate the techno-ideological thrust of the programming, but rather that the static and retrospective character of news shows is often enough to smudge the boundary between *doxa* and *episteme*. Spectacles do not invite situating information into a context. This was most evident in CNN's use of dazzling optical effects as exploding bombs and tracer bullets became luminously pock-marked against darkened skies while the Iraqi soldiers (and civilians) remained largely invisible, except perhaps as empiric battlefield abstractions that resembled the oval forms of Oliver Wascow photographs.

As Jochen and Linda Schulte-Sasse point out, we are speaking here of an event that is potentially more dangerous than what Walter Benjamin referred to as the "aestheticization of politics" since we are witnessing the very process of politics itself being constructed symbolically through the imaginary of media images (1991, p. 70). Not only was the media war in the Gulf "at least in part propelled by [its] power to unify the body politic and to instill in the state's subjects the illusion of being masterful agents of history," the war itself also became an epiphenomenon of the media's production of the war—what could be called "an appendix of image production, an inconvenient though unfortunately still necessary anchor in reality of media simulations" (pp. 70–71). The danger of media-produced wars turning spectators in narrator/agents of history is that it carries with it both the illusion of and addiction to omnipotence. As Jochen and Linda Schulte-Sasse remark:

> While experiencing ourselves, collectively and individually, as a unified body, we simultaneously fall prey to the illusion that we can decipher and master the world, we cover up our actual impotence as agents, which in turn worsens the nation's material situation (economy, infrastructure, educational system, etc.) and increases its dependence on images of superiority. (p. 71)

The "totally administered stylistic environment" of the newscast is one of the best entertainment formats for promulgating "cognitive confusion" and geopolitical misunderstanding. Ewen (1988, p. 265) remarks:

> The highly stylized signature of the news program offers the only over-arching principle of cohesion and meaning. Again, surface makes more sense than substance. The assembled facts, as joined together by the familiar, formulaic, and authoritative personality of "The News," becomes the most accessible version of the larger reality that most Americans have at their disposal. Consciousness *about the world is* continually drawn away from a geopolitical understanding of events as they take place in the world. As nations and people are daily sorted out into boxes marked "good guys," "villains," "victims," and "lucky ones," "style becomes the essence, reality becomes appearance."

Investment in imperialism is important for the United States in order to retain its superpower status because it cannot compete successfully with Japan's and Germany's demilitarized economies. We viewed the war coverage on CNN and other stations as a global

media advertising campaign for sophisticated weapons technology—technology now being sold to countries inhabiting the Gulf region and elsewhere (i.e., Israel and Turkey). The First Gulf War spectacle, in this sense, reflected the global push of transnational capital in the information cultural sphere primarily through the transformation of the "theater" of battle into an international market economy. It was an advertisement for the "new world order" of western-structured development and incorporation into the dominant world business order. However, the kind of new world order to which the Gulf war pointed was framed by a gaudy sideshow of flags, emblems, and military hardware—a counterfeit democracy produced through media knowledges able to effectively harness the affective currency of popular culture in such a way that the average American's investment in being "American" reached an unparalleled high, which has not been approximated since the years surrounding the post-WW II McCarthy hearings.

Doublespeak: The New Language of Democracy

The success of the advertising campaign surrounding both the "selling" and the "displaying" of the First Gulf War was largely due to the strategic use of doublespeak to disguise from television viewers the extent of the real terror and carnage of the military campaign against Iraq. When a euphemism is used to mislead or deceive, it becomes doublespeak. William Lutz (1989, p. 1) writes that doublespeak "is a language that avoids or shifts responsibility, language that is at variance with its real or purported meaning. It is a language that conceals or prevents thought; rather than extending thought, doublespeak limits it." For instance, Lutz reports that in 1984, the U.S. State Department announced it would no longer use the word "killing" in its annual report on the status of human rights in countries around the world. Instead, it chose to employ the term "unlawful or arbitrary deprivation of life." While the State Department claimed that this was a more accurate description of the condition, the term actually functioned to direct attention away from the embarrassing situation of government-sanctioned killings in countries supported by the United States and that have been certified by the United States as respecting the human rights of its citizens (p. 3). "Radiation enhancement device" is a term that has been used by Pentagon officials for nuclear bombs. The neutron bomb was called a "cookie cutter" because it could kill people inside less than a three-quarter-mile radius without harming allied soldiers and civilians nearby.

Doublespeak occurs through the use of terms that are to a large extent technically true, but which serve to function as a lie. For instance, a profit may be described as a "negative deficit"; euphemisms for firing staff may be described as "staff reduction," "non-retention," "dehiring," or "rationalizing of resources."

During the media's production of the First Gulf War, there existed, in the words of Carol E. Cohn (1991, p. 88), a "reversal of metaphors between sentient beings and insentient things." For example, the term "air support" overlooks the devastation and loss of life during bombing raids; "collateral damage" refers to civilian deaths; "incontinent ordinances"

are bombs or missiles that hit allied troops under conditions of "friendly fire"; a "party" is a battle; "bags of tools" refers to weapons; "theater of operations" to a battlefield; "surgical strike" refers to precision bombing; and "delivering a package" to dropping bombs.

Cohn (1991) describes a radio news briefing on the Persian Gulf as "Madison Avenue's idea of a housewife's dream." General Colin Powell (future Secretary of State) talked about fighting in a "sanitary fashion." The air force launches "surgically clean strikes." Instead of bombing the Iraqi troops, U.S. forces are "flying sorties," "engaging" the enemy, "taking out" Iraqi "assets," "servicing" targets, and "softening up" the Republican Guard. Iraqi soldiers do not blow up when bombs or missiles hit them. Instead, their "emplacements absorb the munitions" (p. 88). Human beings become insentient things while weapons become the living actors of war. "Smart" weapons that have eyes and computer "brains" make the decision when and where to drop seven and a half tons of bombs, taking away the moral responsibility of the combatants themselves (p. 88). Margot Norris (1991, p. 224) has noted the Pentagon's consistent strategy of juxtaposing "excessively specific information on the deployment and destruction of weaponry, machines, and 'hard' targets with refusal to stipulate the 'soft' targets or Iraqi bodies"—a move that "has shaped both the fiction and the ideology of the 'technological utopianism' that has become the central defense narrative in President Bush's 'new world order.'"

CNN's spectacularization of the First Gulf War managed to position the viewer so that to be against it was to be "biased" and to be in favor of it was to be "objective." Its narrative apparatus with its apparent realism, or representionality, not only restructured our feelings surrounding the historical conditions being played out, but through strategies of indirection and disinformation was also able to mobilize particular economies of affect. Again, our argument is that the war could be read as one large advertisement that served as unquestionably the "best show in town." Just as sure as U.S. bombs obliterated Iraqi soldiers and civilians, the media's war obliterated the particular historical and political background of western imperialism that served as the context for the actual fighting. In the words reminiscent of an advertisement, Richard Blystone of CNN (1/2/91) described a "Scud" missile as "a quarter-ton of concentrated hatred" while the Patriot missile was described by USA Today (1/22/91) as "three inches longer than a Cadillac Sedan de Ville" (Naureckas, 1991).

It is ironic if not profoundly disturbing that the substanceless unreality of the First Gulf War—its hyper-reality—has become the metanarrative for a renewed U.S. patriotism and the meaning of citizenship. The construction of patriotism through the production of media unreality works—has meaning—as long as the viewer does not know his or her desire is being mobilized and structured through the advertisement mode of information. According to Mark Poster (1990, p. 63):

> As ad after ad is viewed, the representational critic gradually loses interest, becomes lulled into a noncritical stance, is bored, and gradually receives the communication differently . . . the ad only works to the extent that it is not understood to be an ad, not understood instrumentally. Through its linguistic structure, the TV ad communicates at a level other than the instrumental, which is placed in brackets. Floating signifiers, which have no relation to the product, are set in play; images

and words that convey desirable or undesirable states of being are portrayed in a manner that optimizes the viewer's attention without arousing critical awareness.

A communication is enacted in the TV ad, which is not found in any context of daily life. An unreal situation is made real; a set of meanings is communicated, which is more real than reality.

The Mass Spectacle as Totemic Advertisement

Perhaps the most important point to be made about the construction of subjectivity through media as a form of advertisement is its religious function. As Sut Jhally (1990, p. 202) has noted in his historical tracing of the person-object relation in advertisements, advertisements now function as a form of *totemism* in which "utility, symbolization and personalization are mixed and remixed under the sign of the group." Products no longer become venerated for their utility, their value as icons, or their power as fetishes; rather, they now serve in the post-Fordist service economy as a badge of a group—a *form of shared lifestyle*. New world order patriots are now held together by lifestyle rather than particular political commitments. For example, Arnold Schwarzenegger recently purchased a special jeep (nicknamed the "Hummer") used in the First Gulf War by U.S. troops for his own personal use. In the subsequent decade, the Hummer became a huge success in American family car choices. A war vehicle turned into the family van. In New York City, manufacturers of bullet proof vests started *special fashion lines* for toddlers and elementary school children, who might accidentally absorb stray bullets from homeboy dealers in pumps, ten-dollar gold tooth caps, and who carry customized AK 47 assault rifles. The guns are not lifestyle accessories—yet. However, gas masks are. New York celebrity fashion designer, Andre Van Pier, has recently announced a new spring fashion line based on the theme of "Desert Storm." It attempts to capture the "Gulf War look." Fashion accessories revealed include neon-colored gas masks slung renegade-chic over the shoulder. To add insult to injury, a major New York baseball card manufacturer has revealed a new line of Gulf War cards that were supposed to be "educational." Of course, the cards include photos of all the major U.S. war hardware and portraits of the American generals, but the only item represented from Iraq in this "educational" collection is a "Scud" missile. In 2001, the cards were again brought out to portray 52 of Saddam Hussein's most *evil* co-conspirators.

The First Gulf War was packaged for U.S. viewers in the form of the lifestyle politics of watching football spectacles. According to Ernest Larsen (1991, p. 5), following the First Gulf War Superbowl, January 1991, "General Schwartzkopf explained the fine points of bombing runs, with the same delivery style and the same instant replay as the network football commentators have just used."

Further, he notes that the idiom used on television to describe the war also evoked the jingoist jocksniffery of football announcers. The emphasis on number, names, and stats, on graphics, plays, and kicking ass, and later, on "cutting it off and killing it," in Colin Powell's unstudied phrase, are all derived from the sports world, that sweaty utopia of repressed homoerotic ritual combat made up of grown-up males in uniforms whose entire

livelihood is concentrated on their ability to use their fetishized bodies with the forceful precision of high-tech weapons. At one point, Bush even called the war his Super Bowl. (p. 8)

Television Reality as the Discourse of the Other

Soon after the first war ended, our students (both from our respective classrooms in Canada and the United States) began to express regret that they could no longer return to their television sets with the same mixture of commitment and enjoyment that many of them confided they reserved only for their favorite soap operas. CNN's staged desire in its coverage of the war had presented them with unambiguous coordinates to construct *national economies of affect* in the form of binary oppositions (patriot/traitor; good/evil; Christian/Muslim; democracy/ dictatorship; liberated/enslaved). Hussein was compared to other dark-skinned leaders such as Idi Amin, Qadafi, and Noriega while the only European who made this rogues gallery was Stalin (Shohat, 1991). As Shohat points out, television anchors in the United States followed George Bush in calling Hussein by his first name— "Sadd'm"—in order to evoke a series of associations such as Satan, Damn, and Sodom. How many television anchors have you heard refer to George Bush as George? Furthermore, it is interesting to note why Hussein was never compared to Hitler when he was armed by the United States and when he used chemical weapons against Iranians and Kurds. Why, for instance, did television archives reveal the brutal consequences of chemical warfare by using images from WW I or from the Iran-Iraq war while avoiding any images of destruction caused by Agent Orange or napalm during Vietnam strikes (Shohat, 1991, p. 137)? Shohat (1991, p. 37) further notes that the Hussein-Hitler analogy prolonged the historical inter-text of Israeli and American imagery linking Arabs to Nazis. This link, both metonymic and metaphoric, had been a staple of didactic Israeli films (*Hill 24 Doesn't Answer, Rebels, Against the Light*) as well as of Hollywood cinema (*Ship of Fools, Exodus, Raiders of the Lost Ark*).

The use of warring oppositions such as "good/evil" and "democracy/dictatorship" to frame associations between Hussein and Hitler served to decontextualize and dehistoricize the events surrounding the war and to effectively "symmetrize" existing relations of power and privilege in the Gulf region. For instance, by establishing chains of equivalences between the war in the Gulf and WW II, the colonial and neo-colonial legacy of European nations who "parcelled up" the inhabitants of the Ottoman empire and installed monarchies and regimes loyal to the imperial powers was successfully elided. This configuration made it easier for typical colonial narratives to be constructed such as "the rescue of white or dark women from a dark rapist" under the metaphor, "the rape of Kuwait," which followed the "historical oversexualization of Blacks and Indians . . . [which was continued] . . . in the image of Saddam and the Arabs" (Shohat, 1991, p. 140).

The colonial narratives played out for American viewers during CNN's production of the Gulf war echoed the way in which contemporary forms of media knowledges reproduce national images of citizenship such as those modeled on the John-Wayneing of America

and captured in the renumerative cliches, "Go for it!" and "Go ahead. Make my day!" Rocky Balboa's "Go for it!" (which has become the clarion call for the U.S. brand of rugged individualism) and Clint Eastwood's "Go ahead. Make my day!" adorn the discursive fountainhead of United States bravado culture. These slogans have become cultural aphorisms that reveal a great deal about the structural unconscious of the United States. Both Ronald Reagan and George H. W. Bush referred to "Go ahead. Make my day!" during their time in office. (The bar was raised considerably when Bush the Younger claimed that *Wanted Dead or Alive* posters from the Wild West should guide the American foreign policy after 9/11. When Clint Eastwood delivered his famous lines in the movie, *Sudden Impact* (made during the Reagan presidency), he is daring a Black man to murder a woman so that he (Dirty Harry) can kill him. As Michael Rogin (1990) has pointed out, Dirty Harry is willing to sacrifice women and people of color in the name of his own courage. Reagan had made women and black people his targets by destroying their welfare-state tax benefits, an act he was defending when he dared his detractors to "Make my day!" Similarly, George Bush made the black criminal and white rapist of *Sudden Impact* into the figure of Willie Horton, as he attempted for the first time to organize American politics around the ominous image of inter-racial rape (Rogin, 1990).

During the 1992 elections, Bush the Elder used racial hiring quotas in order to achieve a similar effect, the fear of darker-skinned immigrants taking away jobs from better-qualified white people. He did not need to rely on Gulf war footage to remind Americans that they were back on top as a world military power because the American fear of the black man was served well in Lee Atwater's campaign, reinforcing that future threats from dark-skinned people (whether Latinos, African Americans, or Native Americans inside its borders or Arabs or South Americans outside its borders) will be met with a local or international force as swift and as deadly as that of Desert Storm.

The coverage of the Gulf war recalled the warning sounded by the 1975 Trilateral Commission that claimed that the electronic media were creating situations of surplus democracy that made the United States more difficult to govern because television was becoming too adversarial and was challenging leadership practices, policy initiatives, and delegitimizing established institutions (Kellner, 1990, pp. 6–7). In the case of the First Gulf War, only 1.5 percent of network sources protested the war, about the same number as the sources who were asked about how the war had affected their travel plans (Naureckas, 1991, p. 5). The Brookings Institute, which was the most important think tank consulted by the media during the Gulf War, was passed off as a think tank of the left. Representatives from Brookings were called upon to debate those from hard-line conservative think tanks such as the Center for Strategic and International Studies and the American Enterprise Institute. However, the Brookings Institute has been "an institution of the center-right for more than a decade" (Soley, 1991, p. 6). In fact, topping the list of corporate donors to Brookings were media corporations "which drew heavily on Brookings for 'liberal' opinions and sound bites" (Soley, 1991, p. 6).

It should come as little surprise that views from an authentic progressive think tank such as the Institute for Policy Studies were rarely solicited or cited. In fact, "In seven months

of the conflict, IPS was cited 26 times by six major papers (6 percent of Brookings' citations); in the first month, not one IPS representative appeared on a nightly newscast" (Soley, 1991, p. 6).

The New Right and the Deformation of Reality

And we've now moved what amounts to a medium-size American city completely capable of defending itself all the way over to the Middle East.
—*President George Bush (Statement to the press about the U.S. military deployment in Saudi Arabia, Kennebunkport, Maine, August 22, 1990, as cited in O. K. Werckmeister,* Citadel Culture, *p. 187)*

An important, if not urgent, reason for students to become media literate is the power of postmodern literacies, such as film and television, to encode our subjective formations with cultural memory. Because the vector-field of identity has expanded into the electromagnetic spectrum, McKenzie Wark warns that

> the encoding of memory in postmodern culture is in the hands of ever more sophisticated cultural technologies. We no longer have roots; we have aerials. George Lukacs spoke of a second nature, composed of the products of physical labour, over and against which living labour is formed and struggles. It would seem appropriate now to speak of a *third nature*, of an environment shot through with the products of intellectual labour, over and against which intellectual labour is formed and struggles. It is this third nature, which replicates itself in us, and hence, it is no small matter who owns this 'little piece of America's soul.' For we all grew up in America in a place called Hollywood, a place where movie stars have been replaced in the image-bank by teenage crackheads and serial killers. (1991, p. 45)

The New Right has used the media effectively (and affectively) not simply to transform war into a spectacle of national unity based on the Manichean grandeur of good triumphing over evil; nor have they used the media primarily to turn generals into talk show guests through the prodigious use of high-tech image consultants (although they have done both very successfully; see Giroux & McLaren, 1989). Even more impressively, the New Right has been able to seduce Americans through the media to retreat into cultural nostalgia and social amnesia as a way of draining attention away from escalating social problems such as rising incidents of racism in urban settings, the growing number of homeless persons, and the devastation of AIDS. Part of this development has to do with the media's ability to reduce the historical present to a collage of images, a symbiotic coupling of machine and body, a new cult of the simulacrum.

Kellner (1990) claims that under the control of multinational capital, the media have effectively served as ideological mouthpieces for Reagan/Bush disinformation and in so doing have helped to forge a conservative ideological hegemony—what Schiller (1989) calls the "shadowy but many-tentacled disinformation industry." Kellner writes:

It is a historical irony that the 1980s marked the defeat of democracy by capitalism in the United States and the triumph of democracy over state communism in the Soviet bloc countries. At present, the "free" television media in the United States are probably no more adversarial and no less propagandistic than Pravda or the television stations in the Eastern European countries. Hence the very future of democracy is at stake—and development of a democratic communications system is necessary if democracy is to be realized. (p. 219)

Certainly recent events surrounding the official U.S. media censorship imposed by the military during the First Gulf war largely confirmed Kellner's pronouncement. However, the latest victory of the New Right's media disinformation/propaganda campaign has been through the invention of and concurrent attack on what has been called the repressive "left mandarin" regime of "political correctness" that is supposedly sweeping North American university campuses. This so-called movement embraces every hate-provoking stereotype of every alleged "radical" imaginable. Educators who work in the public schools and the universities are currently witnessing a well-orchestrated and singularly scandalous assault on efforts by progressive educators to make race, class, and gender issues central to the curriculum. The new left literacies that have been influenced by continental social theory, feminist theory and critical social theory in its many forms (postmodernist, postcolonialist, and poststructuralist, and so on) are being characterized by New Right critics as a subversion of the political neutrality and ideological disinterestedness that they claim the enterprise of education should be all about.

Media Literacy as Counterhegemonic Practice

Enlightenment, then, is finally bent on leaving nothing extant but its own implicit violence. As it proceeds to blast away each of its own prior pretexts, this explosive rationality comes ever closer, not to "truth"—which category it has long since shattered—but to the open realization of its own coercive animus, purified of *all* delusions—including, finally, rationality itself. Into the ideological vacuum, which it has created so efficiently, there rushes its own impulse to destroy and keep destroying. (Miller, 1988, p. 315)

Largely because of how the media function to shape and merchandize morality and to construct forms of citizenship and individual and collective identity, our understanding of the meaning and importance of democracy has become impoverished in proportion to its dissolution and retreat from contemporary social life. Today's social ugliness that makes the bizarre appear normal is no longer just a surrealist fantasy, a proto-surrealist spin-off, or a Baudrillardean rehearsal for a futureless future. This scenario is the present historical moment, one that has arrived in a body bag—unraveled and stomped on by the logic of the fascist's steel-toed boot. Serial killer Ted Bundy has donated his multiple texts of identity to our structural unconscious, and we are living them.

Current forms of collective sociality have been brought under the *nouvelle* aesthetic sign form of Madonna's hyper-bra and Arnold Schwarzenegger's replicant super-cut biceps—part of a new politics of voyeurism and exhibitionism that celebrates the culture of commodified flesh over the emancipation of the body politic. We rehearse our lives under these signs

rather than live them; we become curators and custodians of the detritus produced by the radical semiurgy that characterizes our current epoch, rather than shapers of a new social vision. We have become unwanted visitors in the house of technology.

The fantasies of De Sade have become the urban equivalent of postmodern city life as affluent neighborhoods of the cyber-bourgeoisie brush shoulders with the post-Holocaust landscape of ravaged inner cities, creating new forms of envy and disgust. Given the current condition of *fin-de-siècle* ennui and paranoia, we have arrived at the zero-degree reality of the kind that once only graced the pages of surrealist manifestos and punk fanzines. Andre Breton's "simplest surrealist act"—firing a pistol into a crowd of strangers—is no longer just a turn-of-the-century symbolic disruption of the grudgingly mundane or a symbolic dislocation circulating in avant-garde broadsheets. It is precisely in this current conjuncture that people really *are* shooting blindly into crowds: at children in hamburger establishments, at lunchtime patrons in small town diners, at employees and employers in factories and post offices, at teachers and classmates in schools, at professors and administrators, and at female engineering students in university seminar rooms. In the nihilistic extrapolation of the mass produced image as the emergent norm of postmodern subjectivity, we witness the eclipse of historical agency and the shrinkage of the democratic imaginary.

In the current historical juncture of democratic decline in the United States, ideals and images have become detached from their anchorage in stable and agreed-upon meaning and associations and are now beginning to assume a reality of their own. The self-referential world of the media is one that splinters, obliterates, peripheralizes, partitions, and segments social space, time, knowledge, and subjectivity in order to unify, encompass, entrap, totalize, and homogenize them *through the meta-form of entertainment*. What needs to be addressed is how capitalism is able to secure this cultural and ideological totalization and homogenization by insinuating itself into social practices and private perceptions through various forms of media knowledge. Questions that need to be asked include: How are the subjectivities and identities of individuals and the production of media knowledges within popular culture mutually articulated? To what extent does the hyper-real correspond to practices of self and social constitution in contemporary society? Do we remain "sunk in the depressing hyperbole of the hyperreal" (Poster, 1990, p. 66), encysted in the monologic self-referentiality of the mode of information? Alternatively, do we establish a politics of refusal that is able to contest the tropes that govern western colonialist narratives of supremacy and oppression? What is not being discussed is the pressing need within pedagogical sites for creating a media literate citizenry that can disrupt, contest, and transform media apparatuses so that they no longer possess the power to infantilize the population and continue to create passive and paranoid social subjects (McLaren & Hammer, 1991; Hammer & McLaren, 1991).

In its unannounced retreat over the past decades, democracy has managed to recreate power through the spectacularization of its after-image, that is, through corporatized image management and the creation of national myths of identity, primarily through mass media techniques that give democracy an "after-glow" once it has faded from the horizon of con-

crete possibility. In other words, the mandarins of media have created democracy as a "necessary illusion." Herman and Chomsky (1988, p. xi) note:

> If . . . the powerful are able to fix the premises of discourse, to decide what the general populace is allowed to see, hear, and think about, and to "manage" public opinion by regular propaganda campaigns, the standard view of how the system works is at serious odds with reality.

A critical media literacy recognizes that we inhabit a photocentric, aural, and televisual culture in which the proliferation of photographic and electronically produced images and sounds serves as a form of media catechism—perpetual pedagogy—through which individuals ritually encode and evaluate the engagements they make in the various discursive contexts of everyday life (McLaren, 1986; Giroux & McLaren, 1992; Giroux & McLaren, 1991; McLaren, 1988). It is a form of literacy that understands media representations—be it photographs, television, print, film, or another form—as not merely productive of knowledge but also of subjectivity. John B. Thompson (1990) has sketched out some elements of the media literacy we have in mind.

Following Thompson, we suggest that media literacy must elucidate the typical modes of appropriation of mass-mediated products (i.e., the technical media of transmission, the availability of the skills, capacities, and resources required to decode the messages transmitted by particular media and the rules, conventions, and practical exigencies associated with such decoding). In other words, how do particular individuals throughout the course of their everyday existence receive ritualized messages and integrate them on a daily basis (see McLaren, 1986)? Individuals do not soak up messages as passive onlookers or "inert sponges," but rather they engage in an ongoing process of interpreting and incorporating such messages. A critical media literacy must therefore be attentive to the social-historical characteristics of contexts of reception and see them as *situated practices*. Here Thompson refers to the spatial and temporal features of reception (in the case of TV, for instance, we would be concerned with who watches, for how long, in what contexts); the relations of power and the distribution of resources among recipients; the social institutions within which individuals appropriate mediated knowledges as well as the systematic asymmetries and differentials that characterize the contexts of reception.

A critical media literacy must also relate the everyday understanding of media messages to social-historical characteristics (i.e., race, class, and gender characteristics). It must analyze how mediated messages are discursively elaborated as individuals reject or incorporate them as part of their everyday social practices. Finally, a critical media literacy needs to explore how the appropriation of mediated messages creates *virtual communities* of recipients that are extended across time and space. Such a media literacy seeks to move beyond Eco's suggestion of creating a "semiological guerrilla movement" based on an anarchistic individualism in which each recipient of mediated messages interprets the transmitted multiplicity of images whichever way he or she chooses (Kearney, 1988). Rather, the critical media literacy we envision seeks to create communities of resistance, counter-public spheres, and oppositional pedagogies that can resist dominant forms of meaning by offering new channels of communication, circuits of semiotic production, codifications of

experience, and perspectives of reception that unmask the political linkage between images, their means of production and reception, and the social practices they legitimate.

However, the credibility of our critical pedagogy of media literacy is handicapped by a formidable paradox: Within certain academic and pedagogical circles, the very recognition of media as powerful hegemonic apparatuses impairs the validity of doing media studies in that those who critique television and other media apparatuses are often seen as complicitous with those very structures of domination that they seek to contest. In addition to constructing a model of media power that speaks to the legitimacy of engaging in a cultural studies approach, a critical media literacy (Kellner, 2001, 2005) needs to address sufficiently *the specificity and partial autonomy of media discourses*, that is, a model that "would analyze how the media produce identities, role models, and ideals; how they create new forms of discourse and experience; how they define situations, set agendas, and filter out oppositional ideas; and how they set limits and boundaries beyond which political discourse is not allowed" (Kellner, 1990, p. 18).

Of serious concern in our own work is how electronic prophets who manufacture personalities and manage personal images have been able to turn wimpy presidents into wrathful avengers and a frustrated and self-hating citizenry into phallo-military warrior citizens, who are currently being conditioned to redirect a media-instilled hatred of "Sad'am" against a familiar enemy within its own ranks: the poor, the homeless, people of color, those who comprise the detritus of capitalism and white man's democracy, those who are already oppressed by race, gender, caste, and circumstance. After all, what is the mission of postmodern media if not the attempt to "Americanize the un-American" through particular forms of cultural assertion linked to capital and patterns of consumption, but also, on a grander scale, to interlocking international networks of finance and surveillance.

Needed is a counterhegemonic media literacy in which subjectivities may be lived and analyzed outside the dominant regime of official print culture, a culture that is informed by a technophobic retreat from emerging technoaesthetic cultures of photography, film, and electronically mediated messages. Different media knowledges manage to reveal in different ways what is at stake in naming ourselves as gendered, sexual, and desiring body/subjects. Not only would a critical media literacy warn us of the dangers in constructing social practices that enforce misogynous, homophobic, and patriarchal acts of naming, it would also construct the grounds for a transformative and emancipatory politics of difference. Much of this work necessarily involves not only understanding the disabling and emancipatory potential of the media knowledges that are available to us, but also the importance of struggling to overturn current arrangements of extra-communicational forms of power and the social relations that undergird, and in some instances, help to overdetermine the production of such knowledges. In this regard, a critical pedagogy of media literacy seeks to produce partial, contingent, but necessary, historical truths that will provide some of the necessary conditions for the emancipation of the many public spheres that make up our social and institutional life, truths which—unlike those created and sponsored by the media—recognize their social constructedness and historicity and the institutional and social arrangements that they help to legitimate.

In his book, *Common Culture* (1990), Paul Willis argues that we live in an era in which high culture or official culture has lost its dominance. Official culture—the best efforts of Allan Bloom and E. D. Hirsch Jr. notwithstanding—cannot hope to colonize, dominate, or contain the everyday and the mundane aspects of life. Formal aesthetics have been replaced by a grounded aesthetics. The main seeds of cultural development are to be found in the commercial provision of cultural commodities.

According to Willis, one way to work for the dialectical development of cultural knowledge is getting it "back to its owners" and letting them develop it. "Let them control the conditions, production, and consumption of their own symbolic resources."

This, however, is no easy task, and there are no guarantees, especially given that symbolic resources "are lodged in their own historical patterns of power and logics of production." However, if the grounded aesthetics of everyday cultural life for youths are concretely embedded in the sensuous human activities of meaning making, there are implications for a critical approach to media literacy. Media literacy must help students "to increase the range, complexity, elegance, self-consciousness, and purposefulness of this involvement" in symbolic work. It must provide them with the symbolic resources for a creative self and social formation so that they can more critically reenter the broader plains of common culture. Symbolic work within informal culture is unlike the symbolic work of school in fundamental ways.

Where everyday symbolic work differs from, what is normally thought of as, "education" is "culturally produced" from its own chosen cultural resources. Psychologically, at least, the informal symbolic workers of common cultures feel they really own and can therefore manipulate their resources as materials and tools—unlike the books at school, which are "owned" by the teachers.

For these reasons, creative symbolic work within informal culture offers important possibilities for oppositional, independent, or alternative symbolizations of the self. Moreover, human beings must not be regarded merely as human capital or labour power, but as creative citizens, full of their own sensuous symbolic capacities and activities, who take a hand in the construction of their own identities. The pursuit of emancipation and equality, therefore, requires more than being made equal as workers. It calls for all to be fully developed as *cultural producers*.

Critical media literacy is essential to this struggle in several ways. We need to be literate enough to deny the injunctions by which identities are constructed through official culture—in whatever form it appears. This concept presupposes that we create what Judith Butler (1991) calls "alternative domains of cultural intelligibility . . . new possibilities . . . that contest the rigid codes of hierarchical binarisms." Within such hybrid pedagogical spaces, educators can give greater attention to the everyday artifacts of popular culture and forms of knowledge that avoid the elitist tyranny of the center. Critical media literacy enables us to rearticulate the role of the social agent so that she or he can make affective alliances with forms of agency that provide new grounds of popular authority, ground to stand on from which to give voice to narratives of human freedom.

Critical media literacy helps us identify and answer the question: How do essentially

arbitrarily organized cultural codes, products of historical struggle among not only regimes of signs but regimes of material production also, come to represent the "real," the "natural," and the "necessary"? A critical literacy reveals that signs correspond neither to an already determined metaphysical real nor are they trans-historically indeterminable or undecidable. Rather, their meaning-making possibilities and their meaningfulness are legitimized through the specificity of discursive and material struggles and the political linkages between them. From a critical perspective, the media also enable teachers and students to understand the dangers in considering literacy to be a private or individual competency—or set of competencies—rather than a complex circulation of economic, political, and ideological practices that inform daily life and that invite or solicit students to acquiesce in their social and gendered positions within a highly stratified society and accept the agenthood assigned to them along the axes of race/class/gender.

To this extent, critical media literacy becomes the interpretation of the social present for the purpose of transforming the cultural life of particular groups, for questioning tacit assumptions and unarticulated presuppositions of our current cultural and social formations and the subjectivities and capacities for the agenthood they foster. Critical media literacy is directed at understanding the ongoing social struggles over the signs of culture and over the definition of social reality—over what is considered legitimate and preferred meaning at any given historical moment.

After a form of this chapter first appeared in *Rethinking Media Literacy: A Critical Pedagogy of Representation* (McLaren, Hammer, et al., 1995), we naively thought the only way to go was up in regards to media literacy. Unfortunately, the subsequent decade became a media-driven device appropriated by the fundamentalist right. After the events of 9/11, all bets were off as the revival of Islamaphobia drove a "coalition of the willing (?)" to a failing and deathly Vietnam redux. At this writing, it appears that it can only get worse. What is it we can do with our students to prevent yet more knee-jerk readings of the media?

Perhaps it has never been more urgent for students to begin to understand how the process of representation and identification works. Precisely because it has the power to constitute our subjective identifications in particular ways, the media possess the power to influence political life. To become media literate in a world of postmodern literacies means that students must become historians of representation who realize that the shared systems of ideological representations we carry with us as agents of history *become* our history.

REFERENCES

Buck-Morss, S. (1989). *The dialectics of seeing: Walter Benjamin and the Arcades Project.* Cambridge, MA: The MIT Press.

Butler, J. (1990). *Gender trouble.* New York and London: Routledge.

Butler, J. (1991). The imperialist subject. *Journal of Urban and Cultural Studies, 2*(1), 73–78.

Cohn, C. E. (1991, May 28). Decoding military doublespeak. *Ms.*, p. 88.

Cooke, M (1991). Phallomilitary spectacles in the DTO. *Journal of Urban and Cultural Studies, 2*(1), 27–40.

Eagleton, T. (Autumn, 1981). Marxism and the crisis of the world. Contemporary Literature, 22 (4), 477-

488.

Ellis, C. Saeeda, K., & Plott, S. (1991, June 21). Highway to hell. *New Statesman and Society*, pp. 21–28.

Ewen, S. (1988). *All consuming images*. New York: Basic Books.

Gerbner, G. (1989/1990). Media literacy: TV vs. reality. *Adbusters, 1*(2), 12.

Giroux H., & McLaren, P. (1989). Introduction. In H. A. Giroux & P. L. McLaren (Eds.), *Critical pedagogy, the state, and cultural struggle*. Albany, NY: State University of New York Press.

Giroux H., & McLaren, P. (1991). Leon Golub's radical pessimism: Toward a pedagogy of representation. *Exposure, 28*(12), 18–33.

Giroux, H., & McLaren, P. (1992). Media hegemony. Introduction to *Media Knowledge* by J. Schwoch, M.White, & S. Reilly. Albany, NY: State University of New York Press.

Gitlin, T. (1986). We build excitement. In T. Gitlin (Ed.), *Watching television*. New York: Pantheon Books.

Grossberg, L. (1988). *It's a sin*. Sydney, Australia: Power Publications.

Hammer, R., & McLaren, P. (1996). Le paradoxe de l'image: Connaissance mediatique et declin de la qualite de la vie. *Anthropologie et Societes* [special issue]. "Pouvoir des Images."

Hammer, R., & McLaren, P. (1991). Rethinking the dialectic. *Educational Theory, 41*(1), 23–46.

Hammer, R. & Wilden, A. (1987). Women in production: The chorus line 1932–1980. In A. Wilden, *The rules are no game* (pp. 283–300). London and New York: Routledge and Kegan Paul.

Haraway, D. (1991). On wimps. *Journal of Urban and Cultural Studies, 2*(1), 41–44.

Herman, E. S., & Chomsky, N. (1988). *Manufacturing consent*. New York: Pantheon Books.

Jhally, S. (1990). *The codes of advertising*. London and New York: Routledge.

Kearney, R. (1988). *In the wake of imagination*. Minneapolis: University of Minnesota Press.

Kellner, D. (1990). *Television and the crisis of democracy*. Boulder and Oxford: Westview Press.

Kellner, D. (2001). *Grand theft 2000: Media spectacle and a stolen election*. Lanham, MD: Rowman and Littlefield.

Kellner, D. . (2005). *Media spectacle and the crisis of democracy: Terrorism, war, and election battles*. Boulder: Paradigm Publishers.

Larsen, E. (1991). Gulf War TV. *Jump Cut, 36*, pp. 3–10.

Lutz, W. (1989). *Doublespeak*. New York: HarperCollins Publishers.

McKenzie, W. (1991). From Fordism to Sonyism: Perverse readings of the new world order. *New Formations, 15*, 43–54.

McLaren, P. (2006). *Radical pedagogy: Postcolonial politics in a post-modern world*. London and New York: Routledge.

McLaren, P. (1985). Contemporary ritual studies: A post-Turnerian perspective. *Semiotic Inquiry, 5*(1), 78–85.

McLaren, P. (1986). *Schooling as a ritual performance: Towards a political economy of educational symbols and gestures*. London and New York: Routledge and Kegan Paul.

McLaren, P. (1988). Critical pedagogy and the politics of literacy. *The Harvard Educational Review, 58*(2), 213–234.

McLaren, P. (2006). Introduction. In P. McLaren (Ed.), *Postmodernism, postcolonialism, and pedagogy*. Albert Park: Australia: James Nicholas Publishers, Ltd.

McLaren, P., & Hammer, R. (1989). Critical pedagogy and the postmodern challenge: Towards a critical postmodernist pedagogy of liberation. *Educational Foundations, 3*(3), 29–62.

McLaren, P., Hammer, R., Sholle, D., & Reilly, S. (1995). *Rethinking media literacy: A critical pedagogy of representation.* New York: Peter Lang.

Miller, C. M. (1989). *Boxed in: The culture of TV.* Evanston, IL: Northwestern University Press.

Naureckas, J. (1991, May). Gulf War courage: The worst censorship was at home. *Extra!, 4*(3), 3–10.

Nelson, J. (1987) The perfect machine, TV in the nuclear age. Toronto: Between the Lines Press.

Norris, M. (1991). Military censorship and the body count in the Persian Gulf War. *Cultural Critique, 19,* 223–245.

Poster, M. (1990). *The mode of information.* Chicago: The University of Chicago Press.

Poster, M. (1991). War in the mode of information. *Cultural Critique, 19,* 217–222.

Postman, N. (1985). *Amusing ourselves to death: Public discourse in the age of show business.* New York: Penguin Books.

Rogin, M. (1990). "Make my day!": Spectacle as amnesia in imperial politics. *Representations, 29,* 99–123.

Schiller, H. I. (1989). *Culture, Inc.: The corporate takeover of public expression.* New York and Oxford: Oxford University Press.

Schulte-Sasse, J. & Schulte-Sasse, L. (1991). War, otherness, and illusionary identifications with the state. *Cultural Critique, 19,* 67–95.

Schwoch, J., White, M., & Reilly, S. (1992). *Media knowledge Readings in popular culture, pedagogy, and critical citizenship.* Albany, NY: State University of New York Press.

Shohat, E. (1991). The media's war. *Social Text, 9*(3), 135–141.

Soley, L. (1991, May). Brookings: Stand-in for the left. *Extra! 4*(3), 6.

Thompson, J. B. (1990). *Ideology and modern culture.* Stanford, CA: Stanford University Press.

Wark, M. (Winter, 1991). From Fordism to Sonyism: Perverse Readings of the New World Order. New Formations, 15, 43-54.

Werckmeister, O. K. (1991). *Citadel culture.* Chicago: The University of Chicago Press.

Wilden, A. (1987). *The rules are no game.* London and New York: Routledge and Kegan Paul.

Willis, P. (1990). *Common culture.* Boulder, CO: Westview Press.

Zizek, S. (1991). *Looking awry: An introduction to Jacques Lacan through popular culture.* Cambridge, MA: The MIT Press.

A version of this chapter originally appeared in P. McLaren, R. Hammer, D. Sholle, & S. Reilly. (1995) *Rethinking media literacy: A critical pedagogy of representation.* New York: Peter Lang.

Media Power (Per-)Formed

The Strategies of Communication Technology and Their Consequences to the Built Environment

Rick Dolphijn

Introducing Monism: The Virtual and the Actual

With the arrival of the Internet, a new spatiality has come into existence in the form of cyberspace. Cyberspace is considered to be a virtual space that is radically different from the actual space of our daily life. The concepts of "virtual reality,," of "net based communities," and even of "e-mail" (as opposed to mail sent via the postal service), have given us the idea that cyberspace made a new world available to us: a better world even, in which space and time do not seem to limit our encounters, and in which our bodily limits (or even deficiencies) do not hold us back. For those with some knowledge of the Christian and Platonic roots of western society, this positivist idea of a second world that is portrayed as better than ours must sound familiar. The Platonic world of ideas and the Christian heaven have also been presented to us as worlds without the physical limitations of our bodily existence. Christianity and Platonism gave rise to western metaphysics, a profoundly dualist way of thinking that has dominated occidental culture for a very long time and created many binary oppositions according to which it organizes the world. The strict separation of heaven and earth is one of them, but the Cartesian difference between body and

mind, the Newtonian difference between space and time, and the Freudian difference between the conscious and the subconscious, are just a few examples of dominance of opposed duality in western culture. The invention of cyberspace presents itself as one of its last products, and one that has the power to be just as influential as the oppositions mentioned above.

In the margins of western thought, however, this major dualist tradition has been held off by a minor monist tradition. Thinkers like Spinoza, Nietzsche, Marx, Einstein, Foucault, Virilio, and Deleuze, to give some well known examples, have all tried to emphasize (in different ways of course) that, although our world consists of various different phenomena, it is first of all through their intermingling, interacting, and interconnecting that these singularities come into being and thus make up for one world. Especially because the focus of these scholars is much more on what happens between the different phenomena, and not so much on trying to find out what the essence of a particular material or immaterial object is (an essence, which in Platonist thinking is nothing but the minor infusion of the pure essence that can only be found in the world of ideas), the perspective of the monist tradition is much more on how the different phenomena actively form the real in the way they relate to one another. In other words, the monist tradition tries to show us in what way the real is a performative construction that is produced with the interweaving of the different objects of which the qualities are never considered to be internal to the things themselves but are attributed to them in the way they relate to the other phenomena that surround them.

It should therefore come as no surprise that the scholars of the monist tradition have great difficulties in making use of the fixed binary opposition of virtual space and actual space; they have big problems with the idea that there are fixed predetermined forms of space that have fully different ontological statuses that are almost incompatible with one another. Of course, dualist thinkers like Descartes were also confronted with this problem, and most of the time this "link" between one reality and the other was the weakest link in their model. Descartes proposed to look for the link between the human mind (the *res cogitans*) and the human body (the *res extensa*) in the pineal gland, where a homunculus (a very small human being) was thought to connect the two realms. Unarguably this was not his strongest argument. The full separation between actual space and virtual space nevertheless seems to ask for a similar contrived solution, a digital homunculus probably that connects virtual reality to actual reality. Again this thought is not very convincing.

The monist tradition offers a radically other way of thinking the virtual. Especially in the work of the already mentioned Deleuze and notably in his reading of Bergson (although critical about Einstein, also very much a monist thinker), we find an idea of virtuality that is different from the definitions attributed to the virtual in the greater part of media literature. Virtuality, in his reading, should not be seen as opposite to the real (as the dualist would claim), but as fully part of it. The virtual, then, is used to indicate the always already present possibilities that can be realized with and through the actual, the material or immaterial living object. The virtual is thus the potential, the reality of change, as Massumi reads it (2001, pp. 1080–1081) that offers ways to happen. The virtual, in a

Deleuzian sense, defines what the real can do, what it is capable of: a truly monist idea, no doubt.

Media and Space

In order to see where this Deleuzian or Bergsonian idea of the virtual will lead us, I propose to take a look at the spaces created by the new media forms throughout the ages. Thus, we should see that the new means of communication had a major impact on the possible as they radically expanded the virtual and thus the ways in which the actual might change. For if we think from the monist perspective, the power (or quality) of new media forms does not so much lie in the physical appearance they might embody (the object itself, or the metaphysical ideas it articulates), but much more in its power to deterritorialize the actual, the living bodies to which it relates and of which it is capable of expanding its possibilities. The introduction of the mobile phone, to give an example most of us still well remember, not only meant that the actual was enriched by a telephone without a cord. In its diminished dependence upon a fixed place, the mobile phone allowed us to call and to be called no matter where we where, enforcing a new form of spatial and social organization upon society. David Morley, for instance, showed that the mobile phone radically deterritorialized family life as it diminished the need for physical contact and questioned the domestic rules that gave form and limited this concept before. The mobile phone brought about a new virtuality, a new set of possibilities, giving rise to a new reality of change that had great impact on how people live their lives, on how the actual is being (re-)produced.

Of course, not only the mobile phone changed society: the introduction of every successful major new means of communication was never limited to the longer or shorter waves in the air and the machines that produced them. On the contrary: " . . . any new means of moving information will alter any power structure whatever" (1964, p. 99), Marshall McLuhan already told us, thus stressing that a major new medium always already produces a new reality, causing a reterritorialization of the actual according to the form and substance of its expression. Marshall McLuhan himself gives us many examples of how the coming of a new medium introduces a new reality. The invention of the printed book by Gutenberg, for instance, did not only cause people to clone the book, producing an endless series of similarly printed paper. He also claims that the rigid textual interpretation of the Holy Word by Martin Luther could not have taken place if it wasn't for the invention of print because his critique of papal power is very much based on strict literal interpretations of the Bible that came to be available to him and his sympathizers owing to this invention. Because printing caused the birth of new social groups that came into new relations with each other, causing new and actually much more fundamental and organized dialogues to occur, it also came with a new type of city, Marshall McLuhan argues: a modern city in which the corporate medieval (feudal) patterns were challenged and replaced by those of the modern time, of the market, of nationalism, and of religious fundamentalism (Luther was the first terrorist of the Western World). Creating political unity via a homogeneity that became feasible for the first time with the coming of print, the city became the center of western culture, whereas

the countryside was not so much shut out, but rather was turned into the main (natural) supplier (of goods and people) to support the (cultured) urban structure.

Comparable to Deleuze and Bergson, McLuhan also proves himself time and again to be a monist thinker: He does not claim that new media revolutions create a new form of space—be it "visual space," "auditory space," "electric space," or even "cyberspace" for that matter—but rather acknowledges that the very different dimensionalities create the world we live in by their interconnectedness, evoking and inciting one another so strongly that they function as one. McLuhan shows that the multiplicity of spatial articulations is displaced with every new technological innovation, and consequently reterritorialized entirely every time new dimensions are added to it, thus creating a new whole that performs the new social, cultural and notably, the new political truths to come.

The Micropolitics of New Media: Three Revolutions in the House

One great advantage of monism is that it allows us to follow the strategies of power as they are expressed with the media. On top of that, it allows us to see in what way the new media forms virtually expand the possibilities of control and thus (re-) create the political real. In fact, we do not have to travel very far to see the spatial micropolitics of new media at work. In every household, the power that comes with communication technology is organizing and stratifying our most private spheres. This is not a new phenomenon, but especially since the middle of the twentieth century, new media technologies have increased their grip on the domestic spaces and not only by intruding our private domains, but just as well by altering them, by reorganizing material forms according to their needs, strengthening our bonds with the social and political forms of organization that implicitly or explicitly rule society. In general we can say that a threefold revolution marks the gradual increase of the organizational skills of media power in terms of its spatial consequences and in how the human being functions in it.

First, the coming of the television took people out of their kitchen/dining room—the center of family life till then—and placed them in the newly formed living room. Whereas the family members sat in a circle around the dining table facing and being in conversation with each other in the kitchen/dining room, the living room required them all to be seated opposed to the television since now it was not the father, the mother, or the child who was the most important discussion partner in the house, but the television. Earlier, the sound of the radio already intruded our personal sphere, but it was the television that first demanded a radical makeover of our most important social space because it not only bothered our ears but also captured our eyes. The television deterritorialized life from the circle-shaped microspace of the kitchen, reterritorializing it in relation to the linear televised space of the living room.

The second major reorganization of the house was taken by the personal computer. Since the 1980s this new machine intruded our homes, though reterritorializing domestic space

very differently from the way television had done that before. The personal computer, being a child of its late capitalist time, was not interested in attacking and paralyzing the family as a whole, but interactively focuses its attention to one individual family member at a time. Contrary to the television which set up a new central space in the household, the PC asked for a private room (a study) or a remote corner, far away from family life, where it could deal with one family member at a time, connecting it, one-on-one, to the social and political strata of the entire world. Whereas the television anaesthetizes the family as a whole with its profusion of illuminating images and signs, the PC expectantly invites its individual user to be interactively incorporated into its digital logic.

Only recently, mobile technology has brought us the iPod, the mobile telephone, and other new (mobile) forms of telecommunication that continue the postmodern strategies of the PC in that they approach one individual family member at a time, and make it part of its interactive universe. Contrary to the PC (and to television), though, mobile technology no longer asks for a (material) architectural reorganization of the house. It does not need to because it clinches onto our body, following us wherever we go. Perhaps it is only in our cars, our most mobile rooms till then, that a minor reorganization of space has taken place according to the needs of mobile technology with the introduction of the mobile headset and the satellite navigation systems.

The Macropolitics of New Media: Three Revolutions in the City

The spatial reterritorialization of modern media is of course in no way limited to the intimacy of the household. New media forms, as McLuhan, the monist, already indicated, reterritorialize spatiality as a whole and thus alter not only the cluster of spaces that create the inside of our homes, but also the urban spaces that enclose it. Because of the size of the city, the spatial politics of new media forms was actualized considerably slower there than within the household. However, also in the strata of cityscapes can we distinguish three major media revolutions functioning as the new horizons according to which urban spatial reorganization has set into motion.

It was already mentioned that McLuhan considered the coming of print of major importance to the rise of the western city as it showed itself to be increasingly capable of organizing and controlling larger groups of people. The occidental city as it has developed since the sixteenth century, therefore still functions as a western village, as it is also organized according to a double power structure (the heavenly and the earthly powers) that point the center of the socioscape (the church and the town hall). Sure, the town house became the city hall and the church became the cathedral or the basilica, but the power structure was unaltered. The only thing that changed was that larger groups of people could be kept under its control. Owing to the printing of the Bible and the civil code, the double power structure of the West gave form to the occidental city as we knew it for a long time: the cathedral and the city house as the tall and the wide building that form the heart of every

western city center, and the concentrically formed extensions that are gradually added to it, expanding the subdominant part of town, increasing the bipolar central power.

A second, equally radical reterritorialization came into being with the introduction of the car—a medium, just like the book, Marshall McLuhan claims, because it is equally capable of transporting information. Following this thought McLuhan even argued that the highway is the major twentieth-century architectural invention. The highways, the car-sized electricity cables that traversed the countryside and streaked the city increasingly since the beginning of the twentieth century, once again rearticulated the relation between the city and the countryside. Earlier we saw that the birth of the western city, as caused by the invention of printing, had created the countryside (and not the other way around) in order to fulfill its needs as it had to produce the goods and the people necessary for the city's survival, emphasizing the cities' intraconsistent powers creating a hierarchy between the dominant (the city) and the village (the subordinate) sociospaces. The coming of the highway—a communication network primarily constructed between cities—emphasized the cities' transconsistent powers as it caused them to focus more and more on keeping up and increasing the trade relations with other cities. Sure, the countryside still somehow supplied goods and people (just as the inter-city relationships were also there before the coming of the highway), but as the asphalt vascular system primarily focused on the relations between cities, the countryside functioned less and less as the production site in relation to which the dominant political economy was constructed but merely as the supply route through which the cities communicated and exchanged their goods and people.

One important consequence of the invention of the car (as with any media revolution) is that it is capable of expanding the human possibilities, increasing the speed of communication, and thus conquering the spatio-temporal limits that restricted us before. As the car was—much more than the book—also a victory over our physical limitations, it allowed us a more liberal use of space. In practice, it gave rise to the late capitalist society in which the worker did not have to live next to the factory (capitalism had already caused the center of the city to lose its pivotal function as it was now less and less the church and the town hall that dominated people's lives, but the factory). The coming of the car thus created the suburbs that radically expanded the surface of the city.

Interestingly enough, the sketched development of the city seems to travel toward the east: from the medieval towns that correlate the European continent, the cities then set foot on American soil and the closer we get to its west coast, the more we witness in what way the coming of the car metamorphoses the urban sphere. Lars Lerup (2000) made a nice analysis of that, when he showed that the American suburbs to be found primarily on the west coast, more and more contradicts concentric urban theory. Most of all because the traditional binary opposition between the core which dominates the city and the suburb that functions according to the will of the core (even if we exchange the church/city hall for the factory or office building), becomes less and less important as we travel further away from America's East Coast. Suburbia does not seem to be very much in need of a center anymore. It is often linked to it, but is increasingly capable of acting independently from both the old city center and the new capitalist centers, disposing the traditional power struc-

tures that formed the cities for such a long time of its social, cultural, and political functions.

The development of urban space, however, does not end with Los Angeles, just as the car was not the last media revolution to have reterritorialized city life. The technological innovations that had already changed the interiors of our houses for the last fifty years—as described above—have a growing impact on the contemporary developments of the urban spheres that surround us. However, if we want to see in what way the newest media give form to the built environment, we should go further to the East, travel across the Pacific, and focus on the massive urban changes that are today reshaping East and Southeast Asia. Especially in China we can nowadays witness the birth of a city form that seems to have released itself completely from the spatio-temporal restrictions that had limited the occidental city before. Think of mega-cities like Wuhan, Chongqing, and Shenzhen, of which the latter only had a few hundred thousand inhabitants two decades ago and that now counts over ten million people. Cities, despite their enormous size, are not even loosely structured around a city center; they seem to make no distinction between the old and the new; and they once again rephrase their relation to the countryside. Earlier we saw that the literate city, in order to define itself, made use of a strict economical distinction between the city (the consumer) and the countryside (the producer). Later, the automobile city turned the countryside into a feeder road, an asphalt vector between the urban correlates. Now, the countryside is completely swallowed by the city, or at least, the difference between them does not seem to exist anymore. The cities that are nowadays constructed in China are not built as a unity or an enlarged village that is cut loose from the countryside. Rather, they are themselves conglomerates of villages, all of them oriented toward the inside and seemingly disconnected from the rest of the town. They are archipelagos, irregularly shaped masses of land occasionally immersed in (liquid) emptiness. They are loose constructions that are not organized according to a point but that increase and decrease, that accelerate and decelerate whenever the economic and political times are right.

It is no coincidence that the contemporary Chinese city started its rise from the 1980s. One could say that this was because of Deng Xiaoping's liberalization of the Chinese market, but from the point of view of media studies, it seems (very) reasonable to say that its rise came with the introduction of the personal computer and the digital revolution that followed from it (it has only been since the late 1990s that China really started its immense growth). For the fragmented internally organized bits and pieces that in their interrelatedness construct the contemporary Chinese city do seem to coincide with the general trend of these late capitalist times as spearheaded by the way the personal computer had always already been interested in organizing and secluding the smallest possible group, a strategy refined by mobile technology that is even less constrained in dispensing its social and political opiates to the individual members of society. (Please keep in mind that Chinese is already by far the most used language on the Internet and that this country is nowadays by far the biggest market for mobile technology in the world.)

New cities are composed that are in no way held together by the spatial strategies that still dominate the cities in Western Europe and those in America. Think of cities like Shenzhen that are neither built around a church or a government building nor around the

economic powers of early capitalism (= factories and businesses) but that have a golf course in the middle, a void, an empty space that in no way functions as the heart of the city. The new Chinese cities do not expand concentrically, according to the city center, but they seem to spread rhizomatically in every direction. They are not obstructed by any social, cultural, or political limit, but they seem to experiment with all the virtual possibilities offered by the current state of communication technology. Thus, skyscrapers are built in the middle of the countryside, whereas the city plans are speckled with empty spaces that lie fallow between the incorporated villages, the skyscrapers, and the flyovers that also populate this part of town. Architect and urban theorist Rem Koolhaas was right when he claimed that the new Asian cities are urbanities without an urban form. Although it is impossible to anticipate the influence this new city form may have on the social and cultural changes that are about to take place everywhere in the world, the new oriental urban spheres, in their actual form and in their virtual possibilities, are sure to have just as much impact on the course of history as did the medieval homogeneous European towns and the car-cities that can be found in the West of the United States. It should thus be no surprise that leading sociologist Manuel Castells already pointed out in 1996 that the southern Chinese megalopolis is sure to rule the world in the near future as the new dominant performer of life.

The New Nomads

The contemporary Chinese city seems to be functioning so well in relation to the media revolutions of today perhaps because of its similar construction. In both cases fragmented small communities are directed toward the inside, and in their loose spatial interrelatedness, they create a giant whole. Not like a static group but like herds they explore and scour the land in search of fortune, joy, or profit. The Internet with its countless communities, discussions, and forums is a conglomerate of microspaces that are somehow linked to one another, but that come under one single uniform rule. Similarly, the contemporary Chinese city—an endless conglomerate of inwardly organized villages—does not correlate into a uniform whole but rather composes an endless variety of social flows.

This contemporary strategy seems to be non-consonant with the communist winds that blew across China for about 50 years and introduced a modernist, concentric architecture to its cities. Modernism gave China's center of power, Beijing, a strong heart: It redecorated the Tiananmen square by nailing the static party offices to its east and west end, planted Mao's mausoleum in its middle, and hung his portrait above the entrance gate to the Forbidden City that bolts its north end. All of these important, impressive, powerful, and, most of all, enormous additions (except for the Forbidden City, there were no major buildings in this area before communism) were built in order to turn the Tiananmen square— once just another broad and short market street—into its fulcrum. In later times, modernism has been applied to do honor to the important buildings in Shanghai's Pudong area (the Oriental Pearl TV Tower in particular), and it is now being used to build the Olympic halls in Beijing.

However, the dominant strategies displayed with the drastic increase of urban expan-

sion as we see it in China today, seem to have much more in common with the urban design techniques that dominated China before the coming of modernism. The new cities in fact seem to be very much in line with the city-forms that had already conquered this part of the world far before Johannes Gutenberg invented book printing. Its horizontal organization has sometimes been replaced by a vertical one (the village becomes the skyscraper), and, though its speed of change might have accelerated, its social function remains unchanged: small strictly inwardly organized communities that hardly seem to be connected to one another yet are capable of forming an endless organic whole. Leonardo Benevolo, an influential scholar in urban history, has noted that the city of Tj'ang-an (contemporary X'ian), comprehended an area of about 20,000 hectares around the year 600 already, unprecedented dimensions in the pre-industrial world (1993, p. 31). However, it had no central square, no concentric organization, and obviously no printing in order to make them act according to the letter of the law.

The coinciding of the hyper-mediated postmodern city and the pre-modern city seems to have closed the urban circle in many ways. It is the end and the beginning of the eastward development of urbanity. It is the end and the beginning of the city as a socioscape opposed to the countryside. It is the end and the beginning of the political stratification of the city by the new media forms. Before book printing and after the digital revolution, there is no such thing as a city, and there is no countryside. There is space-time to be traveled, virtually and actually, that is not to be conquered or to be excluded in order to come to an ideal world, but that, in being traveled opens up the real and explains the possibilities of life.

REFERENCES

Benevolo, L. (1993). *The European city*. Oxford: Blackwell.

Deleuze, G. (1988). *Bergsonism*. New York: Zone Books.

Lerup, L. (2000). *After the city*. Cambridge, MA: MIT Press.

Massumi, B. (2001). Sensing the virtual, building the insensible. In E. Kaufman & K. J. Heller (Eds.), *Deleuze and Guattari: Critical assessments of leading philosophers*. Vol. 3, Part VIII (pp. 1066–1084). London, New York: Routledge.

McLuhan, H. M. (1964). *Understanding media*. New York: Signet.

Visual and Verbal Thinking

Constraining and Enhancing Meaning

Philip M. Anderson

In the multimedia world, image and sound are both central to the construction of meaning. Ever since the brilliant demonstration of sound effects and music in the creation of the images in *Top Gun* (Badalato & Scott, 1986) was shown at the 1987 Academy Awards on primetime television, even the casual viewer of film is aware that the experience of "viewing" is contingent upon more than just the eyes. *Top Gun* was nominated for sound effects editing, sound, music, and film editing, a classic case of all the elements working syncretically. The film, essentially a recruitment film shot with the full cooperation of the military (no Hollywood producer can afford an aircraft carrier), was a summer fun blockbuster in 1986. The sensory experience of the film transformed the political ideology into an adventure-romance. Though, to be fair, not everyone was taken in by the experience. The most interesting transgressive reading was Roger Avary and Quentin Tarantino's elucidation of a homosexual subtext expressed, interestingly enough, by a character played by Tarantino in another film, 1994's *Sleep with Me* (Castleberg & Kelly, 1994).

Sound effects (think of horror films) and music (think of MTV-style music video) are integral to certain genres of film and video. For example, sound enhances the experience of watching horror films—when the sound is turned off, the effect is considerably lessened.

While the full range of sound in the larger picture of multimedia is of interest, in this chapter the focus is on the spoken voice and textual representation and their relationship to the image. In documentary and propaganda films, the text (the written or spoken voice, usually as an omniscient voice-over) constrains the viewer when presented with images. This effect can also be achieved through music, of course. A critical assessment of "entertainment" films involves the same mechanism: The heroic music in *Top Gun*, for example, tells us we should applaud the killing of enemy combatants. However, the main concern here is the educational function of multimedia and the ways in which images are constructed and reconstructed cognitively and emotionally by text. In most cases, words constrain the image's interpretation by the viewer. This statement is not to argue for a deterministic view in the transaction, but rather a clear indication that one cognitive process affects the other, modifying, enhancing, and constraining one another.

At a conference organized around the topic of computer games and learning, one of the speakers, fresh from the MIT Media Lab, began by situating himself pedagogically and politically. This was a conference, of course, where everyone employed a Powerpoint presentation of both text and image. (One participant referred to the arrangement as VGA lottery: a verbal joke about a visual issue.) The presenter announced that he had been a student at Miami University of Ohio when both Henry Giroux and Peter McLaren, two of the founders of critical pedagogy, served on the faculty. He said some disparaging things about his education in education at that time, mostly to the effect that educational study in the critical paradigm appeared to him to be essentially thinking exactly like, or in fact becoming, your professor.

He spoke about why research in cybernetic learning was more interesting than critical pedagogy briefly and then, before moving into his main presentation on learning in gaming environments, flashed pictures of Giroux and McLaren on the screen. The photos were published off the Web and showed each with coiffed longish hair, vaguely bohemian attire, and, in the case of McLaren, dark glasses. (The Giroux photo was taken in 1998 by Greg Grieco and features Henry holding a book entitled *Channel Surfing*; the McLaren photo is courtesy of Laura McLaren-Layera, and is featured on Peter's Web site.) The conference speaker made a dismissive gesture, mumbled something about not being able to identify with these guys, almost as if the images spoke for themselves: these guys can't be serious. This spectacle was presented to an audience adorned with short sleeves, uncombed hair, t-shirts, and cats-eye spectacles, who began to murmur like judges at a witch trial when the images flashed on the screen. It was a powerful and disturbing moment. Even so, it was nothing more than *ad hominem* criticism through image. (Please note, for later reference, the images conjured in your heads in response to my description of the conference audience and your response to my creation of possibly stereotyped images of the techno-geek crowd, a group who call themselves "geeks.")

These photos of Giroux and McLaren were meant to represent the authors in a particular way. The "original" (or maybe "authentic") text under their pictures, or the accompanying text, tells the reader something about the authors, something congruent with the images of the author. There is an expectation of congruence between ideas and images. The

intended relationship of the image and the text is one of reinforcement: These guys are cutting edge, outside the academic mainstream, in touch with the European and bohemian. If one reacts negatively to the images (for whatever reason, including fashion), one is at least impressed by the biographical copy. To remove those images from one context and place them in another changes the meaning of the images. I responded critically (intellectually, at least) to the out-of-context presentation of the images, but not everyone in that setting would. The text, the speaker's indictment of the two professors' teaching, shaped the negative response that was "reinforced" by the images.

The same effect is gained when Fox News shows Arab demonstrators burning symbols of the United States and then labels the image terrorists or rioters or demonstrators or allies of Iran. We frequently see only what we are told we are seeing. To show the viewer idyllic images of Palestinian children and put the label "terrorist" on the image constructs a form of cognitive dissonance that does not serve the propaganda function of the Murdoch news empire. Again, the argument is not that the text determines the viewer's response, but it does constrain the response. Even the politically sophisticated viewer of a propagandist documentary is responding to the attempts by the filmmaker to determine the viewer's response. The nature of critical response is to analyze and critique the relationship of the medium and the message. Whether we "agree" with a point of view in a documentary is contingent upon the reconciling of the image to the text in our vision of social reality or social expectation.

Much of the current work on multimedia engagement appears to assume a single process of "viewing" rather than multiple sensory and mental processes. It tends to focus on the visual element in multimedia with many critics of the media in educational settings arguing against the "passivity" of viewing or complaining that viewing is "replacing" language learning. Proponents of multimedia learning tend to emphasize semiotic or learning styles arguments, many of which are no more sophisticated than the "passivity" argument in their ethical and sociological emphasis. In each case, the image elements are separated from other forms of sensory experience and from other cultural forms of communication and representation.

When the average Hollywood blockbuster involves over 200 scene changes, even common sense tells us that viewing itself cannot be passive. Further, the passivity argument assumes that there is no language processing (or any other kind of aural processing such as sound effects) asked of the "viewer" in watching a film. It also assumes that language and viewing are separate, unrelated mental processes. Unfortunately, many of the proponents of multimedia learning leave out the language element as well, assuming visual learning is a separate learning style or cultural preference. Part of the problem here is the perceived need to establish media studies as a new field rather than connecting it to established research and theory within literacy studies of various sorts.

In studies of the role of visual processing in reading comprehension, Sadoski and Paivio have demonstrated that verbal processing, as in reading a written text, also engages visual mental processing. Simultaneously, studies performed since the1990s employing functional MRI equipment to map mental processes clearly show that the visual cortex is stim-

ulated during the act of reading. Given that dual coding occurs during textual processing, one assumes dual coding also applies to visual response, from both a mental and a cultural perspective.

Indeed, here is the connection between language theory and visual theory for educational purposes. It appears that the attempt to develop a new theory of multimedia understanding is mired in the Marxist critique, expressed by Curran and Gurevitch as, "The media . . . relay interpretive frameworks consonant with the interest of the dominant classes, . . . audiences, while sometimes negotiating and contesting these frameworks, lack ready access to alternative meaning systems that would enable them to reject the definitions offered by the media in favour of oppositional definitions" (1977, pp. 4–5). While the approach has merit, and I demonstrated it above with the *Top Gun* example, the relationship of the viewer to the multimedia "text" is more than merely ideological. To understand the relationship fully, one must engage a range of cognitive processes and interests in sorting out the "effect" of media.

Multimedia text processing suggests reciprocal processes at work, and the visual and the verbal both "enhance" and "constrain" one another. The *constrain* model refers to the critical/analytical aspect, whereas the *enhance* part tends toward the creative and constructive. Media study frequently avoids the cognitive aspect, and hence it may be more fruitful to look elsewhere for a foundation of pedagogical theory for multimedia. The traditions of reader response theory, research on the relationship of the reader and the text (dating back to Abbott & Trabue in 1921, and Richards in 1929) and the relationship of textual readings to one another, are a path to multimedia meaning making. Multimedia theory cannot be separate from other comprehension and response theories, and certainly not less complex given its synthetic nature. Teaching multimedia literacy requires a pedagogy that takes into account all the elements of meaning and production. In fact, research into that pedagogy requires a theoretical framing that includes all the human (and cybernetic) senses.

The curriculum in schools is as much at fault for the separation of text and image as any other influence. Prejudice against media study includes the charge that somehow television and film are not in the "Great Tradition," that they are passive experiences, and non-verbal (or worse, anti-verbal). However, as if we need to be reminded, most films and television shows are not improvised but written. Literacy underlies the so-called visual media, as much as it does most other art forms. When one discusses film and television, one uses language; and, when one develops scripts for filming, one uses language. As for undermining the Great Tradition, there are not enough theaters in the country to hold the number of people who see a single Shakespearean production on public television.

The failure of much classroom film and television study and production is the lack of a script; a film cannot be made without a script, a film cannot be studied without a script. Film is also about revising: the script is written; the script is re-written as many times as necessary before shooting begins; the script is revised after shooting begins; the film is edited (editing involves structuring, revising, and putting in the final touches, like sound effects). The first part of the task of making a film is the teacher's responsibility; scriptwriting is the first part, and probably the key part, of good filmmaking.

When a college film studies class examines a film, the students use a published script of the film for reference. There are no more illiterate students in a film class than there are in any other class. Scripts of most important films are currently available, and "novelizations" of popular films abound. However, that doesn't usually happen in schools or in other subjects. For example, when an English teacher plans to teach *Hamlet*, she provides her class with a script. However, generally, when she wants to study film, she just "shows" the film. Teachers do not need to be filmmakers; they only need to treat film and video like any other dramatic piece.

A brief digression to provide some quick responses to what you are thinking at the moment, all commonsense objections to the points raised above: Television and film are no more relevant than books. Media study does not replace text; it broadens and deepens our understanding of texts. A multi-literate person is more literate, and more culturally literate, than someone who is only book literate. Scriptwriting is not fun. Most writing is not fun: I am not even enjoying writing this and would rather be watching *Jeopardy!* on television. On the other hand, writing of all types must be done at all levels, with all students, including "creative" writing. Most new technology broadens the scope of language: Radio and television bring standard dialects into the home, along with speakers and words, people would never have heard before the invention of these media; computers gave us word-processing with its secretarial function to promote revision of text; the phonograph restored poetry to its bardic function. Now back to our regular programming.

Extensive theory and research on language learning and language skill development suggest that there is a more compelling reason for the inclusion of literacy-based media study than the traditional "relevance" and "enrichment" claims. One would have to believe that the failure of complexity in much multimedia pedagogy and research is a failure to root the investigations in the constitutive activity of language use, oral and written. To base multimedia study in language *use* is to tie it to a century of study by some of the great pedagogical minds of the twentieth century. Below are some snapshots of key theorists and the possible connections with multimedia study.

Louise Rosenblatt's transactional theory of literary reading suggests that reading is a transaction between the reader and the text. The transactional model changes the role of the reader from the passive decoder and consumer of information, to an active participant in the construction of meaning through the text. This view of reading implies that hearing, speaking, and viewing are also interactive processes and, combined with the language theories of Vygotsky, would suggest that this transaction is necessary to verbal thought.

As mentioned above, the popular idea that film and television are "passive," in contrast to "active" reading, does not make psychological sense. The fact that televisions are left turned on when no one is watching probably accounts for the confusion. Does an open magazine on my coffee table prove that reading is passive? Even the most rudimentary form of television, the game show, draws the viewer into active involvement through its competitive framing—most of the new reality television shows are competitions themselves, though through a voyeur's lens.

George Hillocks's research attempting to establish a hierarchy of skills in the compre-

hension of literature suggests that the highest level of understanding in literature study is at the level of "structural generalization" (Kahn, Walter, & Johannessen, 1984). Part of understanding literature at the structural level is comprehending how the conventions of a genre contribute to the meaning of a text. When we ask students to turn a short story into a poem, or turn an essay into a fable, we are asking them to operate at the highest levels of literary understanding. Translating a short story into a film script, or turning a film into an essay are high-level writing and thinking activities. Discussing the difference between a film treatment of a story and the original text demands a high level of literary and imagic understanding.

James Britton and his colleagues' work on the development of writing abilities suggests a useful way to approach literacy in all its forms. This functional model of writing posits three categories of discourse: expressive, transactional (not to be confused with Rosenblatt's transactional model), and poetic. Expressive writing's audience is the writer herself, and functions primarily as a means of generating and recording thought. Transactional discourse is writing that communicates directly to an audience, and the writer assumes the psychological role of participant. Transactional writing includes school essays, letter writing, generalized narrative, and other workhorse categories we teach.

Poetic discourse is what we sometimes call "creative writing" (though all writing is creative, and teachers frequently accept expressive discourse for poetic discourse). Poetic discourse is less concerned with the efficiency of communication, and more concerned with the shaping of a verbal object. The writer of poetic discourse assumes the psychological role of "spectator." No such thing as purely transactional or purely poetic writing exists; imagine that the categories occupy a continuum with the telegram at one extreme and the poetry of the Imagism movement at the other.

Most of the writing we do in schools is transactional in function; we ask our students to write book reports, persuasive essays, or descriptive essays. Transactional writing is an important form of discourse and an important function of writing to develop (in film, the equivalent would be the documentary). Even so, it is no more important than poetic discourse (or expressive for that matter) in the development of writing abilities. Not only is writing in the poetic mode essential to balanced language skill development, but it also appears writing in the poetic mode enhances the ability to write in the transactional mode, the type of writing many of us consider "real world" writing (Young, 1982). Language development, in the end, is contingent upon the range of language experience taught to, and required of, children and adolescents. Lack of experience in one mode of discourse limits one's abilities in the others—this is likely the case with various media forms as well.

In the development of poetic discourse, media study may be of tremendous use to the English teacher. Scriptwriting may be a key way of developing the spectator role necessary to poetic discourse. If students write a story that must be explicitly "visualized," then they need to assume a role not unlike the spectator role. By assuming this stance in writing, it may assist them in developing and understanding the psychological role. In any case, scriptwriting is a legitimate function of writing in the present age, and could be used as a form of "creative writing" with no more difficulty than the short story (a type of writing also

requiring an assumption of the spectator role).

Students might write better short stories if they wrote scripts first, simply because a script's form and function are more obviously different from other types of writing. Frequently students give us essays or personal narrative when we ask for short stories because they are confusing participant and spectator roles. One reason for that problem is the overwhelming assignment of writing tasks in the participant role. When they fail on the occasional creative writing piece, we exhort them to "show," not "tell" (a variation on the spectator and participant notion) without having them first write in a form (the script) that is almost exclusively "show."

Finally, Britton's theories may serve as useful analytic purposes as well. The relationship of transactional to poetic functions, expressed by Britton as a continuum, help distinguish media discussion of communicative and representational elements in film. In other words, sometimes a film is just an image, a beautiful image, and sometimes it is a message to be understood. Many times it is a little or a lot of both. The poetic function as an analytic category keeps the discussion from turning into a vulgar Marxist analysis of the determining effects of the image, and reminds us that humans also love beauty.

The situation is getting more sophisticated in some mainstream media resources and outlets. For example, an enlightening recent piece by James Curtis on analyzing documentary photographs talks about the use of text in shaping both interpretation and presentation of Jacob Riis's and Walker Evans's photographs, written as part of the multimedia History Matters project. James Agee provided the text for Evans's photographs, of course, speaking of the relationship of poetic image to poetic discourse. Even here, though, one senses that the emphasis for analysis is on the "transactional" discourse and the focus is on class-based critique.

Finally, now that science has turned to visualization for research and theory making, the loss of the humanistic elements, particularly language, in media use is even more at risk (Frankel, 2002). Scientists have a long history of arguing against the value of language in the search for Truth. However, in the end, re-connecting the visual and the verbal, and re-connecting with the viewer, is the only way to develop a comprehensive theory of media study and media learning, as well as media use. In the end, failure to focus on the cognitive mechanisms of visual and verbal processing within multimedia theory and practice can only leave us sitting silently in the dark.

REFERENCES

Abbott, A. A., & Trabue, M. R. (1921). A measure of the ability to judge poetry. *Teachers College Record*, 22, 101–126.

Badalato, B. (Executive Producer), & Scott, T. (Director). (1986). *Top Gun* [Motion picture]. United States: Paramount.

Britton, J., Burgess, T., Martin, N., McLeod, A., & Rosen, H. (1975). *The development of writing abilities* (11–18). New York: Macmillan.

Castleberg, J. (Executive Producer), & Kelly, R. (Director). (1994). *Sleep with me* [Motion picture]. United States: United Artists.

Curran, J., & Gurevitch, M., (Eds.). (1977). *Mass media and society.* New York: Oxford University Press.

Curtis, J. (2003, June). Making sense of documentary photography. *History Matters: The U.S. survey course on the Web,* http://historymatters.gmu.edu/mse/Photos/.

Frankel, F. (2002). *Envisioning science: The design and the craft of the science image.* Cambridge, MA: MIT Press.

Hillocks, G., Jr. (1980). Toward a hierarchy of skills in the comprehension of literature. *English Journal, 69*(3), 54–59.

Kahn, E., Walter, C., & Johannessen, L. (1984). *Writing about literature.* Urbana, IL: ERIC / NCTE.

Richards, I. A. (1929). *Practical criticism* (A Harvest Book ed.). New York: Harcourt, Brace & World, Inc.

Rosenblatt, L. (1976). *Literature as exploration* (3rd ed). New York: Noble and Noble.

Rosenblatt, L. (1978). *The reader, the text, the poem.* Carbondale, IL: Southern Illinois University Press.

Sadoski, M., & Paivio, A. (2001). *Imagery and text: A dual code theory of reading and writing.* Mahwah, NJ: Lawrence Erlbaum.

Vygotsky, L. (1962). *Thought and language* (E. Hanfmann & G. Vakar, Trans.). Cambridge: MIT Press.

Young, A. (1982). Considering values: The poetic function of language. In T. Fulwiler & A. Young (Eds.), *Language connections: Writing and reading across the curriculum.* Urbana, IL: National Council of Teachers of English.

Socialization in the Changing Information Environment

Implications for Media Literacy

Veronika Kalmus

The concept of socialization and the concepts of the "information society," the "digital age," "critical media literacy," and so on seem to belong into different discourses or even paradigms. The practices of socialization, however, have not ceased taking place in the conditions of an increasingly digital and multimodal information environment and hyper-reality. Acquisition of digital skills and communicative competence, and media appropriation in general are part and parcel of the socialization process in contemporary society. The practices of socialization are changing, and they are difficult practices to be studied and to be considered in designing educational strategies, but we should try to do it nonetheless.

What Do We Mean by the Concept of Socialization?

The English word *socialization* has several meanings. The social scientific usage of the term embraces two aspects of the designated process. The first aspect derives from the point of view of society. In this sense, socialization means transmission of the culture of the society to individuals. The second aspect of socialization derives from the point of view of the

individual and means the process of becoming human in one's social environment (McCron, 1976).

It is possible to move beyond the society/individual dichotomy by taking a view on socialization as an interactive, dialectical process between two sets of actors (see, e.g., Berger & Luckmann, 1966/1999; Giddens, 1984, Rosengren, 1994)—the individuals being socialized and the agents of socialization (the family, the school, the media, peer groups, the church, the employment system, and the political system). We can see such a process taking place in the *field of* socialization (Kalmus, 2004), which embraces the individuals being socialized, the agents of socialization, the dominant subsystems of society (one in power, another in the opposition) and the peripheral subsystems of society (e.g., subcultures) (Pawelka, 1977). Between these four components, there are mutually influential relationships that can be described in terms of *agency* and *structure*. In the theories of socialization, *structure* usually refers to society and its institutions, which function as the agents of socialization, while *agency* refers to the individual being socialized.

The two main aspects of socialization (society and individuals) are, however, useful as separate analytical categories for distinguishing between the *macro-level* and the *micro-level* of analysis. On the macro-level, socialization can be seen as a set of intentional, mainly discursive, practices guided by the ideological agenda of society or a particular socializing agent. This aspect of socialization can be studied by analyzing, for instance, school curricula, textbooks, media content, and so on. One of the main research questions is: What type of socializing practices do the various interest groups in society employ in order to maintain or build the society, which allows them to pursue their interests and retain or improve their positions of authority? (cf. McCron, 1976).

On the micro-level, socialization refers to practices of interaction between the individual being socialized, and the society or the socializing agent. Such practices can be studied by looking at, for instance, reception of media content or textbooks, or socialization in families (e.g., parents-children interaction). The main question for researchers is: How do individuals engage in and interpret the practices of socialization?

Literacy and Power

In taking the macro-level question first, it is important to pay critical attention to how the informational developments are handled in public discourse. The coming of the information society is often viewed as an entirely natural and logical social advance. That type of discourse, however, disguises or glosses over the reality of domination by powerful, particularly economic, interests and advances the prospect of technocratic control and the so-called "cybernetic order" (Robins & Webster, 1989, p. 8). In fact, Robins and Webster (1989) have urged us to look at the hidden values of technocratic thought, especially in its implications for school curricula. They argue, for instance, that the "information revolution" and the emergence of neo-Fordist management are closely associated with changes in the nature and philosophy of education. Robins and Webster rely on Lyotard's discussion of the "postmodern condition" that has brought along the instrumentalization and commodifi-

cation of knowledge, and its subordination to the principle of "performativity." Robins and Webster are convinced that the discourse of "computer literacy" embellishes and simultaneously clouds the real issue on the government's agenda: work literacy (Robins & Webster, 1989, p. 125). In a similar vain, Broughton (1984) has argued that the hidden curriculum of computer literacy encourages the development of liberal, positivist values such as individualism, voluntarism, instrumentalism, and utilitarianism. Construction of literacy and knowledge (in whatever form) is about the production of symbolic meanings, values, and ideologies, which in turn embody and enact relationships of power (Buckingham, 2003). A task of critical thinking is to raise awareness about the relation between knowledge and power by asking: "What is taught in schools? Why is it taught? In whose interests is it taught in this way at this time? Above all, what is not taught? And why not?" (cf. Robins & Webster, 1989, p. 276).

On the micro-level, a number of points regarding socialization and literacy in the contemporary age deserve attention.

Interpretive Communities, Different Literacies

Individuals are rarely isolated from one another when they engage in and interpret the practices of socialization. In the network society, discursive practices are increasingly more often faced by what Fish (1980) has called "interpretive communities," that is, by groups receiving, interpreting, and interacting with the same messages at the same time. We have a reason to talk about the development of informal, democratic *learning communities* on the Internet where students rely on one another for doing their homework and debate everything online (Tapscott, 1998). More precisely, students also discuss and reflect critically on many aspects of schooling, which has implications for the authority of the school and that of the teachers.

Online communities have various effects on media literacy, both in terms of reading and writing. Warschauer (1999) has shown in his study of computer-mediated communication in college classrooms in the state of Hawaii how students, through electronic interaction and reflection with their peers and teachers, achieved new understandings and reinterpreted their previous readings of texts. Due to new communication channels, young people may even write more than before. Online social networks facilitate developing new codes, which gives us a reason to talk about particular forms of literacy and about different literac*ies* (cf. Buckingham, 2003).

Online communication channels such as chats, blogs, personal pages, and so forth form a huge public medium of expression by and for young people. This medium, however, operates mainly in a circle of friends (Mediappro, 2006). An advantage of such voluntary social confinement is the security of users. A question, however, is whether young people will open up these media to more diversified social spaces, establishing a real itinerary of civic initiation and sanctioning skills. It is not excluded that peers' self-selected online communities will remain relatively isolated networks for a long time, forming a mosaic of "tribes" that turn in on themselves (Mediappro, 2006). Indeed, the skills needed to open up to the

diversity of people and cultures and to communicate with them with respect are far more complex than techniques usually understood as "computer literacy." This is a challenge for educators today.

The Changing Nature of Texts and Authorship

The changing nature of texts has several crucial implications on socialization and literacy. Several theories about hypertext and multimedia (see, e.g., Bolter, 2003; Kress, 2003; Landow, 1997) speak about the changing relationship between author, text, and reader: The importance and authority of the author and the text are lessening, whereas the importance, freedom, and power of the reader are increasing. If we consider the potential of hypertext and multimedia on the World Wide Web, we can see that the processes of reading and writing become analytically even more complicated. First, the Internet places an unprecedented amount of information on any topic at the hands of individuals who have access to it, and second, it makes any computer user a potential "author of a new kind," who can produce and publish texts, alter texts, write, and "write back" (Kress, 2003, p. 173).

A number of online environments such as the *Wikipedia*, multi-user online games, the blogosphere, and so forth break down the boundaries between producers and consumers and enable all participants to be users as well as producers of information and images. Bruns (2006) calls participants in these environments *producers* and their activity *produsage* (production + usage)—"the collaborative and continuous building and extending of existing content in pursuit of further improvement" (p. 276). Within this context, he speaks about a new "Generation C." The letter "C" stands, in the first instance, for "content creation" as well as for "creativity" more generally (Bruns, 2005).

"Generation C," however, is not ubiquitous. International research suggests that creative work of twelve- to eighteen-year-olds is limited: Only few young people develop their own Web sites or blogs, and these products can easily become dormant (Mediappro, 2006). There is an obvious role for schools to *educate producers*—media literacy has to involve critical consumption as well as creative production in digital media (Buckingham, 2003).

The Changing Role of the Agents of Socialization

In the changing information environment, the role and authority of the agents of socialization are altering. Changes in the relative importance of one agent of socialization (e.g., the media) instigate modifications in the role and authority of the others such as the family, the school, and peer groups.

First of all, new technologies have brought along a remarkable increase in time that teenagers spend with the media, electronics in particular. Recent studies show that eleven- to fourteen-year olds in the United States spend on average more than six and a half hours per day with the media (Roberts & Foehr, 2004). Playing with the media or just gazing at them is the main daily activity of the "media generation."

Second, the media in the digital age are less and less mass oriented as markets and audiences have been segmented and specifically targeted (Castells, 1999). We can also speak about the growing fragmentation of audiences and the individualization of media consumption, reception, and production. Such developments have been welcomed by advocates of the "communications revolution" as the increasing empowerment of audiences by the new media. However, more skeptical observers, e.g., Buckingham (2003), argue that audiences are more likely to have just ever increasing opportunities to consume rather similar media contents in terms of quality and the values of consumer society. Another important observation by Buckingham is that previously distinct boundaries between children's and adults' media worlds are simultaneously disappearing and being reinforced: On the one hand, children have easier access to media contents meant for adults, while on the other hand, they are increasingly participating in globalizing cultural and social worlds that are inaccessible and incomprehensible to their teachers and parents.

The impact of children's media and consumer culture on parents' role in socialization is disputable. Some observers are alarmed at the prospect of an "electronic generation gap," in which children are losing contact with the values of their parents (Buckingham, 2003); others deny that such a gap exists: " . . . for the most part kids think their parents are pretty cool" (Tapscott, 1998, p. 43). Research findings (Mediappro, 2006) suggest that parents are rarely included in their children's media universe. This reality concerns, first and foremost, the realm of the Internet. A majority of teenagers talk to their parents about this medium rarely or never. As a result, significant gaps in understanding between parents and children exist. For instance, most parents claim that they directly support their child on the Internet, but their children are less likely to say this (Livingstone & Bober, 2005). In fact, children are gaining social status through their expertise with the new media. In some instances, this ability facilitates *reverse socialization* as children help parents use the Internet. Also, most children play a game of strategy and tactics with their parents: 69% of twelve- to nineteen-year-old home users in the UK have taken some action to hide their online activities from their parents (Livingstone & Bober, 2005). Undoubtedly, this undermines the "democratic" family and calls for new family cultures based on communication, negotiation, and trust, rather than on authority and rules.

The importance of peer groups in socialization of the media generation seems to be growing. On the one hand, the Internet, electronic games, and mobile technology bring continuous interaction with friends into the homes of teenagers. On the other hand, peers tend to be the main source of learning about the Internet followed by the family and the school (Mediappro, 2006).

Regarding the role of the school in socialization, there is a wide consensus: critical as well as celebratory writers agree that the role of the school has diminished in the informatizing society. This claim is supported by the axiom about the death of intermediaries in every field defended, for instance, by Bill Gates (see Mattelart, 2003, p. 138). In line with this, the commodification of knowledge and the simultaneous "industrialization of training" (see Mattelart, 2003, p. 140) lessen the importance of the school and the university as agencies in their own rights and leave the individual as a free-floating unit, faced more

or less directly with the values, offers, and demands of the market and consumer culture.

School-related developments are celebrated by a number of techno-optimistic writers. Papert (1979) has declared that Illich's well-known conception of a deschooled society would become a reality and even a necessity with the presence of computers that would undermine the old vested interests and the hierarchical system of knowledge. Negroponte (1995) proudly proclaims that we may be a society with "far more teaching-disabled environments" and "far fewer learning-disabled children" as the computer facilitates "learning by doing" and "playing with information" that makes the material more meaningful. Tapscott (1998) argues that by exploiting the digital media, educators and students can shift to a new, more powerful and more effective paradigm of interactive learning, which involves, for instance, a shift away from pedagogy to the creation of learning partnerships and learning cultures, a shift from learning as torture to learning as fun, and a shift from the teacher as transmitter to the teacher as facilitator.

Some empirical studies (e.g., Sandholtz, Ringstaff, & Dwyer, 1997; Warschauer, 1999), however, confirm that the socio-cultural context of a school strongly influences how computers are used with students. Moreover, "this influence is neither total nor direct but is mediated by the beliefs of individual teachers" (Warschauer, 1999, p. 37). According to Giroux (1988), teachers are not only objects of societal and institutional influences but also agents for transforming their own teaching and their institutions. In terms of the theoretical model of socialization, it is probably correct to assume that in the field of education, there is a multi-layered system of structures and agencies, in which the agency of individual teachers is still relatively important vis-à-vis the structures of the particular school, the education system and society at large.

The Questions of Expertise and Authority

A number of theories agree that relations of authority and power between adults and children are changing in many aspects in the informatizing society. First of all, children have gained power as consumers of media (and as consumers in general): As they access increasingly more media from their bedrooms, they no longer have to follow the channels that their parents choose (Buckingham, 2003). Also, due to the new media technologies, authorship is no longer rare, which brings about a lessening in the author's and the text's authority. This fact allows Kress (2003) to argue that there is no longer an unquestioned acceptance of textual power (that means, adults' power), not even in schools. Moreover, some empirical studies (e.g., Sandholtz, Ringstaff, & Dwyer, 1997; Warschauer, 1999) have shown that once students got used to working with computers in schools, they began to challenge traditional assumptions about classroom organization.

Probably the bravest assertions on this matter have been put forward by Tapscott (1998). Much of his argumentation is based on the claim that for the first time in history, children are more knowledgeable and literate than their parents and teachers about an innovation central to society, that is, computers and the Internet. He argues that the "Net Generation," the first to grow up surrounded by digital media, "bathed in bits," will trans-

form all traditional institutions. He believes that families are becoming more open in the sense that authority is shared more than in the past because children are an authority on an important issue. Also, the power dynamic between pupils and teachers will be forever altered not only because sometimes pupils train teachers on how to use computers, but also as the education moves from the paradigm of teacher as transmitter of information to pupils learning through discovery and through new media. Tapscott goes further, arguing that because the Net Generation has the tools to question, challenge, and disagree, these kids are becoming a generation of critical thinkers, who will force institutions such as the market, business, and the government to change toward greater democracy, interactivity, responsiveness, and access, and question fundamental tenets of the social order.

We have several reasons for being rather skeptical about the last point. Relations of power and control do not just dissolve away; they may only take another form (Robins & Webster, 1989). The mediating agency (and, hence, authority) of the family and the school in the field of socialization may, however, be lessening, leaving children interacting more directly with the media, the market, and other institutions.

Is the "Net Generation" actually prepared for this challenge? Recent international research evidence suggests that young people are likely to over-estimate their competence: 79% of twelve- to eighteen-year-olds consider they know well how the Internet works, but only 52% are able to evaluate the information they retrieve (Mediappro, 2006, p. 14). Also, many children and young people in the UK encounter difficulties with searching and critical evaluation of online information (Livingstone & Bober, 2005). Thus, the Net Generation is not fully advanced in information literacy and critical literacy. Despite widespread learning from peers and independent learning through discovery, most young people consider that the school should be an important resource and that it is one they need. The majority of twelve- to eighteen-year-olds think it is important that the school teaches them how to find useful Web sites and how to evaluate online information (Mediappro, 2006, p. 14). Furthermore, learning the rules of new media, the relevant legislation and the stakes involved raises keen interest in young people (Mediappro, 2006, p. 56).

In this respect, there is a fundamental gap between what children need and what school curricula and teachers have to offer. At this moment, teachers, indeed, lack expertise (and authority) in the realm of digital literacy: Less than one-half of twelve- to eighteen-year-old students think that their teachers are familiar with the Internet (Mediappro, 2006, p. 14). In this situation, teachers should probably share authority with students and open up themselves to *two-way socialization*: By learning about new technologies from children, adults could use their knowledge about broader social contexts to teach what to do with technology and the media. Obviously, media literacy entails "a capacity to decipher, appreciate, criticize and compose" (Silverstone, 1999, p. 37), but it also requires an understanding of the economic, social, and historical contexts, in which media texts are produced, distributed and used (Buckingham, 2003). A two-way model of socialization into media literacy would also need alternative modes of teaching and learning, which focus more on a collaborative engagement between teachers and students as well as among students themselves (Bruns, 2006).

Individualization and Diversity

We cannot ignore the fact that there are huge information inequalities between different countries and also inside countries. Globally, "most children are not growing up digital" (Tapscott, 1998, p. 12). Moreover, there are several very powerful social and cultural factors such as religion, ethnicity, social class, and gender as well as individual differences that are intervening with the developments outlined above. In addition, the growing individualization of media production and consumption adds details to the picture. Therefore, we cannot actually talk about any uniform model of socialization in the informatizing society. Instead, we have a great diversity of possible socialization patterns.

In line with this, we may expect that children will develop media literacies that vary greatly between cultures and individuals. This anticipation, of course, has challenging implications in terms of how to teach, especially in culturally and socially diverse settings. Peer-to-peer teaching, two-way socialization, and a stronger focus on cooperation between teachers, students, and parents will, nevertheless, remain central issues for contemporary media education.

ACKNOWLEDGMENTS

I am grateful to the Institute for Advanced Studies in the Humanities at the University of Edinburgh for research scholarship that enabled the preparation of this chapter. The work was supported also by the research grant No. 6968 financed by the Estonian Science Foundation.

REFERENCES

Berger, P., & Luckmann, T. (1966/1991). *The social construction of reality: A treatise in the sociology of knowledge*. London: Penguin Books.

Bolter, J. D. (2003). Theory and practice in new media studies. In G. Liestøl, A. Morrison, & T. Rasmussen (Eds.), *Digital media revisited: Theoretical and conceptual innovation in digital domains* (pp. 15–33). Cambridge, MA, & London: The MIT Press.

Broughton, J. M. (1984). The surrender of control: Computer literacy as political socialization of the child. In D. Sloan (Ed.), *The computer in education: A critical perspective* (pp. 102–122). New York & London: Teachers College Press, Columbia University.

Bruns, A. (2005). *Gatewatching: Collaborative online news production*. New York: Peter Lang.

Bruns, A. (2006). Towards produsage: Futures for user-led content production. In F. Sudweeks, H. Hrachovec, & C. Ess (Eds.), *Cultural attitudes towards technology and communication 2006* (pp. 275–284). Murdoch: Murdoch University.

Buckingham, D. (2003). *Media education: Literacy, learning and contemporary culture*. Cambridge: Polity Press.

Castells, M. (1999). Flows, networks, and identities: A critical theory of the informational society. In M. Castells, R. Flecha, P. Freire, H. A. Giroux, D. Macedo, & P. Willis, *Critical education in the new information age* (pp. 37–64). Lanham, MD: Rowman & Littlefield.

Fish, S. (1980). *Is there a text in this class? The authority of interpretive communities*. Cambridge, MA, & London: Harvard University Press.

Giddens, A. (1984). *The constitution of society: Outline of the theory of structuration*. Cambridge: Polity Press.

Giroux, H. A. (1988). *Teachers as intellectuals: Toward a critical pedagogy of learning*. New York: Bergin & Garvey.

Kalmus, V. (2004). What do pupils and textbooks do with each other? Methodological problems of research on socialization through educational media. *Journal of Curriculum Studies, 36*(4), 469–485.

Kress, G. (2003). *Literacy in the new media age*. London & New York: Routledge.

Landow, G. P. (1997). *Hypertext 2.0*. Baltimore & London: Johns Hopkins University Press.

Livingstone, S., & Bober, M. (2005). *UK children go online: Final report of key project findings*. Economic & Social Research Council. Retrieved July 15, 2006. http://www.children-go-online.net

Mattelart, A. (2003). *The information society: An introduction*. London, Thousand Oaks & New Delhi: Sage.

McCron, R. (1976). Changing perspectives in the study of mass media and socialization. In J. D. Halloran (Ed.), *Mass media and socialization: International bibliography and different perspectives* (pp. 13–44). Leeds: IAMCR with the support of UNESCO, J. A. Kavanagh & Sons.

Mediappro. (2006). *A European research project: The appropriation of new media by youth*. Brussels: Chaptal Communication with the Support of the European Commission / Safer Internet Action Plan.

Negroponte, N. (1995). *Being digital*. London: Hodder & Stoughton.

Papert, S. (1979). Computers and learning. In M. L. Dertouzos & J. Moses (Eds.), *The computer age: A twenty-year view*. Cambridge, MA: MIT Press.

Pawelka, P. (1977). *Politische Sozialisation*. Wiesbaden: Akademische Verlagsgesellschaft.

Roberts, D. F., & Foehr, U. L. (2004). *Kids & media in America*. Cambridge: Cambridge University Press.

Robins, K., & Webster, F. (1989). *The technical fix: Education, computers and industry*. Houndmills & London: Macmillan.

Rosengren, K. E. (1994). *Media effects and beyond: Culture, socialization and lifestyles*. London: Routledge.

Sandholtz, J. H., Ringstaff, C., & Dwyer, D. C. (1997). *Teaching with technology: Creating student-centered classrooms*. New York: Teachers College Press.

Silverstone, R. (1999). *Why study the media?* London: Sage.

Tapscott, D. (1998). *Growing up digital: The rise of the Net Generation*. New York: McGraw-Hill.

Warschauer, M. (1999). *Electronic literacies: Language, culture, and power in online education*. Mahwah, NJ, & London: Lawrence Erlbaum.

The Hyper-Reality That Never Happened

Expanding Digital Discourse

Marcus Breen

At its simplest, Information and Communication Technologies (ICT) are tools that can expand and enrich the idea of community, culture, and citizenship. The three "Cs" of ICTs are tied to each other with the imaginary power of new technologies that ring with the possibility of human ambition. This articulation (or linkage) of the three Cs has produced an environment that offers exciting opportunities to view and experience the world with interactive immediacy through the power of digital communications. The most persuasive digital communications model is the Internet and the virtual world it incorporates. As a network of networks the Internet offers the profound possibility of a connected world in which all users realize their potential through the artificial reproduction of reality. In this ultimate model of a technically constructed utopia, virtuality comes from a form of power that leaps over previous communication limitations through the application of telecommunications and digital networks. The power of the network is derived from a relationship where each party in the relationship gains optimal results through others' participation in the network. These "network externalities" are gained from the number of people who can be reached through the network so that the value of access to the network increases with the number of people who can be reached on that network (Brock, 1994, p. 62). With

network externalities, ICTs magnify the three Cs in almost unimagined ways.

At the more abstract level of the hyper-real, digital technology suggests that we can in fact move forward in an imagined new dimension to undertake new endeavors that stretch the capabilities of humanity. In some cases these things are actually happening and being documented almost in real time: a quick flick through any of the latest issues of *Business Week, Wired, Computer World*, or any weekly or daily Technology supplement of a major daily newspaper, and the many academic and research oriented journals, present them to the public like unfolding a massive technology utopia or "technotopia" (Kroker and Weinstein, 1994). It is as if reporting on the impending virtual world has a powerful momentum that is unstoppable, with its bright lights and advertising panache sweeping all along before it in a purposive narrative.

In this chapter, I want to take aspects of this utopian ICT narrative to show how it is an extension of the promotional culture of advanced societies (Wernick, 1991). I will critically assess the narrative for two reasons:

1 to show how virtual reality (used here by the short-hand term *virtuality*) is culturally and economically constructed by powerful forces;
2 to show how the dominant narrative limits the possibilities of using and creating ICTs for development.

In discussing these points, my aim is to show how our reading of virtuality has been limited by dominant forces in developed societies, and thus the scope of our "digital literacy" has been constrained. Furthermore, much of the appeal of virtuality is found in the simulations of the real—the feeling that users are experiencing the real thing through new digital technologies. This concept applies to the three Cs because they have been reconstituted and given renewed meaning by virtuality. According to the narrative, community has been recreated through virtual communication; culture has been invigorated and reproduced; citizenship has been redefined to incorporate a dynamic sense of belonging.

In order to understand the limitations of virtuality, it is helpful to explore the development theories that operate behind the scenes. In tracing these theories, the knowledge that created them and is reproduced within them can be recognized. This is the epistemological landscape of virtuality (Tambakaki, 2006). To be digitally literate is to have the critical facility that comes from recognizing and acting within this landscape.

Development Theories

There are—various approaches to economic and social development that play out along a couple of dominant lines. Before getting to the dominant approach, it is constructive to set up the counter-argument by identifying "development communication theory," which offers "a process of strategic intervention toward social change initiated by institutions and communities," "to advance socially beneficial goals" (Wilkins & Mody, 2001, p. 385). This approach developed as a reaction against "the global expansion of private investment in

communications industries" and defines a normative approach that incorporates the best possible outcomes to emerge from virtuality (Wilkins & Mody, 2001, p. 385). This approach also reflects a progressive ideology that runs counter to the dominant approach and, as I will show, the determining power of economics in development theory.

What does development communication theory intervene into? Generally speaking, its goals oppose what virtuality represents. More precisely, as currently configured in most discussions, virtuality reflects the ideology of the prevailing ideas, views, perspectives, and ultimately the politics of development. Where ideology is derived from theories of how social and economic development will and should take place, the story moves along a number of ideological vectors. These vectors often overlap to create a mix of forces that engage in a sometimes vigorous contest in the public space. In some cases, such as with ideas promoting socialism or wealth and resource reallocation across society, the contest has been "won" by the dominant or pro-capitalist, pro-competitive free-market ideology. However, capitalist ideology is not a solid block, which is somehow set like concrete. In fact, it changes all the time while maintaining the core principles of private property and acquisition within a competitive environment. That change results from what Stuart Hall (1986) suggested is a significant amount of "leakage" as alternative press and news media and now the Internet and the blogosphere offer a stream of new information to counteract the dominant ideological perspective of capitalism.

Ideological vectors have been a feature of the political economy and debates therein for generations. They are important because they feed into key ideas about what Michel Foucault referred to as "governmentality," i.e., the broad scope of ideas that determine how actively the administrative system of a nation circulates alongside and within the social structures of society. Governmentality is found in the institutions of the state and the technologies that they employ to dominate citizens' lives through a refined system of consensus. Thomas Lemke refers to this concept as "Foucault's hypothesis" because it defines a system of regulation where citizens are theorized to be always and already compliant with and constructed by their own sense of what is permitted (2002, p. 4). This compliance constructs ideology through the technologies of the regulatory apparatus of the state and the choices the individual makes to submit to that system of meaning. This "apparatus" mirrors and then extends French philosopher Louis Althusser's idea of the Ideological State Apparatus (1971). Here, ideology becomes the constraining mode under which the citizens of the state live while at the same time those citizens are as it were "self-managed" by their own investment in the state of things.

The idea of willingly investing oneself in a state—or regulating the self—assumes a liberal system that encourages and facilitates the emergence of the citizen within tolerable limits. Such a situation cannot always be assumed to apply because quite simply, dominant ideologies compete with and suppress alternative ideologies. Alternative ideologies bubble up, and the old state apparatus withers to be replaced by the new apparatus and its ideology. The question is: What can the citizen become? The answer is that the question of what we become in society and what society can become is instrumentally determined by the regulatory blinkers of the prevailing ideology. We act within the known limits of the society—

literally, materially, and psychologically—yet we also take some initiative to engage in the opportunities made available to us by alternative and counter-perspectives that emerge due to leakage. This leakage model applies to the political economy of development theory that can recognize the struggle between and across ideologies. However, as this paper argues, virtuality is deeply invested in the regulating ideology of the dominant apparatus and is thus hard pressed to benefit from the leakage.

Understanding the dynamics of ideology helps to reveal the forces at work in theories of development. On the one hand, these forces act as fuel to the engine of development in the most advanced nations, where technology is inextricably linked with economic and social growth. This relationship has been identified by numerous writers and critics and is the focus of significant academic research and ongoing analysis including the branch of U.S. historians gathered around the Society for the History of Technology (SHOT) and journals such as *Technology and Culture*. In the UK there is the journal *History and Technology*. (In the new globalized environment—as applied to the developed world—it seems hardly to matter to differentiate national sites of historical research and publication. On the other hand, though, the trajectory of technology and its link with national development is a crucial, even essential story that defines nation states, as many authors have shown, including Joseph Schumpeter, Thorstein Veblen, Karl Marx, John Kenneth Galbraith, and even Al Gore with the National Information Infrastructure public policy initiative in the late 1990s.) There is a rich history of commentary. Suffice it to say the inquiry can begin with a number of disciplinary traditions. Foremost among these is economics. This articulation between technological advancement and economic growth is assumed to be morally beneficial and positive. The assumption is that greater growth and expansion of the economy create human advances that are characterized as social progress. In contrast, Ernst Schumacher published in 1973 (republished in 1989) a powerful treatise, entitled *Small Is Beautiful: Economics as if People Mattered,* in which he argues differently. He suggests that a counterpoint to the massive scale of contemporary capitalism and growth should be an almost microscopic focus on new forms of development and acquisition. So while, on the one hand, there are powerful forces that act as the fuel to the engine of development, on the other hand, there are alternate forces that bubble away underneath the massified system that is the ideology of corporate, westernized capitalism. The issue that has won dominance since Schumacher's book appeared is that developmental correctness sweeps aside the small and the beautiful in its headlong movement to greater dominance. The result is an ideology where economics promotes growth through technology as a fundamental law of civilization. Alternatively, as Thorstein Veblen noted in commenting on the U.S. model of capitalism in *The Theory of Business Enterprise*, everything gives way to business, because business defines technology which determines social and economic life (1958).

The question to ask is: What is at stake if economics is dominant? To answer that question is to engage in a struggle with the idea of the public interest. Of the concepts that are available to us, "the public interest" is one that fits like a glove into the non-economic space, where new ideas flourish without being determined primarily by economics and business interests. When seen from this perspective, the public interest represents a fight against

economic power where hegemons create large-scale corporations whose ambition is unassailable dominance over social and economic life. That in itself may not be such a negative aspect if we did not know that these same hegemons act monopolistically to achieve two outcomes that are generally antithetical to the public interest:

1 Corporate hegemons destroy social and economic practices and thereby debase the possibilities for human ingenuity and innovation.
2 Corporate hegemons corrupt the political process with self-interested influence.

The diminution of the public interest by hegemonic monopoly interests challenge development theory by limiting the range of possibilities whereby the public interest is constructed. In particular, the destruction and corruption of the process of governance by these forces is an expression of advanced capitalist activity which has been supported and encouraged by economics. For example, commenting on the way the Iraq war had benefited private firms like Haliburton, *New York Times* columnist Frank Rich suggested that "a shadow government of private companies" had taken over from public institutions such as the army in a massive giveaway of public funds to private contractors (2006, para. 4).

The dismal science has a lot to answer for. Not the least of its questionable contributions has been the way economics has expressed the positivist reflex of the American approach to reality, which is empiricism. This tradition has powerfully captured the U.S. approach to development theory so that when development is discussed, it is almost inevitably in terms that express the measured value of an activity. While, on the one hand, this fetish for empiricism—measurement by any other name—is a foundational strength of the U.S. economy and society in general, it is also a weakness. While positivism insists on the scientific process of showing the causal relationship between a theory and its outcome in real measured terms, it is ill equipped to deal with non-measurable ideas. These include cultural, social, and communal manifestations of citizenship, which are philosophical concepts that require intellectual finesse within a public discourse, rather than a calculator. Even so, the calculator has a powerful pull on development theory.

In economics, as Bruce Seely noted in the introductory issue of the journal *Comparative Technology Transfer and Society* in 2003, there are historical patterns that have directly impacted ICTs and technology transfer generally. The dominant approach has been a one-dimensional perspective based on formal economic models. This approach has been a source for debate since the1950s when a small group of economists, including Gunnar Myrdal and Albert Hirschman worked to sketch problems "not solely economic in nature" (Seely, 2003, p. 13). In discussing this alternative to the prevailing economic modeling method, economist and now well-known *New York Times* columnist Paul Krugman referred to their approach as "high development theory" (1997, p. 67). It has taken decades for the interdisciplinary approach of high development theory to fight for space on the same page as economics, and that battle continues. Indeed, it is not yet apparent that the ideological apparatus of economic approaches to development theory have given way to a broader range of options. Established patterns are hard to move. The result is that ICT is still assessed and analyzed through the prejudicial optics of positivist economics. This means that ICTs

have been subjected to a type of economic determinism, where they are expected to meet a specific set of goals and targets for financiers who measure them in terms of western standards of "return on investment," rather than as public goods. There is a considerable amount of literature that adopts and adapts this determinism into a normative set of activities, all the while constructing an image of a utopian virtual world.

Eternal Optimists

Brian McNair, author of *Cultural Chaos: Journalism, News and Power in a Globalized World* (2006) suggested in an article he wrote for the *Melbourne Age* that the Internet has, as it were, promulgated a type of social order that can only be described as chaos. More precisely, he argued—reprising Frankfurt School critics from the 1930s Theodor Adorno and Max Horkheimer—that "cultural chaos" is the prevailing global context which we inhabit because of the rise of the Internet. This situation is characterized by "a media environment in which more information flows faster to more people, and with fewer possibilities for state and government control, than at any time in human history" (2006, para 6). I want to comment on the narrowness of this idea of chaos.

Ultimately it relies on a constricted view of human behavior, where, for example, Christian versus Muslim is the simplistic rendering of a world defined by binary coordinates. These binary opposites can be disabling. With no nuance, no subtlety, and no possibility for cohabitation borne of liberal claims to tolerance, they suggest a world of black and white. In fact, McNair follows the view that either you are for us or against us because technology says so. This gives too much salience to the Internet, which is actually limited to a relatively small percentage of the world's population. More importantly, McNair's argument is that the Internet operates at a quasi-policy level, which creates fewer possibilities for state regulation of human interaction and behavior and that this is actually the cause of the cultural chaos. Such a claim offers a theory of government that cannot go unnoticed or unchallenged. This theory of government works on the premise that pre-Internet, society is managed and regulated effectively, producing some kind of perfectly modulated synchronicity. In other words, information flows and the government are able to meet at a point that avoids chaos, but then along comes the Internet! This idea is not borne out by human history as any number of wars—literally nation-against-nation, and more subtly class warfare—suggest. The chaos has been there on and off at various contingent points throughout history. However, the magnifying power of digital technologies brings chaos to the attention of those attached to the digital world. Virtuality can be seen to emphasize specific aspects of human behavior, which are then generalized to produce an all-encompassing cultural chaos. There is no doubt that those of us attached to the digital are all increasingly subjected to the panopticonic power of its surveilling gaze and feel somewhat disoriented and sometimes fearful, but is it really cultural chaos? More importantly, is it reasonable to characterize the challenge of new technology—the moral panic brought about by the novelty of virtuality—as cultural chaos, when it applies to a relatively small num-

ber of people on the planet who are within the orbit of the "chaos?"

From a different perspective, the binary coordinates that McNair offers are an extreme that emerges as a result of the "echo chamber" effect of virtuality, where its magnifying potential creates the illusion of challenges to ideas of citizenship, government, community, and culture—a kind of hothouse of extremes (Sunstein, 2001). The reality is more likely to be in line with a model of society "made up of both angels and devils and others between these extremes, at which a chief aim of political institutions must be to insure against devilish behavior," as Geoffrey Brennan and Alan Hamlin put it in their book *Democratic Devices and Desires* (2000, p. 100). In terms of McNair's argument that the Internet causes cultural chaos, my argument is that culture is a process that is not reducible to convenient binaries. The Internet may draw us as it were to the devils or devilish behavior, rather than to "the angels of our better nature," as Abraham Lincoln so famously put it in his first inaugural address in 1861, when appealing to the virtues of democracy. The coexistence of angels and devils softens the binary approach and invokes a theory of government more in line with the negotiated efforts associated with the legislative process and the possibilities for public policy. It also offers a way to imagine the three Cs.

The other end of the spectrum sees the Internet as a force that operates to seamlessly empower and unify through Adam Smith's moniker that will not go away, "the invisible hand of the market." This view is represented by Francisco Martínez-López and Carlos Sousa who suggest the following:

> The Internet represents a fundamental force able to integrate and approximate different cultures, each of them with their own values and beliefs, corresponding to all those countries and regions that make regular use of it. (2004, p. 33)

This kind of techno-boosterism offers to globalize and therefore regularize the impact of the Internet with a universalizing determinism. Martínez-López and Sousa ask "Is the Internet a world wide cultural catalyst?" and they answer in the affirmative. They continue:

> Could the Internet be considered as the medium which unifies and generates shared values and beliefs among consumers or, in a broader sense, individuals from different cultures and places of origin? (2004, p. 33)

In making their claims for the unified seamlessness of the Internet, Martínez-López and Sousa go back to a 1983 article, "The Globalization of Markets" by Theodore Levitt in the *Harvard Business Review*. This early iteration of technology boosterism followed the lead provided by Daniel Boorstin in his book *The Americans* (1965), which argued that "The Republic of Technology" established the "supreme law" of convergence, where "everything becomes more like everything else," notes Levitt enthusiatically (1983, p 93). As a leader in corporate marketing theory, Levitt took Boorstin's idea as the basis for a U.S.-centric, technological leveling of reality. In what can be seen as a kind of corporate exceptionalism, Levitt suggested that the industrialized world offered "products and methods" that in turn created laws of consumption that "play a single tune for all the world and all the world eagerly dances for it" (1983, p. 93). Under the additional and combined pressure of "technology and globalization"—the "two vectors" [that] shape the world," according to Levitt—

the dance becomes a flowing series of virtuous interactions overseen by great industrial powers.

> The global corporation accepts for better or worse that technology drives consumers relentlessly toward the same common goals—alleviation of life's burdens and the expansion of discretionary time and spending power (1983, p. 99).

Under Martínez-López and Sousa's direction, the revistitation of Levitt's argument becomes the "ubiquity of desire" thesis, which is presented as the condition sustaining the central power of global technology as seen in the Internet. The inevitable consequences of this technology-desire nexus, argue Martínez-López and Sousa, is the "inevitable homogenization of the needs and desires of consumers from different countries and regions" (2004, p. 33). This is Levitt's case restated for the Internet age—with less nuance. According to the ubiquity of desire thesis, the entire planet is subsumed within technology's domain of pleasure. This virtual world of desire as presented by the techno-boosters of the global business community can be seen as the ideological glue that binds humanity. When this approach is viewed through the endorsing frame of reality as constructed by Levitt and Internet proponents like Martínez-López and Sousa, questions about the seductive power of technology are pushed into the background.

Compared to McNair's cultural chaos theory, the ubiquity of desire thesis appears as another point on the Internet's ideology continuum. From a critical perspective, this ideological continuum that operates in the virtual environment is a reflection and representation of the material world that predates the Internet. The question is how to find the angels along the virtual continuum of new technologies, when that space itself is replete with devils that would do harm to the public interest.

Hyper-Reality: The Dark Side of the Planet

In contrast to the headlong trajectory of the virtual, there is another reality, another parallel universe that impacts the developing world through ICTs. In this universe, community, culture, and citizenship disappear as the power of advanced technologies evacuates them of meaning and utility. This is the virtual nothingness. In other words, a culture of negation has emerged. In the dialectical sense, this virtual culture of advanced digital technology has absorbed the original culture and subsumed it within the virtual. The pre-colonial cultures of tribal life and early capitalism have been absorbed into the single perspective of global virtuality and in so doing, they have been transformed into their exact opposites. This sublation of culture becomes dominant leaving virtuality as the embodiment of human ambition. Sublation here means the transformation of one reality into its opposite, or negation. (In *The Phenomenology of Mind*, his study of moral philosophy written in the early nineteenth century, Frederick Hegel proposed a range of meanings for sublation as part of the synthesis-making logic of the dialectical explanation—the positive and negative antithesis approach—for consciousness.) Because advanced promotional culture moves so quickly, those with few or no digital capabilities have no way of being incorpo-

rated into the virtual and thus are made into thoroughly unwilling subjects with nothing. Indeed, materially, socially, and culturally it is possible to see how virtuality sublates development into an unrecognizable set of economic outcomes that are beyond comprehension to those who know nothing but poverty and colonization. What amounts to an absence of consciousness of virtuality is the result of the destruction of entire histories of people and their loss of knowledge of who they are and how they came to be denied their rights as citizens.

This dialectically informed approach is necessarily pessimistic. It maintains that in the sublated scenario, culture, community and citizenship become their opposites, as the disempowered see their present and future lives only as prospects for incorporation into the vast stateless expanse of globalized economic and social relations. Seen in this light, the virtual world offers no way out, only its opposite.

This situation produces specific types of knowledge. Theories about knowledge or epistemology are wide-ranging and stretch back through the history of philosophy. In the above discussion we saw how the epistemology of sublation creates negation. The consequence is the disempowerment of ICTs in the developing world. However, what happens in the developed world? What kind of knowledge operates in the relationship of the advanced world with the developing world? How would an understanding of these knowledge types enlighten a discussion of literacy? There are pathways of knowledge in the developed world, just as there are pathways in the underdeveloped world. The following discussion will propose two such pathways in the developed world and explain their formation.

The first pathway is the knowledge of forgetting. This is amnesia in the developed world about the rest of the world. This knowledge is the result of ignorance and immaturity and comes into existence because of a lack of experience of the world. Because virtuality is a creation of advanced economies and is largely determined by the quest for profit, this knowledge is incorporated in the architecture of the Internet. We can call this transactional knowledge, because it exists due to the operations of the marketplace, which has come to dominate virtuality. It is almost impossible to gain access to the virtual world without considerable wealth, or at the very least credit. The poor are unlikely to experience virtuality because they do not have the economic power to engage in the type of economic relationships that determine the use of technology. Now while this is a generalization because governments provide access to students in school and public libraries, the dominant use of advanced technology to create virtuality in promotional cultural contexts is by people who use them privately, as a result of private ownership of the software and hardware. Therefore the absence of equivalent transactional economies in the underdeveloped world to the developed world means that the rest of the world is forgotten.

Such a pathway is not without consequences. In this case the second type of knowledge is produced and that is anxiety about the rest of the world. This type of epistemology results from the use of the Internet, which provides an understanding of the prevailing social, economic, and social conditions in the underdeveloped world, including the absence of hyper-reality. The fact that developed world users of virtuality have this anxiety is an expres-

sion of the civilized sense of human value that is incorporated within the virtuality and the media in general. Such representations of "the other" human experiences is a key idea within media and cultural studies because it facilitates recognition of the differences that separate development from underdevelopment. Recognition and analysis of "the other" also encourage comprehension of the context in which new and different epistemologies operate. Even so, by recognizing and acknowledging "the other" through access to the technotopia of virtuality, this creates anxiety for those within the developed virtual space.

To reiterate the relationship between ideology, knowledge, and virtuality: Ideology is expressed in and by technologies. This ideology is also a form of knowledge that is created by virtuality. It incorporates users of technology because of the way ideology is expressed in the creation of technology. Critical thinking is needed to fully comprehend this epistemological landscape so that the interests expressed by technology can be revealed and then managed to be remade or destroyed.

Virtual Literacy

In the developed world, ICTs have created power like never before. This power has transformed community, culture, and citizenship by giving each of these terms new and fresh meaning and in so doing produced emergent forms of knowledge. Potential for action based on the new knowledge formation has yet to be appreciated because much of the so-called action is restricted to the privileged users of virtuality extending their ability to consume and interact with those just like them—witness the birth and growth of e-bay, Amazon, online newspapers, and electoral efforts to get voters to the polls to elect politicians who have little if anything to offer as alternatives to consumerism or new ideas on wealth redistribution. Seen from this perspective, virtuality is an expression of the already existing power of people, institutions, governments, and corporations within the developed world. Virtuality has become, therefore, the realization of generation-long aspirations by the world's great powers to have unfettered access to and domination of the planet's resources.

Conversely, underdeveloped nations have been rendered illiterate through sublation and the self-interest of the developed world in claiming ever larger pieces of the world's available resources. Underdevelopment continues because undeveloped nations see and are offered ever more advanced solutions and ideas about progress through ICTs—a sort of one size must fit all. Consequently the gap grows between the technology of virtuality and its realization because underdevelopment has not produced the interstices of infrastructure to allow virtuality to emerge as it does in the developed nations. Nevertheless, in the developing world the community that coalesces around virtuality is the elites, which, for the most part, share with developed world users the magnified self-interest of consumption and opposition to resource reallocation and wealth redistribution among the citizenry. There is little reason to imagine the elites seeking much else, because they are under the sway of the dominant ideologies of virtuality.

To understand this situation is to recognize why ICTs have not been able to effectively sweep into action to solve the problems of the developing world. Indeed, ICTs have not

solved the problems of the developed world and therein lies yet another part of the dialectic: The possibilities for thinking creatively have themselves been imagined only within the type of history that predominates the developed world. In recognizing these realities, it is possible to see the vista of the epistemological landscape as it is, and in so doing to think more clearly about solutions. Such solutions may come in the form of new types of community, which operate as democratic microcosms, in which hyper-reality may have a very small, even non-existent part. This type of non-ICT solution would be part of the emergence of pluralistic possibilities existing outside virtuality. These possibilities would, in turn, operate outside dominant ideology to create other forms of citizenship within a development theory that offers culture the opportunity to build itself into free communities of association that can, in due course, decide to be incorporated into virtuality. In such a scenario, the angels are sure to take flight.

REFERENCES

Althusser, L. (1971). "Ideology and the ideological state apparatuses (Notes towards an investigation)," pp.121–173, in *Lenin and Philosophy and Other Essays*, Trans. B. Brewster, Monthly Review, New York.

Boorstin, D. (1965). *The Americans*. Vintage Books, New York

Brennan, G., & Hamlin, A. (2000). *Democratic devices and desires: Theories of institutional design*. Cambridge, UK: Cambridge University Press.

Brock, G. W. (1994). *Telecommunication Policy for the Information Age: From Monopoly to Competition*. Harvard University Press, Cambridge, Massachusetts and London, England.

Froeb, K. (2006). Sublation. Retrieved June 21, from Hegel.net, http://www.hegel.net/en/sublation.htm.

Hall, S. (1986). "Media Power and Class Power," in *Bending Reality: The State of the Media* (Ed) J. Curran, Pluto Press, London, 5–14.

Kroker, A., & Weinstein, M. (1994, November 24). The hyper-texted body, or Nietzsche gets a modem. *Event-Scenes: e011*. Retrieved from www.ctheory.net/articles.aspx?id=144

Krugman, P. (1997). *Development, Geography and Economic Theory*, MIT Press, Cambridge, MA.

Lemke, T. (2002). Foucault, governmentality and critique. *Rethinking Marxism, 14*(3), 49–74.

Levitt, T. (1983, May-June). The globalization of markets. *Harvard Business Review, 61*, 92–102.

Martínez-López, F., & Sousa, C. (2004). Is the Internet the worldwide cultural catalyst? A theoretical approach. *Irish Journal of Management, 25*(2), 30–44.

McNair, B. (2006, June 3). The information flood. *The Age*. Retrieved from http://www.theage.com.au/news/technology/the-information-flood/2006/06/02/1148956543953.html?page=#contentSwap1

Rich, F. (2006, June 25). The road from K Street to Yusufiya. *New York Times*.

Schumacher, E. F. (1973/1989). *Small is beautiful: Economics as if people mattered*. New York: Harper and Row.

Seely, B. (2003). Historical patterns in the scholarship of technology transfer. *Comparative Technology Transfer and Society, 1*(1), 7–48.

Sunstein, C. (2001). *Republic.com*, Princeton University Press, Princeton.

Tambakaki, P. (2006). Global community, global citizenship? *Culture Machine*, (8).

Veblen, T. (1958). *The Theory of Business Enterprise*. Mentor Books, New York.

Wernick, A. (1991). *Promotional culture: Advertising, Ideology, and Symbolic Expression*. London: Sage.

Wilkins, K. G., & Mody, B. (2001). Reshaping development communication: Developing communication and communicating development. *Communication Theory*, 11, 385–396.

Chapter 16

Media Mindfulness

Gina M. Serafin

Time and attention are scarce resources in the twenty-first century. American children and teenagers are consuming approximately 6 1/2 hours of electronic media a day (Kaiser Family Foundation, 2005). However, how much we consciously attend to the messages we consume is debatable. Deciding what deserves our attention requires knowing not only how to approach the media, but a desire to engage with them critically. Mindless media consumption is a consequence of a culture inundated with information. As media technologies continue to change the way we understand and communicate with each other, educators recognize that methods that are more responsive to the needs of learners in the twenty-first century are necessary (Hobbs, 2006). The media are dynamic and constantly changing. The way we process them must be as dynamic. The ability to access, analyze, evaluate, and construct media defines our media literacy (Aufderheide, 1997). Critical media literacy encourages a heightened sense of awareness regarding the content and context of the media consumed (Alvermann & Hagood, 2000). One approach for teaching, learning, and processing media that may strengthen current educational efforts is mindfulness theory. Using Langer's (1989, 1997) conceptualization of mindfulness as a model, this chapter will consider how critical media literacy and mindfulness are related, what media

mindfulness entails, how it may be developed through media education, and why it may be a necessary component of critical media literacy.

Defining Mindfulness

Although the concept of mindfulness is not new, defining exactly what it means can be challenging. It appears that many of us understand and know mindlessness much better than mindfulness. The reason for this should be obvious—examples of mindlessness are everywhere. We may read a page or two of text and not remember what we read. We may surf the Internet for hours, not quite sure of the Web sites we visited or why we visited them. We may pass billboards on the highway and cannot recollect what we have seen. The concept of mindlessness is easy to understand because many of us have found ourselves in situations like these at one time or another throughout our lives. Although daily media consumption is estimated at approximately 6 1/2 hours a day, we must ask how closely we attend to the media we consume. Being present and aware of our media environment seems to be a challenge. Even so, it is exactly what many of us need to do in order to fully participate in democratic society. Langer (2000) argues, "Mindfulness theory may help us avoid the 'forced homogenization' that has come to be the dominant view of the 'cultural melting pot'" (p. 132).

"A mindful approach to any activity has three characteristics: the continuous creation of new categories; openness to new information; and an implicit awareness of more than one perspective" (Langer, 1997, p. 4). Being mindful of our media consumption means that the media consumer is aware of what is seen, heard, or read and is constantly negotiating meaning by drawing novel distinctions. The audience member is situated in the present. He or she is engaged with the content and aware of the context of the communication; constantly aware of more than one perspective in what is read, viewed, or heard. Langer and Moldoveanu (2000a) argue, "Mindfulness is not an easy concept to define but can be best understood as the process of drawing novel distinctions" (p. 1). They argue (2000b):

> It doesn't matter whether what is noticed is important or trivial, as long as it is new to the viewer. Actively drawing these distinctions keeps us situated in the present. It also makes us more aware of the context and perspective of our actions than if we rely upon distinction and categories drawn in the past. (p. 2)

Mindfulness focuses on the process of the learning rather than the outcome. Mindfulness theory complements different media education philosophies because it lies at the heart of what it means to be media literate. Media education efforts "have as a central focus the development of students' engagement with texts and their concern for the meaning-making process, the constructed process of authorship and questions about how texts represent social realties" (Hobbs, 2006, p. 22). Efforts may be enhanced through teaching media literacy mindfully. Debates in the media education community have focused on what and how programs should be taught (Alvermann & Hagood, 1993; Buckingham, 1998; Hobbs, 1997; Hobbs, 1998; Silverblatt, 1995; Tyner, 1998); how to and/or where to incorporate

into school curricula (Buckingham, 1990; Considine, 1995; Hobbs, 1998; Kubey & Baker, 1999; Kubey, 2000b), obstacles to integration (Hobbs, 1997; Kubey, 1998); the necessity for media education (Hobbs & Frost, 1998; Kubey, 2000a); and outcomes of media education programs (Hobbs & Frost, 2001a; Scharrer, 2002; Worsnop, 1998). While the content and outcomes of programs are important for their placement and longevity in school curricula, we must continue to ask what exactly do we expect or want to happen *within* students who are taught media literacy skills.

Mindfulness in an Information Age

We learn about the world through our consumption of media texts. As primary sources of information about the world, the mass media play a critical role in our on-going development (Kubey & Csikszentmihalyi, 1990). Many of the media texts we consume are, arguably, accepted mindlessly. Mindlessly accepting points of view, paradigms, or ideas presented through the media may lead to attitudes and behaviors not necessarily in the best interest of the audience. Because we learn and are socialized through the media, we must consider how improving the way we process the information we consume can enrich our lives and the lives of our children. As individuals not taught to view or consume media mindfully from a young age, we must recognize that our habits of 'seeing' are deeply rooted. In order to change this, we need to:

1 have the *ability* to read texts more meaningfully
2 be *motivated* to do so regularly
3 *practice* mindfully attending to our media consumption.

There are at least two reasons why media may lend themselves to mindless consumption. The first is the nature of their construction. The codes and conventions of some media channels are so familiar to the audience that there is little desire to rethink how the information is presented or how the context of the information may actually shape the content. The second relates to how we learn (or do not learn) how to process various media contents. Television, for example, is a medium we learn how to view through exposure. Typically, we are not formally taught how to process the information or images we see and hear. In research done with African villagers unfamiliar with television and film, Hobbs et al. (1988) found that "systematic training was not required to master decoding skills for the medium" (p. 58). Televised information is presented from a single perspective, independent of context, as if it were true (Langer, 1997). The acceptance of this "truth" is embedded within the context and presentation of the message. Langer (2000) states, "The way we initially learn sets us up for mindlessness or mindfulness" (p. 220). The way we initially learn to process certain types of mediated information may actually set us up for mindless consumption. This is even more disconcerting when we consider what, if any, consumption habits have on later cognitive development. Healy (1990) argues that media consumption habits developed early in life may have cognitive consequences on the development

of higher cognitive functioning. She suggests three consequences of heavy viewing:

1 the brain is forced to pay attention
2 the brain may become more passive
3 viewing may suppress mental activity.

Educators, legislators, and parents are obviously concerned. The myriad of possible effects of viewing and other types of media consumption (i.e., video gaming) is reason for concern. Unfortunately, it is this type of thinking which may actually prevent mindful consumption. Nevertheless, one of the concerns echoed by concerned parents, researchers and educators is that some types of media consumption may actually encourage mindlessness (Healy, 1990; Hobbs, 2006; Kubey & Csikszentmihalyi, 1990; Langer, 2000). It is the mindless consumption of any text, where the brain becomes passive and/or habituated, which should concern us. Even if students theoretically have the tools they need to evaluate, analyze, and create media texts, how do we encourage ongoing mindful engagement with media texts?

Media education advocates, although they may have different approaches to teach media literacy, will agree that one of the unstated goals of most programs is increased mindfulness. Cognitive approaches for teaching media literacy have received some attention (Potter, 2004), but the concept of mindfulness has not been specifically applied to media literacy efforts. Teaching media mindfulness as an aspect of critical media literacy may help mitigate potential media effects, increase enjoyment of media texts, and make us better consumers and creators of media. In an attempt to explain what media mindfulness entails, we must consider what might be going on inside the audience or receiver of media texts.

Cognitive Response Approach

Media mindfulness is a cognitive approach for teaching, learning, and practicing media literacy. We "practice" media literacy and mindfulness because they are processes and not end states. We never stop developing or using these skills. Cognitive approaches to learning are concerned with the role played by thoughts that are generated both during and after message reception. The cognitive responses elicited in the individual are the thoughts that arise as the content of the message is consumed and related to existing beliefs and feelings about the topic. The self-generated thoughts (cognitive responses) are presumed to mediate the impact of the message on attitudes and, at times, behaviors.

A type of cognitive approach for understanding attitude change is a dual-process approach also known as the elaboration likelihood model (Petty & Cacioppo, 1986). Although Petty and Cacioppo's research primarily focuses on persuasive communications, the dual process model sheds light on what may be happening within us. When we consider mindfulness as an aspect of dual processing, we make available another way for conceptualizing what it may mean to be media literate. In order to more thoroughly understand why and how mindfulness may help us develop media literacy, the elaboration likelihood theory needs to be discussed.

Heuristic vs. Peripheral Route Processing

A dual-process approach expands the cognitive model to incorporate one of two processes believed to be responsible for attitude change, and it incorporates the idea that attitude change is based on individual perception of and responses to message arguments. The elaboration likelihood model is primarily concerned with how the cognitive processing of a message (the route one takes) affects the persuasiveness or effectiveness of the message. Petty and Cacioppo (1986) suggest that when individuals engage with persuasive communications, attitudes are formed or changed through two different routes of thinking: the central route or the peripheral route. The central route is best described as thinking critically and thoughtfully about persuasive messages. However, if one is to take a central route, two conditions must be met. The individual must be able and motivated (Petty, Cacioppo, Strathman, & Priester, 2005) to process the message. Individuals who actively engage with a persuasive message are following a central route, and are more likely to elaborate upon the message. Petty et al. (2005) explain elaboration as such:

> The effortful elaboration that is necessary to take the central route involves paying close attention to the relevant information in the message, relating that information to previous knowledge stored in memory (e.g., is the message consistent or inconsistent with other facts that I know?), and generating new implications of the information (e.g., what does this mean for my life?). The ultimate goal of this effort is to determine whether the position taken by the source has any merit. (p. 84)

The cognitive thoughts or responses that a person has in response to a message might be favorable or unfavorable. The process of generating cognitive responses may be thought of as a private dialogue in which the person reacts to the information presented.

The peripheral route is more of an automatic response to a message. Individuals exert little effort in processing or thinking about the merits or implication of a message. Heuristic models are generally applied in the quick and efficient evaluation of a message. The audience member is less mindful of the communication. This type of mindlessness, as defined by Langer (1997), "is characterized by an entrapment in old categories; by automatic behavior that precludes attending to new signals; and by action that operates from a single perspective" (p. 4). Individuals following a peripheral route primarily depend on simple cues within the message to make a decision about the persuasiveness of the message. They are engaged in very little elaboration. In other words, individuals do not engage in much private dialogue. They do not think about the context of the message, they notice nothing novel, and they ignore any other viewpoints. They rely on simple cues contained in the message such as source attractiveness and message length. This type of automatic processing saves us both time and energy. However, the costs of mindless media consumption are great. We are poorly served by over-reliance on old categories.

Within the context of media education, media mindfulness is defined here as the motivation and ability to process mediated messages. Mindful media consumption involves central route processing. It requires the media consumer to engage in an internal dialogue about the message, "activity creating new categories, finding novelty and an implicit awareness of more than one perspective" (Langer, 2000, p. 4).

Mindfulness and Media Literacy

Students who participate in media education programs may be better able to approach their media consumption mindfully. Preliminary data from a research study conducted with eighth grade language arts students suggests that the students who participated in a six-week media literacy program were more actively engaged with the advertisements they viewed (Serafin, 2006). Although preliminary, the data suggest that media literacy programs may be able to increase the amount and the quality of the thoughts elicited while viewing. What this may indicate is that when students learn about how and why media texts are created and they create their own, they are more mindful while processing similar types of media.

There appears to be a strong relationship between the goals of media literacy and a mindful approach to media consumption. Media mindfulness may best be viewed as the ongoing process of negotiating meaning with media texts; remaining situated in the present; and finding novelty in the text. It is an attitude of mind a person practices whenever he or she is engaged with a media text. However, in order to practice mindful media consumption, we must have the tools necessary to do so.

Most media literacy programs include any one or all of the following five concepts:

1 all messages are constructions
2 messages are representations
3 messages have economic purposes
4 individuals interpret messages differently
5 media have unique characteristics

Awareness of the fact that media are constructions with imbedded points-of-view opens them up for critical evaluation and analysis. In other words, media education teaches that, even though media content is presented as if it were true (from a single perspective), it may not be. Being situated in the present, the viewer recognizes the context of the communication. He or she also understands that there are multiple ways to see the text, and that individuals interpret messages differently. In addition, the understanding and recognition of the unique characteristics of each medium allow viewers opportunity to find novelty in how messages are constructed dependent on the medium. This allows for a deeper appreciation for how context plays a role in interpretation. The tools to practice media mindfulness are embedded, to a greater or lesser extent, within media education approaches. While a strong relationship exists, what is needed is a concerted effort for teaching mindfulness as an aspect of critical media literacy and to teach critical media literacy mindfully.

Developing Media Mindfulness

Media mindfulness must be consciously encouraged within the learning environments of school and home. Educators may benefit by considering how creating media such as animation is a step toward building critical media literacy and media mindfulness. Grant et al. (2004) suggest the creation of art is one potential method for increasing mindfulness.

They state, "Drawing an object, rather than simply looking at it, requires greater engagement with that object" (p. 262). Serafin (2006) conducted a study where students who participated in a media literacy program were taught to create their own 30-second animated advertisements. Preliminary data suggest that students who participated in the program were thinking more about the advertisements they consumed than students who did not participate. The number of thoughts elicited after viewing different advertisements remained relatively high, even after seven months had passed since students participated in the program.

"Mindfulness is a process in which one views the same situation from several perspectives" (Langer, 2000, p. 221). When students are able to take an active role as media creators, they may be better able to understand or see similar media content more meaningfully. The choices involved while creating media may only become evident and cognitively available as the individual participates in a similar process. The active role of creating media may encourage more mindful consumption.

Teachers may promote media mindfulness by consistently encouraging students to see new things in familiar media content. Langer (1997) found it was easier to pay attention when participants were asked to notice new things in a stimulus, and that the process of noticing new and novel aspects of the stimuli made the activity more likeable. Encouraging students to see new and novel elements in the media they consume may enhance more mindful consumption. Mindfulness situates the learner in the present. The audience member is engaged with what is being consumed. Although differences in taste may vary, if media consumers are aware of what they are consuming and why, their consumption becomes a conscious and deliberate choice. The concern of many who advocate critical media literacy seems to be the lack of agency felt by many adults and young people. While factors outside of our control do affect feelings of agency, media mindfulness may be another step toward the sometimes difficult but necessary process of media literacy.

Media are dynamic and constantly changing within the cultural landscape. Media education programs must be able to adapt to the changes as quickly as they occur. An approach for teaching media literacy that may strengthen current efforts and long- term application of media literacy skills may be media mindfulness. Teaching with and about the media from a mindful perspective provides students tools they can use for ongoing engagement with media texts.

REFERENCES

Alvermann, D. E., & Hagood, M. C. (1993). Critical media literacy: Research, theory, and practice in 'new times.' *Journal of Education Research, 93*(3), 193–205.

Aufderheide, P. (1997). Media literacy: From a report of the national leadership conference on media literacy. In R. Kubey (Ed.), *Media literacy in the information age*. New Brunswick, NJ: Transaction Publishers.

Buckingham, D. (1990). *Watching media learning: Making sense of media education*. London: Falmer.

Buckingham, D. (1998). Media education in the UK: Moving beyond protectionism. *Journal of Communication, 48*(1), 33–43.

Cacioppo, J. T., & Petty, R. E. (1983). Effects of need for cognition on message evaluation, recall, and persuasion. *Journal of Personality and Social Psychology, 4*(4), 805–818.

Considine, D. (1995). An introduction to media literacy: The what, the why and how to's. *Telemedium, 41*, 2.

Grant, A. M., Langer, E. J., Falk, E., & Capodilupo, C. (2004). Mindful creativity: Drawing to draw distinctions. *Creativity Research Journal, 16*(2 & 3), 261–265.

Healy, J. M. (1990). *Endangered minds: Why children don't think and what we can do about it.* New York: Simon & Schuster.

Hobbs, R. (1997). Expanding the concept of literacy. In R. Kubey (Ed.), *Media literacy in the information age.* New Brunswick, NJ: Transaction Publishers.

Hobbs, R. (1998). The seven great debates in the media literacy movement. *Journal of Communication, 48*(1), 16–32.

Hobbs, R. (2006). Multiple visions of multimedia literacy: Emerging areas of synthesis. In M. McKenna, L. Labbo, R. Kieffer, & D. Reinking (Eds.), *Handbook of literacy and technology, Vol. II* (pp. 15–28). Mahwah, NJ: Lawrence Erlbaum. s.

Hobbs, R., & Frost, R. (1998). Instructional practices in media literacy education and their impact on student learning. *New Jersey Journal of Communication, 6*(2), 123–144.

Hobbs, R., Frost, R., Davis, A., & Stauffer, J. (1988). How first time viewers comprehend editing conventions. *Journal of Communication, 38*(4), 50–60.

Hobbs, R., & Frost, R. (2001a). *Measuring the acquisition of media literacy skills: Aan empirical investigation.* Paper presented at the International Communication Association, Washington, DC.

Hobbs, R., & Frost, R. (2001b). *The acquisition of media literacy skills among Australian adolescents.* Unpublished Manuscript.

Kaiser Family Foundation. (2005, March). Generation M: Media in the lives of 8–18 year-olds. (Executive Summary). Washington, DC: Rideout, V. R., Roberts, D. F. & Foeher, U. G.

Kubey, R. (1998). Obstacles to the development of media education in the United States. *Journal of Communication, 48*(1), 59–69.

Kubey, R. (2000a). *Setting research directions for media and health education.* Conference conducted at the Center for Media Studies, New Brunswick, NJ. Unpublished Manuscript.

Kubey, R. (2000b). Media literacy: Required reading for the 21th century. *The High School Magazine, 7*(8), 29–33.

Kubey, R., & Baker, F. (1999). Has media literacy found a curricular foothold? *Education Week, (10)*27, 56–57.

Kubey, R., & Csikszentmihalyi, M. (1990). *Television and the quality of life: How viewing shapes everyday experience.* Hillsdale, NJ: Lawrence Erlbaum.

Langer, E. J. (1993). A mindful education. *Educational Psychologist, 28*(1), 43–50.

Langer. E. J. (1997). *The power of mindful learning.* Cambridge, MA: Da Capo Press.

Langer, E. J. (1989). *Mindfulness.* Cambridge, MA: Da Capo Press.

Langer, E. J. (2000). Mindful learning. *Current Directions in Psychological Science, 9*(6), 220–223.

Langer, E. J., & Moldoveanu, M. (2000a). The construct of mindfulness. *Journal of Social Issues, 56*(1), 129–139.

Langer, E. J., & Moldoveanu, M. (2000b). Mindfulness research and the future. *Journal of Social Issues, 56*(1), 1–9.

Masterman, L. (1985). *Teaching the media.* London: Routledge.

Petty, R. E., & Cacioppo, J. T. (1986). *Communication and persuasion: Central and peripheral routes to attitude change*. New York: Springer/Verlag.

Petty, R., Cacioppo, J. T., Strathman, A. J., & Priester, J. R. (2005). To think or not to think: Exploring two routes to persuasion. In T. Brock & M. C. Green (Eds.), *Persuasion: Psychological insights and perspectives*. Thousand Oaks, CA: Sage.

Potter, W. J. (2004). Cognitive theory of media literacy. Thousand Oaks, CA: Sage.

Scharrer, E. (2002). Making a case for media literacy in the curriculum: Outcomes and assessment [Electronic version]. *Journal of Adolescent & Adult Literacy, 46*(4). Retrieved December 5, 2002 from http://readingonline.org/newliteracies/lit_index.asp?HREF=/new literacies/jaal/12–02_colum/index.html.

Serafin, G. (2006). *Media literacy education: Developing the motivation and ability to critically process advertisements*. Unpublished doctoral dissertation, Rutgers University, New Brunswick.

Silverblatt, A. (1995). *Media literacy: Keys to interpreting media messages*. Westport, CT: Praeger Publishers.

Tyner, K. (1998). *Literacy in a digital world: Teaching and learning in the age of information*. Hillsdale, NJ: Lawrence Erlbaum.

Worsnop, C. (1998). *Assessing media work: Authentic assessment in media education*. Unpublished manuscript.

Chapter 17

Alternative Media

The Art of Rebellion

Zack Furness

Scholars and activists frequently debate the role of mass media in society, but it is commonly understood that media contribute to the formation of cultural practices and political opinions, the evolution of journalism and art, the construction of ideologies (collective ideas about the way the world "should" work) and the development of national, regional, and self-identities. Mass media are an integral part of everyday life, but ironically most people are never taught to understand, evaluate or critically analyze the ways that media work. Media education is virtually absent from most public schools in the United States and until recently the phrase "media literacy" was rarely used in connection with primary or secondary education. Slowly but surely, school districts are beginning to incorporate media education into their standard curricula, but most teachers—aside from those trained in communication, film, or cultural studies—have not been taught how to develop effective media literacy programs.

Effective forms of media literacy require people to develop their critical thinking skills, and students are often very surprised (or shocked) when they begin to learn about the intersecting problems between media conglomeration, production, advertising, representation and reception. Sorting through history, misinformation and misconceptions is

a difficult process and doing so can seem overwhelming to even the most educated person. However, critical media studies can be both rewarding and empowering if approached in the right way. The problem is that many educators feel as if the only way to empower students is to overwhelm them with information and statistics about the insurmountable problems related to mass media without adequately discussing the ways in which people either challenge media power or create alternatives to it. Moreover, teachers often fail to understand why students do not *do* anything with this knowledge once they have been "empowered." The reason why is because teaching media literacy in this manner is not a form of empowerment—it is paralysis.

For any program in critical media literacy/education to be successful, several factors must be present. First of all, students must be willing to develop their critical thinking skills, to engage both their peers and their teachers, and to challenge their own assumptions. Teachers must also be willing to engage in critical dialogue, but they have the additional responsibility of creating an environment that encourages students to learn from one another. Students generally have a vast knowledge of media technologies and media content, and it is important for teachers to help their students utilize such knowledge in the classroom. Most importantly, though, teachers must choose reading materials and topics that address both the problems of mass media as well as some of the viable alternatives to a corporate media model.

In an ideal world, teachers would have the time, resources, and/or freedom necessary to adequately explore media practices that challenge the status quo. However, we all know that the realities of public education in the U.S. are much more grim—students can consider themselves lucky if they attend a district that has adequate funding for books, much less a media literacy curriculum. Nevertheless, teachers who facilitate media literacy programs have a responsibility to expose their students to diverse media content and media practices that are not profit-governed. One of the best ways to achieve such goals is to utilize *alternative media* in the classroom. The study of alternative media can, and should be, incorporated into any media curriculum that aspires to motivate and empower students. In what follows, I will discuss what alternative media are, why people create alternative media, and how alternative media production promotes the ethics of participation and dissent over consumption and passivity.

What Are Alternative Media?

Mass media in the United States have a long history of corporate ownership, from the empire established by newspaper mogul William Randolph Hearst in the 1920s through the contemporary dominance of multinational corporations like Murdoch's News Corporation and Time Warner (Bagdikian 2004, McChesney 2004). The production of alternative media emerged as a response to the problems posed by a profit-driven media system in which only a few corporations (an *oligopoly*) largely determine what types of media will be produced, which topics will be discussed, which forms of expression will be seen/heard, and whose

voices will ultimately be silenced. Alternative media is part of a vibrant spectrum of dissent against consolidated media power (Couldry & Curran 2003) that includes the efforts of media reform groups (who advocate structural change through policy), media watchdog groups (who critique mass media content) and media education organizations (who advocate media literacy). Alternative media could best be defined as non-corporate media that are driven by content, as opposed to profit, and based upon a "Do It Yourself" (DIY) ethic. Political literature, pirate radio, independent record labels, zines, Web zines, "comix" (underground comic books), and blogs are some of the most notable forms of alternative media that differ from mass media in their production, content, and purpose. By appealing to smaller, specialized audiences through a more personal approach to content that is not dependent on corporate advertising, the producers of alternative media can utilize different formats for their own needs, whether one's goal is to make a hip-hop record or circulate pamphlets on radical feminism. In other words, people have greater control over what types of media they can produce and what their media "say." This situation is radically different when compared to the corporate model because corporations have almost exclusive control over the content of their media and they largely base their decisions to feature certain types of media on whether they can sell that product to advertisers. Before I go into more depth about specific types of alternative media, it is useful to explain a little more about the context for alternative media and the relationships between production, content, and purpose.

Production, Power, and Content

Media corporations and advertisers are specifically interested in a group that Eileen Meehan (1990) calls the commodity audience—those people in a given media audience who have disposable income or spending money. A perfect example of the role of the commodity audience can be found in television production. With regard to the content of television programming, the executives of a corporation like NBC do not care whether they show an investigative news program, a made-for-TV movie, or a still photo of the *Friends* cast for an hour, as long as they can convince advertisers that the commodity audience will be watching their station at that particular time. Both corporations and advertisers use rating systems to (roughly) determine who is watching, and they then proceed to haggle about the price of advertising time. To put this more simply, the product being bought and sold is the audience's attention—not the program. Ultimately, the media corporations decide on the content, and the advertisers can influence those decisions based on the prospects of either buying more advertising time or pulling their financial support altogether. While the specific dynamics of the relationship between producers, advertisers, and audience vary between different media industries, the prevailing norm in corporate media is based upon the strategy of making money . . . lots and lots of money.

Although there are some exceptions to the rule, people who make alternative media do so in a much different way, meaning that they do not have to work within a rigid hier-

archical (top-down) system, and they have the ability to largely determine what is made, how much it will cost, and where it will be available. More importantly, their purpose for making media is not profit-motivated. People sometimes confuse the idea of profit vs. profit-motivated, and it is an important distinction to keep in mind when considering how alternative media are different from corporate media. Profit is not necessarily bad because it is an important way to generate money for new media projects and to reimburse people for their energy, time, and/or services. For example, some alternative media companies, such as independent record labels, may seem like smaller or scaled-down versions of corporate record labels because they have small staffs of paid employees and they advertise their products. However, there are important differences with regard to content, creative control, profit distribution, decision-making and ownership that distinguish these companies from their corporate counterparts. Generally speaking, independent recording artists are not expected to sacrifice creative control, or to compromise their artistic expression, in the name of profit.

Media corporations not only exercise power by controlling the content of their media, they also exert power by restricting access to anyone who is not part of their system. We are led to believe that the media industry is a free market, where anyone can take part, but unless a person has millions of dollars and/or access to satellites, studios, airwaves, or distribution networks, he or she cannot broadcast or circulate his or her chosen medium through corporate channels, never mind having the chance to directly compete with them. In other words, there are extremely high financial and technological barriers to entering the corporate media system. In light of this situation, it is easy to see how production, power and content are interrelated, and why these circumstances are loathed by people who view media as a means of creative expression, a form of education, and/or a vital component of a democratic society.

DIY Media

While it is true that most people lack the financial and technological means to take part in the corporate media system, it is a mistake to think that people who make alternative media want to be part of that system in the first place. Most alternative media producers are strongly opposed to the corporate model, and many hate everything it represents. However, this may not be the primary focus of one's work, or the reason why one makes media in the first place. People create media for a number of different, equally important reasons that should be acknowledged and respected.

One of the most basic reasons why a person creates alternative media is because there are no forms of media available that address one's interests, or represent them in any way. For example, science fiction fans in the 1930s created their own publications called "fanzines," or "zines," in order to write about their favorite sci-fi authors, to review books and films, and to debate issues in science fiction. Science fiction zines also included contributors' contact information so that zine readers could exchange letters, books and writing with one other. At the time there were no publications available that interested hardcore sci-fi fans, so they started their own! By including their contact information, they

used fanzines such as *The Comet* (the original fanzine) to create a grassroots community of science fiction fans. The basic model of the zine was widely popularized in the 1970s through the circulation of punk zines like *Sniffin' Glue* and *Punk*. Like their sci-fi predecessors, punk zines featured interviews, editorial columns, reviews and news about a subculture that was generally ignored by mainstream print media. Since the 1970s, people have made zines about thousands of other topics or issues including thrift store shopping, bicycling, feminism, "temp" work, soccer, celebrity murders, ferrets, afros, queer culture, and just about anything else you could think of (in addition to lots of things you would have never thought of).

The "lo-fi" approach to media production embodied in the cheap, photocopied format of the zine is certainly one way in which individuals have learned how to develop their own voices in an environment of mass produced media, but zines are merely one part of a wider DIY movement against corporate media that is manifested through the independent production of nearly every type of medium including books, film, photography, music, posters, radio programs, and Web sites. Through the use of techniques that range from wheat pasting to html coding, alternative media enthusiasts have not only learned how to use a variety of tools to get out their messages, they have also pushed the creative and artistic boundaries of their respective mediums. For example, some of the most innovative and passionate music to emerge throughout the last 30 years was created by artists who either started their own record labels or worked with independent labels that were founded and operated by other musicians. Despite the fact that media corporations have been actively purchasing entire independent music labels or parts of labels that once played a key role in the production of anti-corporate music (such as Rawkus, Sup Pop, Matador) there are thriving independent music scenes throughout the world that are buttressed by the fiercely anti-corporate ethics of labels like Rough Trade, SST, Warp, Dischord, Anticon, K Records, Definitive Jux, No Idea, Ninja Tune, Constellation, Plan-it-X, and the list goes on and on and on.

My point here is not to privilege music above other forms of alternative media, but merely to provide a basic example of how artistic expression is often fostered in noncorporate environments. The DIY response to mass media production has been, and continues to be, shared by millions of people who create media to represent and address their own specific interests. Participation is the key ingredient to alternative media, which makes it fundamentally different from media models in which producers are seen as separate from audiences. Stephen Duncombe, a professor and political activist, suggests that people who make alternative media erode the lines between producer and consumer and they "challenge the dichotomy between active creator and passive spectator that characterizes our culture and society" (1999, p. 127).

With the development of the Internet and digital publishing technologies, the DIY ethic of participation has not only been more visible to wider audiences, it has also resulted in the creation of interactive forums by groups of eager media producers who work outside of, or directly against, corporate media channels. A perfect example of a participatory, Web-based alternative medium is the online news Web site, Indymedia.org, which was started by activists who wanted to document the events of the 1999 World Trade Organization

protest in Seattle. In the years since the WTO protest, there have been Indymedia Web sites developed in almost 200 cities throughout the world, and people have used the interactive resource as a way to cover news stories, debate political issues, publish investigative journalism, and organize activists for protests on a wide range of political issues.

The DIY approach to media production does not solve socioeconomic problems, but it promotes the idea that anyone can learn how to make their own media. In this way, DIY ethics cross race, class, and gender lines and connect different alternative media practices throughout history. However, there are crucial differences to consider when looking at why or how people end up "doing it themselves." For example, white people have an incredible degree of privilege compared to people of color, so it is wrong to suggest that white suburban teenagers who put out political punk records in the twenty-first century are the same as African American abolitionists who printed their own newspapers in the nineteenth century. There are *worlds* of difference between these two groups including their respective historical/cultural contexts, their motivations, and their access to money, materials and volunteer labor. In addition, there are obvious differences in the actual content of their messages, i.e. what is being said and how it is being said. However, the bond that connects these different groups is a mutual recognition that people must create their own media outlets when none exist—because corporations are certainly not going to do it for us. Media scholar Chris Atton sums this up when he says that alternative media offer "the means for democratic communication to people who are normally excluded from media production" (2002, p. 4).

Radical Media

One of the most important reasons why people make alternative media is because they want to express opinions and views that are too critical, confrontational, and/or political for mass media. Media scholar John Downing (2000) refers to this lineage of media production as *radical media* or media that express an oppositional stance against both mainstream society and popular culture. Radical media have a long history in western countries where people had early access to printing press technologies and opposition to radical media is just as old. For example, the English government passed a large tax on newspapers in 1797 in order to put limits on the radical press. Despite the historical power wielded by governments, churches, and multinational corporations, radical media have continued to thrive through the production of newspapers, pamphlets, posters, music, zines, documentaries, films, Web sites, and blogs that challenge the politics, ethics, and logic of the status quo. Radical media have played an especially important role in labor struggles and social movement activism throughout the last 150 years because they have been a way for disenfranchised and oppressed peoples to articulate their experiences, grievances, and perspectives that are consistently ignored, or grossly misrepresented, by the mass media.

Mass media, particularly news, have a powerful agenda setting function, which means that the media do not necessarily tell us what to think, but they give us an extremely limited option for "what to think about and how to think about it" (McChesney 2004, p. 70).

Through this process of coercion (toward a particular set of beliefs) and consent (people's willingness to embrace mass media) a dominant, or hegemonic, paradigm evolves in a given society and ideas that challenge the dominant ideology are viewed with skepticism, anger, or outright hostility. Radical media, in the form of propaganda (intentionally persuasive information) and journalism (reporting about facts and events with a more "objective" approach) directly challenge this model by introducing new ideas into public discourse, by critiquing institutions of power, by documenting cultures that exist under the radar of popular/consumer culture, by promoting participation, and by encouraging solidarity with others who have similar beliefs about how the world should work.

For the millions who do not benefit from capitalism, consumerism, globalization, and concentrated governmental authority, radical media create spaces where people can both discuss and demand alternatives to prevailing socioeconomic and cultural norms. Some notable examples of radical media in this vein are newspapers and pamphlets produced by groups like the Industrial Workers of the World (IWW) and the Black Panther Party for Self-Defense (The Black Panthers). The IWW began as an anarchist/socialist union that argued for the political organization of all working people into "one big union" that could overthrow the wage system through direct action, i.e., strikes, boycotts, and various forms of civil disobedience. At its height in the early 1900s, the IWW had over 100,000 members who were dedicated to the idea that "an injury to one is an injury to all." Publications like *The Industrial Worker*, the IWW newspaper, were used to keep members informed and educated about relevant news, events, and opinions of fellow workers throughout the country.

A similar example of radical media used in support of a political party can be found in the organization of the Black Panthers, a civil rights and self-defense organization started in 1966 by African American activists who spoke out openly against police violence, capitalism, and centuries of racism against black people. The group's principles were laid out in a document called the "Ten Point Program," which was widely circulated in black communities throughout the United States. Along with the oratory skills of their leadership and the development of successful community programs, the Panthers' literature played an important role in the development of black consciousness in the United States, and it aided in the recruitment of new party members during the late 1960s. In addition to the "Ten Point Program," the Panthers published books, newspapers (*The Black Panther*), and various educational pamphlets about community resources, constitutional rights, and the dangers of drug abuse (to name a few topics).

Activists in recent decades have become more media-savvy by studying both the victories and defeats of media campaigns waged by social movements of previous eras. Their efforts have not only resulted in the production and distribution of radical media throughout the world, they have helped to organize activists involved in the environmental movement, the animal rights movement, the anti-globalization movement, the queer rights movement and the anti-war movement. Radical media has been globally utilized by a diverse wave of activists that range from peasant revolutionaries in Mexico to urban anarchists in the U.K., to peace activists in the Israeli-occupied Palestinian territories.

Creating Networks

The production of alternative media is not just about the creation of media texts, it is also about creating a shared sense of community with people who have similar views, interests and beliefs. This is one of the reasons why alternative media has played such a central role in political organizations and subcultures throughout the world. As new forms of media emerge, new channels of communication open up, new communities develop, and the cycle continues. With the added advantage of Web-based communication, the once-small network of alternative media producers, distributors and retailers has grown enormously in recent decades. As a result, it is easier than ever for media producers to gain access to basic materials and distribution networks, assuming that one has the financial means to do so.

Distribution and sales networks are crucial to alternative media production because it is very difficult for people to find places where they can sell media that might be considered "weird," foreign or overtly political. The emergence of giant media retailers (chain stores) and the subsequent closure of "mom and pop" establishments across North America has resulted in fewer stores that are willing to acquire and sell media that are not shipped from a corporate distributor. This also means that fewer stores are willing to support local musicians, writers, artists, and other media producers. Fortunately, there have been diligent media enthusiasts and activists who have devoted incredible amounts of energy to the circulation and distribution of alternative media—oftentimes without being paid. For example, it is not uncommon to see tables set up at DIY punk and/or hip-hop shows where people have boxes of records and CDs for sale from bands whose music will never see the light of day in a Best Buy, Wal-Mart, or Virgin Megastore. At some of the same shows, you will often see touring bands selling music, books, or art from their friends and fellow artists in their hometowns. These types of alternative media distribution networks are often intentionally small and therefore very personal. However, there are certain cases in which these same networks can expand into larger organizations that subsequently help out other independent publishers and distributors.

A case in point is AK Press, a worker-owned collective that publishes political literature and distributes what might be the biggest selection of radical media in the world. AK Press was founded by Ramses Kanaan, an anarchist zine editor who started his distribution network in Scotland. During the late 1980s and early 1990s, Ramses sold political zines while he was on tour with punk bands in Europe, and in 1991 AK Press was turned into a worker-owned cooperative (Vale 1996, p. 106). In recent years, AK has published new books, reprinted older and/or "out of print" books and widened their distribution list to include clothing, buttons, CDs, films, magazines, hundreds of zines and thousands of books— including the entire catalogues of over a dozen independent book publishers/distributors. Through this network, AK Press is not only able to make political literature more widely available, they are also able to help develop and strengthen other alternative media networks that include activists, writers, artists, radical bookstores and "infoshops" (small, volunteer-run collectives that sell and distribute political media). By creating successful, self-sufficient distribution networks, organizations like AK provide vital outlets for people

who would otherwise have no substantial means to sell and/or distribute their work. This not only allows alternative media producers to reach new audiences, it also supports people who want to take artistic/political chances with their media.

Conclusion

While I have only been able to provide a (very) brief glimpse into the world of alternative media, it is easy to see how there are viable options that exist for people who want to create alternative media and others who want access to such resources. Given the vast scope of media produced under the alternative rubric, it is crucial for media scholars, teachers, and students to recognize the ways in which alternative media can enhance, redefine, and challenge our engagement with media in the twenty-first century. Similarly, it is also important to contextualize alternative media as part of a wider resistance movement against corporate power structures that will not save the media on their own account. It is ignorant to dismiss alternative media as a "fringe" activity, but it is also foolish to credit alternative media as being implicitly revolutionary. Alternative media certainly have a distinct role to play in revolutionary politics, and they also have the potential to revolutionize the way in which media are made throughout the world. However, we must not be content with the idea of simply creating alternatives to a commercial, corporate media system that excludes dissent, discourages participation, and negatively represents both the interests and beliefs of billions throughout the world. What we need is more organization among media critics, more pressure applied to corporate media producers, more support for media reform groups, more dialogue, and more media education.

Alternative media teaches us that anyone who wants to make media can do it on their own terms. It teaches us that media production does not require a vast knowledge of media institutions or a great deal of money. It can inform us about a vast array of perspectives on politics, culture, economics and the media industry. Finally, alternative media emphasizes the idea that culture is a "whole way of life" (Williams 1953, p. viii) defined by creation and participation—culture is not simply a product to be consumed.

Learn. Create. Participate. Resist.

REFERENCES

Atton, C. (2002). *Alternative media*. London: Sage.

Bagdikian, B. (2004). *The new media monopoly*. (2004). Boston: Beacon Press.

Downing, J. (2000). *Radical media: Rebellious communication and social movements*. London: Sage.

Couldry, N., & Curran, J. (Eds.). (2003). *Contesting media power*. Lanham, MD: Rowman & Littlefield.

Duncombe, S. (1997). *Notes from underground: Zines and the politics of alternative culture*. London and New York: Verso.

McChesney, R. (2004). *The problem of media*. New York: Monthly Review Press.

Meehan, E. (1990). Why we don't count. In Mellencamp (Ed.), *Logics of television: Essays in cultural criticism* (pp. 117–137). Bloomington: Indiana University Press.

Vale, V. (1996). *Zines!* San Francisco: V/Search.

Williams, R. (1953). *Culture and society: 1780–1950*. New York: Columbia University Press.

FURTHER READING

Armstrong, D. (1984). *A trumpet to arms: Alternative media in America*. Cambridge, MA: South End Press.

Atton, C. (1999). The infoshop: The alternative information centre of the 1990s. *New World Library, 100*(1).

Atton, C. (2005). *An alternative Internet*. Edinburgh: Edinburgh University Press.

Buhle, P., & Schulman, N. (Eds.). (2005). *Wobblies: A graphic history of the industrial workers of the world*. London and New York: Verso.

Jones, C. E. (Ed.). (1998). *The Black Panther Party reconsidered*. Baltimore: Black Classic Press.

Marcos, S. (2004). *Ya Basta! Ten years of the Zapatista uprising*. Oakland: AK Press.

McCombs, M., & Shaw, D. (1972). The agenda-setting function of mass media. *Public Opinion Quarterly, 36*, 176–187.

McKay, G. (1996). *Senseless acts of beauty*. London: Verso.

McKay, G. (1998). *DIY culture: Party and protest in Britain*. London: Verso.

Morris, D. (2004). Globalization and media democracy: The case of the independent media centers." In D. Schuler & P. Day, *Shaping the network society: The new role of civil society in cyberspace*. Cambridge, MA: MIT Press.

Newton, H. P., & Morrison, T. (1995). *To die for the people: The writings of Huey P. Newton*. New York: Writers and Readers Publications.

Nogueira, A. (2002). The birth and promise of the Indymedia revolution. In B. Shepard & R. Hayduk (Eds.), *From ACT UP to the WTO: Urban protest and community building in the era of globalization*. London: Verso.

Renshaw, R. (1967). *The Wobblies: The story of the IWW and syndicalism in the United States*. New York: Doubleday.

Roger, S., & Triggs, T. (2002). *Below critical radar: Fanzines and alternative comics from 1976 to Now*. New York: Codex.

Spencer, A. (2005). *DIY: The rise of lo-fi media*. London: Marion Boyers.

Stein, R. L., & Swedenberg, T. (Eds.). (2005). *Palestine, Israel and the politics of popular culture*. Durham: Duke University Press.

INTERNET RESOURCES

*AK Press (www.akpress.com)

*Democracy Now! (www.democracynow.org)

*International Progressive Publications Network (www.ippn.ws/)

*Microcosm Publishing (www.microcosmpublishing.com)

*The Zine and E-zine Resource Guide (www.zinebook.com)

Chapter 18

Reading Race, Reading Power

C. Richard King

Race is a ubiquitous, though too frequently unnoticed, feature of contemporary media worlds. This reality has profound consequences for material relations, social identities, and cultural politics. However, few media users and consumers fully appreciate its prominence or power, all too often lacking the critical tools to adequately engage its racialized imaginaries and effects. With this in mind, this chapter offers an overview of the articulations of race, media, and power, outlining critical technologies to read and resist them. Focusing on the entanglements of racialization and representation, it details the push within media literacy studies beyond the limitation of stereotyping. Specifically, it attends to the significance of production, reception, pedagogy, and performance. Examples will be drawn from a variety of media, including film, television, music, video games, and sport. Moreover, a comparative approach will be taken, allowing an exploration of the complexities of racialized identities and experiences. Following an overview of race and racism, the discussion moves first to common misreadings of race and subsequently to emergent concepts and established techniques in media literacy that encourage critical re-engagements with the production and consumption of racialized texts. Finally, the conclusion outlines the contours of anti-racist media literacy.

On Race

To begin, race is not a natural fact but a social construct. It is a production, emergent from the work and play of situated human actors. Its precise means and meanings change over time, reflecting specific social struggles and cultural stagings. As Barbara Fields (1990, p. 118) suggests

> Nothing handed down from the past could keep race alive if we did not constantly reinvent and re-ritualize it to fit our own terrain. If race lives on today, it can do so only because we continue to create and re-create it in our social life, continue to verify it, and thus continue to need a social vocabulary that will allow us to make sense, not of what our ancestors did then, but of what we choose to do now.

Media texts not only inscribe, adapt, interpret, and invent much of the social vocabulary through which audiences come to know and understand race, but they also unfold as powerful and pleasurable sites within which social subjects can utilize, negotiate, and apply this vocabulary to craft identities and communities.

As race has been rethought, so too have its connections to power, frequently abbreviated as racism. Racism must not be confused with prejudice; it instead must be understood as domination. It is not simply that whites lack knowledge or have bad attitudes; racism refers to a system of social relations, a set of structural inequalities, cultural forms, and ideological norms, all rooted in racialized conceptions and categories. Moreover, rather than an aberrant, extreme, or antiquated feature of the American experience, racism is understood as normal, everyday, and ever-present, defining American institutions and ideologies (Delgado, 1995, p. xiv; Ladson-Billings, 1999, p. 12). Therefore, like race, Hall (quoted in Gilroy, 1990, p. 265) reminds us, racism must be grounded and understood as constructed and conditional:

> Racism is always historically specific. Though it may draw on the traces deposited by previous historical phases, it always takes on specific forms. It arises out of the present—not past—conditions. Its effects are specific to the present organization of society, to the present unfolding of its dynamic political and cultural processes—not simply to its repressed past.

Racism is both ideological and institutional, involving much more than individual intention, ideas, or attitudes.

For all of this, racism has become increasingly slippery. In the absence of overt markers, racism is often difficult to both define and locate within contemporary discussions. Despite the unwillingness or inability of commentators, pundits, politicians, journalists, and everyday citizens to come to terms with the persistent presence of race and racism, scholars have crafted critical frameworks, noteworthy for the sophistication they bring to bear upon the reconfigurations of racism in post-civil rights America (see, for example, Ansell, 1997; Bonilla-Silva, 2001, 2003; Brown et al., 2003; Doane & Bonilla-Silva, 2003). The deployment of colorblind language and emphasis on "not seeing any color" does not reflect American reality in that "racial considerations shade almost everything in America" (Bonilla-Silva, 2003, p. 1). Notwithstanding these arguments and the vast amount of statistical data illustrating racial inequality, individuals and institutions explain away "the appar-

ent contradiction between professed color blindness, and the United States' color-coded inequality" (Bonilla-Silva, 2003, p. 2). Embracing a variety of lenses and rhetorical strategies, whites are able to rework America's contemporary racial reality to legitimize notions of color blindness, freedom, equality, democracy, and America. The increasing visibility of entertainers of color, the supposed changes in artists' possibilities, and the adoration America has for Denzel Washington, Jay-Z, Halle Berry, and Will Smith are posited as evidence of racial progress and color blindness. Popular culture and its accented color thus serve as the evidence for post-civil rights progress and the hegemony of America's color blindness.

Sociologist Eduardo Bonilla-Silva (2003) conceives of color blindness as a racial ideology that supports and extends the racialized order of things. Like all ideologies, he continues, color blindness works because it offers a set of frames, or interpretive building blocks, to explain (away) race and racism. Specifically, he suggests that whites employ four frames:

1 abstract liberalism, an ethos blending individualism, a rhetoric of equality, and choice
2 naturalization, or the assertion that "racial phenomena . . . are natural occurrences" (p. 28)
3 cultural racism, the appeal to culture to explain difference
4 minimization, or efforts to reduce or dismiss the continuing significance of race and racism.

Importantly, then, color blindness blinds Americans to the realities of white supremacy as both a historical force and a social condition. White supremacy is best understood as a set of ideological and institutional arrangements that has structured U.S. society past and present, endowing Euro-Americans with privileges and advantages on the basis of their skin color. Whereas white supremacy formerly demanded "self-conscious" schemes and explicit hierarchies (such as eugenics and scientific racism), as well as unapologetic restrictions and legal prohibitions (on citizenship, immigration, and race mixing for instance) (Fredrickson, 1981), today, the defense of white power hinges on denial and deflection that locate racism in the past or within "fringe" or "extremist" movements, while recoding racial rhetoric in the languages of diversity, cultural difference, and the key words of the mainstream civil rights movement (reverse racism for instance).

Common (Mis-) Readings of Race in the Media

In late August 2006, the new season of *Survivor* became the subject of much buzz. For the first time, the reality show would feature an equal number of African American, Asian American, Euro-American, and Latina/o competitors. The producers, reportedly, building on the popularity of previous seasons devoted to "the battle of the sexes" or generational clashes, would divide the contestants into four racial "tribes." While the perennial popularity of *Survivor*—with its reliance on racialized notions of exoticism and savagery and banal

reiteration of social Darwinism—should immediately raise questions about how most Americans read racialized media texts, the response to the 2006 fall season, in particular, highlights a range of common misreadings of race in the media.

The producers of the show have asserted and the vast majority of media users appear to have consented that race is a natural fact, creating fixed boundaries between groups and comfortable patterns of affiliation within groups. Within Internet chat rooms, on talk shows, and in the news media generally, efforts to unpack the racial significance of the show's narrative structure and naturalistic assumptions were dismissed, mocked, and trivialized with charges of irrelevance, appeals to the observable word, invocations of political correctness, the insistence that it was just entertainment, and the certainty that it was a publicity ploy meant to generate buzz and increase audience share (and hence profits).

These readings of race as natural, unproblematic, and irrelevant dovetailed nicely with efforts to reiterate difference. Rush Limbaugh, for instance, relished the opportunity to use the show as an occasion to rehearse "commonsense" understandings of racial groups. The conservative radio host claimed that the show was not fair because the number of water events would disadvantage African Americans who, everyone knows (according to Limbaugh), cannot swim as well as others. Hispanics (as he dubbed them) had a better chance, because "they have shown a remarkable ability . . . to cross borders, boundaries—they get anywhere they want to go." Even better, by his estimation, were the odds the Asian Americans would win, because they "will outsmart everybody." Limbaugh was not optimistic about the chances of the Euro-American tribe, unless cheating and oppression were allowed. With the exception of a few alternative media outlets, Limbaugh was not called to answer for his racist diatribe.

Following Hall (1997), critical engagements with media worlds conceive of representations of difference as signifying practices that reflect, extend, and, under the right circumstances, challenge racial hierarchies, and they probe how representations of difference produce meaning. The circulation and consumption of racial representations, then, as the following analysis underscores, actively constitute racial meaning and the broader racialized social order. Activating race has redirected media analyses away from stereotypes toward stories (Denzin, 2002), spectacles (King & Springwood, 2001; McClintock, 1995), discursive fields, most famously Orientalism and Eurocentrism (Said, 1978; Shohat & Stam, 1994; see also Goldberg, 1990), ideologies of identity formation (Ferguson, 1998; Hall & du Gay, 1996), and practices of consumption (Chin, 2001; Manring, 1998). Binding these studies of race, media, and power together is the interrogation of racialization, or processes of making, using, and doing race.

Encoding/Decoding

Representations, of course, are neither flat nor static. Instead, they remain open, in motion, complex, and contested sites in which meaning emerges from situated encounters between subjects and signs. Recognizing this, Stuart Hall (1997) elaborated on the notions of

encoding and decoding, wherein the former stresses the creative processes of communicating, of assembling and sending a message, and the latter highlights the interpretive frames and analytic acts through which audiences make sense of the message, giving it meaning. Moreover, in this model of signification, differently situated interpretive communities arrive at competing and conflicting accounts of meaning. There are to be sure, Hall further postulates, preferred readings or dominant understandings of utterances, actions, and images, which culture industries secure through the manufacture of consent or hegemony.

Disney's *Pocahontas* provides a compelling example of encoding/decoding. To many Americans, the film offers a beautifully drawn and touchingly told love story, in which a young American Indian woman defies prejudice and works for peace and understanding between the English and the Powhatan. In contrast, Native American viewers saw a much more disturbing motion picture. Choosing to ignore its Powhatan consultants, who stressed the historical realities of Euro-American conquest and the inappropriateness of transforming the prepubescent Pocahontas into a nubile princess, in an effort to craft an entertaining and profitable story, the media giant created a story at odds with the sensibilities of many American Indians. To clarify the significance of this alter/native reading, Robert Eaglestaff, a Native American educator and principal in Seattle, suggested that *Pocahontas* would unsettle creators and consumers alike if they saw it like many indigenous people did: It is "like trying to teach about the Holocaust and putting in a nice story about Anne Frank falling love with a German officer" (quoted in Kilpatrick, 1999, p. 151).

Texts That Teach

Media texts, more than parents, or even schools, increasingly teach about race and racism. Nevertheless, faculty, who dismiss popular culture, miss important moments in which they might "teach to transgress" (hooks, 1994). In his book, *Fugitive Cultures: Race, Violence, and Youth*, Henry Giroux argues that within a discourse of critical pedagogy, "images do not dissolve reality into another text: on the contrary, representations become central to revealing the structures of power at work in schools, in society, and in the larger global order" (1996, p. 53). The power of popular culture resides in its dominance of representation and its regulation of meanings. The trilogy teaches lessons; the broader culture industries teach consumers how (not) to read; and when taught about race, students become aware, ambivalent, caught, and critically literate. Of particular importance for students and teachers of media literacy, a number of scholars have reframed the media as teaching machines that inculcate audiences, instructing them in the significance and use of key terms, commonsense explanations, and discursive strategies (Giroux, 1999; McLaren, 1999; McCarthy & Crichlow, 1993). Such popular pedagogies, Henry Giroux (1999, p. 84) observes, "inspire at least as much cultural authority and legitimacy for teaching specific roles, values, and ideals [as] more traditional sites of learning such as public schools, religious institutions and the family."

Racial Cross-Dressing: On Performativity

Media texts do not merely instruct about race, they also enact it as well, taking an active and arguably primary role in the shape and scope of racialization in the contemporary United States. David Leonard (2003) has suggested that video games constitute a (post-) modern form of minstrel performance, enabling whites an opportunity to try on new identities and enjoy forbidden experiences under the cover of blackface. Within ghetto-centric video games, such as Grand Theft Auto III, white youths get to play at being a black gangster, kill and maim, cavort with prostitutes, steal, destroy property, and disrespect authority, all from the comforts of their suburban homes and without jeopardizing the security of their middle-class (and racial) status. A similar argument might be made about the popularity and possibilities of hip-hop music for white youths, who constitute its single largest market share. Likewise, Euro-Americans have long played Indian. Even at the start of the twenty-first century, Indianness serves as a powerful mask for Euro-Americans, whether in blockbusters like *Dances with Wolves* and *The Last of the Mohicans*, half-time performances by beloved mascots, or in youth groups like the Boy Scouts. All of these performances hold in common an effort to lay claim to place, identity, community, and/or history through the staging of imagined Indians. In contrast with approaches devoted to studying static stereotypes, performative media literacy has the potential to highlight the creative and even transformative aspects of racial signification.

Resistance and Reaffirmation

Audiences regularly question, challenge, and reframe the preferred readings of race offered with media texts. In context of denial and color blindness, such counter-readings increasingly take the form of open resistance, including protest, online petitions, and boycotts (see King, forthcoming). Over 30 years ago, Latina/os forced Frito-Lay to retire its supposedly good-natured Frito Bandito. More recently, Arab Americans protested the disparaging and supposedly humorous depictions in *Aladdin*, prompting rewrites and editing by Disney. Asian Americans organized an effective campaign against Abercrombie and Fitch for a line of tee-shirts which employed denigrating imagery and language (such as "Two Wongs Make a White"). In addition, Native Americans have struggled against American Indian mascots, sometimes successfully, for the past 40 years, only slightly less time than African Americans have combated Aunt Jemima. Racialized cultural workers and communities also have used the media to reaffirm their cultures and histories in a white supremacist context.

Conclusions

Media literacy has since its inception embraced and elaborated anti-racism as a project and a problematic issue. The prospect of re-energizing anti-racist pedagogy in the context of new racism presents scholars, educators, and students with an important challenge. The rein-

vigoration of anti-racist politics and pedagogy begins with a set of inter-related undertakings committed to exposing the intersections of signification, power, and race. First, reading race and reading against racism must mean learning to read racialization, not simply race. That is, equipping students with the tools to recognize, engage, and challenge the (re-) articulations of racial identities, ideologies, and hierarchies. Second, the teaching of anti-racist media literacy must be rooted in a pedagogy that is about more than difference or even stereotypes; it must embody and enact a pedagogy that directs its attention toward the disruption of white supremacy as a structured social system. Third, anti-racist media literacy has to be comparative, stressing the ways in which human communities, social problems, performative forms, cultural norms, corporeality, identity, possibility, pleasure, and privilege have been racialized differently for Euro-Americans, Native Americans, Asian Americans, African Americans, and Latinos. This process forces users and consumers to situate themselves, reflecting on mutual productions, social locations, and the centrality of whiteness (and white power) to media worlds. Finally, an anti-racist media literacy can make the biggest difference when it recognizes that "the importance of pedagogy as a mode of cultural criticism" lies in its "useful[ness] for questioning the very conditions under which knowledge, values, and social identities are produced, appropriated" in the name of white supremacy, capitalism, and the maintenance of colorblind hegemony (Giroux, 1996, p. 19).

REFERENCES

Ansell, A. E. (1997). *New right, new racism: Race and reaction in the United States and Britain*. New York: New York University Press.

Bonilla-Silva, E. (2001). *White supremacy and racism in the post-Civil Rights era*. Boulder: Lynne Rienner.

Bonilla-Silva, E. (2003). *Racism without racists: Color-blind racism and the persistence of racial inequality in the United States*. New York: Rowman & Littlefield.

Brown, M. K., Carnoy, M., Currie, E., Duster, T., Oppenheim, D. B., Shultz, M. M., & Wellman, D. (2003). *Whitewashing race: The myth of a color-blind society*. Berkeley: University of California Press.

Chin, E. (2001). *Purchasing power: Black kids and American consumer culture*. Minneapolis: University of Minnesota Press.

Delgado, R. (1995). *Critical race theory: The cutting edge*. Philadelphia: Temple University Press.

Denzin, N. K. (2002). *Reading race*. Walnut Creek, CA: Sage.

Doane, A., & Bonilla-Silva, E. (Eds.). (2003). *White out: The continuing significance of racism*. New York: Routledge.

Ferguson, R. (1998). *Representing 'race': Ideology, identity, and the media*. London: Arnold.

Fields, B. J. (1990). Slavery, race, and ideology in the United States of America. *New Left Review*, 181, 95–118.

Fredrickson, G. M. (1981). *White supremacy: A comparative study in American and South African history*. Oxford: Oxford University Press.

Gilroy, P. (1990). One nation under a groove: The cultural politics of race and racism in Britain. In D. T. Goldberg (Ed.), *Anatomy of racism* (pp. 263–282). Minneapolis: University of Minnesota Press.

Giroux, H. A. (1996). *Fugitive cultures: Race, violence, and youth*. London: Routledge.

Giroux, H. A. (1999). *The mouse that roared: Disney and the end of innocence*. Lanham, MD: Rowman and Littlefield.

Goldberg, D. T. (1990). *Anatomy of racism*. Minneapolis: University of Minnesota Press.

Hall, S. (Ed.). (1997). *Representation*. London: Sage.

Hall, S. & du Gay, P. (Eds.). (1996). *Questions of cultural identity*. London: Sage.

hooks, bell. (1994). *Teaching to Transgress: Education as the Practice of Freedom*. New York: Routledge.

Hunter, B. (2004, March 3). Marge is not all bad, but calling her a hero is going too far. *Columbus Dispatch*, 1H.

Jackman, M. R. (1994). *The velvet glove: Paternalism and conflict in gender, class, and race relations*. Berkeley: University of California Press.

Kilpatrick, J. (1999). *Celluloid Indians: Native Americans and Film*. Lincoln: University of Nebraska Press.

King, C. R., & Leonard, D. J. (2006). Racing *The Matrix*: Audience interpretations of power, difference, and the human future in the film trilogy. *Cultural Studies/Critical Methodologies* 6(3): 354–369.

King, C. R., &. Springwood, C. F. (2001). *Beyond the cheers: Race as spectacle in college sports*. Albany: State University of New York Press.

Ladson-Billings, G. (1999). Just what is critical race theory, and what's it doing in a nice field like education? In L. Parker, D. Deyhle, & S. Villenas (Eds.), *Race is . . . race isn't: Critical race theory and qualitative studies of education*. Boulder: Westview Press.

Leonard, D. (2003). "Live in your world, play in ours": Race, video games, and consuming the other. *Studies in Media & Information Literacy Education*, 3(4). Retrieved 15 Jan 2004 from http://www.utpress.utoronto.ca/journal/ejournals/simile

Leonard, D. J., & King, C. R. (Forthcoming). White power and sports in the contemporary U.S. In C. L. Cole, A. Burgos, & D. Roediger (Eds.), *Capitalizing on sport: America, democracy, and everyday life*.

Limbaugh handicapped races in new Survivor series, suggested "African-American tribe" worst swimmers, Hispanics "will do things other people won't do." Media Matters for America. Retrieved 25 August 2006 from http://mediamatters.org/items/200608240003.

Manring, M. M. (1998). *Slave in a box: The strange career of Aunt Jemima*. Charlottesville: University Press of Virginia.

McCarthy, C., & Crichlow, W. (Eds.). (1993). *Race, identity and representation in education*. New York: Routledge.

McClintock, A. (1995). *Imperial leather: Race, gender, and sexuality in the colonial contest*. New York: Routledge.

McLaren, P. (1999). Gangsta pedagogy and ghettocentricity: The hip hop nation as counterpublic sphere. In C. McCarthy, G. Hudak, S. Miklaucic, & P. Saukko (Eds.), *Sound identities: Popular music and the cultural politics of education* (pp. 19–64). New York: Peter Lang.

Said, E. (1979). *Orientalism*. New York: Vintage.

Shohat, E., & Stam, R. (1994). *Unthinking Eurocentrism: Multiculturalism and the media*. New York: Routledge.

Stedman, R. W. (1982). *Shadows of the Indian: Stereotypes in American culture*. Norman: University of Oklahoma Press.

FILMOGRAPHY

Clemens, R., & Musker, J. (Producers/Directors). (1992). *Aladdin* [Motion picture]. United States: Disney.

Eberts, J. (Executive Producer), & Costner, K. (Director). (1990). *Dances with wolves* [Motion picture]. United States: Tig Productions.

Pentecost, J. (Producer), & Gabriel, M. & Goldberg, E. (Directors). (1995). *Pocahontas* [Motion picture]. United States: Disney.

Robinson, J. G. (Executive Producer), & Mann, M. (Director). (1992). *The Last of the Mohicans* [Motion picture]. United States: Twentieth Century Fox.

TELEVISION SERIES

Burnett, M. et al. (Producers), & Burnett, M. (Director). (2000–present). *Survivor* [Television series]. New York: CBS.

Chapter 19

Putting Reality Together

The Media and Channel One as a Platform of Antidialogic Cultural Action

João Paraskeva

Introduction

This chapter attempts to reveal how common sense is under a non-stop process of perverted meanings and to analyze the role the media play in the meaning-making process. Thus, by anchoring our exegesis in the approaches of radical and critical scholars like Bourdieu, Freire, Macedo, Chomsky, Apple, Molnar, McLaren & Farahmandpur, Steinberg, and Kincheloe, among others, I will analyze how the media fabricate and perpetuate what we might call a commonsensical common sense, by "saying the unsayable"—and how classrooms are towering spaces within this well-orchestrated strategy. I will also expose how Paulo Freire's theory of antidialogical cultural action helps us to understand and transform the way the media "put reality together" by imposing the views and interests of the dominant groups over the oppressed. I end my analysis claiming for the need to work within the sphere of discourse analysis, not only to unveil how texts are produced by media workers in media institutions, the ways the texts are received by audiences, and how the media texts are socially distributed, but also to understand the media as a powerful device of what Freire calls "cultural revolution."

Given this theoretical grounding, I use Channel One as my artifact to examine the use of media in order to promote an ideological agenda within the American public school system. Channel One, brainchild of Christopher Whittle, is a program that places a satellite system and televisions in American public schools gratis in exchange with contracted viewing obligations from each classroom.

Giving News *versus* Giving Views

When one analyzes the media, Bourdieu (1996) argues, one should be aware of convoluted dynamics such as economic and political censorship, the "game" of showing and hiding, the circular circulation of information, and the relation between market share and competition. The media are permeated by censorship—both political and economic. Having television as an example, we experience a "loss of independence linked to the conditions imposed on those who speak on television" (Bourdieu, 1996). In other words, we are faced with political censorship, and we should also be aware that "what gets on television is determined by the owners, by the companies that pay for the ads, or by the government that gives subsidies." In fact, the proximity between media apparatuses and government institutions within a capitalist system is an undisputable reality. As McChesney (2004) argues, our media, "far from being on the sidelines of the capitalist system, are among its greatest beneficiaries." One vividly perceives that such interdependence gives credibility to the fact that it is the state and government apparatus that paves the way for the triumphant journey of market mechanisms (Sommers, 2000). Quite naturally, this sort of relationship leads to what Bourdieu (1996) calls "individual corruption [that in fact] only mask[s] structural corruption."

We confront a particular form of ideological control that is profoundly related to what Bourdieu (1996) calls a "show and hide" strategy. That is to say, "television can hide by showing very specific aspects [of a given event] as a function of their particular perceptual categories, the particular way they see things [categories] that are the product of education, history; [in other words] they used [specific] [eye] glasses." Thus, and as Fiske and Hartley (1998) highlight, since "television is a human construct and the job that it does is the result of human choice, cultural decisions and social pressures," reading television is being radically aware of its "manifest [and] latent content." In essence, one should be aware that in the tension between "giving news *vs.* giving views" (Bourdieu, 1996), the mainstream media align with the latter.

In order to make something extraordinary, the corporate media prize "dramatization" and in so doing they not only produce a "reality effect [but they also produce an] effect on reality." Thus, one should not minimize the role that language plays in the media "milieu," a "milieu" that "allow[s] certain things to be said and proscribe[s] others." As Macedo stresses, "like signs, words have ideological power," and it is "through the manipulation of language that the ideological doctrinal system is able to falsify and distort reality, making it possible for individuals to accommodate to life within a lie" (Macedo, 2006a).

Thus, "both language and television 'mediate' reality" and the fact is that "television extends this ability, and an understanding of the way in which television structures and presents its pictures of reality" (Fiske & Hartley, 1998). Following the same line of analysis, one can say that under the free market economy trend, the media act according to what Herman and Chomsky (2002) call the "propaganda model," and "it is their function to amuse, entertain, and inform, and to inculcate individuals with the values, beliefs, and codes of behavior that will integrate them into the institutional structures of the larger society." The mainstream media helped put reality together in such a way that tragedies like the war in Iraq and in Afghanistan become commonsensically unavoidable.

Mainstream media, through a process of political and economic censorship and circular circulation of information (to use Bourdieu's, 1996, lenses), did act dynamically and overtly in the construction of a complex amalgam of what Fairclough (1992) coined as "social identities," "subject positions," "self typologies," "systems of knowledge and beliefs." These are not only on both sides of the belligerent forces, but also within the western and eastern sides, a framework that naturally helps to pave the way, not only to invade Iraq, but to win the consent over the belligerent U.S. foreign policies. Moreover, and this is quite important, we are under a distorted construction of the *other*—and simultaneously a twisted fabrication—of what I call (Paraskeva, 2005) an "endemic western we" that consistently define[s] international events and especially foreign social movements in ways that [confirm] the dominant political meanings and values of the western white hegemony.

According to Chomsky, forms of "vicious repression of dissident opinion" today are rather different from those in the past. As he reminds us, "the mechanisms today are much more subtle, [and there] is a complex system of filters in the media and educational institutions which ends up ensuring that dissident perspectives are weeded out, or marginalized in one way or another." After unveiling the tension between "how the media 'ought' to function [*vs.*] how they do function," Chomsky argues that the media serve their societal purpose "by the way they select topics, distribute concerns, frame issues, filter information, focus their analysis, through emphasis, tone, and a whole range of other techniques like that" (Chomsky, 2002). Consequently, and inviting Said (1997) into our argument, these particular kinds of ideological filters will help maintain a non-stop process of building specific "communities of interpretation," communities that are built through constant struggle yet only within particular semantic borders that will reward a specific kind of common sense.

It is precisely this propaganda model that promotes actively what Bourdieu (1996) calls "the circular circulation of information," that is to say, given rating dynamics and the race for audiences, the media are competing over the same issues and "in some sense, the choices made on television are choices made by no subject." So, by being virtual hostages of the audience ratings, journalists and the media by and large are acting under the rhythms and cadences of those ratings, which imposed a specific cultural model. Therefore, as one can easily see, "television puts 'reality' together" (Eldridge, 1993). In so doing, as Derrida (2002) argues, television "produces an artifactuality." The news is not something that is "out there." Quite conversely, news is something "doable" in a very biased way.

As we can see the media do act in building a commonsensical common sense by actually having the temerity of saying the unsayable. Within such a well-orchestrated strategy, the power of "the capitalist banking model of education" (Macedo, 2006a) in fabricating (and actually offering) a captive audience should not be marginalized. It is precisely this pertinent concern that one can identify within Molnar's (1996a), Apple's (2000), and McLaren & Farahmandpur's (2002) analyses of the effects of Channel One within schooling—both at the level of the news and of the commercials. Such effects must be framed within what Freire (2003) and Macedo (2006a) felicitously denounce as "dehumanized pedagogy" and as "literacy for stupidification based on a pedagogy of big lies," respectively, that must be contextualized on what Freire (2003) denounces as manipulation practices as well.

Struggling Over Meaning

Through their analyses of the impact of Channel One within schools, Molnar (1996a, 1996b), Apple (2000), and McLaren and Farahmandpur (2002) demonstrate not only the segregated economic, ideological, and cultural dynamics underpinning the advent of Channel One, which create a captive audience, but also how Channel One should be seen as a "paradigm case of the social transformation of our ideas about public and private, and about schooling itself" (Apple, 2000). One should not ignore that television inside and outside of schools is involved in the struggle for meaning (Fiske, 1987). The existence of Channel One offers clear evidence of how the mainstream media play in the complex process of reconfiguring the common sense through the intricate process of articulation.

As Apple (2000) noted, the textbook is not "the only text" in the complex process of curriculum knowledge regulation. We are before a "new version of the text," which is invading the classrooms of the United States in the form of Channel One. We are witnessing, as Molnar (1996a), Apple (2000), and McLaren and Farahmandpur (2002) documented, the emergence and consolidation of a commercially produced television news program that is now invading and colonizing thousands of classrooms and schools in the United Sates. This is a powerful device that also has a strong effect on the intricate process of knowledge regulation. Although, its explanation might be seen as inoffensive—*after all, why should we bother?* Although it is *just* ten minutes of international and national news and two minutes of commercials (originally produced very slickly by Whittle Communications), its effects are devastating. We will examine how Channel One creates a captive audience, and the role that it plays in the struggle over meaning, and also how news constructs the "other" in a distorted way, and the contradictions that this new text promotes within the classrooms.

Channel One is a much more complex and intricate political, economic, and cultural project than a simple and undemanding contract that is signed, which basically stipulates that schools will receive free equipment: a satellite dish, two central VCRs, and what amounts to approximately one color television receiver for each classroom—which enables them to receive the broadcast. Schools' contracts with Channel One force them to guar-

antee that the program must be shown on at least 90% of school days to at least 85% of the school community.

Molnar (1996a), Apple (2000), and McLaren and Farahmandpur (2002) help us to place Channel One in its economic, political, and ideological context. Channel One should be understood in the context of conservative modernization. In fact, Channel One provides clear evidence of the close connection between the so-called public educational chaos, economic policies, and the dangerous transformation that we witnessed in the social and political role of schooling in our societies. Based on the simplistic and dangerous perspective not only of "the realities of the fiscal crises" (Apple, 2000), but also that "our educational institutions are seen as failures" and that "students are horribly misinformed about the world, given the texts and teaching now found in schools" (Apple, 2000), Whittle Communications has invaded the U.S. school system. This invasion followed their widespread incursion into doctors' offices in the 1970s. For Whittle Communications, "students simply do not know enough about the world around them to participate effectively in a democratic society" (Apple, 2000; Molnar, 1996a; McLaren & Farahmandpur, 2002), and Channel One is the "cure" for this "disease."

Thus, the impact of Channel One in schools is precisely the same as it has been for patients in doctors' offices. Because "not only are students sold as commodities to advertisers, but the satellite antennae themselves are 'fixed' to the Channel One station and cannot be used to receive other programs" (Apple, 2000), it is a political, economic, and cultural scheme to construct a "captive audience" and a daily praxis that is 'selling our kids to business' (Molnar, 1996a). According to McLaren (1997) and McLaren and Farahmandpur (2002), Channel One is just one of many other examples of corporatism in schools under the flag of "privatization and commercialization of public education." As they (2002) argue once again, it is quite difficult to deny that "schools operate in sustaining and reiterating the logic of capitalism, functioning as a reproductive force that offers different and unequal kinds of knowledge and rewards based on the social class, gender, and racial characteristics of the learner."

Moreover, it is a political project that participates in constructing and suturing particular meanings. As Apple (2000) accurately stresses, "the production and the struggle over meaning itself are essential elements" of this particular political and pedagogical project. Hence, we need to understand the "ways that meanings are made and circulated" (Apple, 2000). Because the "roles both these meanings and their organizations play in the structures of society and in the structure of the consciousness and unconsciousness of the subjects" are quite crucial, Apple (2000), relying on Johnson's (1983) analyses, highlights the need to embrace in a cultural study "the incessant play of meanings that relate the subject to the social system," and those "that underpin and maintain, and sometimes subvert, that system" (Apple, 2000).

In order to do that, as Fiske (1986) argues, we need to focus our analyses on the diverse dimensions of television discourse by considering not only "how television constructs a picture of the world, and how it makes sense of the real, [but also] theorizing the work these meanings perform in and on the viewing subject." In fact, it is quite crucial to situ-

ate Channel One at the very core of an ideological reconstruction that is going on in schools. We are witnessing a new making of public schooling that transforms schools "into a product to be bought and sold" (Apple, 2000). Thus, we need to relate "this ideological work to the discourse form and mode of address of the television discourse," and "examin[e] closely the negotiations and oppositional 'readings' of television, thereby moving away from the idea of television or any 'text' as closed, as a site where dominant meanings automatically exert considerable or total influence over its reader" (Apple, 2000). The real issue is not the impact of the television. Our concern should focus upon how a particular television work, seen as polysemic potential of meanings, connects with the social life of the viewer or group of viewers (Fiske, 1986). It is important to understand how media texts do participate within the common sense.

It is in this context that we need an analysis of the way in which the news is done in order to build a particular picture of the world (Fiske, 1986). Because "cultural practices are not simply derived from or mirror an already existing order, but are themselves major elements in the construction of that social order reality, our very understanding of our daily life is edified through the "construction, apprehension and utilization of symbolic forms." As Apple continues:

> . . . Meaning in the media, not only . . . is variable, since "real people actively intervene, interrupt, and create meanings in interaction with the media," but it is also patterned "by the social, economic, and political conventions that set limits on what can and cannot be said or shown, and on who can say and show it. (Apple, 2000)

We need to challenge the way the news is done at the level of form and content. I concur with Apple that in order to perceive the way the news is done, we must put forward questions like: *What will be reported? Whose news? Under what ideological umbrella? What counts as news?* And *how is the news created and delivered?* The form and the content are crucial political segments that construct an understanding of reality. The form and the content help create a distorted and perverted view of the so-called "Third World" (such as the *natural* floods in South America and Southern Africa). Because this is a political view based on biased norms, it is of great importance that one engages in a process of deconstructing and reconstructing what counts as news. It is both the form and the content of the news that help construct the other and make the other familiar.

In the realities portrayed in Ellison's (1995) *Invisible Man*, or Macedo's (2006a) analyses of Spritzler, or Kozol's (1999) *Amazing Grace*, it is clear that only particular cultures have a voice within the news apparatuses. When the vast majority of humankind (the oppressed) is able to *make* the news, the issue (whether at the level of the form or of content) is profoundly distorted. The media attribute violence to particular subjects and individuals as though it was something *genetic* and *natural* within those oppressed cultures. As an example, the violent political struggle over apartheid in South Africa and other African nations was often treated in a sparse and simplistic way, labeling the people as culturally undeveloped and unprepared for democratic change. We saw this strategy during the students' revolts in Paris in 2006. Before the turmoil, mainstream media did not hesitate to criticize students' behaviors, portraying them as anti-social, disruptive, felonious, delinquent, and labeling

them as occupants of peripheral communities. The media washed out the political basis of the revolt: segregation, apartheid, and dehumanized living conditions for oppressed communities. This twisted analysis is common in examples like Zimbabwe, the genocide that is going on in Sudan, Rwanda, and the shameful situation involving African immigration in the south of Spain. These ways of constructing reality is what Paulo Freire calls "self-depreciation":

> Self-depreciation is another characteristic of the oppressed, which derives from their internaliza-
> tion of the opinion the oppressors hold of them. So often do they hear they are good for nothing,
> know nothing and are incapable of learning anything—they are sick, lazy, and unproductive—that
> in the end, they become convinced of their own unfitness.

Too many people still have the temerity to bluntly deny that the oppressed "know things that they have learned in their relations with the world and with other women and men" (Freire, 2003).

As Steinberg (2005) reminds us: "[A]s Arabic [and African] peoples and Muslims continue to emigrate in large numbers to the West, it becomes an obligation of critical teachers to facilitate a critical media literacy in which our students are able to acknowledge the construction of stereotypes and racism by Hollywood and the BBC." This diet, Steinberg argues, "is not innocent, it is constructed on obsession, stereotype, fear, and most importantly, what sells." We, in fact, need, as Chomsky (1989) stresses, "to undertake a course of intellectual self-defense to protect [us] from manipulation and control and to lay the basis for more meaningful democracy" (Steinberg, 2006). By intentionally distorting reality, the media hide the real issue: in South Africa white eugenic dominance, based on an inhumane segregated state, considered and treated black and non-white people as not humans. One must not forget, Mphahlele (2006) truthfully argues, "blacks never asked for apartheid," and "the whites in [South Africa and in the world] have placed themselves on a path of no return" (Biko, 2004). Mainstream media have a long record in the process of defending eugenic policies and practices to defend and perpetuate what Steinberg and Kincheloe call a "white supremacist power bloc." As they argue: "[T]he white supremacist power bloc assumes its power in its ability to erase its presence. As the measure of all others, whiteness is unhyphenated, undepicted in cultures of the world in no need of introduction, and absent in most multicultural texts. Undoubtedly, it is one of the most powerful 'nothings' we can conjure" (Steinberg & Kincheloe, 2001). People should not forget that the South African racist regime committed genocide, as determined by the *Truth and Reconciliation Commission*, created on July 26, 1995, under the *Promotion of National Unity and Reconciliation Act n°34–1995*. One must be aware of the dangerous tendency of the news to "focus on personalities rather than social forces or social processes" (Apple, 2000). Drawing from Caragee's analyses, Apple stresses the danger of this premise, as it builds within our commonsense understanding of the world the idea of the individual as the engine of history, while minimizing the crucial importance of collective action. The individual is extracted from a specific collective action context and is understood to be acting in an abstract time and space. One identifies with this sordid strategy in the struggle for freedom in Central and Southern African colonial and neocolonial times. One can only pay serious respect to

Gungunyana, Kwame Nkrumah, Patrice Lumumba, Eduardo Mondlane, Amilcar Cabral, Agostinho Neto, Josina Machel, Samora Machel, Joe Slove, Chris Hani, Joseph Tongogara, Comandante Valódia, Nelson Mandela, Malangatana Valente, José Craveirinha, and others, if we situate their life and struggle in the context of a collective struggle against oppression. Mainstream media are built on overt contradictions.

Channel One constructs similar contradictions within the classroom. First, one cannot make the claim that there is an unproblematic relationship between the message sent and the message received. Apple (2000) argues, because "meanings are polysemic [and] there can be and are multiple meanings in any situation" indeed "what counts as 'the news' may be actively deconstructed by students." Consumers of television are not cultural dupes lapping up any pap that is produced for them (Fiske, 1986; Apple, 2000).

A second curricular impact of Channel One within the classroom is that the news is "walled in and set apart from 'real knowledge'" (Apple, 2000). "[By] admitting that the world outside the school, outside of academic knowledge, is essential and now has an officially sanctioned and recontextualized place in schools' daily life," this creates a condition for what Apple (calls a "semiotic surplus of meanings," a complex quilt of struggles for meanings "that could enable further interrogation of the routine curriculum to go on." This opens a fertile space and time for a complex and elaborated inter(con)textuality generating "subtle pressures upon what counts as more legitimate knowledge."

A third curricular impact of Channel One is what Apple calls the politics of pleasure. Based on a study conducted by DeVaney, Apple (2000) points out that students "do not always engage in such deconstruction of the news process" because, quite often they are talking to each other or doing homework during this segment of the Channel One broadcasts, but become interested when the commercials air.

Advertisement policies were brought to the fore by Williams, to whom, "the sponsorship of programs by advertisers has an effect beyond the separable announcement and recommendation of a brand name." Williams argues, "it is, as a formula of communication, an intrinsic setting of priorities—a partisan indication of social sources." In other words, "to see international news brought by courtesy of a toothpaste is not to see separable elements, but the shape of a dominant cultural form" (Williams, 1974). Molnar's perspectives teach us much about the news:

> . . . Since most advertising propaganda is good propaganda, it never literally lies. It's either empty, in an appeal to the emotions: Pepsi's cool, Sprite is what's happening. And so on. It's empty, it means nothing. I was in Germany and I saw a commercial for Pepsi, and the whole tagline of the commercial was 'Pepsi *is* America.' Well, what's that? It's either empty or, it's really good propaganda in the sense that it doesn't tell you the complete story. In other words, it lies by omission. And most teachers are not able to be well-enough trained, or have the time, to say, 'Look at all the things that are omitted. Look at all the things that weren't said.' (Molnar, 1996b)

It is important to view Channel One in what it is saying and what it is not saying. We must be aware of the possibility that lies or half-truths are stated by omissions. This dangerous reality colonizes many American schools. There is an undisputable connection between a nation's capitalist system and its mainstream media. As McChesney (2004) argues

"research links corporations with largest investment banks and demonstrates how often media corporation board members sit on other Fortune 500 companies' boards." Williams (1987) straightforwardly reminds us, "paid advertisements, or commercials, are now a significantly large element of most newspapers and most broadcasting services, to an extent where, in a majority of the cases, the financial viability of the presumably primary service [is] directly determined by its performance in this area." According to McChesney, "the interconnection of media and capitalism grows that much stronger when one considers the role of advertising, which provides around one-third of all media revenues." In fact, like Sommers (2000), McChesney bluntly stresses, "the very nature of markets is influenced if not explicitly determined by government policies." Thus, McChesney argues, "we need to bury the notions that the media are 'naturally' commercial and that the government has been and is an innocent bystander (or non-productive intruder) in the process of creating media systems" (McChesney, 2004).

Such a prostituted relationship between mainstream media and capitalist impulses becomes even more detrimental when one is before an ideological devise such as Channel One that should be understood under what Freire sharply denounced as "prescription." According to Freire "one of the basic elements of the relationship between oppressor and oppressed. [. . .] . . . every prescription represents the imposition of one individual's choice upon another, transforming the consciousness of the person prescribed to into one that conforms with the prescriber's consciousness. Thus, the behavior of the oppressed is a prescribed behavior, following as it does the guidelines of the oppressor" (Freire, 2003).

Freire states, "we could not rely on the mere process of technological modernization to lead us from a naïve to a critical consciousness." As he argued:

> . . . An analysis of highly technological societies usually reveals the 'domestication' of man's critical faculties by a situation in which he is massified and has only the illusion of choice. Excluded from the sphere of decisions being made by fewer and fewer people, man is maneuvered by the mass media to the point where he believes nothing he has not heard on the radio, seen on television, or read in the newspapers. (Freire, 1974)

Taking into account the neoliberal strategy of selling kids to brand and corporate loyalty, we can see schooling as a lethal path that (re-) produces what Freire called "semi-intransitive consciousness." That is, beings of "semi-intransitive consciousness cannot apprehend problems situated outside their sphere of biological necessity [in other words] their interests center almost totally around survival and they lack a sense of life on a more historic plane." Freire argued, "children need to grow in the exercise of this ability to think, to question and question themselves, to doubt, to experiment with hypothesis for action, and to plan, rather than just following plans that, more than proposed are imposed upon them. Children's right to learn how to decide, which can only be achieved by deciding, must be ensured" (Freire, 2004). Freire makes it clear that we need to fight for an educational platform where men and women "amplify their power to perceive and respond to suggestions and questions arising in their context and increase their capacity to enter into a dialogue not only with other men but with their world." In so doing, Freire argued, men and women "become transitive [and] transitivity of consciousness makes man [sic] 'permeable'" (1974).

We will return to this challenge.

Channel One is the hegemonic construction of semi-intransitive consciousness. Underneath the creation of this semi-intransitive consciousness lies a process of identity construction. Grossberg, Wartella, and Whitney (1998), and Hall (1998) teach us a great deal here, making Molnar's (1996a), Apple's (2000), and McLaren and Farahmandpur's (2002) arguments even more powerful. According to Grossberg and his colleagues (1998), "people have always needed a sense of who they are and a place to ground that sense of their identity in one or more of the institutions or activities of their lives," namely the church, their work, their families, and "increasingly in the twentieth century, their leisure and consumption activities." In a well-considered description of the dimensions through which people have a sense of their own identity, Grossberg et al. argue,

> (1) politically, people exist as citizens and as members of a public, (2) socially, people exist as exemplars of social roles—fathers, children, teachers, and so on—(3) culturally, people exist as exemplars of social groups—often defined within semiotic systems of difference, such as black, white, male and female, and (4) economically, people exist as consumers and members of an audience (Grossberg, Wartella, & Whitney, 1998).

They continue that it would be a "mistake to conceive of the concept of the audience as only an economic category [since] the concept of the audience is intricately bound up with the dimensions of social and cultural identity." Thus, according to these scholars, one has to be deeply concerned with "how the notions of the audience and identity actually involve an image of the entire process of communication." As they argue, the audience is something that is constructed, since an "audience as such does not exist [and] is itself constructed by people who use the term for a particular purpose." That is to say,

> . . . The audience does not exist out there in reality apart from the way in which it is defined by different groups, for different purposes [and how] the concept of audience is constructed determines how it can function and how the relationship between the media and their audiences can be described, measured, and evaluated. (Grossberg, Wartella, & Whitney, 1998)

Thus, the audience is indeed a social construction. It is in this context that Grossberg and his colleagues put forward the notion of audience as a market device. As they stress, "the most common conception of the audience within the media industries is a conglomeration of potential and potentially overlapping markets. That is a market identifies a subset of the population as potential consumers of a particular identifiable product or set of products." Thus, one can see that to Grossberg, Wartella, and Whitney the audience as market implies a two-fold construction, one based on the consumer and the other based on commodities. Additionally,

> . . . The most common way that those involved in the media industries think of the audience is as made up of consumers [that is to say, in order to] sell a book, a film, a record, a videotape, or any media product, or even to get people to watch, listen, or read something, the media producer has in mind the type of person who will purchase or tune in to that product." (Grossberg et al. 1998)

Unsurprisingly, "the media industries spend a great deal of time and money in the search for more and more information about media consumers and the appropriate appeals to make

to convince media consumers to buy a particular media product." In fact, one can gather from Grossberg, Wartella, and Whitney's analyses of the media that by embarking on a non-stop process of categorizing consumers according to market categories "at least part of their identity is defined by their participation in this market." This meticulous process becomes more pernicious when media corporations play close attention to what they call market types, namely demographics (class, race, gender, income level, education level, employment category), taste culture, and lifestyle clusters ("a mixture of demographic categories and consumption habits or tastes").

However, as the authors highlight, "the media not only created a consumer society by constructing the audience for its messages as a market, but it also constructed the audience as a commodity object produced in order to be sold for a profit" (Grossberg et al., 1998). It would seem quite odd for the less cautious "to think of an audience as something that is produced and sold, something from which someone can make a profit," and the fact is that the relation between the media and the advertising process makes the audience one of the most profitable commodities. In fact, this particular concern is quite clear in Molnar's (1996a), Apple's (2000) and McLaren and Farahmandpur's (2002) arguments that Channel One provides clear evidence of how children have been sold as commodities.

As Grossberg et al. stress, "the media produces an audience for their own media products and then delivers that audience to another media producer, namely, an advertiser." Actually, "when people watch their favorite TV program, they are also watching the ads embedded in the show." Despite the fact that few people choose "to watch TV programs for the advertising, [in fact] viewers are inevitably an audience for the ads [and] increasingly, advertisers (as well as other media producers) attempt to link their products to specific, highly desirable social groups and identities." Of course, the need for audiences as commodities can be bypassed through technology achievements (remote controls, digitized video recording, and so on). Ads must continue to become shorter in order to keep the audience's attention.

As the authors argue, one would be naïve not to accept that "the audience is composed of individuals who are each members of one or more social groups that define their identity." Thus, "to characterize the audience as a market and commodity, then, we can think of the audience as cultural identities represented in the media." The media participate not only in the social construction of audiences as simultaneously consumers and commodities, but also in what Grossberg et al. call producing identities. Their perspective pushes us to Stuart Hall's approach toward identity. According to Hall, identity should be seen as part of a non-stop complex process of identification, which is "a process of articulation, a suturing, an over-determination and not a subsumption [that is to say] there is always 'too much,' or 'too little'—an over-determination or a lack, but never a proper fit, a totality" (Hall, 1998). Thus, we do concur with Hall's non-essentialist concept of identity. His strategic and positional concept of identity is not a "stable core of the self unfolding from beginning to end through all the vicissitudes without change." Rather, the strategic and positional concept of identity accepts that identities "are never unified and, in late modern times, are increasingly fragmented and fractured [. . .] never singular, but multiple, constructed across

different, often intersecting and antagonistic discourses, practices and positions." Thus, as Hall accurately reminds us "identities are constructed within, not outside, discourse," and we need to "understand them as produced in specific historical and institutional sites within specific discursive formations and practices, by specific enunciative strategies." In fact, identities, as Hall highlights, emerge "within the play of specific modalities of power, and thus are more the product of the marking of difference and exclusion, than they are the sign of an identical naturally-constituted unity." Thus identity should be seen as

> . . . [A] meeting point, the point of suture, between on the one hand the discourses and practices which attempt to 'interpolate,' speak us or hail us into place as the social subjects of particular discourses, and on the other hand, the processes which produce subjectivities, which construct us as subjects which can be 'spoken' [that is to say] identities are thus points of temporary attachment to the subject positions which discursive practices constructed for us. (Hall, 1998)

The construction of captive audiences—already analyzed as consumer and commodity—is a very powerful strategy of "hailing the subject by [particular kinds] of discourse" (Hall, 1998). Thus, both Grossberg, Wartella, and Whitney's, as well as Hall's analyses allow one to build a more extensive argument around Channel One and to suggest that it constructs a consumerism commodity and thereby a specific set of identities. This claim over the way Channel One acts dynamically within the political, cultural, and economic realm becomes even much more powerful if one dares to dig into what Macedo accurately calls "the pedagogy of big lies [a pedagogy] that not only distorts and falsifies realities but also gives us 'the illusion' of individual freedom, ownership of our own thoughts and decisions." As he argues, we need to fight for the creation of pedagogical spaces where issues of oppression are debated [a debate that] would enable educators to understand the intimate interrelationship between society's discriminatory practices and the 'savage inequalities.'" We need to fight, Macedo claims, against "educational reforms that deform," questioning the following issues,

- Can schools of education that function as cultural reproduction models create pedagogical spaces to prepare teachers who will be agents of change and who will be committed to education for liberation?
- How can schools of education reconcile their technicist and often-undemocratic approach to teacher preparation with the urgency to democratize schools?
- How can schools of education that have been accomplices to racial, cultural, gender, and ethnic discrimination create the necessary pedagogical spaces that will lead to cultural democracy? (Macedo, 2006a)

Too many critical and radical scholars have been trying to address these concerns over the past century. We are definitely before a set of complicated questions. Such complexity becomes even denser in an era that I call in another context "radical neo-centrism," a wise strategy that attempts "righting" the left (Paraskeva, 2006). In order to fight and smash repugnant forms of oppression, we need to understand how power relations do operate, do edify, and crystallize quite particular forms of eugenic hegemonic blocs. Our political target, as critical educators really committed to social justice, has to be a non-negotiable fight to cre-

ate political spaces in our public schools, spaces that will allow the emergence of a critical transitive consciousness. As Freire (1974) highlights "critical transitivity is characteristic of authentically democratic regimes and corresponds to highly permeable, interrogative, restless and dialogical forms of life."

Final Considerations

McChesney (2004) argues, "antidemocratic tendencies in media policy making have grown more powerful over the past quarter century." In fact, it is crucial to understand mainstream media policies within what de Marrais calls a "conservative labyrinth," that is a set of intricate strategies to develop and maintain "a conservative media to disseminate conservative ideologies" (de Marrais, 2003). Such dissemination became a vivid reality, especially under the neoliberal strategy, in which we witnessed a transition from commodity-ism to consumerism (Gee, Hull, & Lankshear, 1996).

What we actually perceive from our analyses over the mainstream media is a clearly quarrelsome struggle over "what and how to make and unmake what constitutes news" (Bourdieu, 1996). It is precisely in this context that Steinberg (2005) intensely warns us for "reading the media in a critical way." This becomes of utter importance especially when, as Fairclough (1995) stresses, "marketization undermines the media as a public sphere." In fact, what we have here is what Freire felicitously calls "the theory of cultural action." A segregated strategy of "antidialogical cultural action" based on manipulation, sloganizing, depositing, and regimentation, is, in essence, "components of the praxis of domination." Unquestionably, Freire's revolutionary non-euphemist analyses teach us a great deal here. His concepts of manipulation, and cultural invasion—quite towering within the antidialogical cultural fabric—allow one to perceive how oppressor groups play within the commonsense [il]logicalities. As Freire argues, in order to institutionalize a platform of "antidialogic cultural action," oppressor groups deeply rely on "manipulation and cultural invasion" strategies, in fact, the cultural pedigree of any strategy of dominance. By means of manipulation, Freire argues, "the dominant elites try to conform the masses to their objectives." Thus, "manipulation is accomplished by means of pacts between the dominant and dominated classes—pacts which, if considered superficially, might give the impression of a dialogue between the classes." In essence, manipulation "attempts to anesthetize the people so they will not think," and, in so doing pave the path for "cultural invasion." That is, dominant groups—the invaders, as Freire highlights—"impose their own view of the world upon those they invade and inhibit the creativity of the invaded by curbing their expression." Thus, "all domination involves invasion [and] invasion is a form of economic and cultural domination." Hence, cultural invasion is always "an act of violence against persons of the invaded culture who lose their originality or face the threat of losing it" (Freire, 2003).

As Fiske (1986) and Apple (2000) argue, we need to examine closely the negotiated and oppositional "readings" of television, thereby moving away from the idea of television or any "text" as closed, as a site where dominant meanings automatically exert considerable or total influence over the reader. Channel One is a dangerous example of how influ-

ence is peddled by corporate ideology to students and sanctioned by the educational system.

Media, as discourse, allow one to perceive how the polysemic potential of meanings connects with the social life, [that is] how is a 'television text' created by the active reading of an audience [and] how does the process of commonsense-making operate (Fiske 1986; Apple, 2000). As Bakhtin (1981) reminds us, one must not merge the world of the text with the world outside the text because they are not the same. Media as discourse must be seen as a powerful device within what Freire (2003) straightforwardly calls "cultural revolution." Such a cultural revolution is a must if one wants to demystify how the media do participate in what Macedo calls a literacy for stupidification. Macedo is quite correct when he stresses that for too many people "the manipulation of people through big lies only occurs in totalitarian, fascist governments such as Hitler's" (Macedo, 2006a). In plutocratic capitalist societies, i.e., societies that are based on a non-stop short-circuit of democracy (Zizek, 2005), such manipulation obstructs public schools to "participate in the process of understanding the past that was packed in a wrong way and that came to us totally deformed, a present dressed with borrowed clothes and a future that is ordered by puzzling interests" (Couto, 2005). Unfortunately, as Macedo (2006a) clearly reminds us, "in the present setup of our educational system, particularly in our schools of education, it is very difficult to acquire the necessary critical tools that would unveil the ideology responsible" for such media manipulation mechanisms. We are actually before an intellectual massacre. Programs such as Channel One provide the arms to begin the kill.

Steinberg (2006) was quite accurate when she claimed that the difference between critical and non-critical work relies on intentional silences over issues related to power and hegemony. Since we cannot afford to "carry on [living] within a lie" (Macedo, 2006a), we have to fight and interrupt such an "intricate and complex web of lies that functions to reproduce the dominant ideology through cultural literacy." For critical social justice educators, I am afraid it is not a choice. It is an honored commitment.

REFERENCES

Apple, M. (2000). *Official knowledge: Democratic education in a conservative age*. New York: Routledge.

Bakhtin, M. (1981). *The dialogic imagination*. Austin: University of Texas Press.

Biko, S. (2004) *I write what I like*. Johannesburg: Picador Africa.

Bourdieu, P. (1996) *On television*. New York: The New York Press.

Celis, W. (1991, June 5). School districts reeling in weakened economy. *The New York Times*, B 10.

Chomsky, N. (1989). *Necessary illusions: Thought control in democratic societies*. Cambridge: South End Press.

Chomsky, N. (2002). The media: An institutional analysis. In P. Mitchell & J. Schoeffel (Eds.), *Understanding power: The indispensable Chomsky* (pp. 12–15). New York: The New Press.

Couto, M. (2005). *Pensatempos*. Lisboa: Caminho.

De Marrais, K. (2006). The haves and the have mores: Fuelling conservative ideological war on public education (or tracking the money). *Educational Studies*, 39(3), 201–240.

Derrida, J. (2002) Artifactuality, homohegemony. In J. Derrida & B. Stiegler (Eds.), *Echographies of television* (pp. 41–55). Cambridge: Polity.

DeVaney, A. (1991). A grammar of educational television. In D. Hlynk & J. Belland (Eds.), *Paradigms regained* (pp. 241–283). Englewood Cliffs, NJ: Educational Technology Publications.

Eldridge, J. (1993). *Getting the message: News, truth and power*. London: Routledge.

Ellison, R. (1995). *Invisible man*. New York: Vintage Books.

Fairclough, N. (1992). *Discourse and social change*. Cambridge: Polity Press.

Fairclough, N. (1995). *Media discourse*. London: Arnold.

Fiske, J. (1986, June). Television and popular culture. *Critical Studies in Mass Communication, 3*.

Fiske, J. (1987). *Television culture*. New York: Methuen.

Fiske, J., & Hartley, J. (1998). *Reading television*. London: Methuen.

Freire, P. (1974). *Education: The practice of freedom*. London: Writers Readers Publishing Cooperative.

Freire, P. (2003). *Pedagogy of the oppressed*. New York: Continuum. (Original work published 1970)

Freire, P. (2004). *Pedagogy of indignation*. Boulder: Paradigm.

Gee, J., Hull, G., Lankshear, C. (1996). *The new work order: Behind the language of the new capitalism*. Boulder: Westview Press.

Grossberg, L., Wartella, E., & Whitney, D. (1998). *Media making: Mass media in a popular culture*. London: Sage.

Hall, S. (1994). Encoding, decoding. In S. During (Ed.), *The cultural studies reader*. (pp. 90–103). London: Routledge.

Hall, S. (1998). Introduction: Who needs identity. In S. Hall & P. du Gay (Eds.), *Questions of cultural identity* (pp. 1–17). London: Sage.

Herman, S., & Chomsky, N. (2002). *Manufacturing consent: The political economy of the mass media*. New York: Pantheon Books.

Johnson, R. (1983). *What is cultural studies anyway?* Centre for Contemporary Cultural Studies, University of Birmingham, N° 74 (mimeographed).

Kozol, J. (1999). *Amazing grace: The lives of children and the conscience of a nation*. New York: Harper Perennial.

Macedo, D. (2006a). *Literacies of power: What Americans are not allowed to know*. Boulder. Westview Press.

Macedo, D. (2006b). *A hegemonia da língua inglesa*. Lisboa: Edições Pedago.

McChesney, R. (2004). *The problem of the media: U.S. communication politics in the 21st century*. New York: Monthly Review Press.

McLaren, P. (1997). *Revolutionary multiculturalism: Pedagogies of dissent for the new millennium*. Boulder: Westview Press.

McLaren, P., & Farahmandpur, R. (2002). Freire, Marx and the new imperialism: Towards a revolutionary praxis. In J. Slater, S. Fain, C. Rossatto (Eds.), *The Freirean legacy—Education for social justice* (pp. 37–56). New York: Peter Lang.

Molnar, A. (1996a). *Giving kids to business: The commercialization of American schools*. Boulder: Westview.

Molnar, A. (1996b). An interview with Alex Molnar, by J. Huber. *Stay free*. Retrieved October 17, 2006 from http://www.stayfreemagazine.org/index.html

Mphahlele, E. (2006). *In corner B*. London: Penguin Books.

Paraskeva, J. (2005) Portugal will always be an African Nation. A Calibanian Prospero or a Prospering Caliban? In D. Macedo & P. Gounari (Eds.), *The globalization of racism* (pp. 241–268). Boulder: Paradigm Press.

Paraskeva, J. (2006). Desterritorializar a teoria curricular. In J. Paraskeva (Ed.), *Currículo e Multiculturalismo*. Lisboa: Edições Pedago.

Ramonet, I. (2001). O que e o Mundo Hoje; Como Funciona; Resistir em Nome de Que? Porto: Campo da Comunicacao.

Said, E. (1997). *Covering Islam: How the media and the experts determine how we the rest of the world* (pp. 36–68). New York: Vintage Books.

Sommers, M. (2000). *Fear and loathing of the public sphere and the naturalization of civil society: How neoliberalism outwits the rest of us*. Paper presented at the Havens Center Conferences Series, University of Wisconsin, Madison.

Steinberg, S. (2005). Usar a Capacidade de Leitura Crítica dos Meios de Comunicação para Ensinar Aspectos sobre o Racismo contra Muçulmanos e Árabes. In J. Paraskeva (Ed.), *Currículo e multiculturalismo* (pp. 51–62). Lisboa: Edições Pedago.

Steinberg, S. (2006). J. Kincheloe, & S. Steinberg, *F scale redux: Empire building in the new millennium*. Keynote Address at the Third International Conference on Education, Labor, and Emancipation Teaching for Global Community: Overcoming the Divide and Conquer Strategies of the Oppressor, El Paso, Texas e Ciudad de Juaréz, Chihuahua, México.

Steinberg, S., & Kincheloe, J. L. (2001). Setting the context for critical multi/interculturalism: The power blocs of class elitism, white supremacy, and patriarchy. In S. Steinberg (Ed.), *Multicultural conversations: A reader* (pp. 3–30). New York: Peter Lang.

Torfing, J. (1999). *New theories of discourse: Laclau, Mouffe and Zizek*. Oxford: Blackwell.

Van Dijk, T. (1985). Introduction: Discourse analysis in (mass) communication research. In T. Van Dijk (Ed.), *Discourse and communication*. Berlin: Walter de Gruyter.

Williams, R. (1974). *Television: Technology and cultural form* (E. Williams, Ed.). London: Routledge.

Williams, R. (1987). Human history and its communications. In O. Boyd-Barrett & P. Braham (Eds.), *Media, knowledge and power* (pp. 32–49). London: Croom Helm/ Open University.

Zizek, S. (2005). O Waterloo liberal—ou finalmente algumas boas notícias vindas de Washington. *Manifesto—Práticas, Direitos, Poderes*, n° 27, pp., 96–100.

The Semantics of Connection and Alienation in Hyper-Reality

Anthony M. Rosselli

Media communications, or more precisely uni-directional media messages and the broader hyper-reality created by technology, are a huge economic enterprise with profits for the corporate world numbering in the billions of dollars. The recipient of those messages, the consumer, rarely questions either the morality of the sender or the desirability of contributing to corporate profits, which hardly ever benefit the public at large. Of course, there are many types of "media" and not all are uni-directional. However, the advertisements for goods and services are, for now at least, a one-way indoctrination system, which has as its primary purpose the convincing of the public to purchase the advertised products. Add to that the potently seductive nature of both the media messages and the products themselves, and there is an enormous threat to the overall identity of the consumer and to the entire notion of freedom. Why? Because the powerful corporations continue to manipulate the consumer through knowledge-seeking mechanisms that ensure a comprehensive profile of everyone's habits, patterns, behaviors, and the like. The consumer, on the other hand, has little power in this "media communication" game. In fact, the teleology is very clear: The consumer acquiesces and in so doing cedes power and control to corporations that have a singular purpose—increase of profit.

Within the context of media communications lies a notion of "meaningfulness," i.e., the semantic process whereby a consumer understands, and acts on, the messages received from media. This is not to imply that an exchange of meaning has occurred. In fact, the consumer rarely gets to modify, add to, or delete from the message. Rather, consumers are coaxed into suspending their own development of cultural memory (and its adjunct moral code) for the sake of fulfillment of what I would call "conformity to technocratic rationality." Given the power of the media, their messages can only be processed unthinkingly and acted on without analysis. Let's examine the social context of this technocratic rationality.

In and of itself, technology can be a useful tool that might improve the human condition: Obvious examples include medical advances and aeronautical progress. Moreover, a collaborative environment, if established on the Internet, can lead to authentic exchanges between the techno-source and the user who has access, theoretically at least, to a huge database of information. For example, there is a site called "WebQuest" (webquest.org) where teachers can have students extend their classroom learning in inquiry activities that are designed to encourage knowledge acquisition and integration of understandings about a given topic, issue, or idea. Nonetheless, these activities also have a strong potential for numbing the learner and creating a resistance to techno-source knowledge because the means of acquiring that knowledge are likely to be eclipsed by more seductive techno-sources: chat rooms, music videos, advertisements, and so on. Even worse, students might tend to take on the characteristics of the consumer and be mystified by the overwhelming number of images and messages pouring forth from the computer. Either way, the potential for establishing a real collaborative environment with- (in) technology is fleeting, and the skills necessary for negotiating the data are not developed. These skills include questioning, analyzing, interpreting, making sense of the issue in question, and so on. Whether we care to admit it or not, critical media literacy is a basic skill necessary for negotiating important human traits: identity, values, ideology, and well-being.

The surfeit of data makes the consumer incapable of processing all that information well and causes a feeling of powerlessness in the struggle to understand the world. While this phenomenon debilitates the ordinary citizen, one can only imagine the effect on consumers with a lower socio-economic status (SES), who cannot compete equally for techno-source knowledge because their lack of well developed literacy is exaggerated within the context of the media blitz. Decoding messages, perhaps a simple task for those who are literate, becomes the albatross for those disenfranchised from society.

Everyday decisions are inextricably linked to one's knowledge of what has cultural and economic currency in the world of hyper-reality. Indeed, to compete effectively for a piece of the virtual pie requires adequate income, health, and a sense of well-being. However, the ecology of language acquisition, when viewed as a critical milieu for accessing data and negotiating the media scape, allows us to question certain assumptions underlying the false sense of easy access to techno-source knowledge. Let us examine a couple of relevant assumptions (see Leather & van Dam, 2003): "Languages are clearly distinct from one another with monolingualism as the societal norm" (Leather & van Dam, 2003, p. 1).

In the United States, we seem to value ideologically the acquisition and use of one language. With an established policy of "one person, one language, one nation," there is more than the possibility of domination; there is an easy hegemony of monolingualism, which extinguishes the use of complex, multilingual, behavior in order to negotiate meaning. This monolithic language policy spills over to cyberspace in that there is an abundance of English language data (and far less linguistic diversity) represented on the Internet, which tends to marginalize, paradoxically, multilingual peoples and nations. Aside from the fact that multilingualism is the global norm, the persistence of cultural distortion on the Internet ends up empowering those who have the technical means and linguistic know-how to negotiate effectively the mediascape.

"Verbal form that encodes logical form is necessary and sufficient to determine meaning" (Leather & van Dam, 2003, p. 5)

There is research to demonstrate that most everyday language interactions "entail inference from knowledge and assumptions that relate to the real world (ibid, p. 8)." Extended to cyberspace, one could argue that the issue of "meanings" is complicated by the existence of multimedia signs and symbols, as well as unclear contexts. This is especially problematic for lower SES, linguistically marginalized consumers who lack either the means or the language competence to negotiate the mediascape. Moreover, "technology-mediated acquisition contexts introduce a whole new set of variables that are as yet imperfectly understood" (Lam, Kramsch, & Van Lier, 2003, p. 12). While it is beyond the scope of this chapter to entertain how the acquisition of a second language interfaces with the practical need to negotiate in hyper-reality, let us assume that non-native speakers of English present more language-based reasons for difficulty in making sense of the content of cyberspace. (However, we must not forget the role of a person's socio-economic status in this difficulty, i.e., issues of access, cultural context, and so forth.) Let us now consider the effect of the acquisition of media literacy on children.

Applying the classic Sapir-Whorfian hypothesis (i.e., that thinking and perception are not only expressed *through* language but are also shaped *by* language), it is easily conceivable that children's cognition is extensively shaped by the media meanings that bombard them daily. While we enjoy debating whether or not media messages can intractably influence the behaviors of children, we have, on the other hand, no doubt that children's behavior often reflects, mimics, copies, or resembles the behaviors seen in the various media (TV, cinema, Internet, electronic games, and so on.). Furthermore, the evidence from research on the ecological nature of semantics, language exchange, and communication makes it fairly indisputable that the consumer (adults, children, indeed everyone) experiences cognitive "meanings" as interwoven with the physical and social world (Leather & van Dam, 2003, p. 13) (and with hyper-reality as well).

As mentioned above, some researchers (Lam & Kramsch, 2003) have attempted to study the role of technology in language acquisition. There is evidence that the social identity of the learner has become more complex. Language and identity are thus seen to be more related to the construction of the self: especially in the case of children, technology (Internet, and so on) seems to allow for the *creation* of identity as opposed to the classical

notion that language and social development proceed as parallel, and complementary, processes. While the theoretical underpinnings of these ideas are well grounded in research, the end result that has been recently observed (i.e., the trade-off between "easier connections" due to technology and a greater sense of alienation caused by those connections), is much less clear and demands a closer examination.

Durkheim's anomie is not estranged from a discussion of media literacy when one recalls that social norms are continually challenged, reshaped, and scrutinized. In a virtual reality pushed to the extreme (hyper-reality) everyone's sense of purpose and identity is put to an uncomfortable test as they try to employ what Erving Goffman called "dramaturgy" (Goffman, 1959) in order to manage others' impressions of themselves. Moreover, the impact of an endless stream of media messages leads to a societal version of Pierre Bourdieu's "symbolic violence," which issues from pedagogic authority in schools. In the case of hyper-reality, control has its origins in randomly embedded messages that have as a primary goal the manipulation of consumers so that their daily behaviors enrich the power elite and corporate sponsors at the expense of everyone else.

It should be emphasized now that the phenomena described above have different effects on different people. Lower SES consumers suffer more losses than the power elite who actually benefit from complacent, obedient others. Even more disturbing is the growing "mediatization of information" (to use Peter McLaren's phrase), which threatens to commodify everything, or at least anything that can be electronically digitalized and spread ubiquitously. Alongside this dismantling of all that is not part of corporate culture, one can uncover easily the predictable state of curricula and schools. Principals find themselves, knowingly or not, as pawnbrokers of a globalization of capital, which marginalizes all knowledge that does not serve the growth of corporate culture. Classrooms, by the same process, continue to reflect the power relations and knowledge distribution systems of that globalization. All these facets ensure a maldistribution of power, income, and content. The end result, every day, is a citizenry besieged by the overwhelming media symbols and signs that devour their independence and promulgate an inequality in almost all aspects of social life.

The antidote to a world in which skills in media literacy distribute normally (e.g., most traits and social assets) is a society that affords access to knowledge, power, identity formations, and cultural capital to all people at all times. Specifically, that kind of access must also be accompanied by an equal opportunity to acquire the habits of mind, the critical knowing, and the quality of a "good life," which at this time is denied to many based on socioeconomic status and multiculturalism. That this maldistribution of goods and services continues to be prevalent within a hegemonic context of social class relationships bodes poorly for the attainment of equal opportunity for all. Perhaps our hope lies in what Bruner (1996) called "collective cultural activity," i.e., rich historical, literary, artistic, philosophical, and political sources of knowledge. For that vision to become reality, however, will require a strong collective will and action geared toward an equal distribution of the processes, facts, and artifacts of hyper-reality. Good intentions are not sufficient; rather, the development of critical media literacy for all consumers might be the start—and only the start—of a constant struggle for access to, and attainment of, the "good life" for all.

REFERENCES

Ballantine, J. (2001). *The sociology of education*. Upper Saddle River, NJ: Prentice-Hall.

Bourdieu, P. (1977). Cultural reproduction and social reproduction. In J. Karabel & A. H. Halsey (Eds.), *Power and ideology in education*. New York: Oxford University Press.

Bruner, J. (1996). *The culture of education*. Cambridge, MA: Harvard University Press.

Durkheim, E. (1956). *Education and sociology*. (S. D. Fox, Trans.). Glencoe, IL: Free Press.

Erikson, E. H. (1968). *Identity, youth, and crisis*. New York: Norton.

Goffman, E. (1959). *The presentation of self in everyday life*. New York: Doubleday.

Gunning, T. (2006). *Closing the literacy gap*. Boston: Pearson/ Allyn and Bacon.

Joseph, P., et al. (2000). *Cultures of curriculum*. New Jersey: Lawrence Erlbaum.

Lam, C. Kramsch, C. & Van Lier, L. (2003). "The ecology of an SLA community. In J. Leather & J. van Dam (Eds.), *Ecology of language acquisition*. Dordrecht, the Netherlands: Kluwer.

Leather, J., & van Dam, J. (Eds.). (2003). *Ecology of language acquisition*. Dordrecht, the Netherlands: Kluwer.

McLaren, P. (Ed.). (2006). *Rage and hope*. New York: Peter Lang.

Part Two

Doing
Media
Literacy

Chapter 21

Drowning Democracy

The Media, Neoliberalism and the Politics of Hurricane Katrina [1]

Henry A. Giroux

Introduction

From the beginning of the Civil Rights Movement to the war in Vietnam, images of human suffering and violence provided the grounds for a charged political indignation and collective sense of moral outrage inflamed by the horrors of poverty, militarism, war, and racism—eventually mobilizing widespread opposition to these antidemocratic forces. Of course, the seeds of a vast conservative counter-revolution were already well underway as images of a previous era—"whites only" signs, segregated schools, segregated housing, and nonviolent resistance to these from African Americans—gave way to a troubling iconography of cities aflame, mass rioting, and armed black youths who came to embody the very precepts of lawlessness, disorder, and criminality. Building on the reactionary rhetoric of Barry Goldwater and Richard Nixon, Ronald Reagan took office in 1981, bringing with him a trickle-down theory that would transform corporate America and a corresponding visual economy. The twin images of the young black male "gangsta" and his counterpart, the "welfare queen," became the primary vehicles for selling the American public on the need to dismantle the welfare state, ushering in an era of unprecedented deregulation, down-

sizing, privatization, and regressive taxation. The propaganda campaign was so successful that George H. W. Bush could launch his 1988 presidential bid with the image of Willie Horton, an African American man convicted of rape and granted early release, and succeed in trouncing his opponent with little public outcry over the overtly racist nature of the campaign. By the beginning of the 1990s, global media consolidation, coupled with the outbreak of a new war that encouraged hyper-patriotism and a rigid nationalism, resulted in a tightly controlled visual landscape—managed both by the Pentagon and by corporate-owned networks—that delivered a paucity of images representative of the widespread systemic violence of war, poverty, and racism.[2] Selectively informed and cynically inclined, Americans inhabited a civic realm that became more sanitized, controlled, and regulated.

Hurricane Katrina may have reversed the self-imposed silence of the media and public numbness in the face of terrible suffering endured by African Americans and enabled by a racist state, Fifty years after the body of Emmett Till was plucked out of the mud-filled waters of the Tallahatchie River, another set of troubling visual representations has emerged that both shocked and shamed the nation. In the aftermath of Hurricane Katrina, grotesque images of bloated corpses floating in the rotting waters that flooded the streets of New Orleans circulated throughout the mainstream media. What first appeared to be a natural catastrophe soon degenerated into a social debacle as further images revealed, days after Katrina had passed over the Gulf Coast, hundreds of thousands of poor people, mostly blacks, some Latinos, many elderly, and a few white people, packed into the New Orleans Superdome and the city's convention center, stranded on rooftops, or isolated on patches of dry highway without food, water, or a place to wash, urinate, or find relief from the scorching sun.[3] Weeks passed as the floodwater gradually receded and the military gained control of the city, and more images of dead bodies surfaced in the national and global media. TV cameras captured bodies emerging from the flood waters as people stood by, indifferently eating their lunch or occasionally snapping a photograph. Most of the dead "were 50 or older, people who tried to wait the hurricane out."[4] Various media soon reported that over 154 bodies had been found in hospitals and nursing homes. The *New York Times* wrote that, "the collapse of one of society's most basic covenants—to care for the helpless—suggests that the elderly and critically ill plummeted to the bottom of priority lists as calamity engulfed New Orleans."[5] Dead people, mostly poor African Americans, left uncollected in electric wheelchairs, on porches and streets, in hospitals, nursing homes, and collapsed houses, prompted some people to claim that America had become like a "Third World country" while others argued that New Orleans resembled a "Third World Refugee Camp."[6] There were now, irrefutably, two Gulf crises. The Federal Emergency Management Agency (FEMA) tried to do damage control by forbidding journalists to "accompany rescue boats as they went out to search for storm victims." As a bureau spokeswoman told Reuters News Agency, "We have requested that no photographs of the deceased be made by the media."[7] Questions about responsibility and answerability, though, would not go away. Even the dominant media rose to the occasion for a short time by posing tough questions about accountability to those in power in light of such egregious acts of incompetence and indifference. The images of dead bodies kept reappearing in New Orleans, refusing to go away. For many,

the bodies of the poor, black, brown, elderly, and sick revealed a vulnerable and destitute segment of the nation's citizenry that conservatives not only refused to see but had spent the better part of two decades demonizing. However, like the incessant beating of Poe's tell-tale heart, cadavers have a way of insinuating themselves in people's consciousness, demanding answers to questions that are not often asked.

Indeed, the black bodies of the dead and walking wounded in New Orleans in 2005 revealed an updated image of the racial state, a different modality of state terrorism, marked less by an overt form of white racism than by a highly mediated displacement of race as a central concept for understanding both Katrina and its place in the broader history of U.S. racism.[8] That is, the decaying black bodies floating in the waters of the Gulf Coast represented a return of race against the media and public insistence that this disaster was more about class than race, more about the shameful and growing presence of poverty, "the abject failure to provide aid to the most vulnerable."[9] The bodies of the Katrina victims laid bare the racial and class fault lines that mark an increasingly damaged and withering democracy, and they revealed the emergence of a new kind of politics, one in which entire populations are now considered disposable, an unnecessary burden on state coffers, and are consigned to fend for themselves. At the same time, what happened in New Orleans also revealed some frightening signposts of those repressive features in American society and demanded that artists, public intellectuals, scholars, and other cultural workers take seriously what Angela Davis insists "are very clear signs of . . . impending fascist policies and practices"; these policies and practices not only construct an imaginary social environment for all of those populations rendered disposable, but also exemplify a site and space "where democracy has lost its claims." [10]

This loss of democracy had an immediate material impact on those abandoned by the government in the aftermath of Hurricane Katrina. Soon after the hurricane hit the Gulf Coast, the consequences of the long legacy of bleeding the social and public service sectors of the state became glaringly evident, as did the government's "staggering indifference to human suffering."[11] Hurricane Katrina made it abundantly clear that only the government had the power, resources, and authority to address complex undertakings such as dealing with the totality of the economic, environmental, cultural, and social destruction that impacted the Gulf Coast. Given the Bush administration's disdain for the legacy of the New Deal, important government agencies were viewed scornfully as oversized entitlement programs, stripped of their power, and served up as a dumping ground to provide lucrative administrative jobs for political hacks, who were often unqualified to lead such agencies. Not only was FEMA downsized and placed under the Department of Homeland Security, but its role in disaster planning and preparation was subordinated to the all-inclusive goal of fighting terrorists. While it was virtually impossible to miss the total failure of the government response in the aftermath of Katrina, what many people saw as incompetence or failed national leadership was more than that. Something more systemic and deep-rooted was revealed in the wake of Katrina—namely, that the state no longer provided a safety net for the poor, sick, elderly, and homeless. Instead, it had been transformed into a punishing institution intent on dismantling the welfare state and treating the homeless,

unemployed, illiterate, and disabled as dispensable populations to be managed, criminal-ized, and made to disappear into prisons, ghettos, and the black hole of despair.

State power no longer legitimates itself through attempts to protect both society and individuals from vagaries of social and economic forces that increase individual misfortune, poverty, and those social provisions necessary to simply survive with a modicum of dignity. On the contrary, battered by malign global economic forces it can no longer control, the social state has been reduced to the prison state focusing largely on matters of personal safety and crime, while augmenting its security, police, and surveillance capabilities to fight the "enemy within," which largely happens to be people of color. Zygmunt Bauman captures this shift in insightful comments:

> Under such circumstances, an alternative legitimation of state authority and another formula for the benefits of dutiful citizenship need to be found; unsurprisingly, it is currently being sought in protection against dangers to personal safety. In the political formula of the personal safety state, the specter of an uncertain future and social degradation against which the then social state swore to insure its citizens not so long ago is being gradually yet consistently replaced by the threat of a pedophile let loose, a serial killer, an obtrusive beggar, mugger, stalker, prowler, poisoner of water and food, terrorist: or better yet by all such threats rolled into one in the virtually interchange-able figures of the native 'underclass' or the illegal immigrant, a foreign body from birth to death and forever a potential 'enemy within', against whom the security state promises to defend its sub-jects tooth and nail. FN 12 Zygmunt Bauman, *Liquid Fear* (London: Polity Press, 2006), p. 149.

The Bush administration was not simply unprepared for Hurricane Katrina as it denied that the federal government alone had the resources to address catastrophic events; it actu-ally felt no responsibility for the lives of poor blacks and others marginalized by poverty and relegated to the outskirts of society. Increasingly, the role of the state seems to be about engendering the financial rewards and privileges of only some members of society, while the welfare of those marginalized by race and class is now viewed with criminal contempt. The coupling of the market state with the racial state under George W. Bush means that policies are aggressively pursued to dismantle the welfare state, eliminate affirmative action, model urban public schools after prisons, create further barriers for immigrants, and incarcerate with impunity Arabs, Muslims, and poor youths of color. The central commit-ment of the new hyper-neoliberalism is now organized around the best way to remove or make invisible those individuals and groups who are either seen as a drain or impediment to market freedoms, free trade, consumerism, and the neoconservative dream of an American empire.

The Second Gulf War

Ultimately, the government opted to remove these human impediments to total market free-dom by treating the citizens it ostensibly represents as foreign threats, an exercise in myth building in which mainstream media colluded. Within a few days after Katrina struck, New Orleans was under martial law, occupied by nearly 65,000 U.S. military personnel. Cries of desperation and help were quickly redefined as the pleas of "refugees," a designation that suggested an alien population lacking both citizenship and legal rights had inhabited the

Gulf Coast. Images of thousands of desperate and poor blacks gave way to pictures of combat-ready troops and soldiers with mounted bayonets canvassing houses in order to remove stranded civilians. Embedded journalists now travelled with soldiers on Humvees, armoured carriers, and military helicopters in downtown USA. What had begun as a botched rescue operation by the federal government was transformed into a military operation. Given the government's propensity to view those who are poor and black with contempt, it was not surprising that the transformation of New Orleans and the Gulf Coast from disaster area to war zone occurred without any audible dissent from either the general public or the dominant media. New Orleans increasingly came to look like a city in Iraq as scores of private soldiers appeared on the scene—either on contract with the Department of Homeland Security or hired by wealthy elites to protect their private estates and businesses. Much like Iraq, the Gulf Coast became another recipient of deregulated market capitalism as soon as the flood waters began to recede. The fruits of privatization and an utter disregard for public values were all too visible as the private mercenaries and security companies hired to guard federal projects often indulged in acts of violence that clearly constituted vigilantism.

Yet even these acts of violence are not powerful enough to rewrite the history of the state's deliberate neglect that can be read on the bodies of the poor, the racialized, and the marginalized. Katrina lays bare what many people in the United States do not want to see: large numbers of poor black and brown people struggling to make ends meet, benefiting very little from a social system that makes it difficult to obtain health insurance, child care, social assistance, cars, savings, and minimum-wage jobs if lucky, and instead offers to black and brown youths inadequate schools, poor public services, and no future, except a possible stint in the penitentiary. As Janet Pelz rightly insists, "These are the people the Republicans have been teaching us to disdain, if not hate, since President Reagan decried the moral laxness of the Welfare mom."[12] While Pelz's comments provide a crucial context for much of the death and devastation of Katrina, I think to more fully understand this calamity, it is important to grasp how the confluence of race and poverty has become part of a new and more insidious set of forces based on a revised set of biopolitical commitments. This new biopolitical agenda has largely denied the sanctity of human life for those populations rendered "at risk" by global neoliberal economies and has instead embraced an emergent security state founded on cultural homogeneity.[13]

Howard Zinn registers such a shift in his comment on the second Bush administration. He writes;

> Still, there seems to be a special viciousness that accompanies the current assault on human rights, in this country and in the world. We have had repressive governments before, but none has legislated the end of habeas corpus, nor openly supported torture, nor declared the possibility of war without end. No government has so casually ignored the will of the people, affirmed the right of the President to ignore the Constitution, even to set aside laws passed by Congress. FN15. Howard Zinn, "Impeachment by the People," *The Progressive* (February, 2007). Online: http://www.progressive.org/node/4473/print

The pathway to the new security state has been beaten by a number of economic policies designed to further marginalize those the Reagan administration denounced and to

undermine the government's own democratic function. In a May 25, 2001, interview, Grover Norquist, head of the right-wing group Americans for Tax Reform, told National Public Radio's Mara Liasson: "I don't want to abolish government. I simply want to reduce it to the size where I can drag it into the bathroom and drown it in the bathtub."[14] As a radical right-wing activist and practical strategist, Norquist has been enormously instrumental and successful in shaping tax policies designed to "starve the beast," a metaphor for policies designed to drive up deficits by cutting taxes, especially for the rich, in order to paralyze government and dry up funds for many federal programs that offer protection for children, the elderly, and the poor. Norquist saw his efforts pay off when thousands of people, most of them poor and black, drowned in the basin of New Orleans, and upwards of one million were displaced. Under such circumstances, a decades-long official policy of *benign* neglect became *malign* neglect, largely rationalized through a market fundamentalism in which the self-interested striving of individuals becomes the cornerstone of both freedom and democracy. This is a politics that wages war against any viable notion of the public good. Furthermore, as Lawrence Grossberg points out, "The free market in neoliberalism is fundamentally an argument against politics, or at least against a politics that attempts to govern society in social rather than economic terms."[15]

The neoliberal efforts to shrink big government and public services must be understood both in terms of those who bore the brunt of such efforts in New Orleans and in terms of the subsequent inability of the government to deal adequately with Hurricane Katrina. Reducing the federal government's ability to respond to social problems is a decisive element of neoliberal policymaking, as was echoed in a *Wall Street Journal* editorial that argued without irony that taxes should be raised for low-income individuals and families, not to make more money available to the federal government for addressing their needs, but to rectify the possibility that they "might not be feeling a proper hatred for the government."[16] If the poor can be used as pawns in this logic to further the political attack on big government, it seems reasonable to assume that those in the Bush administration would refrain from using big government as quickly as possible to save the very lives of such groups, as was evident in the aftermath of Katrina. The vilification of the social state and big government—really an attack on non-military aspects of government—has translated into a steep decline of tax revenues, a massive increase in military spending, and the growing immiseration of poor Americans and people of color. Under the Bush administration, U.S. Census Bureau figures reveal that "since 1999, the income of the poorest fifth of Americans has dropped 8.7 percent in inflation-adjusted dollars . . . [and in 2005] 1.1 million were added to the 36 million already on the poverty rolls."[17] Although the number of Americans living below the poverty line is comparable to the combined populations of Louisiana, Mississippi, Alabama, Texas, and Arkansas, the Bush administration chose to make $70 billion in new tax cuts for the rich in the 2006 budget, while slashing programs that benefit the least fortunate.[18] Similarly, the projected $2.7 trillion budget for 2007 includes a $4.9 billion reduction in health funds for senior citizens (Medicare) and the State Children's Health Insurance Program, a $17 million cut in aid for child-support enforcement, cutbacks in funds for low-income people with disabilities, major reductions in child-

care and development block grants, major defunding for housing for low-income elderly, and an unprecedented rollback in student aid. In addition, the 2007 budget calls for another $70 billion dollars in tax cuts most beneficial to the rich and provides for a huge increase in military spending for the war in Iraq.[19]

While President Bush endlessly argues for the economic benefits of his tax cuts, he callously omits the fact that 13 million children are living in poverty in the United States, "4.5 million more than when Bush was first inaugurated."[20] In fact, New Orleans had the third highest rate of children living in poverty in the United States.[21] The illiteracy rate in New Orleans before the flood struck was 40 percent; the embarrassingly ill-equipped public school system was one of the most underfunded in the nation. Children were not the only people made vulnerable by massive cuts to social spending. Nearly 19 percent of Louisiana residents lacked health insurance, putting the state near the bottom for the percentage of people with health insurance. Robert Scheer, a journalist and social critic, estimated that one third of the 150,000 people living in dire poverty in Louisiana were elderly, left exposed to the flooding in areas most damaged by Katrina.[22] It gets worse. In an ironic twist of fate, one day after Katrina hit New Orleans, the U.S. Census Bureau released two important reports on poverty, indicating that

> Mississippi (with a 21.6 percent poverty rate) and Louisiana (19.4 percent) are the nation's poorest states, and that New Orleans (with a 23.2 percent poverty rate) is the 12th poorest city in the nation. [Moreover,] New Orleans is not only one of the nation's poorest cities, but its poor people are among the most concentrated in poverty ghettos. Housing discrimination and the location of government-subsidized housing have contributed to the city's economic and racial segregation.[23]

Under neoliberal capitalism, the attack on politically responsible government has been matched by an equally harsh attack on social provisions and safety nets for the poor. Furthermore, in spite of the massive failures of market-driven neoliberal policies—extending from a soaring $420 billion budget deficit to the underfunding of schools, public health, community policing, and environmental protection programs—the reigning right-wing orthodoxy of the Bush administration continues to "give precedence to private financial gain and market determinism over human lives and broad public values."[24]

Of course, there is more at work here than the decline of the social state, there is also the toll that American militarism exacts in shifting valuable resources away from crucial social programs to the funding of the imperial war in Iraq. David Leonhardt, a reporter for the *New York Times*, estimates that the war in Iraq has as of January 2007 cost the American taxpayer $1.2 trillion, a figure that is hard to imagine unless you begin to address what this amount of money could finance in terms of addressing real social problems. Leonhardt provides an eye-opening comparison that points to both financial waste and moral indifference. He writes:

> For starters, $1.2 trillion would pay for an unprecedented public health campaign—a doubling of cancer research funding, treatment for every American whose diabetes or heart disease is now going unmanaged and a global immunization campaign to save millions of children's lives. Combined, the cost of running those programs for a decade wouldn't use up even half our money pot. So we

could then turn to poverty and education, starting with universal preschool for every 3- and 4-year-old child across the country. The city of New Orleans could also receive a huge increase in reconstruction funds. The final big chunk of the money could go to national security. The recommendations of the 9/11 Commission that have not been put in place—better baggage and cargo screening, stronger measures against nuclear proliferation—could be enacted. Financing for the war in Afghanistan could be increased to beat back the Taliban's recent gains, and a peace-keeping force could put a stop to the genocide in Darfur. All that would be one way to spend $1.2 trillion. Here would be another: The war in Iraq. FN 27. David Leonhardt, "What $1.2 Trillion Can Buy." *The New York Times* (January 17, 2007), p. C1.

The Bush administration's ideological hostility to the essential role that government should play in providing social services and crucial infrastructure was particularly devastating for New Orleans in the aftermath of Hurricane Katrina. Prior to 9/11, the Federal Emergency Management Agency listed a hurricane strike on New Orleans as one of the three most likely catastrophic disasters facing America. The *Houston Chronicle* wrote in December 2001 that "[t]he New Orleans hurricane scenario may be the deadliest of all."[25] Nevertheless, the Bush administration consistently denied requests for funds by the New Orleans Army Corps of Engineers. Ignoring repeated requests, the Bush administration cut the Army Corps' funding by more than a half-billion dollars in its 2002 budget, leaving unfinished the construction for the levees that eventually burst. Moreover, in spite of repeated warnings far in advance by experts that the existing levees could not withstand a Category 4 hurricane, the Bush administration in 2004 rejected the Southeast Louisiana Urban Flood Control Project's request for $100 million, offering instead a measly $16.5 million. Huge tax cuts for the rich and massive cuts in much-needed programs continued unabated in the Bush administration, all the while putting the lives of thousands of poor people in the Gulf Basin in jeopardy. As David Sirota has reported, this disastrous underfunding of the levee infrastructure, coupled with even more tax cuts for the rich and less revenue for the states, continued right up to the time that Hurricane Katrina struck, making it almost impossible for governments in the Gulf region either to protect their citizens from the impact of a major hurricane or to develop the resources necessary for an adequate emergency response plan in the event of a flood.[26]

President Bush did not address questions about the lack of proper funding for the levees. Instead, he played dumb and, in spite of overwhelming evidence that he was aware of the inadequacy of the embankments, came up with one of the most incredible sound bites of his career: "I don't think anyone anticipated the breach of the levees."[27] In fact, Bush was briefed the day before Katrina hit and was emphatically warned by a number of disaster officials that the levees could be breached, though he later denied having been briefed.[28] Much of the press viewed Bush's remarks about the levees as indicative simply of his cluelessness and indifference to any information that did not conform to his own budget-busting, anti-big government ideology. However, such political and moral indifference is linked less to the narrow-mindedness and rigidity of Bush's character than it is to a broader set of biopolitical commitments at work in a global system that increasingly dictates who lives and who dies in the context of a rabid neoliberalism and a morally bankrupt neoconservatism.[29] But it is more than this still. The government's failure to respond quickly to the

black poor on the Gulf Coast relates to a deeper set of memories of racial injustice and violence, memories that suggest a link between an apartheid past and the present intensification of its utter disregard for populations now considered disposable.

The Politics of Disposability and Drowning Democracy

The notion that some populations are disposable can only be maintained if democracy itself is attacked; if not all lives are equal, then not all voices deserve to be heard. Underneath neoliberalism's corporate ethic and market fundamentalism, the idea of democracy is disappearing and with it the spaces in which democracy is produced and nurtured. Lost public spaces and public culture have been replaced with what Nicholas Mirzoeff calls the modern anti-spectacle. according to Mirzoeff, "the modern anti-spectacle now dictates that there is nothing to see and that instead one must keep moving, keep circulating and keep consuming."[30] Non-stop images coupled with a manufactured culture of fear strip citizens of their visual agency and potential to act as engaged social participants. The visual subject has been reduced to the life-long consumer, always on the go looking for new goods and promising discounts, all the while travelling in spaces that suggest that public space is largely white and middle-class, free of both unproductive consumers and those individuals marked by the trappings of race, poverty, dependence, and disability. Thus, democratic values, identities, and social relations along with public spaces, the common good, and the obligations of civic responsibility are slowly being overtaken by a market-based notion of freedom and civic indifference in which it becomes more difficult to translate private woes into social issues and collective action or to insist on a language of the public good. The upshot to the evisceration of all notions of sociality is a sense of total abandonment, resulting in fear, anxiety, and insecurity over one's future. The presence of the racialized poor, their needs, and vulnerabilities—now visible—becomes unbearable, a shocking sign that consumer-driven citizenship cannot provide the security lost when social programs are dismantled. All solutions as a result now focus on shoring up a diminished sense of personal safety, carefully nurtured by a renewed faith in all things military.[31]

Militaristic values and military solutions are profoundly influencing every aspect of American life, ranging from foreign and domestic policy to the shaping of popular culture and the organization of public schools.[32] Faith in democratic governance and cultural pluralism increasingly gives way to military-style uniformity, discipline, and authority coupled with a powerful nationalism and a stifling patriotic correctness, all of which undermine the force of a genuine democracy by claiming that the average citizen does not have the knowledge or authority to see, engage, resist, protest, or make dominant power accountable.[33]

Regulation replaces representation and social accountability

Complicit with militarism in this regulation are modernism and neoliberalism. Under their logic, the category "waste" includes no longer simply material goods but also human

beings, particularly those rendered redundant in the new global economy, that is, those who are no longer capable of making a living, who are unable to consume goods, and who depend on others for the most basic needs.[34] Defined primarily through the combined discourses of character, personal responsibility, and cultural homogeneity, entire populations are expelled from the benefits of the marketplace and are reified as products without any value. They are to be disposed of as "leftovers in the most radical and effective way: we make them invisible by not looking and unthinkable by not thinking."[35] Even when young black and brown youths try to escape the biopolitics of disposability by joining the military, the seduction of economic security is quickly negated by the horror of senseless violence compounded daily in the streets, roads, and battlefields of Iraq and Afghanistan, and made concrete in the form of body bags, mangled bodies, and amputated limbs—rarely to be seen in the narrow ocular vision of the dominant media.

With the social state in retreat and the rapacious dynamics of neoliberalism unchecked by government regulations, the public and private policies of investing in the public good are dismissed as bad business, just as protecting people from the dire misfortunes of poverty, sickness, or the random blows of fate is viewed as an act of bad faith. Weakness is now a sin, punishable by social exclusion. This sentiment is especially true for those racial groups and immigrant populations who have always been at risk economically and politically. Increasingly, such groups have become part of an ever-growing army of the impoverished and disenfranchised—removed from the prospect of a decent job, productive education, adequate health care, acceptable child care services, and satisfactory shelter. As the state is transformed into the primary agent of terror, and corporate concerns displace democratic values, dominant "power is measured by the speed with which responsibilities can be escaped."[36] With its pathological disdain for social values and public life and its celebration of an unbridled individualism and acquisitiveness, the Bush administration does more than undermine the nature of social obligation and civic responsibility; it also sends a message to those populations who are poor and black—society does not want, care about, or need you.[37] The media coverage and images that accompanied the Katrina disaster revealed with startling and disturbing clarity who these individuals are: African Americans who occupy the poorest sections of New Orleans, those ghettoized frontier zones created by racism coupled with economic inequality. Cut out of any long-term goals and a decent vision of the future, these are the populations who have been rendered redundant and disposable in the age of neoliberal global capitalism.

NOTES

1 Many of the ideas in this essay are drawn from my newest book, *Stormy Weather: Katrina and the Politics of Disposability* (Boulder: Paradigm Press, 2006).

2 Douglas Kellner, *The Persian Gulf TV War* (Boulder: Westview, 1992).

3 It is worth noting how the media portrayals of the war in Iraq and Hurricane Katrina differ when viewed from the contrasting perspectives of a *natural catastrophe* and the ensuing man-made *social debacle*. Labeled as a natural disaster, Katrina initially seemed removed from the political realm and social criticism until it became clear in the aftermath of the tragedy that matters of race and class had to be addressed. The

natural aspect of the disaster opened the door for media coverage of a domestic tragedy that could articulate dissent in a way that the state-manufactured war coverage could not. In other words, natural catastrophes are not supposed to be politicized in themselves; it was only in the aftermath that racial and class politics emerged, enabling the media and the public to criticize the negligence and incompetence of the government. Because the event occurred on domestic soil, the government had less control over the way the media constructed the event, particularly regarding issues related to poverty, race, and inequality. I want to thank Grace Pollock for this insight.

4 Dan Frosch, "Back from the Dead," ALTWeeklies.com, September 28, 2005, 1–3, http://www.altweeklies.com/gyrobase/AltWeeklies/Story?oid=oid%3A151104 (accessed April 26, 2006).

5 Cited in David Rohde, Donald G. McNail Jr., Reed Abelson and Shaila Dewan, "154 Patients Died, Many in Intense Heat, as Rescues Lagged," *New York Times*, September 19, 2005, http://www.nytimes.com/2005/09/19/national/nationalspecial/19victims.html?ex=1284782400&en=65d708e4e7733173&ei=5088&partner=rssnyt&emc=rss (accessed January 14, 2006).

6 Rosa Brooks, "Our Homegrown Third World," *Los Angeles Times*, September 07, 2005, 1–2, http://www.commondreams.org/cgi-bin/print.cgi?file=/views05/0907–24.htm (April 12, 2006).

7 Terry M. Neal, "Hiding Bodies Won't Hide the Truth," *Washington Post*, September 8, 2005, http://www.washingtonpost.com (accessed February 3, 2006).

8 For a brilliant analysis of the racial state, see David Theo Goldberg, *The Racial State* (Malden, MA: Blackwell Publishing, 2001).

9 Eric Foner, "Bread, Roses, and the Flood," *Nation*, October 3, 2005, 8.

10 Angela Davis, *Abolition Democracy: Beyond Empire, Prisons, and Torture* (New York: Seven Stories Press, 2005), 122, 124.

11 Bob Herbert, "A Failure of Leadership," *New York Times*, September 5, 2005, http://www.nytimes.com/2005/09/05/opinion/05herbert.html?ex=1283572800&en=a8bed4004ac0f93e&ei=5090&partner=rssuserland&emc=rss (accessed February 26, 2006).

12 Janet Pelz, "The Poor Shamed Us into Seeing Them," *Seattle Post-Intelligencer*, September 19, 2005, 1–2, http://www.commondreams.org/cgi-bin/print.cgi?file=/views05/0919–26.htm (accessed February 4, 2006).

13 Whereas ultimate political power was once the ability of the state to order the death of its citizens in exceptional circumstances, the new biopolitics regulates ever increasing aspects of life to the point that it is the primary political and pedagogical force through which subjectivities are created and lives are regulated. most menacingly, the biopolitical agenda ascribes different values to different populations; life is measured in terms of its perceived utility to the state. As a result, the human being's right to life is replaced by the state's right to value, devalue or completely impoverish lives of no perceived use. In developing my concept of biopolitics, I have found the following texts useful: Michel Foucault, *The History of Sexuality. An Introduction* (New York: Vintage Books, 1990); Foucault, *Society Must Be Defended: Lectures at the College de France 1975–1976* (New York: Picador, 1997); Michael Hardt and Antonio Negri, *Empire* (Cambridge, MA: Harvard University Press, 2000); Hardt and Negri, *Multitude: War and Democracy in the Age of Empire* (New York: Penguin, 2004); Giorgio Agamben, *Homo Sacer: Sovereign Power and Bare Life*, trans. Daniel Heller-Roazen (Stanford: Stanford University Press, 1998); Agamben, *Remnants of Auschwitz: The Witness and the Archive*, trans. Daniel Heller-Roazen (New York: Zone Books, 2002); and Agamben, *State of Exception*, trans. Kevin Attell (Chicago, IL: University of Chicago, 2003). I further explain my own theory of biopolitics in *Stormy Weather*, particularly on pages 11 through 23.

14 Cited in Thom Hartmann, "You Can't Govern if You Don't Believe in Government," Common Dreams News Center, September 6, 2005, http://www.commondreams.org/views05/0906–21.htm (accessed January 17, 2006).

15 Lawrence Grossberg, *Caught in the Crossfire: Kids, Politics, and America's Future* (Boulder, CO: Paradigm, 2005), 117.

16 Cited in Paul Krugman "Hey Lucky Duckies," *New York Times*, December 3, 2002, 31.

17 Robert Scheer, "The Real Costs of a Culture of Greed," AlterNet, September 06, 2005, 2, http://www.alternet.org/module/printversion/25095 (accessed April 10, 2006).

18 Judd Legum, Faiz Shakir, Nico Pitney, Amanda Terkel, Payson Schwin, and Christy Harvey, "Budget: After Katrina, More of the Same," Think Progress.Org, October 21, 2005, http://www.americanprogressaction.org/ site/apps/nl/content2.asp?c=klLWJcP7H&b=914257&ct=1520271 (accessed April 12, 2006).

19 Jonathan Weisman, "Budget Plan Assumes Too Much, Demands Too Little," *Washington Post*, February 7, 2007, A10.

20 Robert Scheer, "Does Bush Finally See Poor People?" Common Dreams, September 20, 2005, http://www.commondreams.org/views05/0920–28.htm (accessed April 12, 2006).

21 Judd Legum, Faiz Shakir, Nico Pitney, Amanda Terkel, Payson Schwin, and Christy Harvey, "Poverty: A Close Look at 'The Other America,'" Think Progress.Org, September 19, 2005, http://www.americanprogressaction.org/site/apps/nl/content2.asp?c=klLWJcP7H&b=914257&ct=1428461 (accessed May 5, 2006).

22 Robert Scheer, "Rotten Fruit of the 'Reagan Revolution,'" Robert Scheer.com, September 06, 2005, http://www.commondreams.org/views05/0906–23.htm (accessed April 12, 2006).

23 Peter Dreier, "Katrina in Perspective: The Disaster Raises Key Questions About the Role of Government in American Society," *Dissent Magazine*, Summer 2005, http://www.dissentmagazine.org/menutest/articles/ su05/dreier.htm (accessed October 22, 2006).

24 William Greider, "Defining a New 'New Deal,'" *Nation*, September 21, 2005, http://www.alternet.org/ module/printversion/25745 (accessed June 3, 2006).

25 Cited in Paul Krugman, "A Can't-Do Government," *New York Times*, September 2, 2005, http://www.commondreams.org/views05/0902–22.htm (accessed January 30, 2006).

26 David Sirota, "Welcome to New Orleans," *In These Times* (October 24, 2005), 21.

27 Frank Rich notes the revealing similarity between George W. Bush's "I don't think anyone anticipated the breach of levees" and Condoleezza Rice's post–9/11 claim "I don't think anybody could have predicted that these people could take an airplane and slam it into the World Trade Center." See Frank Rich, "Fallujah Floods the Superdome," *New York Times*, September 4, 2005, 10.

28 Spenser S. Husu and Linton Weeks, "Video Shows Bush Being Warned on Katrina," *Washington Post*, March 2, 2006, A01.

29 This is not an argument being made only by critics on the Left. Francis Fukuyama, one of the stars of the neoconservative movement, has recently jumped ship and argued in the *New York Times* that neoconservatism increasingly resembles Leninism and that, "as both a political symbol and body of thought, it has evolved into something he can no longer support." Francis Fukuyama, "After Neoconservatism," *New York Times Sunday Magazine*, February 19, 2006, http://www.nytimes.com/ 2006/02/19/magazine/ neo.html?_r=1&oref=slogin (accessed February 19, 2006).

30 Nicholas Mirzoeff, *Watching Babylon: The War in Iraq and Global Visual Culture* (New York: Routledge, 2005), 16.

31 There is more at stake here than the resurgence of old-style racism; there is the recognition that some groups have the power to protect themselves from stereotypes and others do not, and for those who do not—especially poor blacks—racist myths have a way of producing precise, if not deadly, material con-

sequences. Given the public's preoccupation with violence and safety, crime and terror merge in the all-too-familiar equation of black culture with the culture of criminality, and images of poor blacks are made indistinguishable from images of crime and violence. Criminalizing black behavior and relying on punitive measures to solve social problems do more than legitimate a biopolitics defined increasingly by the authority of an expanding national security state under George W. Bush; they also legitimize a state in which the police and military, often operating behind closed doors, take on functions that are not subject to public scrutiny.

32 See, for example, David A. Gabbard and Kenneth Saltman, eds., *Education as Enforcement* (New York: Routledge, 2003); Randall R. Beger, "Expansion of Police Power in Public Schools and the Vanishing Rights of Students," *Social Justice* 29, nos. 1–2 (2002): 119–130.

33 Richard H. Kohn, "Using the Military at Home: Yesterday, Today, and Tomorrow," *Chicago Journal of International Law* 94, no. 1 (spring 2003): 165–192; Catherine Lutz, "Making War at Home in the United States: Militarization and the Current Crisis," *American Anthropologist* 104, no. 3 (2002): 723–735.

34 Zygmunt Bauman, *Liquid Modernity* (London: Polity, 2000); also Zygmunt Bauman, *Liquid Love*; Zygmunt Bauman, *Liquid Life* (London: Polity, 2005).

35 Bauman, *Wasted Lives*, p. 27.

36 Zygmunt Bauman cited in Nicholas Fearn, "NS Profile: Zygmunt Bauman," *New Statesman*, January 16, 2006), 30.

37 Zygmunt Bauman, *In Search of Politics* (Stanford, CA: Stanford University Press, 1999), 68–69.

Chapter 22

Call Him a Terrorist, the Rest Is Covered

Political Murder in the U.S. Colony of Puerto Rico

José Solís Jordán

Who controls the past controls the future . . . who controls the present controls
the past.

—*Orwell*, 1984

All this was inspired by the principle—which is quite true in itself—that in the big
lie there is always a certain force of credibility; because the broad masses of a nation
are always more easily corrupted in the deeper strata of their emotional nature than
consciously or voluntarily; and thus in the primitive simplicity of their minds they
more readily fall victims to the big lie than the small lie, since they themselves often
tell small lies in little matters but would be ashamed to resort to large-scale false-
hoods. It would never come into their heads to fabricate colossal untruths, and they
would not believe that others could have the impudence to distort the truth so infa-
mously. Even though the facts which prove this to be so may be brought clearly
to their minds, they will still doubt and waver and will continue to think that there
may be some other explanation. For the grossly impudent lie always leaves traces

behind it, even after it has been nailed down, a fact which is known to all expert liars in this world and to all who conspire together in the art of lying. These people know only too well how to use falsehood for the basest purposes.

—Hitler, Mein Kampf

Some Context

September 23 is a national holiday in Puerto Rico. On this date in 1868, the people of the island nation rebelled against Spanish colonial rule and proclaimed the Republic of Puerto Rico in what is known as El Grito de Lares (The Cry of Lares). Thousands of Puerto Rican independentists converge annually on the rural town of Lares to celebrate this holiday as the nation's first great pro-independence affirmation. One hundred and thirty-seven years later, on Friday, September 23, 2005, this day of national celebration would henceforth also be marked as the date on which dozens of FBI agents, sharpshooters, and commandos launched a vicious, bullet-riddled attack on the home of Filiberto Ojeda Ríos, leader of the independentist clandestine EPB-Macheteros (Ejército Popular Boricua, in English, Popular Boricua Army-Machete wielders). Shooting him and leaving him unattended on the floor, Filiberto bled to death while the FBI ransacked his farmhouse. A subsequent autopsy revealed that the bullet wound alone was not the cause of his death and that the nature of the wound suggested sniper fire. Just as the news was hitting the airwaves, I began to receive phone calls at the University of Puerto Rico. Awestruck and angered, many supporters took to their cars from Lares to El Barrio Jagüitas in the western rural town of Hormigueros where the FBI's operation was taking place. Having thrown a wide and broad perimeter around the farm and barrio using FBI agents and later the Puerto Rican Police, federal authorities assured themselves of total control. Radio and TV stations began to report the incident late in the afternoon. A couple of stations went 'round the clock with their reporting of the story. Even so, some 24 hours would transpire before official news of Ojeda Ríos' death was reported; and days before the FBI issued a formal statement in a press conference. In the face of such an injustice and tragedy, we should feel compelled to know more and to act.

Today, the primary sources of immediate information (newspapers, books, movies, music, radio, and television) are the nucleus of a media industry motivated not by values such as truth or truths, critical thinking, and the well-informed community. Rather, they are the instruments of the Orwellian Ministry of Information. To the media industry, the higher value is higher profits. This means the progressive control of variables by facilitating predictability of what is done and how it is to be consumed. Advertising and public relations become the tools with which the media make sense of their operations. With each day that passes we should feel the need to purge ourselves of assumptions and tacit acceptance of what we hear, see, and read in the media. I accepted the invitation to write this piece because

I considered it an important and valuable space from which we might share and engage you, the reader, in reflections about your own assumptions. Filiberto Ojeda Ríos was just a man. He was a very good man. He lived for freedom. He died for freedom. What made him extraordinary was his commitment to helping others see, in the face of so much repression, the liberating power in all of us. This chapter will explore how Puerto Rico's major newspapers covered the story of Filiberto Ojeda Ríos's death on the day following his political assassination. Particular attention will be given to the information presented by the major newspapers following the FBI's attack in the context of the colony and the manufacture of consent. The chapter will also briefly look at how different groups in Puerto Rico responded to Filiberto's death, and how the issue of critical media literacy is being forged by these different groups. Becoming yet another example of the hyperrealization of life in the colony, the news of Filiberto's death sold rapidly and broadly. Layered and saturated by an officialized and decontextualized presentation, coverage was not conducive to critical reflection and debate or dialogue. Such a position assumes the presence of subject activity engaged in and with a pedagogy of the dialectical nature of information, its production, our consumption of it, and how, if exercised, we understand and respond to our reading of the news.

Saturday, September 24, 2005: it was quite warm at 7:30 A.M. My wife and I were returning home after a morning coffee at Gusto, a local café. Looking at each other, we tried hard to convince ourselves that the ambient heaviness we felt, that quality that silence can have when its weight bears down on you, was no more than our own reading of the morning after Filiberto's murder. We were both somewhat anxious to study the coverage published by the major newspapers in Puerto Rico. However, before I continue I need to establish some facts. To this date, Puerto Rico remains a U.S. colony. The U.S. Congress continues to reaffirm its sovereignty over Puerto Rico under Art. 4, § 3, para. 2 of the United States Constitution (known as the "Territorial Clause"). Puerto Rico remains a non-incorporated territory of the United States. While the media in the United States, including the contributions of educational institutions, would have Americans believe that the Puerto Rican economy lives off of federal transfers, among other myths, the same media and the same institutions regenerate the "big lie" by scantly, if ever, juxtaposing and comparing the many more billions of dollars that U.S. corporations make in profits from unique incentive packages, tax-free operations, and cheap labor in Puerto Rico. No attention is paid to the significant number of jobs that Puerto Rico generates in the United States, the result of colonial policies which restrict consumption to products from the United States. Also, the U.S. Congress along with the colonial government periodically manufactures "status votes," incorrectly called plebiscites, in an attempt to have the people believe that something is being done about the unfinished business of the colonial status. Prior congressional authorization is required in order to implement a referendum vote. Furthermore, the U.S. Congress must approve any definition of status options prior to its authorization. In other words, we have yet to experience the exercise of self-determination, an inalienable right of all peoples of the world.

The inalienable right of Puerto Rico to independence and sovereignty and the right to fight toward that end are recognized by numerous United Nations General Assembly resolutions, among other legal agreements and conventions of international law. It is in this

context that we must approach the acts of the U.S. Federal Government and the FBI as those of a criminal nature, of a colonial repressive machine; or fall for that "certain force of credibility" in the big lie. That many of the people of Puerto Rico choose to tolerate the colonial status quo is no more satisfactory a response to the crime of colonial rule than it is to say that a rape is only a rape when the victim is in agreement that she was raped. Thus, if committed to the ideals of freedom and participation, the role of journalism in Puerto Rico should then be motivated by the principles of anti-colonialism and self-determination.

Puerto Rican Media Under U.S. Control

In the past, our stories were the defined interactions of information shared by our immediate community of family, friends, neighborhood, and society. Today, the power of story-telling has fast become dominated by a superhighway of media messages that bombard our sensitivities with canned versions of virtual and hyperrealities against every detail of our lives. The speed with which we live, accompanied by our concurrent fixation with immediate gratification, dissolves our capacity to demand participation, interaction, and as such, any serious reflections of what we hear, see, or read. As we consume the items in that supermarket of information, stories are told to us through a media industry today controlled by a handful of mega-corporations called conglomerates whose chief interest is profit. The images, words, meanings, and references that have been packaged for us by the high priests of that industry shape our understandings of the world. Consequently, in the absence of alternatives, we choose from among the canned messages sold to us; we do not have the time for much else, and we are, apparently, not so predisposed.

Upon the U.S. invasion and occupation of Puerto Rico, Military Governor Guy V. Henry implemented numerous repressive policies, including a "limited freedom of the press." That is, newspapers in Puerto Rico could neither look critically upon the United States' invasion and occupation nor criticize U.S. policies in Puerto Rico. Control of information became a priority for the U.S. colonial regime. Newspapers like, *La Voz del Pueblo*, *El Combate*, *La Bomba*, *La Revolución*, *Bandera Americana*, *La Información*, *La Metralla*, *La Estrella Solitaria*, were all shut down for criticizing U.S. colonialism. Many journalists were arrested and incarcerated. Even larger, more conservative newspapers such as *El Imparcial* and *La Vanguardia* saw some of their journalists arrested. The subsequent expansion of public education on the island also served U.S. ideological and economic interests. The significance of the messages was made abundantly clear to the people: To live in peace meant accepting U.S. colonial rule. Federal government legislation controlled every aspect of education in Puerto Rico. Today, the well engrained colonial messages continue to receive the support of the insular government conditioned by federal authority. Add to this, the controlling role of the Federal Communications Commission (FCC) in Puerto Rico's media activity, and the package is complete.

It is then not surprising that media ownership in Puerto Rico is also a complicit member of U.S. media conglomerate interests. Puerto Rico's local commercial television

includes: Telemundo channel 2 and Televicentro channel 4, owned by General Electric. The Cisneros Group is owned by the ultra-right wing Gustavo Cisneros of Venezuela who owns Univisión, Puerto Rico's channel 11. Channel 7 or SuperSiete is owned by Floridian entrepreneur Jerry Hartmann (a channel of mostly infomercials and advertising). Channel 6, WIPR- TUTV is owned by the colonial insular government. While other stations exist as well as cable services, diversity of opinions is virtually non-existent. The same corporate control is to be found in radio. As for newspapers, *El Nuevo Día*, is owned by the Ferré Rangel family, one of the wealthiest and most influential families in Puerto Rico's recent history with an ideologically conservative and pro-statehood posture. *El Vocero*, is owned by Martin Pompadur, President of the Caribbean International News Corporation and Executive Vice-President of Rupert Murdoch´s News Corporation. *Primera Hora*, is also owned by the Ferré Rangel family. The only English-language newspaper in Puerto Rico, *The San Juan Star* is owned by Cuban-American Gerry Angulo, a business associate of Gustavo Cisneros of Venezuela. It is from this media environment, concentrated and controlled by the right that Puerto Ricans receive their information and from which the people are forging their ideas, positions, and identities. With this backdrop in place, we will now examine how the major newspapers covered the political murder of Filiberto Ojeda Ríos, and people's reactions and responses.

Quite possibly, the mass media industry does more to shape our identities and values than even schools. Nevertheless, the questions remain, what are our expectations of the media? What might we say are the criteria with which we evaluate the quality of the media industry? Here I would like to present three premises from which I will explore the newspaper's coverage on the morning after Filiberto Ojeda Ríos's death. These will serve as reference points for the purpose of juxtaposing these principles against the actual practice by the newspapers. In Robert McChesney's (2004) work *The Problem of the Media*, the author tells us that democratic theory posits that society needs journalism to perform three main duties: to act as a rigorous watchdog of the powerful and those who wish to be powerful; to ferret out truth from lies; and to present a wide range of informed positions on key issues.

Indeed, in a world where a handful of conglomerates (Time Warner, Disney, News Corporation, GE, Viacom, and Bertelsmann) exercise virtual control over the universe of newspapers, TV, radio, movies, magazines, books (including textbooks), music, and so on, these premises present us with a serious challenge as to the nature of a society that would, in principle, subscribe to these democratic ideas amidst the presence of such a clearly profit-driven, monolithic, and anti-democratic media industry.

Just as in the field of education we are told that the good professional educator is the "objective" "unbiased" and "neutral" teacher, so too is it the case in journalism. In part, it is precisely this notion of professionalism that has distanced journalism from its role as a watchdog of the powerful, lending itself to half-truths or outright lies called "spin" and retreating from the widening of well-informed positions toward a more concentrated, consolidated, and conservatively consensual posture reflecting the ideological framework of the conglomerate owners of the industry.

On Saturday, September 24, 2005, how did the headlines of the major newspapers in Puerto Rico read?

- *El Nuevo Día:* "Cae Filiberto Ojeda" (trans.: Filiberto Ojeda falls). This language makes reference to his possible or alleged death.
- *El Vocero:* "En balacera con el FBI Cae Filiberto Ojeda" (trans.: Filiberto Ojeda falls in a shootout with the FBI). This headline reads the same as the above yet adds that a shootout took place.
- *Primera Hora:* "Dan por muerto a Filiberto Ojeda en tiroteo con FBI" (trans.: Filiberto Ojeda taken for dead in shootout with FBI). Here the headline assumes the position that Ojeda Ríos is taken for dead as a result of a shootout with the FBI.
- *The San Juan Star:* "FBI Raids Ojeda Ríos' Hormigueros hideout." This headline includes the implication that Ojeda Ríos was hiding, and hence a fugitive or criminal evading the law.

Filiberto Ojeda Ríos was born in 1933 in El Barrio Río Blanco in the municipality of Naguabo, Puerto Rico. While an accomplished musician, he was popularly known for his leadership role in the clandestine independentist organization, EPB-Macheteros. Living underground for some 15 years, much of what was spoken about Filiberto earned him legendary status. In 1988 he was acquitted in the U.S. Federal Court in Puerto Rico of numerous charges related to the FBI's 1985 raid upon his home. Between 1985 and 1988 he was held in a federal prison without being formally charged. On September 23, 1990, Ojeda Ríos, under house arrest, removed the electronic monitoring device which the U.S. federal government sentenced him to wear while awaiting trial for his alleged participation in the 1983 Wells Fargo heist in Hartford, Connecticut. Never leaving Puerto Rico, but living underground for 15 years among the people and protected by the people, Filiberto would give interviews and prepare taped messages which would find their way to the airwaves, newspapers, and television. In 1992 he was sentenced in abstentia by the U.S. Federal Court to 55 years for his part in the Hartford Wells Fargo case. Many believe Ojeda Ríos' defiance infuriated federal authorities and only fueled their resolve to assassinate him, not arrest him. Remember, this was a man who had not been found guilty of any crime. He may have been awaiting a trial. He may have declared himself leader of the Macheteros. He may have been the comandante of the Macheteros. However, he was not a convict on the loose. He was, in the words of many, a freedom fighter defending the inalienable right of Puerto Rico to be free of U.S. colonial rule.

This is the context wherein it all begins, wherein lies our ignorance surrounding the reality of colonialism in Puerto Rico, and the rights under international law for the colonized to use all means at their disposal to free themselves from the colonial regime. The list of international laws protecting the rights to freedom of colonized peoples is long, yet sufficient argument is found under United Nations General Assembly Resolution 2621 (XXV) Programme of action for the full implementation of the Declaration on the Granting of Independence to Colonial Countries and Peoples (A/8086) of October 12, 1970:

1 Declares the further continuation of colonialism in all its forms and manifestations
 a crime which constitutes a violation of the Charter of the United Nations . . . ;
2 Reaffirms the inherent right of colonial peoples to struggle by all necessary means
 at their disposal against colonial Powers which suppress their aspiration for free-
 dom and independence . . .

Together with other resolutions passed by the General Assembly of the UN and a num-
ber of international agreements, the protocols for the Geneva Conventions establish the
parameters of what constitute fair targets in national liberation struggles. The actions
undertaken by the Macheteros, and in this case, alleged participation by Ojeda Ríos have,
were we to study these, conformed to the protocols.

I was asked in an interview what I thought about Ojeda Ríos' s death. My response began
by establishing the need for a context, a premise, a point of departure from which a discus-
sion might ensue. For example, if you understand that Puerto Rico is a colony, as articu-
lated by history and law, then Filiberto's death was a political assassination against a
freedom fighter. If however, you accept the presence of the United States as the sovereign
power over Puerto Rico and as such legal, then the position that his death was a political
act folds against the understanding that the FBI was out to capture a criminal. Ironically,
though, some three months after Ojeda Ríos's death President George W. Bush's President's
Task Force on Puerto Rico's Status reported that:

> On July 3, 1950, the U.S. Congress passed Public Law 600 (known as the Puerto Rican Federal
> Relations Act), giving Puerto Rico the right to establish a government and a constitution for the
> internal administration of the Puerto Rican government and "on matters of purely local concern."
> . . . It (Congress) expressly upholds the terms of the Jones Act of 1917. . . . The existing form of
> government in Puerto Rico is often described as a "Commonwealth," and this term recognizes the
> powers of self-government that Congress has allowed . . . In addition, the term "Commonwealth"
> has been given other meanings with regard to Puerto Rico . . . However that term may be used,
> Puerto Rico is, for purposes under the U.S. Constitution, "a territory" . . . subject to congressional
> authority (*President's Task Force on Puerto Rico's Status*, December 2005).

Discussion around the report's use of language and meaning would itself prove reveal-
ing. For example, when is a right ever something to be given? Moreover, the fact that the
U.S. Congress should allow for certain powers is nothing less than a reaffirmation of the
colonial structure, called "territory." Thus, never having exercised the right to self-
determination as stipulated under International Law (for example, see United Nations
General Assembly Resolution 1514 (XXV) December, 1960); "belonging to, but not a part
of the United States," as articulated by the U.S. Supreme Court during the Insular Cases
(1901–1922); enjoying political powers as "given" or "allowed" by the U.S. Congress; and
living under the authority of that Congress, how the news is reported and how one under-
stands the news and its context influence significantly one's position regarding the death
of Filiberto Ojeda Ríos, who he was, what he represented, and what his assassination says
about the FBI and the United States federal government's disposition toward Puerto Rico.
Journalistic coverage of his death was then tempered by the dominant colonial political/eco-
nomic and ideological interests that had to be conserved by the major newspapers (and media

generally).

There is a serious concern among scholars in the field of critical media studies that the professional codes followed by journalists have, as expressed by McChesney (2004, p. 68), "decidedly political and ideological implications." The "professionalism" as defined and practiced by the major media firms has managed to manufacture a notion of "objective," "neutral," and "unbiased" journalism that would, "first, remove any controversy connected with story selection by regarding anything done by official sources (government officials and prominent public figures) as the basis for legitimate news" (McChesney, 2004 p. 68). This also has the effect of constructing very strict parameters around what is generally considered the acceptable framework of dialogue or debate on any media-covered material.

Let us explore this point. With no prior knowledge of the FBI's operation, all pertinent insular government agencies and offices (Executive Office of the Governor, Puerto Rico's Secretary of Justice, Puerto Rico Police, and so on) were reportedly left out of the intelligence pipeline. At least, this is what the people were told. Such a set-up would establish well controlled boundaries from which information would flow. All four major newspapers used as a reference term the adverb "hermetically" in referring to the FBI's execution of the operation spearheaded by agents from the states of Florida and the Carolinas, including sharpshooters trained in sniper tactics. With the exception of *The San Juan Star*, each newspaper ran at least one major article off of the headline and a couple of peripheral pieces. *The San Juan Star* ran only one one-page article. We are reminded that some 24 hours had transpired before official word confirming Filiberto's death was released. In fact, it would be days after his death before the FBI would issue any official statement in a press conference.

Notwithstanding, the major articles covering the incident shared some journalistic common ground. Each constructed its articles around the lack of information coming out of the FBI. Each reported that at the closing of the press day, no one had definitive information. However, official Puerto Rican government representatives were interviewed and published in the four papers. Puerto Rico's Secretary of Justice, Roberto Sánchez Ramos, Puerto Rican Insular Prosecuting Attorney, José Nazario, and Police Superintendent, Pedro Toledo represented the "legitimate" sources of information from which the news was being written and reported. We are reminded that no one from the Puerto Rican government had prior knowledge of the operation. FBI spokesman Luis Feliciano was referenced (one line) in a couple of the newspapers with respect to the possibility that the FBI would soon release an official statement. Thus, as asserted by McChesney, the legitimacy of the type of reporting was determined by a reliance on the voices of the insular government's officials. Such officialization of the storyline produced different reactions. First, being officials of the insular government, these men became a kind of buffer or wedge between the U.S. federal Government and the people of Puerto Rico. In classic colonial style, they would "represent" visually, verbally, and politically the "best interests of the people of Puerto Rico," and so too assume responsibility for looking into the matter of Ojeda Ríos's death. Thus, the legitimacy of the news fast became a matter of getting the right information on

what had occurred; and that the best sources for that information were to be found in the colonial government's agencies and subsequent investigations into the FBI's operation. It is precisely our reliance upon the idea that government officials or prominent public figures carry the voices of legitimacy that undermines the possibility of democratic journalism. Indeed, the ideological and political nature of these "official" voices serves poorly the democratic interests of the people, silencing critical understanding and reinforcing the colonial status quo.

Indignation blanketed the country. Many of people gathered in the municipality of Lares in celebration of El Grito de Lares were mobilized, organizing mass protests throughout the island on that night. Coverage of the outrage expressed by the many independentist organizations could be read as a journalistic balancing act in an attempt to be fair. However, the articles projected what many perceived as the spontaneous and impulsive reactions of those groups; reactions that many in Puerto Rico have come to expect from these organizations with little or no consideration given to how these reactions are tied to a history of repression by the FBI in Puerto Rico; thus diminishing the legitimacy of their denunciations and the possibilities that these might carry over into broader and more profound discussions and actions with respect to the significance of what had occurred. The backdrop of the newspapers' official voices dressed with a rationalized calm in the face of what was clearly a vile act of imperialism and coverage of the angry protests of the night constituted the corpus of information upon which the people had to rely. This issue becomes important when considering the next point regarding the problem of journalistic professionalism. Again, McChesney reminds us that in its attempt to conserve an "objective," "unbiased," and "neutral" professional code, journalism also works to avoid contextualization. This is because, "to contextualize is to commit to a position thereby generating the controversy that professionalism is determined to avoid" (McChesney, 2004 p. 71). In the early days of journalism, contextualization was considered a good thing. As newspaper ownership became more concentrated and commercial, there was a need to strengthen the industry's market share. By establishing a professional code for journalists to follow, one that included strict parameters around what and who would be considered a legitimate source for information (government officials and high profile public figures) and by avoiding the controversial nature of contextualizations, the risk of losing market shares and values would be reduced.

We can then begin by asking ourselves, how was context avoided in the coverage of Filiberto Ojeda Ríos's death? First, the reporting that took place stayed strictly within the boundaries of a language that read like a timetable, a precise chronology of events that transpired on that fateful day. Clearly then, the FBI's planning of the operation included an understanding that control of the environment and intelligence about their actions would limit the kind of reporting that would find its way into the public conscience. Once day dawned and the news began to spread about what was happening in Hormigueros, and knowing that this news would mobilize people to the scene, the FBI inserted Puerto Rico's police force into its operation, having the police guard a broad and tight perimeter around the area. In addition, the electrical power of the entire barrio was shut off, leaving everyone and every-

thing in total darkness. Newspaper coverage was then expressed in terms of time capsules and the corresponding activity. This held true for each of the four major newspapers. Whatever context was reported was limited to the fact of his death and the particular "reasons" for the FBI's operation. Articles establishing a context for the FBI's deadly actions also read like timelines relative to Ojeda Ríos's life of political struggle. The report in *El Nuevo Día* was titled: "Filiberto Ojeda Ríos: Una vida en la clandestinidad" (Filiberto Ojeda Ríos: a clandestine life). *El Vocero* reported: "Largo su historial politico-militar" (A long politico-military history). *Primera Hora* announced: "Fugitivo de por vida" (lifelong fugitive). Finally, *The San Juan Star* wrote: "A long life on the lam." Each of these "contextualizing" articles, while possibly including important bullets of information, misinformed and misrepresented the history behind each of the bullets, not to mention doing a grave disservice to a well-informed understanding of how a broader context and frames of reference were needed for a critical and educational reading of the significance of Filiberto's death.

All of the reporting that took place reduced the events to the individualization and decontextualization of an almost mythical and exotic figure. Given Filiberto's many years in the struggle and last 15 years underground, media coverage seemed to present him as legendary and as such a nearly abstract entity. This again leaves many with the challenge of how to place Ojeda Ríos in the context of Puerto Rico and colonialism today. The combination of the FBI's cold, removed, and stealth-like operation, the projection of Filiberto as a criminal, legendary and modern day mythical figure, and the newspaper coverage that, in its particular language, underscored these descriptions with no real consideration for context did little to promote any serious critical understanding and subsequent dialogue about the assassination. Such coverage and reporting contribute generally to a paralysis. The reader is given information as if that information were about facts removed from time and place, culture, and values. Messages and meanings expressed in words are tightly locked in a vacuum-canned version of information with the preservatives and additives necessary for acceptable public consumption. The newspaper and its news content are sold to be consumed and discarded. The point is to sell the news of the day, an instant, a pitch, an item. Without a sense of contextualization; without an understanding of where, how , and why Filiberto Ojeda Ríos lived and died, the reader of the news only knows that this "thing" occurred and that the officials, government and others, responsible for administrating the public, will take care of the rest. Here, the consumer is relieved of all responsibility to respond, both socially and individually. We become, as Foucault reminded us, administrators of our own discipline. Journalism's reliance on the "official" voices and accompanying decontextualization in the service of a profit-driven professionalism can only contribute to disenfranchise, alienate, and atrophy an already dormant, or at best, apathetic and painfully tolerant public. Voices are silenced as human agency slips into a comfortably numbing existence.

Nowhere in the news did the papers place the FBI's actions and Filiberto Ojeda Ríos's death in the context of U.S. colonial rule, the long history of political deaths and persecution, nor any mention of international law and the rights of colonized peoples. Filiberto was presented as a criminal, a fugitive, or at best a legend. Consuming the newspapers' sto-

ries, the people of Puerto Rico were being led to accept the colonial government's official interpretation and expected to understand the incident as a legal action between the FBI and a criminal, or worse, a terrorist. In sum, the status quo was preserved. In the days and weeks that followed, mention of Ojeda Ríos's death in the media included statements of concern from the colonial Governor, Aníbal Acevedo Vilá and the Secretary of Justice, Roberto Sánchez Ramos. They assured the people that the FBI would be subpoenaed under an ongoing investigation into the possibility of a "wrongful" death allegation. In March of 2006, the Puerto Rico Department of Justice filed a lawsuit against the FBI, demanding that all pertinent files be made accessible to the Puerto Rico Department of Justice's investigation into the death of Ojeda Ríos. When interviewed about the actions of the FBI, H.S. "Bert" García, Chief District Attorney for the Federal District of Puerto Rico under the U.S. Department of Justice, stated that Filiberto was a terrorist. When asked to define the term he responded by stating that terrorism was the use of violence for political ends. No newspaper took advantage of his words to discuss the issue of what is to be considered a terrorist act. After all, if we accept his definition, entire nation-states, including the United States, are then terrorists.

Forging Alternatives

Notwithstanding the severity of the limitations for a well informed public in Puerto Rico, the traditional political organizations committed to independence for Puerto Rico including sections of the Puerto Rican Independence Party, The Nationalist Party/Liberation Movement, The Frente Socialista (Socialist Front), The Movimiento Socialista de Trabajadores (Socialist Workers Movement), El Movimiento Independentista Nacional Hostosiano (The Hostos National Independence Movement), La Federación Universitaria Pro Independencia (The Pro Independence University Federation), among many others, organized activities in an effort to educate and better inform the public. Also, alternative groups were formed in the wake of the assassination. These included La Nueva Escuela (the New School) and Rompiendo el Perímetro (Breaking the Perimeter), among others. All of these organizations and smaller ones dedicated to educating the public, developed and implemented educational and mobilization campaigns. Among the activities was an island-wide mural and graffiti campaign. Murals depicting Filiberto in the context of federal repression against Puerto Rico's struggle for self-determination and independence were painted on public walls, different campuses of the University of Puerto Rico, public housing projects, abandoned buildings, highway overpasses and bridges, and schools. Vigils and talks have been held on a monthly basis since September 23, 2005. Held generally on the 23rd of each month, these activities are meant to draw attention to related issues not covered by the mainstream media. A rich and diverse array of activities continue to forge their way into public spaces and the public conscience, including marches, protests, concerts, theatrical performances, art exhibitions, poetry recitals, and workshops on a wide range of topics.

In keeping with the importance of context, on February 10, 2006, some five months later, the FBI, accompanied by helicopters and sharpshooters, raided the homes of numer-

ous independentists in what the FBI reported was an effort to purge information and gather intelligence and evidence regarding leads on the possibility that "terrorist" activities might take place in Puerto Rico. Present at one of the locations in the San Juan area were a number of journalists covering the story. Their presence clearly bothered the FBI. Tension swelled as the journalists ignored the FBI's orders that they move out of the area. Immediately, and issuing no prior warnings, the FBI began dousing the reporters with canisters of pepper spray, knocking them over, forcing and shoving them against the fences and walls which lined the area. While no perimeter was ever officially established, the FBI alleged that the reporters violated their space. Interestingly then, the same journalists responsible for their "professional" coverage of the assassination of Filiberto Ojeda Ríos became victims of the same repressive machine. This interesting irony was not covered by anyone in the media, print or otherwise. While the presence of the FBI in Puerto Rico has always been perceived by many sectors as, at best, tolerable and at worst imperialist, with the exception of annexationists, it has never been embraced. Furthermore, since the days of the COINTELPRO (Counter Intelligence Program) of the FBI and over 60 years of files on hundreds of thousands of Puerto Ricans, the role of the FBI has been seen generally as that of the colonizer's principal police force in Puerto Rico. Many believe that today the counterintelligence program of the FBI remains active in Puerto Rico.

With this context in place, including the arrests of numerous students and workers at different activities in recent months, organizing people has remained difficult. Fear becomes a paralyzing factor. Professional, social, and even personal threats also play into the rubric of repression. Nevertheless, educators and workers have organized alternative forms of education, information, and outreach. Among these is La Nueva Escuela (The New School). La Nueva Escuela is a non-sectarian political organizing project with the purpose of developing independentist political education among the popular classes. It considers itself a promoter of alternative means for the forging of spaces and perspectives regarding the work toward national liberation. Members of La Nueva Escuela have organized different communities of persons in public housing projects throughout the island.

Also contributing to the forging of alternatives to the mainstream media is the organization Rompiendo Perímetro (Breaking the Perimeter). This community group holds monthly vigils and workshops organized in the wake of Ojeda Ríos's death. Thus, while alternative activities and sources of information are developed, what, when, and how information that is made newsworthy generally, remains in the hands of the owners of the media industry in Puerto Rico. In spite of the difficulty, however, resistance and possibility remain alive in the efforts of the many and growing groups of Puerto Ricans unwilling to fall for the "Big Lie."

In conclusion, we are reminded that the very idea of the "Big Lie" attributed to Joseph Goebbels and Adolf Hitler's Nazi propaganda machine was actually modeled after another source. Sponsored propaganda as it has come to be called was the brain-child of U.S. President Woodrow Wilson. In 1917, having declared war on Germany, the Wilson administration created the Committee on Public Information (CPI), representing for the first time, and on a large scale, government sponsorship of propaganda. The effectiveness of its tac-

tics became the source from which Hitler and Goebbels modeled the Nazi propaganda machine of the 1930s. More recently, Madison Avenue's advertising and public relations firms, loyal students and offspring of the CPI's curriculum, continue to profit from the proliferation of that "certain force of credibility" latent in the "Big Lie." Therefore, considering that the media are owned and controlled by a handful of conglomerates and their product is the work of their high priests in advertising and public relations, we would do well, if indeed democracy still matters, to read, view, and listen critically, very critically, and then question everything they have to offer (sell).

Hitler said in *Mein Kampf*:

> The function of propaganda is, for example, not to weigh and ponder the rights of different people . . . but exclusively to emphasize the one right, which it has set out to argue for. . . . Its task is not to make an objective study of the truth, in so far as it favors the enemy, and then set it before the masses with academic fairness; its task is to serve our own right, always and unflinchingly (Hitler, *Mein Kampf*, 1943, Chap. 6).

President George W. Bush said in Greece, New York, May 24, 2005:

> See, in my line of work you got to keep repeating things over and over and over again for the truth to sink in, to kind of catapult the propaganda. (Bush, *Bushism Audio Gallery*, May 24, 2005)

On Sunday, September 25, 2005, at approximately 9:00 P.M., my wife and daughters accompanied me to the Ateneo Puertorriqueño. The Ateneo or Puerto Rican Athenaeum in English, is Puerto Rico's chief cultural institution. It was founded in 1876. Here Filiberto's body would rest in an open casket vigil while thousands came to pay their respects. We were pleasantly surprised by the outpouring of people who waited patiently for hours with their families. The following day, the same vigil was moved to the Colegio de Abogados, or Puerto Rico Bar Association building. Again, thousands came. Children, the elderly, workers of all classes paid tribute to a fallen leader. The procession to the Río Blanco cemetery took over five hours to complete. This is a distance that on a regular day might take about one hour to travel. Many thousands followed the procession. The road along the way was lined by people with the Puerto Rican flag in hand; many with fists raised. Others held posters with words of solidarity. Cars, trucks, and buses painted with messages in white shoe polish made their way into the procession. Rural school children lined the fences of their schoolyards with cardboard machetes in their hands raised high as the funeral cars passed. Some folks just stood humbly but proudly on the porches of their small homes with their hands behind their backs observing, participating in the making of history. The news reported that the tribute paid to Ojeda Ríos surpassed that of past political leaders of Puerto Rico. On September 27, 2005 Filiberto Oejda Ríos went home one last time.

As I was completing this piece, my attention was drawn by the news on Channel 4 Televicentro. On Wednesday, June 21, 2006, the TV news reported that the U.S. Department of Justice would not comply with Puerto Rico's Department of Justice request for the release of the FBI files relevant to the death of Filiberto Ojeda Ríos. The reason given by the United States Department of Justice, it was reported, expressed that given Puerto Rico's relationship with the U.S., Puerto Rico was in no position to file such requests.

REFERENCES

Bush, G.W. *Bushism Audio Gallery*. May 24, 2005, http://politicalhumor.about.com/library/blbushism-propaganda.htm

Hitler, A. (1943). *Mein Kampf*. R. Manheim (Trans.). Boston: Houghton Mifflin Company.

McChesney, R. (2004). *The problem of the media: U.S. communication politics in the 21st century*. New York: Monthly Review Press.

President's Task Force on Puerto Rico's Status. (2005, December). Report by the President's Task Force on Puerto Rico's Status (pp. 4–5). Washington, D.C.

United Nations General Assembly Resolution 2621 (XXV). (1970, October 12). Programme of action for the full implementation of the Declaration on the Granting of Independence to Colonial Countries and Peoples (A/8086) of October 12, 1970.

The Aesthetic Pleasures of War

Understanding Propaganda in an Age of Television

Antonio López

Propaganda is technically a neutral term. A good generic definition from Nancy Snow in her discussion of current propaganda practices in *Information War* is "any organized or concerted effort or movement to spread a particular doctrine or system of doctrines or principles" (2003, p. 61) The pejorative notion of propaganda likely comes from its association with fascist and totalitarian regimes like Nazi Germany or the Soviet Union. "Good guys" don't have propaganda because their cause is justification alone for their actions, such as spreading "liberty," "freedom," or "democracy." The fact that such statements are made regularly without debate or challenge reflects the great success of the modern capitalist state to disseminate its message across all sectors of society. Our propaganda system is hidden within a dominant paradigm that creates an internalized philosophical framework that is ubiquitous and far-reaching. Images, because they are quick and easy message packages, are some of the primary weapons of ideology. As C. Wright Mills remarked many years ago, "Those who rule the management of symbols, rule the world" (1963, pp. 405–406).

The globe has undergone tremendous transformations since World War II, moving into a postmodern intertextual media and economic environment defined by Fredric Jameson (1992) as Late Capitalism. Assuming that propaganda and the needs for it have not gone

away, this essay explores a simple conundrum: If states no longer use the old-fashioned spectacles that dominate our image of state-sponsored propaganda, then how does propaganda manifest itself in the age of television and the Late Capitalist society? This query contains a few assumptions. First, by old-fashioned spectacle, the prototype I refer to is Hitler's Nuremberg rally as portrayed in the film *Triumph of the Will* by Leni Riefenstahl (1935).

It is a theatrical display of aestheticized politics designed to rally the masses for war. I mean technological war mobilization by the national security state, with the structural support of mass media that embody a hegemonic socio-economic agenda (domestic and international) designed to advance the implicit interests of an advanced technocratic elite. Third, "spectacle" implies that visually consumed war is needed to form an ideological position to support a war economy. Finally, as long as the state still requires mobilization for warfare, the need for such spectacles continues, but they are evolving into newer, decentralized, and atomized forms.

Propaganda, War, and the State

"War is the health of the state," Randolph Bourne (quoted in Zinn (2003, p. 359))

Walter Benjamin and other writers of the Frankfurt School were essentially diagramming their media critiques in response to Nazi Germany's deployment of mass media, yet their prognosis remains eerily prescient; no doubt they, too, would say the assessment is not limited to Germany. Fascism, according to Benjamin, "expects war to supply the artistic gratification of a sense perception that has been changed by technology" (2001, p. 64). For the culture industry (i.e., mass media), as described by Horkheimer and Adorno, "Business is their ideology" (2001, p. 81). As will be discussed later, formats and aesthetics of fascist spectacle have changed, but what has come to pass is an even deeper integration between business and media interests, which is briefly outlined here, for it is important to situate how divergent visual media, from war photography to war films, exist within an ideologically structured framework.

Edward Said (1997) outlined in his study *Covering Islam* some guiding principles about reading media. Said warns that much of what we understand about the outside world, and in particular for him concerning the Islamic "Other," is through "communities of interpretation." Because we are immersed in secondhand worlds, we receive information through filters and sources from outside our daily experience. "Between consciousness and existence stand meaning and designs and communication which other men have passed on—first, in human speech itself, and later, by the management of symbols," Said writes. "Symbols focus experience; meaning organizes knowledge, guiding the surface perceptions of an instant no less than aspirations of a lifetime" (Said, 1997, pp. 46–47). Propaganda must be simple, emotional, and generally appeal to an either/or worldview.

Thus, we rely on the cultural apparatus to report and communicate from a distance: "Every man is increasingly dependent upon the observation posts, the interpretation centers, the presentation depots, which in contemporary society are established by means of

what I am going to call the cultural apparatus . . . Together, this powerful concentration of mass media can be said to constitute a communal core of interpretations providing a certain picture of Islam and, of course, reflecting powerful interests in the society served by the media" (Said, 1997, p. 47). Such "powerful interests" are heavily influenced by the petroleum-based economy, which is impossible to deny given that almost every report you ever read or see in the media is within the context of mass media's largest advertisers: the auto industry. When it comes to contemporary war, which happens to center in a region predominantly occupied by Muslims, we need to be keenly aware of our own "Orientalist" bias, one that generally pits the "Other" as a terrorist or greedy oil sheik. Accordingly, when confronted with images of war in the Middle East, a picture's meaning is highly determined by its framework: "By context I mean the picture's setting, its place in reality, the values implicit in it, and, not the least, the kind of attitude it promotes in the beholder" (Said, 1997, pp. 47–48). As Said demonstrated in his case study of news coverage of the Islamist revolution in Iran, "Thereafter the drama has unfolded as if according to an Orientalist program: the so-called Orientals acting the part decreed for them by what so-called Westerners expect; Westerners confirming their status in Oriental eyes as devils" (p. 56).

Reporters and photojournalists normalize and perceive as natural many of these biases, which are internalized through what Gramsci (1971) describes as a hegemonic process of consolidating the dominant ideology within the economic system's superstructure (its intellectual and educational "brain trust"). Raymond Williams (1973) showed that consensus is shaped by ideological social practices and expectations producing a natural order within the culture so that, according to media critic Todd Gitlin (1980), ideology dominates and is distributed by the dominated. Such "consent," as Chomsky and Herman (2002) would put it, comes as a result of the power structure framing reality. As Gitlin remarks, "The central command structure of this order are an oligopolized, privately controlled corporate economy and its intimate ally, the bureaucratic national security state together embedded within capitalist world complex of nation states" (1980 p. 9).

All of this is a longwinded way of stating what is obvious to media critics but less clear to the average consumer of media: The state no longer needs to produce centralized spectacles or rallies that were so prevalent in Nazi Germany or Soviet Russia because the press serves as a pliant client, and merely needs to be managed. Such orchestration, though, playing the "Grand Wurlitzer" in CIA parlance, is not always so easy and is dependent on shorthand ideological pulses, mainly the power of the image to make tautological, concise statements that have emotional appeal, especially through the use of photographed imagery, which is easily disseminated through the Internet and press. As photo critic Susan Sontag comments, "In an era of information overload, the photograph provides a quick way of apprehending something and a compact form of memorizing it" (2002, p. 87). Hence the abundant use of the photo op with the proper visual information in place. President Reagan was a master using this skill, a fitting symbol of information management, given that he was a hybrid actor-politician. It goes to the heart of how much politics is increasingly indistinguishable from entertainment. As Paul Virilio demonstrates in *War and Cinema* (1989), the Nuremberg rally captured on film in the *Triumph of the Will* was explicitly staged for cin-

ema and not necessarily for the benefit of the rally participants. Moreover, Hitler was very much an actor himself, studying magician hand gestures in an effort to enhance his performance charisma. However, even though he used certain hypnotic rhetorical techniques that worked live in person, they translated badly via the medium of radio, which was one of the major techniques Goebbels attempted to use to get Nazi messages into German homes. Thus, spectacle and its attendant visual connotation are more effective when "seeing is believing."

The Power of Images to Represent Reality

Neil Postman argues in *Amusing Ourselves to Death* (1985) that the fate of our society is less Orwellian and more the model of the pleasure seeking pill-poppers of Aldous Huxley's *Brave New World*. "What Huxley teaches us," Postman writes, "is that in an age of advanced technology, spiritual devastation is more likely to come from an enemy with a smiling face than from one whose countenance exudes suspicion and hate. In the Huxleyan prophecy, Big Brother does not watch us, by his choice. We watch him, by ours" (1985, p. 155). In a way, we can view the control strategies envisioned by Orwell and Huxley as modernist versus postmodernist media control practices. In other words, what film is to Orwell, television is to Huxley. Film embodies key elements of modernity's aesthetics through fragmentation, montage, photographic quality, centralized distribution, and time-based construction. By contrast, television's ambivalent spectator confronts a pluralistic, videographic, decentralized, simultaneous, flexible, and space-based media environment. The paradigm of modernity can be compared to a film that is hierarchal, group organized, and machine produced in a studio system for centralized distribution with a captured theater audience. If Hitler was the director of a film production that was World War II, then in the postmodern model the Pentagon manages the TV network, and its embedded workers are the subcontracted producers of content. Moreover, unlike World War II with its clearly defined battlefields, the so-called "war on terror" itself is a postmodern form of warfare with no clearly defined combat zones, its "theater" of operations being a broad spectrum of information nodes.

Eisenstein and Vertov in the Soviet Union and Marinetti in Italy believed that art should reflect the social and technological order, with the former believing film embodied the liberating dialectic qualities of modernism, and the later celebrating the heroic aesthetics of war and its machinery. It is no wonder that television would continue to embody a parallel trajectory of celebrating war and its technological tools of domination (such as "shock and awe"), for technology also becomes a self-defining, self-fulfilling imperative. Accordingly, Virilio demonstrates how entertainment and war technologies are intertwined: "The industrial production of repeating guns and automatic weapons was thus followed by the innovation of repeating images, with the photo gun providing the occasion. As the video signal supplemented the classical radio signal, the video camera further extended such 'cinematography' and allowed the adversary to be kept under remote surveillance in real time, by day and night" (1989, p. 4).

Like war itself, film embodies a "psychotropic derangement and chronological disturbance" (Virilio, 1989, pp. 27–28). Benjamin originally concluded that although mass communications dispensed aesthetic pleasures once limited to specific or elite audiences, rather than promote democratization, the modern spread of aesthetic awareness is a potentially subtle, yet effective propaganda tool that mobilizes the masses for warfare. "All efforts to render politics aesthetic culminate in one thing: war. War and only war can set a goal for mass movements on the largest scale while respecting the traditional property system." He later concludes: "[Mankind's] self-alienation has reached such a degree that it can experience its own destruction as an aesthetic pleasure of the first order. This is the situation of politics which Fascism is rendering aesthetic" (Benjamin, 2001, pp. 63–64).

Benjamin argued that the mass reproduction of images caused them to lose their "aura," their sense of place, origin, and authenticity. In particular film intrigued him because of its ability to make invisible its own process, giving the illusion that it is more real than reality itself: "The equipment-free aspect of reality here has become the height of artifice; the sight of immediate reality has become an orchid in the land of technology" (2001, p. 58).

This is especially relevant because of television's perceived ability to represent visual reality more accurately; TV viewers have already been trained by photography to believe in the verisimilitude of imagery. As Sontag notes, "Photographs furnish evidence . . ." (1977, p. 5) and "Reality has always been interpreted through the reports given by images . . ." (1977, p. 153). In *Camera Lucida* Barthes states, "By nature, the photograph . . . has something tautological about it: a pipe, here, is always and intractably a pipe" (1981, p. 5). Barthes is of course referring to Magritte's famous painting, "The Treachery of Images," in which he rendered a pipe and inscribed below it in French, "This is not a pipe." He was stating that it was an image of a pipe, and not the thing itself. It is almost unsettling how quickly we are deceived when photography is involved.

Although digital manipulation now invalidates photographic evidence, people still believe photos and images truthfully represent reality. As photo critic Fred Ritchin notes, "With the advent of electronic technology photography has the capability to become a vanity medium, providing us with a precisely controlled view packaged as perception. Those in power can take advantage of its enhanced capability to deceive and more expertly project their own worldview, camouflaging it as reporting" (Ritchin, 1999, p. 125).

Film, because of its language of moving images (later enhanced by sound), developed cues that construct stories in a way that it thinks on our behalf. A contemporary extension of this is how TV news networks develop theme music for covering different types of disasters or national emergencies. Hurricanes have heavy melodramatic string orchestrations cuing us to danger as a film would; marshal drum rolls and horns accompany war coverage. This cue system particularly incensed the Frankfurt School's Horkheimer and Adorno. Presaging the impact of TV, they state that in film, "No independent thinking must be expected from the audience: the product prescribes every reaction: not by its natural structure (which collapses under inspection), but by signals" (2001, p. 82). Citing Georges

Duhamel, Benjamin quotes: "'I can no longer think what I want to think. My thoughts have been replaced by moving images'" (Benjamin, 2001, p. 62).

Like Gitlin and Said, Stuart Hall (1982) demonstrates the power of hegemony to shape ideology within the culture industry but stresses the importance of television and its representational power to this end:

> From the viewpoint of the media, what was at issue was no longer specific message-injections, by A to B, to do this or that, but to a shaping of the whole ideological environment: a way of representing the order of things which endowed its limiting perspectives with that natural or divine inevitability which makes them appear universal, natural and coterminous with "reality" itself. This movement—towards the winning of a universal validity and legitimacy for accounts of the world which are partial and particular, and towards the grounding of these particular constructions in the taken-for-grantedness of the "real"—is indeed the characteristic and defining mechanism of "the ideological." (p. 65)

Hall adds that "Much of television's power to signify lay in its visual and documentary character—its inscription of itself as merely a 'window on the world,' showing things as they really are" (p. 75). Thus, the entire spectacle of television, what could be called the corporate dream world (especially as expressed by advertising), is accepted as totally natural. It signifies the order of things.

Under the Nazis, and as with the current White House regime, lies and propaganda are easier to distribute because the objects have been denatured through representation. The commodity is made aesthetically beautiful, but meaningless. This is further extrapolated when Guy Debord quotes Feuerbach: "But certainly for the present age, which prefers the sight to the thing signified, the copy to the original, representation to reality, the appearance to the essence . . . *illusion* only is sacred, *truth* profane" (Debord, 2004, p. 11). Consequently, when sexy images seduce the eye, the one sense organ that has the most direct nerve connections to the brain, the results are dangerously real: objectification makes violence in our culture more palatable. Civilian bombing victims become "collateral damage"; sexual violence is tolerable because women are simply body parts; war is just a video game.

Film, then and now, still promotes and glorifies war, despite the efforts of some directors to mock the sanitization of state-organized violence. *Apocalypse Now* (Coppola, 1979) best exemplifies this critique when Robert Duval declares, "I love the smell of napalm" while trying to orchestrate a surfing run in the midst of combat. However, even the best anti-war films embody a deep-seeded view (foreshadowed by the Futurists) that war is beautiful, converting mechanical carnage into colorful spectacles to be admired and consumed by mass audiences. Anthony Swofford, who fought in the first Gulf War, chronicled his experiences in a memoir, *Jarhead*, where he describes the drunken ritual of watching war movies in boot camp to boost morale:

> There is talk that many films are antiwar, that the message is war is inhumane and look what happens when you train young American men to fight and kill, they turn their fighting and killing everywhere, they ignore their targets and desecrate the entire country, shooting fully automatic, forgetting they were trained to aim. But actually, Vietnam War films are all pro-war, no matter

what the supposed message, what Kubrick or Coppola or Stone intended . . . [soldiers] watch the same films and are excited by them, because the magic brutality of the films celebrate the terrible and despicable beauty of their fighting skills. Fight, rape, war, pillage, burn. Filmic images of death and carnage are pornography for the military man; with film you are stroking his cock, tickling his balls with the pink feather of history, getting him ready for his real first fuck. It doesn't matter how many Mr. and Mrs. Johnsons are antiwar—the actual killers who know how to use the weapons are not. (2003, pp. 6–7)

To some extent Kubrick's *A Clockwork Orange* (1971) also addresses the aesthetic pleasure of violence through its own choreography of brutality, and the state's efforts to condemn the social products of its own engineering. But even when the violent destruction of society is fantasized in film, it's made sexy. The problem, as illustrated by Chris Hedges, a former war correspondent who penned the anti-war tome, *War Is a Force That Gives us Meaning* (2003), is how we *see* war:

The task of carrying out violence, of killing, leads to perversion. The seductiveness of violence, the fascination with the grotesque—the Bible calls it "the lust of the eye"—the god-like empowerment over other human lives and the drug of war combine, like the ecstasy of erotic love, to let our senses command our bodies . . . The dead . . . become pieces of performance art. . . . There are few anti-war movies or novels that successfully portray war, for amidst the horrors is also the seduction of the machine of war, all-powerful, all-absorbing." (p. 89)

Not surprisingly we are inundated with glorified military toys and technology during the news, always pitted against hapless, rag-tag militaries (Grenada, Panama, Sarajevo, Gulf War I and II) as self-evident proof of our technological and hence civilized mastery of the world. The parody film, *Team America* (Aversano, & Garefino, & Parker, 2004), effectively critiques this tableau in a scene in which the terrorist air force buzzes like smoggy motorcycles patched together with tape and wire as they are blasted apart by Team America's sleek, shiny aircraft that border on the erotic.

Hedges delineates between sensory versus mythic reality, the latter being the primary version of war depicted by the press. Even though "[m]ost of those who are thrust into combat soon find it impossible to maintain the mythic perceptions of war"—the "organized murder" of warfare—"The chief institutions that disseminate the myth are the press and the state." (Hedges, 2003, pp. 21–22). Like the communities of interpretation Said delineates, the media become the primary mythmakers. "Peddling the myth of heroism is essential, maybe even more so now, to entice soldiers into war," Hedges writes. "Men in modern warfare are in service to technology. Many combat veterans never actually see the people they are firing at nor those firing at them, and this is true even in low-intensity insurgencies" (p. 86).

Virilio (1989) points out the disappointment experienced by D. W. Griffiths when he was sent to the European trenches by the war department to make a propaganda film in service of the Allies' World War I effort. His desire for epic battle scenes was denied by the lack of the battlefield's visible space, which was wiped out by the advent of the trench system. Hollywood has done much to redress this, with increasingly bloody battlefield spectacles for consumption. The heroic is achieved through productions like *Green Berets* (Wayne, M., & Kellogg, & Wayne, J., 1968) and *Black Hawk Down* (Lustig, Stenson, & West, &

Scott, 2001). Invoking the last great "just war," World War II, *Band of Brothers* (Spielberg, & Frankel, & Hanks, 2001) and *Saving Private Ryan* (Spielberg, 1998) combined with books like anchorman Tom Brokaw's (2004), *The Greatest Generation*, and Marine ads depicting veterans and images from the "Great War," resurrect sentimental feelings to be mined for the current environment of so-called "preventative warfare." When the Afghanistan operation began, the "Army of One" ad campaign released commercials that advertised no recruitment pitch other than a feel good message about the "brotherhood" of the armed forces. These are mini spectacles distributed like information packets across the networks, providing a cumulative symbol set for reinterpretation and management.

The current use of embedded reporters is likely a reaction to the clinical images supplied during Gulf War I when pool reporters were limited to military feeds of videogame-like footage of missile strikes. The military acknowledged the mass media's hunger for more action shots. The embedding of reporters with troops was an absolute stroke of genius because journalists could supply a hungry public a limited set of controlled images of destruction and war it desires, yet the military can maintain control of interpretation centers. Like the forces it marshals and the weapons it unleashes, the Pentagon deploys media with equal vigor. As has been argued repeatedly by the Left, if voters saw the true carnage of war, they would not support it.

Not all reporters on the ground are complicit and some criticize the way war and violence are now depicted. In a PBS documentary, *Reporting America at War* (Ives, 2003), CNN correspondent Christiane Amanpour complains that the 24/7 news cycle hungers for a continual stream of war images, but they are presented with little context, except to state that war is happening and it is on TV. Television is then, simply, self-referential with its ambient images of catastrophe (punctuated with sanitizing images of advertising and car commercials), providing mindless images that can be easily manipulated by information managers. Photography critic Fred Ritchin concurs: "Although war has always been considered an example of what Wilson Hicks, *Life* magazine's early executive and picture editor, called 'self-contained and well-paced drama' whose 'crises come to put up handy packages,' one difference today is that newspapers and magazines publish a continuous stream of generally interchangeable images of violence's apex, milking it for its realism without an exploration of its unfolding or underlying causes" (1999, p. 27). Of course doing so, might require a systemic analysis of the economic system's operating paradigm, the kind of thing we have already established will not take place in a hegemonic media environment. Somehow all this has to fit within an advertising, commercial safe environment.

It is not just the glorification of violence, but disaster and destruction as catharsis that continually feeds the public imagination. Mike Davis, in *Ecology of Fear: Los Angeles and the Imagination of Disaster* (1998), spends a chapter exploring how the City of Angels has repeatedly been destroyed in literature and film. Although he jokes that seeing the film capital's demise may represent a triumph for civilization, what is really at stake is that "[t]he decay of the city's old glamour has been inverted by the entertainment industry into a new glamour of decay" (p. 279). In addition, as Baudrillard (2001) notes in a *La Monde* editorial after 9/11, we have a deep psychological appetite for destructive images: "Numerous

disaster movies are witness to this phantasm [of self-destruction], which they obviously exorcise through images, and submerge under special effects. But the universal attraction these movies exert, as pornography does, shows how (this phantasm's) realization is always close at hand—the impulse to deny any system being all the stronger if such system is close to perfection or absolute supremacy" (paragraph 9).

This can be extended to a grander scale when we see that film constantly reinforces a cycle of waste and consumption through the production of mass spectacles. We are unconsciously trained to view the elaborate cinematic meaning system justify the tremendous waste of human and material resources required for entertainment. Virilio illustrates that "filmmakers served up the technological effects to the public as a novel spectacle, a continuation of the war's destruction of form" (1989, p. 20). Never mind the environmental impact of big budget filmmaking, smash-up car chases, incinerated airplanes, gasoline fires, and ruined machinery. Exploding buildings are so normal, when we see real-life tragedy, as was the case during 9/11, the typical comment is, "It looks just like a movie."

Medium and the Message

"The spectacle of terrorism imposes the terrorism of the spectacle."

Baudrillard (2001, paragraph 46)

If the Bush/Chaney administration traces the mess in Iraq to 9/11 (never mind the possibility that the CIA overthrow of Iranian president Mossadeq in 1953 may have set in motion the string of tragic events that have brought us to the present moment), then we are at the most common trope of all war justifications: "they" started it. As the most skilled propagandist knows, claiming national victimization is one of the first memes to be distributed to the masses. By now most have heard Hitler's Reich Marshall Hermann Göring outline this simple propaganda strategy:

> Naturally, the common people don't want war, but after all it is the leaders of the country to determine policy and it is always a simple matter to drag people along whether it is a democracy or a fascist dictatorship. Voice or no voice, the people can always be brought to the bidding of the leaders. This is easy, all you have to do is tell them they are being attacked and denounce the pacifists for lack of patriotism, and exposing the country to danger. It works the same in every country. (Quoted in Gilbert (1947), p. 278).

No doubt, post 9/11 the U.S. media were quick to toe the administration line, eager to accept whatever justification for war that was distributed and would comply with whatever press management system the Pentagon wanted to establish in Afghanistan and Iraq. When Hedges (2003) observes in the service of war, "The press wanted to be used," it is the consequence of the hegemonic interdependence of state and media. Without this interdependence, it is unlikely the Pentagon would embed reporters with troops in the Gulf War sequel: Iraq Invasion II.

From the war-makers' perspective, so far embedding has been a huge success because it satiates the need for information, but symbols are managed for the community of interpretation that distributes them. For example, the now well-known picture by an embedded *LA Times* photojournalist of the grizzled soldier with the cigarette dangling from his mouth became an iconic image from Fallujah that instantly conjures up all kinds archetypes, from W. Eugene Smith's World War II photos to the Marlboro Man.

As a visual meme that spread very quickly across the mediascape, it reinvigorated a sense of male virility that may have been lacking in war coverage. Accordingly, Sontag remarks, "In the current political mood, the friendliest to the military in decades, the pictures of wretched G.I.s that once seemed subversive of militarism and imperialism may seem inspirational. Their revised subject: ordinary American young men doing their unpleasant, ennobling duty" (2002, p. 88). In another case, the *New York Times* accompanied a riverboat patrol that invoked *Apocalypse Now* which at first may seem contrary to Pentagon image directors, but the film does not recall Vietnam per se (which would be a negative association), but an industrial Conrad's *Heart of Darkness*, conjuring hallucinatory violence and spectacle that is familiar to media savvy audiences, and therefore palatable.

Because we recognize it, the war becomes more comfortable, easier to digest. Even the soldiers quoted in the *New York Times* article likened their river patrols to *Apocalypse Now* and a "Vietnam Disneyland," curious language devoid of preachy rhetoric concerning democracy and freedom. War is a theme park experience, an "intensity," as Jameson (1992) calls emotions in the postmodern era. Demonstrating how short memory can be in the service of war, Jacques Ellul (1973) writes in *Propaganda: The Formation of Men's Attitudes*,

> One thought drives away another; old facts are chased by new ones. Under these conditions there can be no thought. And, in fact, modern man does not think about current problems; he feels them. He reacts, but he does not understand them any more than he takes responsibility for them. He is even less capable of spotting any inconsistency between successive facts; man's capacity to forget is unlimited. This is one of the most important and useful points for the propagandists, who can always be sure that a particular propaganda theme, statement, or event will be forgotten within a few weeks. (pp. 46–47)

In terms of the kinds of photographic images we see coming from Iraq, there is a much larger body of reference images that echoes through our "museum without walls," i.e., the collective unconsciousness of media history and cinema possessed by photojournalists, information managers, and media consumers. Even combatants ham it up for cameras (e.g., the Abu Ghraib photos have a certain photographic self-consciousness to them). That photos have a cinematic quality is only natural to a professional class that is shaped by an aestheticized visual vocabulary; photos are meant to have drama, appeal, revealing "taste," style. Ritchin notes the power that editors and information managers have to stage and manipulate imagery:

> Editors of contemporary publications, as well as politicians orchestrating 'photo opportunities,' understand more than ever before how to borrow from the photograph's perceived authority while at the same time manipulating imagery in the service of their own needs. Photographers are too

often willing accomplices to these strategies. This has helped create a climate in which photojournalists, the timely reporting of people and events, has been to a large extent subsumed within what is now often called 'editorial photography.' In this approach the illustration of preexisting ideas is emphasized, a task for which electronic retouching techniques are particularly well suited. (1999, p. 26)

Thus we see silhouettes at sunset, portraits at the golden hour, low-angle shots that give a sense of power, and views that are almost always from behind a soldier who is in a position behind a gun or at the control of some technological apparatus like a player in a videogame world. Photojournalists, however, need to avoid being too "arty," as Sontag points out, "Photographs tend to transform, whatever their subject; and as an image something may be beautiful—or terrifying, or unbearable, or quite bearable—as it is not in real life. . . . Transforming is what art does, but photography that bears witness to the calamitous and the reprehensible is much criticized if it seems 'aesthetic'; that is, too much like art" (2002, p. 94).

Taking the cue of film theorists like Mulvay, we can say with some confidence that in these photos often these soldiers embody the gaze of cultural and technological superiority. Photos and videos of soldiers fighting from bunkers, tanks and Humvees, are contrasted with the ruins of the "other," whom we often see in puddles of blood on the street or blindfolded in humiliating positions of control. By contrast, it is practically taboo to show a dead U.S. soldier. When we do see insurgents, often they don ski masks and black outfits, perfectly fitting the classic Western narrative of good versus evil. One also sees a disproportionate emphasis on images of white soldiers, who are contrasted with dark Arabs. Through the normalized biases of our society's ideological position, we are meant to mimetically experience victory, heroism, and domination through war. We support war because it vicariously gives us a sense of power when in our own lives we feel it diminishing on a daily basis.

Unanticipated are the images that have undermined the Pentagon's media management strategy. Not surprisingly, they come from leaked or unofficial photos such as the Abu Ghraib pictures, coffin images taken by subcontractors, or the portraits of dead soldiers broadcast on *Nightline*. That dissenting images do appear result from elite opinion splits and the undeniable reality that the war is going badly. Moreover, competing news agencies, such as BBC or Al Jazeera can contradict the war. However, the extent to which these contradictions are spun depends a lot on the compliant domestic media and their punditry. The Pentagon, or any media managers for that matter, can only do so much to cover up the reality of the ground war. Even the Nazis could not disguise the growing losses on the battlefield because anyone with a map and pins could see that each "heroic" battle was getting closer and closer to Berlin or Munich. Indeed, a cursory look at the 2004-year in war pictures from *Newsweek's* Website revealed a shift from optimistic to pessimistic images, from those of bloodless victory to gory combat.

With the banning of Al Jazeera from Iraq and the increasing danger of the ground situation (a high number of journalist casualties), embedded foreign and domestic journalists rely on the military to keep them safe, and hence they are forced to report from enclaves so that our perspective remains that of a typical protagonist in a videogame: the

Table 1: Comparing Film and TV Aesthetics (not absolute—hybrids exist)

Film (Modernist form)	Television (Postmodernist form)
Fragmentation	Streaming
Montage	Simultaneous
Projected	Monitored
Thinking	Reacting
Audience	Participant
Studio	Conglomeration
Machine generated art	Computer generated art
Photographic	Video, digital
Re-presentation	Simulacra
Centralized distribution	Decentralized distribution
Physical	Virtual
Orchestrated	Spontaneous
Continuity	Repetition
Finite	Ephemeral
Singular	Multiple
Fixed	Defused
Time-based	Space-based
Approximate	Distant
Location	Network
Being in Space	Being Space (emplacement)
Nature (?)	Denatures
Text	Hypertext
Novel	Poetic
Genre	Format
Staged event	Event driven
Reproduction	Transmission
Watching	Scanning
"That has been" (moving)	"Presentness"
Narrative	Metanarrative
Absent Spectator	Ambivalent spectator
Stable	Destabilized
Finality	Continuous
Cartesian	Heterotopic
Opaque	Transparent
Absolute truth	Flexible truth
Direct	Ambient
Authorship	Anonymous
Resolution	Endless
Hot (high resolution, low interactivity)	Cool (low resolution, high interactivity)
Utopian	Catastrophic
Illusion	Magic7

enemy is illusive, invisible, and "othered" as "foreign terrorists," "insurgents," "Islamic extremists," "Jihadists," or "enemy combatants," but rarely as people. A lack of images of day-to-day life in combat zones of civilians can also lead to a kind of symbolic annihilation of the populace. From the get-go the Pentagon frames our perspective of the enemy. Inevitably, the soldiers as protectors also become very close to the embedded journalist. Moreover, the Pentagon can manage the news through the placement of reporters (often at a distance, and hence we only see footage of smoke and ruins at the end of battle) and through censorship. For example, operations that prohibit journalists such as the U.S. military occupying a Fallujah hospital, accomplish two things: It removes one source of casualty reports for journalists, and because reporters are excluded from the mission, the event itself is not news.

Reporters who break rules or offend their military overlords (on the field or stateside) through contradictory reporting risk losing access. As Hedges notes, "It is hard, maybe impossible, to fight a war if the cause is viewed as bankrupt. The sanctity of the cause is crucial to the war effort. The state spends tremendous time protecting, explaining, and promoting the cause. And some of the most important cheerleaders of the war are the reporters. . . . The state and institutions of state become, for many, the center of worship in wartime. To expose the holes in the myth is to court excommunication" (2003, pp. 146–147). Thus we hear Dan Rather immediately proclaim during the initial marshalling of forces that if the president tells him to march in a time of war, he will be the first to line up (and when he doesn't, he is fired).

"The Terrorist Auteur"

Of course there is another equation in the image formula: terrorists and the Iraqi opposition. They too have learned to play the media and are capable of their own kind of sophisticated media management. Starting with 9/11, Baudrillard (2001) notes in *Le Monde*, "the new rules of the game are no longer ours." He adds:

> Among the other weapons of the system which they have co-opted against it, terrorists have exploited the real time of images, their instantaneous global diffusion. They have appropriated it in the same way as they have appropriated financial speculation, electronic information or air traffic. The role of images is highly ambiguous. For they capture the event (take it as hostage) at the same time as they glorify it. They can be infinitely multiplied, and at the same time act as a diversion and a neutralization (as happened for the events of May 68). One always forgets that when one speaks of the "danger" of the media. The image consumes the event, that is, it absorbs the latter and gives it back as consumer goods. Certainly the image gives to the event an unprecedented impact, but as an image-event. (paragraph 41)

Hedges (2003) illustrates that, "The dramatic explosions, the fireballs, the victims plummeting to their deaths, the collapse of the towers in Manhattan, were straight out of Hollywood. Where else, but from the industrialized world, did the suicide hijackers learn that huge explosions and death above a city skyline are peculiar and effective forms of communication? They have mastered the language. They understand that the use of dispropor-

tionate violence against innocents is a way to make a statement. We leave the same calling cards" (p. 8). In many ways terrorists are monsters of our own creation because, as Gitlin points out, "mass media produce fields of definition and associating, symbols and rhetoric, through which ideology becomes manifest and concrete" (1980, p. 2) and thus define the opposition.

We can think of the terrorist as evolving into a kind of auteur, as Michael Ignatief did in a column for the *New York Times Magazine*. "Terrorists have been quick to understand that the camera has the power to frame a single atrocity and turn it into an image that sends shivers down the spine of an entire planet. This gives them a vital new weapon," he writes. What is most chilling is "In Iraq, imagery has replaced argument; indeed, atrocity footage has become its own argument. One horrendous picture seems not just to follow the other but also to justify it. . . . This is terrorism pornography, and it acts like pornography: at first making audiences feel curious and aroused, despite themselves, then ashamed, possibly degraded and, finally, perhaps indifferent" (2004, paragraph 7). This dynamic applies to three audiences: local propaganda, the media in need of sensationalist material, and a voyeuristic audience consuming media images of war. This environment conforms to what Sontag deems as the greatest danger of an image culture: "The problem is not that people remember through photography but that they remember only the photographs" (2002, p. 94).

Conclusion

Contemporary politics is a magical combination of image (Bush landing on an aircraft carrier) and language ("Mission Accomplished"). However, reality on the ground potentially catches up to the one on the screen, such as the images from Abu Ghraib. Unfortunately, in general the reverse trend is true: newer meaning systems based on images prepare us to believe in nothing because nothing is real anymore. All is superficial. The saddest and most cynical conclusion put forward by Horkheimer and Adorno: "The triumph of advertising [and hence propaganda] in the culture industry is that consumers feel compelled to buy and use its products even though they see through them" (2001, p. 101). We still march to war, despite all the known lies and justifications such as the missing weapons of mass destruction (WMDs) in Iraq. Recall that a majority of Americans still believe that WMDs were found in Iraq despite evidence to the contrary. This false belief by more than half of the population represents the triumph of the ultimate persuasion technique: the Big Lie. Simply put, if the most outrageous claims are repeated as framed sound bites or printed phrases over and over again, like a mnemonic device such as a soda jingle, they form their own neuro-pathways in a person's brain. Keeping in mind advertisers' best kept secret is that one can put a picture in someone's head but one cannot take it out, image managers always place people like Bush in photographic settings that have phrases ("Mission Accomplished") and/or graphics with symbolic meaning (such as a photo mural of FDR during World War II).

If everything we see is subject to waste and destruction, so too are the images that glorify them. By trivializing "freedom" and "democracy" we cease to have mobilizing principles to unify a population, as was the case post-9/11. The American flag represented a

gathering of tribes for a brief moment, but its desecration through the disregard of fundamental constitutional principles and illegal warfare teaches the deadly lesson that morals are useless obstacles in pursuit of ultimate power. One hopes that unlike the German people who found themselves disoriented by the orgiastic hallucination of war and film, we somehow snap out of our collective shock and awe. In the end, like a daily dose of immune boosters, the simplest and best defense against propaganda is critical thinking and education. Hopefully we have not lost that battle either.

Postscript

This chapter was originally written at the height of President George Bush's popularity and at a time when the U.S. invasion and Iraq occupation still enjoyed popular support. By early 2007, the opposite was true. What happened? As the essay points out, there is no propaganda on Earth that can cover up a war going badly. Propaganda works best during the build up of war, and when war is executed successfully in a climate of fear and paranoia. Would the U.S. public have the same critical attitude about the war in Iraq if American soldiers were not killed on a daily basis and if the military could control the situation on the ground? Consider the legacy of Granada and Panama. Who among the general populace opposes those actions?

When Sidney Kracauer (1945) was commissioned by the U.S. government to survey Nazi newsreels he concluded that one characteristic that separated fascist and democratic propaganda was a complete disregard for truth. Democracies, he argued, have to tell a "good story" and "refer to the truth even if they defy it." In Germany, on the other hand, "where all powers are actually monopolized by the Nazi rulers and their allies in the sphere of great business, truth has lost any authority of its own; for the sole concern is to maintain and extend their monopoly through appropriate propaganda that unhesitatingly confuses truth and untruth to these ends. Thus truth is put in the same position as untruth: it becomes a pure means, it is no longer recognized as truth (p. 4)."

Anthropologist and psychologist Gregory Bateson (2000) argued that deceptions behind the negotiating of the treaty of Versailles set in motion World War II. His point is that communications are cybernetic: they exist in a feedback system, and lying always comes back to haunt the liar (pp. 477–85). There is no running from hypocrisy. After 9/11 the U.S. government had an opportunity to tell a good story, but instead used fear to justify a war with dubious intentions. Over time propaganda cannot hide murder, torture, or illegality, especially when a global society is increasingly transparent. After all, who could have anticipated that one could view Al Jazeera at a falafel stand in Brooklyn, as was the case recently when I stopped in to get a bite to eat. This shatters hierarchal notions of the flow of communications and ideas.

Also, one thing we often forget when discussing propaganda is that it is not simply a situation of the producer inserting information into innocent subjects. Not only do the receivers of information have agency and an ability to contextualize and form their own opinions, but the producers are also susceptible to their own deceptions. Kracauer's analy-

sis should serve as a cautionary tale that spin for power's sake has a self-destructive logic: nice (or scary) metaphors are no substitute for competence or morality. You can't tell a good story if it's based on fallacy and fantasy; that only happens in Hollywood. And when it comes to war, no special effects can solve political or social conflict. It requires human intelligence, negotiation, and a commitment to peace. A social structure predicated on war generates perpetual war. It is poisonous. We as a culture should realize that in a global feedback system that inserting more violence and death into the circuit of civilization is ultimately nihilistic. I have a sense that this is not the definitive path of humanity, and that in the end we'll reject once and for all the deceptions and lies that have driven us towards the brink of oblivion. It remains my belief that education based on the principle of self-empowerment, sustainability and nonviolence is a critical anecdote to the situation that confronts us at this historical juncture. Contrary to the Neocon axiom that Empire defines reality, I believe wholeheartedly that it is humans that shape the world, and in the great drama of known history, they have always rejected empires and petty tyrants regardless of the technology and communications systems they deploy.

REFERENCES

Text References

Barthes, R. (1981). *Camera lucida*. New York: Hill and Wang.

Bateson, G. (2000). *Steps to an ecology of mind*. Chicago: University of Chicago Press.

Baudrillard, J. (2001, November 2). The spirit of terrorism. *Le Monde*. Trans. Rachel Bloul. Retrieved Jan. 16, 2007, from http://www.nettime.org/Lists-Archives/nettime-1 -0111/msg00083.html.

Benjamin, Walter (2001). The work of art in the age of mechanical reproduction. In M. G. Durham & D. M. Kellner (Eds.), *Media and culture studies: Key works* (pp. 48–70). Malden: Blackwell. (Original work published Benjamin, W. (1969) *Illuminations*. New York: Schocken Books, pp. 217–51)

Brokaw, T. (2004). *The greatest generation*. New York: Random House.

Chomsky, N. and Herman, S. (2002) *Manufacturingconsent: The political economy of the mass media*. New York: Pantheon.

Davis, M. (1998). *Ecology of fear: Los Angeles and the imagination of disaster*. New York: Vintage.

Debord, G. (2004). *The society of the spectacle*. New York: Zone Books.

Ellul, J. (1973). *Propaganda: The formation of men's attitudes*. New York: Vintage.

Gilbert, G.M. (1947). *Nuremberg diary*. New York: New American Library.

Gitlin, T. (1980). *The whole world is watching: Mass media in the making and unmaking of the New Left*. Berkeley: University of California Press.

Gramsci, A. (1971) *Selections from the prison notebooks*. Ed. and trans. Quinton Hoarse and Geoffrey Nowell Smith. New York: International.

Hall, S. (1982). The rediscovery of "ideology": Return of the repressed in media studies. In M. Gurevitch, T. Bennett, J. Curran, & J. Woollcott (Eds.), *Culture, society and the media* (pp. 56–99). New York: Methuen.

Hedges, C. (2003). *War is a force that gives us meaning*. New York: Anchor Books.

Horkheimer, M., & Adorno, T. (2001). The culture industry: Enlightenment as mass deception. In M. G. Durham & D. M. Kellner (Eds.), *Media and culture studies: Key works* (pp. 71–101). Malden: Blackwell.

Horkheimer, M, & Adorno, T. (1995). *The Dialectic of Enlightenment.* New York: Continuum, pp. 120–67.

Ignatief, M. (2004, November 14). "The terrorist as auteur." *New York Times Magazine.* Retrieved Jan. 16, 2007, from http://www.nytimes.com/2004/11/14/movies/14TERROR.html?pagewanted=1&ei=5088&en=1ae12e874929aa54&ex=1258174800&partner=rssnyt.

Jameson, J. (1992). *Postmodernism, or, the cultural logic of late capitalism.* Durham: Duke University Press.

Kracauer, S. (1945) The conquest of Europe on the screen: The Nazi newsreel 1939–1940. The Library of Congress: Washington, DC.

Mills, C. W. (1963). *The cultural apparatus. Power, politics and people.* Oxford: Oxford University Press.

Postman, N. (1985). *Amusing ourselves to death.* New York: Viking Penguin.

Ritchin, F. (1999). *In our own image: The coming revolution of photography.* New York: Aperture.

Said, E. (1997). *Covering Islam.* New York: Vintage Books.

Snow, N. (2003). *Information war.* New York: Seven Stories Press.

Sontag, S. (1977). *On photography.* New York: Picador USA.

Sontag, S. (2002, December 9). Looking at war: Photography's view of devastation and death. *New Yorker,* pp. 82–98.

Swofford, A. (2003). *Jarhead.* New York: Scribner.

Virilio, P. (1989). *War and cinema.* New York: Verso.

Williams, R. (1973). Base and superstructure in Marxist cultural theory. *New Left Review,* No. 82, pp. 3–16.

Zinn, H. (2003) *People's history of the United States: 1492–present.* New York: HarperCollins.

Filmography

Aversano, S., & Garefino, A. (Executive Producers), & Parker, T. (Director). (2004). *Team America.* United States: Paramount Pictures.

Coppola, F. F. (Producer & Director). (1979) *Apocalypse Now.* United States: United Artists.

Ives, St. (Co-Producer and Director). (2003). *Reporting America at War.* United States: Insignia Films

Kramer, S., & Langner, P. (Producers), & Kramer, S. (Director). (1961). *Judgment at Nuremberg.* United States: United Artists.

Kubrick, S. (Producer & Director). (1971). *A clockwork orange.* United States: Warner Bros.

Lustig, B., Stenson, M., & West, S. (Executive Producers), & Scott, R. (Director). (2001). *Black hawk down.* United States: Columbia Pictures.

Riefenstahl, L. (Director). (1935). *Triumph of the will.* Germany: Leni Riefenstahl Produktion.

Spielberg, S. (Producer & Director). (1998). *Saving Private Ryan.* United States: Paramount.

Spielberg, S. (Executive Producer), & Frankel, D., & Hanks, T. (Directors). (2001). *Band of Brothers.* United States: HBO.

Wayne, M. (Producer), & Kellogg, R., & Wayne, J. (Directors). (1968). *Green berets.* United States: Batjac Productions.

Pictorial Clashes on the Medial Body of Violence

Abu Ghraib, Nick Berg, and John Paul II

Birgit Richard

During the past few decades, the virtual history of the media image has been determined by technological, visual caesuras that demonstrate a change in the social consideration of pictures. The powerful TV coverage of the attack on the World Trade Center on September 11, 2001, initiated a new debate on the meaning of media images. The photographs of torture in Abu Ghraib and the execution video of the American hostage Nick Berg in 2004 brought a new dimension to what the media labelled "the war of images," in which two forms of pictures—the photographs of U.S. soldiers and the video of hostage takers—are fighting a duel. These depictions show that any "key image" in the mass media is per se a political image; it has an influence on adjacent images by producing new images and disguising former ones.

In reference to the parallel term *schlagbild* constructed by Aby Warburg, key images are single images that are equipped with a strong aesthetic appeal. The expansion of these images is defined by their epidemic structure that leads to an "infection" and to the genesis of new image clusters or neighborhoods. Viewing these key images strengthens the viewers' consciousness about their position as situated viewers (see Rogoff, 1999), who are subject to a politics of visibility embedded in power discourses. One aim of the following analysis of

the so-called "shifting image," an image that is in permanent movement and constantly positions itself into new relations to other images, is to focus on and hence decode the politics of visibility. In a quasi-archaeological process concealed images will be exposed, and they can then be used to construct multiple perspectives. The few official image perspectives that have been chosen were particularly spread through the Internet. Here counter-images develop new forms of an "active spectatorship" (Rogoff, 1999) and an autonomous "Imagineering" (Holert, 2000). At the same time, the high number of disordered images in the Internet generates a hyper-visibility, which cannot be handled without the criteria of order and selection: Images are buried by an information overload suffocating the examination of other images. Although anything is shown on them, these very obtrusive pictures are marked by an impermeable surface that does not present a model for explanation. Opacity is actually one of the basic paradigms in contemporary visual culture (Rogoff, 1999).

New images constantly emerge and direct the debate because of their new technological qualities. A different medial structure implies different forms of images, even if the visible content may remain constant. Therefore, it cannot be possible that images gain an effect throughout or beyond media and that the media can neither strengthen nor weaken images (Bredekamp, 2005). This is to say, an image is not an autonomous instance or an appearance for itself but rather it needs a medium as carrier. So the meaning and condition of pictures are determined by their particular medial structure (see, e.g., the necessary distinction between analogous and numeric image). More specifically, whereas the greenish night recordings of the infrared-camera from the first Iraq war have been discussed in terms of "de-realization" and de-materialization caused by digital media, the next shift of the image is an attempt that leads to a further convergence with the construct of a true, instantaneous "realist-authentic" image. During the second Iraq war the debate first circulated around the images of embedded journalism, namely the integration of professional photo- and video-shooters placed in combat units. However, these photo-shooting professionals, who have a military training, were at the first front of war victims: Documenting in real time how the blood of their colleagues on the camera lens generates a new degree of live image and thus of authenticity. The images of Guantanamo Bay at first find less attention. However, like key images in the waiting zone, they form an important background screen to the following "war of images." Later the images of Abu Ghraib indicate a further shift toward the more spontaneous amateur picture: This process cannot be controlled by military or politics but happens apparently unarranged in the space of the Internet, which is multi-functional and in a permanent process of transformation with the most diverse picture formats.

The movement of images between various picture systems makes it necessary to expand the terminological definition of image and to concentrate on the consideration of image relations within connected medial systems. These picture systems are linked by a non-linear, non-hierarchical structure. There is no clear genealogy of medial picture systems, which may culminate in an all-encompassing digitalism and define the algorithm as the smallest unit (Paech, 1994).

The relationship of single pictures in the diverse medial systems is marked by discontinuities and breaks and not by continuity in the transference from one picture system to

another. The process of an accumulation of pictures and their shifts between medial formats can be well demonstrated with the example of the World Trade Center image complex (Richard, 2003). Here for the first time a content-cultural and a media-structural shift is visible that is mainly based on the Internet. At this point, the Internet turns from a technical image store to a well-organized archive, from which various cultures—partly on the basis of similar visual material—generate their meanings. For this reason, any single image is a "shifting image," for it is never in the same place but constantly set into new relations to other images. It is also called a "shifting image" because it moves between various medial picture systems, such as television, film, print, and the Internet.

With its appearance the key image mentioned above sets neighbored images in motion and even conceals unwanted images as, e.g., civilians who died in the World Trade Centre attacks (Richard, 2003). Any visible and invisible image in the neighborhood of key images has to reposition itself in structure. Basically, regarding technical images, photography, or isolated stills from a sequence, there are no "great still images" (Bolz & Rüffer, 1996).

However, the single image has to be analyzed in its singular appearance, before—in the next step—it can be seen in relation to former, already seen images and the focus set on the constitution of new picture clusters. The term *cluster* implies the technological-medial order of images, while picture neighborhood focuses on the relation of formed images.

The successful search for potential neighbored images allows the reconstruction of the image circle, which also takes account of the genesis of "social interim images" such as immaterial imaginary images, phantasms, and imaginations. Images have to be considered principally as compounded images that have no stable or fixed order (Hoffman as cited in Ernst, 2005).

In the following pages the terms *shifting image* and *key image* will be examined using specific pictures, namely the World Trade Center image complex and image neighborhoods from a period during the Iraq War together with the elements Abu Ghraib, and the execution video of hostage Nick Berg. As is evident from the execution video of Nick Berg, terrorists have been using video technology and the Internet for their means. Bin Laden has repeatedly released video messages to the people who would watch them. The images of the dying Pope John Paul II, a variant of violent medial death image, will be examined in this context. Therefore the following analysis will investigate, if and how the medial shift influences the meaning and quality of these images.

Image Producing Terrorism

Beginning with a look at the pictures of the World Trade Center image complex, the picture will be analyzed at face value without the implication of it concealing a "true" message about so-called reality (see Mitchell, 2004a). This approach is particularly important in the case of the innumerable torture photographs from the prison in Abu Ghraib, which—like any image—refer to the presentational patterns of former medial image systems.

The medial event of September 11 (re-)produces familiar images that have already been seen considering attacks on the United States have always been subject of U.S. fantasies

(Zizek, 2002). In fact, contemporary cinema, and in particular the genre of disaster movies as a machine version of the collective subconscious (see Richard, 2003), has visualized the most diverse fantasy attacks in the form of images, anxieties, or nightmares in western society ("celluloid hallucinations") (Weibel, 2002). The screen appearance of these events breaks with the illusionary idea of western society that the real horror in the world would not be part of our own social reality. The image transgresses and shatters reality or at least our symbolic system that defines what reality actually is (Zizek, 2002).

So what do these images want? The image wants something from the viewer, it wants us, Mitchell (1999) argues. Lyotard's (1989) dialectic argumentation leads in a quite similar direction: The message (the image) is the messenger, "saying": *Here I am*, which means, *I am yours* or *be mine*.

The medially pre-structured view problematizes the recognition of the degree in realism, particularly the distinction between the different levels of the images' virtuality (i.e., film, video, live, still images). American President Bush presents himself as a warrior in *Top Gun* poses from the Hollywood movie. Another indistinctiveness reveals itself in the video of the beheading of Nick Berg. Here, too, movie reception forms a basis that directs the treatment of this disastrous event. Video editions that are sold under the counter with documents of archaic rituals, like "Faces of Death" come to mind. Here we see how any image is a compounded hybrid, consisting of layers from pre-images.

Since September 11, 2001, the battle around the occupation of medial image territories has reached a new quality. Before that date, the terrorists' visual declarations of war were aimed at the primary medium television and its moving images, whereas the more locally concentrated terrorism of the 1970s basically produced "still" images. Terrorism in the 1970s, defined by a clear aim (to liberate a country or to secure the release of imprisoned like-minded people by menace) has found its medial equivalence in photography. However, terrorism in the early twenty-first century tends to occupy the television screen as conquest territory. The occupation reached its peak with the attack on September 11, 2001. The video of the execution of Nick Berg, however, announces a further step. Now the target is the individual screen of the worldwide connected computer user. By generating a creeping, incontrollable expansion of the moving images and stills from amateur cameras, the one-dimensional (Flusser, 1990) TV screen becomes secondary.

The new dimension of the September 11, 2001, terror is the recreation of a filmic horror image and a carefully designed aesthetic of shock and dismay. With the explosion of images after September 11, terrorists have entered a multi-level system of visibility with an ecstatic hyper-visibility, using the diverse medial channels such as the Internet and television and its various sorts of images simultaneously. The Americans, however, choose a more old-fashioned invisibility for their actions (Baghdad, Kabul). Withholding, reducing, or repeating images are the preferred strategies—an obsolete and inferior concept of a politics of visibility. At the same time, but in a futile attempt, they make use of visual high-tech surveillance in order to control their enemies. Thereby visibility diminishes within the field of visibility (Weibel, 2002).

In the beginning, the Americans have nothing in response to the highly symbolic

image of the collapse of the World Trade Center, which is now deeply burned into the collective memory as a sign of the breakdown of the western world. This form of suicide terrorism does not entail a possibility for symbolic exchange (Baudrillard, 2002b). The terrorists, in a sense of symbolic offering, choose their own death as their absolute weapon. The system—so the hypothesis in terrorism—cannot oppose deaths by vying with one another or by equal deaths and thus has to kill itself (Baudrillard, 2002a). The principle of the battle of images is an attempt to reconstruct this process of symbolic exchange. However, the Americans win a short symbolic image victory after September 11 as a compensation for the failure in presenting Bin Laden dead or imprisoned. There are two specifically chosen key images for this: the fall of the Saddam statue in Baghdad and the presentation of the shaggy and dirty dictator Saddam in the cave and his dental examination, an intrusion in the "head of state" (Mitchell, 2004b). However, in the war of images this was no lasting success, because these images will be eclipsed again and covered by the images of Abu Ghraib.

Magical Beating Tactics in the Bilateral Shock and Awe Battle

The images that will be examined here are first of all technical images. They are monads separated from reality—in the sense of Adorno—and have a magical character inappropriate to their structure when humans forget that they are themselves the producers of these images. Thus, they cannot put these images in a relation to other images and therefore develop a magical-ritual behavior toward them. The surface of technical images is "full of good or bad gods"; secret forces float above the images that need to be banned (Flusser, 1990). The question "what is behind technical images" becomes obsolete because of their medial structure. Therefore, it should be asked which images should not be shown because the Internet makes it possible for them to reappear periodically. Images do not disguise any form of truth, but in Flusser's (1990) definition of the technical image, they are pure surfaces. In Flusser's interpretation the image perception searching for a hidden, symbolically encoded truth would be a manifestation of the magical approach toward images because it shows the culturally deeply rooted belief in the technical image's promise of reality. This particular magic of the image is exploited by image warriors from both fundamentalist sides. To actually avoid a magically sound discussion that overlooks the images, we have to consider the "vivid character" of the "shifting image" (Sedlmayr, 1959). Thus, we are interested in the visual relations between the images of various social systems turning images into social carriers of meaning. With the images of Abu Ghraib and the execution video these relations actually have shifted again. There is an action and re-action on the picture level, being called "battle." The word has its roots in the arsenal of military terms that has established itself in the past years to describe the competitions of male youths in hip hop, who suspend real physical confrontation for verbal or musical competition. In the re-introduction to a military battlefield the term is also legitimate: There is a fighting of images, even if this battle now causes dead bodies. This is a battle of the documentation of well-aimed powerful cruelties.

In its pictorial movements and transformations the shifting image, particularly in the space of the Internet, crosses not only social image systems such as art and politics but also diverse cultures. Here it comes to processes of an adaptation of the opponents' language and cultural symbols. Western cultural strategies become integrated into Islamist everyday culture, as e.g., the images of Bert from *Sesame Street* as a companion of Bin Laden (Richard, 2003). Ultraconservative fundamentalisms use powerful aesthetic devices, for example, shocking neon-colors in the production of images, spectacular explosions, and special effects document the final killing of the opponent. The Christian and Islamist positions visualized in the Internet are both based on closed discourses. Fundamentalists from both sides confirm each other in an outright communication of hate (Diedrichsen, 2001).

There are innumerable extreme and unscrupulous hate pages that devise countless modes to humiliate and exterminate the other. On Web sites, this de-standardization happens explicitly on the pictorial level. The category of American "Bin Laden sucks" pages (http://www.sniksnak.com/jokester/osama/osama.html) consists of thousands of Web sites with a huge variety of insults and offenses such as homophobic, sexual degradations of the enemy, e.g., when Bin Laden is shown in sexual intercourse with a man or practicing sodomy. The visualized fantasies of violence, mainly from male Web site operators, show images of headshots, dismemberments, or the skewered head of a terrorist. By the technical manipulation of the image, the concept of enemy is embedded into a controllable, ideological framework, banning the danger in a conjuring ritual. These efforts serve a belated compensation to the former reception of the image delivered by the Islamists.

An apparently seamless transition in the realization of virtual phantasms of violence can also be traced in the photographic visualization of the Abu Ghraib torture methods, executed on the Islamist prisoners standing for Bin Laden. The U.S. soldiers function as mediums who translate the most extreme sexual fantasies of violence that have once been visualized on the example of Bin Laden in the Internet, now in the practice of "real performances." The bodies of the enemy dematerialize.

Abu Ghraib: Pornographic Subordination with Subverted Gender Signs

"The Western Memory Museum is now mostly a visual one."

Sontag, 2004

Images have always been used as political instruments. They have a new quality now in the form of a different visual direction, which has been used both in the images of torture in Abu Ghraib, as well as in the execution video of Nick Berg. This de-professionalized and popularized photography is unconsciously modeled on given visual conventions. The pictorial composition of the military photographic amateurs is based on elements of the aesthetic of cheap pornography and horror movies. They produce images that are based on

milieu-specific perception patterns, and may originally have been meant to be souvenirs or trophies, a photographic loot of their subdued opponent. Recall the broadcast images of naked prisoners piled upon one another, with a guard standing at the back watching.

The most evident torture images follow rather conventional picture compositions from the cultural archive of western societies, formally framing an aesthetic of horror. Honnef (2004) draws a comparison to the art historic motif of the apocalyptic Last Judgment: Separating the good from the bad, the damned are shown with grotesque faces, naked on the leash and their bodies mounted to pyramids (see the paintings of Stefan Lochner or Hieronymus Bosch).

A model to the World Trade Center image complex is the ruin, its so-called shell. The magnum photographers demonstrate in their images the preshaping of the look by setting up a very specific dialogue with diverse images from art history. Here the pictures by English painter William Turner are freed from the art historic image system and placed into an experimental image neighborhood with photographs of the World Trace Center ruin. The medial repetitions of images with people jumping out of the burning WTC arouse art historic associations with Andy Warhol's suicide series.

A photograph from the Abu Ghraib image complex becomes an accomplice to Bush's Iraq politics, dehumanizing the "bad" and exposing them to the destructive hell fire. These photographs not only document a crime, as it is claimed, they are crimes themselves (Rall, 2004). When the photo is regarded the culprit, the authorities' responsibilities magically shift to the image. Thus, the discussion of murderers and victims is suspended, becoming obsolete by the use of pictorial-magical rituals around the technical image. The taking of the photographs is part of the performance and as such a participant in the torture. The tormentors pose for them grinning. To be photographed in degrading poses is part of the victims' suffering. Similarly, Susan Sontag finds comparable humiliation and suffering in the photographs of black lynching victims taken in America during the 1930s, "which show Americans grinning beneath the naked mutilated body of a black man or woman hanging behind them from a tree" (Sontag, 2004,). This kind of trophy photograph also exists from the cruelties of the German Wehrmacht. They serve a heroic self-reflection and are a fetish against death (von Braun, 2004). However, now the snapshots of Abu Ghraib are spread by e-mail. As Sontag notes in the *New York Times* on May 23, 2004: "Where once photographing war was the province of photojournalists, now the soldiers themselves are all photographers—recording their war, their fun, their observations of what they find picturesque, their atrocities—and swapping images among themselves and e-mailing them around the globe" (Sontag, 2004, ; see also Mitchell, 2004b).

The U.S. administration tried to destroy the pictures of torture and to avoid their publication (an impossible attempt in times of digital photography and its relation to the Internet). The pictures have already spread like an uncontrollable virus. It is impossible to censure and limit these epidemic snapshots. Similarly, it was also impossible to avoid the spreading of the video of the execution of Nick Berg. The video was first made available on al-ansar.biz. In the German media the video was not shown, and there was also no link to the Web site (Schröder, 2004). Due to the virtuality of the video on the Internet

and the adaptation to medial stereotypes of the "genre," more specifically the "reality format" of hostage taking, the video—on the pictorial level—can no longer be distinguished from horror videos showing dismembered bodies. The execution video follows pictorial conventions, as they are fixed for the "format" of archaic death rituals and hostage taking: However, the masked terror group presents its victim with one difference, the presentation of the killing act has not been shown before, to support the terrorists' demand only the living hostage was of any use or worth. The terrorists adapt to the medial conventions of hostage taking in the West. They practice this new step of killing in front of the camera with a specific cultural counterpoint: the beheading with the sword of Allah, which in western society is a sign for the "other" cultural orientation.

Therefore the Internet is an image storage place par excellence. The final spread of particular key images happens via the more classic paths, namely via print and TV media, which—after their image selection—return an ordered archive to the Internet. They are no longer the first instance showing pictures exclusively. The process of medial finish is a new and crucial political intervention: The selection of pictures defines which of them may spread worldwide turning into the key image of an event. From this image pool TV and print media choose then their potential "icons," the marketable pictures. With regard to the Abu Ghraib image complex, two pictures feature Lynndie England specifically: In one picture she drags a naked male prisoner on a leash; in the other picture she poses laughing in front of a tower formed by the naked bodies of prisoners. However, what later turns into the dominant icon is the hooded man standing on a box with what appears to be electrical wires strapped to his hands.

This photo pose is a pendent of the image of Christ (Mitchell, 2004a), the Passion of Jesus, who with covered eyes is ridiculed by his tormentors. The cords correspond to the nails of the crucifixion. The picture shows the holiness and dignity of the tortured body. There is an obvious connection to the pictorial traditions in the presentation of the figure of Christ from Fra Angelico up to Mel Gibson (Mitchell, 2004a). In mortal fear the expression is marked by a balance and silent inner equilibrium, an acceptance of destiny, vulnerability, and at the same time forgivingness. This sense is emphasized by the opened arms, which nearly form into a blessing gesture. This photo icon is an image of martyrdom directed at the enemies: In Iraq the picture appears repeatedly as a wall painting; it is a call for resistance against the occupying forces, an image for Al Quaida recruiting (Mitchell, 2004a).

This motif in particular is "representative(s) of the fundamental corruptions of any foreign occupation" (Sontag, 2004,). Thus, the politics of pictures is evident, aiming—though without success—at the recovery of the image control that has been lost through the Internet. In the case of the Abu Ghraib image complex, the Internet spreads a theater of a variety of sexual tortures. The specific form of this control is evident in the treatment of images that show sexual abuses against Arabic men: The victims' genitals are disguised through technical image manipulation.

This disguising finish is produced by the U.S. media and adopted by the European media without critique. The obscenity of the pictures is increased by the fact that, while in the

western sense of modesty the male genitals are covered, the faces partly remain recogniz-able so that the identity and dignity of the victim are exposed. In western newspapers male genitals are not shown because they are not allowed to be shown, even though at the same time the exposed female body must always be present. The phallus is a symbol of power and therefore has to be invisible (von Braun, 2004, p. 17), also beyond cultural boundaries. So it is a paradox that the male genitals are not shown, although these pictures deal with sex-ual violence. The men who are responsible for their publication have a double interest: The images should show the particularly painful degradation of the male enemy through a woman by simultaneously retaining western gender codifications. The pictures are pornographi-cally and sexually charged: Particularly because a woman in such a powerful position is rather unusual, there must be a photographic voyeur in between who is taking these pictures and who disencumbers the viewers in their voyeuristic perception.

The shock and cultural abyss that opens up when a woman sexually abuses and humil-iates Muslim men is not the result of a conscious American provocation. The selection of the key images is done eventually by the media, who unconsciously serve the terrorists' pic-torial regime, underlining the Islamist position about the moral decay of all the unbeliev-ing men and women.

The torture images of Abu Ghraib, chosen on the basis of classical principles of west-ern mechanisms of exclusion, confirm an underlying existence of an intercultural phallic viewing regime: The setting of the torture images is preshaped by pornographic stereotypes. These pre-images are realized on the body of the enemy, though with the difference that in conventional forms of pornographic images it is the female body that is being abused and humiliated. In the next step the images of Iraq serve again a sexual stimulation; they are re-performed as pornographic images on Web sites such as "iraqbabes" (Heidenreich, 2004, p. 4), showing women as the degraded object and counterposed to "real" images of Iraq. Here we have a closed commodity-like circle of oppression and exploitation.

"Francis Bacon Invents the Screaming Pope":[1] Medial Violence Projections of Death

The dying Pope John Paul II produces an image commodity, a Christian image of death. This is particularly evident in the various image series of the print media that showed his attempt to give the blessing on Easter Monday 2005. The images from the apostolic palace show how the pope loses his voice and facial features. The general medial image friend-ship of death is shown in the pope's embedding into four medial sorts of public dying, which are presented in different ways (see Nutt, 2005).

The pope wants the world to watch his death; he wants the world as witness, abusing his medial "face time." In his "performance" he bundles the imaginations of death and dying in western societies by presenting a long process of suffering and not a sudden, relieving death. The pope stands for the performance of a premodern image of death. He has every-thing prepared; a sudden death would have been impossible to mediate for him. Here again

it is evident that medial visibility has produced opacity instead of transparency: The public dying and his inability to talk turn the pope into an embodiment of horror. Despite the sympathy of millions of people, this is a violent event of the destruction of life and the demonstration of the loneliness in death. The pope dramatizes public dying and shows that there is no human form of death (Nutt, 2005). The pictures show an old man not accepting his end, whose textile mantle of authority denies the decay of the body (Kümmel, 2005). The unwillingness to die and the long waiting for the death belong to the program of picture performances of infirm potentates as, e.g., Tito, Breschnev, or Franco (Schümer, 2005, p. 33).

Despite their bodily decay the old men, with their stubbornness and inability to accept the end of life and their official power, apparently prefer to present themselves in the media almost as if to symbolize their vampire-like existence.

Beyond this, the media images also demonstrate that Terry Schiavo (the American woman who suffered severe brain damage as a seizure and whose parents and husband had a lengthy court battle about whether she should be allowed to die) as well as the pope, before the absolute death of body and soul, are already symbolically dead. The pope was present and at the same time not present. With his shocking muteness the screens on the Piazza San Pietro projected simultaneously the dawn of the reality of an incredible death. There was no transmission, no voice from this life. The moving image freezes into a still; the composition of the picture and the medial broadcasting were designed for a living, vivid body.

Now here was a body that was already dead on the symbolic level, a transient body of flesh and blood. This was no longer the body of a sovereign; there is a lack of voice and face. There is an obvious contrast between the image/space setting and the motions of suffering. This contrast, however, is brought to a standstill in single pictures in Muybridge-manner, which are also presentable in print media. The entire medial representation is a paradox of the denial of death with a simultaneous medial visibility of dying.

Again images emerge from other images. As a pre-image the painting of the pope by Francis Bacon immediately comes to mind. Bacon's painting is a composition of two medial image worlds: These new pictures of the pope are generated from a still of Eisenstein's movie *Battleship Potemkin* and from Velásquez's portrait of Innocent X, the constitution of each single picture as a compounded picture becomes again evident.

Image-Quakes: Compounded Images of Death

The interpretation of diverse images has shown that it makes no sense to search for a deeper dimension of these pictures of terror and violence. What we find is not a hidden truth but trapped images. These images are now concretely stored on the Internet, demonstrating its quality as the universal memory space for housing and saving also the dark and illegal sides of western culture and its unwanted images. With the destruction of the World Trade Center in New York, the terrorists have hit a visual double punch. There is no adequate exchange in response to the pictures taken as a result of their actions. In addressing the image pro-

ducing terrorism, it seems the American media were crucial in their perpetuation. First, the attack was broadcast "live" in the media. Second, the images have been continuously repeated, the self-made magical circle has been kept closed. Third, they use the delivered self-presentation of the terrorists, rather than producing their own images, as it has been done with Saddam Hussein. In the case of Saddam the Americans established pictorial tactics worked well: In the beginning they created the figure of a devilish anti-Christ, which then can be destroyed directly on the body of the enemy. The last key image of Saddam Hussein is an image of a dilapidated, scruffy man, vegetating like an undignified animal in a cave. His body is subjected to the dental examination by an American dentist, presenting him as their property without rights. The same power of disposition over the terrorists' bodies is represented in the pictures of Abu Ghraib. In the western world's image machines the bodies of the enemies are turned into a mouldable mass and a designable commodity.

In the visual universe the image shifts are very much influenced by the status of the image producer. If photographers and camera men who work within the scope of the economic logic of the western media system were unintentional accomplices of the terrorists in the case of 9/11, in the case of the torture pictures and the execution video, they are completely deprived of this function. They are now in the second row of use: The publication of the images via the Internet has long happened beyond the governmental control of media regulation. Already on September 11, professional photographers were beaten, so to speak by their amateur counterparts (Mitchell, 2004b). The above mentioned image complexes show the marginalization of the photo reporter as a clarifier or critic. In fact the reality of 9/11 is turned into an expression of art, presented in glossy coffee table books that become Christmas gifts in 2001. In their hyper-aesthetic form these images are no longer shaking up.

There is no creation of "works" but a flood of incidental images, which may, nevertheless, become significant key images at any point in time. The status of these images is rather fleeting; there is a permanent sequence, a continuous *come and go* of key images. This shift in images leads from the professionally directed image production to the amateur picture, which is linked to other image producing systems different from the system of arts. Linked in their references to pornography and the (war-) tourist genre, torture photographs are related to numerous contexts. Amateur aesthetics is characterized by markers of low culture from porno and horror. These are simple U.S. soldiers, some of whom the army may have recruited from the underprivileged social classes. Therefore the images follow milieu-specific viewing patterns (Bourdieu, 1983). Just as in times of analogous photography (e.g., holiday pictures), digital photography now gains a similar function in the reproduction of medial patterns in the performance of reality. The image producers of war are no longer professional image producers. The digital camera disguises itself as a democratic element toward the production of a medial public on the Internet; everybody can shoot a picture and send it away. In the beginning the digital camera seems like a new weapon, comparable to the first light-weight video cameras. When they first became available, artists and political activists of the 1960s saw a new initiation toward the democratization of the

media. However, when the clarifying photo is seen as an art form, on the one hand, and on the other, medial produced artificial appearances present themselves under the label of reality and authenticity (such as documentary soaps and real-life formats), these images have a quite opposite function. Generally the widespread use of digital photography also makes it possible for criminals to digitally record their acts of violence, as, e.g., the phenomenon of "happy slapping" among young men in England.

The media structural references of terrorists happen on a particular level: They make use of the freedom of autonomous media based on the Internet and can be seen as a terrorist offspring of indymedia. This Web site presents alternative medial documents of events (such as the G8 meeting in Genoa) to counter the governmental medial perspective. Terrorists now enter western media blockades with the help of the Internet and Arabic TV stations such as Al Djazeera. The peaceful use of the video as a weapon against governmental oppression, a combination of art and activism toward a liberal unleashing against the government (as could be observed in the combination of video and Internet in Chiapas/Mexico with the distribution of video cameras by the Electronic Disturbance Theater around Ricardo Dominguez, see Richard, 2001) is now being subverted. The pictures serve a total intimidation of the enemy, showing the shift from a politics of defense to the destruction of civil rights. The media turn into conservative instruments that serve the violence of civil rights instead of revealing violence of civil rights and initiating protest.

Thus, the relations between the single images described here get a new component with Abu Ghraib and the execution video of Nick Berg: the image battle. Even though images have always been part of war, in the latest development well-directed retaliations are now featured with the means of images. More specifically, there is a battle that competently uses the structural advantages of particular media by combining video images and the Internet. Particularly in the case of the beheading of Nick Berg the terrorists have worked with the reality effect of the moving image by clearly focusing the process of the killing of an identifiable person. The terrorists set up this video carefully with key objects that are symbols of the enemy, functioning as references in the image battle: The shown objects that people will remember are the hood, the orange shirts of the prisoners in Guatanamo Bay that later resurface in the video of Nick Berg.

The new image complexes also show the disappearance of formerly powerful key images: The image quake of Abu Ghraib changes the meaning of the images of 9/11 that triggered unlimited solidarity with Americans received throughout the western world. Because of the shift from the role of victim to the active role as culprit in the Iraq war, the worldwide sympathy has diminished. The contemporary contrasting of the torture photographs and the execution video serves fundamentalists on both sides in that the United States acts the way the terrorists want it to act. The United States responds in the same logic.

The photographs of John Paul II, too, are violent images in that the portrait of the pope is violated. In his performance of power he is no longer in control to direct the picture; he is put back to his body. With a classically trained eye the professional photographers direct the picture without mercy, situating the weak body within the picture frame and creating

a symbol of the infirmity of an earthly body. The counter-image is the "man on the box" selected from the widely spread amateur images, which present the tortured body as dignified—in contrast to the tormentors' intention of his humiliation. In comparison to this picture, the images of the pope's creeping, natural death have the expression of violence.

The medial shift and inter-medial changes show that a medial image as "shifting image" not only permanently changes its meaning because it is set in relation to other images, but also because as a numeric picture is does not remain in one form (that is still-moving or material-immaterial). Any image is a composite image. This dynamic is evident in the virtual comparison of formal similarities between images. Images are immaterial palimpsests, which have no depth but a medial, plane extension. These surfaces expand through the relations between images. Having no depth means that there can never be a truth extracted from them. Even the consideration of the image producer's intention will not lead to a solution but only to further images. Rather the obvious interrelations between the images of violence, art, and film show the pre-shaping of the view and make evident that a direct presentation of reality is impossible.

"Images are expected to represent directly an outer reality [. . .]. But it is a wrong conclusion to believe that images illustrate reality directly. [. . .] Images never illustrate, not even photographs, but they present, what they present, in their own way" (Bredekamp, 2005, p. 47, author's translation). Because images can only be viewed in relation to other images and are thus always images derived from images, they move within the entire variety of materially fixed images up to realizations of collective imaginations and phantasms, as social interim and pre-images between diverse social systems of reference.

The epidemic structure of the key image corresponds with the epidemic structure of terror. The new phenomenon of a medial body of violence developing in the triad of image, culprit, and victim, already present in the dissolving metabolic body of the World Trade Center terror, reaches a new dimension. The attack creates a sovereign synchronism of image, medium, and human being.

Thereby the body of the enemy becomes an ephemeral, sublime image of a body, whose existence is only perceived as an image. The treatment of the enemy's body forces the dissolution into a pure picture that can be arranged and processed. The aim of terror is to turn bodies into pictures so that the body of the enemy is no longer of flesh and blood. The single body does not count, only in the mass, in the accumulation of bodies that by a violent, explosive dissolution melt into a collective picture body.

Here we see changes in the relation of image and offender/victim and in the relation of look and body/medium. The connection of the technical picture to material reality seems to be torn. A total constructivism becomes the perception mode of the common image producer in that the person on the opposite side is perceived only as an image. Terrorist and individual violence is now only practiced to produce pictures. This statement applies to terrorists, tormentors, as well as to the "happy slapping" youths in England, who will not find any satisfaction in their physical aggression unless they are observed performing it. Offenders need the images to make their own mark; they can only be by being a medial

image producer. Terrorists need images for their political motivation, whose demands only receive worldwide attention via the transmission of violent images. The aim is always the production of a real format that can be disseminated. Who only has a body is inferior and will be injured or killed. The suicide terrorists use their bodies as a means for what they perceive to be a higher cause because it has no higher value than its sacrifice. Global, collective image patterns of fundamentalism are emerging that exhibit both Christian as well an Islamist roots. The fundamentalist disdain of the body shows itself in torture, in the process of Christian dying and in Islamist suicide terrorism. All of these phenomena are aiming at the dissolution of flesh in images.

NOTE

1 It has to be noted, that the following analysis will only focus on the medial appearance of the pope and on cultural references, not on the person of the pope himself. See also Kümmel (2005).

REFERENCES

Baudrillard, J. (2002a). Der Geist des Terrorismus. In *Haus am Lützowplatz/Lettre International* (ed.): Der Schock des 11. September und das Geheimnis des Anderen. (German/English) (pp. 168–183). Köln.

Baudrillard, J. (2002b, March 2). Die Globalisierung hat noch nicht gewonnen. *Frankfurter Rundschau*, p. 19.

Bolz, N., & Rüffer, U. (1996). *Das grosse stille Bild*. München.

Bourdieu, P. et al. (1983). *Eine illegitime Kunst. Die sozialen Gebrauchsweisen der Photographie*. Frankfurt/Main.

Braun, C. Von (2004, May 14). Das Bild als Trophäe. *Frankfurter Rundschau*, p. 17.

Bredekamp, H. (2005, April 6). Im Königsbett der Kunstgeschichte. Ein Interview. *Die Zeit*, p. 47.

Diedrichsen, D (2001, October 6). Das WTC hat es gegeben. TAZ No. 6567, pp. 13–14.

Ernst, W. (2005, July 26). Jenseits der Verschlagwortung? Plädoyer für eine nicht-textbasiertes Bildgedächtnis. Retrieved from http://www.westfaelischer-kunstverein.de/archiv/2000/ausstellungen/nicolai/vortraege/ernst.pdf.

Flusser, V. (1990). *Ins Universum der technischen Bilder*. Göttingen: Vice Versa.

Heidenreich, S. (2004, June). Vorauseilende Inszenierung. *De:bug—Monatszeitung für elektronische Lebensaspekte*, Issue 83, p. 4.

Holert, T. (Ed.). (2000). *Imagineering. Visuelle Kultur + Politik der Sichtbarkeit*. Köln.

Honnef, K. (2004, May 13). Der Erlöser-Präsident und die Fotos aus dem Gefängnis. *Die Welt*. Retrieved from: http://www.welt.de/data/2004/05/13/277079.html?prx=1.

Kümmel, P. (2005, March 31). Stellvertreter. Das öffentliche Leid des Papstes. *Die Zeit*, p. 47.

Lyotard, J.-F. (1989). *Das Inhumane. Plaudereien über die Zeit*. Wien.

Mitchell, W. J. T. (1999). Was wollen Bilder? Im Gespräch Georg Schöllhammer. In Springerin (Ed.), *Widerstände* (pp. 156–163). Wien/Bozen.

Mitchell, W. J. T. (2004a, December 3). Post iconic turn: Cloning terror: The war of images from 9/11 to the Abu Ghraib photographs. Presentation at the Ludwig-Maximilians-Universität Munich, December

3, 2004. Retrieved from http://www.iconic-turn.de/staticpages/index.php?page=StreamMitchell.

Mitchell, W. J. T. (2004b, June 27). Echoes of a Christian symbol. *Chicago Tribune*. Retrieved from Moll, S. (2004, July 21). Der Fotograf als Aufklärer? *Frankfurter Rundschau*, p. 27.

Nutt, H. (2005, April 4). Ein Bild von Francis Bacon. Vom öffentlichen Sterben. *Frankfurter Rundschau*. Retrieved from http://www.fr-aktuellde/fr_home/abschied_von_johannes_paul_ii./cnt=655959.

Paech, J. (1994). Bilder-Rhythmus. In C. Hausherr (Ed.), *Visueller Sound* (pp. 46–63). Luzern.

Rall, V. (2004, December 14). Kein Ende der Fotostrecken. Schreckensbilder aus Irak. *Frankfurter Rundschau*. Retrieved from http://www.fr-aktuell.de/ressorts/kultur_und_medien/feuilleton/?cnt=436320.

Richard, B. (2003). 9–11. World Trade Center Image Complex + "shifting image." In B. Richard & S. Drühl (Eds.), *Kunstforum International: Das Magische* (pp. 36–73).

Richard, B. (2005). *Sheroes—Genderspiele im virtuellen Raum*. Bielefeld.

Richard, B. (2001, January-March). Am Anfang war das Wort: Domain wars! Zur Gewalt des Eigennamens in virtuellen Welten. In B. Richard & S. Drühl (Eds.), *Choreographie der Gewalt. Kunstforum International*, 153, 202–229.

Richard, B. (1995). *Todesbilder. Kunst Subkultur Medien*. München.

Rogoff, I. (1999). Studying visual culture. In N. Mirzoeff (Ed.), *Visual culture reader* (pp. 14–26). London, New York.

Schröder, B. (2004, May 13). Die Medien und die grausamen Bilder. *Telepolis*. Retrieved from http://www.heise.de/tp/deutsch/inhalt/mein/17419/1.html.

Schümer, D. (2005, March 29). Johannes Paul II. Sklave der Bilder. *Frankfurter Allgemeine Zeitung*, p. 33. Retrieved from http://www.faz.net/s/Rub117C535CDF414415BB243B181B8B60AE (Retrieved, April 4, 2005).

Sedlmayr, H. (1959). *Epochen und Werke*. Vol. 1. Wien.

Sontag, S. (2004, May 23). Regarding the torture of others. *The New York Times*. Retrieved from www.nytimes.com/2004/05/23/ magazine/23PRISONS.html.

Weibel, P. (2002). Von Zero Tolerance zu Ground Zero. Zur Politik der Visibilität im panoptischen Zeitalter. In H.-P. Schwerfel (Ed.), *Kunst nach Ground Zero* (pp. 87–105). Köln.

Zizek, S. (2002). Willkommen in der Wüste des Realen. In H.-P. Schwerfel (Ed.), *Kunst nach Ground Zero* (pp. 57–65). Köln.

Chapter 25

Photographic Encounters of the Western Frontier

Kalli Paakspuu

In a time when federal governments used treaties to contain indigenous land rights, the early cross-cultural photography of American E. S. Curtis and Canadian Harry Pollard is evocative of Homi Bhabha's "third space" (1994), a space outside existing relationships where new possibilities can be articulated. Similar to totem poles and other ceremonial objects that have been removed from their communities, the photo archive is part of the larger process of dispossession of indigenous land and cultural signification. As objects of the colonial gaze, these photographs belong to the repatriation process as narratives and ways of seeing. This chapter offers a lens and a postcolonial perspective on indigenous storytelling in photography and examines the embodiment of region and nation from a cross-cultural perspective.

Harriet Martineau, a nineteenth-century British sociologist, believed that observers typically misunderstand the societies they study because they compare them to their own (1988/1838). Photographs as cultural products are records that should be studied:

The eloquence of Institutions and Records, in which the action of the nation is embodied . . . is more comprehensive and more faithful than that of any variety of individual voices. The voice of a whole people goes up in the silent workings of an institution; the condition of the masses is

reflected from the surface of a record. . . . The records of any society . . . whether architectural remains, epitaphs, civic registers, national music, or any other of the thousand manifestations of the common mind which may be found among every people, afford more information on Morals in a day than converse with individuals in a year." (Martineau, 1838/1988, pp. 73–74)

Contemporary cultural theorists examine both the mediation of meaning in the photographic texts and the contexts in which they were produced. In colonial expansion narratives, indigenous peoples are depicted as subaltern, and salvage photography relegates them to a disappearing race. A contrapuntal reading to photography, however, reveals various sites of alternative readings and counter-memory where conflicting interpretations emerge—in both past and present readings. Indigenous subjectivity enters into negotiations with non-indigenous photographers as encounters in production and later in photographic exhibitions. One such location of reception is defined by postcolonialist theorist Gayatri Spivak as "strategic essentialism," where a reinscription of meaning creates an alternative and positive subject position for the indigenous subject (1988; see also Landry & MacLean, 1996). Years after the photograph's production, its meaning may alter as reception moves from naturalization of indigenous subject as "other" into a skepticism of the technological mediation, or into actual projections of indigenous subjectivity. Indigenous curators like Jeff Thomas (also an Iroquoian photographer) (1997) use a positivist essentialism to deconstruct various truths and expose their construction. Reinscription thus makes the photograph a site where politics involving race, class, gender, nation, and region are contested.

On both sides of the camera individuals are engaged in a dialogue about understanding the "other" that congeals into a photograph—a cultural artifact of memory. A third space is constructed through body idioms and a disidentification wherein the subject neither assimilates nor opposes the ascribed roles of genre from the photographer's production script. Disidentification, according to Jose Esteban Munoz, "works on and against dominant ideology . . . this 'working on and against' is a strategy that tries to transform a cultural logic from within, always laboring to enact permanent structural change while at the same time valuing the importance of local or everyday struggles of resistance" (1999, pp. 11–12). Storytelling documents disidentification with assimilation as it paradoxically embraces contradictions and cultural hybridities. The indigenous subject's participation in Pollard's or Curtis's photographs is thus not necessarily an active participation in a fine art photography project for art's sake, but an affirmation of primary culture through a basic survival reflex.

The early anthropological view, dependent on a binary difference between non-western and western culture, located its task of describing cultural organization within a spatial and temporal distinction: over there is equivalent to going back in time. This "art-culture system" as James Clifford (1988) named it, is an interpretive structure in which western art is dependent on being distinguished from non-western culture. Hybridized forms, as Nicholas Mirzoeff has observed, are transcultural: "From present-day perspectives, the monuments of elite culture and anthropological data alike both point in a different direction, towards a modern visual culture that is always cross-cultural, and always hybrid—in short transcultural" (1999, p. 131).

As feminist fieldwork rejects positivism as an aspect of patriarchal thinking that sep-

arates the scientist from the phenomenon under study, a social reality "out there" independent of the observer or photographer is also repudiated (Reinharz, 1992 p. 46). In a constructivist framework, interpretation is acknowledged, as is the very act of defining reality. Within this context let us evaluate the early twentieth-century photography of Canadian Harry Pollard and American E. S. Curtis from a non-positivist perspective and produce some new understandings. Despite the fact that these contemporaries may have photographed some of the same individuals in similar activities, their projects had significant differences as their projects were produced in vastly different economic relations. Pollard's work with the Blackfoot Indians was produced between 1904 and 1916 when Pollard himself became their honorary chief. Most of Curtis's work with the Blackfoot Indians occurred much later in 1926, though he photographed nearly eighty indigenous communities for "The North American Indian."

Curtis's work with indigenous subjects began after the Harriman Alaska Expedition where he worked as official photographer with anthropologist George Bird Grinnell and scientist C. Hart Merriam. An immersion into scientific practices enabled Curtis to envision a project to document "the old time Indian, his dress, his ceremonies, his life and manners." (Library of Congress, 2001) In 1900 at the Sun Dance gathering of Blackfoot, Algonquin, and Blood at the Piegan Reservation in Montana, Grinnell said to Curtis, "Take a good look. We're not going to see this kind of thing much longer. It already belongs to the past." (Smithsonian, 2004, p. 2) This Sun Dance was the inspiration for Curtis to produce *The North American Indian*, the most ambitious and controversial representations of traditional American Indian culture ever produced in a limited edition between 1907 and 1930. *The North American Indian* included over 2000 photogravure plates and described the traditional customs of eighty Indian tribes in twenty volumes, each with an accompanying portfolio, organized by tribes and areas encompassing the Great Plains, Great Basin, Plateau Region, Southwest, California, Pacific Northwest, and Alaska. The published photogravure images included over 1500 illustrations bound in the text volumes, along with over 700 portfolio plates (Library of Congress, 2001).

On December 16, 1905, President Theodore Roosevelt wrote to Curtis, "I regard the work you do as one of the most valuable works which any American could now do." In 1906 railroad magnate J. P. Morgan lent him $15,000 per year interest free for five years so that he could produce the twenty-volume set, which sold for $3,000 each. The reasons for producing these volumes were both economic and political and placed the indigenous peoples in a spatial and temporal distinction, in an "over there," which in salvage photography was "back in time." Conceived as perfectly detached and neutral within the positivist-empiricist principles of scientific enterprise, Curtis's project was what feminist theoretician Donna Haraway (1991) describes as "the god-trick," a "view from nowhere," where representations of indigenous communities escape the specifics of location and historical circumstances. Curtis's genre of "The North American Indian" effectively enabled industrialists like Morgan to succeed in expansionist projects with public approval and aggressive force and deserves comparison to the anthropological studies of Rev. Henri-Alexandre Junod in Africa:

One of the major reasons for undertaking extensive anthropological studies in Africa, according to Junod [Rev. Henri-Alexandre Junod was a Swiss missionary and ethnographer] was to provide Europeans with a picture of their own prehistoric, primitive past. The view that Europe's past could be found in Africa's present drove Junod to produce a form of salvage anthropology that uncoupled "traditional" society from any form of change. This image was reinforced as he strove to present Europeans, experiencing the trauma of industrialisation, with a picture of a primitive, uncomplicated society living close to nature. Junod's vision of what he wanted to find in Africa had an immediate impact on the choice and organization of his illustrative photographs. So, although almost 100,000 workers drawn from southern Mozambique were employed in the mines, farms, plantations and ports of South Africa by the turn of the century, not one photograph of a migrant worker appeared in his anthropological monographs. (Harries, 2002)

A genre is a standard style in which presentation aesthetics are more important than the actual content within the image. Over Curtis's life he established a genre of photography that was exclusive to "The North American Indian." The later work adheres to stylistic and formal qualities of the early work. As the style is reproducible with countless variations, an illusion of political neutrality is naturalized and reinforced. As the art director of his life work, Curtis compares the similarities and differences of the eighty tribes in an artistic construction of the "old time Indian." He erases modern lifestyle from his representations and uses the techniques acquired in a photo studio practice for an artistic effect that is consistent in all twenty volumes. The time frame of "old time Indian" and "glory days" literally exists in an artistic imaginary space displaced from actual time and frequently from place, too. Curtis's views of reservation life thus do not reveal the harsh realities that inhabitants actually faced on disputed lands—in contrast to the later Farm Security Administration photography projects of Roosevelt's New Deal.

As one of Franklin Delano Roosevelt's most famous programs Farm Security Administration was formed as an act of Congress in 1937 to help struggling farmers endure the Great Depression. The FSA organized a historical section to create and promote a record of the Depression's devastation on average Americans and the positive outcomes of FSA projects for needy farmers. Roy Stryker, director of the project, employed photographers Dorothea Lange, Walker Evans, Arthur Rothstein, Ben Shahn, Jack Delano, Russell Lee, Gordon Parks, and Marion Post Wolcott and circulated "a cultural document the likes of which we may never see again" (Anderson, 1977, p. 3), to picture magazines such as *Life*, *Look*, and *Fortune*.

Thirty years after her assignment, Dorothea Lange tells us how she made "Migrant Mother," the most reproduced image in the history of photography:

I saw and approached the hungry and desperate mother, as if drawn by a magnet. I do not remember how I explained my presence or my camera to her, but I do remember she asked me no questions. I made five exposures, working closer and closer from the same direction. I did not ask her name or her history. She told me her age, that she was thirty-two. She said that they had been living on frozen vegetables from the surrounding fields, and birds that the children killed. She had just sold the tires from her car to buy food. There she sat in that lean-to tent with her children huddled around her, and seemed to know that my pictures might help her, and so she helped me. There was a sort of equality about it. (Lange, 1960, p. 264)

In 1978 Migrant Mother (Florence Thompson) told United Press that she was proud to be the subject of the photograph but never made a penny and it had done her no good (Rosler, 1989).

Documentary photography's primary appeal in these documents was to the emotions of American readers of the thirties who lacked a critical perspective on photojournalistic rhetoric. Deserving comparison with Curtis, the FSA photographs animated lively ideological debates about nation and region through the pictorials of sharecroppers in Alabama, labor camp workers in California, and the slum dwellers of Boston. The FSA photographs circulated widely in public reading spaces, exhibits, newspapers, and picture magazines, and this imagery triggered discussions about national and local cultures in a struggle about identities and progressive American social movements (Brady, 1999). Curtis's nostalgic portraits in comparison never quite manage to articulate a consistent theme about region or American nation.

"Portrait of Geronimo" (1905) was taken when Geronimo was on a government-enforced tour with President Roosevelt after officially being a prisoner at Fort Sill, Oklahoma, for more than 20 years. Curtis renders Geronimo in a blanket and ceremonial headdress which disguises Geronimo's contemporary clothing and obliterates the political situation by which the photograph was constructed. As one of his most political representations, the photograph is a prime example of how a non-European subject is represented in ways that are appropriate to the colonizer. Geronimo's portrait denies the political complexity of the Native American experience and completely ignores the struggle that is really lived by his subject in the moment of picture making. Geronimo, the Apache leader of the last American Indian fighting force to surrender to the United States in 1886, died a prisoner of war, unable to return to his homeland and only four years after riding in Theodore Roosevelt's inaugural parade. To this day, "Portrait of Geronimo" and its "glory day" erase the real conflict and replace it with a safe alternative that reduces the historical actuality into an antiseptic spectacle or non-event. In this paradoxical moment of photography Geronimo himself graciously performs "glory days." However, why would this legendary living figure want to be remembered otherwise? The pain of being a prisoner of war is anesthetized by a ceremonial headdress that reinforces Geronimo's authority as a fearless guerilla.

Curtis's aesthetics in ethnological documentation would often result in ambiguous images. In "Hopi Girls Grinding Peke Bread Meal" four unmarried women (recognized by their distinctive hairstyle) are grinding corn, an everyday household activity, while wearing ceremonial clothing. The image presents valuable information on food preparation through the tools and method displayed, but by making his subjects wear ceremonial clothes Curtis creates an anomalous situation. A metonymic reading of the image would place an incongruent ceremonial value on the food preparation. This interpretation of the ethnographic moment compares to contemporary advertisement practices where an image uses two conflicting or contradictory events to attract the public's attention. This image, as well, conforms to the "glory days."

Curtis's photography of indigenous peoples through its ambiguous and anomalous

readings does enable a strategic essentialism to emerge. "Portrait of Geronimo" and "Hopi Girls Grinding Peke Bread Meal" are evocative of ceremonial ritual and undo Curtis's own gaze: these representations then challenge the public's gaze with the something unseen. Curtis's and Pollard's work with prohibited ceremony dismantles our preconceptions about what we think we are seeing and open a portal to an alterity that is itself a site of reinscription—and alternate to any false genre whatsoever.

Alice Beck Kehoe describes a Third Space in the early transformations of culture:

> From a First Nations' perspective, the Blackfoot adopted substitutes for their principal economic resource, the bison, and accepted opportunities to learn English reading, and other means of dealing with the conquerors. To call these strategies "acculturation"—that is moving toward Western culture—misses the essential point that indigenous people were struggling to retain as much of their heritage as possible under the much altered circumstances of the reservation. (Kehoe, 1996, p. 386)

Pollard's portrait of Big Belly (P58 Big Belly Sarci Chief) in front of a teepee is one of many photographs taken during one of Pollard's photographic studies with his Bosche and Lombart lens. Documenting life at traditional ceremonial camps, Pollard's work is possibly the most complete record of a native spiritual and resistance movement to exist. (He also collected photography on ceremonial camps from his predecessors.) Big Belly proudly displays the treaty medals and the clothing from Article 6, Treaty Number 7. The clothing was a negotiated treaty benefit that provided every chief one set of European style (or white man) clothes. The full outfit was a brass buttoned coat, side-striped trousers and plughat. A portrait of a chief wearing the Queen's Medal is a display of strong faith in the great "White Mother." The wearing of the full outfit at a ceremonial camp, however, is a contradiction of assimilation, if not more clearly a disidentification with the colonizer's apparel. As an item that the Sarci (a plains tribe) listed in a treaty negotiation with the Queen, the clothing also represents an assimilationist policy which was a desirable outcome for the Canadian government. The act of wearing it, however, will not make Big Belly with his waist-long braids pass for a white man. In fact, the complete presentation of the self is not only for Pollard, the photographer, but also for the little girl at the left side of the frame for whom this enactment is a performance of disidentification. Not only are the clothes and medals a symbol of assimilation, in the context of this historical camp, they are an appropriation from the colonizer and as a mimicry and theatrical dress-up take on a new political meaning. They are not simply the Queen's clothes.

With his profile clearly presented to the camera, Big Belly's gaze to the side places him in a spatial relationship to the land as one who surveys and commands the space. It is a symbolic representation. The relaxed facial expression and body position show comfort and active participation in the portrait making process. Pollard's gaze thus follows ordinary details from everyday life and the Blackfoot people's resolve to make their culture survive—a defining difference from other contemporary photographers.

Pollard's documentary approach to the Sundance does not anticipate a unified position or genre for the viewing subject. Produced over more than a decade in a relationship of collaboration with his subjects, his subjects may well have anticipated their own uses of the imagery. Unlike his contemporaries, Pollard's work aspires to a historical consciousness in

that it adheres to a local and specific moment in opposition to Haraway's "view from nowhere." He documented the reserve, a place which Gerald McMaster has described as "a negotiated space set aside for Indian people by oppressive colonial governments to isolate them, to extricate them from their cultural habits, and to save them from the vices of the outside world. Paradoxically, isolation helped maintain aboriginal languages and many other traditional practices. Although it may be difficult to view these places as prisons now, at one time Indian people needed special passes to leave the reserve boundaries" (1998, p. 19).

Documenting the Blackfoot Sundance Ritual (a ceremony banned by American and Canadian governments) from 1904 to 1916 Pollard's attention to the local, specific, and embodied possibly provides the most complete record of this native spiritual and resistance movement in existence: Much like Alanis Obomsawin and her performative documentaries, he uses the local, specific, and embodied as a vital locus of social subjectivity, which "gives figuration to and evokes a dimension of the political unconscious that remain suspended between an immediate here and now and a utopian alternative" (Waugh, 1990, p. 36).

The primacy of cultural continuity with land, memory, and knowledge are reasons for indigenous peoples to return to traditional grounds for sacred observances where temporary domiciles are set up by established rules. Returning to a traditional campsite, however, has a new meaning when indigenous peoples are losing their land and rights—which coincidentally was the time of the early period of the camera. Providing a profoundly visible representation of the subject, the camera as apparatus recorded aspects of subject formation and the interpellation with real and imagined conditions of survival.

A critical variable in a photographic narrative is the construction of culturally significant categories like individual and society and the social organization and maintenance of various physical boundaries. Oral and written texts and photographs are windows on constructions of the past from the perspective of participants enmeshed in and negotiating power relations in complex social networks. All societies use narrative structures to enable members to construct and maintain cultural boundaries and reproduce knowledge which either becomes official history or a separate collective memory. At first segregation was seen as the greatest power wielded against blacks in the United States. Roger Wilkins reinscribed it with new meaning in his essay, "White Out": "The greatest power turned out to be what it had always been: the power to define reality where blacks are concerned and to manage perceptions and therefore arrange politics and culture to reinforce those definitions" (Wilkins, 1992, p. 44–48).

Collecting ethnographic artifacts from colonial lands was preceded by ways of seeing that subjected the material culture of indigenous peoples to a controlling "gaze." James Clifford has stated that collecting in the West "has long been a strategy for the deployment of a possessive self, culture and authenticity. Even today these collected "cultures" are often in the "ethnographic present," i.e., explained in the present but conceived as remnants of the human past and thus as timeless and without history. Authenticity is produced by removing objects from their historical situation" (1988, p. 222–225). The collection and preservation of any domain of identity is intermeshed with national politics, restrictive law, and

contested encodings from the past and from the future.

Like Foucault's (1989) story of a white psychologist visiting Africa, different narratives situate a viewer in the cultural text. Foucault's psychologist follows character and plot while the indigenous viewer attends the passage of light and shadows through the trees. Their perspectives are specific to differences in cultural knowledge production. Haraway (1991) argues that vision is always a question of the power to see and that violence is implicit in our visualizing practices. The example of the African and psychologist's different responses to the film illustrate that vision itself is a cultural construction and empowers a particular aesthetic and political perspective.

A postcolonial interpretation involves a deliberate re-appropriation of indigenous forms and motifs. What people have seen or understood when they have looked at artifacts in the past is inseparable from contemporary forms of colonialism, which are recycled into an address to the tourist gaze. Repatriation thus involves re-situating the gaze in renewed mnemonic narratives through a powerful mediation of cultural narrative from a position of resistance. Some cultural centers disallow any access to their photographic collections to ensure that the home community defines the narrative from within: thus an autonomy over cultural narratives is maintained and the possibility of competing narratives is diminished.

Roland Barthes's argument in his essay, "The Death of the Author" (1977) demonstrates that an author is a socially and historically constructed subject that does not exist prior to or outside of language. The "Death of the Author" concept also applies to photographic production because it uses a language of body idioms between subject and photographer that exists prior to the photographic act. Photography conveys what Fabian (1995) describes as "a personally situated process of knowing" (p. 41–50). In Canadian copyright law the person photographed and the photographer must both give their permissions for the photograph to be used beyond a personal use. Thus the negotiation and written agreement between the photographer and the subject is recognized as a legal contract with any limitations agreed upon by either side and is, in effect, a partnership.

As Pollard was directed by the chief to set up in a teepee next to his, the photographer's teepee position also signifies a formal and hierarchical relation in the community, if not an integration; as Pollard uses their teepee and not a military tent. Revered as an honorary chief of the Blackfoot, Pollard had an unparalleled opportunity to document ceremonial events and domestic spaces from his teepee. Though Pollard's and Curtis's Native American subjects may not have understood the photographers' artistic purposes, they actively interpellated the original photographic forms with traditional knowledge and values that address their own people. Photographs, therefore, hold traditional storytelling practices and different forms of knowledge in suspension for future generations to assimilate through observation. The picture construction is thus not only a dialogue between the photographer and the subject but also a performance for any person who sees the picture. The purposes of the picture production are organized differently in the consciousnesses of the photographer and the subject, but mutually through their collaborative act. The photographer emphasizes emotion, composition, and artistic effects, whereas the subject may use

the social occasion as an expression of individuality, competence in the community, or performance of culture.

Old narratives recirculate a hundred years later and Pollard's Big Belly portrait resonates again in a poster for Loretta Todd's film *Kainayssini Imanistaisiwa: The People Go On* (NFB 2003). It features a man with waist-long braids wearing an outfit similar to the clothing from Article 6, Treaty Number 7. The man is in profile and donning a European hat with a smaller brim. He also surveys the land, possibly even the site of a ceremonial camp where much of Todd's film was shot. He wears fashionable sunglasses and holds a black and white sun umbrella, more portable than the teepee: Both items are products of industrialism and signifiers of leisure and recreational pursuits. The poster presents digitized clouds and a paint box yellow fabricated sun. As in Big Belly's portrait, the Queen's white man clothes in this poster are not simply retro fashion. Nostalgia and disidentification coexist in precarious balance. The viewer of the poster looks up at our idol like the girl in the Big Belly portrait. These works are pierced by the traditional storytelling forms of their indigenous subjects in a referentiality to a continuum of history by location, place, and position. The message is clear that "the people go on."

Blackfoot and Sarci people, like other indigenous peoples, appropriated the moment of photographic collaboration with Curtis and Pollard into a continuum of their own historical narrative, particularly on ceremonial and reserve land. Loretta Todd's film *Kainayssini Imanistaisiwa* uses Pollard's photographs in its documentary narrative and reconfigures them into a competing interpretive framework. While drawing on tropes of identity from Euro-Canadians and First Nations communities, she creates a nonlinear and multilayered text where a cross-reading makes a powerful address to indigenous persons.

The notion of a vanishing culture is subverted by a mnemonic outpouring of impressions and historical encounters where indigenous subjectivity surfaces. Land, memory, and knowledge re-circulate through a new use of the colonial photographs that describe elder actions in an encounter with Euro-Canadians. This framework constructs "voice." The Pollard photographs in the Todd film are thus a re-appropriation that recontextualize, refract, and re-present an architecture of national identity (Kapferer & Kapferer, 1997). Indigenous self-identity in these images is at once epistemological, ideological, and subversive because the images challenge all that is invented within the Euro-American trope (Zonn & Winchell, 2002).

The indigenous belief in cultural renewal is the reason for the return of artifacts from distant museums. Collected by colonial travelers entrusted because of expectations that white society would become part of indigenous cultures, these sacred objects occupy a Third Space in the historical narrative and exist in a disidentification with the teleological museum project. On both sides of the camera, individuals engage in a dialogue about understanding the "other" in an ensemble creation of the photograph. Filmmaker Todd places ancestor portraits in recognizable indigenous ceremonial grounds to tell a story differently in a decolonization of a modernist framework of galleries, museums, or institutions of higher learning. She projects them on white flags that wave and ripple on the grasslands, as a powerful evocation of peace, memory, and cultural renewal. If photography can be seen as a tech-

nology of mapping, it thus identifies points of departure, destinies, and trajectories that connect and normalize spatial conceptions. As cross-cultural collaborations, photographs and indigenous media thus may offer new resources and perspectives to Third Space negotiations which impact on treaty processes, particularly where "Indian title" was in the past admitted and where no actual historical agreement actually existed.

REFERENCES

Anderson, J. C. (Ed.). (1977). *Roy Stryker: The humane propagandist.* Louisville: University of Louisville.

Barthes, R. (1977). "The death of the author" from *Image, music, text.* (S. Heath, Trans.). New York: Hill & Wang.

Bhabha, H. (1994). *The location of culture.* New York: Routledge.

Brady, P. (1999, May 10). *Out of one, many: Regionalism in FSA photography: Stryker and the FSA.* Retrieved July 13, 2006, from http://xroads.virginia.edu/~UG99/brady/fsa.html.

Clifford, J. (1988). *On collecting art and culture: The predicament of culture.* Cambridge, MA: Harvard University Press.

Fabian, J. (1995). Ethnographic misunderstanding and the perils of context. *American Anthropologist, 97,* " pp. 41–50 .

Firmstone, J. (1975). *Harry Pollard: Chief Little Picture Man.* Unpublished manuscript, Provincial Archives of Alberta.

Foucault live (interviews, 1966–84). New York: Semiotext(e), 1989.

Foucault, M. (1972/1989). *Archaeology of knowledge.* London: Tavistock Publications.

Haraway, D. (1991). A Cyborg manifesto: Science, technology, and socialist-feminism in the late twentieth century. In Haraway D. (1991) *Simians, Cyborgs and Women: The Reinvention of Nature.* New York: Routledge, pp.149–181.

Harries, P. (2002) *Photography and the rise of anthropology: Henri-Alexandre Junod and the Thonga of Mozambique and South Africa.* University of Cape Town: Iziko Museums of Capetown, South African Museum. Retrieved October 22, 2002. http://www.museums.org.za/sam/conf/enc/harries.htm.

Kapferer, B., & Kapferer, J. (1997). Monumentalizing identity: The discursive practices of hegemony in Australia. In D. Palumbo-Liu & H. U. Gumbrecht (Eds.), *Streams of cultural capital.* Stanford: Stanford University Press.

Kehoe, A. B. (1996). Transcribing Insima, a Blackfoot "old lady." In J S. H. Brown & E. Vibert (Eds.). *Reading beyond words: Contexts for Native history.* Peterborough: Broadview Press Ltd.

Landry, D., & MacLean, G. (Eds.). (1996). *The Spivak reader.* New York: Routledge.

Lange, Dorothea (1960). *Popular photography,* p. 264. See also Library of Congress, Dorothea Lange's "Migrant Mother" Photographs in the Farm Security Administration Collection: An Overview at http://www.loc.gov/rr/print/list/128_migm.html

Library of Congress. (Apr. 25–2001). *Edward S. Curtis's* The North American Indian. Retrieved October 24, 2002, from http://memory.loc.gov/ammem/award98/ienhtml/curthome.html.

Martineau, H. (1988). "How to observe morals and manners." In M. R. Hill (Ed.), *How to Observe Morals and Manners.* New Brunswick, NJ: Transaction Books. (Original work published 1838)

McMaster, G. (1998). *Reservation X: The power of place in Aboriginal contemporary art.* Hull: Goose Lane

Editions/Canadian Museum of Civilization.

Mirzoeff, N. (1999). *An introduction to visual culture*. New York: Routledge.

Munoz, J. E. (1999). *Disidentifications: Queers of color and the performance of politics: Vol. 2. Cultural Studies of the Americas*. Minneapolis: University of Minnesota Press.

National Film Board of Canada. (2003, 70 min.), *Kainayssini Imanistaisiwa: The People Go On*. dir. Loretta Todd.

Reinharz, S. (1992). *Feminist Methods in Social Research*. Oxford: Oxford University Press.

Rosler, Martha (1989) in, around, and afterthoughts on documentary photography, in Richard Bolton (Ed.) *The contest of meaning: critical histories of photography*. MIT Press.

Smithsonian Institution Libraries. *Frontier photographer: Edward S. Curtis*. Retrieved October 23, 2004, from http://www.sil.si.edu/Exhibitions/Curtis/curtis-play-3.htm.

Spivak, G. (1988). Can the subaltern speak? In C. Nelson & L. Grossberg (Eds.), *Marxism and the interpretation of culture* (pp. 271–313). Chicago: University of Illinois Press.

Thomas, Jeff. (1997). "Luminance—Aboriginal photographic portraits" in Aboriginal Portraits Library and Archives Canada, http://www.collectionscanada.ca/aboriginal-portraits/050101_e.html, access date June 7, 2006, p. 4.

Waugh, T. (1990/1991, Winter). Words of command: Notes on cultural and political inflections of direct cinema in Indian Independent Documentary. *Cineaction*, 23.

Wilkins, R. (1992, November/December). "White Out": *Mother Jones*, 17:6, p. 44–48.

Zonn, Leo and Winchell, Dick. (2002) "*Smoke Signals: Locating Sherman Alexie's Narratives of American Indian Identity*," in Cresswell, Tim and Dixon, Deborah, Eds., "*Engaging Film: Geographies of Mobility and Identity*," Rowman & Littlefield Publishers, Inc., New York, pp. 140–158.

Hollywood's Curriculum of Arabs and Muslims in Two Acts

Shirley R. Steinberg

Introduction

One of our students from Brooklyn College called on September 13, 2001 to say she could not attend that evening's class. An observant Muslim, this student wore a modest veil to school. As she attempted to shop on September 12 in her predominantly Muslim part of Flatbush, she was spat upon and called names. She realized that her safety was in danger, and she should not go to school that week. We saw several instances that echoed this student's experience. My partner called the CNN news desk and asked to speak to a researcher. He related the student's story and suggested that CNN investigate and cover the anti-Muslim incidents in Brooklyn during this period. The reporter laughed and told him that they had more important events to cover, and that, indeed, maybe these incidents should happen more often—maybe his student got what she deserved.

After September 11, I continually watched each breaking news story, in every venue. I knew I had to write about what I saw, heard, and felt. Moreover, I was curious to see how others responded to the barrage of media stemming from that fall day. What emerged in my media saturated brain? What was it that kept my attention? Romping through the con-

struction of my consciousness dealing with Muslims and Arabic-speaking people, I realized how very easy it was to hate Arabs, to hate Muslims. As soon as those two planes had hit the Twin Towers, the American public was spewing volatile observations about all Arabs, all Muslims. It really took no time at all for an entire country to explode into rampant Islamophobia.

How long had I been aware of Muslims? Of Arabs? As a Jew, I have always been aware of my sister religion. In early religious classes I learned that a slave woman, Hagar, had borne Ishmael from Abraham and this lineage begat those considered Arabic. The children of Sarah and Abraham became the Jews. Religious mythology followed me throughout my life—stories of how Arabs became dark-skinned, versions of nomadic existence, and exotic tales from *The Arabian Nights*. I remember watching many early films with Arabs as grand fighters, usually brandishing swords, fighting the white man. I recall veils, belly dancing, tents, camels, large-toothed men with rifles and dirty robes.

Act One

When did popular culture collide with my religious stories? In 1962, I sat through *Lawrence of Arabia* (Spiegel & Lean, 1962). It did not take long to get the point, and the remainder of the show was tedious: a minor officer from England was sent to visit Prince Faisal and ended up leading an army of Arabic tribes to fight the Turks—he was a hero. I guess that was my earliest media exposure to Arabs.

Sometime around 1968, *Time Magazine* featured a cover story on the plight of the Arab refugees. I recall giving a speech based on the issue; my sixteen-year-old brain could not understand why the Arabic countries surrounding Israel would not let their Muslim brothers and sisters into their homelands. I understood why the Israelis did not make room—the country was too small and had been given to Jews. My social studies teacher didn't know anything about it.

Then in June 1968, just down the freeway from my school, Robert Kennedy was shot by Sirhan Sirhan, defined in the news as "a man of Jordanian descent." Many readers may remember the dark and swarthy photos of the murderer, who quickly disappeared from our news limelight. A lot of Americans thought all hopes of social equity and freedom died with Bobby that day, at the hand of the Arab.

Four years later, when I began a new college semester, the news hit that Israeli athletes had been kidnapped at the Munich Olympics by Arab terrorists, a group known as Black September. We were glued to the television as we watched cameras cover the occupied residences; we saw shadowy figures identified as the kidnappers on the phone negotiating with authorities. Then we saw the German police shoot and kill the terrorists and athletes on the tarmac of the Munich airport. I have flown to Munich once, and I assumed the tarmac was still there. No one was able to show me where it was. Almost a quarter of a century later, Steven Spielberg produced *Munich* (Kennedy, Mendel, Spielberg, Wilson, & Spielberg, 2005). Ironically, the film did not deal with the city nor with much of the terrorist and ath-

lete action. It was a story of the supposed retaliation of the kidnappings by the Israelis. The film followed the murders of many of the Muslim suspects. The film was problematic on almost every level: the justification of the revenge killings; the fact that the German authorities were never implicated in the shootout at the airport, and the image of the Twin Towers on the horizon at the end of the film. What knowledge did this loosely-historical/fictional film give to the viewers? Many people with whom I spoke had never heard of the Munich massacre, and now Spielberg has given them their history.

I had not visited New York City after the Twin Towers had been built. When the World Trade Center was bombed in 1993 it was shocking, but very removed from my life. I had never seen the buildings. Few were killed, but lots of expensive cars were destroyed. The news reported it was the work of Arabic terrorists. In 1994 we went to New York and scanned the World Trade Center to see where the bomb had hit. We were astounded at how huge the buildings were and how small the bomb damage had been. The buildings were obviously indestructible.

In 1996, I was watching CNN in a hotel in San Francisco—a bomb had destroyed a federal building in Oklahoma City. The first reports from the radio, TV, and papers indicated that Arabic terrorist groups had planned the mass attack. Hours later, a white man was in custody. No apology was offered to the previously identified, supposed perpetrators. Some Arab Americans complained about the erroneous accusation, but the news quickly moved on to the unfolding Timothy McVeigh story. Upon reflection, I do not recall any attempts by American citizens to spit upon Irish Catholics (McVeigh's background), attack McVeigh's hometown, or pull over white men of 30 who resembled the lanky terrorist.

A network break-in to regular programming in 1997 revealed the headline that Princess Diana had been killed in an auto accident along with her boyfriend, Dodi Fayed. Fayed was a Muslim, an Egyptian, whose wealthy father had been denied British citizenship by the Queen—the elder Fayed owned Harrod's of London. Continued tabloid coverage over the years has claimed that Diana could have been murdered in order to keep her from humiliating the royal family by her relationship with an undesirable man.

By the time the first plane hit in lower Manhattan that Tuesday in September, many Americans' cultural curriculums had been imprinted and validated. I believe that was why it was so easy to hate Arabs and Muslims. Naturally, we would be able to hate terrorists, but McVeigh was a terrorist, and our hatred and outrage was limited only to him, not his entire culture, religion, state, or community. Media literacy being my field of study, it was obvious that I would analyze the cultural pedagogy of Hollywood—how had Muslims and Arabs been depicted by Hollywood?

I maintain that if pedagogy involves issues of knowledge production and transmission, the shaping of values, and the construction of subjectivity, then popular culture is the most powerful pedagogical force in contemporary America. The pedagogy of popular culture is ideological, of course, in its production of commonsense assumptions about the world, its influence on our affective lives, and its role in the production of our identities and experiences (Grossberg, 1995). Movies help individuals articulate their feelings and moods that

ultimately shape their behavior. Audiences employ particular images to help define their own taste, image, style, and identity—indeed, they are students of media and film pedagogy. Audiences often allow popular culture vis-à-vis films, to speak for them, to provide narrative structures that help them make sense of their lives. This emotional investment by the audience can often be organized in emotional/ideological/affective alliances with other individuals, texts, and consciousness formations.

Thus, this affect mobilized by the popular culture of film provides viewers with a sense of belonging, an identification with like-minded individuals—this feeling becomes progressively more important in our fragmented society (Grossberg, 1995). Keeping in mind the complexity of the effects of film popular culture, the affect produced is different in varying historical and social contexts. With these notions in mind, I went in search of the assumptions that may have been made in the viewing of films containing Arab or Muslim characters. I did have a couple of research questions in mind: Why is it so easy for many North Americans to hate Muslims? Why are they so easy to fear and blame? With these questions, I hoped the films I viewed would shed some tentative answers, and, more importantly to my own scholarship, ask more questions.

I selected movies when my viewing signaled that there was sufficient depiction of Arabs and or Muslims to discuss. I asked others if they recalled any films that I should be viewing. Consequently, these films were culled out of our combined cultural collective. I did not consult written research in order to gather my films; I wanted to know what stood out in our minds from films that depicted Arabs and Islam. I viewed seventeen films and scripted scenes and/or dialogue that needed re-examination. After I had gathered these data, I revisited my notes in order to identify themes, archetypes, and auteurship in the films.

Islam in Contemporary Film

Most of the films I viewed dealt with Muslim Arabs. However, *Not Without My Daughter* (Ufland, Ufland, & Gilbert, 1990) and *East Is East* (Udwin, Khan-Din, & O'Donnell, 1998) are films about Muslims, not Arabs (those from the Arabian Peninsula). Sally Field's compelling, yet whining performance in *Not Without My Daughter* (based on a true story of one woman's experience), dealt with an American woman married to an Iranian doctor who deceitfully brought his wife and daughter to his home in Iran. Sally did not want to go: "We can't go to Iran—it's much too violent." Swearing on the *Qur'an*, "Moody" promises they will be safe. After reaching Iran, greeted by a slain goat (in their honor), Sally is horrified. Cultural analysis is attempted by Sally and her spouse: "It just seems so primitive." "Beliefs seem primitive when they aren't your own." Mother and daughter become prisoners as the husband reverts to Ayotollah-generated fundamentalism. "Islam is the greatest gift I can give," assured Moody. Persian women (in full black burqahs) are yammering, scheming, whispering, and occasionally beaten by their husbands or other available men—this was a dark, frightening, and smothering world to the former Sister Bertrille.

Field's character is starkly white in comparison to the darkness that cinematographi-

cally depicts the Muslims in the film. Women peering out of slits in their burqahs are routinely belittled, demeaned, and marginalized by their husbands. There are occasions when Field's character attempts to bond with women and ask for their help. Alas, everyone turns against her, shuns her, or turns her in to her husband. Islam is depicted as unreasonable, and Moody is equally unreasonable, as he immediately becomes a tribalized tyrant to his wife and little girl. When Field reminds Moody of his promise made on the *Qur'an* and tells a holy man of this breach of faith, she is met with verbal attacks by everyone within earshot. A message is sent to the viewer that Islamic vows on holy books are not kept, and holy men are indeed, as evil as everyone else. *Not Without My Daughter* is based on a true story. Obviously, I am in sympathy with anyone whose child is stolen and who is abused by a spouse. However, the film does not center on the marital issues as much as it is an indictment of the entire community in Tehran.

East Is East is BBC-produced and deals with a lower-middle class Pakistani man who marries a British woman. He insists on being a traditional Muslim, and his wife respects that—as long as her husband does not catch the children carrying the statue of Jesus during the Easter Parade. As the children are proudly marching in the parade, someone warns them that their father is approaching. They toss the religious statues to other people, peel off their costumes, and dash home to be there before their father opens the door. He is obviously stupid for not catching on, and the family continues the ruse, being Muslim to their father, but really being Christians.

Dad is devastated by his older son bailing out of his own arranged wedding. He tries to match-make the other sons: "I'm not marrying a fucking Paki." As a father he is overbearing in his desire to see his children as happy Muslims—he adds insult to injury as he pushes his gift of an Arabic watch onto each child. He has been saving these watches for a special time and ceremoniously presents each of them with the watch. They explode with anger and disgust imagining that they would actually wear a watch with strange symbols. They are angry when he insists they go to a school to learn the *Qur'an*. After various defeats, a broken man, he begins to beat his wife and children. Once again, cinematography plays an important role as the camera angles began to change; as the father gets meaner, his character is being filmed from below the nostrils of his huge, sweating, bulbous nose—he also had yellowed, crooked teeth. Within an hour of the film, he transforms from a princely, kindly father and husband (in both appearance and context) to an evil fool. Frustrated, he bemoans that neighbors think he is a barbarian.

Sidekicks to White Men

The rest of the films were about Arabs—those from Arabia (or countries divided from Arabia). With the exception of *Lawrence of Arabia* (Spiegel, S., & Lean, D., 1962), all movies were filmed in the West. *Lawrence of Arabia* is a dramatic (and long) saga about a blond, blue-eyed Englishman who, caught up in the myth of Arabia and the desert, convinces marauding rival Bedouin bands of "barbarians" to unite in their fight against the

equally barbaric Turks. Peter O'Toole's character is a prototype to Sean Connery and Mel Gibson and is accompanied by Omar Sharif, once an enemy—now a converted sidekick. Angering the British; "Has he gone native?" Lawrence eventually leaves Arabia—naturally in better condition than he found it: "I did it." "Arabia is for the Arabs now."

Sharif, as a desert sheik, begins as a proud, brilliant warrior. However, as he is tamed by O'Toole, he becomes his bodyguard, brother-in-arms, and gives his life for O'Toole. He is reduced in the film from a man of stature to a colonized camel rider. Naturally, he is the example for others to follow. It is obvious to all who watch that the Arabs in tribal form could never survive and that the British and Lawrence were sent as divine leaders to organize and unite the different groups. Interestingly, even as Lawrence exoticizes the natives, wears their clothing, rides camels, and imitates their lives, he never forgets that he is an Englishman, and that they are barbarians: "Any time spent in a bed would be a waste—they are a nation of sheepskins." "They (the Arabs) are dirty savages." "Arabs are a barbarous people."

As with Sharif in *Lawrence of Arabia,* many of the films introduce a sidekick character for the white male lead. Loyal and faithful to death, the Tonto-ized friend is simpler, devoutly Muslim, full of Islamic platitudes and premonitions, and is frightened easily. In two of the *Indiana Jones films (Indiana Jones and the Raiders of the Lost Ark,* Lucas, & Kazanjian, & Spielberg, 1981) and *Indiana Jones and the Last Crusade* (Lucas, & Marshall, & Boam, & Spielberg, 1989), both of which are set in the Middle East, Indy is accompanied by his Egyptian pal who fears that Indy's ideas are dangerous and will create anger from Allah. He attempts to convince Indiana that he is not stupid: "even in this part of the world we are not entirely uncivilized." Endangered at times, this minstrelized sidekick puts his hands in the air, opens his eyes widely and shouts for safety. Tonto is a Spanish word for stupid or idiot.

Arabs as Window Dressing

Ironically, films that were Arabic in context and content, had little to do with Arabs. *Abbott and Costello Meet the Mummy* (Christie & Grant, & Lamont, 1955), *Casablanca,* (Wallis & Philip, & Epstein, & Curtis, 1943), *The Mummy* (Daniel & Jacks, & Sommers, 1999), *The Mummy Returns* (Jacks, & Daniel, & Underwood, 2001), *Ishtar* (May, 1987), and *The Jewel of the Nile* (Douglas & Rosenthal, & Konner, & Teague, 1985) contain plots directly concerned with Arabic/Islamic themes. Actors with dialogue, though, are western. Depending on the film, extras appeared to be Arabic. Action shots with Arabic peoples are almost exclusively shot in loud marketplaces. No heads are left uncovered; the fez is an accessory of choice for comical extras. The militaristic extras (sword carrying) most often wore a kaffiyeh (couture Arafat), and several Arabs sported turbans. What struck me about the extras was the "clumping" in which they would always appear. Let me borrow from Joe Kincheloe as he describes the French Fry Guys of McDonaldland: "The most compelling manifestation of conformity in McDonaldland involves the portrayal of the French Fry Guys.

As the only group of citizens depicted in the Hamburger Patch, these faceless commoners are numerous but seldom seen" (Kincheloe, 1997).

> They intend to look, act, and think pretty much alike. Parent French Fry Guys are indistinguishable from children, and visa versa. They are so much alike that, so far, no individual French Fry Guy has emerged as a personality identifiable from the others. They resemble little mops with legs and eyes and speak in squeaky, high-pitched voices, usually in unison. They always move quickly, scurrying around in fits and starts . . . (McDonald's Customer Relations Center, 1994)

Kincheloe goes on: "As inhabitants of a McDonaldized McWorld, the French Fry Guys are content to remove themselves from the public space, emerging only for brief and frenetic acts of standardized consumption—their only act of personal assertion." In these films, Hollywood's French-frying of Arabs leaves them to stand in clumps, to surround the action, to yell loudly in the background, and to run the market. They are incompetent in keeping their shop area organized as someone is always running through it, knocking the wares down and leaving a fist-flinging kaffiyeh-clad merchant screaming from behind.

Messianic White Boys and Nasty, Dirty Arabs

Included in my content/discourse analysis of these films was woven the weft of the white, male leader: sent to save citizens or artifacts from unscrupulous individuals. Lawrence and Indiana serve as perfect Aryan messiahs to these dark, mysterious Muslims. The word *barbaric* (or barbarous, barbarian) was used in each film. *Aladdin* (Disney Studios, 1996) opens with an overture and opening song that describes the mysterious, dark, barbaric East. Physical characteristics of the Arabs generally show bad teeth, large hooked noses, and unclean tunics and caftans and headgear that are just a tad too exaggerated. Once again, *Aladdin* does not run more than five minutes without describing one of the Arabic characters as "pungent." The films I viewed metaphorically included aroma vision, as one could vividly smell the camel dirt smeared, sweat clinging clothing of Muslim characters.

The market scenes imply that Islamic countries center their cities and livelihoods on the marketplace. The Shylockization of these people is obvious in their attempts to barter and cheat consumers. Indeed, once again, in *Aladdin*, the fat, toothless, dirty Arab "businessman" flings out his tablecloth and for-sale sign and indicates that anything can be bought for a price. As I take in his hooked nose and sales pitch, the Semite in his character reminds me vividly that both Jews and Arabs share many of the same stereotypes: they lie, cheat, and steal.

Prototyping Hatred

Islamic characters are not only compared to other Semites through an analysis, but to other marginalized groups. There were many, many visible comparisons to Hollywood depictions and assumptions about African Americans. Many times I was sure that the negrofication

of these characters served to show that any hated group can be exchanged with another. Exemplifying this is the language that served to incant slurs to African Americans: sand nigger and dune coon were among the nastiest I heard in the films.

Negative characteristics of Arabs and Muslims are not compared to those of white people. While Indiana Jones deals with Nazis in *Raiders*, their characters adhere to the traditional expectations of viewers. The Nazis are anal, obsessive (anal-obsessed?), cruel—but clean and human. The characterization of Arabs always has an underlying implication that puts them on the borderline between human and animal. In each film, whiteness is the standard to which all Arabs and Muslims are measured. In addition to the racism that whiteness nurtures, the categories, the lexicon, the otherization, all become stenciled from one race and ethnicity to the other. When a group of people has been defined and depicted with such singular definition, it seems apparent that viewers can become complicit in fear and racism.

24 Ways to Stereotype on Television

When I first published a vesion of this article in my and Joe Kincheloe's book, *The Miseducation of the West: How Schools and the Media Distort Our Understanding of the Islamic World* (Kincheloe and Steinberg, 2004), I was concentrating on the images of both Arabic peoples and Muslims in film. 9/11 had just happened, and the public was quick to make connections to the stereotypes of Arabs and Muslims seen in the cinema. Television had, for the most part, ignored, avoided, or just didn't bother with much in the way of Islamic or Arabic themes, characters, or even plots. The short-lived *Whoopi* (2004–2004) sit-com did include Whoopi Goldberg's sidekick, Nasim Khatenjami, played by London-born Iranian comedian, Omid Djalili. The interplay of the two characters was indeed refreshing, and Djalili's character's asides were insightful and addressed issues that were at play in anti-Arabic sentiments (naturally, the show was cancelled within a year). Other than *Whoopi*, Arabic, and Islamic characters had seldom been part of American TV landscape.

When the 24-hour-a-day broadcasts of 9/11 had become yesterday's news, there was a period in which television seemed to have declared a silence on all things Arab. Occasionally a show would mention September 11, and a few dramas would bring in racist behaviors against Muslims. *Law & Order, NYPD Blue* and other dramas were some of the first TV shows to have shows based on racism against Arabs. A common scenario included a store or restaurant owner and a terrorized and tortured family, victims of those who blamed 9/11 on them. The Islamic families were portrayed as hard-working and honest, and the show was well-received. Thematic shows grew around the issue of white/American hatred and fear of Arabs and Muslims. It began to appear that television that different shows were willing to tackle the notion of Islamophobia by association to 9/11. Possibly TV would be a medium which would equalize the overt racism associated with cinematic Muslims and Arabs.

My hopes were brief, the warm vibes that television had begun to radiate cooled off and Arabic- and Muslim-badguy-themed shows emerged. Kiefer Sutherland's blockbusting hit, *24*, was supposed to debut in September 2001. After the World Trade Center attacks, Fox

network and Sutherland determined it would be prudent and politically sensitive to delay the show until late fall. Based on a fictional American *Counter Terrorist Unit*, Sutherland's Jack Bauer would save the day each season fighting world-threatening terrorist threats. Due to the nature of the show, producers felt it would touch nerves so close to September 11, it would be *in bad taste*. The show finally began late in 2001, ranking between 29th and 74th for the first three seasons. Jack Bauer saved the world three years in a row, having fought biological weapons, South American terrorism, and a manipulative and sociopathic First Lady.

In 2004, the fourth season of *24* featured a Muslim family: mother, father and teenaged son engaged in a deadly day. An upstanding, middle-class, suburban family, Navi, Dina, and Berooz Araz are thrown into chaos by Turkish Muslim terrorist Habib Marwan's desire to destroy the United States. Navi and Dina had been planted in Los Angeles as part of a small cell whose existence was based on waiting for Marwan's signal to join the jihad. Sixteen-year-old Berooz had not been aware of his parents' other life, and faced his *own father's* attempt to kill him when Berooz tried to stop the terrorists. Familial love was replaced by Navi's barbaric allegiance to Marwan's evil goals. As I began to view that new season of *24*, I watched the first episodes waiting for the foil—the twist, one that would take us away from the plot that was starting to develop. My media-viewing mind was begging Sutherland to *not go there*. I started to see that Hollywood's détente with Arabs and Muslims was over. They became fair game for directors and producers, and a support system for American governmental policies in the Middle East.

The only twist was the tension produced in a new narrative: the evil terrorist Muslims were counterbalanced by the good Muslims. Young Berooz rebelled against his terrorist inheritance, never wavering from his commitment to goodness and the US. Dina reluctantly worked with Jack Bauer to bring down Habib Marwan, and Navi, the evil father was killed. The season ended with Jack victorious and viewers were torn between the terrorist threat of the Turkish Muslim cell and the innate goodness of young Berooz. A polarized view of the Muslims was left with the audience, for every bad Muslim there was a good Muslim. Other than the depiction of the terrorists as evil, dark-skinned, determined fundamentalists, Fox could claim plausible deniability as to anti-Muslim sentiments. Themes were established that

1 Muslims are in our midst, hiding among us, they can be upscale; can be our next-door neighbors
2 they would do anything, even kill their own child for the cause
3 occasionally there are good Muslims who step up to serve the greater good of America.

Season 4 brought *24* into the top 25 shows of the year. I certainly never expected an Islamic-themed *24* again, Fox had pushed it as far as it could go and was lucky to get away with it. Smartly peppering the bad guys with the redeemable Muslims, they had made it through a highly-rated season.

Season 5 of *24* returned Jack Bauer to a terrorist plot that dealt with internal political

terror. Before the premier of Season 6, the US was going through political changes. The Bush administration suffered an overwhelming loss to the Democrats in the November election and the American public was ostensibly becoming anti-war in regard to the occupation of Iraq. Television news was a hotly contested venue between the far-right via Fox news and conservative talking heads and the newly vocal "liberal" reports. After losing Republican seats and acknowledging that Iraq was not working out as planned, the Bush regime began to repeat their worries of losing to not only the angry Iraqi people, but to the terrorists who wanted to take away our freedom and occupy our own country. There became a need to re-vilify and ratchet up the vilification of Muslims.

An unprecedented media campaign on major news programs highlighted the January 2007 return of Jack Bauer. As in previous seasons, no one was privy to the plot of the new year, and since Jack had conquered Latin American, Russian, Turkish, and presidential terrorists, Fox would have to come up with something new. The first four episodes of the show were aired back-to-back, indicating that again the show was relying on Muslim-themed terrorists.

Premiere Season 6 of 24. Jack Bauer's day begins with his realization of urban unrest. Terrorist attacks are taking place all over the United States; the entire country is in a state of panic and alert. The man who is blamed for the attacks is Assad, and the audience is quickly aware that the plot will again be Muslim terrorists in 2007: "these people are in the stone age," a government agent explains. This time Fox had not anticipated the public and media uproar created by the first six episodes. Within the first two nights, Islamic terrorists had exploded the first of five nuclear bombs in urban Los Angeles. (As the story was told, I narcissistically felt that someone in production had read my work on Hollywood stereotypes and made a point of planting them in every frame possible).

Jack Bauer joins with reformed terrorist Assad, to apprehend Abu Fayed, the author of the domestic chaos and death. Fayed has been running a cell out of Los Angeles. Scene switches to a Los Angeles upscale suburb, and we see two large white men beating a teenaged Muslim Ahmed. He is saved by his best friend's father, and brought to the safety of their home. The father and his son are astonished at the unreasonable racism demonstrated towards an innocent family. Ahmed's father was not home, and they insist he stay with them. Very quickly Ahmed's demeanor changes and he is an irrational Islamicist who is indeed, part of Fayed's cell. Somehow Fayed has recruited this young American Muslim into his plot, unbeknownst to even his father. Ahmed holds the family hostage and threatens to kill them. We learn again, that suburban, upscale "nice" Muslim families can, indeed, be sleeper cells.

Meanwhile, in Washington, the president's sister, who heads the Islamic American Alliance has been arrested along with her colleague, Walid. They have been unlawfully held against their will, she calls her brother who reminds her that these are terrible times and there is no protection from unreasonable search and seizure, that the terrorist activities demand that war measures be taken. The two are taken to a holding camp full of Muslims. Quickly, the sister is released, leaving Walid in the prison yard. Walid overhears men dis-

cussing terrorist activities and quickly realizes they are involved in the attacks all over the country. The viewer is given a second lesson, there is a reason for unlawful arrest, because chances are, badguys will be included in the sweep.

The shell-shocked Jack Bauer had planned to quit CTU, however, after realizing what the Muslim terrorists had done, he remarks that "he is back, he [is not quitting], not after this."

Again, themes are established:

1 they can be anywhere, hiding in our best neighborhoods

2 even the youth are involved in terrorist endeavors; they will kill you, even a best friend who has saved your life

3 suspension of habeas corpus is justified because in the 21st century world of jihad, it works to identify Muslims and Arabs, thus possibly stopping the terrorists and thwarting their actions . . . even if some innocents are involved—it is indeed, for the greater good.

24 is Dick Cheney's favorite show.

Are You Sleeping?

Cable TV's *Sleeper Cell* reinforces the fears that *24* has begun, but takes it miles further. *Sleeper Cell* first aired in December of 2005 on Showtime; its first two seasons went unchallenged and flew far below any entertainment news or network news radar. Created by writing partners, Ethan Reiff and Cyrus Voris, the show features the first American Muslim protagonist, Darwyn, played by African American Michael Ealy. The show taglines may save me time delineating some points:

Friends. Neighbors. Husbands. Terrorists.
The enemy is here.
Know your enemy.
(2005; www.http//indb.com/title/H0465353/taglines)

Sleeper Cell: American Terrorist uses different opening credits. One of the most significant openings played in Season 1: the music was distinctly soft, a cello playing an Arabic tune, a map appears, it shows the boundaries of Iraq on the top and Arabia as the "country" on the bottom of the map; as the credits flash faster, the music picks up, becomes louder, and has women wailing indistinguishable Arabic sounds. Quick vignettes of white children in swimming pools, white people shopping, flashes of the American flag, dark Arabic-type men, flash back to American flag, white kids playing in a park—music gets louder, long shot to a GPS centering in on a neighborhood, then a large, suburban home, the GPS locks on the home, close up, show begins.

To eliminate long summaries, I will bullet some of the episodes from the first two seasons:

Season 1: *Sleeper Cell: American Terror*

- Episode 1: American Muslim Darwyn goes undercover for FBI to uncover sleeper cells. He is recruited at a synagogue by a Holy Warrior. Taken to the desert, Darwyn is encouraged to stone a traitor to the group, he shoots him instead.
- Episode 2: Anthrax becomes the threat, probably for a shopping mall. Darwyn makes more connections.
- Episode 3: Mexican money is to come through the border to finance the plot.
- Episode 4: The Mexican money dries up, so it will come through Canada.
- Episode 7: A young Afghani boy approaches the terrorists to become a jihadist.
- Episode 8: White supremacists cooperate with the Holy Warriors in order to get explosives.
- Episode 9: A truck is hijacked; it is disguised as a LA Airport Mobile Emergency Command Vehicle. Two more cells in the US have been discovered.
- Episode 10: The cell escapes FBI surveillance.

Season Two: *Sleeper Cell: American Terror*

- Episode 1: Darwyn tries to leave FBI and cell, but his FBI contact, a woman, is beheaded in the Sudan by terrorists.
- Episode 2: The leader of the cell, Farik, played by Israeli Oded Fehr seems impossible to break under questioning.
- Episode 3: Farik is deported to Saudi Arabia in hopes that he can be tortured legally there and give up the cell. Cell orders Darwyn to get a weapon.
- Episode 4: Darwyn saves the life of an Islamic televangelist. One of the terrorists watches the evangelist on TV as he runs on a treadmill between two blonde women. Farik escapes Al Queda prison in Saudi Arabia.
- Episode 5: Nukes become the next threat to Los Angeles.

And so it goes. A search of the Showtime website allows the surfer to play a game in which he or she becomes the member of a sleeper cell. An Islamic dictionary is featured: *Learn the definition and history behind some of the Islamic phrases used during the show. Study now!*

At the end of a particularly violent episode, Farik is in a palace in Saudi Arabia, dressed in traditional clothing, he is considering Darwyn becoming the leader of the cell in Los Angeles. The closing credits roll, and a rap song is played loudly. I could not find the artist or all of the lyrics on line or on the episode, so forgive my not crediting the lyrics. Here are some of the phrases from the song:

> *"Tell me what you think at this"*
> *"You can never understand til we do what we do"*
> *"I can prove what we do given a situation"*

"I can come up with a plan"
"Never be ashamed, always be proud"
"So go and do what you do, keep watching the news"
"I got a question for y'all,"
"You think we goin' to let another building fall?"
"Never Again."
"Fuck that. . . . Send me back to Iraq."

Using a type of affective ideology (see Kincheloe, J. and S. Steinberg, *Changing Multiculturalism: New Times, New Curriculum*), the audience is given no reason or argument in a scenario or storyline, instead the music behind the credits goes directly to our primal affect; it bypasses any filters within the brain that may use logic or rationale, and leaves us with a visceral impression. One does not expect the listener to politically deconstruct these lyrics, the affective part of the mind draws the connection between a falling building and Iraq and consequently, the invasion and occupation of Iraq is justified by patriots.

Sleeper Cell may be the very best of the worst in the genre. Each episode is produced with cinematic mastery, every hour with the quality of a fine Hollywood film. The writers and actors are not Arabic, neither are the creators. It is interesting that the lead badguy, Farik, is actually an Israeli Jew who worked for years for Israeli security forces. While Jewish names appear in the credit, distinctly Arabic or Middle Eastern names do not appear. Showtime is a network which has always run edgy and topical shows; however, it has usually leaned to the liberal or left in its ideology.

The cell is extremely threatening to us as viewers; sites chosen for detonation or exposure to deadly chemicals are baseball parks, shopping malls, places in which the normal middle American exists. The cell is insidious, and impossible to break, even with Darwyn planted as a mole, the threat is never extinguished. Ending a season with Darwyn "saving the day," he is handed back his pocket copy of the *Qur'an*; he then finds a lost little blond boy, and the mother thanks him with deep appreciation. He is the Muslim Jack Bauer; he saves the day, but is always aware that the cells grow, and that he must stay with the job. Any badguys that are caught, under the laws of war, are "non-privileged" combatants, they are not put in jail, will not go to trial, and will be placed in holding by the Defense Department. Darwyn's conflicted self is always close to the surface, and when he finishes saving his day, he often retreats to the mosque to receive spiritual solace.

Our themes are repeated and added upon:

1 They are everywhere, they have penetrated to every part of our society.
2 Even vehicles are suspect, an official vehicle can easily masquerade as an emergency vehicle.
3 There may be good Muslims, but there always will be bad Muslims.
4 We are in Iraq for a purpose, to avenge the 9/11 attacks, and to keep Middle Eastern terrorists from American soil.

Again, this content analysis demands that we recognize the advent of *Sleeper Cell* and the seasons of *24* that correspond with the loss of faith in Republican leadership and the demand to leave Iraq from the American public. Media does matter, it speaks to us, and it can be a better tool than any other to reach viewing citizens.

Even the Goodguys Are Badguys

An episode of *Law & Order* (Makris, 2006) opened with an American flag covered by a poster: UNITED AMERICANS FOR ONE AMERICA: ARABS GO HOME. We hear an Anglo voice yelling: "Get up, get up, you Arab pig." A masked man in camouflage pushes a man hooded in black in front of the flag. The entire scene is being videotaped. Another man joins the assailant and they both stand with the victim on his knees flanked by the stars and stripes. The first man speaks: "Lolliyops, towelheads, camel jockeys, you are not Americans, you are parasites living off our citizens, you cheer when our GIs die in Iraq. Why do you live in our country if you hate our way of life?" His partner speaks: "You think we're scared of your jihad? After today, be scared of us, this is our jihad." He takes a knife to the throat of the now-unhooded crying Arabic man, "God bless America!" he slices the throat of the young man. Cut to the law examining the scene. Following the discovery of the video tape, the investigators spend a great deal of time looking for this white supremacist group which is targeting Arabs and Muslims. Going from one dead end to another, the case resolves itself when a cousin of the dead Muslim is found to be guilty. He had created the scenario of supremacists to keep suspicion from falling upon him. Justice is served; the Arabs are the bad guys, and any white supremacists are relieved from suspicion.

In January of 2007, an episode of *Law & Order: Criminal Intent* (Shill, 2007) revolves around the brutal murder of a young Pakistani woman, Meena, who films a group of white and Jewish men beating Latino immigrant workers. The men are seen chasing the woman, trying to take her camera; her film leaves evidence of these white assailants. Hearing a news story of a Jewish woman hit by a car filled with Mexican immigrants on her way to synagogue, the detectives surmise: "this has got to be payback." Discussing the case with a Jewish man (wearing a blue yarmulke with stars of David surrounding it) who admitted being at the beating, he queries: "Some illegal alien runs over a mother and her baby and you arrest me? . . .We didn't hurt the Mexicans, or that Arab girl. We just want these people out of our neighborhood, before they kill any more of our children." Turns out he was telling the truth; his group merely chased her, scared her and went to the synagogue to teach Hebrew. His rabbi backs him up.

The investigators view a film that Meena had made about her family living in New York. Affluent restaurant owners, Meena's parents had lost everything after patrons stopped coming to dine post-9/11. The detectives are emotionally touched as they view this family's own experiences as they are punished for being Muslim.

After investigation, the men who had been filmed beating the men were exonerated. The plot leads detectives to find the Pakistani woman had been in love with an Italian, and

indeed, it seems obvious that he killed her. She was pregnant with his child. The Pakistani parents mourn the death of their daughter and her sexual violation. The father shows his fury by lashing out at the Italian boyfriend. Her brother watches silently as his family disintegrates. A *Romeo and Juliet* story emerges. The families are intent on blaming one another. A marriage had been arranged with a man who has just come to the States from Pakistan. He is gruff and swarthy and much older than the young murder victim. He is a suspect for a few days but makes it clear he would have never hurt her as he had no emotional ties to her. Her pregnancy ruled her unfit to be his wife, and he intended to return to Pakistan.

After Chris Noth's (Detective Logan's) crackerjack psychological cop intervention, Meena's brother breaks down and admits he murdered his own sister to protect the good name of his family: she had humiliated them all.

Both these *Law & Order* episodes promote themes:

1 Even when you think all the Arabs and/or Muslims are not guilty, one of *them* is guilty.
2 Mexican or Arab, immigrants are not welcome in our country.
3 Familial honor is more important than love and loyalty; killing one's sister is honorable.
4 Arabic and Muslim peoples create *white* scenarios to deflect attention from their own criminal activities.

Critical Media Literacy

So then, do we ask why it is easy for many North Americans to hate Muslims? Why are they so easy to fear and blame? We have had concrete reasons to deplore the actions of any terrorists. Islamic terrorism has been tapped as a vehicle to move the causes of many different organizations all over the globe. As a Jew I have always been conflicted as to who has rights over Jerusalem, over the Temple Mount, over Israel. However, my own research has allowed me to reconsider how the construction of my own consciousness has been formed, in large part, by media.

Through my own content analysis of a few TV shows and films, I believe I have isolated dangerous themes which are potent enough to infuse the minds of both children and adult viewers. We offer little or no way to read these themes, to learn how to safely and intelligently view media. Many believe that if it is on TV or placed on film by a legitimate source, then the text is accurate and correct. That text directly feeds our emotional and intellectual selves into making political decisions, personal decisions. If we are able to work with students and parents to learn how to "read" film, the news, the papers, perhaps conversation involving injustice could surround the actions of those that do wrong, not their nationality or religion. We must create a curriculum which enables students to read the media, not to eliminate or censor it, but to *read* it. I maintain my contention that indeed popular culture is a curriculum—an overt, influential curriculum that feeds our need to con-

sume entertainment. This Hollywood diet is not innocent: It is constructed on obsession, stereotype, fear, and most importantly, what sells. I hope we all are able to read the menu.

REFERENCES

Text

Grossberg, L. (1995, Spring). What's in a name? (one more time). *Taboo: The Journal of Culture and Education*, pp. 1–37.

Kincheloe, J. and S. Steinberg. (2004). *The Miseducation of the West: How Schools and The Media Distort Our Understanding of the Islamic World*. Greenwich, Conn.: Praeger Press.

Kincheloe, J. and S. Steinberg. (1997). *Changing Multiculturalism: New Times, New Curriculum*. Open University Press: London, UK.

Kincheloe, J. (1997). McDonald's, power, and children: Ronald McDonald (aka Ray Kroc) does it all for you. In S. R. Steinberg & J. L. Kincheloe (Eds.), *Kinderculture: The corporate control of childhood*. Boulder, CO: Westview Press.

Filmography

Christie, H. (Producer), & Grant, J. (Writer), & Lamont, C. (Director). (1955). *Abbott and Costello meet the mummy*. United States: Universal Studios.

Daniel, S., & Jacks, J. (Producers), & Sommers, S. (Writer/Director). (1999). *The mummy*. United States: Universal Studios.

Disney Studios (Producer). (1992). *Aladdin*. United States: Disney Studios.

Douglas, M. (Producer) & Rosenthal, M., & Konner, L. (Writers) & Teague, L.

(Director). (1985). *The jewel of the Nile*. United States: Twentieth Century Fox.

Jacks, J., & Daniel, S. (Producers), & Sommers, S. (Writer), & Underwood, R. (Director). *The mummy returns*. (2001). United States: Universal Studios.

Kennedy, K., Mendel, B., Spielberg, S., & Wilson, C. (Producers), & Spielberg, S. (Director). (2005). *Munich*. United States: Universal Studios.

Lucas, G., & Kazanjian, H. (Producers). Kasdan, L. & (Writer) & Spielberg, S. (Director). (1981). *Indiana Jones and the raiders of the lost ark*. United States: Paramount.

Lucas, G., & Marshall, F. (Producers), & Boam, J. (Writer), & Spielberg, S. (Director). (1989). *Indiana Jones and the last crusade*. United States: Paramount.

Makris, C. (Director). Nathan, R. and S. Postiglione (Writers). (2006). NBC: *Law & Order*. Season 17, Episode 17006 "Fear America." Airdate: 10/13/06.

May, E. (Director). (1987). *Ishtar*. United States: Columbia Pictures.

Shill, S. (Director), Reingold, J. (Writer). NBC: *Law & Order: Criminal Intent*. Season 6, Episode 06012 "World's Fair." Airdate: 01/02/07.

Spiegel, S., & Lean, D. (Producers), & Lawrence, T. E. (Writer) & Lean, D. (Director). (1962). *Lawrence of Arabia*. United States: Republic Pictures.

Udwin, L. (Producer), & Khan-Din, A. (Writer) & O'Donnell, D. (Director). (1998). *East Is East*. United Kingdom: Miramax.

Ufland, H., & Ufland, M. (Producers), & Gilbert, B. (Director). (1990). *Not without my daughter.* United States: Metro-Goldwyn-Mayer.

Wallis, H. (Producer), & Philip, J., & Epstein, G. (Writers), & Curtiz, M. (Director). (1943). *Casablanca.* United States: Warner Bros.

Culture Weds Capital

A Critical Reading of Gurinder Chadha's *Bride and Prejudice*

Soniya Munshi

Bollywood, the dominant film industry in India, is the largest in the world: It produces over 800 films a year, released to over 13,000 predominantly urban cinemas, in over 100 countries (Mishra, 2002). Bollywood has recently exploded into mainstream western cultural realms. Though popular films from this Bombay-based industry have historically been exported into other sites of the Global South (and, to some extent, the former U.S.S.R), contemporary processes of globalization framed by neo-liberal economic policies, the advent of liberal multiculturalist discourses, and the growth of the South Asian diaspora in the United States and Western Europe have facilitated an expedited entry of these films into the economic North. The growth in the circulation of Bollywood movies has been accompanied by an increase in the circulation of Bollywood-inspired cultural commodities, which often problematically substitute as representations of Indian culture.

The process of commodification and consumption of Bollywood and/or Indian culture is evidenced in diverse popular spheres: fashion (e.g., Saks Fifth Avenue, an upscale department store, has been working on acquiring the works of Indian designers for its stores, the popularity of *kurta*-inspired shirts for women); music (e.g., the trend of American hip-hop artists sampling old Bollywood and/or desi1 tunes, with Jay-Z's sample of Panjabi MC's

Mundian to Bach Ke as perhaps the most recent highly recognizable example); advertising (e.g., Aishwarya Rai, a former Miss World, and current model/actress, appearing in television ads for L'Oreal cosmetics); novels (e.g., the popularity of award-winning South Asian writers such as Jhumpa Lahiri and Monica Ali) and theater (e.g., the much-hyped Broadway production of *Bollywood Dreams*). The term *Bollywood* has even become officially included in the *Oxford English Dictionary*, a gesture that symbolizes its increased social currency.

The circulation of Bollywood films in the West is significantly growing. In 2001, the blockbuster film, *Khabhi Khushi Khabhi Ghum*, opened in the United Kingdom in third place, just behind *Harry Potter and the Philosopher's Stone* and *The 51st State* (a British film starring Samuel L. Jackson). That same year *Lagaan*, which garnered the third-best Foreign Language Film Academy Award nomination in Indian history, was released to international audiences (Willis, 2003). Bollywood films have become literally more physically accessible as well. For example, whereas the predominant screening venues for desi[1] films in the New York metropolitan area have historically been located in the outer boroughs and the suburbs, in early 2002, the Loews State Theater (located in the basement of the Virgin MegaStore in the center of Times Square) started regularly showing the latest Bollywood movies.

In addition to the wider releases of films coming out of the Indian movie industry, there has been an increase in the production of Indian diasporic films. This genre consists of movies made by filmmakers who are descended from India but are located primarily in the West, including, for example, Mira Nair *(Mississippi Masala* (Rodgers & Nair, 1991), *Monsoon Wedding* (Baron & Nair, 2001)), Deepa Mehta *(Fire* (Hamilton & Mehta, 1996), *Bollywood/Hollywood* (Frieberg, Virmani & Mehta, 2002)), and Gurinder Chadha *(Bhaji on the Beach* (Marsh-Edwards & Chadha, 1993), *Bend It like Beckham* (Nayar & Chadha, 2002)). These films have diverse locales, as some take place in the West, some in India, and others in a combination of locations, but are primarily released in the United States and/or the U.K. Commonly, another version of the film will later be released in India, though the original intended audience is western.

A newly emergent strand of the diasporic genre contains films made by second- generation South Asians. In the United States, the film *American Desi* (Katdare, Koewing, Pandya & Pandya, 2001) was the most visible contribution to this genre, though it was preceded by films such as *Chutney Popcorn* (Wyatt & Ganatra, 1999), and followed by an assortment of movies concerned with the experiences of South Asian Americans (e.g., *American Chai* (MacCrae & Mehta, 2001); *Flavors* (Dk, Mittal & Nidimoru, 2003)). These films are generally intended for a somewhat narrow audience of South Asian Americans, and, consequently, have had relatively little box-office success thus far.

An illustration of this trend of commodification of cultural diversity to be consumed by white western normative viewers can be found in the recent Miramax-produced film, *Bride and Prejudice* (Nayar & Chadha, 2004). Directed by British Asian Gurinder Chadha, this project, inspired in content by Jane Austen's novel *Pride and Prejudice*, aims to "make the Bollywood style of films popular with people who have heard about it but don't know what it is like" (quoted in Bhayani, 2004). Touted alternatively as a (heterogeneous) hybrid between western and Indian styles of filmmaking and as a (seamless) fusion of

Hollywood and Bollywood, this movie, as located within a growing genre of popular Indian diasporic films, deserves critical examination.

This chapter is operating with the assumption that popular media have a cultural pedagogical value. Steinberg observes that "if pedagogy involves issues of knowledge production and transmission, the shaping of values, and the construction of subjectivity, then popular culture is the most powerful pedagogical force in contemporary America" (2002, p. 26). Popular films, then, have a particular educative purpose, and critical interrogation is essential to uncover the cultural pedagogical agendas of varied media projects (Kincheloe, 2002). Ella Shohat and Robert Stam state that cinema is the pervasive "simulacral realm of mass culture" through which "all political struggle in the [postmodern] era must pass" (quoted in Mishra, 2002, p. 3). This chapter is then also operating with the understanding that an analysis of cultural products inherently requires an examination of their relationship to institutions, ideologies, and economics, and that popular culture is a site of production through which power is constructed, negotiated, and contested. In addition, films about people in the Global South, especially those geared toward western audiences, often serve as documentation of ideas about cultural practices and thus hold educative power about cultural norms and ideologies, however mis-constructed (Desai, 2004). The combination of the economic and cultural power of Bollywood along with the growth of the Indian diaspora supports the need for inquiries into the cultural pedagogy of Indian diasporic film.

This analysis of *Bride and Prejudice* examines how Indian culture is constructed and transmitted to a western audience within a context of a growing Indian diaspora and circulation of cultural commodities. Through locating Gurinder Chadha's film in a historical context, this analysis is interested in showing how the pedagogy of this film uncritically celebrates a globalized neo-liberal economy and reinforces a false binary where culture is located in opposition to modernity.

A (Brief) Look at the History of Indian Migration to the West

India formally gained independence from the British empire on August 15, 1947. Migration from the South Asian region had occurred before this point, primarily in the form of indentured labor to British colonies. However, there was a notable increase in migration from India after it was officially liberated from its colonizers, a trend common to many postcolonial nations. In the period of late modern capitalism, there has been a consistent pattern of migration from newly nationalized states to the economic centers of the (neo-)colonizing empires (e.g., London, coastal cities in the United States) (Mishra, 2002).

In the United States, migration from the South Asian region was made possible by the passage of the Immigration Act of 1965. This legislation altered the criteria for immigration by privileging labor qualifications over national origin, which facilitated the entry of an educated and professional Indian middle-class who had otherwise been restricted. This

legislative change supported the transnational aspirations of the Indian bourgeoisie whose desire to migrate was fueled by the reality that India's postcolonial economy could not necessarily support a route of upward mobility. Similarly, in Britain, a change in its citizenship law in 1962 provided an impetus for mass immigration of Indian nationals (Desai, 2004).

Migration patterns to the United States have continued to develop in response to the development of immigration and economic policies. For example, family re-unification options, which make it possible for immigrants to sponsor their relatives' immigration applications, as well as diversity visa lotteries, through which people in countries under-represented in the United States, such as Bangladesh, can enter, have led to an increasingly complex and varied South Asian community in the United States. More recently, an explicit opening of borders to recruit highly skilled workers (e.g., in information technology and other comparable industries) has facilitated a new influx of Indian temporary workers. Legislative changes have also led to the expulsion of portions of the South Asian immigrant community. For example, as part of the current War on Terrorism, thousands of South Asian Muslims, predominantly Pakistani men, have been detained and deported back to their countries of origin. The fluid heterogeneity of the South Asian immigrant community, then, is a product of the broader immigration, economic, and, national security and policy agendas of the United States government.

According to the 2000 Census, the number of foreign-born Indians in the United States grew to over 1 million, making this community the third largest immigrant group (following the Filipino and Mexican communities) in the country. The number of Indian immigrants more than doubled between the period of 1990 and 2000 (Grieco, 2003). A comparison between Asian communities categorized in the last Census revealed that the Indian community had the highest percentage of members with a college degree or more (followed by Pakistanis). Indian males had the highest participation in the labor force, were the highest earners, and were most likely to be in management positions. Moreover, Indian families had the highest median household incomes, and had the lowest poverty rates (Reeves & Bennet, 2004). An interrogation of the ability for Census data to provide an accurate representation of the Indian community in the United States is beyond the scope of this paper.[2] These statistics do, however, provide a very general overview of the current demographics of the Indian immigrant community and generally indicate that the economic power of this group, which deals in dollars, as a whole is relevant to both the national economies of India and the United States. This development has contributed to the growth of diasporic Indian filmmaking.

Gurinder Chadha Within a Historical Context of British Asian Filmmaking

British Asian filmmaking has changed significantly over the past few decades, primarily as a result of decreased economic resources, the growth of the hegemonic power of Hollywood, and shifts in discourses of multiculturalism.

In the 1980s, British Asian films were not easily incorporated into British national cinema, mainly because they often openly contested narratives of nationalism. Through social movement efforts that exposed and countered institutionalized racism, eventual state support of British Asian filmmaking efforts ensued. This political and economic shift led to two key outcomes. First, a series of government-sponsored filmmaking workshops were developed to support filmmaking in non-dominant communities. Second, the advent of state-sponsored financial support for these artistic ventures led to state influence over the relationship between filmmaker and audience, and consequently affected the content of the productions. Over time, racial politics within the realm of filmmaking gradually became diluted, and the collectivist spirit that had produced political and economic change in the context of non-dominant art declined. Kobena Mercer, a cultural critic, suggests that during this period filmmaking in non-dominant communities, enabled by a rhetoric of liberal multiculturalism, became commodified and institutionalized. As a result, the focus shifted to prioritizing the commodification of cultural difference in order to incorporate it into mainstream cultural consumption (cited in Desai, 2004).

During this period, the issue of representation, as an expectation and perception that cultural production by non-dominant cultural producers represents the subjectivities, identities, and experiences of the communities of which they are a part, became increasingly complicated. British Asian filmmakers felt pressure from institutional resources to portray communities in ways that were already determined by the dominant discourse, but also experienced pressure from their communities to correct mis-informed images by replacing negative stereotypes with positive ones. The underlying assumption in both of these positions is that someone, in this case, the filmmaker, has the ability to speak for a community. Partly in response to some of these difficult questions of representation, authorial intent, and authenticity, British cultural studies shifted to incorporate questions of audience and reception in its cultural analyses. By the 1990s, the multiculturalist framework's emphasis on voice and visibility still had cultural capital, and the continued outcome was a presentation of cultural difference in a way that avoided critical interrogation of dominant values and ideologies. Visibility of British Asian representation in the public sphere is dependent on the political economy of culture industry, and has been continually integrated into a capitalist expansion founded upon the logic and rhetoric of multiculturalism (Desai, 2004).

Gurinder Chadha's filmmaking emerged during this period of British Asian filmmaking. Born in Kenya to Indian Punjabi immigrant parents, Chadha migrated at an early age, in the 1960s, to Southall, London. She states that, although she self-identifies differently depending on the context, she sees herself as a "British Indian director first" (Connell, 2005). Her first productions were short films and documentaries (*What Do You Call an Indian Woman Who Is Funny?* and *Acting Our Age* (her student films); *I'm British, But . . .* (1989); *A Nice Arrangement* (1990)) (Rajagopal, 2003).

Chadha released her debut full-length feature film, *Bhaji on the Beach*, in 1994, which was the first commercial film released by a British Asian woman director in Britain. The film achieved commercial success but also raised controversy because of outspoken critiques from cultural nationalists, such as the Hindu right wing, who objected to Chadha's repre-

sentations of the community. Chadha reported being hurt by the critiques and posited a homogenous understanding of her audience by stating that she had simply made the film for "all Asians" (Desai, 2004, p. 64).

The commercial success of *Bhaji on the Beach* was facilitated in part by two key factors. First, prior to Chadha's release, Britain had already produced two internationally successful films scripted by a British Asian writer, Hanif Kureishi. These two films, *My Beautiful Laundrette* (1986) and *Sammie and Rosie Get Laid* (1988), dealt with a diasporic Indian subject matter and facilitated the entry of Chadha's film. Another factor is that Chadha's film received state-sponsored financial support and subsequently garnered access to mainstream media (Desai, 2004).

Both Chadha and Kureishi deviated from the historical counter-hegemonic tradition of British Asian filmmaking. Their films are more conventional in narrative form, and thus they were easier to distribute. The transnational circulation of diasporic British films is reliant on their ability to be palatable to western tastes, and because British Asian filmmakers have been more reliant on state support of cultural production, material issues of production and funding conditions have impacted their abilities to participate in a transnational cinematic realm (Desai, 2004).

Chadha's filmmaking developed within this context of limited financial options, which was exacerbated by the growth of the hegemonic power of Hollywood. British Asian filmmakers had been increasingly facing one of two choices. The first was to continue to produce films within a British niche market of "heritage" films that would present a multicultural vision of Britain and reach a predominantly arthouse audience. The second was to model filmmaking after Hollywood productions, which would require bigger budgets and a shift toward mainstream international audiences. The latter option was more economically viable, and thus it placed the filmmaker in a position to frame her work in terms of markets and crossover demographics (i.e., international white western audiences interested in multicultural fare). A filmmaker such as Chadha is consequently placed in a problematic position of cultural translator for viewers in the economic North (Desai, 2005). In 1998, Chadha, frustrated by the lack of financial support for her work decided "to write the most commercial movie [she could] with an Indian girl in the lead" (Brockes, 2004), and initiated the project of *Bend It like Beckham*.

The commodification of cultural diversity was successful for Chadha. *Bend It like Beckham* had the seventh largest opening for a British film in history, which led to the media dubbing her "Queen of the 'Multi'" where "multi" can simultaneously refer to her movie's domination of multi-plex cinema halls, as well as the multicultural content of the narrative (Desai, 2004).

The commercial success of *Bend It like Beckham*, within a growing western market for diasporic Indian film, perhaps indicates what Desai (2004) describes as a shift from the previous complicated burden of representation that British Asian filmmakers faced to a more contemporary spectacle of representation. With a reference to Mercer's idea of "excess visibility," Desai (2004) posits that the link between corporate internationalism and repressive localism leads to an increase in representation of cultural difference in a depoliticized, commodified, and increasingly culturally nationalist form.

The *Bride and Prejudice* **Project**

Although *Bride and Prejudice* was released in 2004, Chadha had originated the project of making a Bollywood-style movie in 1996. Inspired by the film *Dilwale Dulhaniya Le Jayenge* (1995), which was the first major Bollywood movie to address diasporic Indian subjects in its storyline, Chadha had even attempted a project with the Deols (a family of actors/producers/directors in the Indian film industry) that was ultimately not realized (Bhayani, 2004). The collapse of this effort led Chadha to focus on attaining a storyline that would transcend the boundaries of genre. Worried that unfamiliar audiences would be "freaked out by all the Bollywood stuff [. . .], the singing and dancing, big musical numbers, bright colors, big emotions!" (Connell, 2004), Chadha attempted to find a narrative that would appeal to a western market. She found this story in the novel, *Pride and Prejudice*, by British author, Jane Austen.

In an interview with Matt Connell (2004), Chadha relays her thinking behind the adaptation of the classic text:

> I was washing up one day when I had the idea: why not take the most fantastic love story ever written? It was about a big family, they don't have much money, daughters that need marrying off . . . very Indian! And the more I started working on it, the more I realised how pertinent Jane Austen's writing of the late 1700s is to contemporary small-town India. And that's when it all really started fitting and taking shape.

The film is not a literal adaptation of the novel, but the narrative is directly inspired by the story. In *Bride and Prejudice*, the Bakshis are a middle-class Punjabi family of two parents and four daughters, living in Amritsar, India. The mother is fixated on arranging the marriages of her daughters. The oldest daughter, Jaya, falls in love with a diasporic desi, Balraj, who resides in London. The main storyline revolves around the second daughter, Lalitha, who has a conflicted relationship with Darcy, an American capitalist hotel owner who comes to India with Balraj to attend a wedding. At first, Lalitha and Darcy's relationship is tense, and their conflict appears to be rooted in cultural differences. Throughout the course of the narrative, their relationship develops, and they eventually fall in love with each other. Though similar conflicts arise again, ultimately Darcy wins Lalitha over, and the film ends with their marriage. The film takes place in three locations, Amritsar, London, and Los Angeles, which Chadha states is essential to her internationalist vision (Connell, 2004).

Bride and Prejudice is an excellent illustration of a transnational diasporic desi film, where the project furthers a representation of a transnational postcolonial subject (Desai, 2004) whose expression is limited to the confines of the western market/audience. The film produces a hegemonic representation of the elite Indian subject through the creation of a binary of tradition and modernity, in which the East/femininity/anti-colonial is opposed to the West/masculinity/colonial (Desai, 2004) and through which an "indigenous chauvinism" (Virdi, 2003, p. 4) arises. The emergence of a cultural nationalism in the face of resistance to imperial forces is a historical process in which struggles against colonization resulted in an adaptation of culture and tradition into the modern conception of the Indian nation

(Virdi, 2003). This dynamic originates in the nineteenth century when Indian national-ism produced Indian modernity through cultural distinctions as well as through creating terms of sexuality (i.e., tradition equals family and motherhood while modernity is repre-sented by romance and love). National culture is reproduced through women's bodies, where women and feminine values become codes for national values and identity (Virdi, 2003; Desai, 2004).

The outcome, in which tradition is avowed though also rejected and modernity is dis-avowed but also endorsed (Mishra, 2002), is, thus, somewhat conflicted but relies on a foun-dation of oppositional concepts. In the current processes of globalization, this relationship between tradition and modernity is further complicated by capital's need for an increased internationalization of labor which conflicts with the nation state's need for coherency and hegemony, often yielding a reactive increased cultural nationalism. The liberalization of the economy, expanded through policy changes in India in the early 1990s, also further devel-ops the role of (middle-class) women as markers of nationalist ideologies as they are increasingly configured as occupying both modernization (through their labor and consump-tion) and tradition (through their location in the family) (Desai, 2004).

Cultural Transmission Within the Western Gaze

The main character in *Bride and Prejudice* is the second Bakshi daughter, Lalitha. An examination of Lalitha's role can be informed by the writings of Uma Narayan (1997), a postcolonial Third World feminist, who explores three positions that Third-World subjects are assigned to occupy in a western context. Though Narayan's essay is primarily concerned with the roles assigned to Third-World feminists in the context of the western academy, her framework offers a useful way to understand the various forms of transmission of cul-tural information from an original location in the Global South to a western audience.

Narayan proposes three positions: Emissary, Mirror, and Authentic Insider. The Emissary actively conveys information about the riches of the Other culture, almost serving as a mis-sionary who is rescuing westerners from their negative stereotypes and beliefs about Third-World cultures. Through this expression, the Emissary does not allow for any critique of this culture because negative portrayals are interpreted as cooperating with imperialist ideol-ogy. The Mirror role maintains, encourages, and confirms the current and historical processes of western colonization and imperialism and thus facilitates the development of a critical self-awareness by the western audience. The Mirror, though, in its focus on assist-ing the West to understand how it has operated/operates in destructive ways emphasizes the West as the source of all problems. In doing so, the Mirror neglects to interrogate her cul-ture's own internal contributions to injustices and reinforces the idea that the Third World is a passive victim of the West. Both of these positions, though distinct in their goals and methods, share a similar problematic dynamic of being trapped in a western gaze where their relationship to the West defines them. Both of these positions also construct a cultural nationalism in which the culture in question is either portrayed as impervious to criticism and/or damaged only as an effect of imperialist projects. In addition, these two positions

conform to the status quo. By remaining within a western framework, these roles can slightly disrupt dominant ideologies but are not equipped to transform them (Narayan, 1997).

The third position that Narayan posits is that of the Authentic Insider, which has the potential to define itself outside of a western construct, and permits analysis and critical thinking about Third-World institutions and practices. Though this role also has problematic features, such as a reliance on a definitive expertise and a possible assumption of a monolithic authenticity, it is able to transcend the western gaze through utilizing a self-determined framework that is not reactive (Narayan, 1997).

In the film *Bride and Prejudice*, this binary structure of anti-imperial/Indian and imperial/western is most clearly expressed through the character of Lalitha, who alternatively, and sometimes simultaneously, serves as a cultural transmitter and/or translator. Lalitha's portrayal by Aishwarya Rai adds an additional layer to this inter-cultural communication. Rai is the Bollywood actress who has been best positioned to transition into the western market, and *Bride and Prejudice* was her formal launch into Hollywood. A former Miss World, Rai has been called "the most beautiful woman in the world" by Hollywood star Julia Roberts. Though she has been acting in films since 1997, her 2002 movie, *Devdas*, was the first Bollywood picture to be specially screened at the Cannes Film Festival (Parry, 2003) where Rai also served as a jury member. In 2003, Rai appeared in numerous western magazines, landing on *Time Magazine's* list of 100 most influential people on the planet (CBS News, 2005). The following year, Rai became the first Indian female to be immortalized at Madame Tussaud's wax museum in London. Chadha's selection of Rai as the main character in *Bride and Prejudice* was strategic, as, prior to the film, she was the Bollywood actress most familiar to western audiences and extremely popular within India and the diaspora. The fact that Rai is very light-skinned and has blue-green eyes perhaps increases her appeal to the western market as well.

Rai is a visible marker of Bollywood, as it substitutes for Indian culture, and, thus, she becomes the site of transnational desire for a Western audience. She then serves as a native informant but remains trapped within a Western gaze (Desai, 2004).

In *Bride and Prejudice*, Lalitha moves between, and sometimes simultaneously occupies, the roles of Emissary and Mirror, transmitting cultural information primarily to the character of Darcy (and her other love interest, Johnny) and, more broadly, to the western audience. As the underlying theme to their conflicts is tension in relation to cultural difference, Lalitha responds through a reactive evocation of cultural nationalism, either by defensively portraying the riches of Indian culture or through critiquing past and current western imperialist efforts.

Lalitha and Darcy's first interaction is at a wedding in Amritsar. Though they see each other across a crowded dance floor, and end up dancing together, they are later formally introduced by Balraj. Lalitha asks Darcy if he wants to dance again and offers to show him how ("it's easier than you think"). When he declines, Mrs. Bakshi assumes his refusal is rooted in a sense of superiority ("rich American, what does he think? We're not good enough for him?"). Lalitha's pensive expression at this point indicates that she believes her mother is correct. This interaction sets the tone for Lalitha and Darcy's later conversations.

Lalitha and Darcy's first substantial conversation occurs at another wedding event. He reveals that he is a businessman, and they begin to talk about the hotel industry. After Lalitha informs him that the hotel he is staying in is the best one in town, Darcy comments that it is not functional for his purposes ("The computer keeps crashing, the electricity goes, I don't know how business functions here."). In response, Lalitha raises the issue of the economic disparities between India and the United States, by commenting that the cost of a room in one of Darcy's hotels, which is $400 to $500 a night is "more than most people make here in a year." Darcy concedes that he would not have thought of this on his own. This first conversation is an illustration of Lalitha as both an effective Emissary, through her prideful representation of Amritsar's facilities, and Mirror, through her reminding Darcy of his privilege. Darcy's concession indicates that Lalitha did successfully facilitate a moment of critical self-awareness of the dominance of the western economy. Lalitha remains trapped within Darcy's western gaze, however, and can, thus, neglect to engage in any analysis of the economic disparities within India and can avoid her own complicity as a member of the Indian bourgeoisie. The confines of the Emissary and Mirror positions, then, facilitate the production of a hegemonic Indian subject who is defined by and responds to western capital.

Lalitha and Darcy then engage in a conversation about arranged marriage, in which Darcy reveals that he finds it "strange, backward," and Lalitha retorts that this is "such a cliché . . . [arranged marriage] is more like a global dating service." They then have a miscommunication in which she thinks that Darcy is stating that he thinks Indian women are simple. The conversation ends with Lalitha huffily pointing out the arrogance of Americans who critique arranged marriages when they have the highest divorce rates. Here again Lalitha's response is first limited to a defensive mirroring, where she reacts to Darcy's critique by offering him a way to understand this cultural practice in his own terms. She is less concerned about transmitting knowledge or information about the cultural practice on its own terms and is more concerned about superficially refuting the negative stereotypes that surround it. The conclusion of this conversation evokes a haughty cultural and moral superiority, where Lalitha looks down at the hypocrisy of Americans. It is perhaps obvious but still necessary to raise that Lalitha's refusal to engage in a conversation that critically looks at arranged marriages in a globalized, highly technologized era denies the complexities of transnational weddings. In the world we see in *Bride and Prejudice*, weddings are lavish and joyful events in which families are merged and migratory journeys to the illustrious West are initiated and celebrated. The realities of repressive immigration policies, increasing trends of abandonment of wives by their husbands when they arrive in the West, and racism and xenophobia experienced by immigrants attempting to settle into their new locales, are absent from Lalitha's retorts. To address any of these issues would, again, require Lalitha to evaluate her own location of privilege and disrupt the formation of the postcolonial elite subject that is essential to this multicultural project.

The most pungent moment of tension between Lalitha and Darcy occurs when they are in Goa on vacation. Balraj invites Jaya to join him, his sister (Kiran), and Darcy on their trip, and Lalitha is asked to go along for the sake of appearances, as the family feels

it would not be proper for Jaya to go on this trip without accompaniment. While loung-
ing near the pool, Lalitha, Darcy, and Kiran engage in innocuous chatter that eventually
leads to the following exchange:

> Lalitha: You'll have trouble finding your ideal woman in India. I didn't hear simple,
> traditional, subservient on your list.
> Darcy: You're twisting my words.
> Lalitha: I'm sure you think India is beneath you.
> Darcy: If I really thought that, then why would I be thinking about buying this place?
> Lalitha: (laughs). You think this is India?
> Darcy: Well, don't you want to see more investment, more jobs?
> Lalitha: Yes, but who[m] does it really benefit? You want people to come to India
> without having to deal with Indians . . . Isn't that what all tourists want here?
> Five-star comfort with a bit of culture thrown in? Well, I don't want you turn-
> ing India into a theme park. I thought we got rid of imperialists like you.
> Darcy: I'm not British. I'm American.
> Lalitha: Exactly.

This scene is an apt illustration of the content and methodology of cultural transmis-
sion in the film. Lalitha articulates a criticism of western imperialism, and directly names
the United States as an imperialist force. She also questions the merits of globalization and
posits that economic interventions are not actually beneficial to Indians but to western cap-
italists. Even so, the criticisms that Lalitha offers in this scene are performance and part
of the verbal foreplay (eventually concluded with a coy smirk) that she engages in with
Darcy. Although Lalitha inquires into the actual benefits of globalization, she positions India
as a passive victim of western economic policies and neglects to include any discussion of
the Indian government's culpability in pursuing a neo-liberalist agenda. This omission is
necessary to reinforce Lalitha's position as an elite subject. Though her points are salient,
they are, again, limited by their reactivity and her uninterrogated privileged position. Even
though she questions the merits of globalization, it is clear that she is a beneficiary, which
serves to dilute the critique. As the audience is only shown evidence of a flourishing econ-
omy in India, it is thus reassured that Lalitha's criticisms are rooted in a reactive cultural
nationalism and not a thoughtful analysis of the impacts of India's shift into a neo-liberal
economy.

It is also ironic, given Lalitha's statements, that this film project itself serves to pro-
vide its audience with "comfort with a bit of culture thrown in." Though Lalitha scoffs at
Darcy's implication that he has had a diverse and/or authentic experience of India, the film
only represents India in a monolithic and normative manner. This scene also reinforces a
false binary between the United States/West and India that obscures the realities of
Lalitha and Darcy's class aligned positions that, though not equivalent, do transcend
national boundaries in the current processes of globalization.

Another critical scene occurs when Lalitha and her family meet Darcy's mother in Los
Angeles. In this scene, it is revealed that Darcy decided not to buy the hotel in Goa, much
to his mother's dismay. This decision is presumably not because Darcy has decided to resist

participating in global capitalism, but because his love for Lalitha, and perhaps her earlier anti-imperialist critique, led to some degree of self-awareness about this particular business venture in India. This scene also includes an exchange between Darcy's mother and Lalitha, in which the former states that "everyone has their hand on India these days" and cites varied cultural exports now available in the United States (e.g., yoga, spices). Lalitha cleverly responds with, "People haven't stopped going to Italy because Pizza Huts opened up around their corner." Occupying the role of Emissary here, Lalitha lightly mocks Mrs. Darcy's naïve, and also imperialist, assumptions that India can be reduced to cultural commodities, now in active circulation in the West. Lalitha's reaction to this comment, in addition to her earlier statement ("India is such a huge country. I wouldn't know where to begin [in describing it.") carries a cultural nationalist sentiment that the riches of India are too vast to be experienced.

Tradition and Modernity: Heteronormative Romance as Reconciliation

Representations of tradition and modernity, as discussed earlier, are furthered through the gendered body. The emphasis on heteronormative romance and consequent marriage in *Bride and Prejudice* illustrates this dynamic as sexuality and sexual norms are central to a gendered construction of tradition and modernity. The heterosexual romance narrative emphasizes female sexual agency and a disavowal of tradition, consistent with Western liberal feminist philosophies (Virdi, 2003; Desai, 2004).

In *Bride and Prejudice*, this is perhaps best exemplified through the song, "No Life Without Wife," a musical number in which the three sisters tease Lalitha about her suitor, Mr. Kohli. In this song, Lalitha reveals what she wants (and does not want) in a man:

> I don't want a man who ties me down, does what he wants while I hang around . . . wants a pretty wife to make him proud . . . or leaves his dirty dishes in the sink. [. . .] I just want a man with a real soul who wants equality and not control. I just want a man who loves romance . . . who'll clear the floor and ask me to dance . . .

The song then cuts to a fantasy sequence in which Lalitha sings, "Now I dream of what it would be like to be an overseas bride dressed in white," as she enters a church dressed in a white floor-length wedding dress.

Lalitha's expression of agency necessarily requires a rejection of tradition, represented by Mr. Kohli, in favor of modernity, represented by both Johnny and Darcy. The lyrics of the song contain classic western liberal feminist values of empowerment and equality, some of which seem out of place for Lalitha's context. For example, it is slightly jarring to hear Lalitha, who has domestic workers responsible for household chores, express concern about dirty dishes in the sink as this concept seems outside of her frame of reference.

Her fantasy of "romance" is also consistent with a narrative of modernity that implies a favoring of a "love marriage" instead of an arranged marriage. Though defensive of the practice of arranged marriage in her conversation with Darcy, Lalitha has different aspira-

tions. When she rejects Mr. Kohli's proposal, Lalitha reveals that she does not think that they would make each other happy and that she wants to work outside the house. Mrs. Bakshi later chastises her for wanting love to be present from the beginning of a marriage. Eventually Lalitha's best friend gets engaged to Mr. Kohli. She tells Lalitha, "I'm not romantic like you, Lalitha. I didn't want to take the chance that my prince would never come." Lalitha longs for a romance, which can only exist within a western framework, an implication that is strengthened by her church wedding fantasy. Additionally, although Lalitha expresses that she has no desire to migrate to the West (e.g., "Papa needs me. I couldn't leave."), her aspirations shift through the fantasy of romance (e.g., "To have a little home in the country and live in the land of her Majesty."). Thus, Lalitha's embodiment of cultural nationalism is abandoned for her desire of, and for, the West.

In a post/neo-colonial context, marriage is both a symbolic and material act through which a deterritorialized nation (in this case, India) is made stable through a heteronormative transnational marriage, which is implicitly permanent and impervious to broader forces of social, political, or economic development (Desai, 2004). Additionally, in classic Bollywood narratives, women often represent an idealized nation, and the male heroes represent the idealized rescuer who saves the women (nation) from danger (Virdi, 2003).

In *Bride and Prejudice*, the relationship between Lalitha and Darcy is ultimately resolved through marriage. Their strained relationship is repaired through his heroic efforts to locate Lalitha's missing sister, Lucky. Darcy appears at Balraj and Jaya's wedding; Lalitha spots him as part of the *baraat*, playing a drum. She approaches him, they hug, and in the next scene, the two couples have just been married. Lalitha's marriage to Darcy signifies a unification of the two components of the binary of East/tradition and West/modernity. Lalitha as the Indian woman represents culture, tradition, and the nation state, and enters into a permanent and impermeable marriage with Darcy, the western man representing modernity and capital. This marriage signifies that the enactment of an Indian modernity in the current context of neo-liberalism necessarily requires a relationship with western capital. This unification occurs through Lalitha, who can simultaneously hold culture and tradition, but it can also be interpreted as providing Lalitha access to the modernity of the West, thus reinforcing the role of the gendered body.

The centrality of marriage in this narrative also reinforces a static, monolithic, and heteronormative cultural paradigm. The absence of queerness is problematic but not surprising. Though there are tokenized appearances of a group of hijras in two scenes, the film generally offers a normative presentation of gender and sexual identity. One exception to this presentation, however, is offered through the character of Lucky, the youngest Bakshi daughter. With an understanding of a queer paradigm as a paradigm of sex/gender deviance in which normativity is disrupted (Rand, 1995), Lucky is both the straightest and queerest character in the film. In the opening scene, while the daughters are getting dressed for a wedding event, Lucky is modeling in front of a mirror, wearing a short top that reveals her stomach. Her mother is opposed to her wearing this outfit and the third daughter, Maya, agrees that it is inappropriate ("vulgar"). Lucky pouts and replies that her outfit is "killing . . . It's what everyone is wearing in Mumbai." Later at the party, Lucky is seen flirting with

several boys while Maya tells Lalitha, "She's too outrageous. I'm telling you, she'll give us all a bad name. You know she is spending all night texting boys?" Maya then goes over to Lucky to interrupt her flirtations. As the movie progresses, Lucky is repeatedly cast as boy-crazy. Her flirtation with Lalitha's love interest, Johnny, occurs in the Bakshi household, behind her sister's back. Although Johnny implies that he is interested in Lalitha, he only e-mails Lucky after his departure and they later surreptitiously meet in London.

Although Lucky is visibly straight-identified, her outright expression of sexual desire, without a fantastical context of romance, renders her queer. The two older sisters, Jaya and Lalitha, are swept up in heteronormative fantasies that culminate in romantic marriages. The third daughter, Maya, is depicted as asexual and is cast as a traditional woman who, it can be assumed by her close relationship with her mother and her participation in cultural activities, follows gendered expectations. Conversely, Lucky has multiple romantic interests (mostly implied) that do not conform to a monogamous construct. She is easily physically affectionate with Johnny, setting her as distinct from the other sisters who rarely touch men. Lucky's (relative) hyper-sexuality deviates from the apparent norms governing sexual behavior.

Ultimately, though, Lucky is straightened out. Her rendezvous with Johnny ends disastrously. Lucky runs away from the family, and Darcy reveals that Johnny had impregnated his sister in an attempt to marry into Darcy's family. Lucky is rescued by Lalitha and Darcy and is brought back home, embarrassed and defeated. When she apologizes to her mother, Lucky is told, "What sorry? No boy is coming within ten miles of you until you get married." Lucky looks down and nods her head in agreement. The resolution of Lucky's narrative reinforces a dominant ideology of heteronormativity in which deviance is tolerated to an extent but eventually punished and then ultimately (willingly) constrained.

"Life Is Great, Let's Celebrate"

Gurinder Chadha states, "I don't make films that are Eurocentric and I don't make them so that they are Indocentric. I make films that are Diaspora-centered. I operate in global cultural paradigm, so that's the kind of the movie I wanted to make" (Huttner, 2005). Her project is a multicultural venture that attempts to make an unfamiliar genre (Bollywood) translatable and palatable to the western market. She was successful in her attempt; the film brought in over $6 million at the U.S. box office (*Rotten Tomatoes*, 2005). Her intended audience is articulated as a global one, not limited to geo-political location. Chadha has effectively produced a film that furthers dominant ideologies about economics, nation, gender, and sexuality, which are necessary to further a neo-liberal agenda, and that indeed resonates with a global audience, albeit a global bourgeoisie audience. Chadha's film posits elite heteronormative Indian subjects that are both rooted in tradition and defensive cultural nationalism yet also eager to be romanced by the West. The tone of the film, generally, but especially its conclusion, reinforce this multicultural marriage of India to the West is one to be simply celebrated.

NOTE

1 Pronounced "they-see," *desi* is a colloqiual term that is often used by diasporic South Asians to self-identify as descendants of a common region that was carved into national entities through the process of independence from the British Empire. The term comes from the Sanskrit word *desh* and can be translated as "from the motherland." The term is also often invoked to articulate a politicized common identity among South Asians as people of color/migrants in the diaspora. Critics of the term *desi* point out that this term privileges the northern region of South Asia because most of the languages spoken in this area are rooted in Sanskrit whereas southern languages have Dravidian roots and that utilization of this term obscures the complex power relations among South Asian diasporic communities. The term has also become more popular in mainstream western realms as South Asian culture and communities become commodified in the West via processes of globalization/neo-liberalism.

2 The Census Bureau itself identifies some of the limitations of its analysis by discussing the inevitable statistical errors that occur in a data project of this size. In addition, however, the Census data are limited because they do not account for issues such as the reluctance of some people to participate in the survey such as undocumented migrants, members of multiple-family households living in extra-legal conditions, political refugees who have had prior traumatic experiences with the state, and so on. While I am not discounting the Census data—I'm obviously utilizing them here—I am want to raise a question regarding their ability to fully represent different populations.

REFERENCES

Text

Bhayani, V. (2004). Can't imagine Aishwarya in Bollywood film now: Chadha. *IndiaGlitz*. Retrieved December 23, 2005, from http://www.indiaglitz.com/channels/hindi/interview/6073.html.

Brockes, E. (2004, July 10). Laughing all the way to the box office. *The Guardian*. Retrieved December 29, 2005, from http://film.guardian.co.uk/interview/interviewpages/0,6737,1264310,00.html.

CBS News. (2005, January 2). Sixty Minutes: the world's most beautiful woman? *CBS News*. Retrieved January 13, 2007, from http://www.cbsnews.com/stories/2004/12/29/60minutes/main663862_page2.shtml

Connell, M. (2004). Gurinder Chadha interview. Retrieved December 27, 2005, from http://www.radiosargam.com/features/interviews/gcbb.htm.

Connell, M. (2005). Bollywood: *Bride and Prejudice* Director Gurinder Chadha Interview. Retrieved December 23, 2005, from http://www.femalefirst.co.uk/entertainment/5112004.htm.

Desai, J. (2004). *Beyond Bollywood: The cultural politics of South Asian diasporic film*. New York: Routledge.

Desai, J. (2005). Planet Bollywood: Indian cinema abroad. In S. Davé, L. Nishime, & T. G. Oren (Eds.), *East main street: Asian American popular culture*. New York: New York University Press.

Grieco, E. (2003). The foreign born in India in the United States. Washington, DC: Migration Policy Institute, Retrieved December 22, 2005, from http://www.migrationinformation.org/USfocus/display.cfm?id=185.

Huttner, J. L. (2005). *The really good films: Interview with director and screenwriter Gurinder Chadha*. Retrieved December 29, 2005, from http://www.films42.com/chats/gurinder_chadha.asp.

Kincheloe, J. L. (2002). *The sign of the burger: McDonald's and the culture of power*. Philadelphia: Temple University Press.

Mishra, V. (2002). *Bollywood cinema: Temples of desire*. New York: Routledge.

Narayan, U. (1997). *Dislocating cultures: Identities, traditions, and Third-World feminism*. New York: Routledge.

Parry, A. (2003). Queen of Bollywood. *TimeAsia*. Retrieved January 13, 2007, from http://www.time.com/

time/asia/covers/501031027/story.html

Rajagopal, S. S. (2003). The politics of location: Ethnic identity and cultural conflict in the cinema of the South Asian diaspora. *Journal of Communication Inquiry, 27*(1), 49–66.

Rand, E. (1995). *Barbie's queer accessories*. Durham: Duke University Press.

Rotten Tomatoes. (2005). Retrieved December 29, 2005, from http://www.rottentomatoes.com/m/ bride_and_prejudice/numbers.php.

Reeves, T. J., & Bennet, C. E. (2004). We the people: Asians in the United States; Census 2000 Special Reports. Washington, DC: United States Census Bureau, Retrieved December 22, 2005, from http://www.census.gov/prod/2004pubs/censr-17.pdf.

Steinberg, S. R. (2002). French fries, fezzes, and minstrels: The Hollywoodization of Islam. *Critical Methodologies, 2*(2), 205–210.

Virdi, J. (2003). *The cinematic imagiNation*. New Brunswick: Rutgers University Press.

Willis, A. (2003). Locating Bollywood: Notes on the Hindi blockbuster, 1975 to the present. In J. Stringer (Ed.), *Movie Blockbusters* (pp. 255–268) London: Routledge.

Motion Pictures

Baron, C. (Producer), & Nair, M. (Director and Producer). (2001). *Monsoon wedding* [Motion Picture]. United States: Mirabai Films, Inc.

Dk, K. (Producer & Director), Mittal, A. (Producer), & Nidimoru, R. (Producer & Director). (2003). *Flavors* [Motion Picture]. United States: Dreams2Reality Films & Mauj Entertainment.

Frieberg, C. (Executive Producer), Virmani, A. (Executive Producer), & Mehta, D. (Director). (2002). *Bollywood/Hollywood* [Motion Picture]. United States: Bollywood/Hollywood Productions.

Hamilton, D. (Executive Producer), & Mehta, D. (Director & Producer). (1996). *Fire* [Motion Picture]. United States: Fox Searchlight Pictures.

Katdare, D. (Producer), Koewing, C. E. (Producer), Pandya, G. (Producer), & Pandya, P. D. (Producer & Director). (2001). *American desi* [Motion Picture]. United States: Eros Entertainment.

MacCrae, T. (Producer), & Mehta, A. (Director). (2001). *American chai* [Motion Picture]. United States: Fusion Films.

Marsh-Edwards, N. (Producer), & Chadha, G. (Director). (1993). *Bhaji on the beach* [Motion Picture]. United Kingdom: Channel Four Films.

Nayar, D. (Producer), & Chadha, G. (Director & Producer). (2002). *Bend it like Beckham* [Motion Picure]. United States: Fox Searchlight Pictures.

Nayar, D. (Producer), & Chadha, G. (Director & Producer). (2004). *Bride and prejudice* [Motion Picture]. United States: Miramax Films.

Rodgers, C. (Executive Producer), & Nair, M. (Director). (1991). *Mississippi masala* [Motion Picture]. United States: Samuel Goldwyn Film Distributors.

Wyatt, T. (Executive Producer), & Ganatra, N. (Director). (1999). *Chutney popcorn* [Motion Picture]. United States: Mata Productions, Inc.

Bollywood Cinema and Indian Diaspora

Aditya Raj

Today, more than ever, culture bestows a multi-perspectival and multidimensional "site of struggle." The challenge before the pedagogues, therefore, is to join the collaborative contexts with people to further interrogate and illuminate the struggle on the cultural terrain. Production, application, or transmission of knowledge either in educational institutions or in society at large cannot be complete without addressing the multiple ways media culture shapes people's everyday life. It is within this broader contour that I delineate the growing links between Bollywood cinema and the Indian diaspora. The subject matter at hand is vast, and this essay should be seen as an investigation to trigger further debates, discussions, and research across disciplines.

Bollywood is a conflation of Bombay (old name of Mumbai) with Hollywood and is informally being used for the Hindi language film industry in India. There are films made in several different languages in multilingual India, but over time the Hindi language films from Bollywood have assumed prominence probably because Hindi is the national language of India. The Bollywood output is so colossal that even films made in places like Chennai, London, and New York, or languages such as Punjabi and English are subsumed within it.

Cinema first came to India under British colonialism and slowly consumed folk traditions. The first indigenous feature film was made in 1913, and by 1930 films in India assumed

vibrancy. Gokulsing and Dissanayake (2004) suggest that during this time, filmmaking in India was Janus-faced—looking at Indian cultural tradition, on the one hand, and drawing from them, as well as being inspired by the techniques and aura from around the world but mainly from Hollywood, on the other.

During the same era, when Indians in the diaspora looked back nostalgically toward India, they looked at Indian cinema. Bollywood films such as *Anarkali* (Irani & Choudhry, 1928), *Madhuri* (Irani & Choudhry, 1928), *Veer Abhimanyu* (Sagar & Ghosh,1931), *Maya Bazaar* (Sagar & Ghosh,1932), and *Zarina* (Sagar & Ghosh,1932) were screened in Suva, the capital of Fiji, around 1930 (see Mishra, 2002). From the beginning, Bollywood cinema had found a special cultural space among the Indian diaspora. Today, Indian youths in India and in the Indian diaspora find an identity repertoire from Bollywood cinema. Therefore, if cinema is the "temple of modern India" (Dasgupta, 1988) they are the "temple of desire" (Mishra, 2002) for the Indian diaspora.

The study of both India and its diaspora is important especially because of India's growing population, its cultural diversity, and its linguistic complexity. Technological changes of the last century have significantly altered the production and consumption of information in India and its diaspora because of satellite television, transnational travel and tourism, Internet communication, and global consumerism. Sky Entertainment in Fiji, Sahara TV in the United Emirates, or ATN cable in Canada have been "crucial in bringing the homeland into the diaspora" (Mishra, 2002, p. 237). In fact, the ATN cable in Canada broadcasts directly from *Doordarshan* (national television channel) in India just to provide one example of the increasing transnational dimension of Indian media in general.

This essay discusses the link between cinema and the diaspora, especially the cultural and pedagogical power of cinema on youths in the diaspora, on the one hand, and the impact of the diaspora on Bollywood cinema, on the other—the two-way cultural exchange. The locale and constant reference to Punjab in Hindi films indicate the dominance of Punjabis in the Indian diaspora. More specifically, Baldev Singh in *Dilwale Dulhania Le Jayenge* (Chopra & Chopra, 1995) lives in London, but his heart belongs to the "greenery" of Punjab.

It is interesting to consider how Gurinder Chadda packages and constructs the playing of *dandia* (from Gujarat played with two sticks) in Amritsar (Punjab) and how it is depicted in *Bride and Prejudice* (Chadha, Nayar & Chadha, 2005). It is like mixing cultural traits through Punjab to showcase India. Comparable to the cinematic discourse itself, I proceed with three brief "takes" on Bollywood cinema and the Indian diaspora. The first take extends the discussion of the contours of Bollywood cinema. The second zooms a little further to analyze the growing links between the Indian diaspora and the Bollywood cultural industry. In the third take, I focus on the impact of Bollywood cinema on Indian youths, especially in the diaspora.

Take One

Gokulsing and Dissanayake (2004) list a number of elements usually noticeable in Bollywood cinema: lack of realism, escapist plots, melodramatic and exaggerated acting, song and dance

sequences, and obstructive editing. Even so, as Mishra (2002) has pointed out, Bollywood cinema has used metaphysical traditions to explain or resolve historical moments. For example, *Achhut Kanya* (Rai & Osten,1936) contextualizes the subaltern politics of untouchability; *Devdas* (Barua & Barua,1935/Roy & Roy,1955/Shah & Bhansali, 2002) and *Aag* (Kapoor & Kapoor,1948) defines human desire within social constrains; *Mother India* (Khan & Khan,1957) shows the mother as politically naïve, yet humanistic and powerful; *Sholay* (Sippy & Sippy, 1975) and *Deewar* (Rai & Chopra,1975) depict rebellion against the status quo; *Hum Apake Hai Kaun* (Barjatia & Barjatia,1994) features family values; *Fiza* (Guha & Mohamed, 2000) and *Mission Kashmir* (Chopra & Chopra, 2000) points out the vulnerability but simultaneously the unity of the Indian nation, while *Gadar* (Kein & Sharma, 2001) further feeds the crescendo of nationalistic ideology. Mehta's *Earth* (Masson, Mehta & Mehta, 1998), *Water* (Hamilton & Mehta, 2005), and *Fire* (Bedi, Mehta & Mehta, 1996) or Nair's *Monsoon Wedding* (Baron, Nair & Nair, 2001), Chopra's *Dilwale Dulhania Le Jayenge* and their like, attempt to imagine social space outside the nationalist, masculinist, and hetero-normative paradigms.

The most significant element of Bollywood cinema is the "star value" of its actors, which can be positioned as representative of different strains of Indian society. The most popular ones have been Prithviraj Kapoor, Raj Kapoor, Dev Anand, Dilip Kumar, Ashok Kumar, Rajesh Khanna, Amitava Bachchan, Sanjay Dutt, Amir Khan, and Shahrukh Khan. Raj Kapoor's character typically discreetly fights traditions of family and community; the roles played by Dev Anand challenge enemies of the State, and Dilip Kumar's character is usually featured in roles that pitch him against the limitations in human relationships. Amitava Bachchan (AB) is the biggest star ever in Indian cinema. His larger than life status can be attributed to the different issues regarding social and moral order or change in India the characters he has played have addressed. Among the female stars Madhubala, Nargis, Hema Malini, Madhuri Dixit, and Aishwarya Rai have been very popular.

What Amitava Bachchan is to acting, "melody queen" Lata Mangeskar is to singing in Bollywood. Others like K. R. Sehgal, Kishore Kumar, Mukesh, Muhammad Rafi, Udit Narayan, and Asha Bhosle have been prominent singers. In recent times, lyricist Javed Aktar, musician Mani Ratnam, and directors Karan Johar, Deepa Mehta, and Gurinder Chadda have won accolades. Mehta's triology of *Earth, Water,* and *Fire* generated controversy, but their embodiments have highlighted social categories that remain unthinkable within the Hindu nationalist imaginary in India and abroad. Mehta's other successful film is *Bollywood-Hollywood* (Hamilton & Mehta, 2002), the subtitle of which reads "nothing is what appears to be" is at the intersection of two different sets of cultures and values—Indian and Canadian (read, western), and epitomizes the struggle between immigrant parents and second-generation youths. The father (Kulbhushan Kharbanda) in the film is disturbed by his daughter's (Lisa Ray) behavior and says, "you will be lost in Lake Ontario, bobbling without the lifejacket of tradition."

Traditions scuttle dreams, while bending rules allows one to fulfill them. Gurinder Chadha's *Bend It like Beckham* (Nayar, Chadha & Chadha, 2003) is the heart-warming tale of an eighteen-year-old Indian girl in the diaspora, who is caught in the cross-fire of strict family values and her passion for soccer. Chadda's *Bride and Prejudice* (Chadha, Nayar &

Chadha, 2005) visualizes life within transnational dynamics and allows the bride (Aishwarya Rai) to live, love, and finally shed her prejudice. Although Chadda's and Mehta's stories do not take place in India, Bollywood subsumes their albeit fictional experiences in the Indian diaspora.

There has been growing trend in Bollywood to shoot films in foreign locales such as Switzerland, Mauritius, New Zealand, Australia, North America, or Europe. Several recent films are based on Indians in these countries, e.g., *Dilwale Dulhania Le Jayenge*, *Pardes* (Ghai & Ghai, 1997) *Kal Ho Naa Ho* (Hossain et al. & Advani, 2003), and others. *Dil Chahta Hai*. (Sidhwani & Akhtar, 2002) and *Krish* (Roshan & Roshan, 2006). Akash (Amir Khan) and Shalini (Preety Zeinta) in *Dil Chahta Hai* go to Sydney to take care of his father's business and to meet her uncle respectively. It is in Sydney that they fall in love. The supernatural power of *Krish* (Hritik Roshan) is realized in Singapore. Moreover, lack of discipline and abnormality are also seen in foreign locales as manifested in the recent *Kabhie Alvida Naa Kehna* (Johar & Johar, 2006), directed by Karan Johar, which is about Indian families in the United States.

Take Two

The increasingly tight link between Bollywood cinema and the Indian diaspora is indicative of the growing number of Indians living in the diaspora as well as of the fact that many Indians have lived in the diaspora for a long time. In fact, Bollywood generates significant revenue from countries where people from India have made their new home. The demand of Bollywood films in the Middle East is ever growing, and then there are historical markets, such as Mauritius, Fiji, Guyana, Trinidad, and others where Bollywood films are screened around the year in several theaters. Bollywood cinema is also seen by non-Indians. The popularity of Raj Kapoor in Russia, Shahrukh Khan in the Middle East, and Amitava Bachchan worldwide is a case in point.

It is likely that transnational links and connectivity are behind Bollywood's success in several countries, and the recent attempts in such films to incorporate cultural traits usually unfamiliar to Indian masses are further evidence of this trend. Transnationalism begins with defying marked borders and has deterritorialization as its base. According to Appadurai (1996) deterritorialization is one of the central forces of the modern world, and it is this fertile ground in which money, commodities, and persons unendingly chase one another around the world. Bollywood cinema is a cultural product of these deterritorialization phenomena. For example, *Bride and Prejudice* begins with Balraj from London traveling with his sister Kiran and their American friend Darcy to attend a wedding at Amritsar (Punjab). Once there, they meet the daughters of Mr. and Mrs. Bakshi—Jaya, Lalitha, Maya, and Lucky. Events unfold in Amritsar, Goa, London, and Los Angeles, and culminate when Balraj and Darcy marry Jaya and Lalitha, respectively, in Amritsar through what Lalitha refers in the film as "global dating service."

The influence of transnational culture on Bollywood cinema has been profound. Keeping the ever increasing diaspora and global audience in mind, Bollywood has come

further inside the grip of corporate culture. The India that is now being shown through Bollywood cinema covers only the cosmopolitan class. Only few films highlight social issues, and the ones that address these issues do not become "hits" at the box-office. An exception to this scenario is *Rang De Basanti* (Mehra et al. & Mehra, 2006). In this film Indian youths call for revolution against the corrupt and indifferent "power bloc" as it is represented by the political and business elite.

Dasgupta (2006) in her essay entitled "The Hindi Commercial Cinema in the Days of Globalisation" sees a lack of direction and hopelessness in current Bollywood cinema suggesting that it is without an ideology or a concrete message in this age of globalization. Specifically, Dasgupta (2006) suggests that Bollywood cinema has "ceased to be a critique of the system and instead moved into being an adopter" (p. 254). According to her, the current stars as, e.g., Shahrukh Khan (compulsive winner), or Saif Ali Khan (confused and getting along with his confusion), are portrayed as happy go lucky actors with usual Bollywood melodrama and dance numbers. Exceptions to this scenario, as Dasgupta agrees, are Amir Khan's *Lagaan* (Khan & Gowariker, 2001), which is about the anti-hegemonic strategy of Indian peasants to fight British power and their repressive land-tax, *Mangal Pandey* (Bedi & Mehta, 2005), where Amir portrays the life story of a revolutionary martyr, and *Rang De Basanti*.

Most song and dance numbers in Bollywood cinema have become a remix of Indian and outside influence. These cultural elements are as popular with youths in India as with youths in the Indian diaspora. Clubs in Delhi or "desi" clubs in Toronto play the same song numbers to accommodate the "new" taste of Indian youths. Through such intercultural exchange, the superiority of nation over diaspora is no longer valid. Diaspora has become an alternative and intermediary at a time when the role of nation-state is being relegated under the neo-liberal, neo-right schemata (Raj, 2006). Nevertheless, Bollywood cinema still has profound impact on those in the diaspora, especially young people.

Take Three

Cinematic narrative, argues Hall (2003) serves as the repertoire for identification by providing a reservoir of multiple narratives. The themes, contents, and style of Bollywood films provide for identification, mediation, and negotiation of Indian youth identity. Such films may be criticized for lack of proper editing, but these films contain stories within stories that meander with narrative detours. Thereby, they contain something for every age, sex, generation, class, and culture. Cinema is without doubt an urban art and with resurgent globalization and urbanization of Indian society, Bollywood cinema dwells within cosmopolitanism and global urban locales. Cinema can be seen as a leisure activity for all ages, but for youths it also offers opportunities for courtship, fantasy, and motivation. Urban culture represented through Bollywood cinema is shaping the consciousness and social relationships of Indian youths in India and in the diaspora. Fashion, food, gender roles, and

role models are conferred by the representation in such films.

Youths forge identities not with reference to real communities but instead according to taste communities or "lifestyle systems," in which consumption is practiced in the absence of community regulation. Therefore, youths' "lifestyles" can be seen as a vocabulary of self-expression with cultural regulation from Bollywood cinema. Indian youths in the diaspora follow the cultural prescriptions Bollywood cinema has established, as is evident in the young people's clothes, their wedding preparations, salutation style, and mating desire. The stars' attire, their relationships, and their actions have profound impact on Indian diaspora youths. The panoramic narrative appeals to the nostalgia for Indian culture, desire, and reality. In recent years, the depiction of diasporic identities and cultural production has been the language of Bollywood cinema (see Desai, 2004).

Among the Indian youths in the diaspora, *mehndi* (temporary henna tattoos), *bindis* (forehead decoration), *beedis* (tobacco in flavored leaves), *sarees* (long cloth wrapped around the body) are basically the effect of the influence of Bollywood cinema. However, there is a "style" to each of these (and other cultural artifacts) depending on how the Bollywood stars use them. It may be that Madhuri Dixit prefers the *saree* style, Aishwarya Rai likes the *bindi* design, or Rani Mukerjee is most comfortable in *ghagra* (lower . . .) and *choli* (upper decorative body wear). These cultural artifacts and practices of Indian youths in the diaspora have caught the consciousness of popular culture in their respective host societies (see Sandhu, 2004).

In the diaspora, it is common to find a Nirmala, the homemaker in Bharati Mukerjee's diaspora novel *Jasmine* (1989), who rents and watches Hindi films on her VCR every evening at her Flushing, New York, apartment. Similarly, one comes across car stereos playing Hindi songs in places like South Hall (England) or dancing to Punjabi folk dance at a wedding in Durban. However, Bollywood cinema's influence has different effects on different social categories in the Indian diaspora depending on their respective multiaxial social locations.

To the first generation in the diaspora, homeland is pure like Ganga in *Pardes*, where Kishori Lal (Amrish Puri) expresses his emotions melodiously as "I love my India" over and over again. To a young girl like Simran (Kajol) in *Dilwale Dulhani Le Gayage*, Indian culture, as reflected in her father extending his hand to prevent her from going with her lover, is constraining. During social events Bollywood songs (*sangeet*) would be played, the cultural space would be assumed heterosexual, and the participants would wear Indian attire, thus reviving ethnic culture. To the second generation in a ghetto, Bollywood is leisure as well as aspiration for change from the mundane everyday life, which is racist, sexist, homophobic, and oppressive.

I do not want to conclude this essay but rather allow readers to understand the connection between Bollywood cinema and the Indian diaspora. The goal of this brief essay is to encourage discussion, debate, and research across disciplines in the cultural site of cinema. Only when this aim is achieved can the final "take" of Bollywood cinema and the Indian diaspora be made.

REFERENCES

Text

Appadurai, A. (1996). *Modernity at large*. Minneapolis: University of Minnesota Press.

Dasgupta, S. (2006). The Hindi commercial cinema in the days of globalization. In S. Somayaji & G. Somayaji (Eds.), *Sociology of globalisation: Perspectives from India* (pp. 250–263) Jaipur and Delhi: Rawat Publications.

Dasgupta, C. (1988). The painted face of politics: The actor-politicians of South Asia. In W. Dissanayake (Ed.), *Cinema and cultural identity* (pp. 127–147). Lanham, MD: University Press of America.

Desai, J. (2004). *Beyond Bollywood: The cultural politics of South Asian diasporic film*. New York and London: Routledge.

Gokulsing, K. M., & Dissanayake, W. (2004). *Indian popular cinema: A narrative of cultural change*. Oakhill: Trentham Books Ltd.

Hall, S. (2003). Cultural identity and diaspora. In J. Braziel & A Mannur (Eds.). *Theorizing diaspora* (pp. 233–246). U.K.: Blackwell Publishing Ltd.

Mishra, V. (2002). *Bollywood cinema: Temples of desire*. New York and London: Routledge.

Raj, A. (2006). Globalisation from below and the global Indian diaspora. In S. Somayaji & G. Somayaji (Eds.), *Sociology of globalisation: Perspectives from India* (pp. 98–116). Jaipur and Delhi: Rawat Publications.

Sandhu, S. (2004). Instant Karma: The commercialization of Asian Indian culture. In J. Lee & M. Zhou (Eds.), *Asian American youth: Culture, identity, and ethnicity*. New York and London: Routledge.

Motion Pictures

Barjatia, Bro. (Producers), & Barjatia, S. R. (Director) 1994 *Hum Apake Hai Kaun* India: Rajshri Productions

Baron, C. & Nair, M. (Producer), & Nair, M. (Director) 2001 *Monsoon Wedding* United States: Mirabai Films

Barua, P.C. (Producer), & Barua, P.C. (Director) 1935 *Devdas* India: New Theatres

Bedi, B. (Producer), & Mehta, K. (Director) *Mangal Pandey* India: Yash Raj Films

Bedi, B. & Mehta, D. (Producer), & Mehta, D. (Director) 1996 *Fire* United States: New York Video

Chadha, G. & Nayar, D. (Producer), & Chadha, G. (Director) 2005 *Bride and Prejudice* United States: Miramax

Chopra, V.V (Producer), & Chopra, V.V. (Director) 2000 *Mission Kashmir* India: Chopra Productions

Chopra, Y. (Producer), & Chopra, A. (Director) 1995 *Dilwale Dulhania Le Jayenge* India: Yash Raj Films

Ghai, S. (Producer), & Ghai, S. (Director) 1997 *Pardes* India: Mukta Arts

Guha, P. (Producer), & Mohamed, K. (Director) 2000 *Fiza* India: UTV Motion Pictures

Hamilton, D. (Producer), & Mehta, D. (Director) 2005 *Water* Canada: Telefilm Canada, Noble Nomad Pictures, and Echo Lake Productions LLC

Hamilton, D. (Producer), & Mehta, D. (Director) 2002 *Bollywood-Hollywood* Canada: iDream Productions

Hossain, A., Johar, H, Johar, K., Johar,Y. (Producer), & Advani, N. (Director) 2003 *Kal Ho Naa Ho* India: Dharma Productions

Irani, A. (Producer), & Choudhry, R. S. (Director) 1928 *Madhuri* India: Imperial Film Company

Irani, A. (Producer), & Choudhry, R. S. (Director) 1928 *Anarkali* India: Imperial Film Company

Johar, H. (Producer), & Johar, K. (Director) 2006 *Kabhi Alvida Naa Kehna* India: Dharma Productions

Kapoor, R. (Producer), & Kapoor, R. (Director) 1948 *Aag* India: R.K. Films

Keni, N. (Producer), & Sharma, A. (Director) 2001 *Gadar* India: Zee Films

Khan, A. (Producer), & Gowariker, A. (Director) 2001 *Lagaan* India: Aamir Khan Productions

Khan, M. (Producer), & Khan, M. (Director) 1957 *Mother India* India: Mebhoob Productions

Masson, A & Mehta, D. (Producer), & Mehta, D. (Director) 1998 *Earth* United States: New York Video

Mehra, O.P., Khote, D., & Screwala, R. (Producer), & Mehra, O.P (Director) 2006 *Rang De Basanti* India: UTV Motion Pictures

Nayar, D. & Chadha, G., (Producer) & Chadha, G (Director) 2003 *Bend It Like Beckham* U.K: Lionsgate

Rai, G. (Producer), & Chopra, Y. (Director) 1975 *Deewar* India: Trimurti Films

Rai, H. (Producer), & Osten, F. (Director) 1936 *Acchut Kanya* India: Bombay Talkies

Roshan, R. (Producer), & Roshan, R. (Director) 2006 *Krrish* India: Yash Raj Films

Roy, B. (Producer), & Roy, B. (Director) 1955 *Devdas* India: Bimal Roy Productions

Sagar, S. (Producer), & Ghosh, P. (Director) 1931 *Veer Abhimanyu* India: Films Limited

Sagar, S. (Producer), & Ghosh, P. (Director) 1932 *Maya Bazaar* India: Films Limited

Sagar, S. (Producer), & Mir, E. (Director) 1932 *Zarina* India: Films Limited

Sidhwani, R. (Producer). & Akhtar, F. (Director) *Dil Chahta Hai* India: Excel Entertainment

Sippy, G.P. (Producer), & Sippy, R. (Director) 1975 *Sholay* India: Sippy's

Shah, B. (Producer), & Bhansali, S.L. (Director) 2002 *Devdas* India: Mega Bollywood Pvt. Ltd.

Chapter 29

Under Siege and Out of Reach

Steven Seagal and the Paradox and Politics of New Age Masculinity

William Reynolds

The decline of public life demands that we use film as a way of raising questions that are increasingly lost to the forces of market relations, commercialization, and privatization. As the opportunities for civic education and public engagement begin to disappear, film may provide one of the few mediums left that enables conversations that connect politics, personal experiences, and public life to larger social issues.

—*Giroux, 2002, p. 7*

The products of popular cinema can rarely match up to the standards set by high culture—since they are operating within different institutional spaces, and often mobilizing different aesthetic practices. For cultural critics to dismiss the products of popular cinema, or to assert that its appeal is *obvious,* reveals little of its significance.

—*Tasker, 1993, p. 154*

Introduction

I know, I should feel ashamed but I have always liked action movies. As a young skinny kid growing up in the suburbs of Rochester, New York, I remember Saturdays were always reserved for going to the movies. My friends and I would most often ride our bikes to the local theater to see the latest action film. Sometimes it was James Bond movies, sometimes it was Clint Eastwood films. I particularly remember those Italian westerns (sometimes referred to as spaghetti westerns), and there were always World War II movies. Once we were watching the movies, we, of course, became James Bond (Sean Connery), the very seldom smiling Dirty Harry (Eastwood), the ever courageous World War II fighter pilot, or the escaping POW (Steve McQueen). These films allowed us to imagine. Perhaps, the imaginations were not always the best, but the films did more for our imagination and our sense of identity than did the laborious and dreadful curriculum in school. As the single movie theater transformed into the mega movie theaters with multiple screens, we would spend whole Saturdays sneaking in to one theater after the next. We would see as many as three movies in a day for the price of one. Indeed, the conversations after those films were always a favorite time of mine. I still enjoy conversations and discussions of movies. After the movies, we would ride our bikes to Lake Ontario to sit on the benches by the beach, eat, and talk about the movies we had just seen, sometimes until after dark. These were different conversations not constrained by looking for a right answer or someone else's point of view, just talking about what we felt and believed. It did offer a time of pseudo-freedom. "Films pointed to a terrain of pseudo-freedom located in an inner world of dreams, reinforced by the privatized experience of pleasure and joy offered through the twin seductions of escape and entertainment" (Giroux, 2002, p. 3).

A few years later I got my first job. It was as an usher at the Stutson Movie Theater in Rochester and later as a summer job I was an assistant manager at the Stoneridge Theater. This employment allowed me to see movies for free and, when I was not working, I had permission to attend all theaters in that chain without charge. I believe my love of film and narrative moved me to become an English major in undergraduate school, but I remember only one discussion of film in my four years of course work, and it certainly was not an action film. I suspect that love of film has led to this essay.

Action films are the type of viewing pleasure few of us admit we enjoy. It is much more acceptable in educated circles to fawn over the newest foreign film or the latest independently produced movie discussing the angle of the shot or how much it is reminiscent of Alfred Hitchcock. However, many of us flock to the big screen or rent the DVDs of those action films. They offer a pleasurable escape, even now or perhaps particularly now.

> Whilst contemporary action is regularly dismissed as simplistic or reactionary, the films continue to fascinate and to stimulate discussion. The articulation of gender, particularly as expressed through star images and performance, has been central to critical debate. Indeed for many the functioning of action as a site of gender trouble is one of the factors that makes it so compelling (Tasker, 2004, pp. 8–9).

These films offer viewers, especially white male viewers, the idea that the strong macho male, even if he has problems with alcohol, drugs, women, post-traumatic stress syndrome,

or money can emerge triumphant and save the world. The individual white man can save the day.

For many men their early education and their views of masculinity and sexuality may, indeed, come in part from watching such action films. This concept makes the critical analysis of these types of films/media extremely necessary if we are to understand their connections with the development of the type of masculinity the films are manifesting and the ways in which that masculine identity as it is portrayed contributes to the larger global corporatized order.

Therefore, rather than just dwell on the seduction of escape, pleasure, and entertainment; I want to analyze action films, particularly those of Steven Seagal, and their connection to identity formation and masculinity as an example of the ways in which films can be critically interpreted. Many cultural studies researchers are writing about film but focus on a strictly textual analysis that frequently fails to discuss the connection between film and larger global political issues. As Henry Giroux has observed:

> The exclusive emphasis on texts runs the risk of reproducing processes of reification and isolation, as when the performance is framed outside of the context of history, power and politics. In this instance, texts [films] become trapped within a formalism that often succumbs to viewing such issues as one's commitment to the "other," the ethical duty to decide what is better or what is worse, and, by extension, human rights as either meaningless, irrelevant or leftovers from a by-gone age. (2000, p. 131)

For example, I have attended popular culture/cultural studies presentations and read many articles on popular film that discuss interesting and fascinating plots and characters and delve into the intricacies of relations among characters. However these discussions never relate the films to the global, corporate order. These interconnections are at the heart of a critical analysis of film and need to be addressed. During this historical moment of compassionate conservatism, critical analyses of film are a necessity. Here is again Henry Giroux: "I attempt to challenge a voyeuristic reception of films by offering students a modicum of the theoretical resources necessary to engage critically how dominant practices of representation work to secure individual desires, organize specific forms of identification, and regulate particular modes of understanding, knowledge and agency" (2002, p. 14).

This analysis will focus on two of Steven Seagal's films, *On Deadly Ground* (Ho, Nasso, & Seagal, & Seagal, 1994) and *Fire Down Below* (Gilmore, Stuart, Seagal, & Alcala, & Carroll, 1997) but will also include a brief analysis of some of his more recent endeavors from between 1998 and 2006. They will be analyzed to show the evolution of notions of masculinity in the action film and the connections between those conceptualizations of masculinity and political configurations. The major thesis is that, although these Seagal films present a type of new-age masculinity, their underlying message does not significantly challenge the current notions of either masculinity or the current socio-political status quo. His films also do not change the basic machismo male hero presented in action cinema. Although Seagal has a different appearance and manner, the representations of white male supremacy and power through violence have not changed.

Action Films During the 1980s and 1990s

Flashback to the 1980s: The smoke clears, the fire flares, the ground explodes, and out of the haze emerges the muscular body wrapped in a bandoleer of bullets—*Rambo: First Blood Part II* (Kassar, Vajnar, & Cosmatos, 1985) played by Sylvester Stallone or with a long broad sword in *Conan the Barbarian* (Conte, De Laurentiis, & Milius, 1982), or a as cyborg in *The Terminator* (Daly, Gibson, & Cameron, 1984) with Arnold Schwarzenegger in the title role, or a host of other muscled men in the 1980s action films (Jean-Claude Van Damme, Bruce Willis, Clint Eastwood, and Chuck Norris). Many texts have contributed to our understanding of the emergence of the Reagan era films (Tasker, 1993, 2004; Chapman & Rutherford, 1988). These analyses suggest that the 1980s were a time to readjust masculinity. The American people had elected a movie hero as president, and it was time to return America and its men back to a rightful place of power and preeminence. Chapman and Rutherford (1998) suggest that the image of a tough muscle macho man

> advertises a destructive machismo as the solution to men's problems. He is John Wayne with his gloves off, wildly lashing out at everything that threatens and disappoints him. He confronts a world gone soft, pacified by traitors and cowards, dishonorable feminized men. It is a world that has disrupted his notions of manhood and honor. It threatens his comprehension of who he is. And his attempts to recreate order, and subdue the forces that threaten him, degenerate into a series of violent actions. (pp. 28–29).

Much of the muscle men action movies of the 1980s served to bolster masculine spirits after the debacle of Vietnam (Reynolds & Gabbard, 2002) and the consequent Vietnam syndrome. In fact, these muscular heroes helped to rewrite our memories of the politics of Vietnam and reconstruct a more "honorable" masculinity. Giroux has provocatively analyzed films about Vietnam and demonstrated certain aspects of the ways in which those macho men with "spectacular bodies" (Tasker, 1993) rewrote our memories and developed our identities in the Reagan era (Giroux, 1999, 2002; Reynolds & Gabbard, 2003). Specifically, as Giroux (1999) has pointed out:

> At the height of the Reagan Era, Hollywood rewrote the Vietnam War in the image of an unbridled and arrogant machismo. Films such as *Uncommon Valor* (1983), *Missing in Action 2, The Beginning* (1985), *Rambo: First Blood, Part II* (1985), and the *Hanoi Hilton* (1987) used Vietnam as a backdrop to celebrate heroic rescues. Chemical Warfare, forced settlements, and the burning of villages on the part of the U.S. military were written out of the history, as Hollywood invented wooden macho men intent on saving the real victims of Vietnam, the MIAs, from the demonized Vietnamese. (p. 151n)

Giroux continues that what was at issue in this rewriting of history was a Reaganite construction of the image of masculinity that coincided with a conservative image of national identity and patriotism. Although in the films of Steven Seagal, produced in the 1990s, there emerged a new-age macho man, the stubborn role of the violent, macho white male of the 1980s and its connection with the conservative political agenda continued.

Steven Seagal Films and the New-Age Hero

We're outgunned and undermanned, but you know what? We're gonna win. And
you know why? Superior attitude. Superior state of mind.

—*Rich, Rachmil, & Todman, 1990*

Mr. Seagal may take a little explaining. He is big, handsome, imposing, colossally
confident and not quite like any other actor who has ever made a killing, so to speak,
in the action field. Only from afar would it be possible to confuse him with some-
one like Jean-Claude Van Damme, a more typical self-defense star and another
recently arrived contender for the action crown.

—*Maslin, 1991, p. 13*

Steven Seagal's film presence is intermixed with his real life. Seagal, in addition to being
an action film star, holds the rank of a 7th dan in the Japanese martial art aikido, which
he employs in his films. His concern with the abuse of the environment has made its way
into three of his films. In 1997 Seagal publicly announced that one of his Buddhist teach-
ers, His Holiness Penor Rinpoche, had accorded Seagal as a tulku, the reincarnation of a
Buddhist Lama, and, not surprisingly, in most of Seagal's films this spirituality makes an
appearance. Thus, it is not unusual in a Seagal film to see the actor in either Asian or Native
American clothing. In addition, he plays the guitar, and he has released two CDs [*Songs
from the Crystal Cave* (2006) & *Mojo Priest* (2006)]. In a slightly different realm, Seagal has
become somewhat of an industry. Besides his films and CDs, he has an official Web site
(www.stevenseagal.com), and his energy drink line has its own (www.lighteningdrink.com).
The drink is named, *Steven Seagal's Lightning Bolt,* which sports the likeness of Seagal on
the can and a quote from Seagal, "A natural energy drink packed with vitamins and
exotic botanicals." Throughout his career, the star has made several claims of real-life hero-
ics, including black-ops jobs for the CIA and encounters with organized crime figures around
the world. The actor apparently has had a fixation with urban Italian Americans, claim-
ing at one time to be half-Italian when in reality his mother was Irish and his father Jewish.
There is much controversy about a dark side surrounding Seagal, especially with regard to
the rumored CIA connections. Seagal gave an interview for the *Los Angeles Times* in which
he obliquely referred to work he had done for the CIA in Japan. "They saw my abilities,
both with martial arts and with the language," he said. "You could say that I became an
advisor to several CIA agents in the field and through my friends in the CIA, met many
powerful people and did special works and special favors" (Goldstein, 1988, p. 103). In his
films, Seagal frequently portrays either a former or current CIA, DEA, or EPA agent.

Steven Seagal films are an interesting phenomenon. Although they clearly belong to
the genre of action cinema, they can also fit into the subcategory of martial arts films. They
are formulaic, and hence some critics refer to this formula as Seagalism.

Someone Seagal knows gets killed and he has to get to the center of some gang trouble to sort it all out, beating up and killing as many people as possible along the way. Men, women, children, cats, patio furniture none of it is safe. Also there needs to be lots of guns and Seagal cannot get hurt or killed (an exception to the last can be made once in a while though). Extra points if the plot involves drug dealers or terrorists. (The Seagal Formula, http://www.seagalology.com/?formula, 2006)

These various characteristics of the film persona and the real-life personality make Steven Seagal a postmodern hero. Indeed, it is the paradox of these masculine qualities that make it postmodern. On the one hand, there is sufficient killing and mayhem to classify his films as action films, yet on the other hand, there is this type of new-age man quality. More precisely, there is the Buddhist, the environmentalist, the multiculturally concerned feminized man, which is obvious in the Seagal films produced in the 1990s. Seagal's concern with the environment in general and working-class coal miners in Appalachia and Native Americans more specifically demonstrates these facets. Seagal apparently is an action hero with a social conscience. This type of new-age hero is quite different from the muscular hero of the Rambo era. However, despite these differences the type of masculinity represented is in most ways similar and the political message may be as conservative as that of the action films of the 1980s. Cynically one may wonder if all this new ageism is just to make a profit in the corporate order. Perhaps by portraying these qualities of spirituality and an environmental and multicultural conscience, these potentially critical points of view are diffused. As male viewers, we can purchase our social consciousness for the price of a movie ticket or DVD and still see the winning ways of macho man violence. "Social consciousness and activism in this world are about purchasing merchandise, not changing oppressive relations of power" (Giroux, 1994, p. 5). The analysis of Seagal's films reemphasizes Giroux's statement.

On Deadly Ground

The qualities discussed above surface *On Deadly Ground* (Ho, Nasso, Seagal, & Seagal), which was produced in 1994. Seagal plays Forrest Taft, who was once a high level CIA agent and is now an Alaska oil-rig roughneck, who specializes in fighting oil-well fires. He eventually confronts Aegis Oil president, Michael Jennings (Michael Caine), who has determined that oil company profits are more important than the environment. They have put Taft, Masu (Joan Chen) a Native American activist, and other environmentalists on their hit list. Taft, of course, who is an expert in martial arts, explosives, and survival skills manages to kill many of the Aegis oil cronies and even lets Michael Jennings die by allowing him to fall into a vat of oily slime. He destroys a giant oil platform in the process because it was constructed with defective parts, which would eventually break down and lead to an environmental disaster. There is enough blood and gore in this film to please action film fans, particularly in a scene where Taft's friend is murdered by two Aegis thugs using a pipe cutter. However, there are the environmentalist and Native American aspects to the film. After slaughtering countless bad guys, Taft gives an environmental speech to

a large group of Native Americans and the press. Taft comes to the podium dressed in a Native American buckskin jacket with beautiful bead work and fringe. After being asked by the tribal council, he speaks in the film for several minutes on the consequences of cor-poratization and environmental recklessness. His speech is given as scenes of toxic waste dumping are shown. After covering topics such as the combustion engine, alternative engines, big business, air and water pollution, plankton, and bottled water he concludes by stating:

> Taft: I have been asked what we can do. I think we need a responsible body of people that can actively represent us rather than big business. This body of people must not allow the introduc-tion of anything into our environment that is not absolutely biodegradable or able to be chemi-cally neutralized upon production. Finally as long as there is profit to be made from polluting our earth companies and individuals will continue to do what they want. We have to force these com-panies to operate safely and responsibly and with all of our best interests in mind. So that when they don't, we can take back our hearts and our minds and do what is right. (Ho, Nasso, Seagal, & Seagal, 1994)

At the end of the speech Taft is given a Native American blessing and the film ends with a hug between Taft and the chief of the tribe followed by beautiful scenes of the pris-tine Alaskan wilderness. So here is the paradox in the representation of masculinity. Although there is an attempt to give a positive message about men standing up for envi-ronmental causes, Native Americans and political agency in a time of corporate greed, there is also the fact that the white male hero solves the immediate crisis by resorting to violent action in the form of killing. It also demonstrates that the world will be saved by the white male—he will be the savior. Thus, even though there is this new-age wisdom imparted and maybe we feel better for buying a DVD that advocates it and maybe we feel we have demon-strated and secured our social consciousness by doing so, the representation of the white male saving the world through violence remains intact—the ends justify the means. Moreover, because we have purchased our social consciousness the politics of the present remains unchanged, and white men can feel confident that they will be the saviors of the world.

Fire Down Below

In *Fire Down Below* (Gilmore, Stuart, Seagal, & Alcala & Carroll, 1997), dubbed an eco-thriller, Seagal plays EPA agent Jack Taggart, whose fellow agent and friend is murdered in Jackson, Kentucky, a remote former coal mining town in Appalachia. Taggart comes to find out who is responsible for the dumping of toxic waste into the abandoned coal mines. He arrives undercover, disguised as an Appalachian assistance worker, who plans on help-ing people in the community by doing odd fix-up jobs, such as repairing front steps and porches. The Reverend Bob Goodall assists him in his ruse. Although Taggart evidently cares about the people and even falls for the outcast girl in the community, Sarah Kellogg (Marg Helgenberger), the small-town community is distrustful of him as an outsider (a stereotyp-ical portrayal of the people of Appalachia), and they are reluctant to share information with

him. The real guilt lies with big business in the form of a billionaire CEO named Orin Hanner (Kris Kristofferson), who makes huge profits from dumping chemical waste into the abandoned coal mines, thus triggering fires down below. His inept son, Orin Hanner Jr., is in charge of running the town and has the corrupt police force as well, as a number of thugs on his payroll. Taggart frequently confronts the thugs and practices his aikido on them. Seagal's character makes an eco-friendly, working-class buddy speech from the pulpit of Goodall's church.

> Taggart: You know the trouble with rich people is that they don't care about others. These folks that are making profits by dumping these toxic wastes and petroleum by-products and stuff like that—they're the ones that profit. Why don't they dump that in their own backyards? But instead they pay some poor dumb shit (Forgive me Father) five dollars an hour to truck this up into the mountains of Appalachia. Why? Because they think you all are ignorant, barefoot, dumb hillbillies that don't have the money and the power to fight them back. To these people you all are insignificant. You mean nothing and if there is anybody out there who thinks that the three hundred dollars they gave you to buy a new satellite or look the other way is worth selling out the legacy of your ancestors and the future of your children, please raise your hand. You see I don't see no hands. Please think about this. You know why I am here and let's all come together as one family and fight them. (Gilmore, Stuart, Seagal, & Alcala, & Carroll, 1997)

This speech is the catalyst for the people's change in attitude, and they begin to cooperate with Taggart. Sarah gives him her father's plans to the mines. Goodall says he has had a change of heart and will testify against the corrupt police, the thugs, and all those involved in the dumping. However, the thugs who were attending church as well overhear Goodall and burn the church to the ground with him in it. Hanner decides to buy Taggart, and, when he comes to Jackson, he offers him as much money as he wants, but Taggart refuses to be bought. Instead he goes back to a party already in progress and in true new-age fashion plays the guitar and dances with Sarah. Meanwhile, Sarah's abusive and nefarious brother Earl falsely befriends Taggart and takes him to the dump site. They drive down into the mine where there is a host of evildoers. A battle follows, and Taggart kills or injures most of the villains by gun or with aikido moves. Taggart finally has enough evidence to arrest Hanner, and the CEO is found guilty and has to pay a fine. However, as Hanner says: "You see that is what I love about this country. I made three hundred million last year and it only cost me fifty grand" (Gilmore, Stuart, Seagal, & Alcala & Carroll, 1997).

Eventually after beating up a bunch of Hanner Jr.'s thugs and slapping the son around a bit, the son turns evidence on the father, and Taggart goes to Hanner's casino to arrest him. Hanner tries to shoot Taggart, but instead Taggart wounds Hanner. Taggart sends Hanner off to jail with a threat that he will be visited by one of the inmates and most likely be raped while he is serving his time in prison. Taggert, though, as he promised, returns to Jackson and Sarah. The film ends with actual pictures of people from Appalachia and mountain music in the background.

Again, we have this paradox of the new age hero supporting an eco-friendly agenda and working-class camaraderie. He is sensitive to the environment and the poor. However, the poor pay the price for their resistance in beatings and death. This is the conservative caution to the working class that resistance comes with a heavy price. The white middle-class

tough male hero again saves the day. This time it is with traces of homophobia. The way to win and be the savior is through extreme violence. The film demonstrates that really little has changed in the action cinema genre. It still promotes the struggle to reassert or maintain a traditional masculinity, a tough authority. This representation of masculinity comes with a soft voice and kick-ass aikido.

Seagal Films of the Twenty-First Century

Most of the action films featuring Stephen Seagal produced in the last few years have returned to the basic Seagalism formula of violent action without even a hint of the new-age trappings of the 1990s. There is the addition in some of newer Seagal films of African American partners. Not surprisingly, they follow the pattern of the "black buddies and white heroes" (Tasker, 1993) films of the 1980s and early 1990s such as the *Lethal Weapon* series (Mel Gibson and Danny Glover); *The Last Boy Scout* (Black, Josephson, & Scott, 1991) featuring Bruce Willis and Damon Williams; *Die Hard I* (Gordon, & McTiernan, J., 1988) with Bruce Willis and Reginald Veljohnson; *Die Hard II* (Levin, Levy, & Harlin, 1990) again with Bruce Willis and Reginald Veljohnson; *Die Hard with a Vengeance* (Bruce Willis and Samuel L. Jackson); with the significant white male hero and his lesser black buddy. The Seagal films that follow this pattern are *The Glimmer Man* (Hamed, Marion, Rachmil, & Gray, 1996) with Steven Seagal and Keenan Ivory Wayans; *Exit Wounds* (Berman, Silver, Cracchiolo, & Bartkowiak, & Ellis, 2001) (Steven Seagal and DMX), and *Half Past Dead* (Eberts, Schott, Emmett, & Paul, 2002) (Steven Seagal and Ja Rule). The Seagal films do not significantly change this motif. A productive extended critical analysis of the white hero and black buddy films could provide insight into the representations of both white and black male notions of masculinity and their interconnections to politics and race.

In the Seagal films there is also a pattern of Asian buddy and white hero. This depiction keeps Seagal's ties to the Far East evident. In these films, such as *Belly of the Beast* (Dimbort, Lerner, Short, & Tung, Ching, T., & Ching S.-T., 2003), the black buddy is simply replaced with an Asian buddy.

Newer Seagal films spend a short time in theaters, and some are instant video releases. The newest films such as *Submerged* (Lerner, Davidson, Dimbort, & Hickox, 2005), *Today You Die* (Emmett, Furla, Lerner, & Fauntleroy, 2005), *Black Dawn* (Ralph, Stevens, Seagal, & Gruszynski, 2005), *Mercenary for Justice* (Emmett, Furla, Lerner, & Fauntleroy 2006), and *Shadow Man* (Seagal, Spengler, Stevens, & Keusch, 2006) are evidence of the return to the violent combination of martial arts and heavy duty weapons. In *Mercenary for Justice* (2006), a movie with a very weak plot, the initial ten minutes of the film are nothing but gun fire, tank fire, people dying, kidnapping, necks being broken, and other scenes of violence that continue throughout the film. Seagal (John Seeger) is a mercenary. However, those images of an environmentally conscious hero are gone, and we are returned to the gun-toting, arm-breaking macho white hero. Without an in-depth study of these films it is still possible to assert that in a post 9/11 world of Bush compassionate conservatism, it

is politically advantageous for men to have this version of masculinity. After all, there is a war on terrorism, and we need men who will volunteer (at least for now) to fight in that war and the war in Iraq and Afghanistan. Because we have "God's Cowboy Warrior" (McLaren, 2005) in the White House who says "bring it on," it makes perfect sense to bolster representations of tough masculinity. Those notions of tough masculinity further the political agenda of apocalypse and fear now ever present in our society. Once again we can view the connections from analyzing action cinema to the possibilities of an enhanced critical understanding of the political hegemony that surrounds us and is for the most part unquestioned. Perhaps, the critical analyses of films, like those of Steven Seagal, bring us one step closer to that questioning.

The Critical Analysis of Film

Films such as those of Steven Seagal need to be critically analyzed, for they offer the potential of a critical reading of how politics and the representations of action movies can conceal both ideological and hegemonic principles used to legitimize a certain kind of masculinity and a particular brand of heroism that supports particular political ideologies. Steven Seagal action films promote a type of conservative image of masculinity and individualism, even though there are in some cases new-age or postmodern sentiments expressed. These may, indeed, be for profit. As popular cultural texts these films function

> [t]hrough discursive practices and ideological practices that are both pedagogical and political. As part of a larger cultural apparatus [it] signifies the centrality of film as a medium of popular culture, a centrality that must be addressed not simply as a pedagogical apparatus actively involved in diverse identity formations but also for the crucial role it plays in the construction of national identities in the service of global expansion and colonialism. (Giroux, 2002, p. 14)

These Steven Seagal action films operate to help form our identities and to maintain social and political power, and no, they are not the sophisticated fare of the Sundance or Cannes film festivals. Some critics have even said dumb movies for dumb people. However, thousands watch them nonetheless. It seems that they may influence more people than their more prestigious counterparts. The critical analysis of popular action films may be a way to begin to critically engage greater numbers of people/students.

When I was watching all those action films as a kid growing up in Rochester, I know that I was not thinking about how my identity and notions of masculinity were being shaped by the films. I did not realize that they were creating a certain outlook on politics and agency, but they were. I have always loved the movies and still do. Now, however, the admiration for the possibilities of the critical analysis of film and other media has grown so that I can critique what I have always enjoyed. It also allows for the critical pedagogical possibilities with students. I have met very few who do not like movies. Furthermore, films are a way of opening critical complicated conversations that might otherwise remain unspoken. There is nothing better than curling up on the couch with a new DVD release or going to the cinema and enjoying the pleasure of watching a movie and then when the final cred-

its fade anticipating the critical thinking and conversations that will eventually come about. It is why I enjoy the cultural studies of film. It allows me to engage in one of my favorite pastimes—watching movies.

REFERENCES

Text

Chapman, R., & Rutherford, J. (Eds.). (1988). *Male order: Unwrapping masculinity*. London: Lawrence and Wishart.

Giroux, H. A. (1994). *Disturbing pleasures: Learning popular culture*. New York: Routledge.

Giroux, H. A. (1999). *The mouse that roared: Disney and the end of innocence*. New York: Rowman and Littlefield.

Giroux, H. A. (2000). *Impure acts: The practical politics of cultural studies*. New York: Routledge.

Giroux, H. A. (2002). *Breaking into the movies: Film and the culture of politics*. Malden, MA: Blackwell.

Goldstein, P. (1988, February 28). The next tough guy. *The Los Angeles Times*, p. 103.

Maslin, J. (1991, April 28). Seagal packs more than a wallop. *The New York Times*, Arts and Leisure Desk, p. 13.

McLaren, P. (2005). *Capitalists and conquerors: A political pedagogy against empire*. New York: Rowman and Littlefield.

McLaren, P., Hammer, R., Scholle, D., & Reilly, S. (1995). *Rethinking media literacy: A critical pedagogy of representation*. New York: Peter Lang.

Reynolds, W. M., & Gabbard, D. (2002). *We were soldiers:* The rewriting of memory in the brand name corporate order. In D. Gabbard & K. Saltman (Eds.), Education as enforcement: The corporatization and militarization of schools (pp. 288–297). New York: Routledge.

Seagal, S. (2006). *Mojo priest* [CD]. Sherman Oaks, CA: Arc 21 Records.

Seagal, S. (2006). *Songs from the crystal cave* [CD]. New York: Sony International.

Seagal Formula. (n.d.). Retrieved August 23, 2006, from at http://www.seagalology.com/?formula.

Tasker, Y. (1993). *Spectacular bodies: Gender, genre and the action cinema*. New York: Routledge.

Tasker, Y. (Ed). (2004). *Action and adventure cinema*. New York: Routledge.

Filmography

Motion pictures by or with Steven Seagal

Berman, B., Silver, J., Cracchiolo, D., (Producers), & Bartkowiak, A., & Ellis, D. R. (Directors). (2001). *Exit wounds*. United States: Warner Bros.

Choi, P., Niami, N. Baldwin, H. (Producers), & Semler, D. (Director). (1998). *The patriot*. (1998). United States: Touchstone Pictures

Davis, A., Seagal, S, & Ferrandini, D. R. (Producers), & Davis, A. (Director). (1988). *Above the law*. United States: Warner Bros.

Dimbort , D., Lerner, A., & Short, T. (Producers), & Tung, C. S., II, Ching, T., & Ching S.-T. (Directors). (2003). *Belly of the beast*. United States: Studio Eight Productions.

Dimbort , D., Lerner, A., & Short, T. (Producers), & Oblowitz, M. (Director). (2003). *Out for a kill*.

United States: Nu Image Films.

Eberts, C., Schott, U., & Emmett, R. (Producers), & Paul, D. M. (2002). *Half past dead*. United States: Franchise Pictures.

Emmett, R., Furla, G. & Lerner, D. (Producers), & Fauntleroy, D. E. (Director). (2006). *Mercenary for justice*. United States: Nu Image Films.

Emmett, R., Furla, G. & Lerner, D. (Producers), & Fauntleroy, D. E. (Director). (2005). *Today you die*. United States: Nu Image Films.

Gilmore, W. S., Stuart, J., & Seagal, S. (Producers), & Alcala, F. E., & Carroll, L., II (Directors). (1997). *Fire down below*. United States: Seagal/Nasso Productions.

Hamed, S., Marion, E., & Rachmil, M. I. (Producers), & Gray, J. (Director). (1996). *The glimmer man*. United States: Warner Bros.

Ho, A. K., Nasso, J. R., & Seagal, S. (Producers), & Seagal, S. (Director). (1994). *On deadly ground*. United States: Warner Bros.

Lawton, J. F., Goldstein, G. W., & Reuther, S. (Producers), & Davis, A., & Palmisano, C. (Directors). (1992). *Under siege*. United States: Warner Bros.

Lerner, A., Davidson, B., & Dimbort, D. (Producers), & Hickox, A. (Director). (2005). *Submerged*. United States: Nu Image Films.

Lerner, A., Davidson, B., Dimbort, D. (Producers), & Pyun, A. (Director). (2001). *Ticker*. United States: Nu Image Films.

Nahm, M. (Producer), & Doo-Young, K. (Director). *Clementine*. (2004). United States: Pulstar Pictures.

Nasso, J. R., Kopelson, A. Seagal, S. (Producers), & Flynn, J. (Director). (1991). *Out for justice*. United States: Warner Bros.

Perry, S., Gareri, J, & Silver, J. (Producers), & Baird, S., Perry, S., & Hosking, C. (Directors). (1996). *Executive decision*. United States: Warner Bros.

Ralph, D., Stevens, A., & Seagal, S. (Producers), & Gruszynski, A. (2005). *Black dawn*. United States: Screen Gems Inc.

Rich, L., Rachmil, M. I., & Todman, B., Jr. (Producers) & Malmuth, B. (Director). (1990). *Hard to kill*. United States: Warner Bros.

Samaha., E., Goldfine, P., & Stanley, T. (Producers), & Leong, P.-C. (Director). (2004). *Out of reach*. United States: Franchise Pictures.

Samojlowicz, J., Kazimierz, Seagal, S. (Producers), & Oblowitz, M. (Director). (2003). *The foreigner*. United States: Franchise Pictures.

Seagal, S., Milchan, A., & Perry, S. (Producers), & Murphy, G. (Director). (1995). *Under siege 2: Dark territory*. United States: Warner Bros.

Seagal, S., Samaha, E., & van Thompson, K. (Producers), & Morrison, C. II (Director). (2005). *Into the sun*. United States: Franchise Pictures.

Seagal, S., Spengler, P. & Stevens, A. (Producers), & Keusch, M. (Director). (2006). *Shadow man*. United States: Steamroller Productions.

Other Motion Pictures

Black, S., & Josephson, B. (Executive Producers), & Scott, T. (Director). (1991). *The Last Boy Scout*. United States: Warner Bros.

Conte, D. C., & De Laurentiis, D. (Executive Producers), & Milius, J. (Director). (1982). *Conan the Barbarian*. United States: Universal.

Daly, J., & Gibson, D. (Executive Producers), & Cameron, J. (Director). (1984). *The Terminator*. United States: Orion.

Gordon, S. (Producer), & McTiernan, J. (Director). (1988). *Die Hard I*. United States. 20th Century Fox.

Kassar, M., & Vajnar, A. G. (Executive Producers), & Cosmatos, G. P. (Director). (1985). *Rambo: First Blood Part II*. United States: Tristar Pictures.

Levin, L., & Levy, M. (Executive Producers), & Harlin, R. (Director). (1990). *Die Hard II*. United States: 20th Century Fox.

Rich, L. Rachmil, M. I., & Todman, B. (Producers), & Malmuth, B. (Director). (1990). *Hard to kill*. United States: Warner Bros.

Vanjna, A., Feithshans, Lawrence, R. (Producers), & McTiernan, J. & Leonard, T. (Directors). (1995). *Die hard with a vengeance*. United States: 20th Century Fox.

Chapter 30

Buying and Selling Culture

Talk Show Content, Audience, and Labor as Commodities

Christine M. Quail, Kathalene A. Razzano, and Loubna H. Skalli

"Oprah," "Dr. Phil," "Montel," and "Jerry Springer" need no introduction. As celebrity talk show hosts that join us in our living rooms every day, they carry a socio-cultural power that is evident to younger and older viewers alike. Their ability to command authority in defining, addressing, and solving guests' problems has raised questions about the potential effects that these shows have on home audiences' psyches, relationships, and careers. Their appeal to audiences' insecurities and thirst for entertainment is one element contributing to their shows' success. Another element is the political economic dynamics at play in producing and marketing the shows and the hosts as celebrities. A political economic argument is not one that suggests that audiences are "duped" into believing the talk show hype. Rather, this approach interrogates the material conditions that create and sell talk shows. In our book *Vulture Culture: The Politics and Pedagogy of Daytime Television Talk Shows* (2005), we use political economic analysis, cultural studies, and critical cultural pedagogy to thoroughly question the nature of talk shows and their role in television and popular culture. Here, in this chapter, we will highlight one element of understanding this phenomenon: the process of cultural commodification, or the buying and selling of culture.

Defining Commodification

In the simplest terms, commodification means, the process of increasing the realm of what is possible to sell and buy. For example, take a grassy field that kids use to play soccer. This field is part of the neighborhood, open and free to the public. If a developer were to begin to charge cars to park along the edge, and charge kids by the hour to rent the field, the space has become commodified—an item that had previously been in the non-profit sphere, has joined the world of the market as a commodity. The process equally applies to culture and media. A general example could be the co-optation of a youth trend, such as ripped jeans. Young people who started the trend made their own holes in their own jeans. Along comes a jean company such as Guess or Levis, and produces on a mass scale, jeans that have wrinkles, rips, or tears, and sells them to consumers. This process obviously raises questions about divergent meanings of political and cultural statements being made by the original youth culture, versus the corporately constructed culture.

The politics involved in commodification thus are related to the political economics of commercialization and advertising. In today's capitalist context, branding and advertising legitimate the economic system's commodifying production practices by creating desires, wants, or lacks that mass-produced products could fill and by creating brands to which consumers would become loyal. Thus, branding and advertising help encourage consumerism, with the commodity at its heart (see Klein 1999).

What we would like to focus on here is the process of commodification as it expresses itself in media culture, or specifically, talk show culture. In order to fully address how talk shows are commodified, or rather, how culture is commodified through talk shows, we will identify three areas of analysis: talk show content, talk show audiences, and talk show labor. The goal of this chapter is to examine how talk shows play a role in capitalist legitimation and accumulation processes through commodification, commercialization, and the culture of branded advertising.

Theoretical Background

Before we begin our analysis, a brief discussion of out theoretical assumptions is in order. Karl Marx's critqique of capitalism underpins our critique of media culture in a capitalist society. Even more on point, Marx's discussion of commodities can help us understand the cult of the commodity form in capitalism. He has written that in a capitalist structure, the commodity—or, that which is bought and sold—has taken on a life of its own. As he states:

> [T]he relations connecting the labour of one individual with that of the rest appear, not as direct social relations between individuals at work, but as what they really are, material relations between persons and social relations between things. It is only by being exchanged that the products of labour acquire, as values, one uniform social status, distinct from their varied forms of existence as objects of utility. (Marx, 1978, p. 321)

Commodity fetishism allows these social relations between people to be concealed, as the fetish "attaches itself to the products of labour, so soon as they are produced as com-

modities, and which is therefore inseparable from the production of commodities" (Marx, 1978, p. 321). Thus, the commodification process defines the process of transforming use values—the practical value of something in one's life—into exchange values, the dollar value of a product. As political economist of communication Vincent Mosco furthers, by "transforming products whose value is determined by their ability to meet individual and social needs into products whose value is set by what they can bring in the marketplace" (Mosco, 1996, pp. 143–144), commodification removes products from a more meaningful social context into one that primarily benefits businesses and the ideology of "free market" values. A culture based on commodity fetishism, then, values the exchange value of a cultural product as much if not more than the pleasures that it produces. It is a political economic system that concerns itself with numbers and prices of media products, rather than the social value of those media to democracy, self-identity, or social change. Since processes of commodification are perhaps the central forces that propel capitalist expansion into more and varied realms of society, we can argue, then, that commodification should be central to a political economic analysis of media (Mosco, 1996; Garnham, 1990), and talk shows specifically.

The Spectacle, The Problem, and the Intertext: Talk Show Content Commodified

A first step in understanding talk show commodification could be to examine the content of the program itself. In doing so, we can understand how political economic impulses help create what we watch. There are three interrelated sites of content that we have identified and will analyze:

1 The produced program as spectacle
2 The commodified "problems" of the produced show
3 The intertextual commodities used as consumer remedies to commodified aspects of the show

With respect to the first site of commodification, "program as commodified spectacle," the talk show itself as a market product constitutes part of the "culture industry." Television talk show programs, in the broadest terms, exist as marketable commodities, usually syndicated, that are bought and sold in the communications marketplace. A price is paid by the production company to a distribution company, to send the program to networks. In yet another move, in first-run syndication, channels must buy a contract to the distribution company to air the programs. This is purely a market exchange of commodities, much the same as a canned soup company contracting with trucks and delivery to grocery stores. But there's something differentiating canned soup and talk shows, and it isn't the creamy broth—talk shows function as mediated spectacles. Their visual imagery constitutes vulture spectacle, meant to entertain, amuse, and invite participation from the largest segment of audiences and viewers. By garnering a large market share as expressed in ratings, a show can command

more advertising dollars—as share guides ad prices: an advertising dollar spent to reach 100,000 viewers is ten times more efficient than one spent to reach 10,000 viewers, and one hundred times more efficient than one spent to reach 1000 viewers. Thus, the additional market of advertising commodifies the culture of talk shows.

To push this point further, the filmed spectacle/program comprises three types of commodities: confrontation, information, and celebrities. Each of these is a marketable good in so far as each theme competes for popularity and further exposure on the spectacle/show. These second-order commodities can be conceived of as problems that need solutions— the solution being the third-order intertextual commodities. Information problems are solved with useful products; confrontation issues with therapists' books and make-over tie-ins; celebrities with films, TV shows, books, and music. No matter the problem, buy your way to a solution today (available at Wal-Mart for $9.99, while supplies last!).

The additional celebrity factor is the celebrity host, who functions economically because of the branding of celebrity. Oprah Winfrey is a brand in the same way that Nike, Kodak, or Honda are brands. Her very persona and image mark her as a product. In a celebrity culture, loyalty to a celebrity-as-brand can command big bucks. Would mainstream America rather pay $10 to see a movie starring Denzel Washington or George Clooney, or Jimbo Noname? Once an audience member loyally commits to Denzel or Dr. Phil, they will be a return customer. Jimbo is a bigger economic risk for the producer, because a loyal audience has not already been established. Recent examples can be viewed in the last several years of talk shows. New talk show hosts have included Tyra Banks (supermodel and host of reality show *America's Top Model*), Ellen DeGeneres (comedian and film and TV star), and Megan Mullally (popular actress who played Karen on TV's *Will and Grace*).

The third level of content is the intertextual commodity. Intertexts are created as products and texts combine in such a way that "text, intertext, and audiences are simultaneously commodity, product line, and consumer" (Meehan, 1991, p. 61). This process, popularly employed in films, enables talk show commercialization through advertising product placement, tie-ins, and merchandising (Meehan, 1991; Wasko, 1995). In contrast to films, which have event-like releases hyped with consumer products, television talk shows are serial, featuring different guests and themes daily. Talk shows do not have momentous build-up and concentrated marketing schemata as film tie-ins and intertextuality, such as that found with *Batman* (see Meehan, 1991) or Disney films (Wasko, 2001)—the McDonald's Mulan Happy Meal, towels, lunchboxes, jewelry, books, and other toys as Disney's *Mulan* is released to theaters. The nature of talk show tie-ins, though, is longer term, and focused on the celebrity host and guests. Much like the product placement of AOL in *You've Got Mail* (Ephron, 1998) or Wilson basketballs in *Cast Away* (Bradshaw & Zemeckis, 2000), talk shows often function as hour-long infomercials for films, books, albums, videos, fashion, cosmetics, diapers, or politicians. In contrast to movies, talk shows do not have high production costs and production value used to reel in viewers and advertisers with promises of special effects. So, producers construct an overarching theme that includes tie-ins and product-showcasing in order to imbibe in a culture of consumerism, appeal to a consumer-oriented audience, and obtain free products and more advertising money. An

example is *Oprah's* recurring "Favorite Things" episodes, in which she presents a spectacle of products that she loves. The episode focuses on the legitimation of these products through Winfrey's unconditional love for the item, as well as their dispersal to the studio audience. Thus, by contrasting the tactic of ubiquitous consumerism and event consumerism, one can understand the rationalization behind talk shows' processes of commodification and pedagogies of consumerism.

Many talk show episodes center around the commodification of useful information on becoming a better consumer. Such topics as the year's best Christmas gifts, how to apply "natural-looking" make-up, how to get the best airline deals, what one needs to know about the cleanliness of public shopping mall toilets, and which boutiques to shop at for the season's newest bathing suit fashions (not to mention how to "hide" one's physical "flaws" by selecting the proper cut and color for one's "body type"), encourage viewers to become more selective in their consumption, in order to consume the product being offered. This is one of the main tenets of the pedagogy of consumerism elucidated on talk shows. As Ewen (1976) illustrates, people in the Fordist context needed to be educated on consuming in order to use the over-produced goods of industrialized America. Consumer culture became a worldview which inculcated people into the habit of consumption as a path to a fulfilling life.

We argue that this process is continuously re-formulated to suit a particular stage or phase of capitalism. In fact, in the twenty-first century, people in the techno-capitalist context still need to be reminded to consume, and to consume a particular brand, despite movements of ecological and environmental sustainability (Klein, 1999). What is more, they need to re-negotiate their consumption to better adapt to the changing global situations. For example, the new liberal "green mainstream" appropriates the rhetoric of environmentalism yet does not aim to significantly change structures that produce environmental degradation, pesticides, and pseudo-organic plants. By featuring green stories and somewhat environmentally friendly products, talk shows offer a pedagogy of consumption that is flexible enough to justify and legitimate globalized consumer hegemony.

In this commercial venue, spectacle determines market value, as families appear on television to throw turkeys at one another, fight over their women or men, and reveal a shocking secret to their fiancé before the wedding. In some types of shows, the personal (private) is made public through the use of confrontation, and individuals' problems, whether important (or valid) or not, are transformed into commodity (see Munson, 1993). The make-over is a classic talk show confrontation tactic to inculcate lower-income people into re-activating consumerism by giving them Gap or Target clothes, a new hairstyle modeled on *Grey's Anatomy,* and new cosmetics from Revlon. Sometimes representatives from clothing companies and outlets, hair salons, make-up companies, and fashion magazines such as *Vogue* parade audience members around the stage, discussing the "improvements" they have made to their style. Invariably, the changes involve becoming more middle class and mainstream. Types of make-overs include compelling rebellious young people to dress like "normal humans"; encouraging men to shave their beards, cut and style their hair, and wear jackets and ties; making larger women wear "flattering" clothing; and forcing moth-

ers to dress "appropriately," or with longer skirts (see Quail, Razzano, Skalli 2005).

Even psychologists appearing on talk shows help work out such ill-defined "problems" as daughters who dress like vampires, mothers who dress like prostitutes, and large-breasted women who dress "too sexy." Usually the psychologist/therapist is introduced as an expert who just wrote a new self-help bestseller. Often times, the therapist gives incomplete information and then concludes with, "the rest of the solution is in my book; you should buy it," to which Montel Williams advises "buy the book." Not surprisingly, most talk show hosts have written a book. Some are autobiographies, others have done cookbooks (Oprah Winfrey, Kathie Lee Gifford), workout books (Winfrey), books of children's art (Rosie O'Donnell), inspirational books (Williams, Gifford), revealing behind the scenes looks at the shows (Jerry Springer), and pop-psychology workbooks (Dr. Phil McGraw and his son Jay McGraw, and Tyra Banks' self-esteem book for teens).

Through content commodification and intertextuality, talk shows' intertextual commodities help blur the boundaries between program and advertisement, as the ads become topics around which shows are structured, such as a celebrity interview with an artist who showcases and distributes to the audience their new album, such as *Oprah's* Celine Dion's "Miracle Babies" episode in January 2005. Dion sang songs from her new album; she distributed the album and the tie-in Anne Geddes & Celine Dion Miracle 2005 baby photography calendar. Sometimes an artist and album happen to be featured in an upcoming film, which is also plugged on the talk show. As a result, *The Oprah Winfrey Show* (Atkinson, 1986-present) has become the most desirable advertising venue for musicians' new releases. Music industry executives have even admitted that the *Rosie O'Donnell Show's* and *The Oprah Winfrey Show's* ad-friendly atmosphere helps sell CDs and other products, and that this practice is changing the shape of daytime television. For example, Kenny G, Rod Stewart, Madonna, Clint Black and New Edition saw their record sales double in the week following their appearance on *Oprah* (Sandler, 1997).

Another important example of content commodification is *Oprah's Book Club*. Every month since September 1996 (with a brief hiatus), Winfrey has announced a book that home viewers should buy and read. A month later, one taping of the show entails a select group who eat dinner with Winfrey; the dinner tape is later used as an intertextual device to be played during a studio discussion of the book. The purpose behind this project, she says, is to get America reading again and to give attention to books that are life-changing. Each book for the *Book Club* has immediately skyrocketed to tops of bestseller lists (Munson, 1993; "Starbucks & Ophrah," 1997); Winfrey's staff now calls and alerts bookstores and libraries ahead of time, so they can place a larger book order to prepare for the crowds who will visit the mall to buy the latest *Oprah Book Club* book. Thus, there was more than "ethics" at stake with the James Frey *A Million Little Pieces* controversy and confrontations between the talk show host and her author guest, who allegedly fabricated portions of his text, which was discovered after his first appearance on *Oprah*. The concern was also over the money spent and possibly being returned due to this controversy. To complicate matters, at one point, Starbucks Coffee sold the *Book Club's* books in their stores, in a Starbucks/Oprah literacy campaign. In a generous philanthropic move, Winfrey makes no money from the sales, and

Starbucks donated net profits of the books to a literacy training foundation. However, the foundation remained within The Starbucks Foundation, actually keeping the profits in-house by allocating the money to another company division. The ethical blurring of commodification and the appearance of corporate responsibility is at issue. In the same vein rests the *Oprah Angel Network*. Rewarding multi-million dollar conglomerates for donating tax-deductible pocket change in exchange for a free advertisement and the approval of Oprah Winfrey is an extremely limited form of social action. Corporations actually come away from such an experience looking like model citizens—but have they changed their pay scales such that the janitors at the company have the same benefits as the CEO? By promoting the ideology of philanthropy as a social cure, the show is deemed as "socially responsible," which can be marketed and increase the show's value.

The previous examples illustrate how talk shows promote consumption and consumer culture, but the intensity of conspicuous consumption on talk shows was boosted immensely by the entrance of Rosie O'Donnell to the talk show arena. A discussion of her role in talk show commodification is thus in order here and will be continued in the audience commodity section. Before a spattering of negative publicity (unfairly launched at her coming out as a lesbian), a lawsuit against her and her magazine, and her quitting the show, which hired new host Caroline Rhea, O'Donnell was deemed by market gurus, the "Queen of Nice." Her talk show was conceived of and billed as an advertiser's dream. At the start of each celebrity-driven interview show, she would announce that every member of the studio audience could find a Ding Dong and a Koosh Ball under her/his chair. She also reserved the first segment to demonstrate all of the promotional products she received that day, from M&Ms to plastic horses, to Twinkies, to CDs, Barney dolls, and Disney figurines, Warner Brothers' stuffed animals, and Nickelodeon's Rugrats videos. Sometimes, O'Donnell programmed special promotional weeks centered on a product. Once, she featured "Thong Week," during which she tested five companies' thong underwear. Each day she sang an original song about thongs, revealed which brand of thong she was wearing that day, and inspired the audience members to wave around the free thongs located under their chairs. Another intertextual delight involved a news story of two six-year-old white girls who had set up a lemonade stand on their street to raise money to buy new Adidas sneakers for the school year. Unfortunately, someone ran by, stole their money and demolished their stand. To an audience of oooh-ing and aaah-ing adults, the girls told their heart-breaking story. Afterwards, a corporate-speak Adidas representative walked onstage and awarded the girls a prize: he and Adidas would "outfit" them in Adidas shoes, clothes, and accessories until they graduated high school. O'Donnell led the audience in their praise of Adidas' generosity.

Both O'Donnell and Winfrey also launched their own magazines, thus providing more commodities for their loyal consumers, and providing a cross-promotional platform for all of their holdings. "O" and "Rosie" provided a perfect tie-in to the programs. *Oprah* often shows the magazine on screen and bases the episode on the articles in the magazine. Her "Change Your Life" season consisted of special guests to be featured all season on the show and to write a column in the magazine. Gary Zukov, Iyanla Vanzant, Suze Orman,

and Phil McGraw, each with their areas of expertise, doubled as content for both television and magazine. These characters were so well utilized and branded that they each have their own books, and several had or have their own talk shows (Vanzant, Orman, and McGraw). In this way, talk show spin-off commodities have homogenized the television and magazine scene. Rather than take a risk on a new, unique talk show character, the proven success of Orman's "O" and *Oprah* spots induced MSNBC to offer her a financial planning program. Already a branded commodity with a loyal *Oprah* following, Orman's program speaks to the upper-class viewing audience: one can become successful at saving money, she advises, by skipping the daily $5 latte. Likewise, Dr. Phil McGraw, already blessed by *Oprah's* validation through his spots in her program and the development of his own wildly popular talk show, has seen multiple book contracts for himself and his son Jay McGraw, and his wife Robin McGraw; the show is based on the themes in his books, and guests are requested to perform his workbook activities for self-help homework. His branded image was a safe bet for advertisers and book publishers alike. His son and wife were also economically blessed by his celebrity, as well as their own emerging celebrity-by-association and appearances on his show.

Winfrey herself spun off two shows onto the recently formed Oxygen television network. The first program revolved around Winfrey being taught how to use the Internet, a tie-in to Oxygen's Web site. The second program, *Oprah After the Show* (Winfrey, 2002–present) is a mere continuation of *The Oprah Winfrey Show*. It is produced directly following her original program, but guests and audience members stay "after the show" taping to tape further. At this point, the atmosphere becomes more relaxed and informal, and audience questions are sometimes taken. In this respect, *After the Show* harkens back to earlier *Oprah* days of audience participation. This spin-off is low cost, as the entire production is merely a half-hour extension of the more heavily produced *Oprah*. The fact that the show is on Oxygen is no coincidence, however. Winfrey was one of the original handful of private owners of the network. Thus, she owns a stake in the profits of the company, as well as her program.

As evidenced, talk shows socialize viewers by appealing to a sense of reality and practical information. Ironically, though, talk shows' sense of reality is actually one of hyper-reality (Steinberg & Kincheloe, 2004). Constructed stories, produced for ratings and profit, spreading a pedagogy of consumerism and celebrity worship, are naturalized, as evidenced in the theme songs of the programs. For instance, *Leeza's* theme song was: "this could be the best time of your life"; *Jenny Jones:* "So real, everyday people. Make it real"; *Oprah Winfrey:* "get some fire, get inspired, get with the program, Oprah." These attempts to construct the programs as "real life" shape what the popular imagination idealizes as real/normal—these constructions of reality are deeply rooted in classed, gendered, and raced assumptions.

Content commodification thus produces "creative, economic, and cultural implications" (Wasko, 1995, p. 214). The creative process is transformed, making room for advertisers earlier in the writing and producing process and opening the door to further commodification. The talk show genre thus becomes more formulaic and restricted, as its reliance on

revenues from intertexts limits the types of shows this genre can produce (Mosco, 1996). Shows investigating abuses in the American health care system, genocide in Sudan, or the Bush administration's imperial war on Iraq are unlikely to provide easy tie-ins to commercial products or excited advertisers of multinational corporations. Thus, vulture culture is perpetrated on talk shows through their commodification of social problems and de-politicization of culture.

Commodification of the Audience

Let us turn, then, to the second area of commodification, audiences. Talk show audiences play an important role as media institutions bind together the audience, media and advertisers (Mosco, 1996). The reciprocal relationships are such that media "sell audiences which perform three key functions for the survival of the system: audiences market goods to themselves, they learn to vote for candidates in the political sphere, and they reaffirm belief in the legitimacy of the politico economic system" (Jhally, 1988, p. 70). Essentially, advertisers buy access to audiences. Thus, we witness the proliferation and concern over audience demographics and marketing shows to specific demographic groups, such as women aged 18 to 49. Because shows are sold to niche markets, advertisers can better spend their money by directly targeting desired audiences. As such, talk shows become vehicles for slicker marketing ploys and ratings races.

In order to obtain higher ratings and thus more advertising dollars, talk shows need to make themselves suitable for advertisers, as links to the commodified audience must be made solid. As seen in the previous section discussing commodification of content, talk shows become advertisements for second- and third-order products through intertextual tie-ins and special feature segments involving a marketed product, especially other media products. With "advertisers' revenues setting the context within which popular culture production takes place," (Jhally, 1988, p. 77), advertising potential directly affects content and a show's particular hailing of the audience.

Oprah Winfrey's popularity directly reflects this process of attempting to gain audience share. Although Winfrey is a popular celebrity, her show is critically acclaimed and has won numerous awards, the show's ratings, thus potential for ad revenue, waned somewhat in 1994 and 1995. Some critics claim that this is due to newcomers at that time, such as *Ricki Lake*, grabbing ratings from younger demographic groups. Another factor was that Winfrey's "decision to take a higher road in the subjects covered, at a time when TV talk [had] become increasingly criticized for pandering to the worst instincts of the general public" (Scott, 1996, p. 252), prevented the show from successfully competing with the continuing spectacle on other programs. Controversies over subject matter and production tactics escalated until the tragedy befalling guests of the *Jenny Jones Show* in March 1995. Scott Amedure came to the show concerning secret crushes to announce his interest in his friend Jonathan Schmitz. The homophobic Schmitz became outraged at his "ambush" on national television, and shot and killed his friend three days later.

Shortly thereafter, in October 1995, a conservative coalition, Empower America, led by William Bennett and two Democratic Senators, Joseph Lieberman (CT) and Sam Nunn (GA) joined together to denounce talk shows for the "cultural rot" they were promoting. They planned an attack on all shows not conforming to their standards. Lieberman claimed that this was not an act of censorship, but "an effort to confront the people at these companies and get them to consider what is coming out of the end of the pipeline they own" (Stern, 1995, p. 18). Enlisting the help of companies frequently advertising on daytime talk shows, advertisers were asked to boycott the shows until "the sleaze mongers . . . clean[ed] up their act or [got] off the air" (McClellan, 1997, p. 3). They used the argument that the shows are "harmful to children," even though in reality, this demographic only constitutes about 6% of talk show audiences (Stern, 1995, p. 18). Corporations were urged to restrict advertising funding towards certain types of content. Kelloggs, AT&T, and others pressured the shows to respond. Proctor & Gamble even pulled ads from seven talk shows (Flint & Levin, 1995). The programming context of this time period was that the O. J. Simpson trial coverage and proliferation of new talk show clones depressed ratings that year; why would advertisers support shows whose ratings and shares were slipping, and therefore not reaching as large an audience for their dollar? (Flint & Levin, 1995). The proliferation of media products moves "advertisers to the most effective medium as the cost of each becomes uneconomic" (Garnham, 1990, p. 50). Consequently, the top of the market benefits from ad money, while the bottom consists of struggles for larger markets and economies of scale, which result in a homogenization of the talk show content (Garnham, 1990). The ultimate commodification of the audience not as concerned citizens but as a buying public is exemplified in Empower America's coalition with advertisers and their "concern" for the audience's moral sensibilities. The audience, their ratings, as a link between programs and advertisers was exploited in order to nudge shows to make content decisions to please a political organization, the advertisers, and the audience only as a function of the advertisers.

Before Empower America named names, Winfrey decided to change her format, to prevent being singled out by the coalition but also to combat her slipping ratings, and was applauded by the group for sanitizing her show (Stern, 1998, p. 18). This "sanitization," then, can be conceived of as a political and economic rather than purely aesthetic and moral move. Her show continues to focus more on practical issues and topical narratives than previously. In fact, her commodified spectacle continues to amaze, as she presented cars to an entire studio audience at the beginning of the 2004–2005 season. This type of self-regulation in the face of public disapproval is typical whenever business is threatened. In one survey of general managers, 37 percent said "they have canceled a talk show or considered doing so because of the content" (McClellan, 1997, p. 3), and 43 percent said "that talk show [advertising] spots are more difficult to sell because of concerns over content" (McClellan, 1997, p. 3). Concern for profit drives the advertisers and producers, which then drives content and its regulation, in order to remain suitable for advertisers.

Empower America's witch-hunt is reminiscent of the Red Scare in the days of McCarthyism. This movement impacted the talk show genre in the 1950s, playing a central role in the development of the "chatty" prong of talk shows, rather than allowing the

serious issues-oriented programming criticizing big business as corporations and government tried to bust labor unions. The 1990s backlash used big business once again to rein in so-called deviance under the facade of getting to the bottom of the problem, the "cultural rot" of talk shows themselves. Ignoring the political, social, and economic conditions under which the shows are produced and aired, and those within/against which the guests are try-ing to live their lives, the gatekeepers tried to "clean up" the airwaves. Winfrey played into the criticism by making content changes that greatly affected the production, content, and consumption of her show, by commodifying her program further into the land of programs having a "suitable atmosphere for advertising" so that her show could regain its money-making status.

The link between so-called questionable content and being difficult to sell is the link that connects political economic influence back around to content control. During Empower America's crusade, development for the *Rosie O'Donnell Show* was already under-way, to be released in June 1996. From its conception, the show was billed as "advertising friendly" and was the only show picked up in 53 percent of the market in a year when talk shows were the dregs of syndication. As a syndication sale benchmark, in 1995, "Carnie," a quickly canceled program, opened up to 70 percent of the market—a considerably larger market than the fanatically successful *Rosie O'Donnell Show* sold one year later (Littleton, 1996). Thus was born the *Rosie O'Donnell Show*, the most advertising friendly talk show to exist since the days of direct corporate sponsorship (she has featured praise for Listerine, Adidas, Victoria's Secret, M&M, Microsoft, GM, Barney, and many, many more). The threat of competition her new program posed, we argue, constituted another factor in Oprah Winfrey's decision to revamp her own programming—if the trend was shifting, she was sure to be at the forefront and continue to profit.

In the months following the "Jenny Jones murder" and Empower America's assault, talk show ratings tapered off. However, after the initial hype, and the canceling of excess shows which had over-saturated the talk show market and thus made advertising scarce, the ratings began to rise. In 1997, *Oprah* was number one in the early fringe; *Rosie* had shot through the roof, becoming the top rated show in her time slot; and *Leeza* was up 49 per-cent (Littleton, 1996). Before 1995, *Oprah's* content resembled other shows, including *Jenny Jones, Jerry Springer, Rolanda, Ricki Lake, Montel Williams, Leeza,* and *Donahue.* This type of diverse programming—part entertainment, some journalistic stories, a few celebrity sto-ries, and much spectacle—would now probably be considered "trash" and therefore a risk for advertisers who do not want to offend righteous viewers with spending money, or members with potential macro-level power. The show would focus on a topic, showcase tell-all guests who would appear for the duration of the program, and who would be assisted by an expert who would help resolve their problem. Alternately, they would either conduct a celebrity interview or cover a "newsworthy" story.

Oprah still features interviews and stories, but the format of the show is broken up into smaller, more malleable segments. Her 1999 season titled, "Change Your Life TV," aimed to address "important" issues in the face of talk show criticism. Her new set was cozy, dec-orated in warm colors, plush chairs, and filled with large screens and more technologically

advanced televisual effects during special segments. Winfrey has shifted from highlighting controversial and confrontational guests toward a more middle-class/elite discussion-oriented focus on "practical" issues, such as home decorating and baking tips, child care issues, and female bonding activities (such as audience-wide make-overs, fashion shows, and the *Oprah Book Club*). Perhaps more interesting is her overarching focus on philanthropy, volunteerism, and spiritual well-being, three issues which are brought out in special segments and projects with which Winfrey is involved. All of these issues tie in commodities in other sectors, and the talk show as intertextual advertisement increases the surplus value of commodities in other sectors of the economy, as in the CD and *Book Club* examples. Additionally, the shows increase in advertising worth because they are avoiding controversial topics in order to focus on commercial topics, intertexts, and light celebrity fare.

Commodification of Labor

The third aspect of commodification obscured by the dazzling lights of the talk show is related to those who turn the lights on and off. The labor that goes into researching, writing, and producing talk shows is important in understanding how talk shows play a role in media culture. Workers' labor, in all capitalist institutions and organizations, is exploited in order to gain a surplus value for the owners. Labor exploitation is traditionally of two types: absolute (meaning laborers work longer hours for the same or less pay; *e.g.*, using cell phones, laptops, email, and Blackberries to work in the evening from home); or relative (labor is intensified—workers complete more work in the same or less amount of time; *e.g.*, in an eight-hour shift one worker must not only make food, but also tally receipts and clean floors). Talk shows exhibit both types of labor exploitation in their use of new technologies and automated systems used by camera operators, script writers, producers, costumers, interviewers, screeners, and other workers who do not make as much money as the celebrity host, production company, or distribution company. However, talk shows perform a new and improved exploitation as they "employ" an entire studio audience of unpaid volunteers, as well as a panel of guests who appear for free. In this way, talk shows play on people's desires to be famous and appear on television, as a way to exploit labor at no cost—the shows purely profit. Many times the guests have their hotel and travel costs covered by companies donating their services to the show. These services are exchanged for a promotional credit at the end of the show, in essence a short advertisement, sometimes read by the celebrity host. For example, at the conclusion of *Sally Jesse Raphael*, an announcer would read text appearing on the screen: "Some guests in our audience receive compensation and a promotional fee has been provided by . . ." Oprah Winfrey thanks American Airlines for providing transportation for her guests. Not only is this commodification of labor, but again, an advertisement for the companies that have donated products or services.

Finding guests to appear on the shows constitutes a task that comprises some workers' entire job descriptions. These guests can be courted by announcing a topic and phone number at the end of the program, and asking potential guests to call the show if they have that

problem and would like to appear to discuss it. When guests call in, their names and problems are recorded by a production assistant, who then passes on "interesting" situations to interviewers who may call the guests back to discuss the possibility of appearing on the program. This phone work saves time when the guests arrive, as they have already been pre-screened and interviewed. Some shows, such as *Montel Williams*, *The Oprah Winfrey Show*, and *Dr. Phil* have developed a following and created relationships with viewers who feel compelled to write unsolicited letters to the hosts themselves, in the hopes that they can appear on the show and discuss their issues. The names of guests that have indeed appeared on shows are collected and put into a guest directory.

Directories also exist for experts. However, if a show does not want to sift through the expert directories, they are not at a loss: experts who have just written books—or their managers/publishers—contact shows to solicit exposure. Likewise, the celebrity solicitation of musicians, actors, and politicians to appear on talk shows such as *Regis & Kelly*, *The View*, or *Tyra Banks*, or *Ellen DeGeneres* removes added labor of finding guests. As these people vie for interviews, again, a free outlet for celebrity commodification overlaps with the commodification of labor. As a concrete example, *Leeza*, an NBC-owned show, would commonly feature actors from other NBC programs, mostly soap operas (*Days of Our Lives* and short-lived *Sunset Beach*), as guests. This tactic of using monopoly control provided intertextual advertising for other NBC programs, as well as obtaining free labor by having their own actors appear as publicity stints to support other NBC programs. Finally, they did not have to call, write, fly, or otherwise coax guests to appear—these guests pop over from one studio to the next on their lunch break to show their faces and mention the name of their own program.

Additionally, one labor-related special theme often used on talk shows is that of the "update." This tactic involves the host updating the audience and viewers on former guests who were of particular interest. Updates involve showing clips from the original program, and either inviting the guests back to check on their progress, or else an announcer or host simply reads a summary of a phone interview conducted with the former guest. For these programs, barely any production costs are spent, in that most or all of the show's content is simply recycled from earlier programs through editing and brief constructions of computer graphics. At its most intense, a writer and editor must sift through the tapes to find suitable clips.

In conclusion, commodification and commercialization are cornerstones of talk show culture, and what we call *vulture culture*—"the process by which the media scavenge the narratives, discourses, knowledges, and the everday commonsense of our culture and present them back to us as information, spectacle, and entertainment. Vulture culture produces celebrity and relies on celebrity to promote itself. . . . It helps us understand the links between information, entertainment, and social, political, as well as economic institutions" (Quail, Razzano, Skalli, 2005, p. 3). Talk shows' participation in tie-ins, merchandising, and celebrity features shapes daytime television's pedagogy of consumerism. Consumer culture as a cultural ideal is produced, reproduced, and repackaged for contemporary talk show viewers, who are themselves commodified in their roles as advertising viewers and ratings pro-

ducers. The commodification of talk show labor also places talk shows in a cultural category that harkens to wider social processes of downsizing and temporary/transient staffing. Vulture culture feeds on these commodifications of cultural, social, and political life. In the scavenging of content, audience, and labor, talk shows privilege profit imperatives over the guests, problems, and solutions they portend to define. In a media literate world, we can critique and understand commodification of talk shows, but also expand the analysis to examine other elements of culture and vulture culture, such as news programs, fashion, youth culture, new technologies, or reality TV. With the coming of new technologies and new genres of programming, it is important to remember that commodification is a central element in a capitalist media and cultural system, and to critique it as it expressed through new and more insidious ways.

A slightly different version of this chapter originally appeared in *Vulture Culture: The Politics and Pedagogy of Daytime Television Talk Shows*, C. M. Quail, K. A. Rassano, & L. H. Skalli (Eds.). New York: Peter Lang, 2005.

REFERENCES

Atkinson, D. (Executive Producer). (1986–present). *The Oprah Winfrey show.* [Television series]. New York: King World/ABC.

Bradshaw, J. (Executive Producer), & Zemeckis, R. (Director). (2000). *Cast Away* [Motion picture]. United States: 20th Century Fox.

Ephron, N. (Producer & Director). (1998). *You've got mail* [Motion picture]. United States: Warner Bros.

Ewen, S. (1976). *Captains of consciousness: Advertising and the social roots of the consumer culture.* New York: McGraw-Hill.

Flint, J., & Levin, G. (1995, November 20–26). Advertiser won't gamble on trash talk. *Variety*, p. 17.

Garnham, N. (1990). Contribution to a political economy of mass communication. In *Capitalism & communication: Culture and the economics of information* (pp. 20–55). Newbury Park: Sage.

Giroux, H. (2004). Are Disney movies good for your kids? In S. Steinberg & J. L. Kincheloe (Eds.), *Kinderculture: The corporate construction of childhood* (2nd ed., pp. 164–180) Boulder: Westview.

Jhally, S. (1988). The political economy of culture. In I. Angus & S. Jhally. (Eds.), *Cultural Politics in Contemporary America* (pp. 65–81). New York: Routledge.

Klein, N. (1999). *No logo: Taking aim at the brand bullies.* New York: Picador.

Littleton, C. (1996, January 22). The remaking of talk. *Broadcasting & Cable*, pp. 46, 450.

Marx, K. (1978). *Capital: Volume One.* In R. C. Tucker (Ed.), *The Marx-Engels reader* (2nd ed., p. 321). New York: Norton. (Original work published 1867)

McClellan, S. (1997, January 15). 83% of GMs turned off by talk shows. *Broadcasting & Cable*, p. 3.

Meehan, E. (1991). Holy commodity fetish, Batman!" The political economy of a commercial intertext." In R. E. Pearson & W. Uricchio (Eds.), *The many lives of the Batman: Critical approaches to a superhero and his media.* New York: Routledge.

Mosco, V. (1996). *The political economy of communication: Rethinking and renewal* (pp. 143–144). London: Sage.

Munson, W. (1993). *All talk: The talk show in media culture.* Philadelphia: Temple University Press.

O'Donnell, R. (Executive Producer). (1996–2002). *The Rosie O'Donnell show* [Television series]. Los Angeles: Warner Bros. Television.

Oprah's Habitat for Humanity Project. (March 29, 1997). www.oprah.com. Accessed March 29, 1997.

Quail, C.M., K.A. Razzano, L.H. Skalli (2005). *Vulture culture: The politics and pedagogy of daytime television talk shows*. New York: Peter Lang.

Sandler, A. (1996/1997, December 23—January 5, 1997). Warblers warm up at Oprah house, *Variety*, pp. 1, 58.

Scott, G. G. (1996). *Can we talk? The power and influence of talk shows*. New York: Insight.

Starbucks & Oprah fight illiteracy. (1997, May 28). Oprah Online. www.oprah.com. Accessed May 28, 1997.

Stern, C. (1995, October 30). Backlash against TV talk shows. *Broadcasting & Cable*, p. 18.

Wasko, J. (1995). *Hollywood in the information sge*. Austin: University of Texas Press.

Wasko, J. (2001). *Understanding Disney: The manufacture of fantasy*. Cambridge: Polity Press.

Winfrey, O. (Executive Producer). (2002–present). *Oprah after the show* [Television series]. Los Angeles: Warner Bros. Television.

Chapter 31

Mobile TV and IPTV

Two New Forms of Television

Benedetta Prario

Introduction

Convergence has been developing since the mid-1990s and has been described as the "ability of different network platforms to carry out essentially similar kinds of services" or also (in my point of view, rather incorrectly) "the coming together of consumer devices such as the telephone, television and personal computer" (European Commission, 1997, p. 1). Convergence particularly involves the telecommunications, media, and information technology sectors. The maximum degree of technological convergence between these three sectors with all potential consequences at the economic level is found in multimedia and interactive applications that are at the heart of digital television. In an increasingly larger and more strictly interdependent framework, the development of television has been characterized by a trend toward integration with the other sectors of Information Communication Technology (ITC).

The terrestrial television market is changing across Europe. Most countries in Western Europe have launched digital terrestrial television services and the analogue switch-off is currently at the top of the media agenda in these countries. Resuming, from the supply side,

digital terrestrial television, compared with analogue television, creates four different opportunities:

1 the technical multiplication of television channels for the same transmission resources used. This means, for example, that a satellite able to transmit 16 different analogue television programs can be used to transmit around 80 to 100 digital programs with the same definition or that the infrastructures needed to broadcast a terrestrial television channel can transmit around five to six digital programs. The advantage is therefore double: on the one hand, transmission costs decrease to a fifth or a sixth, but the same multiplication is valid for end-users/reception devices. With the availability of more channels, more traditional programs can be offered; to supply the same programs in different time slots to facilitate flexible access (as, for example, in the case of re-transmission on different days or at different times); to broadcast live an attractive program only to paying subscribers who want to watch it (pay per view);

2 the growth in technical quality of audio and video transmission, because digitalization reduces distortions;

3 the opportunity to interconnect the television set to the telephone line to transform the television set into an access device to the services linked to the Internet and to develop access to interactive services;

4 the possibility of making television interactive.

Two of the most important advantages of the switchover from analogue television transmission into digital one are the spectrum release and consequently the possibility to reuse free frequencies for other services, like the mobile television, and the possibility of making television interactive, one of the main features of IPTV (Internet Protocol TV) and mobile television, too. In particular, mobile television and IPTV are two debated issues: with mobile television it means the opportunity to view, directly on its own mobile, traditional television and interactive programs, whereas IPTV refers to a group of related technologies delivering television programming using a broadband connection over the Internet.

Mobile TV and IPTV provide a personal, interactive experience quite different from the passive experience provided by traditional television. They not only offer anytime and anywhere access to a wide range of programs, niche material, and related background information—but also interactive services. The interactivity is an essential feature of these novelties, because these new TV models are strictly joined to the telephone, the pre-eminently interactive communication medium.

Mobile TV and IPTV have not been studied in depth yet primarily because they are still so new. This chapter, therefore, is exploratory and supported by the case study method. Different from quantitative methodologies that seek to predict behavior, the qualitative research method is suited for understanding a topic from a specific perspective.

Italy has been chosen for examination because it represents one of the best developed Mobile TV and IPTV industry at the European level. For this case study the author collected primary and secondary data. Information about the TLC operators supplying Mobile

TV and IPTV services has been derived from a variety of sources such as company press releases and presentations, company annual reports and research reports on industry and company developments. According to Lindlof (1995) documents enable researchers to investigate and reconstruct ongoing processes that are not available for direct observations. As a consequence, the case study is only meant to describe and not explain the phenomenon under study. Indeed, the author has interviewed some operators involved in the launch and commercialization of Mobile TV and IPTV in Italy, as well as users, with the aim to provide direct evidence to underpin the discussion.

It is important to note that the selected case studies do not have the pretension of being used for generalization but simply present an early attempt to understand the new trends of consumption.

Mobile TV

Since 1995 or so, digital technology has encouraged a rapid growth in the personal consumption of media. The advent of personal video recorders (PVRs), video-on-demand, and the multiplication of program offerings have enabled viewers to personalize the content they want to watch. With interactivity (Digitag, 2005), viewers can directly express their preferences to broadcasters. As part of this trend, and alongside the growth of mobile telephony, "the place of viewing is no longer limited to the television receiver at home, or in a vehicle, but is widened to allow personalised viewing of television by individuals wherever they are located" (Digitag, 2005, p. 5).

Thus, mobile television offers the opportunity to view traditional television and interactive programs directly on one's own mobile. The interactivity is an essential feature of the "broadcasting on the move," because this new TV model is closely related to the telephone. Mobile television can be defined as the possibility of watching television programs on a handheld device and "on the move"—in public transport, waiting for an appointment, or while at work.

The idea of watching television while on the move and not at home is not new. As Trefzger (2005) has illustrated, in 1982 Sony introduced its first portable television, the Watchman, but unlike its music peer, the Sony Walkman, it did not have much success. The failure of the Watchman had several reasons, e.g., its dimension (nearly 20 cm high and 9 cm wide), its screen (tiny), and the battery power (too low) (Günthör, 2005). Today, though, seems to be a different story. Consumers are using their mobile phones for multimedia—not just for communication, but also for entertainment (with streamed video, music and games), and for news and information services. With your mobile you can do a whole range of things: calling, sending, and receiving messages and e-mails, managing appointments and addresses, taking photos, listening to music, listening to the radio, playing games, and watching short video clips. Now it seems to be the turn of television. Today, television and the mobile are facilities most people cannot imagine living without. As reported by many studies on media consumption in different countries, more than any other medium, television determines the daily life of many people and it is the most con-

sumed medium (AGF/GfK Fernsehforschung, 2005; Censis, 2005). As the mobile phone is not used solely for communication via voice or SMS anymore, but also for entertainment and information, it appears feasible also to use this companion to receive TV while not at home or in front of a large TV screen.

From several studies conducted throughout Europe, it emerges that viewers have indicated their interest in watching television from a handheld device (Bmco; Nokia; IPDC). In particular, the quality and range of content offered by the mobile TV is highly critical for user acceptance. Participants in different trials carried out by some telecom operators in many European countries (Germany, France, Great Britain, Italy, and Finland) expect that all content from conventional television would also be available on the mobile, even if it was not suited for mobile viewing. The viewers were not familiar with the idea of content specially designed for the mobile and just expected regular TV channels. Indeed, they want to have:

- good picture and sound quality;
- value for money;
- right selection of channels;
- single device to carry (phone);
- simplicity of use;
- service availability.

Analysts believe that just showing existing broadcast channels on the mobile would not create value in the long term, but it is also not very well suited for the intended usage behavior of mobile TV. Television content specifically designed for the mobile reception needs to be developed (Betti, 2004, p. 4, Visiongain, 2004, pp. 156–157).

Booz Allen & Hamilton (2005) estimates that people typically use the mobile phone as a television set for watching short programs such as news and current affairs programs primarily because of technical limitations (picture quality and battery power) and consumers' viewing habits. Most consumers are likely to use mobile TV when they are away from home to kill time, e.g., when waiting for a bus or a train to arrive or just to keep informed when they are on the go. They will not spend hours continuously in front of their mobile phone watching TV (Södergard, 2003).

Therefore, the consumption of mobile television is not limited to the traditional use of television. In fact, people want to have the possibility of watching TV anywhere and anytime. Next to offering live broadcasting, mobile TV services must include video-on-demand services.

So, with mobile TV users could receive not only contents in streaming but video on demand and PPV services, too. To better illustrate this aspect, the next section will schematize the Italian supply of mobile TV services.

The Supply of Mobile TV in Italy

The penetration of the mobile telecommunications service in Italy is above the Western

European average at approximately 123.5 lines per 100 inhabitants at the end of 2005 up from a penetration rate of 109 lines per 100 inhabitants at the end of 2004. Growth rates have been substantially higher than the European average. The increase is due to innovative services and an increase of customers with multiple lines and the number of operators. At the end of 2005, 15 percent of Italian users owned a 3G handheld and three operators—3 Italia, TIM, and Vodafone—had launched mobile TV services. According to Forrester the mobile TV industry is valued at 1,5 billion euros in the world and in Italy 7 million clients and a turnover of 3 billion euros are expected by 2011. Users are interested in these new services, too, as shown by the different trials conducted in Italy by the main Italian TLC operators collaborating with broadcasters such as Mediaset and RAI.

In Italy the main distribution platform for mobile TV services is UMTS (Universal Mobile Telecommunication System). All the above mentioned mobile operators offer three main types of video contents:

1 TV channels in live streaming (RAI, RAI News 24, CNN, Coming Soon, Cartoon Network, . . .);
2 pay per view or video on demand of goals of football matches, video news, reality, videoclip;
3 other content like video MMS, games, and chat.

Without presenting in detail the supplies of each operators, summarized in the table, it is interesting to observe that consumers who also have the diffusive services (it means traditional TV programs) can receive interactive services, too.

Just from this overview of the Mobile TV supplies available in Italy, it emerges that with mobile TV it is not more possible to distinguish between communication point to point and mass communication. In fact, the consumers can receive not only diffusive services that are expressions of a mass communication, but also interactive services and new forms of TV programs that are clear evidence of the communication point to point. As suggested by the term "mobile TV," it embraces two forms of communication: on one side mobile telephony is the expression of the point to point communication and on the other side TV is the expression of the mass communication.

Furthermore, it is important to observe that the same technological device allows a double type of communication: an active communication and a passive one. Specifically, with the mobile TV, users can decide to interact with programs and services or "only" to watch television. They can also decide to watch programs when they prefer to do so, interacting with the electronic program guide, or wait for the beginning of a transmission.

IPTV

The emerging broadband environment is pushing forward a new phase of development for the television medium. Internet and the broadband infrastructure brought more enhanced functions such as interactivity and personalization (Chan-Olmsted & Kang, 2003). IPTV promises to leverage the flexibility and scalability of IP technology to transform the tele-

vision experience by providing access to more content of a superior quality that can be more personalized and interactive than traditional broadcast TV. The terms IPTV, Internet television and TV over the Internet are often used interchangeably (Pyramid Research, 2005). They should not be, for they reflect separate end-user experiences and have different technology requirements. This analysis does not consider video streaming over the Internet, or TV viewed on a PC. It focuses on broadcast and pay-TV services transmitted directly to a TV set , through a set top box, using the fixed Telco access network (ADSL or FTTH—Fiber-to-the-home).

Interactive or enhanced TV features utilizing the Internet conduit to improve the viewing experience of TV viewers have been cited frequently as the future direction of television (Chan-Olmsted & Ha, 2001). In fact, enhanced TV is expected to create a new world of hybrid media content encompassing e-commerce, information, games, music, movies, and advertising.

Referring to Chan-Olmsted & Kang (2003), IPTV can be defined as interactive or enhanced television distributed through either a wire-line or wireless broadband network.

The definition of "interactive television" is not unequivocal. The term *interactivity* denotes the possibility that the subjects of a communication interact with each other. Technically speaking, interactivity implies a return channel from the user to the information source that can transmit in the form of "bits" of data the choices and the reaction of the user (input). As a rule, we can distinguish between symmetric interactivity and asymmetric interactivity: in symmetric interactive systems the flow of information is transmitted equally in both directions, as, for example, during a video conference and chat; in asymmetric interactive systems, the flow of information is predominantly in the direction from sender to receiver, as, for example, television services on demand and databank consultation. Subscribing to Pagani's (2000) basic definition, *interactive television* can be defined as domestic television equipped with interactive functions made possible by the digitization process and the convergence between television, the Internet, and other interactive technologies. The interactive or enhanced television system also needs a customer interfacing device (e.g., set-top boxes or internal decoder in television sets) and a broadband system capable of fast transmission speeds for a larger amount of data. However, what are the contents distributed by IPTV? To answer this question, the next section will illustrate the Italian IPTV supply.

The Supply of IPTV in Italy

As forecast by Pyramid Research (2005), the number of IPTV subscriptions will reach around 40 million by 2010, up from about 1,3 million at the end of the year 2004. At the end of the year 2005 in Italy the broadband accesses were around 5.61 million, and the numbers are expected to increase rapidly in the coming years. The broadband household penetration remains around 20 percent. More precisely, at the end of 2004 the broadband clients of the two IPTV operators, Telecom Italia and Fastweb, are, respectively, 2.23 million and 420 thousand.

IPTV is expected to grow at a brisk pace in the coming few years, as broadband is now available to more than 100 million households worldwide. In fact, many of the world's major telecommunications providers are exploring IPTV as a new revenue opportunity for their markets.

First of all, IPTV covers both live TV (multicasting) as well as stored video (video on demand services).

The main categories of channels supplied by IPTV can be divided into:

- programs based on low cost contents addressed to a target audience (for example, minor sport);
- programs based on high cost contents (for example, recent films; large-scale sport events).

Like the pay-TV supply and going beyond a mono-channel supply, IPTV, as the multi-channel and multi-service television platform supply (Prario, 2005), is organized in packages, with different prices for subscriptions, depending on the marketing strategies used by the operators.

With reference to diffusive services (television programs), the supply can be divided into:

- channels with a basic subscription;
- channels with a premium subscription;
- pay per view channels;
- near video on demand channels.

Basic channels are characterized by a monothematic supply (for example, music, sport, kids, adventure, and so on) that can satisfy the needs and desires of different targets. Although none of these channels is aimed at the mass market, the supply in its entirety can attract a broad audience that allows an increase in the subscriber base.

Premium channels instead supply more programs focalized on attractive and successful contents. More specifically, the content of these channels is represented by recent and successful films and sports preferred by the different national audiences.

The main genres of premium channels are also supplied by pay per view channels. This is a form of payment related to consumption, linked to a single event or service directly requested by the user. The pay per view channels programming is often enriched by concerts or theatre events.

Finally, the video-on-demand channels complete the supply of diffusive services. The video-on-demand systems allow users to select and watch video content over a network as part of an interactive television system. Pay per view and video-on-demand services represent the first service which has been greatly strengthened by the introduction of digital technology, in addition to a successful driving force of the whole supply that allows viewers to have successful programs (cinema and sport) payable depending on consumption and usable at differentiated times.

Besides with IPTV users could receive interactive services that at the moment are yet less developed.

Further Considerations

The television industry is now progressively opening to new services. Although still at the heart of television consumption, traditional broadcasting is now at a mature state, while significant opportunities for expansion seem to be offered by a more targeted and accommodating range of services. They are new services that differ from traditional television in transmission form and in content supply, selection, and consumption. Often these services need a combination of know how that does not belong to the television sector, but to other sectors, such as the telecommunication and information technology sectors.

More specifically, the coming together of these industries is the evidence of the convergence between the telecommunications, media, and information technology sectors. Convergence is not just about technology as illustrated in the *Green Paper* of the European Commission (1997), but it is about services and about new ways of doing business and of interacting with society.

As illustrated above with mobile TV and IPTV, users can receive not only diffusive services but also interactive services. According to Montrucchio (2002), interactive services can be classified as follows:

a enhanced broadcasting;
b interactive broadcasting;

All options that allow to enhance the television supply with multimedia content and that broadcast data cast services and applications like the enhanced teletext are defined as *enhanced broadcasting*. Enhanced television can be considered as "enhancements of both text and graphic, broadcast in combination with some specific television content, i.e., integrated with them, which are optional and may be visualised in specific portions of the screen" (Bogi, 2002, p. 139). An enhanced broadcasting function is the Electronic Programme Guide (EPG) supplying information about the showing updated in real time and about programs of the weekly scheduling, or giving added news about films and events that one may wish to watch.

Compared to *enhanced broadcasting, interactive broadcasting,* including all interactive services linked to and not linked to the broadcast programs, allows the user to interact with the Service Centre through a return channel. In this way, it is possible to have bidirectional services, such as interactive advertising, tele-voting, betting, and so forth. If we observe the supplies of the Italian mobile TV operators and of the IPTV operators, we see that all these above mentioned services are included in their offers.

Conclusion

Because of interactivity, viewers have access to customized services, and they have a more direct participation and involvement and new forms of information (for example, interactive advertising and social networking). Despite all these technological advances, it is important to remember that an increased choice of channels and content alone would not be

sufficient for determining the success or failure of these two new forms of television. Consumers need sophisticated but easy-to-use tools to enable them to make the best use of the available content. Mobile TV and IPTV allow content to be presented in even more compelling formats with increasing quality and convenience of access. Indeed, content is one of the primary drivers for adoption of mobile TV and IPTV services.

Lastly, I would like to mention another important issue. With the advent of mobile TV and IPTV are emerging new frontiers of e-learning and t-learning. Interactive digital broadcasting learning services that are being developed in most countries of Europe enable the viewer to access information independent of the TV channel or linked to it. Innovative learning through digital broadcasting is still far from reaching maturity, but the development of interactive educational services, the penetration of digital television, the plans of the EU are points in favor of the exploitation of these new interactive learning services.

References

AGF/GfK Fernsehforschung. (2005). *Entwicklung der Sehdauer von 1992 bis 2004*. Retrieved April 28, 2005, from http://www.gfk.de/produkte/produkt_pdf/7/entwicklungdersehdauer2004neu.pdf.

Bass, F. M. (1969). *A new product growth model for consumer durables*. In *Management Sciences* (Vol. 15, no. 5). Evanston: Institute for Operations Research and the Management Sciences.

Betti, D. (2004). *Mobile IP datacasting: Mobile operators' positioning (Report)*.

Bmco. (2004). *The bmco project in Berlin on novel, interactive and TV-like services for mobile and portable devices has been completed successfully*. Retrieved from http://www.bmco-berlin.com/docs/bmco_Pressrelease _english_041013.pdf.

Bogi, D. (2002). *La televisione interattiva*, in *Quella deficiente della TV*, De Domenico, F., Gavrila, M., and Preta, A. (eds). Milan: Franco Angeli.

Booz Allen & Hamilton (2005). *Mobile TV—Contenuti e modelli di business*. Milan.

Büllingen, F., & Wörter, M. (2000). *Entwicklungsperspektiven, Unternehmensstrategien und Anwendungsfelder im Mobile Commerce*. Bad Honnef.

Censis (2005). *Rapporto annuale 2005*. Roma.

Chan-Olmsted, S. M., & Ha L. (2001). Enhanced TV as brand extension: TV viewers' perception of enhanced TV features and TV commerce on broadcast networks' Web sites. *International Journal on Media Management*, 3(4), 202–213.

Chan-Olmsted, S. M., & Kang, J. (2003). The emerging broadband television market in the United States: Assessing the strategic differences between cable television and telephone firms. *Journal of Interactive Advertising*, 4(1).

Digitag (2005). *Television on a handheld receiver*. Geneva.

European Commission. (1997). *Green Paper on the convergence of the telecommunications, media and information technology sectors, and the implications for regulations*. Brussels: Author.

Günthör, F. (2005). *In die Röhre sehen*. Retrieved from http://www.guenthoer.de/roehre.htm

IPDC (2005). *Frequency management issues for DVB-H and IP Datacast services*. Retrieved from http://www.- ipdc-forum.org/resources/documents/Keymessagestoregulators.pdf

Lindlof, T. R. (1995). *Qualitative communication research methods* (3rd vol.). Thousand Oaks: Sage.

Montrucchio, S. (2002). Dalla televisione di flusso alla televisione interattiva. In *La tv diventa digitale. Scenari per una difficile transizione*. Fleischner, E. and Solmavico, B. (eds). Milan: Franco Angeli.

Pagani, M. (2000). *La TV nell'era. digitale. Le nuove frontiere tecnologiche e di. marketing della comunicazione televisiva*. Milano: EGEA.

Prario, B. (2005). *Le trasformazioni dell'impresa televisiva verso l'era digitale*. Bern: Peter Lang.

Pyramid Research. (2005). *Transforming telcos with IPTV: Business models, pay TV competition, and content challenge*.

Södergard, C. (2003). *Mobile television—technology and user experiences. Report on the Mobile-TV project*. Finland: VTT.

Trefzger, J. (2005). *Mobile TV: Launch in Germany—Challenges and implications*. Institut für Rundfunkökonomie an der Universität zu Köln.

Visiongain (2004). *Mobile TV: Market analysis and forecasts, 2004–2009*.

Audiences Unmasked

Selling the Aboriginal Peoples Television Network

Frances Helyar

Introduction

The Aboriginal Peoples Television Network (APTN) presents itself as the first and only broadcaster of its kind in the world, a Canadian network with programming for, by, and about Aboriginal peoples. It is an important and powerful media tool, with the stated aim of "building bridges of knowledge and understanding." It serves as a place where Aboriginal people have representation and agency, in a media universe in which they are otherwise invisible. However, while the network achieves this goal in the programming sphere, its public pronouncements are at odds with APTN's sales pitches. This chapter begins with an examination of the network's broadcast schedule on a single day; a more sustained and detailed examination might yield different insights. The main focus, however, is on the network's Web site content, which remains substantially fixed, and presents information that is at the same time supportive of and contradictory to the messages of diversity and inclusiveness embedded in APTN's corporate identity. In particular, the information presented to potential advertisers is problematic in the ways it varyingly erases, minimizes, or essentializes Aboriginal peoples. A note on the use of the term *Aboriginal* at the outset: while

"First Nations, Inuit, and Métis" may be more accurately descriptive terms, the network itself uses the word *Aboriginal*, and for the sake of consistency, this chapter follows its example.

About APTN

The Aboriginal Peoples Television Network was launched in September 1999 as an extension of Television North Canada. It is a mandatory service available in all parts of Canada through a variety of feeds, including cable (always above channel 60 on the latter, a bone of contention for the Canadian Radio and Television Commission or CRTC, the Canadian broadcast regulator). Production is based in Winnipeg, Manitoba, although the network also acquires programming from independent Aboriginal producers from Canada and elsewhere, and also airs programs originating with other networks. The APTN "dream" is that of a national Aboriginal television network (*Home Page*).

APTN operates with two schedules, one for the south and one for the north; on the day in question, the two are identical. Movies run from midnight to 2 A.M., followed by two hours of Aboriginal programming. The ubiquitous infomercials available on other networks put in an appearance from 4 A.M. to 6 A.M. daily. Throughout the daytime schedule, children's programming such as *Tipi Tales II* is interspersed with more adult fare like *Cooking with the Wolfman* featuring Aboriginal chef David Wolfman. Non-Aboriginal children's programming such as *Adventures of the Aftermath Crew* and *Adventures in Sir Arthur Conan Doyle's The Lost World* fill out the schedule. The Canadian drama of the 1980s and 1990s, *Street Legal*, runs twice at 3 P.M. and 8 P.M.; while not based on Aboriginal themes, some episodes do feature Aboriginal writers, or actors including Tantoo Cardinal, Tom Jackson, and Graham Greene. "APTN National News" airs at 1 P.M. and 7 P.M., and the broadcast day wraps up with another Canadian drama, this one from the 1990s and featuring Aboriginal leads, called *North of Sixty*. Other programs during the evening include *Suaangan*, which reports on the arts, *Reel Insights*, featuring documentaries on Aboriginal themes, and *Voices of the Land*, the description of which invites the audience to "Explore the diversity and talent of independent Aboriginal documentary producers who bring new energy and fresh insight to sometimes harsh, often humorous, and always thought-provoking issues of contemporary Aboriginal culture. Broadcast in a variety of Aboriginal languages with English subtitles" (*Voices of the Land*). Movies run five times a week on APTN. Monday and Wednesday movies feature Aboriginal themes, with the former selection comprised of Canadian productions. The rest of the week films tend to be Hollywood blockbusters starring actors of Aboriginal descent. For instance, the week of July 17, 2006, features movies with Val Kilmer, Johnny Depp, and Cher, all of whom claim Cherokee ancestry.

The APTN Web site is unlike those of other networks in Canada in a number of ways. The most significant difference is the amount of text justifying the network's very existence. From the *Home Page*, the link to *Corporate APTN* offers descriptions of the network's governance, its origins, recent CRTC decisions, and other information absent or more deeply

embedded in the Web sites of other networks, including the CBC (Canadian Broadcasting Corporation), CTV (Canadian Television Network) or Vision TV (a network featuring faith-based programming). Aboriginal faces are prominent in most parts of the APTN Web site, particularly those pertaining to programming. The corporate pages also reinforce the identity of the network, with photographs of the members of the board of directors, Aboriginal all. Most members of the senior management team are pictured on their own Web page, and the biographies share a few interesting features. First, their years of experience in the industry are tabulated. Second, if the manager is not Aboriginal, race is not mentioned. However, if the manager is Aboriginal, his or her ancestry is outlined, sometimes through tribal membership, sometimes linguistically, sometimes in other ways. The director of Creative Services and Scheduling, for example, is described as "a proud Métis woman" and "a powerful contributor to APTN." The Director of Programming, in contrast, is not described as "a white woman," proud or otherwise, but her "thirty-five years of experience in film and television production" are highlighted.

Selling APTN

The strong Aboriginal presence at the network is generally evident throughout the APTN Web site. The sales department, however, provides an anomaly. APTN's sales department, unlike the production studios and corporate offices, is located in Canada's financial capital, Toronto. In addition, while the majority of APTN Web site content is available in both French and English, the sales component is unilingual English. From the *French Home Page*, the *Publicité* link leads to a new page listing contact information for two members of the sales department; no further links are available. In contrast, from the English home page, potential advertisers can click on *Advertise with APTN* which takes them to the *Sales Home Page*, featuring five further choices: *Home, About APTN, Our Audience, Research,* and *Programming*. The constant graphic across the top quarter of each of these pages is a person whose face is obscured by a mask. The *Home* page features a head shot of an Aboriginal woman holding a mask, her face visible. The *About APTN* link brings up text which repeats the APTN history from elsewhere on the APTN Web site; aside from the masked person across the top, no people appear on this page. The *Our Audience* page has a subtitle *Our Viewers Unmasked*, and includes further links regarding audience spending habits in the travel, financial, consumables, automotive, and culture/sports sectors, as well as "Aboriginal expertise," which quantifies the ways in which APTN reaches the Aboriginal audience. Each of these sections includes a full body shot of a different Aboriginal person holding a mask. The *Programming* page repeats a description of statistical information about the programming content on APTN, and reiterates how frequently movies are aired on the network: "five times a week!" (*Programming*). Again, other than the masked person across the top of the page, no people appear.

The link to the *Research* page is the most revealing of all the pages in the APTN Web site. Four sub-links are listed; two are pdf files, and two are Power Point files. These for-

mats are standard in business and academia but not necessarily domestic computer software packages. Thus, it is not a given that members of APTN's audience have access to these documents. The Power Point files consist of the network's weekly reach reports since 2003, and a copy of a letter from the Bureau of Broadcast Measurement. The pdf files include a list of the top ten movies broadcast on APTN, and a document described as *Our Audience Unmasked—Details on specific segments of the APTN audience (Research)*. The link for the latter leads to an eight-page document with the headline *Sharing our stories with all Canadians*. This title page is accompanied by two graphics: a stylized raven in red and orange in the upper left corner, and the APTN logo in gray bordered on the left by a strip of five colors ranging, rainbow-like from deep blue on the top to red on the bottom (this image is reminiscent of an inverted gay pride rainbow flag). The logo and rainbow strip are repeated on every subsequent page, with the rainbow strip also rotated ninety degrees counter-clockwise and running across the upper left of each page.

The title of the second page is *The APTN dream is shared with all Canadians*, and the "dream" has already been established elsewhere as that of a national Aboriginal television network. This page features no images other than the aforementioned graphics, but it does highlight two facts: "APTN is available in 10 million Canadian households and commercial establishments, second only to CBC," and "APTN has access to over 80% of all Canadian households." The left margin of the page is bordered by a testimonial from "a non-native person very interested in the issues and lives of Native Peoples." Page three introduces the overriding theme of the document: *Discover the realities*. The pages that follow list "myths" followed by the "reality" regarding the Aboriginal Peoples Television Network. The first myth is that APTN does not draw a significant audience, and the data listed under *Reality* explain that the APTN audience is growing. The accompanying photograph, without caption, is of two polar bears wrestling with each other, with an all-terrain vehicle visible in the background. Page four's myth is that APTN's audience is too small to be of significance, and again the subsequent data refute the assumption. A picture of three polar bears at rest appears on this page.

Page five offers the myth that only Aboriginals watch APTN, and the counter- argument is a fascinating one, with a history. As mentioned, elsewhere on the Sales Web site and in Power Point format, is a letter from the Bureau of Broadcast Measurement (BBM) (The BBM is the organization that measures television audience in Canada; it provides the data from which many networks justify their advertising rates). The letter, dated December 15, 2004, explains that the "BBM does not ask the question 'are you an aboriginal person'" (*BBM Letter*). At the same time, the letter continues, BBM does not recruit from Aboriginal reserves for ratings panels, and "experience has shown that Aboriginal peoples are reluctant to participate in surveys for government or non-Aboriginal organizations" (*BBM Letter*). As a result, explains the page five APTN text, "the audience that is captured by APTN is non-Aboriginal only!" and Aboriginal peoples are "the advertiser's bonus," providing "automatic added value." The accompanying image is, again, a polar bear. The sixth page deals with the myth that only Aboriginal peoples are loyal to APTN using statistics from BBM and Environics, a well-known Canadian polling firm. The summary statement says

"APTN makes a valuable contribution to the diversity and dynamics of Canadian society by building bridges of knowledge and understanding." The photograph to the left is a landscape with a sunset in the background and at least six polar bears walking on ice in the middle ground.

A 2005 study from the Print Measurement Bureau (PMB) is the source of information on page seven, the only page in this document other than page two that is without illustration. The first line, in bold type, exclaims that "The PMB 2005 study confirms 35% of Aboriginal Peoples watch APTN weekly!" (*APTN Viewers Unmasked*). The remaining data outline viewer demographics and consumption; some are racially linked and others are not. For instance, it is unclear whether the description of those who acquired telephone equipment in the past twelve months includes Aboriginal people, non-Aboriginal people, or both. The page ends with the exclamation that "APTN enjoys a loyal audience that spans multi-profiled demographics!" (*APTN Viewers Unmasked*). The final page returns to the *Discover the Realities* theme, debunking the myth that Aboriginal people are a niche market with limited buying power. The text cites Statistics Canada and PMB 2005. This last page features a photograph of an adult and two smaller polar bears.

Analysis

As articulated on its Web site, in order to be fulfilled, the Aboriginal Peoples Television Network's "dream" only needs the network to exist; content does not matter. The APTN Web site makes it clear, however, that in terms of quantity of programming, the network has a firm focus on Aboriginal issues and insights. However, if money is power, then it makes sense to follow the money, which is the rationale for focusing on the APTN sales department Web site (an analysis of the companies and products that choose to advertise on APTN is another study for another time). The *Our Audience* and *Programming* sections make specific reference to Aboriginal people, but only the former offers images of people to complement the text. This trend is continued in the *Research* section where the sole faces on any of the pages accompany the list of APTN's top ten movies (featured actors are Bruce Willis, William H. Macy, and Cameron Diaz, only the last of whom claims Aboriginal ancestry). Counter to the message of the text, thus, the Aboriginal audience is not unmasked, it is effectively obscured.

The *Our Audience Unmasked* document continues this theme. The testimonial on page two suggests that the network has value only in the way it is perceived by non-Aboriginals. Two of the pages in the document refer to movies shown on APTN, which draw comparatively large audiences, but the focus is on Hollywood productions and big box office stars. No mention is made of the rest of the programming schedule. The reference to the BBM on page five confirms that Aboriginal people have no part in audience measurement, and at the same time characterizes the Aboriginal audience as an "advertiser's bonus" and "added value." Thus the Aboriginal audience is firmly positioned as the "other." This is the essence of conservative multiculturalism. Aboriginal viewers are not included

in the network's rating panel, a fact that is reported but apparently remains unchallenged. Potential advertisers are reminded as little as possible of the Aboriginal identity of the audience. The document shifts to a liberal multiculturalism on the final two pages. The data stress that the Aboriginal segment of the audience is "just like us": Aboriginal people speak English, graduate from college or university, and visit Ontario-African Lion Safari, Marineland, and even the grocery store. Aboriginals move from invisible to valued commodities on a par with the white audience. This construction is the inverse of the first page, *Sharing our stories with all Canadians*, which positions Aboriginal people as "us" and the rest of the Canadian population as "them." In this way the Sales department moves through one document from an original focus on Aboriginal people as "us," to a pitch of the network's ability to reach a non-Aboriginal audience, and finally to the construction of an Aboriginal audience that is just like "us," the non-Aboriginal audience.

The most obvious irony of the link to the Sales department research and its title, *Our Audience Unmasked*, is that instead of people pictured in the document, fourteen polar bears appear. No clues are offered as to how or why these bears illustrate the realities of advertising on APTN. In Inuit culture, the polar bear is "the strongest of the Arctic animals and is considered a very powerful helping spirit" (Campbell & Pottle, 2001), while in contemporary environmental discourse, polar bears signify the disappearance of Arctic ice (Krauss, 2006). These symbolic interpretations appear irrelevant in this context; if the bears represent an attempt to lend cultural authenticity to the document, the link is tenuous at best. In addition, current usage distinguishes between the terms *Aboriginal* and *First Nations*, *Inuit*, and *Métis*, to the extent that the latter three are more appropriate terms that affirm the unique and distinctive cultures, histories and identities of First Nation, Inuit and Métis peoples. It is our view that indiscriminate use of the term Aboriginal may unintentionally mask this distinctiveness and fail to recognize differences in historical and present government-to-government relationships. (Task Force on Aboriginal Languages and Cultures, 2005, July, p. 7)

Thus the cultural insensitivity of an Inuit symbol used as a representation of the entire Aboriginal audience is compounded.

This is the text and these are the images, however, assembled by the Sales department in Toronto, approved by the Board of Directors in Winnipeg, and deemed to be ones that should appeal to APTN's potential advertisers. The question, then, is whether these editorial choices offer a greater commentary on the potential advertising clients, the people behind the network, or the society in which both exist. APTN's "valuable contribution to the diversity and dynamics of Canadian society by building bridges of knowledge and understanding" (*APTN Viewers Unmasked*, p. 6) is undermined by choices of text and image that render Aboriginal people invisible. The images in particular do more damage to the cause of diversity than anything else on the APTN Web site. Granted, the advertising dollars secured as a result of this pitch ensure the network's continued existence. It is a Catch-22: The network needs money in order to survive, but management perceives that the money is only available through participating in such problematic practices. The creators of this document clearly accept the notion that potential advertisers do not want to see Aboriginal

faces, but is this notion based on research or on assumption? This is where a genealogy of the campaign would be useful. What was the discussion leading up to the creation of this document? Were the choices conscious, revealing a willingness to go along with the hegemonic construction of Aboriginal peoples for financial gain? Or was there no thought given to the symbolic significance of unmasking the audience to find only polar bears?

Conclusion

As long as the Aboriginal Peoples Television Network exists, the APTN "dream" is fulfilled. Mere existence is not enough, however, because that is tokenism at its worst. The rationale behind the network should articulate a more complex dream, and the network itself should continue to represent First Nations, Inuit, and Métis people, not just in its programming, but in its every aspect. With this goal in mind, the Sales department needs to re-examine its presentation and find a better way to extol the benefits of advertising with APTN. The realities of the business world notwithstanding, it is shocking that in 2006 an entire population can be symbolically erased; it might as well be called the Polar Bear Network.

Appendix: APTN Broadcast Schedules

Thursday, July 20, 2006 *Northern schedule*

Start Time	Program Title
12:00 am	*APTN MOVIES*
02:00 am	*BEYOND WORDS*
02:30 am	*APTN NATIONAL NEWS 2005—2006*
03:00 am	*WAASA INNAABIDA: WE LOOK IN ALL DIRECTIONS*
04:00 am	*NORTHERN RESPONSE*
04:30 am	*NORTHERN RESPONSE*
05:00 am	*NORTHERN RESPONSE*
05:30 am	*NORTHERN RESPONSE*
06:00 am	*C.G. FOR KIDS STRIP*
06:30 am	*ADVENTURES OF THE AFTERMATH CREW*
07:00 am	*TAKUGINAI III-IV*
07:30 am	*ADVENTURES IN SIR ARTHUR CONAN DOYLE'S THE LOST WORLD*
08:00 am	*INUK FRENCH*
08:15 am	*WUMPA'S WORLD II FRENCH*
08:30 am	*TIPI TALES II*
09:00 am	*TIPI TALES II*
09:30 am	*LES DECOUVERTES DE SHANIPIAP*
10:00 am	*OUR DENE ELDERS—VII*
10:30 am	*CREATIVE NATIVE IV—CREE*
11:00 am	*CA CLIQUE!—II*

11:30 am	*ANIMA*
12:00 pm	*ART ZONE*
12:30 pm	*COOKING WITH THE WOLFMAN*
01:00 pm	*APTN NATIONAL NEWS 2005—2006*
01:30 pm	*BEYOND WORDS*
02:00 pm	*VOICES OF THE LAND*
03:00 pm	*STREET LEGAL*
04:00 pm	*C.G. FOR KIDS STRIP*
04:30 pm	*ADVENTURES OF THE AFTERMATH CREW*
05:00 pm	*MIKUAN ET TSHAKO*
05:30 pm	*REGARDS SUR LA NATURE*
06:00 pm	*HAA SHAGOON*
06:30 pm	*TAMAPTA*
07:00 pm	*APTN NATIONAL NEWS 2005—2006*
07:30 pm	*SUAANGAN*
08:00 pm	*STREET LEGAL*
09:00 pm	*REEL INSIGHTS*
10:00 pm	*VOICES OF THE LAND*
11:00 pm	*NORTH OF 60—V & VI*

Thursday, July 20, 2006 *Southern schedule*

Start Time	*Program Title*
12:00 am	*APTN MOVIES*
02:00 am	*BEYOND WORDS*
02:30 am	*APTN NATIONAL NEWS 2005—2006*
03:00 am	*WAASA INNAABIDA: WE LOOK IN ALL DIRECTIONS*
04:00 am	*NORTHERN RESPONSE*
04:30 am	*NORTHERN RESPONSE*
05:00 am	*NORTHERN RESPONSE*
05:30 am	*NORTHERN RESPONSE*
06:00 am	*C.G. FOR KIDS STRIP*
06:30 am	*ADVENTURES OF THE AFTERMATH CREW*
07:00 am	*TAKUGINAI III-IV*
07:30 am	*ADVENTURES IN SIR ARTHUR CONAN DOYLE'S THE LOST WORLD*
08:00 am	*INUK FRENCH*
08:15 am	*WUMPA'S WORLD II FRENCH*
08:30 am	*TIPI TALES II*
09:00 am	*TIPI TALES II*
09:30 am	*LES DECOUVERTES DE SHANIPIAP*
10:00 am	*OUR DENE ELDERS—VII*
10:30 am	*CREATIVE NATIVE IV—CREE*
11:00 am	*CA CLIQUE!—II*
11:30 am	*ANIMA*
12:00 pm	*ART ZONE*

12:30 pm	*COOKING WITH THE WOLFMAN*
01:00 pm	*APTN NATIONAL NEWS 2005—2006*
01:30 pm	*BEYOND WORDS*
02:00 pm	*VOICES OF THE LAND*
03:00 pm	*STREET LEGAL*
04:00 pm	*C.G. FOR KIDS STRIP*
04:30 pm	*ADVENTURES OF THE AFTERMATH CREW*
05:00 pm	*MIKUAN ET TSHAKO*
05:30 pm	*REGARDS SUR LA NATURE*
06:00 pm	*HAA SHAGOON*
06:30 pm	*TAMAPTA*
07:00 pm	*APTN NATIONAL NEWS 2005—2006*
07:30 pm	*SUAANGAN*
08:00 pm	*STREET LEGAL*
09:00 pm	*REEL INSIGHTS*
10:00 pm	*VOICES OF THE LAND*
11:00 pm	*NORTH OF 60—V & VI*

REFERENCES

Aboriginal Peoples Television Network. (July, 2006). *APTN Broadcast Schedule (Northern)*. Retrieved July 18, 2006, from http://www.aptn.ca/index.php?task=viewlist&option=com_wse&Itemid=28&disp-date=07/20/2006&sched=N&TZoneOffset=.

Aboriginal Peoples Television Network. (July, 2006). *APTN Broadcast Schedule (Southern)*. Retrieved July 18, 2006, from http://www.aptn.ca/index.php?task=viewlist&option=com_wse&Itemid=28&disp-date=07/20/2006&sched=S.

Aboriginal Peoples Television Network. (2004, December 5) *BBM Letter*. Retrieved July 18, 2006, from http://www.aptn.ca/sales/files/bbmletter.ppt.

Aboriginal Peoples Television Network. (n.d.). *Advertise on APTN*. Retrieved July 10, 2006, from http://www.aptn.ca/sales/.

Aboriginal Peoples Television Network. (n.d.). *APTN Board of Directors*. Retrieved July 22, 2006, from http://www.aptn.ca/content/view/121/194/.

Aboriginal Peoples Television Network. (n.d.). *APTN Senior Management*. Retrieved July 22, 2006, from http://www.aptn.ca/content/view/443/201/.

Aboriginal Peoples Television Network. (n.d.). *APTN Viewers Unmasked*. Retrieved July 18, 2006, from http://www.aptn.ca/sales/files/APTN-sales.pdf.

Aboriginal Peoples Television Network. (n.d.). *French Home Page*. Retrieved July 10, 2006, from http://www.aptn.ca/content/blogcategory/18/32/.

Aboriginal Peoples Television Network. (n.d.). *Home Page*. Retrieved July 10, 2006, from http://www.aptn.ca/component/option,com_frontpage/Itemid,1/

Aboriginal Peoples Television Network. (n.d.). *Programming*. Retrieved July 10, 2006, from http://www.aptn.ca/sales/programming.php.

Aboriginal Peoples Television Network. (n.d.). *Research*. Retrieved July 10, 2006, from http://www.aptn.ca/sales/research.php.

Aboriginal Peoples Television Network. (n.d.). *Sales Home Page*. Retrieved July 10, 2006, from http://www.aptn.ca/sales/index.php.

Aboriginal Peoples Television Network. (n.d.). *Voices of the Land*. Retrieved July 22, 2006, from http://www.aptn.ca/component/option,com_wse/task,view//id,13495/Itemid,0/.

Associated Press. (2003, April 4). Inuit polar bear hunt combines old and new. *All Things Arctic*. Retrieved July 22, 2006 from http://www.allthingsarctic.com/news/2003/0403/inuit-hunt.aspx).

Campbell, H., & Pottle, B. (2001). *Derrald Taylor: Migration*. Retrieved August 9, 2006, from http://www.ainc-inac.gc.ca/art/inuit/migr/migr_e.html.

Kincheloe, J. L., & Steinberg, S. R. (1997). *Changing Multiculturalism*. Buckingham, UK: Open University Press.

Krauss, C. (2006, May 31). Polar bear becomes unlikely symbol of melting Arctic. *The New York Times*. Retrieved July 23, 2006, from *http://www.iht.com/articles/2006/05/28/news/arctic.php*. Retrieved August 9, 2006, from http://www.aboriginallanguagestaskforce.ca/pdf/foundrpt_e.pdf.

Hunting Down Indigenous Stereotypes Through Introspection

Anie Desautels

Today, although Inuit self-representation *has* evolved, museum exhibits have not, tending still to reflect southern Canadian interest in artifacts from the traditional material culture; in other words, the story of the Inuit as told by another culture for another culture.

—*Renée Hulan (2002)*

Plagued by stereotypes and polluted by the corporate world, fashion teen magazines enchanted my not-so-innocent Inuit grade 5 students. They were particularly captivated with this year's *native* fashion. People from the *South* wore *Kamik*, those warm boots with fur on the outside around the lower leg. The non-indigenous top models in the pictures wore boots like the ones my students had . . . well almost. The synthetic pink fur ones from the Sears catalogue seemed much better in my female pupils' minds than those made by their aunts with real seal skin.

Beads, moccasins, leather vests, shell belts. With the forceful return of the hippie fashion in 2000, indigenous stereotypical images also made a comeback. I should not have been

surprised when I saw the Vancouver 2010 Olympics logo. A colorful inukshuk will be on every single promotional item. Just like the dream catchers (made in China) which flooded the Dollar Stores recently, *native* things are *full cool* as my eleven-year-old sister says.

The commodification of North American indigenous cultures is only part of the problem regarding the image of the Canadian First Nations, Inuit, and Métis (FNIM) inhabiting the mind of the non-indigenous. The created perceptions of the indigenous Other are a complex part of ourselves. They rarely emanate from our live encounters with indigenous peoples unless maybe we are among those few who live, work, or study with First Nations, Inuit, or Métis. Most likely, our perceptions take source in the fabricated images of the FNIM that bombard us everyday through the media, the shopping industry, and so on. These preconceived ideas must constantly be challenged in order to dismantle the prejudices that emerge from our heavy colonial past. Ian Hingley (2000) encourages non-indigenous like me to take on a deep individual reflection, scanning past experiences in order to question inner representation of the indigenous Other. The author explains:

> To truly achieve postcolonial status for nations and a global community, as individuals we must embark on personal voyages of introspection. We must face the disturbing fact that factions of society have systematically internalized the colonial mind-set and have overtly or covertly benefited from the oppression and subjugation of other groups of people. [. . .] We can and must view our neocolonial oppressor mentalities as holding transformative powers whereby we can consciously change ourselves and the world in which we live. (p. 101)

This change is a very personal process that I feel the need to engage in, especially because I just moved back to an Inuit community. I intend to use some of my childhood memories, as well as more recent events in order to cFhallenge my assumptions about FNIM cultures. I will also include some thoughts written by scholars very concerned about the future of indigenous heritages.

Homogeneity

I don't remember dressing up as a *squaw*, although I probably did because it was the cheapest and the easiest costume to make for Halloween. Young girls just needed to get a jute potato sack to make a brown dress and to steal their mommy's bead necklaces from the 1970s. Then, they plaited two large braids on each side of their head. The crucial element of the costume was done by borrowing some feathers from the duster or the neighbor's roaster (if you lived in an agricultural village) to create a headdress. To complete the *native* look, the fake squaws used some lipstick to draw some war patterns on their face and off they went trick-or-treating, charming all the cowboys they encountered on their way. Nowadays, potato sacks are hard to find, and so children just ask to get a well displayed Pocahontas outfit from Wal-Mart.

Just a few months ago, sitting on my balcony in Montreal, I was enjoying the invigorating spring sun when a bell rang. Children from the school across the street hurriedly walked out for lunch. A swarm of kindergarten pupils happily hopped around. Many of them wore

a headdress made of three paper feathers they had laboriously colored and held around their head by a strip of Bristol board. I wondered what their teacher had taught them that morning. They might have worked on toilet paper totem poles as suggested to teachers on the Enchantedlearning.com Web site. Maybe they had sung the famous indigenous lullaby "A ani cououni, cha a ouani . . ." available on several compact discs for children. I also had learnt the song at school ignoring what it meant or where it came from precisely. I remember what it quickly became though: "oh Anie Connie, mets ton Bikini!" (Anie, put on your bikini!). I let the children reach their lunch destination, and I started to wonder about the symbolism of clothing.

These stereotypical images of the indigenous costumes are widely spread. Looking at the well-known pictures of Edward S. Curtis taken at the beginning of the twentieth century, I see how the concept of the Native is romanticized as a result of old Eurocentric ethnographic studies. Henderson (2000) defines Eurocentrism as the cognitive and educational legacy of colonization: "Eurocentrism is an intellectual and educational movement that postulates the superiority of Europeans over non-Europeans. It includes a predatory set of assumptions and beliefs about empirical reality of the world" (p. 63).

An exotic image of the indigenous people was developed by the non-indigenous society and is not representative of their changing reality. Battiste and Henderson (2000) call it the *imaginality*. In the same way, when I worked in an Inuit community of the Nunavik, I might have expected all my students to wear fur coats when in fact most had ordered their modern sport jackets through various catalogues. Strangely enough when I visited the Salon des Métiers d'Art (Artisans Conference) this year in Montreal, at least two artists presented Inuit fashion fur clothing. It was luxurious and heavily inspired by those old photographs of Inuit. Only very rich women could afford those pieces, which would end up on a hanger in the cloakroom during grand expensive evenings.

The Eurocentric portrait of the First Nations and the Inuit is disturbingly homogenous; it shows little if any distinctions between the different nations. Just like all Asian faces in Canada are necessarily Chinese in non-Asian minds, Native Americans are all from the same clan. Generalizations about personality (calm and stoic), spirituality (they all obey a shaman), traditional clothing (feather, leather, and beads), passions (the land) and problems (alcoholism, contraband, poor education) are all attached to the FNIM archetype. Battiste and Henderson (2000) criticize Eurocentric anthropologists that have traditionally organized indigenous cultures into descriptive details such as language, child-rearing practices, totems, taboos, work, and leisure interest, and so on. From these descriptions, the anthropologists inferred patterns good for all:

> By defining culture as a set of shared meaning, the classic norms of anthropological analysis made it difficult to study zones of difference within and between cultures. Indigenous cultures became homogenous rather than diverse. [. . .] Eurocentric thinkers have taken culture as their abstract possession and Indigenous knowledge as merely symbolic and ideational. (p. 31)

This homogeneity is well depicted by the Halloween costumes, which year after year for decades have asserted the stereotype of the Indian as it was portrayed by Curtis's photographs in the 1920s.

Timelessness

My grandfather, whose grandmother was of Abenaki ancestry, once brought to my brother and me a yellow plastic teepee with painted Iroquois red faces on its sides. He had bought the children's tent at his favorite store: Canadian Tire. We played with the teepee that Sunday and then like all the other toys, it went in the garage. Our monster dog enjoyed hiding in the pyramidal tent and soon he finished chewing most of it. I doubt that my grandfather noticed the destruction of the teepee, for every week he brought more toys from Canadian Tire. I wonder what his grandmother would have thought of this kind of shelter.

If someone was to drive through a Mohawk reservation near Montréal, he or she would be unlikely to find plastic teepees like the one we had. Just like a Northern visitor will not greet Inuit living in igloos. First Nations and Inuit people have long resorted to living in houses. This image of the teepee from my childhood supports this idea that FNIM cultures do not progress and remain what they were during the first colonization, as if time had stopped.

Allegorical illustrations of the indigenous people seem timeless. Battiste and Henderson (2000) notice: "Eurocentric scholars confidently asserted that Indigenous knowledge and heritage do not change, only European society progresses" (p. 32). This idea is also reflected in Valaskakis' (2000) writing about the image of North American indigenous women. The author posits:

> Imagine North America's long gaze on the Plains Indian in the period of western settlement. Indians are folkloric figures of the teepee and war bonnet, the buffalo hunt and pow wow. These are images of Indigenous nations frozen in time and history, tribal people constructed in print and celluloid, silent social imaginaries without a past or a future. (p. 119)

It seems that indigenous identity and culture evolve through false representation and appropriation by the FNIM people. Indigenous nations seem held back by the imposed symbolic images of their past as they construct their own future. Battiste and Henderson (2000) worriedly states: "What is more important is that this timelessness is a Eurocentric attempt at limiting the future—another way of forcing Indigenous culture to accept the inevitability of imitating Eurocentric modes of thought and dress" (p. 33). I certainly witnessed this ambivalence in my Inuit students between traditional heritage and the modern non-indigenous world presented to them on television or in magazines.

Romanticism

No one needs to suffer from arthritis in order to notice LàKOTA advertisements on Québec television. An old shaman with the feathers and the beads tells you in a thick accented French that LàKOTA is a traditional medicine. There are ravens and other birds on a pristine landscape of mountains as a background. The whole commercial tries to portray wisdom and freedom. On the LàKOTA Web site one can read that the medicinal formulas were partly invented by a Métis/Cree Canadian horse trainer. The company

was bought by someone with an Anglo-Saxon name, but nowhere can we see his (white?) face. Pictures from the beginning of the century decorate each page of the website. Under *The Legend* heading one can read the story of the horse trainer and that "The LàKOTA brand is an iconic symbol of the collective knowledge and wisdom of all Native North Americans." All the native male stereotypes are catered for in this advertising: the glorified past, the wilderness, the wise Indian, and the rejection of the modern world.

Each time I inadvertently watch that advertisement, I worry about the impact of such a romanticized image of the First Nations. Valaskakis (2000) discussing Aboriginal communications reports: "But recent work in communication and cultural studies suggests that, because we actually construct who we are in the process of identifying with the images and narratives that dominate our ways of seeing and representing the world around us, media also contribute to the formation of social identity" (p. 77). Given the importance of the media in the definition of identity, I can imagine that only few, if any, Canadian First Nation individuals can relate to the LàKOTA Shaman. The picture offered by the pharmaceutical company endlessly reproduces the stereotypes elaborated in non-indigenous ideology. Lise Noël (1994) in a powerful volume on intolerance straightforwardly states: "Having stripped his victims of any individuality of their own, summing them up in a few general characteristics, the oppressor has an even better claim to relegate them to intellectual confines if he believes that he has defined the boundaries of their essence" (p.109). Here the victims, i.e., the First Nations, the Inuit, and the Métis peoples are denied the opportunity of creating a dynamic culture. The oppressor, the dominating group, uses an allegorical representation of the native that is simple and reductive, non-threatening, just like the LàKOTA shaman.

Culture Production

When I started experimenting in the kitchen, my mother taught me how to bake *le pain indien* ("Indian" bread often called bannock). I took immense pleasure from kneading the dough. Within less than half an hour I could cover my warm piece of sweet bread with butter and dip it in maple syrup. My mother said it was the only bread I could ever bake. She had obtained the recipe from a very funny "Indian" chief (her words) on a television show when I was still a toddler. We regularly baked bannock for breakfast on the weekend. Later, in my own apartment, as a university student, I would bake some as comfort food. The bread simply meant home. It did not represent the First Nations other than by its name. Time passed and I accepted a teaching position in an Inuit village. On my very first day, I was first offered a piece of cold bannock. An Inuit woman explained to me in length that it was typical Inuit bread, sort of Inuit staple food. Bannock suddenly encompassed another meaning but yet remained comforting.

The merging of various cultural symbols within the construction of my own culture represents well how cultural heritages can intertwine. There is always the potential, however, that the amalgamation of elements from a dominated culture into a dominant culture leads

to the production of false images. Valaskakis (2000) explains this problem succinctly referring to R. F. Berkhofer (1979) *The white man's Indian:* "North Americans have drawn a certain sense of identity from these images of Indians engraved on the cultural landscape, but like the narratives of the West that position them, these Indians are largely imagined and severely time-distanced" (p. 72). Berkhofer (1979) continues, "For most of the past five centuries, the Indian of the imagination and ideology has been as real, perhaps more real, than the Native American of actual existence and contact" (p.118).

The very funny "Indian" chief that went on television to teach my mom how to make bannock did so during an outdoors cooking show for camping fans. My mom recalls that he had a long black hair plait with spiky hair like *Iroquois* and was wearing *Indian clothes* (italics are her words). The fixed image of the nature lover justified the invitation of a First Nation person to that show of the 1970s to demonstrate woods survival techniques. My mother, enjoying the simple recipe, regularly baked bannock. Overtime, the flat bread gained in significance for my brother and me who associated it with family happy moments. Inuit women also took on baking bannock as it required few ingredients such as flour and baking powder, which were imported from the southern regions. Scottish fur traders most likely brought the recipe in the eighteenth and nineteenth centuries. Nowadays, bannock which can easily be baked on a campfire, is consumed almost daily at home or on hunting and fishing trips. Although it is no longer served with bush tea but with commercial Lipton tea, Inuit bannock has become traditional.

Revisiting my childhood memories and some more recent events, I have come to realize how the stigmatized images of the First Nations, the Inuit, and the Métis peoples are part of my own identity. These romanticized representations are homogenous to all FNIM groups and frozen in a past time. There is little evolution in these allegorical illustrations mainly constructed around non-indigenous generated ideas. Valaskakis (2000) summarizes well the process of identity construction through the images around us: "[C]ulture involves the shared practices and experiences that we construct and express in our social relations and communication. Identity is not formed, then, in internal conceptions of the self, but in the adoption of the changing representations and narratives that we generate, experience, and express in our individual and social experience" (p. 76).

The need to question my preconceived ideas concerning the First Nations, the Inuit and the Métis cultures motivated the elaboration of this essay. I believe that a profound reflection on the evolution of my identity is necessary to understand the curriculum baggage I bring into my classroom. Reading Paulo Freire reinforced my conviction in the necessity for the establishment of meaningful and liberatory collaboration between my students and me. If I carry the non-indigenous colonizing past, my Inuit students suffer from the consequences of sustained oppression. Freire underlines the importance of solidarity: "The oppressor is solidary with the oppressed only when he stops regarding the oppressed as an abstract category and sees them as persons who have been unjustly dealt with, deprived of their voice, cheated in the sale of their labor—when he stops making pious, sentimental, and individualistic gestures and risks an act of love" (1970/2000, pp. 49–50). This act of love can only happen if I work to deconstruct stereotypes of the First Nations, the Inuit, and the Métis living in my mind and to circumvent indigenous cultures' romanticization.

REFERENCES

Battiste, M. A., & Henderson, J. Y. (2000). *Protecting indigenous knowledge and heritage: A global challenge.* Saskatoon, SK: Purich.

Berkhofer, R. F. (1979). *The white man's Indian: Images of the American Indian from Columbus to the present.* New York: Alfred A. Knopf.

Freire, P. (2000). *Pedagogy of the oppressed.* New York: Continuum. (Original work published 1970)

Henderson, J. Y. (2000). Challenges of respecting indigenous world views in Eurocentric education. In R. Neil (Ed.), *Voice of the drum: Indigenous education and culture* (pp. 59–80). Brandon, MB: Kingfisher Publications.

Hingley, I. (2000). Transforming the realities of colonialism: Voyage of self-discovery. In M. Battiste (Ed.), *Reclaiming indigenous voice and vision* (pp. 101–111). Vancouver, BC: UBC Press.

Hulan, R. (2002). *Northern experience and the myths of Canadian culture.* Montréal, QC: McGill-Queen's University Press.

LàKOTA Web site. Retrieved August 23, 2006, from http://www.thelakotaway.com.

Noël, L. (1994). *Intolerance: A general survey.* Montreal, QC: McGill-Queen's University Press.

Northwestern University. *Edward S. Curtis's The North American Indian.* Retrieved August 23, 2006, from http://curtis.library.northwestern.edu/.

Valaskakis, G. (1999). Sacajawea and her sisters: Images and native women. *Canadian Journal of Native Education, 23*(1), 117–134.

Valaskakis, G. (2000). Telling our own stories: The role, development and future of aboriginal communications. In M. B. Castellano, L. Davis & L. Lahache (Eds.), *Aboriginal education: Fulfilling the promise* (pp. 76–96). Vancouver: University of British Columbia Press.

"The toughest chick in the alien world"

"Girl Power" and the Cartoon Network

Sandra Chang-Kredl

It is fitting for media and education researchers to keep in mind Henry Giroux's statement that school is but one form of culture competing with other cultural mechanisms to define, regulate, and order students' worlds (1994, p. 45). In the twenty-first century, the gap between the world that children experience in their classrooms and the world of popular media that they encounter outside of school is widening. I am interested in analyzing media developed for elementary school-aged girls, between six and ten years of age. For girls, these are the years preceding what Orenstein (1995) calls the confidence gap of adolescence, and are critical to consider because girls arrive at adolescence with a history permeated by cultural structures and messages.

Atomic Betty (Gillis, 2004) ("a little girl with a big secret"); *Powerpuff Girls* (McCrecken & Simensky, 1998–2004) ("three little girls with a mission to save the world before bed time"); and *Totally Spies* (Chalvon-Demersay, 2001–present) ("three high school girls who fight crime on an international scale as undercover agents") (Cartoon Network Web site) are examples of what Banet-Weiser calls "mass-mediated 'girl power'" (2004, p. 121). The general premise of all three programs revolves around the girls having double identities: they are normal kids when they are with their friends and families, but in the world

of peril, their secret identities as superheroes or spies are revealed (at least to the audience). The girls in each series rush surreptitiously back and forth between their dual worlds and dual identities. Betty is beckoned away from home or school by the Commander in Chief, Admiral DeGill, to leave the earth for mission duty as "Galactic Guardian and Defender of the Cosmos!" The Powerpuff Girls, cute and mutated Blossom, Bubbles, and Buttercup, are created through an experimental error. They protect their hometown, Townsville, by flying and fighting villains of extraterrestrial proportions. Sam, Clover, and Alex, the *Totally Spies* girls, are a trio of teens who attend high school and are depicted as "three normal teen girls" (they study, shop, and pant when they see 'hottie' boys). The *Totally Spies* girls transform in each episode from everyday teen living to taking on superhero missions. "Girl power" is represented on Cartoon Network by these three animated series.

Third-wave feminism emerged in the early 1990s, in part seeking to develop more complex interpretations of gender and sexuality. The movement challenges second-wave feminism's focus, in the 1970s and 1980s, on women's inclusion into conventionally male-dominated areas, and its treatment of the representative "woman" as white, heterosexual, and middle class. Informed by post-structuralism and postmodernism, third-wave feminism replaces the notion of an essentialist "truth of womanhood" with a more fluid, historically and culturally influenced notion of feminisms and femininities, marked by multiple oppressions (Garrison, 2000, p. 149; Heywood & Drake, 1997, pp. 8–13). Jennifer Reed writes that third wave feminism refuses to adhere to "a singular liberal-humanist subjectivity" and contends that the female identity is made complicated through parodic and irreverent representations (124). Part of third wave feminism's politics includes embracing the value of being female, rather than striving to enter men's spaces (Dicker & Piepmeier, 2003, p. 4). Heywood and Drake argue that third-wave feminism acknowledges and supports the critiques originating from the second wave (especially critiques of power structures in society) while also recognizing the uses of desire, pleasure, and empowerment so emphasized in the third wave (p. 3).

The politically oriented Riot Grrrl's movement was drawn from third-wave feminism, and helped to bring attention to, and popularize, the idea of girl power. This pro-girl movement maintained a DIY (do-it-yourself) empowerment ethic, supported by a proliferation of zines, Web sites (self-published and politically feminist) and all-girl, punk, music bands. On one level, girl power (or "Grrrl Power") promotes a self-reliant, assertive mindset among girls and young women and states that girls, and girls' activities, should be valued. Riordan describes the logic behind girl power as follows: "if we start to value girls more and celebrate their culture, girls in turn will feel positive about themselves and will achieve higher self-esteem" (2001, p. 289).

Girls as Media Commodities

Political economists studying communications examine the structure of communications industries, cultural production, and media as a commodity (Steeves & Wasko, 2001, p. 19).

Riordan (2001) applies concepts of commodification to examine the 'pro-girl' rhetoric as articulated in popular mass media. She describes Marx's concept of commodity fetishism as "the ways in which the economic forms of capitalism conceal social relations because the products of human labor appear independent from those who created them" (p. 284). While Riot Grrrls purposefully challenged capitalist structures through collective and quasi-independent productions and circulations of CDs, zines, and Internet sites, it is questionable whether mass mediated girl power offers a political agenda. Referring to Vincent Mosco's (1996) definition of commodification as "the process of transforming use values into exchange values" (p. 141), the idea of valuing girls and girls' culture is appropriated as the use value, and this use value is transformed into an exchange value in the form of commodities meant to empower girls. The process of appropriating a social movement (such as girl power) into capitalist, mainstream media requires a watering down of the movement so that its commodification can mean something to all. This result is a rearticulation of girl power that appeals to and profits from the widest audience possible.

The notion of the audience as the media's primary commodity links program content with advertisers, audiences and producers (Meehan, 2001, p. 210). In the case of Cartoon Network, the rhetoric of girl power can be seen as the programming which constructs or draws in a target audience (in this case, an audience of young girls) who, as commodities, are then sold to advertisers. Similar to the network Lifetime Television's co-optation of liberal feminism in the 1980s to target women audiences (see Meehan & Byars, 2000, p. 34), Cartoon Network appropriated the subculture of girl power, or some translation of it, and used it to claim a demographic of young girls who could both be sold to advertisers and trained as consumers of program-based girl power merchandise.

Commodity Feminism

The issue of rewriting feminism into the corporate world of consumer culture was termed by Robert Goldman as "commodity feminism" (1992, p. 131). The empowerment of girls, from the perspective of commodity feminism, is an empowerment that takes place through consumption of pro-girl material, a process Riordan sees as being conflated with actual third wave feminism.

With the contemporary addition of multichannel cable television to the television network system, the branding of media properties has changed the scope of cartoon television (Sandler, 2003, p. 102). Branding is a way for cable networks to develop personalized relationships with their target audience, and animation, in turn, is the logical choice for building brand consciousness amongst children, with memorable characters and innumerable brand extension options: toys, clothes, action figures, CDs, and so on. Cross-promotional partnerships, for instance with fast food corporations, help to further develop "a relationship with consumers that resonates so completely that they will remain faithful to the brand no matter what" (2003, p. 95).

An analysis of intertexts, in this case, television texts swelling beyond the television screen into merchandise, enables one to examine how audience members are positioned within this commercial loop of production, circulation and consumption. In the 1990s, over 70% of gross profits from toy sales in America were from tie-in merchandise derived from commercial television and films, such as the *Powerpuff Girls* (Kline, 1993, p. 147). The *Powerpuff Girls*, as a media phenomenon, combines the cartoon program with its product line (Powerpuff dolls, figurines, clothes, key chains, and so forth) in what Van Fuqua (2003) calls "a seamless loop of reception and consumption" (p. 210). The intertexts frame the program's girl power message in a way that equates consumerism with empowerment, with girls positioned as the "ideal consumers of puff stuff" (Van Fuqua, 2003, p. 207). Van Fuqua suggests that the explosion of girl power merchandise, and the construction of a girls' market for those products, highlights how traditional notions of femininity (e.g., girls shop) and masculinity (e.g., boys don't shop) can be used to reframe cultural texts that appear on the surface to question traditional definitions of girlhood. Although boys may watch the *Powerpuff Girls*, the tie-ins or commercial intertexts target girls exclusively and reposition the girls within that feminine terrain of shopping and consumerist activity. Blossom, Bubbles, and Buttercup may have as their motto "saving the world before bedtime," but the substantial intertexts continue to emphasize that "the thing girls do best is buy" (Van Fuqua, 2003, p. 217).

Linking "commodity feminism" with the creation and distribution of the programs and intertexts of *Atomic Betty*, *Powerpuff Girls* and *Totally Spies*, a logical question is whether Cartoon Network is simply capitalizing on a popular trend in the form of girl power, by appropriating it and turning it into innovative cable programming, or whether the network representation of girl power actually articulates a new form of feminist politics. Banet-Weiser (2004) lends support to both sides of the argument, writing that girl power situates itself as a "politics of contradiction and tension," by creating both the ideological claim that girls are strong, powerful, and independent and using this ideological claim to construct commercial merchandise (p. 124). She considers this girl power contradiction to reflect and reinforce the ambivalence found in third wave feminist politics more generally. The Powerpuff Girls, Atomic Betty and the *Totally Spies* girls are fearless in battle *and* apprehensive, insecure, and petty in everyday life. Atomic Betty fights off alien villains only to return to school to worry that she won't receive any Valentine's Day cards (from "Betty's Secret Admirer").

There are certainly contradictions and multiple identities represented in these Cartoon Network girl power series, but when examining issues of political economy, it is questionable whether dominant structures are actually being challenged. In these cartoons, the dominant rhetoric, in terms of choice and freedom for girls, appears to be consumerism. Girls are commodified as audiences and they are encouraged to engage in a form of empowerment that is based in consuming 'pro-girl' items. In other words, consumerism has entered into political thought and has reframed the mass mediated discourses of feminism around issues of commercial choice and freedom.

Kids (and Girls) Only

In discussing girls' representations in culture, as opposed to women's representations, gender is not the only issue at play. The positioning of children in commercial culture is also relevant. The popularization of girl power in mass media developed in the context of media industries' discovery and construction of the child consumer.

Over the past 50 years, marketing industries and mass media have gradually merged to inundate the child's world with images of television and film characters in products ranging from toys to clothes and dishes (Kline, 1993, p. 149). The creation of Cartoon Network (and Nickelodeon) naturally followed these developments in children's culture. According to Henry Jenkins (1998), one way of understanding the branding and structuring of television networks as specifically for kid consumption is to see this as an effort to erect a clear distinction between the culture of children and the culture of adults, in order to emphasize an ever-younger audience of consumers.

Cartoon Network takes a different approach in connecting emotionally with children from Nickelodeon, a competing cartoon cable network. Nickelodeon developed their brand identity as a pro-social, wholesome children's network. This is reflected in their slogans of "Kids-Only Network," "Putting Kids First," and "Nickelodeon® is Kids!" Cartoon Network, on the other hand, uses the slogan "World Cartoon Headquarters" and seems to echo some of Baumgardner and Richards's (2000, p. 103) descriptions of third-wave feminism in describing itself as "mindlessly funny, oftentimes ironic," "wacky and zany," "irreverent and prankish," "whimsically rebellious, undercutting seriousness" (Sandler, 2003, pp. 97–98). Formerly known as Hanna-Barbera Cartoons, which produced popular television cartoons, such as *The Flintstones* and *The Jetsons*, for over 40 years, Cartoon Network currently provides cartoon programming 24 hours a day, with children comprising 68 percent of its audience and adults 32 percent. Children in the six to eleven-year age range serve as its core audience (Turner Entertainment Web site).

Bazalgette and Buckingham (1995) address media texts that are produced explicitly for children. They titled the introduction of their book "the invisible audience" to describe how children's media are a text that is defined in terms of its audience, yet there is very little sense in which children are able to participate in either the production of these texts or the debates as to its quality. A key issue still rampant in discussions on children's media is the notion that media have dangerous effects on children, especially in terms of violence, sexism, and racism. This moral-panic focus has led to a perspective, difficult to dismantle, of children as powerless and in need of protection from the media. Not only is the notion of girl power revolutionary in popular culture, but the very idea of addressing children as an empowered audience is a relatively contemporary development.

Popularizing girl power in the media developed in this context of children's growing consumer culture, along with mass media's attempts to appropriate and commodify notions of feminist rhetoric.

Media Visibility

In the western cultural context, media visibility is often conflated with power (Banet-Weiser, 2004, p. 122). One way that girls are valued within Cartoon Network's co-opted, girl-power ideology is in terms of their commercial and media visibility. There is an obvious value to the visibility of bright, strong, witty, and contradictory girls on Cartoon Network for the imaginaries of young girls watching the programs. Baumgardner and Richards (2000) argue that media visibility is critical to political activism and empowerment. Ellen Seiter (1995), in her research on *My Little Pony*, points out that, even though girl heroines in the 1980s were portrayed as stereotypically girlish with their unfortunate lack of articulations of strength or intelligence, their media visibility did challenge the invisibility of girls in earlier children's television. However, there are limitations to mass-mediated girl power representations. Media visibility may be an important step to empowerment, but it is not unproblematic.

Naomi Klein (2000) claims that media visibility has taken precedence over politics, and it is debatable whether this mainstream, commercialized version of feminism or 'girl power' is actually political and empowering (Banet-Weiner, 2004). The argument is that greater visibility of girls in popular media programs will result in the empowerment of girls viewing the programs. This claim, however, must address two factors: first, in a commercial context, social power is connected with consumption and the acknowledgment of girls as active viewers does not free them from mass media's commercial power; second, the conflicting representations of empowerment articulated within the texts reflect ambivalent or conflicting messages of power.

Connecting the two words *girl* and *power*, once absent in children's popular culture, is an ideologically complex concept. What does the word *empowered* signify and how are young girls powerful or empowered? Girls may be increasingly recognized by media industries as a profitable group of consumers, with more and more money to spend on girl power merchandise, but besides empowerment through consumerism, what messages of empowerment are articulated within the texts of the animated series?

The girls in *Atomic Betty*, *Powerpuff Girls*, and *Totally Spies* are undoubtedly visible and in leading roles, unusual in itself. Of the 106 cartoons listed as regular animated series produced by Cartoon Network, only six cartoons feature girls or young women as lead characters: *Atomic Betty*, *Powerpuff Girls*, *Totally Spies*, *Josie and the Pussycats*, *Hi Hi Puffy AmiYumi*, and *The Perils of Penelope Pitstop*. Of these six programs, *Atomic Betty*, *Powerpuff Girls*, and *Totally Spies* offer girl power programming (Cartoon Network Web site). *Atomic Betty* and *Totally Spies* are scheduled in a viewing block during the coveted afterschool 4:00 P.M. to 4:30 P.M. and 4:30 P.M. to 5:00 P.M. time slots, with the two programs promoted jointly as "The 'Girl Power' Extravaganza Hour." This back-to-back schedule, one could surmise, provides the girl audience with a framework for desirable development from younger girl (*Atomic Betty*) to teen girl (*Totally Spies*).

Betty turns into Atomic Betty—the transformation noted by a sudden outfit switch into her space dress—to rescue the Galaxy. The Powerpuff Girls, Blossom, Bubbles, and

Buttercup are created through an experimental error by a scientist named Professor Utonium, who intended to fabricate three girls by mixing sugar, spice, and everything nice. When a bottle of an unknown product, Chemical X, accidentally spills into the concoction, three girls emerge (Bubbles is sugar, Buttercup is spice, Blossom is everything nice)— with superhero powers to boot. The *Totally Spies* girls, Sam, Clover, and Alex, transform into superheroic sleuths with cool spy gadgets (usually disguised as makeup).

Riordan argues that girls may be taught to be more active, rather than passive, but their active work remains within the conventional bounds of girls and women constructing themselves as objects for the male gaze. Traditionally feminine and objectified codes of appearance and behavior are presented in Cartoon Network's girl power series. The Powerpuff Girls and Atomic Betty are cute as little girls in a typecast way. They have great big eyes and pretty features and hair. A recurring, villainous character in *Atomic Betty*, Icicla, is an ice queen who is dependent on, and obsessed with, obtaining Montego berries, which, when ingested, magically maintain her youth and beauty. She states repeatedly and clearly, amidst her snow servants, that *she* is the most beautiful of all which makes her the most powerful of all, echoing the tone of the Queen in *Snow White*.

Messages of conventional and objectified feminine beauty, desire, and sexuality are represented in the *Totally Spies* series in an ironic manner. The *Totally Spies* girls, teens rather than girls, have appearances and fashions that emulate conventionally sexualized *Lara Croft*-type heroines, regularly sporting form-fitting outfits over their shapely, fashion model bodies. In "Model Citizens," the *Totally Spies* girls fight against a modeling agent who steals people's body parts in order to give her own models perfect bodies. The girls investigate the abductions of the California State Cheerleading Champions in "Black Widows." In terms of reversing traditional sexual roles, *Totally Spies* episodes frequently involve boys as objects of the girls' desires. In "Boy Bands Will Be Boy Bands," the girls face a boy band whose members try to regain their popularity through stealing the faces of members of a new popular band. In "Planet of the Hunks," the girls must rescue hunky men who have been abducted by a rich princess who wants to place the men in her "human zoo." *Totally Spies* enacts feminine, sexual emancipation by turning the tables (or the gaze) on men and objectifying boys.

Jennifer Baumgardner and Amy Richards (2000) argue that a young woman's expression of feminism, power, and energy comes from her owning her sexuality, noting that this feminism supports "girlie culture," in which young women's sexuality and sexual self-esteem became the central issues in the debate on equality. According to Baumgardner and Richards (2000), third-wave girls and women want to be both the active subject and the object of sexualization through embracing their femininities in ironic and playful manners, while accepting varying ways a woman/girl could be sexy or feminine (e.g., athletic, androgynous). Dawn Currie describes the highly sexualized representations of femininity in magazines as embodying "a new wave of women's emancipation" (1999, p. 7). In the framework of third wave sexual rhetoric (ambiguous and contradictory, in itself), the empowering or marginalizing nature of these Cartoon Network representations seems, at best, ambiguous as well.

The girl power lead characters in *Cartoon Network,* visible, heroic, and contradictory though they may be, operate within contexts in which the actual dominant role or leader position is taken by a male figure, even if that male figure is not given as much air time as the girls. Admiral DeGill of *Atomic Betty,* a fish in army gear, is the Commander in Chief of the Galactic Guardians. Jerry of *Totally Spies* is the director of WOOHP World Organization of Human Protection). These men oversee the happenings of the world (or galaxy) and exercise the authority to dictate when and where the girls must perform their heroic feats. The *Powerpuff Girls* program depicts a more ironic patriarchal structure. Professor Utonium possesses some authority as the Powerpuff Girls' father, but of a kindly and solicitous nature. The Mayor commands the girls to move into action, but he is portrayed as a dim-witted bureaucrat who would be lost if not for the support of his assistant, Ms. Sara Bellum, a strikingly beautiful and intelligent woman who undoubtedly is the brains behind the Mayor. The Powerpuff Girls recognize Ms. Bellum's power, which Ms. Bellum (unfortunately) keeps hidden from the public.

Are these representations of girl power, in fact, political? In terms of disrupting power relations or dominant structures, it is unlikely that *Atomic Betty* or *Totally Spies* offer serious challenges, because their superheroic feats take place in the contexts of masculine-run structures. The *Totally Spies* girls may be sexually emancipated, or at least sexually complex, but fighting international crime is still their primary mission and in this arena, they work under the leadership of the white, male, middle-class, British-accented director of WOOHP. The *Powerpuff Girls* offer gender representations that contest traditional stereotypes of power in that, even though the males are situated in positions of authority, the audience understands that the female figures, in fact, possess the power. Cartoon Network's representation of girl power constructs girls as lead characters, who are bright and strong, and the girls/women may even hold the real power. However, this power must be concealed from a "real" world that still needs to function with men at least feigning to be the true leaders.

The problem with appropriating a marginal culture's ideas into mainstream, consumer culture, be it liberal feminism or girl power or punk rock, is that it fails to truly challenge or de-center dominant structures. This is because the co-opted culture must be rearticulated in ways that satisfy both the dominant culture, as commodity audience, and the subculture, in a manner that, in the end, does not necessitate real structural change or significant disruption of power relations. *Atomic Betty,* the *Totally Spies* girls, and the *Powerpuff Girls* may be powerful, but their power is weakened in the context of a conventionally male-dominated power structure. In other words, when girl power is commodified, the feminist politics of empowering girls becomes diluted in order to fit into mainstream dominant culture. Normalizing feminism neutralizes it, and turns it into slogan rather than a movement (Dow, 1996).

Conclusions

The production of girl power culture in contemporary media demonstrates the tensions between media visibility, consumer culture, and power inherent in third wave feminist pol-

itics. Tension resides between the media's "embrace of the 'girl power' consumer market and its role as a producer of 'girl power' ideology" (Banet-Weiser, 2004, p. 121). Mass-mediated representations of girl power provide contradictory forms of power by disrupting the dominant gender relations, in which boys are expected to be lead characters, and by entrenching conventional gender relations. The commodification of audiences and marketing of program merchandise reveal a form of girl empowerment that repositions girls into conventional feminine roles as consumers.

The visibility of strong, bright, and heroic girls in animated network television is understandably valuable for young, female audiences. Less palpable is how the traditional and contradictory feminine representations articulated within these texts are negotiated by actual girl viewers.

Appropriating girl power rhetoric into mainstream, consumer culture does not necessarily disrupt power relations or require real structural change. As girl power is commodified, feminist politics is, in a sense, at risk of being neutralized. The girls may be 'the toughest chick[s],' but the question remains: is a new form of feminist politics really being articulated in these girl power programs?

REFERENCES

Banet-Weiser, S. (2004, June). Girls rule! Gender, feminism, and Nickelodeon. *Critical Studies in Media Communication, 21*(2), (pp. 119–139)

Baumgardner, J., & Richards, A. (2000). *Manifesta: Young women, feminism, and the future.* New York: Farrar, Straus, and Giroux.

Bazalgette, C., & Buckingham, D. (1995). The invisible audience. In *In front of the children: Screen entertainment and young audiences* (pp. 1–14). London: British Film Institute.

Cartoon Network. (1992, October 1). Cartoon Network. Retrieved April 3, 2006, from. <http://www.cartoonnetwork.com>.

Chalvon-Demersay, V. (Executive Producer). (2001-present). *Totally spies.* [Television series]. Cartoon Network.

Currie, D. H. (1999). *Girl talk.* Toronto: University of Toronto Press.

Dicker, R., & Piepmeier, A. (Eds.). (2003). *Catching a wave: Reclaiming feminism for the 21st century.* Boston: Northeastern University Press.

Dow, B. (1996). *Prime-time feminism: Television, media culture, and the women'smovement since 1970.* Philadelphia: University of Pennsylvania Press.

Garrison, E. K. (2000). U.S. feminism Grrrl style! Youth (sub)cultures and the technologies of the third wave. *Feminist Studies, 26*(1), 141–170.

Gillis, K. (Executive Producer). *Atomic Betty* [Television series]. Cartoon Network.

Giroux, H. (1994) *Disturbing pleasures: Learning popular culture.* New York: Routledge.

Goldman, R. (1992). *Reading ads socially.* New York: Routledge.

Heywood, L., & Drake, J. (1997). *Third wave agenda: Being feminist, doing feminism.* Minneapolis: University of Minnesota Press.

Jenkins, H. (1998). *The children's culture reader.* New York: New York University Press.

Klein, N. (2000). *No logo*. New York: Picador.

Kline, S. (1993). *Out of the garden: Toys, TV and children's culture in the age of marketing*. Toronto: Garamond Press.

McCrecken, C., & Simensky, L. (Executive Producers). (1998–2004). *Powerpuff girls* [Television series]. Cartoon Network.

Meehan, E. (2001). Gendering the commodity audience: Critical media research, feminism and political economy. In E. Meehan & E. Riordan (Eds.), *Sex & money: Feminism and political economy in the media* (pp. 209–222). Minneapolis: University of Minnesota Press.

Meehan, E., & Byars, J. (2001). Telefeminism: How Lifetime got its groove, 1984–1997. *Television and New Media, 1*(1), 33–51.

Mosco, V. (1996). *The political economy of communication: Rethinking and renewal*. Thousand Oaks, CA: Sage.

Orenstein, P. (1995). *School girls: Young women, self-esteem, and the confidence gap*. New York: Anchor Books.

Reed, J. (1997). Roseanne: A "killer bitch" for Generation X. In L. Heywood & J. Drake (Eds.), *Third wave agenda*. Minneapolis: University of Minnesota Press.

Riordan, E. (2001). Commodified agents and empowered girls: Consuming and producing feminism. *Journal of Communication Inquiry, 25*(3), 279–297.

Sandler, K. S. (2003). Synergy Nirvana: Brand equity, television animation, and Cartoon Network. In C. A. Stabile & M. Harrison (Eds.), *Prime time animation: Television animation and American culture* (pp. 89–109). New York: Routledge.

Seiter, E. (1995). *Sold separately: Parents and children in consumer culture*. New Brunswick, NJ: Rutgers University Press, 1995.

Steeves, H. L., & Wasko, J. (2001). Feminist theory and political economy: Toward a friendly alliance. In E. Meehan & E. Riordan (Eds.), *Sex & money: Feminism and political economy in the media* (pp. 16–29). Minneapolis: University of Minnesota Press.

Turner Entertainment Web site. (2005). Turner Entertainment. Retrieved April 3, 2006, from <http://www.turner.com/about/networks_and_businesses.html>.

Van Fuqua, J. (2003). What are those little girls made of? *The Powerpuff Girls* and consumer culture. In C. A. Stabile & M. Harrison (Eds.), *Prime time animation: Television animation and American culture* (pp. 205–219). New York: Routledge.

Chapter 35

Just like *Lizzie*

Consumerism, Essentialism, and the Domestication of Rebellion in Disney's *Lizzie McGuire*

Laraine Wallowitz

In response to the prompt, "If you could meet anyone, who would it be and why?" scores of fourth-grade boys and girls at a small, rural elementary school in central Virginia wrote that they would want to meet Hilary Duff, the star of the Disney series, *Lizzie McGuire*. For students about to enter middle school, she is a superstar worth admiring and emulating: she is the star of a popular Disney series, headlines her own rock tour, dances, models, graces the cover of books and countless magazines, and portrays a wholesome, "safe" image to which their parents will not object. As I passed through the hallways, I noticed *Lizzie McGuire* backpacks, folders, notebooks, pens, lunch bags, T-shirts, and other Disney-inspired merchandise. I left the school curious: who is *Lizzie McGuire*? Indeed, what makes her so popular?

Given that popular culture plays a significant role in the lives of today's youths, it is important for me, a feminist educator and researcher, to examine how popular culture constructs the "common" for girls in order to deconstruct its insidious messages and recognize its subversive ones. If the junction of reader and text is the meeting of "discursive constructs both contain[ing] similar, competing or contradictory discourses" (Fiske, 1987, p. 67), then teachers can capitalize on the contradictions to disrupt the common and produce alterna-

tive readings. By producing new readings students learn to use literacy as a vehicle for empowerment and change, not as a form of social control. Counter-hegemonic teaching requires teachers and students to read popular culture as a text, analyzing, discussing, deconstructing, and re-constructing its meaning in the interest of all learners. Questions for investigation include: How do literature and media construct notions of femininity and masculinity? How does popular culture/fiction aimed at young female audiences construct the reading subject? Is the constructed subject one that allows for alternative identities or reinscribes essentialist truths about gender, race, class, and family? How does a popular show like *Lizzie McGuire* write girlhood?

After carefully screening the show and reading fifteen books from the series (new ones are constantly being written based on the TV series by the same name), I found myself conflicted: I tried to reconcile the pleasure I received from reading about Lizzie's adolescence, her friendships with Miranda and Gordo, and her continual attempts at winning Ethan Craft's heart with the fact that Lizzie is a stereotypical girl living in a sanitized Disney fantasy world. I found pleasure as the reader because the collection celebrated and valued "girlhood"—but an essentialized, white, middle-class girlhood. How can fiction that capitalizes on essentialist, classist, and racist notions of femininity and masculinity empower the reader? The answer: *Lizzy McGuire* infuses white girlhood with power and meaning but relies on stereotypical female behavior in order to do so. It values difference at the same time as it exaggerates the differences that have been used in the past to circumscribe women, the poor, and minorities. For white, middle-class female viewers, Lizzie McGuire reflects their values and validates their obsession with their appearance, friendships, popularity, and all things "feminine."

In addition to capitalizing on gender differences, the series appears to be challenging the stereotypes it supports. The dominant narrative in the series is Lizzie's attempts at carving out a niche for herself in a culture dominated by conformity; the storylines center on being "yourself." Young girls can enjoy identifying with a main character that appears to rebel against any attempts to define or contain her behavior: Lizzie is brave, unapologetic, loud, and demanding. The irony, of course, is that Lizzie, with her all-American looks and status as teen idol, never really pays for her rebellion in the book or as the movie star, Hilary Duff. The books' plots co-opt female readers into believing they are defying stereotypes and cultural reproduction without ever having to ostracize themselves or challenge the norms of acceptable teen behavior. In essence, this is the allure of popular culture: Lizzie allows girls to have their cake and eat it too. By domesticating rebellion, the content in a series like *Lizzie McGuire* is insidious precisely because it appears to be challenging the status quo at the same time it reinforces it.

First, I will present the way in which Disney, one of the largest corporations in the world, has been an influential force in constructing American traditions and commodifying childhood through the interest of corporate culture. Next, I will look at how the series shapes essentialist notions of gender and family and stereotypes poor, black, and Latin youth. In addition, I will explore the ways in which Lizzie appears to rebel against adolescent conformity but falls short of actually challenging established norms. Last, I will argue that Disney

productions warrant serious attention by educators and should/can be used as teaching tools in schools by instructing young students how to become "resisting readers" (Fetterley, 1973) of media, the word, and the world.

Writing Reality:
"Lizzie's Family Is Just like Your Family"

Disney's attempt to write reality should not be ignored by educators. The Disney Corporation, a multi-billion dollar company, owns ten cable stations including ABC, ESPN, A & E, and Lifetime, reaching an audience of 720,500; two movie companies (Miramax and Touchstone); forty monthly papers; six weekly papers; resort areas; travel companies; two sports teams; theme parks; and thousands of retail stores. Its advertising reaches hundreds of thousands of people each day. As such, Disney is a powerful force in creating children's imaginary worlds through its stories—stories received by its consumers every time they turn on the TV, read the paper, watch the news, shop, read, or take in a movie. The corporation has the ability to define what is "normal" for children as they imagine their future possibilities, including what constitutes the normal family, the normal neighborhood, and the normal thirteen-year-old. As Giroux (1997) aptly wrote, "[Disney] seems to inspire at least as much cultural authority and legitimacy for teaching specific roles, values, and ideals as do the more traditional sites of learning such as the public schools, religious institutions, and the family" (p. 53). If Lizzie's family is like your family, then what does Disney think is (or want as) the "normal" family?

"Lizzie McGuire" is advertised on Disney as the typical family: "Lizzie McGuire's family is just like your family." Such an assumption begs the questions, what constitutes the "typical" American family? According to *Lizzie McGuire*, the "typical" or standard North American family (SNAF) consists of "a legally married couple sharing a household" (Smith, 1993, p. 50) who are white, middle or upper class, educated, secular Christian, and able-bodied. In addition, the mom stays home, and the father works in an elusive "office," which is often referred to but never elaborated on. The McGuires have a son and a daughter and live in marital bliss in sunny, suburban California. Because this scenario does not make up the majority of households in America, the standard North American family is a construction, not a reflection of society. Therefore, one of the lenses through which the reading subject experiences the series requires him or her to buy into the notion of the standard family, even if his or her lived experiences suggest otherwise. "Typical" is normalized, leaving a large portion of the viewing audience feeling atypical and abnormal.

The picture of "normality," Mr. and Mrs. McGuire occupy stereotypical mutually exclusive male and female spaces. Mrs. McGuire does not work outside of the home; as such, she is always featured in the kitchen cooking, cleaning, or doing the laundry. Mr. McGuire, on the other hand, is seen getting ready for work in the morning or working on one of his many "projects," one of which is his son, Matt. Matt and his father get into all sorts of trouble together and have many adventures. The reader does not really meet David Gordon's

(a.k.a Gordo) parents and Miranda Sanchez's family is introduced in the show, but not included in the books' storylines. The reader does learn, however, that Miranda's mom works outside the home, unlike Mrs. McGuire.

Other than Miranda's mother, alternative families or lifestyles are absent from the series. In the second part of book six, *New Kid in School* (2003), Disney endeavors to be inclusive and present a few "fictional lifestyle[s]" (p. 75) for its sizeable audience. Nevertheless, it falls short of pushing the boundaries of "normal" family roles and ideals. As part of a class project, Lizzie and her friends are assigned a mock marriage. It is their job to create a "fictional lifestyle" and then report to the class one week later at their twenty-year reunion. As incentive (and to encourage competition), the couple who has the "best marriage" does not have to write a paper. Lizzie, wanting to be the "world's most perfect bride" (p. 75), is excited about the prospect of marrying the most popular boy in the school and become "Mrs. Ethan Craft" (p. 84). Unfortunately for Lizzie, the teacher is in charge of assigning the couples (Lizzie marries her best friend, Gordo) and their future jobs are determined by picking out of a hat. Many of the roles place the female characters in professional positions: Lizzie is a lawyer; Kate Sanders, the most popular girl in the school, a TV personality; and Sally, a policewoman. But it is Miranda's life—that of a housewife—that everybody wants: She gets to be "Mrs. Doctor Ethan Craft!" (p. 95).

Miranda, the "soccer mom," and Ethan, the "heart surgeon," represent to the reader and her classmates, the "best marriage" (p. 75) and Disney's version of the American Dream. Miranda brags to her jealous classmates: "'We have three kids: Britney, Gwyneth, and Ethan Junior. I drive the kids to soccer practice in my metallic-blue SUV with beige leather interior'" (p. 112). The couple also enjoys "a vacation house" and "a swimming pool" (p. 130). Her life with Ethan is not unlike the earlier vision of family life sold during the 1950s, after the end of WWII. Disney's "nostalgic view of the past" (Giroux, 1997, p. 55) can also be seen as part of their 5,000-acre residential development, Celebration, which was an attempt to create the ideal small town, suggestive of a Norman Rockwell painting. Unlike (or more like) small-town America, Ethan and Miranda's marriage comes to a dramatic end at the reunion. Ethan has been "cheating" on Miranda with Kate Sanders who then is left by her husband, postal worker (and school Geek), Larry Tugman. In the end, Lizzie and her friends decide that they are "too young to even pretend [they're] married" (p. 137), an ironic statement in light of the fact that the whole book was dedicated to mock marriages and the heterosexual marriage narrative ubiquitous in Disney productions. Young girls learn from a young age, reading Disney books and watching Disney films, that the only route to happiness is winning the love of a (rich/royal) man and becoming the "World's Most Perfect Bride" (p. 77).

Mrs. McGuire, a "perfect" wife and mother, is the mistress of her domain. The first book in the series, entitled *When Moms Attack* (2002), serves as a cautionary tale to its young female readers about leaving men in charge of domestic duties, thereby essentializing masculinity and femininity and reifying domestic gender roles. Mrs. McGuire agrees to chaperone the science class's camping trip, leaving her husband in charge of their son, Matt, the household duties, and a "tuna-noodle casserole" (p. 37). The "men" decide not to eat the

casserole and, fearing starvation, decide to cook. With their copy of *The Complete Idiot's Guide to Cooking*, they attempt to make "duck a l'orange" (p. 30). Instead they create a "science project gone bad," and, in order to salvage it, Matt crams it into the microwave and splatters it inadvertently all over the kitchen (p. 37). In the end, the father has enough sense to order pizza and he and his son decide that it "would be a long time before either of them tried cooking again" (p. 45). What at first appears like an innocent father/son adventure only re-establishes the home as a woman's domain. Mr. McGuire makes enough money at his job to afford a nice home in a nice suburban neighborhood, but he cannot be left at home alone. By infantilizing men, the book gives the girls a false sense of power and further teaches its young readers that women's place is in the home.

Miranda's mother, on the other hand, does work outside of the home. For that reason, Miranda is in charge of babysitting her little sister after school, a point Lizzie uses to convince her parents she is mature enough to babysit her brother, Matt, in Part II of *On the Job* (2004). Miranda, a latchkey child, is also the character who convinces Lizzie to lie in several storylines, gets accused of shoplifting, cheating on her essay for English, and stealing candy out of the bins in the mall (*Picture This*). She tells Lizzie, who hopes to win "best dressed" at school, to buy an overpriced designer outfit at the *Style Shack* and then return it (*Best Dressed*); she convinces Lizzie—twice—to lie to her mother about going over to Gordo's to study so they can go shopping alone at the mall (*Best Dressed; When Moms Attack*) and she agrees to deceive Mrs. McGuire so they can shop for bras because Lizzie is "no good at lying" (*When Moms Attack*, p. 60). As the only character from a household with a working mother, Miranda's ability to lie is disconcerting as well. According to Giroux (1999):

> When it is recognized in the public consciousness that children are not entirely passive and immune and can actually imitate adult behavior, the images of working-class, Latino and black kids are invoked as a media spectacle. Their aberrant behavior is invariably attributed to the irresponsibilities of working mothers, rampant drug use, and other alleged corruption of morality circulating within working-class culture. But little is mentioned about the violence perpetuated by those middle-class values and social formations—such as conspicuous consumption, conformity, snobbery, and ostracism—that reproduce racial, class, and gender exclusions. Nor is much said about how middle-class values legitimate and regulate the cultural hierarchies that demean marginalized groups and reinforce racial and economic inequalities. (pp. 16–17)

Disney's intimation that children without a strong maternal presence are more likely to lie places the blame on mothers or the working poor, not on a culture that places more value on mass consumption and a competitive market.

Just Like *Lizzie*: "I'm not into mass consumption."

The *Lizzie McGuire* book series is based on a Disney-created show of the same name. The books' popularity stems from the shows, which can be seen, in syndication, every afternoon on the Disney channel (5:30 E/ 4:30 C) or on Saturday mornings on ABC kids. The Disney channel, which sponsors the program, does not sell commercial time to advertisers. During program breaks, within the show and between shows, viewers are presented with trailers

for other Disney programs and movies, news for kids, and interviews with the different Disney stars. It is common to see the stars of *Lizzie McGuire*—Hilary Duff, LaLaine, and Adam Lamberg—talking about their favorite books, holidays, and pasttimes or their volunteer efforts. The absence of advertising suggests that Disney is trying to assure the parents that the channel is "safe" for viewing, not "an effective corporate instrument, whose sole purpose is to sell [children] to the advertisers" (Miller, 1988, p. 24). Parents can feel certain their young, impressionable children would not be exposed to violent movie trailers, Victoria's Secret commercials, or companies trying to sell expensive toys. Of course, the idea that TV shows (or Disney stories) are not advocating "mass consumption" is simply false; on the contrary, Disney sells a lifestyle that relies on gender stereotypes, middle-class values, and conformity to sell its merchandise worth billions. As Michael Eisner, the former CEO of Disney, admitted in a memo as quoted in *Mickey Mouse Monopoly: Disney, Childhood, and Corporate Culture* (Sun & Picker, 2001), "To make money is our only objective."

Eisner's admission seems contrary to the books' messages about "being yourself" and not conforming to a set of external standards. Many of the storylines, including *Picture This* (Jones, 2003d) and *On the Job* (Goldman, 2004) comprise Lizzie coming to the conclusion that money can not buy happiness. Upon closer examination, however, the book "celebrates" mass consumption both in the other storylines of the text and through the commodification of the *Lizzie McGuire* franchise. In order to be *Just Like Lizzie*, young readers can buy her posters, notebooks, pencils, T-shirts, dolls, lunchboxes, DVDs, mystery novels, special books, game boy, and folders, earning Disney over $100 million dollars (www.answers.com/topic/lizzie-mcguire). Being "just like Lizzie" requires money and middle-class values: shopping, clothes, music, hair accessories, the perfect outfit, lip gloss, and the mall. Being *Just Like Lizzie* (Jones, 2003a) also means being worth millions like Hilary Duff, the star of the book series and show.

Consumerism plays a seminal role in an adolescence life and in the "life" of Lizzie McGuire by defining what it means to be a girl or a boy. Every student wants to "fit in" somewhere, and fitting in often means conforming to an ideal constructed by the media and popular culture. Girls and boys need to have the *right* music, the *right* clothes, and conform to the *right* standards of beauty. Lizzie and Miranda have been schooled in the ways of popularity and consumer culture: they know what music to listen to (Britney Spears); where to shop for their clothes (Hot Topic; Style Shack); what brands to wear (Delia's); and what to drink (cappuccinos) in order to "fit in." Gordo, on the other hand, does not conform to external pressure; he does offer an alternative model of masculinity to the male readers. Unfortunately, in a consumer culture, he can only define himself by what he owns and buys.

On the surface, Gordo seems to have situated himself outside the boundaries of typical teen behavior. Lizzie describes Gordo, the outcast, in part II of *Lizzie Goes Wild* (Larsen, 2002):

> Gordo was *definitely* not everybody. He was always doing something different. When everybody else at school was Rollerblading, Gordo was riding a unicycle. And when everybody was into chocolate cappuccino, Gordo was drinking some weird plum soda. His latest obsession was Rat Pack lounge

culture. Lately, he was spending all of his free time buying old record albums with titles like *Songs for Swingin'* and *In the Wee Small Hours*. And all his clothes looked like he'd raided his grandfather's closet. (p. 73)

Throughout the series, Lizzie and Miranda were constantly trying to "nudge Gordo into acceptance-ville" (p. 74). Gordo's refrain, "I'm not everybody" seems to set him apart and offer another vision of suburban America. Of course, Gordo's insistence on not being into "mass consumption" (p. 109) is ironic and simply false. He, too, carves out a "distinctive" identity by what he buys and owns and where he shops (indie stores like "Gotta' Load a Disc") not necessarily by what he does. In addition, Gordo is being mass consumed every week as part of Disney's billion dollar advertising and merchandising behemoth. *Lizzie*'s audience can own its books, watch its TV show, and buy its merchandise. Gordo's character still teaches his readers you are what you buy.

Buying at any level is equated with freedom and power. Corporate conglomerations such as Disney, which own most of the advertising space, ensure that America remains a consumer culture by dangling products in the faces of today's youths. Ubiquitous consumerism marks every aspect of teen culture. Lizzie is a "typical teen," and the dream of corporate culture in that she partakes in consumerism every opportunity she gets. In *On the Job* (Goldman, 2004), Lizzie begs her parents for an increase in her allowance for more freedom—more freedom to buy whatever she wants: new jeans, jewel-encrusted hair clips, dangly earrings, lip gloss, and "that cute zebra-striped tank top" (p. 18). When her parents refuse to increase her allowance, Lizzie procures a part-time job at Digital Bean, the local teen hang out. After many mishaps and long days taking orders from obnoxious teens, including her nemesis, Kate Sanders, Lizzie begins to realize that working does not afford her the freedom she imagined: "I want to be free, and I want to be independent! But no! Obviously, that's not going to happen [with a boss and a job]" (p. 53). In the end, Lizzie is fired for yelling at the costumers. She learns that "being independent is harder than it looks" and "the great thing about being a kid is to get good grades [and] hang out with your friends" (p. 42). Then, when Lizzie "wants stuff," she is told to simply ask her Dad.

In part II of *On the Job*, Lizzie, Gordo, and Miranda are assigned the task of creating "the perfect town." Miranda's "perfect town" (a.k.a. Mirandaville) would be "five hundred Hot Topic stores and a ten-story shopping mall" (p. 73); Gordo's ideal town consists of "[a] bookstore containing the works of Navajo and Greek philosophers, a coffeehouse where people only discuss music and politics, a thousand-foot water slide ending in a swim-up counter where they serve free, deep-fried pizza" (p. 75). As mentioned previously in the chapter, Disney's ideal town would consist of a world just like Lizzie's: teens worshiping the mall, spending the money they earned babysitting, doing their chores, or received from their parents. While most teens define themselves by want they wear, buy, and own, it is important to remember that every town is NOT just like Lizzie's. The middle-class emphasis on consumerism puts a strain on families with the means to keep up with the long list of items offered in Disney publications and productions. Parents and educators need to remember that if "making money is [Disney's] only objective," then we are teaching our kids to value "conspicuous consumption, conformity, snobbery, and ostracism" (Giroux, 1999, p. 17). Yes,

"Paychecks Rock!" (Goldman, 2004) as long as they are not being manipulated by billion dollar companies.

Disney and Stereotyping:
"A nice, typical thirteen-year-old-girl"

Disney does not have a good track record when it comes to stereotyping women and minorities. Since its first films, Disney writers have been maligned by activists for their representations of African Americans, women, Arabs, Native Americans, and Asians. The documentary *Mickey Mouse Monopoly: Disney, Childhood, and Corporate Power* (Sun & Picker, 2001), explains how Disney productions and publications tend to ignore race and ethnicity. However, when they do include such characters, the films only support cultural stereotypes: Latinos are featured as reckless Chihuahuas in *Lady and the Tramp* and *Oliver and Company*; "African Americans as jive crows in *Dumbo*, as human-wannabe orangutans in *Jungle Book*, and they are totally absent in *Tarzan's* Africa; Latinos and African-Americans as street-gang thugs in *The Lion King*; Asians as treacherous Siamese cats in *Lady and the Tramp*; Arabs as barbarians in *Aladdin*; and Native Americans as savages in *Peter Pan* and *Pocahontas*" (Pettit, n.d., p. 1). In addition, Disney writers use language, accents, and street-slang to criminalize characters such as the hyenas played by Whoopi Goldberg and Cheech Marin in *The Lion King* or the Siamese cats as "sinister, cunning, manipulative, and [an] insidious" Yellow Peril (Pettit, n.d., p. 8). Even in the new millennium, there has only been one animated black man in any Disney feature film (*Atlantis*).

Disney also misrepresents femininity. Female characters are coy, sexy, seductive, curvaceous, and have Anglo features despite their race or ethnicity. In addition, in keeping with Disney's vision of femininity and family, the females are either rescued by a man and/or willing to risk it all for the affection of a man: Ariel gives up her voice in order to win the prince (and does despite not being able to talk) in *The Little Mermaid*; Snow White, the consummate housewife, is rescued in *Snow White and the Seven Dwarves*; Cinderella, Rapunsel, and Sleeping Beauty are also rescued; Mulan fights off the Huns in China only to return to her husband and domestic duties in *Mulan*; and Belle uses her feminine charm to emancipate her captor in *Beauty and the Beast*, only to marry him in the end.

Continuing the Disney legacy, *Lizzie McGuire* constructs "girlhood" by reifying essentialist notions of femininity and middle-class values at the same time it misrepresents poor, black, and Latino youths. Lizzie is a blond, attractive, able-bodied, intelligent, heterosexual female who tries to win the affections of Ethan Craft. She spends time shopping, worrying about her appearance, and being with her two best friends Gordo, a white, thirteen-year-old male, and Miranda Sanchez, a Latina, thirteen-year-old female. Most of the conflicts are played out either in a coffee shop called "Digital" or in school, away from the parents who remain in the background. As Gordo stated to Lizzie, "You are a nice, typical, thirteen-year-old girl." Gordo's comment suggests that "[o]n the body of [Lizzie McGuire] are written the instructions for being a 'typical' [adolescent] girl" (Byers, 1998, p. 718).

Lizzie McGuire does not offer more than one model of femininity. Similar to the either/or dichotomy that plagues representations of women throughout literature, either a character is just like Lizzie or just like Kate Sanders, her nemesis. Kate, similar to the female antagonists in Disney tales, is popular, competitive, and rich; as such, she is powerful. Power is not rewarded in females; instead, it makes them unlikable and often unattractive. However, an analysis of both Lizzie and her adversary reveals more similarities than differences; both characters embody an acceptable and limited model of femininity. Girlhood, as the characters of Lizzie, Miranda, and Kate write it, means being a slave to fashion, gossip, and boys. Both Lizzie and Kate rule over an exclusive circle of friends; both vie for the attention of the most popular boy, Ethan Craft. Competition is disparaged (gymnastics and soccer) unless it includes fashion or boys. In fact, the same rhetoric Lizzie uses to criticize Kate in the episode entitled *She Said, He Said, She Said* (2002) ("What is she afraid she might break a nail or something?") is then used by her brother, Matt, to disparage her ("All this running around would make [Lizzie] break her nail"). Kate's popularity stems from her class status as a "rich girl" and her "fake" personality. Middle class and "real," Lizzie happily remains excluded from Kate's superficial world. In reality, Lizzie and Kate operate as tropes for girlhood: white, middle to upper class, heterosexual, able bodied, attractive, catty, and fashionable.

Conversely, being male in *Lizzie McGuire* does not mean adhering to one standard of boyhood. David Gordon, in particular, offers an alternative male model of masculinity. Gordo, in contrast to Ethan, associates with two girls, does not play organized sports, or treat girls like trophies. Ethan, on the other hand, employs a male discourse of difference that defines him in opposition to the female characters in the show. Lizzie and Miranda spend much of their time and energy "training" Gordo to become in touch with his "feminine" side. His female influence makes him more attractive to the female viewer, not as a potential love interest at first. In the beginning, Ethan, not Gordo, attracts the girls, including Lizzie. Gordo "strikes out" with the girls in junior high; yet, he is a likable character, eventually winning the romantic affection of Lizzie in "Clue-Less" (Douglas & Maile, 2003). Thus, Gordo and Ethan offer two dissimilar male ways of being.

Ethan Craft, crafted out of dominant stereotypes about teenage maleness, wins the affections of Lizzie, who is attracted yet repulsed by his handsome looks and vacuous personality. Ethan, in every scene, wears his masculinity (his Letterman jacket) not only to attract female admiration, but to conceal the fact that he is indeed "all brawns, no brains." Ethan is in every sense a "cultural dupe." Completely void of any sense of unique self, Ethan relies on the current, teenage slang to interact with Lizzie. Ethan depends on clichés to communicate: "Lizzie, you rock"; "Dude, you stink"; "Lizzie, check ya out bowlin,' right?" "Lizzie, alright!" (Gould & Falcon, 2001). Speaking in only half utterances, Ethan does not understand anything besides girls and sports. During the bowling episode, Gordo strikes out, literally, to prove to himself that winning is not everything. Ethan, on the other hand, cannot comprehend failure. Gordo explains to him, "Ethan, life's a journey," quoting Mr. Digby's words of advice. Ethan responds, "Okay, but my ride's not coming 'till later." Similarly, in another episode entitled *Educating Ethan*, Ethan can only learn fractions by

rearranging cheerleaders, instead of numbers (Bargiel & Rosman, 2001).

Gordo, on the other hand, offers an alternative model of masculinity and does not rely on essentialist ideas of manliness to define himself in opposition to Lizzie and Miranda. Gordo's "masculinity" initially prevents him from joining Lizzie and Miranda in a social event—bowling. Gordo's fear of failure (the last time he went bowling, he threw nine straight gutter balls and his fingers swelled up) become the central narrative of the *Lizzie Strikes Out* as Miranda decides to become his "life coach" in order to teach him that "[y]ou don't have to be the best at everything. Sometimes you can do something for fun." Gordo, who "never thought of that" decides he "will not let [his] fears limit [him]" (Gould & Falcon, 2001). Gordo and Miranda then get to work. Gordo dives into the book, "The Dude Strikes Out" and repeats his mantra, "Bowling is good; bowling will not make my fingers swell." Every time he repeats his mantra, he earns a "treat" from his coach, Miranda. In the end, Gordo rolls a gutter ball and in his triumph over his "masculine" inclination for success, yells out "Gutter ball!" Miranda joins in his jubilation, jumping up and down: "That's the worst I've ever seen." Gordo admits he "couldn't stink without" her. Miranda aids Gordo by de-valuing masculine competitiveness. Once again, the feminine is valued in males, and Gordo continues to re-write the terms for proper male behavior when he does not reproduce masculinity as it is commonly defined by the media. Of course, femininity is essentialized in the above episode and Gordo does not influence Lizzie and Miranda: "masculinity" is valued in boys but not girls.

In the opening scene of one episode, Lizzie and Miranda ruminate over lip-gloss; Gordo, situated in the middle of the two girls, stares at a monster truck magazine and announces, "Monster truck round up is coming." Disinterested, Lizzie asks Gordo, "Since when have you been interested in monster trucks?" Gordo retorts, "I'm sick of talking about girl stuff. I'm a guy and we never talk about guy stuff." Completely ignored, Gordo grows frustrated and walks off muttering, "I gotta start hanging out with more guys." Gordo, seeking testosterone, befriends Lizzie's younger brother, Matt. Matt's form of male play attracts Gordo because it is in direct opposition to the female world of lip-gloss and gossip. Gordo gets to do "stuff" with Matt he "never does with Lizzie": hackey football, catch, water gun fighting, basketball, and riding scooters. Masculinity personified, Gordo and Matt, despite their age difference, connect in ways in which Lizzie and Miranda will not participate. Despite Gordo's regression into conventional maleness, he misses being with his "best friends," even if they are girls. Gordo, missing his best friends, eventually distances himself from Matt; however, they both agree to attend the monster truck round up when it rolls into town. Gordo is a more fully developed character: he displays both feminine and masculine characteristics.

Since the audience for the books is largely female, it is surprising that so few options of girlhood are available to its readership and the most interesting and dynamic character in the series is a boy—Matt McGuire, Lizzie's younger brother. Matt is active, inventive, daring, creative, imaginative, popular, outspoken, and rebellious. Matt throws parties in his backyard, becomes a superhero who fights crime (Matt-Man and the Incredible Oscar in *Lizzie Loves Ethan*, Jones, 2003b), builds his own cave (*When Moms Attack!* Ostrow, 2002),

poses as a movie producer (*New Kid in School*, Jones, 2003c), starts his own talk show (*Picture This*, Jones, 2003d) and is free to do anything he wants. He is also the only character who can communicate with Lanny, one of the few African American characters in the book. Matt, like so many male characters is dynamic in contrast to Lizzie who represents only one version of femininity.

The Domestication of Rebellion: "So, as long as I'm a good person, it's okay to want to look pretty?"

Celebrating their femininity, Lizzie and Miranda offer the female viewer a girl-centered world, where pink replaces blue as the color of choice. By claiming the feminine, the show de-trivializes female activities and ideologies; Lizzie does not apologize for talking endlessly on the phone to her friends, painting her nails, or making a fashion statement by decorating her hair with streaks of pink glitter. Similarly, the show's reoccurring narrative, negotiating an autonomous identity in the conforming world of school, also offers young girls a non-traditional script—be yourself. However, the show's strength is also its downfall. Being you, as it is written by the show, means claiming essentialist girlhood and middle-class values defined by what you own and not who you are. The story does not leave room for girls struggling with their sexuality or with claiming their more stereotypically "masculine" traits like excelling at competitive sports, shunning the female aesthetic, or showcasing their intellectual capabilities.

Disney offers its public a domesticated rebellion, resulting in a female protagonist who eventually submits to her prescribed role as wife, mother, and domestic. In *The Little Mermaid*, Ariel defies her father, Triton, explores the human world, and fights for her independence to marry Prince Eric. Similarly, Belle, in *Beauty and the Beast*, appears to be a rebellious, brainy girl trapped in a small provincial town in eighteenth-century France. She does reject Gaston, a hyper-masculine man who tries to win her heart; however, she gives in to her captor, the Beast. Belle eventually falls in love with him and "becomes a model of etiquette and style as she turns this narcissistic, muscle-bound tyrant into a model of the 'new' man, one who is sensitive, caring, and loving" (Giroux, 1997, p. 59). Mulan, the woman warrior, defends China from the Mongols and then returns home to marry and fulfill her duty as a daughter. She rebels against a repressive culture but does not pay for it in the end. None of the aforementioned characters lose anything as a result of their rebellion. They, like Lizzie, have their cake and eat it too.

Similarly, *Lizzie McGuire*, the book series and the central character, normalizes the idea of the "feminine girl" at the same time as it attempts to challenge stereotypical female behavior. Despite being defined by Gordo and the public as the "typical thirteen-year-old girl," the character's appeal is largely due to Lizzie's endeavor to re-write "popularity" as fake and therefore undesirable. Unaffected by the in-crowd, Lizzie, Gordo, and Miranda seem to exist on the boundaries of popularity without stigmatization; attempting to remain an individual in the conforming world of junior high school makes up most of the show's story lines. While the three teens certainly do not want to be social pariahs, they resist attempts by Kate

Sanders, the queen of junior high, to incorporate Lizzie into her elite social circle. Popularity, as it is defined by the show, means conformity, an objectionable trait to Lizzie and her friends. Readers who are having trouble fitting in at school are able to read the books and watch the show in hopes to learn how to carve out their own niche without feeling like outcasts. However, the Disney created show does not really offer an alternative teenage narrative. Lizzie does not challenge essentialist thinking about femininity, nor does she rebel against typical teenage behavior: shopping, obsessing about clothes, make-up, and boyfriends. What appears to be a challenge to the notion of "conforming" to any set cultural standard is in fact a "faux" rebellion in that she does not pay for any of her challenges to cultural authority in the end because she is Hilary Duff—beautiful, rich, and famous.

Ironically, it is Lizzie's femininity that allows her to test certain sexist television constructions of femaleness. Susan Douglass (1994), in her analysis of media and girlhood, argues that the media images surrounding girls teaches them to "equate not just thinness and beauty but also a soft-spoken, deferential voice with her right to be loved, admired, respected. She will learn that to be listened to, she will also learn that whether she shouts or whispers, she'll barely be listened to at all, because she's just a girl" (p. 301). Lizzie, on the other hand, is neither soft-spoken nor deferential. As the opinionated, trend-setting star of the TV and book series, Lizzie does not apologize for being a girl. She takes risks, like destroying her modeling career to spend more time with her friends, joins in a food fight, defends her best friends, bowls the perfect strike, and shouts in anger in almost every book. Lizzie's attractive and feminine facade allows her to safely extend the boundaries of acceptable female behavior without destabilizing gender as a category of difference because she is the blond-haired, blue-eyed, attractive star of the show.

Modeling, valued by the mainstream, also receives a faux makeover by Lizzie and her friends. After Lizzie decides to model clothes in the "Stylin' and Sassy" fashion show, the popular group attempts to add her into their elite social circle. Suddenly invited to Kate's country club to watch the new DVD not yet released into video stores, Lizzie's closest friends, Miranda and Gordo, transform from her friends into "her people." Gordo, enjoying shrimp toast in the hot tub, uses Lizzie's fame to get invited places; and Miranda, who also sells out to the idea of fame and popularity, begins to schedule Lizzie's social life. Lizzie notices that modeling "is making everyone act freaky" (Douglas, Maile, & Holland, 2001). When Kate compliments Lizzie on her choice of blouse and earrings, Lizzie's cartoon version informs the reader, "I need rubber boots with all this manure she's shoveling" (Douglas, Maile, & Holland, 2001). After Gordo agrees to finish her report on *Lord of the Flies*, Lizzie seeks advice on how to deal with her friends' kissing up to her from the substitute teacher, Mr. Digby. Digby suggests she treat her friends like her posse, and Lizzie commences "operation superstar brat" by ordering her friends around (Douglas, Maile, & Holland, 2001). She shouts at them to buy her jellybeans, write her English paper (which she then uses as a Kleenex), and orders them to bark like dogs. She becomes hierarchical and bossy; she imitates the power structure that forces women to aspire to an artificial idea, pushes them into the limelight, only to abandon them as they lose their youthful beauty. She becomes a bad imitation of patriarchal authority.

To put an end to the special treatment, Miranda suggests that Lizzie become a poor imitation of modeling: "All you have to do is stink at being a model" (Douglas, Maile, & Holland, 2001). In the next fashion show, ironically named "Teen Attitude," Lizzie disrupts the male gaze by dressing in ripped sweats, knotted hair, blackened/missing teeth, and carrying a sizeable chicken leg, which she rips apart during her run on the catwalk. Apparently exuding too much teen attitude for "Teen Attitude," Lizzie is expelled from the show and the modeling world. Lizzie challenges the "fake" world of compliance and beauty by refusing to mold herself into what the public expects her to be—on the show. Of course, what renders her rebellion counterfeit is the fact that Hilary Duff adorns the covers of books and teen and adult magazines as a model. While Lizzie might scoff at the world of modeling, Hilary Duff is one of the most sought after models in the world. Again, Lizzie does not pay for her rebellion against the modeling industry because Hilary Duff plays into the hands of the public as a super star.

Prior to a book series based on a show like *Lizzie McGuire,* many Saturday morning shows featured "cool" boys with "girls as their mirrors, flat, shiny surfaces whose function is to reflect all this coolness back to them and on them" (Douglass, 1994, p. 299). Lizzie turns the tables on the male as hero narrative, and replaces the traditional gendered plot with a "cool" girl in the leading role. While her stereotyped femininity serves to de-trivialize gossip and lip-gloss, it also essentializes gender differences. By essentializing femininity, the series impedes progress by suggesting that women are better in certain prescribed roles in society. In addition, naturalizing gender leaves a large segment of the population (working, single, queer) out of the national dialogue. Lizzie assuages her privileged, female audience by making it okay to be "want to look pretty" and consume "the right goods . . . [to] make [your]self pretty and ornament [your]self properly," provided you are a "good person" (Douglass, 1994, p. 299).

Lizzie McGuire does not only fall short of re-writing gender: As with most Disney productions, Lizzie's world is sanitized, largely ignored are issues of race, class, homosexuality, divorce, and violence. While there are two African American characters in the story—a "cool" substitute teacher named Mr. Digby and Matt's best friend, Lanny—the show does not disrupt notions of race or the institutions that maintain racism. Mr. Digby occupies an interesting position in the books as both a substitute teacher and a representative of "other." His role as a "sub" is to figuratively "subvert" the dominant discourses of school. Existing outside the power structure of school (and society as a black male), he is allowed to explain to the students how things really are. Consequently, Lizzie and her friends often turn to Mr. Digby for guidance and advice. As Lizzie so aptly explains in one episode, "He's just a sub; he can tell us the truth" (Douglas, Maile, & Rosman, 2001). On the surface, one of the only black characters on the show seems "cool" and able to relate to the children in the show. Of course, as a substitute teacher, rather than a regular employee, he is disenfranchised and socially muted in terms of the school's power structure. Youths seem to be his only audience and one doubts, due to his precarious position as a substitute, that he could speak to adults the same way. In this sense, Mr. Digby acts as the wise noble savage, a common trope for black characters, which can be found in such texts as *Song of the South*

and Mark Twain's *Huckleberry Finn*.

Matt's best friend, Lanny, interestingly enough, also exists outside the dominant discourse because he does not talk—he literally has no voice. Matt understands his friend perfectly and Lanny communicates via hand gestures and facial expressions. The symbolic importance of Lanny's voicelessness falls outside the scope of this paper but necessitates further inquiry into the racial subtext of *Lizzie McGuire*. Lanny is one of the two black characters in the book, besides "cool" Mr. Digby. Without a voice, Lanny is rendered powerless. Thus, while Lizzie McGuire appears to be rebelling against the typical teen narrative, race is left unexamined in the show.

Miranda Sanchez, as discussed earlier, represents the one minority character that holds a major role in the series as one of Lizzie's best friends. Miranda's home life is nebulous, but she is responsible for watching her baby sister after school, relies on Mrs. McGuire for trips to the mall, falls victim to an eating disorder (*Inner Beauty*), is accused of shoplifting, uses the "E-Z read condensed version of *The Red Pony*" to write her report (*Picture This*, Jones, 2003d, p. 130), and gets both herself and Lizzie into trouble by lying. She continually relies on Lizzie to get her out of a mess or back her up when she is caught. It is Miranda who suggests that Lizzie, in order to win best dressed in the yearbook, "borrow" expensive jeans from the Style Shack and then return them. She tells Lizzie, "You know, I've heard of people buying their clothes for special occasions, wearing them, and then returning them and getting their money back. All you have to do is tuck a few price tags" (Jones, 2004, p. 35). Of course, the book, *Best Dressed* (Jones, 2004), serves as a cautionary tale, because Miranda spills orange slushy all over the pants. In the same book, Miranda suggests Lizzie lie to her mother about studying so they can go to the mall. They would study afterward, because Lizzie is "a horrible liar" (p. 37). Lizzie lies one other time to her mother, at the behest of Miranda, and gets caught. Miranda's the one who always talks about how she "sneak[s] into the movies" and pretends to be "sick from P.E." (p. 123). Thus, Miranda is not challenging notions of ethnicity. Miranda is the cautionary tale and Lizzie is Miranda's moral compass; she keeps her on the right track.

Even more insidious than its representations of race and ethnicity are the characters' attitudes toward class. The only thing Lizzie fears more than tripping in front of Ethan Craft in the cafeteria is becoming working-class: "I'll end up working at Dairy Freeze" (*New Kid in School*, Jones, 2003c, p. 46). Gordo, too, fears failing, which in his mind is becoming a blue-collar worker. The biggest insult Gordo could give to Ethan Craft is calling him a gas station attendant; he says to Lizzie, " [Why] [u]se the untapped powers of the universe to land a guy who's going to end up working at a gas station. *Part-time*"? (p. 70). When Gordo becomes a sanitation worker for a school project (*New Kid in School*), he is horrified: "Oh, no, I'm a garbageman" (p. 83). Not to be defeated, Gordo takes his lot in life and turns it into an empire: "And I've got plans. Big plans. I'm gonna build a trash empire. With employees and trucks and city contracts. It's gonna be huge" (p. 89). While Gordo's positive attitude is admirable, what message does it send to a reader whose parent works as a sanitation engineer? With creativity, s/he too could build a trash empire? This only reinforces the idea that the American Dream is possible for those who work hard enough to get

it. A series like *Lizzie McGuire* perpetuates the valuing of middle-class values "such as conformity, snobbery, and ostracism that reward racial, class, and gender exclusion" (Giroux, 1997, p. 67). By debasing blue-collar work, Lizzie upholds the status quo and its racial, gender, and economic inequities. Instead of rebelling against the common Disney narrative, it follows it closely.

A critical reading of *Lizzie McGuire* reveals the show and the book to be more than a harmless Disney show about a "normal" girl and her friends facing the challenges of school and peer pressure: the danger lies in its ability to appear subversive at the same time as it constructs a version of reality that normalizes mass consumption and gender, race, and class stereotypes. In order to participate in the text's narrative and identify with Lizzie, the reading subject must allow him/herself to be positioned as a white, female, middle-class, adolescent female. Such a reading may be falsely empowering for a segment of the population, such as myself, who can easily recognize growing up with similar attitudes, beliefs and values as "normal." However, further inquiry should be done into the effects such a subject position has on the members of the reading public who fall outside this construction of reality. What dissonance do young readers experience as they try to identify with Lizzie and her friends? How do students "read" a text that does not fit in with their live reality? How can teachers inspire their students to read and write alternative narratives? It is imperative as consumers, readers, and teachers to consistently ask questions about popular culture's influence on the choices of young, impressionable readers because if being "Just Like Lizzie" means excluding a larger part of the population and adopting middle-class values, then other readings are necessary to challenge the status quo.

Culture is a text that deserves to be read, analyzed, discussed, deconstructed, and reconstructed in a way that empowers all of its readers. Instead of *consuming*—in the manner of Lizzie and her friends—students can learn to *produce* readings by first recognizing and resisting how they are being manipulated and constructed by the text and its narrow vision of the world.

Conclusion: Implications for Teachers

Despite the ubiquity of the mass media, many in charge of socializing young people "dismiss it as vapid entertainment lacking insight, impact, and depth" (Byers, 1998, 731). By ignoring the larger culture in which girls and boys are negotiating their identities, schools will continue to maintain (and enact) the status quo. I maintain that if schools are not sites of social justice, then they are part of the hegemonic structure impeding (gender) equality. Teachers who value critical literacy will benefit from the scholarship of Cultural Studies which has, for the last thirty years, begun to study the cultural production/consumption, reception, and reading practices of popular culture. If popular culture is the site of social struggle, studying television, advertising, children's literature and other forms of the media offers possible points of "resistance and rupture" (Byers, 1998, p. 729).

As a teacher committed to social justice, the popular publication can serve as a tool in which to begin a dialogue with my students about essentialism, the book's role in con-

structing "truth," and gender stereotypes. Teaching for social justice means recognizing gender, race, and class as social constructs and not a natural, fixed part of our reality. As popular culture plays a large role in the lives of students, it is imperative for educators to teach how to "read" media and therefore resist its insidious constructions or recognize its subversive role in re-valuing the feminine and selectively revising it. Literacy in the early twenty-first century must adjust to include popular publications and critical literacy. A politically astute reading "of the word and the world" includes books like *Lizzie McGuire* as texts to be analyzed and re-evaluated.

REFERENCES

Alfonsi, A. (2004a). *Head over heels*. New York: Disney Press.

Alfonsi, A. (2004b). *Lizzie for president*. New York: Disney Press.

Bargiel, N. G. (Writer), & Rosman, M. (Director). (2001, August 24). *Educating Ethan*. [Television Series]. Disney Production.

Byers, M. (1998). Gender/sexuality/desire: Subversion of difference and construction of loss in adolescent drama of My *so called life*. Signs: *Journal of Women in Culture and Society, 23*(3), 713–734.

Douglas, T., & Maile, T. (Writers), & Holland, S. S. (Director). (2001, September 28). *Last year's model*. [Television Series]. Disney Production.

Douglas, T., & Maile, T. (Writers), & Rosman, M. (Director). (2001, October 12). *Facts of life*. [Television Series]. Disney Production.

Douglas, T., & Maile, T. (Writers), & Montgomery, P. (Director). (2003, January 31). *Clue-Less*. [Television Series]. Disney Production.

Douglass, S. (1994). *Where the girls are: Growing up female with the mass media*. New York: Times Books.

Fetterley, J. (1978). *The resisting reader: A feminist approach to American fiction*. Bloomington: Indiana University Press.

Fiske, J. (1987). *Television culture*. London: Methuen.

Giroux, H. (1997). Are Disney movies good for your kids? In S. Steinberg, & J. L. Kincheloe, (Eds.), *Kinderculture: The corporate construction of childhood*. New York: Westview.

Giroux, H. (1999). *The mouse that roared: Disney and the end of innocence*. Lanham, MD: Rowman & Littlefield.

Goldman, L. (2004). *On the job*. New York: Disney Press.

Gould, M. (Writer), & DeJarnatt, S. (Director). (2001, December 7). *The courtship of Miranda Sanchez*. [Television Series]. Disney Production.

Gould, M. (Writer), & Falcon, E. (Director). (2001, August 31). *Lizzie strikes out*. [Television Series]. Disney Production.

Gould, M. (Writer), & Roberts, B. K. (Director). (2002, November 22). *She said, he said, she said* [Television Series]. Disney Production.

Gould, M. (Writer), & Rosman, M. (Director). (2002, August 30). *Inner beauty*. [Television Series]. Disney Production.

Jones, J. (2003a). *Just like Lizzie*. New York: Disney Press.

Jones, J. (2003b). *Lizzie loves Ethan*. New York: Disney Press.

Jones, J. (2003c). *New kid in school*. New York: Disney Press.

Jones, J. (2003d). *Picture this*. New York: Disney Press.

Jones, J. (2004). *Best dressed*. New York: Disney Press.

Larsen, K. (2002). *Lizzie goes wild*. New York: Disney Press.

Lizzie McGuire. June 30, 2006. www.answers.com/topic/lizzie-mcguire.

Miller, M.C. (1988). *Boxed in: The culture of TV*. Evanston: Northwestern University Press.

Ostrow, K. (2002). *When moms attack!* New York: Disney Press.

Pettit, R. B. (n.d.). *Mickey mouse monopoly: Disney, childhood, and corporate power*.

Retrieved June 22, 2005, from http://www.mediaed.org/videos/CommercialismPoliticsAndMedia/MickeyMouseMonopoly.htm.

Rogow, S., & Estelle, S. (Executive Producers). (2001–2004). *Lizzy McGuire* [Television series]. New York: Disney.

Smith, D. E. (1993). The Standard North American Family: SNAF as an ideological code. *Journal of Family Issues, 14*(1), 50–65.

Steinberg, S., & Kincheloe, J. L. (Eds.). (1997). *Kinderculture: The corporate construction of childhood*. New York: Westview.

Sun, C., & Picker, M. (2001). *Mickey mouse monopoly: Disney, childhood, and corporate power*. Northampton, MA: Media Education Foundation.

Walkerdine, V. (1997). *Daddy's girl: Young girls and popular culture*. Cambridge: Harvard University Press.

Television's Mature Women

A Changing Media Archetype: From *Bewitched* to *The Sopranos*

Myrna A. Hant

Despite almost a half century of change and growth for women spurred by the second wave of the women's movement, older women continue to be depicted on television as caricatures informed by ageist ideologies. A feminist textual analysis of mature women on television reveals a surprisingly consistent media archetype and helps to elucidate the politics of representation of older women. It is only in recent years that counter-hegemonic portrayals are acting as "filtering devices" (Cohen, 2002, p. 615) for the examinations of the stereotypes of ageism in the media.

"Media pedagogy . . . helps develop the ability . . . to give individuals power over their cultural environment" (Kellner, 1995, p. 10). A part of media pedagogy is deconstructing the paradigm of ageism on television. In this paradigm an older woman (and, of course, some older men) frequently is seen, first of all, as "the other." Second, she is categorized as "invisible" except for her role as either mother or grandmother. Third, she is used as a "metaphor," all too often linked with disease, isolation, worthlessness, vulnerability, dissatisfaction, and decrepitude. More recently a few counter-hegemonic television portrayals of older women (in *Judging Amy*, *Queer as Folk* and *Six Feet Under*) have been harbingers of change in showing multi-dimensional aspects of mature womanhood.

Ageism, a term defined by Robert Butler in 1975, is a "process of systematic stereotyping of and discrimination against older people because they are old, just as racism and sexism accomplish this with skin colour and gender. Older people are categorized as senile, rigid in thought and manner, old fashioned in morality and skills . . . Ageism allows the younger generation to see old people as different from themselves, thus they subtly cease to identify with their elders as human beings" (Butler, 1975, p. 12). It is so pervasive in society that we hardly notice any more the ridiculous way that older men and specifically older women are portrayed in advertisements, greeting cards, and so often in the media. Television is a particularly ubiquitous and influential means by which people of all ages subconsciously formulate their views about older people.

The tainting of the image of older people had already begun to appear in the United States in popular literature at the end of the nineteenth century (Featherstone & Wernick, 1995, p. 131) creating and reinforcing the views that an older individual should be portrayed as declining, feeble and certainly not mentally alert. Adding further to the denigration of older people was the loosening of beliefs that the elderly were somehow more closely connected to the eternal. "In a society which had lost its fear of the afterlife, and in which awareness and contact with death was not integrated into everyday life (for death no longer held a mythical power over the living) there was no reason to fear any potential revenge from old people" (Featherstone & Wernick, 1995, p. 123). The tarnished imaging of older people, particularly women, has relentlessly continued into the twenty-first century.

The Other

What does it mean to call someone "the other"? The term is credited to Simone de Beauvoir from her book, *The Second Sex* (1977), which was originally published in France in 1949. In it she explains that man makes himself the essential being and woman is "the other." More specifically, the definition of personhood is male so that woman defines herself in terms of the male. Similarly, the essential being or standard of womanhood in American culture is youthfulness. Therefore, if a woman is old, she is not essential woman but rather "the other" and consequently different. Women of all ages know that the standard is youth and to be "not young" is to be devalued by society. The older woman is perceived as menopausal and hence is no longer a recipient of the "male gaze." Moreover, older women adopt this view of themselves and try desperately to be young or at least to "pass" as young and thus, young and old are accomplices in creating a social construct that defines being old as a negative attribute. Simone de Beauvoir laments the "otherness" that forces older people to "stand outside of humanity," a prisoner of society's misconceptions.

> If old people show the same desires, the same feelings and the same requirements as the young, the world looks upon them with disgust: in them love and jealousy seem revolting or absurd, sexuality repulsive and violence ludicrous. Above all they are called upon to display serenity: the world asserts that they possess it, and this assertion allows the world to ignore their unhappiness. The

purified image of themselves that society offers the aged is that of the white-haired and venerable Sage, rich in experience, planing high above the common state of mankind; if they vary from this, then they fall below it. The counterpart of the first image is that of the old fool in his dotage, a laughingstock for children. (de Beauvoir, 1977, p. 10)

Betty Friedan also laments the distortions of society's images of mature adults. In *The Fountain of Age,* Friedan (1993) discusses Vern Bengston's concerns that older people are so often seen only as a societal problem rather than as creators of solutions to problems. What are the consequences? It is a tautological bind; the younger members of society do not expect to see active and productive behavior on the part of seniors and in turn older people accept this deleterious stereotype of themselves.

Susan Sontag refers to a "double standard of aging." (Sontag, 1997, p. 19). In contrast to men, "women are required to match up to the adolescent ideal throughout their lives . . . It is therefore not surprising that many of our representations of women are constructed in terms of physical appearance and that images and self-images of the bodies of older women cause such problems" (Featherstone & Wernick, 1995, p. 8). Frueh concurs that the "older woman is doubly different, doubly degraded, and doubly injured by exterior identity: she is visibly female, different from men and visibly aging, even when cosmetically altered, different from young" (Frueh, 1997, p. 202).

The other side of ageism is the energy and effort put into denying aging, by older people themselves, but particularly by older women. Older women often internalize the self-loathing so frequently promoted in the ageist stereotype and make valiant efforts to separate themselves from the hated "old."

Apparently millions of women are convinced that if they just try hard enough and buy enough, they will not be "junked." Billions of dollars are spent in an effort to become visible, in other words, to become young again. Age passing becomes a state of mind, a measure of self-worth, a guide to choice. When we reflect 'young' tastes in our clothing, cosmetics, activities, friends and lovers, we are passing. "Passing" enables older women to pretend that the key roles that they have grown accustomed to as "object" and "childbearer" are still somehow a possibility, even though they are no longer able to have children. Indeed, there is even a moral dimension to remaining young, a requirement that a woman's well-being is dependent on her ability (or inability) to stay youthful. Thus, this youth concept reinforces the notion "that happiness and self-fulfillment in later life are dependent on the moral responsibility of individuals to reconstruct a youthful body, identity and social life" (Wray, 2003, p. 515).

Letty Pogrebin is not too critical of women who want to remain as young as possible. In a society that reduces every woman to her appearance—a society where, according to Rutgers University psychologist Jeannette Haviland, being attractive turns up at the top of the average female's concerns from age ten on, a society where psychologists at the Oregon Research Institute in Portland found girls as young as twelve to be in a serious state of depression because of their negative body image, it's a brave woman who bucks the system and insists she couldn't care less when age takes the bloom off the rose. (Pogrebin, 1996, p. 131)

Because patriarchal values are so prevalent throughout the culture, both young and older

women have adopted the "young as worthwhile" mythos. This idea, inevitably, pits younger women against older women. Faced with a barrage of media indoctrination, "older women have to be made to disappear. Making our aging appear unseemly, unsightly, unacceptable assures that we will . . . The caricature of the Ugly Feminist appears with every backlash—to scare young women away from identifying with older women and prevent the transmission of authority. The Beauty Myth not only sets women in competition with one another on a daily basis but sets younger women against older" (Pogrebin, 1996, p. 145). It is not by chance that young women feel they have so little to learn from older women and the connection between female generations is systematically and deliberately denigrated. In a more insidious fashion, women young and old are programmed to distrust each other. "Older women fear younger ones, young women fear old, the beauty myth truncates for all the female life span" (Wolf, 1991, p. 14).

Examples of older woman as "other" are common in popular TV shows. One prominent example is Endora in the 1960s television show *Bewitched* (Arnold, 1964–1972). Endora is portrayed as "grotesque by comparison" to her younger counterpart Samantha and represents the "age-old archetype of the witch as a wrinkled and disorderly crone" (Douglas, 1994, p. 132). Samantha dresses attractively and with her blond hair perfectly in place she exemplifies a youthful exuberance. Endora, though, "with her overly bouffant, bright red hairdos, two-inch-long false eyelashes and thick eyeliner that shoots up at a forty-five-degree angle" (Douglas, 1994, p. 132), is neither, exactly, appealing to men nor is her appearance appealing to women either.

In "Samantha's Good News" (Baer & Michaels, 1969), Endora's ex-husband, Maurice, becomes involved with his very young secretary. Endora decides to turn the woman into an old lady because she is angry at him. The episode is amusing and Endora does display "the most powerful one/two punch in the cosmos," but at the same time she cannot escape the ravages of getting older and being denied her position as a powerful young woman. Her solution to the problem is to make the beautiful secretary the most awful thing imaginable, an old woman.

Thus, despite the impressions that Samantha and Endora are powerful manipulators of men, it is really Samantha who is the admired role model, not Endora. Samantha conforms to the prerequisites of approbation: youth and beauty. Even so, Endora cannot be dismissed as a prototypical older woman; she is not frail, weak, and helpless. She is an independent woman who says and does what she wants to do without regard for the consequences from men. For the 1960s, this was a clarion call to liberation. However, it is doubtful that her female audience wants to emulate her—because she is basically pictured as such a ridiculous caricature in most of the episodes.

Another parody is Sophia Petrillo in *Golden Girls* (Witt et al., 1985–1992), the wise-cracking, smart-mouthed senior member of the quadrangle of "golden" women. She comes to live with Dorothy, Rose, and Blanche after her retirement home, Shady Pines, burns down. In her demeanor and dialogue she epitomizes how surveyed audiences consistently describe older women on television: frail, confused, laughable, superficial, and degraded. Never seen without her trademark purse, she clasps it whether she is sleeping, running, or

going to visit someone. Consistently she is presented as a distracted and somewhat insubstantial elder who often is not quite sure what is going on. While "relishing" the freedom of older people, she carries the twin burdens of being uninhibited enough to say exactly what she feels (calling the gay cook at Shady Pines, "the fancy man") but also being excoriated as "the other." She sits on a stool in the kitchen when the three other women are discussing, almost always over cheesecake, their lives. Thus, she is a part of the scene but only on the periphery. She takes many opportunities to malign older people, explaining, "Look, you didn't ask me for my opinion, but I'm old, so I'm giving it anyway."

When she is not sniping at her three roommates, she is talking about illness (her cataract and laser surgery) and loss or how life is not as good as it was. She laments, "People think you should just be glad to be alive. You need a reason to get up in the morning. Life can turn around and spit in your face."

Invisibility: Except for Role as Mother and Grandmother

What does it mean to be invisible as a person? The definition of invisible is "incapable of being seen." To be invisible is to be either the recipient of a totally stereotypical view or to actually not be seen at all. People, particularly men, often ignore older women, because they are not young, not a sex object, and not a reproducer. The older woman can be visible and socially acceptable, however, in her roles as mother or grandmother. Thus, on the television shows that have a mature woman character, she typically exists in either one of these roles. Frequently, the portrayals are the "Jewish Mother schtick" of the whining, devouring, and complaining older woman, whether the character is specifically Jewish or not. To depict an older woman as an intellectually vital, sexually active, productive member of society in her own right is very rare.

"In a youth-oriented patriarchy, especially, to become an older woman is to become invisible, a nonentity" (Bolen, 2001, p. ix). According to Naomi Wolf, women's magazines largely ignore older women and if they do feature an older woman she is air-brushed to look ten to fifteen years younger than she actually is. "The effect of this censorship of a third of the female life span is clear. By now readers have no idea what a real woman's 60-year-old face looks like in print because it's made to look 45. Worse, 60-year-old readers look in the mirror and think they look too old, because they're comparing themselves to some retouched face smiling back at them from a magazine" (Wolf, 1991, p. 82).

This invisibility is piercing for a mature woman not only because she is not worthwhile enough to be visible, but she enters society's radar screen as a symbol of frailty, weakness, and ugliness. Her major roles are gone, and she becomes merely a manifestation of what a young woman wants to avoid. Germaine Greer explains that "the middle-aged woman no longer has the option of fulfilling the demands of a patriarchal society. She can no longer play the obedient daughter, the pneumatic sex object or the madonna. Unless she consents to enter the expensive, time-consuming and utterly futile business of denying that she has

passed her sell-by date, she has sooner or later to register the fact that she has been junked by consumer culture" (Greer, 1997, p. 261).

Emblematic of visible motherhood, but invisible womanhood, are characters such as Edith Bunker (*All in the Family*, Derman et al., 1971–1979), Estelle Costanza (*Seinfeld*, 1989–1998) and Marie Barone (*Everybody Loves Raymond*). While laughing at the ridiculous antics of Edith Bunker, we are also imbued with messages that reiterate her place within an ageist society. She cannot compete as a physically attractive, sexual being. She is invisible in that realm and does not represent any emerging new images for mature women.

Estelle Costanza (*Seinfeld* 1992–1998) and Marie Barone (*Everybody Loves Raymond* 1996–present), both Italian matriarchs, could be any of the stereotypical Jewish mothers so prevalent on television for the last 50 years. They are women, much like the pantheon of Jewish mothers, Ida Morgenstern (*Rhoda*), Sylvia (*The Nanny*), Sheila (*South Park*) and Susie (*Curb Your Enthusiasm*) who "push, weedle, demand, constrain and are insatiable in their expectations and wants" (Prell, 1999, p. 143). Joyce Antler characterizes this mother type as "manipulative, self-indulgent, demanding, and overly protective . . ." (Antler, 1998, p. 249). They are invisible as women in their own right, but painfully invasive as Mother.

In the famous "Outing" episode on *Seinfeld*, Seinfeld and George are mistakenly assumed to be gay by an NYU reporter. Estelle Costanza, while sitting on the toilet, reads the article about them in the paper. Estelle is so shocked she falls off the toilet and her back goes out. When George visits her in the hospital, she blames him again for her condition, and decries, "Every day it's something else with you. I don't know anything about you any more. Maybe you're making porno films!" In "The Contest" Estelle, prone to falling and guilt-tripping, once again lands in the hospital when she collapses after witnessing George in the act of masturbating. From her hospital bed she laments, "You have nothing better to do at 3:00 in the afternoon. You treat your body like an amusement park. Too bad you can't do that for a living. You'd be a big star!" Thus, not only is George infantilized but he is humiliated constantly by his mother regarding his manhood. His worst nightmare is realized when he has to move back with his parents because he can't pay his rent. As soon as he brings his luggage back home his mother forces a bologna sandwich on him, a food he doesn't want to eat. Although he refuses his mother's offering, he knows that this act is interpreted as his rejection of her.

Any interaction between George and his mother is fraught with putdowns in order to emphasize George's inadequacies. He constantly reveals to everyone that he's a nothing and basically a bad person. It is no surprise that his mother is the cause of his miseries because whatever he attempts to do she is convinced it will fail. In "The Finale," George is thrilled because NBC has finally, after five years, accepted the show that he wrote entitled "Jerry." George proudly tells his mother that he's writing. Mom's retort is "You know how to write? Where will you get the ideas? The whole show sounds pretty stupid." George is unendingly diminished by his mother's remarks but always hopeful he can escape the smothering consequences of her parenting style.

Estelle is a perfect caricature of the older mother, a woman who has no existence apart

from her children and feels that the children are unendingly in need of remodeling, remaking, and redoing. Similar to Marie Barone, she is one-dimensional in her nagging demands of compliance from her children.

In *Everybody Loves Raymond*, though, there are daughters-in-law to extend the web of influence and manipulation. The tension between the older generation of women and the young is palpable in each episode of *Everybody Loves Raymond*, an extended battle of wills between daughter-in-law Debra and Marie. In a memorable episode of conflict, Debra is put in jail for being drunk behind the wheel and falling asleep. Debra is driven to drink too much when Marie interferes in the wedding shower for the new daughter-in-law, Amy. Debra decides she is too drunk to drive home, falls asleep and is picked up by a police officer. Marie, in her typical manner, assures Debra that "no matter how much shame you've brought on us," we'll stand behind you. Marie quickly escalates her diatribe by exclaiming, "Now it all makes sense. The messy house, kids running around filthy, the way she talks to me." In Marie's mind, Debra is an alcoholic and thus Marie's involvement is more essential than ever. While complaining to Raymond that she "doesn't have a drinking problem, I have a mother-in-law problem," Debra learns that "mother cannot be defied, only humored. She can't be controlled, merely temporarily contained. She feels it her right to live her son's life as well as her own, and that's that" (Richmond, 2000, p. 178).

Metaphor

Too frequently we see the portrayals of older women as a metaphor for disease, isolation, worthlessness, vulnerability, dissatisfaction and decrepitude. Typically, she is a mother who either lives with the family or lives alone. If she has a love interest in her life it is portrayed as a silly relationship, very childlike and laughable. Married older women are depicted as either totally dominated by a man or as a virago who has so destroyed her husband's ego that he has capitulated to her will long ago. Dressed most often in heavy, frumpy styleless clothes, she is a desexed creature who pathetically spends her time and energy on haranguing her children and/or husband, convincing them that she needs attention. If children or a husband are not available, she will cling to anyone who is willing to help her. Research has found that people look at the old on television and label them stubborn, eccentric, foolish, dependent, frail, vulnerable, worthless, grumpy, and a drain on society (Bazzini et al., 1997).

Betty Friedan discusses a survey conducted by *Retirement Living* on a cross section of people under and over 65 and the "most common adjectives used to describe the way people over sixty were depicted on television were 'ridiculous,' 'decrepit' and 'childish'" (Friedan, 1993, p. 49). In a survey conducted by H. Cohen, participants stereotyped the portrayal of older women as having the following characteristics: living in the past; old fashioned in their behavior, thinking and the way they looked; not interested in sexual activity; basically cared for by their families without giving in return and largely invisible (Cohen, 2002).

Friedan asserts that "gerontologists have pointed out that the television image of peo-

ple over sixty-five is distinctly reminiscent of the 'terrible two' toddler" (Friedan, 1993, p. 56). Zita (1997), in turn, argues that the older female body is a surface for the metaphors of disease, disability, and medical dependency.

An exemplar of the "ill" mother is Italian mama, Livia (mother of Tony, Barbara, Janice), in *The Sopranos*. Father Phil Intintola, the family's priest, explains that "it's her special gift to survive by exercising power through powerlessness" (Rucker, 2000, p. 10). Rucker adds, "She looks frail and acts like she's weak in the head but she's got Tony by the cajones. Maybe it's God's way of punishing him for being a gangster" 2000, p. 10). Perhaps, though, it is any child's quintessential nightmare side of his or her older mother.

Although Tony tries to be a devoted son, "Livia rails against Tony's neglect, rejects his gift CD player and resists his encouragement to move into a well-appointed seniors home" (Yacowar, 2002, p. 23). She makes it very clear to Tony what a terrible son he is and that "once she's locked into a nursing home, I'll die faster." Tony, while talking to his psychiatrist in episode after episode, reveals that "whatever I do I feel guilty." He is asked by his psychiatrist, Dr. Melfi, whether he can remember anything good about his mother. After pausing, the only good experience he can recall is when Tony's father fell down the stairs and everyone laughed. He quickly adds, though, "Hey she's a good woman, I'm the ungrateful fuck," although he admits that his mother "has an almost mystical ability to wreak havoc." When she dies, Tony tells Melfi that Livia was a "selfish, miserable cunt. She ruined my father's life. So, we're probably done here, right? She's dead." However, of course, Tony cannot expunge his mother so easily. She'll be a constant presence in his life as long as he lives.

Counter-Hegemonic Portrayals

Gradually, depictions of older women are breaking the stereotype and instead of being always characterized as the other, the mother and the metaphor, a few portrayals are defying the archetype. As early as 1984 two dynamic older women on popular television shows convinced audiences that mature women can think and be involved in society. *Miss Marple* (periodically from 1984–1992 and returning) and Jessica Fletcher portrayed by Angela Lansbury (*Murder She Wrote*, 1984–1996) are clever agents who investigate murders. One is an amateur detective, the model of decorum, in the British village of St. Mary Mead, and the other is a mystery writer who herself scrutinizes murders in Cabot Cove, Maine, and later New York City. Both use their wits, rather than their physicality to solve the mysteries, applying what might be labeled a feminine approach to sleuthing. Through observation and keen insights into human behavior, these women are the heroines who are not marginalized and certainly not invisible. Noteworthy is the beginning of each segment of *Murder She Wrote*. Jessica Fletcher is shown riding her bicycle and waving at many members of the community. However, both women are "spinsters," presumably so they will have the time to pursue their cases rather than obsess over mothering and their grandchildren.

However, it has essentially only started in the twenty-first century that television departs from the older woman as parody to the nuanced portrayals of such characters as Tyne Daly in *Judging Amy*, Sharon Gless in *Queer as Folk*, and Frances Conroy in *Six Feet*

Under.

Tyne Daly in *Judging Amy* (2001–2005) introduces the audience to a rarity, Maxine Gray. Not only is she a sought-after professional woman, a social worker with the department of children and families in Hartford, Connecticut, but she is a person who is respected for what she says and does. Not physically beautiful and not young, she carries herself with grace and confidence and has love interests in the show, notably the rich businessman Jared Duff to whom she becomes engaged, losing him to a heart attack 48 hours before the wedding, and Ignacio Messina. The audience observes a gray-haired woman who knows who she is and one who is not trying to camouflage her age or her wisdom. Capable of toughness, love, and humor she is also a multi-dimensional character who represents frailties (she has not spoken to her brother in 12 years).

Her relationship with Ignacio Messina, her landscape designer, is not a demeaning one, a coupling of two old folks that are laughable caricatures (like Sophia Petrillo's relationships). Rather they are presented as mature individuals who learn from each other and communicate their feelings and needs. Mr. Messina takes Maxine salsa dancing and remarks that she lacks passion on the dance floor. The implication is that Maxine needs to accept her femininity and enjoy the connection with him as a partner. He is smitten with this gray-haired overweight grandmother, and the attraction is believable and poignant, not ridiculous. He formally asks Maxine if he can "court her," and she is pleased and willing to continue the relationship. Maxine is seen throughout the series advising not only her granddaughter and daughter, but advocating, as a professional, for youngsters who are in trouble.

Sharon Gless in *Queer as Folk* (2000–2005) manages as Debbie Novotny to present a working-class woman who accepts her son and others the way they are. With her lashing tongue and her impatience with intolerance, she is the admirable advocate of justice and humanity. She is frequently contrasted with those who cannot change and must profess their ideologies no matter what the price. It is telling that Brian's mother, a lonely widow whose phone never rings and who is the antithesis of Debbie, is adamant about excoriating her gay son, telling him how sinful his lifestyle is, and that he will surely go to Hell.

Despite Debbie's floozy looks (a throwback to Endora) and her ubiquitous t-shirt ("It's All About Me"), she is not degraded as an older woman and does not pattern her life only after her own demands. In one episode, a gay dead boy is found in the trash bin behind Debbie's restaurant. Detective Horvath labels the corpse, "Jane Doe." Debbie is indignant that the detective is cavalier about the death and yells at him, "This kid has a name. You're a homophobic prick." She is incensed that no one in the community, including the detective, takes this death seriously enough to investigate fully, and she proceeds to find out the identity of the boy. Detective Horvath is so impressed with her perseverance, and perhaps also her humaneness, that he wishes to date Debbie. Again, Debbie is hardly an invisible presence on the show but a pivotal character endowed with street-smart wisdom.

Frances Conroy's Ruth Fisher in *Six Feet Under* reveals an exceedingly complex woman, layered with inadequacies, uncertainties, and struggles. She is an imperfect wife who resorts to an affair with Hiram (Ed Begley, Jr.) while still married to Nathaniel. As a widow she has an active sex life, dating her boss at the florist shop, and ultimately marry-

ing George Sibley (James Cromwell), a geologist and professor. Although she mainly dresses in a plain, matronly style, and is a self-accepting prude, she is a desirable woman who attracts many men.

In "Ecotone," an episode in the woods in which she tries to rekindle her romantic relationship with Hiram, she comes to the conclusion that she is desperately disgusted with all the men in her life who have constantly made demands on her. In an epiphany of self-awareness, she dramatically "shoots" each of the love interests in her life and comes to the conclusion that she no longer needs or is interested in Hiram. Despite George's constant entreaties to travel together "to close the distance between them" and even after George recovers from his mental breakdown, Frances concludes that she wants her freedom. There is nothing "other" about this character who struggles, as do all the characters, regardless of age, to make sense of a world which includes the incomprehensible, such as the death of Nate. Her mother-daughter battles with Claire are representative of the difficulties of familial interaction. She is neither static nor is she purely defined as a mother and a grandmother. Her multi-age support group, her knitting circle, accepts and discusses her problems with men in the light of all women's problems with men, not classifying her as "old" and different. She continues to explore who she is, employee in the florist shop and ultimately an owner along with her friend Bettina of the Four Paws Pet Retreat. There is nothing ageist about her choices and problems.

The decoding of media stereotypes of older women and the awareness of counter-hegemonic representations serve to promote the empowerment for this cohort. Too often older women are puzzled by the bombardment of negative images so prevalent in American media.

> Women doing well are aware of a troubling discrepancy between the positive way they see themselves and social devaluation they perceive and they feel challenged to live lives that contradict the 'over the hill' stereotype. Their sense of 'personhood' is stronger than ever, yet society and the media are fading them into invisibility that does not sit well with the baby boomer generation. They are aware of dissonance between the increased freedom and power they feel and negative cultural stereotypes and media portrayals. (McQuaide, 1998, p. 30)

However, with the politics of representation slowly changing on television, the debilitating stereotype of helplessness, fragility, and aimlessness can be replaced. It is not only older women who will benefit from a new paradigm but all of society as well. The young can look forward to a stage in life that affords new opportunities and possibilities, a time of increased agency and renewed activism.

REFERENCES

Text

Antler, J. (1998). Epilogue: Jewish women on television. In J. Antler (Ed.), *Talking back: Images of Jewish women in American popular culture* (pp. 242–252). Hanover & London: Brandeis University Press.

Bazzini, D. G., McIntosh, W. D., Smith, S. M., Cook, S., Harris, C. (1997). The aging woman in popular film: Underrepresented, unattractive, unfriendly, and unintelligent. *Sex roles: A Journal of Research*, 36(718): 531–543.

Bolen, J. (2001). *Goddesses in older women: Archetypes in women over fifty*. New York: HarperCollins.

Butler, R. (1975). *Why survive? Growing old in America*. New York: Harper & Row.

Chase, D. et al. (Producers), & Taylor, A. et al. (Directors). (2001–present). *The Sopranos* [Cable television series]. New York: HBO.

Cohen, H. (2002). Developing media literacy skills to challenge television's portrayal of older women. *Educational Gerontology, 28*, 599–620.

de Beauvoir, S. (1977). *The Second Sex*. England: Penguin Books.

Douglas, S. (1994). *Where the girls are: Growing up female with the mass media*. New York: Random House.

Featherstone, M., & Wernick, A. (1995). *Images of aging: Cultural representations of later life*. London: Routledge.

Friedan, B. (1993). *The fountain of age*. New York: Simon and Schuster.

Frueh, J. (1997). Women artists and aging. In M. Pearsall (Ed.), *The other within us: Feminist explorations of women and aging* (pp. 197–219). Boulder: Westview.

Greer, G. (1997). Serenity and power. In M. Pearsall (Ed.), *The other within us: Feminist explorations of women and aging* (pp. 253–273). Boulder: Westview.

Kellner, D. (1995) *Media culture*. New York: Routledge.

McQuaide, S. (1998). Women at midlife. In *Social Work*, 43:21+ National Association of Social Workers.

Pogrebin, L. (1996). *Getting over getting older*. Boston: Little, Brown and Co.

Prell, R.-E. (1999). *Fighting to become Americans. Assimilation and the trouble between Jewish women and Jewish men*. Boston: Beacon Press.

Richmond, R. (2000). *TV moms: An illustrated guide*. New York: TV Books, L.L.C.

Rucker, A. (2000). *The Sopranos: A family history*. New York: New American.

Sontag, S. (1997). The double standard of aging. In M. Pearsall (Ed.), *The other within us: Feminist explorations of women and aging* (pp. 19–24). Boulder: Westview.

Wolf, N. (1991). *The beauty myth: How images of beauty are used against women*. New York: Doubleday.

Wray, S. (2003). Women growing older: Agency, ethnicity and culture. In *Sociology*, 37: 511+. London: British Sociological Association.

Yacowar, M. (2002). *The Sopranos on the couch: Analyzing television's greatest series*. New York: Continuum.

Zita, J. (1997). Heresy in the female body: The rhetorics of menopause. In M. Pearsall (Ed.), *The other within us: Feminist explorations of women and aging* (pp. 95–112). Boulder: Westview.

TV Shows

Arnold, D. (Producer). (1964–1974). *Bewitched* [Television series]. New York: ABC.

Baer, R. (Writer), & Michaels, R. (Director). (1969). Samantha's good news [Television series episode]. In D. Arnold (Producer). *Bewitched*. New York: ABC.

Barron, F. et al. (Executive Producers), & Cherones, T. et al. (Directors). (1989–1998). *Seinfeld*. New York: NBC.

Derman, L. et al. (Producers), & Lear, N. et al. (Directors). (1971–1979). *All in the family*. [Television series]. New York: CBS.

Witt, P. J. et al. (Producers). (1985–1992). *The golden girls*. [Television series]. New York: NBC.

Bewitched . . . the 1960s Sitcom Revisited

A Queer Read

Patricia Fairfield-Artman, Rodney E. Lippard, and Adrienne Sansom

Introduction

Bewitched (Arnold, 1964–1969), a television sitcom, presented on the surface a rosy picture of middle corporate America featuring the perfect nuclear family (two heterosexual parents, and two children, a girl and a boy), where the father went out to work and the mother stayed at home. However, this was only on the surface because the overall theme of the program was found in the title, namely *Bewitched*, which presented itself as a seemingly lighthearted situation comedy series about a witch, where mainly the women (but also some men) possess special powers. Once a witch has been brought into the equation, there is the possibility for endless skits around witchery, trickery, magic spells, and clever television land techniques. Central to the storyline, nevertheless, was that the witch, Samantha, attempts to denounce or leave her witch world behind because she is now married to Darrin, a mere mortal. In Darrin's world appearances of normalcy are paramount. There is no place for odd or peculiar things to happen, no place for tricks to occur, and definitely no place to upset the normal everyday lives of good upstanding American folk who live in this neighborhood. What evolves from this premise is a home-loving wife who does

everything to support her husband by promising to leave her magical powers "at the door" in order to try to live a normal life as a housewife. However, as the weekly episodes unfold, we are exposed to the complexities of family dynamics, which introduce us to the mortal and immortal worlds that surround Samantha's life.

There is definitely more to this program than initially meets the eye if we are willing to read or view this through a queer eye/guise! If we take a queer eye and "stop reading straight" (Britzman, 1995) the complex nuances of this program can be unearthed from several different perspectives. The authors of this chapter will look at this popular sitcom from a different perspective through the lens of queer theory. If we consider the title of the show *Bewitched* and connect it to the well-known song "Bewitched, Bothered, and Bewildered" (Rodgers & Hart, 1940), it becomes apparent that the title words of the song are rather apt given the intent of this article.

It appears that we have all been bewitched by society, shaped by the social, cultural, and political issues that influence the general state of the world we live in. Things that do not fit neatly into any specific category have bothered us, until we make even more categories into which we can then categorize those things that were left on the parameters. At the same time we are less bothered about those issues that beset our world daily that reek of social injustice around such topics as race, class, gender, sexuality, age, ability, and religion. We appear to be bewildered by the propaganda that we are fed when it comes to areas of the popular press and popular culture such as movies, television, music, and commercial advertising. We can also be bewildered by the bizarre state of politics, or more precisely, by the dogma dished out by those in power in the name of equality, liberty, and justice for all. These three words become paralyzing agents in the process of hegemonic ideology to dumb down and numb society until there is only one normal way to see the world.

In this context, how can a seemingly lighthearted television show such as *Bewitched* provide another way of seeing? How can a situation comedy delivered on a regular basis into all our homes via the wonderful world of television, stir, disrupt, decenter, or overturn the capitalistic and hegemonic ideals this society upholds and we strive to fulfill? How can we, as viewers and consumers, change our perceptions to create a better world?

This chapter is the authors' collective interpretation of *Bewitched* from three different perspectives as seen through the lens of queer theory. These three angles reflect the feminist and performative perspectives, on the one hand, and *Bewitched* as a gay metaphor, on the other.

In the case of a theory that names itself "queer" but resists defining itself, Turner (2000) offers explanation and illumination. In his book *A Genealogy of Queer Theory*, Turner historicizes queer theoretical thought and elucidates concepts of queer theory. Turner cites Eve Kosofsky and Judith Butler as "founding mothers of queer theory" and identifies feminist, Teresa de Lauretis as first to use the term *queer* in 1991 (p. 5). Turner also notes French philosopher Michel Foucault's influence on queer theory and names his work as integral to its creation. Foucault (1978) contributed to the notion of sexuality as fluid, and as a socially constructed discourse. Turner provides attributes of queer theory, which include a

refusal to accept absolutes with regard to identity and an agreement that gender roles are socially constructed.

Queer theory grapples with gender, sexuality, power, and politics as it attempts to understand identities and cultures. In an essay by Kanner (2003), a central principle of queer theory is illustrated:

> Queerness is about destabilizing conventional categories, subverting the identities derived from and normalized by heteropatriarchy. Queerness defies binary and fixed categories such as homo/heterosexual, female/male, even lesbian/gay. Queerness, in both social performance and in lived identities, interrupts both convention and expectations. (p. 34)

As elucidated above, queer theory challenges heterosexuality as the dominant cultural norm. Queerness exudes resistance to dominant power structures, which marginalizes "other" identities. Queer theory views sexuality and gender as subjects meritorious of study in their own right.

In his book on identity, social theory, and social change, Kirsch (2000) states, "Queer theory promotes the 'self' of the individual as an alternative to wider social interaction . . . [t]he self as a non-conformist becomes part of a stance that disengages politics as a reality of daily life" (p. 79). A mutual assumption among queer scholars is that queer theory seeks to deconstruct heteronormative paradigms grounded in patriarchal discourse. The interpretative nature of queer theory and the space that it creates opens up the possibilities for a new twist, a queer sensibility on *Bewitched*.

Because of the heteronormative assumptions of *Bewitched* held by mainstream American viewers of the Stephens family as a "typical" American family, this situation comedy allows mainstream viewers to feel safe and comfortable while they watch it. A queer reading of the show however destabilizes meanings throughout the text.

In a queer deconstruction of the show, connections can be fashioned between the comedic scenes of witchcraft in *Bewitched,* and thus the performative elements of the show and issues of a queer lifestyle. Many mainstream Americans consider witchcraft and queerness to be taboos. Because of the mystique that surrounds them, many witches and queers have remained "closeted." A queer reader of the show will draw correlations between Samantha's closeted life as a witch living in a heteronormative culture, to their own closeted identity as a queer living in the same culture. *Bewitched* is rich with inadvertent queer content that this chapter seeks to explicate.

In the queering of the 1960s television series *Bewitched*, a postmodernist sensibility or representation is embraced where nothing is absolute and knowledge is socially constructed. It is with this understanding that we explore the question of queer theory and how it applies to *Bewitched*.

Bewitched: a Feminist Focus

Although *Bewitched* was billed as situation comedy dealing with metaphysics and magic in the confines of domestic bliss, it created a space to examine other social issues. It put into

question the representation of self and power. On a more broad scale, it put into question the concept of social conventions.

To the gaze, Samantha Stephens's persona was bewitchingly beautiful. She was a fairy-tale beauty that had it all. We can call her a Barbie of the 60's. A beautifully proportioned body, beautiful long coiffed blonde hair, perfectly manicured, and made up. She was truly the icon of beauty and accomplishment that many of that generation aspired to emulate. As the wife of a successful advertising executive, Darrin Stephens, Samantha had a "front" for the casual observer, which Goffman (1959) describes as, "that part of the individual's performance which regularly functions in a general and fixed fashion to define the situation for those who observe the performance" (p. 22). To the unsuspecting observer, Samantha appeared to follow the stereotypical expectations of performance as the 1960s wife with a beautiful, immaculate house on the right street, beautiful children, and an adoring husband who financially supports their middle-class lifestyle. She is empowered in a way, which both maintains the social status quo and privileges particular needs for her husband and children. This dynamic allows them to perform within the commonly accepted standards by which they become members in their community and social circles; this scenario is also a front.

Behind the closed doors (and sometimes outside them), there is a problem; Samantha has a flaw or stigma (Goffman, 1963). Goffman states, "society establishes the means of categorizing persons and the complement of attributes felt to be ordinary and natural for members of each of these categories" (p. 2). A stigma, according to Goffman is, "a special kind of relationship between the attribute and the stereotype . . . an undesired differentness from what we anticipate" (p. 4). Samantha, without doubt, is definitely different.

Samantha is wrapped in a female gendered body but has power within that body to transcend the normal. She is a trickster and a witch, who, with just the twitch of her nose; a "witch twitch" can alter humans both mortal and immortal and other situations. Week after week she portrays a paradox of power and submissiveness as she lives in the world of mortals. She conflates the paranormal with the normal and hence power with submissiveness. She conflates the light and dark side of humanity. She is doing the unthinkable. Try as he may, Darrin is unable to harness the power Samantha and her flamboyant mother Endora and other relatives are able to exert over him.

Bewitched operates as an apt metaphor for females of the era coming to terms with their power in an increasingly destabilized patriarchal context. It is an awakening of possibilities and provides space for unthinkable thoughts to become thinkable. Watching the show, females can imagine possibilities to remove the sutures of hegemonic dictates of the 1960s and tap into their own multiple personalities for identity, strength, and confidence.

As Elizabeth Montgomery, the show's star, took on multiple characters, women were challenged to internalize and negotiate possibilities within themselves. Within one half-hour episodes, viewers were able to watch Montgomery take on the dual roles of Samantha, the housewife, and Serena, the sexually aggressive, whiny, flighty, and vain cousin. One could even see the possibilities of testing boundaries and become what previously could not be imagined as Samantha refused to have her voice silenced in showing the strength and con-

fidence to reject her family's insistence that she stay faithful to her heritage by marrying into the mortal world. For many, the fantasy of the television world and the everyday world began to blur. We watched, we laughed, and we were bemused; *Bewitched*, destabilized, and even bothered.

Why? On a surface level Samantha who, with the power of a "witch twitch," had the ability to clean a whole house in seconds. However, she took on the mortal drudgery of washing on Monday, ironing on Tuesday, cleaning on Wednesday, and so forth. Why did she choose to perform these labors in a mortal way? The answer—her husband wants and expects her to perform the gender boundary expectations of society. He views his wife's unlimited power as decentering his masculinity. Thus, under the guise of protecting their marriage and maintaining his own status as the patriarchal household head, he forbids her to exercise her natural power. He wants a "normal" wife and mother, and Samantha sees that the way to gain emotional fulfillment is to conceal her power. Even so, Samantha often uses her magic to save him. Nevertheless, even when she employs this magic, she is careful to protect his ego by making him feel that it is his ideas that save the day.

In one instance, there is this strong, powerful woman who could have the world at her fingertips and become a role model for women's rights of the 1960s. However, this is not explicitly realized because Samantha appears to abdicate this position of power to fulfill the role of dutiful wife and mother. Samantha's behaviors as a woman appear as a compromise, as do her rights as a witch. The question begs to be asked, "Did she compromise?" There were times when Samantha did use her magic without the permission of her husband. Was this the sign of a liberated Samantha—a woman who was free to make her own choices? Did she perhaps exercise her agency as a powerful woman, secure in her knowledge that as a witch she had unlimited power but, nevertheless, did what she enjoyed—that is playing the role of a housewife and mother? After all she was raised a witch and being a mortal housewife provided another way of being.

Conversely, was Samantha's free spirit so constricted that she took on the role of her cousin, Serena, her alter ego, a dark haired, mini-skirted, and sexually aggressive, guitar-playing, counter-culture hippie? Was this Samantha in Serena drag? Was it Samantha living her life through Serena that challenged the role of domesticated wife and mother?

Could these be representations of the multiple roles many females today play in attempting to rupture the boundaries of heteronormative structures and ideologies? Are they embracing fluid rather than fixed identities? While *Bewitched* essentially supported family values, there was also that special power Samantha possessed of breaking the bounds of femininity that was so alluring and could be used to defy the patriarchal power and authority Darrin fought so hard to maintain.

The metaphor of Samantha as witch was a call for liberation from a dominant culture that reduced female identity to hollowed-out stereotypes. For millions of women, watching the sitcom brought into focus the challenge of rethinking their identity as woman, wife, and mother. *Bewitched* provided a space to reposition the lens on their own image and to view themselves in a different light. As women they could see themselves as not born into a female body but made into one through socialization, submission, and obedience, and the

dogmas of "thou shalls," and "thou shall nots." As Simone de Beauvior advances in her essays in *The Second Sex* (1952) "One is not born, but rather becomes a woman" (p. 301). With this recognition, women could realize their agency through the awareness that they have the power to make choices about renegotiating their identity through their performativities. Butler (1999) contends that gender and sexuality are achievements rather than givens and are "permanently deferred, never fully what [they are] at any given juncture in time" (p. 22). Sedgwick (1990) adds, "one can, with a bit of imagination, conceive any number of ways to organize sexual identity, including preference(s) for certain acts, certain zones or sensations, certain physical types, a certain frequency, certain symbolic investments, certain relations of age or power, a certain species, a certain number of participants, etc., etc." (p. 8). Fluidity could be embraced rather than fixed.

Bewitched also demonstrated a clash of social conventions. *Bewitched* relied for its laughs on the deviant behaviors of two clearly differentiated groups portrayed in the series—the mortals and the immortals. In *Bewitched* we watched Samantha negotiate these two worlds as she balanced the demands of Darrin and family life. We watched her attempts to maintain peace and good cheer despite the hostility between Darrin, her buffoon husband, and her outrageous mother, Endora, who despised the suburban world in which Samantha was marooned. However, at the same time we witnessed the complex mingling of sex and power as Samantha sometimes exerted her agency.

In his effort to keep his patriarchal identity, Darrin's constant attempt to undermine Samantha's natural power and her family sometimes had the opposite effect when Samantha chose to use her power to manipulate the situation. This agency destabilized Darrin's power, and he definitely felt threatened.

This dynamic serves as an analogy of how the seemingly dominant group (in this show Darrin) attempts to silence the "other" to maintain the status quo, and how power can be exerted by the "other" in the face of oppression. In *Bewitched* we juxtaposed between the "in group" and the "out group" and often became confused about who really had the power. Boundaries were crossed creating questions about what and who was acceptable and what and who was unacceptable. *Bewitched* used humor to parody an uneasy culture driven by power to maintain the contours of a patriarchal society and suppress anything outside those contours.

Bewitched reached its audience on various levels sending multiple and contradictory messages. For some it was pure entertainment, whereas for others it created a space of discourse to explore a range of possibilities about identity, power, and sexual representation. It created a space where females could look at their own performative magic as outsiders looking in.

Bewitched: a Performative Perspective

For the purpose of examining performance through the lens of queer theory and relating it to the television show *Bewitched*, it is useful to take a notion often used in drama where one can look behind the story and delve into the characters and the roles they play or per-

form. This look behind the scenes enables an exploration of the concept of *performativity* through probing into and analyzing the type of performances these characters and actors portray. The focus for this type of examination is on the main characters in the show *Bewitched* and the actors who perform these roles with the intention to shed some light on the worlds of performance, theater, drama, and fiction and their relationship with reality, or, at least, the way we perceive reality and thus our performativity in the world.

In the sitcom *Bewitched* the main role of the witch Samantha, played by the blonde-haired actress Elizabeth Montgomery, is the one who can be seen as the light in the drama world, the one that offers hope, possibility, and goodness. In opposition to her role as Samantha, Elizabeth also plays the role of dark-haired cousin Serena. Serena's character provides the dark component, which creates tension within dramatic theater. However, Serena is still attractive and appealing, but she has not gone to the other side and denied her witch powers as Samantha has tried to do. The actress, Elizabeth Montgomery, also appeared to live two lives, seemingly one of solitude behind the spotlight off-stage, while the other was in full view of the glare of popular television and consequent fame. Thus, even her own life could be seen as representing the dark and the light or that constant tension of trying to be "yourself" while having to fulfill societal and cultural expectations.

When the show began, the actor Dick York initially played the role of Darrin, Samantha's heterosexual normal (that is of the human world) husband. The second actor to play Darrin was Dick Sargent who in real life, as opposed to the fictional world, was gay. It is interesting to note the physical similarities of the two actors who play the role of Darrin as well as the commonality they shared related to their first names. This is probably, however, where the similarities cease. While Dick York was presumably pursuing a character role not that dissimilar to his own life, this was not the case for Dick Sargent. In an article 'Bewitched—and Bothered' it was noted that "few gay personalities ever emerged from the closet quite as dramatically as Dick Sargent" (*People*, 1994, p. 1).

Dick Sargent played the second Darrin from 1969 to 1972, and in order to maintain his acting career, he often chose to present a façade of normalcy or heterosexuality by posing with shapely female actresses. He even added a phony failed marriage to his publicity material in order to keep the truth at bay and pursue the pretense of appearing normal in the way that society has deemed we all should be. In fact, Dick Sargent did not "come out of the closet" until the early 1990s when he was finally tired of pretending. It is ironic in a way that while pretense is a required trait for actors, it is not something that can be easily transferred into the way we live our lives. However, so many people are required to pretend or perform their entire lives as a fantasy or a fiction, in opposition to their "real" selves because society has no tolerance for difference or for allowing people to live the lives they want to live. Sargent, who died of prostate cancer at the age of 64, was strongly involved in gay rights. Sargent also admitted that before he "drifted into movies" and became cast as Darrin in *Bewitched*, he made a couple of attempts at suicide during his college years. The signs that show us that life is not worth living because we are different speak volumes, and yet we pay little attention to the ostracism we inflict upon those outside the frame of declared normalcy.

If one considers the notion that the actor Paul Lynde, who portrayed the warlock uncle on the show, was also known to be gay, although he never publicly self-identified as such, then these two actors provide performances that truly contrast each other, as if they could be living two different lives. On the one hand we have one actor performing as a heterosexual while the other dresses up flamboyantly as someone who is presented as far from normal, and not part of the real or human world. Thus, this form of performativity only goes to confirm that if we present ourselves as different, eccentric, or, in fact, larger than life, we do not represent "real" life, but some form of fiction, fantasy, or abnormal type of existence—something not of this world! Thus our performativity becomes scripted onto the body from outside influences of culture and society where we have either the choice to "fit in" or to be seen and perform as "different" and, as a consequence, live our lives on the periphery.

When it comes to performativity there was no one more grandiose than the actress Agnes Moorehead who played Samantha's mother Endora. As Endora, Agnes swept through the sets as a figure larger than life, constantly stirring up the seemingly sane and normal worlds of both Darrin and Samantha. In her role as Endora, she was disappointed that her daughter, who possessed such wonderful powers, had chosen to live (or perform) a life as an ordinary (or mortal) wife and mother. Darrin, whose name she never seemed to remember (or just perhaps purposefully forgot) appeared to Endora as an entirely unsuitable husband for her daughter. Endora does much to disrupt the relationship between Darrin and Samantha, constantly goading Darrin and treating him as worthless. There was evidence that Endora relegated Darrin to a role of non-existence or invisibility by never confirming his presence as one person, hence the multitude of other names she called him.

Whether it was to disregard the presence of Darrin, particularly as her daughter's husband, or to relegate him to a lesser status, for example, by turning Darrin into a child (Miller, 2000, p. 142), Endora created major disruptions in the normal household of Samantha and Darrin. Endora's intention was to entice Samantha back into the world of witches and warlocks to be proud of who she was and embrace her witchcraft powers. Thus, both Endora and Samantha straddle two worlds pulled between the apparently normal life and the life into which they were born and to which they stayed connected through their powers of witchcraft. If, as it has been rumored, Agnes Moorehead was a lesbian in her real life, her role as Samantha's mother could be seen as a replication of the life the actress lived as a lesbian in a heterosexual world. In the world of fantasy or performance there is permission given to perform another "self" without necessarily revealing that this is part of the "real" self. Agnes, as Endora, was able to perform outrageously and show pride in being different, safe within a fictional role. In real life, however, this may be a completely different story where one's difference is hidden.

As stated by Moseley (2001) shows such as *Bewitched* deal with "questions of difference, otherness, increased power and the impact of these on personal and community relationships: a significant number of them draw on other cult television forms, using supernatural power as a motif through which to explore these concerns. Many shows give the sense that to be a [woman] is not to be quite human" (in Creeber, 2001, p. 43). *Bewitched*

becomes categorized under the general title or genre of family sitcoms, but with a twist, that of being supernatural. This particular genre or aspect introduced into family sitcoms "suggest that like modernity, progress, science and reason themselves, the modern suburban family was shadowed by darker and mostly unspoken 'others' from pre-modern and irrational traditions. Within the sphere of everyday ordinariness, families were fractured at best" (Hartley, 2001, in Creeber, 2001, p. 66). *Bewitched* was in a sense an approach at fracturing the everyday ordinariness of family life and suburbia. It was also an attempt at shattering the meek and mild roles of a supportive wife, without being outright in doing so. Samantha is seen to be supportive of her husband but, in fact, possesses the powers that are way beyond her husband's capabilities or control, and seemingly appears to be far more able in all areas of both domestic and business domains. Samantha has been known to infiltrate Darrin's work space in the advertising business and overturn, with a wiggle of the famous nose, disastrous attempts by Darrin at developing the most appropriate advertising campaign and winning over a client. Despite the fact that Samantha is the one that often saves the day, she is never given recognizable credit, that credit or acknowledgment goes to her husband, because everything that Samantha does is done in secrecy. From this point of view Samantha is the one who is kept "in the closet" so as not to reveal her "true" self and upset the so-called balanced world of business, or more aptly, the men's world of business.

In a sense there is a quasi-familial structure offered in order to satisfy the needs of the viewer, as if it was from our family to yours. This dynamic promotes an allegiance with family values even if those family values are being twisted or queered, sometimes unknowingly from the perspective of the audience. *Bewitched* very much presented the ideal of the nuclear family, although some later shows expanded upon the concept of the family unit. However to base a sitcom on a nuclear family is to affirm rather than question the status quo. Thus, sitcoms that undo the nuclear family are in a sense critical of it as a social institution; the alternate families that develop are social alternatives to the nuclear family status quo. In addition, because Samantha had the ability to retrieve Darrin from ridicule in the business world, this type of performativity also provided a glimpse into challenging the male-dominated capitalistic corporate world. Even the minimal effort conveyed by Samantha, or any of the others capable of witchcraft or magic spells, provides an example of how easy it is for a woman to change the state of affairs with a wiggle of a nose, or a wave of a hand and this definitely comes as a threat to male supremacy.

Although this was generally the case for Samantha and Endora, it was not the case for Aunt Clara, who always had a great deal of trouble getting her magic spells to work as she wanted them to. While providing a comical portrayal of a bumbling witch, the performative aspect related to Aunt Clara was suggestive of other comments on societal attitudes and behaviors. Aunt Clara was an elderly witch, and seemingly it was because of her age that her tricks did not work as well as she would hope. Consequently we are led to believe that as one ages we are less able to perform in the way society expects. Thus, just as in theater, one is required to perform in real life to fit a role that has been scripted on us based on societal and cultural expectations. Those expectations are defined by a powerful few that set the standards that everyone must fulfill.

To make some connection between the show *Bewitched* and queer theory as it relates to the performative the question that needs to be asked is "when we perform what do our performances constitute?" To venture further into this question related to the concept of the performative Nicholson (1995) states: "Judith Butler has argued that the self is constructed, not through fixed communities of discourse, or ontology, but through a series of performative acts. This means that gender relations are not simple givens, but are constituted and reconstituted through social interaction" (p. 31). Nicholson continues to present Butler's argument that "experiences construct cultural distinctions, not, as is thought by some educational dramatists, that there is a pre-linguistic psychological interiority" (p. 31). In other words, our identities are not fixed but fluid and changing and are not just expressive of some form of set discourse. Thus, we take on different roles and perform these roles according to the social constructs and interactions to which we are exposed. Therefore, what we do and say creates who we are at any given moment, rather than some form of inheritance we have been given that becomes an internalized way of being, as if we really have no chance whatsoever to change ourselves. Nicholson further states that Butler contests notions of the self "which assumes various roles within the expectations of modern life while the interior self remains intact" (p. 32). Butler adds:

> If gender attributes are . . . not expressive but performative, then these acts effectively constitute the identity they are said to express or reveal. The distinction is crucial, for if gender attributes are acts, the various ways in which a body shows or produced its cultural signification, are performative, then there is no pre-existing identity by which an act or attribute might be measured. (1990, p. 279, as cited in Nicholson, 1995, p. 32)
>
> Nicholson continues; "She [Butler] goes on to argue that through performative acts, the individual is rewarded for suitable acceptance of gendered behaviour, and that gender division is real insofar as it is performed. Butler's position gives an optimistic view that the self is not entirely socially constructed, part of an ideological inevitability, but unstable and open to renewal" (p. 32).
>
> Gender is not passively scripted onto the body, and neither is it determined by nature, language, the symbolic, or the overwhelming history of patriarchy. Gender is what is put on, invariably, under constraint, with anxiety or pleasure, but if this continuous act is mistaken for a natural or linguistic give, power is relinquished to expand the cultural field. (Butler, as cited in Nicholson, 1995, p. 32)

This statement by Butler can begin to revolutionize the way one thinks about the self, construction, and how we have become seemingly entrenched into a way of being that was out of our control. As Butler further states, "Performing one's gender wrong initiates a set of punishments . . . performing it well provides the reassurance that there is an essentialism of gender identity after all" (p. 279, as cited in Nicholson, 1995, p. 32).

Thus, as Nicholson suggests, "the act of adopting or performing one's gender leads to false affirmation of essentialism" (p. 32). Ultimately the argument Nicholson presents related to the issues of gender roles, is that drama should

> embrace dramatic stories, not as representatives of universal truth, but both as cultural iconography and imaginative fictions. This can provide an opportunity for intextuality within the dramatic act [which can encourage the production of] more thought provoking, challenging and increasingly sophisticated work based on equality. This stems not so much from related to being female,

but more so from the perspective of gendered behavior and dispelling the common pitfall of cre-
ating or perpetuating the binary or "bifurcation of gender roles." (p. 35)

The bifurcation of gender roles is definitely something that was strongly evident in the program *Bewitched*. If we take the notion put forth by Butler that to "perform one's gender wrong" brings about punishment, while to perform it well continues to perpetuate the essentialized roles of gender. On the surface then, the character performances in *Bewitched* suit this notion to a tee. The main character Samantha is definitely rewarded in the "real" world for performing her wifely duties as deemed appropriate by the predominant patriarchal society. Whereas, if she were to perform her witchcraft (that is, to become the "other"), she could only do so if she covered it up in some way so as not to appear unusual in a so-called normal world. When this sitcom was produced, any deviation from the norm was seen as somewhat sacrilegious because it was disrupting the image of wholesome familial characteristics upon which this society was founded. In her role as Samantha, the actress Elizabeth Montgomery certainly conveys a picture perfect performance of the domesticated, supportive housewife. She fulfills her role as a dutiful wife while endeavoring to keep her witchcraft powers hidden.

In a sense, though, we begin to see a splinter, or even a wedge, of 'otherness' creeping into the program albeit in the guise of witchcraft, or something fantastic and, therefore, definitely a fictional performance. Samantha's powers as a witch can very readily move her into another sphere of being where she can do anything she wishes to do, including the housework, with a wiggle of the nose. In her attempt to try to fit the role of a perfect mother and wife, she subsumes her "otherness," which is seen as an abnormality in the world she has chosen to enter. Thus, in doing so, she appears to reject her witchcraft in favor of fitting into the human world.

From one point of view, because Samantha remains steadfast to her mortal husband, it is perhaps Samantha who can be seen as a splinter because she has the opportunity to really get under the skin. By remaining in and becoming part of the mortal world, she is able to infiltrate into the everyday lives of people and to bring about a sense of discomfort (and, quite often, confusion) through mingling the two worlds of mortals and immortals.

Endora, Samantha's mother, on the other hand, is definitely proud to be a witch and to use her witchcraft at will. She is appalled that her daughter should marry a human and then try to keep her talents as a witch under wraps. While Samantha is the splinter, it is, perhaps, Endora who is the wedge because her main intent is to create a rift between Darrin and Samantha, and therefore, break up their marriage. This desire could definitely be seen as challenging the heterosexual world, if we substitute witches or warlocks for 'other' and consider different sexual orientations such as lesbian or gay. Endora is not content to let this union exist without interference and each show is evidence of her menacing power to not only thwart Darrin at every turn but to also pitch Samantha against him. She does this using her magic by revealing or staging Darrin's incompetence or through introducing other women to entice Darrin and upset Samantha's steadfast love for him. Samantha, nevertheless, continues to trust Darrin, knowing that it is her mother's spells that are to blame for Darrin's odd behavior.

Consequently, the underlying premise is to keep the heterosexual roles safely in place in the face of all odds, thereby perpetuating the binary gendered roles we are deemed to perform not only in fiction but in real life even as the main protagonist Endora still gives in to the dominant normal world her daughter has entered despite the enormity of her powers to disrupt whatever she wants. Ultimately, in her role as Endora she performs the expected role of a woman and as a mother where her love for her daughter, however warped it may appear to be, is seen to be the most important aspect.

Both women have the chance in this program to disrupt or decenter what is seen as normal because both possess powers beyond the mere mortals in the show and therefore have the ability to convey that there really can be a place for difference. Given the time constraints, though, this show never really succeeds in breaking those norms; Samantha faithfully stands by Darrin through thick and thin, and Endora, try as she might, never breaks down the family mold. There is, however, another glimmer of light with the arrival of Samantha and Darrin's daughter Tabitha, who turns out to also possess witch powers, a feature that foreshadows the transgression of the boundaries of normalcy in the next generation, a prospect, though, that is yet to be realized.

As Judith Butler (2003) states, "Philosophers rarely think about acting in the theatrical sense, but they do have a discourse of 'acts' that maintains associative semantic meanings with theories of performance and acting" (p. 392). If one comes from a background in drama and understands the power that performance can have this sentence is an important statement because even in the fictional world of drama the language used and therefore conveyed holds incredible and influential potency. Butler refers to "John Searle's 'speech acts,' . . . 'action theory,' a domain of moral philosophy . . . [and] the phenomenological theory of 'acts,' espoused by Edmund Husserl, Maurice Merleau-Ponty and George Herbert Mead, among others" (p. 392).

"Speech acts" appears to refer to the verbal exchange we engage in that "constitutes a moral bond between speakers" while "action theory" is explained as a way of trying to understand "what it is 'to do' prior to any claim of what one *ought* to do" (p. 392). The phenomenological theory of 'acts' seeks to address the way our social reality is constituted through language, gesture and symbolic signs (p. 392). The phenomenological perspective is explained using the quote from Simone de Beauvoir which states "one is not born, but, rather, *becomes* a woman," which is said to be reinterpreting the idea of "constituting acts from a phenomenological tradition" (p. 392).

Here Butler refers to the phenomenological tradition related to gender which "is in no way a stable identity or locus of agency from which various acts proceed; rather, it is an identity tenuously constituted in time—an identity instituted through a *stylized repetition of acts*" (p. 392). The performative aspect of speech or language is evident here and, through its very usage, can be seen to socially construct the roles or performances we enact and consequently the identities we adopt. In addition to the constitution of language, gender is further prescribed through the performance of the body, through the very gestures, movements, and enactments that become "an illusion of an abiding self" (p. 392). The following quote by Butler states this powerfully:

Significantly, if gender is instituted through acts which are internally discontinuous, then the *appearance of substance* is precisely that, a constructed identity, a performative accomplishment which the mundane social audience, including the actors themselves, come to believe and to perform in the mode of belief. If the ground of gender identity is the stylized repetition of acts through time, and not a seemingly seamless identity, then the possibilities of gender transformation are to be found in the arbitrary relation between such acts, in the possibility of a different sort of repeating, in the breaking or subversive repetition of that style. (2003, p. 392)

It is Butler's intention to show how the origins of gender have been understood as established and how, therefore, ideas of gender may also be thought of differently. This is done so from a different perspective "to theatrical or phenomenological models which take the gendered self to be prior to its acts" (Butler, 2003, p. 393), i.e., who we are and how we act is already inscripted on the body. Butler takes the view that the roles we play in life not only create the identity of the 'actor' but in so doing, also create an illusion, "an object of belief" (p. 393). This has always been the premise of drama, to take on a fictional role but to treat it as if it were real. Therefore, in so doing, we bring our reality to bear on the performance thus simply perpetuating the very roles society has proffered as acceptable. For this reason we need to ask the question, "what reality do we bring to that role and what and who are we as we enter that role or performance" (p. 393)?

If, in drama, we know that we create a fictional world with the view that we can change that world, or view it from a different perspective, we need to seriously consider the types of roles and performances we play or reenact. If this were the case, can we not take the same approach in the "real" world? Can we not realize that the roles we play can either reflect the world as it is, or change the world and ourselves in the process? Thus, as Butler states, "in its very character as performative resides the possibility of contesting its reified status" (p. 393).

This notion behooves us to really consider what performances or performativity we create in the way we read or view the world such as those performances found in shows such as *Bewitched* and the roles the characters portray. If we see our lived experiences as something that only reflects our gender roles as presumed by the larger society, and that "sex dictates or necessitates certain social meanings for women's experience" (p. 393) then the embodiment of these perspectives are surely carried through if left unexamined. As pointed out by Merleau-Ponty the body is "an historical idea" rather than "a natural species" (as cited in Butler, p. 393), thus who we are or perform as is established historically, rather than a given. The body encompasses particular cultural and historical aspects or characteristics as prescribed by the society in which one exists and impacts upon how one acts. Consequently, as suggested by Butler, we need to expand the way we view "acts to mean both that which constitutes meaning and that through which meaning is performed or enacted" (p. 393). This translates to the way we perform our gender and relates to performative acts within theatrical contexts. If this is the case, what are the possibilities for transformation of gender and sexuality as conveyed through the performance of the body? How can these acts be disrupted, diverted, or queered?

If we apply this question to the sitcom *Bewitched* (Arnold, 1964–1972), it appears that there are ways in which we can deconstruct how we "see" or "view" things, with the idea

that we can reconfigure our viewing and interpreting. *Bewitched* is a prime example of "otherness" set up in contradiction to "being normal." However, this "otherness" tends to remain in the fictional context unless we, the viewers, apply the underlying messages obtained through queering what we see to the world we live in. If performance is scripted upon the body through societal constructs, how we perform must be "cracked open" in order to find other ways to be in the world so as not to perpetuate hegemonic, standardized, heterosexual parameters that only go to constrain and contain. This is the challenge for culture, education, and society if it is to act as pedagogy of liberation. If the inclusion of queer theory rejects the idea of fixed positionalities, we have, at least, some chance of opening horizons of difference rather than defining difference within a narrowed frame of reference or as a form of opposition to another social category (Ferguson, 2000).

Bewitched: as Gay Metaphor

Now if we turn our queer lens, and look at *Bewitched* as gay metaphor what do we find? In order to expose *Bewitched* to this type of reading, we have asked the following questions: First, is being a witch (or warlock) in *Bewitched* a metaphor for being gay? Can Samantha be read as a gay man? What of her passing for mortal? Are Darrin and Sam(antha) a gay couple?

We begin by examining Samantha Stephens who is the "other"; she is the one attempting to live in a world where she cannot be fully herself, we assume. In other words, she lives in a world that is the mortal normative and Samantha must be in the closet about being a witch.

In Annamarie Jagose's (1996) text, *Queer Theory: An Introduction*, about theorizing same-sex desires, she states that "[t]o a certain extent, debates about what constitutes homosexuality can be understood in terms of the negotiation between so-called essentialist and constructionist positions" (p. 8). We would like to use these two positions in understanding Samantha as well.

To take it from an essentialist viewpoint and here we quote Jagose (1996) quoting Edward Stein, "Essentialists hold that a person's sexual orientation is a culture-independent, objective and intrinsic property" (as cited in Jagose, p. 8). Taking this position with Samantha, then one would say that Samantha was always a witch and will always be a witch as it is part of her core being. This is evidenced in that, first, we have never seen Samantha be anything but a witch; second, she appears to come from a family of witches; third, she has a witch child. In fact, we the viewers are never even led to believe that she would have it any other way. At no time are we ever given the idea that Samantha is anything but comfortable in her existence as a witch, and, when given the opportunity, she practices her witchcraft with great pride. Samantha espouses this theory the best herself in at least one episode in which she, because of her mixed (witch/mortal) marriage is stripped of her powers; in making her plea to the witches' council, she makes the claim that they can strip her of powers, but that she is still and will always be a witch. In addition, we get a clear example of her self-assuredness and pride of being a witch played out in the pride she takes in

her daughter Tabitha's magical abilities, although she does worry how her husband will react and because of him she attempts to put restraints on Tabitha. Nonetheless, she is proud when Tabitha exhibits great skills as a witch. Therefore, it would seem that there is at least some part of Samantha that is intrinsically a witch.

However, it is the other theory, that of the constructionist where we find more clues so that we may read the witch Samantha as a gay man. Again quoting Stein through Jagose, "social constructionists think it is culture-dependent, relational, and perhaps, not objective" (p. 8). Let us now turn this way of thinking onto Samantha. There are many conduits through which Samantha receives her codes of what normal is within the context of the mortal world. Obviously her husband, Darrin, is one of these; however, there are others who model mortal normalcy for Samantha such as Darrin's boss, Larry Tate and his wife Louise, along with the nosy neighbor, Gladys Kravitz and her husband Abner. Neither Samantha nor we, the viewers, ever see any of these others performing magic; therefore, we assume that they are mortal like the rest of the world. Samantha takes her code from these others and acts accordingly so as not to arouse suspicion. It appears as though Samantha stays in the closet and passes as mortal in order to appease her husband, because of her love for him.

If we now take this idea of being a witch and think of it in terms of being gay, how is it similar? More specifically, for the purpose of this reading, we will examine Samantha in terms of being a gay man. For this reason, certain assumptions need to be made. The most notable assumption is that the character of Samantha Stephens would most closely parallel that of a gay man who is out to himself and those close to him but not the larger society. Samantha knows she is a witch; she has self-identified. Most of the time, though, she mimics those whom she presumes to be mortal in order to pass in the mortal world. While she is "out" as a witch to herself and her family, she realizes that in order for her to live in the mortal normative world, she must be in the closet to that world. Is this not similar to the gay man who is out to himself, his family, and friends, yet because of circumstances such as job security, housing, and so on, he believes he must remain in the closet to that area of society? As Samantha gets her codes from those around her in how to be mortal, so do gay men get their codes in how to "act straight." However, does Samantha ever ask the others if they are mortal or does she just assume mortal normalcy? The same could be said of gay men witnessing presumably heterosexual men, as heterosexuality is the norm. However, without knowing how the other person self-identifies, how do we know if that person is mortal or heterosexual? Still either witch, or gay, men are modeling on what society prescribes as the norm, while at the same time resisting the normative paradigm. Therefore, one could say that being a witch or a gay man is a social construct, which is in opposition to the construct of heterosexual or mortal.

When Samantha does practice her witchcraft, it is done so that no one in the presumably mortal world can witness it. Frequently, she will just look around to make certain no one is watching. However, there are times when she will step out of the room, she will stick her head on the other side of the door or she will hide behind bushes, and there are times when she cannot escape the mortals in the room so she covers a side of her nose with her

hand so that she can twitch, thereby her not being seen in the practice of witchcraft leads others to assume that she is mortal. However, when the opportunity arises for her to use her witchcraft, she does not hesitate to do so. Again, when we compare this to gay men who are in the closet, we find many similarities, especially in gay men who are out to themselves and their family while in the closet to the rest of the world. This person does not practice being gay; however, there are times when he can be more fully himself and this is usually not in the presence of the larger heteronormative society. What this person does practice is a way of being seen as heterosexual, and this is what he presents to the world outside of his immediate family and friends, thus assuming if no one sees him "act gay," then the others must assume him to be straight. This same person, however, can be perfectly happy being gay when he is in a presumably safe place, i.e., around other gay men, his friends, and family, or larger gay functions. Again, it is the façade and the witnessing of such that compose the dichotomy between that which is heterosexual, mortal, and that which is gay or a "witch."

Darrin Stephens is Samantha's husband, and while he is the hegemonic conspirator in maintaining the dominant ideology, he did not create it. In fact, he is as constrained by it as Samantha, if not more so. It is Darrin whom Samantha is appeasing by not using witchcraft because he is not comfortable with anything that does not have the appearance of being normal. While Samantha has had the advantage of being "in the life" as a witch prior to her meeting, falling in love with, and marrying Darrin, this alternative lifestyle is completely new for Darrin and therefore he is not as comfortable being in it as is Samantha. Darrin is the most extreme of the closeted gay man; he is not even out to himself. He finds himself in love with a person who happens to be a witch (read same sex); however, instead of celebrating this love and declaring it to the world, he hides it away out of shame and/or fear. Not only does Darrin refuse to publicly acknowledge that his wife is a witch, he forces Samantha to deny herself, and later her children a part of who they are, namely witches. It is almost as if the old adage of "methinks thou protest too much" is in effect here. Deborah Britzman explains Melanie Klein's theory of splitting in that we project, and here Klein uses the Freudian theory of projection, what we do not like and may fear in ourselves onto others and if it is enough of a fear we split ourselves from that which we cannot see in ourselves (Britzman, 2003, pp. 26–27). If we take this theory and apply it to Darrin, he projects his witchness/gayness onto Samantha and Endora, as well as Samantha's other witch/warlock relatives; because Samantha adheres to the same ideologies as Darrin, that being living in the mortal/straight world, Darrin can have a relationship with her. However, Endora and her kin are so comfortable in her/their witchness/gayness that Darrin splits from her as well as the rest, which creates the tension so that he can hate her and them because his self-hate is such. We can also examine the physical gesturing that Darrin makes when referencing being a witch or doing witchcraft. At times, Darrin cannot even say the words as if the mere utterance will make him complicit; instead he uses his fingers to twitch his nose. Darrin's fear of being outed as a witch-lover manifests itself in many ways, not the least of which is physical. For example, in the early years of their marriage, Darrin appears to always be "on edge"; he is fidgety, his voice is high-pitched and quivers. This is espe-

cially true whenever he and Samantha, and usually one of Samantha's relatives are outside of their living environs; however, it also happens when outsiders are in their home. In later years, Darrin appears to mellow and is less excitable when confronted with the idea that he may be found out. Perhaps this is because the last years of the program a different actor plays the part of Darrin Stephens and perhaps he has a different interpretation of the character; however, for the purposes of this read on gay metaphors we are considering the character of Darrin Stephens and not the actor portraying him. Therefore, if we only consider the character of Darrin, there is a pivotal moment in history that happens around the time that the actors playing Darrin change; that pivotal moment being the Stonewall Riots which took place in June of 1969 at the Stonewall Inn in New York City. This event in which the patrons of the Stonewall Inn, a gay club, refused to be complacent in their own harassment by the police is considered to be a defining moment in the gay rights movement. If we take this into consideration when examining the character of Darrin, we see that we have a fidgety, easily excitable pre-Stonewall Darrin who is desperately afraid of being outed and then we have a more mellow post-Stonewall Darrin, who while still afraid of being outed, appears to be more accepting of who he is. Darrin's worst fear is realized during the episode when one of Aunt Clara's spells goes awry and they are transported back to the first Thanksgiving; one of the other pilgrims witnesses Darrin using twentieth century technology, namely a match, and speaking in a strange manner, modern English, so he calls him out as a witch and a trial ensues with everything working out in the end. However, there are instances in which Darrin is given magical powers and during these times he finds himself enjoying the power and must force himself to give it up, lest he becomes seduced by it. Darrin is so entrenched in the hegemonic discourse of mortal normalcy that he is unable to even imagine a world where being mortal is Other. We find in examining just these two characters of Samantha and Darrin that there are multiple ways of being a witch, just as there are multiple ways of being gay.

If we now consider this other reading of the characters Samantha and Darrin, can they be read as a gay couple? To begin, let us think of the naming of these two people, as a married couple they become the Stephenses as Darrin's surname is Stephens. In addition, Darrin often calls Samantha by the diminutive of her name, Sam. This name is usually considered as masculine, thereby giving us the couple Darrin and Sam, alternatively the Stephens family. If we read Darrin and Sam as a gay male couple, Sam is the partner who is out to herself and her family, and it appears, he would be perfectly happy with shedding the mortal world and living completely "in the life" if it were not for his husband. Sam stays closeted because of his love for Darrin, who on the other hand is not out to anyone, least of all himself. Darrin is the partner who strives for mortal (read heterosexual) normalcy; he is the one who must uphold the façade of being mortal either because of fear or shame. Most of the arguments in this household stem from the fact that one of the partners in this couple has self-identified as something other than mortal and is comfortable in this identity while the other has not. This is not to suggest that all male couples have this dichotomous relationship of one being out and the other being closeted; it is only for the purposes of this read-

ing that we are exploring this couple in this way.

Let us also look at the attempts made to dismantle this couple, especially in the light of the current debate on gay marriage. This is where we need to switch our lenses just a little and not necessarily look at being a witch as being gay, but at the couple as a gay couple, the reason for this being that most of the attempts to separate Sam and Darrin are done by the witch community, for they are the ones in the know that this is a mixed marriage. In this instance, the witch community is the one that has the power to dissolve this marriage, or never have it happen in the first place. They, the witch community, allow it to happen in order to appease Sam and because they do not think that it will last; it is just a phase that she is going through and she will come to her senses, eventually, in their way of thinking. Because they do not understand how a witch could love a mortal (or one man another) and commit to him; they choose not to validate the union. Most of the attempts to break up this marriage are done by testing the fidelity of one of the partners, usually Darrin. They, usually in the guise of Endora, try to tempt Darrin into falling for another woman; and oftentimes this other woman is mortal, but sometimes she is immortal as well. Can this be read as Darrin being a witch lover, read gay, because he just has not found the right mortal, read woman, yet? Obviously Darrin is the one who seems to be more susceptible to being seduced into the "normal" world because of his intense fear of being outed. By reading Darrin and Sam in this way the case can be made for them being a metaphor for a gay couple.

What of this magical world that Samantha's relatives inhabit? Would it be comparable to the Castro District in San Francisco for gay men or any other "gay ghetto"? We, the audience, are rarely given a glimpse of this world and when we are, it is usually because some judgment is being passed on Samantha and/or Darrin and/or their mixed witch-mortal marriage. However, we are led to believe that it is a wonderfully open place where one can practice witchcraft freely and can be completely oneself—unless, of course, he or she is a mortal, and then it probably would not be such a wonderful place. What of Samantha's magical relatives? Aside from Uncle Arthur who we are told is Endora's brother, there is never an explanation of how the others are related. Family is a term used in some gay culture speak as in "he's family" meaning he is gay; is it the same in Samantha's lexicon? Are there genetic connections between Samantha and Aunt Clara or Esmerelda, or Agatha; or is it just because these people are witches as well that Samantha refers to them in this way? Or is it that family as we currently define it is a social construction and that it is currently being redefined to mean those who are in close fellowship with you? Either way, it is clear that there are certain codes used by marginalized people to recognize others in their group. This then leads to consideration of witchdar in comparison to gaydar. As radar on a ship can identify other ships in the surrounding area, there is a concept of gaydar in the gay community where one can recognize another through clues and codes. There are certain episodes in the series *Bewitched* where magical persons disguise themselves for various reasons, yet they either identify Samantha as a witch or are identified by either Samantha or Endora as not being what they propose to be. For example in one episode a wood nymph disguises herself as a relative of Darrin's in order to exact a centuries-old curse on him and while Samantha does not identify her, Endora instantly outs her as a wood nymph. In a different episode, a warlock

has turned himself into a chair and is in an antique shop; when Samantha enters the shop the chair immediately takes to her. Therefore, there must be some sort of witchdar in which these magical persons, knowingly or unknowingly, overt or covert, emit a signal or code that is read and identified by the other. Taken separately these issues may not be enough, but when viewed collectively it appears that one can live "in the life" both as a witch and as a gay person.

Bewitched: a Queer Guise

In this chapter, we have shown how we can impose a different reading on *Bewitched* through queer theory, yet what is queer theory? It was our belief that we should demonstrate how one can use queer theory before trying to explain it because one way of thinking about it is that queer theory is the theory that cannot be described. However, we might posit that queer not only cannot be defined, it actually resists definition. As Nikki Sullivan in her text, *A Critical Introduction to Queer Theory*, suggests attempting to define queer theory is a decidedly un-queer thing to do. We can start thinking about what queer theory is with knowledge that it is not stable. Queer theory grows out of a postmodernist, poststructuralist foundation, especially in the ability to deconstruct. However, what queer does is not stop at the deconstruction but opens up new possibilities. To go back to Jagose, she states that "'Queer' is not simply the latest example in a series of words that describe and constitute same-sex desire transhistorically but rather a consequence of the constructionist problematising of any allegedly universal term" (1996, p. 74). Queer is ever changing, again to reference Jagose, "Identity, then is an effect of identification with and against others: being ongoing, and always incomplete, it is a process rather than a property" (1996, p. 79). For our purposes in this chapter, queer is about removing the layers to reveal the underlying assumptions with the very basic assumption being about gender and sexuality, for one cannot have one without the other. Once we recognize that gender and sexuality are a basic assumption we can then start to dismantle what that means in order to imagine new possibilities for being. Quoting Sullivan (2003) again, "the term queer can be used to reinforce rather than deconstruct, the ways in which identity and difference are constructed in terms of binary oppositions, of us and them—oppositions which are never neutral, but are always hierarchical. The queer subject of this kind of discourse reaffirms his or her identity in opposition to the supposedly normative other" (p. 45). While this statement refers to reinforcement rather than deconstruction, we would suggest that in order to reinforce we must as well deconstruct. Sullivan also quotes Steven Seidman who says:

> Queer theory is less a matter of explaining the repression or expression of a homosexual minority, than an analysis of the Hetero/Homosexual figure as a power/knowledge regime that shapes the ordering of desires, behaviors, social institutions, and social relations—in a word, the constitution of the self and society. (p. 51)

Queer theory is ever changing: It suggests to de-stabilize the dominant ideology by looking at the social constructions within the society. It de-centers the Cartesian subject and

peels away assumptions in order to create space for a re-imagining of being in the world—but, don't quote us on that.

One may believe that introducing a witch as a main character and part of the family make-up of a 1960s sitcom is queer in and of itself. While this is certainly true, the authors of this paper believe that the queering did not end there. This introduction of a witch "other" only provided the thread that helped us start to unravel all the pieces that made up this sitcom in order to construct a different garment through "other" lenses. We believe that this is just the beginning. In the course of writing this chapter and having conversations among ourselves, we found many other areas within the sitcom to explore. However, time and space constraints led us to focus on the three areas of feminist, performative, and gay perspectives. In addition, the temporal distance between when the show was created and when this chapter was produced gave us the space we needed to perform our analysis without regard to what the original writers may have been thinking, whereas this may not be the case with some of the more modern television series that are queered. The authors would like to acknowledge that a feature film opened during the summer of 2005 with the title and some of the premise from the sitcom *Bewitched*; however, it was not included in our analysis and retelling; only the original sitcom was used.

This article originally appeared, in slightly different form, in (2005) *Taboo: The Journal of Culture and Education*, 9(2), 27–48.

REFERENCES

Arnold, D. (Producer). (1964–1969). *Bewitched* [Television series]. New York: ABC.

Bewitched—and bothered. (1994, July 25). *People*, p. 142. Retrieved November 11, 2003, from http://libproxy.uncg.edu.

Britzman, D. P. (1995). Is there a queer pedagogy? Or, stop reading straight. *Educational Theory, 45*(2), 151–165.

Britzman, D. P. (2003). *After-education: Anna Freud, Melanie Klein, and psychoanalytic histories of learning.* Albany: State University of New York Press.

Butler, J. (1999). *Gender trouble.* New York: Routledge.

Butler, J. (2003). Performative acts and gender constitution: An essay in phenomenology and feminist theory. In A. Jones (Ed.), *The feminism and visual culture reader.* New York: Routledge, pp. 392–402.

de Beauvior, S. (1952). *The second sex.* New York: Knopf. (Original work published 1949)

Connell, R. W. *Masculinities.* Sydney: Allen & Unwin, 1995.

Doty, A. (1993). *Making things perfectly queer: Interpreting mass culture.* Minneapolis: University of Minnesota Press.

Ferguson, A. (2000). Resisting the veil of privilege: Building bridge identities as an ethico-politics of global feminisms. In U. Narayan & S. Harding (Eds.), *Decentering the center: Philosophy for a multicultural, postcolonial, and feminist world.* Bloomington: Indiana University Press, pp. 189–207.

Foucault, M. (1978). *The history of sexuality.* New York: Random House.

Goffman, E. (1959). *The presentation of self in everyday life.* New York: Doubleday.

Goffman, E. (1963). *Stigma, notes on the management of spoiled identity*. New York: Simon & Schuster.

Hartley, J. (2001). Situation comedy, Part 1. In G. Creeber, (Ed.), *The television genre book*. London: British Film Institute, pp. 65–67.

Jagose, A. (1996). *Queer theory: An introduction*. New York: New York University Press.

Kanner, M. (2003, July-August). Can Will & Grace be "queered"? *The Gay and Lesbian Review*, 34–35.

Kirsch, M. (2000). *Queer theory and social change*. London: Routledge.

Miller, J. (2000). *Something completely different: British television and American culture*. Minneapolis: University of Minnesota Press.

Moseley, R. (2001). The teen series. In G. Creeber (Ed.), *The television genre book*. London: British Film Institute, pp. 41–43.

Nicholson, H. (1995). Performative acts: Drama, education and gender. *NADIE Journal, 19* (1), 27–37.

Rodgers, R., & Hart, L. (1940). Bewitched, bothered and bewildered. Retrieved March 2004, from http://www.nodanw.com/shows_p/pal_joey.htm.

Sedgwick, E. (1990). *Epistemology of the closet*. Berkeley: University of California Press.

Sullivan, N. (2003). *A critical introduction to queer theory*. New York: New York University Press.

Turner, W. (2000). *A genealogy of queer theory*. Philadelphia: Temple University Press.

Masculinities on *The O.C.*

A Critical Analysis
of Representations of Gender

Elizabeth J. Meyer

In the winter of 2005, I was teaching a course on Media, Technology, and Education to a group of undergraduate teacher education candidates, and our class discussions often included references to popular TV shows and other media. It became clear early in the semester that virtually every student in the room was familiar with and had an opinion on the primetime Fox series *The O.C.* (DeLaurentis et al., 2003–present). References to this show elicited passionate discussions about the plot, characters, actors, fashion, and commentary on how they were being influenced by and interacting with the show. This is not surprising because the first season of *The O.C.* was popular from the moment it aired on August 5, 2003. After its first season, it cleaned up at the Teen Choice awards in 2004, winning in four categories: Best TV show, Drama/Action Adventure; TV Breakout Show; TV Actor, Drama/Adventure; and TV Breakout Star, Female (Haberman, 2004). The Nielsen ratings also reflected the success of this series' impact on teen imaginations. *The O.C.* ranked in the top three for both 12 to 17-year-old girls and boys after its second season (Council, 2005).

The way my 18 to 22-year-old students talked about the show and cared about the characters compelled me to examine it further to understand its popularity. It also presented itself as an ideal text for critical analysis to make explicit what gender codes and values were

being conveyed in popular teen culture. Because research has documented the powerful impact television has on youth identity formation (Aubrey & Harrison, 2004; Brown & Pardun, 2004) as well as its role in shaping gender codes and providing models for behavior (Aubrey & Harrison, 2004; Brown & Pardun, 2004; Good, Porter, & Dillon, 2002; Scharrer, 2001), *The O.C.* is an ideal cultural artifact for an investigation on how scripts about gender roles and sexuality are being communicated to the adolescent audience in North America.

Similar work has been done in this field using the popular 1990s series *Beverly Hills, 90210*. What McKinley found in this research with female viewers of the show was that *90210* did work to "perpetuate a dominant notion of female identity—pretty and nice, defined not on her own merits, but in relation to a male—that feminists have argued is oppressive to women" (McKinley, 1997, p. 9). Because the target audience and the settings for these prime time shows are quite similar, it is easy to draw parallels between them, although the creators of *The O.C.* would argue that there are significant differences. They claim to take a postmodern twist on this familiar genre. Josh Schwartz, the show's creator and producer calls the show a "soapedy": half soap opera, half comedy. He explains: "That's how you do a show like this in the 21st century. We live in a post-everything universe, and everyone's hyper self-aware." He describes his show as a "Trojan Horse," which means it has "beautiful surf, sun, mansions, and parties on the outside, soulful, quirky characters as the soldiers inside" (cited in Becker, 2005, p. 17). But does this "thoroughly ironic, post-everything" (Schwartz cited in Becker, 2005) show really transform or mock the time- honored tradition of valorizing wealthy, White, hyper-heterosexual men and women performing their comfortable and normalized gender roles? Alternatively, does it merely reinforce and reinscribe hegemonic values? The present chapter aims to answer this question as well as provide a model for a critical analysis of a selected media text.

Gender and Television Comedy

The O.C. is a show that has achieved popularity with both male and female viewers and offers a unique opportunity to examine what messages are being presented to its audience. The show's creator defines it as a "soap-edy," and it draws on conventions from the situation comedy genre for its comic relief. In order to better understand how comedy is used in television to reinforce and challenge gender roles, this section will examine various forms of humor and how norms of language and culture are used to create comic moments.

The concept of gender as a social construction is one that has been addressed in much feminist literature and is a process that is widely recognized by contemporary gender and sociological theorists. Sandra Bem, a prominent theorist in this field, uses gender schema theory to explain how masculinity and femininity are taught through social practices:

> Gender schema theory contains two fundamental presuppositions about the process of individual gender formation: first, that there are gender lenses embedded in cultural discourse and social

practice that are internalized by the developing child, and second, that once these gender lenses have been internalized, they predispose the child, and later the adult, to construct an identity that is consistent with them. (1993, p. 139)

She effectively introduces a theoretical framework that makes sense of how children learn and perform appropriate gender roles. Research on the portrayal of gender roles on television has shed new light on how this medium can teach and reinforce norms of masculinity and femininity.

Neale and Krunik (1990) explain that much comedy comes from the "surprising, the improper, the unlikely, and the transgressive in order to make us laugh" (cited in Hanke, 1998, p. 74). Therefore, situation comedies use cultural norms as a common reference point from which to depart in order to entertain. The way they apply cultural stereotypes, commonsense assumptions, and theatrical conventions are what make them funny. In his article, "The 'Mock-Macho' Situation Comedy," Hanke explores some of these conventions and how they are used to parody macho or hegemonic masculinity through the two shows: *Home Improvement* and *Coach*. He explains how this self-parody implies that "masculinity is a performance or act that once met a hegemonic norm, but now obviously fails to meet it. To the degree that this performance is regarded as more implausible than plausible, this discursive strategy invites cynical laughter . . . [which] works to serve male agency by delaying the truth of male power" (1998, p. 90). In *The O.C.*, this device is used regularly. We see it in the first five minutes of the first episode when Sandy, a public defender, lightheartedly admits to Ryan, his teen client, that his wife is the real bread-winner in the family (Schwartz, 2003). This information surprises Ryan and the audience. We laugh at the irregularity of the situation: a male professional who earns less than his wife. As a result of this twist, the audience is caught making a false assumption and may begin to read the show as presenting a nontraditional, and even potentially feminist, perspective.

Irony here is a comedic device that is used quite often on *The O.C.* In a recent study of the use of irony in the speech of adolescent males, Korobov argues that irony allows males to retain some deniability in their assertions that allows them to say something potentially hurtful or offensive, "while at the same time partly denying or disclaiming personal ownership of it" (2005, p. 227). An example of this occurs when Luke, the captain of the water polo team, and Marisa's boyfriend says: "I'd be pretty jealous right now if Chino (referring to Ryan) wasn't gay. Doesn't bother me. He was born that way" (Episode 104). His use of irony to insult Ryan is an effective way of, "avoiding the appearance of prejudice while at the same time getting some type of prejudice across" (Korobov, 2005, p. 227). This persistent use of ironic devices such as hyperbole, sarcasm, and rhetorical questions by the creators of *The O.C.* will be examined further in the next section due to its ability to reinforce certain gender norms while appearing to mock and critique them.

The O.C. and the Hierarchy of Masculinities

In the opening scene of the first season of *The O.C.*, we are introduced to Ryan, the show's central figure, who is getting into trouble with his older brother who has convinced him

to steal a car with him by saying, "quit being a little bitch" (Episode 101). Ryan is strong, good-looking, and from the tough neighborhoods of Chino. When he needs help, his public defender, Sandy, offers to take him in. In spite of the obvious class differences, his whiteness and his intelligence enable him to access the inner circle of wealthy Newport Beach society after his new neighbor, Marisa, invites him to a party. We are then introduced to the other main adolescent male character: Sandy's son Seth. In his first scene, he is playing videogames and making sarcastic remarks. He is portrayed as a weak and geeky social outcast who provides an ongoing critique of Newport Beach's rich and beautiful people. These two characters and others in *The O.C.* offer us an example of the various forms of masculinity that are recognized and addressed in the work of gender theorists, and are a useful case study for an analysis of the representations of gender on television.

Gender theorist R. W. Connell introduced the concept of a hierarchy of masculinities where he identified four broad categories of masculinity: *hegemonic, complicit, marginalized, and subordinate* (Connell, 1995). These four types of masculinity describe broad categories of behaviors and provide a conceptual framework for understanding how masculinity is represented in *The O.C.* Each of these types of masculinities will be defined and described with examples from the show to clarify how they work in relation to each other.

The first category, *hegemonic* masculinity, is the most valued form of masculinity in a patriarchal culture and is "constructed in relation to and against femininity and subordinated forms of masculinity. The dominant masculine form is characterized by heterosexuality, power, authority, aggression and technical competence" (Mills, 2001, p. 12). This description presents many traits that are attributed to Ryan. In the first episode, Ryan is established as heterosexually attractive, tough, aggressive, and a rescuer of both Seth and Marisa. Other recurring story lines that demonstrate Ryan's hegemonic masculinity include fighting (41% of episodes), rescuing others (59% of episodes), and heterosexual relationship issues (100%). Because Ryan is the show's hero, whenever he is violent or aggressive, his behavior is justified as a defense of someone else: Seth, Marisa, Kirsten (his adopted Mom), and even Luke. The one time he brawls to defend himself, and not someone else is in response to a homophobic insult from Luke: "shut up, queer" (Episode102). At this point, it is clear that he is not physically defending himself, but rather defending his heterosexuality. To ensure that viewers continue to view Ryan as a good guy, this act of violence is portrayed as self-defense, and is balanced later by proof that Ryan is not homophobic when he is supportive of Luke when he discovers that his father, Carson, is gay.

The second form, *complicit* masculinity, is also well-represented on this show. Men who inhabit the space of complicit masculinity, "do little to challenge the patriarchal gender order, thereby enjoying its many rewards" (Mills, 2001, p. 72). Many boys and men experience this form of masculinity, for they do not act out the extremes of hegemonic masculinity, but they do very little to challenge the existing gender order and thereby reinforce it. Seth, the other lead adolescent male character and his father, Sandy, enact this form of masculinity.

Seth provides the comic relief and a running ironic commentary of the events and people in the show. Ryan's arrival provides the doorway for Seth's first entry into the Newport

Beach social scene from which he had been previously excluded. Late in the season, his girl-friend, Summer, remarks on Seth's lack of hegemonic masculinity by stating, "You don't like hardware stores, you cry during chick flicks, next thing you know you're walking in on Ryan changing" (Episode 124). The audience laughs due to the improbability of his girlfriend openly questioning his heterosexuality. This moment derives its humor from the common stereotypes of marginalized masculinities: if a man is not appropriately macho (stoic and good with power tools), then he must be gay.

At various moments in the show, Seth and Sandy provide commentary on Ryan's hege-monic traits, often expressing some desire to share those qualities. These comments are always done with irony which Korobov points out is essential in, "subverting and (indirectly) asserting different masculine subject positions" (2005, p. 228). In one conversation with his father, Seth says, "We have a real athlete in the family (referring to Ryan). Something that all your Jewishness has kept me from becoming" (Episode 109).

Late in season one, Seth talks to Ryan about their relationship with his usual sarcasm: "I'm the brains, you're the brawn. I'm in the ivory tower, and you're on the ground mak-ing things happen" (Episode 122). By using irony, Seth is able to point out the obvious, yet he also somehow distances himself from the truth of the situation. Seth has clearly bene-fited from Ryan's arrival in Newport Beach and, although he often mocks Ryan's lack of emotion and tendency to brawl, his affiliation with such a friend transforms his social real-ity for the better. Although Seth's masculinity prior to Ryan's arrival might have been a mar-ginalized one ("I'm not a girl, although I did spend several summers being called one," Episode 117), his heterosexuality, ("I'm a man now. I had sex with a girl," Episode 119), and association with Ryan secure his position as a male accomplice in supporting the val-ues of hegemonic masculinity.

The third category is that of *marginalized* masculinities, which are underrepresented in the cast and plotlines of *The O.C.* Men of color and men with disabilities, the most tradi-tionally marginalized masculinities, are noticeably missing from the show. Issues of race are virtually absent from the show with only three lines of dialogue in the entire first season. The first is in Episode 103 when Sandy is justifying his decision to support Ryan when other Newport families resent his presence in their world. He says, "Maybe next time I'll find a Black kid or an Asian kid." The second is in Episode 108 when Seth mocks his mother's pronunciation of the word, "Tijuana." He corrects her and then says, "you're so white, mom." The final reference is in Episode 109 when Seth explains to Ryan, "the master race has been perfected, and they all go to our school." Men of color make brief appearances as investi-gators, hired help, or as bad boys at parties, and rarely utter more than a few sentences in an entire episode, which shows how truly marginalized they are. Men with disabilities do not exist on *The O.C.*

At the bottom end of the hierarchy of masculinities are those identities deemed as *sub-ordinate*. Subordinate masculinities include identities that are perceived as antithetical to masculinity: effeminate and gay men. Anti-gay and sexist language is often used to prove a man's masculinity. Men use power over other men to enforce this system and often act with violence toward individuals who are viewed as "traitors to masculinity." Mills explains

that, "homophobic discourses work to position them outside the norms of 'real' masculinities, as the most notable grouping within the category of 'subordinate masculinities' are gays" (2001, p. 70). This homophobic discourse is used repeatedly in the show by the captain of the water polo team, and Marisa's long-term boyfriend, Luke. He and his friends are repeatedly making anti-gay and sexist comments such as, "Suck it, queer" or "Welcome to the O.C., bitch." The only gay character on the show in season one ends up being Luke's father who is portrayed as ruining Luke's idyllic family and his role as the popular jock at school. This one brief storyline in Episode 112, "The Secret," showed how powerfully the association with homosexuality (having a gay father) can undo every other successful embodiment of hegemonic masculinity and render one a social outcast. The outing of his father, Carson, causes Luke significant humiliation and harassment including social isolation, verbal abuse, and getting his tires slashed at school. These four forms of masculinity, hegemonic, complicit, marginalized, subordinate, and their portrayals in *The* O.C. provide a useful guide for understanding how hegemonic masculinity is reinforced through reiteration of this hierarchy.

The O.C. Rewrites Patriarchy

Although hegemonic masculinity is clearly supported by the plots and characters on this show, the creator of *The* O.C., Josh Schwartz, along with his colleagues attempt to rewrite the reality of the gender hierarchy in society. These writers, directors, and producers create portrayals of women as controlling, powerful, sexual aggressors who are in need of caring men to help them be "good." Although the actors and characters on the show are fairly balanced gender-wise, the people deciding what those characters say and how they act are overwhelmingly male. In season one, 70% of the episodes were written by males, three of which were collaborations with female writers, and 96% were directed by men. Only one episode, 124, "The Proposal" was directed by a woman: Helen Shaver. The representation of female characters on the show is typically negative and leaves viewers with the heterosexist message that women are incomplete and incompetent human beings without men. This attitude is exemplified in Summer's sincere advice to Marisa, "You have to be independent so you can find a new guy" (Episode 122).

In the characters presented on *The* O.C., the women are depicted as troubled and weak (Marisa and Ryan's mother); vain, superficial, and petty (Summer, Julie, and "the Newpsies"—a generic term for the women of Newport Beach); dominating and powerful (Julie, Kirsten, Rachel); and sexually aggressive (Marisa, Summer, Julie, Anna, Gabrielle, Rachel, and Haley). Portrayed in this setting, the male protagonists are shown as intimidated and afraid of these women and easily subjected to their will and desires. This reversing of the dynamic of patriarchy by depicting men as objects of women's wills and desires is an attempt to undermine the project of feminism. By presenting a fantasy world that is dominated and controlled by unlikable women, the audience is induced to sympathize with the plight of the kind and generous men, and is less likely accept arguments that women are still being oppressed by a patriarchal society.

This reversal of male power starts in the first episode when Sandy tries to convince his wife, Kirsten, to allow them to shelter Ryan when he has been kicked out by his abusive, alcoholic mother. Kirsten is rigid and resistant to Sandy and Seth's pleas to allow Ryan to stay, and self-admittedly plays the "bad cop" in the family. This scenario continues until Episode 103 when Ryan finally earns Kirsten's trust, and she makes the final decision for the family and announces: "Ryan's going to stay with us now." We later learn that, although Kirsten is wealthy and powerful, it is due to her position in her father's company, not through accomplishments of her own.

Marisa's mother, Julie, is an example of a woman with a different type of power. Through gossip and party-planning, she wields significant amounts of social power in Newport. She is presented as a domineering, gold-digging, social climber, who only acts in her own self-interest. After divorcing Marisa's father, Jimmy, when he went bankrupt, she pursues Kirsten's wealthy and powerful father, Caleb, and becomes "the most powerful woman in Newport." Both Julie and Kirsten are presented as strong and intimidating women, but a closer analysis of the show demonstrates that they derive their power from their affiliations with the super-hegemonic male, Caleb.

Another strong female character is Dr. Kim, the dean of the Harbor School, where Seth, Marisa, and Summer are enrolled, and Ryan applies to attend. The men all speak of being afraid of her. When Ryan expresses hesitation to meet with Dr. Kim, Sandy tells him, "You went toe-to-toe with Julie Cooper, you can take Dr. Kim" (Episode 108). Later in the season Marisa's father Jimmy states, "Dr. Kim scares me" (Episode 120). It is clear that the women are the gatekeepers of the Newport Beach community and the men are merely there to pay for things or to help the women soften their hard edges.

Conversely, when the women are troubled or in danger, they lose their strength and power, and they need a man to rescue them. Aside from the multiple times Ryan rescues Marisa (passed out in her driveway—episode 101, overdose in Mexico—episode 107, from Oliver holding a gun—episode 118, hiding her mother's affair with her ex-boyfriend, Luke—episode 122), he also defends Kirsten when she is being ogled by a fellow inmate (Episode 101), rescues Haley from her job as a stripper (Episode 122), supports Theresa when she has been punched by her fiancé (Episode 125), and again when she announces her pregnancy (Eepisode 127).

Sandy does less dramatic rescuing, but he is often the first person to whom people go when they are in trouble (Ryan, Seth, Kirsten, Jimmy, Cal, Theresa). He is kind, loyal, and always guides people to do the right thing. When Seth finds himself torn between Summer and Anna after both young women have essentially thrown themselves at him, Sandy advises Seth, "If you are old enough to be in a real relationship, then you are old enough to be a man" (Episode 115). This presentation of Ryan and Sandy as gentle, loving, good-hearted heroes against the backdrop of the women in their world presents a view of society that could lead the audience to be more sympathetic to men and more judgmental of the women.

This skewed representation of gender roles and the power men and women have in society is reinforced by the gender of the most powerful people on the show: the executive producers. Unlike the writers and directors, they are exclusively male: Bob DeLaurentis, Dave

Bartis, Doug Liman, Josh Schwartz, and McG. This dominance of the male perspective and control in writing, directing, and producing makes suspect the show's attempt to present patriarchy and hegemonic masculinity as endangered and men as powerless objects in a woman's world.

This "thoroughly ironic, post-everything" show that claims to package "quirky soulful characters" in a superficially appealing formula actually takes that Trojan horse and instead of releasing soldiers to battle some of the problematic ideologies of dominant culture, it actually sends them in as reinforcements to join the old boys club of Hollywood. A surface examination of the characters and storyline of the first season of *The O.C.* could lead one to erroneously conclude that it has some nontraditional, postmodern twists. Its powerful and sexually aggressive female characters, the frequent self-parody (there are repeated references to a new hit show called *The Valley*), and persistent use of irony to laugh at the rich, powerful, and beautiful people of southern California are a refreshing change in the genre of prime-time dramas. This soap opera that appeals to both men and women has the potential to create new gender scripts for the twenty-first century by truly challenging and questioning core values of patriarchal society. However, as this chapter demonstrates, through a critical analysis of the writing, characters, and themes of this show, *The O.C.* is subtly and persistently reinscribing the power of hegemonic masculinity by presenting patriarchy, or the dominance of men, as an endangered reality. Korobov explains the discursive power behind the use of irony in this show when he explains that, "Irony thus achieves a kind of hedging—a 'have your cake and eat it, too' equivocation that pivots on multiple levels of meaning, a pivoting that suggests that the very stability and adaptability of hegemonic masculinity may very well lie in its ability to be strategically ironized" (Korobov, 2005, p. 227).

This analysis of *The O.C.* is influenced by what Barthes refers to as the "triple context": "the location of the text, the historical moment and the cultural formation of the reader" (Storey, 1993, p. 80). It is important to acknowledge that people bring different contexts to their interpretation of media texts. Youths are becoming more technologically savvy and are active readers of the media texts in their worlds. Through interacting with these shows and their related Web sites, fan 'zines, and other opportunities offered by technology, viewers can create their own meanings and interpretations of the messages presented to them in shows such as *The O.C.* . However, as McKinley has pointed out in her study of *90210* fans: "viewers positioned themselves as authors and sources of television-centered behaviors; in the process, cultural norms could be naturalized and uncritically perpetuated" (McKinley, 1997, p. 152). What we need to do as educators is to provide students with the tools and the knowledge to become more critically literate in reading these texts to empower youths to create their own meanings and cultural artifacts rather than being passive consumers of corporate entertainment. By initiating discussions about gender, race, ability, and sexuality, and asking students to reflect critically on the representations that they see in their favorite shows, films, and music, we will be better able to teach, learn, and interact with them about how they experience and act in the world. This analysis of *The O.C.* is meant to act as a point of departure for these kinds of discussions in the classroom.

REFERENCES

Attias, D., Priestley, J., Lange, M., Melman, J., Rooney, B., Braverman, C., Inch, K. (Executive Producers) (1990–2000) *Beverly Hills, 90210* [Television series]. USA: Fox Television.

Aubrey, J. S., & Harrison, K. (2004). The gender-role content of children's favorite television programs and its links to their gender-related perceptions. *Media Psychology*, 6, 111–146.

Becker, A. (2005, March 7). What a teen wants. *Broadcasting & Cable*, 16–17.

Bem, S. (1993). *The lenses of gender: Transforming the debate on sexual inequality.* New Haven: Yale University Press.

Bendetson, B., Shoenman, E., Ferber, B., Allen, T., Hauck, C. (Executive Producers) (1991–1999) *Home Improvement* [Television series]. USA: American Broadcasting Company.

Brown, J. D., & Pardun, C. J. (2004). Little in common: Racial and gender differences in adolescents' television diets. *Journal of Broadcasting and Electronic Media*, 48(2), 266–278.

Connell, R. W. (1995). *Masculinities.* Berkeley/LA: University of California Press.

Council, P. T. (2005). "It's just harmless entertainment." Oh really? [Electronic version]. *Sex, violence, and profanity in the media fact sheet.* Retrieved January 13, 2006.

DeLaurentis, B., Bartis, D., Liman, D., Schwartz, J., McG (Executive Producers) (2003–present). *The O.C.* [Television series]. USA: Warner Brothers.

Goldstick, O., Rosenthal, P., Astle, T., Bell, W. (Executive Producers) (1989–1997) *Coach* [Television series]. USA: American Broadcasting Company.

Good, G. E., Porter, M. J., & Dillon, M. G. (2002). When men divulge: Portrayals of men's self-disclosure in prime time situation comedies. *Sex Roles*, 46(11/12), 412–427.

Haberman, L. (2004). Teens' choice: Lindsay and Usher [Electronic version]. *E! Online News*, August 9. Retrieved January 13, 2006.

Hanke, R. (1998). The "mock-macho" situation comedy: Hegemonic masculinity and its reiteration. *Western Journal of Communication*, 62(1), 74–93.

Korobov, N. (2005). Ironizing masculinity: How adolescent boys negotiate hetero-normative dilemmas in conversational interaction. *Journal of Men's Studies*, 13(2), 225–246.

McKinley, E. G. (1997). Beverly Hills, 90210: *Television, gender, and identity.* Philadelphia: University of Pennsylvania Press.

Mills, M. (2001). *Challenging violence in schools: An issue of masculinities.* Buckingham: Open University Press.

Scharrer, E. (2001). Tough guys: The portrayal of hypermasculinity and aggression in televised police dramas. *Journal of Broadcasting and Electronic Media*, 45(4), 615–634.

Schwartz, J. (writer). (2003). *The O.C.*: The complete first season [television]. In B. DeLaurentis, D. Bartis, D. Liman, J. Schwartz & McG (Producers), *The O.C.* New York: Warner Brothers.

Storey, J. (1993). Roland Barthes. In *An introductory guide to cultural theory and popular culture* (pp. 77–85). Athens, GA: University of Georgia Press.

Chapter 39

Queer Youths Reframing Media Culture

Rob Linné

I picked up *Rubyfruit Jungle* from a friend in 1973 and felt the world shift around me. Rita Mae Brown wasn't just a lesbian novelist, and her book wasn't just a reassuring romance. Molly Bolt was a completely new way to imagine myself. Goddam and Hello, I shouted, and went home to reinvent my imagination again.

—Dorothy Allison

Scratch the surface of most queer coming out narratives, and you find a story of literacy, about a young person reading between the lines of their culture's texts in search of something that may speak to her or his desires. Many queer women trade stories about their first time furtively searching the school library for *The Color Purple* (because they had heard it was banned some places for queer content). More than a few gay men laugh thinking back to the time they stole an *Out* magazine so nobody would notice their reading materials. Recent generations talk of scanning the Web for coming-of-age while coming-out stories or trying on different personas in a chat room before physically occupying any queer space out in public. In a culture that continues to silence openly queer lives, many young peo-

ple begin their journeys in the quiet of the library or the anonymity of cyberspace (Linné, 2003).

These covert readings represent a unique literacy event that, when closely examined, reveals much about how media culture fashions identity as well as how consumers can and often do adapt or subvert mass produced images for their own means (see Kellner, 1995). Through the struggles of queer youths working to piece together cultural fragments into a personal identity, the hidden workings of social reproduction are exposed. The centrality of media culture to the development of a queer culture as well as individual queer subjectivities illuminates the recursive trajectory of identity formation.

The media inform all aspects of our identities, as we either adapt or purposefully subvert the ubiquitous images capitalist culture bombards us with. How we project class sensibilities, identify with ethnicity or culture, or perform gender cannot be separated from the representations of class, race, gender, and sexuality we see all around us. Unique to queer enculturation, however, is the way many if not most young queers have initially entered the group on a virtual level via art and the media.

Traditional socializing institutions—family, school, Boy Scouts, and Little League—seldom instruct young people in *how to be gay* and remain silent for the most part on the range of possible sexualities. Therefore, young gays and lesbians often *actively* improvise an enculturation process through "secondhand" sources, such as the arts, alternative media, and online communities. Queer fictional characters are the first gay people many youths come to "know," and they serve as important role models and guides to new ways of being in the world. Alternative magazines and gay community Web sites very often become gateways through which individuals struggling to understand or create a sexual identity enter into the social aspects of queer life and culture.

With the explosion of offerings on the Internet, young people can now peruse or purchase queer book titles in the privacy of their homes or make anonymous inquiries through library computer stations. Online texts remove the fear of running into a neighbor while purchasing a gay-themed book or a lesbian audience magazine at the local bookstore. Young people questioning their sexuality or wondering how to "come out" now have the opportunity to discuss their issues safely through thousands of alternative chat rooms or blogs. Although many young queers remain isolated in their home communities, technology and media now offer virtually unlimited resources for learning about queer culture and making connections with other young queers.

Coming out through media culture is a trope repeated in many coming out narratives. However, many of these stories end with a lack of analysis or cultural critique. The part of the coming-out story that discusses first queer readings may oversimplify by explaining the transformative power of art and media in terms only of self-affirmation. Chapters like this usually end with something like, "So after reading this book I knew I was not the *only* one and this allowed me to put away the razor blades and sleeping pills. . . ." While this part of the experience may be literally vital to many, the interaction between media and emerging queer subjectivities goes way beyond the first cathartic pleasures of realizing you are part of a culture, one with a proud history. Through a deeper exchange with cultural texts and

artifacts, the individual notion of self-discovery can move into a larger frame of reference encompassing the social and the political.

A deeper analysis of the dynamics operating between media culture and queer subjectivities uncovers the performative nature of identity. Young queers, just coming out, may speak of not knowing what to do with their early desires, of not knowing "how to be gay." With few if any role models young queers are left with personal desires that have no social context to give them meaning. Like any person becoming part of a culture, gays, lesbians, and transgendered people have to learn the ways of being, knowing, and acting sociodiscursively within the community (Gee, 1990). For young queers, learning the discourse very often begins with media. Many coming out stories include memories of a favorite character from a book on which the young reader closely studied and patterned parts of her or his emerging persona. Like a drag performer putting on a Hollywood version of hyperfemininity, young queers may try on roles they see portrayed in media culture—some empowering, some self-destructive.

Foucault (1991) suggests that the individual is always scavenging pages from the cultural past and pasting them together to create her ostensibly new and unique self. Ways of expressing that identity are not discovered from within an authentic self, but are found out in the world—"proposed, suggested and imposed on him by his culture, his society and his social group" (p. 11). Through active engagement and struggle within a multiplicity of power relations the individual implicitly learns which ways of being in the world are sanctioned and which are punished among various groups and subgroups. Foucault argues that such rules always set up possibilities for resistance. However, resistance is difficult for the individual, especially when the rules (regarding sexualities) prove illusive to contest because socializing institutions refuse to discuss them outside of the joking and taunting on the athletic field and school hallways. Silence is difficult to argue against.

In response, silenced groups have recognized the strength of collective voices. One strategy taken up in recent years is the deliberate appropriation of the culture's stories. Sociolinguist Shirley Brice Heath (1994) conceptualizes *story as theory* and describes the possibilities narratives hold for facilitating informed and reformed actions as being especially relevant for those on the margins. The sharing of stories as a way to create a shared identity makes special sense for those gathered at the margins of society. When there is a theory circulating throughout the culture that certain parts of one's identity—her gender, his race, her sexuality—automatically make her or him inferior, the motivation for searching out an alternative epistemology is not difficult to come by. How else can one explain the relentless drive many young queers describe to find forbidden texts or Web sites deemed for adults only? Coming-out films and books remain wildly popular among gay audiences, although one could argue (as many critics have) that that story has been told and retold enough already. Gay chat rooms and blogs written by and for youths represent a constantly growing dialogic narrative created by many voices seeking to create plots and characters different from the ones offered by the mainstream.

Michael Appiah (1994) argues that, unlike those in the dominant culture, the marginalized individual must find, with conscious effort, a larger story that she can read her-

self into. Without such a context, it is extremely difficult for an individual acting alone to step outside the parameters established by the dominant culture. Minorities, as a group, can however deliberately create and distribute their own cultural stories in order to nurture a group identity individuals can relate to in positive ways. Collective identities may create alternative scripts: narratives that people can use to envision better life plans and new ways of looking at self. Such scripts, once the individual can find them, offer insight into other ways of living. When these counter-texts expose monologic views of culture as simplistic and unrealistic, they encourage readers to see through the dominant discourses and question the rules that typically remain unexamined. Culture begins to seem more contingent and pliable. Subversion begins to seem more necessary.

For example, African Americans after Civil Rights burned the old scripts assuming an inferior race and worked, in community with each other, to construct positive narratives in which Black is Beautiful and Black Power is an alternative to victimization. Similarly, American gays after Stonewall have worked together to write new versions of Pride and Acting Up that replace the tired tales of cowering faggots and man-hating lesbians. In these life scripts the clinically diagnosed homosexual is recoded culturally as being gay or queer, and the coming-out narrative—encompassing each individual story along with the larger coming out narrative of "the Gay Community"—becomes central to the project of altering consciousness. These stories do not accept "tolerance" as an appropriate ending, but they insist on radically redefining the normal and the good.

A narrative research study of young queers negotiating media revealed that while the media remain limited in representations, young people are more than capable of rewriting the media to create more realistic self-images (Linné, 2003). The dominant scripts the media continue to offer represent the negative portrayals of gays that have circulated in the culture for years. The composite figure of the gay or lesbian character in this story is a dangerous person obsessed with sex and little else. He or she (usually he) is typically a middle class white urbanite who threatens family values and has no place in culture or tradition, an aberration with no historical roots. At best, he is a victim to be pitied; at worst he is a criminal who should be punished.

The counter-scripts young queers fight to create represent revised versions of queerness that were found in the readings individuals and groups co-opt from mainstream sources or find in culturally conscious literature and art from alternative sources. The gay characters in this script are more balanced and represent a multiplicity of roles to appropriate. These nuanced scripts include complex characters experiencing romance and committed relationships, productive work lives and artistic expression, family, and community. All of these revisions work in concert to allow lesbians and gays to see themselves as empowered members of a larger community rather than victims constrained by their own isolation. The theme of individual liberation in this story grows into a plotline seeking larger social justice.

The project to redefine queerness requires the tools of critical media literacy. For even as queer groups and individuals have pushed for greater visibility, the increase in media representations too often only reproduces negative stereotypes. Advocates of social justice for all cannot assume that because Ellen came out on television, we have reached full equal-

ity. The inanity of a "partial equality" is clearly evident in rhetorical gymnastics constantly bounced around the media such as "the defense of marriage" and "don't ask, don't tell."

In the past, queer youths were seldom represented in books, films, magazines, or television shows produced for and about young people. Recently, however, more characters and storylines, in a range of media and genres, have focused on the experiences of young people growing up queer as well as older queers and even gay families (Sumara, 1993; Norton & Vare, 2004). Gay characters have played central roles in teen television dramas aimed at adolescent audiences such as *Felicity* (Abram, 1998–2002) and *Dawson's Creek* (Prange, 1998–2003). Popular movies such as *Brokeback Mountain* (Costigan, Hausman, McMurtry, Pohald, & Lee, 2005) and *A Home at the End of the World* (Hogan, Sloss, & Mayer, 2004) have featured young Hollywood stars in gay leading roles. MTV Real World house casts almost always include a queer roommate while many videos now include homoerotic imagery or gay storylines. Popular young adult fiction writers such as Francesca Lia Block and M.E. Kerr focus their novels on issues of sexuality and identity.

Many professionals who work with youths applaud this trend as tremendous progress. Young people now have opportunities to see themselves portrayed in literature, art, or media in ways that could not be imagined a few decades past. However, many who study literature and the media caution against an unquestioning acceptance of the ways queer youths are being portrayed in our culture during this time of emerging acceptance and increased visibility. Critics note that the ways publishers or film producers often portray the lives of queer youths are unrealistic, continue negative stereotypes, or downplay the larger societal structures that allow homophobia and sexism to continue in many ways (see Linné, 2005).

Several problematic patterns or themes emerge when many of the new movies or films based on queer youths characters are read as a whole. Character portrayals may reinforce negative stereotypes, and plot lines may cloud the causes underlying the homophobia that continues to divide our society even today. Many stories focus on the negative and portray young lesbians and gays largely as victims. A large percentage of "early" books and movies from the 1970s through the early 1990s ended up with gay youths either committing suicide or being killed or brutally beaten. Portrayals of gay youths often focus on depression, isolation, loneliness, substance abuse, and unsafe sex. While isolation and gay-bashing do indeed remain as serious issues in our society, young people also need to know of the stories of empowerment and unity.

When not relying on tragedy to tell the stories of gay youths, writers often fall back on comedy. Many television shows, as well as films and books, rely on the stock character of the shallow but funny gay character. While these "non-threatening" characters have been able to make their way onto television and into the movies, thus increasing queer visibility, they do not offer well-rounded, substantive role models for young people. When the only characterizations others see of your culture are comedians or clowns, it is not likely that you will be taken seriously in real life.

Many characterizations stress the gender conformity of the gay characters, thus marginalizing the idea of young queers who may not want to "act straight." Authors and

screenwriters seem to go out of their way to demonstrate that gay boys can be just as "manly" as straight boys, while lesbian girls can be quite feminine. Many books focus on gay male athletes while films with young lesbians make sure the actresses portray "acceptably feminine" girls. While it is important that literature and film debunk stale stereotypes, the attempt to portray the majority of young queer characters as "appropriately" masculine or feminine may marginalize young people who do not fit into society's gender norms. The conformity of gender roles displayed by gay characters in effect suggests that young people can be tolerated as gay, but that they should worry about acting "too gay."

Another clear pattern observed in books, films, magazines, and TV shows is the limiting portrayal of young queers as overwhelmingly white and middle-class. Ostensibly this theme represents an attempt on the writers' part to make the characters more "mainstream" or even "likable." Obviously, such a strategy prejudges one group (racial or ethnic minorities) as not desirable in a misguided attempt to uplift another oppressed group. This portrayal leaves young people of color out of the picture and encourages gay youths to embrace consumerism while understanding style and shopping as central to their identities.

Some books, films, and TV shows do resist falling into the stale themes and clichés. They offer well-rounded characters, who display strength as well as vulnerability. Now films and television shows allow gays to be the main characters instead of just the comedic sidekick. Balanced portrayals of queer youths challenge accepted norms of how people are supposed to act according to their gender and explore a range of issues regarding gender and sexuality. Current authors such as Alex Sanchez and Jacqueline Woodson write about young people from diverse ethnic and cultural backgrounds (see Sanchez, 2001; Woodson, 2003).

As more young people demand to see characters that represent the range of cultures as well as sexualities, writers and producers are left with no choice but to create more realistic portrayals. Schools must follow through and include quality literature and film inclusive of queer voices in their curriculums.

Each year more and more schools allow the formation of Gay/Straight Student Alliance clubs while others enact anti-harassment policies based on sexuality. However, lesbian and gay lives too often remain extracurricular, outside the everyday conversation of school curriculums. The issue of censorship regarding queer voices in school settings continues to limit the availability of films and texts in many classrooms and the effects of such silencing loudly communicate a harsh message to students and their teachers. Although many schools now allow books and films inclusive of young gay characters and storylines to be available for individual students in libraries, fewer schools actively include queer texts as part of the general classroom curriculum for all (see Linné, 2002). Such selective censorship communicates the idea that while queer people may be tolerated in a private, individual way, the voices of young lesbians and gays are not truly honored as valuable contributions to our culture as a whole. Imagine a school where books with female protagonists were allowed in school libraries, but only books with male main characters were ever read in class. Consider how a student might feel if she could only read about her ethnic culture by doing a secret online search for materials on her own, never as part of the everyday curriculum.

Educators now have greatly expanded resources to help choose quality literature and

film as well as guide them through any potential censorship issues in the classroom. With choices expanding, the tools of critical media literacy become more necessary for youths and those charged with helping them grow into healthy individuals and active citizens.

REFERENCES

Abram, J. J. (Executive Producer). (1998–2002). *Felicity* [Television series]. WBTN.

Appiah, M. (1994). Identity, authenticity, survival: Multicultural societies and social reproduction. In A. Gutman (Ed.), *Multiculturalism* (pp. 149–165). Princeton, NJ: Princeton University Press.

Costigan, M., Hausman, M., McMurtry, L., & Pohald, W. (Executive Producers), & Lee, A. (Director). (2005). *Brokeback mountain* [Motion Picture]. United States: Focus Features.

Foucault, M. (1991). The ethic of care for the self as a practice of freedom. In J. Bernauer & D. Rasmussen (Eds.), *The final Foucault* (pp. 1–20). Cambridge: MIT Press.

Gee, J. (1990). *Sociolinguistics and literacies: Ideology in discourse*. London: Falmer.

Heath, S. B. (1994). Stories as ways of acting together. In A. H. Dyson & C. Genishi (Eds.), *The need for story: Cultural diversity in classroom and community* (pp. 206–221). Urbana, IL: NCTE Press.

Hogan, M., & Sloss, J. (Executive Producers), & Mayer, M. (Director). (2004). *A home at the end of the world*. USA: Warner Bros.

Kellner, D. (1995). *Media culture: Cultural studies, identity, and politics between the modern and the postmodern*. New York: Routledge.

Linné, R. (2002). Facing teacher fears about lesbian and gay texts in the classroom. In J. Harmon (Ed.), *Just literacy: Promoting justice through language and learning*. Albany: New York State English Council.

Linné, R. (2003). Alternative textualities: Media, culture, and the proto-queer. *International Journal of Qualitative Studies in Education, 16*(2), 669–690.

Linné, R. (2005). Queer youth and the media. In Steinberg, S., & Parmar, P., & Richard, B. (Eds.), *Contemporary Youth Culture: An International Encyclopedia*. Westport, CT: Greenwood Press.

Norton, T., & Vare, J. (2004). Literature for today's gay and lesbian teens: Subverting the culture of silence. *The English Journal, 94*(2), 65–70.

Prange, G. (Executive Producer). (1998–2003). *Dawson's creek* [Television series]. WBTN.

Sanchez, A. (2001). *Rainbow boys*. New York: Simon & Schuster.

Sumara, D. (1993). Gay and lesbian voices in literature, making room on the shelf. *English Quarterly, 25*(1), 30–34.

Woodson, J. (2003). *The house you pass by on the way*. New York: Grosset & Dunlap.

Chapter 40

We're Here, We're Queer . . . but Have You Dealt with It?

Homosexuality in Today's Media

Jimmy Kalamaras

If you read entertainment magazines, newspapers, or just listen to people chatting on the streets as they walk by, they all seem to reflect how people in the United States have become more accepting of gay men and women in society. Things are better today than they have ever been, and it can be proven by looking at our media and entertainment forms. *Will and Grace* (Burrows et al., 1998–2006) was on national broadcast television and was extremely successful its entire run. Shows like *Queer as Folk* (Cowen, Jonas & Lipman, 2000–2005), *The L Word* (Chaiken et al., 2004–2007) and *Six Feet Under* (Nemhauser et al., 2001–2005) on cable have been extremely popular. *Queer Eye for the Straight Guy* (Eric et al., 2003–2006) took America by storm, and gay characters and gay episodes popped up on *Desperate Housewives* (Cherry, 2004), *Grey's Anatomy* (Rhimes, 2005–2007), *The O.C.* (Loucas, 2003–2007), and *One Tree Hill* (Davola et al., 2003–2007). In the 2006–2007 television season, ABC has added on two more shows with gay characters: *Ugly Betty* (Gaitán & Hayek, 2006–2007) and *Brothers & Sisters* (Berlanti et al., 2006–2007). Even beyond television, there is the "New Queer Cinema"—new and edgy films where gay characters are the protagonists and portray gay life in a way that breaks away from negative stereotypes

of the past.

America has come a long way and is definitely moving in a more inclusive and accepting direction—right? That is the question at hand. Is the United States changing and becoming more accepting of minority groups, in this case members of the gay, lesbian, bisexual, and transgender community? I do not believe this for a second! Despite surface illusions of acceptance and tolerance in the media and among more liberal Americans, the United States is not in fact becoming more accepting of non-heterosexual behavior or activity. Homosexuals are more visible today in American society than they ever have been, but they are not being accepted as gays or lesbians to the fullest extent of these terms. A new kind of homophobia is being forged in response to the GLBT community's fight for recognition and civil rights. This new form of homophobia is more dangerous than the previous one because it hides behind facades of tolerance and acceptance. In fact, this new form of homophobia is transmitted to us latently through everyday media in a manner that reinstitutes homophobia into our present culture while being seemingly innocent, progressive, and, ironically, social justice oriented.

In this essay I propose to do several things. First I will discuss the transformation of homophobia from a blatant form to its new latent form. After having established the groundings of the new homophobia, I will address the power that the media have over our everyday life. Following that discussion, I will tackle some of today's media forms that portray the GLBT community and deconstruct how homosexuals are sometimes made to seem readily acceptable to Americans, but how they are really being framed in ways that protect the heterosexual status quo and reinstitute homophobia in the eye of the consumer.

Anyone that says that racism, sexism, homophobia, and other bigoted sentiments have disappeared from the American psyche is in complete denial. People who believe that we have become a nation acceptable of "others" have been lulled into complacency by pluralistic representations of the diversity that exists in this country. Yes, we have got shows with African Americans, Asians, Southeast Asians, and Latinos; Latinos even have their own television stations, and so do Queers now. However, having non-white and non-heterosexual people on TV, radio, or in films does not constitute true multiculturalism and acceptance. At the same time, while people are happy to live in an "accepting" time, we hear plans to build a wall to protect our southern border with Mexico, we learn about anti-terrorist operations that operate through the racial profiling of Arabs, and we watch as states within the country vote to deny same-sex couples the same civil union rights as heterosexual couples, and any attempt by a woman or an African American to win the presidency would be a political disaster.

So how accepting are we really? What has happened is that we have become so politically correct and careful to not be outwardly belligerent toward people who do not form part of the traditional "American" society, i.e., being white, upper class, wealthy, male, and Christian. On the inside, we still harbor feelings of disapproval, distrust, resentment, and even hatred. However, more often than not, our non-acceptance goes even deeper than well hidden personal opinions. Sometimes we even think we are liberal, when in fact we harbor feeling and tendencies that consciously and subconsciously continue to separate our-

selves from the others in hierarchical fashions. I don't hate Jews, but I am better than they. I don't hate blacks, but I am better than they. I may be white, but I am not white trash. Thoughts and feelings of these kinds are just as racist and bigoted, but they cannot be easily contested as they form part of the private domain of each individual's opinion. This is so dangerous because individuals cannot be forced to change their opinions, but they can be forced to change their behaviors. The Civil Rights movement, Women's movement, and Gay Liberation movement all changed what outward behaviors toward these groups of people would be acceptable, but they did not change the inner thoughts and consciousness of individuals on these matters.

How have these feelings of cultural, sexual, racial superiority gone underground into our subconscious? I suggest the culprit being, ironically, multiculturalism. As Kincheloe and Steinberg (2001) point out in *Changing Multiculturalism*, there are different types of multiculturalism that exist simultaneously in our society. Most types of multiculturalism lack criticality and actually serve to make the public either angry or to make them believe that bigotry is non-existent. Because we are constantly bombarded with images of others and their "successful" integration into American mainstream society, pluralism becomes a

> supreme social virtue [in and of itself]. Diversity becomes intrinsically valuable and is pursued for its own sake to the point that it is exoticized and fetishized. Pluralistic multiculturalism engages in its celebration of differences when the most important issues to those who fall outside of the norm involve powerlessness and violence. Pluralism viewed outside of the power relations of the social structure becomes a vacuous exercise that fails to explore what different issues of difference make in various individuals' lives. Issues of cultural diversity are reduced to points of 'cultural enrichment' that can be extolled without upsetting the power of dominant groups. [With this framework what people come to believe is that] non-whites have a few unique and exotic customs and habits developed in their separate-but-equal experiences. [What is promoted] is a form of cultural tourism that fails to address or understand the harsh realities of subjugation. (Kincheloe & Steinberg, 2001, p.15.)

What we misinterpret as acceptance is really just visibility. Because we see a wide variety of people (including homosexuals) on television, in magazines, in movies, and in advertisements does not mean that they are truly accepted. As a society we have taken plurality for granted and have equated that with a movement toward greater equality and an embracement of diversity. What we Americans need to do is open our eyes and look carefully at media and how they contribute to our blindness or intolerance and how they have the power to work toward or against true tolerance and acceptance of the "other," in this case, the GLBT community.

People think of movies and television as simply being forms of entertainment that do not have any further ideological, ontological, philosophical, political, religious, or normative ramifications. I personally can attest to the messages of hatred and intolerance that I internalized about being gay in this society. The mind-set of perceiving movies as inconsequential forms of entertainment is extremely flawed in that it does not recognize these entertainment forms as an extension of the individuals that created them. One cannot separate the artifact from the producer or the producer from the culture, sub-culture or interest group which has shaped their worldview (Kincheloe, 2004). Intention and ideology play

important roles in the discussion of media production. The film *The Passion of the Christ* (Sisti & Gibson, 2004) cannot be separated from its deeply religious and conservative Catholic director, Mel Gibson. To view and critique the film without taking Gibson's fervent Catholic faith into account would negate "greater" significances of this film beyond being an aesthetic and informative body. On the surface Gibson wanted viewers to see the "truth" and horror of Jesus' crucifixion and associate with his pain. On another level, his intention was also to evangelize and call back the wayward Catholics of this world who have abandoned the Catholic Church, and to criticize the Catholic Church itself for becoming soft and relaxing its strict rules since Vatican Council II. Now after Gibson's arrest during the summer of 2006 and the widely talked about slurs that he spewed out about Jews, previous claims of anti-Semitic sentiments in his film are not so outlandish claims to make anymore. The same interpretive scenario can be applied to the documentary *Fahrenheit 9/11* (Mentre, Weinstein & Weinstein, 2004). Ignoring Michael Moore's political affiliations and affinities would weaken the opportunity for viewers to be critical interpreters of the film no matter what they may or may not think about President George W. Bush's intelligence. Moore is very much anti-Bush, but he was anti-Bush long before piecing together the documentary. Even though I personally love anything that makes President Bush look bad, it must still be recognized that this was Moore's primary intention; knowing this allows for the search of a more critical and multilayered understanding of the tragedy of September 11.

The fact is that movies and television have taken up a pedagogical role in our current postmodern society. The images and information adults and youths are bombarded with each and every day serve not only an entertainment function, but a cultural and pedagogical function as well. Steinberg and Kincheloe explain how "the world of media has expanded what Lev Vygotsky referred to as the *Zone of Proximal Development*—the context that facilitates the learning process of contemporary children [and adults]. In the ZPD individuals learn to take part in social and cultural activities that catalyze their intellectual development" (2004, p.14). Movies and television have supplemented if not supplanted schools and communities in their power, influence, and ability to teach people about their world and culture and the role that they play within it. In this light it would be a mistake to continue to view movies and television as neutral, valueless, and benign entertainment forms. If television and film are in fact the new modalities that form a significant part of people's everyday ZPD, then the intention and ideology of the sources of these forms of entertainment MUST be examined critically. Media must be tackled and dissected head on. Simply condemning media as vehicles for mental rot would further ignore the issues of power and influence that surround the production and consumption of these entertainment forms. What needs to occur is the raising of each individual's critical consciousness when using any form of medium. Consumers need to become students of cultural studies. Through cultural studies consumers can "delineate how cultural artifacts [i.e. movies and television] articulate social ideologies, values and representations of gender, race, class [and sexuality], and how these phenomena are related to each other" (Kellner, 1995, p. 25). This proposition may seem daunting, but in fact it can be accomplished by any person by simply beginning

to engage in a critical process of asking questions: What is the message of this film or show? What does it tell me about the broader perspective about gender, race class and sexuality? If we are to be successful in our attempts to uncover the hidden messages and ideologies in the media, then it is necessary for the endeavor to go beyond academia. Every single individual in society should become empowered to think about the cultural significance of the media artifacts that they are consuming. It is only in this way that we can continue to make sure that minority groups do not continue to be marginalized and victimized.

My interests lie specifically in examining the presence and depictions of homosexual men and homosexuality in television and in the movies. I have a vested interest in this area. I myself was heavily influenced by the images and representations of gays in the movies and television. As a consequence I have struggled for years with issues of self-hate and self-worth. My desire in this work and in future work in gay media studies is to carefully dissect what is being said about homosexuals so that newer generations of young gay men and women do not fall prey to societal homophobia and stereotypes of homosexuals. The spiral of silence must be destroyed so that homosexuals do not have to be oppressed by dominant views that frame them as deviant and continue to marginalize, isolate, and silence them (Kielwasser & Wolff, 1992). I also want for straight men and women to better understand what it means to be homosexual and what it does not mean so that pluralistic multiculturalism does not lead them into believing that nothing is wrong in society. Heterosexuals need to come face to face with the issues and problems that homosexuals face in our society if we want to dismantle homophobia. It is after all the heterosexist paradigm that oppresses homosexuality and not vice versa (although sometimes homosexuals align themselves to heteronormative causes).

Although the images and portrayals of gays in the past are different from the images that are available to us today, there are still many problematic issues with the present portrayals. I am not arguing that the same dynamic of homophobia is alive in the same way as it was 50, even 20 years ago, but that homophobia does continue to exist. Now it has morphed into a different pattern which I will discuss below.

Before proceeding it must also be made perfectly clear that I am not proposing that consumers of media are simply absorbing everything without asking questions. Complete passivity would negate the very real and important existence of individual agency. What I am saying is that there is a very high risk when negative attitudes and ideas about homosexuality (as well as race, class, and gender) are presented in films and television programming. An individual's reactions to these negative images depend heavily on that person's situation in life and past experiences (Rand, 1995). A male who is already homophobic may further internalize feelings of anger, hatred or disgust toward homosexuals, while a female who does not feel threatened in her sexuality may just dismiss homosexuals as pathetic versions of heterosexual males. A homosexual male may react to negative images by either getting angry and refuting the representation or by internalizing the images as truth and developing self-hatred. These are but a few superficial examples of possibilities, and it is always important to remember that a person's life history bears a significant weight on how the individual will interpret and react to the images they consume. In my own personal case, the absence

of discussions about homosexuality at home, the abundance of ridicule at school, and the ignorance of what homosexuality really was caused me to react to negative images of homosexuality by internalizing feelings of guilt and self-hatred. Also remember that many countless people do not react at all outwardly or consciously to images of homosexuals in the media, but subconsciously they take in lessons from these images.

Now let us turn our attention to actually thinking about media that portray homosexuals and begin exercising our critical awareness. It must be made clear that that in cultural studies, people do not go into a "text" to purposely find something wrong with it. The movies and programs that I discuss are movies that I have chosen to watch and television programs that I watch regularly or have been curious about. In other words, I am just an average media consumer. What I have done as a critical theorist is to merely take a closer and more careful look at representations of gay men in the media while asking questions about power, equity, privilege, and sexuality. I organize the following discussion according to subtopics I have identified as being problematic within my studies of homosexuals in the media. I look at the media artifact itself (films and shows) and the artistic representation of homosexuals, as well as the larger overall connection between media production and consumption. Discovering the problematic of homosexuality in today's media is complex, and I have chosen to categorize and discuss them in the following themes.

The Gay Stereotype: The Queen

Where would TV and film be without the standard femme queers? We still see them around. Jack on NBC's *Will & Grace* and the *Queer Eye* guys from the Bravo network's *Queer Eye for the Straight Guy* (Eric et al., 2003–2006) are probably the most prominent. Sean Hayes played Jack McFarland for nine seasons and was the one who made everybody laugh, and giggle, and love fags. He was silly, funny, quipping, bitchy, narcissistic, and of course—fabulous! However, was he fabulous because he was gay, or was he gay because he was so fabulous? I ask this question because it cuts right to the heart about why Jack was so loved by all audiences. Did people love him for who the character was—a gay man who happens to have all these qualities—or because he had all the qualities that made him gay and funny? Americans feel comfortable with the stereotype of the little queer and that is why they loved Jack, NOT because he was a gay man. His gayness did not exist outside of what made him comical and endearing to the public. Thus, viewers identify with Jack the character, and not the issue of homosexuality (Eadie, 2001). In this context and then by extension, Jack became an example of gay men who are acceptable and non-threatening; they are acceptable because their sexuality is erased (Shugart, 2003; Steinberg, 1998). At least he is acceptable on TV because when some people see them in the street, live, and in person, they jeer and laugh at the fags. Gay characters are o.k., but not the real-life, next-door neighbor faggots, who have not been stripped of their sexuality and actually have sex. In the last season of *Queer as Folk*, the show brought up this very same issue in one of its episodes. When Emmet (Peter Paige) was working as the "Queer Guy" for a television station giv-

ing advice about fashion and tips on etiquette, he was adored by fans. The moment he stepped out of this original persona and hinted to his own sexuality, there was a problem. No one wants to hear that gay men actually have sex. Keeping them soft, cuddly, and cute on TV makes society feel better.

This same type of dynamic exists in the reality show *Queer Eye for the Straight Guys*. The Queer Eye guys are "real-life" fags, but they still serve up all the gay character high jinks that audiences love. I watch the Queer Eye guys and see Carson Kressley and the boys critique outfits, hairstyles, and apartment arrangements . . . it's Jack, but now he's real. The "real" gay boys on the show are not acting like anybody else besides themselves, but they are not showing America anything new that they have not already been shown—the silly, campy fag. I love Kyan, Thom, Jai, Ted, and Carson! Being a gay man myself, they are the type of people I want to know. I enjoy watching them, but they are problematic in that they are being marketed toward straight audiences. The show is entitled *Queer Eye for the STRAIGHT Guy*. These wonderful gay men are on TV and are working their magic in service to straight men. Subsequently there is a juxtaposition and dichotomization of two types of men: gay or straight. Guess who comes out on top? (No pun intended.) Straight men are symbolically, ideologically, and hierarchically placed above homosexual men because they cater to the needs of the straight men. Straight men have power over gay men. The Queer Eyes lend all their help and support in an effort to revamp the straight guy to help him reach his goal and get his dream girl. Heterosexual men and heterosexuality are the driving force behind the Queer Eyes servility. While I do not doubt that part of the concept and intent of the show is an attempt to build tolerance and acceptance toward gay men, the actual construction and dynamic of the show work to reify the boundary between straight and gay men. Gay men are ok because they can give fashion tips. Gay men are friendly, cute, and harmless. They do not ever try and hit on straight men on the show, unless it is in jest. They are extremely respectful and at straight men's service. That is the bottom line of the message of *Queer Eye*: Don't knock gay men because they may be of some service to you. However, I do not want to be acceptable to straight people because of what I can possibly do for them! I want to be accepted because there is absolutely nothing wrong with me to begin with. So when straight men and women watch *Queer Eye for the Straight Guy*, they learn not to hate gay men because they could be of some use; they also learn that they have power over homosexuals.

Plot Twists/ Dramatic Elements

A large portion of the homosexual content on television is constructed and placed into shows as dramatic elements, dramatic shifts, or titillating scandal. Homosexuality in this context becomes fetishized and turned into a dramatic device to boost ratings. It is almost fool proof. Sprinkle in some homos, and you have got an instant hit. Look at *Desperate Housewives* in its first season. When the heterosexual and studly John (Jesse Metcalf) stopped "trimming" Mrs. Gabriel Solis's (Eva Longoria) hedges, a new gardener, Justin (Ryan Carnes), came in

to take his spot. Imagine the audience's gasps when he tries to blackmail Gabriel into sleep-ing with him. And then the big bomb . . ."I need to be sure if I'm gay or not." And that's not all the scandal. At the end of the show, we see Justin making out with the very straight-laced and conservative Bree Van De Kamp's (Marcia Cross) son Andrew (Shawn Pyform)—the same character who ran over Mama Solis while drunk. Why has this been inserted into the script? The show's creator actually happens to be gay, but that is not why. A mixed-up gay teenager adds some spice, some mystery and some scandal to the already highly campy show. The show makes no attempt to point out the highly problematic issue of gay youths and the suffering they face when they try to come out. Any possible com-passion for Andrew's character is eliminated by his conniving nature. Coming out was not the focus or main issue of the show. It was the extra added juice, the filth which makes this show so sinful and enticing to its viewers. The second season of the show was not much better on the issue. The gay storyline grew with Andrew continuing to date Justin. Andrew used his gayness to upset his mother and torture her, knowing fully well that she did not approve. That is a great lesson for America—gay sons using their sexual orientation to *tor-ture* and *hurt* others as if being gay was a dirty weapon.

One Tree Hill and *The O.C.* also had young gay situations on the show, but they were treated in exactly the same way that *Desperate Housewives* chose to treat them. As sizzling drama twists that keep audiences guessing and wanting more. Confused and experiment-ing teenagers kissing same sex partners weave in and out of the storylines. I bet you never thought *The O.C.*'s Marissa (Mischa Barton) would make-out with another girl after hav-ing been passionately in love with Ryan (Ben McKenzie) all of last season. However, she did, and Fox advertised the episodes tremendously to get more viewers drawn into the show. Just sprinkle in some homos . . . Even R. Kelly recorded *Out of the Closet* and made a music video which starred a cheating wife and husband. One of the plot twists was a homosex-ual relationship between the husband and another man. R. Kelly is clearly disgusted by this concept throughout the song (although he is not disgusted with sleeping with underage girls) and treats the men with contempt. The gay relationship is disgusting but central to the plot twists and dramatic tension of the story. The final message: Homosexuality is something that is dark and questionable, and therefore adds spice to a drama.

Seemingly Innocent but Anti-Gay Subtext

There are some films that directly attempt to focus on the issue of homosexuality, some-thing that television does not do. In these films homosexuality is the main text or subtext of the storyline, and their purpose can be said to be that of drawing attention to the plight and problems that homosexuals face in society. *Far from Heaven* (Brimm et al., 2002), star-ring Julianne Moore, (Kathy Whitaker) Dennis Quaid (Frank Whitaker) and Dennis Haysbert (Raymond Deagon) came out in 2002 as a highly visible gay-themed main-stream movie and is worth examining closer. The entire film revolves around struggles in the 1950 with issues of racism and homosexuality/homophobia. The message regarding

racism against African Americans is clearly one of disapproval and tragedy. Raymond and Kathy are victims of societal racism when a friendship and budding romance are destroyed due to public disgust and intransigence. Raymond, a black man, was the only one that was consistent and supportive of Kathy, yet he was not a viable friend or lover for her because he was black and she was white. Racism is denounced in this film, and the couple's inability to form a lasting relationship is a tragic element of the story. Homophobia, though, is not necessarily constructed in the same tragic form as racism, despite the powerful and emotional dialogue delivered by Dennis Quaid. Frank breaks down in front of Kathy and sobs, "Oh God, Kathy, I tried. I tried so hard to make it go away. I thought that I could do it for you and for the kids. I can't. I just, I can't . . . I can't" (Brimm et al., 2002). Frank is also a victim. He tried to be straight because of the homophobia that permeated society, and because he was taught to believe that homosexuality was wrong. He too deserves great pity from the audience, but he does not get it in the way Kathy does. Frank, the homosexual husband, does not receive the same tragic status as Kathy and Raymond do. First, Frank is not the main character of the story. Because Kathy is the central character of the story, the audience is bound to feel more loyal to her and side with her emotionally. Second, Frank cheated on his wife. He would go out and look for men to sleep with. He was unfaithful and deceitful. Third, Frank "gave up" on being straight. After Kathy finds Frank kissing another man, she makes him go to a doctor to "get better." He promises to "beat this thing," but he gives into it instead and falls for a young man. Fourth, Kathy is too good of a person. Because she befriends a black man and does everything a good wife is supposed to do, she is the darling of the story. She even tries to support Frank in his fight to achieve heteronormativity. In *Far from Heaven* Kathy and Raymond are the tragic and pity-worthy characters. Frank is not necessarily a pitiable character; his homosexuality does not get pitied either. The scenario where a married man discovers he is gay is an automatic ticket to the bad person dumpster; they are the deceitful party. In pitting Kathy and Frank against each other in unequal protagonistic roles, the pathos that should come from the tragic situation of having to hide one's sexuality out of fear and powerlessness loses to the paradigm of the deceitful man who lies to his wife and leads a double life.

As a point of comparison let us take *Brokeback Mountain* (Costigan et al., 2005). In this film the audience does not turn against the gay characters. Because Ennis (Heath Ledger) and Jack (Jake Gyllenhaal) are the main characters and their wives are supporting characters, greater sympathy and tragic empathy is felt for Jack and Ennis. Although the audience feels badly for Alma (not Lureen so much), her pain in finding out her husband is having a love affair with another man is mitigated by the intense and forbidden love of the two men. All the elements of the story mesh together to portray the relationship between these two men in a tragic love story, a love story that is not allowed to come to full fruition because of societal homophobia acting around and within the characters. In this context the movie takes on a Romeo and Juliet type quality where two lovers are not allowed to be together because of the hatred of others. *Brokeback Mountain* is a much more gay-friendly and sympathetic movie than *Far from Heaven*, although they both deal with the same issue of the forced concealment of homosexuality in the United States. It is all about

the choices that are made in the structuring of the story and the movie. Unfortunately, even when gay men are shown in mainstream films, there is still a great potential to make them unsympathetic to the audience and risk the further distrust of homosexuality. Mere visibility is thus far more problematic than it is largely perceived.

Don't Ask, Don't Tell

If we are really open and accepting of homosexuality, then why is there still an en masse denial of homosexual individuals on television? Let's look specifically at reality television. I have already talked about the gay stereotypes and the construction of gay characters in television series, the next question concerns reality TV. Viewers are more likely to come into contact with gay men and women on reality television that on scripted television. However, the homosexuality of the individuals remains masked. Remember that real queers are a lot scarier than characters or caricatures of gays. *American Idol* during its four seasons has had so many gay men on screen that you could have a whole gay pride parade with just those participants. However, being gay is never allowed to be mentioned. Jim Verraros, a finalist in season 1 of *American Idol* (Fuller et al., 2002–2007), felt the pressure of not being able to freely express himself and be himself—a young aspiring gay male singer. In 2002, Fox even forced him to erase gay friendly comments he had made on his network sponsored Web site (Jim Verraros, 2005). It was only after the season and the tour finished that he professionally came out and became the only openly gay member of *American Idol* to date. Verraros feels that there are probably a lot more gay people on *American Idol*, but that America is not currently in the right position for contestants to be open about it. *American Idol* veteran, Clay Aiken has basically been outed by widespread rumors, but it would not be in his career's best interest to admit it. He would lose his girl fan base. Hmmm . . . could it be because we are a homophobic nation? Let's not forget that Lance Bass from NSync waited years after the demise of his highly successful boy band to come out as gay. It is only now that he does not have much to lose that he can be honest about who he is. This is too high of a cost for anyone to have to pay.

In the summer of 2006, a spin-off of *American Idol*, *So You Think You Can Dance* (Lythgoe, 2005–2006) came to Fox. I remember watching this amazing African American young man do a fantastic dance routine using a Chinese streamer. This young man with his lisp and his body language was clearly gay, but the judge, Nigel Lythogoe, did not approach that issue directly. Nigel told the dancer that the streamer did not fit the performance. In other words, the streamer was too "gay." In a follow-up performance the young man was kicked off the show because he did not dance "masculine" enough. Nigel told him, "You are a male, are you not? You should dance masculine." When the dancer asked for another opportunity to dance more masculine, Nigel replied, "You should not need me to tell you to dance masculine, you should do so naturally." In other words, you should know better to hide your gayness and not flaunt it in front of the American public. This Juilliard -trained dancer was not "good enough" to continue on the show for the sole reason of being too

gay. There was absolutely nothing negative that could have been said about his dancing because it was impeccable, better than any of the other classically trained dancers being chosen. However, he was a flaming queer and that came out *too* obviously and unapologetically for network television to be comfortable with him. The queer boys auditioning for *American Idol* and *So You Think You Can Dance* were plentiful in the first few episodes that showcased the ridiculous and laughable auditions, but once the narrowing down had to happen, the fags had to be dismissed in order to have a real competition among clean cut American youths—not queer ones! The message here: Fags are great to laugh at and make fun of. They are great comic figures, and as such cannot be taken seriously and regarded for their other attributes.

Gay for Pay

I do not think that there is anything necessarily wrong about an actor playing a character that is "different" from his or her real-life sexual orientation. Actors do it all the time. They play characters with different accents, religions, ethnicities, and of course personalities. However, an interesting dynamic takes place when straight actors play gay characters. Hardly anybody asks actors "How does it feel to play an Italian," or a Jew, a peasant, an immigrant, and so on? However actors playing in gay roles are always asked, "How did it feel to play gay? Are you afraid that people will think you are gay or typecast as a gay actor?" There are two major problems in this all too familiar scenario. First, the questions are completely inappropriate. Simply asking the questions marginalizes homosexuality. Why is it necessary for actors to differentiate themselves from the characters they play—especially a homosexual one? This line of questioning exists today because we are still homophobic. If we were not homophobic, then it would not be necessary for reporters to ask about an actor's sexual orientation. Asking actors if they are gay or talking up an actor's heterosexuality serves to reinscribe the hierarchical superiority of heterosexuality over homosexuality. If an actor denies being gay, then it is chocked up to a "just checking for your female fans" sort of thing. If an actor does admit to being gay, then it would be a huge shocker, but outings are not too common these days (don't forget the Jim McGreevy scandal). Gay actors probably avoid playing gay roles so that they do not have to be questioned about their sexuality. In fact, this observation brings me to the second issue surrounding the "Are you gay interview." The way actors answer also serves to reify heterosexuality and homophobia. There are some great gay themed films that I think do not send anti-gay subtexts, unlike *Far from Heaven* which does. I am thinking of *Brokeback Mountain*, *Latter Days* (Harris et al., 2003) and *Eating Out* (Shoel & Brocka, 2004). The story lines may be pro gay, but the way in which the gay for pay actors are publicized and interviewed cheapens the experience for me. This is a different form of homophobic pedagogy. The art form remains pure and emancipatory in theory, but the coverage and interviews surrounding the art is tainted with homophobia. I can't tell you how many articles and reviews of Heath Ledger and Jake Gyllenhaal talk about how they are so heterosexual. Heath Ledger and Michelle Williams even hooked up on the set

of *Brokeback Mountain* and had a child together. All people say about Jake Gyllenhaal is how he was heartbroken from his breakup with Kirsten Dunst. The actors on *Latter Days* and *Eating Out* are also straight and detail their acting "professionalism" in being able to play a gay role and even doing the difficult love scenes. *Latter Days* has DVD extra interviews detailing these discussions and the *Eating Out* stars were interviewed in *The Advocate*. Scott Lunsford (Caleb Peterson) told them how he thought to himself, "Wow, what a challenge. If I do this, there's nothing I can't do" (Vary, 2005). This kind of dialogue lengthens the distance between heterosexuals and homosexuals. Going on and on about their heterosexuality is a conscious and subconscious effort to divorce themselves from homosexuality. It is not just because of who they are, but because it is necessary to remove themselves from that image. The phrase "I am not Gay!" cleanses them of being possibly tainted. Heterosexuality is given power over homosexuality. However, there are some actors that do not talk about their sexuality, and I admire them. Sean Hayes from *Will and Grace* refuses to publicly discuss his personal life as do the majority of the actors of *Queer as Folk* and the *L Word*. These actors recognize the power that these heteronormative questions hold and refuse to take part in subverting the GBLT community's stride toward equality. Bottom line: Gay for pay actors undo any good and positive representations of gay men and women by outwardly rejecting homosexuality and exalting their own heterosexuality.

Mainstream vs. Indie Films—A Gay Market

The emergence of a specifically gay market in film and television is not indicative of true diversity and acceptance. What it actually indicates is a scaled-up marketing strategy on the part of large companies and an effort from within the gay community to provide entertainment and services directly related to the GLBT community. What people mistakenly identify as widespread acceptance is actually an example of supply and demand economics and enclave survival strategies. The film, television, and consumer market has become increasingly stratified with gay and lesbians relying on non-mainstream sources for entertainment and services. Gays and lesbians have done what Latinos have done. Latinos in this country rely heavily on their own means of communication and media. In fact, they have a completely different subculture and lifestyle within this country, and now the GLBT community has moved in the same direction. The gay community produces magazines, novels, music, live shows, and films for consumption by other member of the GLBT community. Indeed, the gay community has developed such a large "new" market with large sums of expendable capital, advertisements from non-GBLT companies are starting to target gay audiences in order to make their products appeal to them and bring in their money (Finkle, 2005).

This system that has been set up is not one that can be thought of as highlighting equality and acceptance. It actually highlights the discrimination and marginalization of homosexuals. Because the GLBT community has been ignored for such a long time, it was forced to find ways to meet the needs of its own community. Now with the gay community being

a viable market, corporations want to get a slice of their pockets, not a slice of their lifestyle. That is why nation wide advertisements are avoided in favor of local gay community based advertisements that will target gay communities and not risk exposing their gay sponsorships to other demographic areas. Wooing homosexuals is a potentially lucrative business venture, but it is also a possible liability because mainstream America does not accept us.

What we have today is sexual segregation. So no matter how wonderful some small independent films are, they remain well hidden from the mainstream. *Latter Days*, *Eating Out*, *Brokeback Mountain* and most other gay themed films were not released en masse across the United States. They were not even released widely in New York City like Hollywood produced movies. *Brokeback Mountain* was released more widely after it was nominated for so many Academy Awards. In addition, most other gay programming remains on paid-for-cable. *Queer as Folk*, *The L Word*, and *Six Feet Under* were all Showtime and HBO productions, widely seen, but definitely not mainstream. The bottom line is that mainstream America remains sheltered from multiple and complex layered representations of homosexual people in movies and on television. Only people who pay extra and tune into gay specific programming will get to experience better GLBT forms of entertainment. Then, if people are paying to watch this stuff, chances are they are already gay or gay friendly and do not need too much of a push to see gays and lesbians in a more positive way. The audience for all gay Here! Network's *Dante's Cove* (Colichman, 2005) is definitely not the same as the audience that tunes in to watch *Desperate Housewives* on Sunday nights.

Conclusion: What's the Point?

On the surface things look good for the GLBT community. Increased visibility of non-heterosexual characters and people in the media have quieted many liberal minded people about the marginalized status of homosexuals. Even so, increased visibility of gays in the media has come at a huge price. People are now less likely to believe that homophobia exists and have lowered their guard when it comes to looking at media critically and thoughtfully. Meanwhile the conservative Christians of this country have stepped up their battle against the acceptance of homosexuals in American society. They have gathered to support and push for legislation to deny same-sex couples the right to marry or even to be legally recognized as a lasting partnership. For them homosexuals are and will continue to be an abomination in the eyes of God. Even our President, George W. Bush, the leader of our nation who fights in Iraq and all over the world to preserve the institution of DEMOCRACY has stated that consenting adults have the freedom to do what they wish in the privacy of their own home. However, marriage is a sacred institution and must remain defined as being the union between a man and a woman. Marriage is a sacred union, and therefore faggots and dykes are immoral and vile and must be barred from being able to get married. Marriage would then be defiled. This is not the kind of attitude that can be said to exist in a society free of homophobia. Feeling sympathy for queers, but denying them certain rights and

freedoms is still homophobia! It is bigotry! It is discrimination! It is Hatred! It is UNDE-MOCRATIC!

That is why an effort must be made to continue to think critically about the images we consume on a daily basis. Homophobia still exists, and we need to become aware of the subtle subtexts that continue to teach people that homosexuals are less than people. People may think that I am overreacting, that I am too sensitive, and that is exactly my point. Because people have internalized the feeling that homophobia is a thing of the past, we miss being able to and willing to pinpoint homophobic elements of media representations of homosexuals. We miss the hidden messages while we continue to be schooled and ruled by them. It is because I do not want to fall into this trap myself that I continuously watch and evaluate the different dynamics that are present in the media, starting with my own favorite movies and series. I will be keeping my eye on those new gay characters who are popping up and how they are constructed. *Ugly Betty* already looks like it may be problematic. I love it because it because it takes on issues of beauty and societal values, but despite its progressive nature in these areas, the show seems to fall too comfortably into gay stereotypes. It stars a very gay personal assistant and a very flaming prepubescent boy. They may be Jack's replacement on mainstream television.

So what happens now that queers are all over the place on television? What happens now in the aftermath of *Brokeback Mountain* winning an Oscar for musical score and breaking records by being nominated for so many awards despite its gay content? Will more people be convinced that homophobia is a thing of the past and that gay men and women in this country have a strong voice? While I am a huge fan of the artistic representation and bravado of *Brokeback Mountain* (Cheers to Annie Proulx—her short story is truly the most amazing work of art brought to life by Ang Lee), I remain skeptical of what is to come. Heath Ledger's acting and both Heath's and Jake's ability to play gay roles will continue to be lauded, but will the issue of repressed, pure, and tragic gay male love also take center stage? I leave you with this final quote from Heath Ledger in his interview with *Entertainment Weekly* (December 6, 2005) on his gay role.

> [Jake and I] took on this story and there's no point in shying away from it. Neither of us wanted to do [the sex scene] again any time soon. But in the end, it was just like kissing a person.

I guess there will always be this question if gays are people after all.

REFERENCES

Text Sources

Eadie, B. (2001, June). The politics of gays and lesbian visibility in the media. *Spectra*, p. 7.

Finkle, J. (2005, March 21). Out of the closet and all over TV. *Broadcasting & Cable*, pp. 24–26.

Kellner, D. (1995). *Media Culture: Cultural studies, identity and politics between the modern and the postmodern*. New York: Routledge.

Kielwasser, A. & Wolff, M. (1992, December). Mainstream television, adolescent homosexuality, and significant silence. *Cultural Studies in Mass Communication*, 9(4), 350–373

Kincheloe, J. (2004). *Critical pedagogy*. New York: Peter Lang.

Kincheloe, J. & Steinberg, S. (2001). *Changing multiculturalism*. Buckingham: Open University Press.

Lesko, N. (2001). Terms of identity: Ellen's intertextual coming out. In S. Talburt & S. Steinberg (Eds.), *Thinking queer: Sexuality, culture, and education*. New York: Peter Lang.

Rand, E. (1995). *Barbie's queer accessories*. Durham, NC: Duke University Press.

Shugart, H. A. (2003, March). Reinventing privilege: The new (gay) man in contemporary popular media. *Critical Studies in Media Communication, 20*(1), 67–91.

Spines, C. (2005, December 9). Western union. *Entertainment Weekly*, pp. 30–38.

Steinberg, S. (1998). Appropriating queerness: Hollywood sanitation. In W. Pinar (Ed.), *Queer theory in education*. Mahwah, NJ: Lawrence Erlbaum.

Steinberg, S., & Kincheloe, J. (Eds.) (2004). *Kinderculture: The corporate construction of childhood* (2nd ed.). Boulder: Westview.

Vary, A. B. (2005, April 26). Starting out on *Eating out. The Advocate*, p. 42.

Verraros, Jim. (2005). Wikipedia. Retrieved on December 6, 2005, from http://en.wikipedia.org/wiki/Jim_Verraros

Motion Pictures

Brimm, T., Clooney, G., & Robison, (Producers), & Haynes, T. (Director). (2002). *Far from heaven*. United States: Clear Blue Sky Productions, Focus Features.

Costigan, M., Hausman, M., McMurtry, L., & Pohald, W. (Executive Producers), & Lee, A. (Director). (2005). *Brokeback mountain*. United States: Focus Features.

Harris, J. T., & Johns, K. (Executive Producers), & Cox, C. J. (Director). (2003). *Latter days*. United States: Funny Boy Films, Davis Entertainment, TLA Releasing.

Mentre, A., Weinstein, B. & Weinstein, H. (Executive Producers), & Moore, M. (Director). (2004). *Farenheit 9/11*. United States: Dog Eat Dog Films, Lions Gate Films, IFC Films.

Shoel, M., (Executive Producer), & Brocka, Q. A. (Director). (2004). *Eating out*. United States: Ariztical Entertainment.

Sisti, E. (Executive Producer), & Gibson, M. (Director). (2004). *The passion of the Christ*. United States: Icon Productions.

Television Series

Berlanti, G., et al. (Producers). (2006–2007). *Brothers and Sisters* [Television series]. New York: American Broadcasting Company (ABC).

Burrows, J., et al. (Producers). (1998–2006). *Will and Grace* [Television series]. New York: National Broadcasting Company (NBC).

Chaiken, I., et al. (Producers). (2004–2007). *The L word* [Television series]. Showtime Networks.

Cherry, M. (Executive Producer). (2004). *Desperate housewives* [Television series]. New York: ABC.

Colichman, P., Hess, A., Jarchow, S. P. (Executive Producers), & Irwin, S. (Director). (2005). *Dante's Cove*. United States: Regent Entertainment.

Cowen, R., Jonas, T., & Lipman, D. (Executive Producers). (2000–2005). *Queer as folk* [Television series] Showtime Networks.

Davola, J. et al. (Producers). (2003–2007). *One tree hill* [Television series] Warner Bros. Television/ CW Television Newtwork.

Eric, R., et al. (Producers). (2003–2006). *Queer eye for the straight guy* [Television series] Bravo Networks/ National Broadcasting Company (NBC).

Fuller, S., et al. (Producers). (2002–2007). *American idol: The search for a superstar* [Television series] New York: Fox Television Network.

Lythgoe, N. (Executive Producer). (2005–2006). *So You Think You Can Dance* [Television series] New York: Fox Television Network.

Gaitán, F., & Hayek, S. (Executive Producers). (2006–2007). *Ugly Betty* [Television series] New York: American Broadcasting Company (ABC).

Loucas, G., et al. (Producers). (2003–2007). *The O.C.* [Television series] New York: Fox Television Network.

Nemhauser, L. J., et al. (Producers). (2001–2005). *Six feet under* [Television series] Home Box Office (HBO).

Rhimes, S. (Executive Producer). (2005–2007). *Grey's anatomy* [Television series] New York: American Broadcasting Company (ABC).

Machinima

Gamers Start Playing Director

Robert Jones

Despite early claims of being a short-lived fad, video games have proven they are here to stay. With revenues surpassing those of Hollywood box office receipts, the video game industry has emerged as a predominant fixture on our media landscape. As with previous new forms of media, the initial impulse has been to protect our children from the seemingly dangerous and addictive qualities of a medium we do not yet fully understand. Much of the rhetoric surrounding the dangers of video games (originating largely from the religious right and the various conservative watchdog groups) aims at categorically vilifying the medium as a threat to family values which celebrates violence and sex. The reality is that only 15 percent of games sold in the United States receive an M rating, which identifies a title as only suitable for ages 17 and older due to graphic violence or language.[1] While games like *Grand Theft Auto* and *Doom* embody the high profile games that get covered by the media as cases of how violent video games have become, they actually represent only a fraction of the gaming market. The vast majority of video games being produced and sold look a lot more like *Mario Kart* and *The Sims 2*. So when we talk about *video games*, it is important to clarify that we cannot talk about them as a single form.

Refusing to adopt the popularly held opinions of video games as violent and addictive, media literacy scholars like Buckingham et al. (2006) and Squire and Jenkins (2003) have made strong arguments for the educational qualities many games offer. From the development of organizational skills and cognitive abilities to teambuilding, video games do much more than threaten the moral fabric of our youths, despite what much of the popular media would have us believe. Therefore, developing a critical media literacy about this emerging form requires that we examine both the larger discourse about video games set forth by reactionaries as well as actually look at the different types of games available and how they are being used.

Machinima, one of the more recent developments within video game culture, demonstrates a classic example of how literacy in a certain medium can transform the relationship between consumers and their media. Put simply, *machinima* is an art form that uses the 3D graphics power of video games to create short animated films. By controlling the avatars on the screen, these *machinimators* act out scenes and add their voices to the characters or use subtitles to tell stories ranging from parody of the game worlds in which they are created to pointed political commentaries on current affairs.[2]

A video game's interactive nature distinguishes it from other traditional media and therefore invites a requisite amount of play on the behalf of the player. It is this level of control and freedom to play that makes video games so compelling. *Machinimators* merely take the agency granted to them by designers and go beyond it, transforming the medium from an interactive game to a filmmaking tool. Once they have created their films, they distribute them online either through Web sites they develop themselves or through the ones dedicated to the distribution of *machinima*. The volume of traffic varies from film to film and site to site, but at its highest point the numbers are quite surprising; the best known *machinima* series *Red vs. Blue* recorded nearly one million downloads a week at its peak (Thompson, 2005).

Though it began over a decade ago, *machinima* has only recently transitioned from a tiny subculture among hardcore gamers to a more widely known online phenomenon. In its earliest days *machinima* required a relatively high level of computer literacy for *machinimators* to get their game-play footage in a video format that could be edited and made into a movie. As game design technology advanced, designers saw that this sort of play by gamers served their interest. Upon realizing that these films served as promotional ads for the branded characters of the games, designers began developing games with built in tools for moviemaking. Will Wright's *The Sims 2* and Peter Molyneux's *The Movies* serve as prime examples of how the penchant for storytelling in gamers has changed the approach to game design. In the case of *The Sims 2*, a simulation game where players control the social interactions of their avatars, a record function was added to the game that allowed players to record their game-play as a video file.

Coupled with the control of the in-game camera, this record function provided the basic tools for making *machinima* available to a large market. *The Movies*, a simulation game where the player controls the success of a movie studio, took this one step further by making a core part of the game-play based on user created films that could then be exported as video

files. Through the use of user-friendly controls, *The Movies* allows for the full control over creating short animated films.

In both cases, designers adapted the game design to cater to a growing need in players to use media as a means of creation and expression.

Video Games as Tools

In order to understand exactly what *machinima* is, it is important to know how video games work in general. Much of the literature on video game theory has made varying attempts at defining precisely what distinguishes video games from other media. The most obvious as well as most common correlation draws a connection to other audio/visual media like film. Because so many of the production elements in contemporary games derive from filmmaking techniques, it is easy to see that this could provide an entry point into understanding video games. However, video games fundamentally differentiate from film in that they are an interactive medium, requiring a constant exchange of information between the user and the game. So while video games appear to look mostly like films (and this is actually really only a portion of games because a lot of games like *Teris* look nothing like films), they actually function as another medium we do not often think of: software.

Despite the various debates as how to best categorize video games, at their primary level all video games function as software. Every video game consists of a certain amount of code that forms sets of rules known as *algorithms* that a player has to then navigate and try and overcome. For example, the basic algorithm of the arcade classic *Pac-Man* would be: consume all the small dots on a level without eating the ghosts, unless you first power up with one of the larger dots. Like most software, user input has some sort of impact on the processes taking place within the computer. Just as keystrokes create text on the screen within word-processing software so too does the input of information through a joystick change the outcome on the screen in *Pac-Man*. For that reason, new media theorist Lev Manovich (2001) insists that we must always think of software as tools that allow the manipulation of data. In the case of video games, the software is creating either 2D or 3D graphics in real time, responding to the input of the player.

To create those graphics, all video games have what are called *engines* as a core part of their software. These engines are a series of processes that create the graphics as well as govern how the avatars and environment interact with each other, including the nature of the physics with which they interact. When Mario jumps onto one of the pipes in a level of *Super Mario Brothers*, the game's engine creates an avatar that can be moved toward a portion of the environment, making it bound through the air with a gravity that resembles cartoons. The purpose of creating engines is to minimize the amount of code that would be needed for every possible action within the game. In the case of *Mario*, the avatar could be changed to whatever the game designers want; it could be Luigi, Princess Peach, or some other character. The engine just knows that it is moving an avatar through the environment; the form that avatar takes does not matter. Similarly, the pipe is a rectangular object

which could easily be replaced by a building or a mushroom. When gamers play a game, their input serves as the instructions to the engine to create the necessary graphics to allow them to play the game.

What makes game engines unique from other forms of software that can create 3D graphics like Maya and 3D Studio Max, is that they create the graphics in real time. In a common example of 3D animation like *Shrek,* which is created using high-end software, the detail in the lighting and the textures is what makes it look so impressive. It requires tremendous computer resources to create those graphics. Just to have Shrek walk down the hall of the castle requires that each frame (24 per second) be *rendered* before motion is even possible.[3] Video game engines do the same things as part of the rendering process in order to create their 3D animations; they simply do them with less detail which allows for them to do it in real-time. Looking at the difference between *Shrek* the movie and *Shrek* the video game, anyone can see that the graphics in the movie are far more detailed and photorealistic than that of the game. Because the images in the movie are *pre-rendered* (meaning hours or days were spent creating the files), they are more detailed. The engine, on the other hand, allows for a player to choose wherever she wants Shrek to go in the environment, and the avatar of Shrek immediately responds. Therefore, since the graphics within games are created in real-time by the game engines, the ability to manipulate those graphics demonstrate Manovich's point of software functioning as a tool. What on the surface may appear to be simply a game, purchased for $50, is actually very powerful software capable of creating vivid 3D graphics in real time. *Machinimators* have recognized this potential in games and have chosen to harness that power by using it to create their own 3D animated films. Traditionally creating 3D animated films requires a number of skills and expensive resources. *Machinima,* however, appropriates a technology already widely available to consumers and uses it in an act of creation that could be best described as virtual puppetry whereby the controlling of avatars on the screen forms the characters of the stories they choose to tell.

Consumer/Producers

According to a recent survey done by the Pew Center of Internet Life, 57% of teens who use the Internet were considered media creators, defined as using the Internet to distribute either original or remixed content.[4] Through the convergence of digital technologies a new landscape has emerged where media consumers are seeking opportunities to become media producers. Media literacy scholars have always noted the importance of an active relationship with media. Whether critically engaging the text by asking the important questions (Who is creating this text? For whom is this text created?) or appropriating the text to serve their needs, an active relationship with media empowers consumers in ways that passive consumption does not. As media technologies become more varied and ubiquitous the importance of critical media literacy becomes an imperative part of citizenship. Moreover, the growing dependency upon information as the most valuable global commodity demonstrates that media literacy is not simply about becoming more responsible con-

sumers. Much in the same way that print literacy enabled and nourished the principles of a democratic society, a comprehensive literacy in media and information systems becomes a requisite part of navigating a world run not by nations but transnational media corporations.

Being media literate does not simply mean that students have the ability to access, analyze and evaluate media in multiple forms. They must also possess the capacity to communicate in those forms as well. The convergence of digital technologies not only suggests that students must be adept at comprehending messages that come in multiple variations, but they must now have a capacity to use those same channels. The growth of the Internet is probably the single biggest contributor to the expansion of the channels of distribution available to consumers. From peep to peer networks to servers that house millions of forums, the Internet provides an incentive to produce some form of media because there is a means of distributing it. While the development of *machinima* is largely dependent upon the rising popularity of video games in general, without the online Web sites dedicated to distributing *machinima*, it would have likely remained the hobby of only hardcore gamers. Through these networks of distribution, *machinima* found a larger audience than just gamers. The *Red vs. Blue* series in particular has been shown at various film festivals in addition to its widespread popularity.

This new generation of students, with access to so many digital technologies, is driven by the need to create. Although the trend of consumers producing their own texts is hardly a new phenomenon (from students writing stories about their favorite shows to clipping pictures from magazines to make their own collages), the relative availability of digital technologies has expanded the variety of what can be created. Students can create their own online diaries in the form of a *blog*, they can make their own music by remixing their favorite songs, they can perform their own talk show and distribute it as a *podcast*, they can make their own films with inexpensive digital cameras and free editing software, and now they can make 3D animated films using the engines of the video games they already play and enjoy.

Gamers have always enacted a certain amount of agency as media consumers due to the interactive quality of video games. The ability to control an avatar in a virtual environment grants the type of control that traditional media simply do not provide. *Machinima's* origin can then easily be attested to the type of play and exploration that games foster. The earliest forms of *machinima* derived from those gamers who grew tired of just playing the game and started playing around with the software. By realizing that those early First Person Shooter games like *Doom* and *Quake* gave the user the ability to control 3D characters on the screen, those gamers made a dramatic shift from a player to a director.[5] They took control of what was actually a very powerful piece of software and used it to tell their stories. Now, more and more games are being designed with this very purpose in mind. Some game developers have even built it into the way that they market their games by creating filmmaking contests and creating Web sites dedicated to *machinima* distribution, acknowledging the fact that gamers prefer having total control over their media. As new media technologies become further integrated into the lives of students, marked by more interaction and user control, this need to create will only develop. In the case of *machinima*, stu-

dents can become the directors of their own stories and create a text that looks rather professional. The fact that gamers discovered this use of a media technology speaks to our growing desire to be creators and not just consumers of media. For media literacy scholars it provides yet another example of how a certain amount of authorship and power can come from understanding how media work, rather than just consuming them. As for now *machinima* may be a small blip on the radar of mainstream culture, but as the inevitable growth in the popularity of video games flourishes, so to will this new form of consumer production.

NOTES

1. For this and more statistics on video game software go to http://www.theesa.com/facts/top_10_facts.php.

2. For an example of parody see the *Red vs. Blue* series and for an example of political commentary see *The French Democracy*. Both are available for download at www.machinima.com.

3. Rendering is a complex process by which every piece of the three dimensional image must be put into its place, adding the proper texturing and lighting. This is very time consuming in that the computer is literally taking many tiny files and bringing them together into a single video clip that can be played.

4. See *Teen Content Creators and Consumers* at http://www.pewinternet.org/PPF/r/166/report_display.asp

5. The First Person Shooter genre, made famous as the "shoot'em ups" vilified in the media due to the violent content, is unique in that it was the first type of game that allowed the player to navigate through three-dimensional space. The importance to *machinima* is that players of these games quickly began to see that the first person perspective of their avatar provides the same view as a camera; therefore, they would move their character through the environment and act as the camera while the other players served as the actors of the movie.

REFERENCES

Buckingham, D., Burn, Carr, & Schott, (2006). *Computer games: Text narrative and play*. Cambridge, UK: Polity Press.

Manovich, L. (2001). *Language of new media*. Cambridge, MA: MIT Press.

Squire, K., & Jenkins, H. (2003). Harnessing the power of video games in education. *Insight, 3,*

Thompson, C. (2005, August 7). The Xbox auteurs. *The New York Times,* 6.21.

FURTHER READING

Jones, R. (2006). From shooting monsters to shooting movies: Machinima and the transformative play of video game fan culture. In K. Hellekson & K. Busse (Eds.), *Fan fiction and fan communities in the age of the Internet* (pp. 261–280). Jefferson, NC: McFarland.

Marino, P. (2004). *3D game-based filmmaking: The art of machinima*. Scottsdale, AZ: Paraglyph.

Morris, D., Kelland, M., & Lloyd, D. (2005) *Machinima*. Course Technology PTR.

Raging Against the Machine

The Internet and Teen Suicide

Teresa Rishel

A Google search on "teen suicide" yields about 15,400,000 hits in less than ten seconds. The sites listed cover a wide range—from statistical data, prevention programs, personal experience stories, and issues related to gays, alcoholics, racial groups, and individuals with bipolar disorders, to a sprinkling of media reports. Page one of the results is focused exclusively on topics related to prevention, awareness, and general information. Changing the search string to "how to commit suicide," however, yields very different results: 16,500,000 hits and direct access to Web sites that provide detailed, action-oriented plans and access to "virtual communities" that view suicide as an acceptable—even laudable—option.

Results listed close to the top of the first page of "how to" include one headlined, "What is the best way to commit suicide when you're under 13?"[1] In this blog style forum, people post messages about their desires (and past attempts) to kill themselves; some of these messages are countered by others that urge patience and suggest alternatives. A suicidal young adult who visited this site could as easily come away confused as relieved. The postings accurately mirror the chaotic mix of despair and hope teens contend with, but they also often fail to provide any clear sense of realistic alternatives. The next hit, "commit suicide on 43 Things,"[2] includes a forum entitled "298 people want to do this," where peo-

ple post entries about their desires to kill themselves. The site also has a link to pictures of people rehearsing their "chosen" method of suicide. One shows a woman dressed in a white kimono. She is stabbing herself in the stomach, and what appears to be blood oozes from her abdomen and mouth. This gruesome site provides visitors with information that could either further an existing interest in suicide or encourage a budding one. A third significant listing among this top-ranked group, an "informational" site, is "Suicide Lodge."[3] This one is especially troubling because it aims to "present facts and resources related to the subject of suicide" in a calmly "neutral," almost studious way. The home page earnestly declares that Suicide Lodge "is not pro, or anti suicide." However, the mingling of links to educational and prevention sites, books, and videos, with links to commentaries on ways to commit suicide, and to pro-suicide and pro-choice sites, has a subtle equalizing effect. Even a fairly sophisticated visitor might not notice how quickly what is at stake in following "pro" versus "con" links. All the links, including one to highly graphic "pictures that show people's bodies after they have committed suicide," seem reassuringly equivalent.

The "teen suicide" and "how to commit suicide" Google searches draw attention to the wide-ranging nature of information available in our technologically advanced society, and how to access it. Any time of day or night, teens with Internet access have at their disposal, *within seconds and on a single page*, enough information to plan and receive support for their own suicide. Alternatively, they also have rapid access to preventative information and crisis counseling. In practice, though, whether out of curiosity or perceived need, teenagers are more likely to conduct the "how to" search. Teenage suicides are the third leading cause of death of individuals aged 14 to 24 in the United States (Satcher, 1999).

Media of all kinds—books, television shows, newspaper stories, songs, and movies—not just the Internet, call attention to suicide. For teenagers, however, it is the Internet that is the greatest information resource. Now the second-largest source of news and entertainment in the world, preceded only by television, the Internet has tremendous power over the lives of youths. It can be a positive force, providing information, interaction, communication, and camaraderie that some teens neither get nor seek anywhere else. With respect to suicide, sites such as the long-standing and comprehensive *PreventSuicideNow.com* and the recently created Internet chat forum, *TakeThisLife.com,* offer realistic support for those who are dealing with suicidal thoughts, among other issues. Because the latter is a monitored forum, predators seeking to encourage suicide or other harmful behaviors are identified quickly and banned, and visitors who are contemplating suicide are channeled toward discussing their problems and seeking alternative solutions. Members share their thoughts and describe their feelings in an environment that allows them free expression of deep-seated and hidden fears and worries, including how these concerns affect loved ones, work relationships, and so on. Most responses by members to one another are encouraging, based on experience, and supportive of professional intervention when needed. Perhaps the most positive aspect of this chat forum is that teenagers are not only safe to express and share their problems, but they can, in turn, also provide support to others.

Despite the availability of these potentially useful sites, however, the Internet's negative effects are a source of increasing concern. Young adults who lack adequate problem-

solving skills, and who have not been taught how to critically appraise the media presentations they see and hear, may be susceptible to the influence of sites that provide direct validation for suicide as a trendy or courageous "solution" to pressing personal problems. These sites form a kind of virtual playground where there is an always ready audience that applauds and encourages such acts. A British research study on the effects of the Internet on a person's decision to commit suicide concluded that teenagers and young adults, in particular, are especially vulnerable (Dobson, 1999). The study noted that compared to the general public, teenagers and young adults generally engage in riskier behaviors, have more difficulties with depression, and are more reluctant to seek professional help. Thus, frequent visits to Web sites with graphic images and detailed text that condones and supports suicide may prompt members of this age group to move from thought to action.

The semi-automatic—or at least unreflective—passage from thought to action is a key component of Internet-based fantasy and adventure games. It can also occur in other aspects of Internet use, as a by-product of the hyperreal nature of Web interactions. Many frequent users quickly forget the once obvious fact that cyber-based encounters are not directly transferable to everyday, real-time life. Although *cyberspace "conversations" involve actual human beings, the simulated environments of these online exchanges make them a problematic guide for action. They are "for the moment" and are by definition disconnected from the routine realities of everyday life.* As a result, the standards and rules of hyperreality can differ dramatically from those of the "real world." For example, in the everyday world, it would be difficult for a young person to find endorsement for her or his plan to commit suicide. In the artificial reality of online chat rooms, however, approval for that act is easily obtainable. Even though almost all adolescents would readily agree with the statement that control over life—or death—should not be placed in the hands of random strangers, many nevertheless do not hesitate to roam the Internet, looking for guidance concerning suicide. Consider this posting on a public forum[4]:

> The reason I am on this site right now is because today is one of those days when I am struggling and by myself and I did a google search—not sure whether I should search for methods of suicide or to search for someone to talk to? (Anonymous, 2006)

Anonymous, like many of her peers, apparently is unaware of the enormous risk involved in posing this potentially fatal question to strangers. Those who seek advice and direction online may find answers, support, and relief from a community of unknown others who present suicide as a normal and acceptable form of death. (The paradoxical fact that these suicide supporters are themselves alive, and well enough to participate in online forums, goes both unnoticed and unchallenged.)

In Britain, this potential for disaster became real. Dobson's research provides a detailed look at the Internet-related suicides of 16 people, aged 14 to 47. These included an unnamed teenager who accessed suicide sites over 6,000 times before his death; "Philip," who made a secret suicide pact with a stranger on a suicide Internet site; "Tim," who used the Internet to accumulate large amounts of information about ways to commit suicide; and "Arwel," who received encouragement to kill himself from a Holland-based Web site.

Two American sites directly linked to these deaths were the Church of Euthanasia (CoE)[5] and ASBS[6]. CoE's mission is clearly defined on the main page of the group's Web site, where suicide, abortion, cannibalism, and sodomy are identified as the "pillars" of the community. Suicide topics include the pros and cons of death, suicide methods, and tips on how to prepare for death. Clicking on the suicide "pillar" links the visitor to the archives of a popular but no longer active usenet group, SH. Members of that group presented themselves as normal, rational individuals who shared the view that suicide is a matter of individual choice—and therefore that it is a viable option for all people, regardless of age or life circumstances. They portrayed suicide as ordinary, even mundane, by using a bus metaphor and depicting themselves as people passing the time chatting while waiting at a bus stop (" . . . Most of us have already gotten our ticket and are just waiting for the right bus to show up. Others are just stopping in to check out the routes . . . every couple months or so, someone gets on a bus and leaves . . ."). The topics this seemingly harmless group chose to "chat" about include "When is the time Just Right?"; "Help needed with information on hanging"; and "So a 357 magnum is the best gun?" Links to these discussions and related topics (e.g., suicide notes, poetry about suicide) remain accessible in ASH archives.

ASBS (ASH Bus Stop), the second site named in Dobson's study, is a spin-off from ASH. The ASBS Web site is designated as for visitors over the age of 18, but nothing prevents its use by younger individuals. It provides, among other services, a pro-choice forum about suicide, and advice about making funeral arrangements, writing suicide notes, and methods of committing suicide. One of the 16 suicides Dobson covered, that of a 20-year-old male, was attributed to communications with the "bus" community. An email message from ASBS on the day this young man died, a message described by his parents as being a "single line of text, a strip of black on a white screen," included the phrase "catching the bus." For students, many of whom ride school buses day in and day out, the bus metaphor may seem comforting. The idea that one never gets off a suicide bus might be especially hard to grasp for those whose point of reference is the routine safety of the daily school bus ride.

Even knowing the risks, though, will not prevent some adolescents from turning to the Internet for information and advice. Anonymity has its comforts, especially for those who are fearful about sharing thoughts or questions about suicide in real life. Communicating on the Web seems easier, as this comment from an online depression chat forum suggests:

> Falling. That's all I really do now, is fall. Deeper and deeper, until I hit rock bottom. I wonder when that will be? Soon, I suppose. I wonder what will happen when I hit rock bottom? Will I die? And when will it happen? I'm pondering this a lot now. For the past few days it's all that's been on my mind; when will I hit and what will happen when I do? (Anonymous, 2006)

Moreover, teenagers grappling with anxieties and fears may seek out or simply chance upon Web sites where they are welcomed *because of* the worries and misgivings that haunt them. Such settings can promote a deadly carelessness, both in sharing personal information and in receiving it. Exchanges between "virtual friends" at sites where choosing death is considered a normal and acceptable option are dangerous for naïve visitors.

Protected by their firm belief that they are "just looking," teens can quickly become drawn in by a realistic-looking plan of action. As the British report indicates, particularly for a depressed adolescent, the line between what is unreal and therefore "safe"—as in "just looking"—and what is real can waver, fade, and eventually dissolve.

Media, Marketing, and Suicide

Glamorizing suicide as entertainment and placing it within a heroic and romantic frame is another way in which the Internet can be a highly toxic environment. The commercialization of suicide is pervasive in teen-oriented media. The word elicits attention, even shock, and the act is associated with rebellion. The superficial use of this hard-core term helps marketers sell otherwise mainstream products to young consumers who are eager to push limits and break with convention. Even products only indirectly suggestive of suicide may be interpreted as such. "As advertisers and marketers have learned, young people are active, analytical viewers who many times make their own meanings of media texts" (Steinberg & Kincheloe, 1998, p. 16).

The use of suicide as a youth-targeted marketing device is especially clear on Web sites dedicated to music about suicide, such as *Suicidal Whirlpools*.[7] The site, which features a comprehensive list of song lyrics focused on the feelings of despair and loneliness associated with suicide, is dedicated to 72 rock stars whose "genius has been lost" through suicide

Coupling suicide and sex is also popular. The *Suicide Beauty Queen of the Week*[8] page on myspace.com entices girls with the question "Are you HOT ENOUGH?" and invites them to submit photos to win the coveted title. As well, the *SuicideGirls*,[9] a soft porn Web site, features pierced, tattooed, and goth young adult girls in sensual poses. A growing phenomenon on the Internet, *SuicideGirls* boasts 15,949,094 posted comments on their Web site.

Marketing suicide as humor is seen on the Web site *explosm.net*[10] [formerly *Stick Suicide*], where cartoon figures depict suicidal scenes, and ways to commit suicide using cyanide. A similar page, Commit Suicide Cartoons, on the *Cartoon Stock*[11] Web site, has a large variety of suicide cartoons arranged by type (e.g., wife, golfer, firefighter, journalist, businessman). One shows a man atop a building; people in the background are saying "Jump, it's a quiet news day." *Thebestpageintheuniverse*,[12] an intentionally tasteless and supposedly comic Web site, suggests visitors "give it [suicide] a chance." The author offers a list of "prompts," such as "You realize that there's no cure for the flu, right? Well, no cure that doesn't involve painting the wall with your brains." Another page provides advice on "How to Kill Yourself Like a Man." Potentially lethal for a distressed adolescent, this kind of twisted humor is harmful even for "normal" kids if their "just looking" behavior turns from net surfing to thoughts of self-destructive actions. In a suicide chat forum, a person struggling with suicidal thoughts alerted others to the danger of the bestpage site:

> Wow . . . It takes all type of people and you know what he is just one of the freaks that feeds on the depression of others. I bet if you look you could find a 1000 more (Anonymous, no posting date provided)

The Virgin Suicides[13] Web site, created in 2000 in tandem with the opening of the movie of the same name, is still functioning, a sign of the high level of interest regarding teenage love, angst, obsession, and suicide. This interest is especially keen among young women. Vulnerable and emotional teens of both sexes often perceive the loss of a relationship as fatal, but girls are more willing than their male peers to kill themselves over the loss of love. Although the plot of *The Virgin Suicides* turns on the suicides of *five* teenaged sisters, suicide as such is minimally represented on this Web site. Nevertheless, the site transmits, perhaps unintentionally, an eerie undertone of support for love-related suicide. Describing the movie as a "dark, grown-up fairy tale," for example, immediately positions the girls' suicides as glamorous, and in so doing subliminally suggests this notion of glamour and then immediately validates it.

"Social" Suicide

Many Web sites and chat forums address the idea of "social suicide." The reference here is not to biological death but to social gaffes (deliberate or accidental) that cut a teenager off from a peer group or other important social circle. Theoretically, Web sites focused on social suicide give teenagers opportunities for camaraderie as they deal with the turmoil of adolescence, but they should also be considered possible "breeding grounds" for *real* suicidal thought and action. Among adolescents, the distance between social ostracism and biological death can be frighteningly narrow. The home page of the rock band *Suicide City*,[14] a group whose song lyrics and album titles often address social suicide, illustrates this potential for overlap. A visitor to the band's site is greeted by an eerily dark page, with the look and sound of a violent storm playing across a desolate terrain. A hanging stick-figure body slowly sways in the foreground. Inside the site, the group explains its name this way: "What's in a name? People put themselves through so much abuse; physically, mentally, emotionally, economically, it's all suicide!"

A visit to a group called "Social Suicide,"[15] located in the *Cultures and Community* category of myspace.com, suggests that teenagers may subliminally accept the idea of a link between social and biological suicide. The Social Suicide group describes itself as "For all those out there fed up with the social society of everyday America." A survey subscribers must complete asks if the applicant has ever been depressed or considered suicide. If the group's purpose is to discuss teenage angst and anger, the state of our culture and society at large, and so on, why are potential members questioned about depression and suicide? Is the survey suggesting that members *should* have these traits, or is the question intended to send a warning that membership ultimately could "hook" the applicant into a relationship with anonymous others whose ideas and opinions might be dangerous for an unhappy or unstable youth? The most popular subgroup within the Social Suicide forum, "Innocently Fucked Up" (described as for those who have been hurt emotionally or who have hurt others), suggests that such a warning might be advisable. At first blush, the exchanges in this category appear to be about support. However, a different view is revealed by comments

such as, "Sometimes you just want to go and jump off of a bridge am I right or what?" The implied message is that suicide (jumping off the bridge) would be a typical reaction for those who feel alienated and/or experience the stigma of being an outcast. The suggestion here is that teenage depressive states and thoughts of suicide not only often *are* connected, but that they *should* be.

Social suicide can indeed have a life and death aspect if an individual is sufficiently depressed, troubled, or alienated. The point is not that adults and concerned peers should consider every reference to social suicide a red flag indicating serious underlying problems. However, they should not simply dismiss "social suicide" as a harmless, trendy phrase either.

Media Literacy, the Internet, and Suicide Prevention

The Internet's popularity and its capacity for providing users with large and readily accessible amounts of information about suicide have created a sense of urgency regarding the importance of educating youths about how best to use this resource. Adults, especially educators, who ignore or dismiss the pressing need for media literacy are short sighted. As Macedo and Steinberg (2006) have pointed out, "The same educators who reject the study of media literacy are the ones who have to cope with its effects" (p. 2). Media representations of suicide—both positive and negative—are an entrenched part of our culture and will remain so. Similarly, adolescence is and will continue to be a period of exploration and testing. Most young people are curious, and for many, that curiosity fuels a desire to explore topics that lie beyond acceptable, ordinary, and mainstream—including suicide. Given all the opportunities adolescents have for potentially dangerous explorations in cyberspace, we need to provide balance in what they discover and how they process it. Currently, only one in ten schools in the United States has in place any type of suicide prevention plan and significantly fewer have programs that are effective (Portner, 2000). Media literacy could provide a potentially useful intervention.

Teenagers are avid media consumers, but few are savvy about that consumption. Teaching students how to approach what they see, hear, and read with a critical, questioning attitude would be a good starting point for helping them deal more successfully with issues related to suicide. Adolescents armed with critical thinking skills are in a better position to identify potentially dangerous Web sites than those who wander naively from one link to the next. To be effective, though, the guidance adults offer adolescents must be both tailored to their needs and non-judgmental.

We can never know with certainty what caused an individual to take his or her life. In the case of adolescents, though, we do know that the sometimes-conflicting expectations of teachers and school administrators, community members, peers, and parents and other family members, along with each individual's own ideas and desires, can cause great and ever-expanding amounts of confusion. Meanwhile, school-based opportunities for airing concerns, asking questions, or finding new directions are shrinking. The current focus on test scores and "standards," coupled with cutbacks in counseling staff and school-based suicide

prevention programs, are rendering the social and emotional needs of students more and more inconsequential and are pushing these needs ever farther outside the scope of a general education. Thus, teens who are contending with pressures related to many different life circumstances must find their own answers—and many do so by turning to the Internet. If we, as adults, are to help make the lives and experiences of youths positive and rewarding, we need to assign their emotional and social needs the same weight as we give their academic needs. Our failure to do so makes us responsible for jeopardizing the very lives we purport to be dedicated to protecting. A crucial step in more fully shouldering our responsibilities is to help make adolescents more savvy consumers of all forms of media by arming them with the skills and basic information they need to succeed in sorting through and meeting the demands and dramas of their daily lives.

NOTES

1 See www.mouchette.org/suicide/answers.php3?cat=experience

2 See www.43things.com/things/view/31735

3 See www.a1b2c3.com/suilodge/

4 In order to comply with the written guidelines of the online chat forums, I am omitting the names of all forums and of those "posting" to the forums.

5 See www.churchofeuthanasia.org/

6 See ashbusstop.org/home.html

7 See www.suicidalwhirlpools.com/

8 See www.myspace.com/suicidebeautyqueen

9 See www.suicidegirls.com/

10 See www.explosm.net/

11 See www.cartoonstock.com/directory/c/commit_suicide.asp

12 See www.thebestpageintheuniverse.net/c.cgi?u=suicide

13 See www.paramountclassics.com/virginsuicides/html_3/

14 See www.suicidecity.com/

15 See groups at http://groups.myspace.com

REFERENCES

Alt.suicide.bus.stop. (2006). *What we are (and what we aren't)*. Retrieved June 10, 2006 from http://ash-busstop.org/AsbsIntro.html

CartoonStock. (2006). *Commit suicide cartoons*. Retrieved June 10, 2006 from http://www.cartoonstock.com/search.asp?x=a&keyword=jump&Category=Media&Boolean=Phrase&Artist=Not+Selected&submit=Search

Church of Euthanasia (2006). *Save the planet: Kill yourself*. Retrieved June 10, 2006 from www.churchofeuthanasia.org/

Dobson, R. (August 7, 1999). Internet sites may encourage suicide. *British Medical Journal Online*. Retrieved

June 20, 2006 from bmj.bmjjournals.com/cgi/content/full/319/7206/337 [Information came from *Psychiatric Bulletin* 1999; 23, 449–451]

Explosm. (2006). *Comics*. Retrieved June 10, 2006 from http://www.explosm.net/comics/771/

43 Things (2006) *What do you want to do with your life? Commit suicide*. Retrieved June 10, 2006 from http://www.43things.com/

Macedo, D., & Steinberg, S. R. (2006). *Handbook of critical media literacy: Call for chapters*. Unpublished document.

Mouchette.org. (2006). "What is the best way to commit suicide when you're under 13?" Retrieved June 10, 2006 from http://www.mouchette.org/

MySpace. (2006). *Cultures and community: Social suicide*. Retrieved June 10, 2006 from http://groups.myspace.com/index.cfm?fuseaction=groups.groupProfile&groupID=104164561&Mytoken=EBB0AF39–3DB4–4B57–8B97E786B0FFB94131998550

MySpace. (2006). *Suicide beauty queen of the week*. Retrieved June 10, 2006 from http://www.myspace.com/suicidebeautyqueen

Portner, J. (April 18, 2000). Suicide: Many schools fall short on prevention. *Education Week, 19*(32), 20–22. Retrieved June 10, 2006 from www.edweek.org/ew/articles/2000/04/19/32solution.h19.html?levelId=1000&levelId=1000.

Satcher, D. (1999). *Mental health: A report of the surgeon general—executive summary*. Rockville, MD: U.S. Department of Health and Human Services.

Steinberg, S. R., & Kincheloe, J. L. (April 1, 1998). Privileged and getting away with it: The cultural studies of white, middle-class youth. *Studies in the Literary Imagination*. Retrieved June 10, 2006 from http://findarticles.com/p/articles/mi_qa3822/is_199804/ai_n8796386/pg_1

Suicidal Whirlpools. (2006). *Music*. Retrieved June 10, 2006 from http://www.suicidalwhirlpools.com/home.htm

Suicide City. (2006). *Homepage* and *Biography*. Retrieved June 10, 2006 from http://www.suicidecity.com/home_iframe.htm

Suicide Girls. (2006). *Pics*. Retrieved June 10, 2006 from http://suicidegirls.com/pics/

Suicide Lodge (2006). *Suicide lodge*. Retrieved June 10, 2006 from www.a1b2c3.com/suilodge/

Thebestpageintheuniverse. (2006). *Suicide isn't so bad, give it a chance*. Retrieved June 10, 2006 from http://www.thebestpageintheuniverse.net/c.cgi?u=suicide

Virgin Suicides Homepage. (2000). Retrieved June 10, 2006 from http://www.paramountvantage.com/virginsuicides/html_3/index.html

CyBjörk: The Representations of Donna Haraway's *A Cyborg Manifesto* Within Björk's Music and Video

Eleonor Berry

Donna Haraway's "A Cyborg Manifesto: Science, Technology, and Socialist-Feminism in the Late Twentieth Century," is a postmodern feminist critique of the twentieth century's women's liberation movement (Haraway, 1991). Haraway frames her "ironic political myth" around the metaphor of the cyborg: "a cybernetic organism, a hybrid of machine and organism, a creature of social reality as well as a creature of fiction" (p. 149). The cyborg has long been a literary figure within contemporary science fiction, as well as a concept associated with modern western medicine. Most recently, it has become the underlying basis for cyber feminism, a branch of feminist theory that has grown out of Haraway's foundational work (Volkart, 2006). "A Cyborg Manifesto" has also been interpreted within other areas of academia, such as anthropology, bioethics, and cultural studies (Manoj & Azariah, 2001). Its application to popular culture exemplifies both the extensive and enduring relevance of Haraway's cyborg theory within contemporary western society. In the context of western mainstream music, the metaphor of the cyborg has not only survived beyond the dawn of the new millennium but thrives within the music and visual art of Björk Gudmundsdøttir.

Björk is the Icelandic musical icon who has been creating a mixture of pop and elec-

tronica music since the early 1990s. Her solo career began with the release of her 1993 album, *Debut*. With its release, Björk attained global recognition for her ability to create highly original, and non-traditional forms of music. Since *Debut*, her albums have become even more experimental and contradictory to the mainstream.

The link between Björk and Haraway's cyborg was first established within Charity Marsh and Melissa West's book chapter entitled, "The Nature/Technology Binary Opposition Dismantled in the Music of Madonna and Björk," published within René T. A. Lysloff and Leslie C. Gay Jr.'s edited book, *Music and Technoculture*. In their analysis, the authors set the foundation for the proceeding discussion of Björk's artistic expressions of Haraway's cyborg theory. Their chapter focused primarily on the musical production of Björk's 1997 album *Homogenic*, in which the disruption of the nature/technology binary was made readily apparent. As the authors suggested, in her successful blending of natural and electronic sounds within electronica, (traditionally been constructed as a masculine genre), and in her ability to retain her distinctively vibrant and soulful voice while doing so (associated with the feminine) Björk aligned her passion for electronica (coded as technology) with her Icelandic roots (coded as natural) (Marsh & West, 2003). In addition, Björk's characterization of *Homogenic* as *Icelandic techno* brought with it an even greater sense of originality: "The electronic beats are the rhythm, the heartbeat. The violins create the old-fashioned atmosphere, the colouring. *Homogenic* is Iceland, my native country, my home" (Björk as cited in van den Berg, 1997, n.p). By this account, Marsh and West's argument was further validated. However, what was also implied in this statement, that goes beyond such "dismantling" of binary opposition, was what came out of its wreckage: a musical form composed of dialectic parts, that was very much partial to Iceland (Haraway, 1991, pp. 149, 150), a country where "everything revolves around nature, 24 hours a day. Earthquakes, snowstorms, rain, ice, volcanic eruptions, geysers . . . Very elementary and uncontrollable. But at the other hand . . . incredibly modern . . . That contradiction is also on *Homogenic*" (Björk as cited in van den Berg, 1997, n.p.).

Marsh and West's (2003) analysis of Björk's disruption of boundaries, as well as their concluding reflections on the representation of Haraway's cyborg within the album art for *Homogenic* has helped to establish Björk's current residency within the cyborg world. However, the extension of this discussion to either *Homogenic's* lyrical contents or to its corresponding music videos remained unexplored in their chapter. Furthermore, due to the fact that Marsh and West's analysis preceded the release of both *Vespertine* and *Medúlla*, its discussion of Björk and Haraway ultimately fails to express the true depth of their connection.

In this chapter, I will analyze the multiple ways in which Björk's music and video express Haraway's metaphorical figure of the cyborg. Within her intentional "confusion of boundaries," (Haraway, 1991, p. 150), Björk challenges the very dichotomies of which Haraway centers her *Manifesto* around. As the feminist icon so accurately stated (1991, p. 177): "Certain dualisms have been persistent in Western traditions . . . self/other, mind/body, culture/nature, male/female, civilized/primitive, reality/appearance, whole/part . . . maker/ made . . . right/wrong . . . truth/illusion, total/partial, [and on p.154] animal/machine, private/public."

Björk addresses all of these within her musical compositions and visual representations.

The result of this resistance to such binary oppositions is the media image of a highly eccentric, non-categorizable Icelandic pop star, known around the world for her constant attempts to create new forms of unfettered and inspired artistic expression.

In the following analysis, Haraway's *Manifesto* will reveal itself within Björk's music and visual art. In *Homogenic's* album art and lyrics, the traditional boundaries between nature and technology, between the scientific and the organic, and between the masculine and the feminine are breached. The elements of irony, intimacy, opposition, and perversion, all of which characterize both the cyborg itself, and the world in which it exists are also revealed within this album.

In the music video for *Hunter*, Haraway's metaphor appears in Björk's embodiment of a human-animal-machine hybrid. This creature is also "resolutely committed to partiality, irony, intimacy, and perversity"; one who is faithful to a "post-gendered world," and one who is "oppositional, utopian and completely without innocence" (Haraway, pp.150–151).

In *Vespertine* one finds a graphic disruption of the binary oppositions of the private/public and adult/child. Björk's courage to open what mostly remains hidden, to reveal her pleasure in the dissolving of the traditional notions of gender, within the most intimate of settings, and to infuse an adult-centered album with child-like features are only some of the ways in which Haraway's *Manifesto* is expressed in this album. Lastly, in her most recent album, *Medúlla*, Björk isolates the discussion of gender, technology and nature to the realm of human-produced sound.

Although elements of the cyborg will undoubtedly be uncovered in this proceeding interpretation of Björk's artistic endeavors, the use of Haraway's *Manifesto* as my critical framework of analysis cannot adequately convey the complexity of either Björk's musical compositions or visual art. Inconsistencies within the following comparison are therefore not only possible but also expected. In light of this reality, I will also include a number of digressions into such contradictions, in an attempt to reframe them in a way that supports rather than contests Haraway's cyborg theory.

Homogenic's Album Art: Björk as a Cyborg in Metamorphosis

Before I proceed to the analysis of *Homogenic's* lyrics and to its corresponding music video for *Hunter*, I will briefly summarize Marsh and West's discussion of *Homogenic's* album art. This cover is, indeed, one of the clearest examples of Björk as a cyborg. Designed by Alexander McQueen, this album art is where Haraway's metaphorical figure materializes. Her creature is obviously expressed within this computer-graphic image of a morphed Björk, as a global cyborg—part human, part alien, and part machine, adorned with a multicultural signification:

> Her costume is a kimono, made of shiny silver and crimson red. The necklace elongates her neck, making her head seem as though it is not quite attached to her body. Her fingernails are longer than claws but perfectly manicured and polished. The hair is divided on her head into what looks

like two large satellite dishes. Her appearance subsumes representations of various cultures. Her dress associates her with the Orient, her necklace with Africa, and her hair with Asia. There is not one line on her face, and her eyes are black and silver. (Marsh & West, 2003, p. 195)

In this cyborg, one finds the blurring of a multitude of boundaries. She is not only a hybrid of organism and machine, but what is more, she is a creature that signifies cultural fusion. In this light, Haraway's conception of a post-gendered world is replaced in this instance by a cyborg living in a post-cultural world, a world in which cyborgs are shed of the socially constructed categories of race, ethnicity, and culture. However, rather than view this fusion as a metaphorical attempt at "organic wholeness through a final appropriation of all the powers of the parts into a higher unity" (Haraway, 1991, p. 150), as Marsh and West (2003) have described this image to be through their descriptor of "cultural synthesis" (p.195), I would argue that Björk's adornment reflects the cyborg's ironic connectedness, one in which "[cultural] contradictions . . . do not resolve into larger wholes" (Haraway, 1991, p. 149). Supporting this element of tension is also the state of metamorphosis in which this cyborg seems to be in, (Marsh & West, 2003, p. 195). Its process of transformation is, in fact, a visual expression of what *Homogenic* represented to Björk at the time: "I wanted *Homogenic* to reflect where I'm from, what I'm about. I wanted the beats to be almost distorted; imagine if there was Icelandic techno. Iceland is one of the youngest countries geographically; it's still in the making. So the sounds would be still in the making" (Micallef, 1997). This description of what is contained within the album, of distortion and unsettlement, is also revealed in its exterior album art.

The blurring of boundaries also resides in both the album cover's background and within its inside jacket. As Marsh and West (2003) have pointed out:

> The background is silver with little blue flowers. The flowers are representations of nature, whereas the silver alludes to the metallic and to the images of technology . . . Inside the jacket there also appears to be a microscopic vision of a living organism or plant. The shades are deep reds, like blood, and it appears fleshy. The image is fluid and organic, scientific and natural at the same time. (p. 195)

In this design, what is usually held in opposition is now placed side by side. The cover's blending of technology and nature signifiers, and the inner jacket's reversal of the private and public through the scientific gaze upon what naturally remains internal suggests the refusal to adhere to the dichotomies of traditional western thought. In total, Björk's *Homogenic* is about "the tension of holding incompatible things together because both or all are necessary and true" (Haraway, 1991, p. 149); it is an irony the cyborg both accepts and embraces.

CyBjörk: Haraway's Cyborg Takes Physical Shape

Some critics may be puzzled by the use of Haraway's abstract and invisible creature within the discussion of an actual physical image. However, although Haraway has described her creature as both "ether" and "quintessence," it does not preclude the possibility of using visual

representations as a way to represent the cyborg theory of her *Manifesto*. Just as the author uses the cyborg as a metaphor for her socialist-feminist critique of the women's liberation movement, so too can it be suggested that Björk uses an image of this creature in order to signify her resistance to the traditional boundaries within mainstream music.

This brief discussion of *Homogenic's* album cover has provided an ample starting point for the following analysis of Björk as a cyborg, or "CyBjörk." My proceeding discussion will concern the ways in which Björk proceeds within her artistic endeavors to incorporate Haraway's metaphorical figure of hybridity.

Images of Haraway's Cyborg within *Homogenic's* Lyrics

In the context of *Homogenic's* lyrics, CyBjörk loses its physical embodiment. However, it remains very much connected to Marsh and West's interpretation of the album art through, for example, its extension of their scientific/organic argument to *Bachelorette*, track four of the album.

In *Bachelorette*, the listener is introduced to this autonomous figure with the following imagery: "I'm a fountain of blood/ In the shape of a girl/ You're bird on the brim/ Hypnotized by the whirl/ Drink me—make me feel real/ Wet your beak in the stream/ The game we're playing is life/ Love's a two way dream."

In this opening verse, Björk is depicted as a "fountain of blood" that both provides the nourishment for, as well as is replenished by a (masculine) bird. Only in the cyborg world can such a combination of multiple opposing elements come together. The scientific and technological quality of the fountain of blood is positioned within an intimate relationship with a natural organism. There is a sense of Haraway's "perversion" within Björk's union of "blood" (human) and "bird" (animal), of the "fountain" (scientific) and the "beak" (natural), and ultimately of "life" (what is real) and a "two-way dream" (what is fiction). In each of these ways, the *Bachelorette* remains faithful to the *Manifesto*.

In both *Hunter* and *Pluto*, which are the opening and closing tracks of the album, respectively, Björk challenges the traditional notions of femininity. Within each song is an element of decisiveness, her choice to assume a position of authority in relation to the masculine other. As Haraway (1991) states, "To be feminized means to be made extremely vulnerable; able to be disassembled, reassembled, exploited . . . leading an existence that always borders on being obscene, out of place, and reducible to sex" (p. 166). Within the lyrics for *Hunter*, Björk's societal role as a woman is intimately related to her decision to reject it. The story behind the lyrics mirrors this experience of oppressiveness within the traditional sphere of womanhood—to its restriction to a sphere of vulnerability and subservience: "I guess that song's about when you have a lot of people that work for you and you sort-of have to write songs or people get unemployed, you know? In most cases, it's inspiring but in that particular song I was pissed off with it. I was ready for a break" (Björk as cited in Hemingway, 2002, n.p.). In this statement, Björk's responsibilities as a caregiver,

as person responsible for the well-being of the group, is an aspect of her role as a woman that can feel burdensome and consuming.

At this same moment in the song, Björk proceeds to leave, to be the hunter; and by doing so, disrupts the nature/culture binary of which Haraway (1991) speaks: "the cyborg defines a technological polls based partly on a revolution of social relations in the oikos, the household. Nature and culture are reworked; the one can no longer be the resource for appropriation or incorporation by the other" (p. 151). Björk has embraced her identity as a hunter and in doing so has expressed her dissatisfaction with the underlying obligations of what it means to be a woman in western society and mainstream music.

In *Pluto*, Björk concludes *Homogenic* with the ultimate retort to gender restrictions. This song is the final battle in Björk's "border war" (Haraway, 1991, p. 150). Its lyrics are brief, and its beats are more machine-like and militaristic in nature, than in any of the album's preceding tracks: "Excuse me/ But I just have to/ Explode/ /Explode this body/ Off me/ /I'll wake-up tomorrow/ /Brand new/ /A little bit tired/ But brand new."

This song can be interpreted in an infinite number of ways; Björk, herself, has explained it as " . . . that need to destroy everything so you can start over again. Having a lot in the planet Pluto, which I do, means you want to cut the crap, throw all the rubbish away. No extra baggage. It's death and birth" (Micallef, 1997, n.p.). If one combines the artist's references of "destruction," with "death and birth" then the "planet Pluto" looks a lot like the cyborg world. In this one verse, Haraway's (1991) description of the cyborg as being "oppositional, utopian and completely without innocence" (p. 151), shines through; through Björk's path of destruction, she will "wake-up tomorrow/ Brand new." Although I have limited my discussion of *Homogenic's* lyrics to only a number of its tracks, the arguments that I've just presented can also be found within *All Neon Like*, *All Is Full of Love*, and *Immature*.

Hunter the Video: CyBjörk as a Hybrid of Human-Animal-Machine

The cyborg appears in myth precisely where the boundary between human and animal is transgressed (Haraway, 1991, p. 152).

In the music video for *Hunter*, produced by Paul White in 1998, Björk reinforces her image as a cyborg. Her embodiment of a three-part hybrid, throughout the entirety of the video, arguably presents an even more powerful representation of the cyborg than what has been presented thus far. It transcends the static, entirely artificial image of Björk's location on the album cover, as well as adds a visual component to the song's aural medium. This visual is, in fact, a life-like computer manipulation of Björk's actual physical body. The production company behind the video "didn't want things to be hidden or faked or obscured. The magic and illusion are all the more powerful when it doesn't feel like it's being performed behind a veil of smoke and mirrors" (Hall, 1997). In a certain sense, the video brings to life this creature, which is part human, part animal, and part machine: CyBjörk is "a crea-

ture of social reality as well as a creature of fiction," it is both the medium and the message of the mainstream music's "world-changing fiction" (Haraway, 1991, p. 149). To investigate the *Hunter* video more closely, I will deconstruct the hybrid to reveal the components of the *Manifesto* within its parts.

If one focuses on the image of the human, outside of its role within the hybrid, a highly ambiguous figure is illuminated. This human is a post-gendered Björk. In her radically altered appearance, gender is problematized. She is effectively stripped of all possible gender signifiers, removing the socially assigned images of the feminine from her representation. Not only is she naked (as she is specifically filmed only from the neckline up, as to exclude the feminine signifier of her body) and hairless; but, as well, she is without clothing, jewelry, and make-up, all of which are also associated with femininity. She attempts to give her audience a problematic image of the gender binary without violating her inherited physical appearance. Her physical beauty, in this way, is nonconforming, (socially) provocative, and authentic. It is important to realize that in this act she is both resisting the social constructions of femininity, as well as embracing her essential physical beauty. Of interest, in and of itself, is the simple fact that she has to expend energy in order to shed these socially constructed signifiers.

In the presence of the polar bear, "the boundary between human and animal is thoroughly breached" (Haraway, 1991, p. 151). As Alistair Beattie, the production company's representative, stated:

> *Hunter* is a song about the two different states of the hunter and the gatherer. The bear symbolizes the hunter state, helping to polarize the difference between the hunter and gatherer, something really extreme and magical. Björk used the polar bear as a literal symbol of strength, ferocity, self-determination and the North, a pioneering roaming spirit. (Hall, 1997, n. p.)

This animal of the hybrid gives CyBjörk her strength and ferocity; her coupling with the bear, therefore, is a source of power.

The hybrid's machine is in the production process of this computer-generated polar bear. The decision to create this techno-bear signifies the movement away from naturalism. According to the production company, the video for *Hunter* had "more to do with the idea of the beating heart of technology . . . It's not photoreal; it's able to collapse itself and rebuild itself at will. We had no desire to make it naturalistic" (Hall, 1997, n. p.). The non-naturalist mode of its production is the very route through which Haraway attempts to contribute to social-feminist theory. In this shared interest, or rather lack of interest in the "natural," the bridge between Björk and Haraway is fortified.

Haraway's references to irony, intimacy, and perversity are all at play within this video. Intimacy is created through the minimalist approach taken in the creation of the video. In the constant and unwavering presentation of her flesh, in her allowance of the 'public' into this 'private' space, and through her relationship with the viewer that lasts throughout the length of the video, intimacy flourishes.

Irony, if one recalls, refers to "the tension of holding incompatible things together because both or all are necessary and true . . . about humor and serious play" (Haraway, 1991,

p. 149). In this video the tension between Björk and the polar bear is not resolved. The viewer is left with the feeling that, even though the bear has subsided, it is definitely not gone. Furthermore, there is undoubtedly a sense of playfulness throughout this video, specifically within the wide-range of CyBjörk's facial expressions. These include everything from (feminine) coyness, agitation, (child-like) shyness, (adult) concentration, (sexual) ecstasy, and (external, masculine) rage. The spectrum of gender and age signifiers in this collection reinforces Björk's embodiment of Haraway's cyborg.

Perversity can also be found here in the sense of *intentionality* that is felt within the video. The absence of any other form of visual or auditory stimuli magnifies the intention of keeping the viewer's fixed attention on the presentation of this cyborg, of this divergence from the ordinary. In *Hunter*, the presence of CyBjörk is difficult to ignore.

Vespertine: The Dismantling of Binaries

Vespertine and vespers are revelatory words that encompass botany, zoology, astronomy, spirit and the rhythms of the universe: a flower opening in the evening, an animal that becomes active after sunset, evening prayer, Venus the evening star, setting and dusk. Poetic words of contradictory multiple allusions: to love, to hunt, to pray, to withdraw into contemplation, to open out as night closes in. (Toop, 2001, n. p.)

As the title's description suggests, *Vespertine* exemplifies Haraway's dismantling of the private/public binary. The subsequent album to Björk's experimental and explosive *Homogenic*, *Vespertine* is a meditative album of intimacy and openness, introversion and self-expression, (Toop, 2001, n.p.). The traditional categories of masculinity and femininity are blurred within the union between the two, both figuratively and literally. *Vespertine* also disrupts the child/adult binary opposition, as it has been described as "an adult album, full of child-like joy, sparkling with the fragile sounds of harp, celesta, clavichord and music box" (Toop, 2001, n. p.).

This album is also about "humor and serious play" (Haraway, 1991, p. 149). Although *Vespertine's* sense of irony does not reflect Haraway's political dimension, it does signify the presence of such qualities within the cocoon that Björk creates within this album:

[*Vespertine* was] partly about creating a cocoon, almost like a paradise that you can escape to. Even though you know it's not true. You couldn't take this cocoon anywhere. It would burst in certain places. But you still believe in the right for it to exist, just because of the need for it for humans. That alone justifies it. (Toop, 2001, n. p.)

This cocoon's qualities of fragility, safety, escape, and necessity are intimately related throughout *Vespertine*; the sense of tension within this description is what gives this gentle album its pulse.

In the album's tenth track, *Heirloom*, the playfulness and fictional quality of the cyborg is magically illuminated in the opening two verses: "I have a recurrent dream/ Every time I lose my voice/ I swallow little glowing lights/ My mother and son baked for me// During

the night/ They do a trapeze walk/ Until they're in the sky/ Right above my bed// While I'm asleep/ My mother and son pour into me/ Warm glowing oil/ Into my wide open throat."

Björk locates herself in this song within a liminal state of being, one in which she finds herself moving both within and between the dream world and conscious reality. The imagery of warm glowing oil being poured down her throat at first seems both violent and intrusive, but because of the warm, ethereal, and dream-like mood that accompanies these lyrics, the sense of pleasure and rejuvenation is what is ultimately conveyed. In this description, Björk, like Haraway's cyborg is "a matter of both fiction and lived experience . . . a condensed image of both imagination and material reality" (pp. 149–150).

In, *Cocoon*, track two of the album, one finds the "emotional centerpiece" of *Vespertine* (Pytlik, 2003, p. 160). The song is a description of the intense pleasure felt by Björk within the most private of settings. The repetition of the verse: "from a mouth of a girl like me/ / To a boy," signifies the disruption of both the binaries of public/private and adult/child.

The boundaries between childhood and the adult-world are also blurred within *Frosti*, an instrumental piece created for and transmitted through a music box. The glacial, solitary atmosphere created through what is most often viewed as a child's toy reflects the simultaneous expression of contemplation and child-like wonder.

The dream world created in *Aurora* is also something that appeals to a child-like imagination. The vocal ensemble of Björk accompanied by an all-female Inuit choir created the magical and airy quality of this song in which Björk addresses the Nature goddess, Aurora. She pays tribute to this goddess during her lone trek along "the glacier head," and although this may at first appear to be strictly reverential in nature, her call to the goddess takes on a radically different form in Björk's expressed desire to merge with her: "to melt into you/ /Aurora." This is, as Björk sings, a plea to be rid of her suffering, possibly to escape her singular body. In *Aurora*, the boundary between the girl and the goddess is breached.

Vespertine's CyBjörk: Oppositional and Without Innocence

This album includes an extremely intimate depiction of heterosexuality, a gender construction that would be highly contestable within the cyborg world. However, Björk's lyrics about a sexual union between a man and a woman in *Cocoon* is neither with the intention of reinforcing such gender binaries nor does it mean that she is confined to traditional notions of femininity. Supporting these points is her openness in sharing this experience of sexual gratification with her audience. Within *Cocoon*, Haraway's "pleasure in the confusion of boundaries" becomes an embodied experience: "He slides inside/ Half awake / half asleep/ We faint back/ Into sleephood/ When I wake up/ The second time in his arms: gorgeousness!/ He's still inside me!"

In addition, within the song entitled *Sun in My Mouth*, Björk's startling allusion to masturbation is positioned within the fantasy-like imagery of burning flowers, sea-girls, darkness and the sun:

> I will wade out/ Till my thighs/ Are steeped/ In burning flowers// I will take the sun in my mouth/ And leap into/ The ripe air/ Alive: with closed eyes// To dash/ Against darkness// In the sleeping curves/ of my body// I shall enter/ Fingers/ Of smooth mastery// With chasteness/ Of sea-girls/ Will I complete the mystery/ Of my flesh/ Will I/ Complete/ The mystery// Of my flesh/ My flesh// la la la la la la la la la la la la la la.

Björk's resounding message of sexual liberation reinforces her resistance to the socially constructed categories of gender. Her opposition in this context is both whimsical and calculated.

The cyborg, according to Haraway, is both oppositional and without innocence. Therefore, the question remains whether or not the disruption of these binaries, of the private and public and of the adult and the child is indicative of an inherent innocence on the part of the singer. Although there is a very strong sense of playfulness and child-like spirit within Björk's music, it does not originate from an "innocent" nature but rather from a highly creative imagination—what may be an authentic and fundamental aspect of her musical persona, but it is also very much a strategically placed quality of her musical compositions.

Medúlla: Abandoning Traditional Notions of Music Through Human-Generated Sound

Lastly, in her most recent album, *Medúlla*, Björk's primary concern is to reveal the breadth and depth of emotion within the human voice, (Ross, 2004). Relying solely on its "myriad textures and timbres," *Medúlla* is, in fact, an attempt to get to the essence of human vocals (*Medúlla Biography*). Although this description may at first seem highly contradictory to Haraway's post-human organism, there are many ways in which this highly organic, earthy album speaks of the cyborg world. Once again, the artist blurs the boundaries between the natural and the technological but does so through the medium of human generated sounds. The musical collaboration behind this album includes human beat-boxers and Inuit throat singers, avant-garde rock and a cappella (Ross, 2004).

In *Medúlla*, Björk, once again, redefines the traditional boundaries both within and between musical genres through her abandonment of both instruments and electronic beats and through her highly unique musical ensemble. In addition, Haraway's post-gendered world is also what encompasses the album's process of musical production. Both the cyborg and Björk problematize gender within their respective realms, the former within the women's liberation front and the latter within her request for unrestricted and indefinable sound on the parts of her musicians.

In *Where Is the Line*, Björk creates a strong sense of this dynamic. Expressing a sense of combativeness, as well as the possibility of ensuing battle, her army is composed of laser-gun sounding shots, a haunting choral arrangement and a low underlying growl (Ross, 2004). A

battle on the music front, the clash between the natural and the unnatural, between the monotone and multi-tonal vocals, and between the technological and the ethereal is realized. There are many examples of naturally produced electronic sounds throughout the album. However, within this song in particular, the composition created is as contradictory as it is coherent.

Furthermore, Björk's abandonment of both instruments and electronic beats extends Marsh and West's (2003) discussion of the dismantling of the nature/technology binary to this musical space in which fluidity reigns and boundaries wane. In *Medúlla*, the nature/technology binary is challenged through Björk's blurring of the natural and the unnatural. By natural, I am referring, not only to what is produced by the human voice, but more specifically, to what is most normally expected from vocals within mainstream music. The musicians are asked to find new sounds, however non-human and noise-like they end up being.

Dispelling the Myth in *Medúlla*

In Haraway's metaphor, "the cyborg has no origin story in the Western sense . . . [it is] an ultimate self untied at last from all dependency" (Haraway, 1991, p. 9). This concept may seem problematic especially within *Medúlla's* collaborative nature and fundamental themes of origin and ancestry. However, Björk's album does not encompass the western humanist's "myth of original unity" or its "seductions of organic wholeness through the final appropriation of all the powers of the parts into a higher unity" (Haraway, 1991, p. 9). Although the album is a result of the collaboration of many musicians, it was most often out of a cooperation that was both dialectical and experimental in nature. In Björk's discussion of *Medúlla*, she reflects upon the many times when she requested from the group: pure human sound, anything that the body could evoke and in any way that the artist wish to express it (*Medúlla Biography*).

Another source criticism is within Haraway's description of the cyborg as neither "reverent" nor "remembering the cosmos" (*Medúlla Biography*). This interpretation may, again, seem to pose a problem to *Medúlla's* ancestral theme. However, because Björk is not interested in the suggestion of either a "garden of Eden" or a final return, the album should not be viewed as an expression of this western humanist sense of reverence. The sense of Haraway's cyborg as being "weary of holism and needy of connection" brings more meaning to *Medúlla's* sense of reverence (Haraway, 1991, p. 151). In both its summoning of forgotten ancestors and collaboration of contradictory sounds, the association with Björk and a higher Power falls within the light of the cyborg's need for partial connections. Its irony in the refusal to comply with a unified collective and the desire for connectedness is the way in which *Medúlla* finds itself within the cyborg world. Therefore, although this ancestral theme suggests a reverential quality to some of its tracks, it is also within the context of an album whose production encompasses an inherently complex web of tension: of a collective of sounds "untied at last from all [musical] dependencies" (Haraway, 1991, p. 151).

Concluding Remarks

"The relation between organism and machine [between Björk and the socially constructed norms within the music industry] has been a border war. The stakes of the border war have been the territories of [music] production, reproduction [of traditional dichotomies], and imagination [of an ontology that disrupts the social norms of gender, music, nature and technology]" (Haraway, 1991, p. 150). Björk's music and visual art can be thought of as this fictional and lived quest for a new frontier in mainstream music. In her combination of the natural and electronic, of the magical and methodological, Björk has undoubtedly breached many boundaries within her artistic pursuits. Therefore, in her future artistic endeavors exists the possibility of the CyBjörk resurfacing.

REFERENCES

Text Sources

Björk official Web site. (n.d.). Retrieved February 14, 2006, from http://www.bjork.com.

Hall, P. (1997). Bear with Me. *I.D. Magazine*, Nov. Retrieved on March 12, 2006 from http://unit.bjork.com/specials/gh/SUB-10/index.htm.

Haraway, D. (1991). A Cyborg Manifesto: Science, Technology, and Socialist-Feminism in the Late Twentieth Century. In *Simians, Cyborgs and Women: The Reinvention of Nature*. New York: Routledge, pp.149–181.

Hemingway, D. (2002, September). Björk. *Record Collector*. Retrieved April 20, 2006, from http://unit.bjork.com/specials/gh/SUB-10/index.htm.

Keen, C. (n.d.). *Carolyn Keen on Haraway, "Cyborg Manifesto."* Retrieved April 10, 2006, from http://www.english.upenn.edu/~jenglish/Courses/keen2.html.

Manoj, V.R., Azariah, J. (2001). Cybofree- Cyborgs, Fantasy, Reality, Ethics, and Education (FREE). *Eubios Journal of International Asian and International Bioethics*. New Zealand: Eubios Ethics Institute, 11:6, pp. 178–184.

Marsh, C., West, M. (2003). The Nature/Technology Binary Opposition Dismantled in the Music of Madonna and Björk. In R. T. A. Lysloff and L. C. Gay Jr. (eds.), *Music and Technoculture* (pp. 182–203). Middletown, Conn.: Wesleyan University Press.

Medúlla Biography. (n.d.). Retrieved April 20, 2006, from http://unit.bjork.com/specials/albums/medulla/medbio.htm.

Micallef, K. (1997, September). Home Is Where the Heart Is. *Raygun*. Retrieved March 20, 2006, from http://www.bjork.com/facts/about.

Penley, C., Ross, M. (1991). Cyborgs at Large: Interview with Donna Haraway. In C. Penley and A. Ross (Eds.), *Technoculture*. Minneapolis: University of Minnesota Press.

Pytlik, M. (2003). *Björk: Wow and flutter*. Toronto: ECW Press.

Ross, A. (2004, August, 23). Profiles: Björk's Saga. *The New Yorker*, 80:23, pp. 48–53, 55–59.

Toop, D. (2001). *Vespertine biography*. Retrieved April 8, 2006, from http://unit.bjork.com/specials/vespertine/pictures/vespbio/index.htm.

van den Berg, E. (1997, September). Homogenic is Iceland, my native country, my home. *Oor*, 18. Retrieved

March 20, 2006, from http://www.bjork.com/facts/about.

Volkart, Y. (2006). *The cyber feminist fantasy of the pleasure of the cyborg*. Retrieved April 22, 2006, from http://www.obn.org/reading_room/writings/down/cyberfem_fantasy.rtf.

Sound Recordings

Björk (Vocalist). (1993). *Debut* [CD]. 61468. Elektra Entertainment. New York, NY: USA.

Björk (Vocalist). (1997). *Homogenic* [CD]. 62061. Elektra Entertainment. New York, NY: USA.

Björk (Vocalist). (2004). *Medúlla* [CD]. 62984. Elektra Entertainment. New York, NY: USA.

Björk (Vocalist). (2001). *Vespertine* [CD]. 62653. Elektra Entertainment. New York, NY: USA.

Video Source

White, P. (Director). (1998). *Hunter* [Music Video]. Me Company. London: UK.

Visual Art

McQueen, A. (Art Director). (1997). *Homogenic* [Album Art]. London: UK

Croc This!

Articulating Young Feminine Identity Through Lacoste

Giuliana Cucinelli

Within these endless white walls, a piercing light creates an aura of intense illumination embracing the subtle rows of pastel tinted attire. I look up and notice a kaleidoscope of polo shirts strategically placed on the back wall. Making my way toward that oasis I arrive at a halt—something has caught my attention. A simple white purse, aesthetically pleasing and full of fashionista potential. The purse would perfectly complement my latest pair of DKNY shoes. They definitely lack comfort, but those four letters on my feet add a certain allure to my post-modern image. Diverting toward the women's accessory section I find myself standing anxiously in the midst of a consumerist ocean filled with small green crocodiles gazing at my wallet and toying with my emotions. Am I ready to be assailed by a crocodile that possesses such flare, style and status? Am I willing to view the world through this crocodile's gaze?

Welcome to a store that draws its audience by its signifier: a crocodile. A tiny green reptile that has signified class, gender, and race for well over half a century. A label that serves as a tool for women and men alike to construct a certain socio-economic image and pseudo-environment. The crocodile acts as shield protecting the authentic person from the rich and lavish cache s/he creates. Lacoste has stood the test of time and the ripples of the

ever-changing fashion realm, while maintaining true to its classic image, expensive textiles and mother of pearl buttons.

My interest in Lacoste sparked long before I spotted the white purse in the local boutique. I recall visiting my beloved chic grandfather in Italy during our summer vacations—hugging him, and always noticing that crocodile on his heart. My grandfather, with his black Alfa Romeo and seeping charm would settle for no other apparel, but the one that exhaled confidence and style. We sent a yearly holiday package to him that would include family photos, letters, cologne, and a Lacoste polo shirt—always classic colors, ranging from a spectrum of black, brown, beige, and blue. Any other color would be too risqué for a man in a remote town in central Italy. On a personal level, Lacoste signifies summer vacation, a day at the beach, a drive down the town's main road—fond memories of times well spent with family in Italy. On a universal platform, the same crocodile signifies so much more.

Think of this chapter as a tennis game. A highly anticipated match between the Lacoste crocodile and fashionable female teenagers. A game where the ball rebounds into the opponent's court with the same power that Lacoste apparel forces its way in the fashion realm. Powerhouse serves are exchanged between Lacoste and young women creating a game where few privileged participants are allowed to observe. With a mean flat serve, Lacoste tantalizes young females through trending clothes with stimulating color palettes and clever marketing strategies. In the Lacsote world, *Autumn Crocus* and *Rosewood* are more than a simple flower and timber—they are a color, an ideology, and a status. Add *Broom* and *Opium* to the mix and we have ourselves a sample of the finest dyed textiles that the croc offers. Let Lacoste's current slogan, *un peu d'air sur terre*, resonate in your mind as we explore this tennis match.

First and foremost, let us begin by exploring both participants. On one side, we have the crocodile—green with ferocious teeth, and crawling in at an inch and a quarter long and three-fourths of an inch high, and thirty-eight grams in weight, the Lacoste croc oozes with snobness. Its opponent, standing thinly at an average 5 foot 7 is a young petite female, barely visible on the court, but budding with style. Sporting a lollipop pink piqué polo the young female is ready for action. Clay court, audience watching, and bright yellow ball suspended in the air as we hold our breath. Will the croc crush its opponent? Or will the young female anticipate every move and strike back with a forceful forehand?

In a world where *mediashares* (see Alvermann, 2006) are omnipresent in our daily routines, it is important for young women to understand the crocodile, and its signifying magnitude. Teens and tweens alike deem the school hallways to be fashion catwalks—books and classrooms come secondary to shoes, handbags and skirts. This is where media literacy and media awareness must become as essential to them as the latest pair of tennis shoes. Within youth Lacoste builds on prior notions of elitism and snob culture and thrives on a platform that it has created over a past century. Clothes for adults, signifier of lifestyles for all ages!

Understanding Lacoste's role in female youth culture is about exploring its history, grappling with its past and understanding its pedagogy. From slick advertising campaigns to buzz marketing (see Hoechsmann, 2006) Lacoste crawls its way into youth culture and takes on

the form of an anchor for all fashionista neomaniacs. The outcome—a subculture of pseudo-preppy young women who play femininity. Each item of clothing fosters the ability to construct their image in various degrees of femininity. Purses signify delicacy, polo piqués showcase class, and the croc—all of the above and much more. As a result, friends, family and society inadvertently read the clothing as a means to categorize these individuals.

This chapter is divided into five sections: an introduction, three sets and the conclusion. In the first set we will examine the history of Lacoste through family, tennis, branding, economy, and sponsorships. The second set will explore the ways in which young women purchase femininity, status and sexuality in Lacoste boutiques. And the final set will answer to notions of Lacoste as a signifier of gender and class within the teen/tween community. Let the game begin!

Set 1: From Tennis to Preppy Pop

The legacy began with an elegant yet timid man named Jean René Lacoste who dominated the tennis game in the 1920's and 30's. With his elegant white polo and a powerful swing Jean René was famous for his ability to "never let go of his prey," earning his nickname *The Crocodile*. Having won seven Grand Slam singles titles, Jean René was inducted into the *International Tennis Hall of Fame* in 1976. He was the son of a wealthy automobile manufacturer, husband to Simone Thion de la Chaume, a French amateur golf champion, and father to Catherine Lacoste, a professional golfer and U.S. Open champion in 1967. The Lacoste family is a fine example of what one is able to achieve through perseverance, hard work and the luxury of wealth. In his determination to excel, Lacoste trained faithfully and read and observed everything, even keeping a notebook on the strengths and weaknesses of his contemporaries (International Tennis Hall of Fame, 2006).

The same athlete who stole the Davis Cup away from the Americans for the first time, in 1927, was also an inventor and industrialist. Jean René contributed more than the petit piqué polo to his humble admirers. He introduced to the world a better racket grip by using sticking plaster around his racket, and also invented a training machine capable of throwing balls to improve his smash technique. In 1963 he designed and produced the first steel racket, the T2000, and in 1974 he invented the "damper," located at the end of the racket shaft that absorbs vibrations while improving accuracy and increasing energy restitution (see Lacoste Story, 2006).

As the Germans appointed Adolf Hitler as chancellor, the Americans greeted Albert Einstein, and the French walked the streets of France in their new 1212 polo. The year was 1933—it marked a new beginning for the Lacoste dynasty. During that year Jean René and André Gillier, owner and chairman of France's largest knitwear manufacturing company at the time, formed a company and began the production and distribution of the first white "petit piqué" cotton polo, code-named the "1212." With the arrival of the polo, the fashion industry opened its arms to novel concepts of branding and consumerism. The piqué established the first time that a brand name appeared on the outside of an article of cloth-

ing (see Lacoste Story, 2006), a concept that has since revolutionized logos and semiotics in popular culture. The original crocodile drawing, by Robert George, depicted an aggressive, brown and large reptile. Since then the croc has been transformed into a delicate, smaller scaled green croc with a tiny red mouth and has taken the form of a global aesthetic commodity.

After Jean René passed away in 1996, his son Bernard Lacoste inherited the company and led it to a billion dollar international success. In the spring of 2006, Bernard resigned from the company due to health reasons and later died the same year. Michael, his brother, succeeded and was joined by newly appointed director, Frank Riboud in late June 2006. Riboud is the current Chairman and CEO, and works with a Board of Directors, composed of numerous siblings of the Lacoste family.

The early 70's served as a transformation period for the apparel company. An eccentric partnership was created with the purchasing of Lacoste by General Mills, combining with Izod. The outcome was cheaper versions of the first class polo shirts brazenly distributed at Wal-Mart and other low-end stores. What was then an affordable clothing item, selling at $35, has now become the hottest and most expensive polo shirt, selling at a whopping $98 for men and $115 for women.

Along with other world renowned logos, such as ponies, eagles, tacky acronyms and the over abundant family names, the crocodile arrives as a breath of fresh air—a zesty lime in a tall glass of bubbling Perrier that complements a side dish of caviar and truffle on buttered bread. Tasty, classy and sophisticated. The French apparel company has skewed fashion with fleeting trends and introduced its own subtle display of power. The vicious crocodile has transcended time and fashion statements.

Originally created for comfort on the tennis courts, he later became a businessman and set a standard for all polo shirts to follow. Fast-forward close to a century later, the same name dominates the court via sponsorship vehicle Andy Roddick. As ambassador for the totem for the next 5 years Roddick himself has set a standard for the game, ending the 2005 season as the N° 1 U.S. player and N° 3 worldwide. Where Roddick's game ends, Lacoste begins. This game though goes beyond love, deuces and the occasional ace.

Set Two: Femininity Anyone? The Sale of the Year!

This symbol of sophistication enters a realm where gender is courting with standards, and women are voluntarily vanishing. Attending these games is simple—reserve yourself a front row seat at the next boardroom meeting, attend any university lecture, walk by any high school or simply turn on the television set. Women of all ages who bear the Lacoste symbol of success have become what Umberto Eco calls a "the multiplication of the medium": Who is the mass medium? Who is sending the message? Who is the producer of this ideology? Where does the plan come from? Suddenly that white purse takes on a new meaning and I have fallen for a cultural artifact that exalts the answers to all these questions.

In Roland Barthes' world, the white purse would clearly connote a function beyond

ornamentation. For Barthes, clothes are seen as an everyday object, and for that reason should be examined in a social context. It is apparent in today's society that young women draw from Barthes' semiotic landscape, concepts such as *dress* and *dressing*:

> *Dressing* means the personal mode with which the wearer adopts (albeit badly) the dress that is proposed to them by their social group. It can have a morphological, psychological or circumstantial meaning, but not sociological. (Barthes, 9)
>
> *Dress* is the proper object of sociological and historical research, and we have already underlined the importance of the notion of vestimentary system.
>
> *Vestimentary System* includes:
>
> > Garments (forms, substance, formalized or ritualized colors, stereotyped acts of dressing, etc.)
> >
> > Systems or Arrangements (apparent global system, partial system forming a meaning, matching of items, dressing that is reconstituted artificially to create a meaning or for the use of a group, etc.)

If a young woman were to cross the path of Barthes sporting the simplicity of a piqué polo and dressed in lavish croc clothing, her *dressing* would only come second to her *dress*. *Dressing* for Lacoste women is the ability to wear the clothes and have no social connection—an impossible task with this apparel company. Lacoste is an excellent example of Barthes' term *dressing*—where the item of clothing takes on a social meaning. In this context, young women draw from the vast selection of clothing offered at a high monetary value. Through this selective process they are capable to articulate their femininity and compose an image with Lacoste's rich *dressing* repertoire, creating a relationship between the wearer and their desired social image/group.

Ironically, the croc also offers women the ability to choose to add a touch of masculinity with the privilege of a popped collar—connoting sportiness, aggressiveness and feminism. Here, women choose from skimpy tennis skirts to sporty running shoes, what they feel they want to articulate—something that is rarely accessible by other apparel companies. Lacoste's pedagogy is to stress femininity, but offer alternatives. In any case, if you forget about femininity for a fraction of a second, Lacoste will remind you that their perfume *Touch of Pink* is perfect for you,

> It is no accident that touch of pink meets the eye with the same spirit of feminine vitality it holds within. Lacoste's touch of pink is a fresh, fun, feminine attitude to life. No pretensions, just the captivating élan of a woman who is true to herself. Live your life and run after the things that make you happy: this is the spirit of touch of pink." (website)

Lacoste may be seen as a market driven quasi-feminist text, where there are two rigid definitions of feminism. One defines a woman as the prefect blond-haired blue-eyed white woman that fits in all the small sizes that the croc offers. The other is the average looking, tall, curvy woman that is considered overweight for the croc sizes and can only perform by purchasing accessories to express her interest in Lacoste. These shifting binaries offer hope for some young women, and despair for others. For the latter, purses and accessories serve

as their only connection to the trendy fashion of the croc. In this case, feminism may be seen as a method to grapple with Lacoste's predetermined standards and use alternatives to channel the same information through other items (purses, wallets, shoes, etc.). Here, the only issue is the fact that Lacoste tailors to a specific target (gender, demographic, race), and gives less valued options to the others, because after all, "It's true that behind each Lacoste shirt there's a real story, and believe me, it's sure to be a long one (Bernard Lacoste, Promotional Brochure). Too bad that no one wants to listen to the stories that the accessories articulate.

Within the finest green stitching of the croc emblem, lay an ideology set for young women to navigate with through their daily routines. Remember, there is no letter *f* in the name Lacoste, but there is a *c*—seen as non-other but in capital form. At first glance one might assume that feminism is non-existent in the croc world. Depictions of thin white women, incredibly petit clothing and an array of particular products selling only femininity. White purses that symbolize purity, lime athletic shoes that represent girlhood, and skimpy tennis dresses that promote sexuality. What would rock my world today, feeling like a sex object or a tomboy? These are choices. Throw in the popped collar as previously mentioned, and women have the luxury to chose their image and propagate their emotions. Lacoste provides women the opportunity to choose the extent of pinkness and chicness they want to exalt. The fact that young women have this opportunity is for them to be able to break away form the typical mundane cookie cut look of *being* and *playing* a woman. Ideals of empowerment and fluidity of feminism are instilled in the way Lacotse attributes their fashion spectrum, "allowing an unprecedented freedom of individuality and sexuality . . . women are expanding their horizons, breaking out of traditional roles, and changing society."(Rowe-Finbeiner, 2004) Women who accept the croc as a fashion statement and enforce a feminist perspective should critically use it as a means to shift attention from the totem to the social, political and global attributes it presents.

Set Three: Gender and Classi*fixation*

In our post-modern society clothes are more than merely textiles that embrace us. Clothing transcends textiles, buttons and zippers—they become as much about attire as they are about music, television, popular culture, mass media, and a lifestyle. Think of Lacoste as the 24-inch rims on a Champagne Cadillac Escalade, considered an accessory, but one worth splurging on. A regular hubcap serves the same purpose, but it is the status of the rim that attracts attention, as does the croc. Size, status and class are three words that lead the way for obsessing adults in their vocational and personal lives, these nouns have taken on different forms and spilled into youth culture disguised as apparel. Lacoste thrives on intertextuality and the croc means nothing without the fusion and influence of other texts. For example, the croc creeps up in the most unexpected of places. While perusing the multiplicity of channels or flipping through the latest issue of GQ, one may spot croc items used as a form of superfluous dissemination to lure a new wave of youth culture. This intertexulaity play takes the form of celebrities sporting Lacoste clothing in the mass media.

Lacoste embodies the essence of superiority and elitism, but what importance do these facts serve in the lives of teens/tweens who are already struggling with the everyday ball curves that society throws at them? The first word that most people associate with Lacoste is snobbery. For the sake of the next few paragraphs, let us define what snob culture is,

> Snobbery often entails taking a petty, superficial, or irrelevant distinction and, so to say, running with it. It is sitting in your BMW 740i and feeling quietly, assuredly better than the poor vulgarian (as you cannot help judging him) who pulls up next to you at the spotlight in his garish Cadillac . . . the snob can have one standard, that of comparison. (Epstein, 2002)

For people caught up in the trendy life, as most Lacoste go-getters are, many ignore the apparent lack of gender, class and race in its advertising campaigns. Take for example, Lacoste's latest print advertisements (Autumn-Winter 2006–2007), composed only of white male and female models. Unlike the multi-colored textiles used to depict seasonal flavors (Black, Mother of Pearl, Torch, Waters, Freesia, Salmon, etc.), the monochromatic scheme of the models' skin tone leaves much to be desired. It is as though Lacoste is trying to convey a form of Aryan perfection to which few people can aspire. Catering to the bourgeois ideology, offering nevertheless a glimmer of conformist hope to the proletariat through the overpriced yet affordable one-size-fits-all accessories.

> The trends are broad and seemingly contradictory: the blurring of the landscape of class and the simultaneous hardening of certain class lines; the rise in standards of living while most people remain moored in their relative places (Scott, Leonhardt, 2005).

This form of conscious opulence procures an insatiable need for a materialistic linkage between reality and croc-reality. It is our innate desire to fit within the social standings of fabricated perfection that can only exist through branding. A reality constructed as a form of hegemonic control over our overbearing and mundane lives.

Conclusion

As we think of the sheer influence and rich history exerted by the Lacoste dynasty, let us reflect on the ethos of Bernard Lacoste's philosophy,

> And it is not by chance that in France and Japan, in Spain and Korea, in Australia and Argentina, in the United States and Brazil, Canada and now also in Thailand, all our partners speak one and the same language; the language of the crocodile. (Bernard Lacoste brochure)

As this tennis match comes to an end, the winner is not evident. Both participants leave the court with a sense of victory, but none come out victorious. In the end, this is the world of the croc. And in this world, it's not whether you win or lose, but about how you look as you are playing the game. Game, set, match!

WORKS CITED

Alvermann, D. (2005). *Adolescents and Literacies in a Digital World.* Peter Lang Publishing, New York.

Barthes, Roland. (2004). *The Language of Fashion.* Berg Publishing, Oxford.

Epstein, J. (2002). *Snobbery: The American Version*. Houghton Mifflin Company, New York.

Hoechsmann, M. (2006). Cool Buzz Marketing. *The Gazette*. [local ed.], p.F22.

International Tennis Hall of Fame. (2006). Retrieved August 18, 2006, from http://www.tennisfame.com/famer.aspx?pgID=867&hof_id=179

"Lacoste Story" (2006,August, 1st). Retrieved August 18, 2006, from http://www.lacotse.com.

Lacoste Advertising Material

 1933.Premiere esquisse de la chemise Lacoste. (Fall-Winter 2005)

 Un peu d'air sur terre. (Fall-Winter 2005/2006)

 Un peu d'air sur terre (Spring-Summer 2006)

 Lacoste Spring Summer Collection (2004)

 Lacoste Spring Summer (2005)

Rowe-Finkbeiner, K. (2004). *The F Word: Feminism in Jeopardy*. Seal Press Publishing, Emeryville.

Scott, J. and Leonhardt, D. (2005). *Shadowy Lines That Still Divide*. Class Matters. Times Books, New York.

Touch of Pink. (2006). Retrieved September 22, 2006, from http://www.lacostepink.com/index.php.

Call Center Job Advertisements in India

Papia Raj

Call centers appear high on the list of service industry jobs that have been outsourced and relocated to India since 1998. Call centers, because they are labor intensive by default, have emerged as one of the major job providers in New Delhi and its surroundings. They are favored destinations for outsourcing services. Conditions of employment in Indian call centers are unique. Because of the differences in the time zones across the globe, employees are required to work at night to accommodate the needs of their European and North American customers. Employees are expected, and trained, to acquire an accent common to the country for which they are working and to adopt English language pseudonyms to put their customers at ease. Despite such labor expectations, these call centers have succeeded to attract a large pool of young adults to join the work force. Advertisements in daily newspapers are the main source of drawing potential employees to call centers in addition to personal contacts. Through advertisements, call centers promise handsome salaries and a fun-filled work atmosphere that attracts a lot of young adults to this service industry. Based on content analyses of printed advertisements for call center jobs, I argue here that these advertisements are means that acculturate Indian young adults to western culture, thus enticing them to join a profession where they can enjoy a western lifestyle.

An analysis of printed call center advertisements from the English newspaper *Times of India* (the most widely read daily English newspaper in New Delhi) from 2000 until 2005 was undertaken. A total of 1208 advertisements were analyzed using content analysis (see Fairclough, 1995; Berg, 2004). The *Times of India* was chosen for several reasons. A preliminary analysis of different English language newspapers in New Delhi revealed that the frequency of call center advertisements was the highest in the *Times of India*. Second, interviews with call center employers showed that they preferred to publish advertisements in the *Times of India* primarily because of its wide audience. This impression was confirmed during my interviews with call center agents, who stated they mainly searched the *Times of India* for call center job advertisements.

Advertisements for Call Center Jobs

The number of call center job advertisements has increased at an exponential rate since 2000. In the year 2000, there were fewer than ten advertisements per month for call center jobs, but the number increased to more than 129 per month by 2005. About 90 percent of the jobs advertised are for customer care executives (commonly called call center agents). The number of vacancies for such jobs in one call center varies between ten and 250 depending on the size of the call center. The required qualifications of potential employees are clearly defined in that advertisers target the age group between 18 and 35, with an educational qualification of either a completed high school degree or enrollment in an undergraduate program, and prospective employees should possess "communication skills."

Since 2004 the call center advertisements have attracted young adults by portraying a fun-filled and entertaining work environment. Hence, these advertisements have also undergone modifications in their appearance mainly in terms of using photographs, graphics, colors, and captions that are not in accordance with mainstream Indian culture. In 2000 all the call center advertisements were black and white with no pictures and only text as shown in Figure 1.

Figure 1. *Times of India*, October 18, 2000

INTL. CALL CENTRE

Needs graduate Boys/Girls below 25 yrs with 0-3 yrs work exposure+basic computer knowledge+impeccable English communication. Excellent Salary, Perk, Transport facility.

DYNAMIC PERSONNEL

J-11, Mini Mkt, Alaknanda Shopping Comp., Kalkaji, N.D-19
Tel. 6219835, 6433246, 6433248

By 2005 around 25 percent of the call center job advertisements had pictures and other visual art form. Moreover, these advertisements have become very colorful and bright, easily attracting the attention of the reader. The types of pictures used in these advertisements have also undergone incredible change. For example, conventionally in 2002, such advertisements featured photographs of women wearing a telephone headset (typical of the call center job). By 2005 the pictures in the advertisements were totally detached and decontexualized from the nature of call center work, as well as the location of such jobs (see Figure 2). The subsequent discussion illuminates the trend in call center job advertisements.

Figure 2. *Times of India*, February 23, 2005

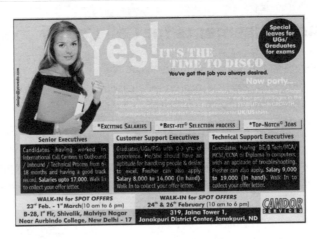

Recent Trends in Call Center Job Advertisements

A common stylistic aspect of recent call center advertisements is to disguise the real purpose of these ads in catchy titles, statements, and metaphors, focusing instead on potential lifestyle changes and individual rewards of prospective employees (see Figure 3). Only when one reads the finer print does the purpose of the advertisement reveal itself. This form of advertisement gives a clear indication that in call centers lifestyle practices have a greater priority than the actual job, which is often described in small fonts in the advertisements.

An analysis of these advertisements shows that they feature three important characteristics. First, they target a specific subgroup of the population, namely urban young adults. Especially the physical appearance and clothing of the people in the advertisements illustrate this point. Second, the advertisements depict the job as a very successful career option with promises of a high salary and various other incentives. Third, they promise the potential agents a distinct type of western lifestyle as highlighted in specific activities and images of certain items suggesting wealth.

Figure 3. *Times of India*, January 19, 2005

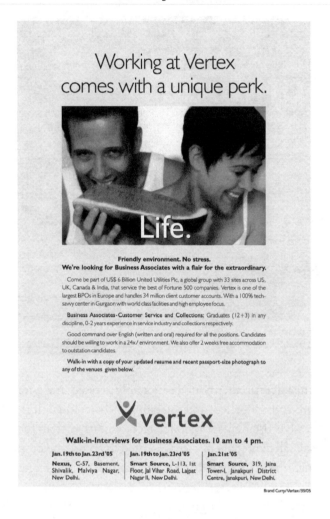

Creating the Call Center Agent Image

One thousand two hundred and eight advertisements were examined, 350 of which had pictures. All of these depicted gender-balanced young, content, "vibrant" people dressed in western attire, who look like college students between the ages of twenty and thirty (see Figure 4). Surprisingly, given the target audience, none of these advertisements feature an Indian face. Rather they portray a multi-ethnic community many of whom suggest western, Black African, or East Asian background. This depiction indicates a de-contextualization of the job alluding that once they join the call center, they would be working in an international environment with multi-ethnic co-workers comparable to offices in western countries.

Figure 4. *Times of India*, November 10, 2004

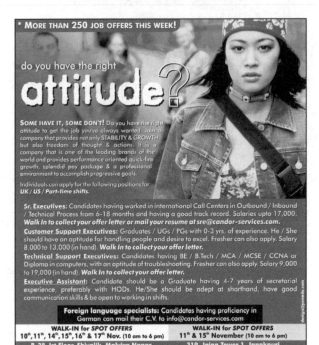

The people in the advertisements are fashionably dressed in western attire; their hair-dos are modern, punk-style or gelled, and the hair may be colored. Indeed, such advertise-ments suggest to be advertisements for model agencies rather than for call centers. Thus, the typical, potential call center agent is represented as an urban youth who is intelligent, outgoing, fashionable, fun-loving, and ready to be a part of the larger youth community across the globe.

I argue that the total absence of Indian faces in the advertisements communicates that once young Indians join the call center industry as agents, they are no longer Indian—at least during working hours. In addition, the multi-ethnic representations are a subtle way of conveying that no special preference is given to applicants based on social criteria such as caste, and everyone is encouraged to apply.[1] The global nature of the call center agents is not only portrayed via the presence of multi-ethnic people, though, in that many of these advertisements contain symbols of the global nature of the work. World maps, clocks show-ing different time zones, various country flags, people tossing the globe on a fingertip, and captions such as "world citizen," all stress this dimension.

Call Center Job as a Career Option

The call center job advertisements do not merely outline the expectations and requirements of the potential agents but also lure them to a fun-filled and entertaining work environ-

ment: work, have fun, and learn culture—all with handsome salaries. The attractive salary package is one of the main motivations for joining a call center. On average the salary packages specified in the advertisements are between Rs. 8000 and Rs. 15,000 (US$ ~ 173 and 325). Usually the salary appears in big and bold fonts in the advertisements. In fact, in many of the advertisements, indeed in 30 percent, the salary is the main theme. Other monetary incentives like "daily sales incentives" are also mentioned in some advertisements. Some other perks promised by call centers advertisements include, "pick up and drop facilities" (35 percent of the advertisements), "free meals" (20 percent), and one advertisement even offered "free/subsidized accommodation."

Often the advertisements paint the call center job as a very successful career option, a "shortcut to success," with a friendly work atmosphere. The job is also presented as being very challenging and competitive with captions such as "some rides are not for the faint at heart," or "talent search." These comments and captions are always highlighted and appear in very colorful and large fonts. Intriguingly, every advertisement from 2004 onward contained the word *fun*, be it related with the nature of the job or the work atmosphere in the call centers. This kind of language is one way to attract young adults to join the industry by giving the impression that a call center is a "cool" place to be. Moreover, an overwhelming majority of the advertisements related the job as the possible realization of applicants' dreams with remarks like "dream job," "live your dream," and so on. The desirability of the job is highlighted in the advertisements with catch phrases such as "your prayer has been answered." In other words, some advertisements appeal to the young people's religious values and encourage them toward coolness or a pleasant conspiracy "shhh . . . keep it a secret," indicating that the advertised position is a rare opportunity available only to select few (see Figure 5). Overall call center jobs are advertised as possible turning points in a person's life with a handsome salary and other appealing incentives.

Figure 5. *Times of India*, March 2, 2005

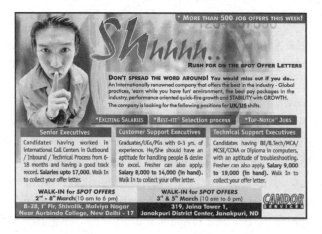

Advertising Lifestyles or Advertising Jobs?

The call center advertisements entice young adults to long for the western lifestyle they might enjoy if they are offered a position. Such promises are illustrated in the advertisements through activities, as well as a number of objects and symbols. Some of the most prominent themes highlighted in these advertisements are monetary gain, glamorous western leisure activities, and socialization with peers. The promise of rewarding salaries is accentuated in part by expressing monetary benefits in American dollar signs rather than Indian *rupees* (see Figure 6) (45 rupees are about the same as one U.S. dollar). Perhaps this is an effort to suggest that, although the salary will be in rupees, it will certainly be much higher than most Indian salaries and one will thus feel as if one is earning American dollars.

Apart from the direct monetary benefits, eight percent of the advertisements also portrayed other wealth indicators such as expensive luxury items, including high quality western perfumes, iPods, and trips to western-style health spas.

Figure 6 *Times of India*, March 30, 2005

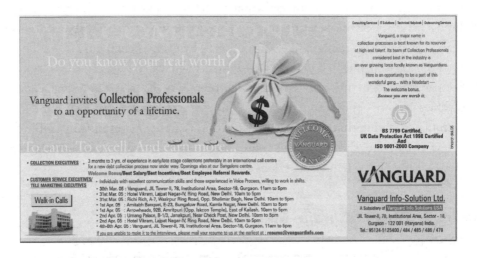

Though I found a gender balance in the visual images of the advertisements with 37 percent of the advertisements showing pictures of only men, 48 percent of only women, and the other 15 percent of both genders, there is a stark contrast in the ways they attempt to attract men and women. Compare Figure 7, a typical picture in which men are represented as successfully racing to join and be part of a competitive career (23 percent of the pictures with men were represented as such), with Figures 4 and 8 in which women pursue leisure activities (24 percent of women in the advertisements).

Earlier studies on advertisements in India have highlighted that the role of women as depicted in advertisements was changing, stating that women were now often represented as ambitious, career oriented, and empowered (Birch, Schirato, & Srivastava, 2001; Chaudhuri, 2001; Mazzarella, 2003). In contrast, though, the call center advertisements

symbolized women as anything but career driven. This characterization can be explained by the fact that in India urban unmarried women consider call center employment as a short-term, fun-filled opportunity, a job they might quit after marriage.

Figure 7. *Times of India,* February 2, 2005

Figure 8. *Times of India,* February 9, 2005

These advertisements are multi-colored in the newspapers, often in florescent shades, and they commonly depict a party atmosphere (see Figure 9). An aura of discotheques and clubs prevails, with as many as 23 percent of the advertisements illustrating groups of young people enjoying themselves or looking ready to party, conveying the message that a call center is a "fun place to be."

Figure 9. *Times of India,* February 16, 2005

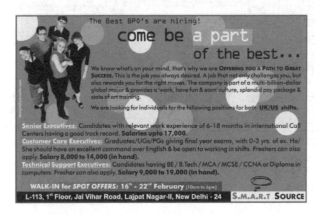

Moreover, the clothes of the young people shown are more casual and party-like than professional attire. In 75 percent of the advertisements people are shown wearing trendy western clothes, whereas only in 25 percent of the advertisements are they shown with western professional attire. Unquestionably, in the vast majority of the advertisements, the work is associated with enjoyment rather than professionalism. The playful and fun-filled atmosphere of the call centers is reemphasized with phrases in advertisement captions such as "It's the time to disco," "Walk, talk, rock," "Freedom to live your dreams," and "Not night shifts, just night outs" (see Figure 10). Indeed, we have the representation here of a lifestyle where clubbing and partying are very common—a specific subculture attracting young people who want to enjoy life.

As noted above, 15 percent of the advertisements show young people in mixed gender groups. Call centers are portrayed as friendly places with a liberal work atmosphere and opportunities to interact and make friends with members of the opposite sex (such as in Figures 3, 9, and 10), potentially even finding a partner. The physical intimacy between the sexes, quite contrary to mainstream Indian societal norms, is thus notable in these advertisements. Indeed, the majority of the advertisements explicitly mention mixed social opportunities being encouraged in the call centers. Such behavioral patterns encourage and legitimize certain values among call center agents and create a type of socialization, which otherwise would not be possible.

Figure 10. *Times of India,* **November 24, 2004**

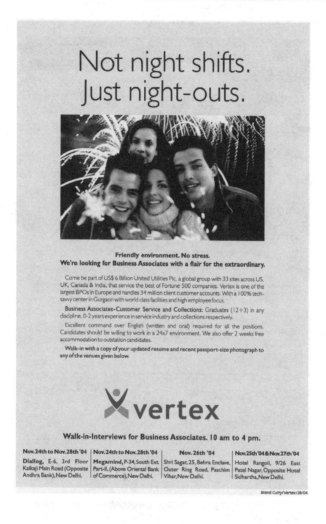

Sports, mainly those common to western countries, such as white water rafting (see Figure 11), beach volleyball, snooker, biking, and snow boarding are another common theme of these advertisements (shown in 17 percent). Some of the advertisements feature still other lifestyle patterns, for instance, women undergoing spa therapy. As such, all these advertisements speak to a specific lifestyle, indicating that it is accessible only to those who can find access to the upper middle class in India and that it is more common in western societies than in traditional Indian society. In direct comparison, it was found that less than one percent (eleven of 1,208) of all the advertisements analyzed, actually featured pictures of men and women working as call center agents. Thus, these advertisements attract young adults by enticing them to a work situation that seems to be more fun than work, a place with lively activities to keep them entertained and amused while at the same time promising a lucrative income. Hence, these advertisements are channels of acculturation to western culture and lifestyle practices.

Figure 11. *Times of India*, November 3, 2004

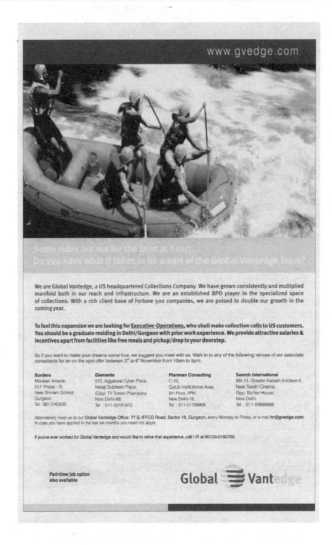

Discussion and Conclusion

The call center industry has made steady progress in gaining a significant position among the major job providers in the environs of New Delhi. The change in the frequency of advertisements, which have increased in an exponential rate between 2000 and 2005, is a clear indication of the growing importance of the industry. People are now more aware of the availability of call center jobs. These advertisements not only publicize job opportunities in call centers but simultaneously educate people about such job options. While in early 2000 such advertisements would comprise a negligible proportion of the newspaper, by 2005 they formed one of the leaders of advertisements, occupying as much as 85 percent of the classified section for job advertisements.

It has been noticed that in a constant effort to motivate young adults to join this type of work, the variety of the advertisements has witnessed changes. Callaghan and Thompson (2002) in their study of call centers in Western Europe suggest that the work of call center agents demands them to be continually energetic and enthusiastic, and this expectation also applies to these types of positions in India as is evident from the advertisements for such jobs. The colorful and flashy advertisements highlight the fun-filled work atmosphere with numerous incentives, including a striking monthly salary. The captions appear in bold and are highlighted in order to capture the immediate attention of the reader.

Aneesh (2006) in his discussion of recruitment strategies for multinational companies in India states that through advertisements the companies use "fantasy as a recruitment strategy" (p. 52). My analysis of call center advertisements suggests a similar situation. In sum, the call center advertisements attract young adults by enticing them to consider a work situation that is really "more fun than work," where they have the opportunity to dress in western clothes, share western tastes in leisure and sporting activities, meet potential partners, and hang out in western style nightspots. These advertisements present prospective call center agents with the image of global youth. This group is most malleable as they are in a phase of transition in terms of career and still "shopping" for their identity. As such, call center job advertisements are the powerful first step toward the acculturation of call center employees to specific western cultures and lifestyle practices. Through these advertisements two closely intertwined processes are operating simultaneously, namely acculturation of western culture and deculturation of traditional Indian culture. The call center agents no longer perceive themselves as typical Indian youths but instead prefer to be identified as part of the global youth community (personal communication, 21 December 2004; Kjeldgaard, 2003). It could thus be argued that these agents fit into the category of "peripheral youth" in that the young people are encouraged to model themselves on and acquire characteristics of their counterparts in western countries who form the "image bank" of the former (Beng-Huat, 2000; Pilkington & Johnson, 2003). These images are conveyed not only by the general media in urban India but specifically in the advertisements for call center jobs. It can hence be concluded that call centers present a decontexualized picture of the work situation through the various advertisements which mainly showcase multi-ethnic youths dressed in trendy western clothes, pursuing western leisure activities, and promoting a western lifestyle that is desirable to urban Indian youths. These advertisements cumulatively add important dimensions to this acculturation process and encourage Indian urban youths to consider a career option filled with possibilities of enjoying western lifestyle practices while living in India.

NOTE

1 In India "a major section of the backward classes have been specified in the constitution as scheduled castes (SC) and scheduled tribes (ST) because their backwardness is patent. There is no definition of SC and ST in the constitution itself. But the President is empowered to draw up the list in consultation with the Governor of each state, subject to revision by Parliament" (Basu, 1960, pp. 314–315). According to reservation policies, in public sector offices certain numbers of jobs are reserved for SCs and STs. However, this rule does not apply to call centers, as these are private sector enterprises.

REFERENCES

Aneesh, A. (2006). *Virtual migration: The programming of globalization*. Durham: Duke University Press.

Basu, D. D. (1960). *Introduction to the constitution of India*. Calcutta: S. C. Sarker & Sons Pvt. Ltd.

Beng-Huat, C. (2000). Consuming Asians: Ideas and issues. In C. Beng-Huat (Ed.), *Consumption in Asia: Lifestyles and identities* (pp. 1–34). New York: Routledge.

Berg, B. L. (2004). *Qualitative research methods*. Boston: Pearson.

Birch, D., Schirato, T., & Srivastava, S. (2001). Gender and sexuality. In *Asia: Cultural politics in the global age* (pp. 126–161). New York: Palgrave.

Callaghan, G., & Thompson, P. (2002). We recruit attitude: The selection and shaping of routine call centre labour. *Journal of Management Studies*, 39(2), 223–254.

Chaudhuri, M. (2001). Gender and advertisements: The rhetoric of globalization. *Women's Studies International Forum*, 24(3/4), 373–385.

Fairclough, N. (1995). *Media discourse*. London: Edward Arnold.

Kjeldgaard, D. (2003). Youth identities in the global cultural economies. *European Journal of Cultural Studies*, 6(3), 285–304.

Mazzarella, W. (2003). *Shoving smoke: Advertising and globalization in contemporary India*. New York: Oxford.

Pilkington, H., & Johnson, R. (2003). Peripheral youth: Relations of identity and power in global/local context. *European Journal of Cultural Studies*, 6(3), 259–285.

Part Three

Media
Literacy
and Pedagogy

The Need for Critical Media Literacy in Teacher Education Core Curricula

Myriam N. Torres and Maria D. Mercado

The information era has brought about new literacies, although most of them are neither part of the K-12 curriculum nor part of the teacher education curriculum. One of these new literacies is critical media literacy. The purpose of this chapter is to document the urgency for including this new literacy in school and teacher education curricula given the crucial role of media as they touch every aspect of human life. Critical media literacy as understood here includes three dimensions:

1 The development of a critical understanding of how corporate for-profit media work, driven by their political and economic vested interests
2 The search for and support of alternative, non-profit media
3 The characterization of the role of teachers in helping students and their parents to become media literate users and supporters of alternative media.

Critical media literacy is founded on the legitimate role of media to serve the public's right to be truly informed, and thereby serve democracy. However, currently we are witnessing an unprecedented concentration of for-profit media into conglomerates, in alliance with the government and especially with the federal regulating agency, the Federal

Communications Commission, and other powerful institutions and corporations. Starting with this big picture, we examine and document specific cases that illustrate how these conglomerates and their allies work to keep and expand their power, by means of filtering information, manufacturing consent, controlling what all of us watch, listen to, read, think, believe, taste, dress, look like, speak, and how we perceive ourselves. The propaganda behind the banning of bilingual education in California is a clear example in the educational arena of the role of media in helping powerful people to manufacture voters' consent through fabricated stories, misleading ballot questions, biased polls, and so on. The second dimension of critical media literacy refers to the active involvement of every person, including school children, to support and advocate for alternative, non-profit, public-service-driven media. Given the reasons and the evidence presented, the authors consider that there is an urgency for including Critical Media Literacy in the K-12 school curricula and, therefore, in the teacher education core curriculum.

Mass Media and Multiple Literacies

"A picture is worth a thousand words." It is commonplace to extol the power of images and to contrast it with the power of words. Unlike words, images encode many messages into the viewers' brains and hearts without them being aware of it. Oftentimes images are accompanied by sounds and other powerful signs and symbols that add to the impact of the message.

We argue that in an "era of information," it is of utmost importance and necessity for everybody to understand how media work in terms of management of information, advertising, and entertainment. Everybody, even a child, knows that the goal of propaganda is to influence the behavior and thinking of the people targeted, toward a subject, product, or object. The truth is that such propaganda works; otherwise it would not be a profitable business. Propaganda strategies are not the exclusive domain of the advertising industry, but they are part of the content of all media programs, including the news industry. Aggressive propaganda by governmental agencies to promote their policies using taxpayers' money has been documented and published by both corporate liberal media such as the *New York Times* (Barstow & Stein, 2005) and also by independent media such as Democracy Now (Stauber, 2005). The federal policy on education, The No Child Left Behind Act of 2002, is one of those. This news erupted (Rendall, 2005) and stayed in the news for a couple of weeks; then it vanished without any conclusive response to the charges.

We frame our chapter within the area of new literacies, which, according to Lankshear and Knobel (2003), implies two things:

a) *new forms* of literacy based on new digital electronic technologies, e.g., critical media literacy;

b) the *new literacies* as new ways of looking at literacy.

The latter are in contrast to the old ways of considering literacy as based on a psychological or technological paradigm. These authors point out that some literacies are not

included in the school curriculum, even though they impact everybody's lives. We argue that critical media literacy is one of them. Literacy as understood in this chapter concurs with the foundations of literacy developed and tested by Paulo Freire (1992, 1994), and Freire and Macedo (1987), when they state that an educated person should be prepared to "read the word and the world."

It is important to clarify here that we are not against mass media communications *per se*. We are concerned with the use and abuse of the power of the media to control masses of people, especially children, for the profit of those who own those media and their political allies. We recognize that with the arrival of electronic media and other technologies including the Internet, communication in general has been facilitated immensely. Nonetheless, as Sholle and Denski (1995) put it, these developments present a paradox. On the one hand, these technological advancements have great potential to enhance communication and thereby human liberation, but on the other hand, these same technologies have been trapped within the capitalist rationality that has also facilitated sophisticated strategies of domination and control.

How Media Work in the Sociopolitical Context: The Big Picture

We believe that it is important to examine the sociopolitical scene in which we live, as well as the role that the media play in order to understand the latest regressive measures and policies in education. As educators we should be dealing with the extraordinary power that media are currently displaying as adjuncts of government for implementing any type of policy that systematically favors the wealthy corporate agenda and right-wing vision of the world. Monbiot (2005) calls this phenomenon of the corporate U.S. media a "televisual fairyland." However, as Matursewicz (2003) indicates, there is a certain indifference among many well-educated people toward examining the macro sociopolitical dynamics of media in order to understand the complexity of the governmental educational policies we are facing now.

Public Interest vs. Profit Interest

The distinction between public-interest and for-profit interest driven media is central to critical media literacy. However, this does not imply that these two basic types of media are monolithic in themselves. Each type may have varying degrees of independence from special interests or, in the case of corporate media, varying degrees of commitment to their own vested interests (economic, political, and so on). At any rate, radio and TV broadcasting use airwaves, which are a public good and hence should be used for the public interest. The basic purpose of getting a license for using the public airwaves is to serve the public through information, entertainment, and other cultural programs. This is the *raison d'être* of the Federal Communications Commission. However, the reality is that the right of peo-

ple to be fully and truthfully informed has been thwarted. Instead, we have corporate for-profit media, which more often than not operate as filters of what people read, listen to, watch, believe, and think. Another crucial issue to consider in critical media literacy is the unprecedented concentration of media into a handful of owners, paralleling the concentration of power and capital in corporations. Ben Bagdikian has followed up the shrinking of the list. He maintains that in 1983 there were 50 major media corporations, and right now the list has dropped to five media conglomerates (2004, *New Media Monopoly*). They are: ABC/Disney, CNN/AOL Time Warner, NBC Bertelsmann, CBS/Viacom, and News Corporation-Fox. The immediate and dangerous consequence is a dramatic reduction of perspectives in reporting and programming and an incredible concentration of power.

In Mother Jones's (2003) flier we find an eloquent statement of the inevitable impact of concentration of power and control of the media: "These huge conglomerates are beholden to every advertiser they can't afford to offend. That's a whole lot of stories they can't afford to run. And a whole lot of digging they can't afford to do." Radio networks, even those independent from the above mentioned media conglomerates, are also getting larger and more powerful. An example is Clear Channel, which currently owns more than 1,200 stations around the country. What is happening now is that the Federal Communications Commission, rather than being the agency that regulates the communications industry and protects the public interest, has become an advocate for the media corporations by lifting the maximum ownership cap at the local level from 35% to 45% of broadcasting stations. As Goodman and Goodman (2004) put it: "There has been a complete abdication by the federal government to genuinely regulate the airwaves and the broadcast industry" (p. 303). Advocacy for the media corporations and not for the public is hardly surprising when we find that the prior chair of the FCC, Michael Powell, then had millions of dollars of shares of AOL stock (DeGraw, 2002). This stock ownership is obviously in conflict with the internal regulation of the FCC, which reads "None of them (five commissioners) can have a financial interest in any Commission-related business" (FCC, Consumer Guide, p. 3). The problem with this conflict of interest is that it leaves completely unprotected the right of people to be truly informed and may permit manipulative control of the public airways by media corporations for their own benefit.

Here we need to differentiate between broadcasting media, such as radio and TV, and the printed media. In the first case, broadcasters use airwaves, a public good, whereas the printed media, the Internet, and satellites have no governmental regulation. At any rate, nowadays freedom of the press belongs to those who own it (Claybrook, 2003, cited by Canipe, 2003); that is, "You are only as liberal as the man [sic] that owns you" (Alterman, 2003, p. 14). When we refer to the media's lack of sensitivity, actually we mean the owners. Ritter (2003) points out the problematic situation in which honest media reporters find themselves: "What reporter would knowingly run a story that questions the business dealings of the company at the top of her or his paycheck? In the end, it's not what the individual reporter wants to write, it's about what drives the profits for the news corporations" (p. 15). Some journalists finally quit the news organization. This is the case of Laurie Garrett (2005) who explains: "When you see news as a product. . . . It's impossible to really serve democracy."

The compromise of public service for self-serving corporate interests, which dominate the corporate media today, is really an assault on democracy (Chomsky, 2000a, 2000b). Chomsky explains the relationship between the market and democracy as follows: "Their roots lie in the power of corporate entities that are totalitarian in internal structure, increasingly interlinked and reliant on powerful states, and largely unaccountable to the people" (Chomsky, 2000a, p. 136). In a democracy it is expected that the media's main mission is to demand accountability from all parties.

Media, Hegemony, and Mind Control

The corporate for-profit media are driven by interests that are antagonistic to their contractual mission of public service. Actually, they are creating hegemony through sophisticated strategies for symbolic and ideological control. Herman and Chomsky's (1988) extensive and systematic analysis of media coverage of transcendental events in Central America and around the world identified a pattern of strategies "by which money and power are able to filter out the news fit to print, marginalize dissent, and allow the government and dominant private interests to get their messages across to the public" (p. 24). They call this pattern the "propaganda model," which consists of five major types of filters:

1 Size, ownership, and profit orientation of the mass media: The more the media are concentrated, the less there is diversity of perspectives, the less democratic, but the richer and more powerful they become.
2 Advertising as the license to do business: If ads are the primary source of income, they will be the primary concern of the media owners and boards of directors.
3 Sources of information: Depending on the topic, the mass media rely on sources whose authority does not challenge their interests, such as government officials and "experts" on the topic. This model allows mainstream media and other corporations behind them to create and maintain hegemony on information from government, businesses, or experts.
4 "Flak" as a way of constraining other media/reporters whose work threatens their interests and hegemony.
5 Communism as a red flag for degrading the opposition and scaring people. Nowadays the evil of terrorism has replaced references to communism. With this propaganda approach to media coverage, it is obvious that selection of stories, victims, and cases is subject to one or more of these filters before the news reaches the public.

Most people have reservations about the impact of the mainstream media. However, it is only when they are confronted with information from a specific story that shows indisputably the bias and manipulation of the media that they understand how problematic the impact of the media really is. The following case is one of those unrefutable examples of media bias. Rendall and Broughel (2003), from The Center for Fairness and Accuracy (FAIR), studied the type of sources mentioned on camera during the major evening news programs (*ABC World News Tonight*, *CBS Evening New*, *NBC Nightly News*, *CNN's Wolf*

Blitzer Report, Fox's *Special Report with Brit Hume*, and PBS's *News Hour With Jim Lehrer*).
The first study was carried out during the weeks before and after February 5, 2003, the date
on which Colin Powell presented to the UN Security Council the reasons for going to war
in Iraq. The second study was realized during three weeks, from March 20 (one day after
the bombing of Iraq started) to April 9, 2003. Even though the total number of sources pre-
sented on camera was different for each study (393 for the first study and 1,617 for the sec-
ond), 76% were U.S. sources, and of those, around 75% were official and pro-war sources.
The anti-war sources were less than 1% in the first study and around 3% in the second study.
These numbers do not represent the position of the general population with respect to the
war, which at that time was around one-third opposed. There were no experts presented
addressing non-military issues such as human rights, international law, environmental
devastation, and human suffering. On the contrary, there was constant cheering for mili-
tary power and achievements.

A resourceful way to support the hegemony of corporate agendas and to enhance con-
trol of people's minds is by conducting public opinion polls. In this respect Sapir and Huff
(2003) note that "corporate polls exist mainly to validate corporate media and government
disinformation and to tell the public what to think rather than reflect how they think. The
population's apparent consent to the war on terror is virtually manufactured by media and
government" (p. 43).

The display of the results of the poll becomes propaganda that may resonate around the
nation, as strategy for manufacturing consent toward the issue polled. Chomsky (1989) points
out how the government, through the media and with the media, is "bounding the think-
able." Thus, polls become a very productive game for the support of the corporate-
government agenda.

At any rate, as Chomsky (1989) points out, the methods of social control in a so-called
democratic society, differ from military regimes, because they are subtle and covert and act
more on "regimenting the minds of the stupid masses" as Lasswell (cited by Chomsky, 2000a)
refers to the propaganda mechanism. In the same vein, Fiske (1993) considers that "hege-
mony depends on the ability of the power bloc to win the consent of the various forma-
tions of the subordinated to the system that subordinates them" (p. 41). This "top-down
consensus" is vulnerable to be contested, and therefore, it needs to be nourished constantly
through comprehensive and repetitive propaganda.

Cultivating Hegemony and Keeping Control

Hegemony works through the combination of consent and coercion (Fiske, 1993), in
which mass media play a major role through persuasive propaganda and the use of filters
as those identified by Herman and Chomsky (1988). George Gerbner (1977) has developed
a "cultivation theory" about the impact of images and message systems on people's percep-
tions of themselves, the world, life, and relationships. "The effects of communications are
not primarily what they make us 'do' but what they contribute to the meaning of all that
is done (or accepted, or avoided)" (p. 205). Actually the cultivation theory refers to a much

more complex process in which dominant cultural patterns affect and are affected in this process. Gerbner explains: "A culture cultivates the image of soft society. The dominant communication system produces the image patterns, they structure the public agenda of existence, values and relationships" (p. 205). People use these public images and understandings to cultivate their own images and understanding and influence the new generations (Gerbner, 1977).

Manufacture of Myths

Gerbner's (1977) cultivation theory helps us to understand how media myths are not only manufactured but cultivated, through comprehensive propaganda, to keep a subtle control of the public mind. The main problem with these myths is that they appear to people as the natural or normal thing to happen. The appearance of normality protects those myths from scrutiny of their socio-historical formation, origins, maintenance, and change.

The following myths have been identified mostly in teaching a unit in Critical Media Literacy in which students examine cartoons, news, and other media products. For most students the completion of the assignments becomes an eye-opener; however, some popular myths emerge in their analysis, such as:

1 The myth of *ideological diversity* in mainstream media, when actually there are merely slight variations of the same underlying ideology. People are led to think that they have different perspectives of a given event just because they have access to different channels, stations, newspapers, and so forth. They are not aware of the homogeneous for-profit interests that underlie the agendas of media decision makers.

2 The myth of *objectivity* by claiming adherence to the "facts." Once people see facts, they do not question how facts were chosen and represented, and they do not question the source of those facts.

3 The myth of *political neutrality* by avoiding taking an overt stance, and by assuming that if one is not dealing with controversial issues, or one is only dealing with facts, one is apolitical.

4 The myth of *balanced information:* On a given issue, when alternative views to the mainstream ones are brought up, many people think that a certain ideal type of balance has been broken. In fact, they believe that the views regarded as the normal or middle-ground perspective of the story should also be presented. However, when corporate media ignore completely the alternative views of a given story, those same people do not notice their absence. As Parry (2004) argues, what we see happening right now is the consolidation of the right-wing media, whereas progressives, democrats, and leftists have not realized/accepted that they lag behind concerning the power of the media to counteract the right-wing agenda. McChesney (2004) maintains that media policy debate and people participation require that these permeating media myths be examined critically. We argue that understanding those myths is one of the first tasks of critical media literacy.

Resonance Effect

The corporate media and government "crosspollination," as Arundhati Roy (2003) refers to it, is currently strategically orchestrated, extremely well funded, and highly effective. One of these strategies is the repetition or saturation of information that favors their agendas. We refer to this strategy as the "resonance effect." It seems to be a key element not only in the manufacture of information, but also in the manipulation of people's minds and emotions. It is a strategy of cultivation of people's minds to give consent to the agenda handed to them. The resonance effect consists of repeating the same information, lemmas, texts, and images over and over again. The repetition is very loud—from coast to coast—morning, noon, and night; day after day; week after week, even over months, until everybody gets the message. Thus, it becomes the unquestionable truth, no matter if it is based on real or fictitious stories. Alterman (2003) refers to the adage "Repeat something often enough and people will believe it"; for him "this is nowhere truer than in American political journalism" (p. 14). An outstanding example of such corporate media propaganda was the Clinton-Lewinsky case. How many times did we see the image of Monica Lewinsky hugging President Clinton? Perhaps thousands of times. Undoubtedly, right-wing groups at corporations and media orchestrated the scandal to depose the Democratic administration and pave the way for a government that would give them more generous prerogatives, and, as we all know, this goal has been accomplished.

How Media Work in the Educational Context: The Manufacture of Consent Against Bilingual Education in California

The sociopolitical context in California when Proposition 227 was voted and won was full of anti-immigrant sentiment. The demographic changes, including the rapid increase of people of color and immigrants from Asia and Latin America, germinated a great deal of fear that was inflated and promoted in the mass media. Writers such as Hanson (2003) and Huntington (2004) continue cultivating this fear as a threat to the national identity, which they assume is white European American. Hanson's book *Mexifornia* reveals his xenophobic and racist attitudes. Unfortunately, these attitudes and discourses have become part of the American narrative produced and reproduced by corporate media. The effect of resonance in the campaign to eliminate bilingual education through Proposition 227 (1998, a mandate requiring "English Only" instruction in California) can be seen by virtue of a disputed story, a misleading question, and what in fact did not resonate about bilingual education. Ron Unz, who conceived, financed, and directed the ballot initiative, used "English for the Children" as his campaign motto to eliminate bilingual education. James Crawford (1997, 1998) describes how Ron Unz and his followers manufactured a story about a protest against bilingual education by Latino parents at Ninth Street Elementary School in downtown Los Angeles. This story served as the basis of a myth that resonated throughout the corporate media. The manufactured story was as follows:

> Immigrant parents were forced to begin a public boycott . . . after the school administration refused to allow their children to be taught English. Enormous numbers of California schoolchildren today leave after years of schooling with limited spoken English and almost no ability to read or write English. We believe that the unity and prosperity of our society is [sic] gravely threatened by government efforts to prevent young immigrant children from learning English. (English for the Children, 1997, cited by Crawford, 1997, p. 3)

Crawford (1997) disputes this story on various grounds. Alice Callaghan, who organized the protest, was also the director of the day care center where the protesting parents had their children. Afterwards, Callaghan became one of the leaders of the "English for the Children" campaign. "English for the Children made skillful use of the Ninth Street boycott, a ready-made narrative so sensational that it was retold by virtually every reporter who covered the campaign (yet almost none ventured any original reporting that might have spoiled the myth)" (Crawford, 1997, p. 5).

However, one end of this story was left loose by its authors (Unz-Callghan), and it is that prior to the protest none of those parents had requested that their children be transferred to all-English instructional classrooms.

This story created a myth about the unpopularity of bilingual education even in the Latino population. This myth became reinforced by a poll carried out by the *Los Angeles Times*, which cultivated in voters a negative opinion of bilingual education. The question in the poll was as follows:

> There is a new initiative trying to qualify for the June primary ballot that would require all public school instruction to be conducted in English and for students not fluent in English to be placed in a short-term English immersion program. If the June 1998 primary election were being held today, would you vote for or against the measure? (Humphrey, 1997, cited by Crawford, 1997)

Eighty percent of likely voters and 84% of Latinos favored this pre-voting question. This vote contrasts with an exit poll, conducted also by the *Los Angeles Times*, in which 63% of Latinos voted against Proposition 227 (Crawford, 1997, 1998). This mismatch gives us some idea of how easy it is to manufacture consent when an agenda-setting outlet such as the *Los Angeles Times* beats the drums and other media resonate the message.

The media bias in favor of the proponents of Proposition 227 can be seen in the study conducted by Media Alliance (1998) on the coverage of this initiative by leading media outlets. Some of their findings included that two-thirds of the stories did not give any definition of bilingual education, no stories examined or evaluated the effectiveness of bilingual education, and none of the stories examined the academic research on bilingual education. They also analyzed the stories published in the *Los Angeles Times*, *Sacramento Bee*, *and* the *San Francisco Chronicle* between November 1, 1997, and January 31, 1998. They found a total of 33 stories in which there were 46 direct quotations from Unz and other spokespeople on behalf of Proposition 227. In contrast, there were only 19 quotations from the campaign "No on Proposition 227" spokespeople. In the same vein, Wiley (2000) criticizes the corporate media role in this matter because they pay more attention to "the anecdotal opinions of pundits opposed to bilingual education rather than to the findings of educational researchers" (p. 35).

Another factor that contributed to the myth of the unpopularity of bilingual education had to do with the lack of clarity and ambiguity of the pre-voting question polled by the *Los Angeles Times*. Krashen, Crawford, and Kim (1998) modified the question to include various implications that Proposition 227 would have on schooling:

1 a severe restriction of the child's native language
2 limitation of special help in English to one year
3 the expectation that English language learners would learn sufficient English after one year to do school work at the same level as native speakers of English of the same age
4 the dismantling of current programs that have been demonstrated to be success-ful in helping children acquire English
5 holding teachers financially responsible if they violate the policy
6 schools will have only 60 days to conform to the policy.

When voters in this poll were informed of the implications of the proposition, only 15% of respondents were in favor while 71% were against the proposal. These figures contrast with those of the respondents to the *Los Angeles Times* pre-voting question that resulted in 57% in favor and 30% against the proposition. As is well known among social and behav-ioral scientists, responses to a question depend strongly on how the question is worded.

Finally, we can also see how the manufacture of consent against bilingual education is carried out by looking to what in fact did not resonate in the media stories. There was a complete absence of fundamental and truthful information about bilingual education research, both theory and practice, such as:

1 Bilingual education is not a uniform program, but rather it is based on local con-texts, addressing the specific needs of English language learners.
2 Research informing bilingual education and second language acquisition processes was totally ignored.
3 Sheltered English immersion education for one year was not based on any studies confirming its effectiveness (Quezada, 2000).
4 There was little or no coverage of actual schools and classrooms implementing bilin-gual education (Aryal, 1998; Crawford, 1997, 1998).

The analysis of the role of media in dismantling bilingual education in California shows their power in configuring and cultivating (using Gerbner's terms) the political and cul-tural panorama of the nation, and to a great extent of the world. Blatant manipulation of information by and through the corporate media is growing every day, hence the urgency by people, especially teachers, of understanding how media work and how to counteract their complete abandonment of real public service. This type of literacy is part of what Freire and Macedo (1987) imply when affirming that being literate is to be able to "read the word and the world" in order to function in that world.

Corporate Culture Is Taking over Public Education

Corporate media, as adjuncts of governmental policies and of other corporations, are taking over education and impacting teacher education, teachers, and children much more than we as educators are aware of and are ready to admit. The case of bilingual education is just one example. There is happening what Deetz (1994) calls a "universalization of managerial efforts." Thus, human interests are not ends in themselves, but they are means in the service of corporate interests under the guise of efficiency and cost benefits. The challenge is for educators to become fully aware of that impact and to start building counter-corporate media, that is, alternative media networks driven by public interest.

Corporate media have played a very instrumental role in what Berliner and Biddle (1995) call "The Manufactured Crisis" in the U.S. public schools, by resonating everything that discredits them and concealing the real issue of funding as one of the creators of disparities among school rankings in achievement. Actually, the NCLB policy aimed at "reforming" public education is facilitating its taking over by corporations including media corporations like Channel One. Meier (2004) and Kohn (2004) point out the interconnectedness of all measures of NCLB toward privatizations, in terms of moving schools from the public domain, and to put them in the hands of a few test and textbook publishers whose main interests are rooted in profit, rather than in improving education for all, which has been the premise of public education. The participation of the corporate media in the manufacture and resonance of the crisis in public education and the promotion of measures such as NCLB as the great saver of this crisis, is reaching levels never achieved before. So is the cover-up of scandals like the one involving Armstrong Williams (Rendall, 2005), who was paid with taxpayers dollars to promote NCLB. This story was buried right away without follow-up and without establishing accountability.

Chomsky (2000a) argues that the privatization and corporatization of schools is an attack on public schooling and hence on human rights. He contends that the predominant culture and curricula of schools, as well as corporate television programming, indoctrinate students so as to prevent them from asking fundamental questions.

Another area of influence of corporate media interests is popular culture through their power of shaping and reshaping fashions, products, identity, body, and beauty parameters. Childhood has not escaped from the influence of information technology and the corporate production of a "kinderculture" as Steinberg and Kincheloe (1997) argue:

> Using fantasy and desire, corporate functionaries have created a perspective on late twentieth century culture that melds with business ideologies and free-market values. The worldviews produced by corporate advertisers to some degree always let children know that the most exciting things life can provide are produced by your friends in corporate America. The economics lesson is powerful when it is repeated hundreds of thousands of times. (p. 4)

Similarly, corporate media also influence the construction and representation of identity, which should be part of the curriculum of media literacy along with that of being a critical consumer (Buckingham, 2003). How media construct identity and values is beyond the scope of this chapter.

Carlos Cortés (2000) conducted a very interesting study observing two of his grand-daughters watch and learn the TV multicultural curriculum. He concludes: "Media teach and media consumers learn" (p. 24). Nonetheless, most of the media's curriculum remains hidden and unrecognized. However, this is not an obstacle for impacting the consumer. Actually, mass media educate more than teachers and parents combined (Bartolomé & Macedo, 1997). These are powerful reasons for educators and parents to embrace critical medial literacy for children and hence for teachers. Children's entertainment programming, for instance, may teach children about market values, stereotypes, prejudices, and so on. This does not imply that they cannot learn also about human values. However, the probability of children learning them is lower because those values are usually not marketable.

In the same vein, Dorfman (1983) calls "secret education" the unconscious impact of media entertainment on people, and especially those more vulnerable such as children:

> Industrially produced fiction has become the primary shaper of our emotions and our intellect in the twentieth century. Although these stories are supposed merely to entertain us, they constantly give us a *secret education*. We are not only taught certain styles of violence, the latest fashions and sex roles by TV, movies, magazines, and comic strips; we are also taught how to succeed, how to buy, how to love, how to conquer, how to forget the past and suppress the future. We are taught more than anything else, how not to rebel. (p. ix)

When teachers and prospective teachers read this quotation, their first reaction is: "It's true." Although with some reservations, many go on to admit how naïve they have been concerning their taking for granted "true" information conveyed to them by the media. By the way, this quote has proven to be a very good way to start a dialogue about critical media literacy with teachers.

Turning to Alternative Non-Profit Media

As corporate media become more and more concentrated, their economic and political power becomes concentrated as well, and the need for alternative non-profit media becomes an urgent and necessary pursuit. Conscientious educators have a crucial role in supporting and/or developing this type of media whose mission it is to inform with the truth and to serve the public they reach. Alternative non-profit media are relevant to society in general and schools in particular. The communities that are marginalized or misrepresented in the mainstream media are by and large the most vulnerable to the negative impact of corporate media, and thus are most in need of alternative media that represent their voices and concerns and help them to obtain resources and development.

Critical Media Literacy in School Curricula

Studies of media, specifically TV (e.g., Albert Bandura's 1973 in psychology, and George Gerbner, 1977, in communication studies) have demonstrated the tremendous impact of media on people, especially those more vulnerable such as children and adoles-

cents. Not surprisingly, those studies have not had the necessary resonance despite their enormous relevance to people's lives. The corporate entertainment industry does not want their clients to know about those findings, or otherwise their interests would be hurt. According to a study sponsored by the Kaiser Family Foundation (Rideout et al., 2003) about the impact of electronic media on infants (6 years old and under), they found that these infants spend an average of two hours daily with electronic media, mostly TV and videos.

This is one of the reasons why Scharrer (2003), a media educator, makes the case for including media literacy in the K-12 curriculum. She focuses media literacy mainly on examining the media critically; developing strategies to mediate the impact of media messages; learning how media messages are created, marketed, and distributed; and developing the ability to participate in wise use of various types of media. She is very concerned about the effectiveness of literacy education, given the massive bombardment of media messages directed at young people and children, and the alarming number of hours that children are exposed to media programming. Scharrer approaches media literacy from a critical perspective and provides good data and insight to make better use of the available media. However, she does not give explicit consideration to alternative non-profit media and their access, support, and development. When people's concerns, ideals, and ways of life are not represented, much less served, we expect that those people would turn to other sources of information. This is a crucial moment for critical media literacy, which should include building counterhegemonic alternative media accessible to many people. Chomsky (1989) sees the need for people to understand the means of control and thus to defend themselves: "citizens of the democratic society should undertake a course of intellectual self-defense to protect themselves from manipulation and control and to lay the basis for more meaningful democracy" (p. viii). In the pursuit of a democratic education, understanding of mass communication is basic for understanding how power and politics work in our society.

As part of the activities of media literacy carried on in the classroom, teachers should help students "read between the lines" of the media messages, question the interests behind them, and learn how to look for alternative ways to be informed and/or entertained. Because many schools have a subscription to Channel One, this can be the starting point for lessons on critical media literacy. Molnar (1996) does an excellent documentation and analysis of Channel One business at schools. Briefly, Channel One consists of a 12-minute daily program: 10 minutes of "current events" and two minutes of advertisements that target adolescents. The contract stipulates that the program must be shown on at least 90% of school days to at least 85% of the student population. What do schools receive in exchange for selling their captive student audience to Channel One? Profits in the millions from the ads go to Channel One's owner Chris Whittle, whereas the school receives (as a loan) a monitor in each classroom, a satellite dish, and the control console. This type of contract leads us to believe that the real purpose of Channel One is not precisely to serve the students but to forge the mercantilist and materialist mentality of the dominant ideology under the guise of curriculum improvement by "bringing students the world."

Unfortunately, the "free" market ideology has become embedded in educational goals, curricula, educational decisions, and criteria, and values and culture of schools. Referring to the taking over of education and democracy by "free market fundamentalism," Giroux

(2004) maintains that "schools more closely resemble either shopping malls or jails . . ." (p. 2). Textbooks are part of this dominant ideology; they define what is to be known, and whose knowledge is worth knowing (Sleeter & Grant, 1991; Apple, 1993, 2004). Although there has been some progress in the past, the standards movement and the *No Child Left Behind* policy are taking us back to prescriptive curricula and pedagogy. Knowledge coming from "scientific-based research" resonates through all types of media-written texts, tests, conferences, broadcast news and interviews. With few exceptions, textbook publishers are more interested in advancing their economic and political agendas than in serving educators and children.

In studying the textbooks, teachers, prospective teachers, and students need to understand the interests underlying the choices of textbooks and prepackaged curricula and materials. Textbooks constitute instructional media. In times of oppressive accountability by top-down curricula, standards, and massive testing, reclaiming the constitutionally guaranteed right of academic freedom to choose textbooks according to the professional judgment of teachers seems an insurmountable task. We believe that this task is not impossible, but it is certainly difficult. Unfortunately, because the situation is deteriorating further each day, it becomes extremely important that educators understand the role of corporate media as adjunct to the government in the current crisis of schools and the profession of teaching. This understanding should be followed by actions, individually and collectively, to counteract the lack of responsiveness and relevance to people's concerns and interests of the media products, starting with the textbooks and pre-packaged curricula.

Understanding the powerful role of mass media in the search and dissemination of knowledge and information, as well as connecting that knowledge and information with power, educators should prepare their students to resist that type of educational system and media disservice and become supporters and creators of alternative non-profit, public interest type of media. We, as educators, can start supporting those publishers who have demonstrated their interests in serving educators and students with high quality, culturally relevant, and socially responsive books (e.g., Cinco Puntos, *Rethinking Schools*). We believe that this type of action represents not only the defense of the basic constitutional right of academic freedom, but a moral duty.

"Media Reform": What Everybody Can Do

At the 2003 Conference on "Media Reform" at the University of Wisconsin, Madison, the representative from Vermont, Bernie Sanders (2003), pointed out how corporate media do not address the moral issue emanating from extremely unequal distribution of wealth in the United States, actually the worst in the world, where the top 1% of the people own more than the bottom 95%. He contends that this is just one example of irrelevance of the corporate media's work to the lives of the majority of people.

> The first problem we have is that what media do is to deflect attention from the most important issues, depoliticize them, and prevent people from understanding the relevance of democratic government and democratic society to their lives. And in that sense, they are doing a major disservice, not just to the issues that we care about, but to American democracy as a whole.

At the same conference, Jonathan Adelstein (2003), the FCC Commissioner who wrote a 39-page dissent to the changes in media ownership rules, indicated that the media "never talk about what is really happening in the local communities. One half of 1% of all of the media coverage, according to one study, is about local public affairs, 14% is infomercials." Adelstein goes on to document the millions of dollars media owners make in those communities, which is never mentioned. In contrast, what resonates in these media is the amount of money raised for the charitable causes they support. He suggests that people, including teachers and school children, should be aware and prepared to take action when the time comes for the local media to have their licenses renewed. They can write to the regulators to make a specific medium comply with the duty of public service that the license implies.

Letters or other actions by individuals or small groups (such as a teacher and her/his classroom) are empowering, but given the accumulation of power and control by the mass media and the government, it would be naïve to think that these types of individualized actions are going to make a significant difference in their policies. Indeed, what we need now are concerted and collective ways to act, if we want to have a real impact on the way media are working. The most recent example of collective action took place when the FCC on behalf of the media corporations—not on behalf of people—asked the U.S. Congress to approve loosening of ownership rules at the local level. According to FCC Commissioner Adelstein (2004), the public response was amusing: About three million messages flooded the FCC, Congress, and other government offices, of which 99% were against this change of rules. This achievement did happen because of concerted efforts among truly public service media (e.g., Radio Prometheus, Free Press, Democracy now) and other organizations (e.g., Fairness and Accuracy in Reporting-FAIR, Center for Public Integrity, and Center for Constitutional Rights), and the FCC Commissioners Adelstein and Philips themselves went around the country talking to people about the implications of these changes. This information does not reach the public because major corporate media do not carry it. Vested interests are more important to them than serving the public.

There are various concrete strategies that educators can embrace to involve students in media reform. Sanders (2003) suggests that the best way to counteract the corporate media's great disservice to the public and to democracy is by making the concentration and corporate control of media a *political issue*. By this he means to make candidates, representatives of the government, and above all the general public talk about it, and to make a commitment to study the issue and work toward having the media comply with their public service duty, or they will face a public boycott. This will be a genuine opportunity to learn about democratic participation. We think that it might make an impact if a local newspaper, TV, or radio station received a letter signed by numerous students stating that they have agreed not to read, watch, or listen to a given program anymore. They could allude to reasons such as misrepresentation and/or stereotyping of some cultural groups, and/or complain that they do not address the real issues that they have.

Another strategy that Sanders proposes has to do with visits and pressure on media at the local level. He considers that it is up to the local people to organize themselves and

to go to the local mass media (newspapers and radio, and TV stations), and request that their directors include progressive voices to counterbalance the mainstream, pro-corporation, and pro-government voices of extreme right-wing pundits. He advises these organized groups to spell out to the corporate media representatives the consequences of not being inclusive, such as boycotts of products advertised there, and the use of means such as protests in front of their buildings.

Sanders (2003) also calls attention to the disservice of public broadcasting to the American people. As soon as he started talking about it, the people attending the media reform conference gave him a tremendous ovation. This fact shows how urgent and relevant this topic is for people. It is common knowledge that the public broadcasting media have sold themselves to major donors such as the oil companies and Wall Street. In this respect, at the Second Media Reform Conference in St. Louis, Bill Moyers (2005) addressed the problem of the chair of the Corporation for Public Broadcasting whose questionable actions show his commitment to the government by his silencing criticisms of the government and interpretations of reality differing from the official. Indeed, Moyers came to understand that today "news is what people want to keep hidden, and everything else is publicity." In the same vein, McChesney (2004) proposes to rescue the mission of public broadcasting by increasing the local relevance, which is almost absent in commercial media, and by working in collaboration with other independent non-profit media.

As educators, we feel at times powerless because we cannot get our voices heard. The voices that resonate in the corporate media also constitute the official discourse of public education, the top-down policies, each one more prescriptive and controlling. Progressive voices have been co-opted, deemphasized, or excluded totally from their programming. We believe that educators, students, and parents can use the strategies that Representative Sanders (2003) is advocating, and many more. We agree with him that "there is in my view no issue more important than this [corporate control of media], because it touches all other issues."

In a study carried out by Charles Lewis (2003) and collaborators in the Center for Public Integrity which produced, among other things, a comprehensive database of the broadcasting radio and TV stations, as well as the cable and telephone networks per geographic area. In order to find out who owns the media within 40 miles of your home, you can just enter your zip code on the Web site of the Center for Public Integrity (www.publicintegrity.org) in the "Well Connected Databases." This is really useful for teachers as well as students and their families to become literate in the type of media that supposedly serve them. By learning about the owners, their prime interests and political orientation, we can make more informed choices.

The Time Is Ripe for Alternative Media

In addition to understanding how corporate media work, critical media literacy includes the ability to search, support, and develop alternative non-profit media. The new technologies of communications (e.g., the Internet) have provided many of us with real possibili-

ties for accessing a growing number of independent non-profit media whose main mission or agenda it is to serve the public with serious, relevant, and opportune information, and often with entertainment as well. Alternative media workers, more often than not, work under very constrained economic situations because they depend on the support of the communities they serve, and are also under pressure from the corporate media that try to suffocate and discredit their work. To keep their independence, they must avoid large donations from corporations or individuals. So, if one is turning to independent media—commercial free—one incurs a moral obligation to support their work financially.

Today, there are facilities for developing alternative non-profit forms of communication such as electronic networks through e-mail and Web sites, as well as non-electronic forms such as art, theater, newsletters, and forums. Willinsky (2002) perceives these new technologies of communication as promising media for creating open access to educational knowledge. He considers that this would bring into being some of the principles of democratic education that Dewey (1916) was promoting, including access to relevant, important, and credible knowledge. The type of electronic public library that Willinsky proposes would provide open access to knowledge produced by educational researchers and practitioners who are willing to publish and share their achievements.

However, as Bettina Fabos (2004) documents, what was created as the 'the information superhighway' has been commercialized at such a rate that we are even losing what we had before the Internet was invented. Fortunately, there is still free access to a great deal of information, and fast communication among special interest groups for their activism. Democracy Now (2004, December 7) brought up the issue of private vs. community based providers of high speed Internet access. Many people cannot afford to pay for it, yet the Internet has become part of the *modus operandi* of communications. It is even necessary for doing homework. Jeffrey Chester, from the Center for Digital Democracy argues that Internet access (40% of households have no Internet access) is a First Amendment right, and that the cable and telephone companies are working to prevent community-based Internet access as another possibility for this service. Steven Titch, from the Heartland Institute counterargues that it is a bad idea to spend community resources for providing a service that is already available at low cost. In addition, this competition is unfair to existent providers of Internet access. We consider that active involvement in defending the Internet from becoming fully privatized and commercialized should be part of the agenda of families, schools, community organizations, and the public in general. However, along with these advances in quantity and quality of ways of communication among people, there is also an enhancement of ways to influence and control people. We agree with Willinsky (2002) about using these new media technologies to make organized scholarly knowledge accessible to all the people. The issue concerning the "digital divide" often is focused merely on the haves and have-nots with respect to computers, telephone lines, and access to the Internet. We think that the most important dimension is free access to information that is important to people's lives and careers, and not simply access to a mountain of information that is becoming absolutely useless and even harmful. The people who are unable to access the Internet from home should be able to access it on public library computers.

Concluding Reflections

We believe that among the latest advancements of the "Age of Information," mass corporate media have become the most powerful instruments to reproduce and maintain dominant values and culture. We have documented the case both in its sociopolitical as well as educational context, indicating the impact of corporate media on the determination of government policies and what we as the public read, watch, listen to, think, believe, and act. We know that corporate control of media and government is happening not only in the United States but everywhere, although with varying degrees of credibility by the people. The impact of media messages is effective even when we do not believe them Cortés (2000).

We consider that the inclusion of critical media literacy as part of the foundations of education, and hence as a component of the core curriculum of teacher education, is long overdue. Teachers as well as students are among the most vulnerable populations to be impacted by the mass media. Unfortunately, this impact is usually not for their benefit. The stories and evidence presented in this chapter make obvious to us the central role of critical media literacy in the curricula of schools and hence of teacher education. It is important to say here that some efforts in this regard are happening. There is, for example, the New Mexico Media Literacy Project which has developed curricula about issues such as advertisements in general and is broadening the scope to areas such as health and social issues. This is a non-profit organization, but it is still not reaching most of the population including public schools.

As teacher educators, we consider that critical media literacy is a *must* considering the current situation in education and the sociopolitical context of privatization of all social services and marketization of education. Subsequently we list what we consider the major purposes of critical media literacy:

1. to function as an intellectual self-defense
2. to discover and support the increase in number and in power of independent non-profit media
3. to develop alternative media networks among special interest groups using the new advanced media and multimedia technologies and to make information available on the democratic premise of education for all.

We want to ratify what we have stated at the beginning of this chapter. Critical media literacy, as we understand it, focuses on the use and abuse of mass media power by putting profit (economic and political) first and service to the public last. Indeed, we are not against the benefits of the mass media's advanced technologies for improving the quality of communication among all sorts of people and facilitating their democratic participation in the society in which they live. Precisely this type of role is what we understand as public service, which should be provided by any type of mass medium operating in the public domain.

REFERENCES

Adelstein, J. (2003, November 7–9, 2003). Media Reform:, Madison Wisconsin. Democracy Now: November 12, 2003, *Media Reform*. Madison, Wisconsin: Democracy Now. Retrieved from www.democracynow.org/archives

Adelstein, J. (2004, June 25). FCC Deputy Commissioner speaking at the UU Assembly: *Defending the airwaves. Democracy University* [Video Series Vol. 61]. Ralph Cole (Producer).

Alterman, E. (2003). *What liberal media? The truth about bias and the news.* New York: Basic Books.

Apple, M. (1993). *Official knowledge: Democratic education in a conservative era.* New York: Routledge.

Apple, M. (2004). *Ideology and curriculum* (3rd ed.). New York: Routledge Falmer.

Aryal, M. (1998). He says, she says how California's major papers have covered Proposition 227. *Mediafile, 17*(1), 1–9. Retrieved from http://www.media-alliance.org/mediafile/17–3/mediafile.html.

Bandura, A. (1973). *Aggression: A social learning analysis* Englewood Cliffs, NJ: Prentice Hall.

Bagdikian, B. H. (2004). *The new media monopoly.* Boston: Beacon Press.

Barabak, M. Z. (1998, October 15). The Times poll bilingual education gets little support. *Los Angeles Times.* Retrieved from http://ourworld.compuserve.com/homepages/jwcrawford/LAT13.htm.

Barstow, D., & Stein, R. (2005, March 13). Under Bush, a new age of prepackaged TV news. *New York Times.* Retrieved from http://www.nytimes.com/2005/03/13/politics/13covert.html

Bartolomé, L. (1996). Beyond the methods fetish: Toward humanizing pedagogy. In P. Leystina, A. Woodrum, & S. A. Sherblom (Eds.), *Breaking free: The transformative power of critical pedagogy* (pp. 229–252). Cambridge, MA: Harvard Educational Review. Reprint Series No. 27.

Bartolomé, L., & Macedo, D. (1997). Dancing with bigotry: The poisoning of racial and ethnic identities. *Harvard Educational Review, 67*(2), 222–245.

Berliner, D. C., & Biddle, B. J. (1995). *The manufactured crisis: Myths, fraud, and the attack on America's public schools.* Reading, MA: Longman.

Bernays, E. (1928). *Propaganda.* New York: Liveright.

Buckingham, D. (2003). Media education and the end of the critical consumer. *Harvard Educational Review, 73*(3), 309–327.

Canipe, L. (2003, July/August). Public airwaves? FCC's new media ownership rules. *Public Citizen News,* p. 4.

Chomsky, N. (1989). *Necessary illusions: Thought control in democratic societies.* Cambridge, MA: South End Press.

Chomsky, N. (2000a). *Chomsky on miseducation.* Oxford: Rowman & Littlefield.

Chomsky, N. (2000b, May 12). Assaulting solidarity—Privatizing education. *ZNet*—Daily Commentaries. Retrieved from: http://www.zmag.org/Sustainers/Conten/2000–05/12chomsky.tmm

Chomsky, N. (2003). *Hegemony or survival: American quest for global domination.* Speech given at Illinois State University, Normal, Illinois. Transmitted in Democracy Now, Pacifica Radio on October 22. Retrieved from www.democracynow.org/archives.

Comstock, G., & Scharrer, E. (1999). *Television: What's on, who's watching, and what it means.* San Diego: Academic Press.

Cortés, C. E. (2000). *The children are watching: How the media teach about diversity.* New York: Teachers College Press.

Crawford, J. (1997). The campaign against Proposition 227: A post mortem. *Bilingual Research Journal, 21*(1), 1–29.

Crawford, J. (1998, June 26). The bilingual education story: Why can't the news media get it right? Speech to the National Association of Hispanic Journalists, Miami, FL. Retrieved from http://ourworld.compuserve.com/homepages/jwcrawford/NAHJ.htm

Deetz, S. (1994). The new politics of the workplace: Ideology and other unobtrusive controls. In H. W. Simons & M. Billig (Eds.), *After postmodernism: Reconstructing ideology critique*. London: Sage.

DeGraw, D. (2002). *Freedom and democracy are under attack: The war on communication.*

Democracy-Now. (2004, December 7). Should the local governments be allowed to provide a broadband access? A debate on community vs. private Internet service. A. Goodman (Director / Interviewer), Guests: J. Chester, Center for Digital Democracy and Steve Titch, Information Technology—Heartland Institute. Retrieved from http://www.democracynow.org/article.pl?sid=04/12/07/1451247

Dewey, J. (1916). *Democracy and education*. New York: Free Press.

Dorfman, A. (1983). *The empire's new clothes: What the Lone Ranger, Babar, and other innocent heroes do to our minds*. New York: Pantheon Books.

Eaken, E. (2003, December 20). How to save the world? Treat it like a business. *The New York Times*. Retrieved from: htpp://www.nytimes.com/2003/12/20/arts/20SOCI.html

English for the children. (1997). Proposition 227: The 1998 California "English for the children" initiative. Retrieved from http://www.onenation.org/index.html.

Fabos, B. (2004). *Wrong turn on the information superhighway: Education and the commercialization of the Internet*. New York: Teachers College Press.

Federal Communications Commission. (2006, November 16). *About the FCC*. Retrieved from www.fcc.gov/aboutus.html .

Fiske, J. (1993). *Power plays, power works*. New York: Verso.

Freire, P. (1992). *Pedagogy of the oppressed*. New York: Continuum. (Original work published 1970).

Freire, P. (1994). *Pedagogy of hope*. New York: Continuum.

Freire, P., & Macedo, D. (1987). *Literacy: Reading the word and the world*. Westport, CT: Bergin and Garvey.

Gardiner, S. (2003, October 17). *Truth from these podia. .* Retrieved from Democracy Now: www.democracynow.org/archives

Garrett, L. (2005). Pulitzer Prize-winning journalist Laurie Garrett quits *Newsday:* When you see news as a product . . . It's impossible to really serve democracy. *Democracy Now* (A. Goodman, Director). Pacifica Network. Retrieved from www.democracynow.org/article.pl?sid=05/03/14/151255.

Gerbner, G. (Ed). (1977). *Mass media analysis in changing cultures*. New York: John Wiley & Sons.

Giroux, H. A. (2004). Neoliberalism and the demise of democracy: Resurrecting hope in dark times. *Dissident Voice*. Retrieved from www.dissidentvoice.org/Aug04/Giroux0807.htm

Goodman, A., & Goodman, D. (2004). *The exception to the rulers: Exposing oily politicians, war profiteers, and the media that love them*. New York: Hyperion.

Hanson, V. D. (2003). *Mexifornia: A state of becoming*. San Francisco, CA. Encounter Books.

Herman, E., & Chomsky, N. (1988). *Manufacturing consent: The political economy of the mass media*. New York: Pantheon Books.

Humphrey, L. (1997, November 9). Pollsters skeptical of anti-bilingual findings. *North County Times*, Retrieved from http://ourworld.compuserve.com/homepages/jwcrawford/NCT2.htm

Huntington, S. P. (2004). *Who are we? The challenges to America's national identity.* New York: Simon and Schuster.

Kohn, A. (1999). *The schools our children deserve: Moving beyond traditional classrooms and 'tougher standards.'* New York: Houghton Mifflin.

Kohn, A. (2004). NCLB and the effort to privatize public education. In D. Meier and G. Wood (Eds.), *Many children left behind: How the No Child Left Behind Act is damaging our children and our schools.* Boston: Beacon Press.

Krashen, S., Crawford, J., & Kim, H. (1998). Bias in polls on bilingual education: A demonstration. Retrieved from http://ourworld.compuserve.com/homepages/jwcrawford/USCpoll.htm

Kurtz, H. (2001, October 31). CNN orders "balance" in war news: Reporters are told to remind you why US is bombing. *Washington Post,* p. C1.

Lankshear, C., & Knobel, M. (2003). *New literacies: Changing knowledge and classroom learning.* Buckingham, England: Open University Press.

Matursewicz, R. (2002). The editor's corner. *Educational Studies, 33*(2), 145–149.

McChesney, R. W. (1999). *Rich media, poor democracy: Communication politics in dubious times.* New York: Free Press.

McChesney, R. W. (2004). *The problem of the media: US communication politics in the 21st century.* New York: Monthly Review Press.

Media Alliance. (1998). *Media analysis of newspaper coverage of bilingual education.* Retrieved from http://www.media-alliance.org/voices/bilingual/analysis/html.

Meier, D. (2004). NCLB and democracy. In D. Meier & G. Wood (Eds.), *Many children left behind: How the No Child Left Behind Act is damaging our children and our schools.* Boston: Beacon Press.

Molnar, A. (1996). *Giving kids the business: The commercialization of American schools.* Boulder, CO: Westview.

Monbiot, G. (2005, January 18). A televisual fairyland: The US media is disciplined by corporate America into promoting the Republican cause. *Guardian,* Retrieved from www.commondreams.org/views05/0118–24.htm.

Moore, M. (2002). *Stupid white men: And other sorry excuses for the state of the nation.* New York: HarperCollins.

Mother-Jones-Editor. (2003). Media conglomerates. Flier.

Moyers, B. (2005, May 15). *Closing address.* Paper presented at the National Conference on Media Reform, St. Louis, MO.

NMMLP (New Mexico Media Literacy Program). About NMMLP. Retrieved from www.nmmlp.org.

No Child Left Behind Act of 2001, 20 U.S.C. 6301 (2002).

Parry, R. (2004, November 3). Too little, too late. Retrieved from www.consortiumnews.com

Quezada, M. S. (2000). And the beat goes on . . . the debate over bilingual education continues: Proposition 227 one year later. *Multilingual Educator, 1*(1), 15–19.

Rendall, S. (2005, January 11). FAIR on Bush admin funding of Armstrong Williams: The government is running a domestic propaganda operation secretly targeting the American people. *Democracy Now,* January 11, (A. Goodman, Director). Retrieved from www.democracynow.org/article.pl?sid=05/01/11

Rendall, S., & Broughel, T. (2003, May/June). Amplifying officials, squelching dissents: FAIR study finds democracy poorly served by war coverage. *Extra!* Retrieved from www.fair.org/extra/0305/warstudy/html

Rideout, V. J., Vandewater, E. A., & Wartella E. A. (2003). Zero to six: Electronic media in the lives of infants, toddlers, and preschoolers. Menlo Park, CA: Henry J. Kaiser Family Foundation.

Ritter, D. (2003, August/September). Delusions of bias: What liberal media? The truth about bias and the news. *Public Citizen News*, p. 15.

Roy, A. (2003). Instant-mix imperial democracy: Buy one, get one free. In *Center for economic and social rights* (pp. 1–19). New York: Riverside Church.

Sanders, B. (2003, November 7–9). *Media reform*. Madison, Wisconsin. Excerpt transmitted in *Democracy Now Radio TV*. Retrieved from www.democracynow.org/archives

Sapir, M., & Huff, M. (2003, October). The public opinion polling fraud: Corporate polls validate corporate agendas. *Z Magazine*, pp. 43–46. .

Scharrer, E. (2003). Making a case for media literacy in the curriculum: Outcomes and assessment. *Journal of Adolescent & Adult Literacy, 46*(4), 354–358.

Sholle, D., & Denski, S. (1995). Critical media literacy: Reading, remapping, Rewriting. In P. McLaren, R. Hammer, D. Sholle, & S. Reilly (Eds.), *Rethinking media literacy: A critical pedagogy of representation* (pp. 7–31). New York: Peter Lang.

Sleeter, C., & Grant, K. (1991). Race, class, gender and disability in current textbooks. In M. Apple & L. Christian-Smith (Eds.), *The politics of textbooks*. New York: Routledge.

Solomon, N. (2003, December 3). Brand loyalty and the absence of remorse. *Z Magazine*, p. 7.

Stauber, J. (2005). State propaganda: How state agencies produce hundreds of prepackaged TV segments the media run as news. Interviewed in Democracy Now TV and radio. Retrieved from www.democracynow.org/article.pl?sid=05/03/14/

Steinberg, S., & Kincheloe, J. L. (1997). Introduction: No more secrets—Kinderculture, information saturation, and the postmodern childhood. In S. Steinberg & J. L. Kincheloe (Eds.), *Kinderculture: The corporate construction of childhood*. Boulder, CO: Westview Press.

Street, P. (2003, March). Broadcast priorities. *Z Magazine*, pp. 2–3.

Wiley, T. G. (2000). Propositions 227: California's new restriction on the educational choices of language minority parents and children. *The Multilingual Educator, 1*(1), 34–35.

Willinsky, J. (2002). Democracy and education: The missing link may be ours. *Harvard Educational Review, 72*(3), 367–392.

Literacy and Learning Through Digital Media

Education or Contradiction?

Leslie B. Mashburn and John A. Weaver

What is contradiction? A friend and I have a way of amusing each other by making trans-lations of the other's name in different languages. Of course, the meanings are spoofs, but that is the point—to make the other person laugh. This little game comes to mind when I think of the meaning of contradiction. At the risk of sounding unsupportive of our national leader, we assert that in the newest edition of the dictionary beside the word con-tradiction, there should be the name George W. Bush. Why do we feel this way? What does this have to do with the chapter at hand? Everything; read on.

In 2002, President George W. Bush signed a piece of legislation titled No Child Left Behind (NCLB). This act has single-handedly contradicted everything we believe about students and education. One of the biggest arguments raised by educators for centuries is that students learn best when the learning is authentic and meaningful. Who, in our world today, would dare argue that students spend their days outside the school setting studying quality and/or traditional works of literature, listening to the classics, and engaging in other, so-called, meaningful learning activities? What students do engage in are acts of learning through means considered by many adults as futile. In this case, we refer to digital means of learning such as films, video games, and animation. So why in this case, do we insist on

educating students through methods and forms of curriculum that are not relevant to their lives? Here we are faced with the first of many contradictions of NCLB with regard to the learning that occurs in public school classrooms today.

In the foreword to NCLB, George W. Bush states, "In a constantly changing world that is demanding increasingly complex skills from its workforce, children are literally being left behind." Our world is increasingly complex; especially in relation to the media, technology, and literacy. We agree with that declaration and the fact that students are not learning at adequate levels. However, it is in the interpretation of this statement by Bush where the conflict arises.

There are twelve standards for the English/Language Arts that have been enacted in part as a result of NCLB. Many of the standards refer to utilizing different methods of learning, comprehending, and utilizing language, text, and other literacy elements. Even so, there is one particular standard that specifically addresses the need for students to possess the ability to use different resources of technology and information to "gather and synthesize information and to create and communicate knowledge" (Georgia Department of Education, 2002). In the very foreword of the act, Bush acknowledges this fact. It is in the blueprint and implementation of the act, however, where focus is lost and students are left behind as a *result* of NCLB.

NCLB aims to focus broadly on the following four elements:

1 Increasing accountability for student performance
2 Focusing on what works
3 Reducing bureaucracy and increasing flexibility
4 Empowering parents.

These statements scream contradiction!

Increasing accountability for student performance: No one would argue that teachers should be held accountable for the learning of the students they teach. In this context, there is a discussion of how to reprimand continually failing schools and how to reward the schools that show improvement. However, consider the following scenario: A fourth-grade teacher, Mrs. Smith, is an excellent teacher. There is one particular student in her class, John, reading on a first-grade level. At the end of the school term, John reads on a third-grade level. Mrs. Smith was able to increase John's reading abilities by two grade levels in one year. Because John will take a standardized test on the fourth-grade level (which is going to prove to be at his frustration level) when Mrs. Smith is held accountable, she will appear a failure. Will the school where Mrs. Smith teaches be sanctioned or rewarded? As people who have spent countless numbers of hours in our public schools, we have witnessed classrooms full of students like John being taught by outstanding teachers such as Mrs. Smith. It is a tragedy that all of the Mrs. Smiths of our world will appear inept at their jobs.

Focusing on what works—great idea! Money should be spent on programs that are effective. The contradiction found within this statement lies in the fact that there is typically a three-year implementation period that is required before it is fair to judge a program as successful. When programs are implemented in classrooms today, students are tested yearly.

Schools are then rewarded or sanctioned based on the results of the assessment. Another issue worthy of further study is the methods by which programs and curricula are deemed worthy of implementation in the schools. An entire book could be written on this statement alone.

The third issue addressed in the blueprint for NCLB is reducing bureaucracy and increasing flexibility. This statement may be the biggest contradiction of all. Is the act itself not a form and the result of bureaucracy and government? Does the implementation of a mandated curriculum not take away freedom in teaching best practices? In the description of this statement there is mention of the additional "flexible funding" that will be allotted at the local level. Any person involved with a school that receives the Reading First Grant, which is a source of funding through NCLB, will voice the truth of restrictions placed on schools because of the additional funding. Schools receiving funds through Reading First are very limited in the choices of the curriculum used to educate students. Is this reducing bureaucracy?

Statement four from the NCLB blueprint is yet another area of contradiction. We refer back to our previous scenario of Mrs. Smith and John. Under this statement, parents will be informed of the ratings of the schools their children attend and will then have options of transferring their students to higher performing schools if necessary. What if students are members of a classroom led by teachers such as Mrs. Smith, and the problem lies in the abilities of the *students*? It seems unfair that parents will be misinformed based on the results of standardized tests that may not show true progress made by students.

We could drone on and on about the contradictions of NCLB, but instead we will now turn toward the effect of the act on literacy, media, and learning. In order to do so, we must first realize that literacy is not limited to the interpretation of a printed word. There are "reading" strategies involved in all of these and other subject areas. There is literacy in all subject areas—math, science, history, technology, and the list is endless. When students encounter the words "find the difference" in mathematics, it is interpreted as the need to subtract. There are sequencing issues involved in experiments in the sciences as with hypertext and hypermedia within technology. Interpreting characters' motives in films is a strategy that will help students be critical and creative thinkers. Take this issue one step further—delving into the intrinsic complexities of digital media will enable students to understand meanings of words through the production of the world. If we admit that student involvement in the digital age is worth of study and implementation into our curriculum, we may then have the ability to rectify the contradictions mentioned previously.

Many television commercials today promote parents becoming involved with their children. The question is asked "Do you know what your child is doing?" Parents and teachers alike should live the reality of their students, which, in many cases, translates into living in a digital age. Some adults do engage in gaming and other interactive forms of media. However, we would venture that the majority of the adults do not participate in this type of activity, which brings us to the point—you CAN teach old dogs new tricks. Instead of dwelling on the past and remembering how we were taught and making an analogy to our current brilliance, we must accept that times have changed and so have the children and

youths in our schools. We reason that adults work hardest when interested and motivated. Students today are no different—it is what motivates and interests them that differs from the "good old days" of adults. Our children love to play video games. As parents, we would prefer they engage in more "educational" activities. As educators we realize the value of the play station as a teaching tool. Leslie's son once said to her after he performed quite well in a baseball game that he knew what to do in the game because he plays baseball so much on his play station—he knew where to throw the ball when a runner was on first base, and he knew to throw the ball home when a runner was about to cross the plate. This same pattern of learning can be utilized in schools as well. Analogies are wonderful teaching tools. Teachers can use what students learn by playing the video baseball game and translate that experience into practice in the classroom. Coming to a word you don't know how to pronounce is like having a runner on first and third, you have to weigh your options, and choose the best strategy. Sequencing can be taught using a discussion of the levels students go through in video games, or the steps they utilize in downloading songs to their I-Pods, and so on. Even more importantly, it is paramount that we teach young people to read critically the images they encounter in any form of medium.

Reading in the Digital Age

We are surrounded by digital images. Digital images save our lives and transform our basic entertainment and everyday interactions with other people. When a critically ill person enters into a hospital with some unknown brain disorder, it is the images of PET and CAT scans enabling doctors to detect possible lesions in the brain. However, the doctors need to know how to read the images or the wrong diagnosis could be made. We can click on the television set and watch commercials where the strong armed quarterback for the Atlanta Falcons, Michael Vick, throws a ball from the field into the second deck of the stadium or we can see Lebron James of the Cleveland Cavaliers hit four consecutive 94-foot shots. If viewers do not know the difference between a real image and a digitally enhanced image, they will be duped into believing Vick or Lebron have Superman qualities. Students learning to discern the digital image will be interpreting media in the complex and changing world referred to by Bush.

Digital images have made progress in transforming some arenas of education. With the Visible Human Project, medical students and others in the field of medicine no longer have to purchase a cadaver to learn the anatomy and the physiology of the human body. Now medical colleges only need to purchase CDs of a male Texas death row inmate and a 49-year-old housewife from Maryland who volunteered to be sliced and downloaded after their deaths onto a computer. Students no longer need to be afraid of making a mistake on their cadaver. If a mistake is made they click back and start over. Lesson learned, images read. The involvement with technology heightens the learning experience.

It is important to keep in mind what a digital image is and why it is prevalent in our world. A digital image, simply stated, is nothing more than zeros and ones of binary codes.

The very core of the digital image is its reduction to bits and bytes of information. This reduction of images to information means that an image no longer has a boundary or limits.[1] What one can place into an image only depends on the amount of information one has access to. For example, within the film industry, filmmakers were limited to what was caught on camera and their abilities to edit what was filmed. There was no other way to alter the images. Now most actors work in front of a blue or green screen, and the computer graphics artists put any image in the background imaginable. Ninety percent of the *Star Wars* trilogy, *Lord of the Rings* trilogy, and *King Kong* were digital images. If every image can be manipulated to the point where the digital is morphed with the real, then how can we tell the difference between what is real and what is digitally altered? The answer lies in how well we teach ourselves and our students to read the digital image. It is easy to teach young people how to learn the difference between an actor and a king-sized gorilla. Even a very young child can tell what is real in this case. However, what about more nuanced images such as the Vick and Lebron commercials? We have heard high school students talk about how they thought Vick and Lebron possess those abilities. Clearly, students need to learn how to read an image and comprehend where the frames of a commercial are spliced and a digital image is introduced, thus creating an image of a Michael Vick throw or a Lebron James shot. There are plenty of greedy corporations and power hungry politicians willing to tell us what digital images mean if we do not learn ourselves and teach it to young people.

What is at stake in the expanding of reading in schools to include digital images is the meaning of our democracy and the ability of young people to live in a world in which meaning is never fixed and always open to negotiation. We need to follow the orders given to us by our president in the foreword of NCLB and prepare students for our complex world. So why is this not happening? It seems to us that students are expected to be proficient readers by the end of grade three, yet the means to teach them to do so are far removed from the standards that would ensure involvement with varying forms of technology. Waiting until students have the potential to examine all forms of media including print is detrimental to the learning process. Critical thinking is not taught *after* students learn to read. It should be taught simultaneously. To present our contention, we want to turn to animation and how a critical reading of animated films needs to be applied.

Conservative Messages of Animated Films and Critical Media Literacy

Before presenting a reading of the recent animated film, *The Incredibles* (Lasseter & Bird, 2004) we want to first offer reasons why animated films have become so popular. There is a technological and monetary reason why animation has experienced a golden age of production.[2] Technologically, the digital age has made it easier to create more animated films than ever before. A team of animators can now make six or seven major feature films in the time that used to take months or sometimes years for a team of animators to produce. The use of digital technology to create animated films does not mean it is easier to do so.

It is very costly for digitally created animated films to be made and the investment of time is still demanding. What digital technology permits artists to do is create an animated world on the computer screen in more detail than traditional animated films and then transfer those digital images onto the movie screen. The rise of the buying power of young people in America has ushered in the golden age of animated films. Although we would suggest that animated films are created for children as well as adults, it is young people who pay to see animated films and buy all the paraphernalia that accompany a new film such as kids' meals at fast food joints, DVDs, music sound tracks, and clothing items. The buying power of young people according to Joe Kincheloe and other cultural studies scholars, ranges anywhere from 9 to 11 billion dollars in direct disposable income and another 160 billion dollars that they influence parents to spend. This income source has flooded the market for animated films, and animation studies have responded to this demand. The growth has been so precipitous that the Academy for Motion Pictures Arts and Sciences has for the past five years created a separate category to honor the best animated films. No other genre of film can proclaim its own category. That fact alone may spark the interest of students who enjoy film. However, a better idea would be to allow students to discover this phenomenon on their own; engage in discovery learning activities. Using technology not only as a motivational tool, but as a learning tool as well will ultimately benefit society as a whole as we produce more educated, well-rounded individuals.

Besides the technological and economic reasons cited above, there are important political messages in animated films to justify the creation of a critical media literacy. To highlight this political dimension of animation we want to focus on *The Incredibles*. *The Incredibles* is a tale of a superhero family unable to fulfill its destiny as heroes in a society mired in mediocrity and envious of excellence. There was a time when this superhero family and other superheroes like them could perform deeds of preserving social norms and tranquility of social order. This period, however, declined because people were no longer interested in being rescued from dangerous situations caused either by natural disasters or villainous arch-enemies of all that is good. Instead of thanking superheroes for saving lives, unscrupulous lawyers encourage the people to sue the superheroes for injuries incurred during a rescue attempt. Eventually, the government organization in charge of overseeing superheroes recommends that superheroes no longer be permitted to perform glorious deeds. As a result of the government edict, the superheroes go underground and emerge as ordinary citizens, working ordinary jobs, and living ordinary humdrum lives. Society then becomes threatened by evildoers who target the very vitality of this tranquil little democratic animated hamlet. Once the ordinary citizens are endangered, they realize their society is not safe unless the natural order is reinstated and the true, natural born leaders are restored to their status as superheroes. With the natural order of things back in place, the Incredibles are able to defeat the villains and protect democracy from itself and outside threats.

The message of *The Incredibles* eerily reflects the political attitudes of current leaders in the United States. The fourth-century B.C. philosopher Plato believed that in a democracy only the truly gifted and anointed people should rule. If the ordinary masses were to rule, then mediocrity would reign and threaten the vitality of the democracy. Plato's beliefs

about democracy and who should rule a democracy have been carried through into the twenty-first century with the ideas of Leo Strauss who believed the good life and democratic civilization can only survive if the most talented rule. The masses' only role is to elect these gifted superheroes and to step aside as they determine what is best for a democratic civilization. While at the University of Chicago, Strauss taught many of the current political leaders including Paul Wolfowitz, the architect of the Iraq war, Leon Kass, and William Kristol, who, as editor of the influential journal *The Weekly Standard*, has argued that the current war in Iraq is good and necessary in order to usher in the new American century.[3] What we find in *The Incredibles*, we recognize in contemporary politics: an inherent distrust of democracy and a divine right of self-appointed superheroes to rule unabated, who are accountable only to what is right and excellent. These beliefs and messages demonstrate why there is a need to create a critical media literacy for the digital age.

Toward a Critical Digital Media Literacy

If digital images and animation were to be introduced into the curriculum of primary and secondary schools what would such a curriculum look like? It is not enough to introduce these artistic forms into classes or to justify their existence in public school curricula because digital images and animation have become a major source of job creation in the United States. Such a rationale is too instrumental and reduces the education of young people to economic means and commodification. The major reason to create a critical media literacy of digital images and animation is to encourage students to become active participants in the construction of a democratic reality. The same thing that Jacques Derrida says about television applies to digital images and animation. "What is possible and . . . desirable are not legislative decisions concerning the production and distribution of whatever it is, but open programs in education and training in the use of this technology . . . You would have to do everything possible so that . . . users of these technical instruments might themselves participate in the production and selection of the programs in question" (Derrida and Steigler, 2002, p. 54). Teachers need to create opportunities for students to "play" with digital technology and animation so students can discover how to create their own ideas and opinions via these technologies. More importantly, using the technology of the digital age permits young people an opportunity to see how easily digital images can be manipulated, and why it is important to learn how to "read" these images and interpret their potential meaning.

To permit playing with and reading of digital images will run counter to current trends, buttressed by NCLB, to feed students disconnected facts and to (over-) test their retention of these facts. Even if such a pedagogical approach runs contradictory to NCLB legislation, the introduction of critical media literacy in public schools supports the idea that young people and adults are neither objects nor subjects to be used by corporations and dynastic powers for exploitive purposes. A critical media literacy can firmly state that young people do not exist to fulfill the needs of corporations, and schools are not the test-

ing and proving grounds of corporations. Introducing digital images and animation into a curriculum can teach young people that schools should be places where the mind is cultivated and the imagination can run free.

REFERENCES

Derrida, J., & Steigler, B. (2002). *Echographies of television*. Oxford: Polity Press.

Georgia Department of Education (2002). K-8 Language Arts and Reading Textbooks Recommended for Use in Georgia Schools. Retrieved July 2, 2005, from http://www.doe.k12.ga.us/_documents/curriculum/instruction/textbooks_recommended_k8arts.pdf .

Hansen, M. (2002). Cinema beyond cybernetics, or how to frame the digital image. *Configurations*, *10*(1), 51–90.

Hansen, M. (2004). *New philosophy for new media*. Boston: MIT.

Jones, G. (2004). *Men of tomorrow: Geeks, gangsters, and the birth of the comic book*. New York: Basic Books.

Lasseter, J. (Executive Producer), & Bird, B. (Writer/Director). (2004). *The incredibles* [Motion picture]. United States: Walt Disney Pictures.

Manovich, L. (2001). *The language of new media*. Boston: MIT.

No Child Left Behind Act of 2001, 20 U.S.C. 6301 (2002). Retrieved from http://www.nationalreading panel.org/Publications/No%20Child%20Left%20Behind.pdf

Norton, A. (2004). *Leo Strauss and the politics of American Empire*. New Haven, CT: Yale University Press.

Rutsky, R. L. (1999). *High techne: Art and technology from the machine aesthetic to the posthuman*. Minneapolis: University of Minnesota Press.

Spiegelman, A. (1986/1991). *Maus*. New York: Pantheon.

Spiegelman, A. (2004). *In the shadow of no tower*. New York: Pantheon.

Wells, P. (2002). *Animation and America*. New Brunswick, NJ: Rutgers University Press.

Wright, B. (2001). *Comic book nation: The transformation of youth culture in America*: Baltimore: Johns Hopkins University Press.

NOTES

1 The literature on the digital image is extensive. If one is interested in how the digital image changes how we see and read the world, one is referred to these sources: Hansen (2004) *New Philosophy for New Media*; Hansen (2002) "Cinema beyond Cybernetics, or How to Frame the Digital Image"; Manovich (2001) *The Language of New Media*; R. L. Rutsky (1999) *High Techne: Art and Technology from the Machine Aesthetic to the Posthuman*.

2 Anyone interested in the history of animation including comic strips can find ample sources including Bradford Wright's (2001) *Comic Book Nation*, Gerard Jones's (2004) *Men of Tomorrow*, and Paul Wells's (2002) *Animation and America*. To understand the evolution of animation and its cutting edge avant garde potential, see Art Spiegelman's work *Maus* (1986/1991) and *In the Shadow of No Tower* (2004).

3 To understand the impact of Leo Strauss's political philosophy of contemporary leaders, see Anne Norton's (2004) *Leo Strauss and the Politics of American Empire*.

"Diving into the Wreck"

Mystory Writing to Enact Critical Media Literacy

Cindy Meyer Sabik, Bethany Davin, Carolyne J. White

Realizing that learning is much closer to invention than to verification, I intended mystoriography primarily as a pedagogy. The modes of academic writing now taught in school tend to be positioned on the side of the already known rather than on the side of wanting to find out (of theoretical curiosity) and hence discourage learning how to learn.

—Ulmer, 1994

Being in tune with every molecule in the universe requires a great deal of concentration. —Robin Williams as the "King of the Moon" in *The Adventures of Baron Munchausen* as his head floats apart from, and above, his body. (Eberts & Gilliam, 1988)

With feminist poet Adrienne Rich (1984), we invite you to join us in "Diving into the Wreck" created from conventional uncritical literacy practices that are normalized in high school and university classrooms. These are our prevailing practices that still manufacture a split between our intellectual work and our lived experience and still position students within the realm of the already known, the realm of reproduction, rather than

inviting them into the realm of critical literacy.

What if modernist forms of writing and inquiry colonize the emotions, bodies, and selves of all involved in the learning process? What if these conventional forms encourage the creation of scholarly machines that speak like disembodied talking heads?

> This is the way with amputations. They don't just heal up like a wish.
> (Sexton, 1971)

Not satisfied to just "re" port, to "re" iterate, to "re" view our "re" search . . . to merely "re" live what has been sanctioned, we reclaim the body as the site of our political action in the world. With Antonia Darder (2006), we cite "the origin of emancipatory possibility and human solidarity [as] resid[ing] in the body" (p. 11).

Mystory writing alters the means of textual production (what it means to write), the means of consumption (what it means to read), and the means of inquiry (what it means to know). A peculiarly postmodern form, mystory writing juxtaposes fragments of personal experience, popular culture, and scholarly discourse, and so the writer participates more fully and more critically in the construction of meaning, and the reader can experience them "talking back" to each other. As Ulmer explains, "each of these institutional discourses has "its own logic, form, mode of proof, preferred medium, sphere of influence. In modernity these institutions are kept strictly separate and are related in terms of a ranked hierarchy. This arrangement is a necessary feature of literacy" (Tabbi & Ulmer, 1996). Mystory writing subverts this hierarchy, providing a radically democratic apparatus to incite critical media literacy.

> The words are purposes.
> The words are maps.
> (Rich, 1984)

BETHANY: *WARNING*: You are entering a new form of multivocal interventionist writing, a mystory textland of impossible missions. The assignment: to stay present in body, mind, and spirit.

We were warned. Students could not say later that they fell down the rabbit hole and into wonderland by accident. Our mad hatter, Carolyne herself, warned us about the journey on which we were embarking, the mystory. I knew immediately the mystory I would write. From the first day of class, Carolyne practiced risky behavior; she told us about her life and her journey to the classroom, making overt her political and social views; she engaged in the pedagogical practices she required her students to perform; and she warned us and showed us the exit door. No one left that class the first day; people seemed glued to their seats for the spectacle. We had a choice. Another section of this same class, taught by a different professor, was being offered at the same time, merely a few doors down the hall where no such difficult work would be required.

CAROLYNE: Bethany's mystory paper was a gift that caught me unprepared. I was assigning mystory writing without fully acknowledging my own confusion about the project. Bethany's paper showed me what a mystory paper could be—gave me a relay to incite mystory contagion in classrooms.

BETHANY: What resonates for me in the mystory form is its visual aspects. I now have a method that allows me to write as I speak. The juxtaposition of text allows the reader to place herself inside the work, to *HEAR* it as personal experience, popular culture, and tra-

"In that direction," the Cat said, waving its right paw round, "lives a Hatter: and in that direction," waving the other paw, "lives a March Hare. Visit either you like: they're both mad." "But I don't want to go among mad people," Alice remarked. "Oh, you can't help that," said the Cat: "we're all mad here. I'm mad. You're mad." "How do you know I'm mad?" said Alice. "You must be, said the Cat, "or you wouldn't have come here." (Carroll, 1865)

ditional scholarship argue, interrupt, insult, and flirt with one another.

In school I was always concerned that my writing did not read like my spoken language. I am no longer concerned. Mystory writing allowed me to re-introduce the I into my writing, the part that had been expunged by enthusiastic teachers, who wished to create future scholars and academics. They convinced us these Is were unprofessional, too casual, and they convinced us to cloak ourselves in traditional scholarship, to take those thoughts as our own. This task is easy because they seem authorless. The author is unpositioned, outside the work, conveniently leaving a place for me to slip into, to assert that these are my thoughts, or they resemble my thoughts, or they would be my thoughts if I had thoughts.

CAROLYNE: It was during my reading of Bethany's paper that I received a note from Norm Denzin about submissions for an upcoming conference. Norm had introduced me to mystory writing, and I knew he used it with his students. I asked Bethany if she would like to do a presentation based around her paper, and she agreed. Following the conference, Norm suggested that we write up the presentation for inclusion in a research annual he edits.

CINDY: I, too, first encountered Ulmer's (1989) mystory writing in a class Carolyne taught. Like Laurel Richardson (1994), I see writing as a way of knowing—of discovering and analyzing both the self at hand and the project/process. Because I ask both teachers and students to seek new ground by breaking rules in order to let more of the self surface in writing, I am ethically obligated to participate in this experiment to create authentic text. I cannot ask others to engage in a more dynamic writing process than I do myself. And so, I wrote my dissertation—(Re)Writing Metaphor and Form: Autoethnographic Enactments from the Postmodern Classroom)—as an enactment of two alternative forms: Ulmer's Mystory (1989) and what Ken Macrorie (1988) calls the "I-Search Paper."

BETHANY: This telling of tales and sharing of secrets is not what Ursula LeGuin names the "father tongue" or the language of power. These tales are told with the "mother tongue," a language not taught in school, a language of storytelling.

> The mother tongue is language not as mere communication but as relation, relationship. It connects. It goes two ways. Many ways, an exchange, a network. Its power is not in dividing but in binding, not in distancing but in uniting. It flies from the mouth on the breath that is our life and is gone. Like the out breath, utterly gone and yet returning, repeated, the breath the same again always, everywhere, and we all know it by heart. (LeGuin, 1989, p. 209)

Lived experience . . . is seldom examined, and of course the problems that surround the representation (and recovery) of lived experience are never examined. — (Denzin, 1997, p. 245)

Inherent in LeGuin's description of the mother tongue is the element of transitiveness, of conversation, of a secret passed from the lips of one softly into the ear of another. How then is the mother tongue changed by the process of writing? Does the writing of the mother tongue steal the soul of

> Hike up your skirt a little more/
> and show your world to me.
> —Dave Mathews Band, Crash (1996)

the speaker comparable to some Indians' belief that a picture taken could steal their souls?

I thought that I held my secrets dear to me, mysterious like the body I contend with, changing, altering in ways that I cannot see—the folds and twists of my tales, intimate and complex as the folds of my sex. I have exposed my secrets; I have outed myself as a sexual being. I willfully engaged in the process of mystory writing; I was unprepared, though, for the consequences of mystory writing. The process required the critical retelling of my tale, the product, a permanent record of the storytelling, a record that could be appropriated, misread, or misunderstood—a product that tore back the curtain of authoritative discourse and left me exposed.

Two years after the telling of my tale, I bought a copy of my story in the university bookstore for $7.95, packaged with the somewhat more anonymous and academic writings of others. This was the paper Carolyne and I prepared for Norm to publish (White & Kimbell-Amos, 1995). Then I sat in a class, a voyeur, as my secrets were discussed and analyzed, agreed with, disagreed with, critically approached and encountered. I was now open to criticism—not my scholarship, myself.

On the final day of class, we were asked to share our thoughts about the material, content, syllabus. One of my classmates shared that, although he had not thought that he would like me, he had in fact grown to do so, and I began to cry. I cried because I had engaged in the politics of the personal and they had been trivialized into an open invitation to comment on my likeableness.

At that moment I wanted my classmates out of my house, like a host who flings open her door to scream at the drunken revelers she invited to the party, "Out! Get out! This party is over, you are not welcome here any longer!"

CINDY: The evening my Philosophy of Education course first met was at the end of what was, for me, an all-too-typical day. I had driven to the university for an 8 A.M. class that I'd been called to team-teach the night before

> Here in the matrix of need and anger, the
> disproof of what we thought possible
> (Rich, 1984)

the semester began. The commitment that should have kept me until 10 A.M. took until 2 P.M., giving me just enough time to retrieve my kindergartner at 2:40. I showed up at her school to find out that she'd wet her pants four times that day—so we went straight to the doctor, then to the pharmacy, then home just in time to deliver her to her father, so that I could drive back for the 5 P.M.–9 P.M. philosophy class. I rushed through the door, asked them if I was in the right place, and pulled out my syllabus, only to discover that I simply could not adjust my focus that quickly. I had to explain to them what my day had looked

like before I could move on to the syllabus. It was a good thing to do. I relaxed, focused, and moved into the work; they were put at ease, got to know me a little bit . . . as a pedagogical strategy, a human connection is never a bad thing—but I've become very adept at revealing only select pieces of myself. Experience has taught me that many students don't want to invest the time and money required for a 600-level course only to show up and find out it's being taught by a *mommy*. But there I was. I'd set sail with them in full mom regalia—confused, pre-occupied, overwhelmed—a virtual mom cliché, worrying about wet pants and doctors' prescriptions.

To make matters worse, I handed them what appeared to be a heavily feminist syllabus. They were to purchase and read Jane Roland Martin's text *Reclaiming a Conversation*, subtitled *The Ideal of the Educated Woman,* in which she re-reads Plato, Rousseau, Mary Wollstonecraft, Catherine Beecher, and Charlotte Perkins Gilman, retrieving lost conversations about the education of women in an ideal society. Of course they asked if this was a "feminist course," and I—feeling pretty at ease at that point—assured them that it was not—that it was simply a course made more complete by virtue of the inclusion of what had been overlooked.

That night I had a dream. . . . While my family, friends, and others, including my mother-in-law and the local bishop, gathered in the church of my childhood for a very solemn, important event, I decided that I would sit in a carriage in front of the church—in nothing but *my* underpants. My husband and teenage daughters pleaded with me to put some clothes on, but I wouldn't. Surely everyone there had seen breasts before—what was the big deal?

Finally they convinced me that my behavior was inappropriate, and as a tidal wave of shame swept over me, I came to the understanding that I had ruined something that could never be retrieved—that I could not just put on my clothes and behave as though nothing had happened. All of the guests had been planning to come to our house following the gathering at the church. We canceled it and went home alone. I woke up, ashamed and embarrassed, and the discomfort of the dream hung over me until mid-morning, when I realized with a shock that it was a result of my performance in class the evening before. I had been revealed—as woman, as mommy, wife, worrier, and the ultimate horror—feminist. I was a college teacher who was not solely preoccupied with the ivory tower. What's more, I didn't just take care of a little girl's wet pants—I talked about it later. I had threatened the sacred, challenged the traditional, and it frightened me, distracted me, and haunted my dreams.

I have, like Virginia Woolf, been called to confront the "Angel in the House," who, she says, comes "between me and my [work]." She describes the angel:

She was intensely sympathetic. She was immensely charming. She was utterly unselfish. She excelled in the difficult arts of family life. She sacrificed herself daily. If there was a chicken, she took the leg; if there was a draught, she sat in it—in short she was so constituted

We are, I am, you are/ by cowardice or courage/the one who find our way/back to this scene/carrying a knife, a camera/a book of myths/in which/our names do not appear. (Rich, 1984)

that she never had a mind or a wish of her own, but preferred to sympathize always with the minds and the wishes of others. Above all—I need not say it—she was pure. (Woolf, 1936/1994, p. 241)

> It is hard to believe my body and I were ever attached. We are so totally incompatible. I mean, he is still dangling from the food chain and I am in the stars. It is so un-metaphysical. (From *The Adventures of Baron Munchausen*)

This angel is not limited to domestic terrorism. When Woolf sat down to write, "the shadow of her wings fell on my page." As she wrote, the conventionality of the predominant male sensibility (and in her case in 1936, the realization that all of the critics were male) stopped her pen. "Men, her reason told her, would be shocked. The consciousness of what men will say of a woman who speaks the truth about her passions had roused her from her artist's state. . . . She could write no more. . . . This I believe to be a very common experience with women writers—they are impeded by the extreme conventionality of the other sex" (p. 243).

I, like my students, am impeded by the same fears borne out of the same female cultural conditioning that Virginia Woolf recognized in 1936. I see it now, "something more permanent/than fish or weed," with her help, and with Adrienne Rich's help, and with the help of like-minded colleagues. I don't see it alone, and I don't see it until I construct an autoethnographic artifact, then dive into the wreck, looking, not only with fresh eyes, but with the eyes of feminist companions.

This work is complicated, it is ongoing, it is collaborative, it is difficult, and it is pleasurable. Once I understood my dream, I loved it.

BETHANY: As we create opportunities to speak Ursula LeGuin's mother tongue, the language of the highly particular and the personal, the language of relationships, we must also create opportunities for a new reader and a new listener. The mystory writer must carefully navigate the question of how to retell the private, in a socially transformative manner, for it is the willingness to share personal and painful experiences that makes the personal political because it challenges the academy's assumption that knowledge is only possible if we assert an objective stance. The mystory listener or reader should not merely view these stories as the indulgent self-exploitation of the writer, but as evidence of the distinctive experience of the oppressed and exploited, and to know the politics of the oppressed is to be invited into personal lives and experiences. The mystory writer is not merely the talking head, the wizard behind the curtain, she is exposed, identified; her subjectivity not only acknowledged, but lit up by bright neon signs.

CINDY: The students in my "non-feminist" philosophy of education class are about to write mystories. I prepare them by assigning an essay called "Narrative in Philosophy of Education: A Feminist Tale of 'Uncertain' Knowledge." The first sentence reads: "Over the past decade or so, narrative has assumed an important place not only overall in educational research and practice but also increasingly in Philosophy of Education." Then, I read them a piece by Nancy Sommers (1992) in which she exhorts us all to find our own voices, to refuse to submit to the guidebook of authority that does all of the thinking for us, that makes the educational enterprise akin to a vacation in which the AAA manual

"direct[s] us, tells us what to see, how to see it, and how long it should take us to see it" (p. 24). Her essay/story begins "I cannot think of my childhood without hearing voices, deep, heavily accented, instructive German voices."

We read through Annie Dillard's "Living like Weasels" (1982), which she closes with, "we can live any way we want. People take vows of poverty, chastity, and obedience—even of silence—by choice. The thing is to stalk your calling in a certain skilled and supple way, to locate the most tender and live spot and plug into that pulse" (70).

There are, for me, two crucial points that emerged from that class. First, several students felt compelled to defend the author of the text about narrative which I presented as an ironic text in which the author discusses the importance of narrative, but fails to place herself in the text. I was not disturbed that some students liked her, that they enjoyed the essay, but rather that they appreciated her ability to meet their expectations. I was, they felt, being too hard on her—a meany—much the way my five-year-old daughter feels I'm "mean" by refusing to honor the infamous Chief Wahoo logo so long revered throughout greater Cleveland. He is, she tells me, *a nice guy.*

The other significant event occurred when I explained the mystory form to them. It's been my experience that students tend to be, at least initially, stymied by the quirky combination of elements in the mystory assignment. Fragments . . . popular culture . . . *juxtaposition.* For a student invested in clarity, for the student who succeeds by carefully following instructions, this is a risky venture, fraught with ambiguity. Students will walk away from the initial assignment confused, frightened, even angry. In this class, I spent very little time explaining the mechanics of the mystory. We had read and heard examples of embodied text; we had heard the writers exhorting us to take hold of our own authority, to "plug into" the pulse of a live moment. We had witnessed enactments, and in light of that, the assignment seemed to make sense. This venture into critical literacy, this experiment in asking students to look at the world differently by writing differently isn't just about what we write; it's also about what we read. It's about what we value, what we hold dear, what we hold as scholarship.

CAROLYNE: My use of mystory writing in classrooms for more than fifteen years has met with varied results. Some students love the challenge and find the form enables them to create and engage a liberating inquiry process. Others hate the challenge and engage a minimal effort. I have come to appreciate the ways my life experiences encouraged my cultivation of a sociological imagination and how explorations of Marxism, feminism, and postmodern scholarship have facilitated my valuing of this form of writing. Recognizing the pervasiveness of psychological over sociological analysis of personal experience, I now assign ourstory rather than mystory papers. Writing collaboratively facilitates students' entry into

sociological rather than psychological analysis. I often add an assigned theme to the work, such as racism, to encourage inquiry into oppression. Thanks to the work of my sista/colleague Mary Weems (see Weems, 2003), I now assign a five-minute performance midterm that requires students to develop an essential question from our course readings and create an artistic performance that addresses this question across their lived history, their current engagement with course content, and their anticipated future professional work. The *performance* invites a crucial addition to the critical literacy they learn to perform on the page. Using our physical bodies to perform our understanding in front of the classroom community re-positions our inquiry within the "body as site of political action."

My pedagogy seeks what Meno and Socrates referred to as the "torpedo's shock." As high school teacher, Donald Thomas (1985), has written about his pedagogy:

> Each time I enter class I bring with me some part of the abyss that I plan to reveal . . . as [students] negotiate these waters, [I remain] ready to deliver the torpedo's touch and pull them under as far as they can go. I want them to leave exhilarated yet perplexed by what they have considered, conscious that we have managed but a glimpse of the depths that surge below. To be educated is to know what depths await us underneath the surface of things, whatever those things may be. (p. 222)

CINDY: Diving into the wreck, as critical methodology, is a continuous undertaking. It is a way of being in the world. To do it once and then proceed only forward is to miss the point. It is a habit leading to a lifetime of critical literacy, or it is an empty gesture.

> These are the things that we have learned to do/ Who live in troubled regions. (Rich, 1984)

Hence, as I construct this document, I revisit the wreck, but I am also reconstituting it in another form, to be revisited again and again. I am *reading and* writing autoethnographically, assembling a construct of my own intellectual history, so that I can dive into the wreck. I make many discoveries the first time through, but there are treasures, and there is damage that I can only recognize by looking back on it, again, in its newly reconstituted form.

There are features that I can only find when I share the document, when I have the benefit of a companion's eyes. As Carolyne, Bethany, and I collaborate as mystorians, as ourstorians, as women, as teachers, as scholars, to critically situate our experiences—personal and collective, private and professional—in the larger culture, we dive together into the wreck. We work, like Laurel Richardson (1990), "within, not above, broader historical, social, and intellectual contexts" (p. 11). This genre, this mystory that cuts across forms of media, that sharpens our critical eye, that provides a way for us to simultaneously enact, critique, and reflect, is our diving bell, our protection, our rescue chamber. As we are called to alter our means of production, consumption, and inquiry, we invite our students to operate with a heightened sense of what critical media literacy might mean, as we alter the standard invitations—how to read and write, how to teach, what it means to learn.

REFERENCES

Carroll, L. (1865). *Alice's adventures in wonderland*. Retrieved July, 2006, from http://www.cs.indiana.edu/metastuff/wonder/ch6.html.

Darder, A. (2006). *Critical pedagogy in a time of incertainty: Forging a new movement*. Paper presented at the University of Illinois, Urbana-Champaign.

Dave Matthews Band. (1996). *Crash*. [CD]. New York: RCA.

Denzin, N. (1997). *Interpretive ethnography: Ethnographic practices for the 21ˢᵗ century*. Thousand Oaks, CA: Sage.

Dillard, A. (1982). Living like weasels. In *Teaching a stone to talk: Expeditions and encounters*. HarperCollins: New York.

Eberts, J. (Executive Producer), & Gilliam, T. (Director) (1988). *The adventures of Baron Munchausen* [Motion picture]. United States: Sony Pictures.

LeGuin, U. (1989). Bryn Mawr commencement address. In *Dancing at the edge of the world: Thoughts on words, women, places* (pp. 147–160). New York: Harper & Row.

Macrorie, K. (1988). *The I-search paper: Revised edition of searching writing*. Portsmouth: Boynton/Cook Publishers.

Martin, J. R. (1985). *Reclaiming a conversation: The ideal of the educated woman*. New Haven, CT: Yale University Press.

Rich, A. (1984). *The fact of a doorframe: Poems selected and new 1950–1984*. New York: Norton.

Richardson, L. (1990). *Writing strategies: Reaching diverse audiences*. Newbury Park: Sage.

Richardson, L. (1994). Writing: A method of inquiry. In N. Denzin & Y. Lincoln (Eds.), *Handbook of qualitative research* (pp. 516–529). Thousand Oaks, CA: Sage.

Sabik, C. (1997). *(Re) Writing metaphor and form*. Unpublished doctoral dissertation, Cleveland State University, Cleveland.

Sexton, A. (1971). *Transformations*. Boston: Houghton Mifflin Co.

Sommers, N. (1992, February). Between the drafts. *College Composition and Communication, 43*(1) 23–31.

Tabbi, J., & Ulmer, G. (1996). An electronic book review. *A Project for a new consultancy*. Retrieved July, 2006, from http://www.electronicbookreview.com/thread/criticalecologies/reinventive.

Thomas, D. W. (1985). The torpedo's touch. *Harvard Educational Review, 55*(2), 220–222.

Ulmer, G. (1989). *Teletheory: Grammatology in the age of video*. New York: Routledge.

Ulmer, G. (1994). *Heuretics: The logic of invention*. Baltimore: Johns Hopkins University Press.

Weems, M. (2003). *Public education and the imagination-intellect: I speak from the wound in my mouth*. New York: Peter Lang.

White, C. J., & Kimbell-Amos, B. (1996). Validity, truth, and method in the post-modern university classroom: *Mystory* writing and the incurably informed. In N. K. Denzin (Ed.), *Studies in symbolic interaction* (*Vol. 19*) (pp. 69–88). Middlesex, England: JAI Press.

Woolf, V. (1994/1936). Professions for women. In G. Henderson, W. Day, & S. Waller (Eds.), *Literature and ourselves*. New York: HarperCollins.

School of (Punk) Rock

An Autobiographical Rant on Education

Antonio López

Whenever I begin a media education project with teenagers, I start by saying that everything I learned about media I learned in the school of punk rock. These generally being postmodern, totally mediated kids, I have to explain a bit about how in the early days of punk, corporate media had little interest in punk youth culture (i.e., they hadn't figured out how to make money from it), and it was up to us kids to produce our own media. The mantra of our movement was "do-it-yourself" (DIY), and when I teach I stress that it's our duty to "be more than a witness." Kids dig the DIY ethic because it appeals to their sense of individuation, and they quickly harness communication tools that did not exist in my teen punk days: personal computers, the Internet, Web sites, blogs, and so on. It sounds archaic to say that we used tape, glue, scissors, and typewriters, but whenever possible I get the kids to do the same because I think it's important for them to use their hands and to learn from scratch how to create media. Moreover, I like to see their fingerprints on the material; personally I'm turned off by the slickness inherent in software templates. Though my harping on the past gets a little tired, students humor me because to them I'm a bit exotic: I teach them to be rebels, which is contrary to what the education system encourages.

My path to punk rock teaching methods starts with the personal. I always was a bad

test taker. I bombed the SAT, and my GRE score left more than a black hole on my official academic profile. It didn't stop me from getting into top schools, or being a straight-A student. I like to believe that one can actually achieve academically while sucking at tests. What's key is that it's all in the individual's learning style. That's where the No Child Left Behind Act of 2001 comes in, or as some have come to call it, the "All Children Left Behind" or "No Child Left Behind for the Military." I'm not a policy wonk, but from what I've seen on the ground, and have suffered through since the law's inception, is a rapid decline in the education being offered to our children, and I am not exaggerating when I say this law is a conspiracy to destroy public education so that schools will be sold off to political cronies who pick off privatized government institutions like vultures munching on road kill.

For four years I was a media arts teacher at a federally funded Native American boarding school in the Southwest. My particular task was to work with the "gifted" students, a label that illustrates faulty thinking within our education paradigm. Our superintendent often stated that Natives see gifted differently, that it's not a matter of academic aptitude. True enough, many of the kids in our gifted program would normally be relegated to the "alternative" programs of regular public schools, which in general are the last stop before a life of imprisonment. What we had was an interesting mix of extremely bright, creative kids and also so-called "special ed" students, who were academically challenged but also fit the school's unconventional concept of gifted. Because these kids had special needs, i.e., to not bore them to death with the mind-drubbing curriculum typically offered in public schools, we gave them creative projects, such as video production, and used as our rubric a portfolio for assessment. As you can imagine, evaluating a student's work through this method is very subjective and impossible to standardize—hence the beauty of it.

Being a product of experimental education in my youth, which was the opposite extreme of NCLB, I was not required to do anything in school. Yes, I can't spell worth a damn (that's what word processors and copy editors are for) and, did I say I suck at tests? It didn't stop me from becoming a professional journalist or educator. This is the lesson I share with my students, often. For as creative projects were whittled away from their regular classes, and innovative programs were slashed to teach to standardized testing, I would have to console these fine, bright children and convince them their futures weren't destroyed because they bombed tests that only measured linear thought processes. I understood them well because, as an insecure teen, I actually believed I was retarded because I didn't get algebra. Really. Indeed, I'm sure many of you reading this had a similar experience.

As I was completing grade school, there was a point when my own perceived lack of literacy became vivid. At age 11 a few friends left our alternative school to attend a regular public school in my neighborhood. I was aware that I barely knew how to read (my mom taught me at home) and could scarcely write a sentence by the end of the fifth grade. I decided that I had to go to a "good school" for a better education, so for the sixth grade I enrolled into the school on top of the hill. Up to that point, I lacked much of a formal education. The radical artists and educators who founded the alternative school that I had attended believed that kids would find their own motivation to learn. If they wanted to,

they would go to class and investigate what interested them. If not, let them play. I played a lot, whether it was baseball or disco dancing. What I didn't do was learn basic grammar, spelling, or math. In a sense I took to heart the concept that if I wanted to learn, I'd be self-motivated, but unfortunately the energy directed me to attend another school.

It was a radical shock. My new classroom had an alien orientation with the desks facing toward a central teacher who was framed by U.S. and California flags. I was assigned (gasp!) to sit in the same place every day. The kid who shared my desk always had clean button-down shirts and perfect handwriting. During our breaks we were consigned what games to play and with whom to play them. In the morning we lined up to recite the "Pledge of Allegiance" in front of the flag. In short, I felt as if I were in a concentration camp. I lasted barely a week.

On my last day at that school, I had such a physical repulsion to the Pledge, I started to vomit, literally. I went to the nurse's office where we called my mother. Within hours I was happily back at the alternative school with my loony friends running around with a baseball mitt and sneaking out to play "Spin the Bottle." True enough, by sixth grade invariably I had become an anarchist, but with some negative emotional consequences. The alternative educational approach that had so conditioned me to be a free spirit also produced a lot of anxiety and made me into a veritable hypochondriac that year. Even though I was free to choose my level of academic achievement, I was still assigned schoolwork. Because I never learned any discipline or work habits, I was unable to freely do the assignments and turn in my workbook when it was required on Fridays. Consequently, every Thursday night I slept little, and in the morning would feign illness to get out of going to school to face the embarrassment of not having completed my homework. On Monday no one ever asked where the work was, and I was never confronted about having never completed a single assignment the entire year. I was shocked when I was promoted to the seventh grade because I had spent the summer convinced that there was no way in hell I would move to the next grade. I believed I was stupid and stressed endlessly about my lack of academic ability. Not surprisingly, the following year when I got my initial report card sent home, it was the first time anyone else understood what I knew deep down inside but had no outlet to express: that I was failing every class I took.

My mom, sitting at her sewing table where she hand made custom dresses, vests, and suits for her clients, read the report card marked with Fs straight down the line and asked without looking up: "Are you proud of this?" Ashamed, I ran upstairs, further internalizing the guilt I felt about school. I never failed a class again, nor rarely got a grade below A. I'm not sure what exactly motivated me to achieve, but that was a decisive moment. I took it upon myself to do my work and pull myself up. This experience led me to a conscious decision to attend a prep school for my high school years, where I struggled during the ninth and tenth grade until things started to click, especially with my writing abilities (one of my English teachers, whom I still know today, recalls that I was practically illiterate). Because I lacked basic skills such as grammar, spelling, and math, I actually believed I suffered from a lower IQ and was terrified to have that verified by a test. When I did take standardized tests such as the SAT, I scored poorly. Again, internally I felt worthless about my academic

achievements. It took a lot of effort on my part to work through that entire trauma. To make things worse, it wasn't until I became a newspaper reporter that I discovered I'm dyslexic.

Now that I'm an educator, I'm reevaluating these experiences and questioning to what extent was my alternative school education constructive. On the one hand, I believe the freedom my early school years afforded me was utterly vital to my development as an artist, thinker, and global citizen. The truth is, I did have the self-motivation to learn when I was ready, though it took me a while, and it left me perpetually behind other students my same age. So in this respect, the architects of the alternative school were correct. On the other hand, I think the permissiveness and lack of supervision reflected the general irresponsibility of 1960s utopian youth culture. I should never have been as stressed out as I was about school or my capacity to learn. There should have been a lot more oversight and "checking-in," so to speak, by my teachers and family. My experience of working with teenagers is that those who have the most involvement with their education by teachers and family succeed the most and generally have a happier time in school. When kids act up in class, it's a telltale sign that they lack attention, and there is a likelihood of abuse—both physical and substance—at home.

What I see in public schools right now is utterly scandalous, and I would argue education has become a racket that ranks among the top officially sanctioned criminal exercises in the history of humanity. I don't mean to disparage the teachers, administrators, or staff, who work tirelessly to educate our youths. What concerns me is the traumatic effect NCLB is having on the youths and its chilling results. Administrators are running around like despondent chickens with their heads lasered off because they fear for their jobs, funding, and failure, in that order. The government acts like a domestic abuser, and the schools behave like battered spouses. Because administrators feel clueless about how to proceed with NCLB, they take the most damaging, conservative route possible. For example, the Native American boarding school where I worked had this really great program in which eighth-graders built a PC from scratch over the course of a year, and if they kept their grades up, they got to take the computer home. This was a fantastic curriculum that taught the kids practical and academic skills, and also enabled their families, who are traditionally in the lower-income bracket, access to the one thing that empowers people in our technologically dependent society: a computer. Because science scores were below average, the program was eliminated in order to teach for the test because without certain achievement levels, federal funding was perpetually threatened to be cut off.

Remember that conspiracy I was telling you about? What happens when you demoralize youths and give them every reason to fail? What options are left for a class of people who are already disenfranchised and marginalized from the general society? Marshal drums please. . . . bring in the military. I used to have the sad job of staffing the journalism and media table on career day. Queries were few, and who could blame the kids? Outside the National Guard hauled in tanks, Humvees, and even a helicopter to wow the kids and lure them into their little bogus video game war rap. So now, not only did I have to fight the feds on their education policy, I had to spend valuable teaching time trying to deprogram the kids from enlisting into the military. My efforts rarely paid off, for in addition to all the

other noise, the school was required by NCLB to turn over the names and phone numbers of my students to military recruiters. Now I have former students, beautiful young people full of life, off fighting that nasty war in Iraq; it breaks my heart every time I think of it. My belief that education is becoming a feeder system for militarism is reinforced by another experience. I had been hired to do media arts work in an after-school program in Brooklyn that serves mainly immigrant African American students who originate in the Caribbean. The classroom where I was located belonged to a history teacher, a former stock trader, who told me that she teaches five classes a day, with a first-period freshman civics class containing 49 students alone. Any right-minded thinker knows this is untenable. You simply cannot learn in this environment. Meanwhile the school is crawling with cops and military recruiters. I found it interesting that a map showing American Iraq war casualties were predominately from urban centers such as Southern California, the Bay Area, Chicago, Detroit, and the North East. Communities like this Brooklyn high school are ground zero for this statistic.

So here's my punk rock response to the situation: do media literacy. As schools become more militarized and simulate virtual police states, school administrators are so bogged down dealing with the failed system it's impossible to innovate any more. I found that there is an easier way to offer inventive educational tools without the hassles of standards, bureaucracy, and scared school boards. Both art and media literacy have become powerful tools that are universally accepted (outside the offices of education bureaucrats) as desirable and effective. Schools especially love anything that has to do with media or technology and will support guest speakers and after-school programs that engage students in media education. I've been able to support myself as a kind of media lit mercenary, going to schools and giving talks on the negative health impacts of media, but also demonstrating positive uses of media, i.e., DIY. Under the pretext of educating on tobacco, alcohol, violence, and/or body image, I'm able to communicate critical thinking skills very quickly using a medium that most kids are engaged in much more actively than the regular school curriculum.

A case in point: I was invited to Phoenix to give a keynote speech at a youth conference centered on drinking and driving. With my laptop, I showed a series of commercials that reflect a pattern of subterfuge, using alcohol ads as my primary focus, but also showing fast food, car, and cereal commercials to demonstrate the consistency of persuasion techniques. During the last breakout sessions, a young Latina raised her hand and asked a pointed question: "If you are saying that all ads are deceptive, is that true of military ads?" Bingo! Now, before I answered her honestly, I had to consider a few things:

A I was in the heart of Republican Phoenix and
B This was a law and order conference.

What were my chances of escaping the room alive? I quickly saw that all the cops, firemen, and other meddlesome adults had magically disappeared to prepare lunch, so I decided that as the "expert" from New York, I might get through to a few kids with the truth. Sure enough, after my swift debunking of military marketing and the war, the room exploded. We're talking over 400 teens yelling and screaming, mostly wanting to kill me,

but several actually taking an antiwar stance. It was wild and exciting, energy I had never felt before, as if the war genie was finally allowed to escape. Clearly these kids had not had the opportunity to discuss the issue publicly before. Regardless of the personal attacks ("If our troops weren't in Iraq, you wouldn't have the freedom to stand there and say what you want," blah, blah, blah), it felt productive to at least release the frustration of ideological suppression, i.e., denial.

I conclude with two anecdotes. First, after being invited to speak at a high school in East LA, I was astonished to learn that all the punk kids at that school were in the Reserve Officers' Training Corps (ROTC). From my old school roots, this seemed utterly implausible, but as a like-minded teacher explained, punk now is just a sign, a fashion statement that means aggression. Perhaps. On the other hand, I still see a lot of politically active youths who call themselves "punk." Ultimately, labels are totally not punk rock. The second point I want to mention is that most kids I work with are into hip hop, but they lack exposure to its activist roots. In a workshop in Brooklyn, I asked a group of African American youths if they knew of any artists who had politically or socially conscious lyrics. None had. Then I showed them Public Enemy's "Fight the Power" video shot by Spike Lee; they were speechless. It was as if aliens had entered the room and seized their brains. However, I'd seen this look before; I knew it meant they were absorbing something meaningful. Rebellion was getting under their skin, and in the school of punk rock, that's what it's all about.

Punk Rock, Hip Hop, and the Politics of Human Resistance

Reconstituting the Social Studies Through Critical Media Literacy

Curry Malott and Brad Porfilio

Nearly one hundred years ago, the social studies discipline was formally introduced in North America as a possible school subject. Business leaders and corporate leaders saw social studies as an avenue for indoctrinating the millions of immigrants, who were entering North America from predominantly European countries, with values conducive to becoming a *productive* worker as well as beliefs that promoted American and Canadian patriotism and colonialism (Russell, 2002). Progressive educators, on the other hand, had a quite different vision of the discipline. They viewed it as a way of fostering within students the ability to critically reflect on their world and take action for social justice. Unfortunately, business and governmental leaders used their privileged position to ensure their vision for this discipline came out victorious; consequently, it became the official model for the social studies curriculum across the educational landscape. We have been left with the legacy that has, while serving the interests of capital, which include fostering the development of an uninformed spectator-oriented citizenry, failed to meet the intellectual needs of the majority of its populace.

Despite the ongoing struggle and subsequent attempts over the past several decades made by progressive educators/activists to revamp the social studies curriculum for creat-

ing a more socially just education and wider social structure, the discipline, officially, has not strayed from its state-building, pro-capitalist function. For instance, in classrooms across North America, youths rarely learn about "the contributions, perspectives, or talents of women or those outside the mainstream culture" (Nieto, 2002, p. 9). Consequently, the social studies curricula, textbooks, and standardized examinations still reflect the values and beliefs of North America's economic and political leaders. In-service teachers in contemporary classrooms frequently alienate and thus fail to engage youths by centering their curriculum on historical narratives that valorize the lives of dead white men as well as the conquests and expeditions of western society.

Likewise, the test-driven environment within public schools and teacher education programs has limited teachers' sense of empowerment and thus willingness to engage in critical multicultural social studies (Malott & Pruyn, 2006). Unable or willing to take the risks needed to spark student interests, teacher educators, and classroom teachers often turn to the "banking model" of education. The pedagogy is inextricably linked to promoting a passive type of citizenship, where the great majority of students become apathetic toward social, political, and economic issues, but become complicit in internalizing dominant beliefs, values, worldviews, and social practices (Case & Clark, 1997, p. 20).

It would not be a stretch to say the social studies curriculum "seems meaningless to almost every student, regardless of race, class or gender" (Kornfeld & Goodman, 1998, p. 306). Contemporary youths have been positioned to lack what Paulo Freire (2005) refers to as "a passion to know"; therefore, they are without the drive to develop the self-discipline needed to learn to not only read the word, but the world as well, a process designed to lead to critical consciousness and ultimately a sense of empowerment needed to transform our dull reality, that is, the material world. For Freire (2005) and others (see Freire & Macedo, 1987; McLaren, 1995) this is what it means to be fully literate and thus equipped with the intellectual tools to participate in the production and reproduction of our world. In short, this is critical literacy. This chapter is a foray into critical media literacy. For us, critical media literacy (Kellner & Share, 2005) is a pedagogical tool that provides us with the theoretical ballast needed to uncover the liberatory potential of countercultural formations and puts forth possible ideas of intervention for teachers, preservice teachers, professors (including ourselves), and other community and cultural workers interested in reinforcing the more transgressive moments in our cultural manifestations—punk rock and hip hop serving as primary examples in this essay.

To revitalize the social studies for the purpose of ensuring it has the potency to be a viable part of the move toward creating a more democratic social order—a society predicated on the principles of equity, social justice, freedom, and diversity—we believe critical theory must be central in this mission. Within critical theory, we can still find examples of unwavering resistance that are withstanding the corporate takeover of higher education. It is within these examples of vibrant militancy that we theoretically depart. These traditions continue to help educators "link learning to social change and education to the imperatives of a critical and global democracy" by focusing our critical lens on cultural artifacts such as music (Giroux, 2005). Current transformative educators also provide us with the

theoretical tools necessary for both knowledge construction and action, assisting our awareness of how educational policies and practices are linked to the social production of labor, the lifeblood of capital, and how we can teach against these draconian formations through a revitalized critical/revolutionary pedagogy (McLaren & Jaramillo, 2005; Allman, McLaren, & Rikowski, 2005). In other words, critical theory provides us with the theoretical tools to not only analyze countercultural formations for their transformative potential against the process of value production, but also challenges us to unearth the unjust practices and social formations that foster economic and social injustices across the globe. In the following analysis, we take a critical approach guiding our analysis and pedagogical project. It is our intent in the pages that follow to provide a theoretically rich project for a critical multicultural social studies (Malott & Pruyn, 2006).

Specifically, we will document how two alternative subcultures—punk rock and hip hop—at their most radical moments, have the potency to provide in-service and pre-service teachers with a critical reading of the word and the world and opportunity to be a part of changing the relationships that define our lives through conscious intervention, to paraphrase Paulo Freire (1998, 2005). By examining these youth subcultures within the context of teacher education programs, we argue schoolteachers will begin to take inventory of the economic, social, and historical forces creating social inequalities within schools and the wider social world, recognize the urgency to develop critical forms of pedagogies for the purpose of ensuring that today's youths are equipped to make sense of the constitutive forces causing injustice and oppression in their own social worlds, take action as empowered agents of change, and understand the importance of linking their pedagogical projects with their students and other global citizens to excavate various forms of injustice in our increasingly morally bankrupt society. What follows is, therefore, first an overview of punk rock and hip-hop lyrics that provide a critical analysis of the contemporary social historical world. What is more, we pay particular attention to how the politics of these artists transcends the forum of music. Next, we discuss pedagogical implications for how this body of work and movement can be used by teacher educators, in-service teachers, administrators, and other cultural workers for the purpose of revitalizing the social studies, empowering youths, and transforming the world.

Subcultures in Context

Both punk rock and hip hop emerged during the 1970s and 1980s in the United States as a response to the increasing success of the economic elites' ability to wage warfare on working people through economic policies and a highly skilled propaganda machine (Chomsky, 2005; Giroux, 1994; McLaren & McLaren, 2004; Malott & Peña, 2004; Porfilio & Malott, 2007) (see Malott & Peña, 2004, for a discussion on the British punk rock movement). That is, policies that have ultimately led to deindustrialization, the increasing globalization of capital through policies such as the North American Free Trade Agreement (NAFTA), the militarization and privatization of everyday life, and a mean-spirited discourse blaming young people for their own dispossessed conditions, which resulted in a material reality that left

many youths alienated from the dominant society, and therefore searching for meaning in a seemingly meaningless world. Armed with a largely intuitive response to the downsizing of their futures, many youths took to their creative impulses. They forged what is now known as punk rock and hip hop.

Both hip hop and punk rock first drew breath in New York City's European American and Afro-American, Latin, and Afro-Caribbean working-class communities, while punk rock was simultaneously born out of the rubble of Los Angeles' "white" and Latina/o barrios (Dancis, 1978; Cohen, 1980; Dimitriadis, 1996; Malott & Peña, 2004). Existing on the fringes of cultural life, both subcultures, at their more critical moments, gained strength and credibility through a creative process of building something out of nothing.

For punk rockers, this pedagogical approach has come to be known as DIY, or Do It Yourself, that is, creating something new within the remains of the old, such as small fanzines, record labels, bands, styles, modes of analysis, and ultimately a movement and way of life. DIY has, therefore, served as a rallying cry for those punk rockers who take pride in surviving against an economic social structure that does not serve their own interests, a system that grows more powerful the more surplus value or unpaid labor hours it is able to extract from the majority of the world's working people.

Similarly, the more progressive elements of hip hop draw on an identity of independence often manifesting itself as a "fight the power" sentiment, which is imbued with Afrocentric pedagogy, as expressed by New York City's Public Enemy (PE). For example, in "Fight the Power" on the *Fear of a Black Planet* (1990) record Chuck D of PE exclaims:

> *. . . I'm Black and I'm proud . . .*
> *Most of my heroes don't appear on stamps*
> *Nothing but rednecks for 400 years if you check . . .*
> *Power to the people no delay . . .*

Contemporary radical hip-hop groups such as Dead Prez and Immortal Technique have built on pro-black counterhegemonic messages from PE and other groups such as the Poor Righteous Teachers and X Clan. Their music has added a more sophisticated class analysis to the hip-hop scene. Brooklyn's Dead Prez (DP), emerging as one of the leading voices in hip hop's cultural and material revolution, identifying themselves as "revolutionary but gangsta, RBG," has upped the radical ante. For instance, the group's song "it's bigger than hip hop" refers to the social revolution they argue is needed at this particular social juncture, an epoch marred by growing global poverty, hunger, a resurgence in white supremacy, among many other indicators of an out-of-control transnational capitalist elite. In the following lyric, like Public Enemy, DP assumes an Afro-centric stance while advocating for a humane social and economic system:

> *Organize the wealth into a socialist economy*
> *Cause the world is controlled by the white male*
> Dead Prez (2000). "Police State." *Let's Get Free.*

DP often refers to the Black Panther Party as a source of pedagogical inspiration. Their music is informed by community activism, Black pride and power, and a desire to cre-

ate a society predicated on symmetrical power relationships (discussed below). They postulate their music is a cross between PE and NWA, and if they had come of age during the 1970s, they would have been Panthers. Coming from Oakland, California, where the Huey P. Newton and Bobby Seale started the Black Panther Party for Self-Defense, The Coup stands as an exemplary example of today's African American revolutionary West Coast U.S. hip hop. Although offering anti-racist sentiments through their songs, The Coup offers a more class-based perspective on what causes systemic oppression. They have also successfully melded their social commentary with political satire in songs such as *Wear Clean Draws* and *5 Million Ways to Kill a CEO* that, respectively, address the issue of African American female body image and how to create the conditions whereby oppressors, motivated by greed, are lured into self-destructing. In the introduction to their album *Party Music* (2001), The Coup chants "every broke motherfucker gonna form a gang, and when we come we're takin everything." In this song The Coup presents a non-racially specific message to working and poor people in general. In another track, "Ghetto Manifesto," The Coup offers a serious yet slightly humorous rallying call against the state and capital. Consider their words:

> *This is my resume slash resignation*
> *A ransom not with proposed legislation*
> *A fevered ultimatum you should take it verbatim . . .*

The class analysis and anti-racism offered by The Coup and other hip-hop artists highlighted above have also been prevalent in the lyrics of many punk rock bands from early groups such as the Dead Kennedys and Bad Religion to more contemporary artists like Anti-Flag, Leftover Crack, and the Fartz. Rising out of San Francisco's underground punk and hardcore scene in the late 1970s and early 1980s the Dead Kennedys (DK) emerged as a leading satire-infused unity punk band with overtly leftist political messages. For example, in their first release, "Nazi Punks Fuck Off" (1979/1980) Jello Biafra, DK lead vocalist, takes a stance against white supremacist infiltrations into the punk scene, exclaiming:

> *You still think swastikas look cool*
> *The real nazis run your schools*
> *They're coaches, businessmen and cops . . .*

Rather than taking aim at hegemonic/counter-revolutionary elements within the scene, Anti-Flag, more recently, offers a devastating blow to the corporate-dominated military complex, which, they allude, usurps both the labor power and physical bodies of working people as cannon fodder. These are key forces in promulgating U.S. imperialism across the globe. Consider their words:

> *Isn't everybody tired of the killing?*
> *Isn't everybody tired of the dying?*
> *Isn't everybody tired of the hatred?*
> Anti-Flag, 2002, "911 for Peace," *Mobilize*.

In another song Anti-Flag extends their plea for peace with a solid analysis of the deleterious effects of the alienating nature of selling one's ability to labor for a wage, thereby

contributing to the creation of a world that benefits the few at the expense of the many.

> To join the corporate army
> For god and country give up your life,
> Don't try to figure out what's wrong of right
> Anti-Flag, 2002, "Their System Doesn't Work for You," *Mobilize*.

Coming from a similar theoretical/political perspective as Anti-Flag and the Dead Kennedys, although employing a more reggae-dub/punk/hardcore sound, New York City's Leftover Crack in "Super Tuesday" connects the North American legacy of colonization and slavery with current economic policies of the World Bank and the International Monetary Fund:

> It ain't a mystery, that US History
> Was built upon the graves
> Of Native ways and beaten slaves . . .

Beyond the Lyrics

Beyond the messages transmitted through their songs, teacher educators, teachers and students can look to the community activism of hip hop and punk artists as guideposts for possible *paths of dissent*. Here we will detail the activism of several key figures highlighted above. They are actions that can lead us beyond our unjust social and economic systems and their hegemonic manifestations, such as patriarchy, white supremacy, and homophobia. Lead singer of Leftover Crack, Stza Sturgeon, has been vociferous in his condemnation of North America's mass media and Bush's presidency. Over the past several years, Sturgeon has conducted several interviews for the purpose of unveiling the mass media's role in concealing how U.S. global policy spreads violence and injustice across the globe, while concomitantly, throwing light on how the Bush regime and the mass media espouse "ultranationalist propaganda to squelch dissent" aimed at their unjust policies and practices (McLaren, 2005, p. 198). He has urged his fans to reflect critically upon the dominant narratives generated by the media and state, and to support political movements designed to bring about a democratic state. On September 11, 2005, he brought his messages to the stage by performing a protest concert with Choking Victim. He made it clear to over 2000 fans that western imperialism, neoliberal economics, and xenophobia are to blame for the 9/11 attacks. Here he implicates Bush and the media for creating false narratives about the causes of terrorism:

> George Bush's brother Marvin Bush was head of security at the World Trade Center up until 9–11, and they were doing nefarious things, . . . They wanted another Pearl Harbor to install the Patriot Act and take us to war. Don't listen to the media; the media is there for maximum security—to tell you lies! (Ferguson)

Likewise, the *raison d'être* of Anti-Flag's work and social projects is to "play the role of educator to fans" about U.S. government and business leaders' 'current war on terrorism'

(Usinger, 2004). In contrast to many artists who have taken part on the Warped Tour, Anti-Flag has openly renounced the United State involvement in Iraq. Not only were the band's shows geared to raise young people's consciousness about 9/11, terrorism, and U.S. imperialism, but they were designed to encourage action against unjust policies perpetuated by greed. Offstage, band members have worked to empower youths alongside U.S. Representative Jim McDermott, who, in 2004, "gave a speech in the House of Representatives, praising Anti-Flag for working to encourage young people to register and vote" (http://en.wikipedia.org/wiki/Anti-Flag). The group has been actively involved in several endeavors that they feel will bring about a more just and humane society. They have taken part in anti-war demonstrations in Washington, DC, and Pittsburgh, backed PETA's stance for humane treatment of animals by bringing members from the organization to its shows, as well as taking part in interviews surrounding animal rights, and started a campaign http://militaryfreezone.org/ to end military recruitment in public schools.

Anti-Flag's central theme of social protest and change is representative of a long tradition of punk rock pedagogy, at its most critical moments. Perhaps one of the most influential punk rock activists since the 1979/1980 release of the aforementioned song, "Nazi Punks Fuck Off," is Jello Biafra and the establishment of Alternative Tentacles Records. Beyond the turbulent and controversial legacy of the Dead Kennedys, wrought with internal conflict that persists to this day (see Malott & Peña, 2004), is the existence and focus of Alternative Tentacles itself, which sarcastically boasts of "25 years of cultural terrorism" (www.alternativetentaclesrecords.com). In 1983 the Dead Kennedys were taken to court and charged with the "distribution of harmful matter to minors," for an insert on their "Frankenchrist" record of a reproduction of a painting by Swiss artist H. R. Giger, "Penis Landscape." However, the prosecution's case did not focus on the insert of "Penis Landscape," but rather on the legacy of the Dead Kennedys, considering it was presented to the court through such tactics as blowing up DK lyrics on large poster boards. The case was eventually overturned, but the trial tore the Dead Kennedys apart and nearly bankrupted Alternative Tentacles as a result of costly court fees and the banning of Dead Kennedys records in most retail outlets with the exception of small independent record stores.

As a result, Jello Biafra, a self-proclaimed "information junky," engaged in a series of spoken word tours, resulting in over 10 spoken words records on Alternative Tentacles. Biafra continues to tour and lecture at colleges and universities throughout the United States and elsewhere on issues from censorship to unjust imperialist wars. In addition to publishing Biafra's lectures, AT also continues to put out original independent music through its many signed artists who, brags Biafra, have 100% artistic freedom, which is antithetical to how mainstream corporate labels tend to be run. Making AT especially significant is its publishing of the lectures of noteworthy radical academics, writers, and activists such as Jim Hightower, Angela Davis, Noam Chomsky, Howard Zinn, Mumia Abu-Jamal, and Ward Churchill, to name a few. The coexistence of such radical thinkers with independent musicians under one label provides the opportunity of many AT music fans to be exposed to political ideas of critique and the possibility for large-scale social change otherwise not happening (Malott & Peña, 2004). Embracing the notion that punk rock is more of an ide-

ology than a style, AT has signed critical artists from Earth First! folk singers, hillbilly country acts, schizophrenic eccentrics, and radical rappers.

However, beyond the efforts of AT, rappers one of the most influential Rap music icons, Public Enemy, continue in their quest to "fight the power" for the sake of forging a democratic society. PE founder, Chuck D, has utilized the radio and television airwaves to condemn the United States' involvement in Iraq. On his (co-hosted with Gia'na) Air America show, *On the Real*, he provides a space for youths and other progressive speakers to be heard on "how life, politics and the history of the American culture work (and who gets sacrificed for it)" (http://shows.airamericaradio.com/onthereal/about). For instance, the show helped to educate youths about the racist and classist response by Washington in the aftermath of Hurricane Katrina, one of the biggest crises, faced primarily by working people, in this country. Along with providing a space for discussion on this crisis, he composed a poem for his listeners, which was eventually turned into the band's song "Hell No We Ain't Right," to express his outrage at today's "new world order:"

> *New Orleans in the morning, afternoon, and night*
> *Hell No We Ain't Alright*
> *Now all these press conferences breaking news alerts*

Chuck D has also shared his insight in relation to social issues at college campuses across North America. In his discussion, "Race, Rap, and Reality," he has "lambasted America's anti-intellectualism and its obsession with celebrity. He criticized the lack of substance in today's rap music and suggested that technology distances us from our fellow man" (Rivers, 2006). His social commentary has spilled over to film. In the short documentary, *Bling: Consequences and Reproductions*, Chuck D's narration illustrates how the Revolutionary United Front has killed between 50,000–75,000 people and amputated many other individuals' limbs to secure Sierra Leone—the most diamond-rich country in the world (Cornish, 2005). The question remains: how can the music, messages, and movements highlighted above be used to enhance and make relevant a social studies curriculum that is if not dead, terminally ill?

Making Connections and Creating Passion Through Music: CMSS

Pedagogically, what role can punk rock and hip hop play in the formation of revolutionary praxis? Drawing on critical media literacy, in the following paragraphs, we put forth the beginnings of a revitalized K-12 social studies education, a possible pedagogical and curricular place of departure.

More so now than ever, students who enter our classrooms, be it classrooms in universities, elementary schools, or high schools, are bringing with them the cultural commodities of punk rock and hip hop. Within these cultural artifacts are embedded ways of understanding and viewing the self and the larger world (as demonstrated within the examples of punk and rap outlined above). It is imperative for educators to understand how

our students know. Honing in on this pedagogical necessity Freire (2005) argues:

> . . . our relationship with learners demands that we respect them and demands equally that we be aware of the concrete conditions of their world, the conditions that shape them . . . Without this, we have no access to the way they think, so only with great difficulty can we perceive what and how they know. (Freire, 2005, p. 58)

Understanding the ways in which students perceive the world enables teachers to begin to create a culturally relevant and engaging education, which are key components in fostering *a passion to know*. For example, in our work teaching high school social studies and teacher education social studies methods courses, we have had students bring in songs that relate to particular social issues such as racism, sexism, among countless other foci. Discussing the messages presented within these songs has offered our classes a focus of critique and an opportunity for us to share more revolutionary/critical examples from the genres, as outlined above.

Such an approach has also provided a powerful and engaging method to teach students about the internal workings of capitalism. Focusing on the commodification and cooptation of punk rock and hip hop has provided our students with a critical lens to better understand the predatory nature of capital, as well as other social forces creating injustices in society. Using critical media literacy in this way has consistently led many of our students to more informed visions of their own subjectivities and the ways in which they are shaped by market forces and capital's divisive hegemonies such as white supremacy. However, because " . . . we are programmed but not predetermined, because we are conditioned but, at the same time, conscious of the conditioning, that we become fit to fight for freedom as a process and not as an endpoint . . ." (Freire, 2005, p. 70). In other words, our approach does not focus on awareness alone, but calls for action.

The activism of the artists described above has allowed many of our students to, first, envision themselves as agents of change, and then, once empowered, be able to overcome their own fear of freedom and to take action for social justice. For example, some of our students have begun with actions such as writing letters to record companies and politicians. While such actions, it can be argued, are ultimately ineffective in their attempts to convince the powers that be to change their policies, they are effective at providing students with that first step at seeing themselves as participants rather than observers. This step is fundamental in their development as critically literate global citizens. Actions our students have taken are by no means limited to letter writing. Other examples include, but are not limited to, joining activist organizations and groups, attending demonstrations, publishing critical work/becoming radical scholars, and developing progressive curricula.

Given the current trends in privatization and standardization, which, together, threaten the democratic potential of the social studies curriculum in particular, and education in general, critical theory, along with critical media literacy, must assist us to meet the democratic challenge put forth by humanity's unrelentless demand for dignity and respect.

REFERENCES

http://shows.airamericaradio.com/onthereal/about). Retrieved, January 22, 2006

Allman, P., McLaren, P., & Rikowski, G. (2005). After the box people: The labor-capital relation as class constitution and its consequences for Marxist educational theory and human resistance. In P. McLaren (Ed.), *Capitalists & conquerors: A critical pedagogy against empire* (pp. 135–165). New York: Rowman and Littlefield.

www.alternativetentaclesrecords.com Retrieved, January 28, 2006 *Anti-Flag: Biography*. Retrieved, January 28, 2006, from http://en.wikipedia.org/wiki/Anti-Flag.

Case, R., & Clark, P. (1997). Four purposes of citizenship education. In R. Case & P. Clark (Eds.), *The Canadian anthology of social studies: Issues and strategies for teachers* (pp. 17–28). Vancouver, BC: University of British Columbia Press.

Chomsky, N. (2005). *Imperial ambitions: Conversations on the post-9/11 world.* New York: Metropolitan Books.

Cohen, P. (1980). Subculture conflict and working-class community. In S. Hall, D. Hobson, A. Lowe, & P. Willis (Eds.), *Culture, media, language: Working papers cultural studies 1972–1979* (pp. 78–87). Birmingham: The Center for Contemporary Cultural Studies, University of Birmingham.

Cornish, M. J. (2005, December 9). *Chuck D narrates 'bling: Consequences and repercussions.'* Retrieved, February 7, 2006, from www.nobodysmiling.com.

The Coup. (2001/2004). *Party music* [CD]. Los Angeles, CA: Epitaph Records.

Dancis, B. (1978). Safety pins and class struggle: Punk rock and the left. *Socialist Review, 8* (39), 58–83.

Dead Kennedys. (1979/1980). Nazi punks fuck off. *In God We Trust, Inc.* San Francisco, CA: Alternative Tentacles Records.

Dead Prez. (2000). "Police State." *Let's Get Free.* New York: Loud Records.

Dimitriadis, G. (1996). Hip hop: From live performance to mediated narrative. *Popular Music, 15*(2), 179–194.

Ferguson, S. (12 September 12, 2005). 9–11 Conspiracists invade Ground Zero. *The Village Voice.* Retrieved, February 6, 2006, from http://www.villagevoice.com/news/0537,fergusonweb2,67726,2.html

Freire, P. (1998). *Pedagogy of the oppressed.* Boulder, CO: Continuum.

Freire, P. (2005). *Teachers as cultural workers: Letters to those who dare teach.* New York: Westview Press.

Freire, P., & Macedo, D. (1987). *Literacy: Reading the word and the world.* South Hadley, MA: Bergin and Garvey.

Giroux, H. A. (1994). Doing cultural studies: Youth and challenges of pedagogy. *Harvard Educational Review, 64*(3), 278–308.

Giroux, H. A. (2005). Cultural studies in dark times: Public pedagogy and the challenge of neoliberalism. *Fast Capitalism, 1*(2). Retrieved, January 22, 2006, from http://www.henryagiroux.com/.

Kellner D., & Share J. (2005). Politics of education towards a critical media literacy: Core concepts, debates, organizations and policy. *Discourse: Studies in the Cultural Politics of Education, 26*(3), 369–386.

Kornfeld, J., & Goodman, J. (1998). Melting the glaze: Exploring student responses to liberatory social studies. *Theory into Practice, 37*(4), 306–314.

Malott, C., & Peña, M. (2004). *Punk rockers' revolution: A pedagogy of race, class, and gender.* New York: Peter Lang.

Malott, C., & Pruyn, M. (2006). Marxism and critical multicultural social studies. In W. Ross (Eds.) *The social studies curriculum: Purposes, problems, and possibilities (3rd Edition)* (pp. 157–170). Albany: State University of New York Press.

McLaren, P. (1995). *Rethinking media literacy: A critical pedagogy of representation.* New York: Peter Lang.

McLaren, P. (2005). *Capitalists & conquerors: A critical pedagogy against empire.* New York: Rowman and Littlefield.

McLaren P., & Jaramillo, N. (2005). God's cowboy warrior: Christianity, globalization, and the false prophets of imperialism. In P. McLaren (Ed.), *Capitalists & conquerors: A critical pedagogy against empire* (pp. 261–334). New York: Rowman and Littlefield.

McLaren, P., & McLaren, J. (2004). Afterword: Remaking the revolution. In C. Malott & M. Peña (Eds.), *Punk rockers' revolution: A pedagogy of race, class, and gender* (pp. 123–127). New York: Peter Lang.

www.militaryfreezone.org/ Retrieved, January 22, 2006

Nieto, S. (2002). Affirmation, solidarity and critique: Moving beyond tolerance in education. In E. Lee, D. Menkart, & M. Okazawa-Rey (Eds.), *Beyond heroes and holidays: A practical guide to K-12 anti-racist, multicultural education and staff development* (pp. 7–18). Washington, DC: Teaching Change.

On the real: About the show. Retrieved, January 25, 2006, from http://shows.airamericaradio.com/ontherealabout/about.

Porfilio, B., & Malott, C. (2007). Neoliberalism. In G. L. Anderson & K. G. Herr (Eds.), *Encyclopedia of activism and social justice.* New York: Sage.

Rivers, K. (2006, February 4). *Chuck D finds a new public enemy.* Retrieved, February 6, 2006, from www.SouthBendTribune.com.

Russell, R. (2002). Bridging the boundaries for a more inclusive citizenship education. In Y. Hebert (Ed.), Citizenship in transformation in Canada (pp. 134–149) Toronto: University of Toronto Press.

Usinger, M. (2004, July 8). *Anti-Flag backs up its bashing.* Retrieved, January 24, 2006, from www.straight.com.

Social Education and Critical Media Literacy

Can Mr. Potato Head Help Challenge Binaries, Essentialism, and Orientalism?

Özlem Sensoy

The Orient has helped to define Europe (or the West) as its contrasting image, idea, personality, experience.

—Edward Said, 1978, p. 2

[T]he act of representing (and hence reducing) others, almost always involves violence of some sort to the subject of the representation, as well as a contrast between the violence of the act of representing something and the calm exterior of the representation itself, the image—verbal, visual, or otherwise—of the subject. Whether you call it a spectacular image, or an exotic image, or a scholarly representation, there is always this paradoxical contrast between the surface, which seems to be in control, and the process which produces it, which inevitably involves some degree of violence, decontextualization, miniaturization. . . . Because, above all, representation involves consumption.

—Edward Said, 2001, p. 40

Introduction

I am Turkish Canadian. Perhaps it's more accurate to say, Turkish and Canadian. For these two identities never quite fused together. I think of my identity more like a Mr. Potato Head doll—the pieces of a particular characteristic never quite matching up seamlessly. At home, I was Turkish, spoke Turkish, ate Turkish food, socialized according to Turkish cultural norms. At school, though, I was "Canadian," moving my lips along with my classmate Heather Goldstein to "God Rest ye Merry Gentlemen" at the annual Christmas pageant.

It is also important to note that I grew up Turkish and white. My experiences were without the most stereotypical of external markers of Turkish-ness (namely brown skin and a veil). Thus, my experience of the margins was different from that of other (brown, veiled) Turks, for example, as well as that of people of color in Canada. My background became a guessing game with my classmates, teachers, and others. I cringed at the roll call when a substitute teacher came to class—counting off the students, Samdano . . . Scott . . . until the inevitable fumbling and gasps of "oh what an interesting name!" demanding explanation. Most couldn't readily guess my background by simply looking. Instead, many thought I had a "funny" name, perhaps inspired by Black Sabbath's Prince of Darkness. In this way, much of my ethnic, religious, and linguistic identity lay, ironically, hidden beneath a shroud. In both school and out in the world, I learned that was where it was safest for it to lie.

In school, I hated socials the most because they taught me to hate myself—or maybe they taught me to hide myself. We (Middle Easterners) were clearly not significant enough in the course of world history to be mentioned in textbooks. However, on the rare occasions when we were mentioned, it was clear that the contributions of the Palestinians, the Iranians, or the Ottoman Turks had frequently been, and perhaps in the minds of some still often are, the cause of trouble for "the allies," and thus have been an impediment to peace in the world in general . . . I hated the Middle East.

In the world "out there," an assistant manager at the store where I worked part time during high school leaned toward me one time as a Muslim family walked out of the store, and said, "it's those Muslims that worry me . . ."—never realizing that I too was one of "those Muslims."

Alongside the world out there, however, was the world of popular media, a world that continued to educate me, and others, about my group. Whenever my true identity was discovered, I inevitably had to answer a potpourri of questions about Turkish prisons, questions inspired by the popular film *Midnight Express* (Guber & Parker, 1978) about a U.S. man held and tortured in a Turkish prison in the 1970s.

I easily drifted further and further away from my ethnic identity. I became the potato head with the eyes, lips, and ears that didn't quite seem to fit together, warped and tilted on the face.

It wasn't until graduate school that I discovered the tools with which to piece my ideas about myself back together. This chapter is about some of those conceptual tools (binaries, essentialism, and Orientalism), and how now, as a university professor, I work with my own

students—who will be future teachers of social education—on applying these tools in our teaching practice. The goal isn't to make, or count on, schools and the world out there to be perfect places, representing exactly or accurately what being Turkish, Muslim, female, and so on, means or looks like. Rather, the goals are to identify the complexities of group identities, in order to collapse artificial binaries embedded in school and media representations of social groups; to develop alternative ways of knowing group stories; to become "perspectives detectives," in order to reveal and preserve the complexities of social histories, social life, and interactions; and ultimately, to understand the role of social power in constructing and sustaining those representations.

Binaries, Essentialism, and Orientalism

Much of life is about binaries. My binaries went something like, studious not lazy; agreeable not difficult; Turkish not Canadian; Muslim not Christian, secular not religious, and so on.

Binaries are a common way in which language and meaning interact, especially with regard to norms and differences. As poststructuralist theorist Jacques Derrida popularly theorized, binaries are never neutral. One "end" of the binary is always preferable to the other. Usually each end of the binary is fixed with an essential set of characteristics that belong together. For example, for a gender binary: man/ woman, there are common, fixed, stereotypical characteristics belonging with each end, such as:

$$
\begin{array}{ll}
\text{Man} &\!\!\!\!—— \text{Woman} \\
\text{Tough} &\!\!\!\!—— \text{Gentle} \\
\text{Rescues} &\!\!\!\!—— \text{Needs to be rescued} \\
\text{Strong} &\!\!\!\!—— \text{Weak}
\end{array}
$$

These types of binaries can act as a useful short-hand to meanings. Generalizing about group characteristics isn't necessarily bad because it is a key to how we make meaning. For instance, I might apply generalized knowledge about Japanese cuisine (characteristics I expect to encounter) to make a decision about which restaurant to go to for lunch. However, the more rigid the characteristics associated with the binaries become, the more "essentialized" we refer to the identity as being.

Essentialism is a concept that is often used in social sciences to refer to the fixed-ness of characteristics perceived as belonging to all members of a group. The more "normal" these characteristics are assumed to be, the more invisible they become as constructed norms. Consider what other norms of behavior, and characteristic attributes might belong with "man" and with "woman." For instance, what norms of behavior might you expect from a Muslim woman? How do you picture her? What do you base your perceptions on? Do you expect her to be veiled? Is she speaking or silent? Does she work? Go to school? Drive a car? Ride a bike? Go shopping? To the movies? Does she read romance novels or science fiction? What is her relationship like with her parents? Her siblings? Her grandparents? Her co-

workers? Her children? The degree of comfort or discomfort you experience thinking about your response to these questions may reveal some clues about how "essentialized" your ideas about the group "Muslim woman" are.

In the context of the Middle East, ideas about women's oppression, or the lack of modernity in the Middle East in general, are common essentialist (or reductive) representations because alternative representations, countering the normal ones, are not familiar. The deep discourses of oppression, backwardness, and hyper-religiosity are still the most familiar elements contributing to how I am known. They shape the expectations people have, expectations that I often have to respond to. These expectations are often influenced by media-based representations about members of my group. Movies such as *Midnight Express* (Guber & Parker, 1978), *Not Without My Daughter* (Ufland, Ufland, & Gilbert, 1990) *True Lies*, (Kasanoff, Sanchini, Shriver, & Cameron, 1994), *Aladdin* (Disney, 1992), or the TV series *I Dream of Jeannie* (Sheldon, 1965–1970), or the "War on Terror" news coverage are some familiar examples of stereotype-generating and sustaining representations. Such stereotypic representations (whether they are positive or negative, true or false, real or fictionalized) contribute to essentializing groups, and associating a limited number of characteristics with those who are (or are assumed to be) members of the group.

Although it is true that popular media often present stereotypes of the Middle East and Islamic culture, media are part of a network of socially constructed institutions (including schools) that represent social groups. Those who are able to most readily influence these institutions and control the means by which a particular set of characteristics are associated with particular groups have social power. They have the power to represent themselves and others. Edward Said referred to this power and the practices associated with it as Orientalism. Orientalism refers to a set of institutional practices, formal, and popular knowledge about "the Orient," a place Said identifies particularly as the Middle East, predominantly Islamic regions of North Africa, and West Asia (Arab/African). In this conceptualization, the Orient is positioned in contrast to the Occident (European/western).

In his seminal work, *Orientalism*, Edward Said (1978) explained that essentialism about the "other" (or those who are different from "us") is a primary way in which we come to know ourselves. By creating binaries such as "us" and "them," we (or, those who have the power within social institutions) establish patterns of characteristics belonging to each end of the binary:

Us —— Them
Civilized —— Savage
Modern —— Backward
Liberated —— Oppressed
. . . and so on.

According to Said, the Orient was recognized as the source of European progress, language, art, and civilization. However, this recognition also sharpened the perception that the Orient was a place perpetually set in the past, historicized, and backward. A set of academic traditions (including history, anthropology, archaeology, and art) began the process

by which European institutions created a methodology and collected artifacts by which the Orient was displayed and became known (see also Sensoy & DiAngelo, 2006).

Orientalism can also be witnessed as manifesting itself in other institutional practices, like eugenics. The eugenicists of the nineteenth and early twentieth centuries believed in the biological superiority and inferiority of certain groups. Many studies were conducted on the Oriental and African body in order to confirm the intellectual, physical, and social inferiority of these groups. As Jacobson (1998) explains, if "they" were inferior, it justified early European colonizing efforts in Africa, Asia, and North America . . . we must help them, bring civilization to their savagery, modernity to their backwardness—and, perhaps in the twenty-first century context, we could add: democracy to their dictatorships.

When Said says that the Orient has helped to define the West by acting as its opposite, he is referring to these types of common binary constructions in (and by) the West. If "they" are evil, "we" are good; they are savage—we are civilized; they are backward—we are modern; they are oppressed—we are liberated. This is the "logic" of binaries. Popular media representations are places where these types of binaries often appear. The familiar discourses of U.S. government officials (you're either with us or against us) are so familiar they are almost normal. The strategies of Orientalism of the nineteenth and twentieth centuries perpetuated binary frameworks of backward races and cultures in a manner that reiterated European/western superiority over Oriental backwardness. Spectacles of exhibitions displaying "the world" were part of the development of academic disciplines. I believe this type of displaying of the world, and the binary "better-ness" of us over them, is still in play, most prominently in media-based representations of social groups. How else might these types of binary frameworks be perpetuating today?

So how do I use media with my students, in ways that challenge the logic of binaries, the essentialist nature of the categories, and the realities of Orientalist discourses that stabilize existing power structures?

Preserving Complexities

As an educator, I work with future teachers of social education (what is known as social studies at the primary level, and the social sciences at the secondary level). With students I often speak about the relationship between the formal school curriculum and the informal societal curriculum. The school curriculum is comprised of those elements of formal instruction we regularly interact with, such as textbooks, worksheets, and other materials used in instruction. The societal curriculum is a term coined by Carlos Cortés (2000) that refers to the informal locations from which we learn about social groups (such as television, movies, newspapers, magazines, and pop music).

One of the key goals in social education is to recognize and identify the contested nature of historical "truths," the multiplicity of social group experiences, and the political nature of all knowledge. Media-based curricula, thus, provide an ideal opportunity to practice identifying perspectives that are often absent, as well as identifying the often invisible perspectives that function as universal givens. Consider how history is recorded and from whose

perspective it is transmitted in schools. Is it an oral phenomenon, transmitted to children by elders? Is history the story of the working poor? It is a cliché to state that those who win the battles of history are the ones to record history. However clichéd, what is important is for us to make the perspectives of those who are absent from history visible.

Like media-based representations, school representations do not permit much space for the representation of complexity (Kincheloe, 2001). Our contemporary education context is predominantly driven by a need to simplify, to identify the correct answers, and to ensure that students are prepared to give those answers when they are called upon. So both media and school-based representations are charged with the same reductionism: simplified, flat characters and formulaic plots, with no space for individuality or complexity.

I have found it useful to bring popular media into the classroom to explore and practice strategies for identifying these complexities and omissions as a way of practicing resistance to the violence Said explains to be part of every binary construction. In my classes, students and I examine the media-based binaries to practice asking questions about complexity.

In the remainder of this chapter, I will share the two primary principles embedded in the strategies I use to foster resistance to the violence of representation that Said cautions about. As you read through these principles, consider how you may apply them in your own day-to-day interactions with all types of representations of social groups.

(1) Practice seeing the world through your social group membership

We are each individuals, but we are also members of multiple social groups (primarily around race, gender, and class). For those of us who have racial, gender, and class privilege, it is hard to see how our own, personal lenses of knowing are shaped by, and influence, our ideas about the world and people in it. For example, how are our individual ideas and preferences shaped by social norms? We are the fish in the water, never seeing the water we spend our entire lives immersed in. In contrast to Mr. Potato Head, the seamless features of Barbie do not readily make visible the manners in which she (her face, body, ears, hair, clothes) is more than a neutral process of doll-making, but how they are rather intimately connected to the people who produced her, and for whom she was produced, and those who made decisions about what kinds of features represent the ideals of beauty, youth, femininity, and fun. These representations do more than "cause" us to think she is an ideal of beauty. This is too simplistic. Rather, she is another element in a collection of representations that create a "normalcy" around certain characteristics (such as long blond hair and a curvaceous figure) belonging to things we describe as beautiful, youthful, feminine, and fun. The valuable question to ask is, in what ways do these common representations contribute to my own preferences and attitudes about what beauty, youth, and fun look like? This work at self-focus also asks us to identify how knowledge (and the perspectives of the knowers) are important locations to analyze in order to understand social histories and perspectives more completely.

Ironically, then, one way to better understand how one's individual lenses are shaped by the normalcy of representations around them (i.e., for the fish to see the water) is to practice noticing the world through our social group memberships (rather than our individual experiences). For example, although I, as a woman, may personally have never experienced sexism, it is a fact that I belong to a historically marginalized social group: women. Consider women's representation and athletics. Women's athletic accomplishments are not regularly or widely reported on the news or in magazines except in special highlights of a "women's" such-and-such team. "Normal" teams (like "the hockey team") refer de facto to male players. So we might ask: Who are the people on the covers of sports magazines? How are the magazines at the drugstore organized in general? Are there patterns for "women's magazines" and "men's magazines"? When and in what ways are women and sports represented together? Why does the evening news always have sports as a regular feature (along with the local, national, and international news, and weather, there is the requisite sports report)? Why don't they have a requisite arts segment on the evening news? And what if anything does this have to do with gender? Which kinds of women are (or are perceived to be) more athletic? How do other social group memberships influence ideas about athleticism, such as social class (remember the ice skaters Tonya Harding and Nancy Kerrigan), or sexuality (tennis player Martina Navratilova), and traditional norms of beauty (tennis stars Venus Williams and Anna Kournikova).

By engaging with questions such as these, by observing the evidence (rather than making assumptions or stating opinions), and by stepping into a group perspective, students can come to some useful habits of mind around understanding the ways in which the most common of group representations have become so normal as to be invisible to us. As an individual, you may not care about sports, or feel that such representations are oppressive. This may well be your opinion as an individual male who doesn't care for sports, or a female who finds competitive male sports an important aspect of your life. However, this principle asks us to practice focusing on the group's representation, which may be challenging. But by doing so, you will begin to notice the patterns of representation, omission, and inclusion in various locations—not just limited to sports.

(2) There is heterogeneity within the group

The second strategy for resisting the violence of representation, and for improving media literacy, is attention to the heterogeneity of group memberships. I do this often by referring to my own fragmented social locations. So it may be useful to begin by identifying the ways in which you, or your students, fit and don't fit into the group's norms, based on gender, race, and class primarily. However, also other social locations such as first language, religion, sexuality, and ability are relevant features to investigate. In my case, I talk about how being a woman has influenced my life. How body weight, pimples, and glasses were (and in many ways still are) a deep part of how I think about myself as an individual and as a member of a gender group that is often encouraged to be preoccupied with body image. I speak about the white privilege I benefit from when I cross the U.S. border. Despite the fact

that I am from the Middle East and a Muslim, my experience is quite different from that of my brown friends crossing international borders. My membership in the group is not assumed, because I do not display the signs commonly associated with belonging to the group "Muslims" (such as brown skin, an Arabic accent, or a veil).

In what ways is this heterogeneity of group membership represented in the media? When I first immigrated to Canada and began schooling, it was on the heels of the release of the very popular movie *Midnight Express* (Guber & Parker, 1978). This film was a fictionalized biographical account of the experiences of a young man from the United States, who was tortured in a Turkish prison after being caught smuggling hashish out of the country. In addition to this very popular media representation of Turkish-ness, there was an absence of images representing Turkish/Muslim women at all, thus leaving space for the stereotypes about the generally oppressive conditions of the Middle East for women to flourish. Of course, many women throughout the world suffer oppression and cruelty at the hands of their male partners. Domestic violence is not a phenomenon that is exclusive to the Middle East or the "Muslim world." However, I often wished there were some representations of the majority of Turkish Muslim women I knew, my mom, aunts, my grandmothers, and great-aunts. These representations wouldn't "correct" those stereotypical ones, but they would make more complex the existing, flat images.

Women like my maternal grandmother, Necmiye, for example, was expelled from her elementary school for a recess fist-fight with the daughter of the principal. I also remember her being a great lover of animals. She once raced down three flights of stairs when a little chick I was playing with on the balcony fell to the garden below. She wanted to save her before the neighborhood cats grabbed her for a little snack. I remember hearing stories about my paternal grandmother Hurisel who was known for her sharp and critical mind, and the iron rule with which she ran a house of six kids. In old photographs, I see the thick glasses she wore, which in an odd way connects me, and my cousins Elvan and Tuba, to her— we all have strong prescriptions and would need thick glasses if we didn't have our contact lenses. Both my grandmothers were religious women. Even so, no women like them were in the stories of Muslim life that I saw. I remember my mom's best friends living on various floors of the same apartment complex I grew up in, in Istanbul. They would take turns going to the local fortune-teller, comparing notes, and assessing the quality of the readings. My aunt Nejla took an early retirement in order to take care of my grandparents as their health slowly deteriorated. My other aunt Hatice kept a wealthy Iranian lover at bay, while weighing her best options for a future, ultimately choosing my portly uncle Burhan for her husband.

None of these strong, engaging Muslim women were part of the media or school curricula I grew up with; none wore the *I Dream of Jeannie* belly-dancing outfit, although I was sometimes asked if anyone I knew did. By identifying these inconsistencies in our own contexts, and by sharing them with one another, we can begin to extract the principle of heterogeneity. While these are my examples, I urge my students to excavate their own. How is the heterogeneity of the groups you belong to represented and not represented?

If the media curriculum is as rigid as I've described it to be—offering very little of the

complexity of representations that is demanded of the curriculum, and if the formal curriculum by necessity must identify a set of features, characteristics, and traits that can be tested and known—how do we work within these boundaries to identify complexities?

Conclusion

Shaheen (2001) offers a compelling thought about essentializing discourses, "al tikrar biallem il hmar. By repetition even the donkey learns. This Arab proverb encapsulates how effective repetition can be when it comes to education. . . . For more than a century, Hollywood has used repetition as a teaching tool" (p. 1). Alongside this thought is the scholarship in education which informs us that for many young people, media provide students' only contact with ethnically diverse people (Gay, 2000), and that media-based representations shape our consciousness about social groups, sometimes in very subtle ways (Steinberg, 2004). Given these observations, Said's warning that representations always involve an element of violence upon the subject demands our collective attention. How might we give it that attention, yet not feel overwhelmed by the magnitude of that task?

I believe that existing media representations offer us an ideal opportunity to practice critical habits of mind. The two principles I offer above can be a strategy for resisting the violence of those representations. This can happen because such habits of mind are not dependent upon the systems of representation changing (although this may ultimately be our hope). Rather, the binary logic upon which their representations rely gives us opportunities to practice critical readings of representations. For instance, how are us/them binaries constructed in everyday representations? How are certain discourses and language used to create a neutral/invisible norm against which "others" are evaluated (such as neutral ideals of what beauty, athletes, victims, or villains are like)? In what types of activities are groups regularly shown? If they are not engaged in these activities, does that reveal an inherent unwillingness or inability to engage?

By asking, we make visible, and by making visible, we keep the questions of representation alive and more than about discovering which are stereotypic or accurate, good or bad representations. So for me, it is good to be Mr. Potato Head because he makes visible the futility of fusing flat, fixed, and non-permeable characteristics to complex, contextual, and historically shifting identities and social histories.

REFERENCES

Cortés, C. E. (2000). *The children are watching: How the media teach about diversity*. New York: Teachers College Press.

Gay, G. (2000). *Culturally responsive teaching: Theory, research, and practice*. New York: Teachers College Press.

Jacobson, M. F. (1998). *Whiteness of a different color*. Cambridge, MA: Harvard University Press.

Kincheloe, J. L. (2001). *Getting beyond the facts: Teaching social studies/ social sciences in the twenty-first century* (2nd ed.). New York: Peter Lang.

Said, E. W. (1978). *Orientalism*. New York: Vintage.

Said, E. W. (2001). In the shadow of the West. In G. Viswanathan (Ed.), *Power, politics, and culture: Interviews with Edward W. Said* (pp. 39–52). New York: Vintage.

Sensoy, Ö., & DiAngelo, R. J. (2006). I wouldn't want to be a woman in the Middle East: White female narratives of Muslim oppression. *Radical Pedagogy, 8*(1).

Shaheen, J. G. (2001). *Reel bad Arabs: How Hollywood vilifies a people*. New York: Olive Branch Press.

Steinberg, S. (2004). Desert minstrels: Hollywood's curriculum of Arabs and Muslims. In J. L. Kincheloe & S. R. Steinberg (Eds.), *The miseducation of the West: How schools and the media distort our understanding of the Islamic world* (pp. 171–179). Westport, CT: Praeger.

FILMOGRAPHY

Disney. (Producer). (1992). *Aladdin* [Animated motion picture]. United States: Disney.

Guber, P. (Executive Producer), & Parker, A. (Director). (1978). *Midnight express* [Motion picture]. United States: Columbia Pictures.

Kasanoff, L., Sanchine, R., & Shriver, R. (Executive Producers), & Cameron, J. (Director). (1994). *True lies* [Motion picture]. United States: 20th Century Fox.

Ufland, H., & Ufland, M. (Producers), & Gilbert, B. (Director). (1990). *Not without my daughter* [Motion picture]. United States: Metro-Goldwyn-Mayer.

TELEVISION SERIES

Sheldon, S. (Executive Producer). (1965–1970). *I dream of Jeannie* [Television series]. New York: NBC.

Critical Media Literacy to Counter Muslim Stereotypes

Leanne Johnny and Shaheen Shariff

Introduction

In a grade ten classroom, in Montreal, Canada, a group of students were given a homework assignment that was meant to increase their cultural awareness. Their media teacher had asked them to find information on the Internet about another country and to present their findings in class the next day. This was in May 2004 shortly after a group of Iraqi militants had filmed the decapitation of an American hostage and posted it on the Internet. With all the media attention surrounding the video (see, for example, CBS News, 2004; CNN, 2004; Fox, 2004), a group of curious students decided to download it from their home computers. Within minutes they had viewed the brutal killing of Nick Berg as if it were taking place right in front of them. Enraged by the violence, they described to their classmates what they had found online. They argued that Muslims had little regard for the importance of human life as evidenced by the brutal killing of an innocent civilian. Their peers were in agreement—*Muslims were to be feared* (see Johnny, 2005).

Information and communications technologies have opened the doors to global learning opportunities. However, as seen in the above example, they have also presented young

people with an infinite amount of information, some of which may lead to essentialized understandings of race, religion, and culture. In a post-9/11 political climate, global conflicts in Iran and Afghanistan have resulted in a backlash against Islam. This is seen in the proliferation of stereotypes in news and entertainment media that position Muslims as extremists, militants, fundamentalists, and even terrorists (Akbarzadeh & Smith, 2005; Martin & Phelan, 2002). Against the backdrop of CNN and Hollywood constructed images, young people have gained access to an endless sea of online information about Islamic ideologies. While there are several Web sites that serve to demystify stereotypes and promote tolerance, there are many others that present the views of a few extremists. Unfortunately, the latter often receive enormous press coverage and therefore play a pivotal role in shaping public perceptions of Islam (Committee on the Study of Religion, 2006).

Numerous studies show that levels of religious discrimination against Muslims have increased significantly in recent years (see, for example, Sheridan, 2006; Nacos & Torres-Reyna, 2002). We are concerned that the mass media and online discourse have played a central role in promoting this prejudice. As we will argue, if we are to teach young people to identify the stereotypes that serve to promote religious and racial intolerance, we need to prepare them to critically address the rapid and rampant information that comes with mass communication and new technologies. With this in mind the first section of our chapter provides an overview of the literature relating to news and entertainment media. As we shall see, the ubiquity of clichés that characterize Muslims and Arabs as fundamentalists and terrorists has been well documented (see for example, Nacos & Torres-Reyna, 2002; Shaheen, 2003; Martin & Phelan, 2002). This section is followed by a discussion of how worldviews, rooted in hegemonic ideologies of race and culture, are reproduced in cyberspace. We argue that, although racial stereotypes were present before the surge of new technologies, the combined effect of the mass media and Hollywood is reproduced and perpetuated through public discourse on the Internet.

In the next section we present a case for an institutional obligation on schools and universities to prepare prospective teachers and students to critically analyze racial stereotypes. As eminent scholars such as Edward Said (1997) have pointed out, prejudice against Muslims has become a sanctioned form of racism in the modern world. We believe that in order to mitigate racism stemming from the media, it is crucial that schools and university teacher preparation programs incorporate a critical media literacy approach into every aspect of their curriculum, one that serves to demystify current misunderstandings associated with Islam. We realize that this is a difficult challenge, given the complete lack of historical, political, or epistemological frameworks about Muslims in our professional development and teacher education programs, let alone our public school curriculums. However, the intellectual richness, diversity, and complexity of Muslim societies cannot be well understood in the absence of such contexts.

Such understanding is especially important if we are to address the stereotypical and increasingly pervasive assumption that all Muslims endorse violence. This myth ignores the range and degrees of difference in religious traditions and ideologies; intellectual scholarship (such as the poetry of Rumi and Khusrow; and writings of Al Ghazali, Avicenna and

Ibn Rushd); Muslim contributions to science, medicine, astronomy, art and architecture; and cultural, demographic, social, and political differences within Islam and among Muslim communities globally. Thus, media and politically informed stereotypes can neither be deconstructed in a vacuum nor can there be adequate "reconstruction" toward an informed, reasoned, and humanistic understanding without acknowledging that Muslims come from many walks of life, live in numerous countries across the world, interpret the Qur'an and practice their faith in many different ways, and live their lives through varying ethical norms, religious commitments, and affiliations to Islam. Contrary to common belief, not all Muslims are Arabs or live in the Middle East. Out of over a billion Muslims worldwide, one-third live in India, Pakistan, and Bangladesh; approximately 170 million in Indonesia, and over 300 million throughout various countries in Africa and Central Asia (*Encyclopedia Britannica*, 2002).

We propose that teacher education and professional development that are informed by historical contexts of Muslim societies provide excellent platforms through which to close existing knowledge gaps about Islam. This may be a slow and difficult process; nonetheless, we suggest that a first step in teacher education ought to be the introduction of a contextual framework that provides prospective educators with conceptual tools to help their students engage in critical media literacy. These tools can be drawn from interdisciplinary sources of scholarship such as substantive law and Islamic studies that have heretofore been overlooked in the field of education. While we do not expect all teachers to obtain degrees in Islamic Studies, we suggest that the resources of a number of universities that have established faculties and institutes of Islamic studies can be tapped through collaborative initiatives between faculties of education and such institutes toward developing comprehensive curriculum models for use in teacher education that are grounded in scholarship. Ultimately, these tools and knowledge bases could be incorporated into school curriculum programs. We propose that this approach would also provide increased knowledge about the valuable contribution of Islamic intellectuals to science, medicine, architecture, philosophy, and education in the West. Such an approach shows greater promise of helping students navigate between media propaganda and useful media knowledge. Ultimately, critical media literacy will help students distinguish media knowledge to understand the rich heritage, diversity, and pluralistic nature of Muslims in their classroom.

Media Representations of Islam

Shortly after the bombing of a government building in Oklahoma City in 1995, news agencies across America reported that two Middle Eastern men were the prime suspects. It was later revealed that Timothy McVeigh, an American with European ancestry, was responsible for this tragic event (Nacos & Torres-Reyna, 2002). Such examples serve to illustrate that anti-Muslim rhetoric is by no means a recent phenomenon but rather has shaped the reporting of journalists for several years. In fact, many visible minority groups in North America have been victims of racism and discrimination in the media. For example, research shows that in the late 1800s newspapers were largely anti-Chinese (Anderson, cited

in Mahtani, 2001), and there was a general absence of women of color for a thirty-year-period in prominent Canadian magazines such as *MacLean's* (MacGregor, cited in Mahtani, 2001). Scholars such as Essed argue that when discrimination of this sort persists and becomes accepted as a normal practice, it is generally not challenged by dominant groups (cited in Mahtani, 2001). Such statements lead to questions about the depiction of Islam in the media today and the extent to which this image is problematized by the public.

News Media

Research indicates that there are certain ethnic identifiers or cultural stereotypes that have been used in the news media to create a cognitive model of terrorism, one that is synonymous with Islam (Martin & Phelan, 2002). While it would be incorrect to assume that all news agencies depict terrorism in the same manner, we must remind ourselves that western media representations are constructed by international conglomerates such as Reuters and the Associated Press, agencies that have been traditionally responsible for over 50% of the information coming from the Middle East (Hafez, 2000). Given the reliance on a handful of media corporations for international stories, it is not uncommon for western news agencies to use similar codes and conventions in their reporting.

Recent studies examining identifying labels have found that news articles have a tendency to use terms such as *Islam* and *Muslim* as adjectives to describe terrorism and religious fundamentalism (Martin & Phelan, 2002). For example, phrases such as "Muslim hardliners," "Islamic fundamentalism," "Muslim fanatics," and "Islamic terrorists" have become commonplace in the international media coverage of political events in the Middle East (Akbarzadeh & Smith, 2005). Martin and Phelan (2002) argue that the association of terrorism with the broader culture from which it emerges creates stereotypes that are propagated through the repetition of identifying labels. Said (1997) reminds us that this construction of non-western cultures as alien and irrational is part of a much larger system of hegemonic colonial forces that have traditionally essentialized and diminished the heterogeneity and diversity of Islam.

Associations between Islam and violence not only appear in news stories covering the Middle East but also pervade what the public perceives of Muslims living in western societies. For example, in an Australian media discourse analysis it was shown that the use of *Islam* or *Muslim* as an adjective has been applied repeatedly in articles about local terrorists and their connections to extremist Islamic groups (Akbarzadeh & Smith, 2005). This form of reporting has also become evident in Canadian newspapers in the wake of events that have led to the arrest of a number of suspected terrorists in Toronto, Ontario. For example, a recent CBC article explained that *home-grown terrorists* are "virtually indistinguishable from other youth. They blend in very well to our society, they speak our language and they appear to be—to all intents and purposes—well-assimilated" (CBC, 2006). Arguably, such statements serve to create suspicion and fear by insinuating that all Canadian Muslims fit the profile of a terrorist. Certainly, one must question the integrity and potential ramifications of journalism that uses rhetoric such as "us" and "them" to create a distinction

between Canadian Muslims and other citizens of Canadian society. As Akbarzadeh & Smith (2005) point out:

> The threat of [local] terrorism collapses the perceived separation between 'Us' and 'Them' because nowadays 'They' are living in 'Our' communities. Although 'They' remain the 'Other,' there is a new sense of fear of 'Them' because they are now near 'Us.' Therefore, the way in which the public understands 'Us' and 'Them' has been recreated to adapt to the new climate of fear. (Akbarzadeh & Smith, 2005, p. 23)

The Committee on the Study of Religion (2006) notes that much of what the public knows about the world around them comes from secondhand information that is passed on through the press. Unfortunately, the news media have largely projected a homogenous view of Islam, one that is foreign or alien to the normalized ideals of western society. One reason that media coverage has produced conventionalized representations can be linked to the political and ideological orientation of journalists. For example, Hafez (2000) argues that all human beings adopt values and theories about the world through a process of socialization that takes place within a national or cultural context. This reality impacts the degree to which journalists can exercise complete balance and objectivity in their reporting as they are largely influenced by ethnocentric attitudes. Furthermore, news agencies benefit from stories covering terrorism and war. This point is exemplified by statistics that indicate close to 50% of all American households watched CNN coverage of the attacks on the World Trade Center on September 11, 2001, compared to their regular share of only 10% (Rappoport, 2002).

Given the proliferation of Muslims in the mass media and the apparent clichés that are repeatedly employed in the news, it is essential to consider the ramifications of these images. Few studies have examined the impact and reception of Muslim stereotypes in the media. However, there is mounting evidence indicating that overall, American society possesses negative associations with Islam. For instance, in a survey conducted by the Council on American-Islamic Relations (CAIR), 25% of the respondents felt that Muslims "teach their children to hate" and that they "value life less than other people" (CAIR, 2005). Moreover, when asked about their impressions of Islam, only 2% of the participants had positive feedback. Similarly, in a Gallup poll released in 2001, it was shown that 49% of the respondents felt that Arabs should carry a special identification card and 58% felt that Arabs should be subjected to more rigorous security checks than other ethnic groups (as cited in Giroux, 2002).

If these statistics are not evidence of the manner in which media representations influence public knowledge and attitudes, then at least they provide an unraveling of some of the complexities and misunderstandings involved with American perceptions of Islam. The CAIR survey found that the respondents with the most negative attitudes were the least educated, whereas more positive views were put forth by respondents who had deemed themselves knowledgeable about Islam. These findings demonstrate the essential role of both formal and informal educational measures in shaping more accepting, open, and factual opinions of religion.

Entertainment Media

Along with the news media, the entertainment industry also has a significant impact on western perceptions of the Middle East. Shaheen (2003), for example, has documented over 900 Hollywood films that include Arab characters. His study suggests that in more than 800 of these movies, Arab men are portrayed as villains and terrorists, demonstrating parallels in the representation of Muslims in both news and entertainment media. Weber (2003) claims that the entertainment media circulate non-knowledge through "the incessant, conscious exchange of some narratives, images and ideas so that others remain unconscious" (p. 191). For instance, Hollywood films often rely upon the use of images that depict Arab men praying in mosques, dressed in white gowns, or participating in military training camps. Likewise, Arab women are generally dressed in black, have few speaking roles, and are seldom shown in the workforce (Elayan, 2005). Through the repetition of these clichés, and a dearth of images that show Muslims as ordinary people, engaged in ordinary lives, the media create popular myths about the everyday experiences of people living in the Middle East (Shaheen, as cited in Elayan, 2005).

As previously discussed, it is arguable that these mass media stereotypes have influenced American perceptions of Islam. There is also evidence suggesting that these misrepresentations have caused Muslim Americans psychological harm. For example, research examining the specific attitudes of American Muslims toward the mass media found that a number of participants felt victimized by media prejudice. Women especially were concerned with the tendency of the media to represent men as violent and women as submissive (Nacos & Torres-Reyna, 2002). Similar results were articulated in a qualitative study conducted by Bullock and Jafri, which showed that a number of Canadian Muslim women felt their reality was misrepresented in the media in favor of a more sensationalized image (cited in Mahtani, 2001) This sensationalized image has likely contributed to the victimization of Muslim women in the West, where it is repeatedly argued that Muslims need to liberate themselves from the wearing of the veil and other so-called oppressive practices.

Along with women, youths have also been impacted by these images. For instance, in research conducted with a group of Muslim high school students in New York, some participants expressed fear of discrimination for expressing their religious beliefs. Others were worried for their own safety given the rise of hate crimes against Muslims in the wake of the attacks in New York and Washington (Vyas, 2004). While our presentation of these findings is not meant to suggest that the film industry has actively sought to increase prejudice against Muslims or traumatize Muslim youths, in an age when many people gain their understanding from movies and television shows, it would seem projecting a more realistic image of the ordinary life of Arabs would serve to educate the public and demystify some of the popular misconceptions associated with Islam.

In recent months, a number of Islamic communities have spoken out against the virulent stereotypes used in the entertainment industry. In particular there is a growing concern with violent video games that situate Muslims and Arabs as the enemy. A Syrian gaming firm, concerned with the anti-Islamic nature of western video games, has created Al-

Quraysh, a game that is meant to correct anti-Islamic images by situating a Muslim as the main character (Roumani, 2006). This game has created a great deal of controversy amongst critics who claim that it incites hatred toward other cultures and promotes violence amongst Muslims. The debate and controversy that have ensued demonstrate that popular culture has become a battleground for the production of power hierarchies and the promotion of competing ideologies. It also illuminates the extent to which the producers of entertainment media are cognizant of the impact their games and movies have on the way Islam is perceived by the public.

Islamophobia and Online Discourse

While it is clear that representations of Muslims in both the news and entertainment media have served to perpetuate certain myths and stereotypes about Islam, what is less visible is how these oppressive ideologies manifest themselves in cyberspace. Certainly, online discourse is an important context to explore given that more than 1 billion people worldwide have access to the Internet (United Nations, 2001). However, few studies have considered the Internet as a site for examining the reproduction of media clichés. The ones that have addressed this issue suggest that online discourse not only mirrors the negative imagery found in the mass media but that negative stereotypes are actually intensified online (Martin & Phelan, 2002). As we shall see, electronic forums have provided another space where Islamophobia, that is, the increasing victimization of Muslims in western society, is flourishing with few restrictions or ramifications for users.

Message Boards

The intensification of Muslims stereotypes is best demonstrated in a recent study conducted by Martin and Phelan (2002), which contrasts representations of Islam on television and the Internet. Using a discourse analysis, this study explores the use of the term *Islamic* in both CNN television transcripts and CNN online message boards shortly after the attacks on the World Trade Center in 2001. The findings suggest there are several similarities between the stereotypes used by television journalists and online discussion participants. However, it also shows that online message boards might actually present more virulent cultural stereotypes. For example, while the most popular noun phrase used in the television transcripts was *Islamic fundamentalists*, the online message board most frequently employed more violent terms such as *Islamic terrorist*. Moreover, on the message board there was a much higher use of noun phrases that included the term *Islamic*. These researchers argue that such language demonstrates a tendency for message board participants to use essentialized reasoning. Certainly, this scenario raises the concern that seemingly impartial discussion forums are actually sites for the promotion of religious intolerance among the public.

Steeves and Wing (2005) raise similar concerns, noting that there are several Web sites

that on the surface represent legitimate educational, research, or religious content but on closer examination entice a captive audience into discussions of hate against specific racial or religious groups. This is not only evident in Web sites that cater to adult audiences but also in electronic forums for young people. For example, the UNICEF *Voices of Youth* Web site (www.unicef.org/voy) provides a message board where adolescents from around the world can participate in discussions and debates about global issues. In July 2006, shortly after hostilities commenced between Israel and Lebanon, young people from around the world began to discuss relations between Arabs and Jews in the Middle East. While such Web sites are closely monitored by administrators, and therefore, language that promotes religious hatred or intolerance is often removed, one can still find posts that include racial slurs such as "what do you expect from Arabs?" Certainly, one wonders how such comments, especially when situated on educational Web sites, might inform what youths perceive as legitimate knowledge.

While we believe that it is valuable for adolescents to engage in political discussion, it is also crucial to note that online forums are not bound by the same rules and regulations that apply to the media. Therefore, journalists are expected to present an objective view, whereas online discourse is not bound by the same restrictions (Martin & Phelan, 2002). Moreover, scholars such as Witschge (2002) have found that virtual communities tend to attract people with similar values, interests, and concerns. This point is evidenced in a study conducted on USENET—a Web site that provides a space for political discussion. An investigation of the dialogue occurring on this site showed that this virtual space is mainly a forum that reinforces dominant ideas. Furthermore, when diverse opinions are expressed, participants show a general lack of civility toward one another (Davis, 1999 as cited in Witschge, 2002). Such findings raise concerns about the manner in which prevailing western beliefs surrounding Islam are perpetuated in cyberspace and the degree to which alternative views are tolerated within online forums. Presently, there is a dearth of information surrounding this issue, especially as it relates to youth forums. This lack of attention to adolescent conversation is dangerous, because this is when they learn to negotiate social relationships, self-consciousness, and power.

Hate Sites

In a British study conducted by Sheridan (2006), Muslim participants indicated that their experiences of implicit or indirect discrimination have risen by 82.6% since September 11, 2001, and that experiences of overt discrimination have also gone up by 76.3% (Sheridan, 2006). From the Afghani Muslim who was set on fire in Indianapolis to the Pakistani who was beaten unconscious in New Jersey (*Christian Science Monitor*, 2003), incidents of physical and verbal abuse against Muslims in western countries have been on the rise. This harassment is also evident in cyber-space. For example, since September 11, 2001, there has been an increase in the number of hate sites on the Internet, not only directed at Muslims, but at a number of different cultural, religious, and racial groups (Canadian Press,

2002). Gerstenfeld, Grant, and Chiang (2003) in their exploration of these sites claim that many white supremacist groups use the Internet to recruit new members and also to promote their ideologies. The advantage in using the Internet rather than brochures or flyers is that its anonymous nature largely protects the identity of individuals, and it is an economically sound means of communication with the potential to reach an international audience. Moreover, given that the Internet is largely unregulated, it is still difficult to prosecute the perpetrators of online hate propaganda.

In examining the nature of hate sites, Gerstenfeld et al. (2003) note that many groups create sites that have a professional look and feel in order to lend greater credibility to the sinister messages that they espouse. For example, the People's Truth Forum (www.peoplestruthforum.com) is a Web site devoted to news and information on terrorism around the world. It uses a layout similar to that of professional news Web sites, thereby intimating that it is produced using journalistic ethics. While it links to articles on terror from professional news syndicates such as CNN, *Time Magazine*, and the *Times* of London, it also has links to ezines and other less reputable sources, ones that have a clear ideological overlay. For instance, one of its recent articles, *Give No Quarter: Ask No Quarter*, incites hatred with the following text:

> To those jihadists, there must be no quarter given and no quarter asked. The swift sword of American might and justice cannot be sheathed to yield to jurisprudence, in our constant quest for fairness, for in this war we must take no prisoners, we must show no mercy . . . with our swords wielded high overhead, ready to smite the first sign of aggression, only then may we coexist with those kneeling in submission in the shadow of our blade. (Bendell, 2006)

Other features that Gerstenfeld et al. (2003) found in their study of hate sites is that many give the impression they are neutral by exhibiting nonviolent statements. This point is exemplified on Brotherhood of the Lamb (www.brotherhoodofthelamb.com), a Web site that hosts violent cartoons, photographs, and videos of the Middle East. On the first page of the Web site it states: *BrotherhoodOfTheLamb.com does not condone violence, bigotry or racism against anyone.* Such statements share the same space with phrases such as *Fascism didn't die with Hitler—Present Day Islamics [are] Fascists.* Another tactic that these sites use to garner support is the inclusion of educational pages. For example, Gerstenfeld et al. (2003) found that in the hate sites they reviewed, 7% included pages for children, some with games, music, and alternative history lessons.

In the past decade there has been a growing awareness of how technology is used to incite hatred. The urgency of addressing this topic was noted at the World Conference Against Racism (2001) where officials met to discuss the regulation of hate speech and racist propaganda on the Internet. One of the central problems with regulating these sites is that current laws make it difficult to shut them down. For example, in the United States, the Communications Decency Act of 1996 grants broad immunity to Internet Service Providers by leaving no one legally accountable for online forms of harassment. Section 230 of this Act provides in part:

1 Treatment of publisher or speaker. No provider or user of an interactive computer

service shall be treated as the publisher or speaker of any information provided by another information content provider.

2 Civil Liability. No provider or user of an interactive computer service shall be held liable on account of—(A) Any action voluntarily taken in good faith to restrict access to or availability of material that the provider or user considers to be obscene, lewd, lascivious, filthy, excessively violent, harassing, or otherwise objectionable, whether or not such material is constitutionally protected; or (B) any action taken to enable or make available to information content providers or others the technical means to restrict access to material described in paragraph (1).

Myers (2006) explains that one landmark case, *Zeran v. America Online, Inc.* (1997) is the general precedent used by American courts to rule on Internet abuse. This case resulted in leaving no legal accountability for injuries caused by anonymous postings on the Internet. It involved a series of anonymous postings on America Online's (AOL) message board following the Oklahoma City bombing in April, 1995. The messages claimed to advertise "naughty Oklahoma t-shirts." The captions on the t-shirts included "Visit Oklahoma . . . It's a Blast!!! And "Finally a Day Care Center That Keeps Kids Quiet—Oklahoma 1995." The individual who posted the messages identified himself as Ken Z and provided Zeran's phone number as the person to call to order the offensive t-shirts. Zeran received abusive telephone calls and even death threats as a result and notified AOL, which in turn terminated the contract from which the messages originated. However, the perpetrator continued to set up new accounts with false names and credit cards. Zeran finally sued AOL claiming negligence. The court ruled that Section 230 of the CDA provided absolute immunity to AOL regardless of its awareness of the defamatory material.

The Zeran ruling, Myers notes, maintains the status of Internet providers as "distributors" rather than "publishers." Publishers (e.g., book publishers) are liable for defamation by third parties using their services, especially if they are made aware of them and fail to act to prevent the behavior. The Zeran decision followed a case in which an Internet provider was elevated to the status of "publisher" (*Stratton Oakmont v. Prodigy Services Co.*, 1995). Prodigy had decided to regulate the content of its bulletin boards (in part, to market itself as a "family oriented" computer service). By taking on an editorial role, Prodigy opened itself up to greater liability than computer networks that do not edit content. Thus, service providers argued that if they agree to monitor and edit online content, they in fact subject themselves to greater liability. This is why most Internet providers ignore reports of abuse. Most are confident that they will not be held liable subsequent to Zeran.

Given there are few laws to control hate speech on the Internet, white supremacist groups have been able to spread their insidious messages about Muslims with few ramifications. Duffy (2003) points out in her study of hate sites that the Internet provides, these groups have access to a much larger audience because people who would generally not have exposure to these messages are able to access them online. Arguably, this situation presents a danger for youths. For instance, a news story published by the Canadian Press in 2002 explained that Tristan Smith, a grade 12 student, was surfing the Internet for information

on Dungeons and Dragons but instead came across sites inciting hatred toward gay men and women who seek abortions. The article claims that these are only two examples of a number of hate sites that are finding their way onto legitimate Internet domains. The matter that still remains, of course, is how many other children encounter such sites, and whether they have the necessary skills to differentiate between what is a factual Web site and what purports to be educational but instead breeds hate, perpetuates stereotypes, and reports with prejudice and bias. As Friedman reminds us:

> There is a dawning realization that the Internet . . . is different from radio, television, and newspapers in that it is totally open, interactive technology—but with no built-in editor, publisher, censor or even filters. With one mouse click, you can wander into a Nazi beer hall or pornographer's library . . . and no one is there to guide you. You interact with the network naked. The only really effective filters are the values, knowledge and judgment your kid brings to the Web in his or her own head and heart. (as cited in Alvermann & Hagood, 2000, p. 193)

Such statements point to the importance of educating young people for responsible and ethical use of new technologies. When we consider the rise in hate crimes against Muslims in North America and the corresponding increase in hate sites on the Internet, it is quite conceivable that Internet users may come across hate sites or even become the targets of their recruitment efforts. With this in mind, there is an urgent need for educational programs that prepare young people to face the new realities and dangers presented in cyberspace.

The Role of Education in Countering Media Stereotypes

Scholars such as McBrien (2005) have questioned whether the mass media influence stereotypes through phrasal associations, such as Muslim and terrorist, or if they merely reflect preexisting social beliefs about Islam. While such questions about the media are certainly not new, many studies seem to demonstrate that, on some level, the media are able to influence attitudes associated with, for example, consumerism and voting to name only a few (Considine & Haley, 1999; Cortés, 2000; Duncan, D'Ippolito, Macpherson, & Wilson, 1996, cited in McBrien, 2005). Freire argues the more we are exposed to the mass media, the more we must use our critical conscience lest we are confused about the real nature of facts (cited in McBrien, 2005). Drawing upon this idea, it is our contention that young people may gain a more authentic understanding of Islam when they are able to interpret media texts in a manner that both uncovers hegemonic beliefs and allows for the creation of new meaning through informed and critical thought.

We believe this can be achieved through critical media literacy—that is literacy skills that enable individuals to "transform their passive relationship to the media into an active, critical engagement" (Bowen, cited in Media Awareness Network, 2006) and "examine the techniques, technologies and institutions involved in media production" (Shepherd, cited in Media Awareness Network, 2006). The very fact that society depends

on the reporting of a few media conglomerates suggests that the media are largely the product of narrowly construed worldviews. If we are to confront the hegemony that continues to marginalize and in some cases demonize Muslims, we must prepare young people to expose the underlying perspectives that frame media discourse. At the same time, we must consider that youths are also involved in media production. With the proliferation of the Internet, for example, many adolescents participate in online chat, contribute to message boards, and also create Web sites. Critical media literacy must therefore, not only prepare young people to resist media manipulation but also encourage them to engage in a process of social transformation using accessible mediums of communication to produce 'alternative media' texts (Kellner, 1995).

It is also crucial that students ground their critiques of the mass media in an understanding of multiple narratives, especially those that have been traditionally silenced in our school system. For instance, the media often quote Qur'anic verses that endorse killing and violence using interviews with select mullahs and imams who agree with this position. These interviews portray one image of Islam as if it were the only version. In this section, as we engage with the notion of pluralism given the increased Muslim diaspora resulting from postcolonialism and globalization to North America and Europe, it is important to bear in mind that history and polemic ideologies divide Muslims from within the *Umma*—particularly the deep divisions among Shi'a and Sunni sects, resulting in persecution of some Shi'a groups because of their humanistic interpretation of the Qur'an. Harvard University Professor Ali Asani (2005) suggests that if we are to overcome stereotypical assumptions, it is essential to avoid blanket references to Islamic attitudes and practices. As he explains:

> To talk about Muslim attitudes toward pluralism, whether inter-religious or intra-religious, is to confront a paradox, by no means unique to Islam, of a religious tradition and its texts being used for contradictory goals; on the one hand, to promote pluralism, harmony and tolerance; on the other, to justify intolerance, persecution, war and even killing. Such contradictory attitudes, in my opinion, can be only partially explained by pursuing a purely textual approach that highlights those verses in the Qur'an that Muslims of various persuasions often use as proof-texts to legitimize their positions, be they exclusive or pluralist. They are better understood by examining the manner in which interpretation of the Qur'an and its teachings are influenced by the *contexts* in which Muslims live. In other words, explanations should be sought in the *lived experiences of Muslims*, realizing that their interpretations of religious texts, either individually or communally, are influenced by a complex web of religious, social, cultural, political, and economic factors. (p. 183, emphasis added)

This statement supports our position that unless we pay sufficient attention to alleviating the contextual knowledge gaps in the West's understanding of Islam, we will likely have little success in overcoming negative stereotypes. Given the significant Muslim diaspora in Europe and North America resulting from postcolonialism and globalization, and political tensions at the international level, it is imperative that this knowledge gap is no longer ignored. North American schools increasingly cater to children from Muslim families. Moreover, political events since September 11, 2001, have resulted in heightened curiosity regarding Islam. It is unfortunate that those who want to learn more have limited avenues available to them, other than official media and political messages that are often loaded with assumptions and de-contextualized, sensationalist headlines or bite-sized com-

ments by politicians that adhere to people's memories. With this in mind, there is an urgent need for teacher education programs to provide training about the realities of Islam so that teachers are sufficiently prepared to aid their students in challenging the taken for granted knowledge about Muslim societies that pervades the mass media.

Critical Media Literacy

In preparing young people to counter negative Muslim stereotypes, we believe it is useful for them to understand how private ownership of the mass media impacts the stories and events deemed newsworthy (McBrien, 2005). As noted by Liederman (2000), while the mass media often reflect certain truths about society, they also decide what events should receive attention. Ewen contends that these events are selected on the basis of what sells because networks are concerned with their ratings and profits (as cited in McLaren & Hammer, 1995). Chomsky and Herman take this argument further noting that commercial sponsorship has generally resulted in a pro-capitalist bias in western journalism (as cited in Weimann & Winn, 1994).

Students might use such observations to examine whose interests are served by the voices that are heard and those that are silenced in the media. For example, is it possible that journalists tacitly endorse American war efforts in the Middle East through stories that glorify the victories of American soldiers while suppressing the views of marginalized populations such as civilians? Arguably, stories aiming to garner support for American foreign policy fail to provide an objective understanding of international events. Moreover, it could even be argued that they reflect the interests of commercial sponsors concerned with gaining greater access to Middle Eastern markets and goods. If young people are able to identify the beneficiaries of news stories, it may help them gain a greater understanding of how the construction "knowledge" and "truth" about Muslims is linked to the economic interests of those involved in the production of media texts.

Along with examining media production, it is also useful for students to uncover the ideological perspectives that dominate the mass media. For instance, in a study conducted by Sigal, it was found that over half of the sources used by the *New York Times* over a 20-year- period were government officials and the second most prominent source was the business community (cited in Weimann & Winn, 1994). Students might question whose values are most prominent when news agencies rely on such limited resources and how this limited selection of interviewees serves to promote hegemonic perspectives in seemingly neutral structures. Giroux (2002) argues that post-9/11 media discourse supports both patriotism and militarism given that stories are framed in a manner that promotes the 'war against terrorism' while obscuring important information about violence waged against Arabs and Muslims in the Middle East. These one-sided views construct Muslims as perpetrators of war and violence and fail to hold Americans accountable for their own acts of aggression.

Consider, for example, politically driven aggression in the name of "democracy" that is used to justify bombings, killing of civilians, and the destruction of infrastructures in cer-

tain Muslim countries, with no accountability by North American politicians or the aggressing countries they support. Words such as "collateral damage," "measured response," and "home-grown terrorists" are increasingly used to justify the infringement of a number of constitutional and international human rights principles that western democracies have so proudly endorsed in the past. It is as if those principles have no relevance when we are dealing with the dehumanized *Muslim*. This observation is neither meant to suggest that Islamic fundamentalists who perpetrate violence are justified to kill in the name of Islam nor to deny that a minority of Muslims has inflicted significant terror, disruption, and inconvenience at the global level. Our point is that the issue has become so polemic at both ends that, increasingly, our own politicians appear to be losing sight of the line at which democratic leadership turns to an arbitrary exercise of power (and endorsement of it) which in its own right takes on radical characteristics, or state bullying, where there is always a power imbalance, exclusion, isolation, and blanket justification that the victim invited the violence (Shariff, 2005).

Right-wing conservative politicians in North America have learned to use blanket anti-Islamic rhetoric and the media for political gain, easily convincing supporters through textual, verbal, and visual de-contextualized associations that Muslims in general are dangerous. As Bibby (2002) observes, there is an emerging religious restlessness in North America, particularly by right-wing Christian fundamentalists. These constituents are easily convinced that the "war on terror" justifies the taking of thousands of innocent civilian lives in faraway countries because they threaten American and Canadian "values." According to Clarke (2005), Canadian values reflect a universal ethic and adherence to principles of justice, equality, the right to life, liberty and security of the person; freedom of thought and expression, freedom of religion and conscience, regardless of religious origin. We observe that most Canadian-born and immigrant Muslims adhere to these principles because they are consistent with the practice of their faith and inform the norms and ethics that guide their daily lives (Asani, 2005). Most North American Muslims in fact, practice their religion very much in keeping with the constitutional frameworks of their adopted countries. Nonetheless, politicians have endorsed legal documents such as the USA Patriot Act of 2001 and Canadian Security Certificates that override their fundamental constitutional rights as American or Canadian citizens and international rights as global citizens. Furthermore, evidence repeatedly emerging from Abu Ghraib (see, for example, Amnesty International, 2006) suggests that American authorities are no less guilty of turning a blind eye and thereby endorsing torture, discrimination, and hate crimes in the guise of democratic political power. Again, this disrespect for others reflects blatant breaches of international humanitarian law.

Steinbrink and Cook (2003) argue that as America becomes more involved in international events, there is an urgent need for citizens to understand how the perspectives presented in print and electronic media in other parts of the world differ from the ones in America. We would add that citizens also need to understand how western media texts might be interpreted differently by various individuals. For example, communications specialists Emmison and Smith (2000), note that people will frequently read the same text differently depending upon their background, life experiences, and subjective positions. By asking stu-

dents to consider mainstream media messages from different social, economic, religious, and cultural perspectives, it may help them understand the multiple ways in which a text can be interpreted. For instance, Steinbrink and Cook (2003) contend that in the Middle East, many individuals perceive America as a superpower that defends its interests in oil while ignoring the impact of its war on terror on the lives of innocent civilians. Students might use these views to perform an oppositional reading of media texts, thereby demythologizing the notion that America is simply a defender of democracy in the Middle East.

It is also valuable for students to identify their own subjectivities when interpreting the meaning of a media text. For example, research has shown that many individuals use cultural clichés or cognitive identifiers when applying meaning to high volumes of information. McBrien (2005) points out:

> Social cognitive psychologists Tajfel (1981) and Taylor (1981) explained that people develop cognitive shortcuts, called heuristics, in order to handle the enormous amount of information they need to process on any given day. Unless they perceive that a belief, assumption, or action might cost them in terms of time, money, self-concept, or reputation, people are likely to be "cognitive misers," relying on heuristic tools such as stereotypes to determine their attitudes and responses. Because people tend to think of media such as television, radio, and many magazines as leisure activities, they are less likely to engage critical thinking skills unless they are trained to do so. (p. 23)

Such statements remind us that individuals use their own biases and worldviews to interact with media texts and produce meaning. In challenging some of these biases, it is useful for students to explore how their heuristics might be aligned with the institutions of power that employ cultural clichés (Giroux, 2006). This goal might be achieved by simply exploring the surface meaning of a text. According to Frith (1998), the surface meaning consists of the overall impressions that one may have from quickly studying a message. Students might grasp a more accurate perception of their ways of thinking by asking probing questions about the subject of the text (i.e., terror, war, democracy, social injustice); whom the text involves (i.e., Muslims, civilians, fundamentalists; ordinary people); and how stereotypes (i.e., terrorist, fundamentalist) shape their understanding of Muslims.

As previously mentioned, Muslim stereotypes are not only prevalent in mainstream media messages but also in chat rooms, message boards, and even Web sites. Given that media clichés might actually be heightened in online spaces, it is not only useful for youths to uncover how they use heuristics to create meaning with media texts but also to probe how they translate this meaning into their online discourse. Certainly, one of the greatest advantages of the Internet is that young people are no longer limited to mainstream media messages. In other words, the Internet has the potential to become a tool for the collective resistance of media hegemony (Williams, 2003). However, for this to occur, it is important that youths are empowered with a language for discussing Islam, one that is free from the shackles of media clichés and misrepresentations. When youths are able to break down their own biases and then build a new understanding of Muslims, it will provide them with a language for engaging in positive online discourse.

Students should also be aware of the frames used to anchor a text. These are the con-

texts within which an image or idea is presented to its audience. This concept helps to unearth how professional looking Web sites, for example, impact the manner in which viewers perceive the legitimacy of information. This observation is crucial because, as previously discussed, the Internet hosts many sites that on the surface represent legitimate education material but upon closer examination promote intolerance toward religious groups. An exploration of media frames could also be applied to the news. Akbarzadeh and Smith (2005) note in their study that even when newspaper articles about Muslims are reported in a neutral fashion, when situated next to stories about war and terror, the audience still applies a negative meaning to them. Students might interrogate why newspapers situate stories about terrorism next to less sensationalized news about the lives of Muslims. They also need to consider binary oppositions—the concepts or signifiers that are arranged in pairs but opposed to each other (Emmison & Smith, 2000). Students might probe how the media use binary oppositions such as "East" and "West" or "Muslim" and "Christian" to create ideologies surrounding "good" and "evil." This counterpositioning may allow them to interrupt messages that place boundaries between "us" and "them" (Rizvi, 2004).

As a last point, we believe it is not only imperative that youths learn to critically analyze the mass media, but that they also are provided with opportunities to engage in social transformation through the production of alternative media texts. With the rise of new technologies, young people have been provided with the tools to voice their opinions to an international audience and also engage in public dialogue with an infinite amount of people. While we have seen a number of examples where the Internet has been used to spread hate and intolerance against religious and cultural groups, it is also clear that new technologies have the potential to promote peace and understanding by providing marginalized groups with the opportunity to communicate their own narratives and thereby challenge mainstream messages. Teachers might encourage youths to use the power of the Internet to engage in social transformation by creating Web sites that serve to demystify hegemonic ideologies in the mass media. Incorporating the use of zines, blogs, and other forms of online communication into the classroom not only provides young people with the opportunity to present their work to the public but also models the potential uses of the Internet as a liberating tool for engaging in media activism.

Teacher Education

While we argue that a critical analysis of media texts will aid young people in creating more authentic interpretations of Islam and resisting the manipulation that is rampant in media representations of Muslims, we also believe that critical literacy skills must include an awareness that all knowledge (including that which is produced in the media) is socially and historically constructed (Rizvi, 2004). For instance, although there are a number of political, social, and historical narratives that could shape the manner in which information is produced, the mass media tend to rely on dominant narratives to frame their interpretation of events. More specifically, it is not enough for critical media literacy to sim-

ply reveal dominant stereotypes of Muslims. Instead, critical and informed thought necessitates an awareness of the ideologies that have produced these stereotypes and the counterhegemonic perspectives that serve to unravel them.

Unfortunately, studies in the United States show that teachers have such inadequate knowledge of oppositional narratives that they may actually pass on their misunderstandings to their students (Vyas, 2004). This problem is exacerbated by the fact that American educational systems often show an incomplete representation of history. For instance, in a study conducted by El-Haj (2005), it was shown that in secondary education history textbooks, there is an incomplete representation of American involvement in Afghanistan prior to 2001 and no mention of American support to the Islamic resistance during the Cold War. Rizvi (2004) argues that the presentation of 'facts' in such textbooks is often the product of an ideological discourse that supports patriotism. Many teachers simply echo these sentiments in their classrooms because they have not been provided with the training needed to engage with this information on a more profound level. Moreover, it is conceivable that they may even see the challenging of dominant discourse as an affront to true citizenship. Arguably, this idea stems from the rhetoric of the Bush administration that maintains, "you are either with us or against us."

Certainly, we have seen countless examples of educational specialists who have been branded un-American or disloyal for speaking out against American foreign policy. For example, Giroux (2002) explains that a group of professors at the City University of New York were denounced by the university chancellor for criticizing American foreign policy. Likewise, Lynne Cheney condemned the Deputy Chancellor of New York City Schools for suggesting that the terrorist attacks in New York have created an urgent need to teach about Muslim culture. Even popular youth idols have been publicly denounced. For example, in 2003 the Dixie Chicks, an American band, stated at their London concert "we're ashamed the president of the United States is from Texas" (ABC News, 2006). This comment resulted in the boycotting of their music by a number of radio stations in America and even threats against their lives, and one wonders what lessons youths learn when their idols are silenced for "unpatriotic" behavior. If schools are to create an educational atmosphere that is consistent with the moral and political principles essential to expanding democratic values, they need to provide a space where students can begin to resist popular ideas surrounding subservience to dominant media discourse (Giroux, 2002). To this end, it is important for teachers to understand the political, historical, and ideological lenses through which media knowledge is constructed.

According to an Islamic studies authority, Professor Mohamed Arkoun (2005), in order to achieve this objective, we first need to consider the impact of modernity on conceptions of authority (religious and political), and their historical evolution to contemporary constructions of Islam. He explains that many cultures have relied on modernity as a horizon of hope to break away from religious tradition and the transmission of values that people learned to obey without asking too many questions. The notion of modernity relates to emerging values—those that challenge traditional norms and values. Modernity creates a dialectic tension within the society on the need to change, and an opposing pressure that

resists total upheaval and destruction of the existing system (religious or political). He describes technology and scientific developments that influence our current way of thinking as "tele-techno-scientific reason," noting that we have entered a period of systemic violence, wherein the means (technology and its means of communication) and organization of forces (such as political forces) work together to exact more pressure on the way we live, and the way we produce our own existence in society. There is no way out once the system has enough power to work in contemporary society.

Professor Arkoun explains that historically, there have been a number of major jumps to modernity. The introduction of Christianity and Islam were jumps to modernity in their own times. The Enlightenment in Europe was another jump to modernity because it led to the Renaissance, neo-platonic thinking, Marxism, and the roots of what we now describe as western democracies and civil societies fathered by John Locke. During the Enlightenment, resistance to church authority brought about questions of accountability and reasoning about who should be the watchdog for legitimate authority. The ultimate result was the notion of civil liberties as formalized in the constitutional protections that bind most western democracies. September 11, 2001, according to Arkoun, was another significant jump, albeit tragic, into modernity because it changed the way we think about our multicultural societies, and created a new dialectic tension. He believes that prevailing approaches to reason and authority no longer work in contemporary multicultural and multiethnic societies. He suggests that historical context cannot be provided without critical inquiry using a multidisciplinary, philological approach:

> My philosophical contention is that the epistemological posture, the conceptualizations and the methodologies used so far under the authority of the reason of enlightenment, which replaced the *auctoras* of the theological-legalistic reason that prevailed for centuries in Christianity and Islam, this whole cognitive system is obsolete and irrelevant to the emerging multi-cultural, multi-ethnic societies. An emerging reasoning is following up these emerging societies; an emerging reason that has to struggle for its specific tasks which are different from the pragmatic, empirical technological tasks assigned to the tele-techno-scientific reason.
>
> Since the highly symbolic year 1492 (Jews and Muslims expelled from Spain, discovery of America and the Atlantic route, beginning of European expansion and hegemony), all societies more or less related to an Islamic authority, had either to catch up with the new European Model of historical action or to stay far away from satanic innovations and hold on its respective ethno-cultural religious codes. The Ottoman Empire tried for a while to challenge European ascension with purely military might; after the eighteenth century, the "sick man of Europe"—a nickname given in Europe to the Ottoman regime—had to await its final death in 1924.
>
> The history of the whole Mediterranean area had not yet been written in the critical, encompassing, emancipating perspective of the new emerging disciplines called historical anthropology, historical sociology, historical psychology, religious anthropology, social and political anthropology. Islamic studies still lag far behind this promising scholarship coupled with a relevant, creative, diversified philosophical search. This is the only way to put an end to a cold, distant, formalist scholarship which says Islam is a given . . . This kind of given can challenge reason, fire the imagination, enhance contemplation, meditation, admiration and pleasure, but it should never be worshipped, used as a device for alienation, oppression or a just war; it must remain the object of constant inquiry, accurate criticism, radical reappraisal and re-appropriation. (pp. 228–229.)

He goes on to explain that if we are to make serious attempts to understand Islam, then one useful approach would be the use of philology. Philology is a methodology of how to write the history of people, by critically assessing how we incorporate our own assumptions to change the lexicon used by them as part of their historical context. It is crucial to recognize their lexicon as used within their specific historical context without imposing our own contextual interpretations. For example, the humanist erudite scholars who flourished in the sixteenth century used philology to provide a critical historical knowledge of Greek and Roman traditions. Without their help, we would not have our current knowledge of those important historical periods. Moreover, we can no longer continue to ignore the rich intellectual heritage of the *Fatimid* period and contributions of Muslim scholars in medieval Spain prior to their expulsion in 1492, to science, medicine, astronomy, law, philosophy, architecture, and so on. It is of substantial importance that what is known about these contributions should be brought into school curricula with a view to affirm that Muslim scholars have indeed contributed significantly to these disciplines as we now understand them. With these facts in mind, we propose that education faculties collaborate with other colleges and university faculties that have philological expertise in Islamic studies so that together they can develop comprehensive and scholarly curriculum content.

Final Thoughts

In conclusion, our review of the literature reveals that Muslims are facing a great deal of scrutiny in the mass media, particularly in print and television news. Hollywood films and video games are also sites for the perpetuation of stereotypes, and, therefore, both kids and adults alike are exposed to the normalized construction of Islam in the mass media. While there is still a dearth of information on Internet use as it relates to the reproduction of these stereotypes, the few studies that exist suggest that electronic forums may actually provide a space for more essentialized descriptions to flourish. In countering these stereotypes and myths, educators need to provide a space where young people can begin to oppose the taken-for-granted assumptions produced in the mass media. We believe that critical media literacy skills can act as a form of resistance to the hegemonic ideals that pervade representations of Muslims in the mass media.

With the proliferation of Muslim stereotypes in the news and entertainment media and the growing number of message boards and online hate sites, it would seem that young people need to possess skills that will allow them to both counter negative stereotypes about Islam and also make ethical decisions relating to Internet use. Schools must take seriously their role in cultivating these skills given that, as institutions of government, they have a responsibility to promote civility and justice amongst the population. In thinking about education after 9/11, Giroux (cited in El-Haj, 2005) notes:

> Educators need to provide spaces of resistance within the public schools and the university that take seriously what it means to educate students to question and interrupt authority, recall what is forgotten or ignored, make connections that are otherwise hidden, while simultaneously pro-

viding the knowledge and skills that enlarge their sense of the social and their possibilities as viable political agents capable of expanding and deepening democratic public life. (p. 28)

We contend that critical media literacy, informed by an understanding of how modernity has influenced the dialectic tensions in changing societies, and their related philology, provides this form of resistance by encouraging young people to question the natural and commonsense assumptions that stifle autonomous reflection and democratic discourse. When politicians, media, policy makers, and ultimately schools fail to encourage critical analysis of hegemonic structures, such as the mass media, arguably it is hard to imagine that our educational institutions are promoting the skills needed for demystifying the media messages that promote racial and religious intolerance. In this sense, if schools are to uphold their commitment to peace, democracy, and justice, critical media literacy is a vital skill that educators must aim to promote in their classrooms.

REFERENCES

ABC News. (2006, August 14). Dixie Chicks speak out on "primetime.." *ABC News Web site*. Retrieved August 2006, from http://abcnews.go.com/Primetime/story?id=131980&page=1

Akbarzadeh, S., & Smith, B. (2005). *The representation of Islam and Muslims in the media: The* Age *and* Herald Sun *newspapers*. Australia: Myer Foundation.

Alvermann, D., & Hagood, M. (2000). Critical media literacy: Research, theory, and practice in "new times." *The Journal of Educational Research, 93*(3) 193–200.

Amnesty International. (2006). Outsourcing facilitating human rights violations. *Annual Report*. Retrieved August 2006 from http://www.amnestyusa.org/annualreport/2006/overview.htm

Arkoun, M. (2005). Authority and power in Islamic thought. In *Islam: To reform or to subvert?* (pp. 200–263). London: Saqi Books.

Asani, A. (2005). On Muslims knowing the 'Muslim' other: Reflections on pluralism and Islam. In P. Strum (Ed.), *Muslims in the United States: Identity, influence and innovation* (pp. 181–190). Washington, DC: Woodrow Wilson Institute.

Bendell, D. (2006, August 12). Give no quarter: Ask no quarter. *The New Media Journals vs A new media news issues ezine*. Retrieved August 2006, fromwww.newmediajournal.us/index.html.

Bibby, R. (2002). *Restless Gods: The renaissance of religion in Canada*. Toronto, ON: Stoddart.

Canadian Press. (2002, October 17). Web hate site on the rise after terror attacks. *CTV Web site*. Retrieved August 2006, from http://www.ctv.ca/servlet/ArticleNews/story/CTVNews/1034878084174_30287284?hub=SciTech.

CBC. (2006, May 29). *Home-grown terrorists living in Canada: CSIS*. CBC Web site. Retrieved August, 2006, from www.cbc.ca/story/canada/national/2006/05/29/csisterrorthreat.html.

CBS News. (2004, May 16). Powell: Arabs too quiet over Berg. *In Special Report, Iraq: After Saddam*. Retrieved August 2006, from http://www.cbsnews.com/stories/2004/05/11/iraq/main616842.shtml.

Christian Science Monitor. (2003, April 10). Rise in hate crimes worries Arab-Americans. *Christian Science Monitor*. Retrieved August 2006, from http://www.csmonitor.com/2003/0410/p0s03-ussc.html.

Clarke, P. (2005). Religion, public education and the *Charter:* Where do we go now? Schools and courts:

Competing rights in the new millennium. In S. Shariff & R. Dolmage (Eds.), *McGill Journal of Education* [Special issue], *40*(3), 351–381.

CNN. (2004, May 16). Should Abu Ghraib pictures, Nick Berg video be shown? *CNN Online*. Retrieved August 2006, from http://transcrpts.cnn.com/TRANSCRIPTS/0405/16/I_C.01.html.

Committee on the Study of Religion. (2006). Struggling against Muslim stereotypes. In Committee on the Study of Religion (Ed.), *On common ground: World religions in America*. New York: Columbia University Press.

Communications Decency Act of1996, S. 652, 105th Cong. (1996).

Council on American-Islamic Relations. (2005). *The status of Muslim civil rights in the United States*. Washington: CAIR.

Duffy, M. (2003). Web of hate: A fantasy theme analysis of the rhetorical vision of hate groups online. *Journal of Communication Inquiry, 27*(3) 291–312.

El-Haj, T. (2005). Race, politics, and Arab American youth shifting frameworks for conceptualizing educational equity. *Educational Policy, 13*(34) 13–34.

Elayan, Y. (2005). *Stereotypes of Arab and Arab-Americans presented in Hollywood movies released during 1994 to 2000*. Unpublished master's thesis, East Tennessee State University, Johnson City.

Emmison, M., & Smith, P. (2000). *Researching the visual*. London: Sage.

Encyclopedia Britannica Online. (2002). *Worldwide adherents of all religions by six continental areas, mid-2002*. Retrieved August 2006, from http://www.britannica.com/eb/article-9394911

Fox News. (2004, May 11). Militants behead American hostage in Iraq. *Fox News Online*. Retrieved August 2006, from: www.foxnews.com/story/0,2933,119615,00.html.

Frith, K. (1998). *Undressing the ad: Reading culture in advertising*. New York: Peter Lang.

Gerstenfeld, P., Grant, D., & Chiang, C. (2003). Hate online: A content analysis of extremist Internet sites. *Analysis of Social Issues and Public Policy, 3*(1), 29–44.

Giroux, H. (2002). Democracy, freedom, and justice after September 11th: Rethinking the role of educators and the politics of schooling. *Teachers College Record, 104*(6), 1138–1162.

Giroux, H. (2006). *Beyond the spectacle of terrorism: Global uncertainty and the challenge of the new media*. London: Paradigm.

Hafez, K. (2000). *The West and Islam in the mass media: Cornerstones for a new international culture of communication in the 21st century*. Center for European Integration Studies.

Johnny, L. (2005, April). *Global education & technology: Educating youth for global citizenship*. Paper presented at the American Association for the Advancement of Curriculum Studies, McGill University, Montreal.

Kellner, D. (1995). Preface. In P. McLaren, R. Hammer, D. Sholle, & S. Smith Reilly (Eds.), *Rethinking media literacy: A critical pedagogy of representation* (pp. xiii-xvii).New York: Peter Lang.

Liederman, L. (2000). Pluralism in education: the display of Islamic affiliation in French and British schools. *Islam and Christian Muslim Relations, 11*(1), 105–117.

Mahtani, M. (2001). Representing minorities: Canadian media and minority identities. *Canadian Ethnic Studies, 33*(3), 99–133.

Martin, M., & Phelan, S. (2002). Representing Islam in the wake of September 11: A comparison of US television and CNN online message board discourses. *Prometheus, 20*(3), 263–269.

McBrien, L. (2005). Uninformed in the information age: Why media necessitate critical thinking in edu-

cation. In G. Schwarz, & P. U. Brown (Eds.), *Media literacy: Transforming curriculum and teaching* (pp. 18–34). *104th yearbook of the National Society for the Study of Education*. Malden, MA: Blackwell.

McLaren, P., & Hammer, R. (1995). Media knowledge, warrior citizenry and postmodern literacies. In P. McLaren, R. Hammer, D. Sholle, & S. Smith Reilly (Eds.), *Rethinking media literacy: A critical pedagogy of representation* (pp. 171–204). New York: Peter Lang.

Media Awareness Network. (2006). What is media literacy? *Media Awareness Network*. Retrieved August 2006, from www.media-awareness.ca.

Myers, D. A. (2006). Defamation and the quiescent anarchy of the Internet: A case study of cyber-targeting. *Penn State Law Review, 3*(110), 667.

Nacos, B., & Torres-Reyna, O. (2002, August 28). *Muslim Americans in the news before and after 9–11*. Paper presented at the Symposium Restless Searchlight: Terrorism, the Media & Public Life, co-sponsored by the APSA Communication Section and the Shorenstein Center at the John F. Kennedy School, Harvard University.

People's Truth Forum. (2006). Retrieved from http://www.peoplestruthforum.com.

Rappoport, P. (2002). The Internet and the demand for news. *Prometheus, 20*(3) 255–262.

Rizvi, F. (2004). Debating globalization and education after September 11. *Comparative Education, 40*(2), 158–171.

Roumani, R. (2006, June 5). Muslims craft their own videogames. *Christian Science Monitor*. Retrieved August 2006, from http://www.csmonitor.com/2006/0605/p07s02-wome.html

Said, E. (1997). *Covering Islam: How the media and the experts determine how we see the rest of the world*. New York: Vintage.

Shaheen, J. (2003). Reel bad Arabs: How Hollywood vilifies a people. *The Annals of the American Academy of Political Social Science, 588*, 171–193.

Shariff, S. (2005). Cyber-Dilemmas in the new millennium: Balancing free expression and student safety in cyber-space. [Special issue]. Schools and courts: Competing rights in the new millennium. *McGill Journal of Education, 40*(3), 467–487.

Sheridan, L. (2006). Islamophobia pre–and post–September 11th, 2001. *Journal of Interpersonal Violence, 21*(3) 317–336.

Steeves, V., & Wing, C. (2005). *Young Canadians in a wired world. Phase II. Trends and recommendations*. Ottawa, CA: Media Awareness Network.

Steinbrink, J., & Cook, W. (2003). Media literacy skills and the "war on terrorism." *The Clearing House, 76*(6), 284–288.

UNICEF. (2006). *Voices of youth Web site*. Retrieved August 2006, from http://www.unicef.org/voy.

USA Patriot Act of 2001, H. R. 3162, 107th Cong. (2001).

United Nations. (2001). *UN report on human development*. New York: United Nations.

Vyas, S. (2004). We are NOT all terrorists! Listening to the voices of Muslim high school students in the post September 11 era. *E-Journal of Teaching and Learning in Diverse Settings, 1*(2).

Washington Times. (2004). Reporting "hate crimes" against Muslims. *Washington Times* Web site. Retrieved August 2006, from www.washtimes.com/op-ed/20040514–083300-9056r.htm.

Weber, C. (2003). The media, the 'war on terrorism' and the circulation of non-knowledge. In D. K. Thussu & D. Freedman (Eds.), *War and the media* (pp. 190–199). London: Sage.

Weimann, G., & Winn, C. (1994). *The theater of terror*. New York: Longman.

Williams, B. (2003). The new media environment, Internet chat rooms and public discourse after 9/11. In D. K. Thussu & D. Freedman (Eds.), *War and the media* (pp. 176–189). London: Sage.

Witschge, T. (2002). *Online deliberation: possibilities of the Internet for deliberative democracy.* Paper presented at Prospects for Electronic Democracy at Community Connections, H. J. Heinz III School of Public Policy and Management, Carnegie Mellon University, Pittsburgh, PA.

World Conference Against Racism. (2001). Retrieved from www.un.org/wcag.

Zeran v. AOL, (1997) 958 F. Supp. 1124, 1127, nn. 3 & 5 (E.D. Va.).

Toward Teaching Social Studies Through Critical Poststructural Constructs

Lee Elliott Fleischer

Introduction

This chapter is primarily a reflective essay based on my experience teaching a social studies methods graduate course to present and future teachers. Drawing extensively from my students' viewpoints, and quoting them at length, the chapter attempts to provide honest glimpses of the students' voices, and more broadly, the challenges and concerns facing social studies teachers today. In addition to using the students' quotes as an indispensable resource, I have woven in my own research on the theory and methods of counterhegemonic teaching,[1] as well as the works of leading educational theorists.

Throughout the course, my approach was to encourage rigorous thought and critical discussion. I sought to provoke a point of view, and then, under close scrutiny, turn that view into a question. In lieu of a textbook, I assigned the students an array of articles and book chapters to be read and discussed over the course of the semester. As the students believed social studies textbooks were "boring," I initially encountered no resistance to this approach. The course was facilitated as a "hybrid" or blended course, with weekly face-to-face sessions and online "discussion boards," usually with students assigned to small groups.

While I had access to their written discussions, I seldom intruded. The discussion board domain was meant to offer a more comfortable, but not necessarily private, venue for students to discuss controversial and sensitive issues. Still, there was an implied understanding that this domain was hands off for the instructor. This chapter does not attempt to evaluate the advantages of face-to-face discussions versus online discussion board "writings." However, the reader should be mindful that the data grounding this chapter come from both sources.

Teaching Social Studies to the Media-Informed

From our very first meeting, recurrent themes concerning the media emerged as a focal point for the class. My students and I agreed that there is an intrinsic connection between teaching social studies and the images transmitted by the media. We began to apply a critical analysis based on discursive analysis to the teaching of controversial topics, whether the subject was historical—Columbus, colonial America, the American Revolution, slavery, and the Civil War, or whether the subject was current—globalization, homophobia, the War in Iraq. Eventually we emerged with a framework for a critical analysis of the media as they inform a critical discourse of social studies teaching.

Within this context, as teachers, we asked many questions, including: What is the role of the media, as a filter or screen between the information we receive and believe to be true, and the social studies we teach? How can we teach students to be critical of their own assumptions, beliefs, and definitions of historical and controversial events? What are the criteria for controversial and "heated" discussions in class? If the media are powerful enough to construct what we believe to be true, how do we know when we are critical?

In addition, given the nationwide cutbacks to the funding of social studies teaching,[2] my students also asked some fundamental questions about the priorities of teaching social studies in schools. How has the government's attempt to marginalize social studies, reducing critical thinking and discussions in their classroom, taken hold? This was one question asked, and others followed: Does social studies prepare students to participate in a democracy as informed, critical citizens? Are math and science more important than social studies in the school curricula?

How Powerful Are the Media
in Teaching Social Studies?

To the question: "Where do you get information about current topics and events, such as the War in Iraq?" the class unanimously responded: "In the media—on television news, radio, and the net." Nevertheless, the students acknowledged the existence of media manipulation. As an example, they cited that not everyone could tell the difference between a real news story and a public relations campaign. The students also provided exam-

ples of a pattern of events that emerged in learning history from the media. They cited a series of communiqués about the war in Iraq or, more generally, terrorism in the world. First, fear is instigated through a report of violence or terror. Next, a crisis to national security is reported, usually signaling a code or color, "yellow" or "orange" alerts. Then, there is a call for support, in the form of patriotism, support for the nation (government), the troops, democracy, and so on. Later, as these events drift into history, other events are reported, counterbalancing or questioning the initial reports. More people begin to ask questions or participate in acts of resistance. Public demonstrations, teach-ins, or marches may occur. Finally, there are investigations and disclosures all too often uncovering distortions, misrepresentations, and deceptions—information very different from what was initially represented by the mainstream media.

Fragmented Learning

Expanding on the media's influence, the students discussed media techniques, such as "sound bites," "talking points," and the most recent phenomenon called CPR, "continuous partial recall." CPR occurs when products are advertised or events are reported through "one-word" images. Although the concepts of sound bites and talking points are widely recognized, there is now an even greater emphasis on capturing the short-term attention span of the public utilizing monolithic images and techniques. With the constant bombardment of images saturating the postmodern world, the new reality of "hyperreality" and "virtual existence" is not surprising.

In this regard, a BBC report[3] also revealed that traditional values, such as family, religion, caring for others, are beginning to lose their hold on the collective memories and linkages between people. The effect is differential, occurring more in communities that are economically advantaged enough to be "hooked up," or connected to the Internet, television, radio, cell phones, and other cyberspace and technologically modern apparatuses. In general, the computer and its technological impact are producing such effects on humanity (Arijon, 1976; Fiske, 1994; Fornäs et al., 2002; Jones, 1997; Liu, 2000; Maasik & Solomon, 2000; Monaco, 2000; McLeskey, 1997; Peters, 1996; Poster, 2001; Rosen, 1986; Schechter, 2005; Spiller, 2005; Storey, 2001; Trend, 2001; Turkle, 2004, 2006). As Sherry Turkle (2004) forecasts, computer-mediated images impacting on our identities and relationships are already eating into the human fabric: "It is not what we are doing with computers . . . [rather] it is what they are doing to us."

The same "fragmenting" effects are reported by social studies inclusive educator Laura Lamash (2004). She reports some interesting effects between her students and computers. To Lamash, students' interaction becomes mediated by computers; their eyes no longer face each other. Along with a fixed gaze to the computer, their thinking becomes integrated to the computer screen. To Lamash, as with Turkle, this effect may be socializing young people to become more and more dependent on inanimate objects, and less and less dependent on human beings. Additionally, Lamash reports that students no longer have tolerance

for ambiguous responses to questions. They quickly go to the "screen," click onto several links in their "Web searches," and continue to "surf" other links, perhaps, prematurely, ignoring a focus that keeps them steadfast to one topic because there are so many "hot links" for the subject they are researching. Lamash's article gave my students pause to reflect on how their classrooms may be mediated by electronics.

A Critique of Textbooks

Initially, my class discussed the reliability of information from the media, and how the media, through digital electronics alone, was not the only source of media information. By the second session, the students had read articles from Michael Parenti's (1999) *History as Mystery*, James Loewen's *Lies My Teacher Taught Me* (1995), Bill Bigelow and Bob Petersen's (1996) *Rethinking Columbus: The Next 500 Years*, along with the first chapter of Howard Zinn's (2002) *A People's History of the United States*, on Columbus. Gradually, the students began to realize how the textbook publishing world—its companies, packages, and advertisements—captures their attention as to what they should be teaching and how their students should be learning.

The students were asked to critique any passage from a social studies textbook that they used in their work or as students. Drawing from the Parenti, Loewen, Bigelow and Petersen, and Zinn readings, the students recognized how the media enter social studies teaching through textbooks. Using Zinn and others as a backdrop, the students were highly critical of their hitherto uncriticized social studies textbooks. No longer accepting a textbook at face-value, one indignant student stated: "I never realized how ethnocentric and narrow we are!"

As the semester progressed, the students acknowledged that the dominant and traditional understandings of history and social studies needed to be rethought and seriously challenged. One student declared:

> It is amazing how closed minded and ignorant we have become to the world around us. We see ourselves as a great, invincible, superior country. Ultimately, past events, natural and man made, have shown us this is not the case. . . . I cannot believe how mis-educated, unaware, and intolerable we Americans are to what is happening in the world around us due to some people's desire for money and power. It amazes me to think that we are all living on the same planet, and how we are so in the dark to our fellow humans' suffering. (#316 and #347, March 26, 2006, April 3, 2006)

Another student, at first shocked, became more contemplative:

> In some aspects, I understand why textbooks lack depth, . . . but I do not think it is right. I feel like a fool for believing what my textbooks have always told me, and now finding out much more unpleasant, controversial, chaotic information is missing from our textbooks and curriculum. . . . I agree, as professionals, we have a responsibility to allow our students every opportunity to decipher for themselves what the truth is by offering as many if not all the sides of history in order to complete our task . . . As a teacher and a graduate student, I know it is my duty to clear up the misinformation that has indoctrinated me from my own academic career. (#241, February 26, 2006)

Continuing, this student added: "My teachers have failed to enlighten me about major injus-

tices that existed in early America, but a part of me makes me think that they were misinformed too" (#241, February, 26, 2006).

The students began to understand how assigned textbooks can be a part of a misinforming media network. They discussed how publishers are pressured into creating textbooks that do not offend anyone. After all, as some of the students argued, publishing is a profit-making business. Another student, who also worked as an editor in a publishing company, adjoined that local community pressures and "state adoption committees," in addition to profits, factor into the content of textbooks. Teachers, she admitted, are typically not invited to be members of these committees. Another student, who was a supervisor of social studies teachers in his school, pointed out that using supplementary sources and materials would probably be acceptable, provided the assigned textbook is the primary source. He warned, "if you want to change the system—forget about it!" explaining that assigned textbooks are purchased by the school district under strict contracts.

The class discussed how political, administrative, legal, and other restrictions may also account for the "boringness" of social studies. The students understood that book publishing was a business, and that it might not be "good business" to distribute literature that was offensive or controversial. The students observed how social studies textbooks are sanitized of conflict and controversy, along with other issues related to class, gender, labor, sexuality, and race.

Overlaying these economic and political dimensions affecting the content of our textbooks, the students also learned how these dimensions may be considered as "layers" of "discourse" (Fleischer, 1999, 2001, 2001, 2004, 2005; Gee, 1991; Weedon, 1991, 1997). In this way, one layer or formation builds upon another, constituting and constituted by poststructural or semiological constructs, as "signifiers" and "chains of subject-positions" interacting with other chains of signifiers, producing complex discursive formations, responsive to group norms.[4] Other dimensions of discourse were explored, revealing how the media provide layers or "chains" of signifiers and discourses that affect one's meaning, identity, relationships, and knowledge-making in teaching social studies. As one student asserted "the idea that words can be arbitrary or contain one-to-one connections between facts and truth, meaning they have a monolithic connection to the things they describe, is no longer true." (#287, March 19, 2006).

The Search for Truth in Controversy

On the subject of homophobia and heterosexism, some students insisted that even the assigned articles given in their methods class, were not up-to-date. As evidence that the problem of gay acceptance has been ameliorated in mainstream society, students pointed to the proliferation of television shows and movies, such as *Will and Grace* (Alden et al., & Burrows, 1998–2006), *Ellen DeGeneres Show* (Lassner et al., & Dimmich, 2003-present), ,*Queer Eye for the Straight Guy* (Collins et al. & Fockele et al. 2003-present)., *Boys Don't Cry* (Koffler et al., & Peirce, (1999), *Brokeback Mountain* (Costigan et al., & Lee, 2005),

and *Transamerica* (Macy & Tucker, 2005). Other students disagreed, citing numerous recent incidents of violence against gays. Not surprisingly, the topic elicited a divided response. After in-depth discussions, the students concluded that popular culture represented in the media may be acting as a secondary discourse, overlaying other discourses that hide homophobia and heterosexism still in existence today. Despite Hollywood's sympathetic treatment of the gay community, the students concluded that intolerance, discrimination, and violence toward gay individuals continue to be widespread in American society.

Provoked to examine the forces that have shaped their fundamental assumptions and beliefs, many of the students undertook a journey of transformation. Paradigms emerged in their week-to-week discourses, oscillating between those students who adhered to a modernist framework of truth, beliefs, and knowledge-making as "truth seeking," and those who embraced a counterhegemonic framework demanding further critical analysis of the modernist paradigm. As the students continued to examine events in their own lives, and wrote about their own experiences teaching social studies, (over 700 postings were entered on our discussion board), changes were evident in their ideas, and what they referred to as "truth."

Initially, many of the students maintained that their own "beliefs" and notions of truth were unmovable, and that what was true in history was removed from interpretive discursive questioning. As one student insisted, "how can we question or change our own beliefs; they are ours! They are mine!" Another student despaired that we cannot expect Americans to change, to be more concerned or caring with other people around the world or those poor, homeless, and immigrant people within our borders. She insisted that "Americans do not have a conscience! It's all about how much money and things one can buy for themselves!"

After extensive discussions and debate—often heated and emotional—the students began to record in their discussion boards that their beliefs, values, and notions of truth were a part of history, constantly in a state of change and flux, and that such an insight would weigh heavily on their hitherto understood or uncritically accepted paradigms of teaching social studies. "Truth" began to undergo a fundamental critique and reconceptualization.

A Semiological "Read" of Media and Changing Notions of Truth and Belief

As the semester progressed, traditional or "modernist" approaches[5] to the students' meaning-making and problem-solving, in their class activities and postings, could not be ignored. In assignments related to "modernist" social studies teaching strategies, taken from a well-known expert (Banks & Banks, 1999), the students appeared to be caught within a preconceived framework. As one student put it, re-echoing the modernist paradigm of social science research, controversial topics and social studies can be discussed in a "calm" and "unemotional" way, in which the facts can be weighed, inferences made, and data eval-

uated in a neutral way. She insisted: "We can see all of the sides, without offending anyone's values or beliefs." In this way, she further argued, we can get to the "whole truth."

Ironically, concomitant to their call for a "factual" and "calm" approach to teaching social studies, the students maintained that social studies was boring. I challenged them to consider that perhaps their belief that social studies was boring, was part and parcel of a discourse system—a modernist orientation that included a notion of facts as linear and objective, not as a subject open to interpretation, conflict, controversy, and the unknown. Once open to this concept, the students began to embrace the tenets of postmodern or semiological aspects of research and knowledge-making insofar as truth and belief systems are constituted and constructed.

Further discussion produced caution about believing the dominance of primary sources over secondary resources. One student acknowledged: "People have biases and see events from different angles." Continuing, she added: "We can't know if something is true if we were not there (in the past)." Still, other students continued to adhere to the notion of truth and facts as residing in an independent or objective domain, as opposed to being interpreted by one person after the other—albeit in a "heated discussion"—layered in a complex of discourses competing against each other for dominance in acts of meaning and knowledge making, in hegemonizing acts of seizing and negotiating power.

Semiological "Reading" of the Media Through Modernist Truth/Belief Systems

In order to explore how meanings are constituted, changed, and lived out in a complex array of subject positions, in grids of culture, class, race, gender, religion, sexual orientation, language, ideology, and power—operating in the world and history, I introduced a semiological system of discourse to the class. I asked the students to critically theorize and see through the system imposed by textbooks and the bombardment of images reported by the press, the Net, and popular culture—images that position them as carriers or reproducers of the textbook and media messages. The subject-position of a mere media receptacle was broken as the students read and discussed articles on ideology, linguistics, and feminism (Fleischer, 1998; Gee, 1997; Kincheloe, 2003; Weedon, 1991, 1997). As one article mentioned (Gee, 1997), by seeing a fresh discourse as a complex of language, ideology, and power, they would be provided with tools of analysis of discourse, constituting an "identity kit." Other postmodern philosophers refer to these tools as a *dispostif* or bricolage (Kincheloe & Berry, 2004) or rhizome (Deleuze, 1982), or tools that can help them dig (like an archaeologist) and lift out surrounding sediments, revealing contours of structures in language that link the micro to the macro, the real to the imaginary, the oppressed to the oppressor.

The students became introspective, connecting events from their own life experiences to those of history and social studies today. One student, originally from India, recounted a story that took her back in time to high school:

I am reminded of an incident from my freshmen (high school) world history class. My teacher pro-

posed the question: "Do the events of the Third World countries have any impact on us in the United States?" One girl raised her hand and said: "I really don't care about the rest of the world. It has nothing to do with me." The teacher asked: "What about the children in this part of the world?" The student, once again responded: "I don't care. It doesn't concern me." I turned to my teacher to see the expression of amazement and sadness on her face. But what really amazed me is that she didn't take the conversation further. (#324, March 27, 2006)

The students understood that social studies should and could be taught in an exciting, meaningful way. They wanted to touch their hearts, as well as their minds, and they sought to construct a discourse system, or set of rules, that would help them become more familiar with and apply how to teach social studies through "controversial topics."

Building a Discourse System or Criteria to Discuss Controversial Topics

By mid-semester, the students recognized how dominant meanings and "truths" circulate in the classroom discourse. To discuss controversial topics with their own students, they would need courage. They also understood that they would need to question their own inculcated beliefs and assumptions, beginning with the education they received in their own childhoods. As one student recounted:

> I never remembered learning about the other side of the statistics—how the rich are getting richer and the poor are getting poorer. I was taught that America is a world power, but I was not taught how America became and is a world power, at the expense of poorer countries. (#313, March 26, 2006)

Another student, further reflecting on her work and beliefs as a social studies teacher, maintained:

> In our first class, most of us said that the chronic problem we found with social studies was its boringness. It was the memorization of unconnected facts. It was a process of rote learning of information without any connection to us today. The "critical system of meaning" (in Kincheloe, 2003) will help us and students and teachers develop complex cognitive skills involved in exploring bodies of new knowledge . . . In other words, lesson plans should be created about the dominant discourse, opposing discourses, and a critical thinking or simulated activities, whereby students are able to socialize, analyze, and develop their own perspectives on issues. (#418, April 14, 2006)

The same student, addressing the need to find "semiological dimensions of knowledge reproduction" in the teaching of social studies (Kincheloe, 2003), as mediated by the media and other forces, added:

> In school I was never asked or taught to do that (question one's assumptions, as cited above). You basically learned what was told to you and basically believed it was correct because you were reading it from the required or assigned textbook and it was being taught by your teacher. (#424, April 16, 2006)

When the students further analyzed and concluded that much of what is printed in assigned social studies was ethnocentric, i.e., portraying the discovery of the new world as

heroic and courageous acts instead of one that required genocide by the explorers of the New World, along with the beginning of the transatlantic slave trade, the students' comments became even more vociferous:

> As we have learned in class, the social studies textbook is not the absolute word . . . It should not be the textbook and the lecture method of teaching to secure our history. The past is too exciting and too rich to be presented in a boring way . . . There are two sides (or more) to a story . . . we have to consider all the truths and not merely one. (#663, May 10, 2006)

Becoming more critical, the students began to debate whether a textbook should be jettisoned for alternate or supplementary sources in finding the "truth" and "beliefs" of what teaching social studies was all about. Despite their antipathy for textbooks, the students still wanted the "whole truth," as if the "truth" could be found in one book or source. Most could not penetrate the boundaries of their assumed or unconscious modernist presuppositions defining truth and belief. Panning outward, one student asserted:

> Historically speaking, most social studies classrooms have been conducted by lectures, along with textbooks that are regarded with the "utmost truth." In order to succeed, one must know how to memorize and take notes. Thankfully, a new generation of teachers is being born that use alternate methods of teaching. They no longer need to rely on the textbook, they can use technology, real people, cooperative activities, field trips, etc. to spark interest in their students. The traditional lecturing, in which what the teachers say is truth, is dying. (#692, May 12, 2006)

Nevertheless, throughout the semester, many of the students maintained a modernist paradigm of truth, attainable through measurable instruments as surveys and sensory perceptions—what you see is what you get. One of the students described how she sought to assess the "beliefs" of her students by using surveys to assess the beliefs of the students before the class began. In this way, she felt she could safeguard both the students and her job, by avoiding those subjects that were "controversial" or might offend their administrators, other teachers, or parents (#661, May 10, 2006). Another student added that alternate materials beyond the textbook, need to be "age appropriate." Other students were "worried" and found it "troubling" that presenting alternate materials, complementing the assigned textbook, would make Americans appear as "ugly" and "violent" people.

Some students, fearing parental and administrative reprisals, jeopardizing their jobs, did not want to use alternate sources—irrespective of how informative and exciting they were. Some merely argued for the inclusion of alternate sources to complement textbooks, but when push came to shove, were not "willing to be a 'sacrificial lamb' for the sake of teaching their students" (#657, May 10, 2006).

Still, other students (#653, May 10, 2006; W658, May 10, 2006; #677, May 11, 2006) resisted their classmates on the grounds that "truth" and "beliefs" are movable and changing, not necessarily fixed or embedded in history or culture. They argued that students need to know the other or "dark sides" of history. This was necessary, they said, because in order to arrive at more than "truth," but further, the multifaceted picture of America's traditions and institutions, their students would have to learn about or be exposed to all the sides of "truth," irrespective of their "beliefs" or those of their parents and the local community. They concluded that it was their responsibility, as educators, to prepare students to be intel-

lectually curious, critically informed citizens.

In addition to a focus on homophobia, many controversial topics in teaching social studies were addressed by the students, including the War in Iraq and American globalization. One student described how her study on globalization would reveal an overlapping of discourses, thereby breaking with the modernist paradigm. She cited her Hispanic students, who were resistant to fearful terrorist reports by the media. Perhaps, she surmised, because they are from outside of the country, from developing nations where such occurrences happen all the time, they have gained a different perspective. She offered: "these students were not easily persuaded or pumped up by fear, unlike other students (white students) who jumped to conclusions about terrorists" (#648, May 9, 2006).

Another student, with a final paper on American patriotism and dissent, maintained a modernist perspective:

> Many students in the United States are not only scared, but also confused. The media's portrayal of national and international events produces a fearful youth population. Not only are the students afraid to choose sides, but are indecisive about committing themselves to any side—liberal or conservative. If students would be presented with the facts, would they be hesitant to choose sides? Teaching current events in the classroom, however, would give these students the opportunity to come up with information enabling them to choose a side according to their *beliefs* and convictions. (#643, May 9, 2006)

Raising the bar, I urged the students to choose a controversial subject that would question their definitions and their school and community standards of what was appropriate, real, true, or believable, on the subject of homophobia. Surprisingly, many of the students chose homosexuality and homophobia as the research topic for their final paper or project. With the introduction of homosexuality and homophobia as an issue concerned with social studies teaching, the students were again divided along modernist and postmodernist definitions of truth, belief, and knowledge. They remained concerned about offending parents and administrators, and issues relative to age appropriateness, local community religious beliefs, and many questioned whether the topic should be taught in schools at all!

Two Frameworks for Discussing Homophobia and Controversy in Teaching

"Truth Seekers" and "Counterhegemonic Criticizers"

Students brought their own biases, subtle and otherwise, to the question: Should homophobia be taught in public schools? Acknowledging the need for supplementary or alternate sources of information, some students expressed the need to teach controversial subjects, such as homophobia, with safeguards. The students were concerned about classroom management issues, as laying down rules concerning behavior, i.e., no giggling or name-calling. They also felt that administrators and parents should be notified in advance,

and that parents should be offered an "opt-out" option for their children. Other students wanted literature in alignment with state health and school standards. They also rationalized that inclusion of such topics should require the traditional textbook, as well as experts in health education and sexually transmitted diseases. They also wanted more recent literature that would reveal the life stories of young teens unafraid to "come out" to their family, friends, and community.

Other students disagreed. They maintained that in the teaching of controversial subjects, it is impossible to anticipate all contingencies that may evoke "provocative questions" and even incite "heated" and "emotional" debates. Avoiding discussions of controversial subjects, they insisted, would leave such topics to the home or to the family, and deny students a more balanced education. They argued that there are too many dysfunctional families and absentee parents in today's society, and children would adopt the prejudices of their family and peer groups, and accept media distortions as "fact." It would be a disservice, these students argued, to neglect their education in this way. These students also felt that a degree of risk and discomfort on the part of teachers was necessary in discussing controversial topics.

A student, a supervisor of social studies teachers, however, warned that while supplementary sources and discussing controversial topics would reduce boredom in the class, a discussion on homophobia would cause administrative and parental reactions: "you can be sure that once you teach stuff on homosexuality you will get a bunch of parent complaints and the principal will have you in his office the next day!"

To some degree, a change in attitude began to occur after the class viewed a film about teaching gay issues to elementary students, *It's Elementary: How to Talk About Homosexuality to Young Kids* (1993). The students' unanimously approved of the film but, nevertheless, insisted on restrictions, such as age appropriateness. The class was divided: some students chose a high school age, some middle school, many chose the fourth grade, and one approved of the subject for kindergarteners.

One student argued:

> If we keep the ultimate goal of our social studies method class in mind (teaching about diversity, justice, and equality), it may be possible for us to teach about homosexuality since health-ed and sex-ed classes don't seem to be doing the job. The articles we read [in methods class] opened my mind, and made it easier to teach . . . (quoting Athanases, 1996) if we are 'committed to social justice and to public education as the vehicle of equality and for participation in a democratic society,' then, as social conscious teachers bringing in controversial topics, won't be as difficult. (#369, April 7, 2006)

Another student talked about a gay guest speaker in her undergraduate sociology college class. Warning about the quality of the guest speaker or the professor, she offered her critical reservations:

> I felt the guest speaker was not informative and did little to dispel some of the myths of homosexuality . . . Our sociology professor invited a gay male to our class to talk about his life. When he opened the floor for questions, a student asked him something to the effect of: "Don't you think being gay is a sin?" The student was very persistent and evidentially anti-gay. The guest speaker responded with something that is in Athanases' (1996) article—he believed that people are people and that they should live out their lives as "love thy neighbor." Afterwards, without anyone joining in the

discussion, my professor went on to the next topic without further discussing what the student brought up in class. This correlates what Athanases (1996) says in his article: "Seldom . . . (do we) . . . address issues of sexual orientation when they arise in lessons." (#377, April 8, 2006)

Another student raised the issue of religion as a factor for not discussing homophobia. She pointed out that people with "high moral standings" may not believe in homosexuality, and it is their wish not to have their children exposed to the subject of homophobia (#376, April 8, 2006). She added schools ought to be accommodated by teaching religious instruction in public schools, too.

Still another student insisted, referring to one of the articles assigned as a supplementary source of information on homophobia, that such fears are disseminated through our society because they are constructed along "chains of binary oppositions" in which classification of people are governed by hierarchical frameworks and relationships (as pointed out in Ormiston, 1996). Thus, homosexuals are inferior to their opposite, heterosexuals; or black or people of color are inferior to their opposite, white people; or poor people are opposed to rich people, or the East and other "developing countries" in the Third World are opposed to America and the West, and so forth.

Discussing homosexuality, a student wrote:

> I believed it was something to be left out of the school. It was always 'assumed' because we try to teach acceptance and respectfulness of one's beliefs, that students will take it and apply it to all different situations they are faced with. That is just not the case. It needs to be a little bit more concrete than that. You are right, it is definitely uncomfortable, and I agree with the fact that if we are as educators just sit back and ignore it, the dominant discourses (i.e., homophobia) will only become more dominant and students will not have the opportunity to understand the various perspectives of this issue. (#666, May 10, 2006)

Similarly, another student added:

> Such issues need to be brought up in class in a manner that will try to prevent causing a fury or commotion. We all know, there will always be parents and administrators that will be against such an education, but we can do our best not to offend or disrespect anyone. I think it is also important to show students how negative comments can hurt gays because, after all, they are also people. There are many things that kids pick up from others, the media, and their surroundings. As we can't force them to choose a side, we (social studies teachers) can help them with that decision by providing them with valuable information. (#667, May 10, 2006)

By the end of the semester, most of the students recognized that there was a need to construct criteria or a framework for the discussion of controversial topics. Only a few students persisted in talking about the "beliefs" of their students and themselves as if they were removed and unalterable; others, however, could not part from the modernist paradigm of truth that limited their discourse. Some wanted to institute behaviorist "techniques," to help predict when teachers should intervene in debates that became too heated. Others wanted to predetermine discourse in the classroom by setting parameters limiting how far debate could go, removing contingency and ambiguity. Others wanted to set rules that would put sanctions against "giggling" and name-calling, limiting the exposure of students talking to each other according to their level of maturity and "age level."

Final Comments: How Do We Know
We Are Critical Social Studies Teachers?

The following comments are representative of the students' conclusions:

> In school you basically learned what was told to you and you basically believed it was correct because you were reading it from a (history) book and it was being taught by your teacher. I think this different process of teaching with post-structural constructs we learned in class this semester allows students to develop the skills to think critically and to question material provided to them. (#424, April 16, 2006)

Continuing her posting, responding to another student, online:

> One article we read said: "We must move beyond the confines. . . . we must construct a critical system of meaning to help us ask new questions, to see from new angles."
>
> Throughout this semester we learned to question and look at things from the 'other side' (from those voices from below in terms of race, class, gender, and more) when teaching our students. I believe this concept can be included in research when discussing various ways to teach against the problematic teaching methods. I think research is a great way to improve on and perceive a new structure of practices apart from the dominant school system. (#420, April 15, 2006)

Another student, adding to the conversation based on an article read in class (Kincheloe, 2003), said:

> At the very beginning of the article I just read, 'that critical research will help teachers to rediscover their professional status and empower their practice in the classroom and improve the quality of education for their pupils.' For me, that epitomizes the importance of constant professional development and meaningful research. By not keeping us constantly informed and engaged in research, we are doing a disservice to our students. . . . The important point that the article brings up is the "semiotic dimensions of power reproduction"—that's the difference between the positivistic tradition of research and critical constructivist action research. *We don't intentionally oppress others or prevent our students from being critical thinkers, but it still happens.* (#464, April 16, 2006, emphasis added)

Still another student added to the discourse:

> If teachers became active researchers, then, they would, in a way, liberate themselves from the dominant ideologies and practices of schools (#385, April 10, 2006).

By the final class, reactions still differed from student to student, but all professed critical views, and all agreed that the course had been transformative in some way. As educators, they felt it was their mission to strive for social justice and democracy. Now, more than ever, they wanted their students to be informed, critical citizens. The students believed that they and their students needed and deserved to be excited about social studies. Recognizing and confronting their fears with an expanded and fundamentally changed perspective, informed by critical-media and post-structural constructs,[6] the students in the methods class were determined to embrace controversial topics in their own classrooms. The class discussions and assigned readings had "opened their eyes," provoked and inspired them to "step up" and "lead by example." And, most heartening to me, they all agreed that social studies was anything but boring.

NOTES

1 Lee Fleischer, *Counter-Hegemonic Social Studies Teaching* (Rotterdam, Netherlands: Sense Publishers, 2007).

2 Sam Dillon, "Schools Cut Back Subjects to Push Reading and Math," *The New York Times*, March 25, 2006, p. 1A.

3 This report was aired as a part of a panel discussion on 93.9FM, National Public Radio (NPR). Some of the guests are employed by the British Broadcasting Corporation (BBC).

4 To most postmodern and poststructuralist philosophers, and more recent works introducing poststructuralist concepts to education, the key insight comes from the seminal work of Jacques Lacan. He insists that in the signifier-signified relationship between words and meaning, there is a non-self-referential activity of the signifier. To Lacan, "a signifier represents the subject for another signifier *along a chain or* chains of other signifiers (Lacan, 1977)." He thereby displaces and de-centers, at once, the modernist paradigm or overarching assumption that the subject is self-referential, consistent, coherent, and centered. To Lacan (1977) and others (Coward & Ellis, 1977; Pecheux, 1982; Weedon, 1991, 1997), layers of words, imbricated onto other words, revealing meanings at the "edges," producing meanings alongside or through other interacting or intervening chains of signifiers and subject-positions. These signifiers and subject-position chains become the places and times whereby we see through and perceive the world (Critchley & Marchart, 2004). Further, these chains of signifiers and subject-positions form and are informed by discourses, which in turn, interact and overlap each other, and in those spaces create or push to the side, other discourses and their formations and systems in the construction of power and knowledge (Foucault, 1977, 1980).

5 To Zizek (1999), the notion of truth and how belief processes are forged into a system of knowledge, may be understood as a "truth event." To be in a "truth event," in which the differences and the textures of differences are removed, is to be in a world that is suspended from truth or the processes that make up truth as a *misrecognition* by the dominant structures imposed on its populace unconsciously through images of the media and other forms of language. The respondent in the experience suspends these differences—qualifications or demands, or reasons.

In a similar manner, the notion of modernist thinking, as distinct from ancient or medieval thinking, is a distinction of the Enlightenment of the sixteenth century, whereby rational thinking rebelled against traditional notions of the Church and pagan superstitions. Philosophers, e.g., Rene Descartes, focused attention on either the scientific truth, in which objects are "outside" human consciousness or, from another position, relying on the notion of *cogito* or consciousness, as the final depository of truth—"I think, therefore I am" or how one's self becomes the norm of positing consciousness as a solitary, self-referential, and consistent and coherent subject. Either way, this binary epistemology of two extremes obscures other realms in between. To Zizek (1999), the "epistemology of the empty" obscured by the domination of subjective and scientific thinking, denies a view of those spaces in between the two, spaces linked to discourse and how, as Heidegger (1962) pointed to, the "clearings" in language or its discursive formations in which one may penetrate the binary chains of the Enlightenment.

Zizek (1999, 2005) argues for a postmodern framework of knowledge-making to reveal the processes in-between or, as Lacan refers to them as the "real" between the "symbolic and "imaginary," teachers must construct their spaces and moments despite administrative and societal constraints. To Heidegger, it is in these in-between spaces where authentic experience or "being there" is encountered, pushing back inauthentic constructions (including administrative and societal constraints). These in-between spaces are also truncated by modernist processes of truth and believing. These truncated or overlapping modernist chains of signifiers or discourses produce subjects as "falling away" from authentic existential experiences. Hence, truth and beliefs become encased in inauthentic talk or chatter, or the incessant repetition of the graduate student's need to "believe" that one cannot change one's "beliefs," and that history was constructed on transcendental "truths" and bases.

Zizek describes the modernist paradigm as mankind's arrogance upon the world, captured in its scientific techniques of objective and neutral measurements. Contrary to the poststructural paradigm, according to Zizek (1999), he asks us to look at those "traces" of the "excesses" of things not completely subsumed by the object of modernist thought. Poststructuralism thus searches for the slippages or edges of memory and the collective experiences of people. Thus, Zizek (2005), taking a central insight from Lacan, declares these traces or edges and excesses of experiences as: *objets petit a*, circulating and connecting signifiers, stitching unconsciousness and consciousness together, resisting or reshaping master signifiers or those signifiers that condense, "pin down," and "assimilate" other signifiers; or, conversely, how signifiers become displaced and metonymic in their meaning networks, connecting the I and the Other and breaking through other binary relations or hierarchical chains of signifiers as rich and poor, man and women, white and black, West and East, developed and developing worlds as their meanings—tiny, "ticklish," and fleeting signifiers—become transparent (Zizek, 1999, 2005).

Zizek maintains, for example, that the primordial event for a Christian, circulating in and through one's consciousness as truth, is the image of the resurrection of Christ. In a similar fashion, to a Russian Marxist, the October Revolution is the "truth event" that runs through the communist collective unconsciousness, surfacing at times as a sudden revelation of inspiration to desire action. Both experiences link the past to the present and the present to the future, thus setting thought into action and reconnecting people as isolates to collectives, and repressed ideas break through for real action. In effect, these fragments of consciousness are the relays that postmodernism (Deleuze & Parnet, 1987; Grossberg, 1992) identifies as the "traces" or "rhizomes" fleeting across, in and through words and their assemblages of meanings (Grossberg, 1992) that drive one to struggle beyond defeat and resignation (Lacan, 1982; Zizek, 1999, pp. 127–170). They are the "connectors" and "cross-over" signifiers that link discourses to each other and their substructures, i.e. chains of signifiers and subject-positions, discursive formations, spreading outward to discourses to group action toward remaking reality, history, truth, beliefs, norms, and hegemony (Chritchley & Marchart, 2004).

6 How the students in the methods class applied poststructural concepts as a tool for counterhegemonic teaching and theorizing is discussed as a chapter in Lee Fleischer, "Freire Illustrated: How the Oppressed Become Oppressors in Overlapping Signifying Chains of Hegemony," in Lee Fleischer, *Counter-Hegemonic Social Studies Teaching* (Rotterdam, Netherlands, 2007). Another work by Fleischer explores how chains of signifiers, when they were sutured in a certain position of discourse, signified to poor and middle-class American colonists, who were at best ambivalent about going to war with Britain, were persuaded to side with the upper or wealthy landowning and merchant classes of colonial society because their beliefs were overlaid with chains of signifiers that appealed to their "individual," as opposed to their class interests (Lee Fleischer, "Deriving a Qualitative Counter-Hegemonic Theory of Discourse in Social Studies Textbooks" prepared for a presentation at the First International Qualitative Research Conference, University of Illinois, May 2005.

REFERENCES

Arijon, D. (1976). *Grammar of the film language*. Beverley Hills, CA: Silman-James Press.

Athanases, S. (1996). A gay themed lesson in an ethnic literature curriculum: Tenth graders' responses to 'Dear Anita'. *Harvard Educational Review, 66*(2), 196, 232–256.

Banks, J., & Banks, C. (1999). *Teaching strategies for the social studies: decision-making and citizen action* (5th ed.). New York: Addison, Wesley, Longman.

Bigelow, B., & Peterson, B. (1996). *Rethinking Columbus: The next 500 years*. Milwaukee, WI: Rethinking Schools Publication.

Bigelow, B., & Peterson, B. (2002). *Rethinking globalization: Teaching for justice in an unjust world*. Milwaukee, WI: Rethinking Schools Publication.

Coward, R., & Ellis, J. (1977). *Language and materialism: Developments of semiology and the theory of the subject*. London: Routledge, Kegan, and Paul.

Critchley, S., & Marchart, O. (Eds.) (2004). *Laclau: A critical reader*. New York: Routledge.

Deleuze, G. (1986). *Foucault* (S. Hand, Trans.). Minneapolis: University of Minnesota Press.

Deleuze, G. (1992). What is a dispostif? In T. J. Armstrong (Ed.), *Michel Foucault, philosopher* (pp. 159–168). New York: Harvester and Wheatsheaf.

Deleuze, G., & Guattari, F. (1982). Rhizome. *Semiotext(e)*, pp. 1–63.

Deleuze, G., & Parnet, C. (1987). *Dialogues*. New York: Columbia University Press.

Dillon, S. (2006, March 26). Schools cut back subjects to push reading and writing. *The New York Times*, pp. 1A, 12A.

Fiske, J. (1994). *Media matters: Everyday culture and political change*. Minneapolis: University of Minnesota Press.

Fleischer, L. (1998). *Living in contradiction: Stories of special education students in New York City*. Unpublished doctoral dissertation, Teachers College, Columbia University.

Fleischer, L. (1999, June). *A journey into the post-structural: A qualitative methodology for examining the classroom as a complex of hegemonic and counter-hegemonic discursive formations*. Paper presented at the Eleventh Annual Ethnographic and Qualitative Research in Education Conference, Teachers College, Columbia University.

Fleischer, L. (2001a, Spring). Speaking post-structurally of John Dewey and G. H. Mead: Reflections on teaching social studies in a core course. *Educational Change*, pp. 32–48.

Fleischer, L. (2001b). Approaching a new paradigm for educational critical theorizing penetrating the macro/micro divide. *Taboo: The Journal of Culture and Education*, 5(1), 122–137.

Fleischer, L. (2001c). Special education students as counter-hegemonic theorizers. In Glenn M. Hudak & Paul Kihn (Eds.), *Labeling: Politics and pedagogy* (pp. 115–125). New York: Routledge.

Fleischer, L. (2004). Toward a counter-hegemonic multicultural grammar. In J. Kincheloe, S. Steinberg, & A. Burstyn (Eds.), *Teaching teachers: Building a quality school of urban education* (pp. 209–228). New York: Peter Lang.

Fleischer, L. (2005a, Fall/Winter). Exceptional youth cultures: A framework for instructional strategies of inclusive classrooms. *Taboo: The Journal for Culture and Education*, 9(2), 97–104.

Fleischer, L. (2005b, May). *Deriving a qualitative counter-hegemonic theory of discourse for teaching and explaining Howard Zinn's A people's history of the United States*. Paper presented at the First International Qualitative Research Conference, University of Illinois, Urbana-Campaign.

Fleischer, L. (2006, Spring). Emphasizing classroom management at the detriment of theory. *Academic Forum, the Academic Affairs Publication, the Official Journal of New Jersey City University*, 14(2), 26–28.

Fleischer, L. (2007). *Counter-hegemonic social studies teaching*. Rotterdam, Netherlands: Sense Publications.

Fornäs, J., Klein, K., Ladendorf, M., Sundén, J., & Sveningsson, M. (2002). *Digital borderlands: Cultural studies of identity and interactivity on the Internet*. New York: Peter Lang.

Foucault, M. (1972). *The archaeology of knowledge and the discourse on language* (A. M. Sheridan, Trans.). New York: Harper and Row.

Foucault, M. (1977). Nietzsche, genealogy, history. In D. Bouchard (Ed.). *Language, counter-memory, practice: Selected essays and interviews by Michel Foucault*. (pp.139–164). Ithaca, NY: Cornell University Press.

Foucault, M. (1980). *The history of sexuality: An introduction*. New York: Vintage Books.

Gee, J. P. (1997). *Social linguistics and literacies: Ideology in discourses* (2nd ed.). New York and Philadelphia: Routledge/Falmer, Taylor and Francis.

Grossberg, L. (1992). *We gotta get out of this place*. New York: Routledge.

Heidegger, M. (1962). *Being and time*. New York: Harper and Row.

Jones, S. (1997). *Virtual culture: Identity and communication in cybersociety*. Thousand Oaks, CA: Sage.

Kincheloe, J. (2003). Values, objectivity, and ideology. In J. L. Kincheloe, *Teachers as researchers: qualitative inquiry as a path to empowerment* (2nd ed.) (pp. 188–205). New York: Routledge/Falmer.

Kincheloe, J., & Berry, K. (2004). *Rigor and complexity in qualitative research: Constructing the bricolage*. London: Open University Press.

Lacan, J. (1977). *The four fundamental concepts of psycho-analysis* (A. Sheridan, Trans.). London: Hogarth Press.

Lamash, L. (2004). Social history, technology, and the building of inclusive classroom communities. In B. Rainforth & J. Kugelmass (Eds.), *Curriculum instruction for all learners: Blending systematic and constructivist approaches in inclusive elementary schools*. Baltimore: Paul H. Brookes Publishing Co.

Leupin, A. (2004). *Lacan today: Psychoanalysis, science, religion*. New York: Other Press.

Liu, C. (2000). *Coping machines: Taking notes for the automaton*. Minneapolis: University of Minnesota Press.

Loewen, J. (1995). *Lies my teacher told me: Everything your American history textbook got wrong*. New York: Touchstone.

Maasik, S., & Solomon, J. (2000). *Signs of life: Readings on popular culture for writers*. New York: St. Martin's Press.

Macdonell, D. (1986). *Theories of discourse: An introduction*. London: Blackwell.

McLeskey, R. (1997). *Corporate media and the threat to democracy*. New York: Open Media Pamphlet Series.

Monaco, J. (2000). *How to read a film: movies, media, multimedia—Language, history, and theory* (3rd ed.). New York: Oxford University Press.

Ormiston, W. (1996). Stone Butch celebration: A trans-gendered inspired revolution in academia. *Harvard Educational Review*, 66(2), 198–215.

Parenti, M. (1986). *Inventing reality: The politics of the mass media*. New York: St. Martin's Press.

Parenti, M. (1999). *History as mystery*. San Francisco: City Light Books.

Pecheux, M. (1982). *Semantics, linguistics, and ideology* (H. Nagpal, Trans.). New York: St. Martin's Press.

Peters, M. (1996). *Postructuralism, politics, and education*. Westport, CT: Bergin & Garvey.

Poster, M. (2001). *The information subject*. Amsterdam, Netherlands: G+B Arts International.

Rosen, P. (Ed.). (1986). *Narrative, apparatus, and ideology: A film theory reader*. New York: Columbia University Press.

Sarup, M. (1993). *Post-structuralism and postmodernism* (2nd ed.). Athens: University of Georgia Press.

Schechter, D. (2005). *The death of the media and the fight to save democracy*. Hoboken, NJ: Melville House of Publishing.

Spiller, N. (Ed.). (2002). *Cyber_reader: Critical writings for the digital era*. London: Phaidon Press Limited.

Storey, J. (2001). *Cultural theory and popular culture* (3rd ed.). Essex, England: Pearson Education Limited.

Trend, D. (Ed). (2001). *Reading digital culture*. Malden, MA: Blackwell.

Turkle, S. (2004). from the new reference "How Computers Change the Way We Think" in http://chronicle.com/weekly/v50/i21/21b2601.html

Turkle, S. (2006). *Seeing through computers*. Retrieved from http://prospect.org/print/V8/31/turkle-s.html.

Weedon, C. (1991). *Feminism, theory, and the politics of difference*. Malden, MA: Blackwell.

Weedon, C. (1997). *Feminist practice & post-structural theory* (2nd ed.). Malden,MA: Blackwell.

Women's Educational Media. (1993). *It's elementary: Talking about gay issues in school*. Produced by H. Cohen and D. Chasnoff, San Francisco, CA.

Zinn, H. (2002). *A people's history of the United States: 1492–present*. New York: Perennial Classics.

Zizek, S. (1991). *Looking awry: An introduction to Jacques Lacan through popular culture*. Cambridge, MA: MIT Press.

Zizek, S. (1994) *The metastases of enjoyment: On women and causality*. New York: Verso.

Zizek, S. (1999). *The ticklish subject: The absent centre of political ontology*. New York: Verso.

Zizek, S. (2005). *Iraq: The borrowed kettle*. New York: Verso.

FILMOGRAPHY

Costigan, M., Hausman, M., McMurtry, L., & Pohald, W. (Executive Producers), & Lee, A. (Director). (2005). *Brokeback mountain* [Motion picture]. United States: Focus Features.

Koffler, P. et al. (Executive Producers), & Peirce, K. (Director). (1999). *Boys don't cry* [Motion picture]. USA: Hart-Sharp Entertainment.

Macy, W. H. (Executive Producer), & Tucker, D. (Writer/Director). (2005). *Transamerica* [Motion picture]. USA: Content Film International.

TELEVISION SERIES

Alden, L. et al. (Producers), & Burrows, J. (Director). (1998–2006). *Will and Grace* [Television series]. New York: NBC.

Collins, D. et al. (Executive Producers), & Fockele, J. et al. (Directors). (2003–present). *Queer eye for the straight guy* [Television series]. New York: NBC.

Lassner, A., et al. (Executive Producers), & Dimmich, M., & Goodside, L. (Directors). (2003–present). *Ellen: The Ellen DeGeneres Show* [Television series]. New York: Time Telepictures Television.

Chapter 54

In the Wake of Katrina

Teaching Immigrant Students
Learning English About Race
and Class in the United States

Daniel Walsh

Pictures

Black man,
White people
in New Orleans

Black man steals,
White people find

Racism makes you believe black people steal,
White people find

Pictures make you believe black people steal,
White people find

Media make you believe black people steal,
White people find

I don't think black people steal,
White people find,
Do you?
—Marie Guerriere, 9th grader (1–1/2 years in the United States)

It was November 2005. Hurricane Katrina had pounded the Gulf Coast almost three months earlier, and its receding floodwaters progressively exposed profound fissures and cracks in the U.S. social fabric. Neglected levees broke. Ill-conceived evacuation plans failed. People died in attics. Barbara Bush announced that evacuees living in an athletic stadium never had it so good, "Let them eat cake!" The media represented poor black people as looters and refugees. I had done nothing in my English classroom to address the issue. I felt negligent, collusive, and complicit.

The pangs of negligence accompanied me to a staff development session in which we discussed developing a curriculum within a projects-based approach. I felt very distanced because it seemed as if the required workshop was just another encroachment on valuable time. My mind wandered to the narrative report cards I needed to write, to the piles of papers on my desk that needed attention. I checked myself and began to conceptualize the valuable lessons the wake of Katrina was teaching. With an hour remaining in the workshop and the facilitator requesting that people share curriculum concepts they were contemplating, I publicly announced that I wanted to develop a unit of study in critical media literacy using Hurricane Katrina as a case study for teaching students about race and class in the United States. The math teacher at my school, who was also present at the workshop, expressed interest in developing an interdisciplinary unit on the topic, using charts, graphs, statistics, and other forms of data to further expose the social injustices experienced in New Orleans. I felt invigorated. The pangs began to subside.

My mind immediately turned to the two highly circulated images, the first of which depicted a young white couple with bags of food and a caption read that they had FOUND food. The second image of a young black man read that he had LOOTED. These were also the images upon which my student based the above poem. How could I turn this compelling reality into a meaningful and comprehensible curriculum for my students? My ninth and tenth graders are all recent immigrants, and the pressure to develop their English language skills and pass five New York State Regents exams in order to graduate from high school so as to prevent their further marginalization in our society is enormous. In addition to teaching them about media literacy, I needed to provide opportunities for vocabulary development, extended reading and writing, and familiarization with United States cultural practices. It would take some serious background knowledge building in order for them to understand the city of New Orleans, racism, and classism in the United States, not to mention the subtle semantic differences between the words *loot* and *steal*. Could I pull this off? The pangs returned. I was falling into the teacher-of-immigrant-students (and other marginalized groups) trap. This was too hard. I couldn't do it; they couldn't do it. On the contrary, as mostly poor students of color, of course, they understood racism and classism. Young adults are passionate about issues of fairness and justice. I would have loved to have learned about issues such as these in school; I rarely did. I would want any young person I cared about to learn about issues such as these; they rarely do. Katrina offered the opportunity for intellectually stimulating and rigorous work that I could not bypass: the history of U.S. cities, governmental policies that keep people poor, how race determines health and wealth in the United States, opportunities for students to write about injustices they

have experienced, a chance to address issues in their own communities that could lead to Katrina-like results, a questioning of U.S. military expenditures on an unjust war, and opportunities for students to analyze and challenge how media construct images and determine the way we see others and ourselves.

This last point served as a springboard for the work my students and I would embark on together. On November 21, 2005, as part of an introductory letter to the unit of study, I wrote the following to my classes: "During the next four weeks we will . . . think about

1 our own experiences with natural disasters
2 how poverty and racism influence what happens to people during natural disasters
3 the connections that Hurricane Katrina has to our own communities
4 ways that we can make change."

With these points in mind, we would delve into the following questions:

1 What are natural disasters and how are people affected by them?
2 Who suffers most during a natural disaster and why?
3 What are the goals and motives of media images? How and why do different images represent people differently?
4 How does what happened in New Orleans relate to us living in New York City?
5 How can we cause change?

Because my students hail from five continents and speak fifteen different languages, our polyglot community needed to develop language around natural disasters. After viewing a powerpoint slide show of various natural disasters, we wrote in our journals about a natural disaster that we had experienced. I shared my experiences with Hurricane Gloria in 1985. Using a character analysis web, the students then wrote more specifically about their thoughts, feelings, and actions during the disaster they experienced. Students who did not personally experience a disaster (most had) were asked to think about a disaster they had seen on television or had read about in newspapers. We then discussed the different ways in which people experience natural disasters; issues of class and classism began to emerge. Students interviewed one another about their experiences and what they noticed happened to themselves and others.

To focus more specifically on Hurricane Katrina, my student teacher and I set up five different stations of pictures depicting Katrina's impact on New Orleans in the classroom so that students could participate in a museum walk. Students were asked to respond to the pictures with whatever words, questions, comments, or reactions first came to mind. Some of their one-word responses included: scared, impossible, death, overwhelmed, horrifying, disgusted, guilty. Other reactions were the following: I feel like my heart is turning into pieces; it looks like they live in hell; it's really sad to see the people suffer; and it upsets me to see them by themselves; where is the help? We completed a K-W-L chart together (common teaching strategy that helps teachers assess what their students already KNOW about a topic, what they WANT to know, and what they are LEARNING). Students had clearly developed some knowledge from the pictures and previous exposure to the disaster and were

outraged by the inhumane treatment. They also noticed that the overwhelming majority of people in the pictures were African American; issues of race and racism in America began to emerge.

From the Alliance for a Media Literate America (www.amlainfo.org), we learned that

1 All media are "constructed."
2 People interpret media messages through the lens of their own experiences, so people may experience the same media message differently.
3 In addition to obvious or overt messages, media convey embedded values and points of view.
4 People who make media have specific goals and motives.

With these tenets of media analysis in mind, we revisited the museum station photos and examined newspaper articles for further information. We used the worksheet below to think about the difference between observation and inference, to think about what media photographs teach us about ourselves and others.

Critical Media Literacy: Reading Media Photographs

What do you see? (observations) What does it mean? (inferences)
Nonverbal gestures (arms, hands, fingers)
Facial expressions (heads, eyes, mouth)
People (age, gender, race, ethnicity)
Clothing (type, color)
Background (objects, setting)
Other

As a class, we analyzed a variety of photographs that depicted, for example, evacuees in boats. We paid attention to the categories listed on the worksheet above and asked the following: What did the state of the houses in the background potentially tell us about the evacuees' socioeconomic status? What did the position of people's hands and the looks on their faces tell us about how they were feeling?

We discussed who these people might be, the foreground and background of the photo, the positions of people's hands, the direction of their gazes and what they might be thinking, and the race and class messages we received. We critically read newspaper articles for new information to add to our K-W-L chart. It is important to note at this point that our school does not track students according to ability or English language proficiency; students who have been in the country for five days are in the same classes as those who have been in the country for five years; students who cannot read, and will never be able to read because of a learning disability, are in the same classes with those who read at, or above, grade level after only being in the United States and instructed in English for two years. We returned to the photographs that had inspired me to teach about media literacy and Hurricane Katrina. We used a Venn diagram to compare and contrast media images and captions. Why

have media determined that black people steal and white people find? We then analyzed the newspaper headlines listed below and grouped them according to their political orientation using the following worksheet to better understand conservative, liberal, and radical views about Hurricane Katrina and its subsequent governmental (non-)response:

Headlines:
- Is Bush to Blame for New Orleans Flooding? He did slash funding for levee projects. But the Army Corps of Engineers says Katrina was just too strong.
- Big Easy Bouncing Back
- *New Orleans is Sinking, But . . .* "Hey, Shoot that Black Guy Running Off with the Bottled Water from Wal-Mart!"
- *Blame It on the Looters:* How Bush Deals with a Disaster He Helped Create
- U.S. Agency Updates Relief Efforts for Hurricanes Katrina, Rita: Agency has provided affected households nearly $4.4 billion to help rebuild
- Another Case of Government for Some: The states hardest hit by Katrina are for many African Americans our real home. Once again we are forced to face the fact that to politicians, black life is cheap.

Grouping Newspaper Headlines

Title 1:	*Title 2:*
Group 1:	*Group 2:*
Characteristics:	*Characteristics:*

Students read the headlines above and we grouped them according to those that supported government actions and those that were critical of government actions. We then developed a title for each column and wrote the characteristics of each group of headlines. During this time, students were also analyzing data in their math such as a pie chart that illustrated the fact that 28 percent of New Orleans residents live in poverty and of that number 84 percent are black. Issues of structural inequalities and governmental policies that keep people poor began to emerge.

In addition to the radical news sources that responded to Katrina, I was inspired by hip hop and spoken-word artists who offered a radical critique of the unnatural disaster. Legendary K.O. remixed Kanye West's "Goldigger" into the following:

> *George Bush don't like black people (repeat 3x)*
> *Hurricane came through, fucked us up round here*
> *Government acting like it's bad luck down here*
> (lyricstogeorgebushdoesntcare.htm)

Legendary K.O. expressed the race and class issues associated with Katrina better

than anyone could have. Students begged for more: "Play it again, Mister!" The questions surrounding the lyrics were profound: Why would George Bush have been in Connecticut twice as fast? What does George Bush have to do with the price of gas? Chuck D from Public Enemy wrote "Hell No We Ain't Alright" (excerpted here):

> *Saying whites find food*
> *Prey for the national guard ready to shoot*
> *'Cause them blacks loot*
> (full lyrics available at allhiphop.com)

Suheir Hammad, a Palestinian-born spoken word artist wrote the following two poems (excerpted here) in response to the disaster:

"a prayer band"	"Of Refuge and Language"
who says this is not the america they know?	No peoples ever choose to claim status of
were the black people so many they could not be counted?	No enslaved people ever called themselves slaves
	What do we pledge allegiance to?
	A government that leaves its old
	To die of thirst surrounded by water
	Is a foreign government

Armed with a critical view of the (non-)response to Katrina as portrayed in the media (of course, not all students agreed with me and thought the government did not have control over what happened in the aftermath), I asked the "so what?" question. What does this have to do with us other than the obvious answers of compassion, empathy, and humanity? To answer this question, students first had to identify issues in their own communities that could result in Katrina-like circumstances and then choose one they were passionate about. Students mentioned environmental pollution, drugs, gangs, affordable housing, homelessness, racism, and infrequent and inaccessible transportation. They then had to USE media to alert an audience to the problem they had identified by choosing a project from the following list, thinking about who their audience would be and why this project would be effective in reaching that particular audience.

Critical Media Literacy

Project Descriptions

1 Persuasive letter—Write a persuasive letter to a senator or local politician that describes the problem you have identified and how you think it can be solved.

2 Poem, song, rap—Write a 3-stanza poem or 3-verse song/rap with a chorus that describes the problem you have identified and what should be done about it. You will perform your poem, song, rap for the class.

3 Talk show—Write a script for a 10-minute talk show that includes a host and 2 guests. The host will interview the guest and this is how you will describe the problem you have identified and what should be done about it. You will videotape your show and present it to the class.

4 Propaganda poster with pamphlet—
 a Create a propaganda poster that identifies how your community feels about the problem you identified.
 b Create a trifoliate pamphlet to inform others in your community about the problem and how it could be solved.

5 Picture book for children—Write a fictitious picture book of at least 10 pages that discusses the problem you identified and how you would solve it. Each page will include an illustration and part of the story. You will also include a cover with your story title and an illustration that represents the theme of your book.

6 Photo essay with captions—Take at least 10 pictures of the problem that you have identified, and its solutions, and write a caption for each. Present your photo essay on a poster board.

7 Powerpoint presentation—Develop a Powerpoint presentation with at least 10 slides that describes with charts, graphs, pictures, and words the problem you have identified and its possible solutions.

In addition to completing one of the above projects, students also had to write an essay expressing their point of view regarding the governmental (non-)response. They used a five-paragraph essay planner to assist with the process. The first paragraph stated their opinion about the response, whether they believed the disaster and its aftermath were natural or unnatural, preventable or unavoidable, or, perhaps they had mixed feelings about the topic. The three subsequent paragraphs provided evidence for their opinion and the final paragraph summarized and concluded their argument.

Finally, students had to research community organizations that dealt with the problem they identified. They used the worksheet on the following page to guide them in their research.

After finding appropriate organizations, selecting one whose mission and programs the students liked and supported, and describing the programs the organization offered, the students had to design a program that they thought the organization lacked and that they, if employed by the organization, would implement. Students found organizations like Homies Unidos, a group of former gang members who educate youths about gangs and provide services such as gang-affiliated tattoo removal.

For weeks after they listened to "George Bush Don't Like Black People," my students could be heard rapping, "Five damn days, five long days" in the hall as we looked at each other and smiled. I felt I had equipped them with some skills and knowledge to challenge

media and their accompanying images and to then narrate counter-stories and paint counter-images to those that would have us believe that black people loot and white people find and that the poor are to blame for their circumstances. As reports of government approval of the razing of housing projects, rising rent prices, and people struggling over the right to return continue to pour out of New Orleans, I have a feeling that Legendary K.O. and Suheir Hammad will re-enter their minds as they strive to make sense of the thousands of images with which they are bombarded.

Find Web sites of community organizations (groups) that deal with your problem. For example, if searching for organizations that deal with gangs, try "Brooklyn gangs community organizations," or if working on environmental issues, try "Bedford-Stuyvesant community organizations environment. Write the Web sites and organizations that you found here.

a

b

c

Choose one organization that really addresses your community issue and whose work you like and support.

The organization I chose is _____.

Write what your organization does to help with the problem you identified in your community. What does it do? What programs does it offer?
a. This community organization does the following:

1

2

3

You now know about an organization that addresses the problem in your community. Design, create, invent a program that you would like to work on with this organization in your community.

Give the program a name: _____.

What will the program do?

The program that I want to design with the community organization I have chosen will

_____.

The author is indebted to the New York Collective of Radical Educators (NYCoRE) for the development the Hurricane Katrina Resource Guide and to Ming Chan, student teacher from CUNY Hunter College, for her dedication and assistance during this unit of study.

Advertising Pedagogy

Teaching and Learning Consumption

Michael Hoechsmann

Historians of the future will not have to rely on the meagre collections of museums . . . to reconstruct a faithful picture of 1926. Day by day a picture of our time is recorded completely and vividly in the advertising in American newspapers and magazines.
—N.W. Ayer & Son [advertising agency], 1926 (quoted in Marchand, 1985, p. xv)

One of the most significant legacies of the past one hundred years has been the ever-increasing centrality of consumption to everyday life. The development of advertising over this period as a profound pedagogical site has helped to elevate consumption to a primary role in defining our social selves. To track the development of advertising over this century is to confront an alternative genealogy in the historical transformation of culturally significant narratives in the global North. The alternative genealogy that I am proposing demonstrates the manner in which the "pedagogy" of advertising can be seen to be in competition with the pedagogy of the school in the socialization, acculturation, and self- and group-identity formation of young people today.

Despite minor differences between and within the nations of the global North, it can be argued that the historical emergence of mass compulsory schooling and advertising occurred virtually simultaneously in the last decades of the nineteenth century. While writers such as Ivan Illich (1970) argue that the school adopted many of the socializing and acculturating roles formerly performed by the Church, and while writers such as Leiss, Kline, and Jhally point out that advertising began "to assume the tasks of instructing individuals how to match their needs and wants with the existing stock of goods and consumption styles" (1990, p. 65), little attention has been paid to these two sites as dialectical counterparts. Whether as citizens or as consumers, young people in the global North have been simultaneously hailed by the pedagogies of mass schooling and the mass media since the late nineteenth century. My intention in this chapter is to examine the emergence of advertising as a pedagogical discourse, while keeping in focus developments in educational discourse over the same period.

The notion that consumption is pedagogical may fly in the face of much educational discourse. The etymology of pedagogy reveals that the term "refers to the science of teaching children," and in common parlance it "is used interchangeably with 'teaching' and 'instruction' referring, with various degrees of specificity, to the act or process of teaching" (Gore, 1993, p. 3). It is a widely held commonplace of educational discourse that pedagogy corresponds to the "how" of teaching and that curriculum corresponds to "what" should be taught. Thus, pedagogy and curriculum tend to refer to elements of a teacher-student relationship. Even critical interventions into educational discourse, those interventions that can be included under the term "critical pedagogy," tend to locate these concepts under the rubric of teacher-student interaction. However, the discourse of critical pedagogy has issued a challenge to more static notions of curriculum and pedagogy. For one, critical pedagogy integrates questions of curriculum directly into questions of instruction. Both Jennifer Gore (1993) and Henry Giroux and Roger Simon (1989) cite David Lusted to make this point: "How one teaches . . . becomes inseparable from what is being taught and, crucially, how one learns" (Gore, 1993, p. 4; Giroux & Simon, 1989, p. 222). Further, critical pedagogy invests in its educational practice some notion of a project for social and political change, whether it be, for example, "critical consciousness" (Freire, 1973), "possibility" (Simon, 1992) or "critical citizenship" (Schwoch, White, & Reilly, 1992).

The pioneering work of Paulo Freire has been central to the development of critical pedagogy. For the purposes of this chapter, I want to draw on two elements of Freire's pedagogy. First, is the assertion that one learns to read the world before one learns to read the word (Freire & Macedo, 1987). Thus, much learning, in fact the base, or initial scaffold, of learning takes place outside of the structures and technologies of traditional schooling. Second, Freire insists that for pedagogy to be effective, it must derive its goals from the experiences and concerns of the learners. These precepts of Freire's pedagogy are grounded in a conception of popular culture which, according to Giroux and Simon, "represents a significant pedagogical site that raises important questions about the relevance of everyday life, student voice, and the investments of meaning and pleasure that structure and anchor the why and how of learning" (p. 221). Schwoch, White, and Reilly agree, "media culture

[is] a highly important—and vaguely understood—site of pedagogy" (1992, p. ix). With these authors, I would like to argue in favor of taking the texts of popular culture—and their reception—seriously as pedagogical sites. My inquiry, however, will focus much more closely on one particular aspect of popular culture, the role of consumption in contemporary everyday life.

By narrowing my inquiry of the pedagogy of popular culture to the consumption imperative inherent in the massified products of the cultural industries, what Paul Smith (1989) has termed the "popular-cultural-commodity-text," I will attempt to advance the process of taking popular culture seriously as a pedagogical force by highlighting a specific problematic that, as yet, has hardly been discussed. Popular culture may be a broad discursive arena that encompasses traditions, practices, and forms of knowledge that circulate outside of, as well as within, circuits of power relations, but in the late twentieth century when the majority of "cultural objects, cultural texts, are . . . commodities which will attempt to situate the subject in some preferred relation to them" (Smith, 1989, p. 33), it is of vital importance to try to come to terms with the cultural impact of consumption. A pedagogical project, which does not recognize that "the struggle over identity can no longer be seriously considered outside the politics of representation and the new formations of consumption" (Giroux, 1994, p. 22), fails to confront one of the most important cultural changes of our time.

Advertising Pedagogy

The developments that occurred in Paris in the late nineteenth century are representative of the growth of a culture of consumption in the nations of the global North. In North America, the transformations to the city, which mirrored similar changes in Paris—the development of city centers, the growth of mass transportation, the emergence of large department stores— took place, first in major cities such as New York and Chicago, but eventually in cities continent-wide. An American writer of the time, Simon Patten, remarked in his *The New Basis of Civilization* (1907) that society should embrace consumption rather than the renunciation of desire (Leiss, Kline, & Jhally, 1990, p. 57). The emergence of advertising in this period, both as a cultural production but also as institutional consolidation of changes which were emergent in the culture at large, furthered the trend toward consumption as a whole way of life. As Leiss, Kline, and Jhally state, a whole new cultural fabric was consolidated at this time:

> New forms of popular entertainment, new vehicles of mass communication, and new consumer products of immense popularity were being stitched together to form a new popular culture, a rich and coherent network of symbolic representations and behavioural cues, to replace the old cultures fading away. (p. 89)

Advertisers emerged as the organic intellectuals of the new "culture of consumption," promoters not only of products but of new ways of life for individuals and groups bewildered by the rapid nature of cultural, social, political, and economic change. In other words, adver-

tisers began to play a mediating role between communities and their social environment, a role traditionally played by priests as well as teachers.

A signal example of the new cultural trend was the marketing of Quaker Oats, a humble product, which even in 1882 was hardly known as a breakfast food. At the instigation of Henry Crowell, oats were packaged in two-pound packages decorated with the Quaker, who was registered as a trademark. Richard Ohmann points out that in packaging and streamlining his product, Crowell was simply recognizing the changing nature of production. The American home, which was no longer the hub of production and in the new urban contexts was too small for bulk storage, was "ready for Crowell's idea":

> He did not so much create a need . . . as show housewives how a generalized and very historical need—itself created by the new factory production that Quaker Oats instanced—might be narrowed and met through the purchase and use of a particular kind of commodity. (1989, p. 111)

Specifically, by creating the first "fast food," Crowell initiated a trend toward the increased commodification of elements of social life, in this case the basic foodstuffs necessary for social reproduction. This novel concept, in turn, helped to facilitate the conditions for the emergence of advertising. "The standardization of weights and measures," according to Susan Willis, "represents a rationalization of sales similar to the Taylorization of production" (1991, p. 1). Packaged in a sleek commodity form, which "hails the consumer," this development provided producers with "greater control over consumption and a more systematic means of exploiting the consumer through advertising" (p. 2).

By 1890, Crowell was running a national ad campaign in the United States with images of the Quaker placed on billboards, streetcars, newspapers, and so on. In 1894, Crowell "turned to a new kind of institution . . . an advertising agency" (Ohmann, 1989, p. 112). The Paul E. Derrick agency began to run the ads in magazines, which had only just dropped their purchase price and had recognized advertising income as an alternate method of commercial viability. Ohmann argues that "what [the magazines] came to sell, like radio and television later on, was us—or more precisely, our attention." This, states Ohmann, was "a development of world-historical importance: the invention of the mind industry or, more commonly, of mass culture" (p. 113). The emergent discourse of advertising focused attention away from the producers, and even from the products themselves, to broader individual and social concerns.

Ohmann suggests that by 1895, when Quaker Oats ads appeared in magazines, people "had acquired a new kind of literacy" (p. 115). It is important to keep in mind that, as a new "literacy" arises, commonly held assumptions, the combination of which inform the popular ethos of an era, are gradually reconfigured to match the new epistemological conditions. Michael Clanchy has shown this in his historical record of the very reluctant adoption of print literacy in England, when commonly held assumptions of the body and of property were eventually transformed in the wake of new epistemological conditions (1979). What emerged with print literacy, argues Ivan Illich, is "a distinct mode of perception in which the book has become the decisive metaphor through which we conceive of the self and its place" (1987, p. 9). With early photographers and cinematographers, advertisers were part of the 'visual turn' in the transmission of cultural values in western culture,

borrowing from, and extending, the use of a visual iconography from the church. The cultural implications of this new discursive condition were far-reaching. As Roland Marchand argues, advertising "contributed to the shaping of a 'community of discourse,' an integrative common language shared by an otherwise diverse audience" (1985, p. xx).

Advertising drew liberally from prevailing discursive conventions, fashioning them into its own new language. This language, according to Marchand, was a "language of urbanity." States Marchand:

> To learn it, just as to learn the language of another national culture, was to experience a transformation—to acquire new perspectives, accept new assumptions, and undergo an initiation into new modes of thinking. Although advertising, like cinema, may not qualify as a language in the sense of possessing discoverable rules of grammar and a consistent syntax . . . still it established and disseminated a vocabulary of visual images and verbal patterns that acculturated people into life on a complex urban scale. (p. 335)

Thus, by fashioning a prominent public discourse in this period of tumultuous change, a discourse which recognized the multimodal nature of human communication, early advertisers positioned themselves as a significant source of moral and intellectual instruction. The emergent multimodal discourse of advertising—which drew from elements of oral, literate, and visual discourse—was attentive to the cultural needs of people who were undergoing dramatic social and economic change. If the Church had long played the role of mediating people's relation to everyday life, in providing the moral and intellectual instruction of everyday life, mass compulsory education was instituted to fill this void in the newly industrialized North. The success of advertising converges with the public school's inability to fill this void alone. Where schools held young people captive, training many into blind obedience and mindless vocationalism while only reproducing the cultural capital of those socialized into privilege, advertising captivated the imaginations of young people across class differences. Advertising was able to respond to the needs and desires of a much broader demographic, offering up feel-good aphorisms and promises of material fulfilment to a population affected by the bewildering pace of social and technological change.

As Sut Jhally argues, if advertising "can 'satisfy' us [and] 'justify' our choices," how does this differ from religion? Like religion, advertising fetishizes objects and ascribes to them the power to integrate "people and things into a magical and supernatural sphere" (1989, p. 225). Further, like religion, advertising is "not, in and of itself, a total spiritual belief system but rather a part of a much larger one" (p. 227). In particular, advertising is a cultural expression of capitalism, what Michael Schudson labels the "capitalist realism" art form (1984, p. 214), which in its inception helped to promote the broad acceptance of technology, as one of the cultural conditions of modernity. States Jhally: "Rather than the spirits of nature invading the body of objects (as in older fetishistic belief systems), in the mythical universe of advertising it is the spirits of technology that invade the body of the commodity and supply the basis for a belief in its power." (1989, p. 229)

While advertising appears to draw on and extend popular experiences of religion to present its message, it is, however, not a closed semantic system. Rather, like the school, it is an evolving site of didactic instruction, adapting to new developments and circum-

stances of cultural and social change.

A Pedagogy of Consumption

Early advertisers recognized their role as popular educators. By the 1920s, the profession blossomed, and the sense of its historical project had grown infectious. Writing in 1924, Edward Filene dramatizes the pedagogical role of advertisers, arguing that they must take a primary role in educating the broad masses, for whom thrift had not been a choice but a necessity, to the dictates of mass consumption. States Filene:

> . . . modern workmen have learned their habits of consumption and their habits of spending (thrift) in the school of fatigue, in a time when high prices and relatively low wages have made it necessary to spend all their energies of the body and mind in providing food, clothing and shelter. We have no right to be overcritical of the way they spend a new freedom or a new prosperity until they have had as long a training in the school of freedom. (quoted in Ewen, 1976, pp. 29–30)

For Filene, this pedagogical function was necessary to educate "the masses" to a "mass production world" (p. 54) and should unite "all our education institutions [to the] great social task of teaching the masses not what to think but how to think" (p. 55). Advertisers, according to Filene, could be leading-edge proponents of a new educational mission, modelling appropriate pedagogy for a culture in transition.

Stuart Ewen and Roland Marchand have carefully chronicled this period in the history of advertising and the "educational turn" that took place. For Ewen, these new 'organic intellectuals' of the changing world were the "captains of consciousness," the ideological side-kicks of the captains of industry who set out to eradicate "indigenous cultural expression and [to elevate] the consumer marketplace to the realm of an encompassing 'Truth'" (1976, p. 67). Ewen stresses that with the growth of consumer demand among workers and the struggle for greater compensation for their labor, the intellectuals of emergent consumerism argued that with a proper education "the aspirations of labor would be profitably coordinated with the aspirations of capital" (p. 28). If workers could learn to channel their goals into consumer desire, not into the control and ownership of the means of production, the captains of industry could count on a compliant workforce and a stable market for their goods. In this way, the needs of industry and the everyday needs of workers coalesced in a way which, despite some ups and downs, has only begun to unravel fifty years later in the post-Fordist era.

Ewen demonstrates how Filene's concept of a "school of freedom" came to play a hegemonic role. "Within governmental and business rhetoric," states Ewen, "consumption assumed an ideological veil of nationalism and democratic lingo" (p. 42). The "freedom" and American "feel-good" patriotism in American popular culture associated with the use of the automobile, for example, "Mom, apple-pie and Chevrolet," speaks volumes to the success of this ideological endeavour. In fact, by adopting "the double purpose of sales and 'civilization,' "advertisements attempted to transform "pockets of resistance" (p. 43) within the population, which was still coming to terms with industrialization and modernization.

A "democratic" mass market for goods, where even those who could not afford goods could at least gaze upon them, had already been established, and now it was the role of advertisers to model new identities for people to emulate and to depoliticize any resistance to it. Thus, advertising offered "a commodity self" (p. 47), and attempted to transform "the notion of 'class' into 'mass' . . . to create an 'individual' who could locate his [sic] needs and frustrations in terms of the consumption of goods rather than the quality and content of his life (work)" (p. 43). As such, advertising set out in the 1920s to play a role, which had long been played by the church and was only recently being played by the public school.

Ewen presents a strong case for understanding the early twentieth-century infiltration of everyday life in the United States by private interests as a deliberate strategy of corporate growth. Fordism, as epitomized by the "line production system" of Henry Ford, depended on the growth of consumer markets for corporate survival. As this analysis demonstrates, moreover, the development of a "culture of consumption"—a popular ethos which embraces the coveting of things, rather than the valorization of self and community— was recognized as an important legitimizing element of the new relations of production. Thus, in the 1920s, we are confronted with another watershed in the historical development of consumption. States Ewen:

> Consumerism, the mass participation in the values of the mass-industrial market, thus emerged in the 1920s not as a smooth progression from earlier and less 'developed' patterns of consumption, but rather as an aggressive device of corporate survival. (p. 54)

What emerges in this period, then, is the active role of private interests in the hegemonic processes of legitimation. As Ewen argues, "more and more, the language of business expressed the imperative of social and ideological hegemony" (p. 52). Thus, what we see here is the consolidation of the "pedagogy of consumption," a social and moral instruction in the workings of culture, which turns on a commoditized vision of self- and group-identity.

Marchand describes advertisers in less authoritarian terms than Ewen, naming them the "missionaries of modernity" who "championed the new against the old, the modern against the old-fashioned" (1985, p. xxi), and who "accepted a therapeutic role in helping Americans adapt to new social and technological complexities" (p. xxii). These metaphors of advertisers as missionaries and therapists, instructive figures who provide people with social and moral visions and assuage the anxieties that develop in a period of profound social change, are consistent with, or at least overlapping with, the role of the teacher. Similarly, borrowing another metaphor from Marchand consistent with the role of the teacher, advertisers assumed "the role of coach and confidante [and] offered the consumer advice and encouragement as together they faced the external challenge" (p. 13). These "missionaries of modernity" would "console, befriend, and reassure the public as well as stimulate and guide it" (p. 336). Summing up the broad, guiding role of the business interests, which lurk behind the advertising text, Ewen states that at this time, "corporate America had begun to define itself as the father of us all" (1976, p. 184).

In advertising, this father-figure could show his gentle side in contrast to his authoritarian, disciplinary side which showed up in the newly Taylorized workplaces of this

period, and in schools which, despite the growing influence of progressive educational theories, were still strict in regard to physical discipline and behavioral management. The difference between the pedagogy of advertising and the pedagogy of a traditional instructional institution like the church, and a modern instructional institution like the school, was the focus on immediate gratification and pleasure, rather than deferred gratification and discipline. Marchand explains this somewhat ironic turn in the development in western culture:

> Inescapably, they [advertisers] seemed confronted by the paradox of modernization: the forging of the final link in an efficient, rationalized system of mass production—its stabilization through the creation of predictable, expanding consumer demand—now required the nurture of qualities like wastefulness, self-indulgence, and artificial obsolescence, which directly negated or undermined the values of efficiency and the work ethic on which the system was based. (1985, p. 158)

This contradiction remains embedded in the fundamental differences between advertising pedagogy and school pedagogy, though educators have long played catch-up in terms of pedagogical reforms, which have tried to code learning tasks in terms of fun and pleasure.

Marchand cautions that most advertisers of the time, and the corporate captains they represented, were contemptuous of the very message they were spreading. For example, Henry Ford, who "has sometimes been characterized as the epitome of the shift from the self-absorbed, production-minded entrepreneur to the consumer-oriented, distribution-minded businessman . . . also personified the resistance of many businessmen to the luxury-minded softness of the consumption ethic" (p. 156). Advertisers too "shared the producers' almost ascetic contempt for the weak-willed, dependent consumer" (p. 158). One tactic used by advertisers was to condemn "drudgery," but not to speak "an ill word against 'work'" (p. 159). This contradiction at the heart of the advertising message speaks to the gradual nature of cultural change, even in the face of radical and ruptural social and economic transformations.

As social roles came up for redefinition, both as a result of the broader social and economic changes underlying the culture of consumption and from the pedagogy of advertisers, early advertisers contested family roles. Thus, another tactic used by advertisers, which was consistent with the notion of corporate America "as the father of us all" and the cultural traditions associated with patriarchy, was to 'feminize' the audience. Marchand argues "advertisers of the 1920s became increasingly committed to a view of 'consumer citizens' as an emotional, feminized mass, characterized by mental lethargy, bad taste, and ignorance" (p. 69). This was congruent with the needs of capital to transfer household power away from the traditional patriarch, who had dominated the production-centered household, to women who were now seen as the modern heads of the household, at least with regard to the disposal of the household income. As Ewen points out, "as factory production had made work an integer within a vastly defined network of processes, the agencies of consumption made the wife a part of corporately defined productive and distributive process" (1976, p. 165). Ewen captures the paradox of the "the modern housewife":

> In the middle of her mechanically engineered kitchen, the modern housewife was expected to be overcome with the issue of whether her "self," her body, her personality were viable in the socio-

sexual market that defined her job. (p. 179)

Thus, women were to usurp some of the traditional power of men, while still encouraged to uphold the "imperative of beauty" (p. 178) to help them keep their husbands.

Ironically, the interpellation of women as the heads of households, even if it only allowed for very limited social power, coalesced neatly with "the feminist demand for equality and freedom [which] was appropriated into the jargon of consumerism" (p. 160). The broadened role for women as heads of the household in this new productive order required her to also redefine "her role as moral educator and socializer [now] adapted to the consumption process" (p. 172). Women, in this new consumptive order, were thus positioned as surrogate educators of the culture of consumption. Given their new role as the domestic ambassadors of the culture of consumption, it is no wonder that the schooling of young women would involve extensive training in home economics. Trained in household sciences, young women were positioned to receive the pedagogies of both advertisers and educators and to manage the modern household.

Young men, too, fell under the scrutiny of the advertiser's gaze. Just as the line-production model valued the strong, compliant young worker, and the wisdom of age was becoming devalued, "youth flourished . . . as a symbolic representation of cultural change" (p. 145) in the sphere of consumption. As both young women and young men came to bring consumer demands into the home and began to make up an important market share themselves, they became "a powerful tool in the ideological framework of business" (p. 139). Ewen argues that the education of youth into the culture of consumption and the "symbolic ascendancy of youth, represents the corporate infiltration of daily life" (p. 146). As the inheritors of a cultural moment, as an innovating force in a period of cultural change, youth were of signal importance to the corporate future. In fact, by the 1950s baby boom period, youth would be firmly centered in the advertising text, both as a primary market and as a set of idealized representations of the fresh face of consumer capitalism.

Advertisers did not confine their pedagogy of consumption to the public sphere but sought to make inroads into public schools. Writing in 1928, the economist Paul Nystrom argued for the importance of education to the growth of consumption. Stated Nystrom: "A democratic system of education . . . is one of the surest ways of creating and greatly extending markets for goods of all kinds and especially those goods in which fashion may play a part" (quoted in Ewen, 1976, p. 90). Schools took an active role in consumer education, fashioning early corporate partnerships with industry. For instance, Ewen reports that some schools instituted "toothbrush drills" at the behest of toothbrush companies, and that science students studied cocoa production "dramatized by models provided conspicuously by the leading producers of cocoa" (1976, p. 90). Michael Schudson points out that consumer education is even more deeply embedded in schools "as part of standard academic curricula." To cite two examples, in social studies, students learn in which countries the products they see on store shelves are produced, and in math they learn how many apples they can buy for a dollar, students "learn not only arithmetic but also the elements of unit pricing" (1984, p. 104). Students may also learn about, and develop brand-loyalty to, products that the schools employ. Schudson argues that "other agencies are engaged in formal

consumer education—government agencies (consumer bulletins), doctors' offices, banks, media, how-to books, travel guides, etc." (p. 105). That some form of consumer education is necessary in a culture of consumption is certain; it is important to recognize, nonetheless, how imbricated the pedagogy of consumption is in the institutions and practices of everyday life.

Michael Schudson cautions that advertising and advertisers not be reified as the creators of the culture of consumption. Schudson argues that it is "difficult to argue that advertising is a prime mover in creating a culture of consumption," though he concedes that "its general role is shaping consciousness and providing a framework for feeling" (p. 43). Advertisers are not just pedagogues, but learners, dependent on "learning the expressed or elicited needs and desires of consumers with disposable income for commercially viable products" (p. 31). Their science is not an exact one, as it has been found that "there was a closer correlation between consumption in a given quarter and advertising in the next quarter than between consumption in the given quarter and advertising in the previous quarter" (p. 17). To properly analyze the place of advertising in the culture and pedagogy of consumption, it is important to distinguish between its various roles:

> . . . advertising as an institution that plays a role in the marketing of consumer goods, advertising as an industry that manufactures the cultural products called advertisements and commercials, and advertising as an omnipresent system of symbols, a pervasive and bald propaganda of consumer culture. (p. 5)

To continue to develop the parallels between advertising and schooling, they are both institutions with an instructive role in that they both create particular instructional texts—whether in the form of curricula or advertisements—they both constitute omnipresent system[s] of symbols and they both play a role in shaping consciousness and providing a framework for thought and feeling. Though their ends and means differ significantly, they are the dominant sources of really useful knowledge and values education in the modern industrialized North.

No Free Lunch: Broadcasting Consumption

While the spectacular growth of the cultural significance of advertising in the 1920s presents an important watershed in the development of a culture of consumption, the development of new media technologies in the ensuing period helped to situate this pedagogical vehicle of the consumptive ethos into public life. The emergence of the cinema at the turn of the century forever changed the nature of the intergenerational transmission of knowledge, fixing the attention of the new cinema-going publics on the silver screen. Early cinematographers such as D. W. Griffiths, whose *The Birth of a Nation* (1915) has the dubious distinction in the United States for resurrecting the Ku Klux Klan (Wyver, 1989, p. 32), were able to stage dramas of a scale unheard of in theater, to command an audience much greater than could literature, and hence to infiltrate the popular imaginary like never before. Cinema was developed as a commercial medium, but its commercial success was

determined primarily at the box office. It was in radio, however, that the culture of con-
sumption found its new messenger, a medium that could spread the words of advertisers to
great numbers of people.

Radio came into its own in the 1920s. In the United States, the Radio Corporation
of America (RCA), which eventually counted among its corporate partners prominent firms
such as General Electric, Westinghouse, AT&T, and United Fruit, was incorporated in 1919.
The first radio experiment in advertising occurred in 1922, when AT&T initiated what
they called "toll broadcasting" with a talk about make-up by the actress Marion Davies paid
for by a cosmetic company (Wyver, 1989, p. 57). The National Broadcasting Company
(NBC) was established in 1925 and, by 1927, was operating two networks received in an
estimated 5 million homes (p. 58). As would be the case with the introduction of televi-
sion, radio was established at the heart of the domestic sphere: "radio manufacturers
worked with the producers of other consumer goods to create an idealised image of the mod-
ern home, and marketing campaigns fixed radio in a domestic setting" (p. 58). In 1927,
the U.S. federal government pronounced the Radio Act which would regulate the subse-
quent development of radio in that country. Eric Barnouw comments: "The industry had
now arrived at a structure that would hold for years; a nationwide system based on adver-
tising . . ." (quoted in Wyver, 1989, p. 58). Advertisers and programmers worked closely
together, "finding ways to work the hosts and themes into the product commentaries and
programme orientation" (Kline, 1993, p. 28), making this a commercial medium par
excellence. Not until the TV scandals of the 1950s, would this intimate relation between
advertiser and programmer be displaced by "spot advertising . . . a more arms-length rela-
tionship between the advertiser and the networks" (p. 28). The boundaries between
advertising and programming have not proven immutable. Arguably, there is even a ten-
dency today toward the opposite, for example, with the development of "product place-
ments" in television and cinema, the rise of infomercials, corporate financed news clips,
and the deregulation of children's television. Perhaps the best single phenomenon of the
new seamlessness between advertising and programming, and one that pertains to the focus
on youth, is the emergence of the global satellite network of MTV (and local offspring such
as Much Music) where the programming consists of advertisements for CDs and concerts,
which are interspersed with the usual range of youth niche market advertisements.

Most significant in the consolidation of the pedagogy of consumption at the center of
everyday life in North America is the eventual introduction of the television, a beacon of
corporate power, and the advertising text, which came to usurp radio for the central posi-
tion in the domestic sphere. The television was first introduced to a broad public at the
1939 World's Fair in New York (and exhibited the same year at the CNE in Toronto).
Though its introduction into the mass market was delayed by the exigencies of WWII, tel-
evision made a meteoric entrance into North American social life shortly after the war. It
is beyond the scope of this study to discuss the history of the introduction of television in
a detailed manner, but some comments on this significant chapter in the development of
the pedagogy of consumption are necessary.

From the outset, television was a commercial medium. Early stars of television were

both entertainers and hucksters, hawking the products of their commercial sponsors directly in their programs or in commercial spots contiguous with the flow of their programs. As Dallas Smythe points out, there was no "free lunch" on network television; rather the programming formed the backdrop to the serious business of television, namely selling "audience power" to corporate advertisers (1981). Stephen Kline asserts that "the cumulative weight of forty years of market-driven experimentation with programming has demonstrated that increasingly business interests, not cultural and artistic considerations, are this medium's main priority" (1993, p. 23). Even so, there are some exceptions to this rule, at least historically, in the formation of public broadcasters such as the British Broadcasting Corporation or the Canadian Broadcasting Corporation and the strict regulation of advertising in many European nations. Of course, the broader commercial nature of the medium has made it increasingly difficult for these exceptions to continue. The early introduction of A.C. Nielson's audience "ratings" in 1950 bears this out (Jeffrey & Shaul, 1995, p. 21). Audience ratings allowed television programmers to determine costs of advertising spots, depending on the numbers of viewers, and to assess the commercial viability of particular programs. In his assessment of the relationship of advertising to programming, Herbert Marcuse argued that if a television program was more spectacular than the advertisements between which it was inserted, then it too would have to be eliminated (1968). In other words, a careful balance was struck between cultivating audience numbers while letting the advertisements stand out as the dominant subtext.

In order to assess the depth of the cultural impact of television on North American life, Lynn Spigel has studied the changing nature of the domestic sphere in the 1950s and the role of television in these transformations (1988). She demonstrates that the development of suburban life was intimately connected to the broader introduction of television. Television was promoted as a surrogate form of community, a community of disparate viewers located across an enormous geographical expanse, united by their participation in various taste cultures. Television would not only replace the informal networks of sociability available in urban neighborhoods, but would become the focal point for the social interactions of family life. The design of suburban homes was predicated on the new domestic centrality of the television set and viewers were presented with vast amounts of advice on how to arrange their furniture and their lives to "make room" for this new commercial medium in their homes.

From their experience in radio, advertisers and television promoters were aware that children would become central to their mission. Already in 1947, the first children's program, "Howdy Doody," was introduced to the airwaves. This was followed soon after with a proliferation of spin-off products aimed at kids:

> Television sold goods, and marketed itself. A profusion of dolls, toys, games, comics, lunch pails, and TV books froze the memories of childhood into consumable objects of nostalgia, beginning with Hopalong Cassidy, the first television-driven mass marketing phenomenon. (Jeffrey & Shaul, 1995, p. 23)

The pedagogical implications of the nexus of television and consumption are tremendous. If, as it has been asserted, "by graduation from high school the average child will have spent over 20,000 hours watching television and only 11,000 in the classroom [and] a child will be exposed each year to 18,000–21,000 commercial messages" (Kline, 1993, p. 17), then the pedagogy of consumption is on solid footing indeed. The tension between school learning, a traditional pedagogy of discipline and work, and media learning, the emergent pedagogy of pleasure and play, has not been lost on either educators or advertisers. However, while educators are more constrained by the weight of tradition, advertisers have consistently excelled in studying, and responding to, the youthful audience of their pedagogy. States Stephen Kline:

> The merchants and marketers of children's goods have always paid more diligent attention than educationists to children's active imaginations and incidental cultural interests. These researchers don't bother to observe comatose children in the classroom being battered with literacy; they study them at play, at home watching television or in groups on the street and in shops. (1993, p. 18)

While Kline may be seen to belittle significant research within educational circles on the nature of children's imagination and learning, his conclusions with regard to taking popular culture seriously is nonetheless significant. If the artifacts of popular culture that are visible in schools, such as lunch boxes, t-shirts, and baseball caps, are viewed by teachers as a mere irritant, a reminder of the crass commercial culture outside the classroom, and not as the tip of the iceberg of a significant pedagogical text which young people experience in their everyday lives, then educators will cede an enormous realm of experience to the exigencies and whims of marketers.

Teaching and learning, the two primary cultural practices that have been institutionalized in the modern public school, take place in a number of ways in a number of settings, both formal and informal. The subject of learning, as construed in the project of modern schooling is constant; youth between the ages of six and eighteen are required to attend, and to participate in the formal educational activities of schools. The subjects of teaching, however, are diverse. A broader pedagogical project must take into consideration the role of parents, community, nation, churches, media, and peer groups, among other influences, in the education of youth. Within this broader context, the pedagogy of consumption takes place in formal and informal ways. The informal pedagogy of consumption takes place across the full range of pedagogical sites, including the modern public school. In our culture of consumption, the pedagogy of consumption occurs every day in every context, whether in subtle or overt ways. Even in its absence, for example, in the use of school uniforms, consumption is present (in this case, in gossip about what a so-and-so was seen wearing the night before). Conversely, the formal pedagogy of consumption, i.e., the instructional enterprise institutionalized in the advertising industry, takes place in very particular, but ubiquitous, sites. The lessons which are taught in the pedagogy of consumption, in both its formal and informal manifestations, play a significant role in the education of youth and we educators must seize the opportunity and necessity to take them seriously.

REFERENCES

Clanchy, M. (1979). *From memory to written record*. London: Edward Arnold.

Ewen, S. (1976). *Captains of consciousness: Advertising and the social roots of the consumer culture*. New York: McGraw-Hill.

Freire, P. (1973). *Education for critical consciousness*. New York: Seabury Press.

Freire, P., & Macedo, D. (1987). *Literacy: Reading the word and the world*. South Hadley, MA: Bergin & Garvey.

Giroux, H. (1994). *Disturbing pleasures: Learning popular culture*. New York: Routledge.

Giroux, H., & Simon, R. (Eds.). (1989). *Popular culture, schooling & everyday life*. Granby, MA: Bergin & Garvey.

Gore, J. (1993). *The struggle for pedagogies*. New York: Routledge.

Illich, I. (1970). *Deschooling society*. New York: Harper & Row.

Illich, I. (1987). A plea for research on lay literacy. *Interchange*, 18, 9–22.

Jeffrey, L & Shaul, S. (Eds.), (1995) *Watching TV: Historic televisions and memorabilia from the MZTV Museum*. Toronto: Royal Ontario Museum.

Jhally, S. (1989). Advertising as religion: The dialectic of technology and magic. In I. Angus & S. Jhally (Eds.), *Cultural politics in contemporary America* (pp. 217–229). New York: Routledge.

Kline, S. (1993). *Out of the garden: Toys and children's culture in the age of tv marketing*. Toronto: Garamond.

Leiss, W., Kline, S., & Jhally, S. (1990). *Social communication in advertising: Persons, products and images of well-being*. Scarborough, ON: Nelson Canada.

Marchand, R. (1985). *Advertising the American dream*. Berkeley: University of California Press.

Marcuse, H. (1969). Repressive tolerance. In R. Wolfe, B. Moore, & H. Marcuse (Eds.), *A critique of pure tolerance* (pp. 81–123) Boston: Beacon Press.

Ohmann, R. (1989). History and literary history: The case of mass culture. In P. Hernadi (Ed.), *The rhetoric of interpretation and the interpretation of rhetoric* (pp. 105–124). Durham, NC: Duke University Press.

Patten, S. (1907). *The new basis of civilization*. New York: Macmillan.

Schudson, M. (1984). *Advertising: The uneasy persuasion*. New York: Basic Books.

Schwoch, J., White, M., & S. Reilly. (1992). *Media knowledge: Readings in popular culture, pedagogy and critical citizenship*. Albany: State University of New York Press.

Simon, R. (1992). *Teaching against the grain*. Westport, CT: Bergin & Garvey.

Smith, P. (1989). Pedagogy and the popular-cultural-commodity-text. In H. Giroux & R. Simon (Eds.), *Popular culture, schooling and everyday life* (pp. 31–46). Granby, MA: Bergin & Garvey.

Smythe, D. (1981). *Dependency road*. Norwood, NJ: Ablex.

Spigel, L. (1988). Installing the television set: Popular discourses on television and domestic space, 1948–1955. *Camera Obscura*, 16, 11–46.

Willis, S. (1991). *A primer for daily life*. New York: Routledge.

Wyver, J. (1989). *The moving image: An international history of film, television and video*. New York: Basil Blackwell.

Media Violence

Why Is It Used to Abuse Children?
How to Oppose It and Win

Jacques Brodeur

Introduction

Over the last quarter century, while some industries polluted our air, water, and food, the entertainment industry increasingly poisoned children's cultural environment with violence carried by television programs, video games, and movies. While society has agreed to regulate the pollution of air, food, and water, governments have been unable to regulate the use of violence in entertainment products for children. The increasing power of the media on public opinion has inspired such fear on decision makers that when having to choose between children's rights and accusation of censorship, none dare to put their political party at risk. This lack of moral fortitude has left the media free to decide what our children will watch, what values will be pushed down their throats, and what cruelty will be used to feed their fantasies. George Gerbner used to call the big media the Secret Ministers of Global Culture. The executives of a handful of big media conglomerates think they own the freedom of the press and that it is their privilege to decide alone what will be aired to children on the global market, "with little to tell but a lot to sell." After witnessing the increased amount of violence carried by entertainment products for children, more citizens ask why they should let children be abused by the media.

Not all TV and other entertainment programs are toxic for children; some informative and even inspiring programs provide positive stimulation and help children and teens to understand the world. In fact, though, an increasing number of programs and movies do exactly the opposite. As a result, parents and teachers have searched for, lobbied, petitioned, requested, and finally created ways to protect children against mental manipulation and emotional desensitization. Fortunately, some of these efforts have allowed discoveries to help reduce the impact of pollution on the cultural environment of young people.

Influence of Toxic Culture

Since the 1977 LaMarsh Commission Report[1]—where the analogy to environmental contamination was first drawn in Canada—well over one thousand studies have routinely confirmed that violent entertainment influences children. In 1995, University of Winnipeg researcher Wendy Josephson, author of *Television Violence: A Review of the Effects on Children of Different Ages*, found more than 650 studies linking real-life violence by children to violence watched on TV.[2]

In 2001, the Media Awareness Network found that "only 4% of violent programs have a strong anti-violence theme [and] only 13% of reality programs that depict violence present any alternatives to violence or show how it can be avoided."[3] University of Washington epidemiologist Brandon Centerwall estimated that TV violence could account for 50% of real-life violence.[4]

Violent entertainment has three kinds of influence on children, depending on their age, how much they watch, and whether they watch alone, with adults, or with peers. Research has revealed that children mimic TV violence because they perceive it as approval for hitting, bullying, and humiliating their peers. It also encourages between 5% and 10% of victims to accept the treatment they suffer without seeking help. Finally, it reduces empathy in the witnesses, who then prefer ganging with the aggressor instead of helping the victim.[5] With increasing exposure to violence in entertainment, children become mentally altered and physically inclined to commit, accept, or enjoy watching real-life violence.

The Industry of Manipulating Children

In recent years, children have been increasingly exposed to violence through toy manufacturers' television programs and by video games. In the early 1980s, the toy industry used violence as a marketing ingredient. In addition to advertising through commercials, companies such as Hasbro produced their own TV programs and paid to have them broadcast on weekdays and Saturday mornings. In 1984, "GI Joe" carried 84 acts of violence per hour and "Transformers," 81.[6] This marketing strategy was so profitable that Hasbro reused it in 1989 with "Ninja Turtles," in 1993 with "Power Rangers," and in 1999 with "Pokemon." Their primary purpose was to persuade children to ask parents and Santa Claus to give them Hasbro toys. Most of these programs, like many video games, include fantasies and stereo-

types that support an aggressive culture of violence, sexism, and war. Stereotypical "real" men are strong, insensitive, and solve conflicts by exterminating their opponents. Women are docile, victims, or decorative trophies, incapable of solving problems.

Gary Ruskin, executive director of Commercial Alert, explained at a 2002 World Health Organization conference:

> Advertisers use many techniques to sell to youth. Mostly these involve manipulating their needs during the stages of their growth into adulthood. Some of the more common needs that advertisers take advantage of to sell products include youth needs for peer acceptance, love, safety, desire to feel powerful or independent, aspirations to be and to act older than they actually are, and the need to have an identity. Much of the child-targeted advertising is painstakingly researched and prepared, at times by some of the most talented and creative minds on the planet. [. . .] Advertisers [. . .] sometimes discuss it in terms of the battle over what they chillingly call "mind share." Some openly discuss "owning" children's minds. . . . In sum, corporations and their advertising agencies have succeeded in setting up their own authority structures to deliver commercial messages almost everywhere that children go.[7]

Public Airwaves Controlled Against Public Interests

Growing public awareness of the dangers of media violence aimed at young people has put pressure on governments to regulate it. In 1994, to prevent such intervention, Canadian broadcasters promised to regulate themselves. Six years later, researchers at Laval University noted that self-regulation had failed to reduce violence, and that violence carried by private broadcasters had increased by 432%.[8] Two developments during this period helped to neutralize public concern. First, many broadcasters provided funding for media literacy programs on the assumption that by studying media in class, students would discover that TV violence is not "real." While such programs seem progressive and useful, they have actually been used as a smokescreen to help broadcasters project an ethical image while increasing the intoxication of children. A second development was the V-Chip. Many parents work full-time and cannot always monitor what their children are watching. Devices such as V-Chips were supposed to allow them to block reception of violent programs. The V-Chip system depends on ratings that are made by the broadcasters themselves. The V-Chip has helped to shift responsibility for regulating TV violence away from polluters onto parents. Those who believe that government regulation of media is an attack on freedom of speech see nothing wrong with manipulating children. They consider this form of child abuse as their constitutional right. Moreover, governments, by fear of being bullied, gave control of pollution to polluters.

Censorship

When citizens request regulation of the use of media violence in cultural products for children, the industry is prompt to consider it as an attack against freedom of expression. These corporations speak about freedom of expression as if they owned it, as if they bought it. The fact that thousands of these media belong to the same owner allows them to reach consid-

erable numbers of viewers, listeners, and readers. They then easily make their views much more familiar to citizens and make them forget that the airwaves belong to the public. The use of violence by big media has nothing to do with freedom of speech. Media violence is the result of choices made by the industry, and it is the result of censorship controlled by the media. The use of violence to attract more children is motivated by commercial interests.

Mary Megee explained why gratuitous violence on TV is a form of censorship by commerce. "In the U.S., most cultural messages are strained through a commercial filter which uses gratuitous violence as an industrial ingredient to keep viewers tuned in, ratings high, and profits up."[9] The first—if not the only—rule that the big media agree to respect is the market. Their argument is simple: whenever people are ready to watch violent programs, broadcasters have the right to air them and NO government should interfere. For leaders of the industry, the law of commerce is the ultimate and most natural rule. All other rules and laws are viewed as obstacles to their interest and appetite for profits. Health, safety, and happiness of vulnerable citizens never appear on their radar screen. Control of the airwaves gives them the authorization to ignore the right of children to live in a safe cultural environment. If the transportation industry acted in a similar way, there would be no speed reduction in school areas and no interdiction of carrying dangerous chemicals in tunnels. Why would owning a big truck or even thousands of them give someone permission to drive on public streets and highways with no care for the public's interest? Why would the artists who build beds for babies get the freedom to space the bars so that they might turn out to be dangerous traps for small children? The argument of airing material despite the interest of children is the opposite of freedom. If there is a choice between freedom of speech and safety for children, all civilized societies give priority to children's safety.

Parents and teachers who request regulation of TV programs and video games for children quickly are stamped with the CENSORSHIP label. In 1997, George Gerbner was Dean Emeritus of the Annenberg School for Communication at the University of Pennsylvania and a pioneer of research on television violence. He had monitored television for over 30 years and found prime time television saturated by an average of five scenes of violence per hour. He found Saturday morning children's programs filled by 20 scenes of violence per hour. "When you can dump Power Rangers on 300 million children in 80 countries, shutting down domestic artists and cultural products, you don't have to care who wants it and who gets hurt in the process. Mindless TV violence is not an expression of artistic freedom or of any measure of reality. On the contrary, it is the product of de facto censorship: a global marketing formula imposed on program creators and foisted on the children of the world."[10]

The reason why parents who request less violence in TV programs for children are labelled as pro-censorship is to hide censorship by the industry and to make citizens forget that they own the airwaves. Why should people who own the airwaves restrict themselves from demanding that they be healthy, free, and fair? Why would the owners be treated in such an abusive way? When any violent program is chosen to be aired, citizens are aware

that censorship by the industry allowed some decision makers to eliminate other programs and films that could have contributed to their children's health and safety. The preference for violence is a decision made by somebody, elected by nobody, prisoner of a toxic culture, who knows that the authority expects him or her to give priority to cruelty, aggression, and hatred. Why did this program selector pick these Ninja Turtles to come and fight in our homes instead of other healthy programs for our children and their folks on our street? Did the network receive money for making that decision? Did profit increase after airing violent programs? Censorship exists; it is controlled by the industry, and millions of children pay the price today. Science also revealed that they will pay the price for their entire life, and the price becomes higher every year as increased doses of verbal and physical violence find their way into their brains.

The Purpose of Media Violence

Media violence is used by the entertainment industry for the main purpose of attracting more viewers, no matter their age, damages to their brains, or cost to society. When used by providers of entertainment products for youths, media violence has become one of the most sophisticated and cruel forms of child abuse. Pokemons, Terminators, Doom, Quake, Basketball Diaries, Grand Theft Auto, Howard Sterns, South Parks, Jackasses, all these cultural products have proven to damage children and teens across the continent.[11] They carry and promote values that help guide and inspire children's attitudes, behaviours, clothing, and relationships with each other. Eminem, Fifty Cents, and Marilyn Manson are the products of the music industry circulating hate propaganda against women and profiting from it. These singers and characters are often portrayed as rebels. In fact, they are nothing but submissive tools for the ideology of profit. They are slaves, rich and famous slaves, but slaves anyway. Valerie Smith monitored the music industry for decades. She wrote: "These guys would still whine in their garage if it was not for the industry that gave them a microphone, print their lyrics, sell their albums and promote them on MTV."[12] Music videos, TV programs, and video games have become the most child-abusive babysitters in North America. Much of their audiences are young people who easily believe that rudeness is an act of courage, of independence, and of freedom. It takes experience, knowledge, critical viewing skills, and empathy to understand that these role models actually teach submission, frustration, and anger. Verbal violence, physical violence, sexism, racism, and consumerism have nothing in common with freedom and justice—they are the opposite. These cultural products glorify violence and misogyny, although they have been the enemy of humanity for centuries, for millenniums. How would children know that? These products glamorize submissiveness of women and prostitution which have been fought by humanity for centuries, for millenniums. How would children know that? They trivialize verbal humiliations of others as if they were humoristic, acceptable, fun, natural, and entertaining. How would children know that? Damages are profound and painful.

A Sophisticated Form of Child Abuse

When compared to many forms of violence against children, media violence looks minor. Many children seem to enjoy it, and parents can get more freedom as their child watches TV. When researchers studied damages made to children by media violence, they discovered that television hurts millions of them very deeply and that most damages will affect them for the rest of their lives. Parents have many reasons to consider the use of media violence as a cruel and sophisticated form of child abuse. Because media violence is primarily used in entertainment to attract human beings, particularly the youngest, we need to ask the question: Why does it work?

Curiosity is not the only reason. We know for a fact that many human beings can hardly turn their head away when they witness their peers suffering or when they see pain inflicted on them. Sane human beings feel guilty to abandon their peers in a situation of danger. Using violence in entertainment for children is a very cruel form of child abuse because children cannot differentiate between fiction and reality. The process of making that difference starts at the age of 7 and is not over before the age of 13. This is a fact despite all the spontaneous answers given by children when parents ask them if they can make that difference. For an increasing number of teens, the process of making that difference is actually completed much later than 13. The Supreme Court of Canada has analysed the issue of children's vulnerability before the age of 13 and the 83-page Irwin Toys Decision is a media literacy lesson all by itself.[13]

The use of violent fiction to lure children before the age of 13 is clearly an unacceptable lack of ethics by the most lucrative industry of the world. In the United States, marketing targeting children has gone from $100 million in 1990 to two billion a decade later. That is a 2000% increase. This appetite for reaching children has allowed advertisers to compete and try various hooking ingredients to lure children and reduce gatekeepers' authority. Violence and the nag factor are two well known marketing ingredients, the most offensive and criminal.

Multiple Victims

It is the business of television to attract audiences and to sell them to advertisers, who then find ways to manipulate their preferences and choices for goods and services. Despite children's vulnerability, violence is commonly used by both the entertainment and the marketing industries for commercial purposes. These industries have studied the psychology of children, similarly to what predators do with their prey. They scrutinized children's needs, hopes, fears, dreams, and desires.[14] Increasing the audience means enormous monetary profits in the short term for these industries. However, media exposure also has enormous short-, mid- and long-term effects on children and society. Well over a thousand studies have linked television to numerous marketing related diseases (MRD) such as obesity, body image, self-esteem, violent crime, physical and verbal abuse, eating disorders, smoking, alcohol,

attention deficit disorder and hyperactivity, compulsive consumerism, perilous driving, and so on. [15] What other industry can afford to generate so much damage to society without any consequences? When *ecoli* bacteria are found in water, meat, or spinach, the public is quickly informed about the risks. Why would research about MRD be deprived of similar coverage?

Exposure to violent entertainment does not only show and teach how to act violently. In the child's inexperienced brain, it links pain infliction with pleasure. Violence was certainly not created by the media, but the use of violence in entertainment by the media has helped to increase the amount, the damages, and the pain for millions of children around the world. Does the industry try to prevent damages? Unfortunately, every time accusations could incriminate them, their answer is simple: raising children is the parents' job, not theirs. Imagine any other industry (guns, alcohol, and so on) trying that line?

'I knew that kid was 10, and, yes, he walked into my pawn shop, bought a fifth of liqueur and a gun, but where were the parents? It's the parents' job to keep him out!' No other industry would try that line. The only other group of individuals who would say that are child abusers: 'I know that little girl was 8, but it's the parents' job to keep me away from her.'

This (media) industry is functioning with child abuser logic, and they will pay a profound price for it." [16] If raising a child requires a whole village, it seems that television is not a member of the village.

Size of the Effect

Research has proven that the effect of media violence is bigger than the effect of exposure to lead on children's brain activity, bigger than the effect of calcium intake on bone mass, bigger than the effect of homework on academic achievement, bigger than the effect of asbestos exposure on cancer, bigger than the effect of exposure to secondhand smoke on lung cancer.[17] Professor Craig Anderson testified before the U.S. Senate Commerce Committee hearing in 2004. He explained that research revealed three effects of exposure to media violence.

- Short-term effects: aggression increases immediately after viewing a violent TV show or movie, and it lasts for at least 20 minutes.
- Long-term effects: children who watch a lot of violent shows become more violent as adults than they would have become had they not been exposed to so much TV and movie violence.
- Long-term and short-term effects occur to both boys and girls.[18]

Video Games Are Murder Simulators

Dr. Michael Rich testified on behalf of the American Academy of Pediatrics before the Public Health Summit on Entertainment Violence. Here is what he had to say about video games:

Video game revenues are $10 billion a year, larger than that of television and movies, and increasing. 50% of 4th graders choose "first person shooter" (FPS) video games as their favorites. The average 7th grader plays these video games for more than 4 hours each week. [. . .] After playing video games, young people exhibit measurable decreases in prosocial and helping behaviours, a 43% increase in aggressive thoughts, and a 17% increase in violent retaliation to provocation. Playing violent video games accounted for 13–22% of the variance in teenagers' violent behavior. By comparison, smoking tobacco accounts for 14% of the variance in lung cancer. [. . .] Active participation increases effective learning. Video games are an ideal environment in which to learn violence: a) they place the player in the role of the aggressor and reward him or her for success at violent behaviour; b) rather than observing part of a violent interaction, video games allow the player to rehearse an entire behavioural script from provocation to choosing to respond violently to resolution of the conflict—this is more effective learning than watching or rehearsing part of the sequence; c) video games are immersive and addictive—kids want to play them for long periods of time to become better. Repetition increases learning. While violent video games are clearly not the sole factor contributing to violence, they are clearly a factor.[19]

Other aspects of this entertainment-induced social engineering project have also come under scrutiny. Apart from the tendency of video games to arouse aggression, researchers note that these games provide little mental stimulation. Professor Ryuta Kawashima and his research team measured the brain activity of hundreds of teenagers while they played a video game and compared the results with those of other groups who did math exercises and read aloud. The researcher found out that computer games do not stimulate crucial areas of the brain, leading to underdevelopment and such behavioral problems as violence.[20] The video game did not stimulate the brain's frontal lobe, an area that plays an important role in the repression of anti-social impulses; the frontal lobe is also associated with memory, learning, and emotions. A lack of stimulation in this area before the age of 20 prevents the neurons from thickening and connecting, thereby impairing the brain's ability to control such impulses as violence and aggression. Professor Kawashima's findings are supported by other studies: "Computer games do not lead to brain development because they require the repetition of simple actions and have more to do with developing quick reflexes than carrying out more mentally challenging activities."[21]

Lt Col Dave Grossman, a retired psychologist from the U.S. Army, co-authored with Gloria DeGaetano a book about the influence of video games on human brains: *Stop Teaching Our Kids to Kill*. Grossman knows that video games were used by the U.S. army as murder simulators for the purpose of conditioning young recruits to "kill without thinking." In many interviews and speeches, Lt Col Grossman explained that "video games give kids and teens the skill, the will and the thrill to kill."[22]

Media Violence Linked with Bullying and Crime

Time exposure to television is actually linked with bullying. Research by Frederick Zimmerman, professor in the University of Washington's School of Public Health, found that "youngsters who spent a typical amount of time—about 31/2 hours daily—in front of the tube had a 25% increased risk of becoming bullies between the ages of 6 and 11. This is a very clear independent effect of television on children's bullying. More kids who

watch a lot of TV go on to become bullies than kids who don't watch very much TV, so that's the risk. Watching a lot of TV doesn't mean that you're going to become a bully, it just means that you have a higher chance that it might happen."[23]

During the last 15 years, school authorities in the United States have noticed that violence has hit lower grades. In California, for example, the latest school crime figures show that from 1995 to 2001, rates of vandalism and other offenses dropped among elementary school students, while assaults nearly doubled. In Philadelphia, the first part of (this) school year 2002–2003 brought the suspensions of 22 kindergartners. Minneapolis schools have suspended more than 500 kindergartners over the past two school years for fighting, indecent exposure, and persistent lack of co-operation. Minnesota schools have suspended nearly 4,000 kindergartners, first- and second- graders, most for fighting, disorderly conduct and the like. In Massachusetts, the percentage of suspended students in pre-kindergarten through third grade more than doubled between 1995 and 2000. In 2001–2002, schools in Greenville, S.C., suspended 132 first-graders, 75 kindergartners and two preschoolers.[24]

In Québec, between 1985 and 2000, the number of elementary school students with troubled behaviors has increased by 300%.[25] Media violence is also linked with later criminal activity, as shown by this 17-year-study in which 700 young people were tracked down into their adult lives. Hours of viewing were correlated with acts of aggression. Surprisingly, viewers watching more TV as children committed more crimes as adults than those already involved in violence when they were kids.[26] In Canada, the violent crime rate for youths is growing much faster than that for adults, and, in the Province of Québec, the violent crime rate of youths is now two times higher than that of adults.[27]

The Social Cost of Desensitization

The most worrying effect of exposure to media violence (more than imitation) is desensitization, the reduction of empathy. Massive exposure to violent entertainment has shown to reduce the capacity of children (and their will) to rescue victims or report about them. Many young criminals often show and feel no remorse after committing horrible crimes. Increasing the punishments or judging them before a court for adults has little or no positive effect. Early desensitization of young humans will carry a heavy cost for the coming generation and the future of civilization. Massive exposure to violent entertainment reduces—if not destroys—the value of life and the power of solidarity in our societies.

Various Responses of Civil Society

All civilized societies show concern about child abuse. Concern about violence against children inspired reactions against the marketing of violence by the entertainment industry. Spontaneously, civil society across North America has developed a wide variety of promising practices to protect children from media violence. If society wants to reduce the manipulation of children by the media, and regulate violence carried by TV programs for

children, increased legislation is necessary. In 2004, the U.S. Federal Trade Commission found that the entertainment industry had marketed products to children that their own ratings do not consider appropriate for them. Children under 17 could easily purchase tickets for movies, music recordings, and video games labelled as suitable "for adults only." Self-regulation has clearly proven to be non-efficient.[28]

Such marketing practices clearly contravene with the Child Rights Convention, where article 17e makes it obligatory to all States to recognize the importance of the media and protect children against "material (danger) injurious to their well-being." Despite such a clear statement, many states, including the United States and Canada, have shown reluctance to enforce it.

If there are going to be attempts by decision makers to legislate this issue, successful efforts must be supported by a wide mobilization throughout civil society. Media have gradually become so powerful to influence public opinion that governments fear to intervene. Solid coalitions of parents, health professionals, education professionals, grassroots organizations, and activists could succeed where legislators alone have failed.

Parents' Education

Such wide mobilization from all sides of the political spectrum requires knowledge and motivation. In 2002, researchers Doug Gentile and David Walsh surveyed parental guidance over children's consumption of media violence and concluded that it was not sufficient. A study conducted by Joanne Cantor in 2002 revealed that most parents have little or no knowledge of the harmful effects of media violence on their child. Other Canadian and U.S. studies have revealed that parents are not aware of the amount of violence their children are exposed to on television, the Internet, and video games. It is therefore obvious that media education is needed. UNICEF Canada also believes that "complementary regulations with parent and child education are needed. Families are important in reducing the harmful effects of media violence. Children themselves believe they should be protected from frightening television programs, websites, and video games."[29] Many parents would be happy to learn why they should avoid purchasing toys that promote imitative play of violent programming, why monitoring their children's video game habits is helpful, why using TV as a babysitter is perilous, and why they should spend more time talking with their children.

Resistance by the Industry

History has shown that other industries have tried to oppose increased legislation to protect citizens. The automobile industry, the tobacco industry, and the food industry, for example, have spent tremendous efforts to deprive citizens and society from protection. The problem with media violence is that the industry accused of abusing children is at the same time responsible of preparing the news. Informing the public therefore becomes barely possible if not impossible. A few countries or states have succeeded in regulating the media

industry targeting children: Greece, Sweden, and Québec are among them.

Legislation Against Advertising to Children

The success story in the Province of Québec is interesting because it was realized right here in North America. Advertising became illegal in the province of Québec in 1976. This type of legislation requires not only courage from political decision makers but also strong support from society at large. The Québec Consumer's Protection Law forbidding advertising to children under 13 became fully enforced in 1980. The toy industry—Irwin Toys Ltd— has challenged this law up to the Supreme Court of Canada, arguing that it restricted its own freedom of expression protected by the Canadian Charter of Rights. The court declared the Québec legislation fully constitutional. The Irwin Toys Decision takes 83 pages to describe pretty accurately (a) sophisticated manipulation techniques used by the marketing industry, (b) why any provincial jurisdiction in Canada has constitutional legitimacy to protect its vulnerable citizens, (c) why children need such protection until the age of 13. This legislation made Québec the first, and still to this day, 30 years later, the only State in North America to protect children from advertising.

During the years following its adoption, lobbying by advertisers argued that the children of Québec were punished by this legislation because TV networks could not sell advertising time. Lack of income had then reduced, they said, the quality and quantity of TV programs for kids. Adopting the law supposedly punished children instead of protecting them. Fifteen years after the law was fully enforced, the Government of Québec asked Professor André Caron, researcher from the University of Montreal, to evaluate the actual impact of the law. The study revealed that programming for children was richer, more diverse, and more educational in Montreal, Quebec, compared to Toronto, Ontario, a city where such protection did not exist.[30] Ruling out advertising to kids has proven to be a very efficient and promising practice to protect children. The Canadian Supreme Court Decision in itself offers a rich media education lesson.[31] An analysis of the decision gives important strategic insights for decision makers in other states and countries trying to legislate and lawyers trying to defend the legitimacy of the legislation in court.

Further research will be necessary to evaluate if regulating advertising to children also impacted child obesity and other MRD diseases. Lately, the American Psychological Association (APA) requested a similar legislation for protecting children in the United States along with a coalition of organizations advocating in favor of children's rights.[32] The *Washington Post* reported about the APA position.[33] A survey conducted in 2006 showed that more than 80% of U.S. citizens agree that advertising to children under 9 should be prohibited. Commercial Alert campaigns for a similar legislation to ban advertising targeting children under 12.35

Other (Most) Promising Practices to Protect Children

Despite powerful opposition against regulation from the media, many promising practices

have been experienced in North America to protect children from media violence. A report sent recently to UN Secretary General as a contribution to the Study on Violence against Children highlights 20 such promising practices by civil society. The report was posted on the Child Rights Information Network (CRIN) Web site.[34] Among these innovative practices, the SMART Program and the 10Day Challenge have proven to be the most efficient to help parents, students, and teachers come together and oppose the media culture of violence.

Student Media Awareness to Reduce Television (SMART)

The SMART Program was tested in 1998 by Dr. Thomas N. Robinson in two elementary schools of San Jose, California. It consists of 18 lessons for teachers preparing students and motivating them to turn off the TV for 10 days and keeping their consumption under 7 hours per week during the following months. The research was reported in the *Journal of the American Medical Association* in 2001. Reducing TV and video games helped reduce verbal violence by 50% and physical violence by 40%.[35] The SMART Program was made available in 2004 by the Stanford Health Promotion Resource Center (SHPRC) affiliated to the Stanford University School of Medicine, CA. Information about the SMART program is posted on their Web site.[36] Dr. Robinson also proved that reducing the time of television watched and video games played helped reduce another MRD. According to the Stanford Study reported by the *Journal of the American Medical Association*, reducing TV had a significant impact on a decrease in obesity.[37]

The SMART Program was successfully implemented in Michigan in 2004. Principal Mike Smajda learned that one of his first-grade pupils at Lemmer Elementary School had watched *The Texas Chainsaw Massacre*. Not long afterward, the boy was playing in a leaf pile with a girl when he suddenly began kicking her in the head. Another boy joined in. "They felt it was part of the game," Smajda said. "They both kicked her until her head was bleeding and she had to go to the hospital." Smajda can't prove the R-rated slasher movie provoked the child, but the November 2004 incident reinforced his commitment to an anti-violence program getting under way at his school. It challenged students to do without TV and all other screen entertainment for 10 days, then limit themselves to just seven hours a week.[38] Other schools joined in over the next year. Administrators and teachers say short-term results were striking: less aggressive behaviour and, in some cases, better standardized test scores.[39]

The SMART Program was successfully implemented in eight schools in 2005–2006. The school district was allowed 2.3 millions dollars for sharing the program in 2006–2007.[40]

The Delta-Schoolcraft School District, based in Escanaba, Michigan, was the first school district in the world to use the SMART curriculum across the entire district. The 10Day TV/videogame turnoff resulted in an 80% reduction in violence. In the spring of 2005, more schools participated in the program. The result was a statistically significant reduction

in violence and bullying. They also witnessed a 15% increase in math scores and an 18% increase in writing scores as compared to the seven schools that did not have the program in place at that point. SMART showed to be effective at reducing violence in a double-blind, controlled experiment conducted by Stanford Medical School. In October 2006, the district had its fourth international conference to teach educators about the curriculum. All attendees were provided with the curriculum and given instruction in the implementation of the curriculum by educators and administrators who had firsthand experience with it.[41]

> The SMART Program is surely the most promising practice in North America to Protect Children from Media Violence

The "10Day Challenge" TV and Video Game Free

The Challenge was a success because of the media education sessions with students, teachers, and parents. It was experienced for the first time in April 2003 in partnership with the parents association of the Québec City region. It received funding from the Public Safety departments of both Québec and Canada.

In May 2003, the Canadian Press (CP) covered the Challenge in St-Malachie.[42] The Challenge was reported in the *Green Teacher Magazine*.[43] Since then, the Challenge has been experienced in over 50 schools in the provinces of Québec and Ontario. Everywhere, the Challenge obtained huge success, as shown in the evaluation by parents, students, and teachers from six elementary schools.[44] In April 2004, the Parents Association launched a 20-minute video (in French) telling the story of the Challenge as it was experienced in two schools. The Canadian Observatory on School Violence Prevention (COSVP) posted the PA press release on its Web site.[45]

In all regions or cities where the Challenge was experienced, it received coverage and support by the media. In April 2005, three daily French newspapers covered the Challenge.

Le Nouvelliste told the story in Trois-Rivières, Québec. *Le Droit* covered the Challenge in Ottawa, Ontario. *Le Soleil* made its front page with the Challenge in Québec City. In the spring of 2005, the Québec Consumers Protection Office added the Challenge to its list of recommended consuming practices and posted it on its Youth Page.[46]

The 10Day Challenge with Teenagers

Commemoration of the 6th anniversary of the Columbine High School shooting in Littleton, Colorado, was the opportunity to analyze the factors around this tragedy. Such an event deserves better attention than what was presented in the movie *Bowling for Columbine*. Despite efforts by the producer to take blame away from the entertainment industry, the media play an important role in the shooting as shown by further inquiry in the lives of the young killers.[47] The preparation of the students for the 10Day Challenge in Louis-Jacques-Casault high school, in Montmagny, Québec, showed how media education could

actually help prevent teen violence. One thousand teenagers attending the high school were offered to turn off the TV and video games for 10 days. Teachers, parents, and students evaluated the outcome of the Challenge. Interviews with teenagers who participated in the Challenge were aired all across Canada by CBC radio and TV. The evaluation below confirms the value of the 10Day Challenge as a "promising practice" with teenagers. The 10Day Challenge has shown to offer a motivating approach, an efficient way to mobilize entire communities in improving protection from media violence.

As mentioned by UNICEF Canada in its consultation document, additional legislation is certainly among promising practices. However, legislation alone will be ineffective unless civil society mobilizes to counter the enormous power of the media, including the video game industry.

Independence of Media Education

Two reporters investigated the funding sources of major public health groups and found that big corporations dump big money into these groups, and pretty soon, the groups start taking the line of the big corporations. They concluded their inquiry by suggesting that such funding was causing the losing of the wars on cancer, heart disease, and diabetes.[48] In the summer of 2006, McDonald's launched its own exercise program to prevent obesity. Again, the P. R. strategy helped take blame away from the impact of junk food on children's health. Canadians and Americans face a similar problem with media education. Organizations funded by media conglomerates were created to promote a kind of media literacy that will take blame away from the media for intoxicating kids and teens. The funding "naturally" helps put the blame on parents, just like the food industry funding helps put the blame for diabetes and obesity on the lack of exercise. Big media corporations know how to protect their image.

The media need to divert the blame for the increasing crime rate among young people for violent offenses in the United Sates and Canada. During three decades, organizations were created to produce "educational material" with the financial contributions of big media. Naturally, the funding helps keep blame away from the polluters and prevent further accusations of child abuse. North American schools receive free kits, including "educational" tools, but the price is disregard for the impact of media violence on society.[49]

Evaluation of the 10Day Challenge by Parents, Students, and Teachers

In the school year of 2003–2004, 20 elementary schools in Québec and Ontario offered media education workshops to prepare students and parents to turn off their television sets. Tabulation of participation revealed that 1,354 students succeeded in saving 19,377 hours of time they would have spent watching TV or playing video games. Students succeeded

in turning off their TV for an average of seven days. In April 2004, one high school did the same with its 1,000 students. In six elementary schools and this single high school, two to three weeks after the turn-off ended, an evaluation form was given to all students, parents, and teachers.

TABLE

Evaluation by 6 elementary schools 2003–2004	Evaluation in one high school, April 2004
Parents, students and teachers evaluated the benefits The following evaluation is based on answers from 365 students, 27 teachers and 247 parents. Students spent an average of 7 days away from the tube. Girls succeeded in turning off one day more than boys. 30% of children kept their TV turned off completely for the whole 10 days.	One thousand students participated in 3 workshops to find motivations to participate in a 10Day turn off. 522 students participated in the evaluation, 168 parents and 32 teachers. Teens succeeded an average of 4.8 days. • 78% of students aged 12–16 say they participated in the Challenge • 6% succeeded in turning off TV and videogames completely for 10 days., • 23% reduced consumption by 75%, • 36% by half, • 35% by a quarter
Useful • 70% of students found the Challenge «very or quite» useful, • 76% of parents found it "very or quite" useful, • 66% of teachers found it "very or quite" useful,	**Useful** • 80% found the Challenge very or quite useful. • Preparation reached all students, including non participants; media literacy workshops helped them obtain some benefits anyway. • Two thirds of parents found the Challenge very or quite useful • 86.2% of staff considered the profit very or quite important
Benefits Time spent in front of the tube deprives children from time to develop social skills. What happened during the turn-off? The Challenge has shown to increase, • Physical activity (62.2%) • Time spent with parents (58.5%) • Time spent with friends (45%) • Helping at home (44.4%) • Relationship with brothers and sisters (31.8%) • Better humor (30.2%)	**Benefits** TV and videogames deprive teens of time that to develop social skills. Self-deprivation of TV had an impact on their quality of life. • Physical activity increased (50%) • 45% of students increased time spent with friends • 25% spent more time with parents and increased help for tasks at home **Influence of TV.** 76% of parents say that they are conscious of it.

(Table continued on page 682)

Answers show that social relations and family ties were positive influences. Participating families have observed: • Closer relations between parents and children (more time together, encouragements to turn-off, help with home chores. • Improved relations between brothers and sisters • Better relationship between school and community. • Community mobilization to support children. • Reduced exposure to TV and videogames after the Challenge	**New dynamics in the school.** 63% of teens say that the Challenge improved it. Majority were girls. This element was the *2nd most improved* by the challenge. **New dynamics in the community.** 58% of teems say it improved, mostly girls. It was the *3rd most improved element* witnessed during the Challenge.
Critical viewing skills • 52% of students say it improved. 3rd most positive benefit. • TV and videogames influence children "much or quite" say 80.3% of parents. • 100% of teachers say that their students' viewing skills have improved.	**Critical viewing skills** • They improved say 65% of teens, mostly girls. Benefit no. 1 Six parents out of 10 (59%) say that they witnessed the improvement of their child's viewing skills. • 9 teachers out of 10 say the same.
Violence • **At home.** Decrease of verbal violence witnessed by 54.7% of students. Benefit no 1 from the Challenge. Decrease of physical violence was witnessed by 54.2% of students. Benefit no 2. • **At school.** Decrease of physical violence witnessed by 44% of students. Decrease of verbal violence witnessed by 40.5% of students.	**Violence** • **At home.** Decrease of verbal violence witnessed by 39% of students. Decrease of physical violence witnessed by 38% of students. That is more than one third. • **At school.** Decrease of physical violence witnessed by 32% of students. Decrease of verbal violence witnessed by 27% of students.
Comments. • Decrease of violence seen by all 3 partners (students, parents and teachers) was significant for both physical and verbal violence, at home and at school. • Decrease of verbal violence has been observed by children more at home (54.7%) than at school (40.5%). Similar result with teens (39% versus 27%). • Decrease of physical violence has been observed by children more at home than at school (54.2% versus 44%). By teens (38 versus 32%). • Evaluation focused more on the sense of security than the actual number of aggressions. The Challenge has ameliorated that sense for 50% of children and 32% of teems	
Repeating the Challenge • Half of student (52.3%) say yes. • Over 2 third of parents (69.1%) say yes. • 2/3 of teachers say yes. Complete analysis.	**Repeating the 10Day Challenge** • 72% of students say yes. That wish is stronger in high school compared to elementary schools. 8 parents out of 10 (79%) recommend other schools try it. The strongest support for repeating the Challenge came from teachers (89.7%). Complete analysis of the 10Day Challenge in a high school available.
Report to Public Safety Departments of Quebec and Canada, May 2005. (50)	

Conclusion

The fact that participation in the Challenge is decided by parents is very important. The Challenge is (and should be) presented as an adult's mobilization to support children's decision and motivation, and hence the Challenge has created a precious opportunity to value the *family government*. The fact that the Challenge is offered to all children of entire schools also helps create a tremendous momentum that contributes to the success of the mobilization.

Preparation for the 10Day Challenge is even more important than the turn-off itself. Workshops for students, professional development training, conferences for parents, follow-up activities by teachers, and advertising in the community are integral parts of the process and help make the Challenge a success.

The involvement of communities in the 10Day Challenge increases the reputation of schools, emphasizes the importance of education, and the children's sense of belonging. Because the challenge is perceived as comparable to an Olympic performance, communities express admiration and support for students and thus reinforce young people's self-esteem and pride.

Surprisingly, during and after the 10Day Challenge, students find themselves in the middle of intense media coverage, particularly on TV. Newspapers, broadcasters, and magazines rush to cover their effort and performance . . . positively. In areas where poverty is common, the media usually come to report about crimes and fights. This time, when students organize to stand up against the small screen addiction, they attract attention and admiration to their neighbourhood. All principals agree to consider the Challenge as an empowering exercise with parents, students, staff, and the whole community.

The 10Day Challenge is great news for all North American parents. It was inspired by the SMART Program from Stanford University, CA. Success obtained with SMART in Escabana, MI, should also be known all across North America.

Teachers appreciate this innovative approach to violence prevention. The reduction of exposure to TV and video game violence, along with lessons to motivate children and parents, have proven to be very efficient ways to prevent violence and bullying in our schools. All health professionals and education professionals in North America should be informed. Many TV stations that reported about the 10Day Challenge conducted interviews with students, parents, and teachers. All media expressed support, showing that they can also actually contribute to youth violence prevention in the global village.

NOTES

1 Report of the Ontario Royal Commission on Violence in the Communications Industry (LaMarsh Commission, 1977) brought forward much research on damages to society by media violence. Corruption of media with violence is compared to pollution of food, air, and water with lead, mercury, and asbestos.

2 Wendy Josephson, Television Violence: A Review of the Effects on Children of Different Ages" Department of Canadian Heritage, 1995, available free of charge from National Clearinghouse on Family Violence, Health Canada, (800) 267–1291.

 How TV Violence Affects Children, TV Violence Fact Sheet from the Kaiser Family Foundation. http://www.kff.org/content/2003/3335

3 Media Awareness Network, found September 30, 2001, http://www.media-awareness.ca/ Le Monde diplomatique, Malaises dans l'éducation, November 2001, www.monde-diplomatique.fr/2001/11/DUFOUR/15871?var_recherche=t%E91%E9+violence

4 Brandon Centerwall, Exposure to Television as a Risk Factor for Violence, *American Journal of Epidemiology*, 129:4 (1989), p. 645.

5 Fred Molitor, The Effect of Media Violence on Children's Toleration of Real-Life Aggression, Southampton Institute of Higher Education, UK, Presentation at the International Conference on Violence in the Media, New York City, October 3–4, 1994.

6 ICAVE, International Coalition Against Violent Entertainment, quoted by PACIJOU in "Cessez-le-feu," Fides, 1987.

7 Gary Ruskin, World Health Organization, Conference on Health Marketing and Youth, April 2002, Treviso, Italy, http://www.commercialalert.org/issues/health/international-public-health/presentation-to-who-conference-on-health-marketing-and-youthhttp://www.commercialalert.org/issues/health/international-public-health/presentation-to-who-conference-on-health-marketing-and-youth

8 Jacques DeGuise and Guy Paquette, Centre d'études sur les médias, Laval University, Principaux indicateurs de la violence sur les réseaux de télévision au Canada, April 19, 2002.

9 Mary Megee, Is Gratuitous Violence in the Media a Form of Censorship by Commerce? International Conference on Violence in the Media, St. John's University, NY, October 1994.

10 George Gerbner, 1994, Press Release.

11 Ralph Nader, Corporate Predators: The Hunt for Mega-Profits and the Attack on Democracy, 1998. http://www.corporatepredators.org/nader.html

12 Valerie Smith, quoted in *NOW Magazine*, Hip hop goes on trial; Human rights body weighs charge that rap pushes violence against women, November 2005, http://www.fradical.com/HMV_selling_hate.htm Valerie Smith, Action Agenda, A Strategic Blueprint for Reducing Exposure to Media Violence in Canada. http://www.fradical.com/Action_Agenda_November_2004.pdf

13 Supreme Court of Canada, The Irwin Toys Decision, Québec has the right to protect children under the age of 13 from advertising because they are vulnerable. http://www.lexum.umontreal.ca/csc-scc/en/pub/1989/v011/html/1989scr1_0927.html

14 Enola G. Aird, Who Owns Our Children's Minds? 2000. http://www.dlc.org/ndol_ci.cfm?kaid=114&subid=144&contentid=2147 Also: Gary Ruskin, Commercial Alert, Psychologists Denounced for Abusing Children, 1999. http://www.commercialalert.org/news/news-releases/1999/09/commercial-alert-psychologists-psychiatrists-call-for-limits-on-the-use-of-psychology-to-influence-or-exploit-children-for-commercial-purposes

15 Gary Ruskin, Marketing Related Diseases, MRD, Presentation to World Health Organization Conference on Health Marketing and Youth, April 2002, Treviso, Italy. http://www.commercialalert.org/issues/health/international-public-health/presentation-to-who-conference-on-health-marketing-and-youth http://www.commercialalert.org/issues/health/international-public-health/presentation-to-who-conference-on-health-marketing-and-youth

16 Lt. Col. Dave Grossman, Update about SMART, September 2006. http://www.edupax.org/Assets/

divers/documentation/4_defi/Update%20About%20Smart.html

17 Dr. Doug Gentile, Correlations Presented at 3rd ACME Summit, Burlington, VT, October 2006. Also
 Media Resource Team of American Association of Pediatrics, "Media Violence," *Archives of Pediatric
 Adolescent Medicine* 108:5 (2001), pp. 17–23, report online at time of publication at http://www.aap.org/
 policy/re0109.html

18 Impact of Entertainment Violence on Children, Joint Statement to the Congressional Public Health
 Summit by the American Academy of Pediatrics, the American Academy of Child & Adolescent
 Psychiatry, the American Psychological Association, the American Medical Association, July 2000.
 http://www.aap.org/advocacy/releases/jstmtevc.htm

19 Michael Rich, Protecting Children in the Information Age, Center on Media and Child Health, Harvard
 School of Public Health, presentation at 3rd ACME Summit, Burlington, Vermont.
 http://www.aap.org/advocacy/rich-mediaviolence.pdf

20 "Computer Games Can Stunt Kids' Brains," *Daily Telegraph*, August 20, 2001. http://www.edupax.org/
 Assets/divers/documentation/7b4_jeux_video/Video%20Game%20Use.html

21 Ibid.

22 Dave Grossman and Gloria DeGaetano, Stop Teaching Our Kids To Kill, A Call To Action Against
 TV, Movie, & Video Game Violence, 1999. http://www.killology.com/reviewbaehr.htm

23 Dr. Frederick Zimmerman, Study Ties TV Time to School Bullying, April 2005. http://www.edupax.org/
 Assets/divers/documentation/7b8_television/Study%20ties%20TV%20time%20to%20school%20bul-
 lying.html

24 School violence hits lower grades, *USA Today*, January 13, 2003. http://www.edupax.org/Assets/
 divers/documentation/17_violence/School_violence_hits_lower_grades.html

25 Students with Behavioural Difficulties in Quebec Elementary Schools. http://www.cse.gouv.qc.ca/EN/
 PUBLICATIONS/index.html?1 =EN

26 Study Ties Television Viewing to Aggression, adults affected as well as Children, Brad Bushman,
 Professor of psychology at Iowa State University at Ames, *Washington Post,* 2002. http://www.edupax.org/
 Assets/divers/documentation/11_recherches/3%20Articles%20on%20Influence%20of%20Tv.html

27 Violent Crime Rate of Youth Twice Higher than Adults,' Public Safety Department of the Province
 of Quebec, Statistics 2001, p. 24. http://www.edupax.org/Assets/divers/documentation/3_criminalite/vio-
 lent_youth_crime_rising.html

28 Katherine Covell, Violence Against Children in North America, UNICEF Canada, June 2005, North
 American Consultation Document for the UN Secretary General's Study on Violence Against
 Children. http://www.violencestudy.org/IMG/pdf/Desk_Review.pdf

29 Katherine Covell, ibid.

30 Professeur André Caron, Revue Option no 20, 2000. http://www.csq.qc.net/sites/1676/options/opt-
 20/andrecar.pdf

31 Decision of the Supreme Court of Canada, Irwin Toys Limited versus Québec
 (Attorney General), 1989, http://scc.lexum.umontreal.ca/en/1989/1989rcs1–927/1989rcs1–927.html

32 Television Advertising Leads to Unhealthy Habits in Children, American Psychological Association
 (APA), 2004. http://www.apa.org/releases/childrenads.html

33 Information or Manipulation? Regulators Urged to Further Limit Ads Aimed at Children, 2004,
 Washington Post. http://www.edupax.org/Assets/divers/documentation/7b5_publicite/PUB_Information_
 or_Manipulation.html

34 Survey Supports Limits on Kid-Targeted Ads. Report on Public Attitudes Toward the Youth Marketing Industry and Its Impact on Children, 2004. http://www.knox.edu/x7232.xml

35 The Leave Children Alone Act would ban television advertising aimed at children under 12 years of age, Parents Bill of Rights, 2004. http://www.commercialalert.org/pbor.pdf

36 Promising Practices to Protect Children from Media Violence Experienced by North American Civil Society, Children Rights International Network (CRIN), 2006. http://www.crin.org/violence/search/closeup.asp?infoID=9187

37 Effects of Reducing Children's Television and Video Game Use on Aggressive Behavior, *Journal of the American Medial Association*, January 2001, http://www.edupax.org/Assets/divers/documentation/4_defi/SMARTAggressivity.pdf

38 Student Media Awareness to Reduce Television, SMART, Stanford Health Promotion Resource Center (SHPRC) affiliated to Stanford University School of Medicine, CA, 2004. http://hprc.stanford.edu/pages/store/itemDetail.asp?169

39 Reducing Children's Television Viewing to Prevent Obesity, JAMA, October 1999. http://www.edupax.org/Assets/divers/documentation/4_defi/SMARTObesity.pdf

40 Michigan Kids Urged to Kick TV Habit, Associated Press, February 2006. http://www.fradical.com/Michigan_kids_urged_to_kick_tv_habit.htm Also: Kicking TV Habit in a Rural Michigan Town, Associated Press, February 2006. http://www.msnbc.msn.com/id/11602458/

41 Lt. Col. Dave Grossman, Update About the SMART Curriculum in Michigan, July 2006. http://www.edupax.org/Assets/divers/documentation/4_defi/Update%20About%20Smart.html

42 Ibid.

43 Canadian Press Release, The 10Day Challenge in St-Malachie, Québec, May 2003. http://www.edupax.org/Assets/divers/documentation/4_defi/article_cyberpresse_030520.html

44 Jacques Brodeur, Confronting Violence in Entertainment, *Green Teacher Magazine*, December 2003. http://www.edupax.org/Assets/divers/documentation/1_articles/Confronting_Violence.pdf

45 Schools are the organisational basis for the 10Day Challenges. http://www.edupax.org/Assets/divers/documentation/4_defi/10_days_challenge.html

46 Canadian Observatory on School Violence Prevention, Press release for the launching the 10Day Challenge Video by the Parents Association of Québec and Chaudière-Appalaches. http://www.preventionviolence.ca/html/Avideo.html

47 Consumers Protection Office, 2004, Développement durable, Consommation responsable, De quoi parle-t-on ? http://www.opc.gouv.qc.ca/dossier/dossier_themtq_dev_dur.asp#top

48 Robert Weissman and Russell Mokhiber, On the Rampage: Corporate Predators and the Destruction of Democracy, quoted in Taking Lessons from Columbine, How Media Literacy Can Help Prevent Youth Violence with Teens, April 2005. http://www.edupax.org/Assets/divers/documentation/1_articles/Taking%20Lessons%20From%20Littleton.htm

49 *The 10Day Challenge in 6 elementary schools and one high school in 2003–2004, Report to the Public Safety Departments of Québec and Canada, May 2004.* http://www.edupax.org/Assets/divers/documentation/4_defi/defi_acp0312/bilan_2003/Le_rapport.htm

 See also Complete evaluation of the 10Day Challenge at high school, April 2004, Montmagny, Québec, Canada. http://www.edupax.org/Assets/divers/documentation/1_articles/Teens%2010Day%20Strike.htm

Critical Media Studies Meets Critical (Hyper-)Pedagogues

Kathleen S. Berry

Introduction

Nina is a thirteen-year-old girl, living in a rural ocean and tourist area. One day, she was walking towards my home. As I watched her, she had an MP3 *player* in one ear, *a cell phone* in the other ear (talking, I discovered, to her mother), *talking with* her two girlfriends beside her, one of whom was pushing Nina's baby brother. They eventually reached my back porch, where I knew they were going to bring me up to date on the latest events and interests in their lives. Over time they did: the latest Harry Potter movie; what videos they would pig-out on at the up-coming sleep-over (my generation called them PJ parties); school events including the up-coming prom; the books they were reading and had read; their parents', grandparents', aunts', and uncles' opinions of teenage behaviors and morals; Barbara's new Game Boy and how she can beat her brother (although boys are usually better at this she informs me—eeks goes my feminist consciousness); the overheard conversation of their parents discussing the legal fracas at the beach—what the lawyer was saying would happen—in a discourse shifting between that of TV's Judge Judy and that of the legalese documents their parents were involved in (the party of the first party, counterclaim, statement

of defense, and so on) and a host of realities of their everyday lives. What Nina's daily life and the daily lives of many like her, have been like has been academically coined as hyper-reality, hypermedia, multi-medias, hypertexts, multiple modalities, multiple literacies, contexts, and discourses, or, as her grandmother describes it, multi-tasking.

Each one of these sources of knowledge and values was real for Nina and her friends. By this I mean, although they knew that, for example, Harry Potter was a fictional piece of work, perhaps what they did not realize was they were drawing knowledge and value from that source into their own constructions of self, others, and the world. In addition, recognizing clearly that the media source was a film, a TV show, or a cell phone call, the listeners and readers of Nina's texts will eventually, at a later date, incorporate, reject, challenge, and store knowledge and values from this moment and many others into their own realities. Although there are clear boundaries between the media sources, there will be, however, a blurring of the knowledge and values accessed, consumed, and constructed, in many cases, without examination or reflection. Much of the knowledge and values accumulated in that brief encounter on my back porch might disappear over time and space. Much of it will be threaded into other personal and social moments and act as authority and legitimization for thoughts, words, and actions in other times, places, contexts, and rationales.

How, in this hyper-world of multiple media, do pedagogues—those in a position of responsibility for and with children—conduct themselves? How critical pedagogues—those concerned about relationships of power with children and the world—intervene in children's access to knowledge and values when the young people are immersed in a world of hyper-realities is the focus of this chapter. To do so, I have created a term—*critical (hyper-) pedagogy*—to describe the multiplicity and complexity of living with young people and to help us as critical pedagogues to intervene and disrupt these hyper-realities produced by the multiple media sources such as those Nina continually accesses.

I consider that any personnel working with children are all involved in *hyper*-pedagogy; be they parents, teachers, or medical practitioners. On a larger scale, they may be family, community, schools, churches, media producers, or other institutions. Whether explicitly or implicitly, the world of hyper-realities is inhabited by hyper-pedagogues as a response to the multiplicity and complexity of a world populated by a host of media technologies. By media, I am referring to any medium that communicates knowledge and values; everything from oral to printed texts;; from telephones to cell phones; from auditory to visual texts; from billboards to architectural spaces; and from paperbacks to digital technologies. Indeed, the latter have the capacity to include multiple media and thus create hyper-realities such as those produced on my back porch by Nina and company.

Most, if not all, of what was accessed that day on my porch will not be part of these young people's school curriculum. Schools are not places where the informality and blurred boundaries of knowledge through multiple media are given attention for a variety of reasons. Traditional ways and sources of teaching and learning, especially those based on scientific rationality, logical positivism, and objectivity and print media, have anchored themselves so strongly in school curricula that the introduction of multiple media, espe-

cially the influx of popular culture, meets with a host of skepticism and rejection. Furthermore, media studies informed by critical theories and practices seem to create an agitated uneasiness among many pedagogues, both in and out of school contexts. Perhaps it is because critical media studies examines sensitive and political issues that challenge personal beliefs and identities and upsets the proverbial "status quo, common-sense" apple cart of society and institutions.

The near-critical pedagogical aspect of the back-porch interaction was that the children, Nina and her friends, held a power over me, the adult. This circumstance is indicative of a space that critical media studies hankers for in and out of school. I barely followed the conversation. Nina and her friends bounced from topic to topic using different media modes yet maintained, to them, a comprehensible, logical form of conversation. In any other context, especially the formality of class discussions and evaluation schemas (including the multi-dimensionality of rubrics), Nina and company would have been considered illogical, off-topic, hyper-active (ADD?), and a host of other deficit categories. In a world of multiple media and hypertexts it was, however, for a postmodernist, critical theorist like myself, a dream come true. There were many moments when I could be silent, mediate, intervene, challenge, question, disrupt, and just join in and enjoy—a space and time for me to be a critical hyper-pedagogue!

Parents and teachers alike are, in some ways, already hyper-pedagogues; always on the alert for media content that is complicit, contradictory, or in conflict with the norms of the family (personal level), community, and institutions such as schools, churches, and businesses. This awareness does not necessarily mean, however, their vigilance is informed by critical theories and discourses. Frequently, agents of intervention may examine media content but possibly only because it does not support what is taken as "common sense" or is "not the norm[al]" or "does not fit with our values," and hence the examination is dismissed or censored. That is unrealistic given that from birth most children today are saturated in multiple media and accessing knowledge and values even when parents, teachers, and society think they have total control over the postmodern world of children. Moments such as I experienced with Nina and friends happen just as much and as often in their private spaces and times (the walk over, school hallways, beach house gatherings, and so on) in the absence of a pedagogue as they do in the presence of a pedagogue. Thus, when the spaces and times are afforded a hyper-pedagogue, in and out of school, we need to be prepared to intervene (even non-intervention is a political act as discussed later in the chapter). Critical hyper-pedagogues cannot rest, dismiss, or censor any content from any media source.

Pedagogical Shifts and Changes

Once pedagogues recognize and accept that hyper-realities exist for most children, it becomes no longer a question of isolation and censorship from the multiplicity and complexity of their worlds but an active engagement with the children and these texts. A commitment, however, to employing the discourses and practices of critical media literacy

demands a specific kind of engagement that hyper-pedagogues can work to accomplish. Pedagogues may utilize a plurality but not be critical. The age of liberal pluralism, a construction of the modern era, where "anything goes" and everyone's individual opinion is heard yet left as mere opinion, is not applying a critical analysis of media texts, whether single or multiple.

One of the first shifts for a critical (hyper-) pedagogue is the move from singular notions of what counts as a text and as literacy. Until recently, the printed text, mainly the book, was the primary medium for which literacy in the literal sense was necessary in order to access and interpret the message and the meaning. In other words, with it came the definition of literacy to mean reading a printed text; learning the letters, words, grammar, punctuation, and comprehending the content. In the field of literacy studies, this interpretation has changed drastically. Texts are multiple; they are oral, visual, printed, auditory, and digital. In fact, borrowing from Paulo Freire, the world is a text. No longer are we considered literate if we can read words but all kinds of symbolic texts, each carrying specific codes and meanings. Literacy has been pluralized to literacies, and a person possesses many literacies. For example, I am literate about curling, a winter sport that many Canadians play. I can play the sport, read books, watch TV shows, read magazines about the sport, talk with friends who also play the sport, write about it for others to read, play a video game version of the sport, know the terminology, and even teach the sport to beginners. I can go to several media texts and "read" about curling. Others are not literate about curling, even though they may read the words, see it being played at the Olympics, see posters, and even laugh at the sport with David Letterman on late night TV. Not only can we access many media sources about a topic, issue, or area of study, we can access many different readings and texts on the same topics through the immediacy, complexity, and multiplicity of digital technologies. These factors shift pedagogues into the world of hyper-texts and hyper-realities, but not necessarily into the world of critical media literacies.

Working Definitions of Critical Literacies

Some working definitions might clarify what constitutes critical literacy. Comber and Nixon (in Evans, 2005) define critical literacy as "the use of language [text] to exercise power . . . to question [and expose] representations and practices of privilege and injustice." Evans (2005) claims critical literacy is a way of "having children look at ways language and images work to represent and misrepresent, include and exclude [knowledge, values beliefs, and so on] and maintain dominant discourses" (p. 128). Alvermann et al. (1999) refer to several other authors' definitions that state:

> Critical media literacy is defined as having to do with providing individuals access to understanding how the print and non-print texts that are part of everyday life help to construct their knowledge of the world and the various social, economic and political positions they occupy within it (p.1).

Another definition reads:

Critical media Literacy is also about creating communities of active readers and writers who can be expected to exercise some degree of agency in deciding what textual positions they will assume or resist as they interact in complex social and cultural contexts. (Alvermann et al., 1999, p. 2)

Here is yet another definition:

Critical media literacy is concerned with the specificity of reading positions and cultural productions on the one hand and, on the other, concerned with the politics of power/knowledge regimes in the media(ted) constructions of identities and knowledge. (Luke, 1998, p. 23)

Although these definitions do not cover all aspects of critical media literacies, they do point to several key areas that distinguish critical literacy from a singular, traditional definition of literacy. In addition, these definitions act as a starting point for hyper-pedagogues to re-consider what, why, when, and how to intervene in the knowledge and value production of children garnered from multiple media sources. In other words, the combination of multimedia and critical media literacies definitely creates a world of hypertexts, hyper-realities, and hyper-pedagogy. This hyper-world produces a different landscape for pedagogues (please note that I am not using the term *hyper* as a psychology discourse with negative connotations; in fact, just the opposite). Thus an awareness of several key features of how this hyper-world intensifies and changes the relationship between the critical pedagogue and children leads to shifts in our thinking and practices.

The first impact this hyper-world might have on the pedagogical relationship is that parents, teachers, news reporters, and others need to turn their attention away from the blaming of media for inappropriate social and violent acts by individuals. It appears there is more violence in the real world than there is in different media content. Perhaps pedagogues might re-direct their gaze to actual social conditions for children, such as poverty and school practices of standardized testing, as a source of violence. Instead, pedagogues can use the multiple meanings, variety of content and contexts, and the pleasure children derive from the many media technologies they encounter daily to engage children in critical literacies. The key element to be a child and a learner is the opportunity to play with reality, bend it, twist it, challenge it. In critical media studies some initial premises are:

1 knowledge is no longer contained in one text as authority
2 knowledge is now fused, fragmented, and unstable
3 knowledge becomes a set of stored competencies
4 certain knowledge produces a set of power relations that produce certain forms of subjectivity and identity
5 certain groups appropriate media for ideological and commercial ends
6 high and low culture are collapsed through multiple media
7 discourses are carried through media
8 although different in form, different media can work to carry dominant messages
9 certain forms of knowledge and values are produced and circulated through media but not others
10 multiple media create different learning environments

11 learners are exposed to various discourse communities

12 multiple media are increasing the semantic domains available to users

13 learners are assembling new semantic domains and resources at an exponential rate

Critical (hyper-) pedagogues work differently with the thirteen points. In fact, they change what counts as teaching and learning in a world that creates a variety of sites and content. With this change in mind, they engage learners in reading, interpreting, questioning, challenging, and re-thinking social practices and alternatives to everyday, local, and global injustices and exclusions.

Recognizing Critical (Hyper-) Pedagogy

An actual example (that I have bent slightly for literary and anonymity reasons) might help to clarify what the points presented above mean for hyper-pedagogy.

A friend found her fourteen-year-old son using the home computer to access pornography sites. She knew that censoring his access to these sites or to the computer as consequences for his actions would perhaps lead him to go elsewhere and/or wait until she was gone from the house. She used this moment as an opportunity to intervene and open conversations about many topics—objectifying women, the porn industry, and who makes money; teenage sexuality; the implicit (soft?) pornographic messages hidden in soap operas, teen TV shows, mainstream movies (even those with a G/PG rating), and magazines; how his friends use sex as a vehicle for social belonging—whether in discourse or actual fact; the use of condoms for safer sex; responsibility for self and others. She was able to go to many different media technologies including phones (sex), video games, books, neighborhood parents (oral media—for different approaches to "handling the situation"), a teacher in the local community (what are they doing in schools?), and me (an academic working in education and critical literacies). She gathered thoughts and solutions from these many different media sources and brought them back to the central question of "why she did not want her son watching pornography." From the field of knowledge and beliefs she accumulated, she and her son engaged in discussions about several issues and made choices for future actions.

At the same time, the variety of opinions and media sources was influencing how her son shaped his identity. The tug of peer pressure, teenage conformity and belonging, mainstream constructions of masculinity and sexuality were silent partners in what the mother brought forward and what the son used as means to shape his identity and actions. The mother, in this case, knew that she did not want her son to watch pornography, but censorship was not an option. She sensed the conflict between her world (as pedagogue) and that of her son's regarding pornography, sexuality, masculinity, and between the different decade of forty years ago in which she lived as a teenager and the media-saturated contexts her son inhabits. She, however, and perhaps unknowingly, employed a host of realities and media, used the hyper-reality of her son's era, positioned herself as a hyper-pedagogue, seized

upon several media technologies including the orality of her neighbors' input to reach a level of complexity and multiplicity that no one text (including her singular authority as a parent) or media source could do.

However, as with any hyper-text/pedagogical process, there were gaps and contradictions in her hyper-pedagogical discourses and interventions noticed mainly by me, an academic with a knowledge of critical theory especially in the application to textual analysis of media and everyday discourses. Although the parent questioned and used several different media sites to examine issues of pornography in her son's life and seemed to implicitly understand the peer pressure he was subjected to, she still was not applying critical literacies to the texts she used. For example, her comments about how teenage boys have a natural sexual drive more so than girls, strongly suggests how she *psychologized* (drives), *pathologized* (will always be so, therefore will never change), *naturalized* (not culturally constructed) and *essentialized* (reduced male behavior as if there was some "essential" "fundamental" aspect to being male—a boy) masculinity and male sexuality. Her assumptions about what constitutes masculinity (boys will be boys) and male sexuality (heterosexuality) still privileged her son's actions as legitimate based on mainstream, biological, natural, and non-critically informed knowledge.

As a critical theorist and critical pedagogue, I informally inserted questions and comments into her teaching process (delicately trying not to jeopardize our friendship) such as:

1 "On what basis are you saying it's *natural* for boys to *need* to watch pornography? Girls too?" (In other words, I was asking her to reflect on where her understanding came from and how it did or did not inform her decisions and actions.)

2 "Where do you think this 'drive' comes from?" (With this question I hoped she might see how her knowledge was constructed by individuals; her history; by society and institutions; by printed, visual, and other texts)

3 "Be careful, it sounds like you think we can't change boys'/men's attitudes and behavior such as objectifying and abusing women?" This comment created a lot of tension in our relationship and does often when I, as a critical feminist, introduce it at informal gatherings or in a conversation with neighbors and friends! Critical [hyper-] pedagogues seem to agitate and disrupt a lot of people's assumptions and beliefs. The struggle is when to and how to check our own assumptions and interventions.

4 "I wonder in how many places and times, teenagers of today and tomorrow are actually accessing pornography when adults aren't around (remember the son was "caught" watching pornography on the home computer) and what we can do to have them think about the content other than "gawking" at it secretly?" (Again, my critical informed intuition or beliefs that censorship doesn't work and hyper-media and hyper-realities can be used to open up conversations to new possibilities for socially just worlds and to re-position media audiences to re-think and re-imagine alternative ways of knowing and being.)

Limitations of the Example

I am not presenting the example of my friend's involvement in (hyper-) pedagogy as an ideal process but as a way of demonstrating the possibilities that lie within the world of multiple media, hyper-texts, and -realities and how we might act as critical (hyper-) pedagogues. At another time, with another pedagogue, the matter might be handled quite differently. Each time I re-read and re-draft this chapter, I notice gaps and contradictions in my own thinking and practices. I used, maybe abused, my authority as an academic to intervene in my friend's pedagogical process with questions and comments that, to many readers, might seem arrogant. I legitimized my actions by positioning myself in the process more as a critical (hyper-) pedagogue than as her friend. To balance the responsibility in the multiplicity and complexity of hyper-realities and hyper-media worlds often leads to overwhelming struggles, sensitive discourse use, and more gaps and stumbles that open spaces for further study and challenges. These conditions are not readily accepted in a modern world where unified, categorical reductionism, positivistic truths, and knowledge and closure are the accepted norm.

Another element I keep noticing is that my examples are taken mainly from out-of-school situations; a result of the fact that government, schools, and many other mainstream institutions construct and control the curriculum so tightly that the integration or implementation of the host of media texts and content seems limited or non-existent in these locations. The opportunity in schools to explore and examine issues of pornography and the "trillions" of other social issues, conditions, and practices from the multiple perspectives that critical multiple media studies offer "threatens established social order . . . a fear that culture as a set of practices, values and institutions is no longer controllable by ruling classes and intellectuals" (Collins, 1989, pp. 8–9) in schools. In the world of hyper-realities, and hyper-pedagogy with the multiple sources and conflicting discourses, beliefs and practices available through multi-media, there is-neither finality nor singularity in meaning or actions. We, as critical (hyper-) pedagogues, need to celebrate, incorporate, include, disrupt, and challenge the vast scope of realities and alternatives, fictional and real, that are available to children and students in order to shape a socially just and inclusive world.

Exploring Possibilities for Critical (Hyper-) Pedagogy

To this point, my argument has been that using critical media studies presents pedagogues golden opportunities to create spaces and times in which to explore just about any area of culture, history, knowledge, and values that exists on the globe. With the addition of critical theories to the mix, the spaces and times to explore texts are unlimited. As you gathered from the examples of Nina and my friend, I hope that parents, teachers and pedagogical institutions will take advantage in this postmodern age, not to censor, reject, or control the vast availability of media technologies, from books to video games (see Gee, 2003), from oral texts to music, from TV to computer hypertexts. I think of the years, I spent on lesson planning at all grade levels from K-12 and even at the university level. Nights, days,

and weekends were spent searching for texts to use, activities to "motivate," group discussions rarely of interest to the students (although when you left the group, they found several other topics to stay focused on!); collecting materials for centers; inventing and creating novel situations that supposedly produce new knowledge and new ways of thinking. Nowadays, a critical (hyper-) pedagogue can take advantage of hyper-media worlds and open the texts to critical readings, discussions, writing, and evaluation. Evans (2005), and many others, describe many considerations and possibilities for moving literacy "beyond" the book and into hyper-textual pathways.

What seems most useful for critical (hyper-) pedagogues to gradually shift into the world of critical media studies is a list of questions and concepts specific to critical studies. In addition, picking up the discourse of the field helps to generate new thinking about what and how to analyze any media texts. Please note that modeling these questions and discourse are helpful for any learner starting at birth. I agree with Grant and Lord (cited in Marsh, 2005) and many other critical theorists and practitioners who are "contesting developmental discourses that position young children as incompetent or as unready for complex [media] literate practices [and I] do not accept normative [or outcome-based] models of literacy development that take it for granted that text analysis and production are for older children."(p. 221).

Possibilities for Entering Critical Media Pedagogy

The subsequent list of critical questions, comments, and conceptual discourse is meant to offer ideas to-(hyper-) pedagogues using multiple media as sources of knowledge and value.

1 To encourage pedagogues to re-consider their practices and beliefs and make a gradual shift into critical literacies, I usually first ask a simple question about *power*. Using the sentence Who _____ counts (has power) and who _____ doesn't (have power)? or What _____ counts and what _____ doesn't count?: The blank can be substituted with any word, issue, discourse, or practices; with words such as knowledge, truth, values, identity, actions, policies, literacy, voice, story, history, representations, sexuality; class, race, gender, or religion; or economic, political, intellectual, social; or individual, institutional, and civilizational (West/East), and so on. Even with university students, I repeat these sentences over and over, at the beginning of courses, throughout, and until the end. I have used it with kindergarten students and they "get it." Parents co-opt it. I always try to bring a discussion, essay, or ideological discourse (liberal humanism, existential individualism, constitutional discourse) back to power and power relationships. Once this structure initiates an understanding of a basic premise of critical literacies, and students recognize the axiological points and movement (when power from one domain crosses with another to shift the power relationships—no power is a fixed unit) then I move on to how and when did it get to be this way? Who is privileged and who is marginalized/excluded by

this power? How is specific power produced, maintained, and circulated? It is here that intellectual, pedagogical tensions emerge when the complexities, complicity, contradictions, conflicting messages, and dualistic constructs (binarisms) are revealed both within a text and between texts. Then back to that initial question—whose *authority/ideology* counts? The difficult task for the critical (hyper-) pedagogue is to provide spaces, times, and personal/social safety for the participants within a field of conflicting voices.

2 In much of the literature on critical media studies, a major area of focus is that of the impact of media on *identity formation*. Academically, the term that helps to understand what this means for pedagogues can be accessed on the Internet under *interpellation*. To interpellate is to identify with a particular idea or identity. "For example, if someone were to shout your name at you in the street, you would interpellate that salutation to mean yourself. It is basically thinking 'that means me.' It is the process by which you recognize yourself to belong to a particular identity. . . . Interpellation specifically involves the moment and process of recognition of interaction with the ideology at hand. . . . When the individual recognizes the system that he or she is working within, such as the creation of gender while clothing shopping or cross dressing, she/he interpellates him/herself." (www. Definitions of *Interpellation*. From Wikipedia: the free encyclopedia, accessed August 16, 2006).

Questions and discussions in the spaces and times of which critical (hyper-) pedagogues take advantage includes those surrounding identity formation of the media consumer, for example:

a What qualities does this character (in the media text) possess that you admire? Don't admire? Why?

b What personal qualities/ideas/actions would you like to possess that this character displays? Why?

c In what ways does this character re-produce or with dominant ideas about what a person should be like? Should do? Shouldn't be like? In what ways and why is this character constructed to 'fit' with what a person in reality should be like? Why do you think so?

d In what ways is this character constructed by the media text to influence/shape your/our identity?

e With what ideology do you think this character works? In what ways and why? How is it a dominant, negotiated, or resistant identity?

f How have the producers constructed this character to make you identify with him/her or not? What features call you to be like this character?

g How has this character's identity made you re-think discourses (language) and practices that will transform social policies, practices, and relationships?

3 Intertextuality is another major feature of critical media pedagogy especially brought into text analysis by the volumes of texts and technologies available.

Intertextuality is "the shaping of texts' meanings by other texts. It can refer to an author's borrowing and transformation of a prior text or to a reader's referencing of one text in reading another. Some postmodern theorists like to talk about the relationship between "intertextuality" and "hypertextuality"; intertextuality makes each text a "mosaic of quotations" (Kristeva, 1980), and part of a larger mosaic of texts, just as each hypertext can be a web of links and part of the whole World Wide Web (www). Notable examples of intertexuality include animated series like *The Simpsons*, *Futurama*, and *Family Guy*, which are very heavily dependent upon intertextual references as a source of humor [and excellent starters for critical theories and practitioners] (http://en.wikipedia.org/wiki/). Although there are several definitions and uses made of the concept of intertextuality, each one provides further and different ways to interact critically with media texts. Questions that direct a reader to intertextuality within and between texts (to mean any type of media text such as oral, printed, visual, and so on) might be:

a What references are made in this media text to other texts on the same topic? How does this intertextual referencing make you re-think or challenge the 'common sense' of the original text?
b In what ways does intertextuality occur within the same text you are reading/watching/using? Why do you think the author used this strategy?
c What references in the text you are using/reading are in conflict, contradictory, complicit, or a negotiation with other texts both imaginary and real?
d In what ways does the intertextuality both within and between texts (to mean any type of medium) reproduce social injustices, exclusions, stereotypes of gender, race, class, religion, and so on?
e In what ways can you use intertextuality and hypertexts to change social policies, practices, actions, and promote social justice in family, school, community, church, among peers, and other social areas?

The three areas discussed above, power, identity formation, and intertextuality are just starting points for critical (hyper-) pedagogues to use. I find these areas mushroom as they are used as a foundation for investigating the multitude of media texts. A dictionary of terms discussing critical theories and terminology is very helpful to support the expansion of a critical (hyper-) pedagogue's repertoire and sets of competencies for examining and critiquing the volumes of media that are accessible in today's postmodern, technologically saturated world.

Final Considerations

Schools and other institutions miss many opportunities to use media as pedagogical means to shift discourses and practices. Imagine the discussions around TV shows that engage stu-

dents in de-centering from mainstream, dominant constructions of sensitive topics such as sexuality. A deconstruction of the prevalence of heterosexual discourse and practices that saturate most of mainstream television including children's and teenagers' shows would lead to a survey, examination, and critique of the various representations of sexuality. With the plethora of media texts available to do so, it is incomprehensible why schools, society, and other institutions are not demanding that media studies and technologies transform, like Bakhtin's carnivalesque, traditional boundaries between curriculum disciplines and peda-gogical relationships. Through multiple media, students become exposed to a host of semantic domains on one topic, such as sexuality. They, with the guidance, disruptions, and critically oriented questions and challenges to their thinking provided by a critical (hyper) pedagogue (herself/himself engaged with an understanding and use of multiple media) move between the various discourse communities that shape knowledge, values, and identity.

Critical media literacies are concerned chiefly with transformations in social practices. If media literacies just means to read multiple texts; to engage students in entertainment and motivation; to accumulated knowledge and values, then we are shortchanging our chil-dren, students, and learners of any age. To read the word and the world, to teach towards social justice, inclusivity, and equity is the responsibility of critical (hyper-) pedagogues at the individual, societal, institutional, local, and global levels. Again, we cannot rest, cen-sor, or dismiss the complexity and multiplicity of this saturated media world.

REFERENCES

Alvermann, D. E., Moon, J. S., & Hagood, M. C. (1999). *Popular culture in the classroom: Teaching and research-ing critical media literacy.* Newark, DE: International Reading Association.

Collins, J. (1989). *Uncommon cultures: Popular culture and post-modernism.* New York: Routledge.

Comber, B. & Nixon, H. (2005). Children reread their local neighborhoods: Critical literacies and iden-tity work. In Evans, J. (Ed.). *Literacy moves on: Popular culture, new technologies, and critical literacy in the elementary classroom.* Portsmouth, NH: Heinemann.

Evans, J. (Ed.). (2005). *Literacy moves on: Popular culture, new technologies, and critical literacy in the elemen-tary classroom.* Portsmouth, NH: Heinemann.

Gee, J. P. (2003). *What video games have to teach us about learning and literacy.* New York: Palgrave Macmillan.

Kristeva, J. (1980). *Desire in language: A semiotic approach to literature and art.* New York: Columbia University Press.

Luke, A. (1998). Getting over method: Literacy teaching in "new times." *Language Arts, 75.*

Marsh, J. (Ed.). (2005). *Popular culture, new media and digital literacy in early childhood.* New York: Routledge -Falmer.

About the Contributors

Alper, Loretta. Since joining Media Education Foundation in 2001, Loretta Alper has written and produced several films including *Captive Audience: Advertising Invades the Classroom* and *Class Dismissed: How Television Frames the Working Class*. She served as the Executive Producer/Script Supervisor on a number of other titles including *Toxic Sludge Is Good for You*; *Rich Media, Poor Democracy*; *No Logo*, and *Spin the Bottle*. Before coming to MEF, she was a high school English teacher for six years.

Anderson, Philip M. Philip M. Anderson is a Professor and the Executive Officer in the doctoral program in Urban Education at the Graduate Center and Professor of Secondary Education at Queens College of the City University of New York. His most recent publications include chapters on aesthetic education, social class in schooling, curriculum and pedagogy. He is a co-editor of the *Praeger Handbook of Urban Education*.

Berry, Eleonor. Eleonor Berry is a graduate student in the Department of Integrated Studies in Education at McGill University. Her research interests emerge out of a critique of global education. In particular, her work focuses on the role of art and technology in the modeling of integral awareness.

Berry, Kathleen S. Kathleen S. Berry teaches Critical Studies, Literacies, and Drama at the University of New Brunswick, Canada. She has published several books and chapters on the impact of critical postmodernism's complexity and multiplicity on pedagogical and research practices, most recently *Rigour and Complexity in Education Research: Conceptualizing the Bricolage* (Open University Press) with Joe Kincheloe.

Breen, Marcus. Marcus Breen teaches in the Department of Communication Studies at Northeastern University, Boston. He has published in the fields of cultural and media studies with an emphasis on institutional economics in cultural industries and information and communication technologies in development contexts.

Brodeur, Jacques. Jacques Brodeur has 30 years experience as a physical education teacher. He started fighting the use of violence as a marketing tool to manipulate children in 1986. Since then, he has created many innovative ways to oppose violent entertainment targeting children and teens.

Chang-Kredl, Sandra. Sandra Chang-Kredl is a Ph.D. candidate in the Department of Integrated Studies in Education at McGill University. She has worked a number of years as an educator and administrator in early childhood education. Her research interests include children's films and literature and, within the context of Quebec's educational curriculum adding "viewing" to its list of language arts, she is studying how children's texts are 'practiced' in schools.

Chomsky, Noam. Noam Chomsky has often said that he does not like biographical sketches. We respectfully thank him for the years of words spoken and the pages of work which has enhanced both the world and our own scholarship.

Cucinelli, Giuliana. Giuliana Cucinelli is a doctoral student at McGill University in the Department of Integrated Studies in Education. Cucinelli is also a media professional, having worked in local newsrooms and independent production companies. She worked as a Production Coordinator for Discovery Channel's Emmy-nominated *How William Shatner Changed the World*. She is currently producing and co-directing several documentaries and is actively involved with youth media empowerment programs. Her area of interest is media literacy, youth culture, cultural studies and new media.

Davin, Bethany. Bethany Davin currently works in the City of Cleveland as a developer of commercial real estate.

Desautels, Anie. In her research, Anie Desautels uses personal narratives to explore prejudice, racism and intolerance. After working in different ESL contexts in Thailand for several years (from primary teaching to training teachers from the Karen hill tribe in a

Burmese refugee camp), Anie returned to her native Quebec, where she has lived and worked in Inuit settlements while completing a graduate degree in education at Montreal's McGill University.

Dolphijn, Rick. Rick Dolphijn lectures in the Cultural Studies Department at Erasmus University, Rotterdam, the Netherlands, and is a fellow at the International Institute for Asian Studies. Recent articles have been published in *Angelaki: Journal for the Theoretical Humanities* and *Gastronomica: the Journal of Food and Culture*. His dissertation (Foodscapes, Towards a Deleuzian Ethics of Consumption) was published in 2004 by Eburon Academic publishers and distributed by the University of Chicago Press. He is currently interested (both in research and in lecturing) in the arts, media theory, and urbanism.

Fairfield-Artman, Patricia. Patricia Fairfield-Artman is a student in the Education Leadership and Cultural Foundations doctoral program at the University of North Carolina at Greensboro. She is also a faculty member in the Communication Studies department at UNCG.

Fleischer, Lee Elliot. Lee Fleischer is a professor at New Jersey City University and is currently teaching social studies methods, special education inclusion, and curriculum courses for the New Pathways Alternate Program for Teaching in New Jersey. Currently, Dr. Fleischer is completing a book on Counter-Hegemonic Social Studies Teaching (Rottendam, Netherlands: Sense Publishers, 2007). He has also published numerous articles and chapters for books.

Furness, Zack. Zack Furness has a Ph.D. in Communication and he has been teaching college courses since 1999. In addition to his work with the *Bad Subjects* Collective, Zack has written for various academic and non-academic publications including *Mobilities*, *Social Epistemology* and *Punk Planet*. He is currently working on his first book, entitled *One Less Car: Bike Culture and the Politics of Cycling* (Temple University Press, forthcoming).

Gerbner, George. George Gerbner was one of the world's most influential and prolific media scholars. His critical theories and long-running research projects have changed the way we think about media institutions, messages, and impacts. The author of countless books and articles, his work has helped shape the academic discipline of communication and has stimulated social movements to alter the cultural environment. Michael Morgan has edited a seminal collection of Gerbner's works, *Against the Mainstream: The Selected Works of George Gerbner*, (2002, Peter Lang Publishing).

Giroux, Henry A. Henry A. Giroux currently holds the Global TV Network Chair Professorship at McMaster University in the English and Cultural Studies Department. He has published many books and articles. His most recent books include: *Take Back Higher*

Education (co-authored with Susan Giroux) (Palgrave, 2006), *America on the Edge: Henry Giroux on Politics, Culture and Education* (Palgrave, 2006), *and Beyond the Spectacle of Terrorism* (2006), *The Giroux Reader* (2006), *Stormy Weather: Katrina and the Politics of Disposability* (2006), and *The University in Chains: Confronting the Military-Industrial-Academic Complex* (2007). His primary research areas are: cultural studies, youth studies, critical pedagogy, popular culture, media studies, social theory, and the politics of higher and public education.

Hammer, Rhonda. Rhonda Hammer is a research scholar at the UCLA Center for the Study of Women and is a lecturer in education and women's studies at UCLA. Her publications include a number of articles and chapters in the areas of critical media literacy, cultural studies and feminist theory and practice. She is the author of *Antifeminism and Family Terrorism: A Critical Feminist Perspective* and co-author of *Rethinking Media Literacy: A Critical Pedagogy of Representation*, with Peter McLaren, David Sholle and Susan Reilly (Peter Lang, 1995).

Hant, Myrna A. Myrna A. Hant is a visiting scholar at The Center for the Study of Women at UCLA. Her research focus is popular culture/television with an emphasis on portrayals of mature women in the media. She is the author of articles on older mothers on popular television programs such as *Bewitched*, *All in the Family*, *The Sopranos* and *Curb Your Enthusiasm*.

Helyar, Frances. Frances Helyar is a doctoral student at McGill University's Faculty of Education. She is a broadcaster and elementary educator with degrees from the University of Toronto and the University of New Brunswick, and a diploma in Broadcast Journalism from the Seneca College School of Communication Arts. She is well known as the voice of the New Brunswick telephone company.

Herman, Edward. Edward S. Herman is Professor Emeritus of Finance, Wharton School, University of Pennsylvania. He received his Ph.D. in Economics from the University of California, Berkeley. Among his books are *Corporate Control, Corporate Power*; *The Real Terror Network: Beyond Hypocrisy: Decoding the News in an Age of Propaganda*; and *Manufacturing Consent* (with Noam Chomsky).

Hoechsmann, Michael. Michael Hoechsmann teaches media and technology in the Faculty of Education at McGill University. His research interests are in the area of youth, media, and multiliteracies.

Johnny, Leanne. Leanne Johnny is a doctoral candidate in the Department of Integrated Studies in Education at McGill University. In her doctoral research she is specializing in children's rights education. She is also working on projects related to cyber-bullying, censorship, and HIV/AIDS education.

Jones, Robert. Robert Jones teaches at New York University. His research focuses on machinima and mods as instances of transformative play within video game culture. He is also interested in digital cinema as participatory culture, Hollywood's convergence with the gaming industry, and the educational potential of video games.

Jordán, José Solís. José Solís Jordán is an Associate Professor at the University of Puerto Rico's Eugenio María de Hostos College of Education, where he teaches courses in the Social Foundations of Education and Educational Research. His books, articles, and presentations in Latin America and the United States are critical examinations of U.S. imperialist policies in the colony of Puerto Rico. José is a former Puerto Rican political prisoner. His activism today includes his work at the university, a political organization project for national liberation, activities with student groups, and a weekly radio show. He is currently engaged in an exploration of critical media studies in the context of teacher education.

Kalamaras, Jimmy. Jimmy I. Kalamaras is a doctoral student at the CUNY Graduate Center and an Adjunct Lecturer at Queens College CUNY. A native New Yorker, he is also an early childhood teacher in the New York City Public Schools. His areas of interest are Teacher Education, Cultural Studies, Media Literacy, Multiculturalism, and ESL education.

Kalmus, Veronika. Veronika Kalmus is Associate Professor in the Department of Journalism and Communication, University of Tartu, Estonia. Her current research interests are socialization in the informatizing society and value change in the context of societal changes. She has published in international journals and collections of papers including *Journal of Curriculum Studies*, *Discourse & Society*, *Journal of Baltic Studies*, and *Trames*.

Kellner, Douglas. Douglas Kellner is George Kneller Chair in the Philosophy of Education at UCLA and is author of many books on social theory, politics, history, and culture, including *Camera Politica: The Politics and Ideology of Contemporary Hollywood Film*, co-authored with Michael Ryan; *Critical Theory, Marxism, and Modernity*; *Jean Baudrillard: From Marxism to Postmodernism and Beyond*; works in cultural studies such as *Media Culture and Media Spectacle*; a trilogy of books on postmodern theory with Steve Best, a trilogy of books on the Bush administration, including *Grand Theft 2000* and his latest book *Media Spectacle and the Crisis of Democracy*. Author of *Herbert Marcuse and the Crisis of Marxism*, Kellner is editing collected papers of Herbert Marcuse, four volumes of which have appeared with Routledge.

Kincheloe, Joe L. Joe L. Kincheloe is the Canada Research Chair at the McGill University Faculty of Education. He is the author of numerous books and articles about pedagogy, education and social justice, racism, class bias, and sexism, issues of cognition and cultural context, and educational reform. His books include: *Teachers as Researchers*, *The Sign of the Burger: McDonald's and the Culture of Power*, *City Kids: Understanding Them, Appreciating*

Them, and Teaching Them, and Changing Multiculturalism (with Shirley Steinberg). His co-edited works include *White Reign: Deploying Whiteness in America* (with Shirley Steinberg et al.) and the Gustavus Myers Human Rights award winner: *Measured Lies: The Bell Curve Examined* (with Shirley Steinberg).

King, C. Richard. C. Richard King, associate professor of comparative ethnic studies at Washington State University, has written extensively on the changing contours of race in post–Civil Rights America. His work has appeared in *American Indian Culture and Research Journal, Journal of Sport and Social Issues, Public Historian,* and *Qualitative Inquiry.* He is also the author/editor of several books, including *Team Spirits: The Native American Mascot Controversy* (a CHOICE 2001 Outstanding Academic Title) and *Postcolonial America.*

Leistyna, Pepi. Pepi Leistyna is an Associate Professor of Applied Linguistics Graduate Studies at the University of Massachusetts, Boston, where he coordinates the research program and teaches courses in cultural studies, media literacy, and language acquisition. Leistyna has published articles in various scholarly journals, and his books include: *Breaking Free: The Transformative Power of Critical Pedagogy; Presence of Mind: Education and the Politics of Deception; Defining and Designing Multiculturalism; Cultural Studies: From Theory to Action,* and *Corpus Analysis: Language Structure and Language Use.* His recent documentary film with the Media Education Foundation is called *Class Dismissed: How TV Frames the Working Class.*

Linné, Rob. Rob Linné is associate professor and chair of Adolescence Education at Adelphi University. He teaches courses on youth culture, secondary school reform, youth literacies, and autobiographical writing. Much of his research literacy research focuses on the ways in which queer youth are portrayed in the media as well as how many youth are able to subvert mainstream understandings of sexuality through alternative readings. He is currently completing a book titled *Organizing the Curriculum: Perspectives on Teaching the Labor Movement.*

Lippard, Rodney E. Rodney E. Lippard is a doctoral student in the Faculty of Education at UNC Greensboro. His areas of research interest include queer theory and library science.

López, Antonio. Antonio López was a content provider for a groundbreaking Spanish language media and health CDROM produced by the New Mexico Media Literacy Project, *Medios y Remedios,* and created a multicultural media literacy curriculum, *Merchants of Culture.* As a producer of dozens of youth media projects, López has a background in print journalism that includes writing for *Hispanic Magazine, Urban Latino, Southwest Art, El Andar, In These Times, New Mexico Magazine, Native Peoples, Tricycle* and *Punk Planet.* He was a staff arts writer for Santa Fe's daily newspaper, *The New Mexican* and the *Albuquerque Journal.* Peter Lang Publishing will release his book on media education, *Media Mindfulness,* at the end of 2007.

Macedo, Donaldo. Donaldo Macedo is a full professor of English and a Distinguished Professor of Liberal Arts and Education at the Unversity of Massachusetts Boston. Internationally respected as a lecturer and author, he has published extensively in the areas of linguistics, critical literacy, and bilingual and multicultural education. His publications include: *Literacy: Reading the Word and the World* (with Paulo Freire, 1987); *Literacies of Power: What Americans Are Not Allowed to Know* (1994, 2006); *Dancing with Bigotry* (with Lilia Bartolomé, 1999); *Critical Education in the New Information Age* (with Paulo Freire, Henry Giroux, and Paul Willis, 1999); *Chomsky on Miseducation* (with Noam Chomsky, 2000); and *Ideology Matters* (with Paulo Freire).

Malott, Curry. Curry Malott, "The Roving Professor," currently teaches, skates and rocks out in Western New York. He is the co-author of *Punk Rockers' Revolution: A Pedagogy of Race, Class, and Gender* (with Milagros Pena, Peter Lang Publishing, 2004).

Mashburn, Leslie. Leslie Mashburn is an Assistant Professor of Reading Education at Georgia Southwestern State University in Americus, GA. She is also the director of the Pre-K program housed on the GSW State University campus. Leslie has presented at numerous local and national conferences including Georgia Educational Research Association (GERA), National Science Teacher's Association (NSTA) and the International Bergamo Conference.

McLaren, Peter L. Peter McLaren is Professor of Urban Schooling at the Graduate School of Education and Information Studies, University of California, Los Angeles. He is the author and editor of over forty books on critical pedagogy and critical social theory. His writings have been translated into 20 languages. McLaren lectures worldwide. His latest books are: *Critical Pedagogy: Where Are We Now?* (New York: Peter Lang, 2007) is co-edited with Joe L. Kincheloe, and *Pedagogy and Praxis in the Age of Empire* (co-authored with Nathalia Jaramillo) is forthcoming with Sense Publishers.

Mercado, Maria. Maria Mercado is an Associate Professor at New Mexico State University. She teaches bilingual education with research interests on better understanding the social context of language education, specifically in dual-language immersion education and biliteracy and bilingualism of young learners.

Meyer, Elizabeth J. Elizabeth J. Meyer is a doctoral candidate at the McGill University Faculty of Education. Her research interests include bullying, harassment and the related issues of sexism, racism and homophobia in secondary schools. From these comes her additional work on the influences of media on adolescent cultures and behaviors in schools. She taught high school French for five years.

Munshi, Soniya. Soniya Munshi is a doctoral student in the Sociology program at the

Graduate Center of the City University of New York and an adjunct instructor at Queens College.

Paakspuu, Kalli. Kalli Paakspuu is an award-winning filmmaker, cultural theorist, theatre and new media artist. She produced and directed the English World Premiere of *Les Mers Rouges* (trans. Leonard Rosmarin) at Toronto's Fringe Theatre Festival, 2005, and is now adapting it into a feature film. She currently teaches film studies at Wilfred Laurier University.

Paraskeva, João. João Menelau Paraskeva teaches at the University of Minho at Braga in Portugal. He is also a visiting professor at the University of Aberdeen, Scotland. An international scholar and lecturer, Paraskeva's research interests lie in critical pedagogy, social justice, sociology of education, and the social, cultural, and historical foundations of education. The author of many books and articles, he is a series editor with Edições Pedago in Portugal.

Pascarella, John. John Pascarella is a researcher, instructor, and doctoral candidate specializing in Culture and Values in the Department of Integrated Studies in Education at McGill University. Mr. Pascarella is a former inner city high school teacher and his work has appeared in books and journals that examine a cultural studies in educational contexts.

Prario, Benedetta. Benedetta Prario received her doctorate in Media Strategy at the University of Lugano, Switzerland, where she graduated in Communication Sciences and has worked as a teaching assistant and researcher since 2001. In 2005, she published her first book, *Le trasformazioni dell'impresa televisiva verso l'era digitale* (Peter Lang Verlag, Bern). Currently, she is studying the evolution of the value chain and the business models of Mobile TV.

Quail, Christine. Christine Quail is an assistant professor at the State University of New York College at Oneonta. Her writing involves media issues such as political economy, gender, race, technology, and media literacy. She is co-author, with Kathalene Razzano and Loubna Skalli, of *Vulture Culture: The Politics and Pedagogy of Daytime Television Talk Shows* (2005). Her latest book is with Peter Lang Publishing, *Media Literacy: A Primer* (2008).

Raj, Aditya. Aditya Raj is a doctoral candidate in The Department of Integrated Studies in Education at McGill Univeristy. His dissertation focuses on the Indian Diaspora Youth in Montreal with an emphasis on educational experience and identity negotiations within global-transnational nexus of subjectivity. His research interests also include Cultural Pedagogy, Sociology of Globalization, Comparative and Transformative Education, Sociology of Education, Transnational Citizenship, and Post-formal Research.

Raj, Papia. Papia Raj is a doctoral candidate in the Geography Department at McGill University. Her research interests include globalization, young adults in India and population dynamics.

Razzano, Kathalene A. Kathalene A. Razzano is a Ph.D. candidate in the Cultural Studies Program at George Mason University and Managing Editor of the *Journal of Social Philosophy*. She is co-author, with Christine Quail and Loubna Skalli, of *Vulture Culture: The Politics and Pedagogy of Daytime Television Talk Shows* (2005). Her research interests include media, gender, economics and welfare.

Reynolds, William M. William M. Reynolds is professor of curriculum studies in the department of Curriculum, Foundations and Reading at Georgia Southern University. He has authored, co-edited and co-authored books including *Reading Curriculum Theory: The Development of a New Hermeneutic* (1989), *Understanding Curriculum as a Phenomenological and Deconstructed Text* (1992), *Inside/Out: Contemporary Critical Perspectives in Education* (1994), *Understanding Curriculum: An Introduction to the Study of Historical and Contemporary Curriculum Discourses* (1995) and *Curriculum: A River Runs Through It* (2003). *Expanding Curriculum Theory: Dis/positions and Lines of Flight* (2004).

Richard, Birgit. Birgit Richard has been a Professor for New Media in Theory and Practice at the Goethe University in Frankfurt since 1998. Her fields of specialization include: aesthetics of everyday life (contemporary youth cultures, fashion, images of death in new media, popular culture, gaming: representation of women in computer games). She is editor of the *Kunstforum International Volumes* on *Fashion, Time, Images of Violence, Art and Life Sciences, Art and Magic* and Founder of the Youth Culture Archive.

Rishel, Teresa. Teresa Rishel is an Assistant Professor in the Department of Teaching, Leadership, and Curriculum Studies, where she teaches undergraduate and graduate courses in Middle Childhood Education and Multicultural Education. Her educational experience includes serving as an elementary principal and teaching elementary and middle level grades. Her research is on adolescent suicide and teacher-student relationships, the hidden curriculum, and effective methods of providing information, knowledge, and support to teachers about suicide.

Roselli, Anthony. Dr. Anthony M. Roselli is an Associate Professor and Chair, Education Department, Merrimack College, North Andover, Massachusetts. His most recent research involves literacy, sociolinguistics, and social context of schooling. He is the author of *Dos and Don'ts of Education Reform: Toward a Radical Remedy for Educational Failure* (Peter Lang Publishing, 2005).

Sabik, Cindy Meyer. Cindy Meyer Sabik chairs the English Department at Gilmour Academy in Gates Mills, Ohio. An adjunct professor, her recent scholarship places environmental literacy at the center of the curriculum.

Sansom, Adrienne. Adrienne Sansom has a Ph.D. from The University of North Carolina at Greensboro, where her focus has been on examining dance education as a means of critical pedagogy. She is a senior lecturer in dance and drama education with the Faculty of Education, School for Visual and Creative Arts in Education, at The University of Auckland, New Zealand.

Sensoy, Özlem. Özlem Sensoy is an assistant professor in the Faculty of Education at Simon Fraser University, where she teaches courses in social education, critical media literacy, and anti-oppression education. Her research examines the relationship between school-derived and media-derived knowledge about social groups.

Serafin, Gina M. Gina M. Serafin is a doctoral candidate at Rutgers University in the School of Communication. Currently an Assistant Professor at the County College of Morris, Gina has been actively involved in the development, delivery and assessment of media education programs in New Jersey, Pennsylvania, and Maryland since 1997.

Share, Jeff. Jeff Share's research and teaching revolve around issues of critical media literacy and young children. He also worked as the Regional Coordinator for Training at the Center for Media Literacy as well as taught Teacher Education, Mass Communication and Photography at various universities in the US and Mexico. Jeff now conducts professional development workshops for teachers, writes curriculum and continues his research on critical media literacy.

Shariff, Shaheen. Shaheen Shariff is an Assistant Professor at McGill University in Montréal, QC. Dr. Shariff's research and teaching are grounded in the study of legal considerations that impact educational policy and practice. She is currently Principal Investigator on two projects funded by Social Science and Humanities Research Council of Canada: 1) to study school policy and legal boundaries involving cyber-bullying and internet harassment; 2) to study the impact of Quebec's intercultural policies on ethnic students. She is also an Associate of the Centre for Human Rights and Legal Pluralism at McGill's Law Faculty.

Skalli, Loubna H. Loubna H. Skalli is a professor at the American University, Washington D.C. Her research and writings focus on gender, development, culture and communications. She is co-author of *Vulture Culture* (2005) with Christine Quail and Kathalene Razzano, and author of *Through a Local Prism: Globalization, Gender and Identity in Moroccan Women's Magazines* (2006).

Steinberg, Shirley R. Shirley R. Steinberg is an associate professor at the McGill University Faculty of Education. She is the author and editor of numerous books and articles and co-edits several book series. The founding editor of *Taboo: The Journal of Culture and Education*, Steinberg edited *Teen Life in Europe*, and with Priya Parmar and Birgit Richard, *The Encyclopedia of Contemporary Youth Culture*. She is the editor of *Multi/Intercultural Conversations: A Reader*. With Joe Kincheloe she has edited *Kinderculture: The Corporate Construction of Childhood* and *The Miseducation of the West: How Schools and the Media Distort Our Understanding of the Islamic World*. She is co-author of *Changing Multiculturalism: New Times, New Curriculum*, and *Contextualizing Teaching* (with Joe Kincheloe). Her areas of expertise and research are in critical media literacy, social drama, and youth studies.

Torres, Myriam N.. Myriam N. Torres is an Assistant Professor at New Mexico State University. She teaches multiple critical literacies, language arts methods, praxis and reflexivity, curriculum and pedagogy, and educational research. Her research and publications are in Latino education, family literacy, pedagogy of language, critical media literacy, critical discourse analysis, and research as praxis.

Wallowitz, Laraine. Laraine Wallowitz is an assistant professor of English Education at Adelphi University. A former secondary English teacher, she currently works with high school students and teacher candidates in the fields of critical and media literacy and gender equity.

Walsh, Daniel. Daniel Walsh is a doctoral student in the Urban Education program at The Graduate Center, CUNY with a specialization in the arts, humanities, and social sciences in education. He also teaches ESL methods and multicultural education at City College. As a founding faculty member of The International High School, Prospects Heights in Brooklyn, NY, he has worked to improve urban schools for immigrant students.

Weaver, John A. John A. Weaver is an Associate Professor of Curriculum Studies and author of *Rethinking Academic Politics* at Georgia Southern University and editor of *Popular Culture and Critical Pedagogy, (Post) Modern Science (Education)*, and *Science Fiction Curriculum: Cyborg Teachers, and Youth Cultures* (Peter Lang Publishing).

White, Carolyne J. Carolyne J. White is a collaborative urban scholar, professor, and chair of the Department of Urban Education at Rutgers-Newark.

Zinn, Howard. A professor, activist, and author, Howard Zinn has dedicated his life to the notion that the knowledge of history is important to people's everyday lives, and can be a powerful force for social change. Zinn is a champion of the notion that historical change occurs more through mass movements of ordinary people than through the wisdom and

insight of so-called Great Men. His best-known book, *A People's History of the United States*, is widely used to illustrate American history from this perspective.